EVERYMAN,
I WILL GO WITH THEE,
AND BE THY GUIDE,
IN THY MOST NEED
TO GO BY THY SIDE

GIORGIO VASARI

LIVES OF THE PAINTERS, SCULPTORS AND ARCHITECTS

TRANSLATED BY
GASTON DU C. DE VERE

WITH AN INTRODUCTION AND NOTES
BY DAVID EKSERDJIAN

VOLUME I

EVERYMAN'S LIBRARY
Alfred A. Knopf New York London Toronto

129

THIS IS A BORZOI BOOK
PUBLISHED BY ALFRED A. KNOPF

First included in Everyman's Library, 1927
Translation by Gaston de Vere first published in 1912; first published in
Everyman's Library, 1996.
Introduction, Notes, Bibliography and Chronology Copyright
© 1996 by Everyman's Library
Typography by Peter B. Willberg
Fifth printing (US)

US website: www.randomhouse.com/everymans

ISBN (US): 978-0-679-45101-3
ISBN (UK): Volume 1 978-1-85715-780-2
Volume 2 978-1-85715-781-9
Volumes 1 and 2 (boxed set) 978-1-85715-779-6

A CIP catalogue reference for this book is available from the
British Library

Library of Congress Cataloging-in-Publication Data
Vasari, Giorgio, 1511–1574.
[Vite de' più eccellenti architetti, pittori et scultori italiani.
English.]
Lives of the painters, sculptors, and architects / translated by
Gaston de Vere; with an introduction by David Ekserdjian.
p. cm.—(Everyman's library)
Includes bibliographical references.
ISBN 978-0-679-45101-3 (hard cover: alk. paper)
1. Artists—Italy—Biography. 2. Art, Renaissance—Italy.
3. Art, Italian. I. De Vere, Gaston du C. II. Title.
N6915.V322513 1996 96-26577
709'.2'245—dc20 CIP

Book design by Barbara de Wilde and Carol Devine Carson

Printed and bound in Germany by GGP Media GmbH, Pössneck

CONTENTS OF VOLUME ONE

CONTENTS OF VOLUME ONE

CONTENTS OF VOLUME ONE

INTRODUCTION

Giorgio Vasari's *Lives of the Painters, Sculptors and Architects* is the Bible of Italian Renaissance – if not all – art history. Like the Bible itself, however, its sheer length means it is almost never read from cover to cover. Confronted by this particular *magnum opus*, the issue of what to read becomes almost as important as the problem of how to read. Yet there is none of it I would wish to be without, and it is impossible to read and especially to reread it without being surprised as well as delighted.

Before Vasari's time the idea of paying so much attention to men who worked with their hands, and got dirty doing it, would have been virtually unthinkable. Leonardo da Vinci, Raphael, and Michelangelo, but above all Michelangelo, had changed all that, and Vasari was in a unique position to honour them and their fellows. (Here, and throughout this introduction, I refer to artists by the names by which they are currently best known.) His timing was fortuitously impeccable: he was born in 1511 and if he had been much older, he might have died before Michelangelo; if he had been much younger, he would have known less of the earlier periods. As it was he died in 1574, six years after the completion of the definitive edition of the *Lives*.

He was a painter and architect of distinction if not genius, which explains why he writes with such technical authority, but he also had the considerable advantage of not being a literary man by profession. As a result he is seldom tiresomely elaborate and over-rhetorical, and what his age might have thought raw, we find fluent and entertaining. He can be moving, but he is also very fond of a good story. We would have to read him even if he were a bore, because of the colossal volume of generally reliable information his book contains which is unavailable anywhere else, but happily he is not.

The first point to be made is that the *Lives* exists in two editions, the original one of 1550 and the expansion and revision of 1568, which is published here. The differences

xv

between them are considerable, but cannot detain us for long. The main ones are that the second edition is not only more substantial and more accurate than its predecessor, with over twenty completely new biographies and numerous corrections to the old ones, but also that its whole approach is more historically-minded. For all these reasons and many more, it is the one to read.

The making of the book, the extent to which Vasari received help from 'research assistants', the possibility recently aired that some of the more theoretical introductory passages may even have been written by other people, are all fascinating scholarly questions, but they too cannot be discussed in any detail. Suffice it to say that Vasari did a great deal of travelling, not only as an industrious and peripatetic artist, but also in the interests of his book. We can only speculate concerning how he gained access – when he did – to private collections, but it is worth remembering that in his day chapels were frequently locked and altarpieces were often covered up. In a revealing passage, Vasari states that he managed to see Bambaia's Tomb of Gaston de Foix, 'although it is difficult to obtain leave to enter that place'. No doubt a number of sacristans and others were persuaded to unveil the treasures in their care.

What is clear, however, is that very little about the *Lives* should be taken on trust, from the story of the book's genesis onwards. Vasari relates that the idea that he might help Paolo Giovio to write a 'treatise with an account of the men who had been illustrious in the art of design from Cimabue down to our own times' was hatched at a dinner party of Cardinal Alessandro Farnese's at an indeterminate date around 1543–6. Then when he took Giovio some of his notes, it was suggested that he should shoulder sole responsibility for the work. This account is generally – and no doubt rightly – thought to have the ring of untruth about it, although Gibbon's equally *ben trovato* set-piece on the birth of his *Decline and Fall* remains sacrosanct. Elsewhere, Vasari says the 1550 edition involved ten years' hard work, and the project was certainly well under way by 27 November 1546, when it is referred to in a letter from Giovio in Rome to Vasari in Florence.

INTRODUCTION

The *Lives* is a book that seems to provoke extreme reactions, with advocates inclined to see profundities in every aside, and critics no less eager to attack Vasari's prose and above all his factual record. Predictably, the truth lies somewhere in between, and what is more, such an immense book, which took decades to write and rewrite, cannot usefully be regarded as a simple unified whole.

At the beginning of the *Paradiso*, Dante remarks that the glory of the Prime Mover is more present in some places than in others. In a similar vein, Vasari is inevitably more illuminating about some people and places – and indeed periods – than about others. He is a child of his time, and the information he provides about artists living around 1300, such as Cimabue, with whom he starts, is necessarily different from the account he gives of a contemporary and personal friend like Francesco Salviati. Similarly, and this will be discussed more fully below, as an artist he is a Florentine, albeit by early adoption, and this affects which artists he considers and how much he knows about them. His loyalty to the Medici family is another obvious conditioning factor, especially in relation to patrons. The fact that he was born in Arezzo, and retained close links with the city, means that he is particularly well informed about its artistic production, whether home-grown or imported. The *Casa Vasari* in Arezzo, which is decorated with frescoes by Giorgio himself, is a testimony not only to his prosperity and position, but also to his affection for the place.

Inevitably, Vasari writes best from a position of strength, and his knowledge of even as major a school of painting as the Venetian is comparatively limited. A good or bad press from Vasari tended to have a considerable effect down the centuries, but posterity's general inability to fill in the gaps he left in the historical record only underlines what a fundamental contribution he has made to our sense of the period. It is also true that Vasari's conception of the whole progress of the arts has had an overwhelming influence upon subsequent criticism. What is not true, however, is that no artist can overcome Vasari's neglect or indifference. Both Giovanni Bellini and Giorgione, as Venetians, receive less than their just deserts in

the *Lives*, but this cannot be said to have harmed their posthumous reputations. Similarly, Vasari went in search of Duccio's *Maestà* in Siena, largely on the basis of Ghiberti's enthusiasm for it, but it had been removed from the high altar of the cathedral there in 1505, and he failed to locate it. After Giotto, Duccio is the most admired Italian painter of the fourteenth century, and no less an authority than the late Sir John Pope-Hennessy recently described the *Maestà* as 'arguably the greatest panel painting that has ever been produced'.

In both editions, and in spite of some changes to the order of the individual biographies, Vasari divided his book into three parts. Part I is concerned with art from the earliest times known to the author (as stated, he starts with Cimabue), and concludes with Taddeo di Bartolo and Lorenzo di Bicci, both painters of a somewhat conservative temperament active in the early fifteenth century. Part II begins with Jacopo della Quercia and ends with Luca Signorelli, and deals in essence with the *Quattrocento*, which in this context is not the same as the fifteenth century. It includes artists – Signorelli is a case in point, as is Carpaccio – who were active after 1500, but only partially assimilated what Vasari called 'the modern manner'. Conversely, artists such as Leonardo da Vinci and Bramante, who were already active in the 1470s and 1480s, are held over for Part III. In fact this final section is set in motion by Leonardo, and in the 1550 edition it was crowned by Michelangelo, the only living artist (apart from the obscure Benedetto da Rovezzano) to be included. By 1568, this principle of exclusion has been considerably relaxed, and the concluding *Life* is that of Vasari himself.

Each Part is preceded by a Preface, and the changes made in 1568 to those of Parts II and III amount to the most minor stylistic tinkerings. The Preface to Part I is a different matter: in both editions, it begins with a discussion of the excellence of ancient art and the regard in which it was held, then moves on to consider its decline, before concluding with its slow revival. At the very end, a now celebrated but seemingly original analogy is drawn between the birth, ageing and death of our bodies and a similar cycle in the arts. Furthermore, the notion of the 'rinascita' ('rebirth') of the arts, which has led to

their present perfection, is aired. In the 1568 edition, however, while the theoretical passages remain unchanged, and the broad structure is the same, the medieval section is more detailed and better informed. There is also a fuller discussion of the Arch of Constantine, whose value as an exemplar of artistic decline was already recognized in Raphael's *Letter to Pope Leo X*, and a clever insertion concerning the ancient bronze of the *Chimera*, discovered at Arezzo in 1554, which is used to demonstrate the quality the best Etruscan art was capable of attaining.

The Preface to Part II begins with a statement to the effect that the author wanted to do more than give a list of artists and their works. There then follows a summary of the achievements – but also the limitations – of the artists considered in Part I, and the preface is rounded off by an introduction to the second age. It also argues that a comparable three-part progression existed in antiquity, culminating in the works of Apelles and others. Finally, in the Preface to Part III the transitional nature of the arts in the second age is contrasted with their final flowering in the third age, and their ultimate perfection in Michelangelo, who in addition excelled in painting, sculpture and architecture. In both these prefaces, the examples given and the critical assessments of individual artists are intimately related to the more thorough evaluations contained in their respective biographies.

*

The 1568 edition of the *Lives* begins with a conscious intention to establish the ultimate founders of the modern manner. To this end, Vasari presents a painter (Cimabue), an architect (Arnolfo di Lapo, better known as Arnolfo di Cambio), and two sculptors, father and son (Nicola and Giovanni Pisano), in exemplary fashion. Cimabue is deemed to be the first painter who began to depart from the 'maniera greca' or Byzantine style, and one of the ways in which Vasari argues his case is on the basis of the evidence of drawings contained in his *Libro*, a personal visual archive which is used increasingly often and is increasingly reliable as he moves forward in time.

The *Libro*, which is frequently referred to *en passant* in the

Lives, is a fascinating enterprise, and one which has been much studied. Above all because Vasari framed and mounted his collection of drawings in a highly distinctive fashion, a considerable number of surviving sheets from the *Libro* have been identified. They reveal his taste, since most are of great quality, and also his range of reference, because quite a few are the only known drawings by artists of considerable obscurity who hardly even feature in the *Lives*.

Other *desiderata* for all the biographies, already adumbrated here, include an attempt at a family history, a date of birth and especially of death, together with any epitaphs, and a reliable portrait likeness. Ideally this would be a self-portrait, but for Cimabue he has to settle for a portrait in the Chapterhouse of Santa Maria Novella in Florence, ascribed by Vasari to 'Simone Sanese' (Simone Martini), but actually part of a fresco cycle now confidently attributed to Andrea da Firenze.

For Vasari, Cimabue's art – or what he imagined was Cimabue's art, since he famously credited him with Duccio's *Rucellai Madonna*, a mistake not corrected until 1899 – was hard to appreciate. The best he can manage on the subject of the *Rucellai Madonna* is that it was carried through the streets in triumph, because the people of the time knew no better.

A similar ambivalence is manifest in the discussion of Nicola and Giovanni Pisano, although their *Life* is a welcome addition to the 1568 edition. Here there is a genuinely perceptive awareness of the Classical basis of Nicola's style, supported by specific reference to a particular sarcophagus, which Vasari thought represented *Meleager Hunting the Calydonian Boar*, and believed was his point of departure when creating his style. No less fascinating is the digression in the form of a lengthy inscription quoted to prove that this same relief was used to adorn the sarcophagus of the mother of the Countess Matilda. If Vasari was pardonably inconsistent about recording inscriptions, signatures and dates, they nonetheless remain one of the most powerful means he exploited in order to understand the past.

Less reassuring for any estimation of Vasari as a critic is his failure to respond to the expressive language of Giovanni Pisano's pulpit in Pisa Cathedral. His willingness to examine

the beginnings of the great progress he chronicles is laudable, and he had as much if not more sympathy for the period in question as any of his contemporaries, but it would be misleading to deny that some of its greatest accomplishments were beyond his comprehension. Thus, whereas Nicola's pulpit in the Pisa Bapistery there is said to be made 'if not with perfect design, at least with infinite patience and diligence', Giovanni's in the Duomo, although also the result of hard work, is roundly condemned: 'It is a pity, truly, that so great cost, so great diligence, and so great labour should not have been accompanied by good design, and should be wanting in perfection and in excellence of invention, grace, and manner, such as any work of our own times would show, even if made with much less cost and labour.' For Vasari, who was obsessed with a particular vision of artistic progress, the idea of Nicola's stately Classicism being followed by Giovanni's highly charged Gothic was hard to take. Indeed, the immediately preceding passage, in which Giovanni's thwarted desire to visit Rome is recorded, becomes a kind of explanation. Later on, Vasari rationalizes the perceived shortcomings of artists as eminent and diverse as Dürer and Correggio in terms of their having failed to see the wonders of Rome. In fact, and although the evidence is not decisive, most modern scholars accept that both men visited Rome.

Arnolfo is another newcomer in the 1568 edition, although he has to share his *Life* with other architects, named and not. He wins more praise from Vasari, who effectively invented the term Gothic and intended it abusively, than might have been expected. The reason, of course, is that Arnolfo was the architect of Florence Cathedral, a masterpiece in its own right, but one which gained an added significance in Vasari's story because it was eventually crowned by Brunelleschi's dome.

The accuracy of Part I of the *Lives* is harder to assess than that of the two later sections, because more of the works discussed are lost, and independent documentary evidence is far from profuse. Artists who were plainly somewhat nebulous figures for Vasari often remain particularly murky to us too. Others, such as Buonamico Buffalmacco, were clearer in his

mind than they are in ours, as is shown by the fact that there is a solid catalogue of works that are now lost as well as a crop of good anecdotes from Boccaccio and Francesco Sacchetti in his biography. Some artists, especially of the first rank, we know better than he did, but it is remarkable how often, even then, he manages to mention what are still considered their major achievements.

By far the most important figure in Part I of the *Lives* is Giotto. This is hardly surprising since he had already been singled out by Dante in the *Purgatorio*, and been honoured by a commemorative roundel in marble in Florence Cathedral carved by Benedetto da Maiano and placed there at the instigation of Lorenzo de' Medici. Vasari's championing of Giotto is revealing, above all, of his desire from the outset to try to recognize achievement in its time. For if the evolution Vasari sought to chronicle was intended to be seen as an ascent leading up to the unsurpassable accomplishment of Michelangelo, then it was the very opposite of an effortless progression. On the contrary, Vasari understood that certain exceptional individuals had made a real difference. Giotto, *par excellence*, was one of them, and Vasari's account dwells on his wit and originality, but also on his particular brand of realism.

The story of Cimabue coming across the young Giotto drawing a sheep ('pecora') on a rock with a pointed stone while tending his father's flocks is no doubt precisely that, a story, but it reveals the fundamental importance of the study of nature for Vasari. Regardless of the extreme stylization of most of Vasari's own artistic production, which belongs to a style that has come to be labelled Mannerism, he presents the ten-year-old boy drawing from the life.

In spite of the justly famous anecdote about Giotto drawing a perfect circle freehand to impress the Pope's emissary, the majority of Vasari's comments on his art concern Giotto's realism. In part this has to do with a supposed ability to reproduce the appearance of actual people, not least in the form of portraits, but it also relates to the conviction that Giotto had transcended the 'rude Greek manner' of Cimabue. Nevertheless, this could not simply be a matter of praising technical verisimilitude, because there had been such advances

in that department since Giotto's day. What Vasari actually admired was Giotto's emotional realism, his genius for bringing the fear of the Annunciate Virgin or the religious fervour of St Francis at the Stigmatization to life. Significantly, the ultimate authority of Michelangelo is invoked, when he is quoted as saying that Giotto's *Dormition of the Virgin* – presumably the panel in Berlin – could not have been more truthful.

Vasari thought Giotto painted the frescoes of the life of St Francis in the Upper Church at Assisi, which many modern scholars would dispute. He discussed his late frescoes in Santa Croce in Florence at the start of his biography, and worst of all almost omitted the Scrovegni Chapel in Padua ('he made a Mundane Glory in the precincts of the Arena' – i.e. Last Judgment – is all he has to say). No doubt this was a matter of inaccessibility, and the private sphere fares far worse than the public throughout the *Lives*. Later on, and far more surprisingly given Vasari's perfervid devotion to the Medici, Benozzo Gozzoli's frescoes of the Journey of the Magi in their palace in Florence are passed over in half a line.

The *Life* of Giotto nevertheless remains a compelling account of the idea of a great artist, and is at the same time a crucial support for Vasari's undeniable tendency to praise Florentine artists above all others. In Part I of the *Lives*, indeed, Florentines and Sienese make up almost the entire strength, and the latter tend to be pretty brutally treated. The way Vasari writes about the Sienese painter Ugolino, who had after all been commissioned to execute the high altarpiece of Santa Croce in Florence, is typical: he is condemned for having clung to the old ways of Cimabue, and is only praised for the good craftsmanship of his work ('bella pratica' is the expression used).

The only non-Tuscan accorded a biography to himself in Part I, Antonio Veneziano, whose style is pure Florentine anyway, is turned into an exemplary victim. He moves to Florence to learn how to paint properly, returns home to Venice but is driven away by jealous rivals, and ends up coming back to Florence. Another non-Tuscan of great distinction, Giovanni da Milano, is reduced to little more than a bit-part player in the *Life* of Taddeo Gaddi, and it is Taddeo who is

credited with his masterly frescoes in the sacristy of Santa Croce.

*

As stated, the second part of the *Lives* is concerned with those artists who worked in what might be described as the nearly modern manner from the early fifteenth century onwards. The end of the previous section includes such figures as Gherardo Starnina, only comparatively recently conclusively identified as the artist previously known as the 'Maestro del Bambino Vispo' (the Master of the Lively Child), and Don Lorenzo Monaco, both of whom represent the delicate late Gothic manner that still dominated Florentine painting until the 1420s.

Vasari did not invent the notion of a radical break at around this time – it is already implied in the Preface to Alberti's treatise *On Painting* and elsewhere – but it has certainly conditioned our conception of Renaissance art. Whereas the start of Part I of the *Lives* is resolutely programmatic, Part II is less rigorously organized. Brunelleschi, Donatello and Masaccio, who were singled out by Alberti as founding fathers, and the first two of whom appear together in a painting in the Louvre sometimes attributed to Uccello, might have seemed inevitable fifteenth-century counterparts for Arnolfo, the Pisani and Cimabue, but Vasari saves them until later on. This does not mean, however, that the very first *Life* is not chosen with care. Interestingly, the artist selected to usher in the new age is neither a Florentine, nor a painter.

Jacopo della Quercia, who spent most of his working life in Lucca, Siena and Bologna, and was one of the unsuccessful competitors for the Florentine Baptistery Doors commission, is a truly modern figure. For all the romantic appeal of the effigy of Ilaria del Carretto in Lucca Cathedral, the child angels round the sides of her tomb are already chunky *all' antica* putti, and the reliefs on the façade of San Petronio in Bologna represent a brutal rejection of the sweet style of terminal Gothic. Amusingly, Vasari has no choice quotation from Michelangelo to buttress his admiration, although it is hard for us to believe that Michelangelo was not influenced

as well as impressed by what is arguably the most powerful depiction of the biblical narrative from the Creation to the Flood before the Sistine Ceiling.

Vasari then proceeds to consider a number of early Renaissance artists, notably Luca della Robbia, Paolo Uccello and Lorenzo Ghiberti, before coming to the trinity of Masaccio, Brunelleschi and Donatello, who are grouped together in that order. The *Life* of Uccello, in which his career is exploited to point a moral, is highly characteristic of an aspect of Vasari's method, far more ruthlessly laboured in 1550 than in 1568. This exemplary approach, and the associated suspicion that it necessarily involves Vasari in distorting the historical record, is one of the least winning aspects of the *Lives*. Vasari's anecdotes are of course marvellously entertaining, but only when they grow out of the characters he brings to life, not when they are exploited to prove a point. In the case of Uccello, the artist is presented as led astray by his obsession with perspective and consequently unable to take what would have been his rightful place as the greatest painter since Giotto. Fortunately Vasari forgets his own agenda in a virtuoso description of the fresco of the *Deluge* in the Chiostro Verde at Santa Maria Novella in Florence, and as so often enthuses over the emotional truth and dramatic realism of a narrative.

With Ghiberti, there are extremely thorough-going but also acute passages on his two bronze doors, together with Michelangelo's 'Gates of Paradise' remark, but the star turn is the discussion of the competition for the commission to execute the North Door. Here Vasari for once goes beyond conventional formulae of praise or blame, and does his best to explain why Ghiberti's *Sacrifice of Isaac* won the day. Five of the seven competitors are comparatively easily discounted: Donatello's relief was of good quality, but he did not finish it on time; Jacopo della Quercia's had good figures, but lacked refinement; Francesco di Valdambrino's had good heads and was well finished, but the composition was confused; Simon da Colle's was well made but poorly designed, and Niccolò d'Arezzo's had gauche figures and was poorly finished. Vasari makes much the same points in the *Life* of Brunelleschi, but finds it hard to explain what made Ghiberti's entry superior

to Brunelleschi's. Instead he praises Ghiberti's for its 'design, diligence, invention, art, and the figures very well wrought', and enlists the assistance of Brunelleschi and Donatello, who supposedly hailed Ghiberti as the worthy winner. The late fifteenth-century biography of Brunelleschi generally agreed to be by Antonio Manetti suggests a less magnanimous version of events.

Masaccio, Brunelleschi and Donatello preside over Part II of the *Lives* in much the same way as Giotto did over Part I. Whereas Ghiberti is implicitly criticized for draperies that hark back to Giotto, these three are, if not quite unsurpassed, certainly worthy of comparison with the best of the moderns. They each receive very different treatments, not least because Masaccio does not really emerge as a rounded character, whereas Brunelleschi had already been the subject of a full-length biography, but their modernity is constantly extolled.

In his consideration of the Brancacci Chapel frescoes, Vasari takes the unusual step of listing by name no less than twenty-five artists who learned their trade there. He also returns to the subject in the *Life* of Perino del Vaga, and furnishes the reader with an account which makes the same point in a slightly different way. Even more tellingly, when Vasari relates the story of Donatello dropping the eggs in awe in front of Brunelleschi's *Crucifix*, now in Santa Maria Novella, in both their *Lives*, neither version is redundant. It would be naive to try to determine which version is more 'true', since the differences are rather an acknowledgement of the fact that even our memory of an event may be subtly modified from one day to the next.

Brunelleschi and Donatello, like Giotto before them, are great artists who are also great characters. Their quips and pranks add spice to Vasari's chronicle, and this certainly contributes to their appeal. Whether a story such as that of Brunelleschi balancing an egg to win over the authorities at the Duomo and be allowed to start work on the cupola project, is based on an actual event is neither here nor there. It gives the flavour of the man, as do to an even greater extent the various sardonic *obiter dicta* attributed to Donatello. These occur in his own *Life*, where he responds to criticism of his

statue of St Louis of Toulouse for being 'goffo' (clumsy, foolish) by saying that Louis was a 'goffo' (fool) to have left his kingdom to become a friar, but also elsewhere. The aged Paolo Uccello unveils a disappointing late work, and Donatello – who is described elsewhere in Paolo's *Life* as his 'amicissimo' (close friend) – announces that this would surely have been the time to cover it up.

Lest it be thought that these *Lives* are all anecdote interspersed with the occasional list of works, it should be stressed that they also contain some of Vasari's finest critical writing. He has not been surpassed in his evocations of the shivering man in Masaccio's *Baptism of the Neophytes*, and of Donatello's *St George*, 'in the head of which there may be seen the beauty of youth, courage and valour in arms, and a proud and terrible ardour; and there is a marvellous suggestion of life bursting out of the stone'. As always, the idea of bringing dead matter – whether stone or paint – to life is fundamental, and never more so than in the tale of Donatello urging his statue of a prophet, nicknamed the Zuccone (pumpkin-head), to speak.

For the rest, Part II of the *Lives* remains predominantly an account of art in Florence, but there are of course exceptions, which will be discussed in due course. Painters such as Fra Angelico and Fra Filippo Lippi receive appropriate consideration, with the account of the piety of the former, who is recorded as having wept when he painted Christ crucified, contrasting nicely with the raciness of the latter.

According to Vasari, Filippo was taken prisoner by Barbary pirates and spent eighteen months as a slave, before a drawing of his master earned him his freedom. More colourful still are the tales of his seduction of a nun called Lucrezia Buti, the subsequent birth of their son Filippino out of wedlock, and other amorous escapades. Vasari even records the gossip that Lucrezia's family poisoned Filippo because of his misdemeanours.

On the critical front, Filippo's qualities are highly praised, albeit in somewhat contradictory fashion. He is credited with being the first artist to paint over-lifesize figures, and thus show the way to others, but elsewhere Vasari asserts that he was at his best on a small scale, notably in predellas. He also

lists a number of his contemporaries who own small pictures by Filippo. This is extremely unusual, a fact which underlines the extent to which Vasari's canon is of publicly accessible works. That this was not a reflection of a belief that only monumental art really counted is proved not only by the piece on Filippo's work on a small scale, but also by Vasari's enthusiasm for the likes of Don Giulio Clovio, the miniaturist, and Valerio Belli, the gem engraver. Furthermore, it seems unlikely that it is a simple reflection of what Vasari had available to him, although some doors must have been closed. Rather it suggests that he hoped his ideal reader would seek out the works discussed, and compare his views with the author's. Significantly, Vasari refers *en passant* to works by Andrea del Castagno in the Monastery of San Benedetto outside Porta Pinti in Florence, and then says 'of which there is no need to make mention, since they were thrown to the ground in the siege of Florence'.

If painters always remain Vasari's favourite subject-matter, then a fair amount of the second part of the *Lives* is also devoted to sculptors and architects. A group of the former – Antonio and Bernardo Rossellino, Desiderio da Settignano and Mino da Fiesole – are consciously given consecutive biographies, while the sculptural activities of Antonio Pollaiuolo and Andrea Verrocchio are by no means ignored. Non-Florentines predictably fare less well, with the Sienese Francesco di Giorgio and Vecchietta being forced to share a *Vita*: as regards sculpture, a single work by each is referred to – the former's bronze *Angels* for the high altar of the cathedral, the latter's bronze *Christ* for the Ospedale della Scala. In northern Italy, Bellano – who is called Vellano – merits a short life, but Riccio and Antico do not. Vasari remarks that most people mistake Bellano's reliefs in the Santo at Padua for Donatello's, and remain in adoration before them all day long – an extremely early description of the vice of name-worship.

Non-Florentine painters fare rather better. A case in point, who may well have benefited from his Aretine links, is Piero della Francesca, whose rediscovery is usually hailed as an early twentieth-century phenomenon (actually he was well thought of in the nineteenth century). No reader of Vasari

could fail to realize that he should be taken seriously, although he also exposes some of the critical limitations in the text. For Vasari, Piero is a masterly realist, whose capacity to create the illusion of night was an inspiration for posterity, a favourite theme this of Part II. Similarly, the verisimilitude of the *Victory of Heraclius over Chosroes* is singled out: at best this is refreshing, but it does not acknowledge that side of Piero which prompted Bernard Berenson to subtitle a book on him 'The Ineloquent in Art'.

Another non-Florentine with Aretine and even more personal links is Luca Signorelli of Cortona, who gave the eight-year-old Vasari jasper to cure his nosebleeds, and encouraged his passion for art. The *Life* of Signorelli, the excellence of whose nudes and foreshortenings is explicitly linked with Michelangelo, ends in highly programmatic fashion, and is intended to lead on to Part III. Interestingly, this whole passage is an addition made in the 1568 edition. The 1550 edition instead concludes with Francia literally dying of grief at the modernity and genius of Raphael's *St Cecilia Altarpiece*, and Perugino, unable to understand the criticism of his high altarpiece for Santissima Annunziata in Florence, retorting 'I have used the figures that you have at other times praised, and which have given you infinite pleasure; if now they do not please you, and you do not praise them, what can I do?'

As regards other parts of Italy, Vasari is inevitably uneven, but far fuller than anyone else. He is enthusiastic if confused about Bologna, and mixes up aspects of Cossa and Costa, but pens one of his finest word-pictures over Ercole de' Roberti's destroyed *Crucifixion* for the Garganelli Chapel in San Pietro. As so often, what appealed to Vasari was a combination of technical prowess as manifested in virtuoso foreshortenings and flawless perspective, together with emotional truthfulness. It is no coincidence that Vasari lived and worked in Bologna as a young man, and if some of his remarks concerning the hostility experienced by Ercole there represent the most thinly veiled of autobiographical utterances, then at least his stay opened his eyes to some Bolognese painting.

Vasari also worked in Venice, but tends to be denounced

for his ignorance of its artists and their works. It is indeed true that his *Life* of Jacopo, Giovanni and Gentile Bellini is not his finest hour, but especially in relation to Giovanni it is astonishing how much reliable factual information concerning his public production it contains. Of his altarpieces for Venice itself, Vasari lists his *Madonnas and Saints* in Santi Giovanni e Paolo (now destroyed), San Giobbe, San Zaccaria and the Frari, only missing out the altarpiece in San Giovanni Crisostomo and the St Vincent Ferrer altarpiece in Santi Giovanni e Paolo, which some scholars do not attribute to Bellini. He even gets them in nearly the right order, although as a rule it is never wise to accept Vasari's chronology in Parts I and II of the *Lives* without some other corroboration.

When it comes to lesser artists, Vasari is less reliable. Only one work by Cima da Conegliano is known to him, and his ignorance is concealed behind the erroneous assertion that he died young. Cima is one of a small army of artists bunched together under the banner of Carpaccio in a job-lot *Life* of a sort that clearly served a purpose for Vasari. There were many artists whom he either regarded as not good enough to merit a *Life* to themselves, or about whom he was insufficiently informed. By this expedient, he was at least able to slip them in. That ignorance was not always the reason is revealed by his few lines on Marco Basaiti (whom he calls Bassiti). After a description of Basaiti's high altarpiece for Sant' Andrea della Certosa, he remarks 'Many other works by this man could be enumerated, but let it be enough to have spoken of this one, which is the best.' Exactly the same formula occurs in the reference to Boltraffio at the end of the *Life* of Leonardo.

Not for the last time, it is hard to disagree, although in fact he discusses other pictures by Basaiti, which he ascribes to one Marco Bassarini, whom he takes to be a different artist. One of them is the *Agony in the Garden* now in the same room of the Accademia as the Sant' Andrea altarpiece. Carpaccio has the *Life* named after him because the much shorter and less detailed chapter in the 1550 edition, which is its point of departure, started off with him. However, Stefano Veronese (Stefano da Zevio), for one, is discussed at far greater length in the text of the 1568 edition.

INTRODUCTION

Throughout Part II of the *Lives* artists are judged in relation to the standards of Vasari's own age. The highest compliment is to suggest that their works are all but unsurpassed, but there is scant tolerance for those who fail to measure up. Already in Alberti's treatise, *On Painting*, it is argued that gold paint is less effective than yellow artfully applied at conveying the radiance of gold. This idea was also dear to Vasari, who mocks Cosimo Rosselli for trying to cover up the weaknesses of his frescoes in the Sistine Chapel with lashings of ultramarine blue and gold, even though he successfully fooled the Pope (Sixtus IV), 'who had little knowledge of such things'. Elsewhere, Pinturicchio is denounced for the same crime, and Vasari remarks on the oddity of Filippino Lippi having painted 'a Crucifix and two figures on a ground of gold', and on a gold ground *Trinity* by Albertinelli. The other side of this particular coin is to be found in the *Life* of Domenico Ghirlandaio, where he is singled out as 'the first who began to counterfeit with colours certain trimmings and ornaments of gold, which had not been done up to that time'. Vasari's conception of the history of art is not only founded on the idea that some artists are divinely inspired geniuses, but also presumes that technical developments are achieved by particular individuals.

*

The third part of the *Lives* is the longest, the most accurate, and also unquestionably the most intellectually absorbing. This does not mean that the colourful anecdotes come to an end, because on the contrary one has a sense of the maddeningly level-headed Vasari constantly dumbstruck by the idiosyncracies and even lunacies of his fellow artists. The ultimate *tour de force* in this vein comes with Piero di Cosimo, whose eccentricity is also apparent in his mythological subject-matter, but whose psychological distress is beautifully brought to life: 'He could not bear the crying of children, the coughing of men, the sound of bells, and the chanting of friars.' Pontormo is another artist who inspires a special kind of treatment because of his bizarre personality, but then so are Sodoma and Rosso Fiorentino.

The same could almost be said of Leonardo da Vinci, and it is no surprise that he was the person given the honour of introducing Part III. Indeed, the account of his angel in Verrocchio's *Baptism of Christ* prompting the master to lay down his brush can be read as an exemplification of the third age surpassing the second. In view of the fact that Leonardo was born in 1452, he was significantly older than almost every other artist discussed in Part III, apart from Bramante, who is the founding architect of the new age. Vasari explicitly wanted to avoid a straightforward chronological ordering: a list he made of death dates cross-referenced to page numbers in his manuscript draft of the 1550 edition of the *Lives* shows that he had determined on his own sequence of biographies at an early stage.

For Vasari, Leonardo the man is as compelling a subject as Leonardo the artist, because his personal grace and what we might call star quality 'did so much honour to painting'. His technical experimentation with oil pigments in mural painting, and even at times on panel, as with a damaged *Madonna* painted for Baldassare Turini, which Vasari saw in Pescia, could hardly be approved of. Furthermore, the artist's habit of not finishing commissions was anathema to the businesslike Vasari, but he was able to hail the achievements of the *Last Supper* and the *Mona Lisa*, which inspires a particularly vivid purple passage. It is salutary to recall that the former was already severely damaged by Vasari's time, and that he can never actually have seen the latter. It is a moot point whether he was more impressed by Leonardo's use of chiaroscuro, which is treated as yet another pioneering breakthrough, or by his ability to bend a horseshoe with his bare right hand.

The other Florentine herald of the third age is Piero di Cosimo, but before him come two north Italians – or Lombards, as Vasari calls them – Giorgione and Correggio. It is no secret that Vasari's factual grasp of Giorgione's career was distinctly rudimentary, and to make matters worse most of the works he singles out are untraceable. He refers to a *David* now in Braunschweig and to the almost entirely destroyed frescoes of the Fondaco dei Tedeschi, as well as to the *Christ Carrying the Cross* in the Scuola di San Rocco, which he elsewhere

attributes to Titian, but his placement of him is indisputably correct.

Again, one of the problems may have been that the majority of Giorgione's works were in private collections inaccessible to Vasari. The information we now have on Giorgione in the notes compiled by Marcantonio Michiel, which were not published until the nineteenth century, concerning such pictures as the *Tempest* and the *Three Philosophers*, resulted from his entrée into the palaces of his aristocratic contemporaries.

In the case of Correggio, Vasari evinces a remarkable appreciation for a painter whose style is unparalleled in the sixteenth century, and which might have been expected not to appeal to him since it is much less rigorous than the standard Tuscan style which Vasari knew best and practised himself. He gets his facts somewhat garbled, and adds a kind of supplement in the *Life* of Garofalo and Girolamo da Carpi, but understands not only the astonishing illusionistic daring of Correggio's dome frescoes, but also the intense sensuality of his painting of nudes, and especially of hair. The fact that he also gives particularly extensive descriptions of the *Notte* in Dresden and an *Agony in the Garden*, presumably the one now in Apsley House, London, underlines his admiration for Correggio's gifts as a painter of night scenes, but as so often he does not neglect his emotional force. Tellingly, he remarks on the laughing angel in Correggio's *Madonna of St Jerome*, and asserts that even the most melancholy spectator is moved to laugh by him, which indicates his understanding of the joyfulness of Correggio's religious paintings, all too frequently mistaken for frivolity.

Vasari's introductory triumvirate of Leonardo, Giorgione and Correggio represents a carefully pondered introduction to the third age, but it would have been impossible to continue indefinitely in such a systematic vein. Indeed, Piero di Cosimo might easily have found himself on the other side of the invisible divide, together with Carpaccio and Signorelli. Even more surprising, perhaps, are the late inclusions of Raffaellino del Garbo and Lorenzo di Credi. They should remind us not to look for too much system.

Nevertheless, another major block of biographies is represented by Bramante, Fra Bartolommeo (with Albertinelli as a sort of postscript), closely followed by Raphael. These three artists were connected by ties of personal affection as well as by stylistic influences, and Vasari clearly wanted to present them as important innovators too. He knew virtually nothing about Bramante's career in Milan, and misguidedly attributed some of his works to Bramantino in the *Life* of Garofalo and Girolamo da Carpi, but was well informed about his work in Rome, and writes about it with the authority one would expect from the architect of the Uffizi. The *Life* begins with a ruthlessly typecasting presentation of Bramante as the Brunelleschi of the modern age, but it can hardly be objected that Vasari's desire to stress a parallelism drove him to distort the historical record unduly in this instance.

Vasari alleges that Raphael instructed Fra Bartolommeo in the art of perspective, which may have more to do with Vasari's admiration for Raphael's gifts in that department – he particularly praises the perspective of the temple in the Brera *Marriage of the Virgin* in the *Life* of Raphael – and for a desire to suggest a *quid pro quo* arrangement than to imply any weakness of Fra Bartolommeo's. What is much more revealing is what Raphael could supposedly learn from the Frate, or – to put it another way – what Vasari particularly admired in the latter's art. He discusses Fra Bartolommeo's unique gifts as a colourist, and the ability he possessed to create lifelike flesh-tones and relief through the use of deep shadow. Vasari almost never discusses the colour-schemes of pictures in any detail – he cannot have made colour notes although others did – and colour is often presented by art historians as an area where the Florentines were unable to compete with the Venetians, but here he is adamant that Fra Bartolommeo was determined to excel not only in 'disegno', but also in 'colorito'. He warns, however, that Fra Bartolommeo's darks, allegedly achieved with 'printer's smoke-black' and 'the black of burnt ivory', have blackened over time. The identical criticism is levelled at Giulio Romano's Santa Maria dell' Anima altarpiece. These are by no means isolated instances of Vasari's concern with how well or badly works of art survive the

passing years. Another example is his assertion that Beccafumi painted an altarpiece and numerous predella panels in tempera, not oils, because he was convinced it lasted better, having compared oil paintings by Pollaiuolo and Signorelli with temperas by Fra Angelico, Fra Filippo Lippi and Benozzo Gozzoli.

The most important of these three *Lives* is inevitably the one devoted to Raphael, which is one of Vasari's *tours de force*. Its main – and notorious – weakness is in the discussion of the frescoes in the Vatican *Stanze*, where reliance on a combination of print sources and memory resulted in considerable confusion and inaccuracies. For the rest, the chronological account is highly impressive, and there are virtually no large-scale works, even from the artist's beginnings, which are not discussed. Most striking, however, is Vasari's concern to chronicle Raphael's stylistic development. This is achieved in somewhat schematic fashion, and presented in terms of the successive influences upon the artist of Perugino, Leonardo and Michelangelo. For a modern reader, bored to death by analysis of artistic careers based upon 'Early Works', 'Mature Works', and 'Late Works', it is not easy to recover the novelty of Vasari's approach. However, if one compares the *Life* of Raphael with the others, it becomes apparent that although Vasari was always at pains to try to tell his story in the right order, he was seldom eager or able to characterize artistic evolution in even the most rudimentary of terms.

Raphael's pupils and followers represent a major strand in Part III of the *Lives*, with Giulio Romano, whom Vasari met in Mantua, receiving a particularly full biography. For Vasari, Guilio was a perfect example of the supremely versatile and highly successful court artist. Giulio did everything from designing the Palazzo del Tè and the frescoes and stuccoes that adorned it to providing drawings for silverware for the Duke's table. There can be no doubt that even if Vasari had even been capable of accepting the notion of a decline in quality after Giulio left Rome for Mantua, he would have regarded it as trivial in the face of so much adulation, security and prosperity. He wrote of his own work on the so-called 'Sala dei cento giorni' in the Palazzo della Cancelleria in

Rome, 'I confess that I did wrong in putting it afterwards in the hands of assistants ... it would have been better to toil over it a hundred months and do it with my own hand', but Giulio's delegation of the execution of major projects to assistants in Mantua is not criticized.

Amusingly enough, Giulio is presented as a figure who could do no wrong, even when he painted the picture of *Two Lovers on a Bed* now in the Hermitage, to which one would have expected the slightly prudish Vasari to object. Rather, his disapprobation is reserved for the admittedly even more explicit *Modi*, known in English as 'Aretino's Postures', but the account of them is reserved for the *Life* of Marcantonio Raimondi, and Vasari scrupulously avoids his habitual cross-referencing. Even a less prominent figure like Polidoro da Caravaggio is lavishly praised, and Rome under Leo X is hailed as a golden age. For Vasari, looking back from what might be described as the wrong side of the Sack of Rome in 1527, it undoubtedly was.

The other Raphael pupil who receives an extensive *Life* is Perino del Vaga. In part this has to do with the information Vasari had at his disposal, especially through their having worked for the same patrons in Pisa Cathedral, and having coincided in the Rome of Pope Paul III, but it is also a recognition of the fact that Perino, like Raphael before him, was a highly efficient professional. For Vasari the artist such men were role models: conversely, he was generally intolerant of the prima donnas.

After the *Life* of Michelangelo, that of Perino was the longest in the 1550 edition, and set a sort of precedent for the new biographies added in 1568. Its only rival is the *Life* of Vasari's teacher, Andrea del Sarto, which is extremely detailed, and also contains telling references to Sarto's beautiful but shrewish wife, which were to inspire a poem by Robert Browning. Vasari himself contracted a possibly loveless and certainly childless marriage to Niccolosa (Cosina) Bacci of Arezzo, a member of the family who had commissioned Piero della Francesca's *Story of the True Cross* frescoes in the previous century. In all sorts of ways it was Sarto's workshop, together with the Florence of his youth, which determined Vasari's

style, and also conditioned his sense of the way things should be done.

One of the most notable features of Part III of the *Lives* is the way Vasari widens his range, both in terms of geography and in terms of what are sometimes dismissed as the minor arts. In both cases the portmanteau *Life*, which had already been introduced in Part II, comes into its own. Thus, the *Life* of Fra Giocondo and Liberale is basically a compendium of information on the arts, and predominantly painting, in Verona, achieved – as Vasari explicitly acknowledges – with the help of Fra Marco de' Medici. No less breathlessly informative are the *Lives* of Dürer and Marcantonio Raimondi, which do their best to cover printmaking north and south of the Alps. Other *Lives* deal with rock crystal and hardstone engraving (Valerio Belli *et al.*), while miniature painting is all but exclusively reserved for Giulio Clovio. This kind of presentation of an individual as the sole worker worthy of praise in a given field is also found in the passages on Fra Giovanni da Verona scattered through the *Lives*, whereas the only mention of Fra Damiano da Bergamo is of a Salviati drawing of *David Anointed by Samuel* sent to him by Cardinal Salviati to be made into an intarsia panel.

Notwithstanding his exploration of such intriguing byways, it is fair to say that Florence, now joined by Rome, remains the prime focus of Vasari's attention. This is inevitable, but we should also be grateful for it, since his knowledge is self-evidently more rewarding than his ignorance. He relates how he first met Francesco Salviati, who was a rival but above all a friend, when he was thirteen years old. The account he gives of Salviati could hardly be more personal, but manages to achieve considerable objectivity. His discussion of notorious enemies of his, such as Baccio Bandinelli and Benvenuto Cellini, is no less remarkably even-handed. Vasari's habit of referring to himself in the third person is in large part a stylistic trick, but it may also suggest a willingness to avoid the over-subjective. Vasari is no more reliable than any other autobiographer, but throughout the *Lives* he rightly sets great store by eyewitness statements, whether made by others or by himself.

In the original 1550 edition of the *Lives*, the grand finale of the book, as well as the climax of the progress of Renaissance art, came with Michelangelo. Although it is no longer the last biography, it remains the most substantial, and – for all its faults – the most revealing *Life* in the 1568 edition. That it is profoundly different from the earlier account will be immediately apparent to anyone who compares them, but in this case there is a reason above and beyond Vasari's general desire in the 1568 edition to get things right.

The 1550 account of Michelangelo was the only biography of a living artist (as stated, apart from that of Benedetto da Rovezzano), which meant that Michelangelo, uniquely, had the opportunity to set the record straight, or – in relation to at least one particular statement of Vasari's – crooked. In 1553, a pupil of Michelangelo's called Ascanio Condivi published a *Life of Michelangelo*, which was an explicit answer to Vasari. There is good reason to believe that Condivi's name was his major contribution to an eloquent and stylish production that was beyond his literary abilities, and recent research has made ingenious suggestions concerning its true authorship. Of greater interest still, however, is the fact that it is in effect a pioneering ghost-written autobiography.

When Vasari came to write the 1568 Michelangelo *Life*, he brought his account up to date, added new information he had gleaned about earlier periods, and was not too proud to incorporate the bulk of Condivi's revisions, especially those concerned with the tangled and protracted commission for the Tomb of Pope Julius II. Where Vasari stuck to his guns was in insisting that Michelangelo was not, as Condivi alleged, a sort of divinely gifted autodidact. To prove the point, he published the agreement between Michelangelo's father and Domenico Ghirlandaio concerning the boy's apprenticeship. Archivally-minded art historians of today should regard Vasari as their patron saint.

A comparison of the treatments of the Sistine Ceiling in all three versions is instructive, because it serves to remind one of how vivid Vasari can be, and of how full and accurate are his descriptions of works he knows well (it is Condivi who gets it wrong, and calls the *Sacrifice of Noah* the *Sacrifice of Cain and*

Abel). Furthermore, it is Vasari who created the idea of Michelangelo the superman, and although others were assiduous about preserving records of a great artist with a memorably sharp turn of phrase, for better or for worse it is Vasari who is responsible for *The Agony and the Ecstasy* and the hordes of tourists.

The number and quality of the biographies added to the 1568 edition of the *Lives* is remarkable, because they reveal Vasari at his most informed. It cannot be claimed that they significantly diminish the book's bias in favour of Florence and Rome, but they undoubtedly emphasize the gap between what Vasari could achieve when writing about contemporaries, and especially friends, and the problems he faced when writing on the basis of rather scanty information.

*

Up to this stage I have endeavoured to give an account of the main lines or high points of the *Lives*, while at the same time conveying a sense of Vasari's strengths and weaknesses as a writer about art. Quite properly, most readers of the *Lives* are bound to be principally concerned with information and with entertainment. It is natural that they should feel tempted to confine themselves to the biographies of the best-known Renaissance artists, and that indeed is why selections from Vasari are popular. The advantage of a complete edition is that there is no such restriction, and I want to conclude by demonstrating how rewarding it can be to stray from the beaten track.

Valuable information is spread throughout the entire work, not arranged into convenient highlights. There is a tendency, fostered by Vasari himself, to glaze over or skip when reading about lost works. We have no way of testing our response against Vasari's, and there is something frustrating about what might have been. Yet it is not infrequently the case that some of Vasari's most interesting *aperçus* or stories are to be found in the darker corners of the *Lives*. The works of the early fifteenth-century artist, Dello Delli, are almost all lost, and modern art history has precious little sense of him as an artistic personality, but it is as an excursus within his biography

that Vasari gives a short but fascinating disquisition on cassone painting.

An important refutation also needs to be made here. A recent, highly hostile attack on Vasari was entitled 'Can You Trust Vasari?', and strove with perverse energy to argue that 'everything new he said about his predecessors needs to be treated with extreme caution'. This is nonsense: Parts I and II of the *Lives* are clearly not wholly satisfactory by modern standards of evidence, but Part III is a different matter altogether, and not just when it comes to Vasari's contemporaries. Nor should it be forgotten that Vasari can only be judged against the achievements of his century. In the admittedly very brief Latin biography of Raphael by Paolo Giovio – the man who supposedly renounced an invitation to write the *Lives* in favour of Vasari – he manages to commit two howling errors of fact in connection with the four works he mentions, and totally fails to explain what the subject of the *Transfiguration* is, so swept up is he in an encomium of the paralytic boy in the foreground.

Above and beyond this, we need to draw a distinction between verifiable fact and what is possible, true to life if not demonstrably true. Reading Vasari, one can gain a unique insight into the way people – or at least one person – in the sixteenth century, if not necessarily before, thought about all sorts of issues connected with art. This means that in those instances without number where we are unable to check up on Vasari, we should stop worrying about whether what he says is true or false, and instead recognize that it is almost bound to be plausible. There are occasions when Vasari deliberately seems to be mythologizing, but they are few and far between. I doubt if he expected his readers to believe that Amico Aspertini painted with both hands simultaneously, using the one for the lights and the other for the darks, not least since this assertion occurs in the context of a celebration of his eccentricity. Furthermore, the fact that Giovanni Battista Armenini, in his treatise on art, the *De' Veri Precetti della Pittura* of 1586, presents a similarly two-handed Luca Cambiaso, suggests that the ambidextrous painter was a proverbial – as opposed to actual – figure.

There are themes contained in the *Lives* that require the reader to follow them through from biography to biography. Only professional scholars are liable to want to explore these trails systematically, but it is important to see how apparently isolated observations or assumptions can combine to clarify Vasari's thinking on a particular subject. In other cases, there may be genuinely isolated insights that deserve to be rescued from the oblivion into which they have fallen.

To start with a subject of obvious interest, often given less than its due, it is an education to read Vasari's scattered comments on the subject of signatures. In almost every case I want to discuss, it seems reasonable to suppose that Vasari had no proof for his assertions. Presumably he simply did what most people tend to do, and jumped to the conclusion that others thought as he did. It is highly unlikely, however, that what he thought was particularly eccentric in the context of his times.

Vasari himself was an infrequent signer, but that should not be construed as meaning he thought signatures uninteresting or unimportant. Not by chance did he interpret the inscription on the Chimera of Arezzo, which is actually a dedication to Tinia (Jupiter), as a signature with a date, designed by its creator to underline its 'perfection'. In the *Life* of Orcagna he notes that he signed his paintings 'sculptor' and his sculptures 'painter', 'wishing that his painting should be known by his sculpture, and his sculpture by his painting', a suggestive observation in relation to later 'cross-signers' like Pisanello, Vecchietta and Francesco Francia. In the discussion of Stefano da Verona in the *Life* of Carpaccio, he refers to the fact that he often included a peacock, his emblem, in his pictures, and also observes that he signed a particular fresco in gold letters 'perchance since it appeared to him to be, as in fact it is, one of the best pictures that he made'.

A similar point is made in connection with Donatello's *Judith and Holofernes*: 'He was so well satisfied with this work that he deigned to place his name on it, which he had not done on the others; and it is to be seen in these words "*Donatelli opus*".' In fact, Donatello signed other works, but that does not diminish the interest of Vasari's comment. Furthermore,

in the 1550 edition Vasari explains Michelangelo's genuinely unique signature on his *Pietà* in St Peter's in exactly the same terms. There is nothing of this in Condivi, but in the 1568 edition, he explains that as a reaction to overhearing some Lombards assert that the author was 'Our Gobbo from Milan' (Cristoforo Solari), Michelangelo crept in at night with a lamp and his tools to sign the statue. This insertion sits uncomfortably with the 1550 account, and its slightly gauche scissors-and-pasting into the previous version, which is otherwise unchanged, may suggest this seemingly tall tale has a grain of truth in it. It should not be forgotten that the 1568 Vasari knew Michelangelo a great deal better than the 1550 one did.

A quite different, and more fashionable *Leitmotif* is represented by what Vasari has to say about the relations between patrons and artists over subject-matter. Since the dedications of churches and chapels in the Renaissance tended to affect, if not determine, the iconography of religious pictures destined for them, it is sometimes assumed that artists had no say in such matters. An anecdote in the *Life* of the minor Florentine sixteenth-century painter, Giovanni Antonio Sogliani, demonstrates that this was not always the case. Sogliani was asked by the Dominican friars of San Marco to paint a fresco for their refectory, and executed a preparatory drawing for a *Feeding of the Five Thousand*, a common subject for such a context, as other examples recorded by Vasari make plain. Instead, the friars insisted on a representation of the *Panis Angelicum*, that is to say St Dominic fed by angels. Vasari's description of the work as executed is followed by an observation of more general import: 'but Sogliani would have been much more successful if he had executed what he had designed, because painters express the conceptions of their own minds better than those of others'. Since the original subject was hardly novel, one assumes that Vasari was concerned with the artist's interpretation of it.

Originality of interpretation is generally praised by Vasari, and he relates in his own *Life* that he decided to represent Ananias curing St Paul's blindness in the Del Monte Chapel in San Pietro in Montorio in Rome, in order to avoid the

precedent of Michelangelo's fresco of the *Conversion* in the Capella Paolina. Predictably, however, in view of his supreme devotion to professionalism, he is not inclined to approve of artists whose innovations justly antagonize their patrons. This seems to be the moral of his account of Domenico Beccafumi, 'cappricioso', who painted a *Fall of the Rebel Angels* with a 'new invention', which was a confused mess and was left unfinished, and then had to produce a second version, which satisfied his patrons and was indeed superior.

Vasari clearly felt that patrons too should know their place, and not only when it came to subject-matter. In the *Life* of Fra Giocondo and Liberale, there is a hilarious anecdote concerning an argument between Giovanni Francesco Caroto and the 'guardiano' (verger) of the Church of San Bernardino in Verona concerning his fresco of *Christ Taking Leave of His Mother*. The friar complained that Caroto's Christ showed insufficient respect for the Virgin, because he was kneeling on one knee. Caroto then asked the 'guardino' to kneel and get up again, and pointed out that he had to go on one knee to do so (there is a fascinating aside concerning the difficulty of interpreting an arrested movement, with the painter failing to specify whether his Christ is on the way up or down). More generally, Vasari appears to have been contemptuous of the interfering ways of the lesser clergy.

Elsewhere, Vasari tells us that subject-matter might be selected or even devised by learned men, not least in the secular context. Thus, in the *Life* of Franciabigio, he discusses the frescoed decoration of the Medici villa at Poggio a Caiano, and states that the 'scenes from ancient history ... had been entrusted by the learned historian, M. Paolo Giovio, Bishop of Nocera ... to Andrea del Sarto, Jacopo da Pontormo and Franciabigio'. The surviving drawings by Pontormo indicate that his subject at least had not been given to him from the beginning, but once again what matters is what Vasari thought. Similarly, in the *Life* of Fra Giocondo and Liberale, he discusses a painting by Giovanni Francesco Caroto for Count Giovan Francesco Giusti, 'executing a subject conceived by that nobleman'. In fact, the invention, which is a kind of Choice of Hercules, is derived from a passage in

Xenophon, which in its turn is based on an idea invented by the sophist Prodicus, but for Vasari it was of the patron's devising. Some would argue these examples show Vasari projecting back the ways of his own age into the past, but the authorship of the programmes is strikingly circumstantial.

Vasari is equally compelling in the information he provides about artistic practice. The theoretical introduction to the 1568 edition of the *Lives*, published in English as 'Vasari on Technique' is omitted here, but there are countless illuminating throwaway lines in the course of the narrative. While his technical observations are invariably instructive, the pragmatic insights into how things were done are arguably even more fascinating. In the *Life* of Jacopo Sansovino, for example, there is the justly celebrated account of the sculptor's apprentice, Pippo del Fabbro, posing for the master's *Bacchus* and then going mad and adopting the pose stark naked in the pouring rain and on rooftops.

In the *Life* of Franciabigio, Vasari records that the artist drew from the nude every day, and 'he always kept men in his pay' to pose for him. No doubt that was the ideal, but Vasari also relates how he and Francesco Salviati in their early days in Rome began to 'study nudes from life ... in a bath-house near there; and afterwards they made some anatomical studies in the Campo Santo'. He occasionally even identifies what might be described as celebrity models: in the case of the young Francesco Granacci's appearance as the son of Theophilus in Filippino Lippi's frescoes in the Brancacci Chapel, the main interest is that the apprentice grew up to be a master; by contrast, the fact that Gino di Lodovico Capponi was reputed to be the model for Antonio Pollaiuolo's St Sebastian in the picture now in the National Gallery, London (information already recorded by earlier sources) is surprising precisely because of his prominent social standing, and indicates not only that he was a famously beautiful young man, but also implies that he did not think it undignified to pose.

Vasari is no less interesting on the subject of how artists made portraits, and especially in underlining the fact that it was not always possible to have a sitting, far less sittings. In the *Life* of Parmigianino, for instance, Vasari – who was also

there – tells how when the Emperor Charles V was in Bologna in 1530 for his Coronation, Parmigianino used to go and watch him dining and then painted his portrait. In the same vein, in the *Life* of Fra Giocondo and Liberale, he writes that Orlando Fiacco (Flacco), who was famous for his portraits, 'made a portrait of Cardinal Caraffa when he was returning from Germany, which he took [literally 'robbed him'] secretly by torch-light while the Cardinal was at supper in the Vescovado [Archbishop's Palace] of Verona; and this was such a faithful likeness that it could not have been improved'.

As well as telling us how works of art were made and for whom, the *Lives* is our fullest guide to how people looked at art in the Renaissance. A crucial concern of Vasari's is the description of what is actually happening in pictures, in terms both of narrative and of characterization. By virtue of these *ekphrases*, Vasari has proved exceptionally if unwittingly useful in allowing posterity to identify exactly which picture he was referring to in those very numerous cases where its location has changed. Sometimes, and almost inevitably, he makes mistakes, but even they are seldom without interest. In his discussion of Correggio's *Madonna of St Jerome* in the 1550 edition of the *Lives*, he calls Mary Magdalene St Catherine, but corrects his *lapsus* in 1568. However, the error is not uninstructive, because it underlines the exceptional intimacy of Correggio's treatment of the Magdalene, which is indeed clearly inspired by pictures of the Mystic Marriage of St Catherine.

It would be wrong, however, to imagine that these descriptions are simply inspired by a yearning for accuracy beyond what is possible within the confines of a short title. On the contrary, the idea of titles – with all their advantages and disadvantages – was in its infancy. In the *Life* of Francesco Francia, Vasari refers to an altarpiece for the Church of the Nunziata 'representing the Madonna receiving the Annunciation from the Angel', and then a couple of pages later he mentions a 'very beautiful Annunciation' for Modena. For Vasari 'Nunziata' does not simply mean 'Annunciate Virgin on her own', although pictures of that subject do indeed exist. Similarly, a painting by Correggio now in the Prado is described as 'a Christ appearing to Mary Magdalene in the

Garden', whereas in another place he speaks of Michelangelo's 'cartoon of a "*Noli me Tangere*"'.

There is no satisfactory way of trying to discern a grand design in the face of these opposing approaches to the same problem; indeed, we should beware of over-interpreting Vasari's formulations, although some of them may be revealing. In view of the fact that he not infrequently refers to altarpieces which depict events as 'histories' or employs a narrative mode prefaced by 'when' in discussions of them, it seems unlikely that he thought of them in purely iconic terms. On the other hand, it would be unwise to infer that Giulio Romano's altarpiece from Sant' Andrea in Mantua, now in the Louvre, did not qualify as a Nativity in his eyes because of the anachronistic saints. It is true that he laboriously chronicles 'Our Lady in the act of adoring the Infant Jesus who is lying on the ground, with S. Joseph, the ass and the ox near a manger, and on one side S. John the Evangelist, and S. Longinus on the other', but then in the *Life* of Perino del Vaga he refers to his *Bacciadonne Altarpiece*, which also has anachronistic saints, as a 'Nativity of Christ'.

What Vasari's descriptions do tend to underline is the potential lack of precision of modern titles. In his book *Painting and Experience in Fifteenth-Century Italy*, Michael Baxandall memorably demonstrated that different pictures, all of which we would describe as Annunciations, actually illustrate distinct moments from the same story. Similarly, when Raphael's *Borghese Entombment*, as it is now usually labelled, is discussed, Vasari begins with the fundamental point that it shows 'a Dead Christ being borne to the Sepulchre' before going on to mention the Virgin, who has fainted, and the emotional reactions of the other figures. If the picture had shown another variation on the theme, such as Christ being lowered from the Cross, or His dead body in the Virgin's lap, or His body actually being placed in the tomb itself, then that is what Vasari would have said. In short, the prolixity of his descriptions can prove preferable to the brevity of our titles.

Another fascinating thread which weaves its way through the book concerns the study and collecting of works of art. Self-evidently Vasari himself, who frequently refers to artists'

drawings in his *Libro*, a good number of which have been identified, is a crucial figure in this context, but he makes it plain that he was not unique. When Garofalo was in Florence in 1500, he studied with Giovanni Baldini 'who possessed many very beautiful drawings by various excellent masters'; as with the discussion of the workshop of Squarcione, there is the idea of artists learning by copying, but also by having access to the works of the best masters, both ancient and modern, as opposed to those of a single mentor. Elsewhere, artists seem to be pioneers in the collection of drawings for aesthetic rather than purely pedagogic reasons. Valerio Belli owned a 'most beautiful book of antiquities, drawn with all the measurements by the hand of Bramantino', and Vasari says that he himself copied them when young, but their principal appeal for Belli must have been as works of art. Conversely, drawings also served a function usually associated with prints, namely that of making images more widely available. In the *Life* of Giulio Romano, Vasari records that he sent Giulio 'three sheets containing the Seven Mortal Sins' copied from Michelangelo's *Last Judgment* just after its unveiling. This is a rare piece of evidence of what must have been a widespread practice. Other references record the collection of drawings by amateurs, and indeed the making of finished drawings intended from the first as works of art in their own right.

Not unrelated, and again clearly very dear to Vasari's heart, were attempts to preserve the memory of works of art, not just by the pen but by means of conservation, however rudimentary. Vasari and his teenage friend Francesco Salviati famously salvaged the left arm of Michelangelo's marble *David* during the fighting around the Palazzo della Signoria at the time of the expulsion of the Medici from Florence in 1527, and he also saved a likeness he believed to have been that of Margaritone d' Arezzo in a fresco by Spinello Aretino before the Old Cathedral in Arezzo, which housed it, was destroyed. Giovio is commended for a similar act of preservation in connection with various portraits in a fresco cycle by Fra Angelico in the Cappella del Sagramento in the Vatican, which was destroyed by Paul III, because he needed to install a staircase. Presumably in these cases copies were made.

Physical rescues, mainly of frescoes, are mentioned at various junctures – Correggio's *Annunciation* is one beneficiary, a now lost Fra Filippo Lippi *Madonna* another – and they make one wonder whether the tale about Francis I exploring the possibility of having Leonardo's *Last Supper* detached and brought to France is more reliable than it might at first seem. There are also references to people saving or at least preserving cartoons and even fragments of them. A particularly precocious instance is the cartoon for Piero di Cosimo's portrait of Duke Valentino, the son of Alexander VI Borgia, which belonged to one of Vasari's great allies and mentors, Cosimo Bartoli, who also owned a book of animal studies by the artist. In the case of the *disjecta membra* of Michelangelo's cartoon for the *Battle of Cascina*, whose destruction is also graphically described, which are 'still to be seen in Mantua in the house of M. Uberto Strozzi', and 'treasured with great reverence', there is more than a hint of the seemingly universal urge to worship the relics of the great.

Following themes of various kinds through the book is unfailingly instructive and guaranteed to upset our preconceptions, but there are also extraordinary one-off surprises. In the nature of things, they can be found here, there and everywhere, but by chance there are three in the *Life* of Signorelli whose variety is a telling indication of Vasari's range.

The first concerns the casual revelation that some 'sportelli' (wings) of a cupboard for San Francesco at Lucignano were painted not to flank a painted or sculptured central image, but a tree of coral topped by a cross, which serves as a reminder that the original contexts of works of art were often other than we imagine them to have been. The second concerns the information that the Christ Child in Signorelli's *Circumcision*, now in the National Gallery in London, was damaged by damp and repainted by Sodoma. A technical analysis might have divined the repair without the help of Vasari, but the identity of the restorer would have remained a mystery for ever. The third comes in the description of Signorelli's son being killed in Cortona, and his having him stripped nude so that he could draw him and thus see whenever he wished what nature gave him and ill fortune took away.

INTRODUCTION

This final example is not chosen entirely at random. In the *Life* of Andrea del Sarto, Vasari relates how the epitaph to Andrea was removed from its original location, but expresses the certainty that his works will live on, and proceeds to confess the hope that his writings will preserve the memory of them for many centuries. The fact that Vasari is indeed still read is a tribute to the artists he wrote about, but also to the way he wrote about them. At his best, he does all that we could ask of anyone writing about art: he inspires us with a burning desire to go and see – or see again – the works of art themselves.

David Ekserdjian

A NOTE ON THE TRANSLATION

There is no complete translation of Vasari's *Lives* into English, but Gaston de Vere's is a far fuller version than that by A. B. Hinds used in previous Everyman editions. De Vere's own preface to his edition rightly stresses his concern for accuracy and fidelity, and in the absence of a completely new modern translation of the entire work, it is without question the most reliable version for readers unable to read Italian, or indeed for anyone trying to read the original but in need of a parallel text. De Vere's usage of painters' names has been retained.

A NOTE ON THE ILLUSTRATIONS

This edition is illustrated by woodcut portraits which originally appeared in the 1568 edition. These portraits were drawn by Vasari and his pupils and were engraved by Cristofano Coriolano.

SELECT BIBLIOGRAPHY

The recent publication of Patricia Lee Rubin's *Giorgio Vasari – Art and History* (New Haven and London, 1995) provides an excellent up-to-date bibliography. It and T. S. R. Boase's *Giorgio Vasari – The Man and the Book* (Princeton, 1979), which is a less interesting book, remain the two main studies of Vasari in English. Both are more concerned with the historian than the artist. P. Barocchi's *Vasari Pittore* (Milan, 1964) and L. Corti's *Vasari – Catalogo Completo* (Florence, 1989) are the major studies of his paintings, while U. Muccini and A. Cecchi's *The Apartments of Cosimo in Palazzo Vecchio* (Florence, 1991) contains excellent reproductions and a readable text. C. Monbeig Goguel's *Musée du Louvre, Cabinet des dessins. Inventaire général des dessins italiens I. Vasari et son temps* (Paris, 1972) is a useful catalogue of drawings by Vasari (a complete drawings catalogue has been announced, but it is not known when it will be published). L. Collobi Ragghianti, *Il Libro de' Disegni del Vasari*, 2 vols (Florence, 1974) is the fullest study of Vasari as a collector of drawings. Studies of Vasari's *Lives* not in English include W. Kallab, *Vasaristudien* (Leipzig and Vienna, 1908) and P. Barocchi, *Studi vasariani* (Turin, 1984).

Louisa S. Maclehose, *Vasari on Technique* (London, 1907) provides a translation of the introduction to the *Lives* omitted from the present edition. The standard edition of the 1568 *Vite* is that of Gaetano Milanesi (Florence 1878–1885, and much reprinted). A convenient one-volume publication of the 1550 *Vite* edited by L. Bellosi and A. Rossi, is currently available (Turin, 1986). The definitive modern scholarly edition, however, is Paola Barocchi and Rosanna Bettarini's six-volume *Le vite de' più eccellenti pittori scultori et architettori nelle redazioni del 1550 e 1568* (Florence, 1966–1987).

In the Introduction I refer to Charles Hope's 'Can You Trust Vasari?', *New York Review of Books*, Vol. XLII, No. 15, 5 October 1995, pp. 10–13, a review of Patricia Lee Rubin's book, which is very biased but makes some interesting points; Michael Baxandall, *Painting and Experience in Fifteenth-Century Italy* (Oxford, 1972); Bernard Berenson, *Piero della Francesca* or *The Ineloquent in Art* (London, 1954) and Sir John Pope-Hennessy, 'Duccio' (1980) in *On Artists and Art Historians – Selected Book Reviews of John Pope-Hennessy* (Florence, 1994) pp. 20–25.

References to texts more contemporary with Vasari are to Leon

Battista Alberti, *On Painting*, translated with Introduction and Notes by John R. Spencer (New Haven and London, 1966) and Giovanni Battista Armenini, *De' Veri Precetti della Pittura*, 1586, ed. Marina Goretti (Turin, 1988). Finally, my reference to the *Paradiso* (Canto I, lines 1–3) in Dante, *The Divine Comedy*, can be found in the Everyman's Library edition (London and New York, 1995), on p. 379.

C H R O N O L O G Y

———

DATE	AUTHOR'S LIFE	CULTURAL CONTEXT
1492		
1494		
1498		Dürer: *Apocalypse.*
1499		Michelangelo: *Pietà*, St Peter's, Rome. Leonardo da Vinci: *The Last Supper.*
1504		Michelangelo: *David.* Leonardo da Vinci: *Mona Lisa.*
1506		Discovery of the *Laocoon.*
1508–20		Raphael: *Stanze*, the Vatican.
1510		Death of Giorgione.
1511	Born 30 July, Arezzo, to Antonio Vasari and Maddalena (*née* dei Tacci).	Erasmus: *The Praise of Folly.*
1512		Michelangelo completes ceiling of Sistine Chapel, the Vatican. Michelangelo: *Moses.*
1513		Machiavelli: *The Prince* (published 1532).
1515		Grünewald: Isenheim altarpiece.
1516		Thomas More: *Utopia.* Ariosto: *Orlando Furioso.* Erasmus: Latin translation of the New Testament.
1517		
1518		Birth of Tintoretto. Titian: *The Assumption.*
1519		Death of Leonardo da Vinci, aged 67.
1520		Raphael: *Transfiguration.* Death of Raphael, aged 37.
1521		
1522		Luther publishes first vernacular translation of the New Testament.

Death of Lorenzo de' Medici ('the Magnificent').
Charles VIII leads French invasion of Italy.
Medici family expelled from Florence; dictatorship of Savonarola.
Execution of Savonarola.
Columbus discovers American continent.
French invasion of Italy led by Louis XII. Ludovico Sforza driven from Milan.

French expelled from Italy. Return of Medici rulers to Florence.

Death of Julius II. Accession of Giovanni de' Medici as Leo X.

Francis I becomes king of France. French army defeats the Swiss at Marignano and captures Milan.
Spain: accession of Charles I.

Wittenberg: Luther's 95 theses.

Charles V (Charles I of Spain) elected Holy Roman Emperor.
Zürich: Zwingli bans sale of indulgences.
Cortez invades Mexico.
Excommunication of Luther.
Magellan Straits discovered.
Germany: Diet of Worms; Luther placed under ban of the Empire.
Occupation of Milan by forces of Charles V and Leo X.
The Turks capture Belgrade.

DATE	AUTHOR'S LIFE	LITERARY CONTEXT
1523		Holbein: *Portrait of Erasmus*.
1524	To Florence under the patronage of Cardinal Silvio Passerini. Taught by the humanist Valeriano with Ippolito and Alessandro de' Medici. Studies art with Andrea del Sarto.	Death of Hans Holbein the Elder.
1524–35		Michelangelo: The Medici Chapel, Florence.
1525		Tyndale's English New Testament published in Cologne.
1526		
1527	Returns to Arezzo. Death of his father from the plague.	Death of Machiavelli.
1528	Altarpiece for Church of S. Piero, Arezzo. Apprenticed to goldsmith in Florence.	Birth of Veronese. Castiglione: *The Book of the Courtier*. Completion of the Palace of Fontainebleau.
1529	Moves to Pisa. Fresco for Company of Florentines.	
1530		
1531		
1532	*The Entombment* for Alessandro de' Medici. *Portrait of Alessandro de' Medici*.	Rabelais: *Pantagruel*. Ariosto: revised edition of *Orlando Furioso*.
1533		Holbein: *The Ambassadors*.
1534		Rabelais: *Gargantua*. Lutheran Bible (complete) first published.
1535	Death of his patron, Ippolito de' Medici.	
c. 1535		Parmigianino: *Madonna of the Long Neck*.
1536		Death of Erasmus. Giulio Romano: decorations, Palazzo del Tè. Calvin: *Institutes of the Christian Religion*.

CHRONOLOGY

Accession of Giulio de' Medici as Clement VII (to 1534).
Zürich: Zwingli's 67 theses.

Battle of Pavia: Francis I of France taken prisoner by Emperor Charles V.

Treaty of Madrid: release of Francis I.
Clement VII allies with French (Holy League of Cognac).
Medici expelled from Florence. Charles V sacks Rome.
Reformation begins in Sweden.

Peace of Cambray: French withdraw from Italy. Francesco Sforza restored
as ruler of Milan.
Vienna besieged by the Turks.
Florence surrenders to Imperial forces after ten-month siege.
Alessandro de' Medici appointed Duke of Florence by Charles V.
Charles V crowned Holy Roman Emperor in Bologna.
Germany: Diet of Augsburg; Confession of Augsburg.
Battle of Kappel and death of Zwingli.
Conquest of Peru.

England: marriage of Henry VIII and Anne Boleyn. Excommunication of
Henry VIII. Catherine de' Medici marries Prince Henry of France.
Act of Supremacy: Henry VIII becomes supreme head of the Church of
England.
Paul III becomes Pope (to 1549). Loyola founds the Society of Jesus.
Death of Francesco Sforza. Execution of Thomas More.

French troops conquer Savoy.
England: dissolution of the monasteries begins.

DATE	AUTHOR'S LIFE	LITERARY CONTEXT
1537		Holbein: Group portrait: *Henry VIII with Jane Seymour, Henry VII and Elizabeth of York.*
1539	Decoration of Refectory of Olivetan convent, S. Michele in Bosco.	
1540	*Baptism of Christ* for Baptistery, Florence.	Death of Parmigianino, aged 37.
c. 1540	*The Allegory of the Immaculate Conception*, SS. Apostoli, Florence.	
1541		Michelangelo: *The Last Judgment*, Sistine Chapel, the Vatican.
1541–2	Venice: designs for Aretino's new play.	
1542		
1543		Copernicus: *On the Revolution of the Heavenly Spheres.*
1544	Altarpiece for Pisa Cathedral. Decoration of Monastery of the Monks of Mount Oliveto.	
1545		
1546	*Room of One Hundred Days*, Palazzo della Cancelleria. *Last Supper*, Convent of the Murate, Florence.	
1547	Altarpiece for Pisa Cathedral.	Birth of Cervantes.
1548		Ignatius Loyola: *Spiritual Exercises.*
1549		England: The Book of Common Prayer.
1550	January: marriage to Niccolosa Bacci (the marriage produced no children). First edition of *Lives of the most eminent Painters, Sculptors and Architects*, dedicated to Cosimo de' Medici.	Italian translation of Alberti: *De re aedificatoria,* Florence, illustrated with woodcuts.
1553		Veronese begins decoration of the Doge's Palace, Venice. Condivi: biography of Michelangelo, which counters certain statements made by Vasari.

CHRONOLOGY

HISTORICAL EVENTS

Murder of Alessandro de' Medici; succession of Cosimo I.

Venice makes peace settlement with Turks.

Inquisition established in Rome.

First session of the Council of Trent.
Death of Luther.

England: death of Henry VIII; accession of Edward VI.
France: death of Francis I.
Russia: coronation of Ivan 'the Terrible'.

England: accession of Mary Tudor; persecution of Protestants.

DATE	AUTHOR'S LIFE	CULTURAL CONTEXT
1555	Official painter of Cosimo de' Medici. In charge of remodelling interior of Palazzo Vecchio (work continued into the 1570s).	Nostradamus: *Centuries*.
1556		Vitruvius: *De Architectura* published thanks to Palladio.
1557		Dolce: *L'Aretino*.
1558	Death of his mother.	
1559		
1560	Directs beginning of building the Uffizi, the state offices, Florence (completed in 1580).	
1561		Publication of Guicciardini's *Storia d'Italia*.
1562	Founded *Accademia del Disegno* in Florence – the first such academy to teach the arts theoretically as well as practically. Redesign of Palazzo dei Cavalieri, Pisa.	Veronese completes decorations, Villa Barbaro, Maser. Tasso: *Rinaldo*.
1563		Veronese: *Wedding Feast at Cana*, San Giorgio Maggiore, Venice (now in the Louvre).
1564	Collaborates on design of Michelangelo's tomb, Santa Croce, Florence.	Birth of Shakespeare. Birth of Galileo. Michelangelo: *Pietà* (Rondanini). Death of Michelangelo, aged 89.
1565	Artistic director (with Borghini) of marriage pageant for Joanna of Austria in Florence. *Vasari's Corridor*, linking Palazzo Vecchio and Palazzo Pitti, completed in five months.	Bruegel the Elder: *The Seasons*.
c. 1565	*Vulcan's Forge*.	
1565–72	Remodelling of Santa Maria Novella, Florence.	
1566		Tintoretto: *Life of St Mark*, Scuola Grande di San Marco, Venice.
1566–84	Remodelling of Santa Croce.	
1567	*The Crucifixion according to St Anselm*, Santa Maria Novella.	Danti: *Treatise on Proportion*, Florence.

lviii

CHRONOLOGY

End of three-year siege of Siena by Spanish and Florentine armies; city incorporated into Tuscany.
Germany: Diet of Augsburg; Religious Peace of Augsburg.
Abdication of Emperor Charles V.

War in Italy between Pope Paul IV, supported by the French, and Philip II of Spain (to 1557). Death of Loyola.

England: accession of Elizabeth I.
Treaty of Cateau-Cambrésis; Habsburg domination of Italy confirmed.
France: accession of Charles IX; regency of Catherine de' Medici.

Massacre of Wassy: beginning of French Wars of Religion.

Dissolution of the Council of Trent.

Death of Calvin.

Pius V becomes Pope (to 1572).

Mary Queen of Scots flees to England.

DATE	AUTHOR'S LIFE	CULTURAL CONTEXT
1568	Second edition of *Lives of the most eminent Painters, Sculptors and Architects*, including his autobiography.	
1569	*Incredulity of St Thomas* altarpiece, Santa Croce.	Death of Bruegel the Elder.
1569–70	*Madonna of the Rosary* altarpiece, Santa Maria Novella.	
1570	Decoration of St Stephen, St Peter Martyr and Archangel Michael chapels, the Vatican.	Death of Jacopo Sansovino. Palladio: *Four Books of Architecture*.
1570–71	*Road to Calvary* altarpiece, Santa Croce.	
1570–72	*The Siege of Florence*, Palazzo Vecchio.	
1571	Made knight of the Golden Spur by Pius V.	Death of Cellini.
c. 1571	Self-portrait (now in Uffizi).	
1572	Unveiling of complete series of paintings in the Sala dei Cinquecento, Palazzo Vecchio.	Death of Bronzino.
1573	Design for the Loggia in Arezzo.	Tintoretto: *The Battle of Lepanto*, Chamber of the Grand Council, the Doges' Palace, Venice. Tasso: *Aminta*.
1574	21 April: death of Cosimo de' Medici. 27 June: dies (leaving painting of dome of Florence Cathedral unfinished).	
1576		Death of Titian.
1577		
1578		Ronsard: *Sonnets pour Hélène*.
1579		El Greco: *Trinity*.
1580		Death of Palladio. Montaigne: Essays. Tasso: *Jerusalem Delivered*.
1581		
1582		
1584	Death of Vasari's widow, Niccolosa.	
1586		El Greco: *The Burial of Count Orgaz*.
1588	Posthumous publication of the *Ragionamenti*.	

CHRONOLOGY

lxi

TRANSLATOR'S PREFACE

Vasari introduces himself sufficiently in his own prefaces and introduction; a translator need concern himself only with the system by which the Italian text can best be rendered in English. The style of that text is sometimes laboured and pompous; it is often ungrammatical. But the narrative is generally lively, full of neat phrases, and abounding in quaint expressions – many of them still recognizable in the modern Florentine vernacular – while, in such Lives as those of Giotto, Leonardo da Vinci, and Michelagnolo, Vasari shows how well he can rise to a fine subject. His criticism is generally sound, solid, and direct; and he employs few technical terms, except in connection with architecture, where we find passages full of technicalities, often so loosely used that it is difficult to be sure of their exact meaning. In such cases I have invariably adopted the rendering which seemed most in accordance with Vasari's actual words so far as these could be explained by professional advice and local knowledge; and I have included brief notes where they appeared to be indispensable.

In Mrs. Foster's familiar English paraphrase – for a paraphrase it is rather than a translation – all Vasari's liveliness evaporates, even where his meaning is not blurred or misunderstood. Perhaps I have gone too far towards the other extreme in relying upon the Anglo-Saxon side of the English language rather than upon the Latin, and in taking no liberties whatever with the text of 1568. My intention, indeed, has been to render my original word for word, and to err, if at all, in favour of literalness. The very structure of Vasari's sentences has usually been retained, though some freedom was necessary in the matter of the punctuation, which is generally bewildering. As Mr. Horne's only too rare translation of the Life of Leonardo da Vinci has proved, it is by some such method that we can best keep Vasari's sense and Vasari's spirit – the one as important to the student of Italian art as is the other to the general reader. Such an attempt, however, places an English translator of the first volume at a conspicuous disadvantage.

Throughout the earlier Lives Vasari seems to be feeling his way. He is not sure of himself, and his style is often awkward. The more faithful the attempted rendering, the more plainly must that awkwardness be reproduced.

Vasari's Introduction on Technique has not been included, because it has no immediate connection with the Lives. In any case, there already exists an adequate translation by Miss Maclehose. All Vasari's other prefaces and introductions are given in the order in which they are found in the edition of 1568.

With this much explanation, I may pass to personal matters, and record my thanks to many Florentine friends for help in technical and grammatical questions; to Professor Baldwin Brown for the notes on technical matters printed with Miss Maclehose's translation of 'Vasari on Technique'; and to Mr. C. J. Holmes, of the National Portrait Gallery, for encouragement in a task which has proved no less pleasant than difficult.

London, March 1912. G. du C. de V.

LIVES OF THE MOST EMINENT PAINTERS, SCULPTORS AND ARCHITECTS

BY GIORGIO VASARI

VOLUME ONE

TO THE MOST ILLUSTRIOUS
AND MOST EXCELLENT SIGNOR
COSIMO DE' MEDICI, DUKE OF
FLORENCE

MY MOST HONOURED LORD,

Seeing that your Excellency, following in this the footsteps of your most Illustrious ancestors, and incited and urged by your own natural magnanimity, ceases not to favour and to exalt every kind of talent, wheresoever it may be found, and shows particular favour to the arts of design, fondness for their craftsmen,* and understanding and delight in their beautiful and rare works; I think that you cannot but take pleasure in this labour which I have undertaken, of writing down the lives, the works, the manners, and the circumstances of all those who, finding the arts already dead, first revived them, then step by step nourished and adorned them, and finally brought them to that height of beauty and majesty whereon they stand at the present day. And because these masters have been almost all Tuscans, and most of these Florentines, of whom many have been incited and aided by your most Illustrious ancestors with every kind of reward and honour to put themselves to work, it may be said that in your state, nay, in your most blessed house the arts were born anew, and that through the generosity of your ancestors the world has recovered these most beautiful arts, through which it has been ennobled and embellished.

* The word 'artist' has become impossible as a translation of 'artefice.' Such words as 'artificer,' 'art-worker,' or 'artisan,' seem even worse. 'Craftsman' loses the alliterative connection with 'art,' but it comes nearest to expressing Vasari's idea of the 'artefice' as a practical workman (*cf.* his remark about Ambrogio Lorenzetti: 'The ways of Ambrogio were rather those of a "gentiluomo" than of an "artefice" ').

3

Wherefore, through the debt which this age, these arts, and
these craftsmen owe to your ancestors, and to you as the heir of
their virtue and of their patronage of these professions, and
through that debt which I, above all, owe them, seeing that I was
taught by them, that I was their subject and their devoted servant,
that I was brought up under Cardinal Ippolito de' Medici, and
under Alessandro, your predecessor, and that, finally, I am infi-
nitely attached to the blessed memory of the Magnificent Ottaviano
de' Medici, by whom I was supported, loved and protected while he
lived; for all these reasons, I say, and because from the greatness of
your worth and of your fortunes there will come much favour for
this work, and from your understanding of its subject there will
come a better appreciation than from any other for its usefulness
and for the labour and the diligence that I have given to its execu-
tion, it has seemed to me that to your Excellency alone could it be
fittingly dedicated, and it is under your most honoured name that I
have wished it to come to the hands of men.

Deign, then, Excellency, to accept it, to favour it, and, if this
may be granted to it by your exalted thoughts, sometimes to read
it; having regard to the nature of the matter therein dealt with
and to my pure intention, which has been, not to gain for myself
praise as a writer, but as craftsman to praise the industry and to
revive the memory of those who, having given life and adorn-
ment to these professions, do not deserve to have their names
and their works wholly left, even as they were, the prey of death
and of oblivion. Besides, at the same time, through the example
of so many able men and through so many observations on so
many works that I have gathered together in this book, I have
thought to help not a little the masters of these exercises and to
please all those who therein have taste and pleasure. This I have
striven to do with that accuracy and with that good faith which
are essential for the truth of history and of things written. But if
my writing, being unpolished and as artless as my speech, be
unworthy of your Excellency's ear and of the merits of so many
most illustrious intellects; as for them, pardon me that the pen of
a draughtsman, such as they too were, has no greater power to
give them outline and shadow; and as for yourself, let it suffice
me that your Excellency should deign to approve my simple
labour, remembering that the necessity of gaining for myself the
wherewithal to live has left me no time to exercise myself with
any instrument but the brush. Nor even with that have I reached

that goal to which I think to be able to attain, now that Fortune promises me so much favour, that, with greater ease and greater credit for myself and with greater satisfaction to others, I may perchance be able, as well with the pen as with the brush, to unfold my ideas to the world, whatsoever they may be. For besides the help and protection for which I must hope from your Excellency, as my liege lord and as the protector of poor followers of the arts, it has pleased the goodness of God to elect as His Vicar on earth the most holy and most blessed Julius III, Supreme Pontiff and a friend and patron of every kind of excellence and of these most excellent and most difficult arts in particular, from whose exalted liberality I expect recompense for many years spent and many labours expended, and up to now without fruit. And not only I, who have dedicated myself to the perpetual service of His Holiness, but all the gifted craftsmen of this age, must expect from him such honour and reward and opportunities for practising the arts so greatly, that already I rejoice to see these arts arriving in his time at the greatest height of their perfection, and Rome adorned by craftsmen so many and so noble that, counting them with those of Florence, whom your Excellency is calling every day into activity, I hope that someone after our time will have to write a fourth part to my book, enriching it with other masters and other masterpieces than those described by me; in which company I am striving with every effort not to be among the last.

Meanwhile, I am content if your Excellency has good hope of me and a better opinion than that which, by no fault of mine, you have perchance conceived of me; beseeching you not to let me be undone in your estimation by the malignant tales of other men, until at last my life and my works shall prove the contrary to what they say.

Now with that intent to which I hold, always to honour and to serve your Excellency, dedicating to you this my rough labour, as I have dedicated to you every other thing of mine and my own self, I implore you not to disdain to grant it your protection, or at least to appreciate the devotion of him who offers it to you; and recommending myself to your gracious goodness, most humbly do I kiss your hand.

Your Excellency's most humble Servant,
GIORGIO VASARI,
Painter of Arezzo.

TO THE MOST ILLUSTRIOUS
AND MOST EXCELLENT SIGNOR
COSIMO DE' MEDICI, DUKE OF
FLORENCE AND SIENA

My most honoured Lord,

Behold, seventeen years since I first presented to your most Illustrious Excellency the Lives, sketched so to speak, of the most famous painters, sculptors and architects, they come before you again, not indeed wholly finished, but so much changed from what they were and in such wise adorned and enriched with innumerable works, whereof up to that time I had been able to gain no further knowledge, that from my endeavour and in so far as in me lies nothing more can be looked for in them.

Behold, I say, once again they come before you, most Illustrious and truly most Excellent Lord Duke, with the addition of other noble and right famous craftsmen, who from that time up to our own day have passed from the miseries of this life to a better, and of others who, although they are still living in our midst, have laboured in these professions to such purpose that they are most worthy of eternal memory. And in truth it has been no small good-fortune for many that I, by the goodness of Him in whom all things have their being, have lived so long that I have almost rewritten this book; seeing that, even as I have removed many things which had been included I know not how, in my absence and without my consent, and have changed others, so too I have added many, both useful and necessary, that were lacking. And as for the likenesses and portraits of so many men of worth which I have placed in this work, whereof a great part have been furnished by the help and co-operation of your Excellency, if they are sometimes not very true to life, and if they all have not that character and resemblance which the vivacity of

colours is wont to give them, that is because the drawing and the
lineaments have not been taken from the life and are not charac-
teristic and natural; not to mention that a great part of them have
been sent me by the friends that I have in various places, and
they have not all been drawn by a good hand. Moreover, I have
suffered no small inconvenience in this from the distance of those
who have engraved these heads, because, if the engravers had
been near me, it might perchance have been possible to use in
this matter more diligence than has been shown. But however
this may be, our lovers of art and our craftsmen, for the conveni-
ence and benefit of whom I have put myself to so great pains,
must be wholly indebted to your most Illustrious Excellency for
whatever they may find in it of the good, the useful, and the
helpful, seeing that while engaged in your service I have had the
opportunity, through the leisure which it has pleased you to give
me and through the management of your many, nay, innumerable
treasures, to put together and to give to the world everything
which appeared to be necessary for the perfect completion of this
work; and would it not be almost impiety, not to say ingratitude,
were I to dedicate these Lives to another, or were the craftsmen
to attribute to any other than yourself whatever they may find in
them to give them help or pleasure? For not only was it with your
help and favour that they first came to the light, as now they do
again, but you are, in imitation of your ancestors, sole father, sole
lord, and sole protector of these our arts. Wherefore it is very
right and reasonable that by these there should be made, in your
service and to your eternal and perpetual memory, so many most
noble pictures and statues and so many marvellous buildings in
every manner.

But if we are all, as indeed we are beyond calculation, most
deeply obliged to you for these and for other reasons, how much
more do I not owe to you, who have always had (would that my
brain and my hand had been equal to my desire and right good
will) so many valuable opportunities to display my little know-
ledge, which, whatsoever it may be, fails by a very great measure
to counterbalance the greatness and the truly royal magnificence
of your mind? But how may I tell? It is in truth better that I
should stay as I am than that I should set myself to attempt what
would be to the most lofty and noble brain, and much more so
to my insignificance, wholly impossible.

Accept then, most Illustrious Excellency, this my book, or rather indeed your book, of the Lives of the craftsmen of design; and like the Almighty God, looking rather at my soul and at my good intentions than at my work, take from me with right good will not what I would wish and ought to give, but what I can.

Your most Illustrious Excellency's most indebted servant,

<div align="right">GIORGIO VASARI.</div>

FLORENCE,
 January 9, 1568.

PIUS PAPA QUINTUS

Motu proprio (et cet.). Cum, sicut accepimus, dilectus filius Philippus Junta, typographus Florentinus, ad communem studiosorum utilitatem, sua impensa, Vitas Illustrium Pictorum et Sculptorum Georgii Vasarii demum auctas et suis imaginibus exornatas, Statuta Equitum Melitensium in Italicam linguam translata, Receptariumque Novum pro Aromatariis, aliaque opera tum Latina, tum Italica, saneque utilia et necessaria, imprimi facere intendat, dubitetque ne hujusmodi opera postmodum ab aliis sine ejus licentia et in ejus grave præjudicium imprimantur; nos propterea, illius indemnitati consulere volentes, motu simili et ex certa scientia, eidem Philippo concedimus et indulgemus ne prædicta opera, dummodo prius ab Inquisitore visa et approbata fuerint, per ipsum imprimenda, infra decennium a quoquo sine ipsius licentia imprimi aut vendi vel in apothecis teneri possint; inhibentes omnibus et singulis Christi fidelibus tam in Italia quam extra Italiam existentibus, sub excommunicationis lata sententia, in terris vero S.R.E. mediate vel immediate subjectis, etiam ducentorum ducatorum auri Cameræ Apostolicæ applicandorum et amissionis librorum pœnis, totiens ipso facto et absque alia declaratione incurrendis quotiens contraventum fuerit, ne intra decennium præfatum dicta opera sine ejusdem Philippi expressa licentia imprimere, seu ab ipsis aut aliis impressa vendere, vel venalia habere; mandantes universis veneralibus fratribus nostris Archiepiscopis, Episcopis, eorumque Vicariis in spiritualibus generalibus, et in Statu S.R.E. etiam Legatis, Vicelegatis, Præsidibus et Gubernatoribus, ut quoties pro ipsius Philippi parte fuerint requisiti, vel eorum aliquis fuerit requisitus, eidem, efficacis defensionis præsidio assistentes, præmissa contra inobedientes et rebelles, per censuras ecclesiasticas, etiam sæpius aggravando, et per alia juris remedia, auctoritate Apostolica exequantur; invocato etiam ad hoc, si opus fuerit, auxilio brachii sæcularis. Volumus autem quod præsentis motus proprii nostri sola signatura

sufficiat, et ubique fidem faciat in judicio et extra, regula contraria non obstante et officii sanctissimæ Inquisitionis Florentinæ.

Placet motu proprio M
 Datum Romæ apud Sanctum Petrum, quintodecimo Cal. Maij, anno secundo.

PREFACE TO THE WHOLE WORK

It was the wont of the finest spirits in all their actions, through a burning desire for glory, to spare no labour, however grievous, in order to bring their works to that perfection which might render them impressive and marvellous to the whole world; nor could the humble fortunes of many prevent their energies from attaining to the highest rank, whether in order to live in honour or to leave in the ages to come eternal fame for all their rare excellence. And although, for zeal and desire so worthy of praise, they were, while living, highly rewarded by the liberality of Princes and by the splendid ambition of States, and even after death kept alive in the eyes of the world by the testimony of statues, tombs, medals, and other memorials of that kind; none the less, it is clearly seen that the ravening maw of time has not only diminished by a great amount their own works and the honourable testimonies of others, but has also blotted out and destroyed the names of all those who have been kept alive by any other means than by the right vivacious and pious pens of writers.

Pondering over this matter many a time in my own mind, and recognizing, from the example not only of the ancients but of the moderns as well, that the names of very many architects, sculptors, and painters, both old and modern, together with innumerable most beautiful works wrought by them, are going on being forgotten and destroyed little by little, and in such wise, in truth, that nothing can be foretold for them but a certain and wellnigh immediate death; and wishing to defend them as much as in me lies from this second death, and to preserve them as long as may be possible in the memory of the living; and having spent much time in seeking them out and used the greatest diligence in discovering the native city, the origin, and the actions of the craftsmen, and having with great labour drawn them from the tales of old men and from various records and writings, left by their heirs a prey to dust and food for worms; and finally, having

13

received from this both profit and pleasure, I have judged it expedient, nay rather, my duty, to make for them whatsoever memorial my weak talents and my small judgment may be able to make. In honour, then, of those who are already dead, and for the benefit, for the most part, of all the followers of these three most excellent arts, Architecture, Sculpture, and Painting, I will write the Lives of the craftsmen of each according to the times wherein they lived, step by step from Cimabue down to our own time; not touching on the ancients save in so far as it may concern our subject, seeing that no more can be said of them than those so many writers have said who have come down to our own age. I will treat thoroughly of many things that appertain to the science of one or other of the said arts; but before I come to the secrets of these, or to the history of the craftsmen, it seems to me right to touch a little on a dispute, born and bred between many without reason, as to the sovereignty and nobility, not of architecture, which they have left on one side, but of sculpture and painting; there being advanced, on one side and on the other, many arguments whereof many, if not all, are worthy to be heard and discussed by their craftsmen.

I say, then, that the sculptors, as being endowed, perchance by nature and by the exercise of their art, with a better habit of body, with more blood, and with more energy, and being thereby more hardy and more fiery than the painters, in seeking to give the highest rank to their art, argue and prove the nobility of sculpture primarily from its antiquity, for the reason that God Almighty made man, who was the first statue; and they say that sculpture embraces many more arts as kindred, and has many more of them subordinate to itself than has painting, such as low-relief, working in clay, wax, plaster, wood, and ivory, casting in metals, every kind of chasing, engraving and carving in relief on fine stones and steel, and many others which both in number and in difficulty surpass those of painting. And alleging, further, that those things which stand longest and best against time and can be preserved longest for the use of men, for whose benefit and service they are made, are without doubt more useful and more worthy to be held in love and honour than are the others, they maintain that sculpture is by so much more noble than painting as it is more easy to preserve, both itself and the names of all who are honoured by it both in marble and in bronze, against all the ravages of time and air, than is painting, which, by its very nature, not to say by external accidents, perishes in the most

sheltered and most secure places that architects have been able to provide. Nay more, they insist that the small number not merely of their excellent but even of their ordinary craftsmen, in contrast to the infinite number of the painters, proves their greater nobility; saying that sculpture calls for a certain better disposition, both of mind and of body, that are rarely found together, whereas painting contents itself with any feeble temperament, so long as it has a hand, if not bold, at least sure; and that this their contention is proved by the greater prices cited in particular by Pliny, by the loves caused by the marvellous beauty of certain statues, and by the judgment of him who made the statue of sculpture of gold and that of painting of silver, and placed the first on the right and the second on the left. Nor do they even refrain from quoting the difficulties experienced before the materials, such as the marbles and the metals, can be got into subjection, and their value, in contrast to the ease of obtaining the panels, the canvases, and the colours, for the smallest prices and in every place; and further, the extreme and grievous labour of handling the marbles and the bronzes, through their weight, and of working them, through the weight of the tools, in contrast to the lightness of the brushes, of the styles, and of the pens, chalk-holders, and charcoals; besides this, that they exhaust their minds together with all the parts of their bodies, which is something very serious compared with the quiet and light work of the painter, using only his mind and hand. Moreover, they lay very great stress on the fact that things are more noble and more perfect in proportion as they approach more nearly to the truth, and they say that sculpture imitates the true form and shows its works on every side and from every point of view, whereas painting, being laid on flat with most simple strokes of the brush and having but one light, shows but one aspect; and many of them do not scruple to say that sculpture is as much superior to painting as is truth to falsehood. But as their last and strongest argument, they allege that for the sculptor there is necessary a perfection of judgment not only ordinary, as for the painter, but absolute and immediate, in a manner that it may see within the marble the exact whole of that figure which they intend to carve from it, and may be able to make many parts perfect without any other model before it combines and unites them together, as Michelagnolo has done divinely well; although, for lack of this happiness of judgment, they make easily and often some of those

blunders which have no remedy, and which, when made, bear witness for ever to the slips of the chisel or to the small judgment of the sculptor. This never happens to painters, for the reason that at every slip of the brush or error of judgment that might befall them they have time, recognizing it themselves or being told by others, to cover and patch it up with the very brush that made it; which brush, in their hands, has this advantage over the sculptor's chisels, that it not only heals, as did the iron of the spear of Achilles, but leaves its wounds without a scar.

To these things the painters, answering not without disdain, say, in the first place, that if the sculptors wish to discuss the matter on the ground of the Scriptures the chief nobility is their own, and that the sculptors deceive themselves very grievously in claiming as their work the statue of our first father, which was made of earth; for the art of this performance, both in its putting on and in its taking off, belongs no less to the painters than to others, and was called 'plastice' by the Greeks and 'fictoria' by the Latins, and was judged by Praxiteles to be the mother of sculpture, of casting, and of chasing, a fact which makes sculpture, in truth, the niece of painting, seeing that 'plastice' and painting are born at one and the same moment from design. And they say that if we consider it apart from the Scriptures, the opinions of the ages are so many and so varied that it is difficult to believe one more than the other; and that finally, considering this nobility as they wish it, in one place they lose and in the other they do not win, as may be seen more clearly in the Preface to the Lives.

After this, in comparison with the arts related and subordinate to sculpture, they say that they have many more than the sculptors, because painting embraces the invention of history, the most difficult art of foreshortening, all the branches of architecture needful for the making of buildings, perspective, colouring in distemper, and the art of working in fresco, an art different and distinct from all the others; likewise working in oils on wood, on stone, and on canvas; illumination, too, an art different from all the others; the staining of glass, mosaics in glass, the art of inlaying and making pictures with coloured woods, which is painting; making sgraffito* work on houses with iron tools; niello

* The process of sgraffito work is described in Professor Baldwin Brown's notes to 'Vasari on Technique' as follows: 'A wall is covered with a layer of tinted plaster, and on this is superimposed a thin coating of white plaster. This outer coating is scratched through (with an iron tool), and the colour behind is

work* and printing from copper, both members of painting; goldsmith's enamelling, and the inlaying of gold for damascening; the painting of glazed figures, and the making on earthenware vessels of scenes and figures to resist the action of water; weaving brocades with figures and flowers, and that most beautiful invention, woven tapestries, that are both convenient and magnificent, being able to carry painting into every place, whether savage or civilized; not to mention that in every department of art that has to be practised, design, which is our design, is used by all; so that the members of painting are more numerous and more useful than those of sculpture. They do not deny the eternity, for so the others call it, of sculpture, but they say that this is no privilege that should make the art more noble than it is by nature, seeing that it comes simply from the material, and that if length of life were to give nobility to souls, the pine, among the plants, and the stag, among the animals, would have a soul more noble beyond compare than that of men; although they could claim a similar immortality and nobility in their mosaics, seeing that there may be seen some as ancient as the most ancient sculptures that are in Rome, and that they used to be made of jewels and fine stones. And as for their small or smaller number, they declare that this is not because the art calls for a better habit of body and greater judgment, but that it depends wholly on the poverty of their resources and on the little favour, or avarice, as we would rather call it, of rich men, who give them no supply of marble and no opportunity to work; in contrast with what may be believed, nay, seen to have happened in ancient times, when sculpture rose to its greatest height. Indeed, it is manifest that he who cannot use and waste a small quantity of marble and hard stone, which are very costly, cannot have that practice in the art that is essential; he who does not practise does not learn it; and he who does not learn it can do no good. Wherefore they should rather excuse with these arguments the imperfection and the small number of their masters, than seek to deduce nobility from them under false colours. As for the higher prices of sculptures, they

revealed. Then all the surface outside the design is cut away, and a cameo-like effect is given to the design.'

* The process of niello is as follows: A design is engraved on silver or bronze, and the lines of the design are filled with a composition of silver and lead. On the application of fire to the whole, this composition turns black, leaving the design strongly outlined.

answer that, although theirs might be much less, they have not
to share them, being content with a boy who grinds their colours
and hands them their brushes or their cheap stools, whereas the
sculptors, besides the great cost of their material, require many
aids and spend more time on one single figure than they them-
selves do on very many; wherefore their prices appear to come
from the quality and the durability of the material itself, from the
aids that it requires for its completion, and from the time that is
taken in working it, rather than from the excellence of the art
itself. And although that does not suffice and no greater price is
found, as would be easily seen by anyone who were willing to
consider it diligently, let them find a greater price than the mar-
vellous, beautiful, and living gift that Alexander the Great made
in return for the most splendid and excellent work of Apelles,
bestowing on him, not vast treasures or high estate, but his own
beloved and most beautiful Campaspe; let them observe, in ad-
dition, that Alexander was young, enamoured of her, and natu-
rally subject to the passions of love, and also both a King and a
Greek; and then, from this, let them draw what conclusion they
please. As for the loves of Pygmalion and of those other rascals
no more worthy to be men, cited as proof of the nobility of the
art, they know not what to answer, if, from a very great blindness
of intellect and from a licentiousness unbridled beyond all natural
bounds, there can be made a proof of nobility. As for the man,
whosoever he was, alleged by the sculptors to have made sculp-
ture of gold and painting of silver, they are agreed that if he had
given as much sign of judgment as of wealth, there would be no
disputing it; and finally, they conclude that the ancient Golden
Fleece, however celebrated it may be, none the less covered noth-
ing but an unintelligent ram; wherefore neither the testimony of
riches nor that of dishonest desires, but those of letters, of prac-
tice, of excellence, and of judgment are those to which we must
pay attention. Nor do they make any answer to the difficulty of
obtaining the marbles and the metals, save this, that it springs
from their own poverty and from the little favour of the power-
ful, as has been said, and not from any degree of greater nobility.
To the extreme fatigues of the body and to the dangers peculiar
to them and to their works, laughing and without any ado they
answer that if greater fatigues and dangers prove greater nobility,
the art of quarrying the marbles from the bowels of mountains
by means of wedges, levers, and hammers must be more noble

than sculpture, that of the blacksmith must surpass the gold-smith's, and that of masonry must be superior to architecture.

They say, next, that the true difficulties lie rather in the mind than in the body, wherefore those things that from their nature call for more study and knowledge are more noble and excellent than those that avail themselves rather of strength of body; and they declare that since the painters rely more on the worth of the mind than the others, this highest honour belongs to painting. For the sculptors the compasses and squares suffice to discover and apply all the proportions and measurements whereof they have need; for the painters there is necessary, besides the know-ledge how to make good use of the aforesaid instruments, an accurate understanding of perspective, for the reason that they have to provide a thousand other things beyond landscapes and buildings, not to mention that they must have greater judgment by reason of the quantity of the figures in one scene, wherein more errors can come than in a single statue. For the sculptor it is enough to be acquainted with the true forms and features of solid and tangible bodies, subordinate on every side to the touch, and moreover of those only that have something to support them. For the painter it is necessary to know the forms not only of all the bodies supported and not supported, but also of all those transparent and intangible; and besides this they must know the colours that are suitable for the said bodies, whereof the multitude and the variety, so absolute and admitting of such infi-nite extension, are demonstrated better by the flowers, the fruits, and the minerals than by anything else; and this knowledge is supremely difficult to acquire and to maintain, by reason of their infinite variety. They say, moreover, that whereas sculpture, through the stubbornness and the imperfection of the material, does not represent the emotions of the soul save with motion, which does not, however, find much scope therein, and with the mere shape of the limbs and not even of all these; the painters demonstrate them with all the forms of motion, which are infi-nite, with the shape of the limbs, however subtle they may be, and even with breath itself and the spiritual essence of sight; and that, for greater perfection in demonstrating not only the pas-sions and emotions of the soul but also the events of the future, as living men do, they must have, besides long practice in the art, a complete understanding of physiognomy, whereof that part suffices for the sculptor which deals with the quantity and the

quality of the members, without troubling about the quality of colours, as to the knowledge of which anyone who judges by the eye knows how useful and necessary it is for the true imitation of nature, whereunto the closer a man approaches the more perfect he is.

After this they add that whereas sculpture, taking away bit by bit, at one and the same time gives depth to and acquires relief for those things that have solidity by their own nature, and makes use of touch and sight, the painters, in two distinct actions, give relief and depth to a flat surface with the help of one single sense; and this, when it has been done by a person intelligent in the art, has caused many great men, not to speak of animals, to stand fast in the most pleasing illusion, which has never been seen to be done by sculpture, for the reason that it does not imitate nature in a manner that may be called as perfect as their own. And finally, in answer to that complete and absolute perfection of judgment which is required for sculpture, by reason of its having no means to add where it takes away; declaring, first, that such mistakes are irreparable, as the others say, and not to be remedied save by patches, which, even as in garments they are signs of poverty of wardrobe, so too both in sculpture and in pictures are signs of poverty of intellect and judgment; and saying, further, that patience, at its own leisure, by means of models, protractors, squares, compasses, and a thousand other devices and instruments for enlarging, not only preserves them from mistakes but enables them to bring their whole work to its perfection; they conclude, then, that this difficulty which they put down as the greater is nothing or little when compared to those which the painters have when working in fresco, and that the said perfection of judgment is in no way more necessary for sculptors than for painters, it being sufficient for the former to execute good models in wax, clay, or something else, even as the latter make their drawings on corresponding materials or on cartoons; and that finally, the quality that little by little transfers their models to the marble is rather patience than aught else.

But let us consider about judgment, as the sculptors wish, and see whether it is not more necessary to one who works in fresco than to one who chisels in marble. For here not only is there no place for patience or for time, which are most mortal enemies to the union of the plaster and the colours, but the eye does not see the true colours until the plaster is well dry, nor can the hand

judge of anything but of the soft or the dry, in a manner that anyone who were to call it working in the dark, or with spectacles of colours different from the truth, would not in my belief be very far wrong. Nay, I do not doubt at all that such a name is more suitable for it than for intaglio, for which wax serves as spectacles both true and good. They say, too, that for this work it is necessary to have a resolute judgment, to foresee the end in the fresh plaster and how the work will turn out on the dry; besides that the work cannot be abandoned so long as the plaster is still fresh, and that it is necessary to do resolutely in one day what sculpture does in a month. And if a man has not this judgment and this excellence, there are seen, on the completion of his work or in time, patches, blotches, corrections, and colours superimposed or retouched on the dry, which is something of the vilest, because afterwards mould appears and reveals the insufficiency and the small knowledge of the craftsmen, even as the pieces added in sculpture lead to ugliness; not to mention that when it comes about that the figures in fresco are washed, as is often done after some time to restore them, what has been worked on the fresh plaster remains, and what has been retouched on the dry is carried away by the wet sponge.

They add, moreover, that whereas the sculptors make two figures together, or at the most three, from one block of marble, they make many of them on one single panel, with all those so many and so varied aspects which the sculptors claim for one single statue, compensating with the variety of their postures, foreshortenings, and attitudes, for the fact that the work of the sculptors can be seen from every side; even as Giorgione da Castelfranco did once in one of his pictures, wherein a figure with its back turned, having a mirror on either side, and a pool of water at its feet, shows its back in the painting, its front in the pool, and its sides in the mirrors, which is something that sculpture has never been able to do. In addition to this, they maintain that painting leaves not one of the elements unadorned and not abounding with all the excellent things that nature has bestowed on them, giving its own light and its own darkness to the air, with all its varieties of feeling, and filling it with all the kinds of birds together; to water, its clearness, the fishes, the mosses, the foam, the undulations of the waves, the ships, and all its various moods; and to the earth, the mountains, the plains, the plants, the fruits, the flowers, the animals, and the buildings; with so great a multitude

of things and so great a variety of their forms and of their true colours, that nature herself many a time stands in a marvel thereat; and finally, giving to fire so much of its heat and light that it is clearly seen burning things, and, almost quivering with its flames, rendering luminous in part the thickest darkness of the night. Wherefore it appears to them that they can justly conclude and declare that contrasting the difficulties of the sculptors with their own, the labours of the body with those of the mind, the imitation of the mere form with the imitation of the impression, both of quantity and of quality, that strikes the eye, the small number of the subjects wherein sculpture can and does demonstrate its excellence with the infinite number of those which painting presents to us (not to mention the perfect preservation of them for the intellect and the distribution of them in those places wherein nature herself has not done so); and finally, weighing the whole content of the one with that of the other, the nobility of sculpture, as shown by the intellect, the invention, and the judgment of its craftsmen, does not correspond by a great measure to that which painting enjoys and deserves. And this is all that on the one side and on the other has come to my ears that is worthy of consideration.

But because it appears to me that the sculptors have spoken with too much heat and the painters with too much disdain, and seeing that I have long enough studied the works of sculpture and have ever exercised myself in painting, however small, perhaps, may be the fruit that is to be seen of it; none the less, by reason of that which it is worth, and by reason of the undertaking of these writings, judging it my duty to demonstrate the judgment that I have ever made of it in my own mind (and may my authority avail the most that it can), I will declare my opinion surely and briefly over such a dispute, being convinced that I will not incur any charge of presumption or of ignorance, seeing that I will not treat of the arts of others, as many have done before to the end that they might appear to the crowd intelligent in all things by means of letters, and as happened, among others, to Phormio the Peripatetic of Ephesus, who, in order to display his eloquence, lecturing and making disputation about the virtues and parts of the excellent captain, made Hannibal laugh not less at his presumption than at his ignorance.

I say, then, that sculpture and painting are in truth sisters, born from one father, that is, design, at one and the same birth, and have no precedence one over the other, save insomuch as

the worth and the strength of those who maintain them make one craftsman surpass another, and not by reason of any difference or degree of nobility that is in truth to be found between them. And although by reason of the diversity of their essence they have many different advantages, these are neither so great nor of such a kind that they do not come exactly into balance together and that we do not perceive the infatuation or the obstinacy, rather than the judgment, of those who wish one to surpass the other. Wherefore it may be said with reason that one and the same soul rules the bodies of both, and by reason of this I conclude that those do evil who strive to disunite and to separate the one from the other. Heaven, wishing to undeceive us in this matter and to show us the kinship and union of these two most noble arts, has raised up in our midst at various times many sculptors who have painted and many painters who have worked in sculpture, as will be seen in the Life of Antonio del Pollaiuolo, of Leonardo da Vinci, and of many others long since passed away. But in our own age the Divine Goodness has created for us Michelagnolo Buonarroti, in whom both these arts shine forth so perfect and appear so similar and so closely united, that the painters marvel at his pictures and the sculptors feel for the sculptures wrought by him supreme admiration and reverence. On him, to the end that he might not perchance need to seek from some other master some convenient resting-place for the figures that he wrought, nature has bestowed so generously the science of architecture, that without having need of others he has strength and power within himself to give to this or the other image made by himself an honourable and suitable resting-place, in a manner that he rightly deserves to be called the king of sculptors, the prince of painters, and the most excellent of architects, nay rather, of architecture the true master. And indeed we can affirm with certainty that those do in no way err who call him divine, seeing that he has within his own self embraced the three arts most worthy of praise and most ingenious that are to be found among mortal men, and that with these, after the manner of a God, he can give us infinite delight. And let this suffice for the dispute raised between the factions, and for our own opinion.

Now, returning to my first intention, I say that, wishing in so far as it lies within the reach of my powers to drag from the ravening maw of time the names of the sculptors, painters, and

architects, who, from Cimabue to the present day, have been of some notable excellence in Italy, and desiring that this my labour may be no less useful than it has been pleasant to me in the undertaking, it appears to me necessary, before we come to the history, to make as briefly as may be an introduction to these three arts, wherein those were valiant of whom I am to write the Lives, to the end that every gracious spirit may first learn the most notable things in their professions, and afterwards may be able with greater pleasure and benefit to see clearly in what they were different among themselves, and how great adornment and convenience they give to their countries and to all who wish to avail themselves of their industry and knowledge.

I will begin, then, with architecture, as the most universal and the most necessary and useful to men, and as that for the service and adornment of which the two others exist; and I will expound briefly the varieties of stone, the manners or methods of construction, with their proportions, and how one may recognize buildings that are good and well-conceived. Afterwards, discoursing of sculpture, I will tell how statues are wrought, the form and the proportion that are looked for in them, and of what kind are good sculptures, with all the most secret and most necessary precepts. Finally, treating of painting, I will speak of draughtsmanship, of the methods of colouring, of the perfect execution of any work, of the quality of the pictures themselves, and of whatsoever thing appertains to painting; of every kind of mosaic, of niello, of enamelling, of damascening, and then, lastly, of the printing of pictures. And in this way I am convinced that these my labours will delight those who are not engaged in these pursuits, and will both delight and help those who have made them a profession. For not to mention that in the Introduction they will review the methods of working, and that in the Lives of the craftsmen themselves they will learn where their works are, and how to recognize easily their perfection or imperfection and to discriminate between one manner and another, they will also be able to perceive how much praise and honour that man deserves who adds upright ways and goodness of life to the excellencies of arts so noble. Kindled by the praise that those so constituted have obtained, they too will aspire to true glory. Nor will little fruit be gathered from the history, true guide and mistress of our actions, in reading of the infinite variety of innumerable accidents

that befell the craftsmen, sometimes by their own fault and very often by chance.

It remains for me to make excuse for having on occasion used some words of indifferent Tuscan, whereof I do not wish to speak, having ever taken thought to use rather the words and names particular and proper to our arts than the delicate or choice words of precious writers. Let me be allowed, then, to use in their proper speech the words proper to our craftsmen, and let all content themselves with my good will, which has bestirred itself to produce this result not in order to teach to others what I do not know myself, but through a desire to preserve this memory at least of the most celebrated craftsmen, seeing that in so many decades I have not yet been able to see one who has made much record of them. For I have wished with these my rough labours, adumbrating their noble deeds, to repay to them in some measure the debt that I owe to their works, which have been to me as masters for the learning of whatsoever I know, rather than, living in sloth, to be a malignant critic of the works of others, blaming and decrying them as men are often wont to do. But it is now time to come to our business.

PREFACE TO THE LIVES

I HAVE no manner of doubt that it is with almost all writers a common and deeply-fixed opinion that sculpture and painting together were first discovered, by the light of nature, by the people of Egypt, and that there are certain others who attribute to the Chaldæans the first rough sketches in marble and the first reliefs in statuary, even as they also give to the Greeks the invention of the brush and of colouring. But I will surely say that of both one and the other of these arts the design, which is their foundation, nay rather, the very soul that conceives and nourishes within itself all the parts of man's intellect, was already most perfect before the creation of all other things, when the Almighty God, having made the great body of the world and having adorned the heavens with their exceeding bright lights, descended lower with His intellect into the clearness of the air and the solidity of the earth, and, shaping man, discovered, together with the lovely creation of all things, the first form of sculpture; from which man afterwards, step by step (and this may not be denied), as from a true pattern, there were taken statues, sculptures, and the science of pose and of outline; and for the first pictures (whatsoever they were), softness, harmony, and the concord in discord that comes from light and shade. Thus, then, the first model whence there issued the first image of man was a lump of clay, and not without reason, seeing that the Divine Architect of time and of nature, being Himself most perfect, wished to show in the imperfection of the material the way to add and to take away; in the same manner wherein the good sculptors and painters are wont to work, who, adding and taking away in their models, bring their imperfect sketches to that final perfection which they desire. He gave to man that most vivid colour of flesh, whence afterwards there were drawn for painting, from the mines of the earth, the colours themselves for the counterfeiting of all those things that are required for pictures. It is true, indeed,

27

that it cannot be affirmed for certain what was made by the men
before the Flood in these arts in imitation of so beautiful a work,
although it is reasonable to believe that they too carved and
painted in every manner; seeing that Belus, son of the proud
Nimrod, about 200 years after the Flood, caused to be made that
statue wherefrom there was afterwards born idolatry, and his
son's wife, the very famous Semiramis, Queen of Babylon, in the
building of that city, placed among its adornments not only
diverse varied kinds of animals, portrayed and coloured from
nature, but also the image of herself and of Ninus, her husband,
and, moreover, statues in bronze of her husband's father, of her
husband's mother, and of the mother of the latter, as Diodorus
relates, calling them by the Greek names (that did not yet exist),
Jove, Juno, and Ops. From these statues, perchance, the Chal-
dæans learnt to make the images of their gods, seeing that 150
years later Rachel, in flying from Mesopotamia together with
Jacob her husband, stole the idols of Laban her father, as is
clearly related in Genesis. Nor, indeed, were the Chaldæans alone
in making sculptures and pictures, but the Egyptians made them
also, exercising themselves in these arts with that so great zeal
which is shown in the marvellous tomb of the most ancient King
Osimandyas, copiously described by Diodorus, and proved by the
stern commandment made by Moses in the Exodus from Egypt,
namely, that under pain of death there should be made to God
no image whatsoever. He, on descending from the mountain,
having found the golden calf wrought and adored solemnly by
his people, and being greatly perturbed to see Divine honours
paid to the image of a beast, not only broke it and reduced it to
powder, but for punishment of so great a sin caused many thou-
sands of the wicked sons of Israel to be slain by the Levites. But
because not the making of statues but their adoration was a
deadly sin, we read in Exodus that the art of design and of
statuary, not only in marble but in every kind of metal, was
bestowed by the mouth of God on Bezaleel, of the tribe of
Judah, and on Aholiab, of the tribe of Dan, who were those that
made the two cherubim of gold, the candlesticks, the veil, the
borders of the priestly vestments, and so many other most beau-
tiful castings for the Tabernacle, for no other reason than to
bring the people to contemplate and to adore them.

From the things seen before the Flood, then, the pride of men
found the way to make the statues of those for whom they

wished that they should remain famous and immortal in the world. And the Greeks, who think differently about this origin, say that the Ethiopians invented the first statues, as Diodorus tells; that the Egyptians took them from the Ethiopians, and, from them, the Greeks; for by Homer's time sculpture and painting are seen to have been perfected, as it is proved, in discoursing of the shield of Achilles, by that divine poet, who shows it to us carved and painted, rather than described, with every form of art. Lactantius Firmianus, by way of fable, attributes it to Prometheus, who, in the manner of Almighty God, shaped man's image out of mud; and from him, he declares, the art of statuary came. But according to what Pliny writes, this came to Egypt from Gyges the Lydian, who, being by the fire and gazing at his own shadow, suddenly, with some charcoal in his hand, drew his own outline on the wall. And from that age, for a time, outlines only were wont to be used, with no body of colour, as the same Pliny confirms; which method was rediscovered with more labour by Philocles the Egyptian, and likewise by Cleanthes and Ardices of Corinth and by Telephanes of Sicyon.

Cleophantes of Corinth was the first among the Greeks who used colours, and Apollodorus the first who discovered the brush. There followed Polygnotus of Thasos, Zeuxis, and Timagoras of Chalcis, with Pythias and Aglaophon, all most celebrated; and after these the most famous Apelles, so much esteemed and honoured by Alexander the Great for his talent, and the most ingenious investigator of slander and false favour, as Lucian shows us; even as almost all the excellent painters and sculptors were endowed by Heaven, in nearly every case, not only with the adornment of poetry, as may be read of Pacuvius, but with philosophy besides, as may be seen in Metrodorus, who, being as well versed in philosophy as in painting, was sent by the Athenians to Paulus Emilius to adorn his triumph, and remained with him to read philosophy to his sons.

The art of sculpture, then, was greatly exercised in Greece, and there appeared many excellent craftsmen, and, among others, Pheidias, an Athenian, with Praxiteles and Polycletus, all very great masters, while Lysippus and Pyrgoteles were excellent in sunk reliefs, and Pygmalion in reliefs in ivory, of whom there is a fable that by his prayers he obtained breath and spirit for the figure of a virgin that he made. Painting, likewise, was honoured and rewarded by the ancient Greeks and Romans, seeing that to

those who made it appear marvellous they showed favour by bestowing on them citizenship and the highest dignities. So greatly did this art flourish in Rome that Fabius gave renown to his house by writing his name under the things so beautifully painted by him in the temple of Salus, and calling himself Fabius Pictor. It was forbidden by public decree that slaves should exercise this art throughout the cities, and so much honour did the nations pay without ceasing to the art and to the craftsmen that the rarest works were sent among the triumphal spoils, as marvellous things, to Rome, and the finest craftsmen were freed from slavery and recompensed with honours and rewards by the commonwealths.

The Romans themselves bore so great reverence for these arts that besides the respect that Marcellus, in sacking the city of Syracuse, commanded to be paid to a craftsman famous in them, in planning the assault of the aforesaid city they took care not to set fire to that quarter wherein there was a most beautiful painted panel, which was afterwards carried to Rome in the triumph, with much pomp. Thither, having, so to speak, despoiled the world, in course of time they assembled the craftsmen themselves as well as their finest works, wherewith afterwards Rome became so beautiful, for the reason that she gained so great adornment from the statues from abroad more than from her own native ones; it being known that in Rhodes, the city of an island in no way large, there were more than 30,000 statues counted, either in bronze or in marble, nor did the Athenians have less, while those at Olympia and at Delphi were many more and those in Corinth numberless, and all were most beautiful and of the greatest value. Is it not known that Nicomedes, King of Lycia, in his eagerness for a Venus that was by the hand of Praxiteles, spent on it almost all the wealth of his people? Did not Attalus the same, who, in order to possess the picture of Bacchus painted by Aristides, did not scruple to spend on it more than 6,000 sesterces? Which picture was placed by Lucius Mummius in the temple of Ceres with the greatest pomp, in order to adorn Rome.

But for all that the nobility of these arts was so highly valued, it is none the less not yet known for certain who gave them their first beginning. For, as has been already said above, it appears most ancient among the Chaldæans, some give it to the Ethiopians, and the Greeks attribute it to themselves; and it may be thought, not without reason, that it is perchance even more

ancient among the Etruscans, as our Leon Batista Alberti testifies, whereof we have clear enough proof in the marvellous tomb of Porsena at Chiusi, where, no long time since, there were discovered underground, between the walls of the Labyrinth, some terracotta tiles with figures on them in half-relief, so excellent and in so beautiful a manner that it can be easily recognized that the art was not begun precisely at that time, nay rather, by reason of the perfection of these works, that it was much nearer its height than its beginning. To this, moreover, witness is likewise borne by our seeing every day many pieces of those red and black vases of Arezzo, made, as may be judged from the manner, about those times, with the most delicate carvings and small figures and scenes in low-relief, and many small round masks wrought with great subtlety by masters of that age, men most experienced, as is shown by the effect, and most excellent in that art. It may be seen, moreover, by reason of the statues found at Viterbo at the beginning of the pontificate of Alexander VI, that sculpture was in great esteem and in no small perfection among the Etruscans; and although it is not known precisely at what time they were made, it may be reasonably conjectured, both from the manner of the figures and from the style of the tombs and of the buildings, no less than from the inscriptions in those Etruscan letters, that they are most ancient and were made at a time when the affairs of this country were in a good and prosperous state. But what clearer proof of this can be sought? seeing that in our own day – that is, in the year 1554 – there has been found a bronze figure of the Chimæra of Bellerophon, in making the ditches, fortifications, and walls of Arezzo, from which figure it is recognized that the perfection of that art existed in ancient times among the Etruscans, as may be seen from the Etruscan manner and still more from the letters carved on a paw, about which – since they are but few and there is no one now who understands the Etruscan tongue – it is conjectured that they may represent the name of the master as well as that of the figure itself, and perchance also the date, according to the use of those times. This figure, by reason of its beauty and antiquity, has been placed in our day by the Lord Duke Cosimo in the hall of the new rooms in his Palace, wherein there have been painted by me the acts of Pope Leo X. And besides this there were found in the same place many small figures in bronze after the same manner, which are in the hands of the said Lord Duke.

But since the dates of the works of the Greeks, the Ethiopians, and the Chaldæans are as doubtful as our own, and perhaps more, and by reason of the greater need of founding our judgment about these works on conjectures, which, however, are not so feeble that they are in every way wide of the mark, I believe that I strayed not at all from the truth (and I think that everyone who will consent to consider this question discreetly will judge as I did), when I said above that the origin of these arts was nature herself, and the example or model, the most beautiful fabric of the world, and the master, that divine light infused by special grace into us, which has not only made us superior to the other animals, but, if it be not sin to say it, like to God. And if in our own times it has been seen (as I trust to be able to demonstrate a little later by many examples) that simple children roughly reared in the woods, with their only model in the beautiful pictures and sculptures of nature, and by the vivacity of their wit, have begun by themselves to make designs, how much more may we, nay, must we confidently believe that these primitive men, who, in proportion as they were less distant from their origin and divine creation, were thereby the more perfect and of better intelligence, that they, by themselves, having for guide nature, for master purest intellect, and for example the so lovely model of the world, gave birth to these most noble arts, and from a small beginning, little by little bettering them, brought them at last to perfection? I do not, indeed, wish to deny that there was one among them who was the first to begin, seeing that I know very well that it must needs be that at some time and from some one man there came the beginning; nor, also, will I deny that it may have been possible that one helped another and taught and opened the way to design, to colour, and relief, because I know that our art is all imitation, of nature for the most part, and then, because a man cannot by himself rise so high, of those works that are executed by those whom he judges to be better masters than himself. But I say surely that the wishing to affirm dogmatically who this man or these men were is a thing very perilous to judge, and perchance little necessary to know, provided that we see the true root and origin wherefrom art was born. For since, of the works that are the life and the glory of the craftsmen, the first and step by step the second and the third were lost by reason of time, that consumes all things, and since, for lack of writers at that time, they could not, at least in that way, become known to

posterity, their craftsmen as well came to be forgotten. But when once the writers began to make record of things that were before their day, they could not speak of those whereof they had not been able to have information, in a manner that there came to be first with them those of whom the memory had been the last to be lost. Even as the first of the poets, by common consent, is said to be Homer, not because there were none before him, for there were, although not so excellent, which is seen clearly from his own works, but because of these early poets, whatever manner of men they were, all knowledge had been lost quite 2,000 years before. However, leaving behind us this part, as too uncertain by reason of its antiquity, let us come to the clearer matters of their perfection, ruin, and restoration, or rather resurrection, whereof we will be able to discourse on much better grounds.

I say, then, it being true indeed, that they began late in Rome, if the first figure was, as is said, the image of Ceres made of metal from the treasure of Spurius Cassius, who, for conspiring to make himself King, was put to death by his own father without any scruple; and that although the arts of sculpture and of painting continued up to the end of the twelve Cæsars, they did not, however, continue in that perfection and excellence which they had enjoyed before, for it may be seen from the edifices that the Emperors built in succession one after the other that these arts, decaying from one day to another, were coming little by little to lose their whole perfection of design. And to this clear testimony is borne by the works of sculpture and of architecture that were wrought in the time of Constantine in Rome, and in particular the triumphal arch raised for him by the Roman people near the Colosseum, wherein it is seen that in default of good masters they not only made use of marble groups made at the time of Trajan, but also of the spoils brought from various places to Rome. And whosoever knows that the votive offerings in the medallions, that is, the sculptures in half-relief, and likewise the prisoners, and the large groups, and the columns, and the mouldings, and the other ornaments, whether made before or from spoils, are excellently wrought, knows also that the works which were made to fill up by the sculptors of that time are of the rudest, as also are certain small groups with little figures in marble below the medallions, and the lowest base wherein there are certain victories, and certain rivers between the arches at the sides, which are very rude and so made that it can be believed most surely that by that time

the art of sculpture had begun to lose something of the good.
And there had not yet come the Goths and the other barbarous
and outlandish peoples who destroyed, together with Italy, all the
finer arts. It is true, indeed, that in the said times architecture had
suffered less harm than the other arts of design had suffered, for
in the bath that Constantine erected on the Lateran, in the en-
trance of the principal porch it may be seen, to say nothing of
the porphyry columns, the capitals wrought in marble, and the
double bases taken from some other place and very well carved,
that the whole composition of the building is very well conceived;
whereas, on the contrary, the stucco, the mosaics, and certain
incrustations on the walls made by masters of that time are not
equal to those that he caused to be placed in the same bath,
which were taken for the most part from the temples of the
heathen gods. Constantine, so it is said, did the same in the
garden of Æquitius, in making the temple which he afterwards
endowed and gave to the Christian priests. In like manner, the
magnificent Church of S. Giovanni Laterano, erected by the same
Emperor, can bear witness to the same – namely, that in his day
sculpture had already greatly declined; for the image of the
Saviour and the twelve Apostles in silver that he caused to be
made were very debased sculptures, wrought without art and with
very little design. Besides this, whosoever examines with diligence
the medals of Constantine and his image and other statues made
by the sculptors of that time, which are at the present day in the
Campidoglio, may see clearly that they are very far removed from
the perfection of the medals and statues of the other Emperors;
and all this shows that long before the coming of the Goths into
Italy sculpture had greatly declined.

Architecture, as has been said, continued to maintain itself, if
not so perfect, in a better state; nor is there reason to marvel at
this, seeing that, as the great edifices were made almost wholly of
spoils, it was easy for the architects, in making the new, to imitate
in great measure the old, which they had ever before their eyes,
and that much more easily than the sculptors could imitate the
good figures of the ancients, their art having wholly vanished.
And that this is true is manifest, because the Church of the Prince
of the Apostles on the Vatican was not rich save in columns,
bases, capitals, architraves, mouldings, doors, and other incrus-
tations and ornaments, which were all taken from various places
and from the edifices built most magnificently in earlier times.

The same could be said of S. Croce in Gierusalemme, which
Constantine erected at the entreaty of his mother Helena, of S.
Lorenzo without the walls of Rome, and of S. Agnesa, built by
him at the request of Constantia, his daughter. And who does not
know that the font which served for the baptism of both her and
her sister was all adorned with works wrought long before, and
in particular with the porphyry basin carved with most beautiful
figures, with certain marble candlesticks excellently carved with
foliage, and with some boys in low-relief that are truly most
beautiful? In short, for these and many other reasons it is clear
how much, in the time of Constantine, sculpture had already
declined, and together with it the other finer arts. And if anything
was wanting to complete this ruin, it was supplied to them amply
by the departure of Constantine from Rome, on his going to
establish the seat of the Empire at Byzantium; for the reason that
he took with him not only all the best sculptors and other
craftsmen of that age, whatsoever manner of men they were, but
also an infinite number of statues and other works of sculpture,
all most beautiful.

After the departure of Constantine, the Cæsars whom he left
in Italy, building continually both in Rome and elsewhere, exerted
themselves to make their works as fine as they could; but, as may
be seen, sculpture, as well as painting and architecture, went ever
from bad to worse, and this perchance came to pass because,
when human affairs begin to decline, they never cease to go ever
lower and lower until such time as they can grow no worse. So,
too, it may be seen that although at the time of Pope Liberius
the architects of that day strove to do something great in con-
structing the Church of S. Maria Maggiore, they were yet not
happy in the success of the whole, for the reason that although
that building, which is likewise composed for the greater part of
spoils, was made with good enough proportions, it cannot be
denied any the less, not to speak of certain other parts, that the
frieze made right round above the columns with ornaments in
stucco and in painting is wholly wanting in design, and that many
other things which are seen in that great church demonstrate the
imperfection of the arts.

Many years after, when the Christians were persecuted under
Julian the Apostate, there was erected on the Cœlian Mount a
church to S. John and S. Paul, the martyrs, in a manner so much
worse than those named above, that it is seen clearly that the art

was at that time little less than wholly lost. The buildings, too, that were erected at the same time in Tuscany, bear most ample testimony to this; and not to speak of many others, the church that was built outside the walls of Arezzo to S. Donatus, Bishop of that city (who, together with the monk Hilarian, suffered martyrdom under the said Julian the Apostate), was in no way better in architecture than those named above. Nor can it be believed that this came from anything else but the absence of better architects in that age, seeing that the said church (as it has been possible to see in our own day), which is octagonal and constructed from the spoils of the Theatre, the Colosseum and other edifices that had been standing in Arezzo before it was converted to the faith of Christ, was built without thought of economy and at the greatest cost, and adorned with columns of granite, of porphyry, and of many-coloured marbles, which had belonged to the said buildings. And for myself I do not doubt, from the expense which was clearly bestowed on that church, that if the Aretines had had better architects they would have built something marvellous; for it may be seen from what they did that they spared nothing if only they might make that work as rich and as well designed as they possibly could, and since, as has been already said so many times, architecture had lost less of its perfection than the other arts, there was to be seen therein some little of the good. At this time, likewise, was enlarged the Church of S. Maria in Grado, in honour of the said Hilarian, for the reason that he had been for a long time living in it when he went, with Donatus, to the crown of martyrdom.

But because Fortune, when she has brought men to the height of her wheel, is wont, either in jest or in repentance, to throw them down again, it came about after these things that there rose up in various parts of the world all the barbarous peoples against Rome; whence there ensued after no long time not only the humiliation of so great an Empire but the ruin of the whole, and above all of Rome herself, and with her were likewise utterly ruined the most excellent craftsmen, sculptors, painters, and architects, leaving the arts and their own selves buried and submerged among the miserable massacres and ruins of that most famous city. And the first to fall into decay were painting and sculpture, as being arts that served more for pleasure than for use, while the other – namely, architecture – as being necessary and useful for bodily weal, continued to exist, but no longer in

its perfection and excellence. And if it had not been that the sculptures and pictures presented, to the eyes of those who were born from day to day, those who had been thereby honoured to the end that they might have eternal life, there would soon have been lost the memory of both; whereas some of them survived in the images and in the inscriptions placed in private houses, as well as in public buildings, namely, in the amphitheaters, the theatres, the baths, the aqueducts, the temples, the obelisks, the colossi, the pyramids, the arches, the reservoirs, the public treasuries, and finally, in the very tombs, whereof a great part was destroyed by a barbarous and savage race who had nothing in them of man but the shape and the name. These, among others, were the Visigoths, who, having created Alaric their King, assailed Italy and Rome and sacked the city twice without respect for anything whatsoever. The same, too, did the Vandals, having come from Africa with Genseric, their King, who, not content with his booty and prey and all the cruelties that he wrought there, carried away her people into slavery, to their exceeding great misery, and among them Eudoxia, once the wife of the Emperor Valentinian, who had been slaughtered no long time before by his own soldiers. For these, having fallen away in very great measure from the ancient Roman valour, for the reason that all the best had gone a long time before to Byzantium with the Emperor Constantine, had no longer any good customs or ways of life. Nay more, there had been lost at one and the same time all true men and every sort of virtue, and laws, habits, names, and tongues had been changed; and all these things together and each by itself had caused every lovely mind and lofty intellect to become most brutish and most base.

But what brought infinite harm and damage on the said professions, even more than all the aforesaid causes, was the burning zeal of the new Christian religion, which, after a long and bloody combat, with its wealth of miracles and with the sincerity of its works, had finally cast down and swept away the old faith of the heathens, and, devoting itself most ardently with all diligence to driving out and extirpating root and branch every least occasion whence error could arise, not only defaced or threw to the ground all the marvellous statues, sculptures, pictures, mosaics, and ornaments of the false gods of the heathens, but even the memorials and the honours of numberless men of mark, to whom, for their excellent merits, the noble spirit of the ancients

had set up statues and other memorials in public places. Nay more, it not only destroyed, in order to build the churches for the Christian use, the most honoured temples of the idols, but in order to ennoble and adorn S. Pietro (to say nothing of the ornaments which had been there from the beginning) it also robbed of its stone columns the Mausoleum of Hadrian, now called the Castello di S. Angelo, and many other buildings that to-day we see in ruins. And although the Christian religion did not do this by reason of hatred that it bore to the arts, but only in order to humiliate and cast down the gods of the heathens, it was none the less true that from this most ardent zeal there came so great ruin on these honoured professions that their very form was wholly lost. And as if aught were wanting to this grievous misfortune, there arose against Rome the wrath of Totila, who, besides razing her walls and destroying with fire and sword all her most wonderful and noble buildings, burnt the whole city from end to end, and, having robbed her of every living body, left her a prey to flames and fire, so that there was not found in her in eighteen successive days a single living soul; and he cast down and destroyed so completely the marvellous statues, pictures, mosaics, and works in stucco, that there was lost, I do not say only their majesty, but their very form and essence. Wherefore, it being the lower rooms chiefly of the palaces and other buildings that were wrought with stucco, with painting, and with statuary, there was buried by the ruins from above all that good work that has been discovered in our own day, and those who came after, judging the whole to be in ruins, planted vines thereon, in a manner that, since the said lower rooms remained under the ground, the moderns have called them grottoes, and 'grotesque' the pictures that are therein seen at the present day.

After the end of the Ostrogoths, who were destroyed by Narses, men were living among the ruins of Rome in some fashion, poorly indeed, when there came, after 100 years, Constantine II, Emperor of Constantinople, who, although received lovingly by the Romans, laid waste, robbed, and carried away all that had remained, more by chance than by the good will of those who had destroyed her, in the miserable city of Rome. It is true, indeed, that he was not able to enjoy this booty, because, being carried by a sea-tempest to Sicily and being justly slain by his own men, he left his spoils, his kingdom, and his life a prey to Fortune. But she, not yet content with the woes of Rome, to the

end that the things stolen might never return, brought thither for the ruin of the island a host of Saracens, who carried off both the wealth of the Sicilians and the spoils of Rome to Alexandria, to the very great shame and loss of Italy and of Christendom. And so all that the Pontiffs had not destroyed (and above all S. Gregory, who is said to have decreed banishment against all the remainder of the statues and of the spoils of the buildings) came finally, at the hands of that most rascally Greek, to an evil end; in a manner that, there being no trace or sign to be found of anything that was in any way good, the men who came after, although rude and boorish, and in particular in their pictures and sculptures, yet, incited by nature and refined by the air, set themselves to work, not according to the rules of the aforesaid arts, which they did not know, but according to the quality of their own intelligence.

The arts of design, then, having been brought to these limits both before and during the lordship of the Lombards over Italy and also afterwards, continued gradually to grow worse, although some little work was done, insomuch that nothing could have been more rudely wrought or with less design than what was done, as bear witness, besides many other works, certain figures that are in the portico of S. Pietro in Rome, above the doors, wrought in the Greek manner in memory of certain holy fathers who had made disputation for Holy Church in certain councils. To this, likewise, bear witness many works in the same manner that are to be seen in the city and in the whole Exarchate of Ravenna, and in particular some that are in S. Maria Rotonda without that city, made a little time after the Lombards had been driven out of Italy. In this church, as I will not forbear to say, there may be seen a thing most notable and marvellous, namely, the vault, or rather cupola, that covers it, which, although it is ten braccia wide and serves for roof and covering to that building, is nevertheless of one single piece, so great and ponderous that it seems almost impossible that such a stone, weighing more than 200,000 libbre,* could have been set into place so high. But to return to our subject; there issued from the hands of the masters of these times those puppet-like and uncouth figures that are still to be seen in the works of old. The same thing happened to architecture, seeing that, since it was necessary to build, and since

* The libbra is twelve ounces of our ordinary pound (avoirdupois).

form and the good method were completely lost by reason of the
death of the craftsmen and the destruction and ruin of their
works, those who applied themselves to this exercise built noth-
ing that either in ordering or in proportion showed any grace, or
design, or reason whatsoever. Wherefore there came to arise new
architects, who brought from their barbarous races the method
of that manner of buildings that are called by us to-day German;
and they made some that are rather a source of laughter for us
moderns than creditable to them, until better craftsmen after-
wards found a better style, in some measure similar to the good
style of the ancients, even as that manner may be seen
throughout all Italy in the old churches (but not the ancient),
which were built by them, such as a palace of Theodoric, King
of Italy, in Ravenna, and one in Pavia, and another in Modena;
all in a barbarous manner, and rather rich and vast than well-
conceived or of good architecture. The same may be affirmed of
S. Stefano in Rimini, of S. Martino in Ravenna, and of the
Church of S. Giovanni Evangelista, erected in the same city by
Galla Placidia about the year of our salvation 438; of S. Vitale,
which was erected in the year 547, of the Abbey of Classi di
Fuori, and in short of many other monasteries and churches
erected after the Lombard rule. All these buildings, as has been
said, are both large and magnificent, but of the rudest architec-
ture, and among them are many abbeys in France erected to S.
Benedict, the Church and Monastery of Monte Casino, and the
Church of S. Giovanni Battista at Monza, built by that Theode-
linda, Queen of the Goths, to whom S. Gregory the Pope wrote
his Dialogues; in which place that Queen caused to be painted
the story of the Lombards, wherein it was seen that they shaved
the back of their heads, and in front they had long locks, and
they dyed themselves as far as the chin. Their garments were of
ample linen, as was the use of the Angles and Saxons, and below
a mantle of diverse colours; their shoes open as far as the toes
and tied above with certain straps of leather. Similar to the afore-
said churches were the Church of S. Giovanni in Pavia, erected
by Gondiberta, daughter of the aforesaid Theodelinda, and in the
same city the Church of S. Salvadore, built by the brother of the
said Queen, Aribert, who succeeded to the throne of Rodoald,
husband of Gondiberta; and the Church of S. Ambrogio in Pavia,
erected by Grimoald, King of the Lombards, who drove Bertrid,
son of Aribert, from his throne. This Bertrid, being restored to

his throne after the death of Grimoald, erected, also in Pavia, a monastery for nuns called the Monasterio Nuovo, in honour of Our Lady and of S. Agatha; and the Queen erected one without the walls, dedicated to the 'Virgin Mary in Pertica.' Cunibert, likewise, son of that Bertrid, erected a monastery and church after the same manner to S. Giorgio, called di Coronate, on the spot where he had gained a great victory over Alahi. Not unlike to these, too, was the church that the King of the Lombards, Luitprand (who lived in the time of King Pepin, father of Charlemagne), built in Pavia, which is called S. Pietro in Cieldauro; nor that one, likewise, that Desiderius built, who reigned after Astolf – namely, S. Pietro Clivate, in the diocese of Milan; nor the Monastery of S. Vincenzo in Milan, nor that of S. Giulia in Brescia, seeing that they were all built at the greatest cost, but in the most ugly and haphazard manner.

Later, in Florence, architecture made some little progress, and the Church of S. Apostolo, that was erected by Charlemagne, although small, was most beautiful in manner; for not to mention that the shafts of the columns, although they are of separate pieces, show much grace and are made with beautiful proportion, the capitals, also, and the arches turned to make the little vaulted roofs of the two small aisles, show that in Tuscany there had survived or in truth arisen some good craftsman. In short, the architecture of this church is such that Filippo di Ser Brunellesco did not disdain to avail himself of it as a model in building the Church of S. Spirito and that of S. Lorenzo in the same city. The same may be seen in the Church of S. Marco in Venice, which (to say nothing of S. Giorgio Maggiore, erected by Giovanni Morosini in the year 978) was begun under the Doge Giustiniano and Giovanni Particiaco, close by S. Teodosio, when the body of that Evangelist was sent from Alexandria to Venice; and after many fires, which greatly damaged the Doge's palace and the church, it was finally rebuilt on the same foundations in the Greek manner and in that style wherein it is seen to-day, at very great cost and under the direction of many architects, in the year of Christ 973, at the time of Doge Domenico Selvo, who had the columns brought from wheresoever he could find them. And so it continued to go on up to the year 1140, when the Doge was Messer Piero Polani, and, as has been said, with the design of many masters, all Greeks. In the same Greek manner and about the same time were the seven abbeys that Count Ugo, Marquis

of Brandenburg, caused to be built in Tuscany, as can be seen in
the Badia of Florence, in that of Settimo, and in the others; which
buildings, with the remains of those that are no longer standing,
bear testimony that architecture was still in a measure holding its
ground, although greatly corrupted and far removed from the
good manner of the ancients. To this can also bear witness many
old palaces built in Florence after the ruin of Fiesole, in Tuscan
workmanship, but with barbaric ordering in the proportions of
those doors and windows of immense length, in the curves of the
pointed quarter-segments, and in the turning of the arches, after
the wont of the foreign architects of those times.

The year afterwards, 1013, it is clear that the art had regained
some of its vigour from the rebuilding of that most beautiful
church, S. Miniato in Sul Monte, in the time of Messer Alibrando,
citizen and Bishop of Florence; for the reason that, besides the
marble ornaments that are seen therein both within and without,
it may be seen from the façade that the Tuscan architects strove
as much as they could in the doors, the windows, the columns,
the arches, and the mouldings, to imitate the good order of the
ancients, having in part recovered it from the most ancient
temple of S. Giovanni in their city. At the same time painting,
which was little less than wholly spent, may be seen to have
begun to win back something, as the mosaic shows that was
made in the principal chapel* of the said Church of S. Miniato.

From such beginnings, then, these arts commenced to grow
better in design throughout Tuscany, as is seen in the year 1016,
from the commencement made by the people of Pisa for the
building of their Duomo, seeing that in those times it was a great
thing for men to put their hands to the construction of a church
made, as this was, with five naves, and almost wholly of marble
both within and without. This church, which was built under the
direction and design of Buschetto, a Greek of Dulichium, an
architect of rarest worth for those times, was erected and adorned
by the people of Pisa with innumerable spoils brought by sea (for
they were at the height of their greatness) from diverse most
distant places, as is well shown by the columns, bases, capitals,

* It is difficult to find a rendering of 'cappella maggiore' that is absolutely
satisfactory. There may be a chapel in some churches that is actually larger than
the 'principal chapel.' The principal chapel generally contains the choir, but not
always, and when Vasari wants to say 'choir' he uses the word 'coro.' The
rendering 'principal chapel' has therefore been adopted as the least misleading.

cornices, and all the other kinds of stonework that are therein seen. And seeing that these things were some of them small, some large, and some of a middle size, great was the judgment and the talent of Buschetto in accommodating them and in making the distribution of all this building, which is very well arranged both within and without; and besides other work, he contrived the frontal slope of the façade very ingeniously with a great number of columns, adorning it besides with columns carved in diverse and varied ways, and with ancient statues, even as he also made the principal doors in the same façade, between which – that is, beside that of the Carroccio – there was afterwards given an honourable burial-place to Buschetto himself, with three epitaphs, whereof this is one, in Latin verses in no way dissimilar to others of those times:

QUOD VIX MILLE BOUM POSSENT JUGA JUNCTA MOVERE,
ET QUOD VIX POTUIT PER MARE FERRE RATIS,
BUSCHETTI NISU, QUOD ERAT MIRABILE VISU,
DENA PUELLARUM TURBA LEVAVIT ONUS.

And seeing that there has been made mention above of the Church of S. Apostolo in Florence, I will not forbear to say that on a marble slab therein, on one side of the high-altar, there may be seen these words:

VIII. V. DIE VI. APRILIS IN RESURRECTIONE DOMINI, KARO-LUS FRANCORUM REX A ROMA REVERTENS, INGRESSUS FLORENTIAM, CUM MAGNO GAUDIO ET TRIPUDIO SUSCEP-TUS, CIVIUM COPIAM TORQUEIS AUREIS DECORAVIT ... ECCLESIA SANCTORUM APOSTOLORUM ... IN ALTARI INCLUSA EST LAMINA PLUMBEA, IN QUA DESCRIPTA APPARET PRÆFATA FUNDATIO ET CONSECRATIO FACTA PER ARCHI-EPISCOPUM TURPINUM, TESTIBUS ROLANDO ET ULIVERIO.

The aforesaid edifice of the Duomo in Pisa, awaking the minds of many to fair enterprises throughout all Italy, and above all in Tuscany, was the cause that in the city of Pistoia, in the year 1032, a beginning was made for the Church of S. Paolo, in the presence of the Blessed Atto, Bishop of that city, as may be read in a contract made at that time, and, in short, for many other buildings whereof it would take too long to make mention at present. I cannot forbear to say, however, following the course of time, that afterwards, in the year 1060, there was erected in Pisa the round church of S. Giovanni, opposite the Duomo and

in the same square. And something marvellous and almost wholly incredible is to be found recorded in an old book of the Works of the said Duomo, namely, that the columns of the said S. Giovanni, the pillars, and the vaulting were raised and completed in fifteen days and no more. In the same book, which anyone can see who has the wish, it may be read that for the building of this church there was imposed a tax of one danaio for each fire, but it is not said therein whether of gold or of small coin; and at that time there were in Pisa, as may be seen in the same book, 34,000 fires. Truly this work was vast, of great cost, and difficult to execute, and above all the vaulting of the tribune, made in the shape of a pear and covered without with lead. The outer side is full of columns, carvings, and groups, and on the frieze of the central door is a Jesus Christ with the twelve Apostles in half-relief, after the Greek manner.

The people of Lucca, about the same time – that is, in the year 1061 – as rivals of the people of Pisa, began the Church of S. Martino in Lucca from the design of certain disciples of Buschetto, there being then no other architects in Tuscany. Attached to the façade of this church there may be seen a marble portico with many ornaments and carvings made in memory of Pope Alexander II, who had been, a short time before he was elected to the Pontificate, Bishop of that city. Of this construction and of Alexander himself everything is fully told in nine Latin verses, and the same may be seen in certain other ancient letters engraved on the marble under the portico, between the doors. On the said façade are certain figures, and under the portico many scenes in marble from the life of S. Martin, in half-relief, and in the Greek manner. But the best, which are over one of the doors, were made 170 years after by Niccola Pisano and finished in 1233, as will be told in the proper place; the Wardens, when these were begun, being Abellenato and Aliprando, as it may be clearly seen from certain letters carved in marble in the same place. These figures by the hand of Niccola Pisano show how much improvement there came from him to the art of sculpture. Similar to these were most, nay, all of the buildings that were erected in Italy from the times aforesaid up to the year 1250, seeing that little or no acquisition or improvement can be seen to have been made in the space of so many years by architecture, which stayed within the same limits and went on ever in that rude manner, whereof many examples are still to be seen, of which I

will at present make no mention, for the reason that they will be spoken of below according to the occasions that may come before me.

In like manner the good sculptures and pictures which had been buried under the ruins of Italy remained up to the same time hidden from or not known to the men boorishly reared in the rudeness of the modern use of that age, wherein no other sculptures or pictures existed than those which a remnant of old Greeks were making either in images of clay or stone, or painting monstrous figures and covering only the bare lineaments with colour. These craftsmen, as the best, being the only ones in these professions, were summoned to Italy, whither they brought sculpture and painting, together with mosaic, in that style wherein they knew them; and even so they taught them rudely and roughly to the Italians, who afterwards made use of them, as has been told and will be told further, up to a certain time. And the men of those times, not being used to see other excellence or greater perfection in any work than that which they themselves saw, marvelled and took these for the best, for all that they were vile, until the spirits of the generation then arising, helped in some places by the subtlety of the air, became so greatly purged that about 1250, Heaven, moved to pity for the lovely minds that the Tuscan soil was producing every day, restored them to their first condition. And although those before them had seen remains of arches, of colossi, of statues, of urns, and of storied columns in the ages that came after the sackings, the destructions, and the burnings of Rome, and never knew how to make use of them or draw from them any benefit, up to the time mentioned above, the minds that came after, discerning well enough the good from the bad and abandoning the old manners, turned to imitating the ancient with all their industry and wit.

But in order that it may be understood more clearly what I call 'old' and what 'ancient,' the 'ancient' were the works made before Constantine in Corinth, in Athens, in Rome, and in other very famous cities, until the time of Nero, the Vespasians, Trajan, Hadrian, and Antoninus; whereas those others are called 'old' that were executed from S. Silvester's day up to that time by a certain remnant of Greeks, who knew rather how to dye than how to paint. For since the excellent early craftsmen had been killed in these wars, as has been said, to the remainder of these Greeks, old but not ancient, there had been left nothing but

elementary outlines on a ground of colour; and to this at the present day witness is borne by an infinity of mosaics, which, wrought throughout all Italy by these Greeks, are to be seen in every old church in any city whatsoever of Italy, and above all in the Duomo of Pisa, in S. Marco at Venice, and in other places as well; and so, too, they kept making many pictures in that manner, with eyes staring, hands outstretched, and standing on tiptoe, as may still be seen in S. Miniato without Florence, between the door that leads into the sacristy and that which leads into the convent; and in S. Spirito in the said city, the whole side of the cloister opposite the church; and in like manner at Arezzo, in S. Giuliano and S. Bartolommeo and in other churches; and in Rome, in the old Church of S. Pietro, scenes right round between the windows – works that have more of the monstrous in their lineaments than of likeness to whatsoever they represent. Of sculptures, likewise, they made an infinity, as may still be seen in low-relief over the door of S. Michele in the Piazza Padella of Florence, and in Ognissanti; and tombs and adornments in many places for the doors of churches, wherein they have certain figures for corbels to support the roof, so rude and vile, so mis-shapen, and of such a grossness of manner, that it appears im-possible that worse could be imagined.

Thus far have I thought fit to discourse from the beginning of sculpture and of painting, and peradventure at greater length than was necessary in this place, which I have done, indeed, not so much carried away by my affection for art as urged by the common benefit and advantage of our craftsmen. For having seen in what way she, from a small beginning, climbed to the greatest height, and how from a state so noble she fell into utter ruin, and that, in consequence, the nature of this art is similar to that of the others, which, like human bodies, have their birth, their growth, their growing old, and their death; they will now be able to recognize more easily the progress of her second birth and of that very perfection whereto she has risen again in our times. And I hope, moreover, that if ever (which God forbid) it should happen at any time, through the negligence of men, or through the malice of time, or, finally, through the decree of Heaven, which appears to be unwilling that the things of this earth should exist for long in one form, that she falls again into the same chaos of ruin; that these my labours, whatsoever they may be worth (if indeed they may be worthy of a happier

fortune), both through what has been already said and through what remains to say, may be able to keep her alive or at least to encourage the most exalted minds to provide them with better assistance; so much so that, what with my good will and the works of these masters, she may abound in those aids and adornments wherein, if I may freely speak the truth, she has been wanting up to the present day.

But it is now time to come to the Life of Giovanni Cimabue, and even as he gave the first beginning to the new method of drawing and painting, so it is just and expedient that he should give it to the Lives, in which I will do my utmost to observe, the most that I can, the order of their manners rather than that of time. And in describing the forms and features of the craftsmen I will be brief, seeing that their portraits, which have been collected by me with no less cost and fatigue than diligence, will show better what sort of men the craftsmen themselves were in appearance than describing them could ever do; and if the portrait of any one of them should be wanting, that is not through my fault but by reason of its being nowhere found. And if the said portraits were not peradventure to appear to someone to be absolutely like to others that might be found, I wish it to be remembered that the portrait made of a man when he was eighteen or twenty years old will never be like to the portrait that may have been made fifteen or twenty years later. To this it must be added that portraits in drawing are never so like as are those in colours, not to mention that the engravers, who have no draughtsmanship, always rob the faces (being unable or not knowing how to make exactly those minutenesses that make them good and true to life) of that perfection which is rarely or never found in portraits cut in wood. In short, how great have been therein my labour, expense, and diligence, will be evident to those who, in reading, will see whence I have to the best of my ability unearthed them.

PART I

VASARI'S LIVES

GIOVANNI CIMABUE, Painter of Florence

By the infinite flood of evils which had laid prostrate and submerged poor Italy there had not only been ruined everything that could truly claim the name of building, but there had been blotted out (and this was of graver import) the whole body of the craftsmen, when, by the will of God, in the city of Florence, in the year 1240, there was born, to give the first light to the art of painting, Giovanni, surnamed Cimabue, of the family, noble in those times, of Cimabue. He, while growing up, being judged by his father and by others to have a beautiful and acute intelligence, was sent, to the end that he might exercise himself in letters, to a master in S. Maria Novella, his relative, who was then teaching grammar to the novices of that convent; but Cimabue, in place of attending to his letters, would spend the whole day, as one who felt himself led thereto by nature, in drawing, on books and other papers, men, horses, houses, and diverse other things of fancy; to which natural inclination fortune was favourable, for certain Greek painters had been summoned to Florence by those who then governed the city, for nothing else but to restore to Florence the art of painting, which was rather out of mind than out of fashion, and they began, among the other works undertaken in the city, the Chapel of the Gondi, whereof to-day the vaulting and the walls are little less than eaten away by time, as may be seen in S. Maria Novella beside the principal chapel, where it stands. Wherefore Cimabue, having begun to take his first steps in this art which pleased him, playing truant often from school, would stand the livelong day watching these masters at work, in a manner that, being judged by his father and by these painters to be in such wise fitted for painting that there could be hoped for him, applying himself to this profession, an honourable success, to his own no small satisfaction he was apprenticed by the said father to these men; whereupon, exercising himself without ceasing, in a short time nature assisted him so

greatly that he surpassed by a long way, both in drawing and in colouring, the manner of the masters who were teaching him. For they, giving no thought to making any advance, had made those works in that fashion wherein they are seen to-day – that is, not in the good ancient manner of the Greeks but in that rude modern manner of those times; and because, although he imitated these Greeks, he added much perfection to the art, relieving it of a great part of their rude manner, he gave honour to his country with his name and with the works that he made, to which witness is borne in Florence by the pictures that he wrought, such as the front of the altar in S. Cecilia, and in S. Croce a panel with a Madonna, which was and still is placed against a pilaster on the right within the choir. After this, he made a S. Francis on a small panel on a gold ground, and portrayed him from nature (which was something new in those times) as best he knew, and round him all the stories of his life, in twenty small pictures full of little figures on a gold ground.

Having next undertaken to make a large panel for the monks of Vallombrosa, in the Abbey of S. Trinita in Florence, he showed in that work (using therein great diligence, so as to rise equal to the esteem which had already been conceived of him) better inventions and a beautiful method in the attitude of a Madonna, whom he made with the Child in her arms and with many angels round her in adoration, on a gold ground; which panel, being finished, was placed by these monks over the high-altar of the said church, and being afterwards removed, in order to give that place to the panel by Alesso Baldovinetti which is there to-day, it was placed in a smaller chapel in the left-hand aisle of the said church.

Working next in fresco on the Hospital of the Porcellana, at the corner of the Via Nuova which goes into the Borg' Ognissanti, on the façade which has in the middle the principal door, and making on one side the Annunciation of the Virgin by the Angel, and on the other Jesus Christ with Cleophas and Luke, figures as large as life, he swept away that ancient manner, making the draperies, the vestments, and everything else in this work, a little more lively and more natural and softer than the manner of these Greeks, all full of lines and profiles both in mosaic and in painting; which manner, rough, rude, and vulgar, the painters of those times, not by means of study, but by a certain convention, had taught one to the other for many and many

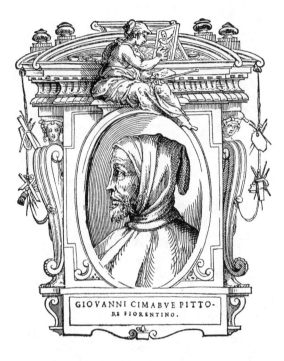

GIOVANNI CIMABVE PITTO-
RE FIORENTINO.

a year, without ever thinking of bettering their draughtsman-
ship, of beauty of colouring, or of any invention that might be
good.

Cimabue, being summoned again after this work by the same
Prior who had caused him to make the works in S. Croce, made
him a large Crucifix on wood, which is still seen to-day in the
church; which work was the reason, it appearing to the Prior that
he had been well served, that he took him to S. Francesco in Pisa,
their convent, in order to make a S. Francis on a panel, which
was held by these people to be a most rare work, there being seen
therein a certain greater quality of excellence, both in the air of
the heads and in the folds of the draperies, than had been shown
in the Greek manner up to that time by anyone who had wrought
anything, not only in Pisa, but in all Italy. Cimabue having next
made for the same church on a large panel the image of Our
Lady, with the Child in her arms and with many angels round
her, also on a ground of gold, it was after no long time removed
from where it had been set up the first time, in order to make
there the marble altar that is there at present, and was placed
within the church beside the door on the left hand; and for this
work he was much praised and rewarded by the people of Pisa.
In the same city of Pisa, at the request of the then Abbot of
S. Paolo in Ripa d'Arno, he made a S. Agnes on a little panel,
and round her, with little figures, all the stories of her life; which
little panel is to-day over the altar of the Virgins in the said
church.

By reason of these works, then, the name of Cimabue being
very famous everywhere, he was brought to Assisi, a city of Um-
bria, where, in company with certain Greek masters, in the lower
Church of S. Francesco, he painted part of the vaulting, and on
the walls the life of Jesus Christ and that of S. Francis. In these
pictures he surpassed by a long way those Greek painters; where-
fore, growing in courage, he began by his own self to paint the
upper church in fresco, and in the chief apse, over the choir, on
four sides, he made certain stories of Our Lady – namely, her
death; when her soul is borne by Christ to Heaven upon a throne
of clouds; and when, in the midst of a choir of angels, He crowns
her, with a great number of saints below, both male and female,
now eaten away by time and by dust. Next, in the sections of the
vaulting of the said church, which are five, he painted in like
manner many scenes. In the first, over the choir, he made the

four Evangelists, larger than life, and so well that to-day there is still recognized in them much that is good, and the freshness of the colours in the flesh shows that painting began to make great progress in fresco work through the labours of Cimabue. The second section he made full of golden stars on a ground of ultramarine. In the third he made in certain medallions Jesus Christ, the Virgin His mother, S. John the Baptist, and S. Francis – namely, in every medallion one of these figures, and in every quarter segment of the vaulting a medallion. And between this and the fifth section he painted the fourth with golden stars, as above, on a ground of ultramarine. In the fifth he painted the four Doctors of the Church, and beside each one of these one of the four chief Religious Orders – a work truly laborious and executed with infinite diligence. The vaulting finished, he wrought, also in fresco, the upper walls of the whole left-hand side of the church, making towards the high-altar, between the windows and right up to the vaulting, eight scenes from the Old Testament, commencing from the beginning of Genesis and following the most notable events. And in the space that is round the windows, up to the point where they end in the gallery that encircles the interior of the wall of the church, he painted the remainder of the Old Testament in eight other scenes. And opposite this work, in sixteen other scenes corresponding to these, he painted the acts of Our Lady and of Jesus Christ. And on the end wall over the principal door, and round the rose window of the church, he made her Ascension into Heaven and the Holy Spirit descending on the Apostles. This work, truly very great and rich and most excellently executed, must have, in my judgment, amazed the world in those times, seeing, above all, that painting had lain so long in such great darkness; and to me, who saw it again in the year 1563, it appeared very beautiful, thinking how in so great darkness Cimabue could see so great light. But of all these pictures (and to this we should give consideration), those on the roof, as being less injured by dust and by other accidents, have been preserved much better than the others. These works finished, Giovanni put his hand to painting the lower walls – namely, those that are from the windows downwards – and made certain works upon them, but being called to Florence on some business of his own, he did not carry this work further; but it was finished, as will be told in the proper place, by Giotto, many years afterwards.

Having returned, then, to Florence, Cimabue painted in the cloister of S. Spirito (wherein there is painted in the Greek manner, by other masters, the whole side facing the church) three small arches by his own hand, from the life of Christ, and truly with much design. And at the same time he sent certain works wrought by himself in Florence to Empoli, which works are still held to-day in great veneration in the Pieve of that township. Next, he made for the Church of S. Maria Novella the panel of Our Lady that is set on high between the Chapel of the Rucellai and that of the Bardi da Vernia; which work was of greater size than any figure that had been made up to that time. And certain angels that are round it show that, although he still had the Greek manner, he was going on approaching in part to the line and method of the modern. Wherefore this work caused so great marvel to the people of that age, by reason of there not having been seen up to then anything better, that it was borne in most solemn procession from the house of Cimabue to the church, with much rejoicing and with trumpets, and he was thereby much rewarded and honoured. It is said, and it may be read in certain records of old painters, that while Cimabue was painting the said panel in certain gardens close to the Porta S. Pietro, there passed through Florence King Charles the Elder of Anjou, and that, among the many signs of welcome made to him by the men of this city, they brought him to see Cimabue's panel; whereupon, for the reason that it had not yet been seen by anyone, in the showing it to the King there flocked together to it all the men and all the women of Florence, with the utmost rejoicing and in the greatest crowd in the world. Wherefore, by reason of the joy that the neighbours had thereby, they called that place the Borgo Allegri; which place, although enclosed in time within the walls, has ever after retained the same name.

In S. Francesco in Pisa, where he wrought, as has been said above, certain other works, there is in the cloister, beside the door that leads into the church, in a corner, a small panel in distemper by the hand of Cimabue, wherein is a Christ on the Cross, with certain angels round Him, who, weeping, are taking with their hands certain words that are written round the head of Christ and are presenting them to the ears of a Madonna who stands weeping on the right, and on the other side to S. John the Evangelist, who is on the left, all grieving. And the words to the Virgin are: MULIER, ECCE FILIUS TUUS; and those to S. John:

ECCE MATER TUA; and those that an angel standing apart holds in his hand, say: EX ILLA HORA ACCEPIT EAM DISCIPULUS IN SUAM. Wherein it is to be observed that Cimabue began to give light and to open the way to invention, assisting art with words in order to express his conception; which was certainly something whimsical and new.

Now because, by means of these works, Cimabue had acquired a very great name, together with much profit, he was appointed as architect, in company with Arnolfo Lapi, a man then excellent in architecture, for the building of S. Maria del Fiore in Florence. But at length, having lived sixty years, he passed to the other life in the year 1300, having little less than resurrected painting. He left many disciples, and among others Giotto, who was afterwards an excellent painter; which Giotto dwelt, after Cimabue, in his master's own house in the Via del Cocomero. Cimabue was buried in S. Maria del Fiore, with that epitaph made for him by one of the Nini:

CREDIDIT UT CIMABOS PICTURÆ CASTRA TENERE,
SIC TENUIT, VIVENS: NUNC TENET ASTRA POLI.

I will not refrain from saying that if to the glory of Cimabue there had not been contrasted the greatness of Giotto, his disciple, his fame would have been greater, as Dante demonstrates in his *Commedia*, wherein, alluding in the eleventh canto of the *Purgatorio* to this very inscription on the tomb, he said:

Credette Cimabue nella pittura
Tener lo campo, ed hora ha Giotto il grido,
Si che la fama di colui s' oscura.

In explanation of these verses, a commentator of Dante, who wrote at the time when Giotto was alive and ten or twelve years after the death of Dante himself – that is, about the year of Christ 1334 – says, speaking of Cimabue, precisely these words: 'Cimabue was a painter of Florence in the time of the author, very noble beyond the knowledge of man, and withal so arrogant and so disdainful that if there were found by anyone any failing or defect in his work, or if he himself had seen one (even as it comes to pass many times that the craftsman errs, through a defect in the material whereon he works, or through some lack in the instrument wherewith he labours), incontinently he would destroy that work, however costly it might be. Giotto was and is

the most exalted among the painters of the same city of Florence, and his works bear testimony for him in Rome, in Naples, in Avignon, in Florence, in Padua, and in many parts of the world.' This commentary is now in the hands of the Very Reverend Don Vincenzio Borghini, Prior of the Innocenti, a man not only most famous for his nobility, goodness, and learning, but also endowed with such love and understanding for all the finer arts that he has deserved to be elected by the Lord Duke Cosimo, most properly, as his Lieutenant in our Academy of Design.

But to return to Cimabue: Giotto, truly, obscured his fame not otherwise than as a great light does the splendour of one much less, for the reason that although Cimabue was, as it were, the first cause of the renovation of the art of painting, yet Giotto, his pupil, moved by laudable ambition and assisted by Heaven and by nature, was he who, rising higher with his thought, opened the gate of truth to those who have brought her to that perfection and majesty wherein we see her in our own century, which, being used to see every day the marvels, the miracles, nay, the imposs- ibilities wrought by the craftsmen in that art, is now brought to such a pitch that nothing that men do, be it even more Divine than human, causes it in any way to marvel. Well is it with those whose labours deserve all praise, if, in place of being praised and admired, they do not thereby incur blame and many times even disgrace.

The portrait of Cimabue, by the hand of Simone Sanese, is to be seen in the Chapter-house of S. Maria Novella, made in profile in the story of the Faith, in a figure that has the face thin, the beard small, reddish, and pointed, with a cap according to the use of those times – that is, wound round and round and under the throat in lovely fashion. He who is beside him is Simone himself, the author of that work, who portrayed himself with two mirrors in order to make his head in profile, placing the one opposite to the other. And that soldier clad in armour who is between them is said to be Count Guido Novello, then Lord of Poppi. There remains for me to say of Cimabue that in the beginning of our book, where I have put together drawings from the own hand of all those who have made drawings from his time to ours, there are to be seen certain small things made by his hand in the way of miniature, wherein, although to-day perchance they appear rather rude than otherwise, it is seen how much excellence was given by his work to draughtsmanship.

ARNOLFO DI LAPO, Architect of Florence

[NOTICE TO READERS IN THE LIFE OF ARNOLFO. – The said
Arnolfo began, in S. Maria Maggiore in Rome, the tomb of
Pope Honorius III, of the house of Savelli; which tomb he
left imperfect, with the portrait of the said Pope, which was
afterwards placed with his design in the principal chapel of
mosaic of S. Paolo in Rome, with the portrait of Giovanni
Gaetano, Abbot of that monastery. And the marble chapel,
wherein is the Manger of Jesus Christ, was one of the last
pieces of sculpture in marble that Arnolfo ever made; and he
made it at the instance of Pandolfo Ippotecorvo, in the year
twelve (?), as an epitaph bears witness that is on the wall
beside the chapel; and likewise the chapel and tomb of Pope
Boniface VIII, in S. Pietro in Rome, whereon is carved the
same name of Arnolfo, who wrought it.]

HAVING discoursed, in the Preface to the Lives, of certain
buildings in a manner old but not ancient, and having been silent,
for the reason that I did not know them, about the names of the
architects who had charge of their construction, I will make men-
tion, in the Preface to this Life of Arnolfo, of certain other
edifices built in his time or a little before, whereof in like manner
it is not known who were the masters; and then of those that
were built in the same times, whereof it is known who were the
architects, either because the manner of the edifices themselves
is recognized very well, or because we have had information
about them by means of the writings and memorials left by them
in the works that they made. Nor will this be outside our subject,
seeing that, although they are neither in a beautiful nor in a good
manner but only vast and magnificent, they are worthy none the
less of some consideration.

There were built, then, in the time of Lapo and of Arnolfo his
son, many edifices of importance both in Italy and abroad,
whereof I have not been able to find the architects, such as
the Abbey of Monreale in Sicily, the Piscopio of Naples, the
Certosa of Pavia, the Duomo of Milan, S. Pietro and S. Petronio
in Bologna, and many others which are seen throughout all Italy,
built at incredible cost. Having seen all these buildings for myself
and studied them, and likewise many sculptures of those times,

particularly in Ravenna, and not having ever found, I do not say any memorials of the masters, but even many times the date when they were built, I cannot but marvel at the rudeness and little desire for glory of the men of that age. But returning to our subject; after the buildings named above, there began at last to arise men of a more exalted spirit, who, if they did not find, sought at least to find something of the good. The first was Buono, of whom I know neither the country nor the surname, for the reason that in making record of himself in some of his works he put nothing but simply his name. He, being both sculptor and architect, first made many palaces and churches and some sculptures in Ravenna, in the year of our salvation 1152; and having become known by reason of these works, he was called to Naples, where he founded (although they were finished by others, as will be told) the Castel Capoano and the Castel dell' Uovo; and afterwards, in the time of Domenico Morosini, Doge of Venice, he founded the Campanile of S. Marco with much consideration and judgment, having caused the foundation of that tower to be so well fixed with piles that it has never moved a hair's-breadth, as many buildings constructed in that city before his day have been seen and still are seen to have done. And from him, perchance, the Venetians learnt to found, in the manner in which they do it to-day, the very beautiful and very rich edifices that every day are being built so magnificently in that most noble city. It is true, indeed, that this tower has nothing else good in it, neither manner, nor ornament, nor, in short, anything that might be worthy of much praise. It was finished under Anastasius IV and Adrian IV, Pontiffs, in the year 1154. In architecture, likewise, Buono made the Church of S. Andrea in Pistoia, and in sculpture he made an architrave of marble that is over the door, full of figures made in the manner of the Goths, on which architrave his name is carved, with the date when this work was made by him, which was the year 1166. Next, being summoned to Florence, he gave the design for enlarging, as was done, the Church of S. Maria Maggiore, which was then without the city, and held in great veneration for the reason that Pope Pelagius had consecrated it many years before, and because, as to size and manner, it was a very fair body of a church.

Being then summoned by the Aretines to their city, Buono built the old habitation of the Lords of Arezzo, namely, a palace

in the manner of the Goths, and beside it a bell-tower. This edifice, which for that manner was good enough, was thrown to the ground, because it was opposite and very near to the fortress of that city, in the year 1533. Afterwards, the art making some little improvement through the works of one Guglielmo, German (I believe) in origin, there were built certain edifices of the greatest cost and in a slightly better manner; for this Guglielmo, so it is said, in the year 1174, together with Bonanno, a sculptor, founded in Pisa the Campanile of the Duomo, where there are certain words carved that say: A.D. MCLXXIV, CAMPANILE HOC FUIT FUNDATUM, MENSE AUG. But these two architects not having much practice of founding in Pisa and therefore not supporting the platform with piles, as they ought, before they had gone halfway with that building it inclined to one side and bent over to the weakest part, in a manner that the said campanile leans six and a half braccia* out of the straight, according as the foundation sank on this side; and although in the lower part this is not much, up above it shows clear enough to make men stand fast in a marvel how it can be that it has not fallen down and has not thrown out cracks. The reason is that this edifice is round both without and within and built in the shape of a hollow well, and bound together with the stones in a manner that it is well-nigh impossible that it should fall; and it is assisted, above all, by the foundations, which have an outwork three braccia wide outside the tower, made, as it is seen, after the sinking of the campanile, in order to support it. I am convinced that if it had been square it would not have been standing to-day, for the reason that the corner-stones of the square sides, as is often seen to happen, would have forced them out in a manner that it would have fallen down. And if the Garisenda, a tower in Bologna, although square, leans and does not fall, that comes to pass because it is slender and does not lean so much, not being burdened by so great a weight, by a great measure, as is this campanile, which is praised, not because it has in it any design or beautiful manner, but simply for its extravagance, it appearing impossible to anyone who sees it that it can in any wise keep standing. And the same Bonanno, while the said campanile was building, made, in the year 1180, the royal door of bronze for the said Duomo of Pisa, wherein are seen these letters:

* The braccio is a very variable standard of measurement. As used by Vasari, it may be taken to denote about 23 inches.

EGO BONANNUS PIS. MEA ARTE HANC PORTAM UNO ANNO
PERFECI, TEMPORE BENEDICTI OPERARII.

Next, from the walls that were made from ancient spoils at
S. Giovanni Laterano in Rome, under Lucius III and Urban III,
Pontiffs, when the Emperor Frederick was crowned by this Urban,
it is seen that the art was going on continually improving, because
certain little temples and chapels, built, as has been said, of spoils,
have passing good design and certain things in them worthy of
consideration, and among others this, that in order not to over-
burden the walls of these buildings the vaulting was made of small
tubes and with partitions of stucco, praiseworthy enough for these
times. And from the mouldings and other parts it is seen that the
craftsmen were going on striving in order to find the good way.

Innocent III afterwards caused two palaces to be built on the
Vatican Hill, which were passing good, in so far as it has been
possible to discover; but since they were destroyed by other
Popes, and in particular by Nicholas V, who pulled down and
rebuilt the greater part of one palace, there will be nothing said
of them but this, that a part of them is to be seen in the great
Round Tower and part in the old sacristy of S. Pietro. This
Innocent III, who ruled for nineteen years and took much delight
in building, made many edifices in Rome; and in particular, with
the design of Marchionne Aretino, both architect and sculptor,
the Conti Tower, so called from his own surname, seeing that he
was of that family. The same Marchionne, in the year when In-
nocent III died, finished the building of the Pieve of Arezzo and
likewise the campanile, making in sculpture, for the façade of the
said church, three rows of columns one above the other, with
great variety not only in the fashion of the capitals and the bases
but also in the shafts of the columns, some among them being
thick, some slender, some joined together two by two, and others
four by four. In like manner there are some twined in the manner
of vines, and some made in the shape of figures acting as sup-
ports, with diverse carvings. He also made therein many animals
of diverse sorts that support on the middle of their backs the
weights of those columns, and all with the most strange and
extravagant inventions that can possibly be imagined, and not
only wide of the good order of the ancients but almost wide of
all just and reasonable proportion. But with all this, whosoever

sets out well to consider the whole sees that he went on striving to do well, and thought peradventure to have found it in that method of working and in that whimsical variety. The same man made in sculpture, on the arch that is over the door of the said church, in barbaric manner, a God the Father with certain angels, in half-relief and rather large; and in the arch he carved the twelve months, placing his own name underneath in round letters, as was the custom, and the date – namely, the year 1216. It is said that Marchionne built in the Borgo Vecchio in Rome, for the same Pope Innocent III, the ancient edifice of the Hospital and Church of S. Spirito in Sassia, where there is still seen something of the old; and the ancient church was still standing in our own day, when it was rebuilt in modern fashion, with greater ornament and design, by Pope Paul III of the house of Farnese.

And in S. Maria Maggiore, also in Rome, he built the marble chapel where there is the Manger of Jesus Christ; here he portrayed from the life Pope Honorius III, whose tomb, also, he made, with ornaments some little better than and different enough from the manner that was then in universal use throughout all Italy. About the same time Marchionne also made the side door of S. Pietro in Bologna, which was truly for those times a work of the greatest mastery, by reason of the many carvings that are seen therein, such as lions in the round that sustain columns, and men in the use of porters, and other animals that support weights; and in the arch above he made the twelve months in full relief, with various fancies, and for each month its celestial sign; which work must have been held marvellous in those times.

About the same time there was founded the Order of the Friars Minor of S. Francis, which was confirmed by the said Innocent III, Pontiff, in the year 1206; and there came such growth, not only in Italy but in all the other parts of the world, both to the devoutness and to the number of the Friars, that there was scarce a city of account that did not erect for them churches and convents of the greatest cost, each according to its power. Wherefore, Frate Elia having erected, two years before the death of S. Francis (while the Saint himself, as General, was abroad preaching, and he, Prior in Assisi), a church with the title of Our Lady, and S. Francis having died, and all Christendom flocking together to visit the body of the Saint, who, in life and in death, had been known as so much the friend of God,

and every man making offering to the holy place according to his power, it was ordained that the said church begun by Frate Elia should be built much greater and more magnificent. But there being a dearth of good architects, and the work which was to be done having need of an excellent one, seeing that it had to be built upon a very high hill at the foot of which there runs a torrent called Tescio, there was brought to Assisi, after much consideration, as the best of all that were then to be found, one Maestro Jacopo Tedesco. He, having considered the site and grasped the wishes of the fathers, who held thereunto a general Chapter in Assisi, designed a very beautiful body of a church and convent, making in the model three tiers, one to be made underground and the others for two churches, one of which, on the lower level, should serve as a court, with a fairly large portico round it, and the other for a church; planning that from the first one should climb to the second by a most convenient flight of steps, which should wind round the principal chapel, opening out into two parts in order to lead more easily into the second church, to which he gave the form of a T, making it five times as long as it is broad and dividing one bay from another with great piers of stone, on which he afterwards threw very bold arches, with groined vaulting between one and another. From a model so made, then, was built this truly very great edifice, and it was followed in every part, save in the buttresses above that had to surround the apse and the principal chapel, and in making the vaulting groined, because they did not make it as has been said, but barrel-shaped, in order that it might be stronger. Next, in front of the principal chapel of the lower church, they placed the altar, and under that, when it was finished, they laid, with most solemn translation, the body of S. Francis. And because the true sepulchre which holds the body of the glorious Saint is in the first – that is, in the lowest church – where no one ever goes, and the doors are walled up, round the said altar there are very large gratings of iron, with rich ornaments in marble and mosaic, that look down therein. This building is flanked on one of the sides by two sacristies, and by a very high campanile, namely, five times as high as it is broad. It had on top a very high octagonal spire, but this was removed because it threatened to fall. This whole work was brought to a finish in the space of four years, and no more, by the genius of Maestro Jacopo Tedesco and by the solicitude of Frate Elia, after whose death, to the end that

such a pile might never through any lapse of time fall into ruin, there were built round the lower church twelve very stout towers, and in each of these a spiral staircase that climbs from the ground up to the summit. And in time, afterwards, there were made therein many chapels and other very rich ornaments, whereof there is no need to discourse further, since this is enough on this subject for the present, and above all because everyone can see how much of the useful, the ornamental, and the beautiful has been added to this beginning of Maestro Jacopo's by many supreme Pontiffs, Cardinals, Princes, and other people of importance throughout all Europe.

Now, to return to Maestro Jacopo; by means of this work he acquired so great fame throughout all Italy that he was summoned by those who then governed the city of Florence, and afterwards received with the greatest possible friendliness; although, according to the use that the Florentines have, and had still more in ancient times, of abbreviating names, he was called not Jacopo but Lapo throughout all the course of his life; for he dwelt ever with his whole family in that city. And although he went at diverse times to erect many buildings throughout Tuscany, such as the Palace of Poppi in the Casentino, for that Count who had had for wife the beautiful Gualdrada, and for her dower, the Casentino; and for the Aretines, the Vescovado,* and the Palazzo Vecchio of the Lords of Pietramala; none the less his home was always in Florence, where, having founded in the year 1218 the piers of the Ponte alla Carraja, which was then called the Ponte Nuovo, he delivered them finished in two years; and a little time afterwards the rest was finished of wood, as was then the custom. And in the year 1221 he gave the design for the Church of S. Salvadore del Vescovado, which was begun under his direction, and that of S. Michele in Piazza Padella, where there are certain sculptures in the manner of those times. Next, having given the design for draining the waters of the city, having caused the Piazza di S. Giovanni to be raised, having built, in the time of Messer Rubaconte da Mandella, a Milanese, the bridge that retains the same man's name, and having discovered that most useful method of paving streets, which before were covered with bricks, he made the model of the Palace, to-day of the

* Vescovado includes both the Cathedral and the Episcopal buildings of Arezzo. Vasari generally uses it to denote the Cathedral.

Podestà, which was then built for the Anziani. And finally, having sent the model of a tomb to Sicily, to the Abbey of Monreale, for the Emperor Frederick and by order of Manfred, he died, leaving Arnolfo, his son, heir no less to the talent than to the wealth of his father.

This Arnolfo, from whose talent architecture gained no less betterment than painting had gained from that of Cimabue, being born in the year 1232, was thirty years of age when his father died, and was held in very great esteem, for the reason that, having not only learnt from his father all that he knew, but having also given attention under Cimabue to design in order to make use of it in sculpture, he was held by so much the best architect in Tuscany, that not only did the Florentines found the last circle of the walls of their city under his direction, in the year 1284, and make after his design the Loggia and the piers of Or San Michele, where the grain was sold, building them of bricks and with a simple roof above, but by his counsel, in the same year when the Poggio de' Magnuoli collapsed, on the brow of S. Giorgio above S. Lucia in the Via de' Bardi, they determined by means of a public decree that there should be no more building on the said spot, nor should any edifice be ever made, seeing that by the sinking of the stones, which have water trickling under them, there would be always danger in whatsoever edifice might be made there. That this is true has been seen in our own day from the ruin of many buildings and magnificent houses of noblemen. In the next year, 1285, he founded the Loggia and Piazza de' Priori, and built the principal chapel of the Badia of Florence, and the two that are on either side of it, renovating the church and the choir, which at first had been made much smaller by Count Ugo, founder of that abbey; and for Cardinal Giovanni degli Orsini, Legate of the Pope in Tuscany, he built the campanile of the said church, which, according to the works of those times, was much praised, although it did not have its completion of grey-stone until afterwards, in the year 1330.

After this there was founded with his design, in the year 1294, the Church of S. Croce, where the Friars Minor have their seat. What with the middle nave and the two lesser ones Arnolfo constructed this so wide, that, being unable to make the vaulting below the roof by reason of the too great space, he, with much judgment, caused arches to be made from pier to pier, and upon

these he placed the roofs on a slope, building stone gutters over
the said arches in order to carry away the rain-water, and giving
them so much fall as to make the roofs secure, as they are, from
the danger of rotting; which device was not only new and
ingenious then, but is equally useful and worthy of being con-
sidered to-day. He then gave the design for the first cloisters of
the old convent of that church, and a little time after he caused
to be removed from round the Church of S. Giovanni, on the
outer side, all the arches and tombs of marble and grey-stone that
were there, and had part of them placed behind the campanile on
the façade of the Canon's house, beside the Company of S.
Zanobi; and then he incrusted with black marble from Prato all
the eight outer walls of the said S. Giovanni, removing the grey-
stone that there had been before between these ancient marbles.
The Florentines, in the meanwhile, wishing to build walls in the
Valdarno di Sopra round Castello di San Giovanni and Castel
Franco, for the convenience of the city and of their victualling by
means of the markets, Arnolfo made the design for them in the
year 1295, and satisfied them in such a manner, as well in this as
he had done in the other works, that he was made citizen of
Florence.

After these works, the Florentines determined, as Giovanni
Villani relates in his History, to build a principal church in their
city, and to build it such that in point of greatness and magni-
ficence there could be desired none larger or more beautiful from
the industry and knowledge of men; and Arnolfo made the design
and the model of the never to be sufficiently praised Church of
S. Maria del Fiore, ordering that it should be all incrusted, with-
out, with polished marbles and with the so many cornices, pilas-
ters, columns, carved foliage, figures, and other ornaments, with
which to-day it is seen brought, if not to the whole, to a great
part at least of its perfection. And what was marvellous therein
above everything else was this, that incorporating, besides S. Rep-
arata, other small churches and houses that were round it, in
making the site, which is most beautiful, he showed so great
diligence and judgment in causing the foundations of so great a
fabric to be made broad and deep, filling them with good material
– namely, with gravel and lime and with great stones below –
wherefore the square is still called 'Lungo i Fondamenti,' that
they have been very well able, as is to be seen to-day, to support
the weight of the great mass of the cupola which Filippo di Ser

Brunellesco raised over them. The laying of such foundations for so great a church was celebrated with much solemnity, for on the day of the Nativity of Our Lady, in 1298, the first stone was laid by the Cardinal Legate of the Pope, in the presence not only of many Bishops and of all the clergy, but of the Podestà as well, the Captains, Priors, and other magistrates of the city, nay, of the whole people of Florence, calling it S. Maria del Fiore. And because it was estimated that the expenses of this fabric must be very great, as they afterwards were, there was imposed a tax at the Chamber of the Commune of four danari in the lira on everything that was put out at interest, and two soldi per head per annum; not to mention that the Pope and the Legate granted very great indulgences to those who should make them offerings thereunto. I will not forbear to say, moreover, that besides the foundations, very broad and fifteen braccia deep, much consideration was shown in making those buttresses of masonry at every angle of the eight sides, seeing that it was these afterwards that emboldened the mind of Brunellesco to superimpose a much greater weight than that which Arnolfo, perchance, had thought to impose thereon. It is said that while the two first side-doors of S. Maria del Fiore were being begun in marble Arnolfo caused some fig-leaves to be carved on a frieze, these being the arms of himself and of Maestro Lapo, his father, and that therefore it may be believed that from him the family of the Lapi had its origin, to-day a noble family in Florence. Others say, likewise, that from the descendants of Arnolfo there descended Filippo di Ser Brunellesco. But leaving this, seeing that others believe that the Lapi came from Ficaruolo, a township on the mouth of the Po, and returning to our Arnolfo, I say that by reason of the greatness of this work he deserves infinite praise and an eternal name, above all because he caused it to be all incrusted, without, with marbles of many colours, and within, with hard stone, and made even the smallest corners of that same stone. But in order that everyone may know the exact size of this marvellous fabric, I say that from the door up to the end of the Chapel of S. Zanobi the length is 260 braccia, and the breadth across the transepts 166; across the three naves it is 66 braccia. The middle nave alone is 72 braccia in height; and the other two lesser naves, 48 braccia. The external circuit of the whole church is 1,280 braccia. The cupola, from the ground up to the base of the lantern, is 154 braccia; the lantern, without the ball, is 36 braccia in height;

the ball, 4 braccia in height; the cross, 8 braccia in height. The whole cupola, from the ground up to the summit of the cross, is 202 braccia.

But returning to Arnolfo, I say that being held, as he was, excellent, he had acquired so great trust that nothing of importance was determined without his counsel; wherefore, in the same year, the Commune of Florence having finished the foundation of the last circle of the walls of the city, even as it was said above that they were formerly begun, and so too the towers of the gates, and all being in great part well advanced, he made a beginning for the Palace of the Signori, designing it in resemblance to that which his father Lapo had built in the Casentino for the Counts of Poppi. But yet, however magnificent and great he designed it, he could not give it that perfection which his art and his judgment required, for the following reason: the houses of the Uberti, Ghibellines and rebels against the people of Florence, had been pulled down and thrown to the ground, and a square had been made on the site, and the stupid obstinacy of certain men prevailed so greatly that Arnolfo could not bring it about, through whatsoever arguments he might urge thereunto, that it should be granted to him to put the Palace on a square base, because the governors had refused that the Palace should have its foundations in any way whatsoever on the ground of the rebel Uberti. And they brought it about that the northern aisle of S. Pietro Scheraggio should be thrown to the ground, rather than let him work in the middle of the square with his own measurements; not to mention that they insisted, moreover, that there should be united and incorporated with the Palace the Tower of the Foraboschi, called the 'Torre della Vacca,' in height fifty braccia, for the use of the great bell, and together with it some houses bought by the Commune for this edifice. For which reasons no one must marvel if the foundation of the Palace is awry and out of the square, it having been necessary, in order to incorporate the tower in the middle and to render it stronger, to bind it round with the walls of the Palace; which walls, having been laid open in the year 1561 by Giorgio Vasari, painter and architect, were found excellent. Arnolfo, then, having filled up the said tower with good material, it was afterwards easy for other masters to make thereon the very high campanile that is to be seen there to-day; for within the limits of two years he finished only the Palace, which has subsequently received from time to time those

improvements which give it to-day that greatness and majesty that are to be seen.

After all these works and many more that Arnolfo made, no less convenient and useful than beautiful, he died at the age of seventy, in 1300, at the very time when Giovanni Villani began to write the Universal History of his times. And because he not only left S. Maria del Fiore founded, but its three principal tribunes, which are under the cupola, vaulted, to his own great glory, he well deserved that there should be made a memorial of him on the corner of the church opposite the Campanile, with these verses carved in marble in round letters:

ANNIS . MILLENIS . CENTUM . BIS . OCTO . NOGENIS .
VENIT . LEGATUS . ROMA . BONITATE . DOTATUS .
QUI . LAPIDEM . FIXIT . FUNDO . SIMUL . ET . BENEDIXIT .
PRÆSULE . FRANCISCO . GESTANTE . PONTIFICATUM .
ISTUD . AB . ARNOLFO . TEMPLUM . FUIT . ÆDIFICATUM .
HOC . OPUS . INSIGNE . DECORANS . FLORENTIA . DIGNE .
REGINÆ . CŒLI . CONSTRUXIT . MENTE . FIDELI .
QUAM . TU . VIRGO . PIA . SEMPER . DEFENDE . MARIA.

Of this Arnolfo we have written the Life, with the greatest brevity that has been possible, for the reason that, although his works do not approach by a great measure the perfection of the things of to-day, he deserves, none the less, to be celebrated with loving memory, having shown amid so great darkness, to those who lived after him, the way to walk to perfection. The portrait of Arnolfo, by the hand of Giotto, is to be seen in S. Croce, beside the principal chapel, at the beginning of the story, where the friars are weeping for the death of S. Francis, in one of two men that are talking together. And the picture of the Church of S. Maria del Fiore – namely, of the outer side with the cupola – by the hand of Simone Sanese, is to be seen in the Chapter-house of S. Maria Novella, copied from the original in wood that Arnolfo made; wherein it is noticeable that he had thought to raise the dome immediately over the walls, at the edge of the first cornice, whereas Filippo di Ser Brunellesco, in order to relieve them of weight and to make it more graceful, added thereto, before he began to raise it, all that height wherein to-day are the round windows; which circumstance would be even clearer than it is, if the little care and diligence of those who have directed the Works of S. Maria del Fiore in the years past had not left the very

model that Arnolfo made to go to ruin, and afterwards those of Brunellesco and of the others.

NICCOLA AND GIOVANNI OF PISA
[*NICCOLA PISANO AND GIOVANNI PISANO*],
Sculptors and Architects

HAVING discoursed of design and of painting in the Life of Cimabue and of architecture in that of Arnolfo di Lapo, in this one concerning Niccola and Giovanni of Pisa we will treat of sculpture, and also of the most important buildings that they made, for the reason that their works in sculpture and in architecture truly deserve to be celebrated, not only as being large and magnificent but also well enough conceived, since both in working marble and in building they swept away in great part that old Greek manner, rude and void of proportion, showing better invention in their stories and giving better attitudes to their figures.

Niccola Pisano, then, chancing to be under certain Greek sculptors who were working the figures and other carved ornaments of the Duomo of Pisa and of the Church of S. Giovanni, and there being, among many marble spoils brought by the fleet of the Pisans, certain ancient sarcophagi that are to-day in the Campo Santo of that city, there was one of them, most beautiful among them all, whereon there was carved the Chase of Meleager after the Calydonian Boar, in very beautiful manner, seeing that both the nude figures and the draped were wrought with much mastery and with most perfect design. This sarcophagus was placed by the Pisans, by reason of its beauty, in the side of the Duomo opposite S. Rocco, beside the principal side-door, and it served for the body of the mother of Countess Matilda, if indeed these words are true that are to be read carved in the marble:

A.D. MCXVI. IX KAL. AUG. OBIIT D. MATILDA FELICIS MEM-
ORIÆ COMITISSA, QUÆ PRO ANIMA GENETRICIS SUÆ DOMINÆ
BEATRICIS COMITISSÆ VENERABILIS, IN HAC TUMBA HONOR-
ABILI QUIESCENTIS, IN MULTIS PARTIBUS MIRIFICE HANC
DOTAVIT ECCLESIAM; QUARUM ANIMÆ REQUIESCANT IN
PACE

And then:

A.D. MCCCIII. SUB DIGNISSIMO OPERARIO D. BURGUNDIO
TADI, OCCASIONE GRADUUM FIENDORUM PER IPSUM CIRCA
ECCLESIAM, SUPRADICTA TUMBA SUPERIUS NOTATA BIS
TRANSLATA FUIT, TUNC DE SEDIBUS PRIMIS IN ECCLESIAM,
NUNC DE ECCLESIA IN HUNC LOCUM, UT CERNITIS,
EXCELLENTEM.

Niccola, pondering over the beauty of this work and being greatly pleased therewith, put so much study and diligence into imitating this manner and some other good sculptures that were in these other ancient sarcophagi, that he was judged, after no long time, the best sculptor of his day; there being in Tuscany in those times, after Arnolfo, no other sculptor of repute save Fuccio, an architect and sculptor of Florence, who made S. Maria sopra Arno in Florence, in the year 1229, placing his name there, over a door, and in the Church of S. Francesco in Assisi he made the marble tomb of the Queen of Cyprus, with many figures, and in particular a portrait of her sitting on a lion, in order to show the strength of her soul; which Queen, after her death, left a great sum of money to the end that this fabric might be finished. Niccola, then, having made himself known as a much better master than was Fuccio, was summoned to Bologna in the year 1225, after the death of S. Domenico Calagora, first founder of the Order of Preaching Friars, in order to make a marble tomb for the said Saint; wherefore, after agreement with those who had the charge of it, he made it full of figures in that manner wherein it is to be seen to-day, and delivered it finished in the year 1231 with much credit to himself, for it was held something remarkable, and the best of all the works that had been wrought in sculpture up to that time. He made, likewise, the model of that church and of a great part of the convent. Afterwards Niccola, returning to Tuscany, found that Fuccio had departed from Florence and had gone to Rome in those days when the Emperor Frederick was crowned by Honorius, and from Rome with Frederick to Naples, where he finished the Castel di Capoana, to-day called the Vicaria, wherein are all the tribunals of that kingdom, and likewise the Castel dell' Uovo; and where he likewise founded the towers he also made the gates over the River Volturno for the city of Capua, and a park girt with walls, for fowling, near Gravina, and another for sport in winter at Melfi; besides many other things that are not related, for the sake of brevity. Niccola, meanwhile, busying himself in Florence, was going on exercising

himself not only in sculpture but in architecture as well, by means of the buildings that were going on being made with some little goodness of design throughout all Italy, and in particular in Tuscany; wherefore he occupied himself not a little with the building of the Abbey of Settimo, which had not been finished by the executors of Count Ugo of Brandenburg, like the other six, as was said above. And although it is read in a marble epitaph on the campanile of the said abbey, GUGLIELM. ME FECIT, it is known, nevertheless, by the manner, that it was directed with the counsel of Niccola. About the same time he made the Palazzo Vecchio of the Anziani in Pisa, pulled down in our day by Duke Cosimo, in order to make the magnificent Palace and Convent of the Knights of S. Stephen on the same spot, using some part of the old, from the design and model of Giorgio Vasari, painter and architect of Arezzo, who has accommodated himself to those old walls as well as he has been able in fitting them into the new. Niccola made, likewise in Pisa, many other palaces and churches, and he was the first, since the loss of the good method of building, who made it the custom to found edifices in Pisa on piers, and on these to raise arches, piles having first been sunk under the said piers; because, with any other method, the solid base of the foundation cracked and the walls always collapsed, whereas the sinking of piles renders the edifice absolutely safe, even as experience shows. With his design, also, was made the Church of S. Michele in Borgo for the Monks of Camaldoli. But the most beautiful, the most ingenious, and the most whimsical work of architecture that Niccola ever made was the Campanile of S. Niccola in Pisa, where is the seat of the Friars of S. Augustine, for the reason that it is octagonal on the outer side and round within, with stairs that wind in a spiral and lead to the summit, leaving the hollow space in the middle free, in the shape of a well, and on every fourth step are columns that have the arches above them on a slant and wind round and round; wherefore, the spring of the vaulting resting on the said arches, one goes climbing to the summit in a manner that he who is on the ground always sees all those who are climbing, those who are climbing see those who are on the ground, and those who are halfway up see both the first and the second – that is, those who are above and those who are below. This fanciful invention, with better method and more just proportions, and with more adornment, was afterwards put into execution by the architect Bramante in the Belvedere in

Rome, for Pope Julius II, and by Antonio da San Gallo in the well that is at Orvieto, by order of Pope Clement VII, as will be told when the time comes.

But returning to Niccola, who was no less excellent as sculptor than as architect; in the façade of the Church of S. Martino in Lucca, under the portico that is above the lesser door, on the left as one enters into the church, where there is seen a Christ Deposed from the Cross, he made a marble scene in half-relief, all full of figures wrought with much diligence, having hollowed out the marble and finished the whole in a manner that gave hope to those who were previously working at the art with very great difficulty, that there soon should come one who, with more facility, would give them better assistance. The same Niccola, in the year 1240, gave the design for the Church of S. Jacopo in Pistoia, and put to work there in mosaic certain Tuscan masters who made the vaulting of the choir-niche, which, although in those times it was held as something difficult and of great cost, moves us to-day rather to laughter and to compassion than to marvel, and all the more because such confusion, which comes from lack of design, existed not only in Tuscany but throughout all Italy, where many buildings and other works, that were being wrought without method and without design, give us to know no less the poverty of their talents than the unmeasured riches wasted by the men of those times, by reason of their having had no masters who might execute in a good manner any work that they might do.

Niccola, then, by means of the works that he was making in sculpture and in architecture, was going on ever acquiring a greater name than the sculptors and architects who were then working in Romagna, as can be seen in S. Ippolito and S. Giovanni of Faenza, in the Duomo of Ravenna, in S. Francesco, in the houses of the Traversari, and in the Church of Porto; and at Rimini, in the fabric of the public buildings, in the houses of the Malatesti, and in other buildings, which are all much worse than the old edifices made about the same time in Tuscany. And what has been said of Romagna can be also said with truth of a part of Lombardy. A glance at the Duomo of Ferrara, and at the other buildings made by the Marquis Azzo, will give us to know that this is the truth and how different they are from the Santo of Padua, made with the model of Niccola, and from the Church of the Friars Minor in Venice, both magnificent and honoured buildings. Many, in the time of Niccola, moved by laudable envy,

applied themselves with more zeal to sculpture than they had done before, and particularly in Milan, whither there assembled for the building of the Duomo many Lombards and Germans, who afterwards scattered throughout Italy by reason of the discords that arose between the Milanese and the Emperor Frederick. And so these craftsmen, beginning to compete among themselves both in marble and in building, found some little of the good. The same came to pass in Florence after the works of Arnolfo and Niccola had been seen; and the latter, while the little Church of the Misericordia was being erected from his design in the Piazza di S. Giovanni, made therein in marble, with his own hand, a Madonna with S. Dominic and another Saint, one on either side of her, which may still be seen on the outer façade of the said church.

The Florentines had begun, in the time of Niccola, to throw to the ground many towers made formerly in barbaric manner throughout the whole city, in order that the people might be less hurt by reason of these in the brawls that were often taking place between the Guelphs and the Ghibellines, or in order that there might be greater security for the State, and it appeared to them that it would be very difficult to pull down the Tower of Guardamorto, which was in the Piazza di S. Giovanni, because the walls had been made so stoutly that they could not be pulled to pieces with pickaxes, and all the more because it was very high. Wherefore, Niccola causing the foot of the tower to be cut away on one side and supporting it with wooden props a braccio and a half in length, and then setting fire to them, as soon as the props were burnt away it fell and was almost entirely shattered; which was held something so ingenious and useful for such affairs that later it passed into use, insomuch that, when there is need, any building is destroyed in very little time with this most easy method. Niccola was present at the first foundation of the Duomo of Siena, and designed the Church of S. Giovanni in the same city; then, having returned to Florence in the same year that the Guelphs returned, he designed the Church of S. Trinita, and the Convent of the Nuns of Faenza, destroyed in our day in order to make the citadel. Being next summoned to Naples, in order not to desert the work in Tuscany he sent thither Maglione, his pupil, a sculptor and architect, who afterwards made, in the time of Conradin, the Church of S. Lorenzo in Naples, finished part of the Piscopio, and made there certain tombs, wherein he imitated closely the manner of Niccola, his master.

Niccola, meanwhile, being summoned by the people of Volterra, in the year 1254 (when they came under the power of the Florentines), in order that their Duomo, which was small, might be enlarged, he brought it to better form, although it was very irregular, and made it more magnificent than it was before. Then, having returned finally to Pisa, he made the pulpit of S. Giovanni, in marble, putting therein all diligence in order to leave a memorial of himself to his country; and among other things, carving in it the Universal Judgment, he made therein many figures, if not with perfect design, at least with infinite patience and diligence, as can be seen. And because it appeared to him, as was true, that he had done a work worthy of praise, he carved at the foot of it these verses:

ANNO MILLENO BIS CENTUM BISQUE TRIDENO
HOC OPUS INSIGNE SCULPSIT NICOLA PISANUS.

The people of Siena, moved by the fame of this work, which greatly pleased not only the Pisans but everyone who saw it, gave to Niccola the making of the pulpit of their Duomo, in which there is sung the Gospel; Guglielmo Mariscotti being Prætor. In this Niccola made many stories of Jesus Christ, with much credit to himself, by reason of the figures that are there wrought and with great difficulty almost wholly detached from the marble. Niccola likewise made the design of the Church and Convent of S. Domenico in Arezzo for the Lords of Pietramala, who erected it. And at the entreaty of Bishop Ubertini he restored the Pieve of Cortona, and founded the Church of S. Margherita for the Friars of S. Francis, on the highest point of that city.

Wherefore, the fame of Niccola ever growing greater by reason of so great works, he was summoned in the year 1267, by Pope Clement IV, to Viterbo, where, besides many other works, he restored the Church and Convent of the Preaching Friars. From Viterbo he went to Naples to King Charles I, who, having routed and slain Conradin on the plain of Tagliacozzo, caused to be made on that spot a very rich church and abbey, burying therein the infinite number of bodies slain on that day, and ordaining afterwards that there should be prayers offered by many monks, day and night, for their souls; in which building King Charles was so well pleased with the work of Niccola that he honoured and rewarded him very greatly. Returning from Naples to Tuscany, Niccola stayed in Orvieto for the building of S. Maria,

and working there in company with some Germans, he made in marble, for the façade of that church, certain figures in the round, and in particular two scenes of the Universal Judgment containing Paradise and Hell; and even as he strove, in the Paradise, to give the greatest beauty that he knew to the souls of the blessed, restored to their bodies, so too in the Hell he made the strangest forms of devils that can possibly be seen, most intent on tormenting the souls of the damned; and in this work he surpassed not merely the Germans who were working there but even his own self, to his own great credit. And for the reason that he made therein a great number of figures and endured much fatigue, it has been nothing but praised up to our own times by those who have had no more judgment than this much in sculpture.

Niccola had, among others, a son called Giovanni, who, because he ever followed his father and applied himself under his teaching to sculpture and to architecture, in a few years became not only equal to his father but in some ways superior; wherefore Niccola, being now old, retired to Pisa, and living there quietly left the management of everything to his son. Pope Urban IV having died at that time in Perugia, a summons was sent to Giovanni, who, having gone there, made a tomb of marble for that Pontiff, which, together with that of Pope Martin IV, was afterwards thrown to the ground when the people of Perugia enlarged their Vescovado, in a manner that there are seen only a few relics of it scattered throughout the church. And the people of Perugia, at the same time, having brought a very great body of water through leaden pipes from the hill of Pacciano, two miles distant from the city, by means of the genius and industry of a friar of the Silvestrines, it was given to Giovanni Pisano to make all the ornaments of the fountain, both in bronze and in marble; wherefore he put his hand thereto and made three tiers of basins, two of marble and one of bronze. The first is placed above twelve rows of steps, each with twelve sides; the other on some columns that stand on the lowest level of the first basin – that is, in the middle; and the third, which is of bronze, rests on three figures, and has in the middle certain griffins, also of bronze, that pour water on every side; and because it appeared to Giovanni that he had done very well in this work, he put on it his name. About the year 1560, the arches and the conduits of this fountain (which cost 160,000 ducats of gold) having become in great part spoilt and ruined, Vincenzio Danti, a sculptor of

Perugia, without rebuilding the arches, which would have been a thing of the greatest cost, very ingeniously reconducted the water to the fountain in the way that it was before, with no small credit to himself.

This work finished, Giovanni, desiring to see again his old and ailing father, departed from Perugia in order to return to Pisa; but, passing through Florence, he was forced to stay, to the end that he might apply himself, together with others, to the work of the Mills on the Arno, which were being made at S. Gregorio near the Piazza de' Mozzi. But finally, having had news that his father Niccola was dead, he went to Pisa, where, by reason of his worth, he was received by the whole city with great honour, every man rejoicing that after the loss of Niccola there still remained Giovanni, as heir both of his talents and of his wealth. And the occasion having come of making proof of him, their opinion was in no way disappointed, because, there being certain things to do in the small but most ornate Church of S. Maria della Spina, they were given to Giovanni to do, and he, putting his hand thereunto, with the help of some of his boys brought many ornaments in that oratory to that perfection that is seen to-day; which work, in so far as we can judge, must have been held miraculous in those times, and all the more that he made in one figure the portrait of Niccola from nature, as best he knew.

Seeing this, the Pisans, who long before had had the idea and the wish to make a place of burial for all the inhabitants of the city, both noble and plebeian, either in order not to fill the Duomo with graves or for some other reason, caused Giovanni to make the edifice of the Campo Santo, which is on the Piazza del Duomo, towards the walls; wherefore he, with good design and with much judgment, made it in that manner and with those ornaments of marble and of that size which are to be seen; and because there was no consideration of expense, the roof was made of lead. And outside the principal door there are seen these words carved in marble:

A.D. MCCLXXVIII. TEMPORE DOMINI FREDERIGI ARCHIEPIS-
COPI PISANI, ET DOMINI TARLATI POTESTATIS, OPERARIO
ORLANDO SARDELLA, JOHANNE MAGISTRO ÆDIFICANTE.

This work finished, in the same year, 1283, Giovanni went to Naples, where, for King Charles, he made the Castel Nuovo of Naples; and in order to have room and to make it stronger, he was forced to pull down many houses and churches, and in

particular a convent of Friars of S. Francis, which was afterwards
rebuilt no little larger and more magnificent than it was before,
far from the castle and under the title of S. Maria della Nuova.
These buildings being begun and considerably advanced, Gio-
vanni departed from Naples, in order to return to Tuscany; but
arriving at Siena, without being allowed to go on farther he was
caused to make the model of the façade of the Duomo of that
city, and afterwards the said façade was made very rich and mag-
nificent from this model. Next, in the year 1286, when the Ves-
covado of Arezzo was building with the design of Margaritone,
architect of Arezzo, Giovanni was brought from Siena to Arezzo
by Guglielmino Ubertini, Bishop of that city, where he made in
marble the panel of the high-altar, all filled with carvings of
figures, of foliage, and other ornaments, distributing throughout
the whole work certain things in delicate mosaic, and enamels laid
on plates of silver, let into the marble with much diligence. In the
middle is a Madonna with the Child in her arms, and on one side
S. Gregory the Pope, whose face is the portrait from life of Pope
Honorius IV; and on the other side is S. Donatus, Bishop and
Protector of that city, whose body, with those of S. Antilla and
of other Saints, is laid under that same altar. And because the said
altar stands out by itself, round it and on the sides there are small
scenes in low-relief from the life of S. Donatus, and the crown
of the whole work are certain tabernacles full of marble figures
in the round, wrought with much subtlety. On the breast of the
said Madonna is a bezel-shaped setting of gold, wherein, so it
is said, were jewels of much value, which have been carried away
in the wars, so it is thought, by soldiers, who have no respect,
very often, even for the most holy Sacrament, together with some
little figures in the round that were on the top of and around that
work; on which the Aretines spent altogether, according to what
is found in certain records, 30,000 florins of gold. Nor does this
seem anything great, seeing that at that time it was something as
precious and rare as it could well be; wherefore Frederick Barba-
rossa, returning from Rome, where he had been crowned, and
passing through Arezzo, many years after it had been made,
praised it, nay, admired it infinitely; and in truth with great
reason, seeing that, besides everything else, the joinings of this
work, made of innumerable pieces, are cemented and put together
so well that the whole work is easily judged, by anyone who has
not much practice in the matters of the art, to be all of one piece.

In the same church Giovanni made the Chapel of the Ubertini, a most noble family, and lords of castles, as they still are to-day and were formerly even more; with many ornaments of marble, which to-day have been covered over with other ornaments of grey-stone, many and fine, which were set up in that place with the design of Giorgio Vasari in the year 1535, for the supporting of an organ of extraordinary excellence and beauty that stands thereon.

Giovanni Pisano likewise made the design of the Church of S. Maria de' Servi, which to-day has been destroyed, together with many palaces of the most noble families of the city, for the reasons mentioned above. I will not forbear to say that Giovanni made use, in working on the said marble altar, of certain Germans who had apprenticed themselves to him rather for learning than for gain; and under his teaching they became such that, having gone after this work to Rome, they served Boniface VIII in many works of sculpture for S. Pietro, and in architecture when he made Città Castellana. Besides this, they were sent by the same man to S. Maria in Orvieto, where, for its façade, they made many figures in marble which were passing good for those times. But among others who assisted Giovanni in the work of the Vescovado in Arezzo, Agostino and Agnolo, sculptors and architects of Siena, surpassed in time all the others, as will be told in the proper place. But returning to Giovanni; having departed from Orvieto, he came to Florence, in order to see the fabric of S. Maria del Fiore that Arnolfo was making, and likewise to see Giotto, of whom he had heard great things spoken abroad; and no sooner had he arrived in Florence than he was charged by the Wardens of the said fabric of S. Maria del Fiore to make the Madonna which is over that door of the church that leads to the Canon's house, between two little angels; which work was then much praised. Next, he made the little baptismal font of S. Giovanni, wherein are certain scenes in half-relief from the life of that Saint. Having then gone to Bologna, he directed the building of the principal chapel of the Church of S. Domenico, wherein he was charged by Bishop Teodorigo Borgognoni of Lucca, a friar of that Order, to make an altar of marble; and in the same place he afterwards made, in the year 1298, the marble panel wherein are the Madonna and eight other figures, reasonably good.

In the year 1300, Niccola da Prato, Cardinal Legate of the Pope, being in Florence in order to accommodate the dissensions

of the Florentines, caused him to make a convent for nuns in Prato, which is called S. Niccola from his name, and to restore in the same territory the Convent of S. Domenico, and so too that of Pistoia; in both the one and the other of which there are still seen the arms of the said Cardinal. And because the people of Pistoia held in veneration the name of Niccola, father of Giovanni, by reason of that which he had wrought in that city with his talent, they caused Giovanni himself to make a pulpit of marble for the Church of S. Andrea, like to the one which he had made in the Duomo of Siena; and this he did in order to compete with one which had been made a little before in the Church of S. Giovanni Evangelista by a German, who was therefore much praised. Giovanni, then, delivered his finished in four years, having divided this work into five scenes from the life of Jesus Christ, and having made therein, besides this, a Universal Judgment, with the greatest diligence that he knew, in order to equal or perchance to surpass the one of Orvieto, then so greatly renowned. And round the said pulpit, on the architrave, over some columns that support it, thinking (as was the truth, according to the knowledge of that age) that he had done a great and beautiful work, he carved these verses:

HOC OPUS SCULPSIT JOANNES, QUI RES NON EGIT INANES,
NICOLI NATUS MELIORA BEATUS,
QUEM GENUIT PISA, DOCTUM SUPER OMNIA VISA.

At the same time Giovanni made the holy-water font, in marble, of the Church of S. Giovanni Evangelista in the same city, with three figures that support it – Temperance, Prudence, and Justice; which work, by reason of its having then been held very beautiful, was placed in the centre of that church as something remarkable. And before he departed from Pistoia, although the work had not up to then been begun, he made the model of the Campanile of S. Jacopo, the principal church of that city; on which campanile, which is on the square of the said S. Jacopo and beside the church, there is this date: A.D. 1301.

Afterwards, Pope Benedict IX having died in Perugia, a summons was sent to Giovanni, who, having gone to Perugia, made a tomb of marble for that Pontiff in the old Church of S. Domenico, belonging to the Preaching Friars; the Pope, portrayed from nature and robed in his pontifical habits, is lying at full

length on the bier, with two angels, one on either side, that are holding up a curtain, and above there is a Madonna with two saints in relief, one on either side of her; and many other ornaments are carved round that tomb. In like manner, in the new church of the said Preaching Friars he made the tomb of Messer Niccolò Guidalotti of Perugia, Bishop of Recanati, who was founder of the Sapienza Nuova of Perugia. In this new church, which had been founded before this by others, he executed the central nave, which was founded by him with much better method than the remainder of the church had been; for on one side it leans and threatens to fall down, by reason of having been badly founded. And in truth, he who puts his hand to building and to doing anything of importance should ever take counsel, not from him who knows little but from the best, in order not to have to repent after the act, with loss and shame, that where he most needed good counsel he took the bad.

Giovanni, having dispatched his business in Perugia, wished to go to Rome, in order to learn from those few ancient things that were to be seen there, even as his father had done; but being hindered by good reasons, this his desire did not take effect, and the rather as he heard that the Court had just gone to Avignon. Returning, then, to Pisa, Nello di Giovanni Falconi, Warden, caused him to make the great pulpit of the Duomo, which is on the right hand going towards the high-altar, attached to the choir; and having made a beginning with this and with many figures in the round, three braccia high, that were to serve for it, little by little he brought them to that form that is seen to-day, placing the pulpit partly on the said figures and partly on some columns sustained by lions; and on the sides he made some scenes from the life of Christ. It is a pity, truly, that so great cost, so great diligence, and so great labour should not have been accompanied by good design, and should be wanting in perfection and in excellence of invention, grace, and manner, such as any work of our own times would show, even if made with much less cost and labour. None the less, it must have caused no small marvel to the men of those times, used to seeing only the rudest works. This work was finished in the year 1320, as appears in certain verses that are round the said pulpit, which run thus:

LAUDO DEUM VERUM, PER QUEM SUNT OPTIMA RERUM,
QUI DEDIT HAS PURAS HOMINEM FORMARE FIGURAS;

HOC OPUS HIS ANNIS DOMINI SCULPSERE JOHANNIS
ARTE MANUS SOLE QUONDAM, NATIQUE NICOLE,
CURSIS VENTENIS TERCENTUM MILLEQUE PLENIS;

with other thirteen verses, which are not written, in order not to weary the reader, and because these are enough not only to bear witness that the said pulpit is by the hand of Giovanni, but also that the men of these times were in all things made thus. A Madonna of marble, also, that is seen between S. John the Baptist and another Saint, over the principal door of the Duomo, is by the hand of Giovanni; and he who is at the feet of the Madonna, on his knees, is said to be Piero Gambacorti, Warden of Works. However this may be, on the base whereon stands the image of Our Lady there are carved these words:

SUB PETRI CURA HÆC PIA FUIT SCULPTA FIGURA,
NICOLI NATO SCULPTORE JOHANNE VOCATO.

In like manner, over the side door that is opposite the campanile, there is a Madonna of marble by the hand of Giovanni, having on one side a woman kneeling with two babies, representing Pisa, and on the other the Emperor Henry. On the base whereon stands the Madonna are these words:

AVE GRATIA PLENA, DOMINUS TECUM;

and beside them:

NOBILIS ARTE MANUS SCULPSIT JOHANNES PISANUS
SCULPSIT SUB BURGUNDIO TADI BENIGNO....

And round the base of Pisa:

VIRGINIS ANCILLA SUM PISA QUIETA SUB ILLA.

And round the base of Henry:

IMPERAT HENRICUS QUI CHRISTO FERTUR AMICUS.

In the old Pieve of the territory of Prato, under the altar of the principal chapel, there had been kept for many years the Girdle of Our Lady, which Michele da Prato, returning from the Holy Land, had brought to his country in the year 1141 and consigned to Uberto, Provost of that church, who placed it where it has been said, and where it had been ever held in great veneration; and in the year 1312 an attempt was made to steal it by a man of Prato, a fellow of the basest sort, and, as it were,

another Ser Ciappelletto; but having been discovered, he was put to death for sacrilege by the hand of justice. Moved by this, the people of Prato determined to make a strong and suitable resting-place, in order to hold the said Girdle more securely; wherefore, having summoned Giovanni, who was now old, they made with his counsel, in the greater church, the chapel wherein there is now preserved the said Girdle of Our Lady. And next, with the same man's design, they made the said church much larger than it was before, and encrusted it without with white and black marbles, and likewise the campanile, as may be seen. Finally, being now very old, Giovanni died in the year 1320, after having made, besides those that have been mentioned, many other works in sculpture and in architecture. And in truth there is much owed to him and to his father Niccola, seeing that, in times void of all goodness of design, they gave in so great darkness no small light to the matters of these arts, wherein they were, for that age, truly excellent. Giovanni was buried in the Campo Santo, with great honour, in the same grave wherein had been laid Niccola, his father. There were as disciples of Giovanni many who flourished after him, but in particular Lino, sculptor and architect of Siena, who made in the Duomo of Pisa the chapel all adorned with marble wherein is the body of S. Ranieri, and likewise the baptismal font that is in the said Duomo, with his name.

Nor let anyone marvel that Niccola and Giovanni did so many works, because, not to mention that they lived very long, being the first masters that were in Europe at that time, there was nothing done of any importance in which they did not have a hand, as can be seen in many inscriptions besides those that have been mentioned. And seeing that, while touching on these two sculptors and architects, there has been something said of matters in Pisa, I will not forbear to say that on the top of the steps in front of the new hospital, round the base that supports a lion and the vase that rests on the porphyry column, are these words:

THIS IS THE MEASURE WHICH THE EMPEROR CÆSAR GAVE TO PISA, WHEREWITH THERE WAS MEASURED THE TRIBUTE THAT WAS PAID TO HIM; WHICH HAS BEEN SET UP OVER THIS COLUMN AND LION, IN THE TIME OF GIOVANNI ROSSO, WARDEN OF THE WORKS OF S. MARIA MAGGIORE IN PISA, A.D. MCCCXIII., IN THE SECOND INDICTION, IN MARCH.

ANDREA TAFI, Painter of Florence

Even as the works of Cimabue awakened no small marvel (he having given better design and form to the art of painting) in the men of those times, used to seeing nothing save works done after the Greek manner, even so the works in mosaic of Andrea Tafi, who lived in the same times, were admired, and he thereby held excellent, nay, divine; these people not thinking, being unused to see anything else, that better work could be done in such an art. But not being in truth the most able man in the world, and having considered that mosaic, by reason of its long life, was held in estimation more than all the other forms of painting, he went from Florence to Venice, where some Greek painters were working in S. Marco in mosaic; and becoming intimate with them, with entreaties, with money, and with promises he contrived in such a manner that he brought to Florence Maestro Apollonio, a Greek painter, who taught him to fuse the glass for mosaic and to make the cement for putting it together; and in his company he wrought the upper part of the tribune of S. Giovanni, where there are the Powers, the Thrones, and the Dominions; in which place Andrea, when more practised, afterwards made, as will be said below, the Christ that is over the side of the principal chapel. But having made mention of S. Giovanni, I will not pass by in silence that this ancient temple is all wrought, both without and within, with marbles of the Corinthian Order, and that it is not only designed and executed perfectly in all its parts and with all its proportions, but also very well adorned with doors and with windows, and enriched with two columns of granite on each wall-face, each eleven braccia high, in order to make the three spaces over which are the architraves, that rest on the said columns in order to support the whole mass of the double vaulted roof, which has been praised by modern architects as something remarkable, and deservedly, for the reason that it showed the good which that art already had in itself to Filippo di Ser Brunellesco, to Donatello, and to the other masters of those times, who learnt the art by means of this work and of the Church of S. Apostolo in Florence, a work so good in manner that it casts back to the true ancient goodness, having all the columns in sections, as it has been said above, measured and put together with so great diligence that much can be learnt by studying it in

all its parts. But to be silent about many things that could be said about the good architecture of this church, I will say only that there was a great departure from this example and from this good method of working when the façade of S. Miniato sul Monte without Florence was rebuilt in marble, in honour of the conversion of the Blessed S. Giovanni Gualberto, citizen of Florence and founder of the Order of the Monks of Vallombrosa; because that and many other works that were made later were in no way similar in beauty to those mentioned. The same, in like manner, came to pass in the works of sculpture, for all those that were made in Italy by the masters of that age, as has been said in the Preface to the Lives, were very rude, as can be seen in many places, and in particular in S. Bartolommeo at Pistoia, a church of the Canons Regular, where, in a pulpit very rudely made by Guido da Como, there is the beginning of the life of Jesus Christ, with these words carved thereon by the craftsman himself in the year 1199:

SCULPTOR LAUDATUR, QUOD DOCTUS IN ARTE PROBATUR,
GUIDO DE COMO ME CUNCTIS CARMINE PROMO.

But to return to the Church of S. Giovanni; forbearing to relate its origin, by reason of its having been described by Giovanni Villani and by other writers, and having already said that from this church there came the good architecture that is to-day in use, I will add that the tribune was made later, so far as it is known, and that at the time when Alesso Baldovinetti, succeeding Lippo, a painter of Florence, restored those mosaics, it was seen that it had been in the past painted with designs in red, and all worked on stucco.

Andrea Tafi and Apollonio the Greek, then, in order to cover this tribune with mosaics, made therein a number of compartments, which, narrow at the top beside the lantern, went on widening as far as the level of the cornice below; and they divided the upper part into circles of various scenes. In the first are all the ministers and executors of the Divine Will, namely, the Angels, the Archangels, the Cherubim, the Seraphim, the Powers, the Thrones, and the Dominions. In the second row, also in mosaic, and after the Greek manner, are the principal works done by God, from the creation of light down to the Flood. In the circle that is below these, which goes on widening with the eight sides of that tribune, are all the acts of Joseph and of his twelve

brethren. Below these, then, there follow as many other spaces
of the same size that circle in like manner onward, wherein there
is the life of Jesus Christ, also in mosaic, from the time when He
was conceived in Mary's womb up to the Ascension into Heaven.
Then, resuming the same order, under the three friezes there is
the life of S. John the Baptist, beginning with the appearing of
the Angel to Zacharias the priest, up to his beheading and to the
burial that his disciples gave him. All these works, being rude,
without design and without art, I do not absolutely praise; but of
a truth, having regard to the method of working of that age and
to the imperfection that the art of painting then showed, not to
mention that the work is solid and that the pieces of the mosaic
are very well put together, the end of this work is much better –
or to speak more exactly, less bad – than is the beginning, al-
though the whole, with respect to the work of to-day, moves us
rather to laughter than to pleasure or marvel. Finally, over the
side of the principal chapel in the said tribune, Andrea made by
himself and without the help of Apollonius, to his own great
credit, the Christ that is still seen there to-day, seven braccia high.
Becoming famous for these works throughout all Italy, and being
reputed in his own country as excellent, he well deserved to be
largely honoured and rewarded. It was truly very great good-
fortune, that of Andrea, to be born at a time when, all work being
rudely done, there was great esteem even for that which deserved
to be esteemed very little, or rather not at all. This same thing
befell Fra Jacopo da Turrita, of the Order of S. Francis, seeing
that, having made the works in mosaic that are in the recess
behind the altar of the said S. Giovanni, notwithstanding that
they were little worthy of praise he was remunerated for them
with extraordinary rewards, and afterwards, as an excellent mas-
ter, summoned to Rome, where he wrought certain things in the
chapel of the high-altar of S. Giovanni Laterano, and in that of
S. Maria Maggiore. Next, being summoned to Pisa, he made the
Evangelists in the principal apse of the Duomo, with other works
that are there, assisted by Andrea Tafi and by Gaddo Gaddi, and
using the same manner wherein he had done his other works; but
he left them little less than wholly imperfect, and they were after-
wards finished by Vicino.

The works of these men, then, were prized for some time; but
when the works of Giotto, as will be said in its own place, were
set in comparison with those of Andrea, of Cimabue, and of the

others, people recognized in part the perfection of the art, seeing the difference that there was between the early manner of Cimabue and that of Giotto, in the figures of the one and of the other and in those that their disciples and imitators made. From this beginning the others sought step by step to follow in the path of the best masters, surpassing one another happily from one day to another, so that from such depths these arts have been raised, as is seen, to the height of their perfection.

Andrea lived eighty-one years, and died before Cimabue, in 1294. And by reason of the reputation and the honour that he gained with his mosaic, seeing that he, before any other man, introduced and taught it in better manner to the men of Tuscany, he was the cause that Gaddo Gaddi, Giotto, and the others afterwards made the most excellent works of that craft which have acquired for them fame and an eternal name. After the death of Andrea there was not wanting one to magnify him with this inscription:

QUI GIACE ANDREA, CH' OPRE LEGGIADRE E BELLE
FECE IN TUTTA TOSCANA, ED ORA E ITO
A FAR VAGO LO REGNO DELLE STELLE.

A disciple of Andrea was Buonamico Buffalmacco, who, being very young, played him many tricks, and had from him the portrait of Pope Celestine IV, a Milanese, and that of Innocent IV, both one and the other of whom he portrayed afterwards in the pictures that he made in S. Paolo a Ripa d' Arno in Pisa. A disciple and perhaps a son of the same man was Antonio d' Andrea Tafi, who was a passing good painter; but I have not been able to find any work by his hand. There is only mention made of him in the old book of the Company of the Men of Design.

Deservedly, then, did Andrea Tafi gain much praise among the early masters, for the reason that, although he learnt the principles of mosaic from those whom he brought from Venice to Florence, he added nevertheless so much of the good to the art, putting the pieces together with much diligence and executing the work smooth as a table, which is of the greatest importance in mosaic, that he opened the way to good work to Giotto, among others, as will be told in his Life; and not only to Giotto, but to all those who have exercised themselves in this sort of painting from his day up to our own times. Wherefore it can

be truly affirmed that those marvellous works which are being made to-day in S. Marco at Venice, and in other places, had their first beginning from Andrea Tafi.

GADDO GADDI, Painter of Florence

GADDO, painter of Florence, displayed at this same time more design in his works, wrought after the Greek manner, than did Andrea Tafi and the other painters that were before him, and this perchance arose from the intimate friendship and intercourse that he held with Cimabue, seeing that, by reason either of their conformity of blood or of the goodness of their minds, finding themselves united one to the other by a strait affection, from the frequent converse that they had together and from their discoursing lovingly very often about the difficulties of the arts there were born in their minds conceptions very beautiful and grand; and this came to pass for them the more easily inasmuch as they were assisted by the subtlety of the air of Florence, which is wont to produce spirits both ingenious and subtle, removing continually from round them that little of rust and grossness that most times nature is not able to remove, together with the emulation and with the precepts that the good craftsmen provide in every age. And it is seen clearly that works concerted between those who, in their friendship, are not veiled with the mask of duplicity (although few so made are to be found), arrive at much perfection; and the same men, conferring on the difficulties of the sciences that they are learning, purge them and render them so clear and easy that the greatest praise comes therefrom. Whereas some, on the contrary, diabolically working with profession of friendship, and using the cloak of truth and of lovingness to conceal their envy and malice, rob them of their conceptions, in a manner that the arts do not so soon attain to that excellence which they would if love embraced the minds of the gracious spirits; as it truly bound together Gaddo and Cimabue, and in like manner Andrea Tafi and Gaddo, who was taken by Andrea into company with himself in order to finish the mosaics of S. Giovanni, where that Gaddo learnt so much that afterwards he made by himself the Prophets that are seen round that church in the square spaces beneath the windows; and having wrought these by

GADDO GADDI PITTOR
FIORENTINO

his own self and with much better manner, they brought him very great fame. Wherefore, growing in courage and being disposed to work by himself, he applied himself continually to studying the Greek manner together with that of Cimabue. Whence, after no long time, having become excellent in the art, there was allotted to him by the Wardens of Works of S. Maria del Fiore the lunette over the principal door within the church, wherein he wrought in mosaic the Coronation of Our Lady; which work, when finished, was judged by all the masters, both foreign and native, the most beautiful that had yet been seen in all Italy in that craft, there being recognized therein more design, more judgment, and more diligence than in all the rest of the works in mosaic that were then to be found in Italy.

Wherefore, the fame of this work spreading, Gaddo was called to Rome in the year 1308 (which was the year after the fire that burnt down the Church and the Palaces of the Lateran) by Clement V, for whom he finished certain works in mosaic left imperfect by Fra Jacopo da Turrita. He then wrought certain works, also in mosaic, in the Church of S. Pietro, both in the principal chapel and throughout the church, and in particular a large God the Father, with many other figures, on the façade; and helping to finish some scenes in mosaic that are in the façade of S. Maria Maggiore, he somewhat improved the manner, and departed also a little from that manner of the Greeks, which had in it nothing whatever of the good.

Next, having returned to Tuscany, he wrought in the Duomo Vecchio without the city of Arezzo, for the Tarlati, Lords of Pietramala, certain works in mosaic on a vault that was all made of sponge-stone and served for roof to the middle part of that church, which, being too much burdened by the ancient vault of stone, fell down in the time of Bishop Gentile of Urbino, who had it afterwards all rebuilt with bricks. Departing from Arezzo, Gaddo went to Pisa, where, in the niche over the Chapel of the Incoronata in the Duomo, he made a Madonna who is ascending into Heaven, and, above, a Jesus Christ who is awaiting her and has a rich chair prepared as a seat for her; which work, for those times, was wrought so well and with so great diligence that it has been very well preserved, even to our own day. After this Gaddo returned to Florence, in mind to rest; wherefore, undertaking to make little panels in mosaic, he executed some with egg-shells, with incredible diligence and patience, as can be seen, among

others, in some that are still to-day in the Church of S. Giovanni in Florence. It is read, also, that he made two of them for King Robert, but nothing more is known of these. And let this be enough to have said of Gaddo Gaddi with regard to work in mosaic.

In painting he made many panels, and among others that which is in S. Maria Novella, in the tramezzo* of the church, in the Chapel of the Minerbetti, and many others that were sent into diverse parts of Tuscany. And working thus, now in mosaic and now in painting, he made both in the one and in the other exercise many passing good works, which maintained him ever in good credit and reputation. I could here enlarge further in discoursing of Gaddo, but seeing that the manners of the painters of those times cannot, for the most part, render great assistance to the craftsmen, I will pass this over in silence, reserving myself to be longer in the Lives of those who, having improved the arts, can give some measure of assistance.

Gaddo lived seventy-three years, and died in 1312, and was given honourable burial in S. Croce by his son Taddeo. And although he had other sons, Taddeo alone, who was held at the baptismal font by Giotto, applied himself to painting, learning at first the principles from his father and then the rest from Giotto. A disciple of Gaddo, besides Taddeo his son, was Vicino, a painter of Pisa, who wrought very well certain works in mosaic in the principal apse of the Duomo of Pisa, as these words demonstrate, that are still seen in that apse:

TEMPORE DOMINI JOANNIS ROSSI, OPERARII ISTIUS ECCLE-
SIÆ, VICINUS PICTOR INCEPIT ET PERFECIT HANC IMAGINEM
BEATÆ, MARIÆ; SED MAJESTATIS, ET EVANGELISTÆ, PER ALIOS
INCEPTÆ, IPSE COMPLEVIT ET PERFECIT, A.D. 1321, DE
MENSE SEPTEMBRIS. BENEDICTUM SIT NOMEN DOMINI DEI
NOSTRI JESU CHRISTI. AMEN.

In the Chapel of the Baroncelli, in the same Church of S. Croce, there is a portrait of Gaddo by the hand of his son Taddeo, in a Marriage of Our Lady, and beside him is Andrea

* The literal meaning of tramezzo is 'something that acts as a partition between one thing and another.' There are cases where it might be translated 'rood-screen'; but in general it may be taken to mean transept, which may be said to divide a church into two parts. In all cases where the word occurs, reference will be made to this note.

Tafi. And in our aforesaid book there is a drawing by the hand of Gaddo, made in miniature, like that of Cimabue, wherein it is seen how strong he was in draughtsmanship.

Now, seeing that in an old book, from which I have drawn these few facts that have been related about Gaddo Gaddi, there is also an account of the building of S. Maria Novella, the Church of the Preaching Friars in Florence, a building truly magnificent and highly honoured, I will not pass by in silence by whom and at what time it was built. I say, then, that the Blessed Dominic being in Bologna, and there being conceded to him the property of Ripoli without Florence, he sent thither twelve friars under the care of the Blessed Giovanni da Salerno; and not many years afterwards these friars came to Florence to occupy the church and precincts of S. Pancrazio, and they were settled there, when Dominic himself came to Florence, whereupon they left that place and went to settle in the Church of S. Paolo, according to his pleasure. Later, there being conceded to the said Blessed Giovanni the precincts of S. Maria Novella, with all its wealth, by the Legate of the Pope and by the Bishop of the city, they were put in possession and began to occupy the said precincts on the last day of October, 1221. And because the said church was passing small and faced westward, with its entrance on the Piazza Vecchia, the friars, being now grown to a good number and having great repute in the city, began to think of increasing the said church and convent. Wherefore, having got together a very great sum of money, and having many in the city who were promising every assistance, they began the building of the new church on St. Luke's Day, in 1278; the first stone of the foundations being most solemnly laid by Cardinal Latino degli Orsini, Legate of Pope Nicholas III to the Florentines. The architects of the said church were Fra Giovanni, a Florentine, and Fra Ristoro da Campi, lay-brothers of the same Order, who rebuilt the Ponte alla Carraja and that of S. Trinita, destroyed by the flood of 1264 on October 1. The greater part of the site of the said church and convent was presented to the friars by the heirs of Messer Jacopo, Cavaliere de' Tornaquinci. The cost, as has been said, was met partly by alms and partly by the money of diverse persons who assisted gallantly, and in particular with the assistance of Frate Aldobrandino Cavalcanti, who was afterwards Bishop of Arezzo and is buried over the door of the Virgin. Some say that, besides everything else, he got together by his own industry all the labour

and material that went into the said church, which was finished
when the Prior of this convent was Fra Jacopo Passavanti, who
was therefore deemed worthy of a marble tomb in front of the
principal chapel, on the left hand. This church was consecrated
in the year 1420, by Pope Martin V, as is seen in an inscription
on marble on the right-hand pillar of the principal chapel, which
runs thus:

A.D. 1420. DIE SEPTIMA SEPTEMBRIS, DOMINUS MARTINUS
DIVINA PROVIDENTIA PAPA V. PERSONALITER HANC EC-
CLESIAM CONSECRAVIT, ET MAGNAS INDULGENTIAS
CONTULIT VISITANTIBUS EANDEM.

Of all these things and of many others there is an account in
a chronicle of the building of the said church, which is in the
hands of the fathers of S. Maria Novella, and in the History of
Giovanni Villani likewise; and I have not wished to withhold
these few facts regarding this church and convent, both because
it is one of the most important and most beautiful churches in
Florence, and also because they have therein, as will be said
below, many excellent works made by the most famous crafts-
men that have lived in the years past.

MARGARITONE, Painter, Sculptor, and Architect, of Arezzo

AMONG the old painters who were much alarmed by the praises
rightly given by men to Cimabue and to his disciple Giotto,
whose good work in painting was making their glory shine
throughout all Italy, was one Margaritone, painter of Arezzo,
who, with the others who in that unhappy century were holding
the highest rank in painting, recognized that their works were
little less than wholly obscuring his own fame. Margaritone, then,
being held excellent among the other painters of these times who
were working after the Greek manner, wrought many panels in
distemper at Arezzo, and he painted in fresco – in even more
pictures, but in a long time and with much fatigue – almost the
whole Church of S. Clemente, Abbey of the Order of Camaldoli,
which is to-day all in ruins and thrown down, together with many
other buildings and a strong fortress called S. Chimenti, for the

reason that Duke Cosimo de' Medici, not only on that spot but right round that city, pulled down many buildings and the old walls (which were restored by Guido Pietramalesco, formerly Bishop and Patron of that city); in order to rebuild the latter with connecting wings and bastions, much stronger and smaller than they were, and in consequence more easy to guard and with few men. There were, in the said pictures, many figures both small and great, and although they were wrought after the Greek manner, it was recognized, none the less, that they had been made with good judgment and lovingly; to which witness is borne by works by the same man's hand which have survived in that city, and above all a panel that is now in S. Francesco, in the Chapel of the Conception, with a modern frame, wherein is a Madonna held by these friars in great veneration. He made in the same church, also after the Greek manner, a great Crucifix which is now placed in that chapel where there is the Office of the Wardens of Works; this is wrought on the planking, with the Cross outlined, and of this sort he made many in that city. For the Nuns of S. Margherita he wrought a work that is to-day set up against the tramezzo* of the church – namely, a canvas fixed on a panel, wherein are scenes with small figures from the life of Our Lady and of S. John the Baptist, in considerably better manner than the large, and executed with more diligence and grace. This work is notable, not only because the said small figures are so well made that they look like miniatures, but also because it is a marvel to see that a work on canvas has been preserved for three hundred years. He made throughout the whole city an infinity of pictures, and at Sargiano, a convent of the Frati de' Zoccoli, a S. Francis portrayed from nature on a panel, whereon he placed his name, as on a work, in his judgment, wrought better than was his wont. Next, having made a large Crucifix on wood, painted after the Greek manner, he sent it to Florence to Messer Farinata degli Uberti, a most famous citizen, for the reason that he had, among other noble deeds, freed his country from imminent ruin and peril. This Crucifix is to-day in S. Croce, between the Chapel of the Peruzzi and that of the Giugni. In S. Domenico in Arezzo, a church and convent built by the Lords of Pietramala in the year 1275, as their arms still prove, he wrought many works, and then returned to Rome (where he had already been

* See note on p. 90.

held very dear by Pope Urban IV), to the end that he might do certain works in fresco at his commission in the portico of S. Pietro; these were in the Greek manner, and passing good for those times.

Next, having made a S. Francis on a panel at Ganghereto, a place above Terra Nuova in Valdarno, his spirit grew exalted and he gave himself to sculpture, and that with so much zeal that he succeeded much better than he had done in painting, because, although his first sculptures were in Greek manner, as four wooden figures show that are in a Deposition from the Cross in the Prieve, and some other figures in the round placed in the Chapel of S. Francesco over the baptismal font, none the less he adopted a better manner after he had seen in Florence the works of Arnolfo and of the other then most famous sculptors. Wherefore, having returned to Arezzo in the year 1275, in the wake of the Court of Pope Gregory, who passed through Florence on his return from Avignon to Rome, there came to him opportunity to make himself more known, for the reason that this Pope died in Arezzo, after having presented thirty thousand crowns to the Commune to the end that there might be finished the building of the Vescovado, formerly begun by Maestro Lapo and little advanced, and the Aretines, besides making the Chapel of S. Gregorio (where Margaritone afterwards made a panel) in the Vescovado, in memory of the said Pontiff, also ordained that a tomb of marble should be made for him by the same man in the said Vescovado. Putting his hand to the work, he brought it to completion, including therein the portrait of the Pope from nature, done both in marble and in painting, in a manner that it was held the best work that he had ever yet made. Next, work being resumed on the building of the Vescovado, Margaritone carried it very far on, following the design of Lapo; but he did not, however, deliver it finished, because a few years later, in the year 1289, the wars between the Florentines and the Aretines were renewed, by the fault of Guglielmino Ubertini, Bishop and Lord of Arezzo, assisted by the Tarlati da Pietramala and by the Pazzi di Valdarno, although evil came to them thereby, for they were routed and slain at Campaldino; and there was spent in that war all the money left by the Pope for the building of the Vescovado. And therefore the Aretines ordained that in place of this there should serve the impost paid by the district (thus do they call a tax), as a particular revenue for that

work; which impost has lasted up to our own day, and continues to last.

Now returning to Margaritone: from what is seen in his works, as regards painting, he was the first who considered what a man must do when he works on panels of wood, to the end that they may stay firm in the joinings, and that they may not show fissures and cracks opening out after they have been painted; for he was used to put over the whole surface of the panels a canvas of linen cloth, attached with a strong glue made from shreds of parchment and boiled over a fire; and then over the said canvas he spread gesso, as is seen in many panels by him and by others. He wrought, besides, on gesso mingled with the same glue, friezes and diadems in relief and other ornaments in the round; and he was the inventor of the method of applying Armenian bole, and of spreading gold-leaf thereon and burnishing it. All these things, never seen before, are seen in many of his works, and in particular in the Pieve of Arezzo, in an altar-front wherein are stories of S. Donatus, and in S. Agnesa and S. Niccolò in the same city.

Finally, he wrought many works in his own country, which went abroad; some of which are at Rome, in S. Giovanni and in S. Pietro, and some at Pisa, in S. Caterina, where, in the tramezzo* of the church, there is set up over an altar a panel with S. Catherine on it, and many scenes from her life with little figures, and a S. Francis with many scenes on a panel, on a ground of gold. And in the upper Church of S. Francesco d' Assisi there is a Crucifix by his hand, painted in the Greek manner, on a beam that crosses the church. All which works were in great esteem among the people of that age, although to-day by us they are not esteemed save as old things, good when art was not, as it is to-day, at its height. And seeing that Margaritone applied himself also to architecture, although I have not made mention of any buildings made with his design, because they are not of importance, I will yet not forbear to say that he, according to what I find, made the design and model of the Palazzo de' Governatori in the city of Ancona, after the Greek manner, in the year 1270; and what is more, he made in sculpture, on the principal front, eight windows, whereof each one has, in the space in the middle, two columns that support in the middle two

* See note on p. 90.

arches, over which each window has a scene in half-relief that reaches from the said small arches up to the top of the window; a scene, I say, from the Old Testament, carved in a kind of stone that is found in that district. Under the said windows, on the façade, there are certain words that are understood rather at discretion than because they are either in good form or rightly written, wherein there is read the date and in whose time this work was made. By the hand of the same man, also, was the design of the Church of S. Ciriaco in Ancona. Margaritone died at the age of seventy-seven, disgusted, so it is said, to have lived so long, seeing the age changed and the honours with the new craftsmen. He was buried in the Duomo Vecchio without Arezzo, in a tomb of travertine, now gone to ruin in the destruction of that church; and there was made for him this epitaph:

HIC JACET ILLE BONUS PICTURA MARGARITONUS,
CUI REQUIEM DOMINUS TRADAT UBIQUE PIUS.

The portrait of Margaritone, by the hand of Spinello, is in the Story of the Magi, in the said Duomo, and was copied by me before that church was pulled down.

GIOTTO,
Painter, Sculptor, and Architect, of Florence

THAT very obligation which the craftsmen of painting owe to nature, who serves continually as model to those who are ever wresting the good from her best and most beautiful features and striving to counterfeit and to imitate her, should be owed, in my belief, to Giotto, painter of Florence, for the reason that, after the methods of good paintings and their outlines had lain buried for so many years under the ruins of the wars, he alone, although born among inept craftsmen, by the gift of God revived that art, which had come to a grievous pass, and brought it to such a form as could be called good. And truly it was a very great miracle that that age, gross and inept, should have had strength to work in Giotto in a fashion so masterly, that design, whereof the men of those times had little or no knowledge, was restored completely to life by means of him. And yet this great man was born at the village of Vespignano, in the district of Florence, fourteen miles distant from that city, in the year 1276, from a father named

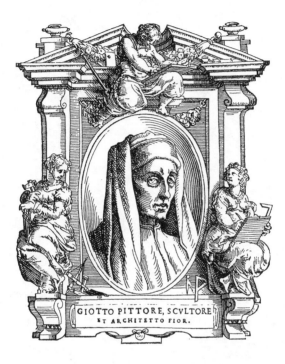

GIOTTO PITTORE, SCVLTORE
ET ARCHITETTO FIOR.

Bondone, a tiller of the soil and a simple fellow. He, having had this son, to whom he gave the name Giotto, reared him conformably to his condition; and when he had come to the age of ten, he showed in all his actions, although childish still, a vivacity and readiness of intelligence much out of the ordinary, which rendered him dear not only to his father but to all those also who knew him, both in the village and beyond. Now Bondone gave some sheep into his charge, and he, going about the holding, now in one part and now in another, to graze them, and impelled by a natural inclination to the art of design, was for ever drawing, on stones, on the ground, or on sand, something from nature, or in truth anything that came into his fancy. Wherefore Cimabue, going one day on some business of his own from Florence to Vespignano, found Giotto, while his sheep were browsing, portraying a sheep from nature on a flat and polished slab, with a stone slightly pointed, without having learnt any method of doing this from others, but only from nature; whence Cimabue, standing fast all in a marvel, asked him if he wished to go to live with him. The child answered that, his father consenting, he would go willingly. Cimabue then asking this from Bondone, the latter lovingly granted it to him, and was content that he should take the boy with him to Florence; whither having come, in a short time, assisted by nature and taught by Cimabue, the child not only equalled the manner of his master, but became so good an imitator of nature that he banished completely that rude Greek manner and revived the modern and good art of painting, introducing the portraying well from nature of living people, which had not been used for more than two hundred years. If, indeed, anyone had tried it, as has been said above, he had not succeeded very happily, nor as well by a great measure as Giotto, who portrayed among others, as is still seen to-day in the Chapel of the Palace of the Podestà at Florence, Dante Alighieri, a contemporary and his very great friend, and no less famous as poet than was in the same times Giotto as painter, so much praised by Messer Giovanni Boccaccio in the preface to the story of Messer Forese da Rabatta and of Giotto the painter himself. In the same chapel are the portraits, likewise by the same man's hand, of Ser Brunetto Latini, master of Dante, and of Messer Corso Donati, a great citizen of those times.

The first pictures of Giotto were in the chapel of the high-altar in the Badia of Florence, wherein he made many works held beautiful, but in particular a Madonna receiving the

Annunciation, for the reason that in her he expressed vividly the fear and the terror that the salutation of Gabriel inspired in Mary the Virgin, who appears, all full of the greatest alarm, to be wishing almost to turn to flight. By the hand of Giotto, likewise, is the panel on the high-altar of the said chapel, which has been preserved there to our own day, and is still preserved there, more because of a certain reverence that is felt for the work of so great a man than for any other reason. And in S. Croce there are four chapels by the same man's hand: three between the sacristy and the great chapel, and one on the other side. In the first of the three, which is that of Messer Ridolfo de' Bardi, and is that wherein are the bell-ropes, is the life of S. Francis, in the death of whom a good number of friars show very naturally the expression of weeping. In the next, which is that of the family of Peruzzi, are two stories of the life of S. John the Baptist, to whom the chapel is dedicated; wherein great vivacity is seen in the dancing and leaping of Herodias, and in the promptness of some servants bustling at the service of the table. In the same are two marvellous stories of S. John the Evangelist – namely, when he brings Drusiana back to life, and when he is carried off into Heaven. In the third, which is that of the Giugni, dedicated to the Apostles, there are painted by the hand of Giotto the stories of the martyrdom of many of them. In the fourth, which is on the other side of the church, towards the north, and belongs to the Tosinghi and to the Spinelli, and is dedicated to the Assumption of Our Lady, Giotto painted her Birth, her Marriage, her Annunciation, the Adoration of the Magi, and when she presents Christ as a little Child to Simeon, which is something very beautiful, seeing that, besides a great affection that is seen in that old man as he receives Christ, the action of the child, stretching out its arms in fear of him and turning in terror towards its mother, could not be more touching or more beautiful. Next, in the death of the Madonna herself, there are the Apostles, and a good number of angels with torches in their hands, all very beautiful. In the Chapel of the Baroncelli, in the said church, is a panel in distemper by the hand of Giotto, wherein is executed with much diligence the Coronation of Our Lady, with a very great number of little figures and a choir of angels and saints, very diligently wrought. And because in that work there are written his name and the date in letters of gold, craftsmen who will consider at what time Giotto, with no glimmer of the good manner, gave a

beginning to the good method of drawing and of colouring, will be forced to hold him in the highest veneration. In the same Church of S. Croce, over the marble tomb of Carlo Marsuppini of Arezzo, there is a Crucifix, with the Madonna, S. John, and Magdalene at the foot of the Cross; and on the other side of the church, exactly opposite this, over the burial-place of Lionardo Aretino, facing the high-altar, there is an Annunciation, which has been recoloured by modern painters, with small judgment on the part of him who has had this done. In the refectory, on a Tree of the Cross, are stories of S. Louis and a Last Supper by the same man's hand; and on the wardrobes in the sacristy are scenes with little figures from the life of Christ and of S. Francis. He wrought, also, in the Church of the Carmine, in the Chapel of S. Giovanni Battista, all the life of that Saint, divided into a number of pictures; and in the Palace of the Guelph party, in Florence, there is a story of the Christian Faith, painted perfectly in fresco by his hand; and therein is the portrait of Pope Clement IV, who created that magisterial body, giving it his arms, which it has always held and holds still.

After these works, departing from Florence in order to go to finish in Assisi the works begun by Cimabue, in passing through Arezzo he painted in the Pieve the Chapel of S. Francesco, which is above the place of baptism; and on a round column, near a Corinthian capital that is both ancient and very beautiful, he portrayed from nature a S. Francis and a S. Dominic; and in the Duomo without Arezzo he painted the Stoning of S. Stephen in a little chapel, with a beautiful composition of figures. These works finished, he betook himself to Assisi, a city of Umbria, being called thither by Fra Giovanni di Muro della Marca, then General of the Friars of S. Francis; where, in the upper church, he painted in fresco, under the gallery that crosses the windows, on both sides of the church, thirty-two scenes of the life and acts of S. Francis – that is, sixteen on each wall – so perfectly that he acquired thereby very great fame. And in truth there is seen great variety in that work, not only in the gestures and attitudes of each figure but also in the composition of all the scenes; not to mention that it enables us very beautifully to see the diversity of the costumes of those times, and certain imitations and observations of the things of nature. Among others, there is one very beautiful scene, wherein a thirsty man, in whom the desire for water is

vividly seen, is drinking, bending down on the ground by a foun-
tain with very great and truly marvellous expression, in a manner
that it seems almost a living person that is drinking. There are
also many other things there most worthy of consideration, about
which, in order not to be tedious, I do not enlarge further. Let it
suffice that this whole work acquired for Giotto very great fame,
by reason of the excellence of the figures and of the order, pro-
portion, liveliness, and facility which he had from nature, and
which he had made much greater by means of study, and was
able to demonstrate clearly in all his works. And because, besides
that which Giotto had from nature, he was most diligent and
went on ever thinking out new ideas and wresting them from
nature, he well deserved to be called the disciple of nature and
not of others. The aforesaid scenes being finished, he painted in
the same place, but in the lower church, the upper part of the
walls at the sides of the high-altar, and all the four angles of the
vaulting above in the place where lies the body of S. Francis; and
all with inventions both fanciful and beautiful. In the first is
S. Francis glorified in Heaven, surrounded by those virtues which
are essential for him who wishes to be perfectly in the grace of
God. On one side Obedience is placing a yoke on the neck of a
friar who is before her on his knees, and the bands of the yoke
are drawn by certain hands towards Heaven; and, enjoining
silence with one finger to her lips, she has her eyes on Jesus
Christ, who is shedding blood from His side. And in company
with this virtue are Prudence and Humility, in order to show that
where there is true obedience there are ever humility and
prudence, which enable us to carry out every action well. In the
second angle is Chastity, who, standing in a very strong fastness,
is refusing to be conquered either by kingdoms or crowns or
palms that some are presenting to her. At her feet is Purity, who
is washing naked figures; and Force is busy leading people to
wash and purify themselves. Near to Chastity, on one side, is
Penitence, who is chasing Love away with a Discipline, and put-
ting to flight Impurity. In the third space is Poverty, who is
walking with bare feet on thorns, and has a dog that is barking
at her from behind, and about her a boy who is throwing
stones at her, and another who is busy pushing some thorns with
a stick against her legs. And this Poverty is seen here being espoused
by S. Francis, while Jesus Christ is holding her hand, there being
present, not without mystic meaning, Hope and Compassion. In

the fourth and last of the said spaces is a S. Francis, also glorified, in the white tunic of a deacon, and shown triumphant in Heaven in the midst of a multitude of angels who are forming a choir round him, with a standard whereon is a Cross with seven stars; and on high is the Holy Spirit. Within each of these angles are some Latin words that explain the scenes. In like manner, besides the said four angles, there are pictures on the side walls which are very beautiful and truly to be held in great price, both by reason of the perfection that is seen in them and because they were wrought with so great diligence that up to our own day they have remained fresh. In these pictures is the portrait of Giotto himself, very well made, and over the door of the sacristy, by the same man's hand and also in fresco, there is a S. Francis who is receiving the Stigmata, so loving and devout that to me it appears the most excellent picture that Giotto made in these works, which are all truly beautiful and worthy of praise.

Having finished, then, for the last, the said S. Francis, he returned to Florence, where, on arriving there, he painted, on a panel that was to be sent to Pisa, a S. Francis on the tremendous rock of La Vernia, with extraordinary diligence, seeing that, besides certain landscapes full of trees and cliffs, which was something new in those times, there are seen in the attitude of a S. Francis, who is kneeling and receiving the Stigmata with much readiness, a most ardent desire to receive them and infinite love towards Jesus Christ, who, being surrounded in the sky by seraphim, is granting them to him with an expression so vivid that anything better cannot be imagined. In the lower part of the same panel there are three very beautiful scenes of the life of the same Saint. This panel, which to-day is seen in S. Francesco in Pisa on a pillar beside the high-altar, and is held in great veneration as a memorial of so great a man, was the reason that the Pisans, having just finished the building of the Campo Santo after the design of Giovanni, son of Niccola Pisano, as has been said above, gave to Giotto the painting of part of the inner walls, to the end that, since this so great fabric was all incrusted on the outer side with marbles and with carvings made at very great cost, and roofed over with lead, and also full of sarcophagi and ancient tombs once belonging to the heathens and brought to Pisa from various parts of the world, even so it might be adorned within, on the walls, with the noblest painting. Having gone to Pisa, then,

for this purpose, Giotto made in fresco, on the first part of a wall in that Campo Santo, six large stories of the most patient Job. And because he judiciously reflected that the marbles of that part of the building where he had to work were turned towards the sea, and that, all being saline marbles, they are ever damp by reason of the south-east winds and throw out a certain salt moisture, even as the bricks of Pisa do for the most part, and that therefore the colours and the paintings fade and corrode, he caused to be made over the whole surface where he wished to work in fresco, to the end that his work might be preserved as long as possible, a coating, or in truth an intonaco or incrustation – that is to say, with lime, gypsum, and powdered brick all mixed together; so suitably that the pictures which he afterwards made thereon have been preserved up to the present day. And they would be still better if the negligence of those who should have taken care of them had not allowed them to be much injured by the damp, because the fact that this was not provided for, as was easily possible, has been the reason that these pictures, having suffered from damp, have been spoilt in certain places, and the flesh-colours have been blackened, and the intonaco has peeled off; not to mention that the nature of gypsum, when it has been mixed with lime, is to corrode in time and to grow rotten, whence it arises that afterwards, perforce, it spoils the colours, although it appears at the beginning to take a good and firm hold. In these scenes, besides the portrait of Messer Farinata degli Uberti, there are many beautiful figures, and above all certain villagers, who, in carrying the grievous news to Job, could not be more full of feeling nor show better than they do the grief that they felt over the lost cattle and over the other misadventures. Likewise there is amazing grace in the figure of a man-servant who is standing with a fan beside Job, who is covered with ulcers and almost abandoned by all; and although he is well done in every part, he is marvellous in the attitude that he strikes in chasing the flies from his leprous and stinking master with one hand, while with the other he is holding his nose in disgust, in order not to notice the stench. In like manner, the other figures in these scenes and the heads both of the males and of the women are very beautiful; and the draperies are wrought to such a degree of softness that it is no marvel if this work acquired for him so great fame, both in that city and abroad, that Pope Benedict IX of Treviso sent one of his courtiers into Tuscany to see

what sort of man was Giotto, and of what kind his works, having designed to have some pictures made in S. Pietro. This courtier, coming in order to see Giotto and to hear what other masters there were in Florence excellent in painting and in mosaic, talked to many masters in Siena. Then, having received drawings from them, he came to Florence, and having gone into the shop of Giotto, who was working, declared to him the mind of the Pope and in what way it was proposed to make use of his labour, and at last asked him for some little drawing, to the end that he might send it to His Holiness. Giotto, who was most courteous, took a paper, and on that, with a brush dipped in red, holding his arm fast against his side in order to make a compass, with a turn of the hand he made a circle, so true in proportion and circumference that to behold it was a marvel. This done, he smiled and said to the courtier: 'Here is your drawing.' He, thinking he was being derided, said: 'Am I to have no other drawing but this?' ''Tis enough and to spare,' answered Giotto. 'Send it, together with the others, and you will see if it will be recognized.' The envoy, seeing that he could get nothing else, left him, very ill-satisfied and doubting that he had been fooled. All the same, sending to the Pope the other drawings and the names of those who had made them, he also sent that of Giotto, relating the method that he had followed in making his circle without moving his arm and without compasses. Wherefore the Pope and many courtiers that were versed in the arts recognized by this how much Giotto surpassed in excellence all the other painters of his time. This matter having afterwards spread abroad, there was born from it the proverb that is still wont to be said to men of gross wits: 'Tu sei più tondo che l' O di Giotto!' ('Thou art rounder than Giotto's circle'). This proverb can be called beautiful not only from the occasion that gave it birth, but also for its significance, which consists in the double meaning; tondo being used, in Tuscany, both for the perfect shape of a circle and for slowness and grossness of understanding.

The aforesaid Pope then made him come to Rome, where, honouring him much and appreciating his talents, he made him paint five scenes from the life of Christ in the apse of S. Pietro, and the chief panel in the sacristy, which were all executed by him with so great diligence that there never issued from his hands any more finished work in distemper. Wherefore he well deserved that the Pope, holding himself to have been well served, should

cause to be given to him six hundred ducats of gold, besides granting him so many favours that they were talked of throughout all Italy.

About this time – in order to withhold nothing worthy of remembrance in connection with art – there was in Rome one Oderigi d' Agobbio, who was much the friend of Giotto and an excellent illuminator for those days. This man, being summoned for this purpose by the Pope, illuminated many books for the library of the palace, which are now in great part eaten away by time. And in my book of ancient drawings are some remains from the very hand of this man, who in truth was an able man; although a much better master than Oderigi was Franco Bolognese, who wrought a number of works excellently in that manner for the same Pope and for the same library, about the same time, as can be seen in the said book, wherein I have designs by his hand both in painting and in illumination, and among them an eagle very well done, and a very beautiful lion that is tearing a tree. Of these two excellent illuminators Dante makes mention in the eleventh canto of the *Purgatorio*, where he is talking of the vainglorious, in these verses:

O, dissi a lui, non se' tu Oderigi,
L' onor d' Agobbio, e l' onor di quell' arte
Che alluminare è chiamata in Parigi?
Frate, diss' egli, più ridon le carte
Che pennelleggia Franco Bolognese;
L' onor è tutto suo, e mio in parte.

The Pope, having seen these works, and the manner of Giotto pleasing him infinitely, ordered him to make scenes from the Old Testament and the New right round S. Pietro; wherefore, for a beginning, Giotto made in fresco the Angel that is over the organ, seven braccia high, and many other paintings, whereof part have been restored by others in our own days, and part, in founding the new walls, have been either destroyed or removed from the old edifice of S. Pietro, up to the space below the organ; such as a Madonna on a wall, which, to the end that it might not be thrown to the ground, was cut right out of the wall and made fast with beams and iron bars and thus removed, and afterwards built in, by reason of its beauty, in the place that pleased the pious love that is borne towards everything excellent in art by Messer Niccolò Acciaiuoli, doctor of Florence, who richly

adorned this work of Giotto with stucco-work and also with modern paintings. By his hand, also, was the Navicella in mosaic that is over the three doors of the portico in the court of S. Pietro, which is truly marvellous and deservedly praised by all beautiful minds, because in it, besides the design, there is the grouping of the Apostles, who are travailing in diverse manners through the sea-tempest, while the winds are blowing into a sail, which has so high a relief that a real one would not have more; and moreover it is difficult to have to make with those pieces of glass a unity such as that which is seen in the lights and shadows of so great a sail, which could only be equalled by the brush with great difficulty and by making every possible effort; not to mention that in a fisherman, who is fishing from a rock with a line, there is seen an attitude of extreme patience proper to that art, and in his face the hope and the wish to make a catch. Under this work are three little arches in fresco, of which, since they are for the greater part spoilt, I will say no more. The praises universally given by craftsmen to this work are well deserved.

Giotto, having afterwards painted on a panel a large Crucifix coloured in distemper, for the Minerva, a church of the Preaching Friars, returned to his own country, having been abroad six years. But no long time after, by reason of the death of Pope Benedict IX, Clement V was created Pope in Perugia, and Giotto was forced to betake himself with that Pope to the place where he brought his Court, to Avignon, in order to do certain works there; and having gone there, he made, not only in Avignon but in many other places in France, many very beautiful panels and pictures in fresco, which pleased the Pontiff and the whole Court infinitely. Wherefore, the work dispatched, the Pope dismissed him lovingly and with many gifts, and he returned home no less rich than honoured and famous; and among the rest he brought back the portrait of that Pope, which he gave afterwards to Taddeo Gaddi, his disciple. And this return of Giotto to Florence was in the year 1316. But it was not granted to him to stay long in Florence, because, being summoned to Padua by the agency of the Signori della Scala, he painted a very beautiful chapel in the Santo, a church built in those times. From there he went to Verona, where, for Messer Cane, he made certain pictures in his palace, and in particular the portrait of that lord; and a panel for the Friars of S. Francis. These works completed, in returning to Tuscany he was forced to stay in Ferrara, and he painted at the

behest of those Signori d' Este, in their palace and in S. Agostino, some works that are still seen there to-day. Meanwhile, it coming to the ears of Dante, poet of Florence, that Giotto was in Ferrara, he so contrived that he brought him to Ravenna, where he was living in exile; and he caused him to make round the Church of S. Francesco, for the Signori da Polenta, some scenes in fresco that are passing good. Next, having gone from Ravenna to Urbino, there too he wrought some works. Then, chancing to pass through Arezzo, he could not but comply with the wish of Piero Saccone, who had been much his friend; wherefore he made for him in fresco, on a pillar in the principal chapel of the Vescovado, a S. Martin who has cut his cloak in half and is giving one part of it to a beggar, who is standing before him almost wholly naked. Then, having made for the Abbey of S. Fiore a large Crucifix painted in distemper on wood, which is to-day in the middle of that church, he returned finally to Florence, where, among many other works, he made some pictures in the Convent of the Nuns of Faenza, both in fresco and in distemper, that are not in existence to-day, by reason of the destruction of that convent. In the year 1322, likewise – Dante, very much his friend, having died in the year before, to his great sorrow – he went to Lucca, and at the request of Castruccio, then Lord of that city, his birthplace, he made a panel in S. Martino with a Christ in air and four Saints, Protectors of that city – namely, S. Peter, S. Regulus, S. Martin, and S. Paulinus – who appear to be recommending a Pope and an Emperor, who, according to what is believed by many, are Frederick of Bavaria and the Anti-Pope Nicholas V. Some, likewise, believe that Giotto designed the castle and fortress of Giusta, which is impregnable, at San Frediano, in the same city of Lucca.

Afterwards, Giotto having returned to Florence, Robert, King of Naples, wrote to Charles, King of Calabria, his first-born son, who chanced to be in Florence, that he should send him Giotto to Naples at all costs, for the reason that, having finished the building of S. Chiara, a convent of nuns and a royal church, he wished that it should be adorned by him with noble paintings. Giotto, then, hearing himself summoned by a King so greatly renowned and famous, went more than willingly to serve him, and, on arriving, painted many scenes from the Old Testament and the New in some chapels of the said convent. And the scenes from the Apocalypse that he made in one of the said chapels are

said to have been inventions of Dante; and this may be also true of those at Assisi, so greatly renowned, whereof there has been enough said above. And although Dante at that time was dead, they may have held discourse on these matters, as often comes to pass between friends.

But to return to Naples; Giotto made many works in the Castel dell' Uovo, and in particular the chapel, which much pleased that King, by whom he was so greatly beloved that many times, while working, Giotto found himself entertained by the King in person, who took pleasure in seeing him at work and in hearing his discourse. And Giotto, who had ever some jest on his tongue and some witty repartee in readiness, would entertain him with his hand, in painting, and with pleasant discourse, in his jesting. Wherefore, the King saying to him one day that he wished to make him the first man in Naples, Giotto answered, 'And for that end am I lodged at the Porta Reale, in order to be the first in Naples.' Another time, the King saying to him, 'Giotto, an I were you, now that it is hot, I would give over painting for a little;' he answered, 'And I, i' faith, an I were you.' Being then very dear to the King, he made for him a good number of pictures in a hall (that King Alfonso I pulled down in order to make the Castle), and also in the Incoronata; and among others in the said hall were the portraits of many famous men, and among them that of Giotto himself. Now the King having one day out of caprice besought him to paint his realm for him, Giotto, so it is said, painted for him an ass saddled, that had at its feet a new pack-saddle, and was sniffing at it and making semblance of desiring it; and on both the old pack-saddle and the new one were the royal crown and the sceptre of sovereignty; wherefore Giotto, being asked by the King what such a picture signified, answered that such were his subjects and such the kingdom, wherein every day a new lord was desired.

Departing from Naples in order to go to Rome, Giotto stopped at Gaeta, where he was forced to paint some scenes from the Old Testament in the Nunziata, which are now spoilt by time, but yet not so completely that there may not be seen in them very well the portrait of Giotto himself, near a large and very beautiful Crucifix. This work finished, not being able to refuse this to Signor Malatesta, he first occupied himself in his service for some days in Rome, and afterwards he betook himself to Rimini, of which city the said Malatesta was lord; and there,

in the Church of S. Francesco, he made very many pictures, which were afterwards thrown to the ground and destroyed by Gismondo, son of Pandolfo Malatesta, who rebuilt the whole said church anew. In the cloisters of the said place, also, opposite to the wall of the church, he painted in fresco the story of the Blessed Michelina, which was one of the most beautiful and excellent works that Giotto ever made, by reason of the many and beautiful ideas that he had in working thereon; for besides the beauty of the draperies, and the grace and vivacity of the heads, which are miraculous, there is a young woman therein as beautiful as ever a woman can be, who, in order to clear herself from the false charge of adultery, is taking oath over a book in a most wonderful attitude, holding her eyes fixed on those of her husband, who was making her take the oath by reason of mistrust in a black son born from her, whom he could in no way bring himself to believe to be his. She, even as the husband is showing disdain and distrust in his face, is making clear with the purity of her brow and of her eyes, to those who are most intently gazing on her, her innocence and simplicity, and the wrong that he is doing to her in making her take oath and in proclaiming her wrongly as a harlot.

In like manner, very great feeling was that which he expressed in a sick man stricken with certain sores, seeing that all the women who are round him, overcome by the stench, are making certain grimaces of disgust, the most gracious in the world. The foreshortenings, next, that are seen in another picture among a quantity of beggars that he portrayed, are very worthy of praise and should be held in great price among craftsmen, because from them there came the first beginning and method of making them, not to mention that it cannot be said that they are not passing good for early work. But above everything else that is in this work, most marvellous is the gesture that the aforesaid Blessed Michelina is making towards certain usurers, who are disbursing to her the money from the sale of her possessions for giving to the poor, seeing that in her there is shown contempt of money and of the other things of this earth, which appear to disgust her, and, in them, the personification of human avarice and greed. Very beautiful, too, is the figure of one who, while counting the money, appears to be making sign to the notary who is writing, considering that, although he has his eyes on the notary, he is yet keeping his hands on the money, thus revealing his love of it, his

avarice, and his distrust. In like manner, the three figures that are upholding the garments of S. Francis in the sky, representing Obedience, Patience, and Poverty, are worthy of infinite praise, above all because there is in the manner of the draperies a natural flow of folds that gives us to know that Giotto was born in order to give light to painting. Besides this, he portrayed Signor Malatesta on a ship in this work, so naturally that he appears absolutely alive; and some mariners and other people, in their promptness, their expressions, and their attitudes – and particularly a figure that is speaking with some others and spits into the sea, putting one hand up to his face – give us to know the excellence of Giotto. And certainly, among all the works of painting made by this master, this may be said to be one of the best, for the reason that there is not one figure in so great a number that does not show very great craftsmanship, and that is not placed in some characteristic attitude. And therefore it is no marvel that Signor Malatesta did not fail to reward him magnificently and to praise him.

Having finished his labours for that lord, he complied with the request of a Prior of Florence who was then at S. Cataldo d' Arimini, and made a S. Thomas Aquinas, reading to his friars, without the door of the church. Departing thence, he returned to Ravenna and painted a chapel in fresco in S. Giovanni Evangelista, which is much extolled. Having next returned to Florence with very great honour and ample means, he painted a Crucifix on wood and in distemper for S. Marco, larger than life and on a ground of gold, which was placed on the right hand in the church. And he made another like it in S. Maria Novella, whereon Puccio Capanna, his pupil, worked in company with him; and this is still to-day over the principal door, on the right as you enter the church, over the tomb of the Gaddi. And in the same church, over the tramezzo,* he made a S. Louis for Paolo di Lotto Ardinghelli, and at the foot thereof the portrait of him and of his wife, from the life.

Afterwards, in the year 1327, Guido Tarlati da Pietramala, Bishop and Lord of Arezzo, died at Massa di Maremma in returning from Lucca, where he had been to visit the Emperor, and after his body had been brought to Arezzo and the most

* See note on p. 90.

magnificent funeral honours had been paid to it, Piero Saccone and Dolfo da Pietramala, the brother of the Bishop, determined that there should be made for him a tomb in marble worthy of the greatness of so notable a man, who had been a lord both spiritual and temporal, and head of the Ghibelline party in Tuscany. Wherefore, having written to Giotto that he should make the design of a tomb very rich and with all possible adornment, and having sent him the measurements, they prayed him afterwards that he should place at their disposal the sculptor who was the most excellent, according to his opinion, of all that were in Italy, because they were relying wholly on his judgment. Giotto, who was most courteous, made the design and sent it to them; and after this design, as will be told in the proper place, the said tomb was made. And because the said Piero Saccone had infinite love for the talent of this man, having taken Borgo a San Sepolcro no long time after he had received the said design, he brought from there to Arezzo a panel with little figures by the hand of Giotto, which afterwards fell to pieces; and Baccio Gondi, nobleman of Florence, a lover of these noble arts and of every talent, being Commissary of Arezzo, sought out the pieces of this panel with great diligence, and having found some brought them to Florence, where he holds them in great veneration, together with some other works that he has by the hand of the same Giotto, who wrought so many that their number is almost beyond belief. And not many years ago, chancing to be at the Hermitage of Camaldoli, where I have wrought many works for those reverend Fathers, I saw in a cell, whither it had been brought by the Very Reverend Don Antonio da Pisa, then General of the Congregation of Camaldoli, a very beautiful little Crucifix on a ground of gold, with the name of Giotto in his own hand; which Crucifix, according to what I hear from the Reverend Don Silvano Razzi, monk of Camaldoli, is kept to-day in the cell of the Superior of the Monastery of the Angeli, as being a very rare work and by the hand of Giotto, in company with a most beautiful little picture by Raffaello da Urbino.

For the Frati Umiliati of Ognissanti in Florence, Giotto painted a chapel and four panels, in one of which there was the Madonna, with many angels round her and the Child in her arms, and a large Crucifix on wood, whereof Puccio Capanna took the design and wrought many of them afterwards throughout all Italy, having much practice in the manner of Giotto. In the

tramezzo* of the said church, when this book of the Lives of the
Painters, Sculptors, and Architects was printed the first time,
there was a little panel in distemper painted by Giotto with infi-
nite diligence, wherein was the death of Our Lady, with the
Apostles round her and with a Christ who is receiving her soul
into His arms. This work was much praised by the craftsmen of
painting, and in particular by Michelagnolo Buonarroti, who
declared, as was said another time, that the quality of this painted
story could not be more like to the truth than it is. This little
panel, I say, having come into notice from the time when the
book of these Lives was first published, was afterwards carried
off by someone unknown, who, perhaps out of love for art and
out of piety, it seeming to him that it was little esteemed, became,
as said our poet, impious. And truly it was a miracle in those
times that Giotto had so great loveliness in his painting,
considering, above all, that he learnt the art in a certain measure
without a master.

After these works, in the year 1334, on July 9, he put his hand
to the Campanile of S. Maria del Fiore, whereof the foundation
was a platform of strong stone, in a pit sunk twenty braccia deep
from which water and gravel had been removed; upon this plat-
form he made a good mass of concrete, that reached to the
height of twelve braccia above the first foundation, and the rest
– namely, the other eight braccia – he caused to be made of
masonry. And at this beginning and foundation there officiated
the Bishop of the city, who, in the presence of all the clergy and
all the magistrates, solemnly laid the first stone. This work, then,
being carried on with the said model, which was in the German
manner that was in use in those times, Giotto designed all the
scenes that were going into the ornamentation, and marked out
the model with white, black, and red colours in all those places
wherein the marbles and the friezes were to go, with much
diligence. The circuit round the base was one hundred braccia –
that is, twenty-five braccia for each side – and the height, one
hundred and forty-four braccia. And if that is true, and I hold it
as of the truest, which Lorenzo di Cione Ghiberti has left in
writing, Giotto made not only the model of this campanile, but
also part of those scenes in marble wherein are the beginnings of
all the arts, in sculpture and in relief. And the said Lorenzo

* See note on p. 90.

declares that he saw models in relief by the hand of Giotto, and
in particular those of these works; which circumstance can be
easily believed, design and invention being father and mother of
all these arts and not of one alone. This campanile was destined,
according to the model of Giotto, to have a spire, or rather a
pyramid, four-sided and fifty braccia high, as a completion to
what is now seen; but, for the reason that it was a German idea
and in an old manner, modern architects have never done aught
but advise that it should not be made, the work seeming to be
better as it is. For all these works Giotto was not only made
citizen of Florence, but was given a pension of one hundred
florins yearly by the Commune of Florence, which was something
very great in those times; and he was made overseer over this
work, which was carried on after him by Taddeo Gaddi, for he
did not live so long as to be able to see it finished.

Now, while this work continued to be carried forward, he
made a panel for the Nuns of S. Giorgio, and three half-length
figures in an arch over the inner side of the door of the Badia in
Florence, now covered with whitewash in order to give more light
to the church. And in the Great Hall of the Podestà of Florence
he painted the Commune (an idea stolen by many), representing
it as sitting in the form of Judge, sceptre in hand, and over its head
he placed the balanced scales as symbol of the just decisions ad-
ministered by it, accompanying it with four Virtues, that are,
Strength with courage, Wisdom with the laws, Justice with arms,
and Temperance with words; this work is beautiful as a picture,
and characteristic and appropriate in invention.

Afterwards, having gone again to Padua, besides many other
works and chapels that he painted there, he made a Mundane
Glory in the precincts of the Arena, which gained him much
honour and profit. In Milan, also, he wrought certain works, that
are scattered throughout that city and held most beautiful even
to this day. Finally, having returned from Milan, no long time
passed before he gave up his soul to God, having wrought so
many most beautiful works in his life, and having been no less
good as Christian than he was excellent as painter. He died in the
year 1336, to the great grief of all his fellow-citizens – nay, of all
those who had known him or even only heard his name – and
he was buried, even as his virtues deserved, with great honour,
having been loved by all while he lived, and in particular by the
men excellent in all the professions, seeing that, besides Dante,

of whom we have spoken above, he was much honoured by Petrarca, both he and his works, so greatly that it is read in Petrarca's testament that he left to Signor Francesco da Carrara, Lord of Padua, among other things held by him in the highest veneration, a picture by the hand of Giotto containing a Madonna, as something rare and very dear to him. And the words of that clause in the testament run thus:

'Transeo ad dispositionem aliarum rerum; et prædicto igitur domino meo Paduano, quia et ipse per Dei gratiam non eget, et ego nihil aliud habeo dignum se, mitto tabulam meam sive historiam Beatæ Virginis Mariæ, opus Jocti pictoris egregii, quæ mihi ab amico meo Michæle Vannis de Florentia missa est, in cujus pulchritudinem ignorantes non intelligunt, magistri autem artis stupent; hanc iconam ipsi domino lego, ut ipsa Virgo benedicta sibi sit propitia apud filium suum Jesum Christum.'

And the same Petrarch, in a Latin epistle in the fifth book of his *Familiar Letters*, says these words:

'Atque (ut a veteribus ad nova, ab externis ad nostra transgrediar) duos ego novi pictores egregios, nec formosos, Joctum Florentinum civem, cujus inter modernos fama ingens est, et Simonem Senensem. Novi scultores aliquot,' etc.

Giotto was buried in S. Maria del Fiore, on the left side as you enter the church, where there is a slab of white marble in memory of so great a man. And, as was told in the Life of Cimabue, a commentator of Dante, who lived at the same time as Giotto, said: 'Giotto was and is the most eminent among painters in the same city of Florence, and his works bear testimony for him in Rome, in Naples, in Avignon, in Florence, in Padua, and in many other parts of the world.'

His disciples were Taddeo Gaddi, held by him at baptism, as has been said, and Puccio Capanna of Florence, who, working at Rimini in the Church of S. Cataldo, belonging to the Preaching Friars, painted perfectly in fresco the hull of a ship which appears to be sinking in the sea, with men who are throwing things into the sea, one of whom is Puccio himself portrayed from life among a good number of mariners. The same man painted many works after the death of Giotto in the Church of S. Francesco at Assisi, and in the Church of S. Trinita in Florence, near the side-door towards the river, he painted the Chapel of the Strozzi, wherein is the Coronation of the Madonna in fresco, with a choir of angels which draw very much to the manner of Giotto; and

on the sides are stories of S. Lucia, very well wrought. In the Badia of Florence he painted the Chapel of S. Giovanni Evangelista, belonging to the family of Covoni, beside the sacristry; and in Pistoia he wrought in fresco the principal chapel of the Church of S. Francesco and the Chapel of S. Lodovico, with the stories of those Saints, passing well painted. In the middle of the Church of S. Domenico, in the same city, there are a Crucifix, a Madonna, and a S. John, wrought with much sweetness, and at their feet a complete human skeleton, wherein (and this was something unusual in those times) Puccio showed that he had sought to find the foundations of art. In this work there is read his name, written by himself in this fashion: PUCCIO DI FIOREN-ZA ME FECE. In the arch over the door of S. Maria Nuova in the said church there are three half-length figures by his hand, Our Lady with the Child in her arms, and S. Peter on one side, and on the other S. Francis. He also painted in the aforesaid city of Assisi, in the lower Church of S. Francesco, some scenes of the Passion of Jesus Christ in fresco, with good and very resolute mastery, and in the chapel of the Church of S. Maria degli Angeli he wrought in fresco a Christ in Glory, with the Virgin praying to Him for the Christian people; this work, which is passing good, has been all blackened by the smoke of the lamps and the candles that are burning there continually in great quantity. And in truth, in so far as it can be judged, Puccio had the manner and the whole method of working of his master Giotto, and knew how to make good use of it in the works that he wrought, even if, as some have it, he did not live long, having fallen sick and died by reason of labouring too much in fresco. By his hand, in so far as is known, is the Chapel of S. Martino in the same church, with the stories of that Saint, wrought in fresco for Cardinal Gentile. There is seen, also, in the middle of the street called Portico, a Christ at the Column, and in a square picture there is Our Lady, with S. Catherine and S. Clara, one on either side of her. There are works by his hand scattered about in many other places, such as a panel with the Passion of Christ, and stories of S. Francis, in the tramezzo* of the church in Bologna; and many others, in short, that are passed by for the sake of brevity. I will say, indeed, that in Assisi, where most of his works are, and where it appears to me that he assisted Giotto in painting, I have

* See note on p. 90.

found that they hold him as their fellow-citizen, and that there are still to-day in that city some of the family of the Capanni. Wherefore it may easily be believed that he was born in Florence, having written so himself, and that he was a disciple of Giotto, but that afterwards he took a wife in Assisi, that there he had children, and that now he has descendants there. But because it is of little importance to know this exactly, it is enough to say that he was a good master.

Likewise a disciple of Giotto and a very masterly painter was Ottaviano da Faenza, who painted many works at Ferrara in S. Giorgio, the seat of the Monks of Monte Oliveto; and in Faenza, where he lived and died, he painted, in the arch over the door of S. Francesco, a Madonna, S. Peter and S. Paul, and many other works in his said birthplace and in Bologna.

A disciple of Giotto, also, was Pace da Faenza, who stayed with him long and assisted him in many works; and in Bologna there are some scenes in fresco by his hand on the façade of S. Giovanni Decollato. This Pace was an able man, particularly in making little figures, as can be seen to this day in the Church of S. Francesco at Forlì, in a Tree of the Cross, and in a little panel in distemper, wherein is the life of Christ, with four little scenes from the life of Our Lady, all very well wrought. It is said that he wrought in fresco, in the Chapel of S. Antonio at Assisi, some stories of the life of that Saint, for a Duke of Spoleto who is buried in that place together with his son, both having died fighting in certain suburbs of Assisi, according to what is seen in a long inscription that is on the sarcophagus of the said tomb. In the old book of the Company of Painters it is found that the same man had another disciple, Francesco, called di Maestro Giotto, of whom I have nothing else to relate.

Guglielmo of Forlì was also a disciple of Giotto, and besides many other works he painted the chapel of the high-altar in S. Domenico at Forlì, his native city. Disciples of Giotto, also, were Pietro Laurati and Simon Memmi of Siena, Stefano, a Florentine, and Pietro Cavallini, a Roman; but, seeing that of all these there is account in the Life of each one of them, let it suffice to have said in this place that they were disciples of Giotto, who drew very well for his time and for that manner, whereunto witness is borne by many sheets of parchment drawn by his hand in water-colour, outlined with the pen, in chiaroscuro, with the high lights in white, which are in our book of drawings, and are truly a

marvel in comparison with those of the masters that lived before him.

Giotto, as it has been said, was very ingenious and humorous, and very witty in his sayings, whereof there is still vivid memory in that city; for besides that which Messer Giovanni Boccaccio wrote about him, Franco Sacchetti, in his three hundred Stories, relates many of them that are very beautiful. Of these I will not forbear to write down some with the very words of Franco himself, to the end that, together with the story itself, there may be seen certain modes of speech and expressions of those times. He says in one, then, to give it its heading:

'To Giotto, a great painter, is given a buckler to paint by a man of small account. He, making a jest of it, paints it in such a fashion that the other is put to confusion.'

The story: 'Everyone must have heard already who was Giotto, and how great a painter he was above every other. A clownish fellow, having heard his fame and having need, perchance for doing watch and ward, to have a buckler of his painted, went off incontinent to the shop of Giotto, with one who carried his buckler behind him, and, arriving where he found Giotto, said, "God save thee, master, I would have thee paint my arms on this buckler." Giotto, considering the man and the way of him, said no other word save this, "When dost thou want it?" And he told him; and Giotto said, "Leave it to me"; and off he went. And Giotto, being left alone, ponders to himself, "What meaneth this? Can this fellow have been sent to me in jest? Howsoever it may be, never was there brought to me a buckler to paint, and he who brings it is a simple manikin and bids me make him his arms as if he were of the blood-royal of France; i' faith, I must make him a new fashion of arms." And so, pondering within himself, he put the said buckler before him, and, having designed what seemed good to him, bade one of his disciples finish the painting, and so he did; which painting was a helmet, a gorget, a pair of arm-pieces, a pair of iron gauntlets, a cuirass and a back-piece, a pair of thigh-pieces, a pair of leg-pieces, a sword, a dagger, and a lance. The great man, who knew not what he was in for, on arriving, comes forward and says, "Master, is it painted, that buckler?" Said Giotto, "Of a truth, it is; go, someone, and bring it down." The buckler coming, that would-be gentleman begins to look at it and says to Giotto, "What filthy mess is this that thou hast painted for me?" Said Giotto, "And it will seem to thee

a right filthy business in the paying." Said he, "I will not pay four farthings for it." Said Giotto, "And what didst thou tell me that I was to paint?" And he answered, "My arms." Said Giotto, "And are they not here? Is there one wanting?" Said the fellow, "Well, well!" Said Giotto, "Nay, 'tis not well, God help thee! And a great booby must thou be, for if one asked thee, 'Who art thou?' scarce wouldst thou be able to tell; and here thou comest and sayest, 'Paint me my arms!' An thou hadst been one of the Bardi, that were enough. What arms dost thou bear? Whence art thou? Who were thy ancestors? Out upon thee! Art not ashamed of thyself? Begin first to come into the world before thou pratest of arms as if thou wert Dusnam of Bavaria. I have made thee a whole suit of armour on thy buckler; if there be one piece wanting, name it, and I will have it painted." Said he, "Thou dost use vile words to me, and hast spoilt me a buckler;" and taking himself off, he went to the justice and had Giotto summoned. Giotto appeared and had him summoned, claiming two florins for the painting, and the other claimed them from him. The officers, having heard the pleadings, which Giotto made much the better, judged that the other should take his buckler so painted, and should give six lire to Giotto, since he was in the right. Wherefore he was constrained to take his buckler and go, and was dismissed; and so, not knowing his measure, he had his measure taken.'

It is said that Giotto, while working in his boyhood under Cimabue, once painted a fly on the nose of a figure that Cimabue himself had made, so true to nature that his master, returning to continue the work, set himself more than once to drive it away with his hand, thinking that it was real, before he perceived his mistake. Many other tricks played by Giotto and many witty retorts could I relate, but I wish that these, which deal with matters pertinent to art, should be enough for me to have told in this place, leaving the rest to the said Franco and others.

Finally, seeing that there remained memory of Giotto not only in the works that issued from his hands, but in those also that issued from the hand of the writers of those times, he having been the man who recovered the true method of painting, which had been lost for many years before him; therefore, by public decree and by the effort and particular affection of the elder Lorenzo de' Medici, the Magnificent, in admiration of the talent of so great a man his portrait was placed in S. Maria del Fiore, carved in marble by Benedetto da Maiano, an excellent sculptor,

together with the verses written below, made by that divine man, Messer Angelo Poliziano, to the end that those who should become excellent in any profession whatsoever might be able to cherish a hope of obtaining, from others, such memorials as these that Giotto deserved and obtained in liberal measure from his goodness:

> Ille ego sum, per quem pictura extincta revixit,
> Cui quam recta manus, tam fuit et facilis.
> Naturæ deerat nostræ quod defuit arti;
> Plus licuit nulli pingere, nec melius.
> Miraris turrim egregiam sacro ære sonantem?
> Hæc quoque de modulo crevit ad astra meo.
> Denique sum Jottus, quid opus fuit illa referre?
> Hoc nomen longi carminis instar erit.

And to the end that those who come after may be able to see drawings by the very hand of Giotto, and from these to recognize all the more the excellence of so great a man, in our aforesaid book there are some that are marvellous, sought out by me with no less diligence than labour and expense.

AGOSTINO AND AGNOLO OF SIENA, Sculptors and Architects

Among others who exercised themselves in the school of the sculptors Giovanni and Niccola of Pisa, Agostino and Agnolo, sculptors of Siena, of whom we are at present about to write the Life, became very excellent for those times. These, according to what I find, were born from a father and mother of Siena, and their forefathers were architects, seeing that in the year 1190, under the rule of the three Consuls, they brought to perfection the Fontebranda, and afterwards, in the following year, under the same Consulate, the Customs-house of that city and other buildings. And in truth it is clear that very often the seeds of talent germinate in the houses where they have lain for some time, and throw out shoots which afterwards produce greater and better fruits than the first plants had done. Agostino and Agnolo, then, adding great betterment to the manner of Giovanni and Niccola of Pisa, enriched the art with better design and invention, as their

works clearly demonstrate. It is said that the aforesaid Giovanni, returning from Naples to Pisa in the year 1284, stayed in Siena in order to make the design and foundation for the façade of the Duomo, wherein are the three principal doors, to the end that it might be all adorned very richly with marbles; and that then Agostino, being no more than fifteen years of age, went to be with him in order to apply himself to sculpture, whereof he had learnt the first principles, being no less inclined to this art than to the matters of architecture. And so, under the teaching of Giovanni, by means of continual study he surpassed all his fellow-disciples in design, grace, and manner, so greatly that it was said by all that he was the right eye of his master. And because, between people who love each other, there is no gift, whether of nature, or of soul, or of fortune, that is mutually desired so much as excellence, which alone makes men great and noble, and what is more, most happy both in this life and in the other, therefore Agostino, seizing this occasion of assistance from Giovanni, drew his brother Agnolo into the same pursuit. Nor was it a great labour for him to do this, seeing that the intercourse of Agnolo with Agostino and with the other sculptors had already, as he saw the honour and profit that they were drawing from such an art, fired his mind with extreme eagerness and desire to apply himself to sculpture; nay, before Agostino had given a thought to this, Agnolo had wrought certain works in secret.

Agostino, then, being engaged in working with Giovanni on the marble panel of the high-altar in the Vescovado of Arezzo, whereof there has been mention above, contrived to bring there the said Agnolo, his brother, who acquitted himself in this work in such a manner that when it was finished he was found to have equalled Agostino in the excellence of his art. Which circumstance, becoming known to Giovanni, was the reason that after this work he made use of both one and the other in many other works of his that he wrought in Pistoia, in Pisa, and in other places. And seeing that he applied himself not only to sculpture but to architecture as well, no long time passed before, under the rule of the Nine in Siena, Agostino made the design of their Palace in Malborghetto, which was in the year 1308. In the making of this he acquired so great a name in his country, that, returning to Siena after the death of Giovanni, they were made, both one and the other, architects to the State; wherefore afterwards, in the year 1317, there was made under their direction the

front of the Duomo that faces towards the north, and in the year 1321, with the design of the same men, there was begun the construction of the Porta Romana in that manner wherein it stands to-day, and it was finished in the year 1326; which gate was first called Porta S. Martino. They rebuilt, also, the Porta a Tufi, which at first was called Porta di S. Agata all' Arco. In the same year, with the design of the same Agostino and Agnolo, there was begun the Church and Convent of S. Francesco, in the presence of Cardinal di Gaeta, Apostolic Legate. No long time after, by the action of some of the Tolomei who were living as exiles at Orvieto, Agostino and Agnolo were summoned to make certain sculptures for the work of S. Maria in that city; wherefore, going there, they carved some prophets in marble which are now, in comparison with the other statues in that façade, the finest and best proportioned in that so greatly renowned work.

Now it came to pass in the year 1326, as it has been said in his Life, that Giotto was called by means of Charles, Duke of Calabria, who was then staying in Florence, to Naples, in order to make some things for King Robert in S. Chiara and other places in that city; wherefore Giotto, passing by way of Orvieto on his way to Naples, in order to see the works that had been made and were still being made there by so many men, wished to see everything minutely. And because the prophets of Agostino and Agnolo of Siena pleased him more than all the other sculptures, it came about therefore that Giotto not only commended them and held them, much to their contentment, among his friends, but also presented them to Piero Saccone da Pietramala as the best of all the sculptors then living, for the making of the tomb of Bishop Guido, Lord and Bishop of Arezzo, which has been mentioned in the Life of Giotto himself. And so then Giotto having seen in Orvieto the works of many sculptors and having judged the best to be those of Agostino and Agnolo of Siena, this was the reason that the said tomb was given to them to make – in that manner, however, wherein he had designed it, and according to the model which he himself had sent to the said Piero Saccone. Agostino and Agnolo finished this tomb in the space of three years, executing it with much diligence, and built it into the Church of the Vescovado of Arezzo, in the Chapel of the Sacrament. Over the sarcophagus, which rests on certain great consoles carved more than passing well, there is stretched the body of that Bishop in marble, and at

the sides are some angels that are drawing back certain curtains very gracefully. Besides this, there are carved in half-relief, in compartments, twelve scenes from the life and actions of that Bishop, with an infinite number of little figures. I will not grudge the labour of describing the contents of these scenes, to the end that it may be seen with what great patience they were wrought, and how zealously these sculptors sought the good manner.

In the first is the scene when, assisted by the Ghibelline party of Milan, which sent him money and four hundred masons, he is rebuilding the walls of Arezzo all anew, making them much longer than they were and giving them the form of a galley. In the second is the taking of Lucignano di Valdichiana. In the third, that of Chiusi. In the fourth, that of Fronzoli, then a strong castle above Poppi, and held by the sons of the Count of Battifolle. The fifth is when the Castle of Rondine, after having been many months besieged by the Aretines, is surrendering finally to the Bishop. In the sixth is the taking of the Castle of Bucine in Valdarno. The seventh is when he is taking by storm the fortress of Caprese, which belonged to the Count of Romena, after having maintained the siege for several months. In the eighth the Bishop is having the Castle of Laterino pulled down and the hill that rises above it cut into the shape of a cross, to the end that it may no longer be possible to build a fortress thereon. In the ninth he is seen destroying Monte Sansovino and putting it to fire and flames, chasing from it all the inhabitants. In the eleventh is his coronation, wherein are to be seen many beautiful costumes of soldiers on foot and on horseback, and of other people. In the twelfth, finally, his men are seen carrying him from Montenero, where he fell sick, to Massa, and thence afterwards, now dead, to Arezzo. Round this tomb, also, in many places, are the Ghibelline insignia, and the arms of the Bishop, which are six square stones 'or,' on a field 'azure,' in the same ordering as are the six balls in the arms of the Medici; which arms of the house of the Bishop were described by Frate Guittone, chevalier and poet of Arezzo, when he said, writing of the site of the Castle of Pietramala, whence that family had its origin:

> Dove si scontra il Giglion con la Chiassa
> Ivi furono i miei antecessori,
> Che in campo azurro d'or portan sei sassa.

Agnolo and Agostino of Siena, then, executed this work with better art and invention and with more diligence than there had been shown in any work executed in their times. And in truth they deserve nothing but infinite praise, having made therein so many figures and so great a variety of sites, places, towers, horses, men, and other things, that it is indeed a marvel. And although this tomb was in great part destroyed by the Frenchmen of the Duke of Anjou, who sacked the greater part of that city in order to take revenge on the hostile party for certain affronts received, none the less it shows that it was wrought with very good judgment by the said Agostino and Agnolo, who cut on it, in rather large letters, these words:

HOC OPUS FECIT MAGISTER AUGUSTINUS ET MAGISTER
ANGELUS DE SENIS.

After this, in the year 1329, they wrought an altar-panel of marble for the Church of S. Francesco at Bologna, in a passing good manner; and therein, besides the carved ornamentation, which is very rich, they made a Christ who is crowning Our Lady, and on each side three similar figures – S. Francis, S. James, S. Dominic, S. Anthony of Padua, S. Petronius, and S. John the Evangelist, with figures one braccio and a half in height. Below each of the said figures is carved a scene in low-relief from the life of the Saint that is above; and in all these scenes is an infinite number of half-length figures, which make a rich and beautiful adornment, according to the custom of those times. It is seen clearly that Agostino and Agnolo endured very great fatigue in this work, and that they put into it all diligence and study in order to make it, as it truly was, a work worthy of praise; and although they are half eaten away, yet there are to be read thereon their names and the date, by means of which, it being known when they began it, it is seen that they laboured eight whole years in completing it. It is true, indeed, that in that same time they wrought many other small works in diverse places and for various people.

Now, while they were working in Bologna, that city, by the mediation of a Legate of the Pope, gave herself absolutely over to the Church; and the Pope, in return, promised that he would go to settle with his Court in Bologna, saying that he wished to erect a castle there, or truly a fortress, for his own security. This being conceded to him by the Bolognese, it was immediately built

under the direction and design of Agostino and Agnolo, but it had a very short life, for the reason that the Bolognese, having found that the many promises of the Pope were wholly vain, pulled down and destroyed the said fortress, with much greater promptness than it had been built.

It is said that while these two sculptors were staying in Bologna the Po issued in furious flood from its bed and laid waste the whole country round for many miles, doing incredible damage to the territory of Mantua and Ferrara and slaying more than ten thousand persons; and that they, being called on for this reason as ingenious and able men, found a way to put this terrible river back into its course, confining it with dykes and other most useful barriers; which was greatly to their credit and profit, because, besides acquiring fame thereby, they were recompensed by the Lords of Mantua and by the D' Este family with most honourable rewards.

After this they returned to Siena, and in the year 1338, with their direction and design, there was made the new Church of S. Maria, near the Duomo Vecchio, towards Piazza Manetti; and no long time after, the people of Siena, remaining much satisfied with all the works that these men were making, determined with an occasion so apt to put into effect that which had been discussed many times, but up to then in vain – namely, the making of a public fountain on the principal square, opposite the Palagio della Signoria. Wherefore, this being entrusted to Agostino and Agnolo, they brought the waters of that fountain through pipes of lead and of clay, which was very difficult, and it began to play in the year 1343, on the first day of June, with much pleasure and contentment to the whole city, which remained thereby much indebted to the talent of these its two citizens.

About the same time there was made the Great Council Chamber in the Municipal Palace; and so too, with the direction and design of the same men, there was brought to its completion the tower of the said Palace, in the year 1344, and there were placed thereon two great bells, whereof they had one from Grosseto and the other was made in Siena. Finally, while Agnolo chanced to be in the city of Assisi, where he made a chapel and a tomb in marble in the lower Church of S. Francesco for a brother of Napoleone Orsino, a Cardinal and a friar of S. Francis, who had died in that place – Agostino, who had remained in Siena in the service of the State, died while he was busy making

the design for the adornments of the said fountain in the square, and was honourably buried in the Duomo. I have not yet found, and cannot therefore say anything about the matter, either how or when Agnolo died, or even any other works of importance by their hand; and therefore let this be the end of their Life.

Now, seeing that it would be without doubt an error, in following the order of time, not to make mention of some who, although they have not wrought so many works that it is possible to write their whole life, have none the less contributed betterment and beauty to art and to the world, I will say, taking occasion from that which has been said above about the Vescovado of Arezzo and about the Pieve, that Pietro and Paolo, goldsmiths of Arezzo, who learnt design from Agnolo and Agostino of Siena, were the first who wrought large works of some excellence with the chasing-tool, since, for an arch-priest of the said Pieve of Arezzo, they executed a head in silver as large as life, wherein was placed the head of S. Donatus, Bishop and Protector of that city; which work was worthy of nothing but praise, both because they made therein some very beautiful figures in enamel and other ornaments, and because it was one of the first works, as it has been said, that were wrought with the chasing-tool.

About the same time, the Guild of Calimara in Florence caused Maestro Cione, an excellent goldsmith, to make the greater part, if not the whole, of the silver altar of S. Giovanni Battista, wherein are many scenes from the life of that Saint embossed on a plate of silver, with passing good figures in half-relief; which work, both by reason of its size and of its being something new, was held marvellous by all who saw it. In the year 1330, after the body of S. Zanobi had been found beneath the vaults of S. Reparata, the same Maestro Cione made a head of silver to contain a piece of the head of that Saint, which is still preserved to-day in the same head of silver and is borne in processions; which head was then held something very beautiful and gave a great name to its craftsman, who died no long time after, rich and in great repute.

Maestro Cione left many disciples, and among others Forzore di Spinello of Arezzo, who wrought every kind of chasing very well but was particularly excellent in making scenes in silver enamelled over fire, to which witness is borne by a mitre with most beautiful adornments in enamel, and a very beautiful pastoral staff of silver, which are in the Vescovado of Arezzo. The

same man wrought for Cardinal Galeotto da Pietramala many works in silver that remained after his death with the friars of La Vernia, where he wished to be buried. There, besides the wall that was erected in that place by Count Orlando, Lord of Chiusi, a small town below La Vernia, the Cardinal built the church, together with many rooms in the convent and throughout that whole place, without putting his arms there or leaving any other memorial. A disciple of Maestro Cione, also, was Leonardo di Ser Giovanni, a Florentine, who wrought many works in chasing and soldering, with better design than the others before him had shown, and in particular the altar and panel of silver in S. Jacopo at Pistoia; in which work, besides the scenes, which are numerous, there was much praise given to a figure in the round that he made in the middle, representing S. James, more than one braccio in height, and wrought with so great finish that it appears rather to have been made by casting than by chasing. This figure is set in the midst of the said scenes on the panel of the altar, round which is a frieze of letters in enamel, that run thus:

AD HONOREM DEI ET SANCTI JACOBI APOSTOLI, HOC OPUS
FACTUM FUIT TEMPORE DOMINI FRANC. PAGNI DICTÆ OPERÆ
OPERARII SUB ANNO 1371 PER ME LEONARDUM SER
JO. DE FLOREN. AURIFIC.

Now, returning to Agostino and Agnolo: they had many disciples who, after their death, wrought many works of architecture and of sculpture in Lombardy and other parts of Italy, and among others Maestro Jacopo Lanfrani of Venice, who founded S. Francesco of Imola and wrought the principal door in sculpture, where he carved his name and the date, which was the year 1343. And at Bologna, in the Church of S. Domenico, the same Maestro Jacopo made a tomb in marble for Giovanni Andrea Calduino, Doctor of Laws and Secretary to Pope Clement VI; and another, also in marble and in the said church, very well wrought, for Taddeo Peppoli, Conservator of the people and of Justice in Bologna. And in the same year, which was the year 1347, or a little before, this tomb being finished, Maestro Jacopo went to his native city of Venice and founded the Church of S. Antonio, which was previously of wood, at the request of a Florentine Abbot of the ancient family of the Abati, the Doge being Messer Andrea Dandolo. This church was finished in the year 1349. Jacobello and Pietro Paolo, also, Venetians and

disciples of Agostino and Agnolo, made a tomb in marble for Messer Giovanni da Lignano, Doctor of Laws, in the year 1383, in the Church of S. Domenico at Bologna.

All these and many other sculptors went on for a long space of time following one and the same method, in a manner that with it they filled all Italy. It is believed, also, that the Pesarese, who, besides many other works, built the Church of S. Domenico in his native city, and made in sculpture the marble door with the three figures in the round, God the Father, S. John the Baptist, and S. Mark, was a disciple of Agostino and Agnolo; and to this the manner bears witness. This work was finished in the year 1385. But, seeing that it would take too long if I were to make mention minutely of the works that were wrought by many masters of those times in that manner, I wish that this, that I have said of them thus in general, should suffice me for the present, and above all because there is not any benefit of much account for our arts from such works. Of the aforesaid it has seemed to me proper to make mention, because, if they do not deserve to be discussed at length, yet, on the other hand, they were not such as to need to be passed over completely in silence.

STEFANO, Painter of Florence, and UGOLINO SANESE
[UGOLINO DA SIENA]

STEFANO, painter of Florence and disciple of Giotto, was so excellent, that he not only surpassed all the others who had laboured in the art before him, but outstripped his own master himself by so much that he was held, and deservedly, the best of all the painters who had lived up to that time, as his works clearly demonstrate. He painted in fresco the Madonna of the Campo Santo in Pisa, which is no little better in design and in colouring than the work of Giotto; and in Florence, in the cloister of S. Spirito, he painted three little arches in fresco. In the first of these, wherein is the Transfiguration of Christ with Moses and Elias, imagining how great must have been the splendour that dazzled them, he fashioned the three Disciples with extraordinary and beautiful attitudes, and enveloped in draperies in a manner that it is seen that he went on trying to do something that had never been done before – namely, to suggest the nude form of

the figures below new kinds of folds, which, as I have said, had not been thought of even by Giotto. Under this arch, wherein he made a Christ delivering the woman possessed, he drew a building in perspective, perfectly and in a manner then little known, executing it in good form and with better knowledge; and in it, working with very great judgment in modern fashion, he showed so great art and so great invention and proportion in the columns, in the doors, in the windows, and in the cornices, and so great diversity from the other masters in his method of working, that it appears that there was beginning to be seen a certain glimmer of the good and perfect manner of the moderns. He invented, among other ingenious ideas, a flight of steps very difficult to make, which, both in painting and built out in relief – wrought in either way, in fact – is so rich in design and variety, and so useful and convenient in invention, that the elder Lorenzo de' Medici, the Magnificent, availed himself of it in making the outer staircase of the Palace of Poggio a Cajano, now the principal villa of the most Illustrious Lord Duke. In the other little arch is a story of Christ when he is delivering S. Peter from shipwreck, so well done that one seems to hear the voice of Peter saying: 'Domine, salva nos, perimus.' This work is judged much more beautiful than the others, because, besides the softness of the draperies, there are seen sweetness in the air of the heads and terror in the perils of the sea, and because the Apostles, shaken by diverse motions and by phantoms of the sea, have been represented in attitudes very appropriate and all most beautiful. And although time has eaten away in part the labours that Stefano put into this work, it may be seen, although but dimly, that the Apostles are defending themselves from the fury of the winds and from the waves of the sea with great energy; which work, being very highly praised among the moderns, must have certainly appeared a miracle in all Tuscany in the time of him who wrought it. After this he painted a S. Thomas Aquinas beside a door in the first cloister of S. Maria Novella, where he also made a Crucifix, which was afterwards executed in a bad manner by other painters in restoring it. In like manner he left a chapel in the church begun and not finished, which has been much eaten away by time, wherein the angels are seen raining down in diverse forms by reason of the pride of Lucifer; where it is to be noticed that the figures, with the arms, trunks, and legs foreshortened much better than any foreshortenings that had been made before,

give us to know that Stefano began to understand and to demonstrate in part the difficulties that those men had to reduce to excellence, who afterwards, with greater science, showed them to us, as they have done, in perfection; wherefore the surname of 'The Ape of Nature' was given him by the other craftsmen.

Next, being summoned to Milan, Stefano made a beginning for many works for Matteo Visconti, but was not able to finish them, because, having fallen sick by reason of the change of air, he was forced to return to Florence. There, having regained his health, he made in fresco, in the tramezzo* of the Church of S. Croce, in the Chapel of the Asini, the story of the martyrdom of S. Mark, when he was dragged to death, with many figures that have something of the good. Being then summoned to Rome by reason of having been a disciple of Giotto, he made some stories of Christ in S. Pietro, in the principal chapel wherein is the altar of the said Saint, between the windows that are in the great choir-niche, with so much diligence that it is seen that he approached closely to the modern manner, surpassing his master Giotto considerably in draughtsmanship and in other respects.

After this, on a pillar on the left-hand side of the principal chapel of the Araceli, he made a S. Louis in fresco, which is much praised, because it has in it a vivacity never displayed up to that time even by Giotto. And in truth Stefano had great facility in draughtsmanship, as can be seen in our said book in a drawing by his hand, wherein is drawn the Transfiguration (which he painted in the cloister of S. Spirito), in such a manner that in my judgment he drew much better than Giotto.

Having gone, next, to Assisi, he began in fresco a scene of the Celestial Glory in the niche of the principal chapel of the lower Church of S. Francesco, where the choir is; and although he did not finish it, it is seen from what he did that he used so great diligence that no greater could be desired. In this work there is seen begun a circle of saints, both male and female, with so beautiful variety in the faces of the young, the men of middle age, and the old, that nothing better could be desired. And there is seen a very sweet manner in these blessed spirits, with such great harmony that it appears almost impossible that it could have been done in those times by Stefano, who indeed did do it; although there is nothing of the figures in this circle finished save the

* See note on p. 90.

heads, over which is a choir of angels who are hovering playfully about in various attitudes, appropriately carrying theological symbols in their hands, and all turned towards a Christ on the Cross, who is in the middle of this work, over the head of a S. Francis, who is in the midst of an infinity of saints. Besides this, in the border of the whole work, he made some angels, each of whom is holding in his hand one of those Churches that S. John the Evangelist described in the Apocalypse; and these angels are executed with so much grace that I am amazed how in that age there was to be found one who knew so much. Stefano began this work with a view to bringing it to the fullest perfection, and he would have succeeded, but he was forced to leave it imperfect and to return to Florence by some important affairs of his own.

During that time, then, that he stayed for this purpose in Florence, in order to lose no time he painted for the Gianfigliazzi, by the side of the Arno, between their houses and the Ponte alla Carraja, a little shrine on a corner that is there, wherein he depicted a Madonna sewing, to whom a boy dressed and seated is handing a bird, with such diligence that the work, small as it is, deserves to be praised no less than do the works that he wrought on a larger and more masterly scale.

This shrine finished and his affairs dispatched, being called to Pistoia by its Lords in the year 1346, he was made to paint the Chapel of S. Jacopo, on the vaulting of which he made a God the Father with some Apostles, and on the walls the stories of that Saint, and in particular when his mother, wife of Zebedee, asks Jesus Christ to consent to place her two sons, one on His right hand and the other on His left hand, in the Kingdom of the Father. Close to this is the beheading of the said Saint, a very beautiful work.

It is reputed that Maso, called Giottino, of whom there will be mention below, was the son of this Stefano; and although many, by reason of the suggestiveness of the name, hold him the son of Giotto, I, by reason of certain records that I have seen, and of certain memoirs of good authority written by Lorenzo Ghiberti and by Domenico del Ghirlandajo, hold it as true that he was rather the son of Stefano than of Giotto. Be this as it may, returning to Stefano, it can be credited to him that he did more than anyone after Giotto to improve painting, for, besides being more varied in invention, he was also more harmonious, more mellow, and better blended in colouring than all the others;

and above all he had no peer in diligence. And as for those fore-shortenings that he made, although, as I have said, he showed a faulty manner in them by reason of the difficulty of making them, none the less he who is the pioneer in the difficulties of any exercise deserves a much greater name than those who follow with a some-what more ordered and regular manner. Truly great, therefore, is the debt that should be acknowledged to Stefano, because he who walks in darkness and gives heart to others, by showing them the way, brings it about that its difficult steps are made easy, so that with lapse of time men leave the false road and attain to the desired goal. At Perugia, too, in the Church of S. Domenico, he began in fresco the Chapel of S. Caterina, which remained unfinished.

There lived about the same time as Stefano a man of passing good repute, Ugolino, painter of Siena, very much his friend, who painted many panels and chapels throughout all Italy, although he held ever in great part to the Greek manner, as one who, grown old therein, had wished by reason of a certain obstinacy in himself to hold rather to the manner of Cimabue than to that of Giotto, which was so greatly revered. By the hand of Ugolino, then, is the panel of the high-altar of S. Croce, on a ground all of gold, and also a panel which stood many years on the high-altar of S. Maria Novella and is to-day in the Chapter-house, where the Spanish nation every year holds most solemn festival on the day of S. James, with other offices and funeral ceremonies of its own. Besides these, he wrought many other works with good skill, without departing, however, from the manner of his master. The same man made, on a brick-pier in the Loggia that Lapo had built on the Piazza d' Orsanmichele, that Madonna which worked so many miracles, not many years later, that the Loggia was for a long time full of images, and is still held in the greatest veneration. Finally, in the Chapel of Messer Ridolfo de' Bardi, which is in S. Croce, where Giotto painted the life of S. Francis, he painted a Crucifix in distemper on the altar-panel, with a Magdalene and a S. John weeping, and two friars, one on either side. Ugolino passed away from this life, being old, in the year 1349, and was buried with honour in Siena, his native city.

But returning to Stefano, of whom they say that he was also a good architect, which is proved by what has been said above, he died, so it is said, in the year when there began the jubilee, 1350, at the age of forty-nine, and was laid to rest in the tomb of his fathers, in S. Spirito, with this epitaph:

STEPHANO FLORENTINO PICTORI, FACIUNDIS IMAGINIBUS
AC COLORANDIS FIGURIS NULLI UNQUAM INFERIORI,
AFFINES MOESTISS. POS. VIX. AN. XXXXIX.

PIETRO LAURATI
[*PIETRO LORENZETTI*],
Painter of Siena

Pietro Laurati, an excellent painter of Siena, proved in his
life how great is the contentment of the truly able, who feel that
their works are prized both at home and abroad, and who see
themselves sought after by all men, for the reason that in the
course of his life he was sent for and held dear throughout all
Tuscany, having first become known through the scenes that he
painted in fresco for the Scala, a hospital in Siena, wherein he
imitated in such wise the manner of Giotto, then spread
throughout all Tuscany, that it was believed with great reason that
he was destined, as afterwards came to pass, to become a better
master than Cimabue and Giotto and the others had been; for
the figures that represent the Virgin ascending the steps of the
Temple, accompanied by Joachim and Anna, and received by the
priest, and then in the Marriage, are so beautifully adorned, so
well draped, and so simply wrapped in their garments, that they
show majesty in the air of the heads, and a most beautiful manner
in their bearing. By reason of this work, which was the first
introduction into Siena of the good method of painting, giving
light to the many beautiful intellects which have flourished in that
city in every age, Pietro was invited to Monte Oliveto di Chiusuri,
where he painted a panel in distemper that is placed to-day in the
portico below the church. In Florence, next, opposite to the
left-hand door of the Church of S. Spirito, on the corner where
to-day there is a butcher, he painted a shrine which, by reason of
the softness of the heads and of the sweetness that is seen in it,
deserves the highest praise from every discerning craftsman.

Going from Florence to Pisa, he wrought in the Campo
Santo, on the wall that is beside the principal door, all the lives
of the Holy Fathers, with expressions so lively and attitudes so
beautiful that he equalled Giotto and gained thereby very great
praise, having expressed in certain heads, both with drawing and
with colour, all that vivacity that the manner of those times was

able to show. From Pisa he went to Pistoia, where he made a Madonna with some angels round her, very well grouped, on a panel in distemper, for the Church of S. Francesco; and in the predella that ran below this panel, in certain scenes, he made certain little figures so lively and so vivid that in those times it was something marvellous; wherefore, since they satisfied himself no less than others, he thought fit to place thereon his name, with these words: PETRUS LAURATI DE SENIS.

Pietro was summoned, next, in the year 1355, by Messer Guglielmo, arch-priest, and by the Wardens of Works of the Pieve of Arezzo, who were then Margarito Boschi and others; and in that church, built long before with better design and manner than any other that had been made in Tuscany up to that time, and all adorned with squared stone and with carvings, as it has been said, by the hand of Margaritone, he painted in fresco the apse and the whole great niche of the chapel of the high-altar, making there twelve scenes from the life of Our Lady with figures large as life, beginning with the expulsion of Joachim from the Temple, up to the Nativity of Jesus Christ. In these scenes, wrought in fresco, may be recognized almost the same inventions (the lineaments, the air of the heads, and the attitudes of the figures) which had been characteristic of and peculiar to Giotto, his master. And although all this work is beautiful, what he painted on the vaulting of this niche is without doubt better than all the rest, for in representing the Madonna ascending into Heaven, besides making the Apostles each four braccia high, wherein he showed greatness of spirit and was the first to try to give grandness to the manner, he gave so beautiful an air to the heads and so great loveliness to the vestments that in those times nothing more could have been desired. Likewise, in the faces of a choir of angels who are flying in the air round the Madonna, dancing with graceful movements, and appearing to sing, he painted a gladness truly angelic and divine, above all because he made the angels sounding diverse instruments, with their eyes all fixed and intent on another choir of angels, who, supported by a cloud in the form of an almond, are bearing the Madonna to Heaven, with beautiful attitudes and all surrounded by rainbows. This work, seeing that it rightly gave pleasure, was the reason that he was commissioned to make in distemper the panel for the high-altar of the aforesaid Pieve; wherein, in five parts, with figures as far as the knees and large as life, he made Our Lady

with the Child in her arms, and S. John the Baptist and S. Mat-
thew on the one side, and on the other the Evangelist and S.
Donatus, with many little figures in the predella and in the border
of the panel above, all truly beautiful and executed in very good
manner. This panel, after I had rebuilt the high-altar of the afore-
said Pieve completely anew, at my own expense and with my own
hand, was set up over the altar of S. Cristofano at the foot of the
church. Nor do I wish to grudge the labour of saying in this
place, with this occasion and not wide of the subject, that I,
moved by Christian piety and by the affection that I bear towards
this venerable and ancient collegiate church, and for the reason
that in it, in my earliest childhood, I learnt my first lessons,
and that it contains the remains of my fathers: moved, I say, by
these reasons, and by it appearing to me that it was wellnigh
deserted, I have restored it in a manner that it can be said that it
has returned from death to life; for besides changing it from a
dark to a well-lighted church by increasing the windows that were
there before and by making others, I have also removed the
choir, which, being in front, used to occupy a great part of the
church, and to the great satisfaction of those reverend canons I
have placed it behind the high-altar. This new altar, standing by
itself, has on the panel in front a Christ calling Peter and Andrew
from their nets, and on the side towards the choir it has, on
another panel, S. George slaying the Dragon. On the sides are
four pictures, and in each of these are two saints as large as life.
Then above, and below in the predella, there is an infinity of
other figures, which, for brevity's sake, are not enumerated. The
ornamental frame of this altar is thirteen braccia high, and the
predella is two braccia high. And because within it is hollow, and
one ascends to it by a staircase through an iron wicket very
conveniently arranged, there are preserved in it many venerable
relics, which can be seen from without through two gratings that
are in the front part; and among others there is the head of S.
Donatus, Bishop and Protector of that city, and in a coffer of
variegated marble, three braccia long, which I have had restored,
are the bones of four Saints. And the predella of the altar, which
surrounds it all right round in due proportion, has in front of it
the tabernacle, or rather ciborium, of the Sacrament, made of
carved wood and all gilt, about three braccia high; which taber-
nacle is in the round and can be seen as well from the side of the
choir as from in front. And because I have spared no labour and

no expense, considering myself bound to act thus in honour of God, this work, in my judgment, has in all those ornaments of gold, of carvings, of paintings, of marbles, of travertines, of variegated marbles, of porphyries, and of other stones, the best that could be got together by me in that place.

But returning now to Pietro Laurati; that panel finished whereof there has been talk above, he wrought in S. Pietro at Rome many works which were afterwards destroyed in making the new building of S. Pietro. He also wrought some works in Cortona and in Arezzo, besides those that have been mentioned, and some others in the Church of S. Fiora e Lucilla, a monastery of Black Friars, and in particular, in a chapel, a S. Thomas who is putting his hand on the wound in the breast of Christ.

A disciple of Pietro was Bartolommeo Bologhini of Siena, who wrought many panels in Siena and other places in Italy, and in Florence there is one by his hand on the altar of the Chapel of S. Silvestro in S. Croce. The pictures of these men date about the year of our salvation 1350; and in my book, so many times cited, there is seen a drawing by the hand of Pietro, wherein a shoemaker who is sewing, with simple but very natural lineaments, shows very great expression and the characteristic manner of Pietro, the portrait of whom, by the hand of Bartolommeo Bologhini, was in a panel in Siena, when I copied it from the original in the manner that is seen above.

ANDREA PISANO, Sculptor and Architect

THE art of painting never flourished at any time without the sculptors also pursuing their exercise with excellence, and to this the works of all ages bear witness for the close observer, because these two arts are truly sisters, born at one and the same time, and fostered and governed by one and the same soul. This is seen in Andrea Pisano, who, practising sculpture in the time of Giotto, made so great improvement in this art, that both in practice and in theory he was esteemed the greatest man that the Tuscans had had up to his times in this profession, and above all in casting in bronze. Wherefore his works were honoured and rewarded in such a manner by all who knew him, and above all by the Florentines, that it was no hardship to him to change country, relatives,

ANDREA PISANO, SCVLTO-
RE, ET ARCHITETTO.

property and friends. He received much assistance from the difficulties experienced in sculpture by the masters who had lived before him, whose sculptures were so uncouth and worthless that whosoever saw them in comparison with those of this man judged the last a miracle. And that these early works were rude, witness is borne, as it has been said elsewhere, by some that are over the principal door of S. Paolo in Florence and some in stone that are in the Church of Ognissanti, which are so made that they move those who view them rather to laughter than to any marvel or pleasure. And it is certain that the art of sculpture can recover itself much better, in the event of the essence of statuary being lost (since men have the living and the natural model, which is wholly rounded, as that art requires), than can the art of painting; it being not so easy and simple to recover the beautiful outlines and the good manner, in order to bring the art to the light, for these are the elements that produce majesty, beauty, grace and adornment in the works that the painters make. In one respect fortune was favourable to the labours of Andrea, because there had been brought to Pisa, as it has been said elsewhere, by means of the many victories that the Pisans had at sea, many antiquities and sarcophagi that are still round the Duomo and the Campo Santo, and these brought him such great assistance and gave him such great light as could not be obtained by Giotto, for the reason that the ancient paintings had not been preserved as much as the sculptures. And although statues are often destroyed by fires and by the ruin and fury of war, and buried or transported to diverse places, nevertheless it is easy for the experienced to recognize the difference in the manner of all countries; as, for example, the Egyptian is slender and lengthy in its figures, the Greek is scientific and shows much study in the nudes, while the heads have almost all the same expression, and the most ancient Tuscan is laboured in the hair and somewhat uncouth. That of the Romans (I call Romans, for the most part, those who, after the subjugation of Greece, betook themselves to Rome, whither all that there was of the good and of the beautiful in the world was carried) – that, I say, is so beautiful, by reason of the expressions, the attitudes, and the movements both of the nude and of the draped figures, that it may be said that they wrested the beautiful from all the other provinces and moulded it into one single manner, to the end that it might be, as it is, the best – nay, the most divine of all.

All these beautiful manners and arts being spent in the time
of Andrea, that alone was in use which had been brought by the
Goths and by the uncivilized Greeks into Tuscany. Wherefore he,
having studied the new method of design of Giotto and those
few antiquities that were known to him, refined in great part the
grossness of so miserable a manner with his judgment, in such
wise that he began to work better and to give much greater
beauty to statuary than any other had yet done in that art up to
his times. Therefore, his genius and his good skill and dexterity
becoming known, he was assisted by many in his country, and
while still young he was commissioned to make for S. Maria a
Ponte some little figures in marble, which brought him so good
a name that he was sought out with very great insistence to come
to work in Florence for the Office of Works of S. Maria del
Fiore, which, after a beginning had been made with the façade
containing the three doors, was suffering from a dearth of mas-
ters to make the scenes that Giotto had designed for the begin-
ning of the said fabric. Andrea, then, betook himself to Florence
for the service of the said Office of Works. And because the
Florentines desired at that time to gain the friendship and love
of Pope Boniface VIII, who was then Supreme Pontiff of the
Church of God, they wished that, before anything else, Andrea
should make a portrait in marble of the said Pontiff, from the life.
Wherefore, putting his hand to this work, he did not rest until he
had finished the figure of the Pope, with a S. Peter and a S. Paul
who are one on either side of him; which three figures were
placed in the façade of S. Maria del Fiore, where they still are.
Andrea then made certain little figures of prophets for the middle
door of the said church, in some shrines or rather niches, from
which it is seen that he had brought great betterment to the art,
and that he was in advance, both in excellence and design, of all
those who had worked up to then on the said fabric. Wherefore
it was resolved that all the works of importance should be given
to him to do, and not to others; and so, no long time after, he
was commissioned to make the four statues of the principal Doc-
tors of the Church, S. Jerome, S. Ambrose, S. Augustine, and
S. Gregory. And these being finished and acquiring for him
favour and fame with the Wardens of Works – nay, with the whole
city – he was commissioned to make two other figures in marble
of the same size, which were S. Stephen and S. Laurence, now
standing in the said façade of S. Maria del Fiore, at the outermost

corners. By the hand of Andrea, likewise, is the Madonna in marble, three braccia and a half high, with the Child in her arms, which stands on the altar of the little Church of the Company of the Misericordia, on the Piazza di S. Giovanni in Florence; which was a work much praised in those times, and above all because he accompanied it with two angels, one on either side, each two braccia and a half high. Round this work there has been made in our own day a frame of wood, very well wrought by Maestro Antonio, called Il Carota; and below, a predella full of most beautiful figures coloured in oil by Ridolfo, son of Domenico Ghirlandajo. In like manner, that half-length Madonna in marble that is over the side door of the same Misericordia, in the façade of the Cialdonai, is by the hand of Andrea, and it was much praised, because he imitated therein the good ancient manner, contrary to his wont, which was ever far distant from it, as some drawings testify that are in our book, wrought by his hand, wherein are drawn all the stories of the Apocalypse.

Now, seeing that Andrea had applied himself in his youth to the study of architecture, there came occasion for him to be employed in this by the Commune of Florence; for Arnolfo being dead and Giotto absent, he was commissioned to make the design of the Castle of Scarperia, which is in the Mugello, at the foot of the mountains. Some say, although I would not indeed vouch for it as true, that Andrea stayed a year in Venice, and there wrought, in sculpture, some little figures in marble that are in the façade of S. Marco, and that at the time of Messer Piero Gradenigo, Doge of that Republic, he made the design of the Arsenal; but seeing that I know nothing about it save that which I find to have been written by some without authority, I leave each one to think in his own way about this matter. Andrea having returned from Venice to Florence, the city, fearful of the coming of the Emperor, caused a part of the walls to be raised with lime post-haste to the height of eight braccia, employing in this Andrea, in that portion that is between San Gallo and the Porta al Prato; and in other places he made bastions, stockades, and other ramparts of earth and of wood, very strong.

Now because, three years before, he had shown himself to his own great credit to be an able man in the casting of bronze, having sent to the Pope in Avignon, by means of Giotto, his very great friend, who was then staying at that Court, a very beautiful cross cast in bronze, he was commissioned to complete in bronze

one of the doors of the Church of S. Giovanni, for which Giotto had already made a very beautiful design; this was given to him, I say, to complete, by reason of his having been judged, among so many who had worked up to then, the most able, the most practised and the most judicious master not only of Tuscany but of all Italy. Wherefore, putting his hand to this, with a mind determined not to consent to spare either time, or labour, or diligence in executing a work of so great importance, fortune was so propitious to him in the casting, for those times when the secrets were not known that are known to-day, that within the space of twenty-two years he brought it to that perfection which is seen; and what is more, he also made during that same time not only the shrine of the high-altar of S. Giovanni, with two angels, one on either side of it, that were held something very beautiful, but also, after the design of Giotto, those little figures in marble that act as adornment for the door of the Campanile of S. Maria del Fiore, and round the same Campanile, in certain mandorle, the seven planets, the seven virtues, and the seven works of mercy, little figures in half-relief that were then much praised. He also made during the same time the three figures, each four braccia high, that were set up in the niches of the said Campanile, beneath the windows that face the spot where the Orphans now are – that is, towards the south; which figures were thought at that time more than passing good. But to return to where I left off: I say that in the said bronze door are little scenes in low relief of the life of S. John the Baptist, that is, from his birth up to his death, wrought happily and with much diligence. And although it seems to many that in these scenes there do not appear that beautiful design and that great art which are now put into figures, yet Andrea deserves nothing but the greatest praise, in that he was the first to put his hand to the complete execution of such a work, which afterwards enabled the others who lived after him to make whatever of the beautiful, of the difficult and of the good is to be seen at the present day in the other two doors and in the external ornaments. This work was placed in the middle door of that church, and stood there until the time when Lorenzo Ghiberti made that one which is there at the present day; for then it was removed and placed opposite the Misericordia, where it still stands. I will not forbear to say that Andrea was assisted in making this door by Nino, his son, who was afterwards a much better master than his father had been,

and that it was completely finished in the year 1339, that is, not only made smooth and polished all over, but also gilded by fire; and it is believed that it was cast in metal by some Venetian masters, very expert in the founding of metals, and of this there is found record in the books of the Guild of the Merchants of Calimara, Wardens of the Works of S. Giovanni.

While the said door was making, Andrea made not only the other works aforesaid but also many others, and in particular the model of the Church of S. Giovanni at Pistoia, which was founded in the year 1337. In that same year, on January 25, in excavating the foundations of this church, there was found the body of the Blessed Atto, once Bishop of that city, who had been buried in that place one hundred and thirty-seven years. The architecture, then, of this church, which is round, was passing good for those times. In the principal church of the said city of Pistoia there is also a tomb of marble by the hand of Andrea, with the body of the sarcophagus full of little figures, and some larger figures above; in which tomb is laid to rest the body of Messer Cino d' Angibolgi, Doctor of Laws, and a very famous scholar in his time, as Messer Francesco Petrarca testifies in that sonnet:

> Piangete, donne, e con voi pianga Amore;

and also in the fourth chapter of the *Triumph of Love*, where he says:

> Ecco Cin da Pistoia, Guitton d' Arezzo,
> Che di non esser primo par ch' ira aggia.

In that tomb there is seen the portrait of Messer Cino himself in marble, by the hand of Andrea; he is teaching a number of his scholars, who are round him, with an attitude and manner so beautiful that, although to-day it might not be prized, in those days it must have been a marvellous thing.

Andrea was also made use of in matters of architecture by Gualtieri, Duke of Athens and Tyrant of the Florentines, who made him enlarge the square, and caused him, in order to safeguard himself in his palace, to secure all the lower windows on the first floor (where to-day is the Sala de' Dugento) with iron bars, square and very strong. The said Duke also added, opposite S. Pietro Scheraggio, the walls of rustic work that are beside the palace, in order to enlarge it; and in the thickness of the wall he made a secret staircase, in order to ascend and descend unseen.

And at the foot of the said wall of rustic work he made a great
door, which serves to-day for the Customs-house, and above that
his arms, and all with the design and counsel of Andrea; and
although these arms were chiselled out by the Council of Twelve,
which took pains to efface every memorial of that Duke, there
remained none the less in the square shield the form of the lion
rampant with two tails, as anyone can see who examines it with
diligence. For the same Duke Andrea built many towers round
the walls of the city, and he not only made a magnificent begin-
ning for the Porta a S. Friano and brought it to the completion
that is seen, but also made the walls for the vestibules of all the
gates of the city, and the lesser gates for the convenience of the
people. And because the Duke had it in his mind to make a
fortress on the Costa di S. Giorgio, Andrea made the model for
it, which afterwards was not used, for the reason that the work
was never given a beginning, the Duke having been driven out in
the year 1343. Nevertheless, there was effected in great part the
desire of that Duke to bring the palace to the form of a strong
castle, because, to that which had been made originally, he added
the great mass which is seen to-day, enclosing within its circuit
the houses of the Filipetri, the tower and the houses of the Amidei
and Mancini, and those of the Bellalberti. And because, having
made a beginning with so great a fabric and with the thick walls
and barbicans, he had not all the material that was essential
equally in readiness, he held back the construction of the Ponte
Vecchio, which was being worked on with all haste as a work of
necessity, and availed himself of the stone hewn and the wood
prepared for it, without the least scruple. And although Taddeo
Gaddi was not perhaps inferior in the matters of architecture to
Andrea Pisano, the Duke would not avail himself of him in these
buildings, by reason of his being a Florentine, but only of An-
drea. The same Duke Gualtieri wished to pull down S. Cecilia, in
order to see from his palace the Strada Romana and the Mercato
Nuovo, and likewise to destroy S. Pietro Scheraggio for his own
convenience, but he had not leave to do this from the Pope; and
meanwhile, as it has been said above, he was driven out by the
fury of the people.

Deservedly then did Andrea gain, by the honourable labours of
so many years, not only very great rewards but also the citizenship;
for he was made a citizen of Florence by the Signoria, and was given
offices and magistracies in the city, and his works were esteemed

both while he lived and after his death, there being found no one
who could surpass him in working, until there came Niccolò
Aretino, Jacopo della Quercia of Siena, Donatello, Filippo di Ser
Brunellesco, and Lorenzo Ghiberti, who executed the sculptures
and other works that they made in such a manner that people
recognized in how great error they had lived up to that time; for
these men recovered with their works that excellence which had
been hidden and little known by men for many and many a year.
The works of Andrea date about the year of our salvation 1340.

Andrea left many disciples; among others, Tommaso Pisano,
architect and sculptor, who finished the Chapel of the Campo
Santo and added the finishing touch to the Campanile of the
Duomo – namely, that final part wherein are the bells. Tommaso
is believed to have been the son of Andrea, this being found
written in the panel of the high-altar of S. Francesco in Pisa,
wherein there is, carved in half-relief, a Madonna, with other
Saints made by him, and below these his name and that of his
father.

Andrea was survived by Nino, his son, who applied himself
to sculpture; and his first work was in S. Maria Novella, where
he finished a Madonna in marble begun by his father, which is
within the side door, beside the Chapel of the Minerbetti. Next,
having gone to Pisa, he made in the Spina a half-length figure in
marble of Our Lady, who is suckling an infant Jesus Christ
wrapped in certain delicate draperies. For this Madonna an or-
namental frame of marble was made in the year 1522, by the
agency of Messer Jacopo Corbini, and another frame, much
greater and more beautiful, was made then for another Madonna
of marble, which was of full length and by the hand of the same
Nino; in the attitude of which Madonna the mother is seen hand-
ing a rose with much grace to her Son, who is taking it in a
childlike manner, so beautiful that it may be said that Nino was
beginning to rob the stone of its hardness and to reduce it to the
softness of flesh, giving it lustre by means of the highest polish.
This figure is between a S. John and a S. Peter in marble, the
head of the latter being a portrait of Andrea from the life. Besides
this, for an altar in S. Caterina, also in Pisa, Nino made two
statues of marble – that is, a Madonna, and an Angel who is
bringing her the Annunciation, wrought, like his other works,
with so great diligence that it can be said that they are the best
that were made in those times. Below this Madonna receiving the

Annunciation Nino carved these words on the base: ON THE
FIRST DAY OF FEBRUARY, 1370; and below the Angel: THESE
FIGURES NINO MADE, THE SON OF ANDREA PISANO. He also
made other works in that city and in Naples, whereof it is not
needful to make mention.

Andrea died at the age of seventy-five, in the year 1345, and
was buried by Nino in S. Maria del Fiore, with this epitaph:

> INGENTI ANDREAS JACET HIC PISANUS IN URNA,
> MARMORE QUI POTUIT SPIRANTES DUCERE VULTUS,
> ET SIMULACRA DEUM MEDIIS IMPONERE TEMPLIS
> EX ÆRE, EX AURO CANDENTI, ET PULCRO ELEPHANTO.

BUONAMICO BUFFALMACCO,
Painter of Florence

BUONAMICO DI CRISTOFANO, called Buffalmacco, painter of
Florence, who was a disciple of Andrea Tafi, and celebrated for
his jokes by Messer Giovanni Boccaccio in his *Decameron*, was, as
is known, a very dear companion of Bruno and Calandrino,
painters equally humorous and gay; and as may be seen in his
works, scattered throughout all Tuscany, he was a man of passing
good judgment in his art of painting. Franco Sacchetti relates in
his three hundred Stories (to begin with the things that this man
did while still youthful), that Buffalmacco lived, while he was a
lad, with Andrea, and that this master of his used to make it a
custom, when the nights were long, to get up before daylight to
labour, and to call the lads to night-work. This being displeasing
to Buonamico, who was made to rise out of his soundest sleep,
he began to think of finding a way whereby Andrea might give
up rising so much before daylight to work, and he succeeded; for
having found thirty large cockroaches, or rather blackbeetles, in
a badly swept cellar, with certain fine and short needles he fixed
a little taper on the back of each of the said cockroaches, and, the
hour coming when Andrea was wont to rise, he lit the tapers and
put the animals one by one into the room of Andrea, through a
chink in the door. He, awaking at the very hour when he was wont
to call Buffalmacco, and seeing those little lights, all full of fear
began to tremble and in great terror to recommend himself under
his breath to God, like the old gaffer that he was, and to say his

prayers or psalms; and finally, putting his head below the bed-clothes, he made no attempt for that night to call Buffalmacco, but stayed as he was, ever trembling with fear, up to daylight. In the morning, then, having risen, he asked Buonamico if he had seen, as he had himself, more than a thousand demons; where-upon Buonamico said he had not, because he had kept his eyes closed, and was marvelling that he had not been called to night-work. 'To night-work!' said Tafo, 'I have had something else to think of besides painting, and I am resolved at all costs to go and live in another house.' The following night, although Buonamico put only three of them into the said room of Tafo, none the less, what with terror of the past night and of those few devils that he saw, he slept not a wink; nay, no sooner was it daylight than he rushed from the house, meaning never to return, and a great business it was to make him change his mind. At last Buonamico brought the parish priest, who consoled him the best that he could. Later, Tafo and Buonamico discoursing over the affair, Buonamico said: 'I have ever heard tell that the greatest enemies of God are the demons, and that in consequence they must also be the most capital adversaries of painters; because, besides that we make them ever most hideous, what is worse, we never attend to aught else than to making saints, male and female, on walls and panels, and to making men more devout and more upright thereby, to the despite of the demons; wherefore, these demons having a grudge against us for this, as beings that have greater power by night than by day they come and play us these tricks, and worse tricks will they play if this use of rising for night-work is not given up completely.' With these and many other speeches Buffalmacco knew so well how to manage the business, being borne out by what Sir Priest kept saying, that Tafo gave over rising for night-work, and the devils ceased going through the house at night with little lights. But Tafo beginning again, for the love of gain, not many months afterwards, having almost forgot-ten all fear, to rise once more to work in the night and to call Buffalmacco, the cockroaches too began again to wander about; wherefore he was forced by fear to give up the habit entirely, being above all advised to do this by the priest. Afterwards this affair, spreading throughout the city, brought it about that for a time neither Tafo nor other painters made a practice of rising to work at night. Later, and no long time after this, Buffalmacco, having become a passing good master, took leave of Tafo, as the

same Franco relates, and began to work for himself; and he never lacked for something to do.

Now, Buffalmacco having taken a house, to work in and to live in as well, that had next door a passing rich woolworker, who, being a simpleton, was called Capodoca (Goosehead), the wife of this man would rise every night very early, precisely when Buffalmacco, having up to then been working, would go to lie down; and sitting at her wheel, which by misadventure she had planted opposite to the bed of Buffalmacco, she would spend the whole night spinning her thread; wherefore Buonamico, being able to get scarce a wink of sleep, began to think and think how he could remedy this nuisance. Nor was it long before he noticed that behind a wall of brickwork, that divided his house from Capodoca's, was the hearth of his uncomfortable neighbour, and that through a hole it was possible to see what she was doing over the fire. Having therefore thought of a new trick, he bored a hole with a long gimlet through a cane, and, watching for a moment when the wife of Capodoca was not at the fire, he pushed it more than once through the aforesaid hole in the wall and put as much salt as he wished into his neighbour's pot; wherefore Capodoca, returning either for dinner or for supper, more often than not could not eat or even taste either broth or meat, so bitter was everything through the great quantity of salt. For once or twice he had patience and only made a little noise about it; but after he saw that words were not enough, he gave blows many a time for this to the poor woman, who was in despair, it appearing to her that she was more than careful in salting her cooking. She, one time among others that her husband was beating her for this, began to try to excuse herself, wherefore Capodoca, falling into even greater rage, set himself to thrash her again in a manner that the woman screamed with all her might, and the whole neighbourhood ran up at the noise; and among others there came up Buffalmacco, who, having heard of what Capodoca was accusing his wife and in what way she was excusing herself, said to Capodoca: 'I' faith, comrade, this calls for a little reason; thou dost complain that the pot, morning and evening, is too much salted, and I marvel that this good woman of thine can do anything well. I, for my part, know not how, by day, she keeps on her feet, considering that the whole night she sits up over that wheel of hers, and sleeps not, to my belief, an hour. Make her give up this rising at midnight, and thou wilt see that,

having her fill of sleep, she will have her wits about her by day and will not fall into such blunders.' Then, turning to the other neighbours, he convinced them so well of the grave import of the matter, that they all said to Capodoca that Buonamico was speaking the truth and that it must be done as he advised. He, therefore, believing that it was so, commanded her not to rise in the night, and the pot was then reasonably salted, save when perchance the woman on occasion rose early, for then Buffalmacco would return to his remedy, which finally brought it about that Capodoca made her give it up completely.

Buffalmacco, then, among the first works that he made, painted with his own hand the whole church of the Convent of the Nuns of Faenza, which stood in Florence on the site of the present Cittadella del Prato; and among other scenes that he made there from the life of Christ, in all which he acquitted himself very well, he made the Massacre that Herod ordained of the Innocents, wherein he expressed very vividly the emotions both of the murderers and of the other figures; for in some nurses and mothers who are snatching the infants from the hands of the murderers and are seeking all the assistance that they can from their hands, their nails, their teeth, and every movement of the body, there is shown on the surface a heart no less full of rage and fury than of woe.

Of this work, that convent being to-day in ruins, there is to be seen nothing but a coloured sketch in our book of drawings by diverse masters, wherein there is this scene drawn by the hand of Buonamico himself. In the doing of this work for the aforesaid Nuns of Faenza, seeing that Buffalmacco was a person very eccentric and careless both in dress and in manner of life, it came to pass, since he did not always wear his cap and his mantle, as in those times it was the custom to do, that the nuns, seeing him once through the screen that he had caused to be made, began to say to the steward that it did not please them to see him in that guise, in his jerkin; however, appeased by him, they stayed for a little without saying more. But at last, seeing him ever in the same guise, and doubting whether he was not some knavish boy for grinding colours, they had him told by the Abbess that they would have liked to see the master at work, and not always him. To which Buonamico answered, like the good fellow that he was, that as soon as the master was there, he would let them know; taking notice, none the less, of the little confidence that

they had in him. Taking a stool, therefore, and placing another
above it, he put on top of all a pitcher, or rather a water-jar, and
on the mouth of that he put a cap, hanging over the handle,
and then he covered the rest of the jar with a burgher's mantle, and
finally, putting a brush in suitable fashion into the spout through
which the water is poured, he went off. The nuns, returning to
see the work through an opening where the cloth had slipped,
saw the supposititious master in full canonicals; wherefore, be-
lieving that he was working might and main and was by way of
doing different work from that which the untidy knave was doing,
they left it at that for some days, without thinking more about it.
Finally, having grown desirous to see what beautiful work the
master had done, fifteen days having passed, during which space
of time Buonamico had never come near the place, one night,
thinking that the master was not there, they went to see his
paintings, and remained all confused and blushing by reason of
one bolder than the rest discovering the solemn master, who in
fifteen days had done not one stroke of work. Then, recognizing
that he had served them as they merited and that the works that
he had made were worthy of nothing but praise, they bade the
steward recall Buonamico, who, with the greatest laughter and
delight, returned to the work, having given them to know what
difference there is between men and pitchers, and that it is not
always by their clothes that the works of men should be judged.
In a few days, then, he finished a scene wherewith they were
much contented, it appearing to them to be in every way satis-
factory, except that the figures appeared to them rather wan and
pallid than otherwise in the flesh-tints. Buonamico, hearing this,
and having learnt that the Abbess had some Vernaccia, the best
in Florence, which was used for the holy office of the Mass, said
to them that in order to remedy this defect nothing else could be
done but to temper the colours with some good Vernaccia; be-
cause, touching the cheeks and the rest of the flesh on the figures
with colours thus tempered, they would become rosy and col-
oured in most lifelike fashion. Hearing this, the good sisters, who
believed it all, kept him ever afterwards furnished with the best
Vernaccia, as long as the work lasted; and he, rejoicing in it, from
that time onwards made the figures fresher and more highly col-
oured with his ordinary colours.

 This work finished, he painted some stories of S. James in
the Abbey of Settimo, in the chapel that is in the cloister, and

dedicated to that Saint, on the vaulting of which he made the four Patriarchs and the four Evangelists, among whom S. Luke is doing a striking action in blowing very naturally on his pen, in order that it may yield its ink. Next, in the scenes on the walls, which are five, there are seen beautiful attitudes in the figures, and the whole work is executed with invention and judgment. And because Buonamico was wont, in order to make his flesh-colour better, as is seen in this work, to make a ground of purple, which in time produces a salt that becomes corroded and eats away the white and other colours, it is no marvel if this work is spoilt and eaten away, whereas many others that were made long before have been very well preserved. And I, who thought formerly that these pictures had received injury from the damp, have since proved by experience, studying other works of the same man, that it is not from the damp but from this particular use of Buffalmacco's that they have become spoilt so completely that there is not seen in them either design or anything else, and that where the flesh-colours were there has remained nothing else but the purple. This method of working should be used by no one who is anxious that his pictures should have long life.

Buonamico wrought, after that which has been described above, two panels in distemper for the Monks of the Certosa of Florence, whereof one is where the books of chants are kept for the use of the choir, and the other below in the old chapels. He painted in fresco the Chapel of the Giochi and Bastari in the Badia of Florence, beside the principal chapel; which chapel, although afterwards it was conceded to the family of the Boscoli, retains the said pictures of Buffalmacco up to our own day. In these he made the Passion of Christ, with effects ingenious and beautiful, showing very great humility and sweetness in Christ, who is washing the feet of His Disciples, and ferocity and cruelty in the Jews, who are leading Him to Herod. But he showed talent and facility more particularly in a Pilate, whom he painted in prison, and in Judas hanging from a tree; wherefore it is easy to believe what is told about this gay painter – namely, that when he thought fit to use diligence and to take pains, which rarely came to pass, he was not inferior to any painter whatsoever of his times. And to show that this is true, the works in fresco that he made in Ognissanti, where to-day there is the cemetery, were wrought with so much diligence and with so many precautions, that the water which has rained over them for so many years has

not been able to spoil them or to prevent their excellence from being recognized, and that they have been preserved very well, because they were wrought purely on the fresh plaster. On the walls, then, are the Nativity of Jesus Christ and the Adoration of the Magi – that is, over the tomb of the Aliotti. After this work Buonamico, having gone to Bologna, wrought some scenes in fresco in S. Petronio, in the Chapel of the Bolognini – that is, on the vaulting; but by reason of some accident, I know not what, supervening, he did not finish them.

It is said that in the year 1302 he was summoned to Assisi, and that in the Church of S. Francesco, in the Chapel of S. Caterina, he painted all the stories of her life in fresco, which have been very well preserved; and there are therein some figures that are worthy to be praised. This chapel finished, on his passing through Arezzo, Bishop Guido, by reason of having heard that Buonamico was a gay fellow and an able painter, desired him to stop in that city and paint for him, in the Vescovado, the chapel where baptisms are now held. Buonamico, having put his hand to the work, had already done a good part of it when there befell him the strangest experience in the world, which was, according to what Franco Sacchetti relates, as follows. The Bishop had an ape, the drollest and the most mischievous that there had ever been. This animal, standing once on the scaffolding to watch Buonamico at work, had given attention to everything, and had never taken his eyes off him when he was mixing the colours, handling the flasks, beating the eggs for making the distempers, and in short when he was doing anything else whatsoever. Now, Buonamico having left off working one Saturday evening, on the Sunday morning this ape, notwithstanding that he had, fastened to his feet, a great block of wood which the Bishop made him carry in order that thus he might not be able to leap wherever he liked, climbed on to the scaffolding whereon Buonamico was used to stand to work, in spite of the very great weight of the block of wood; and there, seizing the flasks with his hands, pouring them one into another and making six mixtures, and beating up whatever eggs there were, he began to daub over with the brushes all the figures there, and, persevering in this performance, did not cease until he had repainted everything with his own hand; and this done, he again made a mixture of all the colours that were left him, although they were but few, and, getting down from the scaffolding, went off. Monday morning having come,

Buonamico returned to his work, where, seeing the figures spoilt, the flasks all mixed up, and everything upside down, he stood all in marvel and confusion. Then, having pondered much in his own mind, he concluded finally that some Aretine had done this, through envy or through some other reason; wherefore, having gone to the Bishop, he told him how the matter stood and what he suspected, whereat the Bishop became very much disturbed, but, consoling Buonamico, desired him to put his hand again to the work and to repaint all that was spoilt. And because the Bishop had put faith in his words, which had something of the probable, he gave him six of his men-at-arms, who should stand in hiding with halberds while he was not at work, and, if anyone came, should cut him to pieces without mercy. The figures, then, having been painted over again, one day that the soldiers were in hiding, lo and behold! they hear a certain rumbling through the church, and a little while after the ape climbing on to the scaffolding; and in the twinkling of an eye, the mixtures made, they see the new master set himself to work over the saints of Buonamico. Calling him, therefore, and showing him the culprit, and standing with him to watch the beast at his work, they were all like to burst with laughter; and Buonamico in particular, for all that he was vexed thereby, could not keep from laughing till the tears came. Finally, dismissing the soldiers who had mounted guard with their halberds, he went off to the Bishop and said to him: 'My lord, you wish the painting to be done in one fashion, and your ape wishes it done in another.' Then, relating the affair, he added: 'There was no need for you to send for painters from elsewhere, if you had the true master at home. But he, perhaps, knew not so well how to make the mixtures; now that he knows, let him do it by himself, since I am no more good here. And his talent being revealed, I am content that there should be nothing given to me for my work save leave to return to Florence.' The Bishop, hearing the affair, although it vexed him, could not keep from laughing, and above all as he thought how an animal had played a trick on him who was the greatest trickster in the world. However, after they had talked and laughed their fill over this strange incident, the Bishop persuaded Buonamico to resume the work for the third time, and he finished it. And the ape, as punishment and penance for the crime committed, was shut up in a great wooden cage and kept where Buonamico was working, until this work was entirely finished; and no one could imagine

the contortions which that creature kept making in this cage with his face, his body, and his hands, seeing others working and himself unable to take part.

The work in this chapel finished, the Bishop, either in jest or for some other reason known only to himself, commanded that Buffalmacco should paint him, on one wall of his palace, an eagle on the back of a lion which it had killed. The crafty painter, having promised to do all that the Bishop wished, had a good scaffolding made of planks, saying that he refused to be seen painting such a thing. This made, shutting himself up alone inside it, he painted, contrary to what the Bishop wished, a lion that was tearing to pieces an eagle; and, the work finished, he sought leave from the Bishop to go to Florence in order to get some colours that he was wanting. And so, locking the scaffolding with a key, he went off to Florence, in mind to return no more to the Bishop, who, seeing the business dragging on and the painter not returning, had the scaffolding opened, and discovered that Buonamico had been too much for him. Wherefore, moved by very great displeasure, he had him banished on pain of death, and Buonamico, hearing this, sent to tell him to do his worst; whereupon the Bishop threatened him to a fearful tune. But finally, remembering that he had begun the playing of tricks and that it served him right to be tricked himself, he pardoned Buonamico for his insult and rewarded him liberally for his labours. Nay, what is more, summoning him again no long time after to Arezzo, he caused him to make many works in the Duomo Vecchio, which are now destroyed, treating him ever as his familiar friend and very faithful servant. The same man painted the niche of the principal chapel in the Church of S. Giustino, also in Arezzo.

Some writers tell that Buonamico being in Florence and often frequenting the shop of Maso del Saggio with his friends and companions, he was there, with many others, arranging the festival which the men of the Borgo San Friano held on May 1 in certain boats on the Arno; and that when the Ponte alla Carraia, which was then of wood, collapsed by reason of the too great weight of the people who had flocked to that spectacle, he did not die there, as many others did, because, precisely at the moment when the bridge collapsed on to the structure that was representing Hell on the boats in the Arno, he had gone to get some things that were wanting for the festival.

Being summoned to Pisa no long time after these events, Buonamico painted many stories of the Old Testament in the Abbey of S. Paolo a Ripa d'Arno, then belonging to the Monks of Vallombrosa, in both transepts of the church, on three sides, and from the roof down to the floor, beginning with the Creation of man, and continuing up to the completion of the Tower of Nimrod. In this work, although it is to-day for the greater part spoilt, there are seen vivacity in the figures, good skill and loveliness in the colouring, and signs to show that the hand of Buonamico could very well express the conceptions of his mind, although he had little power of design. On the wall of the right transept which is opposite to that wherein is the side door, in some stories of S. Anastasia, there are seen certain ancient costumes and head-dresses, very charming and beautiful, in some women who are painted there with graceful manner. Not less beautiful, also, are those figures that are in a boat, with well-conceived attitudes, among which is the portrait of Pope Alexander IV, which Buonamico had, so it is said, from Tafo his master, who had portrayed that Pontiff in mosaic in S. Pietro. In the last scene, likewise, wherein is the martyrdom of that Saint and of others, Buonamico expressed very well in the faces the fear of death and the grief and terror of those who are standing to see her tortured and put to death, while she stands bound to a tree and over the fire.

A companion of Buonamico in this work was Bruno di Giovanni, a painter, who is thus called in the old book of the Company; which Bruno (also celebrated as a gay fellow by Boccaccio), the said scenes on the walls being finished, painted the altar of S. Ursula with the company of virgins, in the same church. He made in one hand of the said Saint a standard with the arms of Pisa, which are a white cross on a field of red, and he made her offering the other hand to a woman who, rising between two mountains and touching the sea with one of her feet, is stretching both her hands to her in the act of supplication; which woman, representing Pisa, and having on her head a crown of gold and over her shoulders a mantle covered with circlets and eagles, is seeking assistance from that Saint, being much in travail in the sea. Now, for the reason that in painting this work Bruno was bewailing that the figures which he was making therein had not the same life as those of Buonamico, the latter, in his waggish way, in order to teach him to make his figures not merely

vivacious but actually speaking, made him paint some words issuing from the mouth of that woman who is supplicating the Saint, and the answer of the Saint to her, a device that Buonamico had seen in the works that had been made in the same city by Cimabue. This expedient, even as it pleased Bruno and the other thick-witted men of those times, in like manner pleases certain boors to-day, who are served therein by craftsmen as vulgar as themselves. And in truth it seems extraordinary that from this beginning there should have passed into use a device that was employed for a jest and for no other reason, insomuch that even a great part of the Campo Santo, wrought by masters of repute, is full of this rubbish.

The works of Buonamico, then, finding much favour with the Pisans, he was charged by the Warden of the Works of the Campo Santo to make four scenes in fresco, from the beginning of the world up to the construction of Noah's Ark, and round the scenes an ornamental border, wherein he made his own portrait from the life – namely, in a frieze, in the middle of which, and on the corners, are some heads, among which, as I have said, is seen his own, with a cap exactly like the one that is seen above. And because in this work there is a God, who is upholding with his arms the heavens and the elements – nay, the whole body of the universe – Buonamico, in order to explain his story with verses similar to the pictures of that age, wrote this sonnet in capital letters at the foot, with his own hand, as may still be seen; which sonnet, by reason of its antiquity and of the simplicity of the language of those times, it has seemed good to me to include in this place, although in my opinion it is not likely to give much pleasure, save perchance as something that bears witness as to what was the knowledge of the men of that century:

> Voi che avisate questa dipintura
> Di Dio pietoso, sommo creatore,
> Lo qual fe' tutte cose con amore,
> Pesate, numerate ed in misura;
> In nove gradi angelica natura,
> In ello empirio ciel pien di splendore,
> Colui che non si muove ed è motore,
> Ciascuna cosa fece buona e pura.
> Levate gli occhi del vostro intelletto,
> Considerate quanto è ordinato
> Lo mondo universale; e con affetto

Lodate lui che l' ha sì ben creato;
Pensate di passare a tal diletto.
Tra gli Angeli, dov' è ciascun beato.
Per questo mondo si vede la gloria,
Lo basso e il mezzo e l' alto in questa storia.

And to tell the truth, it was very courageous in Buonamico to undertake to make a God the Father five braccia high, with the hierarchies, the heavens, the angels, the zodiac, and all the things above, even to the heavenly body of the moon, and then the element of fire, the air, the earth, and finally the nether regions; and to fill up the two angles below he made in one, S. Augustine, and in the other, S. Thomas Aquinas. At the head of the same Campo Santo, where there is now the marble tomb of Corte, Buonamico painted the whole Passion of Christ, with a great number of figures on foot and on horseback, and all in varied and beautiful attitudes; and continuing the story he made the Resurrection and the Apparition of Christ to the Apostles, passing well.

Having finished these works and at the same time all that he had gained Pisa, which was not little, he returned to Florence as poor as he had left it, and there he made many panels and works in fresco, whereof there is no need to make further record. Meanwhile there had been entrusted to Bruno, his great friend (who had returned with him from Pisa, where they had squandered everything), some works in S. Maria Novella, and seeing that Bruno had not much design or invention, Buonamico designed for him all that he afterwards put into execution on a wall in the said church, opposite to the pulpit and as long as the space between column and column, and that was the story of S. Maurice and his companions, who were beheaded for the faith of Jesus Christ. This work Bruno made for Guido Campese, then Constable of the Florentines, whose portrait he had made before he died in the year 1312; in that work he painted him in his armour, as was the custom in those times, and behind him he made a line of men-at-arms, armed in ancient fashion, who make a beautiful effect, while Guido himself is kneeling before a Madonna who has the Child Jesus in her arms, and is appearing to be recommended to her by S. Dominic and S. Agnes, who are on either side of him. Although this picture is not very beautiful, yet, considering the design and invention of Buonamico, it is

worthy to be in part praised, and above all by reason of the costumes, helmets, and other armour of those times. And I have availed myself of it in some scenes that I have made for the Lord Duke Cosimo, wherein it was necessary to represent men armed in ancient fashion, and other similar things of that age; which work has greatly pleased his most Illustrious Excellency and others who have seen it. And from this it can be seen how much benefit may be gained from the inventions and works made by these ancients, although they may not be very perfect, and in what fashion profit and advantage can be drawn from their performances, since they opened the way for us to the marvels that have been made up to our day and are being made continually.

While Bruno was making this work, a peasant desiring that Buonamico should make him a S. Christopher, they came to an agreement in Florence and arranged a contract in this fashion, that the price should be eight florins and that the figure should be twelve braccia high. Buonamico, then, having gone to the church where he was to make the S. Christopher, found that by reason of its not being more than nine braccia either in height or in length, he could not, either without or within, accommodate the figure in a manner that it might stand well; wherefore he made up his mind, since it would not go in upright, to make it within the church lying down. But since, even so, the whole length would not go in, he was forced to bend it from the knees downwards on to the wall at the head of the church. The work finished, the peasant would by no means pay for it; nay, he made an outcry and said he had been cozened. The matter, therefore, going before the Justices, it was judged, according to the contract, that Buonamico was in the right.

In S. Giovanni fra l'Arcore was a very beautiful Passion of Christ by the hand of Buonamico, and among other things that were much praised therein was a Judas hanging from a tree, made with much judgment and beautiful manner. An old man, likewise, who was blowing his nose, was most natural, and the Maries, broken with weeping, had expressions and aspects so sad, that they deserved to be greatly praised, since that age had not as yet much facility in the method of representing the emotions of the soul with the brush. On the same wall there was a good figure in a S. Ivo of Brittany, who had many widows and orphans at his feet, and two angels in the sky, who were crowning him, were made with the sweetest manner. This edifice and the pictures

together were thrown to the ground in the year of the war of 1529.

In Cortona, also, for Messer Aldobrandino, Bishop of that city, Buonamico painted many works in the Vescovado, and in particular the chapel and panel of the high-altar; but seeing that everything was thrown to the ground in renovating the palace and the church, there is no need to make further mention of them. In S. Francesco, however, and in S. Margherita, in the same city, there are still some pictures by the hand of Buonamico. From Cortona going once more to Assisi, Buonamico painted in fresco, in the lower Church of S. Francesco, the whole Chapel of Cardinal Egidio Alvaro, a Spaniard; and because he acquitted himself very well, he was therefore liberally rewarded by that Cardinal. Finally, Buonamico having wrought many pictures throughout the whole March, in returning to Florence he stopped at Perugia, and painted there in fresco the Chapel of the Buontempi in the Church of S. Domenico, making therein stories of the life of S. Catherine, virgin and martyr. And in the Church of S. Domenico Vecchio, on one wall, he painted in fresco the scene when the same Catherine, daughter of King Costa, making disputation, is convincing and converting certain philosophers to the faith of Christ; and seeing that this scene is more beautiful than any other that Buonamico ever made, it can be said with truth that in this work he surpassed himself. The people of Perugia, moved by this, according to what Franco Sacchetti writes, commanded that he should paint S. Ercolano, Bishop and Protector of that city, in the square; wherefore, having agreed about the price, on the spot where the painting was to be done there was made a screen of planks and matting, to the end that the master might not be seen painting; and this made, he put his hand to the work. But before ten days had passed, every passer-by asking when this picture would be finished, as though such works were cast in moulds,* the matter disgusted Buonamico; wherefore, having come to the end of the work and being distracted with such importunity, he determined within himself to take a gentle vengeance on the impatience of these people. And this came to pass, for, when the work was finished, before unveiling it, he let them see it, and it was entirely to their satisfaction; but on the people of Perugia wishing to remove the screen

* Proverbial expression, equivalent to our 'twinkling of an eye.'

at once, Buonamico said that for two days longer they should leave it standing, for the reason that he wished to retouch certain parts on the dry; and so it was done. Buonamico, then, having mounted the scaffolding, removed the great diadem of gold that he had given to the Saint, raised in relief with plaster, as was the custom in those times, and made him a crown, or rather garland, right round his head, of roaches; and this done, one morning he settled with his host and went off to Florence. Now, two days having passed, the people of Perugia, not seeing the painter going about as they had been used, asked the host what had become of him, and, hearing that he had returned to Florence, went at once to remove the screen; and finding their S. Ercolano crowned solemnly with roaches, they sent word of it immediately to their governors. But although these sent horsemen post-haste to look for Buonamico, it was all in vain, seeing that he had returned in great haste to Florence. Having determined, then, to make a painter of their own remove the crown of roaches and restore the diadem to the Saint, they said all the evil that can be imagined about Buonamico and the rest of the Florentines.

Buonamico, back in Florence and caring little about what the people of Perugia might say, set to work and made many paintings, whereof, in order not to be too long, there is no need to make mention. I will say only this, that having painted in fresco at Calcinaia a Madonna with the Child in her arms, he who had charged him to do it, in place of paying him, gave him words; whence Buonamico, who was not used to being trifled with or being fooled, determined to get his due by hook or by crook. And so, having gone one morning to Calcinaia, he transformed the child that he had painted in the arms of the Virgin into a little bear, but in colours made only with water, without size or distemper. This change being seen, not long after, by the peasant who had given him the work to do, almost in despair he went to find Buonamico, praying him for the sake of Heaven to remove the little bear and to paint another child as before, for he was ready to make satisfaction. This the other did amicably, being paid for both the first and the second labour without delay; and for restoring the whole work a wet sponge sufficed. Finally, seeing that it would take too long were I to wish to relate all the tricks, as well as all the pictures, that Buonamico Buffalmacco made, and above all when frequenting the shop of Maso del Saggio, which was the resort of citizens and of all the gay and

mischievous spirits that there were in Florence, I will make an end of discoursing about him.

He died at the age of seventy-eight, and being very poor and having done more spending than earning, by reason of being such in character, he was supported in his illness by the Company of the Misericordia in S. Maria Nuova, the hospital of Florence; and then, being dead, he was buried in the Ossa (for so they call a cloister, or rather cemetery, of the hospital), like the rest of the poor, in the year 1340. The works of this man were prized while he lived, and since then, for works of that age, they have been ever extolled.

AMBROGIO LORENZETTI, Painter of Siena

If that debt is great, as without doubt it is, which craftsmen of fine genius should acknowledge to nature, much greater should that be that is due from us to them, seeing that they, with great solicitude, fill the cities with noble and useful buildings and with lovely historical compositions, gaining for themselves, for the most part, fame and riches with their works; as did Ambrogio Lorenzetti, painter of Siena, who showed beautiful and great invention in grouping and placing his figures thoughtfully in historical scenes. That this is true is proved by a scene in the Church of the Friars Minor in Siena, painted by him very gracefully in the cloister, wherein there is represented in what manner a youth becomes a friar, and how he and certain others go to the Soldan, and are there beaten and sentenced to the gallows and hanged on a tree, and finally beheaded, with the addition of a terrible tempest. In this picture, with much art and dexterity, he counterfeited in the travailing of the figures the turmoil of the air and the fury of the rain and of the wind, wherefrom the modern masters have learnt the method and the principle of this invention, by reason of which, since it was unknown before, he deserved infinite commendation. Ambrogio was a practised colourist in fresco, and he handled colours in distemper with great dexterity and facility, as it is still seen in the panels executed by him in Siena for the little hospital called Mona Agnesa, where he painted and finished a scene with new and beautiful composition. And at the great hospital, on one front, he made in fresco the Nativity of Our Lady

and the scene when she is going with the virgins to the Temple.
For the Friars of S. Augustine in the same city he painted their
Chapter-house, where the Apostles are seen represented on the
vaulting, with scrolls in their hands whereon is written that part
of the Creed which each one of them made; and below each is a
little scene containing in painting that same subject that is sig-
nified above by the writing. Near this, on the main front, are
three stories of S. Catherine the martyr, who is disputing with the
tyrant in a temple, and, in the middle, the Passion of Christ, with
the Thieves on the Cross, and the Maries below, who are sup-
porting the Virgin Mary who has swooned; which works were
finished by him with much grace and with beautiful manner.

In a large hall of the Palazzo della Signoria in Siena he painted
the War of Asinalunga, and after it the Peace and its events,
wherein he fashioned a map perfect for those times; and in the
same palace he made eight scenes in terra-verde, highly finished.
It is said that he also sent to Volterra a panel in distemper which
was much praised in that city. And painting a chapel in fresco
and a panel in distemper at Massa, in company with others, he
gave them proof how great, both in judgment and in genius, was
his worth in the art of painting; and in Orvieto he painted in
fresco the principal Chapel of S. Maria. After these works, pro-
ceeding to Florence, he made a panel in S. Procolo, and in a
chapel he painted the stories of S. Nicholas with little figures, in
order to satisfy certain of his friends, who desired to see his
method of working; and, being much practised, he executed this
work in so short a time that there accrued to him fame and
infinite repute. And this work, on the predella of which he made
his own portrait, brought it about that in the year 1335 he was
summoned to Cortona by order of Bishop Ubertini, then lord of
that city, where he wrought certain works in the Church of
S. Margherita, built a short time before for the Friars of S. Fran-
cis on the summit of the hill, and in particular the half of the
vaulting and the walls, so well that, although to-day they are
wellnigh eaten away by time, there are seen notwithstanding most
beautiful effects in the figures; and it is clear that he was deser-
vedly commended for them.

This work finished, Ambrogio returned to Siena, where he
lived honourably the remainder of his life, not only by reason of
being an excellent master in painting, but also because, having
given attention in his youth to letters, they were a useful and

pleasant accompaniment to him in his painting, and so great an ornament to his whole life that they rendered him no less popular and beloved than did his profession of painting; wherefore he was not only intimate with men of learning and of taste, but he was also employed, to his great honour and advantage, in the government of his Republic. The ways of Ambrogio were in all respects worthy of praise, and rather those of a gentleman and a philosopher than of a craftsman; and what most demonstrates the wisdom of men, he had ever a mind disposed to be content with that which the world and time brought, wherefore he supported with a mind temperate and calm the good and the evil that came to him from fortune. And truly it cannot be told to what extent courteous ways and modesty, with the other good habits, are an honourable accompaniment to all the arts, and in particular to those that are derived from the intellect and from noble and exalted talents; wherefore every man should make himself no less beloved with his ways than with the excellence of his art.

Finally, at the end of his life, Ambrogio made a panel at Monte Oliveto di Chiusuri with great credit to himself, and a little afterwards, being eighty-three years of age, he passed happily and in the Christian faith to a better life. His works date about 1340.

As it has been said, the portrait of Ambrogio, by his own hand, is seen in the predella of his panel in S. Procolo, with a cap on his head. And what was his worth in draughtsmanship is seen in our book, wherein are some passing good drawings by his hand.

PIETRO CAVALLINI, Painter of Rome

For many centuries Rome had been deprived not only of fine letters and of the glory of arms but also of all the sciences and fine arts, when, by the will of God, there was born therein Pietro Cavallini, in those times when Giotto, having, it may be said, restored painting to life, was holding the sovereignty among the painters in Italy. He, then, having been a disciple of Giotto and having worked with Giotto himself on the Navicella in mosaic in S. Pietro, was the first who, after him, gave light to that art, and he began to show that he had been no unworthy disciple of so

great a master when he painted, over the door of the sacristy of
the Araceli, some scenes that are to-day eaten away by time, and
very many works coloured in fresco throughout the whole
Church of S. Maria di Trastevere. Afterwards, working in mosaic
on the principal chapel and on the façade of the church, he
showed in the beginning of such a work, without the help of
Giotto, that he was no less able in the execution and bringing to
completion of mosaics than he was in painting. Making many
scenes in fresco, also, in the Church of S. Grisogono, he strove
to make himself known both as the best disciple of Giotto and
as a good craftsman. In like manner, also in Trastevere, he
painted almost the whole Church of S. Cecilia with his own hand,
and many works in the Church of S. Francesco appresso Ripa.
He then made the façade of mosaic in S. Paolo without Rome,
and many stories of the Old Testament for the central nave. And
painting some works in fresco in the Chapter-house of the first
cloister, he put therein so great diligence that he gained thereby
from men of judgment the name of being a most excellent mas-
ter, and was therefore so much favoured by the prelates that they
commissioned him to do the inner wall of S. Pietro, between the
windows. Between these he made the four Evangelists, wrought
very well in fresco, of extraordinary size in comparison with the
figures that at that time were customary, with a S. Peter and a
S. Paul, and a good number of figures in a ship, wherein, the
Greek manner pleasing him much, he blended it ever with that
of Giotto; and since he delighted to give relief to his figures, it is
recognized that he used thereunto the greatest efforts that can be
imagined by man. But the best work that he made in that city
was in the said Church of Araceli on the Campidoglio, where he
painted in fresco, on the vaulting of the principal apse, the
Madonna with the Child in her arms, surrounded by a circle of
sunlight, and beneath is the Emperor Octavian, to whom the
Tiburtine Sibyl is showing Jesus Christ, and he is adoring Him;
and the figures in this work, as it has been said in other places,
have been much better preserved than the others, because those
that are on the vaulting are less injured by dust than those that
are made on the walls.

After these works Pietro went to Tuscany, in order to see the
works of the other disciples of his master Giotto and those of
Giotto himself; and with this occasion he painted many figures
in S. Marco in Florence, which are not seen to-day, the church

having been whitewashed, except the Annunciation, which stands covered beside the principal door of the church. In S. Basilio, also, in the Canto alla Macine, he made another Annunciation in fresco on a wall, so like to that which he had made before in S. Marco, and to another one that is in Florence, that some believe, and not without probability, that they are all by the hand of this Pietro; and in truth they could not be more like, one to another, than they are. Among the figures that he made in the said S. Marco in Florence was the portrait of Pope Urban V from the life, with the heads of S. Peter and S. Paul; from which portrait Fra Giovanni da Fiesole copied that one which is in a panel in S. Domenico, also of Fiesole; and that was no small good-fortune, seeing that the portrait which was in S. Marco and many other figures that were about the church in fresco were covered with whitewash, as it has been said, when that convent was taken from the monks who occupied it before and given to the Preaching Friars, the whole being whitewashed with little attention and consideration.

Passing afterwards, in returning to Rome, through Assisi, not only in order to see those buildings and those notable works made there by his master and by some of his fellow-disciples, but also to leave something there by his own hand, he painted in fresco in the lower Church of S. Francesco – namely, in the transept that is on the side of the sacristy – a Crucifixion of Jesus Christ, with men on horseback armed in various fashions, and with many varied and extravagant costumes of diverse foreign peoples. In the air he made some angels, who, poised on their wings in diverse attitudes, are in a storm of weeping; and some pressing their hands to their breasts, others wringing them, and others beating the palms, they are showing that they feel the greatest grief at the death of the Son of God; and all, from the middle backwards, or rather from the middle downwards, melt away into air. In this work, well executed in the colouring, which is fresh and vivacious and so well contrived in the junctions of the plaster that the work appears all made in one day, I have found the coat of arms of Gualtieri, Duke of Athens; but by reason of there not being either a date or other writing there, I cannot affirm that it was caused to be made by him. I say, however, that besides the firm belief of everyone that it is by the hand of Pietro, the manner could not be more like his than it is, not to mention that it may be believed, this painter having lived at

the time when Duke Gualtieri was in Italy, that it was made by Pietro as well as by order of the said Duke. At least, let everyone think as he pleases, the work, as ancient, is worthy of nothing but praise, and the manner, besides the public voice, shows that it is by the hand of this man.

In the Church of S. Maria at Orvieto, wherein is the most holy relic of the Corporal, the same Pietro wrought in fresco certain stories of Jesus Christ and of the Host, with much diligence; and this he did, so it is said, for Messer Benedetto, son of Messer Buonconte Monaldeschi and lord at that time, or rather tyrant, of that city. Some likewise affirm that Pietro made some sculptures, and that they were very successful, because he had genius for whatever he set himself to do, and that he made the Crucifix that is in the great Church of S. Paolo without Rome; which Crucifix, as it is said and may be believed, is the one that spoke to S. Brigida in the year 1370.

By the hand of the same man were some other works in that manner, which were thrown to the ground when the old Church of S. Pietro was pulled down in order to build the new. Pietro was very diligent in all his works, and sought with every effort to gain honour and to acquire fame in the art. He was not only a good Christian, but most devout and very much the friend of the poor, and he was beloved by reason of his excellence not only in his native city of Rome but by all those who had knowledge of him or of his works. And finally, he devoted himself at the end of his old age to religion, leading an exemplary life, with so much zeal that he was almost held a saint. Wherefore there is no reason to marvel not only that the said Crucifix by his hand spoke to the Saint, as it has been said, but also that innumerable miracles have been and still are wrought by a certain Madonna by his hand, which I do not intend to call his best, although it is very famous in all Italy and although I know very certainly and surely, by the manner of the painting, that it is by the hand of Pietro, whose most praiseworthy life and piety towards God were worthy to be imitated by all men. Nor let anyone believe, for the reason that it is scarcely possible and that experience continually shows this to us, that it is possible to attain to honourable rank without the fear and grace of God and without goodness of life. A disciple of Pietro Cavallini was Giovanni da Pistoia, who made some works of no great importance in his native city.

Finally, at the age of eighty-five, he died in Rome of a colic caught while working in fresco, by reason of the damp and of

standing continually at this exercise. His pictures date about the year 1364, and he was honourably buried in S. Paolo without Rome, with this epitaph:

QUANTUM ROMANÆ PETRUS DECUS ADDIDIT URBI
PICTURA, TANTUM DAT DECUS IPSE POLO.

His portrait has never been found, for all the diligence that has been used; it is therefore not included.

SIMONE SANESE
[*SIMONE MEMMI OR MARTINI*],
Painter

TRULY happy can those men be called, who are inclined by nature to those arts that can bring to them not only honour and very great profit, but also, what is more, fame and a name wellnigh eternal, and happier still are they who have from their cradles, besides such inclination, courtesy and honest ways, which render them very dear to all men. But happiest of all, finally, talking of craftsmen, are they who not only receive a love of the good from nature, and noble ways from the same source and from education, but also live in the time of some famous writer, from whom, in return for a little portrait or some other similar courtesy in the way of art, they gain on occasion the reward of eternal honour and name, by means of their writings; and this, among those who practise the arts of design, should be particularly desired and sought by the excellent painters, seeing that their works, being on the surface and on a ground of colour, cannot have that eternal life which castings in bronze and works in marble give to sculpture, or buildings to the architects.

Very great, then, was that good-fortune of Simone, to live at the time of Messer Francesco Petrarca and to chance to find that most amorous poet at the Court of Avignon, desirous of having the image of Madonna Laura by the hand of Maestro Simone, because, having received it as beautiful as he had desired, he made memory of him in two sonnets, whereof one begins:

> Per mirar Policleto a prova fiso
> Con gli altri che ebber fama di quell' arte;

and the second:

Quando giunse a Simon l' alto concetto
Ch' a mio nome gli pose in man lo stile.

These sonnets, in truth, together with the mention made of
him in one of his *Familiar Letters*, in the fifth book, which begins:
'Non sum nescius,' have given more fame to the poor life of
Maestro Simone than all his own works have ever done or ever
will, seeing that they must at some time perish, whereas the writ-
ings of so great a man will live for eternal ages. Simone Memmi
of Siena, then, was an excellent painter, remarkable in his own
times and much esteemed at the Court of the Pope, for the
reason that after the death of Giotto his master, whom he had
followed to Rome when he made the Navicella in mosaic and the
other works, he made a Virgin Mary in the portico of S. Pietro,
with a S. Peter and a S. Paul, near to the place where the bronze
pine-cone is, on a wall between the arches of the portico on the
outer side; and in this he counterfeited the manner of Giotto very
well, receiving so much praise, above all because he portrayed
therein a sacristan of S. Pietro lighting some lamps before the
said figures with much promptness, that he was summoned with
very great insistence to the Court of the Pope at Avignon, where
he wrought so many pictures, in fresco and on panels, that he
made his works correspond to the reputation that had been
borne thither. Whence, having returned to Siena in great credit
and much favoured on this account, he was commissioned by the
Signoria to paint in fresco, in a hall of their Palace, a Virgin Mary
with many figures round her, which he completed with all per-
fection to his own great credit and advantage. And in order to
show that he was no less able to work on panel than in fresco,
he painted in the said Palace a panel which led to his being
afterwards made to paint two of them in the Duomo, and a
Madonna with the Child in her arms, in a very beautiful attitude,
over the door of the Office of the Works of the said Duomo. In
this picture certain angels, supporting a standard in the air, are
flying and looking down on to some saints who are round the
Madonna, and they make a very beautiful composition and great
adornment.

This done, Simone was brought by the General of the Augus-
tinians to Florence, where he painted the Chapter-house of
S. Spirito, showing invention and admirable judgment in the
figures and the horses that he made, as is proved in that place by

SIMONE SANESE
PITTOR

Y

the story of the Passion of Christ, wherein everything is seen to have been made by him with ingenuity, with discretion, and with most beautiful grace. There are seen the Thieves on the Cross yielding up their breath, and the soul of the good one being carried to Heaven by the angels, and that of the wicked one going, accompanied by devils and all harassed, to the torments of Hell. Simone likewise showed invention and judgment in the attitudes and in the very bitter weeping of some angels round the Crucifix. But what is most worthy of consideration, above everything else, is to see those spirits visibly cleaving the air with their shoulders, almost whirling right round and yet sustaining the motion of their flight. This work would bear much stronger witness to the excellence of Simone, if, besides the fact that time has eaten it away, it had not been spoilt by those Fathers in the year 1560, when they, being unable to use the Chapter-house, because it was in bad condition from damp, made a vaulted roof to replace a worm-eaten ceiling, and threw down the little that was left of the pictures of this man. About the same time Simone painted a Madonna and a S. Luke, with some other Saints, on a panel in distemper, which is to-day in the Chapel of the Gondi in S. Maria Novella, with his name.

Next, Simone painted three walls of the Chapter-house of the said S. Maria Novella, very happily. On the first, which is over the door whereby one enters, he made the life of S. Dominic; and on that which follows in the direction of the church, he represented the Religious Order of the same Saint fighting against the heretics, represented by wolves, which are attacking some sheep, which are defended by many dogs spotted with black and white, and the wolves are beaten back and slain. There are also certain heretics, who, being convinced in disputation, are tearing their books and penitently confessing themselves, and so their souls are passing through the gate of Paradise, wherein are many little figures that are doing diverse things. In Heaven is seen the glory of the Saints, and Jesus Christ; and in the world below remain the vain pleasures and delights, in human figures, and above all in the shape of women who are seated, among whom is the Madonna Laura of Petrarca, portrayed from life and clothed in green, with a little flame of fire between her breast and her throat. There is also the Church of Christ, and as a guard for her, the Pope, the Emperor, the Kings, the Cardinals, the Bishops, and all the Christian Princes; and among them, beside a Knight of

Rhodes, is Messer Francesco Petrarca, also portrayed from the life, which Simone did in order to enhance by his works the fame of the man who had made him immortal. For the Universal Church he painted the Church of S. Maria del Fiore, not as it stands to-day, but as he had drawn it from the model and design that the architect Arnolfo had left in the Office of Works for the guidance of those who had to continue the building after him; of which models, by reason of the little care of the Wardens of Works of S. Maria del Fiore, as it has been said in another place, there would be no memorial for us if Simone had not left it painted in this work. On the third wall, which is that of the altar, he made the Passion of Christ, who, issuing from Jerusalem with the Cross on His shoulder, is going to Mount Calvary, followed by a very great multitude. Arriving there, He is seen raised on the Cross between the Thieves, with the other circumstances that accompany this story. I will say nothing of there being therein a good number of horses, of the casting of lots by the servants of the court for the garments of Christ, of the raising of the Holy Fathers from the Limbo of Hell, and of all the other well-conceived inventions, which belong not so much to a master of that age as to the most excellent of the moderns; inasmuch as, taking up the whole walls, with very diligent judgment he made in each wall diverse scenes on the slope of a mountain, and did not divide scene from scene with ornamental borders, as the old painters were wont to do, and many moderns, who put the earth over the sky four or five times, as it is seen in the principal chapel of this same church, and in the Campo Santo of Pisa, where, painting many works in fresco, he was forced against his will to make such divisions, for the other painters who had worked in that place, such as Giotto and Buonamico his master, had begun to make their scenes with this bad arrangement.

In that Campo Santo, then, following as the lesser evil the method used by the others, Simone made in fresco, over the principal door and on the inner side, a Madonna borne to Heaven by a choir of angels, who are singing and playing so vividly that there are seen in them all those various gestures that musicians are wont to make in singing or playing, such as turning the ears to the sound, opening the mouth in diverse ways, raising the eyes to Heaven, blowing out the cheeks, swelling the throat, and in short all the other actions and movements that are made in music. Under this Assumption, in three pictures, he made

some scenes from the life of S. Ranieri of Pisa. In the first scene he is shown as a youth, playing the psaltery and making some girls dance, who are most beautiful by reason of the air of the heads and of the loveliness of the costumes and head-dresses of those times. Next, the same Ranieri, having been reproved for such lasciviousness by the Blessed Alberto the Hermit, is seen standing with his face downcast and tearful and with his eyes red from weeping, all penitent for his sin, while God, in the sky, surrounded by a celestial light, appears to be pardoning him. In the second picture Ranieri, distributing his wealth to God's poor before mounting on board ship, has round him a crowd of beggars, of cripples, of women, and of children, all most touching in their pushing forward, their entreating, and their thanking him. And in the same picture, also, that Saint, having received in the Temple the gown of a pilgrim, is standing before a Madonna, who, surrounded by many angels, is showing him that he will repose on her bosom in Pisa; and all these figures have vivacity and a beautiful air in the heads. In the third Simone painted the scene when, having returned after seven years from beyond the seas, he is showing that he has spent thrice forty days in the Holy Land, and when, standing in the choir to hear the Divine offices, he is tempted by the Devil, who is seen driven away by a firm determination that is perceived in Ranieri not to consent to offend God, assisted by a figure made by Simone to represent Constancy, who is chasing away the ancient adversary not only all in confusion but also (with beautiful and fanciful invention) all in terror, holding his hands to his head in his flight, and walking with his face downcast and his shoulders shrunk as close together as could be, and saying, as it is seen from the writing that is issuing from his mouth: 'I can no more.' And finally, there is also in this picture the scene when Ranieri, kneeling on Mount Tabor, is miraculously seeing Christ in air with Moses and Elias; and all the features of this work, with others that are not mentioned, show that Simone was very fanciful and understood the good method of grouping figures gracefully in the manner of those times. These scenes finished, he made two panels in distemper in the same city, assisted by Lippo Memmi, his brother, who had also assisted him to paint the Chapter-house of S. Maria Novella and other works.

He, although he had not the excellence of Simone, none the less followed his manner as well as he could, and made many

works in fresco in his company for S. Croce in Florence; the panel of the high-altar in S. Caterina at Pisa, for the Preaching Friars; and in S. Paolo a Ripa d' Arno, besides many very beautiful scenes in fresco, the panel in distemper that is to-day over the high-altar, containing a Madonna, S. Peter, S. Paul, S. John the Baptist, and other Saints; and on this Lippo put his name. After these works he wrought by himself a panel in distemper for the Friars of S. Augustine in San Gimignano, and thereby acquired so great a name that he was forced to send to Arezzo, to Bishop Guido de' Tarlati, a panel with three half-length figures which is to-day in the Chapel of S. Gregorio in the Vescovado.

While Simone was at work in Florence, one his cousin, an ingenious architect called Neroccio, undertook in the year 1332 to make to ring the great bell of the Commune of Florence, which, for a period of seventeen years, no one had been able to make to ring without twelve men to pull at it. He balanced it, then, in a manner that two could move it, and once moved one alone could ring it without a break, although it weighed more than six thousand libbre; wherefore, besides the honour, he gained thereby as his reward three hundred florins of gold, which was great payment in those times.

But to return to our two Memmi of Siena; Lippo, besides the works mentioned, wrought a panel in distemper, with the design of Simone, which was carried to Pistoia and placed over the high-altar of the Church of S. Francesco, and was held very beautiful. Finally, both having returned to their native city of Siena, Simone began a very large work in colour over the great gate of Camollia, containing the Coronation of Our Lady, with an infinity of figures, which remained unfinished, a very great sickness coming upon him, so that he, overcome by the gravity of the sickness, passed away from this life in the year 1345, to the very great sorrow of all his city and of Lippo his brother, who gave him honourable burial in S. Francesco.

Lippo afterwards finished many works that Simone had left imperfect, and among these was a Passion of Jesus Christ over the high-altar of S. Niccola in Ancona, wherein Lippo finished what Simone had begun, imitating that which the said Simone had made and finished in the Chapter-house of S. Spirito in Florence. This work would be worthy of a longer life than peradventure will be granted to it, there being in it many horses and

soldiers in beautiful attitudes, which they are striking with various animated movements, doubting and marvelling whether they have crucified or not the Son of God. At Assisi, likewise, in the lower Church of S. Francesco, he finished some figures that Simone had begun for the altar of S. Elizabeth, which is at the entrance of the door that leads into the chapels, making there a Madonna, a S. Louis King of France, and other Saints, in all eight figures, which are only as far as the knees, but good and very well coloured. Besides this, in the great refectory of the said convent, at the top of the wall, Simone had begun many little scenes and a Crucifix made in the shape of a Tree of the Cross, but this remained unfinished and outlined with the brush in red over the plaster, as may still be seen to-day; which method of working was the cartoon that our old masters used to make for painting in fresco, for greater rapidity; for having distributed the whole work over the plaster, they would outline it with the brush, reproducing from a small design all that which they wished to paint, and enlarging in proportion all that they thought to put down. Wherefore, even as this one is seen thus outlined, and many others in other places, so there are many others that had once been painted, from which the work afterwards peeled off, leaving them thus outlined in red over the plaster.

But returning to our Lippo, who drew passing well, as it may be seen in our book in a hermit who is reading with his legs crossed; he lived for twelve years after Simone, executing many works throughout all Italy, and in particular two panels in S. Croce in Florence. And seeing that the manner of these two brothers is very similar, one can distinguish the one from the other by this, that Simone used to sign his name at the foot of his works in this way: SIMONIS MEMMI SENENSIS OPUS; and Lippo, leaving out his baptismal name and caring nothing about a Latinity so rough, in this other fashion: OPUS MEMMI DE SENIS ME FECIT.

On the wall of the Chapter-house of S. Maria Novella – besides Petrarca and Madonna Laura, as it has been said above – Simone portrayed Cimabue, the architect Lapo, his son Arnolfo, and himself, and in the person of that Pope who is in the scene he painted Benedetto XI of Treviso, one of the Preaching Friars, the likeness of which Pope had been brought to Simone long before by Giotto, his master, when he returned from

the Court of the said Pope, who had his seat in Avignon. In the same place, also, beside the said Pope, he portrayed Cardinal Niccola da Prato, who had come to Florence at that time as Legate of the said Pontiff, as Giovanni Villani relates in his History.

Over the tomb of Simone was placed this epitaph:

SIMONI MEMMIO PICTORUM OMNIUM OMNIS ÆTATIS CELEBERRMO.
VIXIT ANN. LX, MENS. II, D. III.

As it is seen in our aforesaid book, Simone was not very excellent in draughtsmanship, but he had invention from nature, and he took much delight in drawing portraits from the life; and in this he was held so much the greatest master of his times that Signor Pandolfo Malatesti sent him as far as Avignon to portray Messer Francesco Petrarca, at the request of whom he made afterwards the portrait of Madonna Laura, with so much credit to himself.

TADDEO GADDI, Painter of Florence

It is a beautiful and truly useful and praiseworthy action to reward talent largely in every place, and to honour him who has it, seeing that an infinity of intellects which might otherwise slumber, roused by this encouragement, strive with all industry not only to learn their art but to become excellent therein, in order to advance themselves and to attain to a rank both profitable and honourable; whence there may follow honour for their country, glory for themselves, and riches and nobility for their descendants, who, upraised by such beginnings, very often become both very rich and very noble, even as the descendants of the painter Taddeo Gaddi did by reason of his work. This Taddeo di Gaddo Gaddi, a Florentine, after the death of Giotto – who had held him at his baptism and had been his master for twenty-four years after the death of Gaddo, as it is written by Cennino di Drea Cennini, painter of Colle di Valdelsa – remained among the first in the art of painting and greater than all his fellow-disciples both in judgment and in genius; and he wrought his first works, with a great facility given to him by nature rather than acquired by art, in the Church of S. Croce in Florence, in the chapel of the

sacristy, where, together with his companions, disciples of the
dead Giotto, he made some stories of S. Mary Magdalene, with
beautiful figures and with most beautiful and extravagant cos-
tumes of those times. And in the Chapel of the Baroncelli and
Bandini, where Giotto had formerly wrought the panel in distem-
per, he made by himself in fresco, on one wall, some stories of
Our Lady which were held very beautiful. He also painted over
the door of the said sacristy the story of Christ disputing with the
Doctors in the Temple, which was afterwards half ruined when
the elder Cosimo de' Medici, in making the noviciate, the chapel,
and the antechamber in front of the sacristy, placed a cornice of
stone over the said door. In the same church he painted in fresco
the Chapel of the Bellacci, and also that of S. Andrea by the side
of one of the three of Giotto, wherein he made the scene of Jesus
Christ taking Andrew and Peter from their nets, and the cruci-
fixion of the former Apostle, a work greatly commended and
extolled both then when it was finished and still at the present
day. Over the side-door, below the burial-place of Carlo Marsup-
pini of Arezzo, he made a Dead Christ with the Maries, wrought
in fresco, which was very much praised; and below the tramezzo*
that divides the church, on the left hand, above the Crucifix of
Donato, he painted in fresco a story of S. Francis, representing a
miracle that he wrought in restoring to life a boy who was killed
by falling from a terrace, together with his apparition in the air.
And in this story he portrayed Giotto his master, Dante the poet,
Guido Cavalcanti, and, some say, himself. Throughout the said
church, also, in diverse places, he made many figures which are
known by painters from the manner. For the Company of the
Temple he painted the shrine that is at the corner of the Via del
Crocifisso, containing a very beautiful Deposition from the
Cross.

In the cloister of S. Spirito he wrought two scenes in the little
arches beside the Chapter-house, in one of which he made Judas
selling Christ, and in the other the Last Supper that He held with
the Apostles. And in the same convent, over the door of the
refectory, he painted a Crucifix and some Saints, which give us
to know that among the others who worked here he was truly an
imitator of the manner of Giotto, which he held ever in the
greatest veneration. In S. Stefano del Ponte Vecchio he painted

* See note on p. 90.

the panel and the predella of the high-altar with great diligence; and on a panel in the Oratory of S. Michele in Orto he made a very good picture of a Dead Christ being lamented by the Maries and laid to rest very devoutly by Nicodemus in the Sepulchre.

In the Church of the Servite Friars he painted the Chapel of S. Niccolò, belonging to those of the palace, with stories of that Saint, wherein he showed very good judgment and grace in a boat that he painted, demonstrating that he had complete understanding of the tempestuous agitation of the sea and of the fury of the storm; and while the mariners are emptying the ship and jettisoning the cargo, S. Nicholas appears in the air and delivers them from that peril. This work, having given pleasure and having been much praised, was the reason that he was made to paint the chapel of the high-altar in that church, wherein he made in fresco some stories of Our Lady, and another figure of Our Lady on a panel in distemper, with many Saints wrought in lively fashion. In like manner, in the predella of the said panel, he made some other stories of Our Lady with little figures, whereof there is no need to make particular mention, seeing that in the year 1467 everything was destroyed when Lodovico, Marquis of Mantua, made in that place the tribune that is there to-day and the choir of the friars, with the design of Leon Battista Alberti, causing the panel to be carried into the Chapter-house of that convent; in the refectory of which Taddeo made, just above the wooden seats, the Last Supper of Jesus Christ with the Apostles, and above that a Crucifix with many Saints.

Having given the last touch to these works, Taddeo Gaddi was summoned to Pisa, where, for Gherardo and Bonaccorso Gambacorti, he wrought in fresco the principal chapel of S. Francesco, painting with beautiful colours many figures and stories of that Saint and of S. Andrew and S. Nicholas. Next, on the vaulting and on the front wall is Pope Honorius, who is confirming the Order; here Taddeo is portrayed from the life, in profile, with a cap wrapped round his head, and at the foot of this scene are written these words:

MAGISTER TADDEUS GADDUS DE FLORENTIA PINXIT HANC HISTORIAM SANCTI FRANCISCI ET SANCTI ANDREÆ ET SANCTI NICOLAI, ANNO DOMINI MCCCXLII, DE MENSE AUGUSTI.

Besides this, in the cloister also of the same convent he made in fresco a Madonna with her Child in her arms, very well coloured, and in the middle of the church, on the left hand as one enters, a S. Louis the Bishop, seated, to whom S. Gherardo da Villamagna, who had been a friar of this Order, is recommending a Fra Bartolommeo, then Prior of the said convent. In the figures of this work, seeing that they were taken from nature, there are seen liveliness and infinite grace, in that simple manner which was in some respects better than that of Giotto, above all in expressing supplication, joy, sorrow, and other similar emotions, which, when well expressed, ever bring very great honour to the painter.

Next, having returned to Florence, Taddeo continued for the Commune the work of Orsanmichele and refounded the piers of the Loggia, building them with stone dressed and well shaped, whereas before they had been made of bricks, without, however, altering the design that Arnolfo left, with directions that there should be made over the Loggia a palace with two vaults for storing the provisions of grain that the people and Commune of Florence used to make. To the end that this work might be finished, the Guild of Porta S. Maria, to which the charge of the fabric had been given, ordained that there should be paid thereunto the tax of the square of the grain-market and some other taxes of very small importance. But what was far more important, it was well ordained with the best counsel that each of the Guilds of Florence should make one pier by itself, with the Patron Saint of the Guild in a niche therein, and that every year, on the festival of each Saint, the Consuls of that Guild should go to church to make offering, and should hold there the whole of that day the standard with their insignia, but that the offering, none the less, should be to the Madonna for the succour of the needy poor. And because, during the great flood of the year 1333, the waters had swept away the parapets of the Ponte Rubaconte, thrown down the Castle of Altafronte, left nothing of the Ponte Vecchio but the two piers in the middle, and completely ruined the Ponte a S. Trinita except one pier that remained all shattered, as well as half the Ponte alla Carraia, bursting also the weir of Ognissanti, those who then ruled the city determined no longer to allow the dwellers on the other side of the Arno to have to return to their homes with so great inconvenience as was caused by their having to cross in boats. Wherefore, having sent for

Taddeo Gaddi, for the reason that Giotto his master had gone to Milan, they caused him to make the model and design of the Ponte Vecchio, giving him instructions that he should have it brought to completion as strong and as beautiful as might be possible; and he, sparing neither cost nor labour, made it with such strength in the piers and with such magnificence in the arches, all of stone squared with the chisel, that it supports to-day twenty-two shops on either side, which make in all forty-four, with great profit to the Commune, which drew from them eight hundred florins yearly in rents. The extent of the arches from one side to the other is thirty-two braccia, that of the street in the middle is sixteen braccia, and that of the shops on either side eight braccia. For this work, which cost sixty thousand florins of gold, not only did Taddeo then deserve infinite praise, but even to-day he is more than ever commended for it, for the reason that, besides many other floods, it was not moved in the year 1557, on September 13, by that which threw down the Ponte a S. Trinita and two arches of that of the Carraia, and shattered in great part the Rubaconte, together with much other destruction that is very well known. And truly there is no man of judgment who can fail to be amazed, not to say marvel, considering that the said Ponte Vecchio in so great an emergency could sustain unmoved the onset of the waters and of the beams and the wreckage made above, and that with so great firmness.

At the same time Taddeo directed the founding of the Ponte a S. Trinita, which was finished less happily in the year 1346, at the cost of twenty thousand florins of gold; I say less happily, because, not having been made like the Ponte Vecchio, it was entirely ruined by the said flood of the year 1557. In like manner, under the direction of Taddeo there was made at the said time the wall of the Costa a S. Gregorio, with piles driven in below, including two piers of the bridge in order to gain additional ground for the city on the side of the Piazza de' Mozzi, and to make use of it, as they did, to make the mills that are there.

While all these works were being made by the direction and design of Taddeo, seeing that he did not therefore stop painting, he decorated the Tribunal of the Mercanzia Vecchia, wherein, with poetical invention, he represented the Tribunal of Six (which is the number of the chief men of that judicial body), who are standing watching the tongue being torn from Falsehood by

Truth, who is clothed with a veil over the nude, while Falsehood
is draped in black; with these verses below:

> LA PURA VERITÀ, PER UBBIDIRE
> ALLA SANTA GIUSTIZIA, CHE NON TARDA,
> CAVA LA LINGUA ALLA FALSA BUGIARDA.

And below the scene are these verses:

> TADDEO DIPINSE QUESTO BEL RIGESTRO;
> DISCEPOL FU DI GIOTTO IL BUON MAESTRO.

Taddeo received a commission for some works in fresco in
Arezzo, which he carried to the greatest perfection in company
with his disciple Giovanni da Milano. Of these we still see one
in the Company of the Holy Spirit, a scene on the wall over the
high-altar, containing the Passion of Christ, with many horses,
and the Thieves on the Cross, a work held very beautiful by
reason of the thought that he showed in placing Him on the
Cross. Therein are some figures with vivid expressions which
show the rage of the Jews, some pulling Him by the legs with a
rope, others offering the sponge, and others in various attitudes,
such as the Longinus who is piercing His side, and the three
soldiers who are gambling for His raiment, in the faces of whom
there is seen hope and fear as they throw the dice. The first of
these, in armour, is standing in an uncomfortable attitude await-
ing his turn, and shows himself so eager to throw that he appears
not to be feeling the discomfort; the other, raising his eyebrows,
with his mouth and with his eyes wide open, is watching the dice,
in suspicion, as it were, of fraud, and shows clearly to anyone
who studies him the desire and the wish that he has to win. The
third, who is throwing the dice, having spread the garment on the
ground, appears to be announcing with a grin his intention of
casting them. In like manner, throughout the walls of the church
are seen some stories of S. John the Evangelist, and throughout
the city other works made by Taddeo, which are recognized as
being by his hand by anyone who has judgment in art. In the
Vescovado, also, behind the high-altar, there are still seen some
stories of S. John the Baptist, which are wrought with such mar-
vellous manner and design that they cause him to be held in
admiration. In the Chapel of S. Sebastiano in S. Agostino, beside
the sacristy, he made the stories of that martyr, and a Disputation
of Christ with the Doctors, so well wrought and finished that it

is a miracle to see the beauty in the changing colours of various sorts and the grace in the pigments of these works, which are finished to perfection.

In the Church of the Sasso della Vernia in the Casentino he painted the chapel wherein S. Francis received the Stigmata, assisted in the minor details by Jacopo di Casentino, who became his disciple by reason of this visit. This work finished, he returned to Florence together with Giovanni, the Milanese, and there, both within the city and without, they made very many panels and pictures of importance; and in process of time he gained so much, turning all into capital, that he laid the foundation of the wealth and the nobility of his family, being ever held a prudent and far-sighted man.

He also painted the Chapter-house in S. Maria Novella, being commissioned by the Prior of the place, who suggested the subject to him. It is true, indeed, that by reason of the work being large and of there being unveiled, at that time when the bridges were being made, the Chapter-house of S. Spirito, to the very great fame of Simone Memmi, who had painted it, there came to the said Prior a desire to call Simone to the half of this work; wherefore, having discussed the whole matter with Taddeo, he found him well contented therewith, for the reason that he had a surpassing love for Simone, because he had been his fellow-disciple under Giotto and ever his loving friend and companion. Oh! minds truly noble! seeing that without emulation, ambition, or envy, ye loved one another like brothers, each rejoicing as much in the honour and profit of his friend as in his own! The work was divided, therefore, and three walls were given to Simone, as I said in his Life, and Taddeo had the left-hand wall and the whole vaulting, which was divided by him into four sections or quarters in accordance with the form of the vaulting itself. In the first he made the Resurrection of Christ, wherein it appears that he wished to attempt to make the splendour of the Glorified Body give forth light, as we perceive in a city and in some mountainous crags; but he did not follow this up in the figures and in the rest, doubting, perchance, that he was not able to carry it out by reason of the difficulty that he recognized therein. In the second section he made Jesus Christ delivering S. Peter from shipwreck, wherein the Apostles who are manning the boat are certainly very beautiful; and among other things, one who is fishing with a line on the shore of the sea (a subject

already used by Giotto in the mosaics of the Navicella in S. Pietro) is depicted with very great and vivid feeling. In the third he painted the Ascension of Christ, and in the fourth the coming of the Holy Spirit, where there are seen many beautiful attitudes in the figures of the Jews who are seeking to gain entrance through the door. On the wall below are the Seven Sciences, with their names and with those figures below them that are appropriate to each. Grammar, in the guise of a woman, with a door, teaching a child, has the writer Donato seated below her. After Grammar follows Rhetoric, and at her feet is a figure that has two hands on books, while it draws a third hand from below its mantle and holds it to its mouth. Logic has the serpent in her hand below a veil, and at her feet Zeno of Elea, who is reading. Arithmetic is holding the tables of the abacus, and below her is sitting Abraham, its inventor. Music has the musical instruments, and below her is sitting Tubal-Cain, who is beating with two hammers on an anvil and is standing with his ears intent on that sound. Geometry has the square and the compasses, and below, Euclid. Astrology has the celestial globe in her hands, and below her feet, Atlas. In the other part are sitting seven Theological Sciences, and each has below her that estate or condition of man that is most appropriate to her – Pope, Emperor, King, Cardinals, Dukes, Bishops, Marquises, and others; and in the face of the Pope is the portrait of Clement V. In the middle and highest place is S. Thomas Aquinas, who was adorned with all the said sciences, holding below his feet some heretics – Arius, Sabellius, and Averroes; and round him are Moses, Paul, John the Evangelist, and some other figures, that have above them the four Cardinal Virtues and the three Theological, with an infinity of other details depicted by Taddeo with no little design and grace, insomuch that it can be said to have been the best conceived as well as the best preserved of all his works.

In the same S. Maria Novella, over the tramezzo* of the church, he also made a S. Jerome robed as a Cardinal, having such a devotion for that Saint that he chose him as the protector of his house; and below this, after the death of Taddeo, his son caused a tomb to be made for their descendants, covered with a slab of marble bearing the arms of the Gaddi. For these descendants, by reason of the excellence of Taddeo and of their merits,

* See note on p. 90.

Cardinal Jerome has obtained from God most honourable offices in the Church – Clerkships of the Chamber, Bishoprics, Cardinalates, Provostships, and Knighthoods, all most honourable; and all these descendants of Taddeo, of whatsoever degree, have ever esteemed and favoured the beautiful intellects inclined to the matters of sculpture and painting, and have given them assistance with every effort.

Finally, having come to the age of fifty and being smitten with a most violent fever, Taddeo passed from this life in the year 1350, leaving his sons Agnolo and Giovanni to apply themselves to painting, recommending them to Jacopo di Casentino for ways of life and to Giovanni da Milano for instruction in the art. After the death of Taddeo this Giovanni, besides many other works, made a panel which was placed on the altar of S. Gherardo da Villamagna in S. Croce, fourteen years after he had been left without his master, and likewise the panel of the high-altar of Ognissanti, where the Frati Umiliati had their seat, which was held very beautiful, and the tribune of the high-altar at Assisi, wherein he made a Crucifix, with Our Lady and S. Chiara, and stories of Our Lady on the walls and sides. Afterwards he betook himself to Milan, where he wrought many works in distemper and in fresco, and there finally he died.

Taddeo, then, adhered constantly to the manner of Giotto, but did not better it much save in the colouring, which he made fresher and more vivacious than that of Giotto, the latter having applied himself so ardently to improving the other departments and difficulties of this art, that although he gave attention to this, he could not, however, attain to the privilege of doing it, whereas Taddeo, having seen that which Giotto had made easy and having learnt it, had time to add something and to improve the colouring.

Taddeo was buried by Agnolo and Giovanni, his sons, in the first cloister of S. Croce, in that tomb which he had made for Gaddo his father, and he was much honoured with verses by the men of culture of that time, as a man who had been greatly deserving for his ways of life and for having brought to completion with beautiful design, besides his pictures, many buildings of great convenience to his city, and besides what has been mentioned, for having carried out with solicitude and diligence the construction of the Campanile of S. Maria del Fiore, from the design left by Giotto his master; which campanile was built in

such a manner that stones could not be put together with more diligence, nor could a more beautiful tower be made, with regard either to ornament, or cost, or design. The epitaph that was made for Taddeo was this that is to be read here:

HOC UNO DICI POTERAT FLORENTIA FELIX
VIVENTE; AT CERTA EST NON POTUISSE MORI.

Taddeo was very resolute in draughtsmanship, as it may be seen in our book, wherein is drawn by his hand the scene that he wrought in the Chapel of S. Andrea, in S. Croce at Florence.

ANDREA DI CIONE ORCAGNA,
Painter, Sculptor, and Architect, of Florence

RARELY is a man of parts excellent in one pursuit without being able easily to learn any other, and above all any one of those that are akin to his original profession, and proceed, as it were, from one and the same source, as did the Florentine Orcagna, who was painter, sculptor, architect, and poet, as it will be told below. Born in Florence, he began while still a child to give attention to sculpture under Andrea Pisano, and pursued it for some years; then, being desirous to become abundant in invention in order to make lovely historical compositions, he applied himself with so great study to drawing, assisted by nature, who wished to make him universal, that having tried his hand at painting with colours both in distemper and in fresco, even as one thing leads to another, he succeeded so well with the assistance of Bernardo Orcagna, his brother, that this Bernardo took him in company with himself to paint the life of Our Lady in the principal chapel of S. Maria Novella, which then belonged to the family of the Ricci. This work, when finished, was held very beautiful, although, by reason of the neglect of those who afterwards had charge of it, not many years passed before, the roof becoming ruined, it was spoilt by the rains and thereby brought to the condition wherein it is to-day, as it will be told in the proper place. It is enough for the present to say that Domenico Ghirlandajo, who repainted it, availed himself greatly of the invention put into it by Orcagna, who also painted in fresco in the same church the Chapel of the Strozzi, which is near to the door of the sacristy and of the belfry,

in company with Bernardo, his brother. In this chapel, to which one ascends by a staircase of stone, he painted on one wall the glory of Paradise, with all the Saints and with various costumes and head-dresses of those times. On the other wall he made Hell, with the abysses, centres, and other things described by Dante, of whom Andrea was an ardent student. In the Church of the Servites in the same city he painted in fresco, also with Bernardo, the Chapel of the family of Cresci; with a Coronation of Our Lady on a very large panel in S. Pietro Maggiore, and a panel in S. Romeo, close to the side-door. In like manner, he and his brother Bernardo painted the outer façade of S. Apollinare, with so great diligence that the colours in that exposed place have been preserved marvellously vivid and beautiful up to our own day.

Moved by the fame of these works of Orcagna, which were much praised, the men who at that time were governing Pisa had him summoned to work on a portion of one wall in the Campo Santo of that city, even as Giotto and Buffalmacco had done before. Wherefore, putting his hand to this, Andrea painted a Universal Judgment, with some fanciful inventions of his own, on the wall facing towards the Duomo, beside the Passion of Christ made by Buffalmacco; and making the first scene on the corner, he represented therein all the degrees of lords temporal wrapped in the pleasures of this world, placing them seated in a flowery meadow and under the shade of many orange-trees, which make a most delicious grove and have some Cupids in their branches above; and these Cupids, flying round and over many young women (all portraits from the life, as it seems clear, of noble ladies and dames of those times, who, by reason of the long lapse of time, are not recognized), are making a show of shooting at the hearts of these young women, who have beside them young men and nobles who are standing listening to music and song and watching the amorous dances of youths and maidens, who are sweetly taking joy in their loves. Among these nobles Orcagna portrayed Castruccio, Lord of Lucca, as a youth of most beautiful aspect, with a blue cap wound round his head and with a hawk on his wrist, and near him other nobles of that age, of whom we know not who they are. In short, in that first part, in so far as the space permitted and his art demanded, he painted all the delights of the world with exceeding great grace. In the other part of the same scene he represented on a high

mountain the life of those who, drawn by repentance for their sins and by the desire to be saved, have fled from the world to that mountain, which is all full of saintly hermits who are serving the Lord, busy in diverse pursuits with most vivacious expressions. Some, reading and praying, are shown all intent on contemplation, and others, labouring in order to gain their livelihood, are exercising themselves in various forms of action. There is seen here among others a hermit who is milking a goat, who could not be more active or more lifelike in appearance than he is. Below there is S. Macarius showing to three Kings, who are riding with their ladies and their retinue and going to the chase, human misery in the form of three Kings who are lying dead but not wholly corrupted in a tomb, which is being contemplated with attention by the living Kings in diverse and beautiful attitudes full of wonder, and it appears as if they are reflecting with pity for their own selves that they have in a short time to become such. In one of these Kings on horseback Andrea portrayed Uguccione della Faggiuola of Arezzo, in a figure which is holding its nose with one hand in order not to feel the stench of the dead and corrupted Kings. In the middle of this scene is Death, who, flying through the air and draped in black, is showing that she has cut off with her scythe the lives of many, who are lying on the ground, of all sorts and conditions, poor and rich, halt and whole, young and old, male and female, and in short a good number of every age and sex. And because he knew that the people of Pisa took pleasure in the invention of Buffalmacco, who gave speech to the figures of Bruno in S. Paolo a Ripa d'Arno, making some letters issue from their mouths, Orcagna filled this whole work of his with such writings, whereof the greater part, being eaten away by time, cannot be understood. To certain old men, then, he gives these words:

> DACCHÈ PROSPERITADE CI HA LASCIATI,
> O MORTE, MEDICINA D'OGNI PENA,
> DEH VIENI A DARNE OMAI L'ULTIMA CENA!

with other words that cannot be understood, and verses likewise in ancient manner, composed, as I have discovered, by Orcagna himself, who gave attention to poetry and to making a sonnet or two. Round these dead bodies are some devils who are tearing their souls from their mouths, and are carrying them to certain pits full of fire, which are on the summit of a very high mountain. Over against these are angels who are likewise taking the souls

from the mouths of others of these dead people, who have be-
longed to the good, and are flying with them to Paradise. And in
this scene there is a scroll, held by two angels, wherein are these
words:

ISCHERMO DI SAVERE E DI RICCHEZZA,
DI NOBILTADE ANCORA E DI PRODEZZA,
VALE NIENTE A I COLPI DI COSTEI;

with some other words that are difficult to understand. Next,
below this, in the border of this scene, are nine angels who are
holding legends both Italian and Latin in some suitable scrolls,
put into that place below because above they were like to spoil
the scene, and not to include them in the work seemed wrong to
their author, who considered them very beautiful; and it may be
that they were to the taste of that age. The greater part is omitted
by us, in order not to weary others with such things, which are
not pertinent and little pleasing, not to mention that the greater
part of these inscriptions being effaced, the remainder is little less
than fragmentary. After these works, in making the Judgment,
Orcagna set Jesus Christ on high above the clouds in the midst
of His twelve Apostles, judging the quick and the dead; showing
on one side, with beautiful art and very vividly, the sorrowful
expressions of the damned who are being dragged weeping by
furious demons to Hell, and, on the other, the joy and the jubi-
lation of the good, whom a body of angels guided by the Arch-
angel Michael are leading as the elect, all rejoicing, to the right,
where are the blessed. And it is truly a pity that for lack of
writers, in so great a multitude of men of the robe, chevaliers,
and other lords, that are clearly depicted and portrayed there
from the life, there should be not one, or only very few, of whom
we know the names or who they were; although it is said that a
Pope who is seen there is Innocent IV, friend* of Manfredi.

After this work, and after making some sculptures in marble
for the Madonna that is on the abutment of the Ponte Vecchio,
with great honour for himself, he left his brother Bernardo to
execute by himself a Hell in the Campo Santo, which is described
by Dante, and which was afterwards spoilt in the year 1530 and

* This is probably a printer's error for 'nemico,' as that Pope was anything
but the friend of Manfredi.

restored by Sollazzino, a painter of our own times; and he returned to Florence, where, in the middle of the Church of S. Croce, on a very great wall on the right, he painted in fresco the same subjects that he painted in the Campo Santo of Pisa, in three similar pictures, excepting, however, the scene where S. Macarius is showing to three Kings the misery of man, and the life of the hermits who are serving God on that mountain. Making, then, all the rest of that work, he laboured therein with better design and more diligence than he had done in Pisa, holding, nevertheless, to almost the same plan in the invention, the manner, the scrolls, and the rest, without changing anything save the portraits from life, for those in this work were partly of his dearest friends, whom he placed in Paradise, and partly of men little his friends, who were put by him in Hell. Among the good is seen portrayed from life in profile, with the triple crown on his head, Pope Clement VI, who changed the Jubilee in his reign from every hundred to every fifty years, and was a friend of the Florentines, and had some of Orcagna's pictures, which were very dear to him. Among the same is Maestro Dino del Garbo, a most excellent physician of that time, dressed as was then the wont of doctors, with a red bonnet lined with miniver on his head, and held by the hand by an angel; with many other portraits that are not recognized. Among the damned he portrayed Guardi, serjeant of the Commune of Florence, being dragged along by the Devil with a hook, and he is known by three red lilies that he has on his white bonnet, such as were then wont to be worn by the serjeants and other similar officials; and this he did because Guardi once made distraint on his property. He also portrayed there the notary and the judge who had been opposed to him in that action. Near to Guardi is Ceccho d' Ascoli, a famous wizard of those times; and a little above – namely, in the middle – is a hypocrite friar, who, having issued from a tomb, is seeking furtively to put himself among the good, while an angel discovers him and thrusts him among the damned.

Besides Bernardo, Andrea had a brother called Jacopo, who was engaged in sculpture, but with little profit; and in making on occasion for this Jacopo designs in relief and in clay, there came to him the wish to make something in marble and to see whether he remembered the principles of that art, wherein, as it has been said, he had worked in Pisa; and so, putting himself with more study to the test, he made progress therein in such a fashion that

afterwards he made use of it with honour, as it will be told. Afterwards he devoted himself with all his energy to the study of architecture, thinking that at some time or another he would have to make use of it. Nor did his thought deceive him, seeing that in the year 1355, the Commune of Florence having bought some citizens' houses near their Palace (in order to have more space and to make a larger square, and also in order to make a place where the citizens could take shelter in rainy or wintry days, and carry on under cover such business as was transacted on the Ringhiera when bad weather did not hinder), they caused many designs to be made for the building of a magnificent and very large Loggia for this purpose near the Palace, and at the same time for the Mint where the money is struck. Among these designs, made by the best masters in the city, that of Orcagna being universally approved and accepted as greater, more beautiful, and more magnificent than all the others, by decree of the Signori and of the Commune there was begun under his direction the great Loggia of the square, on the foundations made in the time of the Duke of Athens, and it was carried on with squared stone very well put together, with much diligence. And what was something new in those times, the arches of the vaulting were made no longer quarter-acute, as it had been the custom up to that time, but they were turned in half-circles in a new and laudable method, which gave much grace and beauty to this great fabric, which was brought to completion in a short time under the direction of Andrea. And if there had been taken thought to put it beside S. Romolo and to turn the arches with the back to the north, which they did not do, perchance, in order to have it conveniently near to the gate of the Palace, it would have been as useful a building for the whole city as it is beautiful in workmanship; whereas, by reason of the great wind, in winter no one can stand there. In this Loggia, between the arches on the front wall, in some ornamental work by his own hand, Orcagna made seven marble figures in half-relief representing the seven Theological and Cardinal Virtues, as accompaniment to the whole work, so beautiful that they made him known for no less able as sculptor than as painter and architect; not to mention that he was in all his actions as pleasant, courteous, and lovable a man as was ever any man of his condition. And because he would never abandon the study of any one of his professions for that of another, while the Loggia was building he made a panel in

distemper with many large figures, with little figures in the predella, for that chapel of the Strozzi wherein he had formerly made some works in fresco with his brother Bernardo; on which panel, it appearing to him that it could bear better testimony to his profession than the works wrought in fresco could do, he wrote his name with these words: ANNO DOMINI MCCCLVII, ANDREAS CIONIS DE FLORENTIA ME PINXIT.

This work completed, he made some pictures, also on panel, which were sent to the Pope in Avignon and are still in the Cathedral Church of that city. A little while afterwards the men of the Company of Orsanmichele, having collected large sums of money from offerings and donations given to their Madonna by reason of the mortality of 1348, resolved to make round her a chapel, or rather shrine, not only very ornate and rich with marbles carved in every way and with other stones of price, but also with mosaic and ornaments of bronze, as much as could possibly be desired, in a manner that both in workmanship and in material it might surpass every other work of so great a size wrought up to that day. Wherefore, the charge of the whole being given to Orcagna as the most excellent of that age, he made so many designs that finally one of them pleased the authorities, as being better than all the others. The work, therefore, being allotted to him, they put complete reliance in his judgment and counsel; wherefore, giving the making of all the rest to diverse master-carvers brought from several districts, he applied himself with his brother to executing all the figures of the work, and, the whole being finished, he had them built in and put together very thoughtfully without mortar, with clamps of copper fixed with lead, to the end that the shining and polished marbles might not become discoloured; and in this he succeeded so well, with profit and honour from those who came after him, that to one who studies that work it appears, by reason of such union and methods of joining discovered by Orcagna, that the whole chapel has been shaped out of one single piece of marble. And although it is in a German manner, for that style it has so great grace and proportion that it holds the first place among the works of those times, above all because its composition of figures great and small, and of angels and prophets in half-relief round the Madonna, is very well executed. Marvellous, also, is the casting of the bands of bronze, diligently polished, which, encircling the whole work, enclose and bind it together in a manner that it is therefore

as stout and strong as it is beautiful in all other respects. But how much he laboured in order to show the subtlety of his intellect in that gross age is seen in a large scene in half-relief on the back part of the said shrine, wherein, with figures of one braccio and a half each, he made the twelve Apostles gazing on high at the Madonna, while she, in a mandorla, surrounded by angels, is ascending to Heaven. In one of these Apostles he portrayed himself in marble, old, as he was, with the beard shaven, with the cap wound round the head, and with the face flat and round, as it is seen above in his portrait, drawn from that one. Besides this, he inscribed these words in the marble below: ANDREAS CIONIS, PICTOR FLORENTINUS, ORATORII ARCHIMAGISTER EXTITIT HUJUS, MCCCLIX.

It is known that the building of this Loggia and of the marble shrine, with all the master-work, cost ninety-six thousand florins of gold, which were very well spent, for the reason that it is, both in the architecture and in the sculptures and other ornaments, as beautiful as any other work whatsoever of those times, and is such that, by reason of the parts made therein by him, the name of Andrea Orcagna has been and will be ever living and great.

He used to write in his pictures: FECE ANDREA DI CIONE, SCULTORE; and in his sculptures: FECE ANDREA DI CIONE, PITTORE; wishing that his painting should be known by his sculpture, and his sculpture by his painting. There are throughout all Florence many panels made by him, which are partly known by the name, such as a panel in S. Romeo, and partly by the manner, such as one that is in the Chapter-house of the Monastery of the Angeli. Some of them that he left unfinished were completed by Bernardo, his brother, who survived him, but not for many years. And because, as it has been said, Andrea delighted in making verses and various forms of poetry, when already old he wrote some sonnets to Burchiello, then a youth; and finally, being sixty years of age, he finished the course of his life in 1389, and was borne with honour from his dwelling, which was in the Via Vecchia de' Corazzai, to his tomb.

There were many men able in sculpture and in architecture at the same time as Orcagna, of whom the names are not known, but their works are to be seen, and these are worthy of nothing but praise and commendation. Among their works is not only the Monastery of the Certosa of Florence, made at the expense of the noble family of the Acciaiuoli, and in particular of Messer

Niccola, Grand Seneschal of the King of Naples, but also the tomb of the same man, whereon he is portrayed in stone, and that of his father and one of his sisters, which has a covering of marble, whereon both were portrayed very well from nature in the year 1366. There, too, wrought by the hand of the same men, is the tomb of Messer Lorenzo, son of the said Niccola, who, dying at Naples, was brought to Florence and laid to rest there with the most honourable pomp of funeral obsequies. In like manner, in the tomb of Cardinal Santa Croce of the same family, which is in a choir then built anew in front of the high-altar, there is his portrait on a slab of marble, very well wrought in the year 1390.

Disciples of Andrea in painting were Bernardo Nello di Giovanni Falconi of Pisa, who wrought many panels in the Duomo of Pisa, and Tommaso di Marco of Florence, who, besides many other works, made in the year 1392 a panel that is in S. Antonio in Pisa, set up against the tramezzo* of the church.

After the death of Andrea, his brother Jacopo, who occupied himself in sculpture, as it has been said, and in architecture, was employed in the year 1328 on the foundation and building of the Tower and Gate of S. Piero Gattolini, and it is said that he made the four marzocchi† of stone which were placed on the four corners of the Palazzo Principale of Florence, all overlaid with gold. This work was much censured, by reason of there being laid on those places, without necessity, a greater weight than peradventure was expedient; and many would have been pleased to have the marzocchi made rather of plates of copper, hollow within, and then, after being gilded in the fire, set up in the same place, because they would have been much less heavy and more durable. It is said, too, that the same man made the horse, gilded and in full relief, that is in S. Maria del Fiore, over the door that leads to the Company of S. Zanobi, which horse is believed to be there in memory of Piero Farnese, Captain of the Florentines; however, knowing nothing more about this, I could not vouch for it. About the same time Mariotto, nephew of Andrea, made in fresco the Paradise of S. Michele Bisdomini, in the Via de' Servi in Florence, and the panel with an Annunciation that is on the altar; and for Monna Cecilia de' Boscoli he made another panel with many figures, placed near the door of the same church.

* See note on p. 90.
† Lions of stone, emblems of the city of Florence.

But among all the disciples of Orcagna none was more excellent than Francesco Traini, who made a panel with a ground of gold for a nobleman of the house of Coscia, who is buried at Pisa in the Chapel of S. Domenico, in the Church of S. Caterina; which panel contained a S. Dominic standing two braccia and a half high, with six scenes of his life on either side of him, animated and vivacious and well coloured. And in the same church, in the Chapel of S. Tommaso d' Aquino, he made a panel in distemper with fanciful invention, which is much praised, placing therein the said S. Thomas seated, portrayed from the life: I say from the life, because the friars of that place had an image of him brought from the Abbey of Fossa Nuova, where he died in the year 1323. Below, round S. Thomas, who is placed seated in the air with some books in his hand, which are illuminating the Christian people with their rays and lustre, there are kneeling a great number of doctors and clergy of every sort, Bishops, Cardinals, and Popes, among whom is the portrait of Pope Urban VI. Under the feet of S. Thomas are standing Sabellius, Arius, Averroes, and other heretics and philosophers, with their books all torn; and the said figure of S. Thomas is placed between Plato, who is showing him the *Timæus*, and Aristotle, who is showing him the *Ethics*. Above, a Jesus Christ, in like manner in the air between the four Evangelists, is blessing S. Thomas, and appears to be in the act of sending down upon him the Holy Spirit, and filling him with it and with His grace. This work, when finished, acquired very great fame and praise for Francesco Traini, for in making it he surpassed his master Andrea by a great measure in colouring, in harmony, and in invention. This Andrea was very diligent in his drawings, as it may be seen in our book.

TOMMASO, CALLED GIOTTINO,
Painter of Florence

WHEN those arts that proceed from design come into competition and their craftsmen work in rivalry, without doubt the good intellects, exercising themselves with much study, discover new things every day in order to satisfy the various tastes of men; and some, speaking for the present of painting, executing works obscure and unusual and demonstrating in them the difficulty of

making them, make known by the shadows the brightness of
their genius. Others, fashioning the sweet and delicate, thinking
these to be likely to be more pleasing to the eyes of all who
behold them by reason of their having more relief, easily attract
to themselves the minds of the greater part of men. Others,
again, painting with unity and lowering the tones of the colours,
reducing to their proper places the lights and shades of their
figures, deserve very great praise, and reveal the thoughts of the
intellect with beautiful dexterity of mind; even as they were ever
revealed with a sweet manner in the works of Tommaso di Ste-
fano, called Giottino, who, being born in the year 1324 and hav-
ing learnt from his father the first principles of painting, resolved
while still very young to attempt, in so far as he might be able
with assiduous study, to be an imitator of the manner of Giotto
rather than of that of his father Stefano. In this attempt he suc-
ceeded so well that he gained thereby, besides the manner,
which was much more beautiful than that of his master, the sur-
name of Giottino, which never left him; nay, by reason both
of the manner and of the name it was the opinion of many,
who, however, were in very great error, that he was the son of
Giotto; but in truth it is not so, it being certain, or to speak more
exactly, believed (it being impossible for such things to be
affirmed by any man) that he was the son of Stefano, painter of
Florence.

He was, then, so diligent in painting and so greatly devoted to
it, that, although many of his works are not to be found, those
nevertheless that have been found are good and in a beautiful
manner, for the reason that the draperies, the hair, the beards,
and all the rest of his work were made and harmonized with so
great softness and diligence, that it is seen that without doubt he
added harmony to this art and had it much more perfect than his
master Giotto and his father Stefano. In his youth Giottino
painted a chapel near the side-door of S. Stefano al Ponte Vec-
chio in Florence, wherein, although it is to-day much spoilt by
damp, the little that has remained shows the dexterity and the
genius of the craftsman. Next, he made the two Saints, Cosimo
and Damiano, for the Frati Ermini in the Canto alla Macine, but
little is seen of them to-day, for they too have been ruined by
time. And he wrought in fresco a chapel in the old S. Spirito in
that city, which was afterwards ruined in the burning of that
church; and in fresco, over the principal door of the church, the

story of the Sending of the Holy Spirit; and on the square before the said church, on the way to the Canto alla Cuculia, on the corner of the convent, he painted that shrine that is still seen there, with Our Lady and other Saints round her, wherein both the heads and the other parts lean strongly towards the modern manner, for the reason that he sought to vary and to blend the flesh-colours, and to harmonize all the figures with grace and judgment by means of a variety of colours and draperies. In like manner he wrought the stories of Constantine with much diligence in the Chapel of S. Silvestro in S. Croce, showing very beautiful ideas in the gestures of the figures; and then, behind an ornament of marble made for the tomb of Messer Bertino de' Bardi, a man who at that time had held honourable military rank, he made this Messer Bertino in armour, after the life, issuing from a sepulchre on his knees, being summoned with the sound of the trumpets of the Judgment by two angels, who are in the air accompanying a beautifully-wrought Christ in the clouds. On the right hand of the entrance of the door of S. Pancrazio the same man made a Christ who is bearing His Cross, and some Saints near Him, that have exactly the manner of Giotto. In S. Gallo (which convent was without the Gate called by the same name, and was destroyed in the siege) in a cloister, there was a Pietà painted in fresco, whereof there is a copy in the aforesaid S. Pancrazio, on a pillar beside the principal chapel. In S. Maria Novella, in the Chapel of S. Lorenzo de' Giuochi, as one enters by the door on the left, on the front wall, he wrought in fresco a S. Cosimo and a S. Damiano, and, in Ognissanti, a S. Christopher and a S. George, which were spoilt by the malice of time, and then restored by other painters by reason of the ignorance of a Provost little conversant with such matters. In the said church there has remained whole the arch that is over the door of the sacristy, wherein there is in fresco a Madonna with the Child in her arms by the hand of Tommaso, which is a good work, by reason of his having wrought it with diligence.

By means of these works Giottino had acquired so good a name, imitating his master both in design and in invention, as it has been told, that there was said to be in him the spirit of Giotto himself, both because of the vividness of his colouring and of his mastery in draughtsmanship; and in the year 1343, on July 2, when the Duke of Athens was driven out by the people and when he had renounced the sovereignty and restored their

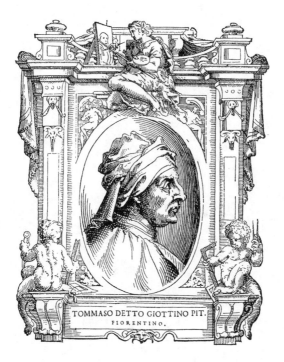

TOMMASO DETTO GIOTTINO PIT.
FIORENTINO.

liberty to the Florentines, Giottino was forced by the twelve Reformers of the State, and in particular by the prayers of Messer Agnolo Acciaiuoli, then a very great citizen, who had great influence with him, to paint in contempt, on the tower of the Palace of the Podestà, the said Duke and his followers, who were Messer Ceritieri Visdomini, Messer Maladiasse, his Conservator, and Messer Ranieri da San Gimignano, all with the cap of Justice ignominiously on their heads. Round the head of the Duke were many beasts of prey and other sorts, signifying his nature and his character; and one of those his counsellors had in his hand the Palace of the Priors of the city, and was handing it to him, like a disloyal traitor to his country. And all had below them the arms and emblems of their families, and some writings which can hardly be read to-day because they have been eaten away by time. In this work, both by reason of the draughtsmanship and of the great diligence wherewith it was executed, the manner of the craftsman gave universal pleasure to all. Afterwards, at the Campora, a seat of the Black Friars without the Porta a S. Piero Gattolini, he made a S. Cosimo and a S. Damiano, which were spoilt in the whitewashing of the church; and on the bridge of Romiti in Valdarno he painted in fresco the shrine that is built over the middle, with his own hand and in a beautiful manner.

It is found recorded by many who wrote thereon that Tommaso applied himself to sculpture and wrought a figure in marble on the Campanile of S. Maria del Fiore in Florence, four braccia high and facing the place where the Orphans now dwell. In S. Giovanni Laterano in Rome, likewise, he brought to fine completion a scene wherein he represented the Pope in several capacities, which is now seen to have been eaten away and corroded by time; and in the house of the Orsini he painted a hall full of famous men; with a very beautiful S. Louis on a pillar in the Araceli, on the right hand beside the altar.

In the lower church of S. Francesco at Assisi, in an arch over the pulpit (there being no other space that was not painted) he wrought the Coronation of Our Lady, with many angels round her, so gracious, so beautiful in the expressions of the faces, and so sweet and delicate in manner, that they show, with the usual harmony of colour which was something peculiar to this painter, that he had proved himself the peer of all who had lived up to that time; and round this arch he made some stories of S. Nicholas. In like manner, in the Monastery of S. Chiara in the

same city, in the middle of the church, he painted a scene in fresco, wherein is S. Chiara supported in the air by two angels who appear real; she is restoring to life a child that was dead, while round her are standing many women all full of wonder, with great beauty in the faces and in the very gracious head-dresses and costumes of those times that they are wearing. In the same city of Assisi, over the gate of the city that leads to the Duomo – namely, in an arch on the inner side – he made a Madonna with the Child in her arms, with so great diligence that she appears alive, and a S. Francis and another Saint, both very beautiful; both of which works, although the story of S. Chiara remained unfinished by reason of Tommaso having fallen sick and returned to Florence, are perfect and most worthy of all praise.

It is said that Tommaso was melancholic in temperament and very solitary, but with respect to art devoted and very studious, as it is clearly seen from a panel in the Church of S. Romeo in Florence, wrought by him in distemper with so great diligence and love that there has never been seen a better work on wood by his hand. In this panel, which is placed in the tramezzo* of the church, on the right hand, is a Dead Christ with the Maries and Nicodemus, accompanied by other figures, who are bewailing His death with bitterness and with very sweet and affectionate movements, wringing their hands with diverse gestures, and beating themselves in a manner that in the air of the faces there is shown very clearly their sharp sorrow at the so great cost of our sins. And it is something marvellous to consider, not that he penetrated with his genius to such a height of imagination, but that he could express it so well with the brush. Wherefore this work is consummately worthy of praise, not so much by reason of the subject and of the invention, as because in it the craftsman has shown, in some heads that are weeping, that although the lineaments of those that are weeping are distorted in the brows, in the eyes, in the nose, and in the mouth, this, however, neither spoils nor alters a certain beauty which is wont to suffer much in weeping when the painters do not know well how to avail themselves of the good methods of art. But it is no great thing that Giottino should have executed this panel with so much consideration, since in his labours he ever aimed rather at fame and glory than at any other reward, being free from the greed of gain, that

* See note on p. 90.

makes our present masters less diligent and good. And even as he did not seek to have great riches, so he did not trouble himself much about the comforts of life – nay, living poorly, he sought to satisfy others rather than himself; wherefore, taking little care of himself and enduring fatigue, he died of consumption at the age of thirty-two, and was given burial by his relatives at the Martello Gate without S. Maria Novella, beside the tomb of Bontura.

Disciples of Giottino, who left more fame than wealth, were Giovanni Tossicani of Arezzo, Michelino, Giovanni dal Ponte, and Lippo, who were passing good masters of this art, but above all Giovanni Tossicani, who made many works throughout all Tuscany after Tommaso and in the same manner as his, and in particular the Chapel of S. Maria Maddalena, belonging to the Tuccerelli, in the Pieve of Arezzo, and a S. James on a pillar in the Pieve of the township of Empoli. In the Duomo of Pisa, also, he wrought some panels which have since been removed in order to make room for the modern. The last work that he made was in a chapel of the Vescovado of Arezzo, for the Countess Giovanna, wife of Tarlato da Pietramala – namely, a very beautiful Annunciation, with S. James and S. Philip; which work, by reason of the back of the wall being turned to the north, was little less than completely spoilt by damp, when Maestro Agnolo di Lorenzo of Arezzo restored the Annunciation, and shortly afterwards Giorgio Vasari, still a youth, restored the S. James and S. Philip, to his own great profit, having learnt much, at that time when he had not the advantage of other masters, by studying Giovanni's method of painting and the shadows and colours of that work, spoilt as it was. In this chapel there are still read these words in an epitaph of marble, in memory of the Countess who had it built and painted:

ANNO DOMINI 1335, DE MENSE AUGUSTI, HANC CAPELLAM CONSTITUI FECIT NOBILIS DOMINA COMITISSA JOANNA DE SANCTA FLORA, UXOR NOBILIS MILITIS DOMINI TARLATI DE PETRAMALA, AD HONOREM BEATÆ MARIÆ VIRGINIS.

Of the works of the other disciples of Giottino there is no mention made, seeing that they were but ordinary and little like those of the master and of Giovanni Tossicani, their fellow-disciple. Tommaso drew very well, as it may be seen in our book, in certain drawings wrought by his hand with much diligence.

GIOVANNI DAL PONTE, Painter of Florence

ALTHOUGH there is no truth and not much confidence to be placed in the ancient proverb that the prodigal's purse is never empty, and although, on the contrary, it is very true that he who does not live a well-ordered life in his own degree lives at the last in want and dies miserably, it is seen, nevertheless, that fortune sometimes aids rather those who squander without restraint than those who are in all things careful and self-restrained; and when the favour of fortune ceases, there often comes death, to make up for her defection and for the bad management of men, supervening at the very moment when such men would begin with infinite dismay to recognize how miserable a thing it is to have squandered in youth and to want in old age, living and labouring in poverty, as would have happened to Giovanni da Santo Stefano a Ponte of Florence, if, after having consumed his patrimony and much gain which had been brought to his hands rather by fortune than by his merits, with some inheritances that came to him from an unexpected source, he had not finished at one and the same time the course of his life and all his means.

This man, then, who was a disciple of Buonamico Buffalmacco, and who imitated him more in attending to the pleasures of life than in seeking to become an able painter, was born in the year 1307, and after being in early youth a disciple of Buffalmacco, he made his first works in the Chapel of S. Lorenzo, in the Pieve of Empoli, painting there in fresco many scenes of the life of that Saint, with so great diligence that he was summoned to Arezzo in the year 1344, a better development being expected after so fine a beginning; and there he painted the Assumption of Our Lady in a chapel in S. Francesco. And a little time afterwards, being in some credit in that city for lack of other painters, he painted the Chapel of S. Onofrio in the Pieve, with that of S. Antonio, which to-day is spoilt by damp. He also made some other pictures that were in S. Giustina and in S. Matteo, but these were thrown to the ground by Duke Cosimo, together with the said churches, in the making of fortifications for that city; and exactly in that place, at the foot of the abutment of an ancient bridge beside the said S. Giustina, where the stream entered the city, there were then found a head of Appius Cæcus and one of his son, both in marble and very beautiful, with an ancient

epitaph, likewise very beautiful, which are all now in the guarda-roba* of the said Lord Duke.

Giovanni, having returned to Florence at the time when there was finished the closing of the middle arch of the Ponte a S. Trinita, painted many figures both within and without a chapel built over one pier and dedicated to S. Michelagnolo, and in particular all the front wall; which chapel, together with the bridge, was carried away by the flood of the year 1557. It is by reason of these works that some maintain, besides what has been said about him at the beginning, that he was ever afterwards called Giovanni dal Ponte. In Pisa, also, in the year 1355, he made some scenes in fresco behind the altar of the principal chapel of S. Paolo a Ripa d' Arno, which are now all spoilt by damp and by time. Giovanni also painted the Chapel of the Scali in S. Trinita in Florence, with another that is beside it, and one of the stories of S. Paul by the side of the principal chapel, where is the tomb of Maestro Paolo, the astrologer. In S. Stefano al Ponte Vecchio he painted a panel, with other pictures in distemper and in fresco both within and without Florence, which brought him considerable credit.

He gave contentment to his friends, but more in his pleasures than in his works, and he was the friend of men of learning, and in particular of all those who pursued the studies of his own profession in order to become excellent therein; and although he had not sought to have in himself that which he desired in others, yet he never ceased to encourage others to work valiantly. Finally, having lived fifty-nine years, Giovanni was seized by pleurisy and in a few days departed this life, wherein, had he survived a little longer, he would have suffered many discomforts, there being left in his house scarce as much as sufficed to give him decent burial in S. Stefano al Ponte Vecchio. His works date about 1365.

In our book of drawings by diverse ancients and moderns there is a drawing in water-colour by the hand of Giovanni, wherein is a S. George on horseback who is slaying the Dragon, and a skeleton, which bear witness to the method and manner that he had in drawing.

* Guardaroba, the room or rooms where everything of value was stored – clothes, linen, art treasures, furniture, etc.

AGNOLO GADDI, Painter of Florence

How honourable and profitable it is to be excellent in a noble art is manifestly seen in the talent and management of Taddeo Gaddi, who, having acquired very good means as well as fame with his industry and labours, left the affairs of his family so well arranged, when he passed to the other life, that Agnolo and Giovanni, his sons, were easily able to give a beginning to the very great riches and to the exaltation of the house of Gaddi, to-day very noble in Florence and in great repute throughout all Christendom. And in truth it has been very reasonable, seeing that Gaddo, Taddeo, Agnolo, and Giovanni adorned many honoured churches with their talent and their art, that their successors have been since adorned by the Holy Roman Church and by the Supreme Pontiffs of the same with the greatest ecclesiastical dignities.

Taddeo, then, of whom we have already written the Life, left his sons Agnolo and Giovanni in company with many of his disciples, hoping that Agnolo, in particular, would become very excellent in painting; but he, who in his youth showed promise of surpassing his father by a great measure, did not succeed further in justifying the opinion that had already been conceived of him, for the reason that, being born and bred in easy circumstances, which are often an impediment to study, he was given more to traffic and to trading than to the art of painting; which should not appear a thing new or strange, seeing that avarice very often bars the way to many intellects which would ascend to the greatest height of excellence, if the desire of gain did not impede their path in their earliest and best years. Working as a youth in S. Jacopo tra' Fossi in Florence, Agnolo wrought a little scene, with figures little more than a braccio high, of Christ raising Lazarus on the fourth day after death, wherein, imagining the corruption of that body, which had been dead three days, with much thought he made the grave-clothes which held him bound discoloured by the decay of the flesh, and round the eyes certain livid and yellowish marks in the flesh, that seems half living and half dead; not without stupefaction in the Apostles and in other figures, who, with attitudes varied and beautiful, and with their draperies to their noses in order not to feel the stench of that corrupt body, are no less afraid and awestruck at such a

marvellous miracle than Mary and Martha are joyful and content to see life returning to the dead body of their brother. This work was judged so excellent that many deemed the talent of Agnolo to be destined to surpass all the disciples of Taddeo, and even Taddeo himself; but the event proved otherwise, because, even as in youth the will conquers every difficulty in order to acquire fame, so a certain negligence that the years bring with them often causes a man, instead of advancing, to go backwards, as did Agnolo. Having given so great a proof of his talent, he was commissioned by the family of Soderini, who had great hopes of him, to paint the principal chapel of the Carmine, and he painted therein all the life of Our Lady, so much less well than he had done the resurrection of Lazarus, that he gave every man to know that he had little wish to attend with every effort to the art of painting; for the reason that in all that great work there is nothing else of the good save one scene, wherein, round Our Lady, in a room, are many maidens who are wearing diverse costumes and head-dresses, according to the diversity of the use of those times, and are engaged in diverse exercises: this one is spinning, that one is sewing, that other is winding thread, one is weaving, and others working in other ways, all passing well conceived and executed by Agnolo.

For the noble family of the Alberti, likewise, he painted in fresco the principal chapel of the Church of S. Croce, making therein all that came to pass in the discovery of the Cross, and he executed that work with much mastery of handling but not with much design, for only the colouring is beautiful and good enough. Next, in painting in fresco some stories of S. Louis in the Chapel of the Bardi in the same church, he acquitted himself much better. And because he used to work by caprice, now with more zeal and now with less, working in S. Spirito, also in Florence, within the door that leads from the square into the convent, he made in fresco, over another door, a Madonna with the Child in her arms, and S. Augustine and S. Nicholas, so well that the said figures appear as if made only yesterday.

And because in a certain manner there had come to Agnolo, by way of inheritance, the secret of working in mosaic, and he had at home the instruments and all the materials that his grand-father Gaddo had used in this, he would make something in mosaic when it pleased him, merely to pass time and by reason of that convenience of material, rather than for aught else. Now,

seeing that time had eaten away many of those marbles that cover
the eight faces of the roof of S. Giovanni, and that the damp
penetrating within had therefore spoilt much of the mosaic which
Andrea Tafi had wrought there at a former time, the Consuls of
the Guild of Merchants determined, to the end that the rest
might not be spoilt, to rebuild the greater part of that covering
with marble, and in like manner to have the mosaic restored.
Wherefore, the direction and commission for the whole being
given to Agnolo, he, in the year 1346, had it recovered with new
marbles and the pieces laid over each other at the joinings, with
unexampled diligence, to the breadth of two fingers, cutting each
slab to the half of its thickness; then, joining them together with
cement made of mastic and wax melted together, he fitted them
with so great diligence that from that time onwards neither the
roof nor the vaulting has received any damage from the rains.
Agnolo, having afterwards restored the mosaic, brought it about
by means of his counsel and of a design very well conceived that
there was rebuilt, round the said church, all the upper cornice of
marble below the roof, in that form wherein it now remains;
which cornice was much smaller than it is and very common-
place. Under direction of the same man there was also made the
vaulting of the Great Hall of the Palace of the Podestà, which
before was directly under the roof, to the end that, besides the
adornment, fire might not again be able to do it damage, as it had
done a long time before. After this, by the counsel of Agnolo,
there were made round the said Palace the battlements that
are there to-day, which before were in no wise there.

The while that these works were executing, he did not desert
his painting entirely, and painted in distemper, in the panel that
he made for the high-altar of S. Pancrazio, Our Lady, S. John the
Baptist, and the Evangelist, and beside them the Saints Nereus,
Archileus, and Pancratius, brothers, with other Saints. But the
best of this work – nay, all that is seen therein of the good – is
the predella alone, which is all full of little figures, divided into
eight stories of the Madonna and of S. Reparata. Next, in 1348,
he painted the panel of the high-altar of S. Maria Maggiore, also
in Florence, for Barone Cappelli, making therein a passing good
dance of angels round a Coronation of Our Lady. A little after-
wards in the Pieve of the district of Prato, rebuilt under direction
of Giovanni Pisano in the year 1312, as it has been said above,
Agnolo painted in fresco, in the chapel wherein was deposited

the Girdle of Our Lady, many scenes of her life; and in other churches of that district, which was full of monasteries and convents held in great honour, he made other works in plenty. In Florence, next, he painted the arch over the door of S. Romeo; and in Orto S. Michele he wrought in distemper a Disputation of the Doctors with Christ in the Temple. And at the same time, many houses having been pulled down in order to enlarge the Piazza de' Signori, and in particular the Church of S. Romolo, this was rebuilt with the design of Agnolo. There are many panels by his hand throughout the churches in the said city, and many of his works may also be recognized in the domain, which were wrought by him with much profit to himself, although he worked more in order to do as his forefathers had done than for any love of it, having his mind directed on commerce, which brought him better profit; as it is seen when his sons, not wishing any longer to be painters, gave themselves over completely to commerce, holding a house open for this purpose in Venice together with their father, who, from a certain time onward, did not work save for his own pleasure, and, in a certain manner, in order to pass time. Having thus acquired great wealth by means of trading and by means of his art, Agnolo died in the sixty-third year of his life, overcome by a malignant fever which in a few days made an end of him.

His disciples were Maestro Antonio da Ferrara, who made many beautiful works in S. Francesco at Urbino, and at Città di Castello; and Stefano da Verona, who painted in fresco most perfectly, as it is seen in many places at Verona, his native city, and also in many of his works at Mantua. This man, among other things, was excellent in giving very beautiful expressions to the faces of children, of women, and of old men, as it may be seen in his works, which were all imitated and copied by that Piero da Perugia, illuminator, who illuminated all the books that are in the library of Pope Pius in the Duomo at Siena, and was a practised colourist in fresco. A disciple of Agnolo, also, was Michele da Milano, as was Giovanni Gaddi, his brother, who made, in the cloister of S. Spirito where are the little arches of Gaddo and of Taddeo, the Disputation of Christ in the Temple with the Doctors, the Purification of the Virgin, the Temptation of Christ in the Wilderness, and the Baptism of John; and finally, having created very great expectation, he died. A pupil of the same Agnolo in painting was Cennino di Drea Cennini of Colle di

Valdelsa, who, having very great affection for the art, wrote a book describing the methods of working in fresco, in distemper, in size, and in gum, and, besides, how illuminating is done, and all the methods of applying gold; which book is in the hands of Giuliano, goldsmith of Siena, an excellent master and a friend of these arts. And in the beginning of this his book he treated of the nature of colours, both the minerals and the earth-colours, according as he learnt from Agnolo his master, wishing, for the reason perchance that he did not succeed in learning to paint perfectly, at least to know the nature of the colours, the distempers, the sizes, and the application of gesso, and what colours we must guard against as harmful in making the mixtures, and in short many other considerations whereof there is no need to discourse, there being to-day a perfect knowledge of all those matters which he held as great and very rare secrets in those times. But I will not forbear to say that he makes no mention (and perchance they may not have been in use) of some earth-colours, such as dark red earths, cinabrese, and certain vitreous greens. Since then there have been also discovered umber, which is an earth-colour, giallo santo,* the smalts both for fresco and for oils, and some vitreous greens and yellows, wherein the painters of that age were lacking. He treated finally of mosaics, and of grinding colours in oils in order to make grounds of red, blue, green, and in other manners; and of the mordants for the application of gold, but not then for figures. Besides the works that he wrought in Florence with his master, there is a Madonna with certain saints by his hand under the loggia of the hospital of Bonifazio Lupi, coloured in such a manner that it has been very well preserved up to our own day.

This Cennino, in the first chapter of his said book, speaking of himself, uses these very words: 'I, Cennino di Drea Cennini, of Colle di Valdelsa, was instructed in the said art for twelve years by Agnolo di Taddeo of Florence, my master, who learnt the said art from Taddeo, his father, who was held at baptism by Giotto and was his disciple for four-and-twenty years; which Giotto transmuted the art of painting from Greek into Latin, and brought it to the modern manner, and had it for certain more perfected than anyone ever had it.' These are the very words of Cennino, to

* A yellow-lake made from the unripe berries of the spin cervino, a sort of brier.

whom it appeared that even as those who translate any work
from Greek into Latin confer very great benefit on those who do
not understand Greek, so, too, did Giotto in transforming the art
of painting from a manner not understood or known by anyone,
save perchance as very rude, to a beautiful, facile, and very pleas-
ing manner, understood and known as good by all who have
judgment and the least grain of reason.

All these disciples of Agnolo did him very great honour, and
he was buried by his sons, to whom it is said that he left the sum
of fifty thousand florins or more, in S. Maria Novella, in the
tomb that he himself had made for himself and for his descend-
ants, in the year of our salvation 1387. The portrait of Agnolo,
made by himself, is seen in the Chapel of the Alberti, in S. Croce,
beside a door in the scene wherein the Emperor Heraclius is
bearing the Cross; it is painted in profile, with a little beard, and
with a rose-coloured cap on his head according to the use of
those times. He was not excellent in draughtsmanship, in so far
as is shown by some drawings by his hand that are in our book.

BERNA, Painter of Siena

IF those who labour to become excellent in some art did not
very often have the thread of life cut by death in their best years,
I have no doubt that many intellects would arrive at that rank
which is most desired both by them and by the world. But the
short life of men and the bitterness of various accidents, which
threaten them from all sides, snatch them from us sometimes
prematurely, as could be seen in poor young Berna of Siena, who,
although he died young, nevertheless left so many works that he
appears to have lived very long; and those that he left were made
in such a way, that it may well be believed from this showing that
he would have become excellent and rare if he had not died so
soon. In two chapels of S. Agostino in Siena there are seen some
little pictures with figures in fresco, by his hand; and in the
church, on a wall now pulled down in order to make chapels
there, was a scene of a youth led to execution, as well made as it
could possibly be imagined, there being seen expressed in it the
pallor and fear of death, in so lifelike a manner that he deserved
therefore the highest praise. Beside the said youth was a friar

painted in a very fine attitude, and, in short, everything in that
work is so vividly wrought that it appears, indeed, that in
this work Berna imagined this event as most horrible, as it must
be, and full of most bitter and cruel terror, seeing that he portrayed
it so well with the brush that the same scene appearing in reality
would not stir greater emotion.

In the city of Cortona, also, besides many other works scat-
tered in many places in that city, he painted the greater part of
the vaulting and of the walls of the Church of S. Margherita,
where to-day is the seat of the Frati Zoccolanti. From Cortona
he went to Arezzo in the year 1369, exactly when the Tarlati,
formerly Lords of Pietramala, had caused Moccio, a sculptor and
architect of Siena, to finish the Convent and the body of the
Church of S. Agostino in that city, in the lesser aisles of which
many citizens had caused chapels and tombs to be made for their
families; and there, in the Chapel of S. Jacopo, Berna painted in
fresco some little scenes of the life of that Saint, and especially
vivid is the story of Marino the swindler, who, having by reason
of greed of gold given his soul to the Devil and made thereunto
a written contract in his own hand, is making supplication to the
Saint to free him from this promise, while a Devil, showing him
the contract, is pressing him with the greatest insistence in the
world. In all these figures Berna expressed the emotions of the
mind with much vivacity, and particularly in the face of Marino,
which shows on one side fear, and on the other the faith and
trust that make him hope for his liberation from S. James, al-
though opposite there is seen the Devil, hideous to a marvel, who
is warmly speaking and declaring his rights to the Saint, who,
after having instilled into Marino extreme penitence for his sin
and for the promise made, is liberating him and leading him back
to God. This same story, says Lorenzo Ghiberti, by the hand of
the same man, was in a chapel of the Capponi, dedicated to
S. Nicholas, in S. Spirito at Florence, before that church was
burnt down. After this work, then, Berna painted a great Crucifix
in a chapel of the Vescovado of Arezzo for Messer Guccio di
Vanni Tarlati da Pietramala, and at the foot of the Cross a Ma-
donna, S. John the Evangelist, and S. Francis, in most sorrowful
attitudes, together with a S. Michelagnolo, with so much diligence
that it merits no small praise, and above all by reason of having
been so well preserved that it appears made only yesterday.
Below, moreover, is the portrait of the said Guccio, kneeling in

armour at the foot of the Cross. In the Pieve of the same city, in
the Chapel of the Paganelli, he painted many stories of Our Lady,
and portrayed there after the life the Blessed Rinieri, a holy man
and prophet of that house, who is giving alms to many beggars
who are round him. In S. Bartolommeo, also, he painted some
stories of the Old Testament and the story of the Magi; and
in the Church of Spirito Santo he painted some stories of S. John
the Evangelist, and in certain figures the portrait of himself and
of many of his friends, nobles of that city.

Returning after these works to his own country, he made on
wood many pictures both small and great; but he made no long
stay there, because, being summoned to Florence, he painted in
S. Spirito the Chapel of S. Niccolò, which we have mentioned
above, and which was much extolled, and other works that were
consumed in the miserable burning of that church. In the Pieve
of San Gimignano in Valdelsa he wrought in fresco some stories
of the New Testament, which he had already very nearly brought
to completion, when, falling by a strange accident from his scaf-
folding to the ground, he bruised himself internally in such a
manner, and injured himself so grievously, that in the space of
two days, with greater loss to art than to himself, who went to a
better place, he passed from this life. And the people of San
Gimignano, honouring him much in the way of obsequies, gave
to his body honourable burial in the aforesaid Pieve, holding him
after death in the same repute wherein they had held him in life,
and not ceasing for many months to attach round his tomb epi-
taphs both Latin and Italian, by reason of the men of that
country being naturally given to fine letters. So, then, they con-
ferred a suitable reward on the honest labours of Berna, celebra-
ting with their pens him who had honoured them with his
pictures.

Giovanni da Asciano, who was a pupil of Berna, brought
to completion the remainder of that work; and he painted
some pictures in the Hospital of the Scala at Siena, and
also some others in the old houses of the Medici at Florence,
which gave him considerable fame. The works of Berna of Siena
date about 1381. And because, besides what has been said, Berna
was passing dexterous in draughtsmanship and was the first who
began to portray animals well, as bears witness a drawing by his
hand that is in our book, all full of wild beasts of diverse sorts,
he deserves to be consummately praised and to have his name

held in honour by craftsmen. His disciple, too, was Luca di Tomè of Siena, who painted many works in Siena and throughout all Tuscany, and in particular the panel and the chapel that are in S. Domenico at Arezzo, belonging to the family of the Dragomanni; which chapel, German in architecture, was very well adorned, by means of the said panel and of the work that is therein in fresco, by the hand and by the judgment and genius of Luca of Siena.

DUCCIO, Painter of Siena

WITHOUT doubt those who are inventors of anything notable receive the greatest attention from the pens of the writers of history, and this comes to pass because the first inventions are more observed and held in greater marvel, by reason of the delight that the novelty of the thing brings with it, than all the improvements made afterwards by any man whatsoever when works are brought to the height of perfection, for the reason that if a beginning were never given to anything, there would be no advance and improvement in the middle stages, and the end would not become excellent and of a marvellous beauty. Duccio, then, painter of Siena and much esteemed, deserved to carry off the palm from those who came many years after him, since in the pavement of the Duomo of Siena he made a beginning in marble for the inlaid work of the figures in chiaroscuro, wherein to-day modern craftsmen have made the marvels that are seen in them. He applied himself to the imitation of the old manner, and with very sane judgment gave dignified forms to his figures, which he fashioned very excellently in spite of the difficulties of such an art. With his own hand, imitating the pictures in chiaroscuro, he arranged and designed the beginnings of the said pavement, and he made in the Duomo a panel that was then placed on the high-altar, and afterwards removed thence in order to place there the Tabernacle of the Body of Christ, which is seen there at the present day. In this panel, according to the description of Lorenzo di Bartolo Ghiberti, there was a Coronation of Our Lady, wrought, as it were, in the Greek manner, but blended considerably with the modern. And as it was painted both on the back part and on the front, the said high-altar being isolated right round, on the said back part there had been made by Duccio with much diligence all the principal

stories of the New Testament, with very beautiful little figures. I have sought to learn where this panel is to be found to-day, but, for all the diligence that I have thereunto used, I have never been able to discover it, or to learn what Francesco di Giorgio, the sculptor, did with it when he remade the said tabernacle in bronze, as well as the marble ornaments that are therein.

He made, likewise, many panels on grounds of gold throughout Siena, and one in Florence, in S. Trinita, wherein there is an Annunciation. He painted, next, very many works for diverse churches in Pisa, in Lucca, and in Pistoia, which were all consummately praised and acquired for him very great fame and profit. Finally, it is not known where this Duccio died, nor what relatives, disciples, or wealth he left; it is enough that, for having left art the heir to his invention of making pictures of marble in chiaroscuro, he deserves infinite commendation and praise for such a benefit to art, and that he can be assuredly numbered among the benefactors who confer advancement and adornment on our profession, considering that those who go on investigating the difficulties of rare inventions leave their memory behind them, besides all their marvellous works.

They say in Siena that Duccio, in the year 1348, gave the design for the chapel that is in the square, against the wall of the Palazzo Principale; and it is read that there lived in his times a sculptor and architect of passing good talent from the same country, named Moccio, who made many works throughout all Tuscany, and particularly one in the Church of S. Domenico in Arezzo, namely, a tomb of marble for one of the Cerchi, which tomb acts as support and ornament for the organ of the said church; and although it may appear to some that it is not a very excellent work, yet, if it is considered that he made it while still a youth, in the year 1356, it cannot but seem passing good. This man served in the building of S. Maria del Fiore as under-architect and as sculptor, making certain works in marble for that fabric; and in Arezzo he rebuilt the Church of S. Agostino, which was small, in the manner that it is to-day, and the expense was borne by the heirs of Piero Saccone de' Tarlati, according as he had ordained before he died in Bibbiena, a place in the Casentino; and because Moccio erected this church without any vaulting, and laid the weight of the roof on the arches of the columns, he exposed himself to a great peril and was truly too bold. The same man made the Church and Convent of S. Antonio, which,

before the siege of Florence, was at the Porta a Faenza, and to-day is wholly ruined; and he wrought in sculpture the door of S. Agostino in Ancona, with many figures and ornaments similar to those which are on the door of S. Francesco in the same city. In this Church of S. Agostino he also made the tomb of Fra Zenone Vigilanti, Bishop, and General of the Order of the said S. Augustine; and finally, he built the Loggia de' Mercatanti of that city, which has since received, now for one reason and now for another, many improvements in the modern manner, with ornaments of various sorts. All these works, although they are in these days much less than passable, were then much extolled, according to the standard of knowledge of these men. But returning to our Duccio, his works date about the year of our salvation 1350.

ANTONIO VINIZIANO, Painter

Many who would fain stay in the country where they are born, being torn by the tooth of envy and oppressed by the tyranny of their fellow-citizens, take themselves off, and choosing for country those places where they find that their talent is recognized and rewarded, they make their works therein; and striving to become very excellent in order to put to shame, in some sort, those by whom they have been outraged, they become very often great men, whereas, by staying quietly in their country, they would peradventure have had little more than a mediocre success in their arts. Antonio Viniziano, who betook himself to Florence in the wake of Agnolo Gaddi in order to learn painting, grasped the good method of working so well that he was not only esteemed and loved by the Florentines, but also greatly cherished by reason of this talent and of his other good qualities. Whereupon, being seized by a wish to show himself in his own city in order to enjoy some fruit of the fatigues endured by him, he returned to Venice, where, having made himself known by many works wrought in fresco and in distemper, he was commissioned by the Signoria to paint one of the walls of the Council Chamber. This he executed so excellently and with so great majesty that, according to his merit, he would have obtained an honourable reward; but the emulation, or rather, the envy of the craftsmen, and the favour that some gentlemen showed to other painters

from abroad, caused the affair to fall out otherwise. Wherefore the poor Antonio, finding himself thus crushed and overborne, took the wiser part and returned to Florence, with the intention never again to consent to return to Venice, and determined once and for all that his country should be Florence. Establishing himself, then, in that city, he painted in the cloister of S. Spirito, in a little arch, a Christ who is calling Peter and Andrew from their nets, and Zebedee and his sons; and below the three little arches of Stefano he painted the story of the miracle of Christ with the loaves and fishes, wherein he showed infinite diligence and lovingness, as it is clearly seen in the figure of Christ Himself, who, in the air of His countenance and in His aspect, is showing the compassion that He has for the multitude, and the ardour of the love wherewith He is causing the bread to be dispensed. Great affection, likewise, is seen in the very beautiful action of an Apostle, who is exerting himself greatly in dispensing the bread from a basket. From this work all who belong to art learn ever to paint their figures in a manner that they may appear to be speaking, for otherwise they are not prized. Antonio demonstrated the same thing on the outer frontal in a little scene of the Manna, wrought with so great diligence, and finished with so fine grace, that it can be truly called excellent. Afterwards, in S. Stefano al Ponte Vecchio, on the predella of the high-altar, he made some stories of S. Stephen, with so great lovingness that it is not possible to see either more gracious or more beautiful figures, even if they were done in miniature. In S. Antonio al Ponte alla Carraja, moreover, he painted the arch over the door, which, with the whole church, was thrown to the ground in our own day by Monsignor Ricasoli, Bishop of Pistoia, because it took away the view from his houses; although, even if he had not done this, we should to-day, in any case, be deprived of that work, the late flood of 1557, as it has been said before, having carried away on that side two arches and the abutment of the bridge on which was built the said little Church of S. Antonio.

Antonio, being summoned after these works to Pisa by the Warden of Works of the Campo Santo, continued therein the painting of the stories of the Blessed Ranieri, a holy man of that city, formerly begun by Simone Sanese, following his arrangement. In the first part of the work painted by Antonio there is seen, in company with the said Ranieri when he is embarking in order to return to Pisa, a good number of figures wrought with

diligence, among which is the portrait of Count Gaddo, who died ten years before, and that of Neri, his uncle, once Lord of Pisa. Among the said figures, also, that of a maniac is very notable, for, with the features of madness, with the person writhing in distorted gestures, the eyes blazing, and the mouth gnashing and showing the teeth, it resembles a real maniac so greatly that it is not possible to imagine either a more lifelike picture or one more true to nature. In the next part, which is beside that named above, three figures (who are marvelling to see the Blessed Ranieri showing the Devil, in the form of a cat on a barrel, to a fat host, who has the air of a gay companion, and who, all fearful, is commending himself to the Saint) can be said to be truly very beautiful, being very well executed in the attitudes, the manner of the draperies, the variety of the heads, and all the other parts. Not far away are the host's womenfolk, and they, too, could not be wrought with more grace, Antonio having made them with certain tucked-up garments and with certain ways so peculiar to women who serve in hostelries, that nothing better can be imagined. Nor could that scene likewise be more pleasing than it is, wherein the Canons of the Duomo of Pisa, in very beautiful vestments of those times, no little different from those that are used to-day and very graceful, are receiving S. Ranieri at table, all the figures being made with much consideration. Next, in the painting of the death of the said Saint, he expressed very well not only the effect of weeping, but also the movement of certain angels who are bearing his soul to Heaven, surrounded by a light most resplendent and made with beautiful invention. And truly one cannot but marvel as one sees, in the bearing of the body of that Saint by the clergy to the Duomo, certain priests who are singing, for in their gestures, in the actions of their persons, and in all their movements, as they chant diverse parts, they bear a marvellous resemblance to a choir of singers; and in that scene, so it is said, is the portrait of the Bavarian.* In like manner, the miracles that Ranieri wrought as he was borne to his tomb, and those that he wrought in another place when already laid to rest therein in the Duomo, were painted with very great diligence by Antonio, who made there blind men receiving their sight, paralytics regaining the use of their members, men possessed by the Devil being delivered, and other miracles, all represented very

* *I.e.*, Emperor.

vividly. But among all the other figures, that of a dropsical man deserves to be considered with marvel, for the reason that, with the face withered, with the lips shrivelled, and with the body swollen, he is such that a living man could not show more than does this picture the very great thirst of the dropsical and the other effects of that malady. A wonderful thing, too, in those times, was a ship that he made in this work, which, being in travail in a tempest, was saved by that Saint; for he made therein with great vivacity all the actions of the mariners, and everything which is wont to befall in such accidents and travailings. Some are casting into the insatiable sea, without a thought, the precious merchandize won by so much sweat and labour, others are running to see to their vessel, which is breaking up, and others, finally, to other mariners' duties, whereof it would take too long to relate the whole; it is enough to say that all are made with so great vividness and beautiful method that it is a marvel. In the same place, below the lives of the Holy Fathers painted by Pietro Laurati of Siena, Antonio made the body of the Blessed Oliverio (together with the Abbot Panuzio, and many events of their lives), in a sarcophagus painted to look like marble; which figure is very well painted. In short, all these works that Antonio made in the Campo Santo are such that they have been universally held, and with great reason, the best of all those that have been wrought by many excellent masters at various times in that place, for the reason that, besides the particulars mentioned, the fact that he painted everything in fresco, never retouching any part on the dry, brought it about that up to our day they have remained so vivid in the colouring that they can teach the followers of that art and make them understand how greatly the retouching of works in fresco with other colours, after they are dry, causes injury to their pictures and labours, as it has been said in the treatise on Theory; for it is a very certain fact that they are aged, and not allowed to be purified by time, by being covered with colours that have a different body, being tempered with gums, with tragacanths, with eggs, with size, or some other similar substance, which tarnishes what is below, and does not allow the course of time and the air to purify that which has been truly wrought in fresco on the soft plaster, as they would have done if other colours had not been superimposed on the dry.

Having finished this work, which, being truly worthy of all praise, brought him honourable payment from the Pisans, who loved him

greatly ever afterwards, Antonio returned to Florence, where, at Nuovoli without the Porta a Prato, he painted in a shrine, for Giovanni degli Agli, a Dead Christ, the story of the Magi with many figures, and a very beautiful Day of Judgment. Summoned, next, to the Certosa, he painted for the Acciaiuoli, who built that place, the panel of the high-altar, which was consumed by fire in our day by reason of the inadvertence of a sacristan of that monastery, who left the thurible full of fire hanging from the altar, wherefore the panel was burnt, and afterwards the altar was made by those monks, as it stands to-day, entirely of marble. In that same place, also, the same master made in fresco, over a wardrobe that is in the said chapel, a Transfiguration of Christ which is very beautiful. And because he studied the science of herbs in Dioscorides, being much inclined thereunto by nature, and delighting to understand the property and virtue of each one of them, at last he abandoned painting and gave himself to the distilling of simples and to seeking them out with all diligence. Changing thus from painter to physician, for a long time he followed this art. Finally, falling sick from disease of the stomach, or, as others say, from plague caught while acting as physician, he finished the course of his life at the age of seventy-four, in the year 1384, when there was a very great plague in Florence, having been no less expert as physician than he was diligent as painter; wherefore, having made infinite experiments in medicine by means of those who had availed themselves of him in their necessities, he left to the world a very good name for himself in both one and the other of these arts. Antonio drew very graciously with the pen, and so well in chiaroscuro, that some drawings by him which are in our book, wherein he made the little arch of S. Spirito, are the best of those times. A disciple of Antonio was Gherardo Starnina, the Florentine, who imitated him greatly; and Paolo Uccello, who was likewise his disciple, did him no small honour.

The portrait of Antonio Viniziano, by his own hand, is in the Campo Santo in Pisa.

JACOPO DI CASENTINO, Painter

Now that the fame and the renown of the pictures of Giotto and his disciples had been heard for many years, many, desirous of acquiring fame and riches by means of the art of painting, and

animated by zealous aspirations and by the inclination of nature, began to advance towards the improvement of the art, with a firm belief that, exercising themselves therein, they would surpass in excellence both Giotto and Taddeo and the other painters. Among these was one Jacopo di Casentino, who, being born, as it is read, of the family of Messer Cristoforo Landino of Prato-vecchio, was apprenticed by a friar of the Casentino, then Prior at the Sasso della Vernia, to Taddeo Gaddi, while Taddeo was working in that convent, to the end that he might learn drawing and colouring in the art, wherein in a few years he succeeded so well that, betaking himself to Florence and executing many works in company with Giovanni da Milano in the service of Taddeo their master, he was made to paint the shrine of the Madonna of the Mercato Vecchio, with the panel in distemper, and likewise the one at the corner of the Piazza di S. Niccolò and the Via del Cocomero, which were restored a few years ago, both one and the other, by a worse master than was Jacopo; and for the Dyers he painted that which is in S. Nofri, at the corner of the wall of their garden, opposite to S. Giuseppe. In the meanwhile, the vaults of Orsanmichele over the twelve piers having been brought to a finish, a low rustic roof was placed upon them, in order to pursue as soon as might be possible the building of that palace, which was to be the granary of the Commune; and it was given to Jacopo di Casentino, as a person then much practised, to paint these vaults, with instructions that he should make there, as he did, together with the patriarchs, some prophets and the chiefs of the tribes, which were in all sixteen figures on a ground of ultramarine, to-day half spoilt, not to mention the other orna-ments. Next, on the walls below and on the piers, he made many miracles of the Madonna, and other works that are recognized by the manner.

This work finished, Jacopo returned to the Casentino, and after he had made many works in Pratovecchio, in Poppi, and other places in that valley, he betook himself to Arezzo, which then governed itself with the counsel of sixty of its richest and most honoured citizens, to whose care was committed the whole administration. There, in the principal chapel of the Vescovado, he painted a story of S. Martin, and in the Duomo Vecchio, now in ruins, a number of pictures, among which was the portrait of Pope Innocent VI, in the principal chapel. Next, in the Church of S. Bartolommeo, for the Chapter of the Canons of the Pieve,

he painted the wall where the high-altar is, and the Chapel of
S. Maria della Neve; and in the old Company of S. Giovanni de'
Peducci he made many stories of that Saint, which to-day are
covered with whitewash. In the Church of S. Domenico, likewise,
he painted the Chapel of S. Cristofano, portraying there from
nature the Blessed Masuolo, who is liberating from prison a mer-
chant of the Fei family, who caused that chapel to be built; which
Blessed Masuolo, as prophet, predicted many misadventures to
the Aretines in his lifetime. In the Church of S. Agostino, in the
chapel and on the altar of the Nardi, he painted in fresco some
stories of S. Laurence, with marvellous manner and execution.

And because he exercised himself also in the things of archi-
tecture, by order of the sixty aforesaid citizens he reconducted
under the walls of Arezzo the water that comes from the foot of
the hill of Pori, three hundred braccia distant from the city. This
water, in the time of the Romans, had been brought first to the
theatre, whereof the remains are still there, and from that theatre,
which was on the hill where to-day there is the fortress, to the
amphitheatre of the same city, on the plain; but these edifices and
conduits were wholly ruined and spoilt by the Goths. Jacopo,
then, as it has been said, having brought this water below the
walls, made the fountain which was then called the Fonte Gui-
zianelli, and which is now named, by the corruption of the word,
the Fonte Viniziana; this work endured from that time, which
was the year 1354, up to the year 1527, and no more, for the
reason that the plague of that year, the war that came afterwards,
the fact that many intercepted the water at their own convenience
for the use of their gardens, and still more the fact that Jacopo
did not sink it, brought it about that to-day it is not, as it should
be, standing.

The while that the aqueduct was going on being built, Jacopo,
not leaving aside his painting, wrought many scenes from the acts
of Bishop Guido and Piero Sacconi in the palace that was ·in the
old citadel, now in ruins; for these men, both in peace and in war,
had done great and honourable deeds for that city. In the Pieve,
likewise, below the organ, he wrought the story of S. Matthew
and many other works. And so, making works with his own hand
throughout the whole city, he showed to Spinello Aretino the
principles of that art which was taught to him by Agnolo, and
which Spinello taught afterwards to Bernardo Daddi, who, work-
ing in his own city, honoured it with many beautiful works of

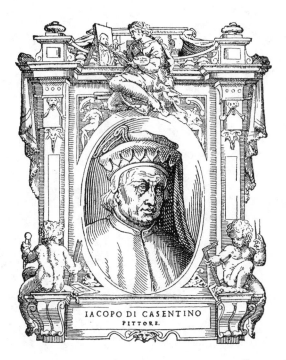

IACOPO DI CASENTINO
PITTORE.

painting, which, together with his other most noble qualities, brought it about that he was much honoured by his fellow-citizens, who employed him much in magistracies and in other public affairs. The paintings of Bernardo were many and in much esteem, and above all the Chapel of S. Lorenzo and of S. Stefano, belonging to the Pulci and Berardi, in S. Croce, and many other paintings in diverse places in the said church. Finally, having made some pictures over the gates of the city of Florence on the inner side, he died, laden with years, and was given honourable burial in S. Felicita, in the year 1380.

But returning to Jacopo; besides what has been told, in his time, in the year 1350, there was founded the Company and Confraternity of Painters; for the masters who were then living, both those of the old Greek manner and those of the new man-ner of Cimabue, being a great number, and reflecting that the arts of design had had their new birth in Tuscany – nay rather, in Florence itself – created the said Company under the name and protection of S. Luke the Evangelist, both in order to render praise and thanks to God in its oratory, and also to come together sometimes and to give succour, in spiritual matters as well as in temporal, to anyone who on occasion might have need of it; which custom is also in use among many Guilds in Florence, but was much more so in ancient times. Their first oratory was the principal chapel of the Hospital of S. Maria Nuova, which was conceded to them by the family of the Porti-nari. And those who were the first governors of the said Com-pany, with the title of captains, were six, besides two counsellors and two treasures, as it may be seen in the old book of the said Company, begun at that time, whereof the first chapter begins thus: 'These articles and ordinances were drawn up and made by good and discreet men of the Guild of Painters in Florence, and at the time of Lapo Gucci, painter; Vanni Cinuzzi, painter; Cor-sino Buonaiuti, painter; Pasquino Cenni, painter; Segna d'Antig-nano, painter. The counsellors were Bernardo Daddi and Jacopo di Casentino, painters; and the treasurers, Consiglio Gherardi and Domenico Pucci, painters.'

The said Company being created in this way, at the request of the captains and of the others Jacopo di Casentino painted the panel of their chapel, making therein a S. Luke who is portraying Our Lady in a picture, and on one side of the predella the men of the Company, and on the other all the women, kneeling. From

this beginning, sometimes assembling and sometimes not, this Company has continued up to its arrival at the condition wherein it stands to-day, as it is narrated in its new articles, approved by the most Illustrious Lord Duke Cosimo, most benign protector of these arts of design.

Finally, being heavy with years and much fatigued, Jacopo returned to the Casentino, and died in Pratovecchio at the age of eighty, and was buried by his relatives and friends in S. Agnolo, the Abbey of the Order of Camaldoli, without Pratovecchio. His portrait, by the hand of Spinello, was in the Duomo Vecchio, in a story of the Magi; and of the manner of his drawing there is an example in our book.

SPINELLO ARETINO, Painter

LUCA SPINELLI having gone to dwell in Arezzo on one of the several occasions when the Ghibellines were driven out of Florence, there was born to him in that city a son, to whom he gave the name of Spinello, so much inclined by nature to be a painter, that almost without a master, while still a boy, he knew what many exercised under the discipline of the best masters do not know; and what is more, having had friendship with Jacopo di Casentino while he worked in Arezzo, and having learnt something from him, before he was twenty years of age he was by a long way a much better master, young as he was, than was Jacopo himself, already an old painter. Spinello, then, began to be reputed a good painter, and Messer Dardano Acciaiuoli, having caused the Church of S. Niccolò to be built near the Sala del Papa, behind S. Maria Novella, in the Via della Scala, and having given burial therein to one his brother, a Bishop, caused him to paint the whole of that church in fresco with stories of S. Nicholas, Bishop of Bari; and he delivered it completely finished in the year 1334, having been at work on it two years without ceasing. In this work Spinello acquitted himself so well, both in the colouring and in the design, that up to our own day the colours had remained very well preserved and the excellence of the figures was clearly visible, when, a few years since, they were in great part spoilt by a fire that burst out unexpectedly in that church, which had been unwisely filled with straw by some foolish men who

made use of it as a barn or storehouse for straw. Attracted by the fame of this work, Messer Barone Capelli, citizen of Florence, caused Spinello to paint in fresco, in the principal chapel of S. Maria Maggiore, many stories of the Madonna and some of S. Anthony the Abbot, and near these the consecration of that very ancient church, consecrated by Pope Paschal, second of that name; and all this Spinello wrought so well that it appears made all in one day, and not in many months, as it was. Beside the said Pope is the portrait of Messer Barone himself from the life, in the dress of those times, made very well and with very good judgment. This chapel finished, Spinello painted in fresco, in the Church of the Carmine, the Chapel of S. James and S. John, the Apostles, wherein, among other things, there is wrought with much diligence the scene when the wife of Zebedee, mother of James, is demanding of Jesus Christ that He should cause one of her sons to sit on the right hand of the Father in the Kingdom of Heaven, and the other on the left; and a little beyond are seen Zebedee, James, and John abandoning their nets and following Christ, with liveliness and admirable manner. In another chapel of the same church, which is beside the principal chapel, Spinello made, also in fresco, some stories of the Madonna, and the Apostles appearing to her miraculously before her death, and likewise the moment when she dies and is then borne to Heaven by the Angels. And because the scene was large and the diminutive chapel, which was not longer than ten braccia and not higher than five, would not contain the whole, and above all the Assumption of Our Lady herself, Spinello, with beautiful judgment, caused it to curve round within the length of the picture, on to a part where Christ and the Angels are receiving her. In a chapel in S. Trinita he made in fresco a very beautiful Annunciation; and in the Church of S. Apostolo, on the panel of the high-altar, he made in distemper the Holy Spirit being sent down on the Apostles in tongues of fire. In S. Lucia de' Bardi, likewise, he painted a little panel, and another in S. Croce, larger, for the Chapel of S. Giovanni Battista, which was painted by Giotto.

After these works, being recalled to Arezzo by the sixty citizens who governed that place, by reason of the great name that he had acquired while working in Florence, he was made by the Commune to paint the story of the Magi in the Church of the Duomo Vecchio, without the city, and, in the Chapel of S. Gismondo, a S. Donatus who is slaying a serpent with his

benediction. In like manner, he made diverse figures on many pilasters in that Duomo, and, on a wall, the Magdalene anointing the feet of Christ in the house of Simon; with other pictures, whereof there is no need to make mention, since that church, which was full of tombs, of bones of saints, and of other memorable things, is to-day wholly ruined. I will say, indeed, to the end that there may at least remain this memory of it, that it was erected by the Aretines more than thirteen hundred years since, at the time when first they came into the faith of Jesus Christ, converted by S. Donatus, who was afterwards Bishop of that city; and that it was dedicated to his name, and richly adorned, both within and without, with very ancient spoils. The ground-plan of this edifice, whereof we have discoursed at length in another place, was divided without into sixteen sides, and within into eight, and all were full of the spoils of those temples which before had been dedicated to the idols; and it was, in short, as beautiful as a temple thus made and very ancient can be, when it was destroyed.

After the many pictures made in the Duomo, Spinello painted in S. Francesco, in the Chapel of the Marsuppini, Pope Honorius confirming and approving the Order of that Saint, and made there from nature the portrait of Innocent IV, from whatsoever source he had it. He painted also in the same church, in the Chapel of S. Michelagnolo, many stories of him, in the place where the bells are rung; and a little below, in the Chapel of Messer Giuliano Baccio, an Annunciation, with other figures, which are much praised; all which works made in this church were wrought in fresco, with very resolute handling, from 1334 up to 1338. Next, in the Pieve of the same city, he painted the Chapel of S. Pietro e S. Paolo, and below it, that of S. Michelagnolo; and, for the Confraternity of S. Maria della Misericordia, he painted in fresco, on the same side of the church, the Chapel of S. Jacopo e S. Filippo; and over the principal door of the Confraternity, which opens on to the square – namely, on the arch – he painted a Pietà, with a S. John, at the request of the Rectors of that Confraternity, which had its origin in the following way. A certain number of good and honourable citizens had begun to go about collecting alms for the poor who were ashamed to beg, and to succour them in all their needs: and in the year of the plague of 1348, by reason of the great name acquired by these good men for the Confraternity in assisting the

poor and the sick, in burying the dead, and in doing other similar
works of charity, so many were the legacies, the donations, and
the inheritances that were left to it, that it inherited the third of
the riches of Arezzo; and the same came to pass in the year 1383,
when there was likewise a great plague. Spinello, then, belonging
to this Company, it was often his turn to visit the sick, to bury
the dead, and to do other similar pious exercises, such as the best
citizens of that city have ever done and still do to-day; and in
order to make some memorial of this in his pictures, he painted
for that Company, on the façade of the Church of S. Laurentino
e S. Pergentino, a Madonna who, having her mantle open in
front, has under it the people of Arezzo, among whom are por-
trayed from life many of the chief men of the Confraternity, with
their wallets on their shoulders and with wooden hammers
in their hands, like to those that they use for knocking at the doors
when they go seeking alms. In like manner, for the Company of
the Annunciation he painted the great shrine that is without the
church, and part of a portico that is opposite to it, and the panel
of that Company, wherein there is likewise an Annunciation in
distemper. A work of Spinello's, likewise, is the panel which is
now in the Church of the Nuns of S. Giusto, wherein a little
Christ, who is in the arms of His mother, is marrying S.
Catherine, together with six little scenes, with small figures, of her
acts; and it is much praised.

Being next summoned to the famous Abbey of Camaldoli in
the Casentino, in the year 1361, he made for the hermits of that
place the panel of the high-altar, which was removed in the year
1539, when, that church having been just rebuilt completely
anew, Giorgio Vasari made a new panel, and painted in fresco
the whole of the principal chapel of that abbey, and the
tramezzo* of the church, also in fresco, and two other panels.
Summoned thence to Florence by Don Jacopo d' Arezzo, Abbot
of S. Miniato sul Monte, of the Order of Monte Oliveto, Spinello
painted on the vaulting and on the four walls of the sacristy of
that monastery, besides the panel in distemper for the altar, many
scenes in fresco of the life of S. Benedict, with great mastery and
with much vivacity of colouring, learnt by him by means of long
practice and of labouring continually with zeal and diligence, even
as in truth all must do who wish to acquire any art perfectly.

* See note on p. 90.

After these works, the said Abbot departed from Florence, having been made Governor of the Monastery of S. Bernardo, of the same Order, in his own country, precisely when the building was almost wholly finished on the site conceded by the Aretines to those monks, just where there was the Colosseum; and he caused Spinello to paint in fresco two chapels that are beside the principal chapel, and two others that are one on either side of the door that leads into the choir, in the tramezzo* of the church. In one of these, which is beside the principal chapel, is an Annunciation in fresco, made with very great diligence, and on a wall beside it is the Madonna ascending the steps of the Temple, accompanied by Joachim and Anna. In the other chapel is a Christ Crucified, with the Madonna and S. John, who are bewailing Him, and a S. Bernard kneeling, who is adoring Him. He made, also, on that inner wall of the church where there is the altar of Our Lady, the Virgin herself with her Son in her arms, which was held a very beautiful figure; together with many others that he made for that church, over the choir of which he painted Our Lady, S. Mary Magdalene, and S. Bernard, very vividly. In the Pieve of Arezzo, likewise, in the Chapel of S. Bartolommeo, he made many scenes of the life of that Saint; and opposite to it, in the other aisle, in the Chapel of S. Matteo (which is below the organ, and was painted by Jacopo di Casentino, his master), he made in certain medallions on the vaulting – besides many stories of that Saint, which are passing good – the four Evangelists in a bizarre manner, seeing that, making the busts and members human, he gave to S. John the head of an eagle, to Mark the head of a lion, to Luke that of an ox, and to Matthew alone the face of a man, or rather, of an angel.

Without Arezzo, also, in the Church of S. Stefano, erected by the Aretines on many columns of granite and of marble in order to honour and to preserve the memory of many martyrs who were put to death by Julian the Apostate on that spot, he painted many figures and scenes, with infinite diligence, and with such a manner of colouring that they had remained very fresh up to our own day, when, not many years since, they were ruined. But what was marvellous in that place, besides the stories of S. Stephen made with figures larger than life, was to see Joseph, in a story of the Magi, beside himself with joy at the coming of those

* See note on p. 90.

Kings, on whom he was gazing with most beautiful manner, while they were opening their vessels full of treasures and were offering them to him. A Madonna in that same church, who is handing a rose to the Infant Christ, was and still is held in so great veneration among the Aretines, as being a very beautiful and devout figure, that without regard for any difficulty or expense, when the Church of S. Stefano was thrown to the ground, they cut the wall away round her, and, binding it together ingeniously, they bore her into the city and placed her in a little church, in order to honour her, as they do, with the same devotion that they showed to her before. Nor should this appear anything wonderful, because, it having been something peculiar and natural to Spinello to give to his figures a certain simple grace, which has much of the modest and the saintly, it appears that the figures that he made of saints, and above all of the Virgin, breathe out a certain quality of the saintly and the divine, which moves men to hold them in supreme reverence; as it may be seen, apart from the said figure, in the Madonna that is on the Canto degli Albergotti, and in that which is on an outer wall of the Pieve in the Seteria, and in one of the same sort, likewise, that is on the Canto del Canale.

By the hand of Spinello, also, on a wall of the Hospital of Spirito Santo, is a scene of the Apostles receiving the Holy Spirit, which is very beautiful; and so, too, are the two scenes below, wherein S. Cosimo and S. Damiano are cutting off a sound leg from a dead Moor, in order to attach it to a sick man, from whom they had cut off one that was mortified; and likewise the very beautiful 'Noli me tangere,' which is between those two works. In the Company of the Puraccioli, on the Piazza di S. Agostino, in a chapel, he made an Annunciation very well coloured, and in the cloister of that convent he wrought in fresco a Madonna, a S. James, and a S. Anthony; and he portrayed there a soldier in armour on his knees, with these words: HOC OPUS FECIT FIERI CLEMENS PUCCI DE MONTE CATINO, CUJUS CORPUS JACET HIC, ETC. ANNO DOMINI 1367, DIE 15 MENSIS MAII. Likewise, with regard to the chapel that is in that church, with paintings of S. Anthony and other Saints, it is known by the manner that they are by the hand of Spinello, who, shortly afterwards, working in the Hospital of S. Marco (which is to-day the Monastery of the Nuns of S. Croce, by reason of their monastery, which was without the city, having been thrown to

the ground), painted a whole portico with many figures, and portrayed there Pope Gregory IX from nature, to represent S. Gregory the Pope, who is standing beside a Misericordia.

The Chapel of S. Jacopo e S. Filippo, which is in S. Domenico in the same city, just as one enters the church, was wrought in fresco by Spinello with beautiful and resolute handling, as was also the half-length of S. Anthony painted on the façade of his church, so beautiful that he appears alive, in the midst of four scenes of his life; which same scenes, with many more also of the life of S. Anthony, likewise by the hand of Spinello, are in the Church of S. Giustino, in the Chapel of S. Antonio. In the Church of S. Lorenzo, on one side, he made some stories of the Madonna, and without the church he painted her seated, showing great grace in this work in fresco. In a little hospital opposite to the Nunnery of S. Spirito, near the gate that leads to Rome, he painted a portico entirely by his own hand, showing, in a Christ lying dead in the lap of the Maries, so great genius and judgment in painting, that he is recognized to have proved himself the peer of Giotto in design, and to have surpassed him by a long way in colouring. In the same place, also, he represented Christ seated, with a theological significance very ingeniously contrived, having placed the Trinity within a sun in such wise that from each of the three figures there are seen issuing the same rays and the same splendour. But to this work, to the great loss, truly, of the lovers of this art, there has befallen the same thing as to many others, for it was thrown to the ground in fortifying the city. Without the Church of the Company of the Trinità there is seen a shrine wrought very well in fresco by Spinello, containing the Trinity, S. Peter, and S. Cosimo and S. Damiano clothed in such garments as physicians used to wear in those times.

The while that these works were in progress, Don Jacopo d'Arezzo was made General of the Congregation of Monte Oliveto, nineteen years after he had caused many works to be wrought in Florence and in Arezzo, as it has been said above, by our Spinello; and living, according to the custom of these dignitaries, at Monte Oliveto Maggiore di Chiusuri in the district of Siena, as the most honoured seat of that Order, he conceived a desire to have a very beautiful panel made in that place. Sending therefore for Spinello, by whom he had found himself very well served at another time, he caused him to paint in distemper the panel of the

principal chapel, wherein Spinello made an infinite number of figures both great and small on a ground of gold, with much judgment; and an ornament being made for it afterwards, carved in half-relief, by Simone Cini, the Florentine, he made for it in certain parts, with gesso mixed with size and rather thick, or truly gelatinous, another ornament which turned out very beautiful, and which was afterwards all overlaid with gold by Gabriello Saracini, who wrote at the foot of the said panel these three names:

SIMONE CINI, THE FLORENTINE, MADE THE CARVING; GABRIELLO SARACINI OVERLAID IT WITH GOLD; AND SPINELLO DI LUCA OF AREZZO PAINTED IT IN THE YEAR 1385.

This work finished, Spinello returned to Arezzo, having received from that General and from the other monks, besides payment, many kindnesses; but making no long stay there, because Arezzo was harassed by the Guelph and Ghibelline parties, and was sacked in those days, he betook himself with his family and his son Parri, who was studying painting, to Florence, where he had friends and relatives enough. There, without the Porta a S. Piero Gattolini, on the Strada Romana, where one turns to go to Pazzolatico, he painted an Annunciation, as it were to pass the time, in a shrine that to-day is half-ruined, and other pictures in another shrine near the hostelry of Galluzzo.

He was then summoned to Pisa in order to finish, below the stories of S. Ranieri in the Campo Santo, certain stories that were lacking in a space that had remained not painted; and in order to connect them together with those that had been made by Giotto, Simone Sanese, and Antonio Viniziano, he made in that place, in fresco, six stories of S. Petito and S. Epiro. In the first is S. Epiro, as a youth, being presented by his mother to the Emperor Diocletian, and being made General of the armies that were to march against the Christians; and also Christ appearing to him as he is riding, showing him a white Cross and commanding the Saint not to persecute Him. In another story there is seen the Angel of the Lord giving to that Saint, who is riding, the banner of the Faith with the white Cross on a field of red, which has been ever since the ensign of the Pisans, by reason of S. Epiro having prayed to God that He should give him a standard to bear against His enemies. Beside this story there is seen another, wherein, a fierce battle being contested between the Saint and the pagans, many angels in armour are combating to the end that he may be

victorious. Here Spinello wrought many things worthy of consideration for those times, when the art had as yet neither strength nor any good method of expressing vividly with colour the conceptions of the mind; and such, among the many other things that are there, were two soldiers, who, having gripped each other by the beard with one hand, are seeking with their naked swords, which they have in the other hand, to rob each other of life, showing in their faces and in all the movements of their members the desire that each has to come out victorious, and how fearless and fiery of soul they are, and how courageous beyond all belief. And so, too, among those who are combating on horseback, that knight is very well painted who is pinning to the ground with his lance the head of his enemy, whom he has hurled backwards from his horse, all dismayed. Another story shows the same Saint when he is presented to the Emperor Diocletian, who examines him with regard to the Faith, and afterwards causes him to be put to the torture, and to be placed in a furnace, wherein he remains unscathed, while the ministers of torture, who are showing great readiness there on every side, are burnt in his stead. And in short, all the other actions of that Saint are there, up to his beheading, after which his soul is borne to Heaven; and, for the last, we see the bones and relics of S. Petito being borne from Alexandria to Pisa. This whole work, both in colouring and in invention, is the most beautiful, the most finished, and the best executed that Spinello made, a circumstance which can be recognized from this, that it is so well preserved as to make everyone who sees it to-day marvel at its freshness.

Having finished this work in the Campo Santo, he painted many stories of S. Bartholomew, S. Andrew, S. James, and S. John, the Apostles, in a chapel in S. Francesco, which is the second from the principal chapel, and perchance he would have remained longer at work in Pisa, since in that city his works were known and rewarded; but seeing the city all in confusion and uproar by reason of Messer Pietro Gambacorti having been slain by the Lanfranchi, citizens of Pisa, he returned once again with all his family, being now old, to Florence, where, in the one year and no more that he stayed there, he made many stories of the lives and deaths of S. Philip and S. James in the Chapel of the Macchiavelli in S. Croce, dedicated to those Saints; and as for the panel for the said chapel, being desirous to return to Arezzo, his native city, or, to speak more exactly, held by him as his native

city, he wrought it in Arezzo, and from there sent it finished in the year 1400.

Having returned there, then, at the age of seventy-seven or more, he was received lovingly by his relatives and friends, and was ever afterward cherished and honoured up to the end of his life, which was at the age of ninety-two. And although he was very old when he returned to Arezzo, and, having ample means, could have done without working, yet, as one who was ever used to working, he knew not how to take repose, and undertook to make for the Company of S. Agnolo in that city certain stories of S. Michael, which he sketched in red on the intonaco of the wall, in that rough fashion wherein the old craftsmen used generally to do it; and in one corner, for a pattern, he wrought and coloured completely a single story, which gave satisfaction enough. Then, having agreed on the price with those who had charge thereof, he finished the whole wall of the high-altar, wherein he represented Lucifer fixing his seat in the North; and he made there the Fall of the Angels, who are being transformed into devils and raining down to earth; while in the air is seen a S. Michael, who is doing combat with the ancient serpent of seven heads and ten horns; and below, in the centre, there is a Lucifer, already transformed into a most hideous beast. And Spinello took so much pleasure in making him horrible and deformed, that it is said (so great, sometimes, is the power of imagination) that the said figure painted by him appeared to him in a dream, asking Spinello where he had seen him so hideous, and why he had offered him such an affront with his brushes; and that he, awaking from his sleep, being unable to cry out by reason of his fear, shook with a mighty trembling, insomuch that his wife, awaking, came to his rescue. But he was none the less thereby in peril – his heart being much strained – of dying on the spot by reason of such an accident; and although he lived a little afterwards, he was half mad, with staring eyes, and he slipped into the grave, leaving great sorrow to his friends, and to the world two sons, of whom one was Forzore, the goldsmith, who worked admirably at Florence in niello, and the other was Parri, who, imitating his father, laboured continually at painting, and surpassed him by a long way in design. This sinister misfortune, for all that Spinello was old, was a great grief to the Aretines, who were robbed of the so great talent and excellence that were his. He died at the age of ninety-two, and was given burial at

Arezzo in S. Agostino, where there is still seen to-day a tomb-stone with a coat of arms made according to his fancy, containing a hedgehog. Spinello knew much better how to draw than how to execute a painting, as it may be seen in our book of the drawings of diverse ancient painters, in two Evangelists in chiaroscuro and a S. Louis, drawn by his hand and very beautiful. And the portrait of the same man, which is seen above, was copied by me from one that was in the Duomo Vecchio before it was pulled down. His pictures date from 1380 up to 1400.

GHERARDO STARNINA, Painter

VERILY he who journeys far from his own country, dwelling in those of other men, gains very often a disposition and character of a fine temper, for, in seeing abroad diverse honourable customs, even though he might be perverse in nature, he learns to be tractable, amiable, and patient, with much greater ease than he would have done by remaining in his own country. And in truth, he who desires to refine men in the life of the world need seek no other fire and no better touchstone than this, seeing that those who are rough by nature are made gentle, and the gentle become more gracious. Gherardo di Jacopo Starnina, painter of Florence, being nobler in blood than in nature, and very harsh and rough in his manners, brought more harm thereby on himself than on his friends; and more harm still would this have brought on him if he had not dwelt a long time in Spain, where he learnt gentleness and courtesy, seeing that in those parts he became in such wise contrary to that first nature of his, that on his returning to Florence an infinite number of those who bore him deadly hatred before his departure, received him on his return with very great lovingness, and ever after loved him very straitly, so thoroughly had he become gentle and courteous.

Gherardo was born in Florence in the year 1354, and growing up, as one who had an intellect inclined by nature to design, he was placed with Antonio Viniziano in order to learn to draw and to paint; and having in the course of many years not only learnt drawing and the practice of colouring, but also given proof of himself in certain works wrought with beautiful manner, he took his leave of Antonio, and beginning to work by himself he made

in S. Croce, in the Chapel of the Castellani (which was given him to paint by Michele di Vanni, an honoured citizen of that family), many stories in fresco of S. Anthony the Abbot, and also some of S. Nicholas the Bishop, with so great diligence and with so beautiful a manner that they caused him to become known to certain Spaniards, who were then staying in Florence on some business of their own, as an excellent painter, and what is more, caused them to take him into Spain to their King, who saw him and received him very willingly, and above all because there was then a dearth of good painters in that land. Nor was it a great labour to persuade him to leave his country, for the reason that, having had rough words with certain people in Florence after the affair of the Ciompi and after Michele di Lando had been made Gonfalonier, he was rather in peril of his life than otherwise. Going, then, to Spain, and executing many works for that King, he became, by reason of the great rewards that he gained for his labours, as rich and highly honoured as any man of his own rank; wherefore, being desirous to make himself seen and known by his friends and relatives in that better state, he returned to his country, and was there much cherished and received lovingly by all the citizens.

Nor was it long before he was commissioned to paint the Chapel of S. Girolamo in the Carmine, where, making many stories of that Saint, he painted, in the story of Paola and Eustachio and Jerome, certain costumes that the Spaniards wore at that time, with very characteristic invention, and with an abundance of manners and conceptions in the attitudes of the figures. Among other things, painting a scene of S. Jerome learning his first letters, he made a master who has caused a boy to climb on the back of another and is beating him with his rod, in a manner that the poor lad, kicking out with his legs by reason of the great pain, appears to be howling and trying to bite the ear of the one who is holding him; and all this Gherardo expressed gracefully and very charmingly, as one who was going on investigating on every side the things of nature. Likewise, in the scene where S. Jerome, at the point of death, is making his testament, he counterfeited some friars with beautiful and very ready manner; for while some are writing and others earnestly listening and gazing on him, they are all hanging with great affection on the words of their master.

This work having acquired for Starnina rank and fame among the craftsmen, and his ways of life, with the sweetness of his

manners, bringing him very great reputation, the name of Gherardo was famous throughout all Tuscany – nay, throughout all Italy – when, being called to Pisa in order to paint in that city the Chapter-house of S. Niccola, he sent thither in his stead Antonio Vite of Pistoia, in order not to leave Florence. This Antonio, having learnt the manner of Starnina under his teaching, wrought in that chapter-house the Passion of Jesus Christ, and delivered it finished in that fashion wherein it is seen to-day, in the year 1403, to the great satisfaction of the Pisans. Starnina having then finished, as it has been said, the Chapel of the Pugliesi, and the Florentines being greatly pleased with the stories of S. Jerome that he made there, by reason of his having represented vividly many expressions and attitudes that had never been depicted up to that time by the painters who had lived before him, the Commune of Florence – in the year when Gabriel Maria, Lord of Pisa, sold that city to the Florentines at the price of 200,000 crowns, after Giovanni Gambacorti had sustained a siege of thirteen months, and had at last agreed to the sale – caused him to paint in memory of this, on the façade of the Palace of the Guelph party, a picture of S. Dionysius the Bishop, with two angels, and below him the city of Pisa, portrayed from nature; in which work he used so great diligence in everything, and particularly in colouring it in fresco, that in spite of the air, the rains, and its being turned to the north, it has always remained and still remains at the present day a picture worthy of much praise, by reason of its having been preserved as fresh and beautiful as though it had only just been painted. Gherardo, then, having come by reason of this and of his other works into very great repute and fame, both in his own country and abroad, envious death, ever the enemy of noble actions, cut short in the finest period of his labour the infinite expectation of much greater works, for which the world was looking from him; for at the age of forty-nine he came unexpectedly to his end, and was buried with most honourable obsequies in the Church of S. Jacopo Sopra Arno.

Disciples of Gherardo were Masolino da Panicale, who was first an excellent goldsmith and afterwards a painter, and certain others, of whom, seeing that they were not very able men, there is no need to speak. The portrait of Gherardo is in the aforesaid story of S. Jerome, in one of the figures that are round that Saint when he is dying, in profile, with a cap wound round the head

and wearing a buckled mantle. In our book are certain drawings by Gherardo, made with the pen on parchment, which are not otherwise than passing good.

LIPPO, Painter of Florence

INVENTION has ever been held, and ever will be, the true mother of architecture, of painting, and of poetry – nay, of all the finer arts also, and of all the marvellous works that are made by men, for the reason that it pleases the craftsmen much, and displays their fantasies and the caprices of fanciful brains that seek out variety in all things; and these discoveries ever exalt with marvellous praise all those who, employing themselves in honourable ways, give a form marvellous in beauty, under the covering and shadow of a veil, to the works that they make, now praising others dexterously, and now blaming them without being openly understood. Lippo, then, a painter of Florence, who was as rare and as varied in invention as he was truly unfortunate in his works and in his life – for it lasted but a little time – was born in Florence, about the year of our salvation 1354; and although he applied himself to the art of painting very late, when already grown up, nevertheless, he was so well assisted by nature, which inclined him to this, and by his intelligence, which was very beautiful, that soon he produced therein marvellous fruits. Wherefore, beginning his labours in Florence, he made in S. Benedetto (a very large and beautiful monastery of the Order of Camaldoli, without the Porta a Pinti, and now in ruins) many figures that were held very beautiful, and in particular a chapel painted entirely with his own hand, which showed how soon diligent study can produce great works in one who labours honourably through desire of glory.

Being summoned from Florence to Arezzo, he made in fresco, for the Chapel of the Magi in the Church of S. Antonio, a large scene wherein the Magi are adoring Christ; and in the Vescovado he painted the Chapel of S. Jacopo e S. Cristofano for the family of the Ubertini. All these works were very beautiful, Lippo showing invention in the composition of the scenes and in the colouring, and above all because he was the first who began to sport, so to speak, with the figures, and to awaken the

minds of those who came after him; a thing which had not even been suggested, much less put into use, before his time.

Having afterwards wrought many works in Bologna, and a panel in Pistoia which was passing good, he returned to Florence, where, in the year 1383, he painted the stories of S. John the Evangelist in the Chapel of the Beccuti, in S. Maria Maggiore. On the wall of the church beside this chapel, which is on the left hand of the principal chapel, there follow six stories of the same Saint by the same man's hand, very well composed and ingeniously ordered, wherein, among other things, there is very vividly depicted a S. John who is causing his own garment to be placed by S. Dionysius the Areopagite over some corpses, which are returning to life in the name of Jesus Christ, to the great marvel of some who, being present at this deed, can scarce believe their own eyes. In the figures of the dead, likewise, there is seen very great mastery in some foreshortenings, whereby it is clearly demonstrated that Lippo knew, and in part grappled with, certain difficulties of the art of painting. It was Lippo, likewise, who painted the folding leaves in the Church of S. Giovanni – namely, those of the shrine wherein are the angels and the S. John in relief by the hand of Andrea; and on them he wrought very diligently in distemper stories of S. John the Baptist. And because he also delighted in working in mosaic, in the said S. Giovanni, over the door that leads to the Misericordia, between the windows, he made a beginning, which was held very beautiful and the best work in mosaic which had been made in that place up to that time; and he also restored some works in that church, likewise in mosaic, which were spoilt. Without Florence, too, in S. Giovanni fra l' Arcora without the Porta a Faenza, a church which was destroyed in the siege of the said city, he painted in fresco, beside a Passion of Christ wrought by Buffalmacco, many figures which were held very beautiful by all who saw them. In like manner, in certain little hospitals at the Porta a Faenza, and in S. Antonio within the said gate, near the hospital, he painted certain beggars in fresco, in diverse beautiful manners and attitudes; and within the cloisters, with beautiful and new invention, he painted a vision wherein he represented S. Anthony gazing on the snares of the world, and beside these the will and the desires of men, who are drawn by both the first and the second to the diverse things of this world; and all this he painted with much thought and judgment. Lippo also wrought works in mosaic in many parts of

Italy, and in the Palace of the Guelph party in Florence he made a figure with the head glazed; and in Pisa, also, there are many of his works. But none the less it can be said that he was truly unfortunate, not only because the greater part of his labours are now thrown down, having gone to ruin in the havoc of the siege of Florence, but also because he ended the course of his life very unhappily; for Lippo being a litigious person and fonder of discord than of peace, and having one morning used very ugly words towards an adversary at the tribunal of the Mercanzia,* he was waylaid by this man one evening when he was returning to his house, and stabbed in the breast with a knife so grievously, that a few days afterwards he died miserably. His pictures date about 1410.

About the same time as Lippo there was in Bologna another painter, Dalmasi, also called Lippo, who was an able man, and who painted, among other works, in the year 1407 (as it may be seen in S. Petronio in Bologna), a Madonna which is held in great veneration; and in fresco, the arch over the door of S. Procolo; and in the Church of S. Francesco, in the tribune of the high-altar, he made a large Christ between S. Peter and S. Paul, with good grace and manner, and below this work there is seen his own name written in large letters. He drew passing well, as it may be seen in our book; and he taught the art to M. Galante da Bologna, who afterwards drew much better than he, as it may be seen in the said book, in a portrait from the life, a figure in a short coat with puffed sleeves.

DON LORENZO MONACO,
of the Angeli in Florence, Painter

For a good and religious person, I believe, there must be great contentment in having ready to his hand some honourable exercise, whether that of letters, or of music, or of painting, or of any other liberal or mechanical arts, such as are not blameworthy, but rather useful and helpful to other men; for the reason that after the divine offices the time passes honourably with the delight that is taken in the sweet labours of these pleasant exercises. And to this it may be added that not only is he esteemed and held in

* The Tribunal of commerce.

price by others the while that he lives, provided that they be not envious and malign, but that he is also honoured after death by all men, by reason of his works and of the good name that he leaves to those who survive him. And in truth one who spends his time in this manner, lives in quiet contemplation and without being molested by those ambitious desires which are almost always seen, to their shame and loss, in the idle and unoccupied, who are for the most part ignorant. And even if it comes about that our virtuous man is sometimes smitten by the malign, so powerful is the force of virtue that time covers up and buries the malice of the wicked, and the virtuous man, throughout the ages that follow, remains ever famous and illustrious.

Don Lorenzo, then, a painter of Florence, was a monk of the Order of Camaldoli in the Monastery of the Angeli, which monastery was founded in the year 1294 by Fra Guittone d'Arezzo, of the Militant Order of the Virgin Mother of Jesus Christ, or rather, as the monks of that Order were vulgarly called, of the Joyous Friars; and he applied himself in his earliest years to design and to painting with so great zeal, that he was afterwards deservedly numbered among the best of the age in that exercise. The first works of this painter-monk, who held to the manner of Taddeo Gaddi and his disciples, were in his Monastery of the Angeli, where, among many other things, he painted the panel of the high-altar, which is still seen to-day in their church, and which was completely finished, as it may be seen from letters written below on the ornament, in the year 1413, when it was set in place. On a panel, likewise, which was in the Monastery of S. Benedetto, of the same Order of Camaldoli, which was outside the Porta a Pinti and was destroyed in 1529, in the siege of Florence, Don Lorenzo painted a Coronation of Our Lady, even as he had also done in the panel for his own Church of the Angeli; and this panel, painted for S. Benedetto, is to-day in the first cloister of the said Monastery of the Angeli, in the Chapel of the Alberti, on the right hand. About the same time, or perchance before, in S. Trinita at Florence, he painted in fresco the Chapel of the Ardinghelli, with its panel, which was much praised at that time; and there he made from nature the portraits of Dante and of Petrarca. In S. Piero Maggiore he painted the Chapel of the Fioravanti, and the panel in a chapel in S. Piero Scheraggio; and in the said Church of S. Trinita he painted the Chapel of the Bartolini. In S. Jacopo Sopra Arno, also, there is seen a panel by his

hand, very well wrought and executed with infinite diligence according to the manner of those times. In the Certosa without Florence, likewise, he painted some pictures with good mastery; and in S. Michele in Pisa, a monastery of his Order, he painted some panels that are passing good. And in Florence, in the Church of the Romiti* (also belonging to the Order of Camaldoli), which, being in ruins together with the monastery, has to-day left no memory but the name to that quarter on the other side of the Arno, which is called Camaldoli from the name of that holy place, among other works, he painted a Crucifix on panel, with a S. John, which were held very beautiful. Finally, falling sick of a cruel imposthume, which kept him suffering for many months, he died at the age of fifty-five, and was honourably buried by his fellow-monks, as his virtues deserved, in the chapter-house of their monastery.

And because it often happens, as experience shows, that from one single germ, with time and by means of the study and intelligence of men, there spring up many, in the said Monastery of the Angeli, where in former times the monks ever applied themselves to painting and to design, not only was the said Don Lorenzo excellent among them, but many men excellent in the matters of design also flourished there for a long space of time, both before and after him. Wherefore it appears to me by no means right to pass over in silence one Don Jacopo, a Florentine, who lived long before the said Don Lorenzo, for the reason that, even as he was a very good and very worthy monk, so was he a better writer of large letters than any who lived either before or after him, not only in Tuscany, but in all Europe, as it is clearly proved not only by the twenty very large volumes of choral books that he left in his monastery, which are the most beautiful, as regards the writing, as well as the largest that there are perchance in Italy, but also by an infinity of others which are to be found in Rome, in Venice, and in many other places, and above all in S. Michele and in S. Mattia di Murano, a monastery of his Order of Camaldoli; for which works this good father well deserved, very many years after he had passed to a better life, not only that Don Paolo Orlandini, a very learned monk of the same monastery, should celebrate him with many Latin verses, but that his right hand, wherewith he wrote the said books, should be

* Church of the Hermits.

preserved with much veneration in a shrine, as it still is, together
with that of another monk called Don Silvestro, who, according
to the standard of those times, illuminated the said books no less
excellently than Don Jacopo had written them. And I, who have
seen them many times, remain in a marvel that they were executed
with so much design and with so much diligence in those times,
when the arts of design were little less than lost; for the works of
these monks date about the year of our salvation 1350, more or
less, as it may be seen in each of the said books. It is said, and
some old men still remember it, that when Pope Leo X came to
Florence he wished to see the said books and examine them care-
fully, remembering that he had heard them much praised to
Lorenzo de' Medici the Magnificent, his father; and that after he
had looked at them with attention and admiration, as they all lay
open on the desks of the choir, he said, 'If they were according
to the Roman Church, and not, as they are, according to the
monastic use and ordering of Camaldoli, we would be pleased to
take some volumes of them for S. Pietro in Rome, giving just
recompense to the monks'; in which church there were formerly,
and perhaps there still are, two others of them by the hand of the
same monks, both very beautiful. In the same Monastery of the
Angeli there are many ancient embroideries, wrought with very
beautiful manner and with much design by the ancient fathers of
that place, while they were living in perpetual enclosure under the
name not of monks but of hermits, without ever issuing from the
monastery, in such wise as do the sisters and nuns of our own day;
which enclosure lasted until the year 1470.

But to return to Don Lorenzo; he taught Francesco Fiorenti-
no, who, after his death, painted the shrine that is on the Canto
di S. Maria Novella, at the head of the Via della Scala, on the way
to the Sala del Papa; and he taught another disciple, a Pisan, who
painted a Madonna, S. Peter, S. John the Baptist, S. Francis, and
S. Ranieri, and three scenes with little figures on the predella of
the altar, in the Church of S. Francesco at Pisa, in the Chapel of
Rutilio di Ser Baccio Maggiolini; and this work, painted in 1315,
was held passing good for something wrought in distemper. In
my book of drawings I have, by the hand of Don Lorenzo, the
Theological Virtues done in chiaroscuro with good design and
beautiful and graceful manner, insomuch that they are peradven-
ture better than the drawings of any other master whatsoever of
those times. A passing good painter in the time of Don Lorenzo

was Antonio Vite of Pistoia, who, besides many other works –
as it has been said in the Life of Starnina – painted, in the Palace
of the Ceppo at Prato, the life of Francesco di Marco, founder
of that holy place.

TADDEO BARTOLI, Painter of Siena

IT is the due of those craftsmen who, in order to acquire a name,
put themselves to much fatigue in painting, that their works
should be placed, not in a dark and dishonourable position,
wherefore they may be blamed by those who have no more
understanding than this, but in some spot where, through the
nobility of the place, through the lights, and through the air, they
can be rightly seen and studied by all, as was and still is the public
work of the chapel that Taddeo Bartoli, painter of Siena, wrought
in the Palazzo della Signoria in Siena.

Taddeo, then, was the son of Bartolo di Maestro Fredi, who
was a mediocre painter in his day and painted the whole wall (on
the left hand as one enters) of the Pieve of San Gimignano with
stories of the Old Testament; in which work, which in truth was
not very good, there may still be read in the middle this epitaph:

A.D. 1356, BARTOLUS MAGISTRI FREDI DE SENIS ME PINXIT.

At this time Bartolo must have been young, because in a panel
containing the Circumcision of Our Lord, together with some
saints, wrought likewise by him in the year 1388 in S. Agostino,
in the same territory, on the left hand as one enters the church
through the principal door, it is seen that he had a much better
manner both in drawing and in colouring, seeing that some heads
therein are beautiful enough, although the feet of those figures
are in the ancient manner. In short, there are seen many other
works by the hand of Bartolo in those parts.

But to return to Taddeo: the painting of the Chapel of the
Palazzo della Signoria in his native city being entrusted to him,
as it has been said, as the best master of those times, it was
wrought by him with so great diligence, and so greatly honoured
with regard to its situation, and paid for by the Signoria in such
a manner, that Taddeo largely increased his glory and fame there-
by; wherefore not only did he afterwards paint many panels in

his own country, to his great honour and infinite profit, but he
was invited with great favour and sought for from the Signoria
of Siena by Francesco da Carrara, Lord of Padua, to the end that
he might go, as he did, to paint certain works in that most noble
city; where, particularly in the Arena and in the Santo, he wrought
some panels and other works with much diligence, to his own
great honour and to the satisfaction of that Lord and of the
whole city. Returning afterwards to Tuscany, he wrought a panel
in distemper, which inclines to the manner of Ugolino Sanese, in
San Gimignano; and this panel is to-day behind the high-altar of
the Pieve, and faces the choir of the priests. Going next to Siena,
he did not stay there long before he was invited by one of the
Lanfranchi, the Warden of Works of the Duomo, to Pisa; and
betaking himself thither, he made in fresco, in the Chapel of the
Nunziata, the scene when the Madonna ascends the steps of the
Temple, at the head of which the priest is awaiting her in full
canonicals – a highly-finished work. In the face of this priest he
portrayed the said Warden of Works, and beside him his own
self. This work finished, the same Warden of Works made him
paint over the chapel in the Campo Santo a Madonna being
crowned by Jesus Christ, with many angels in very beautiful atti-
tudes and very well coloured. In like manner, for the Chapel of
the Sacristy of S. Francesco in Pisa Taddeo made a Madonna and
some saints on a panel painted in distemper, placing thereon his
name and the year when it was painted, which was the year 1394.
And about this same time he wrought certain panels in distemper
at Volterra, and a panel at Monte Oliveto, with a Hell in fresco
on a wall, wherein he followed the invention of Dante in so far
as relates to the division of the sins and to ·the form of the
punishments, but in the place itself he either could not or would
not imitate him, or knew not how. He also sent to Arezzo a panel
that is in S. Agostino, wherein he portrayed Pope Gregory XI –
namely, the Pope who brought the Court back to Italy after it
had been so many decades of years in France.

Returning after these works to Siena, he made no very long
stay there, because he was called to work at Perugia in the Church
of S. Domenico, where, in the Chapel of S. Caterina, he painted
in fresco all the life of that Saint; and in S. Francesco, beside the
door of the sacristy, he made some figures which, although to-
day little can be discerned of them, are known to be by the hand
of Taddeo, who held ever to one unchanging manner. A little

time afterwards there befell the death of Biroldo, Lord of Perugia, who was murdered in the year 1398; whereupon Taddeo returned to Siena, where, labouring continually, he applied himself so zealously to the studies of his art, in order to become an able painter, that it can be affirmed, if perchance he did not realize his intention, that this was certainly not by reason of any defect or negligence that he showed in his work, but rather through indisposition caused by an internal obstruction, which afflicted him in a manner that he could not attain to the fulness of his desire. Having taught the art to one his nephew, called Domenico, Taddeo died at the age of fifty-nine; and his pictures date about the year of our salvation 1410.

He left, then, as it has been said, Domenico Bartoli, his nephew and disciple, who, following the art of painting, painted with greater and better mastery, and in the scenes that he wrought he showed much more fertility, varying them in diverse ways, than his uncle had done. In the pilgrim's hall of the great hospital at Siena there are two large scenes, wrought in fresco by Domenico, wherein are seen perspectives and other adornments very ingeniously composed. Domenico is said to have been modest and gentle, and a man of singular amiability and most liberal courtesy; and this is said to have done no less honour to his name than the art of painting itself. His works date about the year of our Lord 1436, and the last were a panel containing an Annunciation in S. Trinita in Florence, and the panel of the high-altar in the Church of the Carmine.

There lived at the same time and painted in almost the same manner, although he made the colouring more brilliant and the figures lower, one Alvaro di Piero, a Portuguese, who made many panels in Volterra, and one in S. Antonio in Pisa, and others in other places, whereof, seeing that they are of no great excellence, there is no need to make further record. In our book there is a drawing made with great mastery by Taddeo, wherein are Christ and two angels.

LORENZO DI BICCI, Painter of Florence

WHEN men who are excellent in any honourable exercise whatsoever accompany their ability in working with gentle ways and

good habits, and particularly with courtesy, serving readily and willingly all who have need of their assistance, they secure without fail, together with much praise and profit for themselves, everything that in a certain sense is desirable in this world; as did Lorenzo di Bicci, painter of Florence, who, being born in Florence in 1400, precisely when Italy was beginning to be harassed by the wars which shortly afterwards brought her to an evil pass, was in very good credit almost from his childhood, for the reason that, having learnt good ways under the discipline of his father and the art of painting from the painter Spinello, he had ever the name not only of an excellent painter, but of a most courteous and honourable and able man. Lorenzo, then, young as he was, having made some works in fresco both within and without Florence for the sake of practice, Giovanni di Bicci de' Medici, seeing his good manner, caused him to paint in the hall of the old house of the Medici – which afterwards came into the possession of Lorenzo, brother of Cosimo the Elder, when the great palace was built – all those famous men that are still seen there to-day, very well preserved. This work finished, seeing that Lorenzo di Bicci wished to exercise himself in his study of painting in places where work was not so minutely examined, as the doctors still do, who make experiments in their art on the hides of needy countrymen, for some time he accepted all the work that came to his hand, and therefore painted a shrine on the bridge of Scandicci, without the Porta a S. Friano, in the manner wherein it is still seen to-day, and at Cerbaia, on a wall below a portico, he painted many saints very creditably, together with a Madonna. Next, being commissioned by the family of the Martini to paint a chapel in S. Marco in Florence, he wrought in fresco on the walls many stories of the Madonna, and on the panel the Virgin herself in the midst of many saints; and in the same church, over the Chapel of S. Giovanni Evangelista, belonging to the family of the Landi, he painted in fresco an Angel Raphael with Tobias. And afterwards, in the year 1418, for Ricciardo di Messer Niccolò Spinelli, on the façade of the Convent of S. Croce facing the square, he painted a large scene in fresco of S. Thomas looking for the wound in the side of Jesus Christ, and beside him and round him all the other Apostles, who, kneeling reverently, are watching this event. And beside the said scene he made, likewise in fresco, a S. Christopher twelve braccia and a half high, which is something rare, because up to then, excepting

the S. Christopher of Buffalmacco, there had not been seen a greater figure, nor, for something so large, any image more creditable or better proportioned in all its parts than that one, although it is not in a good manner; not to mention that these pictures, both the one and the other, were wrought with so much mastery, that, although they have been exposed to the air for many years and buffeted by the rains and tempests, being turned to the North, yet they have never lost their vividness of colouring, nor have they been injured in any part. Within the door, moreover, which is between these figures, called the Martello door, the same Lorenzo, at the request of the said Ricciardo and of the Prior of the convent, made a Crucifixion with many figures, and, on the walls around, the confirmation of the Rule of S. Francis by Pope Honorius, and beside it the martyrdom of certain friars of that Order, who went to preach the Faith among the Saracens. On the arches and on the vaulting he made certain Kings of France, friars and devout followers of S. Francis, and he portrayed them from nature; and likewise many learned men of that Order, and men distinguished for dignity of rank, such as Bishops, Cardinals, and Popes, among whom are portraits from nature, in two medallions on the vaulting, of Pope Nicholas IV and Pope Alexander V. In all these figures, although Lorenzo made their garments grey, he varied them, nevertheless, by reason of the good practice that he had in working, in a manner that they are all different one from the other; some incline to reddish, others to bluish, while some are dark and others lighter, and in short, all are varied and worthy of consideration; and what is more, it is said that he wrought this work with so great facility and readiness, that being called once by the Prior, who was bearing his expenses, to his dinner, at the very moment when he had made the intonaco for a figure and had begun it, he answered: 'Pour out the soup. Let me finish this figure, and I'm with you.' Wherefore it is with good reason that men say that Lorenzo had so great rapidity of hand, so great practice in colouring, and so great resolution, that no other man ever had more.

By his hand are the shrine in fresco which is on the corner of the Convent of the Nuns of Foligno, and the Madonna and some saints that are over the door of the church of that convent, among whom is a S. Francis who is espousing Poverty. In the Church of the Order of Camaldoli in Florence, also, he painted

for the Company of the Martyrs some scenes of the martyr-
dom of some saints, and two chapels in the church, one on either
side of the principal chapel. And because these pictures gave
universal pleasure to the whole city, after he had finished them
he was commissioned by the family of the Salvestrini – which
to-day is almost extinct, there being to my knowledge none left
save a friar of the Angeli in Florence, called Fra Nemesio, a good
and worthy churchman – to paint a wall of the Church of the
Carmine, whereon he made the scene when the martyrs, being
condemned to death, are stripped naked and made to walk bare-
foot over spikes strewn by ministers of the tyrants, while they
were going to be placed on the cross; and higher up they are seen
placed thereon, in various extravagant attitudes. In this work,
which was the largest that had ever been made up to that time,
everything is seen to have been done, according to the knowledge
of those times, with much mastery and design, for it is all full of
those various emotions that nature arouses in those who are
made to die a violent death; wherefore I do not marvel that many
able men have contrived to avail themselves of certain things that
are seen in this picture. After these he made many other figures
in the same church, and particularly in two chapels in the tramez-
zo.* And about the same time he painted the shrine of the Canto
alla Cuculia, and that which is on the house-front in the Via de'
Martelli; and, over the Martello door in S. Spirito, a S. Augustine
in fresco presenting the Rule to his friars. In S. Trinita, in the
Chapel of Neri Compagni, he painted in fresco the life of
S. Giovanni Gualberto; and, in the principal chapel of S. Lucia in
the Via de' Bardi, some scenes in fresco of the life of that Saint,
for Niccolò da Uzzano, who was portrayed by him there from
the life, together with some other citizens.

This Niccolò, with the direction and model of Lorenzo, built
a palace for himself near the said church, and a magnificent be-
ginning for a university, or rather, a school, between the Convent
of the Servi and that of S. Marco – namely, where there are now
the Lions. This work, truly most praiseworthy and rather that of
a magnanimous prince than of a private citizen, was never
finished, for the very large sums of money that Niccolò left at

* See note on p. 90.

the Monte* in Florence for the building and maintenance of this school, were spent by the Florentines in certain wars or for other necessities of the city. And although Fortune will never be able to obscure the memory and the greatness of soul of Niccolò da Uzzano, it is none the less true that the public interest suffered very great harm from the fact that this work was not finished. Wherefore, if a man desires to benefit the world in similar ways, and to leave an honourable memorial of himself, let him do it by himself while he has life, and let him not put his trust in the good faith of posterity and of his heirs, since anything that has been left to be done by successors is rarely seen brought to perfect completion.

But returning to Lorenzo: he painted, besides what has been said, a Madonna and certain saints in fresco, passing good, in a shrine on the Ponte Rubaconte. And no long time after, Ser Michele di Fruosino, being Director of the Hospital of S. Maria Nuova in Florence – which hospital was founded by Folco Portinari, citizen of Florence – determined that, even as the wealth of the hospital had increased, so its church, which was then without Florence and very small, dedicated to S. Egidio, should be enlarged. Whereupon, having taken counsel thereon with Lorenzo di Bicci, who was very much his friend, on September 5, in the year 1418, he began the new church, which was finished in a year in the manner wherein it stands to-day, and was then solemnly consecrated by Pope Martin V at the request of the said Ser Michele, who was the eighth Director of the Hospital, and of the men of the family of Portinari. This consecration Lorenzo afterwards painted, according to the wish of Ser Michele, on the façade of that church, portraying there from life that Pope and some Cardinals; and this work, as something new and beautiful, was then much praised. Wherefore he obtained the honour of being the first to paint in the principal church of his city – that is, in S. Maria del Fiore, where, beneath the windows of each chapel, he painted that Saint to whom it is dedicated, and then, on the pilasters and throughout the church, the twelve Apostles with the crosses of consecration; for that church had been most solemnly consecrated in that same year by Pope Eugenius IV, the Venetian. In the same church the Wardens of Works, by order of the State, caused him to paint in fresco, on one wall, a tomb in imitation of marble, in memory of Cardinal Corsini, who is

* Treasury of public funds.

portrayed there from nature on the sarcophagus; and above that
he made a similar one in memory of Maestro Luigi Marsili, a very
famous theologian, who went as ambassador, with Messer Luigi
Guicciardini and Messer Guccio di Gino, most honourable cava-
liers, to the Duke of Anjou.

Lorenzo was then summoned to Arezzo by Don Laurentino,
Abbot of S. Bernardo, a monastery of the Order of Monte Oliv-
eto, in the principal chapel of which he painted in fresco, for
Messer Carlo Marsuppini, stories of the life of S. Bernard. But
while planning to paint the life of S. Benedict in the cloister of
the convent (I mean, after having painted for the elder Francesco
de' Bacci the principal chapel of the Church of S. Francesco,
where he wrought by himself the vaulting and half of the arch)
he fell sick of a pleurisy; wherefore, having himself carried to
Florence, he left directions that Marco da Montepulciano, his
disciple, should paint the scenes of the life of S. Benedict in the
said cloister, from the design that he had made and left with Don
Laurentino; and this Marco did as best he knew, delivering the
whole work finished in chiaroscuro on April 24, in the year 1448,
as it may be seen written by his hand in verses and words that
are no less rude than the pictures. Having returned to his country
and being restored to health, Lorenzo painted, on the same wall
of the Convent of S. Croce whereon he had made the S. Chris-
topher, the Assumption into Heaven of Our Lady, surrounded
by a choir of angels, and below her a S. Thomas, who is receiving
the Girdle. In the execution of this work, being indisposed,
Lorenzo caused Donatello, then a youth, to help him; wherefore,
with assistance so able, it was finished in the year 1450, in such
wise that I believe that it is the best work, both in design and in
colouring, that was ever made by Lorenzo, who, no long time
after, being old and worn out, died at the age of about sixty,
leaving two sons who applied themselves to painting; one of
whom, named Bicci, gave him assistance in making many works,
while the other, who was called Neri, portrayed his father and
himself in the Chapel of the Lenzi in Ognissanti, in two medal-
lions with letters round them, which give the name of both one
and the other. In this chapel the same man, in painting some
stories of the Madonna, strove to counterfeit many costumes of
those times, both of men and of women; and he made the panel
in distemper for the chapel. In like manner, he made some panels
for the Abbey of S. Felice in Piazza at Florence, belonging to the

Order of Camaldoli, and one for the high-altar of S. Michele in Arezzo, a church of the same Order. And at S. Maria delle Grazie without Arezzo, in the Church of S. Bernardino, he made a Madonna that has under her mantle the people of Arezzo, and on one side that S. Bernardino kneeling with a wooden cross in his hand, such as he was wont to carry when he went preaching through Arezzo, and on the other side and about her S. Nicholas and S. Michelagnolo; and on the predella are painted stories of the acts of the said S. Bernardino, and of the miracles that he wrought, particularly in that place. The same Neri made the panel of the high-haltar of S. Romolo in Florence; and in S. Trinita, in the Chapel of the Spini, he painted in fresco the life of S. Giovanni Gualberto, and in distemper the panel that is over the altar. From these works it is recognized that if Neri had lived, and had not died at the age of thirty-six, he would have made more numerous and better works than did Lorenzo, his father, whose Life, seeing that he was the last of the masters of the old manner of Giotto, will also be the last of this First Part, which with the aid of the blessed God we have brought to conclusion.

PART II

PREFACE TO THE SECOND PART

W<small>HEN</small> first I undertook to write these Lives, it was not my intention to make a list of the craftsmen, and an inventory, so to speak, of their works, nor did I ever judge it a worthy end for these my labours – I will not call them beautiful, but certainly long and fatiguing – to discover their numbers, their names, and their countries, and to tell in what cities, and in what places exactly in those cities, their pictures, or sculptures, or buildings were now to be found; for this I could have done with a simple table, without interposing my own judgment in any part. But seeing that the writers of history – those of them who, by common consent, are reputed to have written with the best judgment – have not only refused to content themselves with the simple narration of the succession of events, but, with all diligence and with the greatest power of research at their disposal, have set about investigating the methods, the means, and the ways that men of mark have used in the management of their enterprises; and seeing that they have striven to touch on their errors, and at the same time on their fine achievements and on the expedients and resolutions sometimes wisely adopted in their government of affairs, and on everything, in short, that these men have effected therein, sagaciously or negligently, or with prudence, or piety, or magnanimity; which these writers have done as men who knew history to be truly the mirror of human life, not in order to make a succinct narration of the events that befell a Prince or a Republic, but in order to observe the judgments, the counsels, the resolutions, and the intrigues of men, leading subsequently to fortunate and unfortunate actions; for this is the true soul of history, and is that which truly teaches men to live and makes them wise, and which, besides the pleasure that comes from seeing past events as present, is the true end of that art; for this reason, having undertaken to write the history of the most noble craftsmen, in order to assist the arts in so far as my powers

permit, and besides that to honour them, I have held to the best
of my ability, in imitation of men so able, to the same method,
and I have striven not only to say what these craftsmen have
done, but also, in treating of them, to distinguish the better from
the good and the best from the better, and to note with no small
diligence the methods, the feeling, the manners, the charac-
teristics, and the fantasies of the painters and sculptors; seeking
with the greatest diligence in my power to make known, to those
who do not know this for themselves, the causes and origins of
the various manners and of that amelioration and that deterio-
ration of the arts which have come to pass at diverse times and
through diverse persons. And because at the beginning of these
Lives I spoke of the nobility and antiquity of these arts, in so far
as it was then necessary for our subject, leaving on one side many
things from Pliny and other authors whereof I could have availed
myself, had I not wished – contrary, perhaps, to the judgment of
many – to leave each man free to see the fantasies of others in
their proper sources; it appears to me expedient to do at present
that which, in avoidance of tedium and prolixity (mortal enemies
of attention), it was not permitted me to do then – namely, to
declare more diligently my mind and intention, and to demon-
strate to what end I have divided this book of the Lives into
Three Parts.

Now it is true that greatness in the arts springs in one man
from diligence, in another from study, in this man from imitation,
in that man from knowledge of the sciences, which all render
assistance to the arts, and in some from all the aforesaid sources
together, or from the greater part of them; yet I, none the less,
having discoursed sufficiently, in the Lives of the individuals, of
their methods of art, their manners, and the causes of their good,
better, and best work, will discourse of this matter in general
terms, and rather of the characteristics of times than of persons;
having made a distinction and division, in order not to make too
minute a research, into Three Parts, or we would rather call them
ages, from the second birth of these arts up to the century where-
in we live, by reason of that very manifest difference that is seen
between one and another of them. In the first and most ancient
age these three arts are seen to have been very distant from their
perfection, and, although they had something of the good, to
have been accompanied by so great imperfection that they cer-
tainly do not merit too great praise; although, seeing that they

gave a beginning and showed the path and method to the better work that followed later, if for no other reason, we cannot but speak well of them and give them a little more glory than the works themselves have merited, were we to judge them by the perfect standard of art.

Next, in the second, it is manifestly seen that matters were much improved, both in the inventions and in the use of more design, better manner, and greater diligence, in their execution; and likewise that the rust of age and the rudeness and disproportion, wherewith the grossness of that time had clothed them, were swept away. But who will be bold enough to say that there was to be found at that time one who was in every way perfect, and who brought his work, whether in invention, or design, or colouring, to the standard of to-day, and contrived the sweet gradation of his figures with the deep shades of colour, in a manner that the lights remained only on the parts in relief, and likewise contrived those perforations and certain extraordinary refinements in marble statuary that are seen in the statues of to-day? The credit of this is certainly due to the third age, wherein it appears to me that I can say surely that art has done everything that it is possible for her, as an imitator of nature, to do, and that she has climbed so high that she has rather to fear a fall to a lower height than to ever hope for more advancement.

Having pondered over these things intently in my own mind, I judge that it is the peculiar and particular nature of these arts to go on improving little by little from a humble beginning, and finally to arrive at the height of perfection; and of this I am persuaded by seeing that almost the same thing came to pass in other faculties, which is no small argument in favour of its truth, seeing that there is a certain degree of kinship between all the liberal arts. Now this must have happened to painting and sculpture in former times in such similar fashion, that, if the names were changed round, their histories would be exactly the same. For if we can put faith in those who lived near those times and could see and judge the labours of the ancients, it is seen that the statues of Canachus were very stiff and without any vivacity or movement, and therefore very distant from the truth; and the same is said of those of Calamis, although they were somewhat softer than those aforesaid. Then came Myron, who was no very close imitator of the truth of nature, but gave so much proportion and grace to his works that they could be reasonably called

beautiful. There followed in the third degree Polycletus and the other so famous masters, who, as it is said and must be believed, made them entirely perfect. The same progress must have also come about in painting, because it is said, and it is reasonable to suppose that it was so, that in the works of those who painted with only one colour, and were therefore called Monochromatists, there was no great perfection. Next, in the works of Zeuxis, Polygnotus, Timanthes, and the others who used only four colours, there is nothing but praise for their lineaments, outlines, and forms; yet, without doubt, they must have left something to be desired. But in Erion, Nicomachus, Protogenes, and Apelles, everything is perfect and most beautiful, and nothing better can be imagined, seeing that they painted most excellently not only the forms and actions of bodies, but also the emotions and passions of the soul.

But, passing these men by, since for knowledge of them we must refer to others, who very often do not agree in their judgments on them, or even, what is worse, as to the dates, although in this I have followed the best authorities; let us come to our own times, wherein we have the help of the eye, a much better guide and judge than the ear. Is it not clearly seen how great improvement was acquired by architecture – to begin with one starting-point – from the time of the Greek Buschetto to that of the German Arnolfo and of Giotto? See the buildings of those times, and the pilasters, the columns, the bases, the capitals, and all the cornices, with their ill-formed members, such as there are in Florence, in S. Maria del Fiore, in the external incrustations of S. Giovanni, and in S. Miniato sul Monte; in the Vescovado of Fiesole, in the Duomo of Milan, in S. Vitale at Ravenna, in S. Maria Maggiore at Rome, and in the Duomo Vecchio without Arezzo; wherein, excepting that little of the good which survived in the ancient fragments, there is nothing that has good order or form. But these men certainly improved it not a little, and under their guidance it made no small progress, seeing that they reduced it to better proportion, and made their buildings not only stable and stout, but also in some measure ornate, although it is true that their ornamentation was confused and very imperfect, and, so to speak, not greatly ornamental. For they did not observe that measure and proportion in the columns that the art required, or distinguish one Order from another, whether Doric, Corinthian, Ionic, or Tuscan, but mixed them all together with a rule of their

own that was no rule, making them very thick or very slender, as suited them best; and all their inventions came partly from their own brains, and partly from the relics of the antiquities that they saw; and they made their plans partly by copying the good, and partly by adding thereunto their own fancies, which, when the walls were raised, had a very different appearance. Nevertheless, whosoever compares their works with those before them will see in them an improvement in every respect, although he will also see some things that give no little displeasure to our own times; as, for example, some little temples of brick, wrought over with stucco, at S. Giovanni Laterano in Rome.

The same do I say of sculpture, which, in that first age of its new birth, had no little of the good; for after the extinction of the rude Greek manner, which was so uncouth that it was more akin to the art of quarrying than to the genius of the craftsmen – their statues being entirely without folds, or attitudes, or movement of any kind, and truly worthy to be called stone images – when design was afterwards improved by Giotto, many men also improved the figures in marble and stone, as did Andrea Pisano and his son Nino and his other disciples, who were much better than the early sculptors and gave their statues more movement and much better attitudes; as also did those two Sienese masters, Agostino and Agnolo, who made the tomb of Guido, Bishop of Arezzo, as it has been said, and those Germans who made the façade at Orvieto. It is seen, then, that during this time sculpture made a little progress, and that there was given a somewhat better form to the figures, with a more beautiful flow of folds in the draperies, and sometimes a better air in the heads and certain attitudes not so stiff; and finally, that it had begun to seek the good, but was nevertheless lacking in innumerable respects, seeing that design was in no great perfection at that time and there was little good work seen that could be imitated. Wherefore those masters who lived at that time, and were put by me in the First Part of the book, deserve to be thus praised and to be held in that credit which the works made by them merit, if only one considers – as is also true of the works of the architects and painters of those times – that they had no help from the times before them, and had to find the way by themselves; and a beginning, however small, is ever worthy of no small praise.

Nor did painting encounter much better fortune in those times, save that, being then more in vogue by reason of the

devotion of the people, it had more craftsmen and therefore
made more evident progress than the other two. Thus it is seen
that the Greek manner, first through the beginning made by
Cimabue, and then with the aid of Giotto, was wholly extin-
guished; and there arose a new one, which I would fain call the
manner of Giotto, seeing that it was discovered by him and by
his disciples, and then universally revered and imitated by all. By
this manner, as we see, there were swept away the outlines that
wholly enclosed the figures, and those staring eyes, and the feet
stretched on tiptoe, and the pointed hands, with the absence of
shadow and the other monstrous qualities of those Greeks; and
good grace was given to the heads, and softness to the colouring.
And Giotto, in particular, gave better attitudes to his figures, and
revealed the first effort to give a certain liveliness to the heads
and folds to his draperies, which drew more towards nature than
those of the men before him; and he discovered, in part, some-
thing of the gradation and foreshortening of figures. Besides this,
he made a beginning with the expression of emotions, so that
fear, hope, rage, and love could in some sort be recognized; and
he reduced his manner, which at first was harsh and rough, to a
certain degree of softness; and although he did not make the eyes
with that beautiful roundness that makes them lifelike, and with
the tear-channels that complete them, and the hair soft, and the
beards feathery, and the hands with their due joints and muscles,
and the nudes true to life, let him find excuse in the difficulty of
the art and in the fact that he saw no better painters than himself;
and let all remember, amid the poverty of art in those times, the
excellence of judgment in his stories, the observation of feeling,
and the subordination of a very ready natural gift, seeing that his
figures were subordinate to the part that they had to play. And
thereby it is shown that he had a very good, if not a perfect
judgment; and the same is seen in the others after him, as in the
colouring of Taddeo Gaddi, who is both sweeter and stronger,
giving better tints to the flesh and better colour to the draperies,
and more boldness to the movements of his figures. In Simone
Sanese there is seen dignity in the composition of stories; and
Stefano the Ape* and his son Tommaso brought about great
improvement and perfection in design, invention in perspective,
and harmony and unity in colouring, ever maintaining the manner

* The Ape of Nature

of Giotto. The same was done for mastery and dexterity of hand-ling by Spinello Aretino and his son Parri, Jacopo di Casentino, Antonio Viniziano, Lippo, Gherardo Starnina, and the other painters who laboured after Giotto, following his feeling, linea-ments, colouring, and manner, and even improving them some-what, but not so much as to make it appear that they were aiming at another goal. Whosoever considers this my discourse, there-fore, will see that these three arts were up to this time, so to speak, only sketched out, and lacking in much of that perfection that was their due; and in truth, without further progress, this improvement was of little use and not to be held in too great account. Nor would I have anyone believe that I am so dull and so poor in judgment that I do not know that the works of Giotto, of Andrea Pisano, of Nino, and of all the others, whom I have put together in the First Part by reason of their similarity of manner, if compared with those of the men who laboured after them, do not deserve extraordinary or even mediocre praise; or that I did not see this when I praised them. But whosoever considers the character of those times, the dearth of craftsmen, and the difficulty of finding good assistance, will hold them not merely beautiful, as I have called them, but miraculous, and will take infinite pleasure in seeing the first beginnings and those sparks of excellence that began to be rekindled in painting and sculpture. The victory of Lucius Marcius in Spain was certainly not so great that the Romans did not have many much greater; but in consideration of the time, the place, the circumstances, the men, and the numbers, it was held stupendous, and even to-day it is held worthy of the infinite and most abundant praises that are given to it by writers. To me, likewise, by reason of all the aforesaid considerations, it has appeared that these masters deserve to be not only described by me with all diligence, but praised with that love and confidence wherewith I have done it. Nor do I think that it can have been wearisome to my brother-craftsmen to read these their Lives, and to consider their manners and methods, and from this, perchance, they will derive no little profit; which will be right pleasing to me, and I will esteem it a good reward for my labours, wherein I have sought to do nought else but give them profit and delight to the best of my power.

And now that we have weaned these three arts, to use such a fashion of speaking, and brought them through their childhood,

there comes their second age, wherein there will be seen infinite improvement in everything; invention more abundant in figures, and richer in ornament; more depth and more lifelike reality in design; some finality, moreover, in the works, which are executed thoughtfully and with diligence, although with too little mastery of handling; with more grace in manner and more loveliness in colouring, so that little is wanting for the reduction of everything to perfection and for the exact imitation of the truth of nature. Wherefore, with the study and the diligence of the great Filippo Brunelleschi, architecture first recovered the measures and proportions of the ancients, both in the round columns and in the square pilasters, and in the corner-stones both rough and smooth; and then one Order was distinguished from another, and it was shown what differences there were between them. It was ordained that all works should proceed by rule, should be pursued with better ordering, and should be distributed with due measure. Design grew in strength and depth; good grace was given to buildings; the excellence of that art made itself known; and the beauty and variety of capitals and cornices were recovered in such a manner, that the ground-plans of his churches and of his other edifices are seen to have been very well conceived, and the buildings themselves ornate, magnificent, and beautifully proportioned, as it may be seen in the stupendous mass of the cupola of S. Maria del Fiore in Florence, and in the beauty and grace of its lantern; in the ornate, varied, and graceful Church of S. Spirito, and in the no less beautiful edifice of S. Lorenzo; in the most bizarre invention of the octagonal Temple of the Angeli; in the most fanciful Church and Convent of the Abbey of Fiesole, and in the magnificent and vast beginning of the Pitti Palace; besides the great and commodious edifice that Francesco di Giorgio made in the Palace and Church of the Duomo at Urbino, and the very strong and rich Castle of Naples, and the impregnable Castle of Milan, not to mention many other notable buildings of that time. And although there were not therein that delicacy and a certain exquisite grace and finish in the mouldings, and certain refinements and beauties in the carving of the leafage and in making certain extremities in the foliage, and other points of perfection, which all came later, as it will be seen in the Third Part, wherein there will follow those who will attain to all that perfection, whether in grace, or refinement, or abundance, or dexterity, to which the old architects did not attain; none the less,

they can be safely called beautiful and good. I do not call them yet perfect, because later there was seen something better in that art, and it appears to me that I can reasonably affirm that there was something wanting in them. And although there are in them some parts so miraculous that nothing better has yet been done in our own times, nor will be, peradventure, in times to come, such as, for example, the lantern of the cupola of S. Maria del Fiore, and, in point of grandeur, the cupola itself, wherein Filippo was emboldened not only to equal the ancients in the extent of their structures, but also to excel them in the height of the walls; yet we are speaking generically and universally, and we must not deduce the excellence of the whole from the goodness and perfection of one thing alone.

This I can also say of painting and sculpture, wherein very rare works of the masters of that second age may still be seen to-day, such as those in the Carmine by Masaccio, who made a naked man shivering with cold, and lively and spirited figures in other pictures; but in general they did not attain to the perfection of the third, whereof we will speak at the proper time, it being necessary now to discourse of the second, whose craftsmen, to speak first of the sculptors, advanced so far beyond the manner of the first and improved it so greatly, that they left little to be done by the third. They had a manner of their own, so much more graceful and more natural, and so much richer in order, in design, and in proportion, that their statues began to appear almost like living people, and no longer figures of stone, like those of the first age; and to this those works bear witness that were wrought in that new manner, as it will be seen in this Second Part, among which the figures of Jacopo della Quercia have more movement, more grace, more design, and more diligence; those of Filippo, a more beautiful knowledge of muscles, better proportion, and more judgment; and so, too, those of their disciples. But the greatest advance came from Lorenzo Ghiberti in the work of the gates of S. Giovanni, wherein he showed such invention, order, manner, and design, that his figures appear to move and to have souls. But as for Donato,* although he lived in their time, I am not wholly sure whether I ought not to place him in the third age, seeing that his works challenge comparison with the good works of the ancients; but this I will say, that he can be

* *I.e.*, Donatello

called the pattern of the others in this second age, having united in his own self all the qualities that were divided singly among many, for he brought his figures to actual motion, giving them such vivacity and liveliness that they can stand beside the works of to-day, and, as I have said, beside the ancient as well.

The same advance was made at this time by painting, from which that most excellent Masaccio swept away completely the manner of Giotto in the heads, the draperies, the buildings, the nudes, the colouring, and the foreshortenings, all of which he made new, bringing to light that modern manner which was followed in those times and has been followed up to our own day by all our craftsmen, and enriched and embellished from time to time with better grace, invention, and ornament; as it will be seen more particularly in the Life of each master, wherein there will appear a new manner of colouring, of foreshortenings, and of natural attitudes, with much better expression for the emotions of the soul and the gestures of the body, and an attempt to approach closer to the truth of nature in draughtsmanship, and an effort to give to the expressions of the faces so complete a resemblance to the living men, that it might be known for whom they were intended. Thus they sought to imitate that which they saw in nature, and no more, and thus their works came to be better planned and better conceived; and this emboldened them to give rules to their perspectives and to foreshorten them in a natural and proper form, just as they did in relief; and thus, too, they were ever observing lights and shades, the projection of shadows, and all the other difficulties, and the composition of stories with more characteristic resemblance, and attempted to give more reality to landscapes, trees, herbs, flowers, skies, clouds, and other objects of nature, insomuch that we may boldly say that these arts were not only reared but actually carried to the flower of their youth, giving hope of that fruit which afterwards appeared, and that, in short, they were about to arrive at their most perfect age.

With the help of God, then, we will begin the Life of Jacopo della Quercia of Siena, and afterwards those of the other architects and sculptors, until we come to Masaccio, who, having been the first to improve design in the art of painting, will show how great an obligation is owed to him for the new birth that he gave to her. Having chosen the aforesaid Jacopo for the honour of beginning this Second Part, I will follow the order of the various

manners, and proceed to lay open, together with the Lives themselves, the difficulties of arts so beautiful, so difficult, and so highly honoured.

JACOPO DELLA QUERCIA
[*JACOPO DELLA FONTE*],
Sculptor of Siena

THE sculptor Jacopo, son of Maestro Piero di Filippo of La Quercia, a place in the district of Siena, was the first – after Andrea Pisano, Orcagna, and the others mentioned above – who, labouring in sculpture with greater zeal and diligence, began to show that it was possible to make an approach to nature, and the first who encouraged the others to hope to be able in a certain measure to equal her. His first works worthy of account were made by him in Siena at the age of nineteen, with the following occasion. The people of Siena having their army in the field against the Florentines under the captainship of Gian Tedesco, nephew of Saccone da Pietramala, and of Giovanni d' Azzo Ubaldini, this Giovanni d' Azzo fell sick in camp and was carried to Siena, where he died; wherefore, being grieved at his death, the people of Siena caused to be made for his obsequies, which were most honourable, a catafalque of wood in the shape of a pyramid, and on this they placed the statue of Giovanni himself on horse-back, larger than life, made by the hand of Jacopo with much judgment and invention. For he, in order to execute this work, discovered a method of making the skeletons of the horse and of the figure which had never been used up to that time – namely, with pieces of wood and planking fastened together, and then swathed round with hay, tow, and ropes, the whole being bound firmly together; and over all there was spread clay mixed with paste, glue, and shearings of woollen cloth. This method, truly, was and still is better than any other for such things, for, although the works that are made in this fashion have the appearance of weight, none the less after they are finished and dried they turn out light, and, being covered with white, look like marble and are very lovely to the eye, as was the said work of Jacopo. To this it may be added that statues made in this fashion and with the said mixtures do not crack, as they would do if they were made simply

257

of pure clay. And in this manner are made to-day the models for sculpture, with very great convenience for the craftsmen, who, by means of these, have ever before them the patterns and the true measurements of the sculptures that they make; and for this method no small obligation is owed to Jacopo, who is said to have been its inventor.

After this work, Jacopo made in Siena two panels of lime-wood, carving the figures in them, with their beards and hair, with so great patience that it was a marvel to see. And after these panels, which were placed in the Duomo, he made some prophets in marble, of no great size, which are in the façade of the said Duomo; and he would have continued to labour at the works of this building, if plague, famine, and the discords of the citizens of Siena had not brought that city to an evil pass; for, after having many times risen in tumult, they drove out Orlando Malevolti, by whose favour Jacopo had enjoyed creditable employment in his native city. Departing then from Siena, he betook himself by the agency of certain friends to Lucca, and there, in the Church of S. Martino, he made a tomb for the wife, who had died a short time before, of Paolo Guinigi, who was Lord of that city; on the base of which tomb he carved some boys in marble that are supporting a garland, so highly finished that they appeared to be of flesh; and on the sarcophagus laid on the said base he made, with infinite diligence, the image of the wife of Paolo Guinigi herself, who was buried within it, and at her feet, from the same block, he made a dog in full relief, signifying the fidelity shown by her to her husband. After Paolo had departed, or rather, had been driven out of Lucca in the year 1429, when the city became free, this sarcophagus was removed from that place and was almost wholly destroyed, by reason of the hatred that the people of Lucca bore to the memory of Guinigi; but the reverence that they bore to the beauty of the figure and of the so many ornaments restrained them, and brought it about that a little time afterwards the sarcophagus and the figure were placed with diligence near the door of the sacristy, where they are at present, while the Chapel of Guinigi was taken over by the Commune.

Meanwhile Jacopo had heard that the Guild of the Merchants of Calimara in Florence wished to have a bronze door made for the Church of S. Giovanni, where, as it has been said, Andrea Pisano had wrought the first; and he had come to Florence in order to make himself known, above all because this work was to

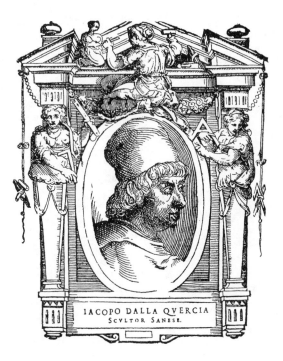

IACOPO DALLA QVERCIA
SCVLTOR SANESE.

be allotted to the man who, in making one of those scenes in bronze, should give the best proof of himself and of his talent. Having therefore come to Florence, he not only made the model, but delivered one very well executed scene, completely finished and polished, which gave so great satisfaction, that, if he had not had as rivals those most excellent masters, Donatello and Filippo Brunelleschi, who in truth surpassed him in their specimens, it would have fallen to him to make this work of so great importance. But the business having concluded otherwise, he went to Bologna, where, by the favour of Giovanni Bentivogli, he was commissioned by the Wardens of Works of S. Petronio to make in marble the principal door of that church, which he continued in the German manner, in order not to alter the style wherein it had already been begun, filling up what was lacking in the design of the pilasters that support the cornice and the arch, with scenes wrought with infinite love within the space of the twelve years that he was engaged in this work, wherein he made with his own hand all the foliage and ornamentation of the said door, with the greatest diligence and care that he could command. On each of the pilasters that support the architrave, the cornice, and the arch, there are five scenes, and five on the architrave, making fifteen in all; and in them all he carved in low-relief stories from the Old Testament – namely, from the Creation of man by God up to the Deluge and Noah's Ark, thus conferring very great benefit on sculpture, since from the ancients up to that time there had been no one who had wrought anything in low-relief, wherefore that method of working was rather out of mind than out of fashion. In the arch of this door he made three figures in marble, as large as life and all in the round – namely, a very beautiful Madonna with the Child in her arms, S. Petronius, and another Saint, all very well grouped and in beautiful attitudes; wherefore the people of Bologna, who did not think that there could be made a work in marble, I do not say surpassing, but even equalling that one which Agostino and Agnolo of Siena had made in the ancient manner on the high-altar of S. Francesco in their city, were amazed to see that this one was by a great measure more beautiful.

After this, being requested to return to Lucca, Jacopo went there very willingly, and made on a marble panel in S. Friano, for Federigo di Maestro Trenta del Veglia, a Virgin with her Son in her arms, and S. Sebastian, S. Lucia, S. Jerome, and S. Gismondo, with good manner, grace, and design; and in the predella below

he made in half-relief, under each Saint, some scene from the life of each, which was something very lovely and pleasing, seeing that Jacopo gave gradation to his figures from plane to plane with beautiful art, making them lower as they receded. In like manner, he gave much encouragement to others to acquire grace and beauty for their works with new methods, when he portrayed from the life the patron of the work, Federigo, and his wife, on two great slabs wrought in low-relief for two tombs; on which slabs are these words:

HOC OPUS FECIT JACOBUS MAGISTRI PETRI DE SENIS, 1422.

Afterwards, on Jacopo coming to Florence, the Wardens of Works of S. Maria del Fiore, by reason of the good report that they had heard of him, commissioned him to make in marble the frontal that is over that door of the church which leads to the Nunziata, wherein, in a mandorla, he made the Madonna being borne to Heaven by a choir of angels sounding instruments and singing, with the most beautiful movements and the most beautiful attitudes – seeing that they have vivacity and motion in their flight – that had ever been made up to that time. In like manner, the Madonna is draped with so great grace and dignity that nothing better can be imagined, the flow of the folds being very beautiful and soft, while the borders of the draperies are seen following closely the nude form of the figure, which, with its very covering, reveals every curve of the limbs; and below this Madonna there is a S. Thomas, who is receiving the Girdle. In short, this work was executed by Jacopo in four years with all the possible perfection that he could give to it, for the reason that, besides the natural desire that he had to do well, the rivalry of Donato, of Filippo, and of Lorenzo di Bartolo, from whose hands there had already issued some works that were highly praised, incited him even more in the doing of what he did; and that was so much that this work is studied even to-day by modern craftsmen, as something very rare. On the other side of the Madonna, opposite to S. Thomas, Jacopo made a bear that is climbing a pear-tree; and with regard to this caprice, even as many things were said then, so also there could be others said by me, but I will forbear, wishing to let everyone believe and think in his own fashion in the matter of this invention.

After this, desiring to revisit his own country, Jacopo returned to Siena, where, on his arrival, there came to him, according to

his desire, an occasion to leave therein some honourable memorial of himself. For the Signoria of Siena, having resolved to make a very rich adornment in marble for the waters that Agostino and Agnolo of Siena had brought into the square in the year 1343, allotted that work to Jacopo, at the price of 2,200 crowns of gold; wherefore he, having made the model and collected the marbles, put his hand to the work and finally completed it so greatly to the satisfaction of his fellow-citizens, that he was ever afterwards called, not Jacopo della Quercia, but Jacopo della Fonte. In the middle of this work, then, he carved the Glorious Virgin Mary, the particular Patroness of that city, a little larger than the other figures, and in a manner both gracious and singular. Round her, next, he made the seven Theological Virtues, the heads of which are delicate, pleasing, beautiful in expression, and wrought with certain methods which show that he began to discover the good and the secrets of the arts, and to give grace to the marble, sweeping away that ancient manner which had been used up to that time by the sculptors, who made their figures rigid and without the least grace in the world; whereas Jacopo made them as soft as flesh, giving finish to his marble with patience and delicacy. Besides this, he made there some stories from the Old Testament – namely, the Creation of our first parents, and the eating of the forbidden fruit, wherein, in the figure of the woman, there is seen an expression of countenance so beautiful, with a grace and an attitude so deferential towards Adam as she offers him the apple, that it appears impossible for him to refuse it; to say nothing of the remainder of the work, which is all full of most beautiful ideas, and adorned with most beautiful children and other ornaments in the shape of lions and she-wolves, emblems of the city, all executed by Jacopo with love, mastery, and judgment in the space of twelve years. By his hand, likewise, are three very beautiful scenes in half-relief from the life of S. John the Baptist, wrought in bronze, which are round the baptismal font of S. Giovanni, below the Duomo; and also some figures in the round, likewise in bronze, one braccio in height, which are between each of the said scenes, and are truly beautiful and worthy of praise. Wherefore, by reason of these works, which showed his excellence, and of the goodness and uprightness of his life, Jacopo was deservedly made chevalier by the Signoria of Siena, and, shortly afterwards, Warden of Works of the Duomo; which office he filled so well that neither before nor since were

these Works better directed, for, although he did not live more than three years after undertaking this charge, he made many useful and honourable improvements in that Duomo. And although Jacopo was only a sculptor, nevertheless he drew passing well, as is demonstrated by some drawings made by him, to be found in our book, which appear to be rather by the hand of an illuminator than of a sculptor. And his portrait, similar to the one that is seen above, I had from Maestro Domenico Beccafumi, painter of Siena, who has related to me many things about the excellence, goodness, and gentleness of Jacopo, who finally died, exhausted by fatigues and by continuous labour, at the age of sixty-four, and was lamented and honourably buried in Siena, the place of his birth, by his friends and relatives – nay, by the whole city. And truly it was no small good-fortune for him to have his so great excellence recognized in his own country, seeing that it rarely comes to pass that men of excellence are universally loved and honoured in their own country.

A disciple of Jacopo was Matteo, a sculptor of Lucca, who made the little octagonal temple of marble – in the Church of S. Martino in his own city, in the year 1444, for Domenico Galigano of Lucca – wherein there is the image of the Holy Cross, a piece of sculpture miraculously wrought, so it is said, by Nicodemus, one of the seventy-two disciples of the Saviour; which temple is truly nothing if not very beautiful and well-proportioned. The same man carved in marble a figure of S. Sebastian wholly in the round, three braccia high, and very beautiful by reason of its having been made with good design and in a beautiful attitude and wrought with a high finish. By his hand, also, is a panel wherein there are three very beautiful figures in three niches, in the church where the body of S. Regulus is said to be; and likewise the panel that is in S. Michele, wherein are three figures in marble; and in like manner the statue that is on the corner of the said church, on the outer side – namely, a Madonna, which shows that Matteo was ever striving to equal his master Jacopo.

Niccolò Bolognese was also a disciple of Jacopo, and he, among other works, brought to completion divinely well – having found it unfinished – the marble sarcophagus full of scenes and figures wherein lies the body of S. Dominic, a work made long ago by Niccola Pisano in Bologna; and he gained thereby, besides profit, that name of honour, Maestro Niccolò dell' Arca, which he bore ever after. He finished this work in the year 1460, and

afterwards, for the façade of the palace where the Legate of Bologna now lives, he made a Madonna in bronze, four braccia high, and placed it in position in the year 1478. In a word, he was an able master and a worthy disciple of Jacopo della Quercia of Siena.

NICCOLÒ ARETINO
[*NICCOLÒ D'AREZZO OR NICCOLÒ DI PIERO LAMBERTI*],
Sculptor

ABOUT the same time, engaged in the same pursuit of sculpture, and almost of the same excellence in the art, lived Niccolò di Piero, a citizen of Arezzo, to whom Nature was as liberal with her gifts of intellect and vivacity of mind as Fortune was niggardly with her benefits. He, then, being a needy fellow, and having received some affront from his nearest of kin in his own country, departed, in order to come to Florence, from Arezzo, where – under the discipline of Maestro Moccio, sculptor of Siena, who, as it has been said in another place, wrought some works in Arezzo – he had applied himself to sculpture with no little fruit, although the said Maestro Moccio was not very excellent. And so, having arrived in Florence, Niccolò at first for many months wrought whatsoever work came to his hand, both because poverty and want were pressing him hard, and also out of rivalry with certain young men, who, competing together honourably with much study and labour, were occupying themselves with sculpture. Finally, after many labours, Niccolò became a creditable sculptor, and was commissioned by the Wardens of Works of S. Maria del Fiore to make two statues for the Campanile; these statues, having been placed therein on the side facing the Canon's house, stand one on either side of those that Donato afterwards made; and since nothing better in full-relief had been seen, they were held passing good.

Next, departing from Florence by reason of the plague of 1383, he went to his own country. There he found that by reason of the said plague the men of the Confraternity of S. Maria della Misericordia, whereof we have spoken above, had acquired great wealth by means of bequests made by diverse persons in the city through the devotion that they felt for that holy place and for its brethren, who attend to the sick and bury the dead in every

pestilence, without fear of any peril; and that therefore they wished to make a façade for that place, but in grey-stone, for lack of a supply of marble. This work, which had been begun before in the German style, he undertook to do; and assisted by many stonecutters from Settignano, he brought it to perfect completion, making with his own hand, in the lunette of the façade, a Madonna with the Child in her arms, and certain angels who are holding open her mantle, under which the people of that city appear to be taking shelter, while S. Laurentino and S. Pergentino, kneeling below, are interceding for them. Next, in two niches at the sides, he made two statues, each three braccia high – namely, one of S. Gregory the Pope, and one of S. Donatus the Bishop, Protector of that city, with good grace and passing good manner. It appears that in his youth, before making these works, he had formerly made three large figures of terra-cotta which were placed over the door of the Vescovado, and which are now in great part eaten away by frost, as is also a S. Luke of greystone, made by the same man while he was a youth and placed in the façade of the said Vescovado. In the Pieve, likewise, in the Chapel of S. Biagio, he made a very beautiful figure of the said Saint in terra-cotta; and one of that Saint in the Church of S. Antonio, also in terra-cotta and in relief; and another Saint, seated, over the door of the hospital of the said city.

While he was making these and some other similar works, the walls of Borgo a San Sepolcro were ruined by an earthquake, and Niccolò was sent for to the end that he might make – as he did with good judgment – a design for a new wall, which turned out much better and stronger than the first. And so, continuing to work now in Arezzo, and now in the neighbouring places, Niccolò was living very quietly and at his ease in his own country, when war, the capital enemy of the arts, compelled him to leave it, for, after the sons of Piero Saccone had been driven out of Pietramala and the castle had been destroyed down to its foundations, the city and the district of Arezzo were all in confusion. Wherefore, departing from that territory, Niccolò betook himself to Florence, where he had worked at other times, and for the Wardens of Works of S. Maria del Fiore he made a statue of marble, four braccia high, which was afterwards placed on the left hand of the principal door of that church. In this statue, which is an Evangelist seated, Niccolò showed that he was truly an able sculptor, and he was therefore much praised, since up to then

there had not been seen, as there was afterwards, any better work in wholly round relief. Being then summoned to Rome by order of Pope Boniface IX, as the best of all the architects of his time, he fortified and gave better form to the Castle of S. Angelo. On returning to Florence, he made two little figures in marble for the Masters of the Mint, on that corner of Orsanmichele that faces the Guild of Wool, in the pilaster, above the niche wherein there is now the S. Matthew, which was made afterwards; and these figures were so well made and so well placed on the summit of that shrine that they were then much extolled, as they have been ever afterwards, and in them Niccolò appears to have surpassed himself, for he never did anything better. In short, they are such that they can stand beside any other work of that kind; wherefore he acquired so great credit that he was thought worthy to be in the number of those who were under consideration for the making of the bronze doors of S. Giovanni, although, when the proof was made, he was left behind, and they were allotted, as it will be said in the proper place, to another. After these labours Niccolò went to Milan, where he was made Overseer of the Works of the Duomo in that city; and there he wrought some things in marble which gave great satisfaction.

Finally, being called back to his own country by the Aretines to the end that he might make a tabernacle for the Sacrament, while returning he was forced to stay in Bologna and to make the tomb of Pope Alexander V, who had finished the course of his years in that city, for the Convent of the Friars Minor. And although he was very unwilling to accept this work, he could not, however, but comply with the prayers of Messer Leonardo Bruni, the Aretine, who had been a highly-favoured Secretary of that Pontiff. Niccolò, then, made the said tomb and portrayed that Pope thereon from nature; although it is true that from lack of marble and other stone the tomb and its ornaments were made of stucco and brick-work, and likewise the statue of the Pope on the sarcophagus, which is placed behind the choir of the said church. This work finished, Niccolò fell grievously sick and died shortly afterwards at the age of sixty-seven, and was buried in the same church, in the year 1417. His portrait was made by Galasso of Ferrara, very much his friend, who was painting at that time in Bologna in competition with Jacopo and Simone, painters of Bologna, and one Cristofano – I know not whether of Ferrara, or, as others say, of Modena – who all painted many works in

fresco in a church called the Casa di Mezzo, without the Porta di
S. Mammolo. Cristofano painted scenes on one side, from the
Creation of Adam by God up to the death of Moses, Simone and
Jacopo painted thirty scenes, from the Birth of Christ up to the
Last Supper that He held with the Apostles, and Galasso then
painted the Passion, as it is seen from the name of each man,
written below. These pictures were made in the year 1404, and
afterwards the rest of the church was painted by other masters
with stories of David, wrought with a high finish. And in truth
it is not without reason that these pictures are held in much
esteem by the Bolognese, both because, for old things, they are
passing good, and also because the work, having been preserved
fresh and vivacious, deserves much praise. Some say that the said
Galasso, when very old, painted also in oil, but neither in Ferrara
nor in any other place have I found any works of his save in
fresco. A disciple of Galasso was Cosmè, who painted a chapel
in S. Domenico at Ferrara, and the folding doors that close the
organ of the Duomo, and many other works, which are better
than the pictures of Galasso, his master.

Niccolò was a good draughtsman, as it may be seen in our
book, wherein there are an Evangelist and three heads of horses
by his hand, very well drawn.

DELLO, Painter of Florence

ALTHOUGH of Dello the Florentine, while he lived, had only
the name of painter, which he has had ever since, he applied
himself none the less also to sculpture – nay, his first works were
in sculpture, seeing that, long before he began to paint, he made
in terra-cotta a Coronation of Our Lady in the arch that is over
the door of the Church of S. Maria Nuova, and, within the
church, the twelve Apostles; and, in the Church of the Servi, a
Dead Christ in the lap of the Virgin, with many other works
throughout the whole city. But, being capricious, and also per-
ceiving that he was gaining little by working in terra-cotta and
that his poverty had need of some greater succour, he resolved,
being a good draughtsman, to give his attention to painting; and
in this he succeeded with ease, for the reason that he soon ac-
quired a good mastery in colouring, as many pictures demonstrate

that he made in his own city, and above all those with little figures, wherein he showed better grace than in the large. And this ability served him in good stead, because the citizens of those times used to have in their apartments great wooden chests in the form of a sarcophagus, with the covers shaped in various fashions, and there were none that did not have the said chests painted; and besides the stories that were wrought on the front and on the ends, they used to have the arms, or rather, insignia of their houses painted on the corners, and sometimes elsewhere. And the stories that were wrought on the front were for the most part fables taken from Ovid and from other poets, or rather, stories related by the Greek and Latin historians, and likewise chases, jousts, tales of love, and other similar subjects, according to each man's particular pleasure. Then the inside was lined with cloth or with silk, according to the rank and means of those who had them made, for the better preservation of silk garments and other precious things. And what is more, it was not only the chests that were painted in such a manner, but also the couches, the chair-backs, the mouldings that went right round, and other similar magnificent ornaments for apartments which were used in those times, whereof an infinite number may be seen throughout the whole city. And for many years this fashion was so much in use that even the most excellent painters exercised themselves in such labours, without being ashamed, as many would be to-day, to paint and gild such things. And that this is true has been seen up to our own day from some chests, chair-backs, and mouldings, besides many other things, in the apartments of the Magnificent Lorenzo de' Medici, the Elder, whereon there were painted – by the hand, not of common painters, but of excellent masters, and with judgment, invention, and marvellous art – all the jousts, tournaments, chases, festivals, and other spectacles that took place in his times. Of such things relics are still seen, not only in the palace and the old houses of the Medici, but in all the most noble houses in Florence; and there are men who, out of attachment to these ancient usages, truly magnificent and most honourable, have not displaced these things in favour of modern ornaments and usages. Dello, then, being a very good and practised painter, and above all, as it has been said, in making little pictures with much grace, applied himself for many years, to his great profit and honour, to nothing else save adorning and painting chests, chair-backs, couches, and other ornaments in the

manner described above, insomuch that it can be said to have been his principal and peculiar profession. But since nothing in this world has permanence or can endure any long time, however good and praiseworthy it may be, it was not long before the refinement of men's intellects led them from that first method of working to the making of richer ornaments and of carvings in walnut-wood overlaid with gold, which make a very rich adornment, and to the painting and colouring in oil of very beautiful stories on similar pieces of household furniture, which have made known, as they still do, both the magnificence of the citizens who use them and the excellence of the painters.

But to come to the works of Dello, who was the first who occupied himself with diligence and good mastery in such labours; for Giovanni de' Medici, in particular, he painted the whole furniture of an apartment, which was held something truly rare and very beautiful of its kind, as some relics demonstrate that are still left. And Donatello, then quite young, is said to have assisted him, making there by his own hand, with stucco, gesso, glue, and pounded brick, some stories and ornaments in low-relief, which, being afterwards overlaid with gold, made a beautiful accompaniment for the painted stories. Of this work and many others like it Drea Cennini makes mention in a long discourse in his work, whereof there has been enough said above; and since it is a good thing to maintain some memory of these old things, I have had some of them, by the hand of Dello himself, preserved in the Palace of the Lord Duke Cosimo, where they are, and they will be ever worthy of being studied, if only for the various costumes of those times, both of men and women, that are seen in them. Dello also wrought the story of Isaac giving his benediction to Esau, in fresco and with terra-verde, in a corner of the cloister of S. Maria Novella.

A little after this work, being summoned to Spain to enter the service of the King, he came into so great credit that no craftsman could have desired much more; and although it is not known precisely what works he made in those parts, it may be judged, seeing that he returned thence very rich and highly honoured, that they were numerous and beautiful and good. After a few years, having been royally rewarded for his labours, Dello conceived the wish to return to Florence, in order to show his friends how he had climbed from extreme poverty to great riches. Wherefore, having gone for permission to that King, not only did

he obtain it readily (although the former would have willingly retained him, if Dello had been so minded), but he was also made chevalier by that most liberal King, as a greater sign of gratitude. Whereupon he returned to Florence in order to obtain the banners and the confirmation of his privileges, but they were denied him by the agency of Filippo Spano degli Scolari, who had just come back from his victories over the Turks as Grand Seneschal of the King of Hungary. But Dello having written immediately to the King of Spain to complain of this affront, the King wrote so warmly on his behalf to the Signoria that the due and desired honour was conceded to him without opposition. It is said that Dello, while returning to his house on horseback, with his banners, having been honoured by the Signoria and robed in brocade, was mocked at, in passing through Vaccereccia, where there were then many goldsmiths' shops, by certain old friends, who, having known him in youth, did this either in scorn or in jest; and that he, turning in the direction whence he had heard the voice, made a gesture of contempt with both his hands and went on his way without saying a word, so that scarcely anyone noticed it save those who had derided him. By reason of this and other signs, which gave him to know that envy was no less active against him in his own country than malice had been formerly when he was very poor, he determined to return to Spain; and so, having written, and having received an answer from the King, he returned to those parts, where he was welcomed with great favour and ever afterwards regarded with affection, and there he devoted himself to work, living like a nobleman, and ever painting from that day onwards in an apron of brocade. Thus, then, he gave way before envy, and lived in honour at the Court of that King; and he died at the age of forty-nine, and was given honourable burial by the same man, with this epitaph:

DELLUS EQUES FLORENTINUS
PICTURÆ ARTE PERCELEBRIS
REGISQUE HISPANIARUM LIBERALITATE
ET ORNAMENTIS AMPLISSIMUS.
H. S. E.
S. T. T. L.

Dello was no very good draughtsman, but was well among the first who began to show judgment in revealing the muscles in nude bodies, as it is seen from some drawings in our book, made

by him in chiaroscuro. He was portrayed in chiaroscuro by Paolo Uccello in S. Maria Novella, in the story wherein Noah is made drunk by his son Ham.

NANNI D' ANTONIO DI BANCO,
Sculptor of Florence

Nanni d' Antonio di Banco was not only rich enough by patrimony, but also by no means humble in origin, yet, delighting in sculpture, he was not only not ashamed to learn and practise it, but took no small pride therein, and made so much advance that his fame will ever endure; and it will be all the more celebrated in proportion as men know that he applied himself to this noble art not through necessity, but through a true love of the art itself. This man, who was one of the disciples of Donato, although I have placed him before his master because he died long before him, was a somewhat sluggish person, but modest, humble, and kindly in his dealings. There is by his hand, in Florence, the S. Philip of marble which is on a pilaster on the outside of the Oratory of Orsanmichele. This work was at first allotted to Donato by the Guild of Shoemakers, and then, since they could not agree with him about the price, it was transferred, as though in despite of Donato, to Nanni, who promised that he would take whatsoever payment they might give him, and would ask no other. But the business fell out otherwise, for, when the statue was finished and set in its place, he asked a much greater price for his work than Donato had done at the beginning; wherefore the valuation of it was referred by both parties to Donato, the Consuls of that Guild believing firmly that he, out of envy at not having made it, would value it at much less than if it were his own work; but they were disappointed in their belief, for Donato judged that much more should be paid to Nanni for his statue than he had demanded. Being in no way willing to abide by this judgment, the Consuls made an outcry and said to Donato: 'Why dost thou, after undertaking to make this work at a smaller price, value it higher when made by the hand of another, and constrain us to give him more for it than he himself demands? For thou knowest, even as we do also, that from thy hands it would have come out much better.' Donato

answered, laughing: 'This good man is not my equal in the art, and endures much more fatigue than I do in working; wherefore, if you wish to give him satisfaction, like the just men that I take you for, you are bound to pay him for the time that he has spent.' And thus the award of Donato was carried into effect, both parties having agreed to abide by it.

This work stands well enough, and has good grace and liveliness in the head; the draperies are not hard, and are in no wise badly arranged about the figure. In another niche below this one there are four saints in marble, which the same Nanni was commissioned to make by the Guild of Smiths, Carpenters, and Masons; and it is said that, having finished them all in the round and detached one from another, and having prepared the niche, it was with great difficulty that he could get even three of them into it, for he had made some of them in attitudes with the arms outstretched; and that he besought Donato, in grief and despair, to consent with his counsel to repair his own misfortune and lack of foresight. And Donato, laughing over the mischance, answered: 'If thou wilt promise to pay for a supper for me and all my apprentices, I will undertake to get the saints into the niche without any trouble.' This Nanni promised to do right willingly, and Donato sent him to Prato, to take certain measurements and to do some other business that would take him some days. Whereupon, Nanni having departed, Donato, with all his disciples and apprentices, set to work and cut some of the statues down in the shoulders and some in the arms, in such wise that he contrived to group them close together, each making place for the other, while he made a hand appear over the shoulders of one of them. And thus the judgment of Donato, having joined them harmoniously together, concealed the error of Nanni so well that they still show, in that place where they were fixed, most manifest signs of concord and brotherhood; and anyone who does not know the circumstance sees nothing of the error. Nanni, finding on his return that Donato had corrected everything and put all his disorder to rights, rendered him infinite thanks, and with great goodwill paid for the supper for him and his pupils. Under the feet of these four saints, in the ornament of the shrine, there is a scene in marble and in half-relief, wherein a sculptor is carving a boy with great animation, and a master is building, with two men assisting him; and all these little figures are seen to be very well grouped and intent on what they are doing.

In the façade of S. Maria del Fiore, on the left side as one enters the church by the central door, there is an Evangelist by the hand of the same man, which is a passing good figure for those times. It is also reputed that the S. Lo which is without the said Oratory of Orsanmichele, and which was made for the Guild of Farriers, is by the hand of the same Nanni, and likewise the marble shrine, in the base of which, at the foot, there is a scene wherein S. Lo, the Farrier, is shoeing a frenzied horse, so well made that Nanni deserved much praise for it; and he would have deserved and obtained much greater praise with other works, if he had not died, as he did, while still young. None the less, by reason of these few works Nanni was held a passing good sculptor; and being a citizen, he obtained many offices in his native city of Florence, and because he bore himself like a just and reasonable man both in these and in all his other affairs, he was greatly beloved. He died of colic in the year 1430, at the age of forty-seven.

LUCA DELLA ROBBIA, Sculptor of Florence

LUCA DELLA ROBBIA, sculptor of Florence, was born in the year 1388 in the house of his ancestors, which is in Florence, below the Church of S. Barnaba; and therein he was honestly brought up until he had learnt not only to read and write but also to cast accounts, in so far as it was likely to be needful, after the custom of most Florentines. And afterwards he was placed by his father to learn the art of the goldsmith with Leonardo di Ser Giovanni, who was then held the best master of that art in Florence. Now, having learnt under this man to make designs and to work in wax, Luca grew in courage and applied himself to making certain things in marble and in bronze, which, seeing that he succeeded in them well enough, brought it about that he completely abandoned his business of goldsmith and applied himself to sculpture, insomuch that he did nothing but ply his chisel all day and draw all night; and this he did with so great zeal, that, feeling his feet very often freezing at night, he took to keeping them in a basket full of shavings, such as carpenters strip from planks when they shape them with the plane, in order to warm them without giving up his drawing. Nor do I marvel in

any way at this, seeing that no one ever became excellent in any exercise whatsoever without beginning from his childhood to endure heat, cold, hunger, thirst, and other discomforts; wherefore those men are entirely deceived who think to be able, at their ease and with all the comforts of the world, to attain to honourable rank. It is not by sleeping but by waking and studying continually that progress is made.

Luca was barely fifteen years of age when he was summoned, together with other young sculptors, to Rimini, in order to make some figures and other ornaments in marble for Sigismondo di Pandolfo Malatesti, Lord of that city, who was then having a chapel made in the Church of S. Francesco, and a tomb for his wife, who had died. Luca had given an honourable proof of his knowledge in some low-reliefs in this work, which are still seen there, when he was recalled by the Wardens of Works of S. Maria del Fiore to Florence, where, for the campanile of that church, he made five little scenes in marble, which are on the side that faces the church, and which were wanting, according to the design of Giotto, to go with that wherein are the Sciences and Arts, formerly made, as it has been said, by Andrea Pisano. In the first Luca made Donato teaching grammar; in the second, Plato and Aristotle, standing for philosophy; in the third, a figure playing a lute, for music; in the fourth, a Ptolemy, for astrology; and in the fifth, Euclid, for geometry. These scenes, in perfection of finish, in grace, and in design, were far in advance of the two made, as it has been said, by Giotto, in one of which Apelles, standing for painting, is working with his brush, while in the other Pheidias, representing sculpture, is labouring with his chisel. Wherefore the said Wardens of Works – who, besides the merits of Luca, were persuaded thereunto by Messer Vieri de' Medici, then a great citizen and a friend of the people, who loved Luca dearly – commissioned him, in the year 1405, to make the marble ornament for the organ which the Office of Works was then having made on a very grand scale, to be set up over the door of the sacristy of the said church. In certain scenes at the base of this work Luca made the singing choirs, chanting in various fashions; and he put so much zeal into this labour and succeeded so well therein, that, although it is sixteen braccia from the ground, one can see the swelling of the throats of the singers, the leader of the music beating with his hands on the shoulders of the smaller ones, and, in short, diverse manners of sounds, chants, dances,

and other pleasing actions that make up the delight of music. Next, on the great cornice of this ornament Luca placed two figures of gilded metal – namely, two nude angels, wrought with a high finish, as is the whole work, which was held to be something very rare, although Donatello, who afterwards made the ornament of the other organ, which is opposite to the first, made his with much more judgment and mastery than Luca had shown, as will be told in the proper place; for Donatello executed that work almost wholly with bold studies and with no smoothness of finish, to the end that it might show up much better from a distance, as it does, than that of Luca, which, although it is wrought with good design and diligence, is nevertheless so smooth and highly finished that the eye, by reason of the distance, loses it and does not grasp it well, as it does that of Donatello, which is, as it were, only sketched.

To this matter craftsmen should pay great attention, for the reason that experience teaches us that all works which are to be viewed from a distance, whether they be pictures, or sculptures, or any other similar thing whatsoever, have more vivacity and greater force if they are made in the fashion of beautiful sketches than if they are highly finished; and besides the fact that distance gives this effect, it also appears that very often in these sketches, born in a moment from the fire of art, a man's conception is expressed in a few strokes, while, on the contrary, effort and too great diligence sometimes rob men of their force and judgment, if they never know when to take their hands off the work that they are making. And whosoever knows that all the arts of design, not to speak only of painting, are similar to poetry, knows also that even as poems thrown off by the poetic fire are the true and good ones, and better than those made with great effort, so, too, the works of men excellent in the arts of design are better when they are made at one sitting by the force of that fire, than when they go about investigating one thing after another with effort and fatigue. And he who has from the beginning, as he should have, a clear idea of what he wishes to do, ever advances resolutely and with great readiness to perfection. Nevertheless, seeing that all intellects are not of the same stamp, there are some, in fact, although they are rare, who cannot work well save at their leisure; and to say nothing of the painters, it is said that the most reverend and most learned Bembo – among the poets – sometimes laboured many months, perchance even years, at the

making of a sonnet, if we can believe those who affirm it; wherefore it is no great marvel that this should happen sometimes to some of the masters of our arts. But for the most part the rule is to the contrary, as it has been said above, although the vulgar think more of a certain external and obvious delicacy that proves to lack the essential qualities, which are made up for by diligence, than of the good, wrought with reason and judgment, but not so highly finished and polished on the outside.

But to return to Luca; the said work being finished and giving great satisfaction, he was entrusted with the bronze door of the said sacristy, which he divided into ten squares – namely, five on either side, making the head of a man at every corner of each square, in the border; and he varied the heads one from another, making young men, old, and middle-aged, some bearded and some shaven, and, in short, each one beautiful of its kind in diverse fashions, so that the framework of that door was beautifully adorned. Next, in the scenes in the squares – to begin at the upper part – he made the Madonna with the Child in her arms, with most beautiful grace; and in the one beside it, Jesus Christ issuing from the Sepulchre. Below these, in each of the first four squares, is the figure of an Evangelist; and below these, the four Doctors of the Church, who are writing in different attitudes. And the whole of this work is so highly finished and polished that it is a marvel, and gives us to know that it was a great advantage to Luca to have been a goldsmith.

But since, on reckoning up after these works how much there had come to his hand and how much time he spent in making them, he recognized that he had gained very little and that the labour had been very great, he resolved to abandon marble and bronze and to see whether he could gather better fruits from another method. Wherefore, reflecting that clay could be worked easily and with little labour, and that it was only necessary to find a method whereby works made with it might be preserved for a long time, he set about investigating to such purpose that he found a way to defend them from the injuries of time; for, after having made many experiments, he found that by covering them with a coating of glaze, made with tin, litharge, antimony, and other minerals and mixtures fused together in a special furnace, he could produce this effect very well and make works in clay almost eternal. For this method of working, as being its inventor, he gained very great praise, and all the ages to come will therefore owe him an obligation.

Having then succeeded in this as much as he could desire, he resolved that his first works should be those that are in the arch over the bronze door which he had made for the sacristy, below the organ of S. Maria del Fiore; and therein he made a Resurrection of Christ, so beautiful for that time that it was admired, when placed in position, as something truly rare. Moved by this, the said Wardens of Works desired that the arch over the door of the other sacristy, where Donatello had made the ornament of the other organ, should be filled by Luca in the same manner with similar figures and works in terra-cotta; wherefore Luca made therein a very beautiful Jesus Christ ascending into Heaven.

Now, not being yet satisfied with this beautiful invention – so lovely and so useful, above all for places where there is water, and where, because of damp or other reasons, there is no scope for paintings – Luca went on seeking further progress, and, instead of making the said works in clay simply white, he added the method of giving them colour, with incredible marvel and pleasure to all. Wherefore the Magnificent Piero di Cosimo de' Medici, one of the first to commission Luca to fashion coloured works in clay, caused him to execute the whole of the round vaulting of a study in the Palace – built, as it will be told, by his father Cosimo – with various things of fancy, and likewise the pavement, which was something singular and very useful for the summer. And seeing that this method was then very difficult, and that many precautions were necessary in the firing of the clay, it is certainly a marvel that Luca could execute these works with so great perfection that both the vaulting and the pavement appear to be made, not of many pieces, but of one only. The fame of these works spreading not only throughout Italy but throughout all Europe, there were so many who desired them that the merchants of Florence, keeping Luca, to his great profit, continually at this labour, sent them throughout the whole world. And because he could not supply the whole, he took his brothers, Ottaviano and Agostino, away from the chisel, and set them to work on these labours, wherein the three of them together gained much more than they had done up to then with the chisel, for the reason that, besides those of their works that were sent to France and Spain, they also wrought many things in Tuscany; and in particular, for the said Piero de' Medici, in the Church of S. Miniato al Monte, the vaulting of the marble chapel, which rests on four columns in the middle of the church, and which they

divided most beautifully into octagons. But the most notable work of this kind that ever issued from their hands was the vaulting of the Chapel of S. Jacopo, where the Cardinal of Portugal is buried, in the same church. In this, although it has no salient angles, they made the four Evangelists in four medallions at the corners, and the Holy Spirit in a medallion in the middle of the vaulting, filling the other spaces with scales which follow the curve of the vaulting and diminish little by little till they reach the centre, insomuch that there is nothing better of that kind to be seen, nor anything built and put together with more diligence.

Next, in a little arch over the door of the Church of S. Piero Buonconsiglio, below the Mercato Vecchio, he made the Madonna with some angels round her, all very vivacious; and over a door of a little church near S. Piero Maggiore, in a lunette, he made another Madonna with some angels, which are held very beautiful. And in the Chapter-house of S. Croce, likewise, built by the family of the Pazzi under the direction of Pippo di Ser Brunellesco, he made all the glazed figures that are seen therein both within and without. And Luca is said to have sent some very beautiful figures in full-relief to the King of Spain, together with some works in marble. For Naples, also, he made in Florence the marble tomb for the infant brother of the Duke of Calabria, with many glazed ornaments, being assisted by his brother Agostino.

After these works, Luca sought to find a way of painting figures and scenes on a level surface of terra-cotta, in order to give long life to pictures, and made an experiment in a medallion which is above the shrine of the four saints without Orsanmichele, on the level surface of which, in five parts, he made the instruments and insignia of the Guilds of the Masters in Wood and Stone, with very beautiful ornaments. And he made two other medallions in the same place, in relief, in one of which, for the Guild of Apothecaries, he made a Madonna, and in the other, for the Mercatanzia, a lily on a bale, which has round it a festoon of fruits and foliage of various sorts, so well made, that they appear to be real and not of painted terra-cotta. In the Church of S. Brancazio, also, he made a tomb of marble for Messer Benozzo Federighi, Bishop of Fiesole, and Federighi himself lying on it, portrayed from nature, with three other half-length figures; and in the ornament of the pilasters of this work, on the level surface, he painted certain festoons with clusters of fruit and foliage, so lifelike and natural, that nothing better could be done in

oil and on panel with the brush. Of a truth, this work is marvellous and most rare, seeing that Luca made the lights and shades in it so well, that it scarcely appears possible for this to be done by the action of fire. And if this craftsman had lived longer than he did, even greater works would have been seen to issue from his hands, since, a little before he died, he had begun to make scenes and figures painted on a level surface, whereof I once saw some pieces in his house, which lead me to believe that he would have easily succeeded in this, if death, which almost always snatches the best men away just when they are on the point of conferring some benefit on the world, had not robbed him of life before his time.

Luca was survived by Ottaviano and Agostino, his brothers, and from Agostino there was born another Luca, who was very learned in his day. Now Agostino, pursuing the art after the death of Luca, made the façade of S. Bernardino in Perugia in the year 1461, with three scenes in low-relief therein and four figures in the round, executed very well and with a delicate manner; and on this work he put his name in these words, AUGUSTINI FLORENTINI LAPICIDÆ.

Of the same family was the nephew of Luca, Andrea, who worked very well in marble, as it is seen in the Chapel of S. Maria delle Grazie, without Arezzo, where he made for the Commune, in a great ornament of marble, many little figures both in the round and in half-relief; which ornament was made for a Virgin by the hand of Parri di Spinello of Arezzo. The same man made the panel in terra-cotta for the Chapel of Puccio di Magio, in the Church of S. Francesco in the same city, and that representing the Circumcision for the family of the Bacci. In S. Maria in Grado, likewise, there is a very beautiful panel by his hand with many figures; and on the high-altar of the Company of the Trinità there is a panel by his hand containing a God the Father, who is supporting Christ Crucified in His arms, surrounded by a multitude of angels, while S. Donatus and S. Bernard are kneeling below. In the church and in other parts of the Sasso della Vernia, likewise, he made many panels, which have been well preserved in that desert place, where no painting could have remained fresh for even a few years. The same Andrea wrought all the figures in glazed terra-cotta which are in the Loggia of the Hospital of S. Paolo in Florence, and which are passing good; and likewise the boys, both swathed and nude, that are in the medallions between one arch and another in the Loggia of the Hospital of the Innocenti, which are all truly admirable and prove the great

talent and art of Andrea; not to mention many, nay, innumerable other works that he made in the course of his life, which lasted eighty-four years. Andrea died in the year 1528, and I, while still a boy, talked with him and heard him say – nay, boast – that he had taken part in bearing Donato to the tomb; and I remember that the good old man showed no little pride as he spoke of this.

But to return to Luca; he was buried, with the rest of his family, in their ancestral tomb in S. Piero Maggiore, and in the same tomb there was afterwards buried Andrea, who left two sons, friars in S. Marco, where they received the habit from the Reverend Fra Girolamo Savonarola, to whom that Della Robbia family was ever devoted, portraying him in that manner which is still seen to-day in the medals. The same man, besides the said two friars, had three other sons: Giovanni, who devoted himself to art and had three sons, Marco, Lucantonio, and Simone, who died of plague in the year 1527, having given great promise; and Luca and Girolamo, who devoted themselves to sculpture. Of these two, Luca was very diligent in glazed works, and he made with his own hand, besides many other things, the pavements of the Papal Loggie which Pope Leo X caused to be made in Rome under the direction of Raffaello da Urbino, and also those of many apartments, wherein he put the insignia of that Pontiff. Girolamo, who was the youngest of all, devoted himself to working in marble, in clay, and in bronze, and had already become an able man, by reason of competing with Jacopo Sansovino, Baccio Bandinelli, and other masters of his time, when he was brought by certain Florentine merchants to France, where he made many works for King Francis at Madri, a place not far distant from Paris, and in particular a palace with many figures and other ornaments, with a kind of stone like our Volterra gypsum, but of a better quality, for it is soft when it is worked, and afterwards with time becomes hard. He also wrought many things in clay at Orleans and made works throughout that whole kingdom, acquiring fame and very great wealth. After these works, hearing that he had no relative left in Florence save his brother Luca, and being himself rich and alone in the service of King Francis, he summoned his brother to join him in those parts, in order to leave him in credit and good circumstances, but it fell out otherwise, for in a short time Luca died there, and Girolamo once more found himself alone and without any of his kin; wherefore he resolved to return, in order to enjoy in his own country the riches that

his labour and sweat had brought him, and also to leave therein some memorial of himself, and he was settling down to live in Florence in the year 1553, when he was forced to change his mind, as it were, for he saw that Duke Cosimo, by whom he was hoping to be honourably employed, was occupied with the war in Siena; whereupon he returned to die in France. And not only did his house remain closed and his family become extinct, but art was deprived of the true method of making glazed work, for the reason that, although there have been some after them who have practised that sort of sculpture, nevertheless they have all failed by a great measure to attain to the excellence of the elder Luca, Andrea, and the others of that family. Wherefore, if I have spoken on this subject at greater length, perchance, than it appeared to be necessary, let no man blame me, seeing that the fact that Luca discovered this new form of sculpture – which, to my knowledge, the ancient Romans did not have – made it necessary to discourse thereon, as I have done, at some length. And if, after the Life of the elder Luca, I have given some brief account of his descendants, who have lived even to our own day, I have done this in order not to have to return to this subject another time.

Luca, then, while passing from one method of work to another, from marble to bronze, and from bronze to clay, did this not by reason of laziness or because he was, as many are, capricious, unstable, and discontented with his art, but because he felt himself drawn by nature to new things and by necessity to an exercise according to his taste, both less fatiguing and more profitable. Wherefore the world and the arts of design became the richer by a new, useful, and most beautiful art, and he gained immortal and everlasting glory and praise. Luca was an excellent and graceful draughtsman, as it may be seen from some drawings in our book with the lights picked out with white lead, in one of which is his portrait, made by him with much diligence by looking at himself in a mirror.

PAOLO UCCELLO, Painter of Florence

PAOLO UCCELLO would have been the most gracious and fanciful genius that was ever devoted to the art of painting, from Giotto's day to our own, if he had laboured as much at figures

and animals as he laboured and lost time over the details of perspective; for although these are ingenious and beautiful, yet if a man pursues them beyond measure he does nothing but waste his time, exhausts his powers, fills his mind with difficulties, and often transforms its fertility and readiness into sterility and constraint, and renders his manner, by attending more to these details than to figures, dry and angular, which all comes from a wish to examine things too minutely; not to mention that very often he becomes solitary, eccentric, melancholy, and poor, as did Paolo Uccello. This man, endowed by nature with a penetrating and subtle mind, knew no other delight than to investigate certain difficult, nay, impossible problems of perspective, which, although they were fanciful and beautiful, yet hindered him so greatly in the painting of figures, that the older he grew the worse he did them. And there is no doubt that if a man does violence to his nature with too ardent studies, although he may sharpen one edge of his genius, yet nothing that he does appears done with that facility and grace which are natural to those who put each stroke in its proper place temperately and with a calm intelligence full of judgment, avoiding certain subtleties that rather burden a man's work with a certain laboured, dry, constrained, and bad manner, which moves those who see it rather to compassion than to marvel; for the spirit of genius must be driven into action only when the intellect wishes to set itself to work and when the fire of inspiration is kindled, since it is then that excellent and divine qualities and marvellous conceptions are seen to issue forth.

Now Paolo was for ever investigating, without a moment's intermission, the most difficult problems of art, insomuch that he reduced to perfection the method of drawing perspectives from the ground-plans of houses and from the profiles of buildings, carried right up to the summits of the cornices and the roofs, by means of intersecting lines, making them foreshortened and diminishing towards the centre, after having first fixed the eye-level either high or low, according to his pleasure. So greatly, in short, did he occupy himself with these difficulties, that he introduced a way, method, and rule of placing figures firmly on the planes whereon their feet are planted, and foreshortening them bit by bit, and making them recede by a proportionate diminution; which hitherto had always been done by chance. He discovered, likewise, the method of turning the intersections and arches of

vaulted roofs; the foreshortening of ceilings by means of the convergence of the beams; and the making of round columns at the salient angle of the walls of a house in a manner that they curve at the corner, and, being drawn in perspective, break the angle and cause it to appear level. For the sake of these investigations he kept himself in seclusion and almost a hermit, having little intercourse with anyone, and staying weeks and months in his house without showing himself. And although these were difficult and beautiful problems, if he had spent that time in the study of figures, he would have brought them to absolute perfection; for even so he made them with passing good draughtsmanship. But, consuming his time in these researches, he remained throughout his whole life more poor than famous; wherefore the sculptor Donatello, who was very much his friend, said to him very often – when Paolo showed him mazzocchi* with pointed ornaments, and squares drawn in perspective from diverse aspects; spheres with seventy-two diamond-shaped facets, with wood-shavings wound round sticks on each facet; and other fantastic devices on which he spent and wasted his time – 'Ah, Paolo, this perspective of thine makes thee abandon the substance for the shadow; these are things that are only useful to men who work at the inlaying of wood, seeing that they fill their borders with chips and shavings, with spirals both round and square, and with other similar things.'

The first pictures of Paolo were in fresco, in an oblong niche painted in perspective, at the Hospital of Lelmo – namely, a figure of S. Anthony the Abbot, with S. Cosimo on one side and S. Damiano on the other. In the Annalena, a convent of nuns, he made two figures; and within the Church of S. Trinita, over the left-hand door, he painted stories of S. Francis in fresco – namely, the receiving of the Stigmata; the supporting of the Church, which he is upholding with his shoulders; and his conference with S. Dominic. In S. Maria Maggiore, also, in a chapel near the side-door which leads to S. Giovanni, where there are the panel and predella of Masaccio, he wrought an Annunciation in fresco, wherein he made a building worthy of consideration,

* Mazzocchi are probably coronets placed on the arms of noble families; also caps of a peculiar shape, such as those worn by Taddeo Gaddi and others in the portraits placed by Vasari at the beginning of each Life; and possibly, also, the wooden hoops placed inside these caps to keep them in shape.

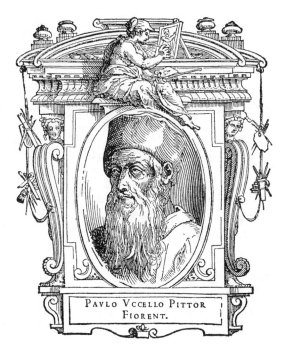

PAVLO VCCELLO PITTOR
FIORENT.

which was something new and difficult in those times, seeing that it was the first possessing any beauty of manner which was seen by craftsmen, showing them with grace and proportion how to manage the receding of lines, and how to give so great an extent to a level space which is small and confined, that it appears far distant and large; and when to this, with judgment and grace, men can add shadows and lights by means of colours in their proper places, there is no doubt that they cause an illusion to the eye, so that it appears that the painting is real and in relief. And not being satisfied with this, he wished to demonstrate even greater difficulties in some columns, which, foreshortened in perspective, curve round and break the salient angle of the vaulting wherein are the four Evangelists; which was held something beautiful and difficult, and, in truth, in that branch of his profession Paolo was ingenious and able.

In a cloister of S. Miniato without Florence, also, he wrought the lives of the Holy Fathers, chiefly in terra-verde, and partly in colour; wherein he paid little regard to effecting harmony by painting with one colour, as should be done in painting stories, for he made the fields blue, the cities red, and the buildings varied according to his pleasure; and in this he was at fault, for something which is meant to represent stone cannot and should not be tinted with another colour. It is said that while Paolo was labouring at this work, the Abbot who was then head of that place gave him scarcely anything to eat but cheese. Wherefore Paolo, having grown weary of this, determined, like the shy fellow that he was, to go no more to work there; whereupon the Abbot sent to look for him, and Paolo, when he heard friars asking for him, would never be at home, and if peradventure he met any couples of that Order in the streets of Florence, he would start running and flying from them with all his might. Now two of them, more curious than the rest and younger than Paolo, caught him up one day and asked him for what reason he did not return to finish the work that he had begun, and why he fled at the sight of a friar; and Paolo answered: 'You have murdered me in a manner that I not only fly from you, but cannot show myself near any carpenter's shop or pass by one, and all because of the thoughtlessness of your Abbot, who, what with pies and with soups always made of cheese, has crammed so much cheese into me that I am in terror lest, being nothing but cheese, they may use me for making glue. And if it were to go on any longer, I

would probably be no more Paolo, but cheese.' The friars, leaving him with peals of laughter, told everything to the Abbot, who made him return to his work, and ordered him some other fare than cheese.

After this, he painted the dossal of S. Cosimo and S. Damiano in the Carmine, in the Chapel of S. Girolamo (of the Pugliesi). In the house of the Medici he painted some scenes on canvas and in distemper, representing animals; in these he ever took delight, and in order to paint them well he gave them very great attention, and, what is more, he kept ever in his house pictures of birds, cats, dogs, and every sort of strange animal whereof he could get the likeness, being unable to have them alive by reason of his poverty; and because he delighted in birds more than in any other kind, he was given the name of 'Paolo of the Birds' (Paolo Uccelli). In the said house, among other pictures of animals, he made some lions, which were fighting together with movements and a ferocity so terrible that they appeared alive. But the rarest scene among them all was one wherein a serpent, combating with a lion, was showing its ferocity with violent movements, with the venom spurting from its mouth and eyes, while a country girl who is present is looking after an ox made with most beautiful foreshortening. The actual drawing for this ox, by the hand of Paolo, is in my book of drawings, and likewise that of the peasant girl, all full of fear, and in the act of running away from those animals. There are likewise certain very lifelike shepherds, and a landscape which was held something very beautiful in his time. In the other canvases he made some studies of men-at-arms of those times, on horseback, with not a few portraits from the life.

Afterwards he was commissioned to paint some scenes in the cloister of S. Maria Novella; and the first, which are at the entrance from the church into the cloister, represent the Creation of the animals, with an infinite number and variety of kinds belonging to water, earth, and air. And since he was very fanciful and took great delight, as it has been said, in painting animals to perfection, he showed in certain lions, who are seeking to bite each other, the great ferocity that is in them, and swiftness and fear in some stags and fallow-deer; not to mention that the birds and fishes, with their feathers and scales, are most lifelike. He made there the Creation of man and of woman, and their Fall, with a beautiful manner and with good and careful execution. And in this work he took delight in making the trees with

colours, which the painters of those times were not wont to do very well; and in the landscapes, likewise, he was the first among the old painters to make a name for himself by his work, executing them well and with greater perfection than the painters before him had done; although afterwards there came men who made them more perfect, for with all his labour he was never able to give them that softness and harmony which have been given to them in our own day by painting them in oil-colours. It was enough for Paolo to go on, according to the rules of perspective, drawing and foreshortening them exactly as they are, making in them all that he saw – namely, ploughed fields, ditches, and other minutenesses of nature – with that dry and hard manner of his; whereas, if he had picked out the best from everything and had made use of those parts only that come out well in painting, they would have been absolutely perfect. This labour finished, he worked in the same cloister below two stories by the hand of others; and lower down he painted the Flood, with Noah's Ark, wherein he put so great pains and so great art and diligence into the painting of the dead bodies, the tempest, the fury of the winds, the flashes of the lightning, the shattering of trees, and the terror of men, that it is beyond all description. And he made, foreshortened in perspective, a corpse from which a raven is picking out the eyes, and a drowned boy, whose body, being full of water, is swollen out into the shape of a very great arch. He also represented various human emotions, such as the little fear of the water shown by two men who are fighting on horseback, and the extreme terror of death seen in a woman and a man who are mounted on a buffalo, which is filling with water from behind, so that they are losing all hope of being able to save themselves; and the whole work is so good and so excellent, that it brought him very great fame. He diminished the figures, moreover, by means of lines in perspective, and made mazzocchi and other things, truly very beautiful in such a work. Below this story, likewise, he painted the drunkenness of Noah, with the contemptuous action of his son Ham – in whom he portrayed Dello, the Florentine painter and sculptor, his friend – with Shem and Japhet, his other sons, who are covering him up as he lies showing his nakedness. Here, likewise, he made in perspective a cask that curves on every side, which was held something very beautiful, and also a pergola covered with grapes, the wood-work of which, composed of squared planks, goes on diminishing to a

point; but here he was in error, since the diminishing of the plane
below, on which the figures are standing, follows the lines of the
pergola, and the cask does not follow these same receding lines;
wherefore I marvel greatly that a man so accurate and diligent
could make an error so notable. He made there also the Sacrifice,
with the Ark open and drawn in perspective, with the rows of
perches in the upper part, distributed row by row; these were the
resting-places of the birds, many kinds of which are seen issuing
and flying forth in foreshortening, while in the sky there is seen
God the Father, who is appearing over the sacrifice that Noah
and his sons are making; and this figure, of all those that Paolo
made in this work, is the most difficult, for it is flying, with the
head foreshortened, towards the wall, and has such force and
relief that it seems to be piercing and breaking through it. Besides
this, Noah has round him an infinite number of diverse animals,
all most beautiful. In short, he gave to all this work so great
softness and grace, that it is beyond comparison superior to all
his others; wherefore it has been greatly praised from that time
up to our own.

In S. Maria del Fiore, in memory of Giovanni Acuto, an Eng-
lishman, Captain of the Florentines, who had died in the year
1393, he made in terra-verde a horse of extraordinary grandeur,
which was held very beautiful, and on it the image of the Captain
himself, in chiaroscuro and coloured with terra-verde, in a picture
ten braccia high on the middle of one wall of the church; where
Paolo drew in perspective a large sarcophagus, supposed to con-
tain the corpse, and over this he placed the image of him in his
Captain's armour, on horseback. This work was and still is held
to be something very beautiful for a painting of that kind, and if
Paolo had not made that horse move its legs on one side only,
which naturally horses do not do, or they would fall – and this
perchance came about because he was not accustomed to ride,
nor used to horses as he was to other animals – this work would
be absolutely perfect, since the proportion of that horse, which
is colossal, is very beautiful; and on the base there are these
letters: PAULI UCCELLI OPUS.

At the same time, and in the same church, he painted in
colours the hour-dial above the principal door within the church,
with four heads coloured in fresco at the corners. He wrought in
terra-verde, also, the loggia that faces towards the west above the
garden of the Monastery of the Angeli, painting below each arch

a story of the acts of S. Benedict the Abbot, and of the most notable events of his life, up to his death. Here, among many most beautiful scenes, there is one wherein a monastery is destroyed by the agency of the Devil, while a friar is left dead below the stones and beams. No less notable is the terror of another monk, whose draperies, as he flies, cling round his nude form and flutter with most beautiful grace; whereby Paolo awakened the minds of the craftsmen so greatly, that they have ever afterwards followed that method. Very beautiful, also, is the figure of S. Benedict, the while that with dignity and devoutness, in the presence of his monks, he restores the dead friar to life. Finally, in all these stories there are features worthy of consideration, and above all in certain places where the very tiles of the roof, whether flat or round, are drawn in perspective. And in the death of S. Benedict, while his monks are performing his obsequies and bewailing him, there are some sick men and cripples, all most beautiful, who stand gazing on him; and it is noticeable, also, that among many loving and devout followers of that Saint there is an old monk with crutches under his arms, in whom there is seen a marvellous expression, with even a hope of being made whole. In this work there are no landscapes in colour, nor many buildings, nor difficult perspectives, but there is truly great design, with no little of the good.

In many houses of Florence there are many pictures in perspective by the hand of the same man, for the adornment of couches, beds, and other little things; and in Gualfonda, in particular, on a terrace in the garden which once belonged to the Bartolini, there are four battle-scenes painted on wood by his hand, full of horses and armed men, with very beautiful costumes of those days; and among the men are portraits of Paolo Orsino, Ottobuono da Parma, Luca da Canale, and Carlo Malatesti, Lord of Rimini, all captains-general of those times. And these pictures, since they were spoilt and had suffered injury, were restored in our own day by the agency of Giuliano Bugiardini, who did them more harm than good.

Paolo was summoned to Padua by Donato, when the latter was working there, and at the entrance of the house of the Vitali he painted some giants in terra-verde, which, as I have found in a Latin letter written by Girolamo Campagnola to Messer Leonico Tomeo, the philosopher, are so beautiful that Andrea Mantegna held them in very great account. Paolo wrought in fresco the

Volta de' Peruzzi, with triangular sections in perspective, and in
the angles of the corners he painted the four elements, making
for each an appropriate animal – for the earth a mole, for the
water a fish, for the fire a salamander, and for the air a cha-
meleon, which lives on it and assumes any colour. And because
he had never seen a chameleon, he painted a camel, which is
opening its mouth and swallowing air, and therewith filling its
belly; and great, indeed, was his simplicity in making allusion by
means of the name of the camel to an animal that is like a little
dry lizard, and in representing it by a great uncouth beast.

Truly great were the labours of Paolo in painting, for he drew
so much that he left to his relatives, as I have learnt from their
own lips, whole chests full of drawings. But, although it is a good
thing to draw, it is nevertheless better to make complete pictures,
seeing that pictures have longer life than drawings. In our book
of drawings there are many figures, studies in perspective, birds,
and animals, beautiful to a marvel, but the best of all is a maz-
zocchio drawn only with lines, so beautiful that nothing save the
patience of Paolo could have executed it. Paolo, although he was
an eccentric person, loved talent in his fellow-craftsmen, and in
order that some memory of them might go down to posterity, he
painted five distinguished men with his own hand on a long
panel, which he kept in his house in memory of them. One was
Giotto, the painter, standing for the light and origin of art; the
second was Filippo di Ser Brunellesco, for architecture; Donatel-
lo, for sculpture; himself, for perspective and animals; and, for
mathematics, Giovanni Manetti, his friend, with whom he often
conferred and discoursed on the problems of Euclid.

It is said that having been commissioned to paint, over the
door of S. Tommaso in the Mercato Vecchio, that Saint feeling
for the wound in the side of Christ, Paolo put into that work all
the effort that he could, saying that he wished to show therein
the full extent of his worth and knowledge; and so he caused a
screen of planks to be made, to the end that no one might be
able to see his work until it was finished. Wherefore Donato,
meeting him one day all alone, said to him: 'And what sort of
work may this be of thine, that thou keepest it screened so close-
ly?' And Paolo said in answer: 'Thou shalt see it. Let that suffice
thee.' Donato would not constrain him to say more, thinking to
see some miracle, as usual, when the time came. Afterwards,
chancing one morning to be in the Mercato Vecchio buying fruit,

Donato saw Paolo uncovering his work, whereupon he saluted him courteously, and was asked by Paolo himself, who was curious and anxious to hear his judgment on it, what he thought of that picture. Donato, having studied the work long and well, exclaimed: 'Ah, Paolo, thou oughtest to be covering it up, and here thou art uncovering it!' Whereupon Paolo was much aggrieved, feeling that he was receiving much more by way of blame than he expected to receive by way of praise for this last labour of his; and not having courage, lowered as he was, to go out any more, he shut himself up in his house, devoting himself to perspective, which kept him ever poor and depressed up to his death. And so, growing very old, and having but little contentment in his old age, he died in the eighty-third year of his life, in 1432, and was buried in S. Maria Novella.

He left a daughter, who had knowledge of drawing, and a wife, who was wont to say that Paolo would stay in his study all night, seeking to solve the problems of perspective, and that when she called him to come to bed, he would say: 'Oh, what a sweet thing is this perspective!' And in truth, if it was sweet to him, it was not otherwise than dear and useful, thanks to him, to those who exercised themselves therein after his time.

LORENZO GHIBERTI
[*LORENZO DI CIONE GHIBERTI OR LORENZO DI BARTOLUCCIO GHIBERTI*],
Painter of Florence

THERE is no doubt that in every city those who, by reason of any talent, come into some fame among men, are a most blessed light and example to many who are either born after them or live in the same age, not to mention the infinite praise and the extraordinary rewards that they themselves gain thereby while living. Nor is there anything that does more to arouse the minds of men, and to render the discipline of study less fatiguing to them, than the honour and profit which are afterwards won by labouring at the arts, for the reason that these make every difficult undertaking easy to them all, and give a greater stimulus to the growth of their talents, when they are urged to greater efforts by the praises of the world. Wherefore infinite numbers of men, who feel and see this, put themselves to great fatigues, in order

to attain to the honour of winning that which they see to have been won by some compatriot; and for this reason in ancient times men of talent were rewarded with riches, or honoured with triumphs and images. But since it is seldom that talent is not persecuted by envy, men must continue to the best of their power, by means of the utmost excellence, to assure it of victory, or at least to make it stout and strong to sustain the attacks of that enemy; even as Lorenzo di Cione Ghiberti, otherwise called Di Bartoluccio, was enabled to do both by his own merits and by fortune. This man well deserved the honour of being placed before themselves by the sculptor Donato and by the architect and sculptor Filippo Brunelleschi, both excellent craftsmen, since they recognized, in truth, although instinct perchance constrained them to do the contrary, that Lorenzo was a better master of casting than they were. This truly brought glory to them, and confusion to many who, presuming on their worth, set themselves to work and occupy the place due to the talents of others, and, without producing any fruits themselves, but labouring a thousand years at the making of one work, impede and oppress the knowledge of others with malignity and with envy.

Lorenzo, then, was the son of Bartoluccio Ghiberti, and from his earliest years learnt the art of the goldsmith from his father, who was an excellent master and taught him that business, which Lorenzo grasped so well that he became much better therein than his father. But delighting much more in the arts of sculpture and design, he would sometimes handle colours, and at other times would cast little figures in bronze and finish them with much grace. He also delighted in counterfeiting the dies of ancient medals, and he portrayed many of his friends from the life in his time.

Now, while he was working with Bartoluccio and seeking to make progress in his profession, the plague came to Florence in the year 1400, as he himself relates in a book by his own hand wherein he discourses on the subject of art, which is now in the possession of the Reverend Maestro Cosimo Bartoli, a gentleman of Florence. To this plague were added civil discords and other troubles in the city, and he was forced to depart and to go in company with another painter to Romagna, where they painted for Signor Pandolfo Malatesti, in Rimini, an apartment and many other works, which were finished by them with diligence and to the satisfaction of that Lord, who, although still young, took great

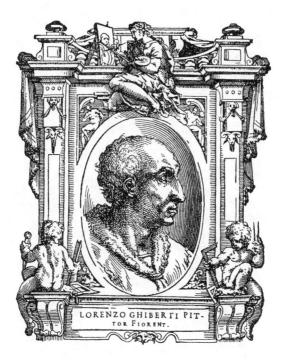

LORENZO GHIBERTI PIT-
TOR FIORENT.

delight in matters of design. Meanwhile Lorenzo did not cease to study the arts of design, and to work in relief with wax, stucco, and other similar materials, knowing very well that these small reliefs are the drawing-exercises of sculptors, and that without such practice nothing can be brought by them to perfection. Now, when he had been no long time out of his own country, the pestilence ceased; wherefore the Signoria of Florence and the Guild of Merchants – since at that time sculpture had many excellent craftsmen, both foreign and Florentine – determined that there should be made, as it had been already discussed many times, the other two doors of S. Giovanni, a very ancient temple, indeed, the oldest in that city; and they ordained among themselves that instructions should be sent to all the masters who were held the best in Italy, to repair to Florence in order that their powers might be tested by a specimen scene in bronze, similar to one of those which Andrea Pisano had formerly made for the first door.

Word of this determination was written to Lorenzo, who was working at Pesaro, by Bartoluccio, urging him to return to Florence in order to give a proof of his powers, and saying that this was an occasion to make himself known and to demonstrate his genius, not to mention that he might gain such profit that neither the one nor the other of them would ever again need to labour at making ear-rings.

The words of Bartoluccio stirred the spirit of Lorenzo so greatly, that although Signor Pandolfo, with all his Court and the other painter, kept showing him the greatest favour, Lorenzo took leave of that lord and of the painter, and they, with great unwillingness and displeasure, allowed him to go, neither promises nor increase of payment availing to detain him, since to Lorenzo every hour appeared a thousand years until he could return to Florence. Having departed, therefore, he arrived safely in his own city. Many foreigners had already assembled and presented themselves to the Consuls of the Guild, by whom seven masters were elected out of the whole number, three being Florentines and the others Tuscans; and it was ordained that they should have an allowance of money, and that within a year each man should finish a scene in bronze by way of test, of the same size as those in the first door. And for the subject they chose the story of Abraham sacrificing his son Isaac, wherein they thought that the said masters should be able to show their powers with

regard to the difficulties of their art, seeing that this story contained landscapes, figures both nude and clothed, and animals, while the foremost figures could be made in full-relief, the second in half-relief, and the third in low-relief.

The competitors for this work were Filippo di Ser Brunellesco, Donato, and Lorenzo di Bartoluccio, all Florentines; Jacopo della Quercia of Siena, and Niccolò d'Arezzo, his pupil; Francesco di Valdambrina; and Simone da Colle, called Simone de' Bronzi. All these men promised before the Consuls that they would deliver their scenes finished within the said time; and each making a beginning with his own, with all zeal and diligence they exerted all their strength and knowledge in order to surpass one another in excellence, keeping their work hidden and most secret, lest they should copy each other's ideas. Lorenzo alone, who had Bartoluccio to guide him and to compel him to labour at many models before they resolved to adopt any one of them – Lorenzo alone was ever inviting the citizens, and sometimes any passing stranger who had some knowledge of the art, to see his work, in order to hear what they thought, and these opinions enabled him to execute a model very well wrought and without one defect. And so, when he had made the moulds and cast the work in bronze, it came out very well; whereupon, with his father Bartoluccio, he polished it with such love and patience that nothing could be executed or finished better. And when the time came for comparing the various works, his and those of the other masters were completely finished, and were given to the Guild of Merchants for judgment; but after all had been seen by the Consuls and by many other citizens, diverse opinions were expressed about them. Many foreigners had assembled in Florence, some painters, some sculptors, and others goldsmiths; and they were invited by the Consuls to give judgment on these works, together with the other men of that profession who lived in Florence. They numbered thirty-four in all, each well experienced in his own art. Now, although there were differences of opinion among them, some liking the manner of one man and some that of another, nevertheless they were agreed that Filippo di Ser Brunellesco and Lorenzo di Bartoluccio had composed and completed their scenes better and with a richer abundance of figures than Donato had done in his, although in that one, also, there was grand design. In that of Jacopo della Quercia the figures were good, but they had no delicacy, although they were made with

design and diligence. The work of Francesco di Valdambrina had good heads and was well finished, but was confused in the composition. That of Simone da Colle was a beautiful casting, because the doing of this was his art, but it had not much design. The specimen of Niccolò d' Arezzo, which was made with good mastery, had the figures squat and was badly finished. Only that scene which Lorenzo made as a specimen, which is still seen in the Audience Chamber of the Guild of Merchants, was in every part wholly perfect. The whole work had design, and was very well composed. The figures had so graceful a manner, being made with grace and with very beautiful attitudes, and the whole was finished with so great diligence, that it appeared not made by casting and polished with tools of iron, but blown with the breath. Donato and Filippo, seeing the diligence that Lorenzo had used in his work, drew aside, and, conferring together, they resolved that the work should be given to Lorenzo, it appearing to them that thus both the public and the private interest would be best served, and that Lorenzo, being a young man not more than twenty years of age, would be able to produce by this exercise of his profession those greater fruits that were foreshadowed by the beautiful scene which he, in their judgment, had executed more excellently than the others; saying that there would have been more sign of envy in taking it from him, than there was justice in giving it to him.

Beginning the work of that door, then, for that entrance which is opposite to the Office of Works of S. Giovanni, Lorenzo made for one part of it a large framework of wood, of the exact size that it was to be, with mouldings, and with the ornaments of the heads at the corners, round the various spaces wherein the scenes were to be placed, and with those borders that were to go round them. Having then made and dried the mould with all diligence, he made a very great furnace (that I remember seeing) in a room that he had hired opposite to S. Maria Nuova, where to-day there is the Hospital of the Weavers, on the spot that was called the Aia, and he cast the said framework in bronze. But, as chance would have it, it did not come out well; wherefore, having realized the mischief, without losing heart or giving way to depression, he promptly made another mould and cast it again, without telling anyone about it, and it came out very well. Whereupon he went on and continued the whole work in this manner, casting each scene by itself, and putting it, when finished, into its

place. The arrangement of the scenes was similar to that which Andrea Pisano had formerly made in the first door, which Giotto designed for him. He made therein twenty scenes from the New Testament; and below, in eight spaces similar to these, after the said scenes, he made the four Evangelists, two on each side of the door, and likewise the four Doctors of the Church, in the same manner; which figures are all different in their attitudes and their draperies. One is writing, another is reading, others are in contemplation, and all, being varied one from another, appear lifelike and very well executed; not to mention that in the framework of the border surrounding the scenes in squares there is a frieze of ivy leaves and other kinds of foliage, with mouldings between each; and on every corner is the head of a man or a woman in the round, representing prophets and sibyls, which are very beautiful, and demonstrate with their variety the excellence of the genius of Lorenzo. Above the aforesaid Doctors and Evangelists, which are in the four squares below, there follows, on the side towards S. Maria del Fiore, the first scene; and here, in the first square, is the Annunciation of Our Lady, wherein, in the attitude of the Virgin, he depicted terror and a sudden alarm, as she turns away gracefully by reason of the coming of the Angel. And next to this he made the Nativity of Christ, wherein the Madonna, having given birth to Him, is lying down and taking repose; with Joseph in contemplation, the shepherds, and the Angels singing. In the scene next to this, on the other half of the door, on the same level, there follows the story of the coming of the Magi, and of their adoration of Christ, while they give Him their tribute; and their Court is following them, with horses and other equipage, wrought with great genius. And beside this, likewise, there is His Disputation with the Doctors in the Temple, wherein the admiration and the attention which the Doctors give to Christ are no less well expressed than the joy of Mary and Joseph at finding Him again. Above these – beginning again over the Annunciation – there follows the story of the Baptism of Christ by John in the Jordan, wherein there are seen in their gestures the reverence of the one and the faith of the other. Beside this there follows the Temptation of Christ by the Devil, who, terrified by the words of Jesus, stands in an attitude of terror, showing thereby that he knows Him to be the Son of God. Next to this, on the other side, is the scene where He is driving the traders from the Temple, overturning their money

and the victims, doves, and other merchandise; wherein the figures, falling over each other, have a very beautiful and well conceived grace in their headlong flight. Next to this Lorenzo placed the shipwreck of the Apostles, wherein S. Peter is issuing from the ship and is sinking into the water, and Christ is upholding him. This scene shows an abundance of various gestures in the Apostles, who are toiling to save the ship; and the faith of S. Peter is recognized in his coming towards Christ. Beginning again above the story of the Baptism, on the other side, there is His Transfiguration on Mount Tabor, wherein Lorenzo demonstrated, in the attitudes of the three Apostles, how celestial visions dazzle the eyes of mortals; even as the Divinity of Christ is also recognized as He holds His head high and His arms outstretched, between Elias and Moses. And next to this is the Resurrection of the dead Lazarus, who, having issued from the sepulchre, is standing upright with his feet and his hands bound, to the marvel of the bystanders. Martha is there, with Mary Magdalene, who is kissing the feet of the Lord with very great humility and reverence. Beside this, on the other half of the door, there follows the scene when He rides on an ass into Jerusalem, while the children of the Hebrews, in various attitudes, are casting their garments on the ground, with the olives and palms; not to mention the Apostles, who are following the Saviour. And next to this is the Last Supper, very beautiful and well composed, the Apostles being placed at a long table, half on the near side and half on the farther side. Above the scene of the Transfiguration there is the Prayer in the Garden, wherein the three Apostles are seen asleep in various attitudes. And beside this there follows the scene when He is taken and Judas kisses Him, wherein there are many things worthy of consideration, since we see therein both the Apostles, who are flying, and the Jews, who, in taking Christ, are making most violent gestures and efforts. On the other side, next to this, is the scene when He is bound to the Column, wherein is the figure of Jesus Christ writhing not a little with the pain of the blows, in a pitiful attitude, while there are seen, in those gestures that the Jews who are scourging Him are making, terrible rage and lust of vengeance. Next to this there follows the leading of Christ before Pilate, who washes his hands and condemns Him to the Cross. Above the Prayer in the Garden, on the other side and in the last row of scenes, is Christ bearing His Cross and going to His death, led by a crowd of

soldiers, who appear, with strange attitudes, to be dragging Him
by force; besides the gestures of sorrow and lamentation that the
Maries are making, insomuch that one who was present could not
have seen them better. Beside this he made Christ on the Cross,
and Our Lady and S. John the Evangelist seated on the ground,
with gestures full of sorrow and wrath. Next to this, on the other
side, there follows His Resurrection, wherein the guards, stunned
by the thunder, are lying like dead men, while Christ is ascending
on high in such an attitude that He truly appears glorified, by
reason of the perfection of His beautiful limbs, wrought by the
most ingenious industry of Lorenzo. In the last space is the com-
ing of the Holy Spirit, wherein are very sweet expressions and
attitudes in those who are receiving it.

This work was brought to that completion and perfection
without sparing any labour or time that could be devoted to a
work in bronze, seeing that the limbs of the nudes are most
beautiful in every part; and in the draperies, although they hold
a little to the old manner of Giotto's time, there is a general
feeling that inclines to the manner of the moderns, and produces,
in figures of that size, a certain very lovely grace. And in truth
the composition of each scene is so well ordered and so finely
arranged, that he rightly deserved to obtain that praise which
Filippo had given him at the beginning – nay, even more. And
in like manner he gained most honourable recognition among his
fellow-citizens, and was consummately extolled by them and by
the native and foreign craftsmen. The cost of this work, with the
exterior ornaments, which are also of bronze, wrought with fes-
toons of fruits and with animals, was 22,000 florins, and the
bronze door weighed 34,000 libbre.

This work finished, it appeared to the Consuls of the Guild
of Merchants that they had been very well served, and by reason
of the praises given by all to Lorenzo they determined that he
should make a statue of bronze, four braccia and a half high, in
memory of S. John the Baptist, on a pilaster without Orsan-
michele, in one of the niches there – namely, the one facing the
Cloth-dressers. This he began, nor did he ever leave it until he
delivered it finished. It was and still is a work highly praised, and
in it, on the mantle, he made a border of letters, wherein he wrote
his own name. In this work, which was placed in position in the
year 1414, there is seen the beginning of the good modern man-
ner, in the head, in an arm which appears to be living flesh, in

the hands, and in the whole attitude of the figure. He was thus the first who began to imitate the works of the ancient Romans, whereof he was an ardent student, as all must be who desire to do good work. And in the frontal of that shrine he tried his hand at mosaic, making therein a half-length prophet.

The fame of Lorenzo, by reason of his most profound mastery in casting, had now spread throughout all Italy and abroad, insomuch that Jacopo della Fonte, Vecchietto of Siena, and Donato having made for the Signoria of Siena some scenes and figures in bronze that were to adorn the baptismal font of their Church of S. Giovanni, the people of Siena, having seen the works of Lorenzo in Florence, came to an agreement with him and caused him to make two scenes from the life of S. John the Baptist. In one he made S. John baptizing Christ, accompanying it with an abundance of figures, both nude and very richly draped; and in the other he made S. John being taken and led before Herod. In these scenes he surpassed and excelled the men who had made the others; wherefore he was consummately praised by the people of Siena, and by all others who have seen them.

The Masters of the Mint in Florence had a statue to make for one of those niches that are round Orsanmichele, opposite to the Guild of Wool, and it was to be a S. Matthew, of the same height as the aforesaid S. John. Wherefore they allotted it to Lorenzo, who executed it to perfection; and it was much more praised than the S. John, for he made it more in the modern manner. This statue brought it about that the Consuls of the Guild of Wool determined that he should make in the same place, for the niche next to that, a statue likewise in bronze, which should be of the same proportions as the other two, representing S. Stephen, their Patron Saint. And he brought it to completion, giving a very beautiful varnish to the bronze; and this statue gave no less satisfaction than the other works already wrought by him.

The General of the Preaching Friars at that time, Maestro Lionardo Dati, wishing to leave a memorial of himself to his country in S. Maria Novella, where he had taken his vows, caused Lorenzo to construct a tomb of bronze, with himself lying dead thereon, portrayed from nature; and this tomb, which was admired and extolled, led to another being erected by Lodovico degli Albizzi and Niccolò Valori in S. Croce.

After these things, Cosimo and Lorenzo de' Medici, wishing to honour the bodies and relics of the three martyrs, Protus,

Hyacinthus, and Nemesius, had them brought from the Casentino, where they had been held in little veneration for many years, and caused Lorenzo to make a sarcophagus of bronze, in the middle of which are two angels in low-relief who are holding a garland of olive, within which are the names of those martyrs; and they caused the said relics to be put into the said sarcophagus, which they placed in the Church of the Monastery of the Angeli in Florence, with these words below, carved in marble, on the side of the church of the monks:

CLARISSIMI VIRI COSMAS ET LAURENTIUS FRATRES NEGLEC-
TAS DIU SANCTORUM RELIQUIAS MARTYRUM RELIGIOSO
STUDIO AC FIDELISSIMA PIETATE SUIS SUMPTIBUS ÆREIS
LOCULIS CONDENDAS COLENDASQUE CURARUNT.

And on the outer side, facing the little church in the direction of the street, below a coat of arms of balls, there are these other words carved on marble:

HIC CONDITA SUNT CORPORA SANCTORUM CHRISTI MAR-
TYRUM PROTI ET HYACINTHI ET NEMESII, ANN. DOM. 1428.

And by reason of this work, which succeeded very nobly, there came a wish to the Wardens of Works of S. Maria del Fiore to have a sarcophagus and tomb of bronze made to contain the body of S. Zanobi, Bishop of Florence. This tomb was three braccia and a half in length, and two in height; and besides adorning it with diverse varied ornaments, he made therein on the front of the body of the sarcophagus itself a scene with S. Zanobi restoring to life a child which had been left in his charge by the mother, and which had died while she was on a pilgrimage. In a second scene is another child, who has been killed by a wagon, and also the Saint restoring to life one of the two servants sent to him by S. Ambrose, who had been left dead on the Alps; and the other is there, making lamentation in the presence of S. Zanobi, who, seized with compassion, said: 'Go, he doth but sleep; thou wilt find him alive.' And at the back are six little angels, who are holding a garland of elm-leaves, within which are carved letters in memory and in praise of that Saint. This work he executed and finished with the utmost ingenuity and art, insomuch that it received extraordinary praise as something beautiful.

The while that the works of Lorenzo were every day adding lustre to his name, by reason of his labouring and serving

innumerable persons, working in bronze as well as in silver and gold, it chanced that there fell into the hands of Giovanni, son of Cosimo de' Medici, a very large cornelian containing the flaying of Marsyas by command of Apollo, engraved in intaglio; which cornelian, so it is said, once served the Emperor Nero for a seal. And it being something rare, by reason both of the size of the stone, which was very great, and of the marvellous beauty of the intaglio, Giovanni gave it to Lorenzo, to the end that he might make a gold ornament in relief round it; and he, after toiling at it for many months, finished it completely, making round it a work in relief of a beauty not inferior to the excellence and perfection of the intaglio on the stone; which work brought it about that he wrought many other things in gold and silver, which to-day are not to be found. For Pope Martin, likewise, he made a gold button which he wore in his cope, with figures in full-relief, and among them jewels of very great price – a very excellent work; and likewise a most marvellous mitre of gold leaves in open-work, and among them many little figures in full-relief, which were held very beautiful. And for this work, besides the name, he acquired great profit from the liberality of that Pontiff. In the year 1439, Pope Eugenius came to Florence – where the Council was held – in order to unite the Greek Church with the Roman; and seeing the works of Lorenzo, and being no less pleased with his person than with the works themselves, he caused him to make a mitre of gold, weighing fifteen libbre, with pearls weighing five libbre and a half, which, with the jewels set in the mitre, were estimated at 30,000 ducats of gold. It is said that in this work were six pearls as big as filberts, and it is impossible to imagine, as was seen later in a drawing of it, anything more beautiful and bizarre than the settings of the jewels and the great variety of children and other figures, which served for many varied and graceful ornaments. For this work he received infinite favours from that Pontiff, both for himself and his friends, besides the original payment.

Florence had received so much praise by reason of the excellent works of this most ingenious craftsman, that the Consuls of the Guild of Merchants determined to commission him to make the third door of S. Giovanni, likewise in bronze. Now, in the door that he had made before, he had followed their directions and had made it with that ornament which goes round the figures, and which encircles the framework of both parts of the

door, as in the one of Andrea Pisano; but on seeing how greatly
Lorenzo had surpassed him, the Consuls determined to remove
that of Andrea from its position in the centre, and to place it in
the doorway that is opposite to the Misericordia, and to com-
mission Lorenzo to make a new door to be placed in the centre,
looking to him to put forth the greatest effort of which he was
capable in that art. And they placed themselves in his hands,
saying that they gave him leave to make it as he pleased, and in
whatsoever manner he thought it would turn out as ornate, as
rich, as perfect, and as beautiful as it could be made or imagined;
nor was he to spare time or expense, to the end that, even as he
had surpassed all other sculptors up to his own time, he might
surpass and excel all his own previous works.

Lorenzo began the said work, putting therein all the know-
ledge that he could; wherefore he divided the said door into ten
squares, five on each side, so that the spaces enclosing the scenes
were one braccio and a third in extent, and round them, to adorn
the framework that surrounds the scenes, there are niches – up-
right, in that part of the door – containing figures in almost
full-relief, twenty in number and all most beautiful, such as a
nude Samson, who, embracing a column, with a jawbone in his
hand, displays a perfection as great as can be shown by anything
made in the time of the ancients, in their figures of Hercules,
whether in bronze or in marble; and to this a Joshua bears wit-
ness, who, in the act of speaking, appears to be really addressing
his army; besides many prophets and sibyls, all of which he
adorned with various manners of draperies over their shoulders,
and with head-dresses, hair, and other adornments; not to men-
tion twelve figures which are lying down in the niches that go
horizontally along the ornament of the scenes. At the intersec-
tions of the corners, in certain medallions, he made heads of
women, of youths, and of old men, to the number of thirty-four;
among which, in the middle of the said door, near the place
where he engraved his own name, is the portrait of his father
Bartoluccio, who is the oldest of them, while the youngest is his
son Lorenzo himself, the master of the whole work; besides an
infinite quantity of foliage, mouldings, and other ornaments,
made with the greatest mastery. The scenes that are in the said
door are from the Old Testament; and in the first is the Creation
of Adam, and of Eve, his wife, who are executed most perfectly,
it being evident that Lorenzo strove to make their limbs as

beautiful as he was able to do, wishing to show that, even as these figures by the hand of God were the most beautiful that were ever made, so these by his own hand should surpass all the others that had been made by him in his other works – truly a very grand intention. In the same scene, likewise, he made them eating the apple, and also being driven out of Paradise; and in these actions the figures express the effect, first of their sin, recognizing their nakedness and covering it with their hands, and then of repentance, when they are made by the Angel to go forth out of Paradise. In the second square are figures of Adam and Eve, with Cain and Abel as little children, born from them; and there, also, is Abel making a sacrifice of his firstlings, with Cain making one not so good, while in the expression of Cain there is shown envy against his brother, and in Abel love towards God. And what is singularly beautiful is to see Cain ploughing the earth with a pair of oxen, which, with their labouring to pull at the yoke of the plough, appear real and natural; and the same is shown in Abel, who is watching his flocks, and Cain puts him to death, when he is seen, in a most impious and cruel attitude, slaughtering his brother with a club, in such a manner that the very bronze shows the limpness of the dead limbs in the most beautiful person of Abel; and in the distance, likewise, there is God asking Cain what he has done with Abel. Each square contains the representation of four stories. In the third square Lorenzo made Noah issuing from the Ark, with his wife, his sons and daughters, and his sons' wives, together with all the animals, both of the air and of the earth, which, each in its kind, are wrought with the greatest perfection wherewith art is able to imitate nature; the Ark is seen open, with the poles in perspective, in very low-relief, insomuch that their grace cannot be expressed; besides that, the figures of Noah and of his kindred could not be more lively or more vivacious, while, as he is offering sacrifice, there is seen the rainbow, a sign of peace between God and Noah. But much more excellent than all the others are the scenes where he is planting the vine, and, having been made drunk by the wine, is showing his nakedness, and his son Ham is deriding him; and in truth a man sleeping could not be imitated better, the limbs being seen outstretched in drunken abandonment, while his other two sons, with consideration and love, are covering him in very beautiful attitudes; not to mention that there are the cask, the vine-leaves, and the other features of the vintage, so carefully made and fitted

into certain places, that they do not impede the story, but serve as a most beautiful adornment. In the fourth scene it pleased Lorenzo to make the apparition of the three Angels in the valley of Mamre, giving them a close likeness one to the other, while that most holy patriarch is seen adoring them, with much appropriateness and vivacity in the position of his hands and the expression of his countenance; and, in addition, Lorenzo showed very beautiful feeling in the figures of his servants, who, remaining at the foot of the mountain with an ass, are awaiting Abraham, who had gone to sacrifice his son. Isaac is placed naked on the altar, and his father, with uplifted arm, is about to show his obedience, but he is hindered by the Angel, who is restraining him with one hand, while with the other he is pointing to where is the ram for the sacrifice, and delivering Isaac from death. This scene is truly very beautiful, since, among other things, there is seen a very great difference between the delicate limbs of Isaac and those of the servants, which are more robust; insomuch that there appears to be no touch therein that was not given with the greatest art. In this work, also, Lorenzo showed that he surpassed his own self in the difficulties of making buildings; in the birth-scene of Isaac, Jacob, and Esau; in the scene when Esau is hunting, at the wish of his father; and in that when Jacob, instructed by Rebecca, is offering the cooked kid, with its skin wrapped round his neck, while Isaac is feeling for him and giving him his blessing. In this scene there are some dogs, very beautiful and lifelike, besides the figures, which produce the very same effect that Jacob, Isaac, and Rebecca did by their actions when they were alive.

Emboldened by his study of the art, which was making it ever easier to him, he tried his genius on matters more complicated and difficult; wherefore, in the sixth square, he made Joseph cast by his brethren into the well, and the scene when they sell him to the merchants, and where he is given by them to Pharaoh, to whom he interprets the dream of the famine; together with the provision against it, and the honours given by Pharaoh to Joseph. Likewise there is Jacob sending his sons for corn into Egypt, and Joseph recognizing them and making them return for their father; in which scene Lorenzo made a round temple, drawn in perspective with great mastery, wherein are figures in diverse manners which are loading corn and flour, together with some marvellous asses. Likewise there is the feast that Joseph gives them, and the hiding of the gold cup in Benjamin's sack, and its discovery, and how he embraces

and acknowledges his brethren; which scene, by reason of the many effects and the great variety of incidents, is held the most noble, the most difficult, and the most beautiful of all his works.

And in truth, having so beautiful a genius and so good a grace in this manner of statuary, when there came into his mind the compositions of beautiful scenes, Lorenzo could not but make the figures most beautiful; as it is apparent in the seventh square, where he represents Mount Sinai, and on its summit Moses, who is receiving the Laws from God. Reverently kneeling, half-way up the mountain, is Joshua, who is awaiting him, and at the foot are all the people, terrified by the thunder, lightning, and earthquakes, in diverse attitudes wrought with very great vivacity. After this, he showed diligence and great love in the eighth square, wherein he made Joshua marching against Jericho and turning back the Jordan, and placed there the twelve tents of the twelve Tribes, full of very lifelike figures; but more beautiful are some in low-relief, in the scene when, as they go with the Ark round the walls of the aforesaid city, these walls fall down at the sound of trumpets, and the Hebrews take Jericho; and here the landscape is ever diminished and made lower with great judgment, from the first figures to the mountains, from the mountains to the city, and from the city to the distant part of the landscape, in very low relief, the whole being executed with great perfection. And since Lorenzo became from day to day more practised in that art, there is next seen, in the ninth square, the slaying of the giant Goliath by David, who is cutting off his head in a proud and boyish attitude; and the host of the Lord is routing that of the Philistines, wherein Lorenzo made horses, chariots, and other warlike things. Next, he made David returning with the head of Goliath in his hand, and the people are meeting him, sounding instruments and singing; and these effects are all appropriate and vivacious. It now remained for Lorenzo to do all that he was able in the tenth and last scene, wherein the Queen of Sheba is visiting Solomon, with a very great train; in this part he made a very beautiful building drawn in perspective, with all the other figures similar to the aforesaid scenes; not to mention the ornaments of the architraves, which go round the said doors, wherein are fruits and festoons made with his usual excellence.

In this work, both in detail and as a whole, it is seen how much the ability and the power of a craftsman in statuary can effect by means of figures, some being almost in the round, some

in half-relief, some in low-relief, and some in the lowest, with invention in the grouping of the figures, and extravagance of attitude both in the males and in the females; and by variety in the buildings, by perspectives, and by having likewise shown a sense of fitness in the gracious expressions of each sex throughout the whole work, giving to the old gravity, and to the young elegance and grace. And it may be said, in truth, that this work is in every way perfect, and that it is the most beautiful work which has ever been seen in the world, whether ancient or modern. And right truly does Lorenzo deserve to be praised, seeing that one day Michelagnolo Buonarroti, having stopped to look at this work, and being asked what he thought of it, and whether these doors were beautiful, answered: 'They are so beautiful that they would do well for the gates of Paradise': praise truly appropriate, and given by an able judge. And well indeed might Lorenzo complete them, seeing that from the age of twenty, when he began them, he worked at them for forty years, with labour beyond belief.

Lorenzo was assisted in finishing and polishing this work, after it was cast, by many men, then youths, who afterwards became excellent masters – namely, by Filippo Brunelleschi, Masolino da Panicale, and Niccolò Lamberti, goldsmiths; and by Parri Spinelli, Antonio Filarete, Paolo Uccello, Antonio del Pollaiuolo, who was then quite young, and many others, who, growing intimate together over that work, and conferring one with another, as men do when they work in company, gained no less advantage for themselves than they gave to Lorenzo. To him, besides the payment that he had from the Consuls, the Signoria gave a good farm near the Abbey of Settimo, and no long time elapsed before he was made one of the Signori, and honoured with the supreme magistracy of the city; wherefore the Florentines deserve no less to be praised for their gratitude to him, than they deserve to be blamed for having been little grateful to other excellent men of their city.

After this most stupendous work, Lorenzo made the ornament in bronze for that door of the same church which is opposite to the Misericordia, with that marvellous foliage which he was not able to finish, death coming unexpectedly upon him when he was preparing – having already almost made the model – to reconstruct the said door, which Andrea Pisano had formerly made; which model has now been lost, although I saw it formerly, when a youth, in Borgo Allegri, before it was allowed to be lost by the descendants of Lorenzo.

Lorenzo had a son called Bonaccorso, who finished with his own hand the frieze and that ornament, which had been left incomplete, with very great diligence; which ornament, I declare, is the rarest and most marvellous work that there is to be seen in bronze. Bonaccorso, dying young, did not afterwards make many works, as he would have done, seeing that he had been left with the secret of making castings in such a way as to make them come out delicate, and also with the knowledge and the method of perforating the metal in that manner which is seen in the works left by Lorenzo. The latter, besides the works by his own hand, bequeathed to his heirs many antiquities both in marble and in bronze, such as the bed of Polycletus, which was something very rare; a leg of bronze as large as life; some heads, both male and female; together with some vases, all procured by him from Greece at no small cost. He left, likewise, some torsi of figures, and many other things; and all were dispersed together with the property of Lorenzo, some being sold to Messer Giovanni Gaddi, then Clerk of the Chamber to the Pope, and among these was the said bed of Polycletus, with the rest of the finer things.

Bonaccorso had a son called Vittorio, who survived him. He applied himself to sculpture, but with little profit, as it is shown by the heads that he made at Naples for the Palace of the Duke of Gravina, which are not very good, since he never applied himself to art with love or with diligence, but rather to scattering the property and the other things which had been left him by his father and his grandfather. Finally, going to Ascoli as architect under Pope Paul III, he had his throat cut one night by one of his servants, who came to rob him. And thus the family of Lorenzo became extinct, but not so his fame, which will live to all eternity.

But returning to the said Lorenzo: he applied himself, while he lived, to many things, and delighted in painting and in working in glass, and for S. Maria del Fiore he made the round windows that are round the cupola, excepting one, which is by the hand of Donato – namely, the one wherein Christ is crowning Our Lady. Lorenzo likewise made the three that are over the principal door of the same S. Maria del Fiore, and all those of the chapels and of the tribunes, and also the rose-window in the façade of S. Croce. In Arezzo he made a window for the principal chapel of the Pieve, containing the Coronation of Our Lady, with two

other figures, for Lazzaro di Feo di Baccio, a very rich merchant; but since they were all of Venetian glass, loaded with colour, they make the places where they were put rather dark than otherwise. Lorenzo was chosen to assist Brunellesco, when the latter was commissioned to make the Cupola of S. Maria del Fiore, but he was afterwards relieved of the task, as it will be told in the Life of Filippo.

The same Lorenzo wrote a book in the vulgar tongue, wherein he treated of many diverse matters, but in such wise that little profit can be drawn from it. The only good thing in it, in my judgment, is this, that after having discoursed of many ancient painters, and particularly of those cited by Pliny, he makes brief mention of Cimabue, Giotto, and many others of those times; and this he did, with much more brevity than was right, for no other reason but to slip with a good grace into a discourse about himself, and to enumerate minutely, as he did, one by one, all his own works. Nor will I forbear to say that he feigns that his book was written by another, whereas afterwards, in the process of writing – as one who knew better how to draw, to chisel, and to cast in bronze, than how to weave stories – talking of himself, he speaks in the first person, 'I made,' 'I said,' 'I was making,' 'I was saying.' Finally, having come to the sixty-fourth year of his age, and being assailed by a grievous and continuous fever, he died, leaving immortal fame for himself by reason of the works that he made, and through the pens of writers; and he was honourably buried in S. Croce. His portrait is on the principal bronze door of the Church of S. Giovanni, on the border that is in the middle when the door is closed, in the form of a bald man, and beside him is his father Bartoluccio; and near them may be read these words: LAURENTII CIONIS DE GHIBERTIS MIRA ARTE FABRICATUM. The drawings of Lorenzo were most excellent, being made with much relief, as it is seen in our book of drawings, in an Evangelist by his hand, and in some others in chiaroscuro, which are very beautiful.

His father Bartoluccio was also a passing good draughtsman, as it is shown by another Evangelist in the said book, which is by his hand, but no little inferior to that of Lorenzo. These drawings, with some by Giotto and by others, I had from Vittorio Ghiberti in the year 1528, when a youth, and I have ever held and still hold them in veneration, both because they are beautiful and as memorials of men so great. And if, when I was living in

strait friendship and intimacy with Vittorio, I had known what I know now, it would have been easy for me to obtain many other truly beautiful things by the hand of Lorenzo. Among many verses, both in Latin and in the vulgar tongue, which were written at diverse times in honour of Lorenzo, it will be enough for me, in order not to weary my readers overmuch, to put down these that follow below:

> Dum cernit valvas aurato ex aere nitentes
> In templo Michael Angelus, obstupuit:
> Attonitusque diu, sic alta silentia rupit:
> O divinum opus! O janua digna polo!

MASOLINO DA PANICALE, Painter

TRULY great, I believe, must be the contentment of those who are approaching the highest rank in the science wherein they are labouring; and those, likewise, who, besides the delight and pleasure that they feel in working valiantly, enjoy some fruit from their labours, without doubt live a quiet and very happy life. And if perchance it comes to pass that one, while advancing towards perfection in any science or art, is overtaken by death in the happy course of his life, his memory does not become wholly spent, if only he has laboured worthily in order to attain to the true end of his art. Wherefore every man should labour the most that he can in order to attain to perfection, since, although he may be hindered in the midst of his course, he will gain praise, if not for the works that he has not been able to finish, at least for the excellent intention and diligent study which are seen in the little that he leaves behind.

Masolino da Panicale of Valdelsa, who was a disciple of Lorenzo di Bartoluccio Ghiberti, was a very good goldsmith in his youth, and the best finisher that Lorenzo had in the labour of the doors; and he was very dexterous and able in making the draperies of the figures, and had very good manner and understanding in the work of finishing. Wherefore with his chisel he made with all the more dexterity certain soft and delicate hollows, both in human limbs and in draperies. He devoted himself to painting at the age of nineteen, and practised it ever afterwards,

learning the art of colouring from Gherardo Starnina. And having gone to Rome in order to study, the while that he dwelt there he painted the hall of the old house of the Orsini on Monte Giordano; and then, having returned to Florence by reason of a pain in the head that the air was causing him, he made in the Carmine, beside the Chapel of the Crucifixion, that figure of S. Peter which is still seen there. This figure, being praised by the craftsmen, brought it about that he was commissioned to adorn the Chapel of the Brancacci, in the said church, with the stories of S. Peter; of which chapel, with great diligence, he brought a part to completion, as on the vaulting, where there are the four Evangelists, with Christ taking Andrew and Peter from the nets and then Peter weeping for the sin committed in denying Him, and next to that his preaching in order to convert the Gentiles. He painted there the shipwreck of the Apostles in the tempest, and the scene when S. Peter is delivering his daughter Petronilla from sickness; and in the same scene he made him going with S. John to the Temple, where, in front of the portico, there is the lame beggar asking him for alms, and S. Peter, not being able to give him either gold or silver, is delivering him with the sign of the Cross. Throughout all that work the figures are made with very good grace, and they show grandeur in the manner, softness and harmony in the colouring, and relief and force in the draughtsmanship; the work was much esteemed by reason of its novelty and of the methods used in many parts, which were totally different from the manner of Giotto; but, being overtaken by death, he left these scenes unfinished.

Masolino was a person of very good powers, with much harmony and facility in his pictures, which are seen to have been executed with diligence and with great love. This zeal and this willingness to labour, which he never ceased to show, brought about in him a bad habit of body, which ended his life before his time and snatched him prematurely from the world. Masolino died young, at the age of thirty-seven, cutting short the expectations that people had conceived of him. His pictures date about the year 1440. And Paolo Schiavo – who painted the Madonna and the figures with their feet foreshortened on the cornice on the Canto de' Gori in Florence – strove greatly to follow the manner of Masolino, from whose works, having studied them many times, I find his manner very different from that of those who were before him, seeing that he added majesty to the figures,

and gave softness and a beautiful flow of folds to the draperies. The heads of his figures, also, are much better than those made before his day, for he was a little more successful in making the roundness of the eyes, and many other beautiful parts of the body. And since he began to have a good knowledge of light and shade, seeing that he worked in relief, he made many difficult foreshortenings very well, as is seen in that beggar who is seeking alms from S. Peter; for his leg, which is trailing behind him, is so well proportioned in its outlines, with regard to draughtsmanship, and in its shadows, with regard to colouring, that it appears to be really piercing the wall. Masolino began likewise to give more sweetness of expression to the faces of women, and more loveliness to the garments of young men, than the old craftsmen had done; and he also drew passing well in perspective. But that wherein he excelled, more than in anything else, was colouring in fresco, for this he did so well that his pictures are blended and harmonized with so great grace, that his painting of flesh has the greatest softness which one is able to imagine; wherefore, if he had shown absolute perfection in draughtsmanship, as perchance he might have done if he had lived longer, he might have been numbered among the best, since his works are executed with good grace, and with grandeur in the manner, softness and harmony in the colouring, and much relief and force in the draughtsmanship, although this is not in all parts perfect.

PARRI SPINELLI, Painter of Arezzo

PARRI DI SPINELLO SPINELLI, painter of Arezzo, having learnt the first principles of art from his own father, was brought to Florence by the agency of Messer Leonardo Bruni of Arezzo, and was received by Lorenzo Ghiberti into his school, where many young men were learning under his discipline: and since the doors of S. Giovanni were then being given their finish, he was put to labour on those figures, in company with many others, as it has been said above. And having, in this work, contracted a friendship with Masolino da Panicale, and being pleased with his method of drawing, he set about imitating him in many respects, as he also imitated in others the manner of Don Lorenzo degli Angeli.

Parri made his figures much longer and more slender than any painter who had lived before him, and whereas the others make them in the proportion of ten heads at most, he gave them eleven, and sometimes twelve; nor did this make them awkward, although they were slender and were ever bent in an arch either to the right side or to the left, for the reason that this, as it appeared to him, and as he himself said, gave them more vigour. The flow of his draperies was very delicate, with abundance of folds, which fell from the arms of his figures right down to the feet. He coloured very well in distemper, and perfectly in fresco, and he was the first who, in working in fresco, ceased to use verdaccio below flesh-colours, to be afterwards washed over with rosy flesh-tints in chiaroscuro, in the manner of water-colours, as Giotto and the other old masters had done. Parri, on the other hand, used body colours in making his grounds and tints, placing them with much discretion where it appeared to him that they would look best – that is, the lights on the highest points, the middle tints towards the sides, and the darks on the outlines; with which method of painting he showed more facility in his works and gave longer life to pictures in fresco, seeing that, having laid the colours in their places, he would blend them together with a rather thick and soft brush, and would execute his works with so high a finish that nothing better can be desired; and his colouring has no equal.

Parri, then, having been absent many years from his country, was recalled by his relatives, after the death of his father, to Arezzo, where, besides many works which it would take too long to recount, he made some which do not in any way deserve to be passed over in silence. In the Duomo Vecchio he made in fresco three different figures of Our Lady; and within the principal door of that church, on the left hand as one enters, he painted in fresco a story of the Blessed Tommasuolo, a sack-cloth hermit and a holy man of that time. And since this man was wont to carry in his hand a mirror wherein he saw, so he declared, the Passion of Christ, Parri portrayed him in that story kneeling, with that mirror in his right hand, which he was holding uplifted towards Heaven. And painting Jesus Christ above on a throne of clouds, and round him all the Mysteries of the Passion, with most beautiful art he made them all reflected in that mirror, in such wise that not only the Blessed Tommasuolo but all who beheld that picture could see them, which invention was truly fanciful

and difficult, and so beautiful that it taught those who came after him to counterfeit many things by means of mirrors. Nor will I forbear to tell, now that I am dealing with this subject, what this holy man did once in Arezzo; and it is this. Labouring continually, without ever ceasing, to induce the Aretines to live at peace with one another, now preaching, and now foretelling many misadventures, he recognized finally that he was wasting his time. Whereupon, entering one day into the Palace where the Sixty were wont to assemble, the said Blessed Tommasuolo – who saw them every day deliberating, and never coming to any resolution save such as injured the city – when he saw that the Hall was full, placed a quantity of burning coals into a great fold in his robe, and, advancing with these towards the Sixty and all the other magistrates of the city, he threw them boldly at their feet, saying: 'My lords, the fire is among you; take heed lest ruin come upon you;' and this said, he went his way. Such was the effect of the simplicity, and, as it pleased God, of the good counsel of that holy man, that the said action completely accomplished what his preachings and threatenings had never been able to do, insomuch that, becoming united among themselves no long time after, they governed that city for many years afterwards with much peace and quiet for all.

But returning to Parri: after the said work, he painted in fresco in a chapel of the Church and Hospital of S. Cristofano, beside the Company of the Nunziata, for Mona Mattea de' Testi, wife of Carcascion Florinaldi, who left a very good endowment to that little church; and there he made Christ Crucified, with many angels round Him and above Him, flying in a certain dark sky and weeping bitterly. At the foot of the Cross, on one side, are the Magdalene and the other Maries, who are holding the fainting Madonna in their arms: and on the other side are S. James and S. Christopher. On the walls he painted S. Catherine, S. Nicholas, the Annunciation, and Jesus Christ at the Column; and, in an arch over the door of the said church, a Pietà, S. John, and Our Lady. But the paintings within (save those of the chapel) have been spoilt, and the arch was pulled down in the substituting of a modern door of grey-stone, and in the making of a convent for one hundred nuns with the revenues of that Company. For this convent Giorgio Vasari made a most careful model, but it was afterwards altered, nay, reduced to the vilest form, by those who most unworthily had charge of so great a fabric. For it comes to

pass very often that one stumbles against certain men, said to be very learned, but for the most part ignorant, who, under pretence of understanding, set themselves arrogantly many times to try to play the architect and to superintend; and more often than not they spoil the arrangements and the models of those who, having spent their lives in the study and practice of building, can act with judgment in works of architecture; and this brings harm to posterity, which is thus deprived of the utility, convenience, beauty, ornament, and grandeur that are requisite in buildings, and particularly in those that are to be used for the public service.

In the Church of S. Bernardo, also, a monastery of the Monks of Monte Oliveto, Parri painted two chapels, one on either side within the principal door. In that which is on the right hand, dedicated to the Trinity, he made a God the Father, who is supporting Christ Crucified in His arms, and above there is the Dove of the Holy Spirit in the midst of a choir of angels; and on one wall of the same chapel he painted some saints in fresco, perfectly. In the other, dedicated to Our Lady, is the Nativity of Christ, with some women who are washing Him in a little wooden tub, with a womanly grace marvellously well expressed. There are also some shepherds in the distance, who are guarding their sheep, clothed in the rustic dress of those times and very lifelike, and listening attentively to the words of the Angel, who is telling them to go to Nazareth. On the opposite wall is the Adoration of the Magi, with baggage, camels, giraffes, and all the Court of those three Kings, who, reverently offering their treasures, are adoring Christ, who is lying upon the lap of His mother. Besides this, he painted on the vaulting, and in the frontals of some arches outside, some very beautiful scenes in fresco.

It is said that while Parri was executing this work, Fra Bernardino da Siena, a friar of S. Francis and a man of holy life, was preaching in Arezzo, and that having brought many of his brother monks into the true religious life, and having converted many other persons, he caused Parri to make the model for the Church of Sargiano, which he was building for them; and that afterwards, having heard that many evil things were going on in a wood near a fountain, a mile distant from the city, he went there one morning, followed by the whole people of Arezzo, with a great wooden cross in his hand, such as he was wont to carry, and after preaching a solemn sermon he had the fountain destroyed and the wood cut down; and a little later he caused a

beginning to be made with a little chapel which was built there in honour of Our Lady, with the title of S. Maria delle Grazie, wherein he afterwards asked Parri to paint with his own hand, as he did, the Virgin in Glory, who, opening her arms, is covering under her mantle the whole people of Arezzo. This most holy Virgin afterwards worked and still continues to work many miracles in that place. The Commune of Arezzo has since caused a very beautiful church to be built in this place, accommodating within it the Madonna made by Parri, for which many ornaments of marble have been made, with some figures, both round and above the altar, as it has been said in the Lives of Luca della Robbia and of his nephew Andrea, and as it will be said in due succession in the Lives of those whose works adorn that holy place.

No long time after, by reason of the devotion that he bore to that holy man, Parri portrayed the said S. Bernardino in fresco on a large pilaster in the Duomo Vecchio; in which place, in a chapel dedicated to the same Saint, he also painted him glorified in Heaven and surrounded by a legion of angels, with three half-length figures, one on either side – Patience and Poverty – and one above – Chastity – with which three virtues that Saint held company up to his death. Under his feet he had some Bishops' mitres and Cardinals' hats, in order to show that, laughing at the world, he had despised such dignities; and below these pictures was portrayed the city of Arezzo, such as it was in those times. For the Company of the Nunziata, likewise, in a little chapel, or rather maestà,* without the Duomo, Parri made a Madonna in fresco, who, receiving the Annunciation from the Angel, is turning away all in terror; and in the sky on the vaulting, which is groined, he made angels, two in each angle, who, flying through the air and making music with various instruments, appear to be playing together, so that one almost hears a very sweet harmony; and on the walls are four saints – namely, two on each side. But the pictures wherein he showed best his power of varying the expression of his conception are seen on the two pilasters that support the arch in front, where the entrance is, for the reason that on one there is a very beautiful Charity, who is affectionately suckling one infant, fondling a second, and holding a third by the hand, while on the other there is Faith, painted in a new manner,

* A street-shrine, generally containing a picture of the Virgin in Glory.

holding the Chalice and the Cross in one hand, and in the other a cup of water, which she is pouring over the head of a boy, making him a Christian. All these figures are without doubt the best that Parri ever made in all his life, and even in comparison with the modern they are marvellous.

Within the city, in the Church of S. Agostino, in the choir of the friars, the same man painted many figures in fresco, which are known by the manner of the draperies, and by their being long, slender, and bent, as it has been said above. In the tramez-zo* of the Church of S. Giustino he painted in fresco a S. Martin on horseback, who is cutting off a piece of his garment to give it to a beggar, and two other saints. In the Vescovado, also, on the face of one wall, he painted an Annunciation, which to-day is half spoilt through having been exposed for many years. In the Pieve of the same city he painted the chapel which is now near the Office of Works; and this has been almost wholly ruined by damp. Truly unfortunate has this poor painter been with his works, seeing that almost the greater part of them have been destroyed, either by damp or by the ruin of the buildings. On a round column in the said Pieve he painted a S. Vincent in fresco; and in S. Francesco he made some saints round a Madonna in half-relief, for the family of the Viviani, with the Apostles on the arch above, receiving the Holy Spirit, and some other saints in the vaulting, and on one side Christ with the Cross on His shoulder, pouring blood from His side into the Chalice, and round Christ some angels very well wrought. Opposite to this, in the Chapel of the Company of Stone-cutters, Masons, and Car-penters, dedicated to the four Crowned Saints, he made a Ma-donna, and the said Saints with the instruments of those trades in their hands, and below, also in fresco, two scenes of their acts, and the Saints being beheaded and thrown into the sea. In this work there are very beautiful attitudes and efforts in the figures that are raising those bodies, placed in sacks, on their shoulders, in order to carry them to the sea, for there are seen in them liveliness and vivacity. In S. Domenico, also, near the high-altar, on the right-hand wall, he painted in fresco a Madonna, S. An-thony, and S. Nicholas, for the family of the Alberti da Catenaia, of which place they were the Lords before its destruction, when they came to dwell, some in Arezzo and some in Florence. And

* See note on p. 90.

that they are one and the same family is shown by the arms of both one and the other, which are the same; although it is true that to-day those of Arezzo are called, not 'Degli Alberti,' but 'Da Catenaia,' and those of Florence not 'Da Catenaia,' but 'Degli Alberti.' And I remember to have seen, and also read, that the Abbey of the Sasso – which was in the mountains of Catenaia, and which has now been pulled down and rebuilt lower down towards the Arno – was erected by the same Alberti for the Congregation of Camaldoli; and to-day it belongs to the Monastery of the Angeli in Florence, which acknowledges it as coming from the said family, which is among the noblest in Florence.

In the old Audience Chamber of the Fraternity of S. Maria della Misericordia, Parri painted a Madonna who has under her mantle the people of Arezzo, wherein he portrayed from the life those who then ruled that holy place, clothed according to the use of those times; and among them one called Braccio, who is now called, when there is talk of him, Lazzaro Ricco, and who died in the year 1422, leaving all his riches and means to that place, which dispenses them in the service of God's poor, performing the holy works of mercy with much charity. On one side of this Madonna is S. Gregory the Pope, and on the other S. Donatus, Bishop and Protector of the people of Arezzo. And since those who then ruled that Fraternity had been very well served in this work by Parri, they caused him to make on a panel, in distemper, a Madonna with the Child in her arms, with some angels who are opening her mantle, beneath which is the said people; with S. Laurentino and S. Pergentino, the martyrs, below. This panel is brought out every year on the second day of June, and, after it has been borne in solemn procession by the men of the said Company as far as the church of the said Saints, there is placed over it a coffer of silver, wrought by the goldsmith Forzore, brother of Parri, within which are the bodies of the said SS. Laurentino and Pergentino; it is brought out, I say, and the said altar is made under covering of a tent in the Canto alla Croce, where the said church stands, because, being a small church, it would not hold all the people who assemble for this festival. The predella whereon the said panel rests contains the martyrdom of those two Saints, made with little figures, and so well wrought, that for a small work it is truly a marvel. In Borgo Piano, under the projection of a house, there is a shrine by the hand of Parri,

within which is an Annunciation in fresco, which is much extolled; and in S. Agostino, for the Company of the Puraccioli, he made in fresco a very beautiful picture of S. Catherine, virgin and martyr. In the Church of Muriello, likewise, for the Fraternity of the Clerks, he painted a S. Mary Magdalene, three braccia high; and in S. Domenico, at the entrance of the door, where the bell-ropes are, he painted in fresco the Chapel of S. Niccolò, making therein a large Crucifix with four figures, so well wrought that it seems made only yesterday. In the arch he painted two stories of S. Nicholas – namely, his throwing the golden balls to the maidens, and his delivering two from death, while the executioner is seen apparelled and ready to cut off their heads, and very well wrought.

The while that Parri was making this work, he was set upon with weapons by some of his relatives, with whom he had a dispute about some dowry; but, since some other men ran up immediately, he was succoured in a manner that they did him no harm. But nevertheless, so it is said, the fright that he experienced brought it about that, besides making his figures bending over to one side, from that day onward he made them almost always with an expression of terror. And since he found himself many times attacked by slanderous tongues and torn by the tooth of envy, he made in that chapel a scene of tongues burning, with some devils round them that were heaping them with fire; and in the sky was Christ cursing them, and on one side these words: 'To the false tongue.'

Parri was very studious in the matters of art, and drew very well, as it is shown by many drawings by his hand, which I have seen, and in particular by a border of twenty scenes from the life of S. Donatus, made for a sister of his own, who embroidered very well; and this he is reputed to have done because there was a question of making adornments for the high-altar of the Vescovado. And in our book there are some drawings by his hand, done very well with the pen. Parri was portrayed by Marco da Montepulciano, a disciple of Spinello, in the cloister of S. Bernardo in Arezzo. He lived fifty-six years, and he shortened his life by reason of being by nature melancholic, solitary, and too assiduous in the studies of his art and in his labours. He was buried in S. Agostino, in the same tomb wherein his father Spinello had been laid, and his death caused displeasure to all the men of culture who knew him.

MASACCIO, Painter of San Giovanni in Valdarno

IT is the custom of nature, when she makes a man very excellent in any profession, very often not to make him alone, but at the same time, and in the same neighbourhood, to make another to compete with him, to the end that they may assist each other by their talent and emulation; which circumstance, besides the singular advantage enjoyed by the men themselves, who thus compete with each other, also kindles beyond measure the minds of those who come after that age, to strive with all study and all industry to attain to that honour and that glorious reputation which they hear highly extolled without ceasing in those who have passed away. And that this is true we see from the fact that Florence produced in one and the same age Filippo, Donato, Lorenzo, Paolo Uccello, and Masaccio, each most excellent in his own kind, and thus not only swept away the rough and rude manners that had prevailed up to that time, but incited and kindled so greatly, by reason of the beautiful works of these men, the minds of those who came after, that the work of those professions has been brought to that grandeur and to that perfection which are seen in our own times. Wherefore, in truth, we owe a great obligation to those early craftsmen who showed to us, by means of their labours, the true way to climb to the greatest height; and with regard to the good manner of painting, we are indebted above all to Masaccio, seeing that he, as one desirous of acquiring fame, perceived that painting is nothing but the counterfeiting of all the things of nature, vividly and simply, with drawing and with colours, even as she produced them for us, and that he who attains to this most perfectly can be called excellent. This truth, I say, being recognized by Masaccio, brought it about that by means of continuous study he learnt so much that he can be numbered among the first who cleared away, in a great measure, the hardness, the imperfections, and the difficulties of the art, and that he gave a beginning to beautiful attitudes, movements, liveliness, and vivacity, and to a certain relief truly characteristic and natural; which no painter up to his time had ever done. And since he had excellent judgment, he reflected that all the figures that did not stand firmly with their feet in foreshortening on the level, but stood on tip-toe, were lacking in all goodness of manner in the essential points, and that those who

make them thus show that they do not understand fore-shortening. And although Paolo Uccello had tried his hand at this, and had done something, solving this difficulty to some extent, yet Masaccio, introducing many new methods, made fore-shortenings from every point of view much better than any other who had lived up to that time. And he painted his works with good unity and softness, harmonizing the flesh-colours of the heads and of the nudes with the colours of the draperies, which he delighted to make with few folds and simple, as they are in life and nature. This has been of great use to craftsmen, and he deserves therefore to be commended as if he had been its inventor, for in truth the works made before his day can be said to be painted, while his are living, real, and natural, in comparison with those made by the others.

This man was born at Castello San Giovanni in Valdarno, and they say that one may still see there some figures made by him in his earliest childhood. He was a very absent-minded and careless person, as one who, having fixed his whole mind and will on the matters of art, cared little about himself, and still less about others. And since he would never give any manner of thought to the cares and concerns of the world, or even to clothing himself, and was not wont to recover his money from his debtors, save only when he was in the greatest straits, his name was therefore changed from Tommaso to Masaccio,* not, indeed, because he was vicious, for he was goodness itself, but by reason of his so great carelessness; and with all this, nevertheless, he was so amiable in doing the service and pleasure of others, that nothing more could be desired.

He began painting at the time when Masolino da Panicale was working on the Chapel of the Brancacci in the Carmine, in Florence, ever following, in so far as he was able, in the steps of Filippo and Donato, although their branch of art was different, and seeking continually in his work to make his figures very lifelike and with a beautiful liveliness in the likeness of nature. And his lineaments and his painting were so modern and so different from those of the others, that his works can safely stand in comparison with any drawing and colouring of our own day. He was very zealous at his labours, and a marvellous master of the difficulties of perspective, as it is seen in a story painted by

* Careless Tom, or Hulking Tom (not necessarily in disapproval).

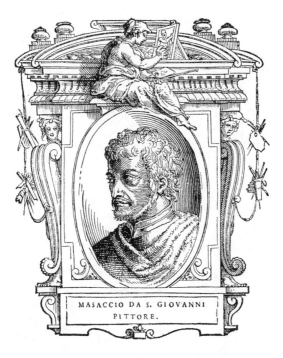

MASACCIO DA S. GIOVANNI
PITTORE.

him with small figures, which is to-day in the house of Ridolfo del Ghirlandajo. In this story, besides a Christ who is delivering the man possessed by a devil, there are very beautiful buildings in perspective, drawn in a manner that they show at one and the same time both the inside and the outside, by reason of his having chosen the point of view, not of the front, but over the corners, as being more difficult. He sought more than any other master to make his figures nude and foreshortened, which was little done before his day. He had great facility in handling, and, as it has been said, he is very simple in his draperies.

There is a panel by his hand, wrought in distemper, wherein is a Madonna upon the lap of S. Anne, with the Child in her arms. This panel is to-day in S. Ambrogio in Florence, in the chapel that is beside the door that leads to the parlour of the nuns. And in the tramezzo* of the Church of S. Niccolò, on the other side of the Arno, there is a panel by the hand of Masaccio, painted in distemper, wherein, besides the Madonna, who is receiving the Annunciation from the Angel, there is a building with many columns, drawn in perspective and very beautiful, seeing that, besides the drawing of the lines, which is perfect, he made it recede by means of the colouring, in a manner that little by little, almost imperceptibly, it is lost to view; thus showing clearly his knowledge of perspective. In the Badia of Florence, on a pilaster opposite to one of those that support the arch of the high-altar, he painted in fresco S. Ivo of Brittany, representing him within a niche, in order that the feet might appear foreshortened to the eye below; which device, not having been used so well by others, acquired for him no small praise. And below the said Saint, over another cornice, he made a throng of widows, orphans, and beggars, who receive assistance from that Saint in their needs. In S. Maria Novella, also, below the tramezzo* of the church, he painted a Trinity in fresco, which is placed over the altar of S. Ignazio, with Our Lady on one side and S. John the Evangelist on the other contemplating Christ Crucified. On the sides are two figures on their knees, which, in so far as it can be determined, are portraits of the men who had the picture painted; but little is seen of them, for they have been covered with a gilt ornament. But the most beautiful thing, apart from the figures, is a barrel-shaped vaulting, drawn in perspective and

* See note on p. 90.

divided into squares filled with rosettes, which are foreshortened
and made to diminish so well that the wall appears to be pierced.
In S. Maria Maggiore, also, near the side-door that leads to S.
Giovanni, on the panel of a chapel, he painted a Madonna, with
S. Catherine and S. Julian. On the predella he made some little
figures, connected with the life of S. Catherine, with S. Julian
murdering his father and mother; and in the middle he made the
Nativity of Christ, with that simplicity and vividness which were
characteristic of his work.

In the Church of the Carmine in Pisa, on a panel that is in a
chapel in the tramezzo,* there is a Madonna with the Child, by
his hand, and at her feet are certain little angels sounding instru-
ments, one of whom, playing on a lute, is listening attentively to
the harmony of that sound. On either side of the Madonna are
S. Peter, S. John the Baptist, S. Julian, and S. Nicholas, all very
lifelike and vivacious figures. In the predella below are scenes
from the lives of those Saints, with little figures; and in the centre
are the three Magi offering their treasures to Christ. In this part
are some horses portrayed from life, so beautiful that nothing
better can be desired; and the men of the Court of those three
Kings are clothed in various costumes that were worn in those
times. And above, as an ornament for the said panel, there are,
in several squares, many saints round a Crucifix. It is believed that
the figure of a saint, in the robes of a Bishop and painted in
fresco, which is in that church, beside the door that leads into
the convent, is by the hand of Masaccio; but I hold it as certain
that it is by the hand of Fra Filippo, his disciple.

Returning from Pisa to Florence, he wrought there a panel
containing a man and a woman, nude and of the size of life,
which is to-day in the Palla Rucellai Palace. Then, not feeling at
ease in Florence, and stimulated by his affection and love for art,
he determined to go to Rome, in order to learn and to surpass
others; and this he did. And having acquired very great fame
there, he painted for Cardinal San Clemente a chapel in the
Church of S. Clemente, wherein he made in fresco the Passion
of Christ, with the Thieves on the Cross, and the stories of
S. Catherine the martyr. He also made many panels in distemper,
which have been all lost or destroyed in the troublous times of
Rome; one being in the Church of S. Maria Maggiore, in a little

* See note on p. 90.

chapel near the sacristy, wherein are four saints, so well wrought
that they appear to be in relief, and in the midst of them is
S. Maria della Neve, with the portrait from nature of Pope Mar-
tin, who is tracing out the foundations of that church with a hoe,
and beside him the Emperor Sigismund II. Michelagnolo and I
were one day examining this work, when he praised it much, and
then added that these men were alive in Masaccio's time. To him,
while Pisanello and Gentile da Fabriano were labouring in Rome
for Pope Martin on the walls of the Church of S. Gianni, these
masters had allotted a part of the work, when he returned to
Florence, having had news that Cosimo de' Medici, by whom he
was much assisted and favoured, had been recalled from exile;
and there he was commissioned to paint the Chapel of the Bran-
cacci in the Carmine, by reason of the death of Masolino da
Panicale, who had begun it; but before putting his hand to this,
he made, by way of specimen, the S. Paul that is near the bell-
ropes, in order to show the improvement that he had made in
his art. And he demonstrated truly infinite excellence in this pic-
ture, for in the head of that Saint, who is Bartolo di Angiolino
Angiolini portrayed from life, there is seen an expression so awful
that there appears to be nothing lacking in that figure save
speech; and he who has not known S. Paul will see, by looking
at this picture, his honourable Roman culture, together with the
unconquerable strength of that most divine spirit, all intent on
the work of the faith. In this same picture, likewise, he showed a
power of foreshortening things viewed from below upwards
which was truly marvellous, as may still be seen to-day in the feet
of the said Apostle, for this was a difficulty that he solved com-
pletely, in contrast with the old rude manner, which, as I said a
little before, used to make all the figures on tip-toe; which man-
ner lasted up to his day, without any other man correcting it, and
he, by himself and before any other, brought it to the excellence
of our own day.

It came to pass, the while that he was labouring at this work,
that the said Church of the Carmine was consecrated; and Ma-
saccio, in memory of this, painted the consecration just as it took
place, with terra-verde and in chiaroscuro, over the door that
leads into the convent, within the cloister. And he portrayed
therein an infinite number of citizens in mantles and hoods, who
are following the procession, among whom he painted Filippo
di Ser Brunellesco in wooden shoes, Donatello, Masolino da

Panicale, who had been his master, Antonio Brancacci, who
caused him to paint the chapel, Niccolò da Uzzano, Giovanni di
Bicci de' Medici, and Bartolommeo Valori, who are all also port-
rayed by the hand of the same man in the house of Simon Corsi,
a gentleman of Florence. He also painted there Lorenzo Ridolfi,
who was at that time the ambassador of the Florentine Republic
in Venice; and not only did he portray there the aforesaid
gentlemen from the life, but also the door of the convent and the
porter with the keys in his hand. This work, truly, shows great
perfection, for Masaccio was so successful in placing these
people, five or six to a file, on the level of that piazza, and in
making them diminish to the eye with proportion and judgment,
that it is indeed a marvel, and above all because we can recognize
there the wisdom that he showed in making those men, as if they
were alive, not all of one size, but with a certain discretion which
distinguishes those who are short and stout from those who are
tall and slender; while they are all standing with their feet firmly
on one level, and so well foreshortened along the files that they
would not be otherwise in nature.

After this, returning to the work of the Chapel of the Bran-
cacci, and continuing the stories of S. Peter begun by Masolino,
he finished a part of them – namely, the story of the Chair, the
healing of the sick, the raising of the dead, and the restoring of
the cripples with his shadow as he was going to the Temple with
S. John. But the most notable among them all is that one wherein
S. Peter, at Christ's command, is taking the money from the belly
of the fish, in order to pay the tribute, since (besides the fact that
we see there in an Apostle, the last of the group, the portrait of
Masaccio himself, made by his own hand with the help of a
mirror, so well that it appears absolutely alive) we can recognize
there the ardour of S. Peter in his questioning and the attentive-
ness of the Apostles, who are standing in various attitudes round
Christ, awaiting his determination, with gestures so vivid that
they truly appear alive. Wonderful, above all, is the S. Peter who,
while he is labouring to draw the money from the belly of the
fish, has his head suffused with blood by reason of bending
down; and he is even more wonderful as he pays the tribute, for
here we see his expression as he counts it, and the eagerness of
him who is receiving it and looking at the money in his hand with
the greatest pleasure. There, also, he painted the resurrection of
the King's son, wrought by S. Peter and S. Paul; although by

reason of the death of Masaccio the work remained unfinished, and was afterwards completed by Filippino. In the scene wherein S. Peter is baptizing, a naked man, who is trembling and shivering with cold among the others who are being baptized, is greatly esteemed, having been wrought with very beautiful relief and sweet manner; which figure has ever been held in reverence and admiration by all craftsmen, both ancient and modern. For this reason that chapel has been frequented continually up to our own day by innumerable draughtsmen and masters; and there still are therein some heads so lifelike and so beautiful, that it may truly be said that no master of that age approached so nearly as this man did to the moderns. His labours therefore deserve infinite praise, and above all because he gave form in his art to the beautiful manner of our times. And that this is true is proved by the fact that all the most celebrated sculptors and painters, who have lived from his day to our own, have become excellent and famous by exercising themselves and studying in this chapel – namely, Fra Giovanni da Fiesole, Fra Filippo, Filippino, who finished it, Alesso Baldovinetti, Andrea dal Castagno, Andrea del Verrocchio, Domenico del Ghirlandajo, Sandro di Botticello, Leonardo da Vinci, Pietro Perugino, Fra Bartolommeo di San Marco, Mariotto Albertinelli, and the most divine Michelagnolo Buonarroti; likewise Raffaello da Urbino, who owed to this chapel the beginning of his beautiful manner, Granaccio, Lorenzo di Credi, Ridolfo del Ghirlandajo, Andrea del Sarto, Rosso, Franciabigio, Baccio Bandinelli, Alonso Spagnuolo, Jacopo da Pontormo, Pierino del Vaga, and Toto del Nunziata; and in short, all those who have sought to learn that art have ever gone to this chapel to learn and to grasp the precepts and the rules for good work from the figures of Masaccio. And if I have not named many foreigners and many Florentines who have gone to that chapel for the sake of study, let it suffice to say that where the heads of art go, the members also follow. But although the works of Masaccio have ever been in so great repute, it is nevertheless the opinion – nay, the firm belief – of many, that he would have produced even greater fruits in his art, if death, which tore him from us at the age of twenty-six, had not snatched him away from us so prematurely. But either by reason of envy, or because good things rarely have any long duration, he died in the flower of his youth, and that so suddenly, that there were not wanting people who put it down to poison rather than to any other reason.

It is said that Filippo di Ser Brunellesco, hearing of his death, exclaimed, 'We have suffered a very great loss in Masaccio,' and that it grieved him infinitely, for he had spent much time in demonstrating to Masaccio many rules of perspective and of architecture. He was buried in the same Church of the Carmine in the year 1443, and although, since he had been little esteemed when alive, no memorial was then placed over his tomb, yet after his death there were not wanting men to honour him with these epitaphs:

BY ANNIBAL CARO.

PINSI, E LA MIA PITTURA AL VER FU PARI;
 L'ATTEGGIAI, L'AVVIVAI, LE DIEDI IL MOTO,
 LE DIEDI AFFETTO. INSEGNI IL BUONARROTO
 A TUTTI GLI ALTRI, E DA ME SOLO IMPARI.

BY FABIO SEGNI.

INVIDA CUR LACHESIS PRIMO SUB FLORE JUVENTAE
 POLLICE DISCINDIS STAMINA FUNEREO?
HOC UNO OCCISO INNUMEROS OCCIDIS APELLES;
 PICTURAE OMNIS OBIT, HOC OBEUNTE, LEPOS.
HOC SOLE EXTINCTO, EXTINGUUNTUR SIDERA CUNCTA.
 HEU! DECUS OMNE PERIT, HOC PEREUNTE, SIMUL.

FILIPPO BRUNELLESCHI
[*FILIPPO DI SER BRUNELLESCO*],
Sculptor and Architect

MANY men are created by nature small in person and in features, who have a mind full of such greatness and a heart of such irresistible vehemence, that if they do not begin difficult – nay, almost impossible – undertakings, and bring them to completion to the marvel of all who behold them, they have never any peace in their lives; and whatsoever work chance puts into their hands, however lowly and base it may be, they give it value and nobility. Wherefore no one should turn up his nose when he encounters people who have not, in their aspect, that primal grace or beauty which nature should give, on his coming into the world, to a man who works at any art, seeing that there is no doubt that beneath the clods of the earth are hidden veins of gold. And very often, in those who are most insignificant in form, there are born so

great generosity of mind and so great sincerity of heart, that, if nobility be mingled with these, nothing short of the greatest marvels can be looked for from them, for the reason that they strive to embellish the ugliness of the body with the beauty of the intellect; as it is clearly seen in Filippo di Ser Brunellesco, who was no less insignificant in person than Messer Forese da Rabatta and Giotto, but so lofty in intellect that it can be truly said that he was sent to us by Heaven in order to give new form to architecture, which had been out of mind for hundreds of years; for the men of those times had spent much treasure to no purpose, making buildings without order, with bad method, with sorry design, with most strange inventions, with most ungraceful grace, and with even worse ornament. And Heaven ordained, since the earth had been for so many years without any supreme mind or divine spirit, that Filippo should bequeath to the world the greatest, the most lofty, and the most beautiful building that was ever made in modern times, or even in those of the ancients, proving that the talent of the Tuscan craftsmen, although lost, was not therefore dead. Heaven adorned him, moreover, with the best virtues, among which was that of kindliness, so that no man was ever more benign or more amiable than he. In judgment he was free from passion, and when he saw worth and merit in others he would sacrifice his own advantage and the interest of his friends. He knew himself, he shared the benefit of his own talent with many, and he was ever succouring his neighbour in his necessities. He declared himself a capital enemy of vice, and a friend of those who practised virtue. He never spent his time uselessly, but would labour to meet the needs of others, either by himself or by the agency of other men; and he would visit his friends on foot and ever succour them.

It is said that there was in Florence a man of very good repute, most praiseworthy in his way of life and active in his business, whose name was Ser Brunellesco di Lippo Lapi, who had had a grandfather called Cambio, who was a learned person and the son of a physician very famous in those times, named Maestro Ventura Bacherini. Now Ser Brunellesco, taking to wife a most excellent young woman from the noble family of the Spini, received, as part payment of her dowry, a house wherein he and his sons dwelt to the day of their death. This house stands opposite to one side of S. Michele Berteldi, in a close past the Piazza degli Agli. The while that he was occupying himself thus and living

happily, in the year 1398 there was born to him a son, to whom
he gave the name Filippo, after his own father, now dead; and he
celebrated this birth with the greatest gladness possible. There-
upon he taught him in his childhood, with the utmost attention,
the first rudiments of letters, wherein the boy showed himself so
ingenious and so lofty in spirit that his brain was often in doubt,
as if he did not care to become very perfect in them – nay, it
appeared that he directed his thoughts on matters of greater
utility – wherefore Ser Brunellesco, who wished him to follow his
own vocation of notary, or that of his great-great-grandfather,
was very much displeased. But seeing him continually investigat-
ing ingenious problems of art and mechanics, he made him learn
arithmetic and writing, and then apprenticed him to the gold-
smith's art with one his friend, to the end that he might learn
design. And this gave great satisfaction to Filippo, who, not many
years after beginning to learn and to practise that art, could set
precious stones better than any old craftsman in that vocation.
He occupied himself with niello and with making larger works,
such as some figures in silver, whereof two, half-length prophets,
are placed at the head of the altar of S. Jacopo in Pistoia; these
figures, which are held very beautiful, were wrought by him for
the Wardens of Works in that city; and he made works in low-
relief, wherein he showed that he had so great knowledge in his
vocation that his intellect must needs overstep the bounds of that
art. Wherefore, having made acquaintance with certain studious
persons, he began to penetrate with his fancy into questions of
time, of motion, of weights, and of wheels, and how the latter
can be made to revolve, and by what means they can be set in
motion; and thus he made some very good and very beautiful
clocks with his own hand.

Not content with this, there arose in his mind a very great
inclination for sculpture; and this took effect, for Donatello, then
a youth, being held an able sculptor and one of great promise,
Filippo began to be ever in his company, and the two conceived
such great love for each other, by reason of the talents of each,
that one appeared unable to live without the other. Whereupon
Filippo, who was most capable in various ways, gave attention to
many professions, nor had he practised these long before he was
held by persons qualified to judge to be a very good architect, as
he showed in many works in connection with the fitting up of
houses, such as the house of Apollonio Lapi, his kinsman, in the

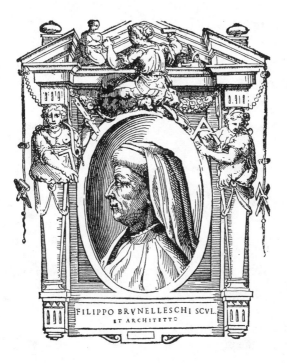

FILIPPO BRVNELLESCHI SCVL.
ET ARCHITETTO

Canto de' Ciai, towards the Mercato Vecchio, wherein he occupied himself greatly while the other was having it built; and he did the same in the tower and in the house of Petraia, at Castello without Florence. In the Palace that was the habitation of the Signoria, he arranged and distributed all those rooms wherein the officials of the Monte had their office, and he made doors and windows there in the manner copied from the ancient, which was then little used, for architecture was very rude in Tuscany. In Florence, a little later, there was a statue of lime-wood to be made for the Friars of S. Spirito, representing S. Mary Magdalene in Penitence, to be placed in a chapel; and Filippo, who had wrought many little things in sculpture, desiring to show that he was able to succeed in large works as well, undertook to make the said figure, which, when put into execution and finished, was held something very beautiful; but it was destroyed afterwards, together with many other notable works, in the year 1471, when that church was burnt down.

He gave much attention to perspective, which was then in a very evil plight by reason of many errors that were made therein; and in this he spent much time, until he found by himself a method whereby it might become true and perfect – namely, that of tracing it with the ground-plan and profile and by means of intersecting lines, which was something truly most ingenious and useful to the art of design. In this he took so great delight that he drew with his own hand the Piazza di S. Giovanni, with all the compartments of black and white marble wherewith that church was incrusted, which he foreshortened with singular grace; and he drew, likewise, the building of the Misericordia, with the shops of the Wafer-Makers and the Volta de' Pecori, and the column of S. Zanobi on the other side. This work, bringing him praise from craftsmen and from all who had judgment in that art, encouraged him so greatly that it was not long before he put his hand to another and drew the Palace, the Piazza, and the Loggia of the Signori, together with the roof of the Pisani and all the buildings that are seen round that Piazza; and these works were the means of arousing the minds of the other craftsmen, who afterwards devoted themselves to this with great zeal. He taught it, in particular, to the painter Masaccio, then a youth and much his friend, who did him credit in this art that Filippo showed him, as it is apparent from the buildings in his works. Nor did he refrain from teaching it even to those who worked in

tarsia, which is the art of inlaying coloured woods; and he stimu-
lated them so greatly that he was the source of a good style and
of many useful changes that were made in that craft, and of many
excellent works wrought both then and afterwards, which have
brought fame and profit to Florence for many years.

Now Messer Paolo dal Pozzo Toscanelli, returning from his
studies, and chancing one evening to be at supper in a garden
with some of his friends, invited Filippo, who, hearing him dis-
course on the mathematical arts, formed such an intimacy with
him that he learnt geometry from Messer Paolo; and although
Filippo had no learning, he reasoned so well in every matter with
his instinct, sharpened by practice and experience, that he would
many times confound him. And so he went on to give attention
to the study of the Christian Scriptures, never failing to be pres-
ent at the disputations and preachings of learned persons, from
which he gained so much advantage, by reason of his admirable
memory, that the aforesaid Messer Paolo was wont to extol him
and to say that in hearing Filippo argue he appeared to be hearing
a new S. Paul. He also gave much attention at this time to the
works of Dante, which he understood very well with regard to
the places described and their proportions, and he would avail
himself of them in his conversations, quoting them often in mak-
ing comparisons. He did naught else with his thoughts but invent
and imagine ingenious and difficult things; nor could he ever find
an intellect more to his satisfaction than that of Donato, with
whom he was ever holding familiar discourse, and they took
pleasure in one another and would confer together over the
difficulties of their vocation.

Now in those days Donato had finished a Crucifix of wood,
which was placed in S. Croce in Florence, below the scene of the
child being restored to life by S. Francis, painted by Taddeo
Gaddi, and he wished to have the opinion of Filippo about this
work; but he repented, for Filippo answered that he had placed
a ploughman on the Cross; whence there arose the saying, 'Take
wood and make one thyself,' as it is related at length in the Life
of Donato. Whereupon Filippo, who would never get angry,
whatever might be said to him, although he might have reason
for anger, stayed in seclusion for many months until he had
finished a Crucifix of wood of the same size, so excellent, and
wrought with so much art, design, and diligence, that Donato —
whom he had sent to his house ahead of himself, as it were to

surprise him, for he did not know that Filippo had made such a
work – having an apron full of eggs and other things for their
common dinner, let it fall as he gazed at the work, beside himself
with marvel at the ingenious and masterly manner that Filippo
had shown in the legs, the trunk, and the arms of the said figure,
which was so well composed and united together that Donato,
besides admitting himself beaten, proclaimed it a miracle. This
work is placed to-day in S. Maria Novella, between the Chapel of
the Strozzi and that of the Bardi da Vernia, and it is still very
greatly extolled by the moderns. Wherefore, the talent of these
truly excellent masters being recognized, they received a com-
mission from the Guild of Butchers and from the Guild of
Linen-Manufacturers for two figures in marble, to be made for
their niches, which are on the outside of Orsanmichele. Having
undertaken other work, Filippo left these figures to Donato to
make by himself, and Donato executed them to perfection.

After these things, in the year 1401, now that sculpture had
risen to so great a height, it was determined to reconstruct the
two bronze doors of the Church and Baptistery of S. Giovanni,
since, from the death of Andrea Pisano to that day, they had not
had any masters capable of executing them. This intention being,
therefore, communicated to those sculptors who were then in
Tuscany, they were sent for, and each man was given a provision
and the space of a year to make one scene; and among those
called upon were Filippo and Donato, each of them being re-
quired to make one scene by himself, in competition with Loren-
zo Ghiberti, Jacopo* della Fonte, Simone da Colle, Francesco di
Valdambrina, and Niccolò d' Arezzo. These scenes, being
finished in the same year and being brought together for com-
parison, were all most beautiful and different one from the other;
one was well designed and badly wrought, as was that of Donato;
another was very well designed and diligently wrought, but the
composition of the scene, with the gradual diminution of the
figures, was not good, as was the case with that of Jacopo della
Quercia; a third was poor in invention and in the figures, which
was the manner wherein Francesco di Valdambrina had executed
his; and the worst of all were those of Niccolò d' Arezzo and
Simone da Colle. The best was that of Lorenzo di Cione Ghiber-
ti, which had design, diligence, invention, art, and the figures very

* *I.e.*, Jacopo della Quercia.

well wrought. Nor was that of Filippo much inferior, wherein he
had represented Abraham sacrificing Isaac; and in that scene a
slave who is drawing a thorn from his foot, while he is awaiting
Abraham and the ass is browsing, deserves no little praise.

The scenes, then, being exhibited, Filippo and Donato were
not satisfied with any save with that of Lorenzo, and they judged
him to be better qualified for that work than themselves and the
others who had made the other scenes. And so with good
reasons they persuaded the Consuls to allot the work to Lorenzo,
showing that thus both the public and the private interest would
be best served; and this was indeed the true goodness of friend-
ship, excellence without envy, and a sound judgment in the
knowledge of their own selves, whereby they deserved more
praise than if they had executed the work to perfection. Happy
spirits! who, while they were assisting one another, took delight
in praising the labours of others. How unhappy are those of our
own day, who, not sated with injuring each other, burst with envy
while rending others. The Consuls besought Filippo to undertake
the work in company with Lorenzo, but he refused, being
minded rather to be first in an art of his own than an equal or a
second in that work. Wherefore he presented the scene that he
had wrought in bronze to Cosimo de' Medici, who after a time
had it placed on the dossal of the altar in the old Sacristy of
S. Lorenzo, where it is to be found at present; and that of Do-
nato was placed in the Guild of the Exchange.

The commission being given to Lorenzo Ghiberti, Filippo and
Donato, who were together, resolved to depart from Florence in
company and to live for some years in Rome, to the end that
Filippo might study architecture and Donato sculpture; and
this Filippo did from his desire to be superior both to Lorenzo
and to Donato, in proportion as architecture is held to be more
necessary for the practical needs of men than sculpture and paint-
ing. After he had sold a little farm that he had at Settignano, they
departed from Florence and went to Rome, where, seeing the
grandeur of the buildings and the perfection of the fabrics of the
temples, Filippo would stand in a maze like a man out of his
mind. And so, having made arrangements for measuring the cor-
nices and taking the ground-plans of those buildings, he and
Donato kept labouring continually, sparing neither time nor ex-
pense. There was no place, either in Rome or in the Campagna
without, that they left unvisited, and nothing of the good that

they did not measure, if only they could find it. And since Filippo was free from domestic cares, he gave himself over body and soul to his studies, and took no thought for eating or sleeping, being intent on one thing only – namely, architecture, which was now dead (I mean the good ancient Orders, and not the barbarous German, which was much in use in his time). And he had in his mind two vast conceptions, one being to restore to light the good manner of architecture, since he believed that if he could recover it he would leave behind no less a name for himself than Cimabue and Giotto had done; and the other was to find a method, if he could, of raising the Cupola of S. Maria del Fiore in Florence, the difficulties of which were such that after the death of Arnolfo Lapi there had been no one courageous enough to think of raising it without vast expenditure for a wooden framework. Yet he did not impart this his invention to Donato or to any living soul, nor did he rest in Rome till he had considered all the difficulties connected with the Ritonda, wondering how the vaulting was raised. He had noted and drawn all the ancient vaults, and was for ever studying them; and if peradventure they had found pieces of capitals, columns, cornices, and bases of buildings buried underground, they would set to work and have them dug out, in order to examine them thoroughly. Wherefore a rumour spread through Rome, as they passed through the streets, going about carelessly dressed, so that they were called the 'treasure-seekers,' people believing that they were persons who studied geomancy in order to discover treasure; and this was because they had one day found an ancient earthenware vase full of medals. Filippo ran short of money and contrived to make this good by setting jewels of price for certain goldsmiths who were his friends; and thus he was left alone in Rome, for Donato returned to Florence, while he, with greater industry and labour than before, was for ever investigating the ruins of those buildings. Nor did he rest until he had drawn every sort of building – round, square, and octagonal temples, basilicas, aqueducts, baths, arches, colossea, amphitheatres, and every temple built of bricks, from which he copied the methods of binding and of clamping with ties, and also of encircling vaults with them; and he noted the ways of making buildings secure by binding the stones together, by iron bars, and by dove-tailing; and, discovering a hole hollowed out under the middle of each great stone, he found that this was meant to hold the iron instrument, which is called

by us the ulivella,* wherewith the stones are drawn up; and this he reintroduced and brought into use afterwards. He then distinguished the different Orders one from another – Doric, Ionic, and Corinthian; and so zealous was his study that his intellect became very well able to see Rome, in imagination, as she was when she was not in ruins. In the year 1407 the air of that city gave Filippo a slight indisposition, wherefore, being advised by his friends to try a change of air, he returned to Florence. There many buildings had suffered by reason of his absence; and for these, on his arrival, he gave many designs and much advice.

In the same year a congress of architects and engineers of the country was summoned by the Wardens of Works of S. Maria del Fiore and by the Consuls of the Guild of Wool, to discuss methods for raising the cupola. Among these appeared Filippo, giving it as his advice that it was necessary, not to raise the fabric directly from the roof according to the design of Arnolfo, but to make a frieze fifteen braccia in height, with a large round window in the middle of each of its sides, since not only would this take the weight off the supports of the tribunes, but it would become easier to raise the cupola; and models were made in this way, and were put into execution. Filippo, being restored to health after some months, was standing one morning in the Piazza di S. Maria del Fiore with Donato and other craftsmen, when they began to talk of antiquities in connection with sculpture, and Donato related how, when he was returning from Rome, he had made the journey through Orvieto, in order to see that marble façade of the Duomo, a work greatly celebrated, wrought by the hands of diverse masters and held to be something notable in those times; and how, in passing afterwards by Cortona, he entered the Pieve and saw a very beautiful ancient sarcophagus, whereon there was a scene in marble – a rare thing then, when there had not been unearthed that abundance which has been found in our own day. And as Donato went on to describe the method that the master of that work had used in its execution, and the finish that was to be seen therein, together with the perfection and the excellence of the workmanship, Filippo became fired with an ardent desire to see it, and went off on foot just as he was, in his mantle, cap, and wooden shoes, without saying where he was going, and allowed himself to be carried to

* This was probably something like the modern lewis.

Cortona by the devotion and love that he bore to art. And having seen the sarcophagus, and being pleased with it, he made a drawing of it with the pen, and returned with that to Florence, without Donato or any other person knowing that he had been away, for they thought he must have been drawing or inventing something.

Having thus returned to Florence, he showed him the drawing of the sarcophagus, which he had made with great patience, whereat Donato marvelled not a little, seeing how much love Filippo bore to art. After this he stayed many months in Florence, where he kept making models and machines in secret, all for the work of the cupola, exchanging jokes the while with his fellow-craftsmen – for it was then that he played the jest of 'the Fat Man and Matteo' – and going very often, for recreation, to assist Lorenzo Ghiberti in polishing some part of his doors. But hearing that there was some talk of providing engineers for the raising of the cupola, and being taken one morning with the idea of returning to Rome, he went there, thinking that he would be in greater repute and would be more sought for from abroad than he would be if he stayed in Florence. When he was in Rome, therefore, the work came to be considered, and so, too, the great acuteness of his intellect, for he had shown in his discourse such confidence and such courage as had not been found in the other masters, who, together with the builders, were standing paralyzed and helpless, thinking that no way of raising the cupola could ever be found, nor beams to make a bridge strong enough to sustain the framework and the weight of so great an edifice; and having determined to make an end of the matter, they wrote to Filippo in Rome, praying him to come to Florence. He, desiring nothing better, returned with great readiness; and the Wardens of Works of S. Maria del Fiore and the Consuls of the Guild of Wool, assembling on his arrival, explained to Filippo all the difficulties, from the greatest to the smallest, which were being raised by the masters, who were in his presence at the audience together with them. Whereupon Filippo spoke these words: 'My Lords the Wardens, there is no doubt that great enterprises ever present difficulties in their execution, and if any ever did so, this of yours presents them, and even greater than perchance you are aware of, for the reason that I do not know whether even the ancients ever raised a vault so tremendous as this will be; and although I have often pondered over the framework necessary both within and without, and how it may be possible to work at

it securely, I have never been able to come to any resolution, and I am aghast no less at the breadth than at the height of the edifice, for the reason that, if it could be made round, we might use the method used by the Romans in raising the dome over the Pantheon in Rome, that is, the Ritonda, whereas here we must follow the eight sides, and bind the stones together with ties and by dove-tailing them, which will be something very difficult. But remembering that this is a temple consecrated to God and to the Virgin, I am confident, since this is being done in memory of her, that she will not fail to infuse knowledge where it is lacking, and to give strength, wisdom, and genius to him who is to be the author of such a work. But how can I help you in this matter, since the task is not mine? I tell you, indeed, that if the work fell to me, I would have resolution and courage enough to find the method whereby the vault might be raised without so many difficulties; but as yet I have given no thought to it, and you would have me tell you the method! And when at last your Lordships determine to have it raised, you will be forced not only to make trial of me, for I do not think myself able to be the sole adviser in so great a matter, but also to spend money and to ordain that within a year and on a fixed day many architects shall come to Florence, not merely Tuscans and Italians, but Germans, French, and of every other nation; and to propose this work to them, to the end that, after discussing and deciding among so many masters, it may be begun, being entrusted to him who shall give the most direct proof of ability or possess the best method and judgment for such an undertaking. Nor could I give you other counsel or a better plan than this.'

The plan and the counsel of Filippo pleased the Consuls and the Wardens of Works, but they would have liked him in the meanwhile to have made a model and to have given thought to the matter. But he showed that he cared nothing for it; nay, taking leave of them, he said that he had received letters soliciting him to return to Rome. Whereupon the Consuls, perceiving that their prayers and those of the Wardens did not avail to detain him, caused many of his friends to entreat him; but Filippo would not give way, and one morning (on May 26, 1417) the Wardens decreed him a present of money, which is found entered to the credit of Filippo in the books of the Office of Works; and all this was to conciliate him. But he, steadfast in his resolution, took his departure none the less from Florence and returned to Rome,

where he studied continuously for that undertaking, making arrangements and preparing himself for the completion of the work, thinking, as was true, that no other than himself could carry it out. And as for his counsel that new architects should be summoned, Filippo had advanced it for no other reason but that they might serve to prove the greatness of his own intellect, and not because he thought that they would be able to vault that tribune or to undertake such a charge, which was too difficult for them. And thus much time was consumed before those architects arrived from their countries, whom they had caused to be summoned from afar by means of orders given to Florentine merchants who dwelt in France, in Germany, in England, and in Spain, and who were commissioned to spend any sum of money, if only they could obtain the most experienced and able intellects that there were in those regions from the Princes of those countries, and send them to Florence.

By the year 1420, all these ultramontane masters were finally assembled in Florence, and likewise those of Tuscany and all the ingenious craftsmen of design in Florence; and so Filippo returned from Rome. They all assembled, therefore, in the Office of Works of S. Maria del Fiore, in the presence of the Consuls and of the Wardens, together with a select body of the most ingenious citizens, to the end that these might hear the mind of each master on the question and might decide on a method of vaulting this tribune. Having called them, then, into the audience, they heard the minds of all, one by one, and the plan that each architect had devised for that work. And a fine thing it was to hear their strange and diverse opinions about the matter, for the reason that some said that piers must be built up from the level of the ground, which should have the arches turned upon them and should uphold the wooden bridges for sustaining the weight; others said that it was best to make the cupola of sponge-stone, to the end that the weight might be less; and many were agreed that a pier should be built in the centre, and that the cupola should be raised in the shape of a pavilion, like that of S. Giovanni in Florence. Nor were there wanting men who said that it would have been a good thing to fill it with earth mingled with small coins, to the end that, when it had been raised, anyone who wanted some of that earth might be given leave to go and fetch it, and thus the people would carry it away in a moment without any expense. Filippo alone said that it could be raised without so much woodwork, without piers, without earth, without so great

expenditure on so many arches, and very easily without any framework.

It appeared to the Consuls, who were expecting to hear of some beautiful method, and to the Wardens of Works and to all those citizens, that Filippo had talked like a fool; and deriding him with mocking laughter, they turned away, bidding him talk of something else, seeing that this was the plan of a madman, as he was. Whereupon Filippo, feeling himself affronted, answered: 'My Lords, rest assured that it is not possible to raise the cupola in any other manner than this; and although you laugh at me, you will recognize, unless you mean to be obstinate, that it neither must nor can be done in any other way. And it is necessary, if you wish to erect it in the way that I have thought of, that it should be turned with the curve of a quarter-acute arch, and made double, one vault within, and the other without, in such wise that a man may be able to walk between the one and the other. And over the corners of the angles of the eight sides the fabric must be bound together through its thickness by dove-tailing the stones, and its sides, likewise, must be girt round with oaken ties. And it is necessary to think of the lights, the staircases, and the conduits whereby the rain-water may be able to run off; and not one of you has remembered that you must provide for the raising of scaffoldings within, when the mosaics come to be made, together with an infinite number of difficulties. But I, who see the vaulting raised, know that there is no other method and no other way of raising it than this that I am describing.' And growing heated as he spoke, the more he sought to expound his conception, to the end that they might understand it and believe in it, the greater grew their doubts about his proposal, so that they believed in him less and less, and held him to be an ass and a babbler. Whereupon, having been dismissed several times and finally refusing to go, he was carried away bodily from the audience by their servants, being thought to be wholly mad; and this affront was the reason that Filippo could afterwards say that he did not dare to pass through any part of the city, for fear lest someone might say: 'There goes that madman.'

The Consuls remained in the Audience Chamber all confused, both by the difficult methods of the original masters and by this last method of Filippo's, which they thought absurd, for it appeared to them that he would ruin the work in two ways: first, by making the vaulting double, which would have made it

enormous and unwieldy in weight; and secondly, by making it without a framework. On the other hand, Filippo, who had spent so many years in study in order to obtain the commission, knew not what to do and was often tempted to leave Florence. However, wishing to prevail, he was forced to arm himself with patience, having insight enough to know that the brains of the men of that city did not abide very firmly by any one resolution. Filippo could have shown a little model that he had in his possession, but he did not wish to show it, having recognized the small intelligence of the Consuls, the envy of the craftsmen, and the instability of the citizens, who favoured now one and now another, according as it pleased each man best; and I do not marvel at this, since every man in that city professes to know as much in these matters as the experienced masters know, although those who truly understand them are but few; and let this be said without offence to those who have the knowledge. What Filippo, therefore, had not been able to achieve before the tribunal, he began to effect with individuals, talking now to a Consul, now to a Warden, and likewise to many citizens; and showing them part of his design, he induced them to determine to allot this work either to him or to one of the foreigners. Wherefore the Consuls, the Wardens of Works, and those citizens, regaining courage, assembled together, and the architects disputed concerning this matter, but all were overcome and conquered by Filippo with many arguments; and here, so it is said, there arose the dispute about the egg, in the following manner. They would have liked Filippo to speak his mind in detail, and to show his model, as they had shown theirs; but this he refused to do, proposing instead to those masters, both the foreign and the native, that whosoever could make an egg stand upright on a flat piece of marble should build the cupola, since thus each man's intellect would be discerned. Taking an egg, therefore, all those masters sought to make it stand upright, but not one could find the way. Whereupon Filippo, being told to make it stand, took it graciously, and, giving one end of it a blow on the flat piece of marble, made it stand upright. The craftsmen protested that they could have done the same; but Filippo answered, laughing, that they could also have raised the cupola, if they had seen the model or the design. And so it was resolved that he should be commissioned to carry out this work, and he was told that he must give fuller information about it to the Consuls and the Wardens of Works.

Going to his house, therefore, he wrote down his mind on a sheet of paper as clearly as he was able, to give to the tribunal, in the following manner: 'Having considered the difficulties of this structure, Magnificent Lords Wardens, I find that it is in no way possible to raise the cupola perfectly round, seeing that the surface above, where the lantern is to go, would be so great that the laying of any weight thereupon would soon destroy it. Now it appears to me that those architects who have no regard for the durability of their structures, have no love of lasting memorials, and do not even know why they are made. Wherefore I have determined to turn the inner part of this vault in pointed sections, following the outer sides, and to give to these the proportion and the curve of the quarter-acute arch, for the reason that this curve, when turned, ever pushes upwards, so that, when it is loaded with the lantern, both will unite to make the vaulting durable. At the base it must be three braccia and three quarters in thickness, and it must rise pyramidically, narrowing from without, until it closes at the point where the lantern is to be; and at this junction the vaulting must be one braccio and a quarter in thickness. Then on the outer side there must be another vault, which must be two braccia and a half thick at the base, in order to protect the inner one from the rain. This one must also diminish pyramidically in due proportion, so that it may come together at the foot of the lantern, like the other, in such wise that at the summit it may be two-thirds of a braccio in thickness. At each angle there must be a buttress, making eight in all: and in the middle of every side there must be two buttresses, making sixteen in all: and between the said angles, on every side, both within and without, there must be two buttresses, each four braccia thick at the base. The two said vaults, built in the form of a pyramid, must rise together in equal proportion up to the height of the round window closed by the lantern. There must then be made twenty-four buttresses with the said vaults built round them, and six arches of grey-stone blocks, stout and long, and well braced with irons, which must be covered with tin; and over the said blocks there must be iron ties, binding the said vaulting to its buttresses. The first part of the masonry, up to the height of five braccia and a quarter, must be solid, leaving no vacant space, and then the buttresses must be continued and the two vaults separated. The first and second courses at the base must be strengthened throughout with long blocks of grey-stone laid horizontally across them, in

such wise that both vaults of the cupola may rest on the said blocks. At the height of every nine braccia in the said vaults there must be little arches between one buttress and another, with thick ties of oak, to bind together the said buttresses, which support the inner vault; and then the said ties of oak must be covered with plates of iron, for the sake of the staircases. The buttresses must be all built of grey-stone and hard-stone, and all the sides of the cupola must be likewise of hard-stone and bound with the buttresses up to the height of twenty-four braccia; and from there to the top the material must be brick, or rather, sponge-stone, according to the decision of the builder, who must make the work as light as he is able. A passage must be made on the outside above the windows, forming a gallery below, with an open parapet two braccia in height, proportionately to those of the little tribunes below; or rather, two passages, one above the other, resting on a richly adorned cornice, with the upper passage uncovered. The rain-water must flow from the cupola into a gutter of marble, a third of a braccio wide, and must run off through outlets made of hard-stone below the gutter. Eight ribs of marble must be made at the angles in the outer surface of the cupola, of such thickness as may be required, rising one braccio above the cupola, with a cornice above by way of roof, two braccia wide, to serve as gable and eaves to the whole; and these ribs must rise pyramidically from their base up to the summit. The two vaults of the cupola must be built in the manner described above, without framework, up to the height of thirty braccia, and from that point upwards in the manner recommended by those masters who will have the building of them, since practice teaches us what course to pursue.'

Filippo, having finished writing all that is above, went in the morning to the tribunal and gave them that paper, which they studied from end to end. And although they could not grasp it all, yet, seeing the readiness of Filippo's mind, and perceiving that not one of the other architects had better ground to stand on – for he showed a manifest confidence in his speech, ever repeating the same thing in such wise that it appeared certain that he had raised ten cupolas – the Consuls, drawing aside, were minded to give him the work, saying only that they would have liked to see something to show how this cupola could be raised without framework, for they approved of everything else. To this desire fortune was favourable, for Bartolommeo Barbadori having

previously resolved to have a chapel built in S. Felicita and having spoken of this to Filippo, the latter had put his hand to the work and had caused that chapel to be vaulted without framework, at the right hand of the entrance into the church, where the holy-water basin is, also made by his hand. In those days, likewise, he caused another to be vaulted beside the Chapel of the High Altar in S. Jacopo sopra Arno, for Stiatta Ridolfi; and these works were the means of bringing him more credit than his words. And so the Consuls and the Wardens of Works, being assured by the writing and by the work that they had seen, gave him the commission for the cupola, making him principal superintendent by the vote with the beans. But they did not contract with him for more than twelve braccia of the whole height, saying to him that they wished to see how the work succeeded, and that if it succeeded as well as he promised they would not fail to commission him to do the rest. It appeared a strange thing to Filippo to see so great obstinacy and distrust in the Consuls and Wardens, and, if it had not been that he knew himself to be the only man capable of executing the work, he would not have put his hand to it. However, desiring to gain the glory of its construction, he undertook it, and pledged himself to bring it to perfect completion. His written statement was copied into a book wherein the provveditore kept the accounts of the debtors and creditors for wood and marble, together with the aforesaid pledge; and they undertook to make him the same allowance of money as they had given up to then to the other superintendents.

The commission given to Filippo becoming known among the craftsmen and the citizens, some thought well of it and others ill, as it has ever been the case with the opinions of the populace, of the thoughtless, and of the envious. The while that the preparations for beginning to build were being made, a faction was formed among craftsmen and citizens, and they appeared before the Consuls and the Wardens, saying that there had been too much haste in the matter, and that such a work as this should not be carried out by the counsel of one man alone; that they might be pardoned for this if they had been suffering from a dearth of excellent masters, whereas they had them in abundance; and that it was not likely to do credit to the city, because, if some accident were to happen, as is wont to come to pass sometimes in buildings, they might be blamed, as persons who had laid too great a charge on one man, without considering the loss and the

shame that might result to the public interest; wherefore it would be well to give Filippo a companion, in order to restrain his rashness.

Now Lorenzo Ghiberti had come into great repute, by reason of having formerly given proof of his genius in the doors of S. Giovanni; and that he was beloved by certain men who were very powerful in the Government was proved clearly enough, since, seeing the glory of Filippo waxing so great, they wrought on the Consuls and the Wardens so strongly, under the pretext of love and affection towards that building, that he was united to Filippo as his colleague in the work. How great were the despair and the bitterness of Filippo, on hearing what the Wardens had done, may be seen from this, that he was minded to fly from Florence; and if it had not been for Donato and Luca della Robbia, who comforted him, he would have lost his reason. Truly impious and cruel is the rage of those who, blinded by envy, put into peril the honours and the beautiful works of others in their jealous emulation! It was no fault of theirs, in truth, that Filippo did not break his models into pieces, burn his designs, and throw away in less than half an hour all that labour which had occupied him for so many years. The Wardens at first made excuses to Filippo and exhorted him to proceed, saying that he himself and no other was the inventor and the creator of so noble a building; but at the same time they gave the same salary to Lorenzo as to Filippo. The work was pursued with little willingness on the part of Filippo, who saw that he must endure the labours that it entailed, and must then divide the honour and the fame equally with Lorenzo. Making up his mind, however, that he would find means to prevent Lorenzo from continuing very long in the work, he went on pursuing it in company with him, in the manner suggested by the writing given to the Wardens. Meanwhile, there arose in the mind of Filippo the idea of making such a model as had not yet been made; wherefore, having put his hand to this, he had it wrought by one Bartolommeo, a carpenter, who lived near the Studio. In this model, which had all the exact proportions measured to scale, he made all the difficult parts, such as staircases both lighted and dark, and every sort of window, door, tie, and buttress, together with a part of the gallery. Lorenzo, hearing of this, wished to see it, but Filippo refused to let him, whereupon he flew into a rage and ordered another model to be made for himself, to the end that he might not

appear to be drawing his salary for nothing and to be of no account in the work. With regard to these models, Filippo was paid fifty lire and fifteen soldi for his, as we see from an order in the book of Migliore di Tommaso, dated October 3, 1419, whereas three hundred lire are entered as paid to Lorenzo Ghiberti for the labour and expense of his model, more in consequence of the friendship and favour that he enjoyed than of any profit or need that the building had of it.

This torment lasted before the eyes of Filippo until 1426, the friends of Lorenzo calling him the inventor equally with Filippo; and this annoyance disturbed the mind of Filippo so greatly that he was living in the utmost restlessness. Now, having thought of various new devices, he determined to rid himself entirely of Lorenzo, recognizing that he was of little account in the work. Filippo had already raised the cupola right round, what with the one vault and the other, to the height of twelve braccia, and he had now to place upon them the ties both of stone and of wood; and as this was a difficult matter, he wished to discuss it with Lorenzo, in order to see if he had considered this difficulty. And he found Lorenzo so far from having thought of such a matter, that he replied that he referred it to Filippo as the inventor. Lorenzo's answer pleased Filippo, since it appeared to him that this was the way to get him removed from the work, and to prove that he did not possess that intelligence which was claimed for him by his friends, and to expose the favour that had placed him in that position. Now the masons engaged on the work were at a standstill, waiting to be told to begin the part above the twelve braccia, and to make the vaults and bind them with ties. Having begun the drawing in of the cupola towards the top, it was necessary for them to make the scaffoldings, to the end that the masons and their labourers might be able to work without danger, seeing that the height was such that merely looking down brought fear and terror into the stoutest heart. The masons and the other master-builders were standing waiting for directions as to the ties and the scaffoldings; and since no decision was made either by Lorenzo or by Filippo, there arose a murmuring among the masons and the other master-builders, who saw no signs of the solicitude that had been shown before; and because, being poor people, they lived by the work of their hands, and suspected that neither one nor the other of the architects had enough courage to carry the work any further, they went about the building

occupying themselves, to the best of their knowledge and power, with filling up and finishing all that had as yet been built.

One morning Filippo did not appear at the work, but bound up his head and went to bed, and caused plates and cloths to be heated with great solicitude, groaning continually and pretending to be suffering from colic. The master-builders, who were standing waiting for orders as to what they were to do, on hearing this, asked Lorenzo what they were to go on with: but he replied that it was for Filippo to give orders, and that they must wait for him. There was one who said, 'What, dost thou not know his mind?' 'Yes,' answered Lorenzo, 'but I would do nothing without him'; and this he said to excuse himself, because, not having seen the model of Filippo, and having never asked him what method he intended to follow, he would never commit himself in talking of the matter, in order not to appear ignorant, and would always make a double-edged answer, the more so as he knew that he was employed in the work against the will of Filippo. The illness of the latter having already lasted for more than two days, the provveditore and many of the master-masons went to see him and asked him repeatedly to tell them what they were to do. And he replied, 'You have Lorenzo, let him do something'; nor could they get another word out of him. Whereupon, this becoming known, there arose discussions and very adverse judgments with regard to the work: some saying that Filippo had gone to bed in his vexation at finding that he had not the courage to raise the cupola, and that he was repenting of having meddled with the matter; while his friends defended him, saying that his anger, if anger it was, came from the outrage of having been given Lorenzo as colleague, but that his real trouble was colic, caused by fatiguing himself overmuch at the work. Now, while this noise was going on, the building was at a standstill, and almost all the work of the masons and stone-cutters was suspended; and they murmured against Lorenzo, saying, 'He is good enough at drawing the salary, but as for directing the work, not a bit of it! If we had not Filippo, or if he were ill for long, what would the other do? Is it Filippo's fault that he is ill?' The Wardens of Works, seeing themselves disgraced by this state of things, determined to go and find Filippo; and after arriving and sympathizing with him first about his illness, they told him in how great confusion the building stood and what troubles his illness had brought upon them. Whereupon Filippo, speaking with great heat both under

the cloak of illness and from love of the work, replied, 'Is not that Lorenzo there? Can he do nothing? And I marvel at you as well.' Then the Wardens answered, 'He will do naught without thee'; and Filippo retorted, 'But I could do well without him.' This retort, so acute and double-edged, was enough for them, and they went their way, convinced that Filippo was ill from nothing but the desire to work alone. They sent his friends, therefore, to get him out of bed, with the intention of removing Lorenzo from the work. Wherefore Filippo returned to the building, but, seeing that Lorenzo was still strongly favoured and that he would have his salary without any labour whatsoever, he thought of another method whereby he might disgrace him and demonstrate conclusively his little knowledge in that profession; and he made the following discourse to the Wardens in the presence of Lorenzo: 'My Lords the Wardens of Works, if the time that is lent to us to live were as surely ours as the certainty of dying, there is no doubt whatsoever that many things which are begun would be completed instead of remaining unfinished. The accident of this sickness from which I have suffered might have cut short my life and put a stop to the work; wherefore I have thought of a plan whereby, if I should ever fall sick again, or Lorenzo, which God forbid, one or the other may be able to pursue his part of the work. Even as your Lordships have divided the salary between us, let the work also be divided, to the end that each of us, being spurred to show his knowledge, may be confident of acquiring honour and profit from our Republic. Now there are two most difficult things which have to be put into execution at the present time: one is the making of the scaffoldings to enable the masons to do their work, which have to be used both within and without the building, where they must support men, stones, and lime, and sustain the crane for lifting weights, with other instruments of that kind; the other is the chain of ties which has to be placed above the twelve braccia, surrounding and binding together the eight sides of the cupola, and clamping the fabric together, so that it may bind and secure all the weight that is laid above, in such a manner that the weight may not force it out or stretch it, and that the whole structure may rest firmly on its own basis. Let Lorenzo, then, take one of these two works, whichever he may think himself best able to execute; and I will undertake to accomplish the other without difficulty, to the end that no more time may be lost.'

Hearing this, Lorenzo was forced for the sake of his honour to accept one of these tasks, and, although he did it very unwillingly, he resolved to take the chain of ties, as being the easier, relying on the advice of the masons and on the remembrance that in the vaulting of S. Giovanni in Florence there was a chain of stone ties, wherefrom he might take a part of the design, if not the whole. And so one put his hand to the scaffoldings and the other to the ties, and each carried out his work. The scaffoldings of Filippo were made with so great ingenuity and industry, that the very opposite opinion was held in this matter to that which many had previously conceived, for the builders stood on them, working and drawing up weights, as securely as if they had been on the surface of the ground; and the models of the said scaffoldings were preserved in the Office of Works. Lorenzo had the chain of ties made on one of the eight sides with the greatest difficulty; and when it was finished, the Wardens caused Filippo to look at it. To them he said nothing, but he discoursed thereon with some of his friends, saying that it was necessary to have some form of fastening different from that one, and to apply it in a better manner than had been done, and that it was not strong enough to withstand the weight that was to be laid above, for it did not bind the masonry together firmly enough; adding that the supplies given to Lorenzo, as well as the chain that he had caused to be made, had been simply thrown away. The opinion of Filippo became known, and he was charged to show what was the best way of making such a chain. Whereupon, having already made designs and models, he immediately showed them, and when they had been seen by the Wardens and the other masters, it was recognized into what great error they had fallen by favouring Lorenzo; and wishing to atone for this error and to show that they knew what was good, they made Filippo overseer and superintendent of the whole fabric for life, saying that nothing should be done in that work without his command. And as a proof of approbation they gave him one hundred florins, decreed by the Consuls and Wardens under date of August 13, 1423, by the hand of Lorenzo Paoli, notary to the Office of Works, and under the name of Gherardo di Messer Filippo Corsini; and they voted him an allowance of one hundred florins a year as a provision for life. Wherefore, giving orders for the building to be pushed on, he pursued it with such scrupulous care and so great attention, that not a stone could be put into place without his having wished to

see it. Lorenzo, on the other hand, finding himself vanquished, and, as it were, put to shame, was favoured and assisted by his friends so powerfully that he went on drawing his salary, claiming that he could not be dismissed until three years had passed.

Filippo was for ever making, on the slightest occasion, designs and models of stages for the builders and of machines for lifting weights. But this did not prevent certain malicious persons, friends of Lorenzo, from putting Filippo into despair by spending their whole time in making models in opposition to his, insomuch that some were made by one Maestro Antonio da Verzelli and other favoured masters, and were brought into notice now by one citizen and now by another, demonstrating their inconstancy, their little knowledge, and their even smaller understanding, since, having perfection in their grasp, they brought forward the imperfect and the useless.

The ties were now finished right round the eight sides, and the masons, being encouraged, were labouring valiantly; but being pressed more than usual by Filippo, and resenting certain reprimands received with regard to the building and other things that were happening every day, they had conceived a grievance against him. Wherefore, moved by this and by envy, the foremen leagued themselves together into a faction and declared that the work was laborious and dangerous, and that they would not build the cupola without great payment – although their pay had been raised higher than usual – thinking in this way to take vengeance on Filippo and to gain profit for themselves. This affair displeased the Wardens and also Filippo, who, having pondered over it, made up his mind one Saturday evening to dismiss them all. They, seeing themselves dismissed and not knowing how the matter would end, were very evilly disposed; but on the following Monday Filippo set ten Lombards to work, and by standing ever over them and saying, 'Do this here,' and, 'Do that there,' he taught them so much in one day that they worked there for many weeks. The masons, on the other hand, seeing themselves dismissed, deprived of their work, and thus disgraced, and having no work as profitable as this, sent mediators to Filippo, saying that they would willingly return, and recommending themselves to him as much as they were able. Filippo kept them for many days in suspense as to his willingness to take them back; then he reinstated them at lower wages than they had before; and thus

where they thought to gain they lost, and in taking vengeance on Filippo they brought harm and disgrace on themselves.

The murmurings were now silenced, and meanwhile, on seeing that building being raised so readily, men had come to recognize the genius of Filippo; and it was already held by those who were not prejudiced that he had shown such courage as perchance no ancient or modern architect had shown in his works. This came to pass because he brought out his model, wherein all could see how much thought he had given to the planning of the staircases and of the lights both within and without, in order that no one might be injured in the darkness by reason of fear, and how many diverse balusters of iron he had placed where the ascent was steep, for the staircases, arranging them with much consideration. Besides this, he had even thought of the irons for fixing scaffoldings within, in case mosaics or paintings had ever to be wrought there; and in like manner, by placing the different kinds of water-conduits, some covered and some uncovered, in the least dangerous positions, and by duly accompanying these with holes and diverse apertures, to the end that the force of the winds might be broken and that neither exhalations nor the tremblings of the earth might be able to do any harm, he showed how great assistance he had received from his studies during the many years that he stayed in Rome. And in addition, when men considered what he had done in the way of dove-tailing, joining, fixing, and binding together the stones, it made them marvel and tremble to think that one single mind should have been capable of all that the mind of Filippo had proved itself able to execute. So greatly did his powers continue to increase that there was nothing, however difficult and formidable, that he did not render easy and simple; and this he showed in the lifting of weights by means of counterweights and wheels, so that one ox could raise what six pairs could scarcely have raised before.

The building had now risen to such a height that it was a very great inconvenience for anyone who had climbed to the top to descend to the ground, and the builders lost much time in going to eat and drink, and suffered great discomfort in the heat of the day. Filippo therefore made arrangements for eating-houses with kitchens to be opened on the cupola, and for wine to be sold there, so that no one had to leave his labour until the evening, which was convenient for the men and very advantageous for the

work. Seeing the work making great progress and succeeding so happily, Filippo had grown so greatly in courage that he was continually labouring, going in person to the furnaces where the bricks were being shaped and demanding to see the clay and to feel its consistency, and insisting on selecting them with his own hand when baked, with the greatest diligence. When the stone-cutters were working at the stones, he would look at them to see if they showed flaws and if they were hard, and he would give the men models in wood or wax, or* made simply out of turnips; and he would also make iron tools for the smiths. He invented hinges with heads, and hinge-hooks, and he did much to facilitate architecture, which was certainly brought by him to a perfection such as it probably had never enjoyed among the Tuscans.

In the year 1423 the greatest possible happiness and rejoicing were prevailing in Florence, when Filippo was chosen as one of the Signori for the quarter of San Giovanni, for May and June, Lapo Niccolini being chosen as Gonfalonier of Justice for the quarter of Santa Croce. And if he is found registered in the Priorista as 'Filippo di Ser Brunellesco Lippi,' no one need marvel, seeing that he was called thus after his grandfather Lippo, and not 'de' Lapi,' as he should have been; which method is seen from the said Priorista to have been used in innumerable other cases, as is well known to all who have seen it or who know the custom of those times. Filippo exercised that office and also other magisterial functions that he obtained in his city, wherein he ever bore himself with most profound judgment.

Seeing that the two vaults were beginning to close in on the round window where the lantern was to rise, it now remained to Filippo (who had made many models of clay and of wood for both the one and the other in Rome and in Florence, without showing them) to make up his mind finally which of these he would put into execution. Wherefore, having determined to finish the gallery, he made diverse designs, which remained after his death in the Office of Works; but they have since been lost by reason of the negligence of those officials. In our own day, to the end that the whole might be completed, a part of it was made on one of the eight sides, but by the advice of Michelagnolo Buonarroti it was abandoned and not carried further, because it

* To make this passage intelligible, the word 'or' has been added in the later editions.

clashed with the original plan. Filippo also made with his own hand a model for the lantern; this was octagonal, with proportions in harmony with those of the cupola, and it turned out very beautiful in invention, variety, and adornment. He made therein the staircase for ascending to the ball, which was something divine, but, since Filippo had stopped up the entrance with a piece of wood let in below, no one save himself knew of this staircase. And although he was praised and had now overcome the envy and the arrogance of many, he could not prevent all the other masters who were in Florence from setting themselves, at the sight of this model, to make other in various fashions, and finally a lady of the house of Gaddi had the courage to compete with the one made by Filippo. But he, meanwhile, kept laughing at their presumption, and when many of his friends told him that he should not show his model to any craftsmen, lest they should learn from it, he would answer that there was but one true model and that the others were of no account. Some of the other masters had used some of the parts of Filippo's model for their own, and Filippo, on seeing these, would say, 'The next model that this man makes will be my very own.' Filippo's model was infinitely praised by all; only, not seeing therein the staircase for ascending to the ball, they complained that it was defective. The Wardens determined, none the less, to give him the commission for the said work, but on the condition that he should show them the staircase. Whereupon Filippo, removing the small piece of wood that there was at the foot of the model, showed in a pilaster the staircase that is seen at the present day, in the form of a hollow blow-pipe, having on one side a groove with rungs of bronze, whereby one ascends to the top, putting one foot after another. And because he could not live long enough, by reason of his old age, to see the lantern finished, he left orders in his testament that it should be built as it stood in the model and as he had directed in writing; protesting that otherwise the structure would collapse, since it was turned with the quarter-acute arch, so that it was necessary to burden it with this weight in order to make it stronger. He was not able to see this edifice finished before his death, but he raised it to the height of several braccia, and caused almost all the marbles that were going into it to be well wrought and prepared; and the people, on seeing them prepared, were amazed that it should be possible for him to propose to lay so great a weight on that vaulting. It was the opinion of many

ingenious men that it would not bear the weight, and it appeared to them great good-fortune that he had carried it so far, and a tempting of Providence to burden it so heavily. Filippo, ever laughing to himself, and having prepared all the machines and all the instruments that were to be used in building it, spent all his time and thought in foreseeing, anticipating, and providing for every detail, even to the point of guarding against the chipping of the dressed marbles as they were drawn up, insomuch that the arches of the tabernacles were built with wooden protections; while for the rest, as it has been said, there were written directions and models.

How beautiful is this building it demonstrates by itself. From the level of the ground to the base of the lantern it is one hundred and fifty-four braccia in height; the body of the lantern is thirty-six braccia; the copper ball, four braccia; the cross, eight braccia; and the whole is two hundred and two braccia. And it can be said with confidence that the ancients never went so high with their buildings, and never exposed themselves to so great a risk as to try to challenge the heavens, even as this structure truly appears to challenge them, seeing that it rises to such a height that the mountains round Florence appear no higher. And it seems, in truth, that the heavens are envious of it, since the lightning keeps on striking it every day. The while that this work was in progress, Filippo made many other buildings, which we will enumerate below in their order.

With his own hand he made the model of the Chapter-house of S. Croce in Florence, a varied and very beautiful work, for the family of the Pazzi; and the model of the house of the Busini, for the habitation of two families; and also the model of the house and loggia of the Innocenti, the vaulting of which was executed without framework, a method that is still followed by all in our own day. It is said that Filippo was summoned to Milan in order to make the model of a fortress for Duke Filippo Maria, and that he left this building of the Innocenti in charge of Francesco della Luna, who was very much his friend. This Francesco made an architrave-ornament running downward from above, which is wrong according to the rules of architecture. Wherefore Filippo, on returning, reproved him for having done such a thing, and he answered that he copied it from the Church of S. Giovanni, which is ancient. 'There is one sole error,' said Filippo, 'in that edifice, and thou hast followed it.' The model of

this building, by the hand of Filippo, was for many years in the hands of the Guild of Por Santa Maria, being held in great account because a part of the fabric was still unfinished; but it is now lost. He made the model of the Abbey of the Canons-Regular of Fiesole, for Cosimo de' Medici, the architecture being ornate, commodious, fanciful, and, in short, truly magnificent. The church is lofty, with the vaulting barrel-shaped, and the sacristy, like all the rest of the monastery, has its proper conveniences. But what is most important and most worthy of consideration is that, having to place that edifice on the downward slope of that mountain and yet on the level, he availed himself of the part below with great judgment, making therein cellars, wash-houses, bread-ovens, stables, kitchens, rooms for storing firewood, and so many other conveniences, that it is not possible to see anything better; and thus he laid the base of the edifice on the level. Wherefore he was afterwards able to make the loggie, the refectory, the infirmary, the noviciate, the dormitory, and the library, with the other principal rooms proper to a monastery, on one plane. All this was carried out by the Magnificent Cosimo de' Medici at his own expense, partly through the piety that he showed in all matters in connection with the Christian faith, and partly through the affection that he bore to Don Timoteo da Verona, a most excellent preacher of that Order, whose conversation he was so anxious to enjoy that he also built many rooms for himself in that monastery and lived there at his own convenience. On this edifice Cosimo spent one hundred thousand crowns, as may be seen in an inscription. Filippo also designed the model for the fortress of Vico Pisano; and he designed the old Citadel of Pisa, and fortified the Ponte a Mare, and also gave the design for the new Citadel, closing the bridge with the two towers. In like manner, he made the model for the fortress of the port of Pesaro. Returning to Milan, he made many designs for the Duke, and some for the masters of the Duomo of that city.

The Church of S. Lorenzo had been begun in Florence at this time by order of the people of that quarter, who had made the Prior superintendent of that building. This person made profession of much knowledge in architecture, and was ever amusing himself therewith by way of pastime. And they had already begun the building by making piers of brick, when Giovanni di Bicci de' Medici, who had promised the people of that quarter and the Prior to have the sacristy and a chapel made at his own expense,

invited Filippo one morning to dine with him, and after much discourse asked him what he thought of the beginning of S. Lorenzo. Filippo was constrained by the entreaties of Giovanni to say what he thought, and being compelled to speak the truth, he criticized it in many respects, as something designed by a person who had perchance more learning than experience of buildings of that sort. Whereupon Giovanni asked Filippo if something better and more beautiful could be made: to which Filippo replied, 'Without a doubt, and I marvel that you, being the chief in the enterprise, do not devote a few thousand crowns to building a body of a church with all its parts worthy of the place and of so many noble owners of tombs, who, seeing it begun, will proceed with their chapels to the best of their power; above all, because there remains no memorial of us save walls, which bear testimony for hundreds and thousands of years to those who built them.' Giovanni, encouraged by the words of Filippo, determined to build the sacristy and the principal chapel, together with the whole body of the church, although only seven families were willing to co-operate, since the others had not the means: these seven were the Rondinelli, Ginori, Dalla Stufa, Neroni, Ciai, Marignolli, Martelli, and Marco di Luca, and these chapels were to be made in the cross. The sacristy was the first part to be undertaken, and afterwards the church, little by little. The other chapels along the length of the church came to be granted afterwards, one by one, to other citizens of the quarter. The roofing of the sacristy was not finished when Giovanni de' Medici passed to the other life, leaving behind him his son Cosimo, who, having a greater spirit than his father and delighting in memorials, caused this one to be carried on. It was the first edifice that he erected, and he took so great delight therein that from that time onwards up to his death he was for ever building. Cosimo pressed this work forward with greater ardour, and while one part was being begun, he would have another finished. Looking on the work as a pastime, he was almost always there, and it was his solicitude that caused Filippo to finish the sacristy, and Donato to make the stucco-work, with the stone ornaments for those little doors and the doors of bronze. In the middle of the sacristy, where the priests don their vestments, he had a tomb made for his father Giovanni, under a great slab of marble supported by four little columns; and in the same place he made a tomb for his own family, separating that of the women from

that of the men. In one of the two little rooms that are on either side of the altar in the said sacristy he made a well in one corner, with a place for a lavatory. In short, everything in this fabric is seen to have been built with much judgment. Giovanni and the others had arranged to make the choir in the middle, below the tribune; but Cosimo changed this at the wish of Filippo, who made the principal chapel – which had been designed at first as a smaller recess – so much greater, that he was able to make the choir therein, as it is at present. This being finished, there remained to be made the central tribune and the rest of the church; but this tribune, with the rest, was not vaulted until after the death of Filippo. This church is one hundred and forty-four braccia in length, and many errors are seen therein, one being that the columns are placed on the level of the ground instead of being raised on a dado, which should have been as high as the level of the bases of the pilasters which stand on the steps, so that, as one sees the pilasters shorter than the columns, the whole of that work appears badly proportioned. All this was caused by the counsels of his successors, who were jealous of his name and had made models in opposition to his during his lifetime. For these they had been put to shame with sonnets written by Filippo, and after his death they took vengeance on him in this manner, not only in this work but in all those that remained to be carried out by them. He left the model for the presbytery of the priests of S. Lorenzo, and part of the building finished, wherein he made the cloister one hundred and forty-four braccia in length.

The while that this edifice was building, Cosimo de' Medici determined to have a palace made for himself, and therefore revealed his intention to Filippo, who, putting aside every other care, made him a great and very beautiful model for the said palace, which he wished to place opposite to S. Lorenzo, on the Piazza, entirely isolated on every side. In this the art of Filippo had achieved so much that Cosimo, thinking it too sumptuous and great a fabric, refrained from putting it into execution, more to avoid envy than by reason of the cost. While the model was making, Filippo used to say that he thanked his fortune for such an opportunity, seeing that he had such a house to build as he had desired for many years, and because he had come across a man who had the wish and the means to have it built. But, on learning afterwards the determination of Cosimo not to put this project into execution, in disdain he broke the design into a

thousand pieces. Deeply did Cosimo repent, after he had made that other palace, that he had not adopted the design of Filippo; and this Cosimo was wont to say that he had never spoken to a man of greater intelligence and spirit than Filippo. He also made the model of the most bizarre Temple of the Angeli, for the family of the Scolari; but it remained unfinished and in the condition wherein it is now to be seen, because the Florentines spent the money which lay in the Monte for this purpose on certain requirements of their city, or, as some say, in the war that they waged formerly against the people of Lucca, wherein they also spent the money that had been left in like manner by Niccolò da Uzzano for building the Sapienza, as it has been related at length in another place. And in truth, if this Temple of the Angeli had been finished according to the model of Brunellesco, it would have been one of the rarest things in Italy, for the reason that what is seen of it cannot be sufficiently extolled. The drawings by the hand of Filippo for the ground-plan and for the completion of this octagonal temple are in our book, with other designs by the same man.

Filippo also designed a rich and magnificent palace for Messer Luca Pitti at a place called Ruciano, without the Porta a San Niccolò in Florence, but this failed by a great measure to equal the one that he began in Florence for the same man, carrying it to the second range of windows, with such grandeur and magnificence that nothing more rare or more magnificent has yet been seen in the Tuscan manner. The doors of this palace are double, with the opening sixteen braccia in length and eight in breadth; the windows both of the first and second range are in every way similar to these doors, and the vaultings double; and the whole edifice is so masterly in design, that any more beautiful or more magnificent architecture cannot be imagined. The builder of this palace was Luca Fancelli, an architect of Florence, who erected many buildings for Filippo, and one for Leon Batista Alberti, namely, the principal chapel of the Nunziata in Florence, by order of Lodovico Gonzaga, who took him to Mantua, where he made many works and married a wife and lived and died, leaving heirs who are still called the Luchi from his name. This palace was bought not many years ago by the most Illustrious Lady Leonora di Toledo, Duchess of Florence, on the advice of the most Illustrious Lord Duke Cosimo, her consort; and she increased the grounds all round it so greatly that she made a very

large garden, partly on the plain, partly on the top of the hill, and partly on the slope, filling it with all the sorts of trees both of the garden and of the forest, most beautifully laid out, and making most delightful little groves with innumerable sorts of evergreens, which flourish in every season; to say nothing of the waters, the fountains, the conduits, the fishponds, the fowling-places, the espaliers, and an infinity of other things worthy of a magnanimous prince, about which I will be silent, because it is not possible, without seeing them, ever to imagine their grandeur and their beauty. And in truth Duke Cosimo could have chanced upon nothing more worthy of the power and greatness of his mind than this palace, which might truly appear to have been erected by Messer Luca Pitti, from the design of Brunellesco, for his most Illustrious Excellency. Messer Luca left it unfinished by reason of his cares in connection with the State, and his heirs, having no means wherewith to complete it, and being unwilling to let it go to ruin, were content to make it over to the Duchess, who was ever spending money on it as long as she lived, but not so much as to give hope that it would be soon finished. It is true, indeed, according to what I once heard, that she was minded to spend 40,000 ducats in one year alone, if she lived, in order to see it, if not finished, at least well on the way to completion. And because the model of Filippo has not been found, his Excellency has caused Bartolommeo Ammanati, an excellent sculptor and architect, to make another, according to which the work is being carried on; and a great part of the courtyard is already completed in rustic work, similar to the exterior. And in truth, if one considers the grandeur of this work, one marvels how the mind of Filippo could conceive so great an edifice, which is truly magnificent not only in the external façade, but also in the distribution of all the apartments. I say nothing of the view, which is most beautiful, and of the kind of theatre formed by the most lovely hills that rise round the palace in the direction of the walls, because, as I have said, it would take too long to try to describe them in full, nor could anyone, without seeing this palace, imagine how greatly superior it is to any other royal edifice whatsoever.

It is also said that the machinery for the 'Paradise' of S. Felice in Piazza, in the said city, was invented by Filippo in order to hold the Representation, or rather, the Festival of the Annunciation, in the manner wherein the Florentines were wont to hold

it in that place in olden times. This was truly something marvellous, demonstrating the genius and the industry of him who was its inventor, for the reason that there was seen on high a Heaven full of living figures in motion, with an infinity of lights appearing and disappearing almost in a flash. Now I do not wish to grudge the labour of giving an exact description of the machinery of that engine, seeing that it has all disappeared and that the men who could speak of it from personal knowledge are dead, so that there is no hope of its being reconstructed, that place being inhabited no longer by the Monks of Camaldoli, but by the Nuns of S. Pier Martire; and above all since the one in the Carmine has been destroyed, because it was pulling down the rafters that support the roof.

For this purpose, then, Filippo had suspended, between two of the beams that supported the roof of the church, the half of a globe in the shape of an empty bowl, or rather, of a barber's basin, with the rim downwards; this half-globe was made of thin and light planks fastened to a star of iron which radiated round the curve of the said half-globe, and these planks narrowed towards the point of equilibrium in the centre, where there was a great ring of iron round which there radiated the iron star that secured the planks of the half-globe. The whole mass was upheld by a stout beam of pine-wood, well shod with iron, which lay across the timbers of the roof; and to this beam was fastened the ring that sustained and balanced the half-globe, which from the ground truly appeared like a Heaven. At the foot of the inner edge it had certain wooden brackets, large enough for one person to stand on and no more, and at the height of one braccio there was also an iron fastening, likewise on the inner edge; on each of these brackets there was placed a boy about twelve years old, who was girt round with the iron fastening one braccio and a half high, in such wise that he could not have fallen down even if he had wanted to. These boys, who were twelve in all, were placed on the brackets, as it has been said, and dressed like angels, with gilded wings and hair made of gold thread; and when it was time they took one another by the hand and waved their arms, so that they appeared to be dancing, and the rather as the half-globe was ever moving and turning round. Within it, above the heads of the angels, were three circles or garlands of lights, contained in certain little lamps that could not be overturned. From the ground these lights appeared like stars, and the brackets, being

covered with cotton-wool, appeared like clouds. From the afore-
said ring there issued a very stout bar of iron, which had at the
end another ring, to which there was fastened a thin rope reaching
to the ground, as it will be told later. The said stout bar of iron
had eight arms, spreading out in an arc large enough to fill the
space within the hollow half-globe, and at the end of each arm
there was a stand about the size of a trencher; on each stand was
a boy about nine years old, well secured by an iron soldered on
to the upper part of the arm, but loosely enough to allow him to
turn in every direction. These eight angels, supported by the said
iron, were lowered from the space within the half-globe by means
of a small windlass that was unwound little by little, to a depth
of eight braccia below the level of the square beams that support
the roof, in such a manner that they were seen without conceal-
ing the view of the angels who were round the inner edge of the
half-globe. In the midst of this cluster of eight angels – for so
was it rightly called – was a mandorla of copper, hollow within,
wherein were many holes showing certain little lamps fixed on
iron bars in the form of tubes; which lamps, on the touching of
a spring which could be pressed down, were all hidden within the
mandorla of copper, whereas, when the spring was not pressed
down, all the lamps could be seen alight through some holes
therein. When the cluster of angels had reached its place, this
mandorla, which was fastened to the aforesaid little rope, was
lowered very gradually by the unwinding of the rope with another
little windlass, and arrived at the platform where the Rep-
resentation took place; and on this platform, precisely on the spot
where the mandorla was to rest, there was a raised place in the
shape of a throne with four steps, in the centre of which there
was a hole wherein the iron point of the mandorla stood upright.
Below the said throne was a man who, when the mandorla had
reached its place, made it fast with a bolt without being seen, so
that it stood firmly on its base. Within the mandorla was a youth
about fifteen years of age in the guise of an angel, girt round the
middle with an iron, and secured by a bolt to the foot of the
mandorla in a manner that he could not fall; and to the end that
he might be able to kneel, the said iron was divided into
three parts, whereof one part entered readily into another as he
knelt. Thus, when the cluster of angels had descended and the
mandorla was resting on the throne, the man who fixed
the mandorla with the bolt also unbolted the iron that supported

the angel; whereupon he issued forth and walked across the platform, and, having come to where the Virgin was, saluted her and made the Annunciation. He then returned into the mandorla, and the lights, which had gone out on his issuing forth, being rekindled, the iron that supported him was once more bolted by the man who was concealed below, the bolt that held the mandorla firm was removed, and it was drawn up again; while the singing of the angels in the cluster, and of those in the Heaven, who kept circling round, made it appear truly a Paradise, and the rather because, in addition to the said choir of angels and to the cluster, there was a God the Father on the outer edge of the globe, surrounded by angels similar to those named above and supported by irons, in such wise that the Heaven, the God the Father, the cluster, and the mandorla, with innumerable lights and very sweet music, truly represented Paradise. In addition to this, in order to be able to open and close that Heaven, Filippo had made two great doors, each five braccia both in length and breadth, which had rollers of iron, or rather, of copper, in certain grooves running horizontally; and these grooves were oiled in a manner that when a thin rope, which was on either side, was pulled by means of a little windlass, any one could open or close the Heaven at his pleasure, the two parts of the door coming together or drawing apart horizontally along the grooves. And these two doors, made thus, served for two purposes: when they were moved, being heavy, they made a noise like thunder; and when they were closed, they formed a platform for the apparelling of the angels and for the making of the other preparations which it was necessary to carry out within. These engines, made thus, together with many others, were invented by Filippo, although others maintain that they had been invented long before. However this may be, it was well to speak of them, seeing that they have gone completely out of use.

But to return to Filippo himself; his renown and his name had grown so great that he was sent for from far distant places by all who wished to erect buildings, in their desire to have designs and models by the hand of so great a man; and to this end the most powerful means and friendships were employed. Wherefore the Marquis of Mantua, among others, desiring to have him, wrote with great insistence to the Signoria of Florence, by whom he was sent to that city, where he gave designs for dykes on the Po and certain other works according to the pleasure of that Prince, who

treated him very lovingly, being wont to say that Florence was as worthy to have Filippo as a citizen as he was to have so noble and beautiful a city for his birthplace. In Pisa, likewise, Count Francesco Sforza and Niccolò da Pisa, being surpassed by him in the making of certain fortifications, commended him in his presence, saying that if every State possessed a man like Filippo it would be possible to live in security without arms. In Florence, also, Filippo gave the design for the house of the Barbadori, near the tower of the Rossi in the Borgo San Jacopo, but it was not put into execution; and he also made the design for the house of the Giuntini on the Piazza d' Ognissanti, on the Arno. Afterwards, the Captains of the Guelph party in Florence, wishing to build an edifice containing a hall and an audience-chamber for that body, gave the commission to Francesco della Luna, who began the work, and he had already raised it to the height of ten braccia above the ground, making many errors therein, when it was put into the hands of Filippo, who brought the said palace to that magnificent form which we see. In this work he had to compete with the said Francesco, who was favoured by many. Even so did he spend his whole life, competing now with one man and now with another; for many were ever making war against him and harassing him, and very often seeking to gain honour for themselves with his designs, so that he was reduced in the end to showing nothing and trusting no one. The hall of this palace is no longer used by the said Captains of the Guelphs, because the flood of the year 1557 did so great damage to the papers of the Monte, that the Lord Duke Cosimo, for the greater security of the said papers, which are of the greatest importance, removed them to the said hall together with the institution itself. And to the end that the old staircase of this palace might serve for the said body of Captains – who gave up that hall in favour of the Monte and retired to another part of that palace – Giorgio Vasari was commissioned by his Excellency to make the very commodious staircase that now ascends to the said hall of the Monte. In like manner, from a design by the same man there was made a coffer-work ceiling which was placed, after the plans of Filippo, on certain fluted pillars of grey-stone.

One year the Lenten sermons in S. Spirito had been preached by Maestro Francesco Zoppo, who was then very dear to the people of Florence, and he had strongly recommended the claims of that convent, of the school for youths, and particularly of the

church, which had been burnt down about that time. Whereupon
the chief men of that quarter, Lorenzo Ridolfi, Bartolommeo
Corbinelli, Neri di Gino Capponi, and Goro di Stagio Dati, with
very many other citizens, obtained an order from the Signoria for
the rebuilding of the Church of S. Spirito, and made Stoldo Fres-
cobaldi provveditore. This man, by reason of the interest that he
had in the old church, the principal chapel and the high-altar of
which belonged to his house, took very great pains therewith;
nay, at the beginning, before the money had been collected from
the taxes imposed on the owners of burial-places and chapels, he
spent many thousands of crowns of his own, for which he was
repaid.

Now, after the matter had been discussed, Filippo was sent
for and asked to make a model with all the features, both useful
and honourable, that might be possible and suitable to a Christian
church. Whereupon he urged strongly that the ground-plan of
that edifice should be turned right round, because he greatly
desired that the square should extend to the bank of the Arno,
to the end that all those who passed that way from Genoa, from
the Riviera, from the Lunigiana, and from the districts of Pisa
and Lucca, might see the magnificence of that building. But since
certain citizens objected, refusing to have their houses pulled
down, the desire of Filippo did not take effect. He made the
model of the church, therefore, with that of the habitation of
the monks, in the form wherein it stands to-day. The length
of the church was one hundred and sixty-one braccia, and the
width fifty-four braccia, and it was so well planned, both in
the ordering of the columns and in the rest of the ornaments,
that it would be impossible to make a work richer, more lovely,
or more graceful than that one. And in truth, but for the
malevolence of those who are ever spoiling the beautiful begin-
nings of any work in order to appear to have more understanding
than others, this would now be the most perfect church in Christ-
endom; and even as it stands it is more lovely and better designed
than any other, although it has not been carried out according to
the model, as may be seen from certain parts begun on the out-
side, wherein the design observed within has not been followed,
as it appears from the model that the doors and the borders
round the windows were meant to do. There are some errors,
attributed to him, about which I will be silent, for it is believed
that if he had completed the building he would not have endured

them, seeing that he had brought all his work to perfection with so much judgment, discrimination, intellect, and art; and this work likewise established him as a genius truly divine.

Filippo was very humorous in his discourse and very acute in repartee, as he showed when he wished to hit at Lorenzo Ghiberti, who had bought a farm on Monte Morello, called Lepriano, on which he spent twice as much as he gained by way of income, so that he grew weary of this and sold it. Some one asked Filippo what was the best thing that Lorenzo had ever done, thinking perchance, by reason of the enmity between them, that he would criticize Lorenzo; and he replied, 'The selling of Lepriano.' Finally, having now grown very old – he was sixty-nine years of age – he passed to a better life on April 16, in the year 1446, after having exhausted himself greatly in making the works that enabled him to win an honoured name on earth and to obtain a place of repose in Heaven. His death caused infinite grief to his country, which recognized and esteemed him much more when dead than it had done when he was alive; and he was buried with the most honourable obsequies and distinctions in S. Maria del Fiore, although his burial-place was in S. Marco, under the pulpit opposite to the door, where there is a coat of arms with two fig-leaves and certain green waves on a field of gold, because his family came from the district of Ferrara, that is, from Ficaruolo, a township on the Po, as it is shown by the leaves, which denote the place, and by the waves, which signify the river. He was mourned by innumerable brother-craftsmen, and particularly by the poorer among them, whom he was ever helping. Thus then, living the life of a Christian, he left to the world the sweet savour of his goodness and of his noble talents. It seems to me that it can be said for him that from the time of the ancient Greeks and Romans to our own there has been no rarer or more excellent master than Filippo; and he is all the more worthy of praise because in his times the German manner was held in veneration throughout all Italy and practised by the old craftsmen, as it may be seen in innumerable edifices. He recovered the ancient mouldings and restored the Tuscan, Corinthian, Doric and Ionic Orders to their original forms. He had a disciple from Borgo a Buggiano, called Il Buggiano, who made the lavatory of the Sacristy of S. Reparata, with certain boys who pour out water; and he made a head of his master in marble, taken from the life, which was placed after the death of Filippo in S. Maria del Fiore, beside the

door on the right hand as one enters the church, where there is also the following epitaph, placed there by public decree in order to honour him after his death, even as he had honoured his country when alive:

D.S.

QUANTUM PHILIPPUS ARCHITECTUS ARTE DÆDALEA VA-
LUERIT, CUM HUJUS CELEBERRIMI TEMPLI MIRA TESTUDO,
TUM PLURES ALIÆ DIVINO INGENIO AB EO ADINVENTÆ
MACHINÆ DOCUMENTO ESSE POSSUNT; QUAPROPTER OB EXI-
MIAS SUI ANIMI DOTES SINGULARESQUE VIRTUTES XV KAL.
MAIAS ANNO MCCCCXLVI EJUS B.M. CORPUS HAC HUMO
SUPPOSITA GRATA PATRIA SEPELIRI JUSSIT.

To do him even greater honour, others have gone so far as to add these two other inscriptions:

PHILIPPO BRUNELLESCO ANTIQUÆ ARCHITECTURÆ INSTAUR-
ATORI S.P. Q.F. CIVI SUO BENE MERENTI.

Giovan Battista Strozzi made the second:

TAL SOPRA SASSO SASSO
DI GIRO IN GIRO ETERNAMENTE IO STRUSSI;
CHE COSÌ PASSO PASSO
ALTO GIRANDO AL CIEL MI RICONDUSSI.

Other disciples of Filippo were Domenico dal Lago di Luga-no; Geremia da Cremona, who worked very well in bronze, together with a Sclavonian who made many works in Venice; Simone, who died at Vicovaro while executing a great work for the Count of Tagliacozzo, after having made the Madonna in Orsanmichele for the Guild of the Apothecaries; Antonio and Niccolò, both Florentines, who, working in metal at Ferrara, made a horse of bronze for Duke Borso in the year 1461; and many others, of whom it would take too long to make particular mention. Filippo was unfortunate in certain respects, for, besides the fact that he ever had some one to contend with, some of his buildings were not completed in his time and are still unfinished. To mention only one, it was a great pity that the Monks of the Angeli, as it has been said, could not finish the temple begun by him, since, after they had spent on the portion that is now seen more than three thousand crowns, drawn partly from the Guild of Merchants and partly from the Monte, where their money was

kept, the capital was squandered and the building remained, as it still remains, unfinished. Wherefore, as it was said in the life of Niccolò da Uzzano, if a man desires to leave such memorials behind him, let him do it for himself the while that he lives, and let him not put his trust in anyone; and what has been said of this edifice could be said of many others designed by Filippo Brunelleschi.

DONATO
[*DONATELLO*],
Sculptor of Florence

Donato, who was called Donatello by his relatives and wrote his name thus on some of his works, was born in Florence in the year 1403. Devoting himself to the arts of design, he was not only a very rare sculptor and a marvellous statuary, but also a practised worker in stucco, an able master of perspective, and greatly esteemed as an architect; and his works showed so great grace, design, and excellence, that they were held to approach more nearly to the marvellous works of the ancient Greeks and Romans than those of any other craftsman whatsoever. Wherefore it is with good reason that he is ranked as the first who made a good use of the invention of scenes in low-relief, which he wrought so well that it is recognized from the thought, the facility, and the mastery that he showed therein, that he had a true understanding of them, making them with a beauty far beyond the ordinary; for not only did no craftsman in this period ever surpass him, but no one even in our own age has equalled him.

Donatello was brought up from his early childhood in the house of Ruberto Martelli, where, by his good qualities and by his zealous talent, he won the affection not only of Martelli himself but of all that noble family. As a youth he wrought many things, which were not held in great account, by reason of their number; but what made him known for what he was and gave him a name was an Annunciation in grey-stone, which was placed close to the altar of the Chapel of the Cavalcanti, in the Church of S. Croce in Florence. For this he made an ornament composed in the grotesque manner, with a base of varied intertwined work and a decoration of quadrantal shape, adding six boys bearing certain festoons, who appear to be holding one another securely

with their arms in their fear of the height. But the greatest genius and art that he showed was in the figure of the Virgin, who, alarmed by the unexpected apparition of the Angel, is making a most becoming reverence with a sweet and timid movement of her person, turning with most beautiful grace towards him who is saluting her, in a manner that there are seen in her countenance that humility and gratitude which are due to one who presents an unexpected gift, and the more when the gift is a great one. Besides this, Donato showed a masterly flow of curves and folds in the draperies of that Madonna and of the Angel, demonstrating with the suggestion of the nude forms below how he was seeking to recover the beauty of the ancients, which had lain hidden for so many years; and he displayed so great facility and art in this work, that nothing more could be desired, in fact, with regard to design, judgment, and mastery in handling the chisel.

In the same church, below the tramezzo,* and beside the scene painted by Taddeo Gaddi, he made a Crucifix of wood with extraordinary care; and when he had finished this, thinking that he had made a very rare work, he showed it to Filippo di Ser Brunellesco, who was very much his friend, wishing to have his opinion. Filippo, whom the words of Donato had led to expect something much better, smiled slightly on seeing it. Donato, perceiving this, besought him by all the friendship between them to tell him his opinion; whereupon Filippo, who was most obliging, replied that it appeared to him that Donato had placed a ploughman on the Cross, and not a body like that of Jesus Christ, which was most delicate and in all its parts the most perfect human form that was ever born. Donato, hearing himself censured, and that more sharply than he expected, whereas he was hoping to be praised, replied, 'If it were as easy to make this figure as to judge it, my Christ would appear to thee to be Christ and not a ploughman; take wood, therefore, and try to make one thyself.' Filippo, without another word, returned home and set to work to make a Crucifix, without letting anyone know; and seeking to surpass Donato in order not to confound his own judgment, after many months he brought it to the height of perfection. This done, he invited Donato one morning to dine with him, and Donato accepted the invitation. Whereupon, as they were going together to the house of Filippo, they came to

* See note on p. 90.

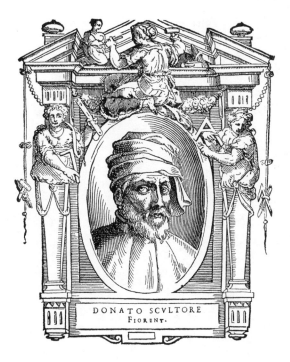

DONATO SCVLTORE
FIORENT.

the Mercato Vecchio, where Filippo bought some things and gave them to Donato, saying, 'Do thou go with these things to the house and wait for me there, I am coming in a moment.' Donato, therefore, entering the house and going into the hall, saw the Crucifix of Filippo, placed in a good light; and stopping short to study it, he found it so perfectly finished, that, being overcome and full of amazement, like one distraught, he spread out his hands, which were holding up his apron; whereupon the eggs, the cheese, and all the other things fell to the ground, and everything was broken to pieces. But he was still marvelling and standing like one possessed, when Filippo came up and said with a laugh, 'What is thy intention, Donato, and what are we to have for dinner, now that thou hast upset everything?' 'For my part,' answered Donato, 'I have had my share for this morning: if thou must have thine, take it. But enough; it is thy work to make Christ and mine to make ploughmen.'

In the Church of S. Giovanni in the same city Donato made a tomb for Pope Giovanni Coscia, who had been deposed from the Pontificate by the Council of Constance. This tomb he was commissioned to make by Cosimo de' Medici, who was very much the friend of the said Coscia. He wrought therein with his own hand the figure of the dead man in gilded bronze, together with the marble statues of Hope and Charity that are there; and his pupil Michelozzo made the figure of Faith. In the same church, opposite to this work, there is a wooden figure by the hand of Donato of S. Mary Magdalene in Penitence, very beautiful and excellently wrought, showing her wasted away by her fastings and abstinence, insomuch that it displays in all its parts an admirable perfection of anatomical knowledge. On a column of granite in the Mercato Vecchio there is a figure of Abundance in hard grey-stone by the hand of Donato, standing quite by itself, so well wrought that it is consummately praised by craftsmen and by all good judges of art. The column on which this statue is placed was formerly in S. Giovanni, where there are the others of granite supporting the gallery within; it was removed and its place was taken by a fluted column, on which, in the middle of that temple, there once stood the statue of Mars which was taken away when the Florentines were converted to the faith of Jesus Christ. The same man, while still a youth, made a figure of the Prophet Daniel in marble for the façade of S. Maria del Fiore, and afterwards one of S. John the Evangelist seated, four braccia

high, and clothed in a simple garment: which figure is much extolled. On one corner of the same place, on the side that faces towards the Via del Cocomero, there is an old man between two columns, more akin to the ancient manner than any other work that there is to be seen by the hand of Donato, the head revealing the thoughts that length of years brings to those who are exhausted by time and labour. Within the said church, likewise, he made the ornament for the organ, which stands over the door of the old sacristy, with those figures so boldly sketched, as it has been said, that they appear to the eye to have actual life and movement. Wherefore it may be said of this man that he worked as much with his judgment as with his hands, seeing that many things are wrought which appear beautiful in the rooms where they are made, and afterwards, on being taken thence and set in another place, in a different light or at a greater height, present a different appearance, and turn out the contrary to what they appeared; whereas Donato made his figures in such a manner, that in the room where he was working they did not appear half as good as they turned out to be in the positions where they were placed. For the new sacristy of the same church he made the design for those boys who uphold the festoons that go round the frieze, and likewise the design for the figures that were wrought in the glass of the round window which is below the cupola, namely, that one which contains the Coronation of Our Lady; which design is greatly superior to those of the other round windows, as it is clearly evident. For S. Michele in Orto in the said city he wrought the marble statue of S. Peter which is to be seen there, a most masterly and admirable figure, for the Guild of Butchers; and for the Guild of Linen-manufacturers he wrought the figure of S. Mark the Evangelist, which, after being commissioned to make it in company with Filippo Brunelleschi, he finished by himself with the consent of Filippo. This figure was wrought by Donato with so great judgment that its excellence was not recognized, while it stood on the ground, by those who had no judgment, and the Consuls of that Guild were inclined to refuse to have it put into place; whereupon Donato besought them to let him set it on high, saying that he wished to work on it and to show them a different figure as the result. His request being granted, he covered it up for a fortnight, and then uncovered it without having otherwise touched it, filling everyone with wonder.

For the Guild of Armourers he made a most spirited figure of S. George in armour, in the head of which there may be seen the

beauty of youth, courage and valour in arms, and a proud and terrible ardour; and there is a marvellous suggestion of life bursting out of the stone. It is certain that no modern figure in marble has yet shown such vivacity and such spirit as nature and art produced in this one by means of the hand of Donato. In the base that supports the shrine enclosing that figure he wrought in marble the story of the Saint killing the Dragon, in low-relief, wherein there is a horse that is much esteemed and greatly extolled; and in the frontal he made a half-length figure of God the Father in low-relief. Opposite to the church of the said oratory he wrought the marble shrine for the Mercatanzia, following the ancient Order known as Corinthian, and departing entirely from the German manner; this shrine was meant to contain two statues, but he refused to make them because he could not come to an agreement about the price. After his death these figures were made in bronze by Andrea del Verrocchio, as it will be told. For the main front of the Campanile of S. Maria del Fiore he wrought four figures in marble, five braccia in height, of which the two in the middle are portrayed from life, one being Francesco Soderini as a youth, and the other Giovanni di Barduccio Cherichini, now called Il Zuccone.* The latter was held to be a very rare work and the most beautiful that Donato ever made, and when he wished to take an oath that would command belief he was wont to say, 'By the faith that I place in my Zuccone'; and the while that he was working on it, he would keep gazing at it and saying, 'Speak, speak, plague take thee, speak!' Over the door of the campanile, on the side facing the Canon's house, he made Abraham about to sacrifice Isaac, with another Prophet: and these figures were placed between two other statues.

For the Signoria of that city he made a casting in metal which was placed under an arch of their Loggia in the Piazza, representing Judith cutting off the head of Holofernes; a work of great excellence and mastery, which, if one considers the simplicity of the garments and aspect of Judith on the surface, reveals very clearly below the surface the great spirit of that woman and the assistance given to her by God, even as one sees the effect of wine and sleep in the expression of Holofernes, and death in his

* *I.e.*, Bald-head.

limbs, which have lost all life and are shown cold and limp. This work was so well executed by Donato that the casting came out delicate and very beautiful, and it was afterwards finished so excellently that it is a very great marvel to behold. The base, likewise, which is a baluster of granite, simple in design, appears full of grace and presents an aspect pleasing to the eye. He was so well satisfied with this work that he deigned to place his name on it, which he had not done on the others; and it is seen in these words, 'Donatelli opus.' In the courtyard of the Palace of the said Signori there is a life-size David, nude and in bronze. Having cut off the head of Goliath, he is raising one foot and placing it on him, holding a sword in his right hand. This figure is so natural in its vivacity and its softness, that it is almost impossible for craftsmen to believe that it was not moulded on the living form. This statue once stood in the courtyard of the house of the Medici, but it was transported to the said place on the exile of Cosimo. In our own day Duke Cosimo, having made a fountain on the spot occupied by this statue, had it removed, and it is being kept for a very large courtyard that he intends to make at the back of the palace, that is, where the lions formerly stood. In the hall where there is the clock of Lorenzo della Volpaia, on the left, there is a very beautiful David in marble; between his legs, under his feet, he has the head of the dead Goliath, and in his hand he holds the sling wherewith he slew him. In the first courtyard of the house of the Medici there are eight medallions of marble, wherein there are copies of ancient cameos and of the reverse sides of medals, with certain scenes, all made by him and very beautiful, which are built into the frieze between the windows and the architrave above the arches of the loggie. In like manner he restored an ancient statue of Marsyas in white marble, which was placed at the entrance of the garden; and a great number of ancient heads, which were placed over the doors, were restored and embellished by him with wings and diamonds (the emblem of Cosimo), wrought very well in stucco. He made a very lovely vessel of granite, which poured forth water, and he wrought a similar one, which also pours forth water, for the garden of the Pazzi in Florence. In the said Palace of the Medici there are Madonnas of marble and bronze made in low-relief, besides some scenes in marble with most beautiful figures, marvellous in their flat-relief. So great was the love that Cosimo bore to the talent of Donato that

he kept him continually at work, and Donato, on the other hand, bore so great love to Cosimo that he could divine his patron's every wish from the slightest sign, and obeyed him in all things.

It is said that a Genoese merchant caused Donato to make a life-size head of bronze, which was very beautiful and also very light, because it had to be carried to a great distance; and that the commission for this work came to him through the recommendation of Cosimo. Now, when the head was finished and the merchant came to pay for it, it appeared to him that Donato was asking too much; wherefore the matter was referred to Cosimo, who had the head carried to the upper court of the palace and placed between the battlements that overlook the street, to the end that it might be seen better. When Cosimo sought to settle the difference, he found the offer of the merchant very far from the demand of Donato, and he turned round and said that it was too little. Whereupon the merchant, thinking it too much, said that Donato had wrought it in a month or little more, and that this meant a gain of more than half a florin a day. Donato, thinking this too much of an insult, turned round in anger and said to the merchant that in the hundredth part of an hour he would have been able to spoil the value of a year's labour; and giving the head a push, he sent it flying straightway into the street below, where it broke into a thousand pieces; saying to him that this showed that he was more used to bargaining for beans than for statues. Wherefore the merchant, regretting his meanness, offered to give him double the sum if he would make another; but neither his promises nor the entreaties of Cosimo could induce Donato to make it again. In the houses of the Martelli there are many scenes in marble and in bronze; among others, a David three braccia high, with many other works presented by him as a free gift to that family in proof of the devotion and love that he bore them; above all, a S. John of marble, made by him in the round and three braccia high, a very rare work, which is to-day in the house of the heirs of Ruberto Martelli. With regard to this work, a legal agreement was made to the effect that it should be neither pledged, nor sold, nor given away, without heavy penalties, as a testimony and token of the affection shown by them to Donato, and by him to them out of gratitude that he had learnt his art through the protection and the opportunities that he received from them.

He also made a tomb of marble for an Archbishop, which was
sent to Naples and is in S. Angelo di Seggio di Nido; in this tomb
there are three figures in the round that support the sarcophagus
with their heads, and on the sarcophagus itself is a scene in
low-relief, so beautiful that it commands infinite praise. In the
house of the Count of Matalone, in the same city, there is the
head of a horse by the hand of Donato, so beautiful that many
take it for an antique. In the township of Prato he wrought the
marble pulpit where the Girdle is shown, in which, in several
compartments, he carved a dance of children so beautiful and so
admirable, that he may be said to have demonstrated the perfec-
tion of his art no less in this work than in his others. To support
this pulpit, moreover, he made two capitals of bronze, one
of which is still there, while the other was carried away by the
Spaniards who sacked that district.

It came to pass about this time that the Signoria of Venice,
hearing of his fame, sent for him to the end that he might make
the monument of Gattamelata in the city of Padua; wherefore he
went there right willingly and made the bronze horse that is on
the Piazza di S. Antonio, wherein are perceived the panting and
neighing of the horse, with great spirit and pride, most vividly
expressed by his art, in the figure of the rider. And Donato
proved himself such a master in the proportions and excellence
of so great a casting, that he can truly bear comparison with any
ancient craftsman in movement, design, art, proportion, and di-
ligence; wherefore it not only astonished all who saw it then, but
continues to astonish every person who sees it at the present day.
The Paduans, moved by this, did their utmost to make him their
fellow-citizen, and sought to detain him with every sort of en-
dearment. In order to keep him in their midst, they commis-
sioned him to make the stories of S. Anthony of Padua on the
predella of the high-altar in the Church of the Friars Minor,
which are in low-relief, wrought with so great judgment, that the
most excellent masters of that art stand marvelling and amazed
before them, as they consider their beautiful and varied com-
positions, with the great abundance of extraordinary figures and
diminishing perspectives. Very beautiful, likewise, are the Maries
that he made on the altar-dossal, lamenting the Dead Christ. In
the house of one of the Counts Capodilista he wrought the skele-
ton of a horse in wood, which is still to be seen to-day without
the neck; wherein the various parts are joined together with so

much method, that, if one considers the manner of this work, one can judge of the ingenuity of his brain and the greatness of his mind. In a convent of nuns he made a S. Sebastian in wood at the request of a chaplain, a Florentine, who was their friend and an intimate of his own. This man brought him a figure of that Saint that they had, old and clumsy, beseeching him to make the new one like it. Wherefore Donato strove to imitate it in order to please the chaplain and the nuns, but, although he imitated it, clumsy as it was, he could not help showing in his own the usual excellence of his art. Together with this figure he made many others in clay and in stucco, and on one end of an old piece of marble that the said nuns had in their garden he carved a very beautiful Madonna. Throughout that whole city, likewise, there are innumerable works by his hand, by reason of which he was held by the Paduans to be a marvel and was praised by every man of understanding; but he determined to return to Florence, saying that if he remained any longer in Padua he would forget everything that he knew, being so greatly praised there by all, and that he was glad to return to his own country, where he would gain nothing but censure, since such censure would urge him to study and would enable him to attain to greater glory. Having departed from Padua, therefore, he returned by way of Venice, where, as a mark of his friendliness towards the Florentine people, he made them a present of a S. John the Baptist, wrought by him in wood with very great diligence and study, for their chapel in the Church of the Friars Minor. In the city of Faenza he carved a S. John and a S. Jerome in wood, which are no less esteemed than his other works.

Afterwards, having returned to Tuscany, he made a marble tomb, with a very beautiful scene, in the Pieve of Montepulciano, and a lavatory of marble, on which Andrea Verrocchio also worked, in the Sacristy of S. Lorenzo in Florence; and in the house of Lorenzo della Stufa he wrought some heads and figures that are very spirited and vivacious. Then, departing from Florence, he betook himself to Rome, in order to try to imitate the antiques to the best of his ability; and during this time, while studying these, he made a tabernacle of the Sacrament in stone, which is to be seen in S. Pietro at the present day. Passing through Siena on his way back to Florence, he undertook to make a door of bronze for the Baptistery of S. Giovanni; and he had already made the wooden model, and the wax moulds were

almost finished and successfully covered with the outer mould, ready for the casting, when there arrived, on his way back from Rome, one Bernardetto di Mona Papera, a Florentine goldsmith and an intimate friend of Donato, who wrought upon him so strongly both with words and in other ways, either for some business of his own or for some other reason, that he brought him back to Florence; wherefore that work remained unfinished, nay, not begun. There only remained in the Office of Works of the Duomo in that city a S. John the Baptist in bronze by his hand, with the right arm missing from the elbow downwards; and this Donato is said to have done because he had not been paid in full.

Having returned to Florence, therefore, he wrought the Sacristy of S. Lorenzo in stucco for Cosimo de' Medici, making four medallions on the pendentives of the vault containing stories of the Evangelists, with grounds in perspective, partly painted and partly in low-relief. And in the said place he made two very beautiful little doors of bronze in low-relief, with the Apostles, Martyrs, and Confessors; and above these he made some flat niches, one containing a S. Laurence and a S. Stephen, and the other S. Cosimo and S. Damiano. In the transept of the church he executed four saints in stucco, each five braccia high, which are wrought in a masterly manner. He also designed the bronze pulpits that contain the Passion of Christ, a work displaying design, force, invention, and an abundance of figures and buildings; but these his old age prevented him from executing, and his pupil Bertoldo finished them and brought them to the utmost perfection. For S. Maria del Fiore he made two colossal figures of brick and stucco, which are placed by way of ornament without the church, at the corners of the chapels. Over the door of S. Croce there is still to be seen a S. Louis wrought by him in bronze, five braccia high; for this someone criticized him, saying that it was stupid and perhaps the least excellent work that he had ever made, and he answered that he had made it so of set purpose, seeing that the Saint had been stupid to give up his throne and become a monk. The same man made the head of the wife of the said Cosimo de' Medici in bronze, and this head is preserved in the guardaroba of the Lord Duke Cosimo, wherein there are many other works in bronze and marble by the hand of Donato; among others, a Madonna with the Child in her arms, sunk in the marble in flat-relief, which is the most beautiful work that it is possible to see, and the rather as it is surrounded by a border

of scenes done in miniature by Fra Bartolommeo,* which are admirable, as it will be told in the proper place. The said Lord Duke has a very beautiful, nay, miraculous Crucifix in bronze, by the hand of Donato, in his study, wherein there are innumerable rare antiquities and most beautiful medals. In the same guarda-roba there is a bronze panel containing the Passion of Our Lord in low-relief, with a great number of figures; and in another panel, also in metal, there is another Crucifixion. In like manner, in the house of the heirs of Jacopo Capponi, who was an excellent citizen and a true gentleman, there is a marble panel with the Madonna in half-relief, which is held to be a very rare work. Messer Antonio de'Nobili, who was Treasurer to his Excellency, had in his house a marble panel by the hand of Donato, in which there is a half-length Madonna in low-relief, so beautiful that the said Messer Antonio valued it as much as all his possessions; nor is it less valued by his son Giulio, a youth of singular goodness and judgment, a friend to lovers of art and to all men of excellence. In the house of Giovan Battista d'Agnol Doni, a gentleman of Florence, there is a Mercury of metal in the round by the hand of Donato, one braccio and a half in height and clothed in a certain bizarre manner; which work is truly very beautiful, and no less rare than the others that adorn his most beautiful house. Bartolommeo Gondi, of whom we have spoken in the Life of Giotto, has a Madonna in half-relief by the hand of Donato, wrought with so great love and diligence that it is not possible to see anything better, or to imagine the fancifulness which he gave to her head-dress and the loveliness that he put into the garments which she is wearing. In like manner, Messer Lelio Torelli, First Auditor and Secretary to our Lord the Duke, and no less devoted a lover of all the honourable sciences, arts, and professions, than he is excellent as a jurist, has a marble panel of Our Lady by the hand of the same Donatello.

But if one were to give a complete account of his life and of the works that he made, it would be a far longer story than it is our intention to give in writing the Lives of our craftsmen, seeing that he put his hand not only to great things, of which there has been enough said, but also to the smallest things of art, making the arms of families on the chimney-pieces and on the fronts of

* Vasari says Fra Ber.... Fra Bernardo has been suggested, but nothing is known of him. It is more reasonable to read Fra Bartolommeo (della Porta).

the houses of citizens, a most beautiful example of which may be seen in the house of the Sommai, which is opposite to that of the baker Della Vacca. For the family of the Martelli, moreover, he made a coffin in the form of a cradle wrought of wicker-work, to serve for a tomb; but it is beneath the Church of S. Lorenzo, because no tombs of any kind are to be seen above, save only the epitaph of the tomb of Cosimo de' Medici, and even that one has its entrance below, like the others.

It is said that Simone, the brother of Donato, having wrought the model for the tomb of Pope Martin V, sent for Donato to the end that he might see it before it was cast. Going to Rome, therefore, Donato found himself in that city at the very moment when the Emperor Sigismund was there to receive the crown from Pope Eugenius IV; wherefore he was forced, in company with Simone, to occupy himself with making the magnificent preparations for that festival, whereby he acquired very great fame and honour.

In the guardaroba of Signor Guidobaldo, Duke of Urbino, there is a very beautiful head of marble by the hand of the same man, and it is believed that it was given to the ancestors of the said Duke by the Magnificent Giuliano de' Medici, at the time when he was staying at that Court, which was full of most cultured gentlemen. In short, the talent of Donato was such, and he was so admirable in all his actions, that he may be said to have been one of the first to give light, by his practice, judgment, and knowledge, to the art of sculpture and of good design among the moderns; and he deserves all the more commendation, because in his day, apart from the columns, sarcophagi, and triumphal arches, there were no antiquities revealed above the earth. And it was through him, chiefly, that there arose in Cosimo de' Medici the desire to introduce into Florence the antiquities that were and are in the house of the Medici; all of which he restored with his own hand. He was most liberal, gracious, and courteous, and more careful for his friends than for himself; nor did he give thought to money, but kept his in a basket suspended by a cord from the ceiling, wherefore all his workmen and friends could take what they needed without saying a word to him. He passed his old age most joyously, and, having become decrepit, he had to be succoured by Cosimo and by others of his friends, being no longer able to work. It is said that Cosimo, being at the point of death, recommended him to the care of his son Piero, who,

as a most diligent executor of his father's wishes, gave him a farm
at Cafaggiuolo, which produced enough to enable him to live in
comfort. At this Donato made great rejoicing, thinking that he
was thus more than secure from the danger of dying of hunger;
but he had not held it a year before he returned to Piero and gave
it back to him by public contract, declaring that he refused to lose
his peace of mind by having to think of household cares and
listen to the importunity of the peasant, who kept pestering him
every third day – now because the wind had unroofed his dove-
cote, now because his cattle had been seized by the Commune
for taxes, and now because a storm had robbed him of his wine
and his fruit. He was so weary and disgusted with all this, that he
would rather die of hunger than have to think of so many things.
Piero laughed at the simplicity of Donato; and in order to deliver
him from this torment, he accepted the farm (for on this Donato
insisted), and assigned him an allowance of the same value or
more from his own bank, to be paid in cash, which was handed
over to him every week in the due proportion owing to him;
whereby he was greatly contented. Thus, as a servant and friend
of the house of Medici, he lived happily and free from care for
the rest of his life. When he had reached the age of eighty-three,
however, he was so palsied that he could no longer work in any
fashion, and took to spending all his time in bed in a poor little
house that he had in the Via del Cocomero, near the Nunnery of
S. Niccolò; where, growing worse from day to day and wasting
away little by little, he died on December 13, 1466. He was buried
in the Church of S. Lorenzo, near the tomb of Cosimo, as he had
himself directed, to the end that his dead body might be near
him, even as he had been ever near him in spirit when alive.

His death caused great grief to his fellow-citizens, to the crafts-
men, and to all who knew him when living. Wherefore, in order
to honour him more after death than they had done in his life,
they gave him most honourable obsequies in the aforesaid
church, and he was accompanied to the grave by all the painters,
architects, sculptors, and goldsmiths, and by almost all the people
of that city, which continued for a long time to compose in his
honour various kinds of verses in diverse tongues, whereof it
must suffice us to cite the few that are to be read below.

But before I come to the epitaphs, it will not be amiss to relate
the following story of him as well. When he had fallen sick, and
only a little before his death, certain of his relatives went to visit

him; and after they had greeted him, as is customary, and condoled with him, they said that it was his duty to leave them a farm that he had in the district of Prato, although it was small and produced a very meagre income; and they prayed him straitly to do it. Hearing this, Donato, who showed something of the good in all that he did, said to them, 'I cannot satisfy you, my kinsmen, because I intend to leave it – as it appears to me reasonable – to the peasant, who has always worked it and endured great labour thereby, and not to you, who, without having bestowed upon it anything more profitable than the thought of possessing it, expect me to leave it to you because of this your visit! Go, and may God bless you!' Of a truth such relatives, who have no love unconnected with advantage or with the hope of it, should be ever treated in this fashion. Sending therefore for a notary, he left the said farm to the labourer who had always worked it, and who perchance had behaved better to him in his need than those relatives had done. His art-possessions he left to his pupils, namely, Bertoldo, a sculptor of Florence, who imitated him closely enough, as may be seen from a very beautiful battle between men on horseback, wrought in bronze, which is now in the guardaroba of the Lord Duke Cosimo; Nanni d'Antonio di Banco, who died before him; and Rossellino, Desiderio, and Vellano da Padova. In short, it may be said that every man who has sought to do good work in relief since the death of Donato, has been his disciple. He was resolute in draughtsmanship, and he made his drawings with such mastery and boldness that they have no equals, as may be seen in my book, wherein I have figures drawn by his hand, both clothed and nude, animals that make all who see them marvel, and other most beautiful things of that kind. His portrait was made by Paolo Uccello, as it has been said in his Life. The epitaphs are as follows:

SCULTURA H.M. A FLORENTINIS FIERI VOLUIT DONATELLO, UTPOTE HOMINI, QUI EI, QUOD JAMDIU OPTIMIS ARTIFICIBUS MULTISQUE SÆCULIS TUM NOBILITATIS TUM NOMINIS ACQUISITUM FUERAT, INJURIAVE TEMPOR. PERDIDERAT IPSA, IPSE UNUS UNA VITA INFINITISQUE OPERIBUS CUMULATISS. RESTITUERIT: ET PATRIÆ BENEMERENTI HUJUS RESTITUTÆ VIRTUTIS PALMAM REPORTARIT.

EXCUDIT NEMO SPIRANTIA MOLLIUS ÆRA; VERA CANO; CERNES MARMORA VIVA LOQUI.

GRÆCORUM SILEAT PRISCA ADMIRABILIS ÆTAS
 COMPEDIBUS STATUAS CONTINUISSE RHODON.
NECTERE NAMQUE MAGIS FUERANT HÆC VINCULA DIGNA
 ISTIUS EGREGIAS ARTIFICIS STATUAS.

QUANTO CON DOTTA MANO ALLA SCULTURA
 GIÀ FECER MOLTI, OR SOL DONATO HA FATTO;
 RENDUTO HA VITA A' MARMI, AFFETTO, ED ATTO;
CHE PIÙ, SE NON PARLAR, PUÒ DAR NATURA?

The world remained so full of his works, that it may be affirmed right truly that no craftsman ever worked more than he did. For, delighting in every kind of work, he put his hand to anything, without considering whether it was of little or of great value. Nevertheless it was indispensable to sculpture, this vast activity of Donato in making figures in every kind of relief, full, half, low, and the lowest; because, whereas in the good times of the ancient Greeks and Romans it was by means of many that it became perfect, he alone by the multitude of his works brought it back to marvellous perfection in our own age. Wherefore craftsmen should trace the greatness of this art rather to him than to any man born in modern times, seeing that, besides rendering the difficulties of the art easy, in the multitude of his works he combined together invention, design, practice, judgment, and every other quality that ever can or should be looked for in a divine genius. Donato was very resolute and ready, executing all his works with consummate facility, and he always accomplished much more than he had promised.

He left all his work to be completed by his pupil Bertoldo, and particularly the bronze pulpits of S. Lorenzo, which were afterwards finished in great part by him, and brought to the state in which they are seen in the said church.

I will not forbear to say that the most learned and very reverend Don Vincenzo Borghini, of whom mention has been made above with regard to some other matter, has collected into a large book innumerable drawings by excellent painters and sculptors, both ancient and modern; and on the ornamental borders of two leaves opposite to each other, which contain drawings by the hand of Donato and of Michelagnolo Buonarroti, he has written, with much judgment, these two Greek epigrams; on Donato's, 'ἢ Δωνατὸς Βοναρρωτίζει,' and on Michelagnolo's, 'ἢ Βοναρρωτὸς Δωνατίζει'; which mean in Latin, 'Aut Donatus

Bonarrotum exprimit et refert; aut Bonarrotus Donatum,' and in our own tongue, 'Either the spirit of Donato works in Buonarroto, or that of Buonarroto began by working in Donato.'

MICHELOZZO MICHELOZZI,
Sculptor and Architect of Florence

IF every man who lives in this world were to realize that he may have to live when he is no longer able to work, there would not be so many reduced to begging in their old age for that which they consumed without any restraint in their youth, when their large and abundant gains, blinding their true judgment, made them spend more than was necessary and much more than was expedient. For, seeing how coldly a man is looked upon who has fallen from wealth to poverty, every man should strive – honestly, however, and maintaining the proper mean – to avoid having to beg in his old age. And whosoever will act like Michelozzo – who did not imitate his master Donato in this respect, although he did in his virtues – will live honourably all the course of his life, and will not be forced in his last years to go about miserably hunting for the wherewithal to live.

Now Michelozzo applied himself in his youth to sculpture under Donatello, and also to design; and although he realized their difficulties, nevertheless he went on ever practising so diligently with clay, with wax, and with marble, that he ever showed ability and great talent in the works that he made afterwards. There was one art in which he surpassed many and even his own self, for, after Brunellesco, he was held to be the most methodical architect of his times, and the one who was best able to arrange and contrive palaces, convents, and houses for human habitation, and who designed them with the greatest judgment, as will be told in the proper place. Of this man Donatello availed himself for many years, because he was very well practised in working marble and in the business of casting in bronze; of which we have proof in a tomb in S. Giovanni at Florence (which was made by Donatello, as it has been said, for Pope Giovanni Coscia), since the greater part was executed by Michelozzo; and there we can see a very beautiful marble statue by his hand, two braccia and a half in height, representing Faith (in company with one of Hope and one of Charity made by Donatello,

of the same size), which does not suffer by comparison with the others. Moreover, above the door of the sacristy and the Office of Works, opposite to S. Giovanni, Michelozzo made a little S. John in full-relief, wrought with diligence, which was much extolled.

Michelozzo was so intimate with Cosimo de' Medici that the latter, recognizing his genius, caused him to make the model for the house and palace at the corner of the Via Larga, beside S. Giovannino; for he thought that the one made by Filippo di Ser Brunellesco, as it has been said, was too sumptuous and magnificent, and more likely to stir up envy among his fellow-citizens than to confer grandeur or adornment on the city, or bring comfort to himself. Wherefore, being pleased with the model that Michelozzo had made, he had the building brought to completion under his direction in the manner that we see at the present day, with all the beautiful and useful arrangements and graceful adornments that are seen therein, which have majesty and grandeur in their simplicity; and Michelozzo deserves all the greater praise in that this was the first palace which was built in that city on modern lines, and which was divided up into rooms both useful and most beautiful. The cellars are excavated to more than half their depth underground, namely, four braccia below, with three above for the sake of light; and there are also wine-cellars and store-rooms. On the ground-floor there are two courtyards with magnificent loggie, on which open saloons, chambers, antechambers, studies, closets, stove-rooms, kitchens, wells and staircases both secret and public, all most convenient. On each floor there are apartments with accommodation for a whole family, with all the conveniences that are proper not only to a private citizen, such as Cosimo then was, but even to the most splendid and most honourable of Kings; wherefore in our own times Kings, Emperors, Popes, and all the most illustrious Princes of Europe have been comfortably lodged there, to the infinite credit both of the magnificence of Cosimo and of the excellent ability of Michelozzo in architecture.

In the year 1433, when Cosimo was driven into exile, Michelozzo, who loved him very greatly and was most faithful to him, accompanied him of his own free will to Venice and insisted on remaining with him all the time that he stayed there; and in that city, besides many designs and models that he made for private dwellings and public buildings and decorations for the friends of Cosimo and for many gentlemen, he built, at the command and

expense of Cosimo, the library of the Monastery of S. Giorgio Maggiore, a seat of the Black Friars of S. Justina; and this was not only finished with regard to walls, book-shelves, woodwork, and other adornments, but was also filled with many books. Such was the occupation and amusement of Cosimo during that exile, from which he was recalled to his country in the year 1434; whereupon he returned almost in triumph, and Michelozzo with him. Now, while Michelozzo was in Florence, the Palazzo Pubblico della Signoria began to threaten to collapse, for some columns in the courtyard were giving way, either because there was too much weight pressing on them, or because their foundations were weak and awry, or even perchance because they were made of pieces badly joined and put together. Whatever may have been the reason, the matter was put into the hands of Michelozzo, who accepted the undertaking willingly, because he had provided against a similar peril near S. Barnaba in Venice, in the following manner. A gentleman had a house that was in danger of falling down, and he entrusted the matter to Michelozzo; wherefore he – according to what Michelagnolo Buonarroti once told me – caused a column to be made in secret, and prepared a number of props; and hiding everything in a boat, into which he entered together with some builders, in one night he propped up the house and replaced the column. Michelozzo, therefore, emboldened by this experience, averted the danger from the palace, doing honour both to himself and to those by whose favour he had received such a charge; and he refounded and rebuilt the columns in the manner wherein they stand to-day. First he made a stout framework of props and thick beams standing upright to support the centres of the arches, made of nut-wood, and upholding the vaulting, so that this came to support equally the weight that was previously borne by the columns; then, little by little removing those that were made of pieces badly joined together, he replaced them with others made of pieces and wrought with diligence, in such a manner that the building did not suffer in any way and has never moved a hair's breadth. And in order that his columns might be known from the others, he made some of them at the corners with eight sides, with capitals that have the foliage carved in the modern fashion, and some round; and all are very easily distinguished from the old columns that Arnolfo made formerly. Afterwards, by the advice of Michelozzo, it was ordained by those who then governed the city that

the arches of those columns should be unburdened and relieved of the weight of the walls that rested upon them; that the whole courtyard should be rebuilt from the arches upwards, with a row of windows in modern fashion, similar to those that he had made for Cosimo in the courtyard of the Palace of the Medici; and that designs in rustic-work should be carved on the walls, for the reception of those golden lilies that are still seen there at the present day. All this Michelozzo did with great promptitude; and on the second tier, directly above the windows of the said courtyard, he made some round windows (so as to have them different from the aforesaid windows), to give light to the rooms on that floor, which are over those of the first floor, where there is now the Sala de' Dugento. The third floor, where the Signori and the Gonfalonier lived, he made more ornate, and on the side towards S. Piero Scheraggio he arranged a series of apartments for the Signori, who had previously slept all together in one and the same room. These apartments consisted of eight for the Signori and a larger one for the Gonfalonier, and they all opened on a corridor which had windows overlooking the courtyard. Above this he made another series of commodious rooms for the household of the Palace, in one of which, used to-day as the Treasury, there is a portrait by the hand of Giotto of Charles, Duke of Calabria, son of King Robert, kneeling before a Madonna. There, also, he made apartments for the bailiffs, ushers, trumpeters, musicians, pipers, mace-bearers, court-servants, and heralds, with all the other apartments that are required in such a palace. On the upper part of the gallery, moreover, he made a stone cornice that went right round the courtyard, and beside it a water-cistern that was filled by the rains, to make some artificial fountains play at certain times. Michelozzo also directed the restoration of the chapel wherein Mass is heard, and beside it many rooms, with very rich ceilings painted with golden lilies on a ground of blue. He had other ceilings made both for the upper and the lower rooms of the Palace, covering up all the old ceilings that had been made before in the ancient manner. In short, he gave it all the perfection that was demanded by so great a building; and he contrived to convey the water from the wells right up to the highest floor, to which it could be drawn up by means of a wheel more easily than was usual. One thing alone the genius of Michelozzo could not remedy, namely, the public staircase, because it was badly conceived from the beginning, badly situated, awkwardly built, steep, and without lights,

while from the first floor upwards the steps were of wood. He laboured to such purpose, however, that he made a flight of round steps at the entrance of the courtyard, and a door with pilasters of hard-stone and most beautiful capitals carved by his hand, besides a well-designed cornice with a double architrave, in the frieze of which he placed all the arms of the Commune. And what is more, he made the whole staircase of hard-stone up to the floor where the Signori lived, fortifying it at the top and half-way up with a portcullis at each point, in case of tumults; and at the head of the staircase he made a door which was called the 'catena,'* beside which there was ever standing an usher, who opened or closed it according as he was commanded by those in authority. He strengthened the tower of the campanile, which had cracked by reason of the weight of that part which stands out over space on corbels on the side towards the Piazza, with very stout bands of iron. Finally, he improved and restored that Palace so greatly, that he was therefore commended by the whole city and made, besides other rewards, a member of the College, which is one of the most honourable magistracies in Florence. And if it should appear to anyone that I have perchance spoken at greater length about this building than was needful, I deserve to be excused, because – after having shown in the Life of Arnolfo, in connection with its original erection, which was in the year 1298, that it was built out of the square and wholly wanting in reasonable proportion, with unequal columns in the courtyard, arches both large and small, inconvenient stairs, and rooms awry and badly proportioned – it was necessary for me to show also to what condition it was brought by the intellect and judgment of Michelozzo; although even he did not arrange it in such a manner that it could be inhabited comfortably, without very great inconvenience and discomfort. Finally, when the Lord Duke Cosimo came to occupy it in the year 1538, his Excellency began to bring it into better form; but since those architects who served the Duke for many years in that work were never able to grasp or to carry out his conception, he determined to see whether he could effect the restoration without spoiling the old part, in which there was no little of the good; giving better order, convenience, and proportion, according to the plan that he had in mind, to the awkward and inconvenient stairs and apartments.

* Chain.

Sending to Rome, therefore, for Giorgio Vasari, painter and architect of Arezzo, who was working for Pope Julius III, he commissioned him not only to put in order the rooms that he had caused to be begun in the upper part of the side opposite to the Corn Market, which were out of the straight with regard to the ground-plan, but also to consider whether the interior of the Palace could not, without spoiling the work already done, be brought to such a form that it might be possible to go all over it, from one part to another and from one apartment to another, by means of staircases both secret and public, with an ascent as easy as possible. Thereupon, while the said rooms, already begun, were being adorned with gilded ceilings and scenes painted in oil, and with pictures in fresco on the walls, and others were being wrought in stucco, Giorgio took a tracing of the ground-plan right round the whole of the Palace, both the new part and the old; and then, having arranged with no small labour and study for the execution of all that he intended to do, he began to bring it little by little into a good form, and to unite, almost without spoiling any of the work already done, the disconnected rooms, which previously varied in height even on the same floor, some being high and others low. But in order that the Duke might see the design of the whole, in the space of six months he had made a well-proportioned wooden model of the whole of that pile, which has the form and extent rather of a fortress than of a palace. According to this model, which gained the approval of the Duke, the building was united and many commodious rooms were made, as well as convenient staircases, both public and secret, which give access to all the floors; and in this manner a burden was removed from the halls, which were formerly like public streets, for it had been impossible to ascend to the upper floors without passing through them. The whole was magnificently adorned with varied and diverse pictures, and finally the roof of the Great Hall was raised twelve braccia above its former height; insomuch that if Arnolfo, Michelozzo, and the others who laboured on the building from its first foundation onwards, were to return to life, they would not recognize it – nay, they would believe that it was not theirs but a new erection and a different edifice.

But let us now return to Michelozzo; the Church of S. Giorgio had just been given to the Friars of S. Domenico da Fiesole, but they only remained there from about the middle of July to the end of January, for Cosimo de' Medici and his brother Lorenzo obtained for them from Pope Eugenius the Church and Convent

of S. Marco, which was previously the seat of Silvestrine Monks, to whom the said S. Giorgio was given in exchange. And Cosimo and Lorenzo, being very devoted to religion and to divine service and worship, ordained that the said Convent of S. Marco should be rebuilt entirely anew after the design and model of Michelozzo, and should be made very vast and magnificent, with all the conveniences that the said friars could possibly desire. This work was begun in the year 1437, and the first part to be built was that opening out above the old refectory, opposite to the ducal stables, which Duke Lorenzo de' Medici formerly caused to be built. In this place twenty cells were built, the roof was put on, and the wooden furniture was made for the refectory, the whole being finished in the manner wherein it still stands to-day. But for some time the work was carried no further, for they had to wait to see what would be the end of a law-suit that one Maestro Stefano, General of the said Silvestrines, had brought against the Friars of S. Marco with regard to that convent. This suit having concluded in favour of the said Friars of S. Marco, the building was once more continued. But since the principal chapel, which had been built by Ser Pino Bonaccorsi, had afterwards come into the hands of a lady of the Caponsacchi family, and from her to Mariotto Banchi, some law-suit was fought out over this, and Mariotto, having upheld his rights and having taken the said chapel from Agnolo della Casa, to whom the said Silvestrines had given or sold it, presented it to Cosimo de' Medici, who gave Mariotto 500 crowns in return for it. Later, after Cosimo had likewise bought from the Company of the Spirito Santo the site where the choir now stands, the chapel, the tribune, and the choir were built under the direction of Michelozzo, and completely furnished in the year 1439. Afterwards the library was made, eighty braccia in length and eighteen in breadth, and vaulted both above and below, with sixty-four shelves of cypress wood filled with most beautiful books. After this the dormitory was finished, being brought to a square shape; and finally the cloister was completed, together with all the truly commodious apartments of that convent, which is believed to be the best designed, the most beautiful, and the most commodious that there is in Italy, thanks to the talent and industry of Michelozzo, who delivered it completely finished in the year 1452. It is said that Cosimo spent 36,000 ducats on this fabric, and that while it was building he gave the monks 366 ducats every year for their maintenance. Of

the construction and consecration of this holy place we read in
an inscription on marble over the door that leads into the sacri-
sty, in the following words:

CUM HOC TEMPLUM MARCO EVANGELISTÆ DICATUM MAG-
NIFICIS SUMPTIBUS CL. V. COSMI MEDICIS TANDEM ABSOLU-
TUM ESSET, EUGENIUS QUARTUS ROMANUS PONTIFEX
MAXIMA CARDINALIUM, ARCHIEPISCOPORUM, EPISCOPORUM,
ALIORUMQUE SACERDOTUM FREQUENTIA COMITATUS, ID
CELEBERRIMO EPIPHANIÆ DIE, SOLEMNI MORE SERVATO,
CONSECRAVIT. TUM ETIAM QUOTANNIS OMNIBUS, QUI
EODEM DIE FESTO ANNUAS STATASQUE CONSECRATIONIS
CEREMONIAS CASTE PIEQUE CELEBRARINT VISERINTVE,
TEMPORIS LUENDIS PECCATIS SUIS DEBITI SEPTEM ANNOS
TOTIDEMQUE QUADRAGESIMAS APOSTOLICA REMISIT
AUCTORITATE, A. MCCCCXLII.

In like manner, Cosimo erected from the design of Micheloz-
zo the noviciate of S. Croce in Florence, with the chapel of the
same, and the entrance that leads from the church to the sacristy,
to the said noviciate, and to the staircase of the dormitory. These
works are not inferior in beauty, convenience, and adornment to
any building whatsoever of all those which the truly magnificent
Cosimo de' Medici caused to be erected, or which Michelozzo
carried into execution; and besides other parts, the door that
leads from the church to the said places, which he made of grey-
stone, was much extolled in those times by reason of its novelty
and of its beautifully made frontal, for it was then very little the
custom to imitate the good manner of antique work, as this door
does. Cosimo de' Medici also built, with the advice and design of
Michelozzo, the Palace of Cafaggiuolo in Mugello, giving it the
form of a fortress with ditches round it; and he laid out farms,
roads, gardens, fountains with groves round them, fowling-
places, and other appurtenances of a villa, all very splendid; and
at a distance of two miles from the said palace, in a place called
the Bosco a' Frati, with the advice of Michelozzo, he carried out
the building of a convent for the Frati de' Zoccoli of the Order
of S. Francis, which is something very beautiful. At Trebbio,
likewise, he made many other improvements which are still to be
seen; and at a distance of two miles from Florence, also, he built
the palatial Villa of Careggi, which was very rich and magnificent;
and thither Michelozzo brought the water for the fountain that
is seen there at the present day. For Giovanni, son of Cosimo de'

Medici, the same master built another magnificent and noble palace at Fiesole, sinking the foundations for the lower part in the brow of the hill, at great expense but not without great advantage, for in that lower part he made vaults, cellars, stables, vat-stores, and many other beautiful and commodious offices; and above, besides the chambers, halls, and other ordinary rooms, he made some for books and certain others for music. In short, Michelozzo showed in this building how great was his skill in architecture, for, besides what has been mentioned, it was constructed in such a manner that, although it stands on that hill, it has never moved a hair's breadth. This palace finished, he built above it, almost on the summit of the hill, the Church and Convent of the Friars of S. Girolamo, at the expense of the same man. The same Michelozzo made the design and model which Cosimo sent to Jerusalem for the hospice that he caused to be erected there, for the pilgrims who visit the Sepulchre of Christ. He also sent the design for six windows in the façade of S. Pietro in Rome, which were made there afterwards with the arms of Cosimo de' Medici; but three of them were removed in our own day and replaced by Pope Paul III with others bearing the arms of the house of Farnese. After this, hearing that there was a lack of water at S. Maria degli Angeli in Assisi, to the very great discomfort of the people who go there every year on August 1 to receive Absolution, Cosimo sent thither Michelozzo, who brought the water of a spring, which rose half-way up the brow of the hill, to the fountain, which he covered with a very rich and lovely loggia resting on some columns made of separate pieces and bearing the arms of Cosimo. Within the convent, also at the commission of Cosimo, he made many useful improvements for the friars; and these the magnificent Lorenzo de' Medici afterwards renewed with more adornment and at greater expense, besides presenting to that Madonna the image of her in wax which is still to be seen there. Cosimo also caused the road that leads from the said Madonna degli Angeli to the city to be paved with bricks; nor did Michelozzo take his leave of those parts before he had made the design for the old Citadel of Perugia. Having finally returned to Florence, he built a house on the Canto de' Tornaquinci for Giovanni Tornabuoni, similar in almost every way to the palace that he had made for Cosimo, save that the façade is not in rustic-work and has no cornices above, but is quite plain.

After the death of Cosimo, by whom Michelozzo had been loved as much as a dear friend can be loved, his son Piero caused him to build the marble Chapel of the Crucifix in S. Miniato sul Monte; and in the half-circle of the arch at the back of the said Chapel Michelozzo carved in low-relief a Falcon with the Diamond (the emblem of Cosimo, father of Piero), which was truly a very beautiful work. After these things, the same Piero de' Medici, intending to build the Chapel of the Nunziata, in the Church of the Servi, entirely of marble, besought Michelozzo, now an old man, to give him his advice in the matter, both because he greatly admired his talents and because he knew how faithful a friend and servant he had been to his father Cosimo. This Michelozzo did, and the charge of constructing it was given to Pagno di Lapo Partigiani, a sculptor of Fiesole, who, as one who wished to include many things in a small space, showed many ideas in this work. This chapel is supported by four marble columns about nine braccia high, made with double flutings in the Corinthian manner, with the bases and capitals variously carved and with double members. On the columns rest the architrave, frieze, and cornice, likewise with double members and carvings and wrought with various things of fancy, and particularly with foliage and the emblems and arms of the Medici. Between these and other cornices made for another range of lights, there is a large inscription, very beautifully carved in marble. Below, between the four columns, forming the ceiling of the chapel, there is a coffer-work canopy of marble all carved, full of enamels fired in a furnace and of various fanciful designs in mosaic wrought with gold colour and precious stones. The surface of the pavement is full of porphyry, serpentine, variegated marbles, and other very rare stones, put together and distributed with beautiful design. The said chapel is enclosed by a grille made of bronze ropes, with candelabra above fixed into an ornament of marble, which makes a very beautiful finish to the bronze and to the candelabra; and the door which closes the chapel in front is likewise of bronze and very well contrived. Piero left orders that the chapel should be lighted all round by thirty silver lamps, and this was done. Now, as these were ruined during the siege, the Lord Duke gave orders many years ago that new ones should be made, and the greater part of them are already finished, while the work still goes on; but in spite of this there has never been a moment when there has not been that full number of lamps

burning, according to the instructions of Piero, although, from the time when they were destroyed, they have not been of silver. To these adornments Pagno added a very large lily of copper, issuing from a vase which rests on the corner of the gilt and painted cornice of wood which holds the lamps; but this cornice does not support so great a weight by itself, for the whole is sustained by two branches of the lily, which are of iron painted green, and are fixed with lead into the corner of the marble cornice, holding those that are of copper suspended in the air. This work was truly made with judgment and invention; wherefore it is worthy of being much extolled as something beautiful and bizarre. Beside this chapel, he made another on the side towards the cloister, which serves as a choir for the friars, with windows which take their light from the court and give it both to the said chapel and also (since they stand opposite to two similar windows) to the room containing the little organ, which is by the side of the marble chapel. On the front of this choir there is a large press, in which the silver vessels of the Nunziata are kept; and on all these ornaments and throughout the whole are the arms and emblem of the Medici. Without the Chapel of the Nunziata and opposite to it, the same man made a large chandelier of bronze, five braccia in height, as well as the marble holy-water font at the entrance of the church, and a S. John in the centre, which is a very beautiful work. Above the counter where the friars sell the candles, moreover, he made a half-length Madonna of marble with the Child in her arms, in half-relief, of the size of life and very devout; and a similar work in the Office of the Wardens of Works of S. Maria del Fiore.

Pagno also wrought some figures in S. Miniato al Tedesco in company with his master Donato, while a youth; and he made a tomb of marble in the Church of S. Martino in Lucca, opposite to the Chapel of the Sacrament, for Messer Piero di Nocera, who is portrayed there from nature. Filarete relates in the twenty-fifth book of his work that Francesco Sforza, fourth Duke of Milan, presented a very beautiful palace in Milan to the Magnificent Cosimo de' Medici, and that Cosimo in order to show the Duke how pleased he was with such a gift, not only adorned it richly with marbles and with carved wood-work, but also enlarged it under the direction of Michelozzo, making it eighty-seven braccia and a half, whereas it had previously been only eighty-four braccia. Besides this, he had many pictures painted there, particularly

the stories of the life of the Emperor Trajan in a loggia, wherein, among certain decorations, he caused Francesco Sforza himself to be portrayed, with the Lady Bianca, his consort, Duchess of Milan, and also their children, with many other noblemen and great persons, and likewise the portraits of eight Emperors; and to these portraits Michelozzo added that of Cosimo, made by his own hand. Throughout all the apartments he placed the arms of Cosimo in diverse fashions, with his emblem of the Falcon and Diamond. The said pictures were all by the hand of Vincenzio di Zoppa, a painter of no small repute at that time and in that country.

It is recorded that the money that Cosimo spent in the restoration of this palace was paid by Pigello Portinari, a citizen of Florence, who then directed the bank and the accounts of Cosimo in Milan and lived in the said palace. There are some works in marble and bronze by the hand of Michelozzo in Genoa, and many others in other places, which are all known by the manner; but what we have already said about him must suffice. He died at the age of sixty-eight, and he was buried in his own tomb in S. Marco at Florence. His portrait, by the hand of Fra Giovanni, is in the Sacristy of S. Trinita, in the figure of an old man with a cap on his head, representing Nicodemus, who is taking Christ down from the Cross.

ANTONIO FILARETE AND SIMONE,
Sculptors of Florence

If Pope Eugenius IV, when he resolved to make the bronze door for S. Pietro in Rome, had used diligence in seeking for men of excellence to execute that work (and he would easily have been able to find them at that time, when Filippo di Ser Brunellesco, Donatello, and other rare craftsmen were alive), it would not have been carried out in the deplorable manner which it reveals to us in our own day. But perchance the same thing happened to him that is very often wont to happen to the greater number of Princes, who either have no understanding of such works or take very little delight in them. Now, if they were to consider how important it is to show preference to men of excellence in public works, by reason of the fame that comes from these, it is certain that neither they nor their ministers would be so negligent; for the reason that he who encumbers himself with poor and inept

craftsmen ensures but a short life to his works or his fame, not to mention that injury is done to the public interest and to the age in which he was born, for it is firmly believed by all who come after, that, if there had been better masters to be found in that age, the Prince would have availed himself rather of them than of the inept and vulgar.

Now, after being created Pontiff in the year 1431, Pope Eugenius IV, hearing that the Florentines were having the doors of S. Giovanni made by Lorenzo Ghiberti, conceived a wish to try to make one of the doors of S. Pietro in like manner in bronze. But since he had no knowledge of such works, he entrusted the matter to his ministers, with whom Antonio Filarete, then a youth, and Simone, the brother of Donatello, both sculptors of Florence, had so much interest, that the work was allotted to them. Putting their hands to this, therefore, they toiled for twelve years to complete it; and although Pope Eugenius fled from Rome and was much harassed by reason of the Councils, yet those who had charge of S. Pietro contrived to prevent that work from being abandoned. Filarete, then, wrought that door in low-relief, making a simple division, with two upright figures in each part – namely, the Saviour and the Madonna above, and S. Peter and S. Paul below; and at the foot of S. Peter is that Pope on his knees, portrayed from life. Beneath each figure, likewise, there is a little scene from the life of the Saint that is above; below S. Peter, his crucifixion, and below S. Paul, his beheading; and beneath the Saviour and the Madonna, also, some events from their lives. At the foot of the inner side of the said door, to amuse himself, Antonio made a little scene in bronze, wherein he portrayed himself and Simone and their disciples going with an ass laden with good cheer to take their pleasure in a vineyard. But since they were not always at work on the said door during the whole of those twelve years, they also made in S. Pietro some marble tombs for Popes and Cardinals, which were thrown to the ground in the building of the new church.

After these works, Antonio was summoned to Milan by Duke Francesco Sforza, then Gonfalonier of Holy Church (who had seen his works in Rome), to the end that there might be made with his design, as it afterwards was, the Albergo de' poveri di Dio,* which is a hospital that serves for sick men and women,

* Literally, Hospice for God's poor.

and for the innocent children born out of wedlock. The division for the men in this place is in the form of a cross, and extends 160 braccia in all directions; and that of the women is the same. The width is 16 braccia, and within the four square sides that enclose the crosses of each of these two divisions there are four courtyards surrounded by porticoes, loggie, and rooms for the use of the director, the officials, the servants, and the nurses of the hospital, all very commodious and useful. On one side there is a channel with water continually running for the service of the hospital and for grinding corn, with no small benefit and convenience for that place, as all may imagine. Between the two divisions of the hospital there is a cloister, 80 braccia in extent in one direction and 160 in the other, in the middle of which is the church, so contrived as to serve for both divisions. In a word, this place is so well built and designed, that I do not believe that there is its like in Europe. According to the account of Filarete himself, the first stone of this building was laid with a solemn procession of the whole of the clergy of Milan, in the presence of Duke Francesco Sforza, the Lady Bianca Maria, and all their children, with the Marquis of Mantua, the Ambassador of King Alfonso of Arragon, and many other lords. On the first stone which was laid in the foundations, as well as on the medals, were these words:

FRANCISCUS SFORTIA DUX IV, QUI AMISSUM PER PRÆCESS-
ORUM OBITUM URBIS IMPERIUM RECUPERAVIT, HOC MUNUS
CHRISTI PAUPERIBUS DEDIT FUNDAVITQUE MCCCCLVII, DIE
XII APRIL.

These scenes were afterwards depicted on the portico by Maestro Vincenzio di Zoppa, a Lombard, since no better master could be found in those parts.

A work by the same Antonio, likewise, was the principal church of Bergamo, which he built with no less diligence and judgment than he had shown in the above-named hospital. And because he also took delight in writing, the while that these works of his were in progress he wrote a book divided into three parts. In the first he treats of the measurements of all edifices, and of all that is necessary for the purpose of building. In the second he speaks of the methods of building, and of the manner wherein a most beautiful and most convenient city might be laid out. In the third he invents new forms of buildings, mingling the ancient

with the modern. The whole work is divided into twenty-four books, illustrated throughout by drawings from his own hand; but, although there is something of the good to be found in it, it is nevertheless mostly ridiculous, and perhaps the most stupid book that was ever written. It was dedicated by him in the year 1464 to the Magnificent Piero di Cosimo de' Medici, and it is now in the collection of the most Illustrious Lord Duke Cosimo. And in truth, since he put himself to so great pains, the book might be commended in some sort, if he had at least made some records of the masters of his day and of their works; but as there are few to be found therein, and those few are scattered throughout the book without method and in the least suitable places, he has toiled only to beggar himself, as the saying goes, and to be thought a man of little judgment for meddling with something that he did not understand.

But I have said quite enough about Filarete, and it is now time to turn to Simone, the brother of Donato. This man, after the work of the door, made the bronze tomb of Pope Martin. He likewise made some castings that were sent to France, of many of which the fate is not known. For the Church of the Ermini, in the Canto alla Macine in Florence, he wrought a life-size Crucifix for carrying in processions, and to render it the lighter he made it of cork. In S. Felicita he made a terra-cotta figure of S. Mary Magdalene in Penitence, three braccia and a half in height and beautifully proportioned, and revealing the muscles in such a manner as to show that he had a very good knowledge of anatomy. He also wrought a marble tombstone for the Company of the Nunziata in the Church of the Servi, inlaying it with a figure in grey and white marble in the manner of a painting (which was much extolled), like the work already mentioned as having been done by the Sienese Duccio in the Duomo of Siena. At Prato he made the bronze grille for the Chapel of the Girdle. At Forlì, over the door of the Canon's house, he wrought a Madonna with two angels in low-relief; and he adorned the Chapel of the Trinità in S. Francesco with work in half-relief for Messer Giovanni da Riolo. In the Church of S. Francesco at Rimini, for Sigismondo Malatesti, he built the Chapel of S. Sigismondo, wherein there are many elephants, the device of that lord, carved in marble. To Messer Bartolommeo Scamisci, Canon of the Pieve of Arezzo, he sent a Madonna with the Child in her arms, made of terra-cotta, with certain angels in half-relief, very

well executed; which Madonna is now in the said Pieve, set up against a column. For the baptismal font of the Vescovado of Arezzo, likewise, he wrought, in some scenes in low-relief, a Christ being baptized by S. John. In the Church of the Nunziata in Florence he made a marble tomb for Messer Orlando de' Medici. Finally, at the age of fifty-five, he rendered up his spirit to God who had given it to him. Nor was it long before Filarete, having returned to Rome, died at the age of sixty-nine, and was buried in the Minerva, where he had caused Giovanni Foccora, a painter of no small repute, to make a portrait of Pope Eugenius, while he was staying in Rome in the service of that Pontiff. The portrait of Antonio, by his own hand, is at the beginning of his book, where he gives instructions for building. His disciples were Varrone and Niccolò, both Florentines, who made the marble statue for Pope Pius II near Pontemolle, at the time when he brought the head of S. Andrew to Rome. By order of the same Pope they restored Tigoli almost from the foundations; and in S. Pietro they made the ornament of marble that is above the columns of the chapel wherein the said head of S. Andrew is preserved. Near that chapel is the tomb of the said Pope Pius, made by Pasquino da Montepulciano, a disciple of Filarete, and Bernardo Ciuffagni. This Bernardo wrought a tomb of marble for Gismondo Malatesti in S. Francesco at Rimini, making his portrait there from nature; and he also executed some works, so it is said, in Lucca and in Mantua.

GIULIANO DA MAIANO, Sculptor and Architect

No small error do those fathers of families make who do not allow the minds of their children to run the natural course in their childhood, and do not suffer them to follow the calling that is most in accordance with their taste; for to try to turn them to something for which they have no inclination is manifestly to prevent them from ever being excellent in anything, because we almost always find that those who labour at something that they do not like make little progress in any occupation whatsoever. On the other hand, those who follow the instinct of nature generally become excellent and famous in the arts that they pursue; as was seen clearly in Giuliano da Maiano. The father of this man, after

living a long time on the hill of Fiesole, in the part called Maiano, working at the trade of stone-cutter, finally betook himself to Florence, where he opened a shop for the sale of dressed stone, keeping it furnished with the sort of work that is apt very often to be called for without warning by those who are erecting some building. Living in Florence, then, there was born to him a son, Giuliano, whom his father, growing convinced in the course of time that he had a good intelligence, proposed to make into a notary, for it appeared to him that his own occupation of stone-cutting was too laborious and too unprofitable an exercise. But this did not come to pass, because, although Giuliano went to a grammar-school for a little, his thoughts were never there, and in consequence he made no progress; nay, he played truant very often, and showed that he had his mind wholly set on sculpture, although at first he applied himself to the calling of joiner and also gave attention to drawing.

It is said that in company with Giusto and Minore, masters of tarsia,* he wrought the seats of the Sacristy of the Nunziata, and likewise those of the choir that is beside the chapel, and many things in the Badia of Florence and in S. Marco; and that, having acquired a name through these works, he was summoned to Pisa, in the Duomo of which he wrought the seat that is beside the high-altar, in which the priest, the deacon, and the sub-deacon sit when Mass is being sung; making in tarsia on the back of this seat, with tinted and shaded woods, the three prophets that are seen therein. In this work he availed himself of Guido del Servellino and Maestro Domenico di Mariotto, joiners of Pisa, to whom he taught the art so well that they afterwards wrought the greater part of that choir both with carvings and with tarsia-work; which choir has been finished in our own day, with a manner no little better, by Batista del Cervelliera of Pisa, a man truly ingenious and fanciful.

But to return to Giuliano; he made the presses of the Sacristy of S. Maria del Fiore, which were held at that time to be admirable examples of tarsia and inlaid-work. Now, while Giuliano thus continued to devote himself to tarsia, to sculpture, and to architecture, Filippo di Ser Brunellesco died; whereupon, being chosen by the Wardens of Works to succeed him, he made the borders, incrusted with black and white marble, which are round

* Inlaying with various kinds of coloured wood.

the circular windows below the vault of the cupola; and at the corners he placed the marble pilasters on which Baccio d' Agnolo afterwards laid the architrave, frieze, and cornice, as will be told below. It is true that, as it appears from some designs by his hand that are in our book, he wished to make another arrangement of frieze, cornice, and gallery, with pediments on each of the eight sides of the cupola; but he had not time to put this into execution, for, being carried away by an excess of work from one day to another, he died.

Before this happened, however, he went to Naples and designed the architecture of the magnificent Palace at Poggio Reale for King Alfonso, with the beautiful fountains and conduits that are in the courtyard. In the city, likewise, he made designs for many fountains, some for the houses of noblemen and some for public squares, with beautiful and fanciful inventions; and he had the said Palace of Poggio Reale all wrought with paintings by Piero del Donzello and his brother Polito. Working in sculpture, likewise, for the said King Alfonso, then Duke of Calabria, he wrought scenes in low-relief over a door (both within and without) in the great hall of the Castle of Naples; and he made a marble gate for the castle after the Corinthian Order, with an infinite number of figures, giving to that work the form of a triumphal arch, on which stories from the life of that King and some of his victories are carved in marble. Giuliano also wrought the decorations of the Porta Capovana, making therein many varied and beautiful trophies; wherefore he well deserved that great love should be felt for him by that King, who, rewarding him liberally for his labours, enriched his descendants.

Giuliano had taught to his nephew Benedetto the arts of tarsia and architecture, and something about working in marble; and Benedetto was living in Florence, devoting himself to working at tarsia, because this brought him greater gains than the other arts did. Now Giuliano was summoned to Rome by Messer Antonio Rosello of Arezzo, Secretary to Pope Paul II, to enter the service of that Pontiff. Having gone thither, he designed the loggie of travertine in the first court of the Palace of S. Pietro, with three ranges of columns, of which the first is on the lowest floor, where there are now the Signet Office and other offices; the second is above this, where the Datary and other prelates live; and the third and last is where those rooms are that look out on the court of S. Pietro, which he adorned with gilded ceilings and

other ornaments. From his design, likewise, were made the marble loggie from which the Pope gives his benediction – a very great work, as may still be seen to-day. But the most stupendous and marvellous work that he made was the palace that he built for that Pope, together with the Church of S. Marco in Rome, for which there was used an infinite quantity of travertine blocks, said to have been excavated from certain vineyards near the Arch of Constantine, where they served as buttresses for the foundations of that part of the Colosseum which is now in ruins, perchance because of the weakening of that edifice.

Giuliano was sent by the same Pontiff to the Madonna of Loreto, where he rebuilt the foundations and greatly enlarged the body of the church, which had formerly been small and built over piers in rustic-work. He did not go higher than the string-course that was there already; but he summoned his nephew Benedetto to that place, and he, as will be told, afterwards raised the cupola. Being then forced to return to Naples in order to finish the works that he had begun, Giuliano received a commission from King Alfonso for a gate near the castle, which was to include more than eighty figures, which Benedetto had to execute in Florence; but the whole remained unfinished by reason of the death of that King. There are still some relics of these figures in the Misericordia in Florence, and there were others in our own day in the Canto alla Macine; but I do not know where these are now to be found. Before the death of the King, however, Giuliano died in Naples at the age of seventy, and was greatly honoured with rich obsequies; for the King had fifty men clothed in mourning, who accompanied Giuliano to the grave, and then he gave orders that a marble tomb should be made for him.

The continuation of his work was left to Polito, who completed the conduits for the waters of Poggio Reale. Benedetto, devoting himself afterwards to sculpture, surpassed his uncle Giuliano in excellence, as will be told; and in his youth he was the rival of a sculptor named Modanino da Modena, who worked in terra-cotta, and who wrought for the said Alfonso a Pietà with an infinite number of figures in the round, made of terra-cotta and coloured, which were executed with very great vivacity, and were placed by the King in the Church of Monte Oliveto, a very highly honoured monastery in the city of Naples. In this work the said King is portrayed on his knees, and he appears truly more than alive; wherefore Modanino was remunerated by him

with very great rewards. But when the King died, as it has been said, Polito and Benedetto returned to Florence; where, no long time after, Polito followed Giuliano into eternity. The sculptures and pictures of these men date about the year of our salvation 1447.

PIERO DELLA FRANCESCA
[*PIERO BORGHESE*],
Painter of Borgo a San Sepolcro

TRULY unhappy are those who, labouring at their studies in order to benefit others and to make their own name famous, are hindered by infirmity and sometimes by death from carrying to perfection the works that they have begun. And it happens very often that, leaving them all but finished or in a fair way to completion, they are falsely claimed by the presumption of those who seek to conceal their asses' skin under the honourable spoils of the lion. And although time, who is called the father of truth, sooner or later makes manifest the real state of things, it is none the less true that for a certain space of time the true craftsman is robbed of the honour that is due to his labours; as happened to Piero della Francesca of Borgo a San Sepolcro. He, having been held a rare master of the difficulties of drawing regular bodies, as well as of arithmetic and geometry, was yet not able – being overtaken in his old age by the infirmity of blindness, and finally by the close of his life – to bring to light his noble labours and the many books written by him, which are still preserved in the Borgo, his native place. The very man who should have striven with all his might to increase the glory and fame of Piero, from whom he had learnt all that he knew, was impious and malignant enough to seek to blot out the name of his teacher, and to usurp for himself the honour that was due to the other, publishing under his own name, Fra Luca dal Borgo, all the labours of that good old man, who, besides the sciences named above, was excellent in painting.

Piero was born in Borgo a San Sepolcro, which is now a city, although it was not one then; and he was called Della Francesca after the name of his mother, because she had been left pregnant with him at the death of her husband, his father, and because it was she who had brought him up and assisted him to attain to the rank that his good-fortune held out to him. Piero applied

himself in his youth to mathematics, and although it was settled
when he was fifteen years of age that he was to be a painter, he
never abandoned this study; nay, he made marvellous progress
therein, as well as in painting. He was employed by Guidobaldo
Feltro the elder, Duke of Urbino, for whom he made many very
beautiful pictures with little figures, which have been for the most
part ruined on the many occasions when that state has been
harassed by wars. Nevertheless, there were preserved there some
of his writings on geometry and perspective, in which sciences he
was not inferior to any man of his own time, or perchance even
to any man of any other time; as is demonstrated by all his works,
which are full of perspectives, and particularly by a vase drawn
in squares and sides, in such a manner that the base and the
mouth can be seen from the front, from behind, and from the
sides; which is certainly a marvellous thing, for he drew the smal-
lest details therein with great subtlety, and foreshortened the cur-
ves of all the circles with much grace. Having thus acquired credit
and fame at that Court, he resolved to make himself known in
other places; wherefore he went to Pesaro and Ancona, whence,
in the very thick of his work, he was summoned by Duke Borso
to Ferrara, where he painted many apartments in his palace,
which were afterwards destroyed by Duke Ercole the elder in the
renovation of the palace, insomuch that there is nothing by the
hand of Piero left in that city, save a chapel wrought in fresco in
S. Agostino; and even that has been injured by damp. Afterwards,
being summoned to Rome, he painted two scenes for Pope
Nicholas V in the upper rooms of his palace, in competition with
Bramante da Milano; but these also were thrown to the ground
by Pope Julius II – to the end that Raffaello da Urbino might
paint there the Imprisonment of S. Peter and the Miracle of the
Corporale of Bolsena – together with certain others that had
been painted by Bramantino, an excellent painter in his day.

Now, seeing that I cannot write the life of this man, nor
particularize his works, because they have been ruined, I will not
grudge the labour of making some record of him, for it seems an
apt occasion. In the said works that were thrown to the ground,
so I have heard tell, he had made some heads from nature, so
beautiful and so well executed that speech alone was wanting to
give them life. Of these heads not a few have come to light,
because Raffaello da Urbino had them copied in order that he
might have the likenesses of the subjects, who were all people of

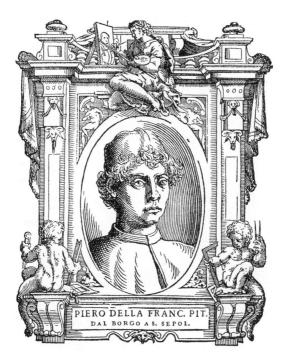

PIERO DELLA FRANC. PIT.
DAL BORGO A S. SEPOL.

importance; for among them were Niccolò Fortebraccio, Charles VII, King of France, Antonio Colonna, Prince of Salerno, Francesco Carmignuola, Giovanni Vitellesco, Cardinal Bessarione, Francesco Spinola, and Battista da Canneto. All these portraits were given to Giovio by Giulio Romano, disciple and heir of Raffaello da Urbino, and they were placed by Giovio in his museum at Como. Over the door of S. Sepolcro in Milan I have seen a Dead Christ wrought in foreshortening by the hand of the same man, in which, although the whole picture is not more than one braccio in height, there is an effect of infinite length, executed with facility and with judgment. By his hand, also, are some apartments and loggie in the house of the Marchesino Ostanesia in the same city, wherein there are many pictures wrought by him that show mastery and very great power in the foreshortening of the figures. And without the Porta Vercellina, near the Castle, in certain stables now ruined and destroyed, he painted some grooms currying horses, among which there was one so lifelike and so well wrought, that another horse, thinking it a real one, lashed out at it repeatedly with its hooves.

But to return to Piero della Francesca; his work in Rome finished, he returned to the Borgo, where his mother had just died; and on the inner side of the central door of the Pieve he painted two saints in fresco, which are held to be very beautiful. In the Convent of the Friars of S. Augustine he painted the panel of the high-altar, which was a thing much extolled; and he wrought in fresco a Madonna della Misericordia for a company, or rather, as they call it, a confraternity; with a Resurrection of Christ in the Palazzo de' Conservadori, which is held the best of all the works that are in the said city, and the best that he ever made. In company with Domenico da Vinezia, he painted the beginning of a work on the vaulting of the Sacristy of S. Maria at Loreto; but they left it unfinished from fear of plague, and it was afterwards completed by Luca da Cortona,* a disciple of Piero, as will be told in the proper place.

Going from Loreto to Arezzo, Piero painted for Luigi Bacci, a citizen of Arezzo, the Chapel of the High-altar of S. Francesco, belonging to that family, the vaulting of which had been already begun by Lorenzo di Bicci. In this work there are Stories of the Cross, from that wherein the sons of Adam are burying him and

* Luca Signorelli.

placing under his tongue the seed of the tree from which there came the wood for the said Cross, down to the Exaltation of the Cross itself performed by the Emperor Heraclius, who, walking barefoot and carrying it on his shoulder, is entering with it into Jerusalem. Here there are many beautiful conceptions and attitudes worthy to be extolled; such as, for example, the garments of the women of the Queen of Sheba, executed in a sweet and novel manner; many most lifelike portraits from nature of ancient persons; a row of Corinthian columns, divinely well proportioned; and a peasant who, leaning with his hands on his spade, stands listening to the words of S. Helena – while the three Crosses are being disinterred – with so great attention, that it would not be possible to improve it. Very well wrought, also, is the dead body that is restored to life at the touch of the Cross, together with the joy of S. Helena and the marvelling of the bystanders, who are kneeling in adoration. But above every other consideration, whether of imagination or of art, is his painting of Night, with an angel in foreshortening who is flying with his head downwards, bringing the sign of victory to Constantine, who is sleeping in a pavilion, guarded by a chamberlain and some men-at-arms who are seen dimly through the darkness of the night; and with his own light the angel illuminates the pavilion, the men-at-arms, and all the surroundings. This is done with very great thought, for Piero gives us to know in this darkness how important it is to copy things as they are and to ever take them from the true model; which he did so well that he enabled the moderns to attain, by following him, to that supreme perfection wherein art is seen in our own time. In this same story he represented most successfully in a battle fear, animosity, dexterity, vehemence, and all the other emotions that can be imagined in men who are fighting, and likewise all the incidents of battle, together with an almost incredible carnage, what with the wounded, the fallen, and the dead. In these Piero counterfeited in fresco the glittering of their arms, for which he deserves no less praise than he does for the flight and submersion of Maxentius painted on the other wall, wherein he made a group of horses in foreshortening, so marvellously executed that they can be truly called too beautiful and too excellent for those times. In the same story he made a man, half nude and half clothed in the dress of a Saracen, riding a lean horse, which reveals a very great mastery of anatomy, a science little known in his age. For this work,

therefore, he well deserved to be richly rewarded by Luigi Bacci, whom he portrayed there in the scene of the beheading of a King, together with Carlo and others of his brothers and many Aretines who were then distinguished in letters; and to be loved and revered ever afterwards, as he was, in that city, which he had made so illustrious with his works.

In the Vescovado of the same city, also, he made a S. Mary Magdalene in fresco beside the door of the sacristy; and for the Company of the Nunziata he painted the banner that is carried in processions. At the head of a cloister at S. Maria delle Grazie, without that district, he painted S. Donatus in his robes, seated in a chair drawn in perspective, together with certain boys; and in a niche high up on a wall of S. Bernardo, for the Monks of Monte Oliveto, he made a S. Vincent, which is much esteemed by craftsmen. In a chapel at Sargiano, a seat of the Frati Zoccolanti di S. Francesco, without Arezzo, he painted a very beautiful Christ praying by night in the Garden.

In Perugia, also, he wrought many works that are still to be seen in that city; as, for example, a panel in distemper in the Church of the Nuns of S. Anthony of Padua, containing a Madonna with the Child in her lap, S. Francis, S. Elizabeth, S. John the Baptist, and S. Anthony of Padua. Above these is a most beautiful Annunciation, with an Angel that seems truly to have come out of Heaven; and, what is more, a row of columns diminishing in perspective, which is indeed beautiful. In the predella there are scenes with little figures, representing S. Anthony restoring a boy to life; S. Elizabeth saving a child that has fallen into a well; and S. Francis receiving the Stigmata. In S. Ciriaco at Ancona, on the altar of S. Giuseppe, he painted a most beautiful scene of the Marriage of Our Lady.

Piero, as it has been said, was a very zealous student of art, and gave no little attention to perspective; and he had a very good knowledge of Euclid, insomuch that he understood all the best curves drawn in regular bodies better than any other geometrician, and the clearest elucidations of these matters that we have are from his hand. Now Maestro Luca dal Borgo, a friar of S. Francis, who wrote about the regular geometrical bodies, was his pupil; and when Piero, after having written many books, grew old and finally died, the said Maestro Luca, claiming the authorship of these books, had them printed as his own, for they had fallen into his hands after the death of Piero.

Piero was much given to making models in clay, on which he spread wet draperies with an infinity of folds, in order to make use of them for drawing.

A disciple of Piero was Lorentino d' Angelo of Arezzo, who made many pictures in Arezzo, imitating his manner, and completed those that Piero, overtaken by death, left unfinished. Near the S. Donatus that Piero wrought in the Madonna delle Grazie, Lorentino painted in fresco some stories of S. Donatus, with very many works in many other places both in that city and in the district, partly because he would never stay idle, and partly to assist his family, which was then very poor. In the said Church of the Grazie the same man painted a scene wherein Pope Sixtus IV, between the Cardinal of Mantua and Cardinal Piccolomini (who was afterwards Pope Pius III), is granting an indulgence to that place; in which scene Lorentino portrayed from the life, on their knees, Tommaso Marzi, Piero Traditi, Donato Rosselli, and Giuliano Nardi, all citizens of Arezzo and Wardens of Works for that building. In the hall of the Palazzo de' Priori, moreover, he portrayed from the life Cardinal Galeotto da Pietramala, Bishop Guglielmino degli Ubertini, and Messer Angelo Albergotti, Doctor of Laws; and he made many other works, which are scattered throughout that city.

It is said that once, when the Carnival was close at hand, the children of Lorentino kept beseeching him to kill a pig, as it is the custom to do in that district; and that, since he had not the means to buy one, they would say, 'What will you do about buying a pig, father, if you have no money?' To which Lorentino would answer, 'Some Saint will help us.' But when he had said this many times and the season was passing by without any pig appearing, they had lost hope, when at length there arrived a peasant from the Pieve a Quarto, who wished to have a S. Martin painted in fulfilment of a vow, but had no means of paying for the picture save a pig, which was worth five lire. This man, coming to Lorentino, told him that he wished to have the S. Martin painted, but that he had no means of payment save the pig. Whereupon they came to an agreement, and Lorentino painted him the Saint, while the peasant brought him the pig; and so the Saint provided the pig for the poor children of this painter.

Another disciple of Piero was Pietro da Castel della Pieve,* who painted an arch above S. Agostino, and a S. Urban for the

* Pietro Perugino.

Nuns of S. Caterina in Arezzo, which has been thrown to the ground in rebuilding the church. His pupil, likewise, was Luca Signorelli of Cortona, who did him more honour than all the others.

Piero Borghese, whose pictures date about the year 1458, became blind through an attack of catarrh at the age of sixty, and lived thus up to the eighty-sixth year of his life. He left very great possessions in the Borgo, with some houses that he had built himself, which were burnt and destroyed in the strife of factions in the year 1536. He was honourably buried by his fellow-citizens in the principal church, which formerly belonged to the Order of Camaldoli, and is now the Vescovado. Piero's books are for the most part in the library of Frederick II, Duke of Urbino, and they are such that they have deservedly acquired for him the name of the best geometrician of his time.

FRA GIOVANNI DA FIESOLE
[*FRA ANGELICO*],
Painter of the Order of Preaching Friars

FRA GIOVANNI ANGELICO DA FIESOLE, who was known in the world as Guido, was no less excellent as painter and illuminator than he was upright as churchman, and for both one and the other of these reasons he deserves that most honourable record should be made of him. This man, although he could have lived in the world with the greatest comfort, and could have gained whatever he wished, besides what he possessed, by means of those arts, of which he had a very good knowledge even in his youth, yet resolved, for his own peace and satisfaction, being by nature serious and upright, and above all in order to save his soul, to take the vows of the Order of Preaching Friars; for the reason that, although it is possible to serve God in all walks of life, nevertheless it appears to some men that they can gain salvation in monasteries better than in the world. Now in proportion as this plan succeeds happily for good men, so, on the contrary, it has a truly miserable and unhappy issue for a man who takes the vows with some other end in view.

There are some choral books illuminated by the hand of Fra Giovanni in his Convent of S. Marco in Florence, so beautiful that words are not able to describe them; and similar to these are some others that he left in S. Domenico da Fiesole, wrought with

incredible diligence. It is true, indeed, that in making these he was assisted by an elder brother, who was likewise an illuminator and well practised in painting.

One of the first works in painting wrought by this good father was a panel in the Certosa of Florence, which was placed in the principal chapel (belonging to Cardinal Acciaiuoli); in which panel is a Madonna with the Child in her arms, and with certain very beautiful angels at her feet, sounding instruments and singing; at the sides are S. Laurence, S. Mary Magdalene, S. Zanobi, and S. Benedict; and in the predella are little stories of these Saints, wrought in little figures with infinite diligence. In the cross of the said chapel are two other panels by the hand of the same man; one containing the Coronation of Our Lady, and the other a Madonna with two saints, wrought with most beautiful ultramarine blues. Afterwards, in the tramezzo* of S. Maria Novella, beside the door opposite to the choir, he painted in fresco S. Dominic, S. Catherine of Siena, and S. Peter Martyr; and some little scenes in the Chapel of the Coronation of Our Lady in the said tramezzo. On canvas, fixed to the doors that closed the old organ, he painted an Annunciation, which is now in the convent, opposite to the door of the lower dormitory, between one cloister and the other.

This father was so greatly beloved for his merits by Cosimo de' Medici, that, after completing the construction of the Church and Convent of S. Marco, he caused him to paint the whole Passion of Jesus Christ on a wall in the chapter-house; and on one side all the Saints who have been heads and founders of religious bodies, mourning and weeping at the foot of the Cross, and on the other side S. Mark the Evangelist beside the Mother of the Son of God, who has swooned at the sight of the Saviour of the world Crucified, while round her are the Maries, all grieving and supporting her, with S. Cosimo and S. Damiano. It is said that in the figure of S. Cosimo Fra Giovanni portrayed from the life Nanni d' Antonio di Banco, a sculptor and his friend. Below this work, in a frieze above the panelling, he made a tree with S. Dominic at the foot of it, and, in certain medallions encircled by the branches, all the Popes, Cardinals, Bishops, Saints, and Masters of Theology whom his Order of Preaching Friars had produced up to that time. In this work he made many portraits from nature, being assisted by the friars, who sent for them to

* See note on p. 90.

various places; and they were the following: S. Dominic in the middle, grasping the branches of the tree; Pope Innocent V, a Frenchman; the Blessed Ugone, first Cardinal of that Order; the Blessed Paolo, Florentine and Patriarch; S. Antonino, Archbishop of Florence; the Blessed Giordano, a German, and the second General of that Order; the Blessed Niccolò; the Blessed Remigio, a Florentine; and the martyr Boninsegno, a Florentine; all these are on the right hand. On the left are Benedict II* of Treviso; Giandomenico, a Florentine Cardinal; Pietro da Palude, Patriarch of Jerusalem; Alberto Magno, a German; the Blessed Raimondo di Catalonia, third General of the Order; the Blessed Chiaro, a Florentine, and Provincial of Rome; S. Vincenzio di Valenza; and the Blessed Bernardo, a Florentine. All these heads are truly gracious and very beautiful. Then, over certain lunettes in the first cloister, he made many very beautiful figures in fresco, and a Crucifix with S. Dominic at the foot, which is much extolled; and in the dormitory, besides many other things throughout the cells and on the surface of the walls, he painted a story from the New Testament, of a beauty beyond the power of words to describe. Particularly beautiful and marvellous is the panel of the high-altar of that church; for, besides the fact that the Madonna rouses all who see her to devotion by her simplicity, and that the Saints that surround her are like her in this, the predella, in which there are stories of the martyrdom of S. Cosimo, S. Damiano, and others, is so well painted, that one cannot imagine it possible ever to see a work executed with greater diligence, or little figures more delicate or better conceived than these are.

In S. Domenico da Fiesole, likewise, he painted the panel of the high-altar, which has been retouched by other masters and injured, perchance because it appeared to be spoiling. But the predella and the Ciborium of the Sacrament have remained in better preservation; and the innumerable little figures that are to be seen there, in a Celestial Glory, are so beautiful, that they appear truly to belong to Paradise, nor can any man who approaches them ever have his fill of gazing on them. In a chapel of the same church is a panel by his hand, containing the Annunciation of Our Lady by the Angel Gabriel, with features in profile, so devout, so delicate, and so well executed, that they appear truly to have been made rather in Paradise than by the hand of man;

* This seems to be a mistake for Benedict XI.

and in the landscape at the back are Adam and Eve, because of whom the Redeemer was born from the Virgin. In the predella, also, there are some very beautiful little scenes.

But superior to all the other works that Fra Giovanni made, and the one wherein he surpassed himself and gave supreme proof of his talent and of his knowledge of art, was a panel that is beside the door of the same church, on the left hand as one enters, wherein Jesus Christ is crowning Our Lady in the midst of a choir of angels and among an infinite multitude of saints, both male and female, so many in number, so well wrought, and with such variety in the attitudes and in the expressions of the heads, that incredible pleasure and sweetness are felt in gazing at them; nay, one is persuaded that those blessed spirits cannot look otherwise in Heaven, or, to speak more exactly, could not if they had bodies; for not only are all these saints, both male and female, full of life and sweet and delicate in expression, but the whole colouring of that work appears to be by the hand of a saint or an angel like themselves; wherefore it was with very good reason that this excellent monk was ever called Fra Giovanni Angelico. Moreover, the stories of the Madonna and of S. Dominic in the predella are divine in their own kind; and I, for one, can declare with truth that I never see this work without thinking it something new, and that I never leave it sated.

In the Chapel of the Nunziata in Florence which Piero di Cosimo de' Medici caused to be built, he painted the doors of the press (in which the silver is kept) with little figures executed with much diligence. This father painted so many pictures, now to be found in the houses of Florentine citizens, that I sometimes stand marvelling how one single man could execute so much work to such perfection, even in the space of many years. The Very Reverend Don Vincenzio Borghini, Director of the Hospital of the Innocenti, has a very beautiful little Madonna by the hand of this father; and Bartolommeo Gondi, as devoted a lover of these arts as any gentleman that one could think of, has a large picture, a small one, and a Crucifix, all by the same hand. The pictures that are in the arch over the door of S. Domenico are also by the same man; and in the Sacristy of S. Trinita there is a panel containing a Deposition from the Cross, into which he put so great diligence, that it can be numbered among the best works that he ever made. In S. Francesco, without the Porta a S. Miniato, there is an Annunciation; and in S. Maria Novella, besides the works already named, he painted

with little scenes the Paschal candle and some Reliquaries which are placed on the altar in the most solemn ceremonies.

Over a door of the cloister of the Badia in the same city he painted a S. Benedict, who is making a sign enjoining silence. For the Linen-manufacturers he painted a panel that is in the Office of their Guild; and in Cortona he painted a little arch over the door of the church of his Order, and likewise the panel of the high-altar. At Orvieto, on a part of the vaulting of the Chapel of the Madonna in the Duomo, he began certain prophets, which were finished afterwards by Luca da Cortona. For the Company of the Temple in Florence he painted a Dead Christ on a panel; and in the Church of the Monks of the Angeli he made a Paradise and a Hell with little figures, wherein he showed fine judgment by making the blessed very beautiful and full of jubilation and celestial gladness, and the damned all ready for the pains of Hell, in various most woeful attitudes, and bearing the stamp of their sins and unworthiness on their faces. The blessed are seen entering the gate of Paradise in celestial dance, and the damned are being dragged by demons to the eternal pains of Hell. This work is in the aforesaid church, on the right hand as one goes towards the high-altar, where the priest sits when Mass is sung. For the Nuns of S. Piero Martire – who now live in the Monastery of S. Felice in Piazza, which used to belong to the Order of Camaldoli – he painted a panel with Our Lady, S. John the Baptist, S. Dominic, S. Thomas, and S. Peter Martyr, and a number of little figures. And in the tramezzo* of S. Maria Nuova there may also be seen a panel by his hand.

These many labours having made the name of Fra Giovanni illustrious throughout all Italy, Pope Nicholas V sent for him and caused him to adorn that chapel of his Palace in Rome wherein the Pope hears Mass with a Deposition from the Cross and some very beautiful stories of S. Laurence, and also to illuminate some books, which are most beautiful. In the Minerva he painted the panel of the high-altar, and an Annunciation that is now set up against a wall beside the principal chapel. He also painted for the said Pope in the Palace the Chapel of the Sacrament, which was afterwards destroyed by Paul III in the making of a staircase through it. In that work, which was an excellent example of his manner, he had wrought in fresco some scenes from the life of

* See note on p. 90.

Jesus Christ, and he had made therein many portraits from life of distinguished persons of those times, which would probably now be lost if Giovio had not caused the following among them to be preserved for his museum – namely, Pope Nicholas V; the Emperor Frederick, who came to Italy at that time; Frate Antonino, who was afterwards Archbishop of Florence; Biondo da Forlì; and Ferrante of Arragon. Now Fra Giovanni appeared to the Pope to be, as indeed he was, a person of most holy life, peaceful and modest; and, since the Archbishopric of Florence was at that time vacant, the Pope had judged him worthy of that rank; but the said friar, hearing this, implored His Holiness to find another man, for the reason that he did not feel himself fitted for ruling others, whereas his Order contained a brother most learned and well able to govern, a God-fearing man and a friend of the poor, on whom that dignity would be conferred much more fittingly than on himself. The Pope, hearing this and remembering that what he said was true, granted him the favour willingly; and thus the Archbishopric of Florence was given to Frate Antonino of the Order of Preaching Friars, a man truly very famous both for sanctity and for learning, and of such a character, in short, that he was deservedly canonized in our own day by Adrian VI.

Great excellence was that of Fra Giovanni, and a thing truly very rare, to resign a dignity and honour and charge so important, offered to himself by a Supreme Pontiff, in favour of the man whom he, with his singleness of eye and sincerity of heart, judged to be much more worthy of it than himself. Let the churchmen of our own times learn from this holy man not to take upon themselves charges that they cannot worthily carry out, and to yield them to those who are most worthy of them. Would to God, to return to Fra Giovanni (and may this be said without offence to the upright among them), that all churchmen would spend their time as did this truly angelic father, seeing that he spent every minute of his life in the service of God and in benefiting both the world and his neighbour. And what can or ought to be desired more than to gain the kingdom of Heaven by living a life of holiness, and to win eternal fame in the world by labouring virtuously? And in truth a talent so extraordinary and so supreme as that of Fra Giovanni could not and should not descend on any save a man of most holy life, for the reason that those who work at religious and holy subjects should be religious and holy men; for it is seen, when such works are executed by

persons of little faith who have little esteem for religion, that they often arouse in men's minds evil appetites and licentious desires; whence there comes blame for the evil in their works, with praise for the art and ability that they show. Now I would not have any man deceive himself by considering the rude and inept as holy, and the beautiful and excellent as licentious; as some do, who, seeing figures of women or of youths adorned with loveliness and beauty beyond the ordinary, straightway censure them and judge them licentious, not perceiving that they are very wrong to condemn the good judgment of the painter, who holds the Saints, both male and female, who are celestial, to be as much more beautiful than mortal man as Heaven is superior to earthly beauty and to the works of human hands; and, what is worse, they reveal the unsoundness and corruption of their own minds by drawing evil and impure desires out of works from which, if they were lovers of purity, as they seek by their misguided zeal to prove themselves to be, they would gain a desire to attain to Heaven and to make themselves acceptable to the Creator of all things, in whom, as most perfect and most beautiful, all perfection and beauty have their source. What would such men do if they found themselves, or rather, what are we to believe that they do when they actually find themselves, in places containing living beauty, accompanied by licentious ways, honey-sweet words, movements full of grace, and eyes that ravish all but the stoutest of hearts, if the very image of beauty, nay, its mere shadow, moves them so profoundly? However, I would not have any believe that I approve of those figures that are painted in churches in a state of almost complete nudity, for in these cases it is seen that the painter has not shown the consideration that was due to the place; because, even although a man has to show how much he knows, he should proceed with due regard for circumstances and pay respect to persons, times, and places.

Fra Giovanni was a man of great simplicity, and most holy in his ways; and his goodness may be perceived from this, that, Pope Nicholas V wishing one morning to entertain him at table, he had scruples of conscience about eating meat without leave from his Prior, forgetting about the authority of the Pontiff. He shunned the affairs of the world; and, living a pure and holy life, he was as much the friend of the poor as I believe his soul to be now the friend of Heaven. He was continually labouring at his painting, and he would never paint anything save Saints. He

might have been rich, but to this he gave no thought; nay, he used to say that true riches consist only in being content with little. He might have ruled many, but he would not, saying that it was less fatiguing and less misleading to obey others. He had the option of obtaining dignities both among the friars and in the world, but he despised them, declaring that he sought no other dignity save that of seeking to avoid Hell and draw near to Paradise. And what dignity, in truth, can be compared to that which all churchmen, nay, all men, should seek, and which is to be found only in God and in a life of virtue? He was most kindly and temperate; and he lived chastely and withdrew himself from the snares of the world, being wont very often to say that he who pursued such an art had need of quiet and of a life free from cares, and that he whose work is connected with Christ must ever live with Christ. He was never seen in anger among his fellow-friars, which is a very notable thing, and almost impossible, it seems to me, to believe; and it was his custom to admonish his friends with a simple smile. With incredible sweetness, if any sought for works from him, he would say that they had only to gain the consent of the Prior, and that then he would not fail them. In short, this never to be sufficiently extolled father was most humble and modest in all his works and his discourse, and facile and devout in his pictures; and the Saints that he painted have more the air and likeness of Saints than those of any other man. It was his custom never to retouch or improve any of his pictures, but to leave them ever in the state to which he had first brought them; believing, so he used to say, that this was the will of God. Some say that Fra Giovanni would never have taken his brushes in his hand without first offering a prayer. He never painted a Crucifix without the tears streaming down his cheeks; wherefore in the countenances and attitudes of his figures one can recognize the goodness, nobility, and sincerity of his mind towards the Christian religion.

He died in 1455 at the age of sixty-eight, and left disciples in Benozzo, a Florentine, who ever imitated his manner, and Zanobi Strozzi, who painted pictures and panels throughout all Florence for the houses of citizens, and particularly a panel that is now in the tramezzo* of S. Maria Novella, beside that by Fra Giovanni, and one in S. Benedetto, a monastery of the Monks of

* See note on p. 90.

Camaldoli without the Porta a Pinti, now in ruins. The latter panel is at present in the little Church of S. Michele in the Monastery of the Angeli, before one enters the principal church, set up against the wall on the right as one approaches the altar. There is also a panel in the Chapel of the Nasi in S. Lucia, and another in S. Romeo; and in the guardaroba of the Duke there is the portrait of Giovanni di Bicci de' Medici, with that of Bartolommeo Valori, in one and the same picture by the hand of the same man. Another disciple of Fra Giovanni was Gentile da Fabriano, as was also Domenico di Michelino, who painted the panel for the altar of S. Zanobi in S. Apollinare at Florence, and many other pictures.

Fra Giovanni was buried by his fellow-friars in the Minerva in Rome, near the lateral door beside the sacristy, in a round tomb of marble, with himself, portrayed from nature, lying thereon. The following epitaph may be read, carved in the marble:

NON MIHI SIT LAUDI, QUOD ERAM VELUT ALTER APELLES,
 SED QUOD LUCRA TUIS OMNIA, CHRISTE, DABAM;
ALTERA NAM TERRIS OPERA EXTANT, ALTERA CŒLO.
 URBS ME JOANNEM FLOS TULIT ETRURIÆ.

In S. Maria del Fiore are two very large books illuminated divinely well by the hand of Fra Giovanni, which are held in great veneration and richly adorned, nor are they ever seen save on days of the highest solemnity.

A celebrated and famous illuminator at the same time as Fra Giovanni was one Attavante, a Florentine, of whom I know no other name. This man, among many other works, illuminated a Silius Italicus, which is now in S. Giovanni e Polo in Venice; of which work I will not withhold certain particulars, both because they are worthy of the attention of craftsmen, and because, to my knowledge, no other work by this master is to be found; nor should I know even of this one, had it not been for the affection borne to these noble arts by the Very Reverend Maestro Cosimo Bartoli, a gentleman of Florence, who gave me information about it, to the end that the talent of Attavante might not remain, as it were, buried out of sight.

In the said book, then, the figure of Silius has on the head a helmet with a crest of gold and a chaplet of laurel; he is wearing a blue cuirass picked out with gold in the ancient manner, while he is holding a book in his right hand, and the left he has on a short sword. Over the cuirass he has a red chlamys, fastened in

front with a knot, and fringed with gold, which hangs down from his shoulders. The inside of this chlamys is seen to be of changing colours and embroidered with gold. His buskins are yellow, and he is standing on his right foot in a niche. The next figure in this work represents Scipio Africanus. He is wearing a yellow cuirass, and his sword-belt and sleeves, which are blue in colour, are all embroidered with gold. On his head he has a helmet with two little wings and a fish by way of crest. The young man's countenance is fair and very beautiful; and he is raising his right arm proudly, holding in that hand a naked sword, while in the left hand he has the scabbard, which is red and embroidered with gold. The hose are green in colour and plain; and the chlamys, which is blue, has a red lining with a fringe of gold all round, and it is fastened at the throat, leaving the front quite open, and falling behind with beautiful grace. This young man, who stands in a niche of mixed green and grey marble, with blue buskins embroidered with gold, is looking with indescribable fierceness at Hannibal, who faces him on the opposite page of the book. This figure of Hannibal is that of a man about thirty-six years of age; he is frowning, with two furrows in his brow expressive of impatience and anger, and he, too, is looking fixedly at Scipio. On his head he has a yellow helmet, with a green and yellow dragon for crest and a serpent for chaplet. He is standing on his left foot and raising his right arm, with which he holds the shaft of an ancient javelin, or rather, of a little partisan. His cuirass is blue, his sword-belt partly blue and partly yellow, his sleeves of changing blue and red, and his buskins yellow. His chlamys, of changing red and yellow, is fastened on the right shoulder and lined with green; and, holding his left hand on his sword, he is standing in a niche of varicoloured marbles, yellow, white, and changing. On another page is Pope Nicholas V, portrayed from the life, with a mantle of changing purple and red and all embroidered with gold. He is without a beard and in full profile, and he is looking towards the beginning of the book, which is opposite to him; and he is pointing to it with his right hand, as though in a marvel. The niche is green, white, and red. Then in the border there are certain little half-length figures in an ornament composed of ovals and circles, and other things of that kind, together with an infinite number of little birds and children, so well wrought that nothing more could be desired. Close to this, in like manner, are Hanno the Carthaginian, Hasdrubal, Laelius,

Massinissa, C. Salinator, Nero, Sempronius, M. Marcellus, Q. Fabius, the other Scipio, and Vibius. At the end of the book there is seen a Mars in an antique chariot drawn by two reddish horses. On his head he has a helmet of red and gold, with two little wings; on his left arm he has an antique shield, which he holds before him, and in his right hand a naked sword. He is standing on his left foot only, holding the other in the air. He has a cuirass in the antique manner, all red and gold, as are his hose and his buskins. His chlamys is blue without, and within all green and embroidered with gold. The chariot is covered with red cloth embroidered with gold, with a border of ermine all round; and it stands in a verdant and flowery champaign country, surrounded by cliffs and rocks; while landscapes and cities are seen in the distance, with a sky of a most marvellous blue. On the opposite page is a young Neptune, whose clothing is in the shape of a long shirt, embroidered all round with the colour formed from terretta verde. The flesh-colour is very pale. In his right hand he is holding a little trident, and with his left he is raising his dress. He is standing with both feet on the chariot, which has a covering of red, embroidered with gold and fringed all round with sable. This chariot has four wheels, like that of Mars, but it is drawn by four dolphins, and accompanied by three sea-nymphs, two boys, and a great number of fishes, all wrought with a water-colour similar to the terretta, and very beautiful in expression. After these is seen Carthage in despair, in the form of a woman standing upright with dishevelled hair. Her upper garment is green, and it is open from the waist downwards, being lined with red cloth embroidered in gold; and through this opening there may be seen another garment, delicate and of changing purple and white colour. The sleeves are red and gold, with certain puffs and floating folds made by the upper garment, and she is stretching out her left hand towards Rome, who is opposite to her, as though saying, 'What is thy wish? I have my answer ready;' and in her right hand she holds a naked sword, with an air of frenzy. Her buskins are blue, and she is standing on a rock in the middle of the sea, surrounded by a very beautiful sky. Rome is a maiden as beautiful as it is possible for man to imagine, with dishevelled hair and certain tresses wrought with infinite grace. Her clothing is pure red, with only an embroidered border at the foot; the lining of her robe is yellow, and the garment beneath, which is seen through the opening, is of changing purple and

white. Her buskins are green; in her right hand she has a sceptre, in her left a globe; and she, too, is standing on a rock, in the midst of a sky that could not be more beautiful than it is. Now, although I have striven to the best of my power to show with what great art these figures were wrought by Attavante, let no one believe that I have said more than a very small part of what might be said about their beauty, seeing that, considering the time, there are no better examples of illumination to be seen, nor any work wrought with more invention, judgment, and design; and the colours, above all, could not be more beautiful or laid in their places more delicately, so perfect is their grace.

LEON BATISTA ALBERTI,
Architect of Florence

VERY great is the advantage bestowed by learning, without exception, on all those craftsmen who take delight in it, but particularly on sculptors, painters, and architects, for it opens up the way to invention in all the works that are made; not to mention that a man cannot have a perfect judgment, be his natural gifts what they may, if he is deprived of the complemental advantage of being assisted by learning. For who does not know that it is necessary, in choosing sites for buildings, to show enlightenment in the avoidance of danger from pestiferous winds, insalubrious air, and the smells and vapours of impure and unwholesome waters? Who is ignorant that a man must be able, in whatever work he is seeking to carry out, to reject or adopt everything for himself after mature consideration, without having to depend on help from another man's theory? For theory, when separated from practice, is generally of very little use; but when the two chance to come together, there is nothing that is more helpful to our life, both because art becomes much richer and more perfect by the aid of science, and because the counsels and the writings of learned craftsmen have in themselves greater efficacy and greater credit than the words or works of those who know nothing but mere practice, whether they do it well or ill. And that all this is true is seen manifestly in Leon Batista Alberti, who, having studied the Latin tongue, and having given attention to architecture, to perspective, and to painting, left behind him books written in such a manner, that, since not one of our modern

craftsmen has been able to expound these matters in writing, although very many of them in his own country have excelled him in working, it is generally believed – such is the influence of his writings over the pens and speech of the learned – that he was superior to all those who were actually superior to him in work. Wherefore, with regard to name and fame, it is seen from experience that writings have greater power and longer life than anything else; for books go everywhere with ease, and everywhere they command belief, if only they be truthful and not full of lies. It is no marvel, then, if the famous Leon Batista is known more for his writings than for the work of his hands.

This man, born in Florence of the most noble family of the Alberti, of which we have spoken in another place, devoted himself not only to studying geography and the proportions of antiquities, but also to writing, to which he was much inclined, much more than to working. He was excellent in arithmetic and geometry, and he wrote ten books on architecture in the Latin tongue, which were published by him in 1481, and may now be read in a translation in the Florentine tongue made by the Reverend Maestro Cosimo Bartoli, Provost of S. Giovanni in Florence. He wrote three books on painting, now translated into the Tuscan tongue by Messer Lodovico Domenichi; he composed a treatise on traction and on the rules for measuring heights, as well as the books on the 'Vita Civile,' and some erotic works in prose and verse; and he was the first who tried to reduce Italian verse to the measure of the Latin, as is seen in the following epistle by his pen:

> Questa per estrema miserabile pistola mando
> A te, che spregi miseramente noi.

Arriving at Rome in the time of Nicholas V, who had turned the whole of Rome upside down with his manner of building, Leon Batista, through the agency of Biondo da Forlì, who was much his friend, became intimate with that Pope, who had previously carried out all his building after the advice of Bernardo Rossellino, a sculptor and architect of Florence, as will be told in the Life of his brother Antonio. This man, having put his hand to restoring the Pope's Palace and to certain works in S. Maria Maggiore, thenceforward, according to the will of the Pope, ever sought the advice of Leon Batista. Wherefore, using one of them as adviser and the other as executor, the Pope carried out many useful and praiseworthy works, such as the restoring of the

conduit of the Acqua Vergine, which was in ruins; and there was made the fountain on the Piazza de' Trevi, with those marble ornaments that are seen there, on which are the arms of that Pontiff and of the Roman people.

Afterwards, having gone to Signor Sigismondo Malatesti of Rimini, he made for him the model of the Church of S. Francesco, and in particular that of the façade, which was made of marble; and likewise the side facing towards the south, which was built with very great arches and with tombs for the illustrious men of that city. In short, he brought that building to such a form that in point of solidity it is one of the most famous temples in Italy. Within it are six most beautiful chapels, one of which, dedicated to S. Jerome, is very ornate; and in it are preserved many relics brought from Jerusalem. In the same chapel are the tombs of the said Signor Sigismondo and of his wife, constructed very richly of marble in the year 1450; on one there is the portrait of Sigismondo himself, and in another part of the work there is that of Leon Batista.

After this, in the year 1457, when the very useful method of printing books was discovered by Johann Gutenberg the German, Leon Batista, working on similar lines, discovered a way of tracing natural perspectives and of effecting the diminution of figures by means of an instrument, and likewise the method of enlarging small things and reproducing them on a greater scale; all ingenious inventions, useful to art and very beautiful.

In Leon Batista's time Giovanni di Paolo Rucellai wished to build the principal façade of S. Maria Novella entirely of marble at his own expense, and he spoke of this to Leon Batista, who was very much his friend; and having received from him not only counsel, but the actual model, Giovanni resolved to have the work executed at all costs, in order to leave it behind him as a memorial of himself. A beginning having been made, therefore, it was finished in the year 1477, to the great satisfaction of all the city, which was pleased with the whole work, but particularly with the door, from which it is seen that Leon Batista took more than ordinary pains. For Cosimo Rucellai, likewise, he made the design for the palace which that man built in the street which is called La Vigna, and that for the loggia which is opposite to it. In the latter, having turned his arches over columns close together, both in the front and at the ends, since he wished to adhere to this plan and not to make one single arch, he had a certain space left

over on each side; wherefore he was forced to make certain projections at the inner corners. And then, when he wished to turn the arch of the inner vaulting, having seen that he could not give it the shape of a half-circle, which would have been flat and awkward, he resolved to turn certain small arches at the corners from one projection to another; and this lack of judgment in design gives us to know clearly that practice is necessary as well as science, for the judgment can never become perfect unless science attains to experience by actual work.

It is said that the same man made the design for the house and garden of these Rucellai in the Via della Scala. This house is built with much judgment and very commodious, for, besides many other conveniences, it has two loggie, one facing south and the other west, both very beautiful, and made without arches on the columns, which is the true and proper method that the ancients used, for the reason that the architraves which are placed on the capitals of the columns lie level, whereas a four-sided thing like a curving arch cannot rest on a round column without the corners jutting out over space. The good method, therefore, demands that architraves should rest on columns, and that, when arches are to be turned, pilasters and not columns should be made.

For the same Rucellai Leon Batista made a chapel in the same manner in S. Pancrazio, which rests on great architraves placed on two columns and two pilasters, piercing the wall of the church below; which is a difficult thing, but safe; wherefore this work is one of the best that this architect ever made. In the middle of this chapel is a tomb of marble, wrought very well in the form of a rather long oval, and similar, as may be read on it, to the Sepulchre of Jesus Christ in Jerusalem.

About the same time Lodovico Gonzaga, Marquis of Mantua, wished to build the tribune and the principal chapel in the Nunziata, the Church of the Servi in Florence, after the design and model of Leon Batista; and pulling down a square chapel, old, not very large, and painted in the ancient manner, which stood at the head of the church, he built the said tribune in the bizarre and difficult form of a round temple surrounded by nine chapels, all curving in a round arch, and each within in the shape of a niche. Now, since the arches of the said chapels rest on the pilasters in front, the result is that the stone dressings of the arches, inclining towards the wall, tend to draw ever backwards in order to meet the said wall, which turns in the opposite

direction according to the shape of the tribune; wherefore, when the said arches of the chapels are looked at from the side, it appears that they are falling backwards, and that they are clumsy, as indeed they are, although the proportions are correct, and the difficulties of the method must be remembered. Truly it would have been better if Leon Batista had avoided this method, for, although there is some credit for the difficulty of its execution, it is clumsy both in great things and in small, and it cannot have a good result. And that this is true of great things is proved by the great arch in front, which forms the entrance to the said tribune; for, although it is very beautiful on the outer side, on the inner side, where it has to follow the curve of the chapel, which is round, it appears to be falling backwards and to be extremely clumsy. This Leon Batista would perhaps not have done, if, in addition to science and theory, he had possessed practical experience in working; for another man would have avoided this difficulty, and would have rather aimed at grace and greater beauty for the edifice. The whole work is otherwise in itself very beautiful, bizarre, and difficult; and nothing save great courage could have enabled Leon Batista to vault that tribune in those times in the manner that he did. Being then summoned by the same Marquis Lodovico to Mantua, Leon Batista made for him the models of the Church of S. Andrea and of some other works; and on the road leading from Mantua to Padua there may be seen certain temples built after his manner. Many of the designs and models of Leon Batista were carried into execution by Salvestro Fancelli, a passing good architect and sculptor of Florence, who, according to the desire of the said Leon Batista, executed with judgment and extraordinary diligence all the works that he undertook in Florence. For those in Mantua he employed one Luca, a Florentine, who, living ever afterwards in that city and dying there, left his name – so Filarete tells us – to the family of the Luchi, which is still there to-day. It was no small good-fortune for him to have friends who understood him and were able and willing to serve him, because architects cannot be always standing over their work, and it is of the greatest use to them to have a faithful and loving assistant; and if any man ever knew it, I know it very well by long experience.

In painting Leon Batista did not do great or very beautiful works, for the few by his hand that are to be seen do not show much perfection; nor is this to be wondered at, seeing that he

devoted himself more to his studies than to draughtsmanship. Yet he could express his conceptions well enough in drawing, as may be seen from some sketches by his hand that are in our book, in which there are drawn the Bridge of S. Angelo and the covering that was made for it with his design in the form of a loggia, for protection from the sun in summer and from the rain and wind in winter. This work he was commissioned to execute by Pope Nicholas V, who had intended to carry out many similar works throughout the whole of Rome; but death intervened to hinder him. There is a work of Leon Batista's in a little Chapel of Our Lady on the abutment of the Ponte alla Carraja in Florence – namely, an altar-predella, containing three little scenes with some perspectives, which he was much more able to describe with the pen than to paint with the brush. In the house of the Palla Rucellai family, also in Florence, there is a portrait of himself made with a mirror; and a panel with rather large figures in chiaroscuro. He also made a picture of Venice in perspective, with S. Marco, but the figures therein were executed by other masters; and this is one of the best examples of his painting that there are to be seen.

Leon Batista was a person of most honest and laudable ways, the friend of men of talent, and very open and courteous to all; and he lived honourably and like a gentleman – which he was – through the whole course of his life. Finally, having reached a mature enough age, he passed content and tranquil to a better life, leaving a most honourable name behind him.

LAZZARO VASARI, Painter of Arezzo

TRULY great is the pleasure of those who find one of their ancestors and of their own family to have been distinguished and famous in some profession, whether that of arms, or of letters, or of painting, or any other noble calling whatsoever; and those men who find some honourable mention of one of their fore-fathers in history, if they gain nothing else thereby, have an incitement to virtue and a bridle to restrain them from doing anything unworthy of a family which has produced illustrious and very famous men. How great is this pleasure, as I said at the beginning, I have experienced for myself in finding that one

among my ancestors, Lazzaro Vasari, was famous as a painter in his day not only in his native place, but throughout all Tuscany; and that certainly not without reason, as I could clearly prove, if it were permissible for me to speak as freely of him as I have spoken of others. But, since I was born of his blood, it might be readily believed that I had exceeded all due bounds in praising him; wherefore, leaving on one side the merits of the man himself and of the family, I will simply tell what I cannot and should not under any circumstances withhold, if I would not fall short of the truth, on which all history hangs.

Lazzaro Vasari, then, a painter of Arezzo, was very much the friend of Piero della Francesca of Borgo a San Sepolcro, and ever held intercourse with him while Piero was working, as it has been said, in Arezzo. And, as it often comes to pass, this friendship brought him nothing but advantage, for the reason that, whereas Lazzaro had formerly devoted himself only to making little figures for certain works according to the custom of those times, he was persuaded by Piero della Francesca to set himself to do bigger things. His first work in fresco was a S. Vincent in S. Domenico at Arezzo, in the second chapel on the left as one enters the church; and at his feet he painted himself and his young son Giorgio kneeling, clothed in honourable costumes of those times, and recommending themselves to the Saint, because the boy had inadvertently cut his face with a knife. Although there is no inscription on this work, yet certain memories of old men belonging to our house, and the fact that it contains the Vasari arms, enable us to attribute it to him without a doubt. Of this there must certainly have been some record in that convent, but their papers and everything else have been destroyed many times by soldiers, and I do not marvel at the lack of records. The manner of Lazzaro was so similar to that of Piero Borghese, that very little difference could be seen between one and the other. Now it was very much the custom at that time to paint various things, such as the quarterings of arms, on the caparisons of horses, according to the rank of those who bore them; and in this work Lazzaro was an excellent master, and the rather as it was his province to make very graceful little figures, which were very well suited to such caparisons. Lazzaro wrought for Niccolò Piccino and for his soldiers and captains many things full of stories and arms, which were held in great price, with so much profit for himself, that the gains that he drew from this work enabled him

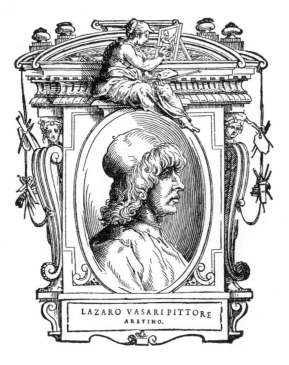

LAZARO VASARI PITTORE
ARETINO.

to recall to Arezzo many of his brothers, who were living at Cortona and working at the manufacture of earthenware vases. He also brought into his house his nephew, Luca Signorelli of Cortona, his sister's son, whom he placed, by reason of his good intelligence, with Piero Borghese, to the end that he might learn the art of painting; which he contrived to do very well, as will be told in the proper place.

Lazzaro, then, devoting himself continually to the study of art, became every day more excellent, as is shown by some very good drawings by his hand that are in our book. And because he took much pleasure in depicting certain natural effects full of emotions, in which he expressed very well weeping, laughing, crying, fear, trembling, and the like, his pictures are mostly full of such inventions; as may be seen in a little chapel painted in fresco by his hand in S. Gimignano at Arezzo, wherein there is a Crucifix, with the Madonna, S. John, and the Magdalene at the foot of the Cross, in various attitudes, and weeping so naturally, that they acquired credit and fame for him among his fellow-citizens. For the Company of S. Antonio, in the same city, he painted a cloth banner that is borne in processions, on which he wrought Jesus Christ at the Column, naked and bound and so lifelike, that He appears to be trembling, and, with His shoulders all drawn together, to be enduring with incredible humility and patience the blows that two Jews are giving Him. One of these, firmly planted on his feet, is plying his scourge with both his hands, turning his back towards Christ in an attitude full of cruelty. The other is seen in profile, raising himself on tip-toe; and grasping the scourge with his hands, and gnashing his teeth, he is wielding it with so great rage that words are powerless to express it. Both these men Lazzaro painted with their garments torn, the better to reveal the nude, contenting himself with covering after a fashion their private and less honourable parts. This work painted on cloth has lasted all these years – which truly makes me marvel – right up to our own day; and by reason of its beauty and excellence the men of that Company caused a copy to be made of it by the French Prior,* as we will relate in the proper place. At Perugia, also, Lazzaro wrought some stories of the Madonna, with a Crucifix, in a chapel beside the Sacristy of the Church of the Servi. In the Pieve of Montepulciano he executed a predella

* Guglielmo da Marcilla.

with little figures, and at Castiglione Aretino he painted a panel in distemper in S. Francesco; together with many other works, which, for the sake of brevity, I refrain from describing, more particularly many chests that are in the houses of citizens, which he painted with little figures. In the Palace of the Guelphs in Florence, among the ancient arms, there may be seen some caparisons wrought very well by him. He also painted a banner for the Company of S. Sebastiano, containing the said Saint at the column, with certain angels crowning him; but it is now spoilt and all eaten away by time.

In Lazzaro's time there was one who made glass windows in Arezzo, Fabiano Sassoli, a young Aretine of great excellence in that profession, as is proved by those of his works that are in the Vescovado, the Abbey, the Pieve, and other places in that city; but he knew little of design, and he was very far from reaching the excellence of those that Parri Spinelli made. Wherefore he determined that, even as he knew well how to fire, to put together, and to mount the glass, so he would make some work that should also be passing good with regard to the painting; and he caused Lazzaro to execute for him two cartoons of his own invention, in order to make two windows for the Madonna delle Grazie. Having obtained these from Lazzaro, who was his friend and a courteous craftsman, he made the said windows, which turned out so beautiful and so well wrought that there are not many to which they have to give precedence. In one there is a very beautiful Madonna; and in the other, which is by far the better of the two, there is the Resurrection of Christ, with an armed man in foreshortening in front of the Sepulchre; and it is a marvel, considering the small size of the window and consequently of the picture, how those figures can appear so large in so small a space. Many other things could I tell of Lazzaro, who was a very good draughtsman, as may be seen from certain drawings in our book; but I think it best for me to pass them by.

Lazzaro was a pleasant person and very witty in his speech; and although he was much given to pleasure, nevertheless he never strayed from the path of right living. His life lasted seventy-two years, and he left a son called Giorgio, who occupied himself continually with the ancient Aretine vases of terra-cotta; and at the time when Messer Gentile of Urbino, Bishop of Arezzo, was dwelling in that city, Giorgio rediscovered the method of giving red and black colours to terra-cotta vases, such as those that the

ancient Aretines made up to the time of King Porsena. Being a most industrious person, he made large vases with the potter's wheel, one braccio and a half in height, which are still to be seen in his house. Men say that while searching for vases in a place where he thought that the ancients had worked, he found three arches of their ancient furnaces three braccia below the surface in a field of clay near the bridge at Calciarella, a place called by that name; and round these he found some of the mixture for making the vases, and many broken ones, with four that were whole. These last were given by Giorgio, through the mediation of the Bishop, to the Magnificent Lorenzo de' Medici on his visiting Arezzo; wherefore they were the source and origin of his entering into the service of that most exalted family, in which he remained ever afterwards. Giorgio worked very well in relief, as may be seen from some heads by his hand that are in his house. He had five sons, who all followed the same calling; two of them, Lazzaro and Bernardo, were good craftsmen, of whom the latter died very young in Rome; and in truth, by reason of his intelligence, which is known to have been dexterous and ready, if death had not snatched him so prematurely from his house, he would have brought honour to his native place.

The elder Lazzaro died in 1452, and his son, Giorgio, died in 1484 at the age of sixty-eight; and both were buried in the Pieve of Arezzo at the foot of their own Chapel of S. Giorgio, where the following verses were set up after a time in praise of Lazzaro:

ARETII EXULTET TELLUS CLARISSIMA; NAMQUE EST
REBUS IN ANGUSTIS, IN TENUIQUE LABOR.
VIX OPERUM ISTIUS PARTES COGNOSCERE POSSIS:
MYRMECIDES TACEAT; CALLICRATES SILEAT.

Finally, the last Giorgio Vasari, writer of this history, in gratitude for the benefits for which he has to thank in great measure the excellence of his ancestors, having received the principal chapel of the said Pieve as a gift from his fellow-citizens and from the Wardens of Works and Canons, as was told in the Life of Pietro Laurati, and having brought it to the condition that has been described, has made a new tomb in the middle of the choir, which is behind the altar; and in this he has laid the bones of the said Lazzaro the elder and Giorgio the elder, having removed them from their former resting-place, and likewise those of all the other members of the said family, both male and

female; and thus he has made a new burial-place for all the descendants of the house of Vasari. In like manner, the body of his mother (who died in Florence in the year 1557), after having remained for some years in S. Croce, has been deposited by him in the said tomb, according to her own desire, together with Antonio, her husband and his father, who died of plague at the end of the year 1527. In the predella that is below the panel of the said altar there are portraits from nature, made by the said Giorgio, of Lazzaro, of the elder Giorgio, his grandfather, of his father Antonio, and of his mother Monna Maddalena de' Tacci. And let this be the end of the Life of Lazzaro Vasari, painter of Arezzo.

ANTONELLO DA MESSINA, Painter

WHEN I consider within my own mind the various qualities of the benefits and advantages that have been conferred on the art of painting by many masters who have followed the second manner, I cannot do otherwise than call them, by reason of their efforts, truly industrious and excellent, because they sought above all to bring painting to a better condition, without thinking of discomfort, expense, or any particular interest of their own. They continued, then, to employ no other method of colouring save that of distemper for panels and for canvases, which method had been introduced by Cimabue in the year 1250, when he was working with those Greeks, and had been afterwards followed by Giotto and by the others of whom we have spoken up to the present; and they were still adhering to the same manner of working, although the craftsmen recognized clearly that pictures in distemper were wanting in a certain softness and liveliness, which, if they could be obtained, would be likely to give more grace to their designs, loveliness to their colouring, and greater facility in blending the colours together; for they had ever been wont to hatch their works merely with the point of the brush. But although many had made investigations and sought for something of the sort, yet no one had found any good method, either by the use of liquid varnish or by the mixture of other kinds of colours with the distemper. Among many who made trial of these and other similar expedients, but all in vain, were Alesso Baldovinetti, Pesello, and many others, not one of whom

succeeded in giving to his works the beauty and excellence that he had imagined. And even if they had found what they were seeking, they still lacked the method of making their figures on panel adhere as well as those painted on walls, and also that of making them so that they could be washed without destroying the colours, and would endure any shock in handling. These matters a great number of craftsmen had discussed many times in common, but without result.

This same desire was felt by many lofty minds that were devoted to painting beyond the bounds of Italy – namely, by all the painters of France, Spain, Germany, and other countries. Now, while matters stood thus, it came to pass that, while working in Flanders, Johann* of Bruges, a painter much esteemed in those parts by reason of the great mastery that he had acquired in his profession, set himself to make trial of various sorts of colours, and, as one who took delight in alchemy, to prepare many kinds of oil for making varnishes and other things dear to men of inventive brain, such as he was. Now, on one occasion, having taken very great pains with the painting of a panel, and having brought it to completion with much diligence, he gave it the varnish and put it to dry in the sun, as is the custom. But, either because the heat was too violent, or perchance because the wood was badly joined together or not seasoned well enough, the said panel opened out at the joinings in a ruinous fashion. Whereupon Johann, seeing the harm that the heat of the sun had done to it, determined to bring it about that the sun should never again do such great damage to his works. And so, being disgusted no less with his varnish than with working in distemper, he began to look for a method of making a varnish that should dry in the shade, without putting his pictures in the sun. Wherefore, after he had made many experiments with substances both pure and mixed together, he found at length that linseed oil and oil of nuts dried more readily than all the others that he had tried. These, then, boiled together with other mixtures of his, gave him the varnish that he – nay, all the painters in the world – had long desired. Afterwards, having made experiments with many other substances, he saw that mixing the colours with those oils gave them a very solid consistency, not only securing the work, when dried, from all danger from water, but also making the colour so

* Jan van Eyck.

brilliant as to give it lustre by itself without varnish; and what appeared most marvellous to him was this, that it could be blended infinitely better than distemper. Rejoicing greatly over such a discovery, as was only reasonable, Johann made a beginning with many works and filled all those parts with them, with incredible pleasure for others and very great profit for himself; and, assisted by experience from day to day, he kept on ever making greater and better works.

No long time passed before the fame of his invention, spreading not only throughout Flanders but through Italy and many other parts of the world, awakened in all craftsmen a very great desire to know by what method he gave so great a perfection to his works. These craftsmen, seeing his works and not knowing what means he employed, were forced to extol him and to give him immortal praise, and at the same time to envy him with a blameless envy, the rather as he refused for some time to allow himself to be seen at work by anyone, or to reveal his secret to any man. At length, however, having grown old, he imparted it to Roger of Bruges, his pupil, who passed it on to his disciple Ausse* and to the others whom we have mentioned in speaking of colouring in oil with regard to painting. But with all this, although merchants did a great business in his pictures and sent them all over the world to Princes and other great persons, to their own great profit, yet the knowledge did not spread beyond Flanders; and although these pictures had a very pungent odour, given to them by the mixture of colours and oils, particularly when they were new, so that it seemed possible for the secret to be found out, yet for many years it was not discovered. But certain Florentines, who traded between Flanders and Naples, sent to King Alfonso I of Naples a panel with many figures painted in oil by Johann, which became very dear to that King both for the beauty of the figures and for the novel invention shown in the colouring; and all the painters in that kingdom flocked together to see it, and it was consummately extolled by all.

Now there was one Antonello da Messina, a person of good and lively intelligence, of great sagacity, and skilled in his profession, who, having studied design for many years in Rome, had first retired to Palermo, where he had worked for many years, and finally to his native place, Messina, where he had confirmed by his works the

* It is reasonable to suppose that this stands for Hans (Memling).

good opinion that his countrymen had of his excellent ability in painting. This man, then, going once on some business of his own from Sicily to Naples, heard that the said King Alfonso had received from Flanders the aforesaid panel by the hand of Johann of Bruges, painted in oil in such a manner that it could be washed, would endure any shock, and was in every way perfect. Thereupon, having contrived to obtain a view of it, he was so strongly impressed by the liveliness of the colours and by the beauty and harmony of that painting, that he put on one side all other business and every thought and went off to Flanders. Having arrived in Bruges, he became very intimate with the said Johann, making him presents of many drawings in the Italian manner and other things, insomuch that the latter, moved by this and by the respect shown by Antonello, and being now old, was content that he should see his method of colouring in oil; wherefore Antonello did not depart from that place until he had gained a thorough knowledge of that way of colouring, which he desired so greatly to know. And no long time after, Johann having died, Antonello returned from Flanders in order to revisit his native country and to communicate to all Italy a secret so useful, beautiful, and advantageous. Then, having stayed a few months in Messina, he went to Venice, where, being a man much given to pleasure and very licentious, he resolved to take up his abode and finish his life, having found there a mode of living exactly suited to his taste. And so, putting himself to work, he made there many pictures in oil according to the rules that he had learned in Flanders; these are scattered throughout the houses of noblemen in that city, where they were held in great esteem by reason of the novelty of the work. He made many others, also, which were sent to various places. Finally, having acquired fame and great repute there, he was commissioned to paint a panel that was destined for S. Cassiano, a parish church in that city. This panel was wrought by Antonio with all his knowledge and with no sparing of time; and when finished, by reason of the novelty of the colouring and the beauty of the figures, which he had made with good design, it was much commended and held in very great price. And afterwards, when men heard of the new secret that he had brought from Flanders to that city, he was ever loved and cherished by the magnificent noblemen of Venice throughout the whole course of his life.

Among the painters who were then in repute in Venice, a certain Maestro Domenico was held very excellent. This man, on

the arrival of Antonello in Venice, received him with such great
lovingness and courtesy, that he could not have shown more to
a very dear and cherished friend. For this reason Antonello, who
would not be beaten in courtesy by Maestro Domenico, after a
few months taught him the secret and method of colouring in
oil. Nothing could have been dearer to Domenico than this extra-
ordinary courtesy and friendliness; and well might he hold it dear,
since it caused him, as he had foreseen, to be greatly honoured
ever afterwards in his native city. Grossly deceived, in truth, are
those who think that, while they grudge to others even those
things that cost them nothing, they should be served by all for
the sake of their sweet smile, as the saying goes. The courtesies
of Maestro Domenico Viniziano wrested from the hands of
Antonello that which he had won for himself with so much
fatigue and labour, and which he would probably have refused to
hand over to any other even for a large sum of money. But since,
with regard to Maestro Domenico, we will mention in due time
all that he wrought in Florence, and who were the men with
whom he generously shared the secret that he had received as a
courteous gift from another, let us pass to Antonello.

After the panel for S. Cassiano, he made many pictures and
portraits for various Venetian noblemen. Messer Bernardo Vec-
chietti, the Florentine, has a painting by his hand of S. Francis
and S. Dominic, both in the one picture, and very beautiful.
Then, after receiving a commission from the Signoria to paint
certain scenes in their Palace (which they had refused to give to
Francesco di Monsignore of Verona, although he had been great-
ly favoured by the Duke of Mantua), he fell sick of a pleurisy
and died at the age of forty-nine, without having set a hand to
the work. He was greatly honoured in his obsequies by the
craftsmen, by reason of the gift bestowed by him on art in the
form of the new manner of colouring, as the following epitaph
testifies:

D. O. M.

ANTONIUS PICTOR, PRÆCIPUUM MESSANÆ SUÆ ET SICILIÆ
TOTIUS ORNAMENTUM, HAC HUMO CONTEGITUR. NON
SOLUM SUIS PICTURIS, IN QUIBUS SINGULARE ARTIFICIUM
ET VENUSTAS FUIT, SED ET QUOD COLORIBUS OLEO MISCEN-
DIS SPLENDOREM ET PERPETUITATEM PRIMUS ITALICÆ
PICTURÆ CONTULIT, SUMMO SEMPER ARTIFICIUM STUDIO
CELEBRATUS.

The death of Antonello was a great grief to his many friends, and particularly to the sculptor Andrea Riccio, who wrought the nude marble statues of Adam and Eve, held to be very beautiful, which are seen in the courtyard of the Palace of the Signoria in Venice. Such was the end of Antonello, to whom our craftsmen should certainly feel no less indebted for having brought the method of colouring in oil into Italy than they should to Johann of Bruges for having discovered it in Flanders. Both of them benefited and enriched the art; for it is by means of this invention that craftsmen have since become so excellent, that they have been able to make their figures all but alive. Their services should be all the more valued, inasmuch as there is no writer to be found who attributes this manner of colouring to the ancients; and if it could be known for certain that it did not exist among them, this age would surpass all the excellence of the ancients by virtue of this perfection. Since, however, even as nothing is said that has not been said before, so perchance nothing is done that has not been done before, I will let this pass without saying more; and praising consummately those who, in addition to draughtsmanship, are ever adding something to art, I will proceed to write of others.

ALESSO BALDOVINETTI, Painter of Florence

So great an attraction has the noble art of painting, that many eminent men have deserted the callings in which they might have become very rich, and, drawn by their inclination against the wishes of their parents, have followed the promptings of their nature and devoted themselves to painting, to sculpture, or to some similar pursuit. And, to tell the truth, if a man estimates riches at their true worth and no higher, and regards excellence as the end of all his actions, he acquires treasures very different from silver and gold; not to mention that he is never afraid of those things that rob us in a moment of those earthly riches, which are foolishly esteemed by men at more than their true value. Recognizing this, Alesso Baldovinetti, drawn by a natural inclination, abandoned commerce – in which his relatives had ever occupied themselves, insomuch that by practising it honourably they had acquired riches and lived like noble citizens – and devoted himself to painting, in which he showed a peculiar ability

to counterfeit very well the objects of nature, as may be seen in the pictures by his hand.

This man, while still very young, and almost against the wish of his father, who would have liked him to give his attention to commerce, devoted himself to drawing; and in a short time he made so much progress therein, that his father was content to allow him to follow the inclination of his nature. The first work that Alesso executed in fresco was in S. Maria Nuova, on the front wall of the Chapel of S. Gilio, which was much extolled at that time, because, among other things, it contained a S. Egidio that was held to be a very beautiful figure. In like manner, he painted in S. Trinita the chapel in fresco and the chief panel in distemper, for Messer Gherardo and Messer Bongianni Gian-figliazzi, most honourable and wealthy gentlemen of Florence. In this chapel Alesso painted some scenes from the Old Testament, which he first sketched in fresco and then finished on the dry, tempering his colours with yolk of egg mingled with a liquid varnish prepared over a fire. This vehicle, he thought, would preserve the paintings from damp; but it was so strong that where it was laid on too thickly the work has peeled off in many places; and thus, whereas he thought he had found a rare and very beautiful secret, he was deceived in his hopes.

He drew many portraits from nature, and in the scene of the Queen of Sheba going to hear the wisdom of Solomon, which he painted in the aforesaid chapel, he portrayed the Magnificent Lorenzo de' Medici, father of Pope Leo X, and Lorenzo della Volpaia, a most excellent maker of clocks and a very fine astrologer, who was the man who made for the said Lorenzo de' Medici the very beautiful clock that the Lord Duke Cosimo now has in his Palace; in which clock all the wheels of the planets are perpetually moving, which is a rare thing, and the first that was ever made in this manner. In the scene opposite to that one Alesso portrayed Luigi Guicciardini the elder, Luca Pitti, Dioti-salvi Neroni, and Giuliano de' Medici, father of Pope Clement VII; and beside the stone pilaster he painted Gherardo Gian-figliazzi the elder, the Chevalier Messer Bongianni, who is wearing a blue robe, with a chain round his neck, and Jacopo and Giovanni, both of the same family. Near these are Filippo Strozzi the elder and the astrologer Messer Paolo dal Pozzo Toscanelli. On the vaulting are four patriarchs, and on the panel is the Trinity, with S. Giovanni Gualberto kneeling, and another Saint.

All these portraits are very easily recognized from their similarity to those that are seen in other works, particularly in the houses of their descendants, whether in gesso or in painting. Alesso gave much time to this work, because he was very patient and liked to execute his works at his ease and convenience.

He drew very well, as may be seen from a mule drawn from nature in our book, wherein the curves of the hair over the whole body are done with much patience and with beautiful grace. Alesso was very diligent in his works, and he strove to be an imitator of all the minute details that Mother Nature creates. He had a manner somewhat dry and harsh, particularly in draperies. He took much delight in making landscapes, copying them from the life of nature exactly as they are; wherefore there are seen in his pictures streams, bridges, rocks, herbs, fruits, roads, fields, cities, castles, sand, and an infinity of other things of the kind. In the Nunziata at Florence, in the court, exactly behind the wall where the Annunciation itself is painted, he painted a scene in fresco, retouched on the dry, in which there is a Nativity of Christ, wrought with so great labour and diligence that one could count the stalks and knots of the straw in a hut that is there; and he also counterfeited there the ruin of a house with the stones mouldering, all eaten away and consumed by rain and frost, and a thick ivy root that covers a part of the wall, wherein it is to be observed that with great patience he made the outer side of the leaves of one shade of green, and the under side of another, as Nature does, neither more nor less; and, in addition to the shepherds, he made a serpent, or rather, a grass-snake, crawling up a wall, which is most life-like.

It is said that Alesso took great pains to discover the true method of making mosaic, but that he never succeeded in anything that he wanted to do, until at length he came across a German who was going to Rome to obtain some indulgences. This man he took into his house, and he gained from him a complete knowledge of the method and the rules for executing mosaic, insomuch that afterwards, having set himself boldly to work, he made some angels holding the head of Christ over the bronze doors of S. Giovanni, in the arches on the inner side. His good method of working becoming known by reason of this work, he was commissioned by the Consuls of the Guild of Merchants to clean and renovate all the vaulting of that church, which had been wrought, as has been said, by Andrea Tafi; for it

had been spoilt in many places, and was in need of being renewed
and restored. This he did with love and diligence, availing himself
for that purpose of a wooden staging made for him by Cecca,
who was the best architect of that age. Alesso taught the craft of
mosaic to Domenico Ghirlandajo, who portrayed him afterwards
near himself in the Chapel of the Tornabuoni in S. Maria Novel-
la, in the scene where Joachim is driven from the Temple, in the
form of a clean-shaven old man with a red cap on his head.

Alesso lived eighty years, and when he began to draw near to
old age, as one who wished to be able to attend with a quiet mind
to the studies of his profession, he retired into the Hospital of
S. Paolo, as many men are wont to do. And perhaps to the end
that he might be received more willingly and better treated (or it
may have been by chance), he had a great chest carried into his
rooms in the said hospital, giving out that it contained a good
sum of money. Wherefore the Director and the other officials of
the hospital, believing this to be true, and knowing that he had
bequeathed to the hospital all that might be found after his death,
showed him all the attention in the world. But on the death of
Alesso, there was nothing found in it save drawings, portraits on
paper, and a little book that explained the preparation of the
stones and stucco for mosaic and the method of using them. Nor
was it any marvel, so men said, that no money was found there,
because he was so open-handed that he had nothing that did not
belong as much to his friends as to himself.

A disciple of Alesso was the Florentine Graffione, who wrought
in fresco, over the door of the Innocenti, that figure of God the
Father and those angels that are still there. It is said that the
Magnificent Lorenzo de' Medici, conversing one day with
Graffione, who was an original, said to him, 'I wish to have all the
ribs of the inner cupola adorned with mosaic and stucco-work;'
and that Graffione replied, 'You have not the masters.' To which
Lorenzo answered, 'We have enough money to make some.'
Graffione instantly retorted, 'Ah, Lorenzo, 'tis not the money that
makes the masters, but the masters that make the money.' This
man was a bizarre and fantastic person. In his house he would
never eat off any table-cloth save his own cartoons, and he slept
in no other bed than a chest filled with straw, without sheets.

But to return to Alesso; he took leave of his art and of his life
in 1448, and he was honourably buried by his relatives and
fellow-citizens.

VELLANO DA PADOVA, Sculptor

So great is the effect of counterfeiting anything with love and diligence, that very often, when the manner of any master of these our arts has been well imitated by those who take delight in his works, the imitation resembles the thing imitated so closely, that no difference is discerned save by those who have a sharpness of eye beyond the ordinary; and it rarely comes to pass that a loving disciple fails to learn, at least in great measure, the manner of his master.

Vellano da Padova strove with so great diligence to counterfeit the manner and the method of Donato in sculpture, particularly in bronze, that in his native city of Padua he was left the heir to the excellence of the Florentine Donatello; and to this witness is borne by his works in the Santo, which nearly every man that has not a complete knowledge of the matter attributes to Donato, so that every day many are deceived, if they are not informed of the truth. This man, then, fired by the great praise that he heard given to Donato, the sculptor of Florence, who was then working in Padua, and by a desire for those profits that come into the hands of good craftsmen through the excellence of their works, placed himself under Donato in order to learn sculpture, and devoted himself to it in such a manner, that, with the aid of so great a master, he finally achieved his purpose; wherefore, before Donatello had finished his works and departed from Padua, Vellano had made such great progress in the art that great expectations were already entertained about him, and he inspired such confidence in his master as to induce him (and that rightly) to leave to his pupil all the equipment, designs, and models for the scenes in bronze that were to be made round the choir of the Santo in that city. This was the reason why, when Donato departed, as has been said, the commission for the whole of that work was publicly given to Vellano in his native city, to his very great honour. Whereupon he made all the scenes in bronze that are on the outer side of the choir of the Santo, wherein, among others, there is the scene of Samson embracing the column and destroying the temple of the Philistines, in which one sees the fragments of the ruined building duly falling, and the death of so many people, not to mention a great diversity of attitudes among them as they die, some through the ruins, and

some through fear; and all this Vellano represented marvellously. In the same place are certain works in wax and the models for these scenes, and likewise some bronze candelabra wrought by the same man with much judgment and invention. From what we see, this craftsman appears to have had a very great desire to attain to the standard of Donatello; but he did not succeed, for he aimed too high in a most difficult art.

Vellano also took delight in architecture, and was more than passing good in that profession; wherefore, having gone to Rome in the year 1464, at the time of Pope Paul the Venetian, for which Pontiff Giuliano da Maiano was architect in the building of the Vatican, he too was employed in many things; and by his hand, among other works that he made, are the arms of that Pontiff which are seen there with his name beside them. He also wrought many of the ornaments of the Palace of S. Marco for the same Pope, whose head, by the hand of Vellano, is at the top of the staircase. For that building the same man designed a stupendous courtyard, with a commodious and elegant flight of steps, but the death of the Pontiff intervened to hinder the completion of the whole. The while that he stayed in Rome, Vellano made many small things in marble and in bronze for the said Pope and for others, but I have not been able to find them. In Perugia the same master made a bronze statue larger than life, in which he portrayed the said Pope from nature, seated in his pontifical robes; and at the foot of this he placed his name and the year when it was made. This figure is in a niche of several kinds of stone, wrought with much diligence, without the door of S. Lorenzo, which is the Duomo of that city. The same man made many medals, some of which are still to be seen, particularly that of the aforesaid Pope, and those of Antonio Rosello of Arezzo and Batista Platina, both Secretaries to that Pontiff.

Having returned after these works to Padua with a very good name, Vellano was held in esteem not only in his native city, but in all Lombardy and in the March of Treviso, both because up to that time there had been no craftsmen of excellence in those parts, and because he had very great skill in the founding of metals. Afterwards, when Vellano was already old, the Signoria of Venice determined to have an equestrian statue of Bartolommeo da Bergamo made in bronze; and they allotted the horse to Andrea del Verrocchio of Florence, and the figure to Vellano. On hearing this, Andrea, who thought that the whole work should

fall to him, knowing himself to be, as indeed he was, a better master than Vellano, flew into such a rage that he broke up and destroyed the whole model of the horse that he had already finished, and went off to Florence. But after a time, being recalled by the Signoria, who gave him the whole work to do, he returned once more to finish it; at which Vellano felt so much displeasure that he departed from Venice, without saying a word or expressing his resentment in any manner, and returned to Padua, where he afterwards lived in honour for the rest of his life, contenting himself with the works that he had made and with being loved and honoured, as he ever was, in his native place. He died at the age of ninety-two, and was buried in the Santo with that distinction which his excellence, having honoured both himself and his country, had deserved. His portrait was sent to me from Padua by certain friends of mine, who had it, so they told me, from the very learned and very reverend Cardinal Bembo, whose love of our arts was no less remarkable than his supremacy over all other men of our age in all the rarest qualities and gifts both of mind and body.

FRA FILIPPO LIPPI, Painter of Florence

FRA FILIPPO DI TOMMASO LIPPI, a Carmelite, was born in Florence in a street called Ardiglione, below the Canto alla Cuculia and behind the Convent of the Carmelites. By the death of his father Tommaso he was left a poor little orphan at the age of two, with no one to take care of him, for his mother had also died not long after giving him birth. He was left, therefore, in the charge of one Mona Lapaccia, his aunt, sister of his father, who brought him up with very great inconvenience to herself; and when he was eight years of age and she could no longer support him, she made him a friar in the aforesaid Convent of the Carmine. Living there, in proportion as he showed himself dexterous and ingenious in the use of his hands, so was he dull and incapable of making any progress in the learning of letters, so that he would never apply his intelligence to them or regard them as anything save his enemies. This boy, who was called by his secular name of Filippo, was kept with others in the noviciate under the discipline of the schoolmaster, in order to see what he could do; but in place of studying he would never do anything save

deface his own books and those of the others with caricatures. Whereupon the Prior resolved to give him every opportunity and convenience for learning to paint. There was then in the Carmine a chapel that had been newly painted by Masaccio, which, being very beautiful, pleased Fra Filippo so greatly that he would haunt it every day for his recreation; and continually practising there in company with many young men, who were ever drawing in it, he surpassed the others by a great measure in dexterity and knowledge, insomuch that it was held certain that in time he would do something marvellous. Nay, not merely in his maturity, but even in his early childhood, he executed so many works worthy of praise that it was a miracle. It was no long time before he wrought in terra-verde in the cloister, close to the Consecration painted by Masaccio, a Pope confirming the Rule of the Carmelites; and he painted pictures in fresco on various walls in many parts of the church, particularly a S. John the Baptist with some scenes from his life. And thus, making progress every day, he had learnt the manner of Masaccio very well, so that he made his works so similar to those of the other that many said that the spirit of Masaccio had entered into the body of Fra Filippo. On a pilaster in the church, close to the organ, he made a figure of S. Marziale which brought him infinite fame, for it could bear comparison with the works that Masaccio had painted. Wherefore, hearing himself so greatly praised by the voices of all, at the age of seventeen he boldly threw off his monastic habit.

Now, chancing to be in the March of Ancona, he was disporting himself one day with some of his friends in a little boat on the sea, when they were all captured together by the Moorish galleys that were scouring those parts, and taken to Barbary, where each of them was put in chains and held as a slave; and thus he remained in great misery for eighteen months. But one day, seeing that he was thrown much into contact with his master, there came to him the opportunity and the whim to make a portrait of him; whereupon, taking a piece of dead coal from the fire, with this he portrayed him at full length on a white wall in his Moorish costume. When this was reported by the other slaves to the master (for it appeared a miracle to them all, since drawing and painting were not known in these parts), it brought about his liberation from the chains in which he had been held for so long. Truly glorious was it for this art to have caused one to whom the power of condemnation and punishment was granted by law, to

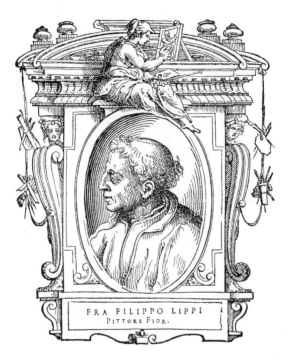

FRA FILIPPO LIPPI
PITTORE FIOR.

do the very opposite – nay, in place of inflicting pains and death, to consent to show friendliness and grant liberty! After having wrought some works in colour for his master, he was brought safely to Naples, where he painted for King Alfonso, then Duke of Calabria, a panel in distemper for the Chapel of the Castle, where the guard-room now is.

After this there came upon him a desire to return to Florence, where he remained for some months. There he wrought a very beautiful panel for the high-altar of the Nuns of S. Ambrogio, which made him very dear to Cosimo de' Medici, who became very much his friend for this reason. He also painted a panel for the Chapter-house of S. Croce, and another that was placed in the chapel of the house of the Medici, on which he painted the Nativity of Christ. For the wife of the said Cosimo, likewise, he painted a panel with the same Nativity of Christ and with S. John the Baptist, which was to be placed in the Hermitage of Camaldoli, in one of the hermits' cells, dedicated to S. John the Baptist, which she had caused to be built in proof of her devotion. And he painted some little scenes that were sent by Cosimo as a gift to Pope Eugenius IV, the Venetian; wherefore Fra Filippo acquired great favour with that Pope by reason of this work.

It is said that he was so amorous, that, if he saw any women who pleased him, and if they were to be won, he would give all his possessions to win them; and if he could in no way do this, he would paint their portraits and cool the flame of his love by reasoning with himself. So much a slave was he to this appetite, that when he was in this humour he gave little or no attention to the works that he had undertaken; wherefore on one occasion Cosimo de' Medici, having commissioned him to paint a picture, shut him up in his own house, in order that he might not go out and waste his time; but after staying there for two whole days, being driven forth by his amorous – nay, beastly – passion, one night he cut some ropes out of his bed-sheets with a pair of scissors and let himself down from a window, and then abandoned himself for many days to his pleasures. Thereupon, since he could not be found, Cosimo sent out to look for him, and finally brought him back to his labour; and thenceforward Cosimo gave him liberty to go out when he pleased, repenting greatly that he had previously shut him up, when he thought of his madness and of the danger that he might run. For this reason he strove to keep a hold on him for the future by kindnesses; and so he was served by Filippo with greater readiness,

and was wont to say that the virtues of rare minds were celestial beings, and not slavish hacks.

For the Church of S. Maria Primerana, on the Piazza of Fiesole, he painted a panel containing the Annunciation of Our Lady by the Angel, which shows very great diligence, and there is such beauty in the figure of the Angel that it appears truly a celestial thing. For the Nuns of the Murate he painted two panels: one, containing an Annunciation, is placed on the high-altar; and the other is on an altar in the same church, and contains stories of S. Benedict and S. Bernard. In the Palace of the Signoria he painted an Annunciation on a panel, which is over a door; and over another door in the said Palace he also painted a S. Bernard. For the Sacristy of S. Spirito in Florence he executed a panel with the Madonna surrounded by angels, and with saints on either side – a rare work, which has ever been held in the greatest veneration by the masters of these our arts. In the Chapel of the Wardens of Works in S. Lorenzo he wrought a panel with another Annunciation; with one for the Della Stufa Chapel, which he did not finish. For a chapel in S. Apostole, in the same city, he painted a panel with some figures round a Madonna. In Arezzo, by order of Messer Carlo Marsuppini, he painted the panel of the Chapel of S. Bernardo for the Monks of Monte Oliveto, depicting therein the Coronation of Our Lady, surrounded by many saints; which picture has remained so fresh, that it appears to have been made by the hand of Fra Filippo at the present day. It was then that he was told by the aforesaid Messer Carlo to give attention to the painting of the hands, seeing that his works were much criticized in this respect; wherefore from that day onwards, in painting hands, Fra Filippo covered the greater part of them with draperies or with some other contrivance, in order to avoid the aforesaid criticism. In this work he portrayed the said Messer Carlo from the life.

For the Nuns of Annalena in Florence he painted a Manger on a panel; and some of his pictures are still to be seen in Padua. He sent two little scenes with small figures, painted by his hand, to Cardinal Barbo in Rome; these were very excellently wrought, and executed with great diligence. Truly marvellous was the grace with which he painted, and very perfect the harmony that he gave to his works, for which he has been ever esteemed by craftsmen and honoured by our modern masters with consummate praise; nay, so long as the voracity of time allows his many excellent

labours to live, he will be held in veneration by every age. In Prato, near Florence, where he had some relatives, he stayed for many months, executing many works throughout that whole district in company with Fra Diamante, a friar of the Carmine, who had been his comrade in the noviciate. After this, having been commissioned by the Nuns of S. Margherita to paint the panel of their high-altar, he was working at this when there came before his eyes a daughter of Francesco Buti, a citizen of Florence, who was living there as a ward or as a novice. Having set eyes on Lucrezia (for this was the name of the girl), who was very beautiful and graceful, Fra Filippo contrived to persuade the nuns to allow him to make a portrait of her for a figure of Our Lady in the work that he was doing for them. With this opportunity he became even more enamoured of her, and then wrought upon her so mightily, what with one thing and another, that he stole her away from the nuns and took her off on the very day when she was going to see the Girdle of Our Lady, an honoured relic of that township, being exposed to view. Whereupon the nuns were greatly disgraced by such an event, and her father, Francesco, who never smiled again, made every effort to recover her; but she, either through fear or for some other reason, refused to come back – nay, she insisted on staying with Filippo, to whom she bore a male child, who was also called Filippo, and who became, like his father, a very excellent and famous painter.

In S. Domenico, in the aforesaid Prato, there are two of his panels; and in the tramezzo* of the Church of S. Francesco there is a Madonna, in the removing of which from the place where it was at first, it was cut out from the wall on which it was painted, in order not to spoil it, and bound round with wood, and then transported to that wall of the church where it is still to be seen to-day. In a courtyard of the Ceppo of Francesco di Marco, over a well, there is a little panel by the hand of the same man, containing the portrait of the said Francesco di Marco, the creator and founder of that holy place. In the Pieve of the said township, on a little panel over the side-door as one ascends the steps, he painted the Death of S. Bernard, by the touch of whose bier many cripples are being restored to health. In this picture are friars bewailing the death of their master, and it is a marvellous thing to see the beautiful expression of the sadness of lamenta-

* See note on p. 90.

tion in the heads, counterfeited with great art and resemblance to nature. Here there are draperies in the form of friars' gowns with most beautiful folds, which deserve infinite praise for their good design, colouring, and composition; not to mention the grace and proportion that are seen in the said work, which was executed with the greatest delicacy by the hand of Fra Filippo. The Wardens of Works for the said Pieve, in order to have some memorial of him, commissioned him to paint the Chapel of the High-Altar in that place; and he gave great proof of his worth in that work, which, besides its general excellence and masterliness, contains most admirable draperies and heads. He made the figures therein larger than life, thus introducing to our modern craftsmen the method of giving grandeur to the manner of our own day. There are certain figures with garments little used in those times, whereby he began to incite the minds of men to depart from that simplicity which should be called rather old-fashioned than ancient. In the same work are the stories of S. Stephen (the titular Saint of the said Pieve), distributed over the wall on the right hand – namely, the Disputation, the Stoning, and the Death of that Protomartyr, in whose face, as he disputes with the Jews, Filippo depicted so much zeal and so much fervour, that it is a difficult thing to imagine it, and much more to express it; and in the faces and the various attitudes of the Jews he revealed their hatred, disdain, and anger at seeing themselves overcome by him. Even more clearly did he make manifest the brutality and rage of those who are slaying him with stones, which they have grasped, some large, some small, with a horrible gnashing of teeth, and with gestures wholly cruel and enraged. None the less, amid so terrible an onslaught, S. Stephen, raising his countenance with great calmness to Heaven, is seen making supplication to the Eternal Father with the warmest love and fervour for the very men who are slaying him. All these conceptions are truly very beautiful, and serve to show to others how great is the value of invention and of knowing how to express emotions in pictures; and this he remembered so well, that in those who are burying S. Stephen he made gestures so dolorous, and some faces so afflicted and broken with weeping, that it is scarcely possible to look at them without being moved. On the other side he painted the Birth of S. John the Baptist, the Preaching, the Baptism, the Feast of Herod, and the Beheading of the Saint. Here, in his countenance as he is preaching, there is

seen the Divine Spirit; with various emotions in the multitude that is listening, joy and sorrow both in the women and in the men, who are all hanging intently on the teaching of S. John. In the Baptism are seen beauty and goodness; and, in the Feast of Herod, the majesty of the banquet, the dexterity of Herodias, the astonishment of the company, and their immeasurable grief when the severed head is presented in the charger. Round the banqueting-table are seen innumerable figures with very beautiful attitudes, and with good execution both in the draperies and in the expressions of the faces. Among these, with a mirror, he portrayed himself dressed in the black habit of a prelate; and he made a portrait of his disciple Fra Diamante among those who are bewailing S. Stephen. This work is in truth the most excellent of all his paintings, both for the reasons mentioned above, and because he made the figures somewhat larger than life, which encouraged those who came after him to give grandeur to their manner. So greatly was he esteemed for his excellent gifts, that many circumstances in his life that were worthy of blame were passed over in consideration of the eminence of his great talents. In this work he portrayed Messer Carlo, the natural son of Cosimo de' Medici, who was then Provost of that church, which received great benefactions from him and from his house.

In the year 1463, when he had finished this work, he painted a panel in distemper, containing a very beautiful Annunciation, for the Church of S. Jacopo in Pistoia, by order of Messer Jacopo Bellucci, of whom he made therein a most vivid portrait from the life. In the house of Pulidoro Bracciolini there is a picture by his hand of the Birth of Our Lady; and in the Hall of the Tribunal of Eight in Florence he painted in distemper a Madonna with the Child in her arms, on a lunette. In the house of Lodovico Capponi there is another picture with a very beautiful Madonna; and in the hands of Bernardo Vecchietti, a gentleman of Florence and a man of a culture and excellence beyond my power of expression, there is a little picture by the hand of the same man, containing a very beautiful S. Augustine engaged in his studies. Even better is a S. Jerome in Penitence, of the same size, in the guardaroba of Duke Cosimo; for if Fra Filippo was a rare master in all his pictures, he surpassed himself in the small ones, to which he gave such grace and beauty that nothing could be better, as may be seen in the predelle of all the panels that he painted. In

short, he was such that none surpassed him in his own times, and few in our own; and Michelagnolo has not only always extolled him, but has imitated him in many things.

For the Church of S. Domenico Vecchio in Perugia, also, he painted a panel that was afterwards placed on the high-altar, containing a Madonna, S. Peter, S. Paul, S. Louis, and S. Anthony the Abbot. Messer Alessandro degli Alessandri, a Chevalier of that day and a friend of Filippo, caused him to paint a panel for the church of his villa at Vincigliata on the hill of Fiesole, containing a S. Laurence and other Saints, among whom he portrayed Alessandro and two sons of his.

Fra Filippo was much the friend of gay spirits, and he ever lived a joyous life. He taught the art of painting to Fra Diamante, who executed many pictures in the Carmine at Prato; and he did himself great credit by the close imitation of his master's manner, for he attained to the greatest perfection. Sandro Botticelli, Pesello, and Jacopo del Sellaio of Florence worked with Fra Filippo in their youth (the last-named painted two panels in S. Friano, and one wrought in distemper in the Carmine), with a great number of other masters, to whom he ever taught the art with great friendliness. He lived honourably by his labours, spending extraordinary sums on the pleasures of love, in which he continued to take delight right up to the end of his life. He was requested by the Commune of Spoleto, through the mediation of Cosimo de' Medici, to paint the chapel in their principal church (dedicated to Our Lady), which he brought very nearly to completion, working in company with Fra Diamante, when death intervened to prevent him from finishing it. Some say, indeed, that in consequence of his great inclination for his blissful amours some relations of the lady that he loved had him poisoned.

Fra Filippo finished the course of his life in 1438, at the age of fifty-seven, and left a will entrusting to Fra Diamante his son Filippo, a little boy of ten years of age, who learnt the art of painting from his guardian. Fra Diamante returned with him to Florence, carrying away three hundred ducats, which remained to be received from the Commune of Spoleto for the work done; with these he bought some property for himself, giving but a little share to the boy. Filippo was placed with Sandro Botticelli, who was then held a very good master; and the old man was buried in a tomb of red and white marble, which the people of

Spoleto caused to be erected in the church that he had been painting.

His death grieved many friends, particularly Cosimo de' Medici, as well as Pope Eugenius, who offered in his life-time to give him a dispensation, so that he might make Lucrezia, the daughter of Francesco Buti, his legitimate wife; but this he refused to do, wishing to have complete liberty for himself and his appetites.

While Sixtus IV was alive, Lorenzo de' Medici became ambassador to the Florentines, and made the journey to Spoleto, in order to demand from that community the body of Fra Filippo, to the end that it might be laid in S. Maria del Fiore in Florence; but their answer to him was that they were lacking in ornaments, and above all in distinguished men, for which reason they demanded Filippo from him as a favour in order to honour themselves, adding that since there was a vast number of famous men in Florence, nay, almost a superfluity, he should consent to do without this one; and more than this he could not obtain. It is true, indeed, that afterwards, having determined to do honour to him in the best way that he could, he sent his son Filippino to Rome to paint a chapel for the Cardinal of Naples; and Filippino, passing through Spoleto, caused a tomb of marble to be erected for him at the commission of Lorenzo, beneath the organ and over the sacristy, on which he spent one hundred ducats of gold, which were paid by Nofri Tornabuoni, master of the bank of the Medici; and Lorenzo also caused Messer Angelo Poliziano to write the following epigram, which is carved on the said tomb in antique lettering:

CONDITUS HIC EGO SUM PICTURÆ FAMA PHILIPPUS;
 NULLI IGNOTA MEÆ EST GRATIA MIRA MANUS.
ARTIFICES POTUI DIGITIS ANIMARE COLORES,
 SPERATAQUE ANIMOS FALLERE VOCE DIU.
IPSA MEIS STUPUIT NATURA EXPRESSA FIGURIS,
 MEQUE SUIS FASSA EST ARTIBUS ESSE PAREM.
MARMOREO TUMULO MEDICES LAURENTIUS HIC ME
 CONDIDIT; ANTE HUMILI PULVERE TECTUS ERAM.

Fra Filippo was a very good draughtsman, as may be seen in our book of drawings by the most famous painters, particularly in some wherein the panel of S. Spirito is drawn, with others showing the chapel in Prato.

PAOLO ROMANO AND MAESTRO MINO
[*MINO DEL REGNO, OR MINO DEL REAME*],
Sculptors, AND CHIMENTI CAMICIA, Architect

W E have now to speak of Paolo Romano and Mino del Regno, who were contemporaries and of the same profession, but very different in character and in knowledge of art, for Paolo was modest and quite able, and Mino much less able, but so presumptuous and arrogant, that he was not only overbearing in his actions, but also with his speech exalted his own works beyond all due measure. When Pope Pius II gave a commission for a figure to the Roman sculptor Paolo, Mino tormented and persecuted him out of envy so greatly, that Paolo, who was a good and most modest man, was forced to show resentment. Whereupon Mino, falling into a rage with Paolo, offered to bet a thousand ducats that he would make a figure better than Paolo's; and this he said with the greatest presumption and effrontery, knowing the nature of Paolo, who disliked any annoyance, and believing that he would not accept such a challenge. But Paolo accepted the invitation, and Mino, half repentant, bet a hundred ducats merely to save his honour. The figures finished, the victory was given to Paolo as a rare and excellent master, which he was; and Mino was scorned as the sort of craftsman whose words were worth more than his works.

By the hand of Mino are certain works in marble at Naples, and a tomb at Monte Cassino, a seat of the Black Friars in the kingdom of Naples; the S. Peter and the S. Paul that are at the foot of the steps of S. Pietro in Rome, and the tomb of Pope Paul II in S. Pietro. The figure that Paolo made in competition with Mino was the S. Paul that is to be seen on a marble base at the head of the Ponte S. Angelo, which stood unnoticed for a long time in front of the Chapel of Sixtus IV. It afterwards came to pass that one day Pope Clement VII observed this figure, which pleased him greatly, for he was a man of knowledge and judgment in such matters; wherefore he determined to have a S. Peter made of the same size, and also, after removing two little chapels of marble, dedicated to those Apostles, which stood at the head of the Ponte S. Angelo and obstructed the view of the Castle, to put these two statues in their place.

It may be read in the work of Antonio Filarete that Paolo was not only a sculptor but also an able goldsmith, and that he wrought

part of the twelve Apostles in silver which stood, before the sack of Rome, over the altar of the Papal Chapel. Part of the work of these statues was done by Niccolò della Guardia and Pietro Paolo da Todi, disciples of Paolo, who were afterwards passing good masters in sculpture, as is seen from the tombs of Pope Pius II and Pope Pius III, on which the said Pontiffs are portrayed from nature. By the hand of the same men are medals of three Emperors and other great persons. The said Paolo made a statue of an armed man on horseback, which is now on the ground in S. Pietro, near the Chapel of S. Andrea. A pupil of Paolo was the Roman Gian Cristoforo, who was an able sculptor; and there are certain works by his hand in S. Maria Trastevere and in other places.

Chimenti Camicia, of whose origin nothing is known save that he was a Florentine, was employed in the service of the King of Hungary, for whom he made palaces, gardens, fountains, churches, fortresses, and many other buildings of importance, with ornaments, carvings, decorated ceilings, and other things of the kind, which were executed with much diligence by Baccio Cellini. After these works, drawn by love for his country, Chimenti returned to Florence, whence he sent to Baccio (who remained there), as presents for the King, certain pictures by the hand of Berto Linaiuolo, which were held very beautiful in Hungary and much extolled by that King. This Berto (of whom I will not refrain from making this record as well), after having painted many pictures in a beautiful manner, which are in the houses of many citizens, died at the very height of his powers, cutting short the great expectations that had been formed of him. But to return to Chimenti; he had not been long in Florence when he returned to Hungary, where he continued to serve the King; but while he was journeying on the Danube in order to give designs for mills, in consequence of fatigue he was seized by a sickness, which carried him off in a few days to the other life. The works of these masters date about the year 1470.

About the same time, during the pontificate of Pope Sixtus IV, there lived in Rome one Baccio Pintelli, a Florentine, who was rewarded for the great skill that he had in architecture by being employed by that Pope in all his building enterprises. With his design, then, were built the Church and Convent of S. Maria del Popolo, and certain highly ornate chapels therein, particularly that of Domenico della Rovere, Cardinal of San Clemente and nephew of that Pope. The same Pontiff erected a palace in Borgo

Vecchio after the design of Baccio, which was then held to be a very beautiful and well-planned edifice. The same master built the Great Library under the apartments of Niccola, and that chapel in the Palace that is called the Sistine, which is adorned with beautiful paintings. He also rebuilt the structure of the new Hospital of S. Spirito in Sassia (which was burnt down almost to the foundations in the year 1471), adding to it a very long loggia and all the useful conveniences that could be desired. Within the hospital, along its whole length, he caused scenes to be painted from the life of Pope Sixtus, from his birth up to the completion of that building – nay, up to the end of his life. He also made the bridge that is called the Ponte Sisto, from the name of that Pontiff; this was held to be an excellent work, because Baccio built it with such stout piers and with the weight so well distributed, that it is very strong and very well founded. In the year of the Jubilee of 1475, likewise, he built many new little churches throughout Rome, which are recognized by the arms of Pope Sixtus – in particular, S. Apostolo, S. Pietro in Vincula, and S. Sisto. For Cardinal Guglielmo, Bishop of Ostia, he made the model of his church, with that of the façade and of the steps, in the manner wherein they are seen to-day. Many declare that the design of the Church of S. Pietro a Montorio in Rome was by the hand of Baccio, but I cannot say with truth that I have found this to be so. This church was built at the expense of the King of Portugal, almost at the same time that the Spanish nation had the Church of S. Jacopo erected in Rome.

The talent of Baccio was so highly esteemed by that Pontiff, that he would never have done anything in the way of building without his counsel; wherefore, in the year 1480, hearing that the Church and Convent of S. Francesco at Assisi were threatening to fall, he sent Baccio thither; and he, making a very stout counterfort on the side of the plain, rendered that marvellous fabric perfectly secure. On one buttress he placed a statue of that Pontiff, who, not many years before, had caused to be made in that same convent many apartments, in the form of chambers and halls, which are known not only by their magnificence but also by the arms of the said Pope that are seen in them. In the courtyard there is one coat of arms much larger than the others, with some Latin verses in praise of Pope Sixtus IV, who gave many proofs that he held that holy place in great veneration.

ANDREA DAL CASTAGNO OF MUGELLO AND DOMENICO VINIZIANO
[*ANDREA DEGL' IMPICCATI AND DOMENICO DA VENEZIA*],
Painters

How reprehensible is the vice of envy, which should never exist in anyone, when found in a man of excellence, and how wicked and horrible a thing it is to seek under the guise of a feigned friendship to extinguish not only the fame and glory of another but his very life, I truly believe it to be impossible to express with words, for the wickedness of the act overcomes all power and force of speech, however eloquent. For this reason, without enlarging further on this subject, I will only say that in such men there dwells a spirit not merely inhuman and savage but wholly cruel and devilish, and so far removed from any sort of virtue that they are no longer men or even animals, and do not deserve to live. For even as emulation and rivalry, when men seek by honest endeavour to vanquish and surpass those greater than themselves in order to acquire glory and honour, are things worthy to be praised and to be held in esteem as necessary and useful to the world, so, on the contrary, the wickedness of envy deserves a proportionately greater meed of blame and vituperation, when, being unable to endure the honour and esteem of others, it sets to work to deprive of life those whom it cannot despoil of glory; as did that miserable Andrea dal Castagno who was truly great and excellent in painting and design, but even more notable for the rancour and envy that he bore towards other painters, insomuch that with the blackness of his crime he concealed and obscured the splendour of his talents.

This man, having been born at a small village called Castagno in Mugello, in the territory of Florence, took that name as his own surname when he came to live in Florence, which came about in the following manner. Having been left without a father in his earliest childhood, he was adopted by an uncle, who employed him for many years in watching his herds, since he saw him to be very ready and alert, and so masterful, that he could look after not only his cattle but the pastures and everything else that touched his own interest. Now, while he was following this calling, it came to pass one day that he chanced to seek shelter

from the rain in a place wherein one of those local painters, who work for small prices, was painting a shrine for a peasant. Whereupon Andrea, who had never seen anything of the kind before, was seized by a sudden marvel and began to look most intently at the work and to study its manner; and there came to him on the spot a very great desire and so violent a love for that art, that without losing time he began to scratch drawings of animals and figures on walls and stones with pieces of charcoal or with the point of his knife, in so masterly a manner that it caused no small marvel to all who saw them. The fame of this new study of Andrea's then began to spread among the peasants; whereupon, as his good-fortune would have it, the matter coming to the ears of a Florentine gentleman named Bernardetto de' Medici, whose possessions were in that district, he expressed a wish to know the boy; and finally, having seen him and having heard him discourse with great readiness, he asked him whether he would like to learn the art of painting. Andrea answered that nothing could happen to him that would be more welcome or more pleasing than this, and Bernardetto took the boy with him to Florence, to the end that he might become perfect in that art, and set him to work with one of those masters who were then esteemed the best.

Thereupon Andrea, following the art of painting and devoting himself heart and soul to its studies, displayed very great intelligence in the difficulties of that art, above all in draughtsmanship. But he was not so successful in the colouring of his works, which he made somewhat crude and harsh, thus impairing to a great extent their excellence and grace, and depriving them, above all, of a certain quality of loveliness, which is not found in his colouring. He showed very great boldness in the movements of his figures and much vehemence in the heads both of men and of women, making them grave in aspect and excellent in draughtsmanship. There are works coloured in fresco, painted by his hand in his early youth, in the cloister of S. Miniato al Monte as one descends from the church to go into the convent, including a story of S. Miniato and S. Cresci leaving their father and mother. In S. Benedetto, a most beautiful monastery without the Porta a Pinti, both in a cloister and in the church, there were many pictures by the hand of Andrea, of which there is no need to make mention, since they were thrown to the ground in the siege of Florence. Within the city, in the first cloister of the Monastery of the Monks of the Angeli, opposite to the principal

door, he painted the Crucifix that is still there to-day, with the Madonna, S. John, S. Benedict, and S. Romualdo; and at the head of the cloister, which is above the garden, he made another like it, only varying the heads and a few other details. In S. Trinita, beside the Chapel of Maestro Luca, he painted a S. Andrew. In a hall at Legnaia he painted many illustrious men for Pandolfo Pandolfini; and a standard to be borne in processions, which is held very beautiful, for the Company of the Evangelist.

In certain chapels of the Church of the Servi in the said city he wrought three flat niches in fresco. In one of these, that of S. Giuliano, there are scenes from the life of that Saint, with a good number of figures, and a dog in foreshortening that was much extolled. Above this, in the chapel dedicated to S. Girolamo, he painted that Saint shaven and wasted away, with good design and great diligence. Over this he painted a Trinity, with a Crucifix so well foreshortened that Andrea deserves to be greatly extolled for it, seeing that he executed the foreshortenings with a much better and more modern manner than the others before him had shown; but this picture, having been afterwards covered with a panel by the family of the Montaguti, can no longer be seen. In the third, which is beside the one below the organ, and which was erected by Messer Orlando de' Medici, he painted Lazarus, Martha, and the Magdalene. For the Nuns of S. Giuliano, over their door, he made a Crucifix in fresco, with a Madonna, a S. Dominic, a S. Julian, and a S. John; which picture, one of the best that Andrea ever made, is universally praised by all craftsmen.

In the Chapel of the Cavalcanti in S. Croce he painted a S. John the Baptist and a S. Francis, which are held to be very good figures. But what caused all the craftsmen to marvel was a very beautiful picture in fresco that he made at the head of the new cloister of the said convent, opposite to the door, of Christ being scourged at the Column, wherein he painted a loggia with columns in perspective, and groined vaulting with diminishing lines, and walls inlaid in a pattern of mandorle, with so much art and so much diligence, that he showed that he had no less knowledge of the difficulties of perspective than he had of design in painting. In the same scene there are beautiful and most animated attitudes in those who are scourging Christ, showing hatred and rage in their faces as clearly as Jesus Christ is showing patience and humility. In the body of Christ, which is bound tightly with ropes to the Column, it appears that Andrea tried to demonstrate

the suffering of the flesh, while the Divinity concealed in that body maintains a certain noble splendour, which seems to be moving Pilate, who is seated among his councillors, to seek to find some means of liberating Him. In short, this picture is such that, if the little care that has been taken of it had not allowed it to be scratched and spoilt by children and simpletons, who have scratched all the heads and the arms and almost the entire persons of the Jews, as though they would thus take vengeance on them for the wrongs of Our Lord, it would certainly be the most beautiful of all the works of Andrea. And if Nature had given grace of colouring to this craftsman, even as she gave him invention and design, he would have been held truly marvellous.

In S. Maria del Fiore he painted the image of Niccolò da Tolentino on horseback; and while he was working at this a boy who was passing shook his ladder, whereupon he flew into such a rage, like the brutal man that he was, that he jumped down and ran after him as far as the Canto de' Pazzi. In the cemetery of S. Maria Nuova, also, below the Ossa, he painted a S. Andrew, which gave so much satisfaction that he was afterwards commissioned to paint the Last Supper of Christ with His Apostles in the refectory, where the nurses and other attendants have their meals. Having acquired favour through this work with the house of Portinari and with the Director of the hospital, he was appointed to paint a part of the principal chapel, of which another part was allotted to Alesso Baldovinetti, and the third to the then greatly celebrated painter Domenico da Venezia, who had been summoned to Florence by reason of the new method that he knew of painting in oil. Now, while each of them applied himself to his part of the work, Andrea was very envious of Domenico, because, while knowing himself to be superior to the other in design, he was much displeased that the Venetian, although a foreigner, should be welcomed and entertained by the citizens; wherefore anger and disdain moved him so strongly, that he began to think whether he could not in one way or another remove him from his path. Andrea was no less crafty in dissimulation than he was excellent in painting, being cheerful of countenance at his pleasure, ready of speech, fiery in spirit, and as resolute in every bodily action as he was in mind; he felt towards others as he did towards Domenico, and, if he saw some error in the works of other craftsmen, he was wont to mark it secretly with his nail. And in his youth, when his works

were criticized in any respect, he would give the critics to know by means of blows and insults that he was ever able and willing to take revenge in one way or another for any affront.

But let us say something of Domenico, before we come to the work of the said chapel. Before coming to Florence, Domenico had painted some pictures with much grace in the Sacristy of S. Maria at Loreto, in company with Piero della Francesca; which pictures, besides what he had wrought in other places (such as an apartment in the house of the Baglioni in Perugia, which is now in ruins), had made his fame known in Florence. Being summoned to that city, before doing anything else, he painted a Madonna in the midst of some saints, in fresco, in a shrine on the Canto de' Carnesecchi, at the corner of two streets, of which one leads to the new Piazza di S. Maria Novella and the other to the old. This work, being approved and greatly extolled by the citizens and by the craftsmen of those times, caused even greater disdain and envy to blaze up in the accursed mind of Andrea against poor Domenico; wherefore Andrea, having determined to effect by deceit and treachery what he could not carry out openly without manifest peril to himself, pretended to be very much the friend of Domenico, who, being a good and affectionate fellow, fond of singing and devoted to playing on the lute, received him as a friend very willingly, thinking Andrea to be a clever and amusing person. And so, continuing this friendship, so true on one side and so false on the other, they would come together every night to make merry and to serenade their mistresses; and this gave great delight to Domenico, who, loving Andrea sincerely, taught him the method of colouring in oil, which as yet was not known in Tuscany.

Andrea, then (to take events in their due order), working on his wall in the Chapel of S. Maria Nuova, painted an Annunciation, which is held very beautiful, for in that work he painted the Angel in the air, which had never been done up to that time. But a much more beautiful work is held to be that wherein he made the Madonna ascending the steps of the Temple, on which he depicted many beggars, and one among them hitting another on the head with a pitcher; and not only that figure but all the others are wondrously beautiful, for he wrought them with much care and love, out of rivalry with Domenico. There is seen, also, in the middle of a square, an octagonal temple drawn in perspective, standing by itself and full of pilasters and niches, with the

façade very richly adorned with figures painted to look like marble. Round the square are various very beautiful buildings; and on one side of these there falls the shadow of the temple, caused by the light of the sun – a beautiful conception, carried out with great ingenuity and art.

Maestro Domenico, on his part, painting in oil, represented Joachim visiting his consort S. Anna, and below this the Birth of Our Lady, wherein he depicted a very ornate chamber, and a boy beating very gracefully with a hammer on the door of the said chamber. Beneath this he painted the Marriage of the Virgin, with a good number of portraits from the life, among which are those of Messer Bernardetto de' Medici, Constable of the Florentines, wearing a large red barret-cap; Bernardo Guadagni, who was Gonfalonier; Folco Portinari, and others of that family. He also painted a dwarf breaking a staff, very life-like, and some women wearing garments customary in those times, lovely and graceful beyond belief. But this work remained unWnished, for reasons that will be told below.

Meanwhile Andrea had painted in oil on his wall the Death of Our Lady, in which, both by reason of his rivalry with Domenico and in order to make himself known for the able master that he truly was, he wrought in foreshortening, with incredible diligence, a bier containing the dead Virgin, which appears to be three braccia in length, although it is not more than one and a half. Round her are the Apostles, wrought in such a manner, that, although there is seen in their faces their joy at seeing their Madonna borne to Heaven by Jesus Christ, there is also seen in them their bitter sorrow at being left on earth without her. Among the Apostles are some angels holding burning lights, with beautiful expressions in their faces, and so well executed that it is seen that he was as well able to manage oil-colours as his rival Domenico. In these pictures Andrea made portraits from life of Messer Rinaldo degli Albizzi, Puccio Pucci, and Falganaccio, who brought about the liberation of Cosimo de' Medici, together with Federigo Malevolti, who held the keys of the Alberghetto. In like manner he portrayed Messer Bernardo di Domenico della Volta, Director of that hospital, who is kneeling and appears to be alive; and in a medallion at the beginning of the work he painted himself with the face of Judas Iscariot, whom he resembled both in appearance and in deed.

Now Andrea, having carried this work very nearly to completion, being blinded by envy of the praises that he heard given to

the talent of Domenico, determined to remove him from his path; and after having thought of many expedients, he put one of them into execution in the following manner. One summer evening, according to his custom, Domenico took his lute and went forth from S. Maria Nuova, leaving Andrea in his room drawing, for he had refused to accept the invitation to take his recreation with Domenico, under the pretext of having to do certain drawings of importance. Domenico therefore went to take his pleasure by himself, and Andrea set himself to wait for him in hiding behind a street corner; and when Domenico, on his way home, came up to him, he crushed his lute and his stomach at one and the same time with certain pieces of lead, and then, thinking that he had not yet finished him off, beat him grievously on the head with the same weapons; and finally, leaving him on the ground, he returned to his room in S. Maria Nuova, where he put the door ajar and sat down to his drawing in the manner that he had been left by Domenico. Meanwhile an uproar had arisen, and the servants, hearing of the matter, ran to call Andrea and to give the bad news to the murderer and traitor himself, who, running to where the others were standing round Domenico, was not to be consoled, and kept crying out: 'Alas, my brother! Alas, my brother!' Finally Domenico expired in his arms; nor could it be discovered, for all the diligence that was used, who had murdered him; and if Andrea had not revealed the truth in confession on his death-bed, it would not be known now.

In S. Miniato fra le Torri in Florence Andrea painted a panel containing the Assumption of Our Lady, with two figures; and in a shrine in the Nave a Lanchetta, without the Porta alla Croce, he painted a Madonna. In the house of the Carducci, now belonging to the Pandolfini, the same man depicted certain famous men, some from imagination and some portrayed from life, among whom are Filippo Spano degli Scolari, Dante, Petrarca, Boccaccio, and others. At Scarperia in Mugello, over the door of the Vicar's Palace, he painted a very beautiful nude figure of Charity, which has since been ruined. In the year 1478, when Giuliano de' Medici was killed and his brother Lorenzo wounded in S. Maria del Fiore by the family of the Pazzi and their adherents and fellow-conspirators, it was ordained by the Signoria that all those who had shared in the plot should be painted as traitors on the wall of the Palace of the Podestà. This work was offered to Andrea, and he, as a servant and debtor of the house of

Medici, accepted it very willingly, and, taking it in hand, executed it so beautifully that it was a miracle. It would not be possible to express how much art and judgment were to be seen in those figures, which were for the most part portraits from life, and which were hung up by the feet in strange attitudes, all varied and very beautiful. This work, which pleased the whole city and particularly all who had understanding in the art of painting, brought it about that from that time onwards he was called no longer Andrea dal Castagno but Andrea degl' Impiccati.*

Andrea lived in honourable style, and since he spent his money freely, particularly on dress and on maintaining a fine household, he left little property when he passed to the other life at the age of seventy-one. But since the crime that he had committed against Domenico, who loved him so, became known a short time after his death, it was with shameful obsequies that he was buried in S. Maria Nuova, where, at the age of fifty-six, the unhappy Domenico had also been buried. The work begun by the latter in S. Maria Nuova remained unfinished, nor did he ever complete it, as he had done the panel of the high-altar in S. Lucia de' Bardi, wherein he executed with much diligence a Madonna with the Child in her arms, S. John the Baptist, S. Nicholas, S. Francis, and S. Lucia; which panel he had brought to perfect completion a little before he was murdered.

Disciples of Andrea were Jacopo del Corso, who was a passing good master, Pisanello, Marchino, Piero del Pollaiuolo, and Giovanni da Rovezzano.

GENTILE DA FABRIANO
AND VITTORE PISANELLO OF VERONA†,
Painters

VERY great is the advantage enjoyed by one who follows in the steps of a predecessor who has gained honour and fame by means of some rare talent, for the reason that, if only he follows to some extent the path prepared by his master, he seldom fails

* *I.e.*, hung up.

† It has recently been shown that Pisanello's name was not Vittore but Antonio; see article by G. F. Hill, on p. 288, vol. xiii. of the *Burlington Magazine*. In the translation, however, Vittore, the name given by Vasari, will be kept.

to arrive without much fatigue at an honourable goal; whereas, if he had to reach it by himself, he would have need of a much longer time and far greater labours. The truth of this could be seen, ready for the finger to point to, as the saying is, among many other examples, in that of Pisano, or rather, Pisanello, a painter of Verona, who, having spent many years in Florence with Andrea dal Castagno, and having finished his works after his death, acquired so much credit by means of Andrea's name, that Pope Martin V, coming to Florence, took him in his train to Rome, where he caused him to paint some scenes in fresco in S. Giovanni Laterano, which are very lovely and beautiful beyond belief, because he used therein a great abundance of a sort of ultramarine blue given to him by the said Pope, which was so beautiful in colour that it has never yet been equalled.

In competition with Pisanello, below the aforesaid scenes, certain others were painted by Gentile da Fabriano; of which Platina makes mention in his Life of Pope Martin, saying that when that Pontiff had caused the pavement, the ceiling, and the roof of S. Giovanni Laterano to be reconstructed, Gentile da Fabriano painted many pictures there, and, among other figures between the windows, in terretta and in chiaroscuro, certain prophets, which are held to be the best paintings in the whole of that work. The same Gentile executed an infinite number of works in the March, particularly in Agobbio, where some of them are still to be seen, and likewise throughout the whole state of Urbino. He worked in S. Giovanni at Siena; and in the Sacristy of S. Trinita in Florence he painted the Story of the Magi on a panel, wherein he portrayed himself from the life. In S. Niccolò, near the Porta a S. Miniato, for the family of the Quaratesi, he painted the panel of the high-altar, which appears to me without a doubt the best of all the works that I have seen by his hand, for, not to mention the Madonna surrounded by many saints, all well wrought, the predella of the said panel, full of scenes with little figures from the life of S. Nicholas, could not be more beautiful or executed better than it is. In S. Maria Nuova in Rome, in a little arch over the tomb of the Florentine Cardinal Adimari, Archbishop of Pisa, which is beside that of Pope Gregory IX, he painted the Madonna with the Child in her arms, between S. Benedict and S. Joseph. This work was held in esteem by the divine Michelagnolo, who was wont to say, speaking of Gentile, that his hand in painting was similar to his name. The same master executed a very beau-

tiful panel in S. Domenico in Perugia; and in S. Agostino at Bari he painted a Crucifix outlined in the wood, with three very beautiful half-length figures, which are over the door of the choir.

But to return to Vittore Pisano; the account that has been given of him above was written by us, with nothing more, when this our book was printed for the first time, because we had not then received that information and knowledge of the works of this excellent craftsman which we have since gained from notices supplied by that very reverend and most learned Father, Fra Marco de' Medici of Verona, of the Order of Preaching Friars, and from the narrative of Biondo da Forlì, where he speaks of Verona in his 'Italia Illustrata.' Vittore was equal in excellence to any painter of his age; and to this, not to speak of the works enumerated above, most ample testimony is borne by many others that are seen in his most noble native city of Verona, although many are almost eaten away by time. And because he took particular delight in depicting animals, he painted in the Chapel of the Pellegrini family, in the Church of S. Anastasia at Verona, a S. Eustace caressing a dog spotted with white and tan, which, with its feet raised and leaning against the leg of the said Saint, is turning its head backwards as though it had heard some noise; and it is making this movement with so great vivacity, that a live dog could not do it better. Beneath this figure there is seen painted the name of Pisano, who used to call himself sometimes Pisano, and sometimes Pisanello, as may be seen from the pictures and the medals by his hand. After the said figure of S. Eustace, which is truly very beautiful and one of the best that this craftsman ever wrought, he painted the whole outer wall of the same chapel; and on the other side he made a S. George clad in white armour made of silver, as was the custom in that age not only with him but with all the other painters. This S. George, wishing to replace his sword in the scabbard after slaying the Dragon, is raising his right hand, which holds the sword, the point of which is already in the scabbard, and is lowering the left hand, to the end that the increased distance may make it easier for him to sheathe the sword, which is long; and this he is doing with so much grace and with so beautiful a manner, that nothing better could be seen. Michele San Michele of Verona, architect to the most illustrious Signoria of Venice, and a man with a very wide knowledge of these fine arts, was often seen during his life contemplating these works of Vittore in a marvel, and then heard

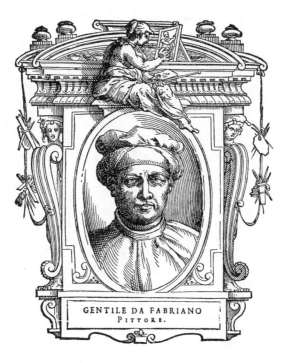

GENTILE DA FABRIANO
PITTORE.

to say that there was little to be seen that was better than the S. Eustace, the dog, and the S. George described above. Over the arch of the said chapel is painted the scene when S. George, having slain the Dragon, is liberating the King's daughter, who is seen near the Saint, clad in a long dress after the custom of those times. Marvellous, likewise, in this part of the work, is the figure of the same S. George, who, armed as above, and about to remount his horse, is standing with his face and person turned towards the spectator, and is seen, with one foot in the stirrup and his left hand on the saddle, almost in the act of leaping on to the horse, which has its hindquarters towards the spectator, so that the whole animal, being foreshortened, is seen very well, although in a small space. In a word, it is impossible to contemplate without infinite marvel – nay, amazement – a work executed with such extraordinary design, grace, and judgment.

The same Pisano painted a picture in S. Fermo Maggiore at Verona (a church of the Conventual Friars of S. Francis), in the Chapel of the Brenzoni, on the left as one enters by the principal door of the said church, over the tomb of the Resurrection of Our Lord, wrought in sculpture and very beautiful for those times; he painted, I say, as an ornament for that work, the Virgin receiving the Annunciation from the Angel, which two figures, picked out with gold according to the use of those times, are very beautiful, as are certain very well drawn buildings, as well as some little animals and birds scattered throughout the work, which are as natural and lifelike as it is possible to imagine.

The same Vittore cast in medallions innumerable portraits of Princes and other persons of his time, from which there have since been made many portraits in painting. And Monsignor Giovio, speaking of Vittore Pisano in an Italian letter written to the Lord Duke Cosimo, which may be read in print together with many others, says the following words:

'This man was also very excellent in the work of low-relief, which is esteemed very difficult among craftsmen, because it is the mean between the flat surface of painting and the roundness of statuary. For this reason there are seen many highly esteemed medals of great Princes by his hand, made in a large form, and in the same proportions as that reverse of the horse clad in armour that Guidi has sent me. Of these I have that of the great King Alfonso with his hair long, with a captain's helmet on the reverse; that of Pope Martin, with the arms of the house of

Colonna as the reverse; that of the Sultan Mahomet (who took Constantinople), showing him on horseback in Turkish dress, with a scourge in his hand; Sigismondo Malatesta, with Madonna Isotta of Rimini on the reverse; and that of Niccolò Piccinino, wearing a large oblong cap on his head, with the said reverse sent to me by Guidi, which I am returning. Besides these, I have also a very beautiful medal of John Palæologus, Emperor of Constantinople, with that bizarre Greek cap which the Emperors used to wear. This was made by Pisano in Florence, at the time of the Council of Eugenius, at which the aforesaid Emperor was present; and it has on the reverse the Cross of Christ, sustained by two hands – namely, the Latin and the Greek.'

So far Giovio, and still further. Vittore also made medals with portraits of Filippo de' Medici, Archbishop of Pisa, Braccio da Montone, Giovan Galeazzo Visconti, Carlo Malatesta, Lord of Rimini, Giovan Caracciolo, Grand Seneschal of Naples, Borso and Ercole D'Este, and many other nobles and men distinguished in arms and in letters.

By reason of his fame and reputation in that art, this master gained the honour of being celebrated by very great men and rare writers; for, besides what Biondo wrote of him, as has been said, he was much extolled in a Latin poem by the elder Guerino, his compatriot and a very great scholar and writer of those times; of which poem, called, from the surname of its subject, 'Il Pisano del Guerino,' honourable mention is made by Biondo. He was also celebrated by the elder Strozzi, Tito Vespasiano, father of the other Strozzi, both of whom were very rare poets in the Latin tongue. The father honoured the memory of Vittore Pisano with a very beautiful epigram, which is in print with the others. Such are the fruits that are borne by a worthy life.

Some say that when he was learning art in Florence in his youth, he painted in the old Church of the Temple, which stood where the old Citadel now is, the stories of that pilgrim who was going to S. Jacopo di Galizia, when the daughter of his host put a silver cup into his wallet, to the end that he might be punished as a robber; but he was rescued by S. Jacopo, who brought him back home in safety. In this Pisano gave promise of becoming, as he did, an excellent painter. Finally, having come to a good old age, he passed to a better life. And Gentile, after making many works in Città di Castello, became palsied, and was reduced to such a state that he could no longer do anything good; and at length, wasted away by

old age, and having lived eighty years, he died. The portrait of Pisano I have not been able to find in any place whatsoever. Both these painters drew very well, as may be seen in our book.

PESELLO AND FRANCESCO PESELLI
[*PESELLINO, OR FRANCESCO DI PESELLO*],
Painters of Florence

IT is rarely wont to happen that the disciples of the best masters, if they observe their precepts, fail to become very excellent, or, if they do not actually surpass them, at least to equal them and to make themselves in every way like them. For the burning zeal of imitation, with assiduity in studying, has power to make them equal the talent of those who show them the true method of working; wherefore the disciples become such that they afterwards compete with their masters, and even find it easy to outstrip them, because it is always but little labour to add to what has been discovered by others. That this is true is proved by Francesco di Pesello, who imitated the manner of Fra Filippo so well that he would have surpassed him by a long way, if death had not cut him off so prematurely. It is also known that Pesello imitated the manner of Andrea dal Castagno; and he took so much pleasure in counterfeiting animals, of which he kept some of all sorts alive in his house, and made them so lifelike and vivacious, that there was no one in his time who equalled him in this branch of his profession. He worked up to the age of thirty under the discipline of Andrea, learning from him, and became a very good master. Wherefore, having given good proof of his knowledge, he was commissioned by the Signoria of Florence to paint a panel in distemper of the Magi bringing offerings to Christ, which was placed half-way up the staircase of their Palace, and acquired great fame for Pesello, above all because he had made certain portraits therein, including that of Donato Acciaiuoli. In S. Croce, also, in the Chapel of the Cavalcanti, below the Annunciation of Donato, he painted a predella with little figures, containing stories of S. Nicholas. In the house of the Medici he adorned some panelling very beautifully with animals, and certain coffers with little scenes of jousts on horseback. And in the same house there are seen to this day certain canvases by his hand, representing lions pressing against a grating, which appear absolutely alive; and

he made others on the outside, together with one fighting with a serpent; and on another canvas he painted an ox, a fox, and other animals, very animated and vivacious. In the Chapel of the Alessandri, in S. Piero Maggiore, he made four little scenes with little figures of S. Peter, of S. Paul, of S. Zanobi restoring to life the son of the widow, and of S. Benedict. In S. Maria Maggiore in the same city of Florence, in the Chapel of the Orlandini, he made a Madonna and two other very beautiful figures. For the children of the Company of S. Giorgio he painted a Crucifix, S. Jerome, and S. Francis; and he made an Annunciation on a panel in the Church of S. Giorgio. In the Church of S. Jacopo at Pistoia he painted a Trinity, S. Zeno, and S. James; and throughout the houses of citizens in Florence there are many pictures, both round and square, by the hand of the same man.

Pesello was a temperate and gentle person; and whenever it was in his power to assist his friends, he would do it very lovingly and willingly. He married young, and had a son named Francesco, known as Pesellino, who became a painter, following very closely in the steps of Fra Filippo. From what is known of this man, it is clear that if he had lived longer he would have done much more than he did, for he was a zealous student of his art, and would draw all day and night without ceasing. In the Chapel of the Noviciate in S. Croce, below the panel by Fra Filippo, there is still seen a most marvellous predella with little figures, which appear to be by the hand of Fra Filippo. He made many little pictures with small figures throughout Florence, where, having acquired a great name, he died at the age of thirty-one; to the great grief of Pesello, who followed him after no long time, at the age of seventy-seven.

BENOZZO GOZZOLI,* Painter of Florence

HE who pursues the path of excellence in his labours, although it is, as men say, both stony and full of thorns, finds himself finally at the end of the ascent on a broad plain, with all the blessings that he has desired. And as he looks downwards and sees the difficult and perilous way that he has come, he thanks God for having brought him out safely, and with the greatest contentment

* In the heading to the Life Vasari calls him simply Benozzo.

he blesses those labours that he has just been finding so burdensome. And so, recompensed for his past sufferings by the gladness of the happy present, he labours without fatigue, in order to demonstrate to all who see him how heat, cold, sweat, hunger, thirst, and all the other discomforts that are endured in the acquiring of excellence, deliver men from poverty, and bring them to that secure and tranquil state in which, with so much contentment, Benozzo Gozzoli enjoyed repose from his labours.

This man was a disciple of Fra Giovanni Angelico, by whom he was loved with good reason; and by all who knew him he was held to be a practised master, very rich in invention, and very productive in the painting of animals, perspectives, landscapes, and ornaments. He wrought so many works in his day that he showed that he cared little for other delights; and although, in comparison with many who surpassed him in design, he was not very excellent, yet in this great mass of work he surpassed all the painters of his age, for in such a multitude of pictures he succeeded in making some that were good. In his youth he painted a panel for the altar of the Company of S. Marco in Florence, and, in S. Friano, a picture of the passing of S. Jerome, which has been spoilt in restoring the façade of the church along the street. In the Chapel of the Palace of the Medici he painted the Story of the Magi in fresco.

In the Araceli at Rome, in the Chapel of the Cesarini, he painted the stories of S. Anthony of Padua, wherein he made portraits from life of Cardinal Giuliano Cesarini and Antonio Colonna. In the Conti Tower, likewise, over a door under which one passes, he made in fresco a Madonna with many saints; and in a chapel in S. Maria Maggiore, on the right hand as one enters the church by the principal door, he painted many figures in fresco, which are passing good.

After returning from Rome to Florence, Benozzo went to Pisa, where he worked in the cemetery called the Campo Santo, which is beside the Duomo, covering the surface of a wall that runs the whole length of the building with stories from the Old Testament, wherein he showed very great invention. And this may be said to be a truly tremendous work, seeing that it contains all the stories of the Creation of the world from one day to another. After this come Noah's Ark and the inundation of the Flood, represented with very beautiful composition and an abundance of figures. Then there follow the building of the proud

Tower of Nimrod, the burning of Sodom and the other neigh-
bouring cities, and the stories of Abraham, wherein there are
some very beautiful effects to be observed, for the reason that,
although Benozzo was not remarkable for the drawing of figures,
yet he showed his art effectually in the Sacrifice of Isaac, for there
he painted an ass foreshortened in such a manner that it seems
to turn to either side, which is held something very beautiful.
After this comes the Birth of Moses, together with all those signs
and prodigies that were seen, up to the time when he led his
people out of Egypt and fed them for so many years in the
desert. To these he added all the stories of the Hebrews up to
the time of David and his son Solomon; and in this work Benozzo
displayed a spirit truly more than bold, for, whereas so great an
enterprise might very well have daunted a legion of painters, he
alone wrought the whole and brought it to perfection. Wherefore,
having thus acquired very great fame, he won the honour of hav-
ing the following epigram placed in the middle of the work:

QUID SPECTAS VOLUCRES, PISCES, ET MONSTRA FERARUM,
 ET VIRIDES SILVAS ÆTHEREASQUE DOMOS,
ET PUEROS, JUVENES, MATRES, CANOSQUE PARENTES,
 QUEIS SEMPER VIVUM SPIRAT IN ORE DECUS?
NON HÆC TAM VARIIS FINXIT SIMULACRA FIGURIS
 NATURA, INGENIO FŒTIBUS APTA SUO:
EST OPUS ARTIFICIS: PINXIT VIVA ORA BENOXUS;
 O SUPERI, VIVOS FUNDITE IN ORA SONOS.

Throughout this whole work there are scattered innumerable por-
traits from the life; but, since we have not knowledge of them all,
I will mention only those that I have recognized as important, and
those that I know by means of some record. In the scene of the
Queen of Sheba going to visit Solomon there is the portrait of
Marsilio Ficino among certain prelates, with those of Argiropolo,
a very learned Greek, and of Batista Platina, whom he had pre-
viously portrayed in Rome; while he himself is on horseback, in
the form of an old man shaven and wearing a black cap, in the
fold of which there is a white paper, perchance as a sign, or
because he intended to write his own name thereon.

In the same city of Pisa, for the Nuns of S. Benedetto a Ripa
d'Arno, he painted all the stories of the life of that Saint; and in the
building of the Company of the Florentines, which then stood
where the Monastery of S. Vito now is, he wrought the panel and

many other pictures. In the Duomo, behind the chair of the Archbishop, he painted a S. Thomas Aquinas on a little panel in distemper, with an infinite number of learned men disputing over his works, among whom there is a portrait of Pope Sixtus IV, together with a number of Cardinals and many Chiefs and Generals of various Orders. This is the best and most highly finished work that Benozzo ever made. In S. Caterina, a seat of the Preaching Friars in the same city, he executed two panels in distemper, which are known very well by the manner; and he also painted another in the Church of S. Niccola, with two in S. Croce without Pisa.

In his youth, Benozzo also painted the altar of S. Bastiano in the Pieve of San Gimignano, opposite to the principal chapel; and in the Hall of the Council there are some figures, partly by his hand, and partly old works restored by him. For the Monks of Monte Oliveto, in the same territory, he painted a Crucifix and other pictures; but the best work that he made in that place was in the principal chapel of S. Agostino, where he painted stories of S. Augustine in fresco, from his conversion to his death; of the whole of which work I have the design by his hand in my book, together with many drawings of the aforesaid scenes in the Campo Santo of Pisa. In Volterra, likewise, he executed certain works, of which there is no need to make mention.

Now, while Benozzo was working in Rome, there was another painter there called Melozzo, who came from Forlì; and many who know no more than this, having found the name of Melozzo written and having compared the dates, have believed that Melozzo stands for Benozzo; but they are mistaken, for the said painter was one who lived at the same time and was a very zealous student of the problems of art, devoting particular diligence and study to the making of foreshortenings, as may be seen in S. Apostolo at Rome, in the tribune of the high-altar, where, in a frieze drawn in perspective, as an ornament for that work, there are some figures picking grapes, with a cask, which show no little of the good. But this is seen more clearly in the Ascension of Jesus Christ, in the midst of a choir of angels who are leading him up to Heaven, wherein the figure of Christ is so well foreshortened that it seems to be piercing the ceiling, and the same is true of the angels, who are circling with various movements through the spacious sky. The Apostles, likewise, who are on the earth below, are so well foreshortened in their various attitudes that the work brought him much praise, as it still does, from the craftsmen, who have

learnt much from his labours. He was also a great master of perspective, as is demonstrated by the buildings painted in this work, which he executed at the commission of Cardinal Riario, nephew of Pope Sixtus IV, by whom he was richly rewarded.

But to return to Benozzo; wasted away at last by length of years and by his labours, he went to his true rest, in the city of Pisa, at the age of seventy-eight, while dwelling in a little house that he had bought in Carraia di San Francesco during his long sojourn there. This house he left at his death to his daughter; and, mourned by the whole city, he was honourably buried in the Campo Santo, with the following epitaph, which is still to be read there:

HIC TUMULUS EST BENOTII FLORENTINI, QUI PROXIME HAS PINXIT HISTORIAS. HUNC SIBI PISANOR. DONAVIT HUMANITAS, MCCCCLXXVIII.

Benozzo ever lived the well-ordered life of a true Christian, spending all his years in honourable labour. For this and for his good manner and qualities he was long looked upon with favour in that city. The disciples whom he left behind him were Zanobi Macchiavelli, a Florentine, and others of whom there is no need to make further record.

FRANCESCO DI GIORGIO, Sculptor and Architect of Siena, AND LORENZO VECCHIETTO, Sculptor and Painter of Siena

FRANCESCO DI GIORGIO of Siena, who was an excellent sculptor and architect, made the two bronze angels that are on the high-altar of the Duomo in that city. These were truly very beautiful pieces of casting, and he finished them afterwards by himself with the greatest diligence that it is possible to imagine. This he could do very conveniently, for he was endowed with good means as well as with a rare intelligence; wherefore he would work when he felt inclined, not through greed of gain, but for his own pleasure and in order to leave some honourable memorial behind him. He also gave attention to painting and executed some pictures, but these did not equal his sculptures. He had very good judgment in architecture, and proved that he had a very good knowledge of that profession; and to this ample testimony is borne by the palace that he built for Duke

Federigo Feltro at Urbino, which is commodiously arranged and beautifully planned, while the bizarre staircases are well conceived and more pleasing than any others that had been made up to his time. The halls are large and magnificent, and the apartments are conveniently distributed and handsome beyond belief. In a word, the whole of that palace is as beautiful and as well built as any other that has been erected down to our own day.

Francesco was a very able engineer, particularly in connection with military engines, as he showed in a frieze that he painted with his own hand in the said palace at Urbino, which is all full of rare things of that kind for the purposes of war. He also filled some books with designs of such instruments; and the Lord Duke Cosimo de' Medici has the best of these among his greatest treasures. The same man was so zealous a student of the warlike machines and instruments of the ancients, and spent so much time in investigating the plans of the ancient amphitheatres and other things of that kind, that he was thereby prevented from giving equal attention to sculpture; but these studies brought him and still bring him no less honour than sculpture could have gained for him. For all these reasons he was so dear to the said Duke Federigo, whose portrait he made both on medals and in painting, that when he returned to his native city of Siena he found his honours were equal to his profits.

For Pope Pius II he made all the designs and models of the Palace and Vescovado of Pienza, the native place of the said Pope, which was raised by him to the position of a city, and called Pienza after himself, in place of its former name of Corsignano. These buildings were as magnificent and handsome as they could be for that place; and he did the same for the general form and the fortifications of the said city, together with the palace and loggia built for the same Pontiff. Wherefore he ever lived in honour, and was rewarded with the supreme magistracy of the Signoria in his native city; but finally, having reached the age of forty-seven, he died. His works date about 1480. He left behind him his companion and very dear friend, Jacopo Cozzerello, who devoted himself to sculpture and architecture, making some figures of wood in Siena, and a work of architecture without the Porta a Tufi – namely, S. Maria Maddalena, which remained unfinished by reason of his death. To him we are also indebted for the portrait of the aforesaid Francesco, which he made with his own hand; to which Francesco much gratitude is

due for his having facilitated the art of architecture, and for his having rendered to it greater services than any other man had done from the time of Filippo di Ser Brunellesco to his own.

A Sienese and also a much extolled sculptor was Lorenzo, the son of Piero Vecchietti, who, having first been a highly esteemed goldsmith, finally devoted himself to sculpture and to casting in bronze; which arts he studied so zealously that he became excellent in them, and was commissioned to make a tabernacle in bronze for the high-altar of the Duomo in his native city of Siena, together with the marble ornaments that are still seen therein. This casting, which is admirable, acquired very great fame and repute for him by reason of the proportion and grace that it shows in all its parts; and whosoever observes this work well can see that the design is good, and that the craftsman was a man of judgment and of practised ability. For the Chapel of the Painters of Siena, in the great Hospital of the Scala, the same man made a beautiful metal casting of a nude Christ, of the size of life and holding the Cross in His hand; which work was finished with a love and diligence worthy of the beautiful success of the casting. In the pilgrim's hall in the same place there is a scene painted in colours by Lorenzo. Over the door of S. Giovanni he painted an arch with figures wrought in fresco; and in like manner, since the baptismal font was not finished, he wrought for it certain little figures in bronze, besides finishing, also in bronze, a scene formerly begun by Donatello. In this place two scenes in bronze had been already wrought by Jacopo della Fonte, whose manner Lorenzo ever imitated as closely as he was able. This Lorenzo brought the said baptismal font to perfect completion, adding to it some bronze figures, formerly cast by Donato but entirely finished by himself, which are held to be very beautiful.

For the Loggia of the Ufficiali* in Banchi Lorenzo made two life-size figures in marble of S. Peter and S. Paul, wrought with consummate grace and executed with fine mastery. He disposed the works that he made in such a manner that he deserves as much praise for them after death as he did when alive. He was a melancholic and solitary person, ever lost in contemplation; which was perchance the reason that he did not live longer, for he passed to the other life at the age of fifty-eight. His works date about the year 1482.

* The officials of the Mercanzia.

GALASSO FERRARESE,* Painter
[*GALASSO GALASSI*]

WHEN strangers come to do work in a city in which there are
no craftsmen of excellence, there is always some man whose
intelligence is afterwards stirred to strive to learn that same art,
and to bring it about that from that time onwards there should
be no need for strangers to come and embellish his city and carry
away her wealth, which he now labours to deserve by his own
ability, seeking to acquire for himself those riches that seemed to
him too splendid to be given to foreigners. This was made clearly
manifest by Galasso Ferrarese, who, seeing Piero dal Borgo a San
Sepolcro rewarded by the Duke of Ferrara for the works that he
executed, and also honourably received in Ferrara, was incited so
strongly by such an example, after Piero's departure, to devote
himself to painting, that he acquired the name of a good and
excellent master in Ferrara. Besides this, he was held in all the
greater favour in that place for having gone to Venice and there
learnt the method of painting in oil, which he brought to his
native place, for he afterwards made an infinity of figures in that
manner, which are scattered about in many churches throughout
Ferrara.

Next, having gone to Bologna, whither he was summoned by
certain Dominican friars, he painted in oil a chapel in S. Domeni-
co; and so his fame increased, together with his credit. After this
he painted many pictures in fresco in S. Maria del Monte, a seat
of the Black Friars without Bologna, beyond the Porta di
S. Mammolo; and the whole church of the Casa di Mezzo, on the
same road, was likewise painted by his hand with works in fresco,
in which he depicted the stories of the Old Testament.

His life was ever most praiseworthy, and he showed himself
very courteous and agreeable; which arose from his being used to
live and dwell more out of his native place than in it. It is true,
indeed, that through his being somewhat irregular in his way of
living, his life did not last long; for he left it at the age of about
fifty, to go to that life which has no end. After his death he was
honoured by a friend with the following epitaph:

* This Life appears only in Vasari's first edition.

GALASSUS FERRARIENSIS.

SUM TANTO STUDIO NATURAM IMITATUS ET ARTE
DUM PINGO RERUM QUÆ CREAT ILLA PARENS;
HÆC UT SÆPE QUIDEM NON PICTA PUTAVERIT A ME,
A SE CREDIDERIT SED GENERATA MAGIS.

In these same times lived Cosmè, also of Ferrara. Works by his hand that are to be seen are a chapel in S. Domenico in the said city, and two folding-doors that close the organ in the Duomo. This man was better as a draughtsman than as a painter; indeed, from what I have been able to gather, he does not seem to have painted much.

ANTONIO ROSSELLINO, Sculptor of Florence
[*ROSSELLINO DAL PROCONSOLO*],
AND BERNARDO, HIS BROTHER

It has ever been a truly laudable and virtuous thing to be modest and to be adorned with that gentleness and those rare qualities that are easily recognized in the honourable actions of the sculptor Antonio Rossellino, who put so much grace into his art that he was esteemed by all who knew him as something much more than man, and adored almost as a saint, for those supreme virtues that were united to his talent. Antonio was called Rossellino dal Proconsolo, because he ever had his shop in a part of Florence called by that name. He showed such sweetness and delicacy in his works, with a finish and a refinement so perfect, that his manner may be rightly called the true one and truly modern.

For the Palace of the Medici he made the marble fountain that is in the second court; in which fountain are certain children opening the mouths of dolphins that pour out water; and the whole is finished with consummate grace and with a most diligent manner. In the Church of S. Croce, near the holy-water basin, he made a tomb for Francesco Nori, with a Madonna in low-relief above it; and another Madonna in the house of the Tornabuoni, together with many other things sent to various foreign parts, such as a tomb of marble for Lyons in France. At S. Miniato al Monte, a monastery of White Friars without the walls of Florence, he was commissioned to make the tomb of the Cardinal of Portugal, which was executed by him so marvellously and

ANTONIO ROSSELLINO
SCVLTORE FIOR.

with such great diligence and art, that no craftsman can ever expect to be able to see any work likely to surpass it in any respect whatsoever with regard to finish or grace. And in truth, if one examines it, it appears not merely difficult but impossible for it to have been executed so well; for certain angels in the work reveal such grace, beauty, and art in their expressions and their draperies, that they appear not merely made of marble but absolutely alive. One of these is holding the crown of chastity of that Cardinal, who is said to have died celibate; the other bears the palm of victory, which he had won from the world. Among the many most masterly things that are there, one is an arch of grey-stone supporting a looped-back curtain of marble, which is so highly-finished that, what with the white of the marble and the grey of the stone, it appears more like real cloth than like marble. On the sarcophagus are some truly very beautiful boys and the dead man himself, with a Madonna, very well wrought, in a med-allion. The sarcophagus has the shape of that one made of porphyry which is in the Piazza della Ritonda in Rome. This tomb of the Cardinal was erected in 1459; and its form, with the architecture of the chapel, gave so much satisfaction to the Duke of Malfi, nephew of Pope Pius II, that he had another made in Naples by the hand of the same master for his wife, similar to the other in every respect save in the figure of the dead. For this, moreover, Antonio made a panel containing the Nativity of Christ and the Manger, with a choir of angels over the hut, danc-ing and singing with open mouths, in such a manner, that he truly seems to have given them all possible movement and expression short of breath itself, and that with so much grace and so high a finish, that iron tools and man's intelligence could effect nothing more in marble. Wherefore his works have been much esteemed by Michelagnolo and by all the rest of the supremely excellent craftsmen. In the Pieve of Empoli he made a S. Sebastian of marble, which is held to be a very beautiful work; and of this we have a drawing by his hand in our book, together with others of all the architecture and the figures in the said chapel in S. Miniato al Monte, and likewise his own portrait.

Antonio finally died in Florence at the age of forty-six, leaving a brother called Bernardo, an architect and sculptor, who made a marble tomb in S. Croce for Messer Lionardo Bruni of Arezzo, who wrote the History of Florence and was a very learned man, as all the world knows. This Bernardo was much esteemed for

his knowledge of architecture by Pope Nicholas V, who loved
him dearly and made use of him in very many works that he
carried out in his pontificate, of which he would have executed
even more if death had not intervened to hinder the works that
he had in mind. He caused him, therefore, according to the ac-
count of Giannozzo Manetti, to reconstruct the Piazza of Fab-
riano, in the year when he spent some months there by reason
of the plague; and whereas it was narrow and badly designed, he
enlarged it and brought it to a good shape, surrounding it with a
row of shops, which were useful, very commodious, and very
beautiful. After this he restored and founded anew the Church of
S. Francesco in the same district, which was going to ruin. At
Gualdo he rebuilt the Church of S. Benedetto; almost anew, it
may be said, for he added to it good and beautiful buildings. At
Assisi he made new and stout foundations and a new roof for
the Church of S. Francesco, which was ruined in certain parts and
threatened to go to ruin in certain others. At Civitavecchia he
built many beautiful and magnificent edifices. At Città Castellana
he rebuilt more than a third part of the walls in a good form.
At Narni he rebuilt the fortress, enlarging it with good and beau-
tiful walls. At Orvieto he made a great fortress with a most
beautiful palace – a work of great cost and no less magnificence.
At Spoleto, likewise, he enlarged and strengthened the fortress,
making within it dwellings so beautiful, so commodious, and so
well conceived, that nothing better could be seen. He restored
the baths of Viterbo at great expense and in a truly royal spirit,
making certain dwellings there that would have been worthy not
merely of the invalids who went to bathe there every day, but of
the greatest of Princes. All these works were executed by the said
Pontiff without the city of Rome, from the designs of Bernardo.

In Rome he restored, and in many places renewed, the walls
of the city, which were for the greater part in ruins; adding to
them certain towers, and enclosing within these some new for-
tifications that he built without the Castle of S. Angelo, with
many apartments and decorations that he made within. The said
Pontiff also had a project in his mind, of which he brought the
greater part nearly to completion, of restoring or rebuilding,
according as it might be necessary, the forty Churches of the
Stations formerly instituted by the Saint, Pope Gregory I, who
received the surname of Great. Thus he restored S. Maria Trast-
evere, S. Prassedia, S. Teodoro, S. Pietro in Vincula, and many

other minor churches. But it was with much greater zeal, adornment, and diligence that he did this for six of the seven greater and principal churches – namely, S. Giovanni Laterano, S. Maria Maggiore, S. Stefano in Celio Monte, S. Apostolo, S. Paolo, and S. Lorenzo extra muros. I say nothing of S. Pietro, for of this he made an undertaking by itself.

The same Pope was minded to make the whole of the Vatican into a separate city, in the form of a fortress; and for this he was designing three roads that should lead to S. Pietro, situated, I believe, where the Borgo Vecchio and the Borgo Nuovo now are; and on both sides of these roads he meant to build loggie, with very commodious shops, keeping the nobler and richer trades separate from the humbler, and grouping each in a street by itself. He had already built the Great Round Tower, which is still called the Torrione di Niccola. Over these shops and loggie were to be erected magnificent and commodious houses, built in a very beautiful and very practical style of architecture, and designed in such a manner as to be sheltered and protected from all the pestiferous winds of Rome, and freed from all the inconveniences of water and garbage likely to generate unhealthy exhalations. All this the said Pontiff would have finished if he had been granted a little longer life, for he had a great and resolute spirit, and an understanding so profound, that he gave as much guidance and direction to the craftsmen as they gave to him. When this is so, and when the patron has knowledge of his own and capacity enough to take an immediate resolution, great enterprises can be easily brought to completion; whereas an irresolute and incapable man, wavering between yes and no in a sea of conflicting designs and opinions, very often lets time slip past unprofitably without doing anything. But of this design of Nicholas there is no need to say any more, since it was not carried into effect.

Besides this, he wished to build the Papal Palace with so much magnificence and grandeur, and with so many conveniences and such loveliness, that it might be in all respects the greatest and most beautiful edifice in Christendom; and he intended that it should not only serve for the person of the Supreme Pontiff, the Chief of all Christians, and for the sacred college of Cardinals, who, being his counsellors and assistants, had always to be about him, but also that it should provide accommodation for the transaction of all the business, resolutions, and judicial affairs of the Court; so that the grouping together of all the offices and

courts would have produced great magnificence, and, if such a word may be used in such a context, an effect of incredible pomp. What is infinitely more, it was meant for the reception of all Emperors, Kings, Dukes, and other Christian Princes who might, either on affairs of their own or out of devotion, visit that most holy apostolic seat. It is incredible, but he proposed to make there a theatre for the crowning of the Pontiffs, with gardens, loggie, aqueducts, fountains, chapels, libraries, and a most beautiful building set apart for the Conclave. In short, this edifice – I know not whether I should call it palace, or castle, or city – would have been the most superb work that had ever been made, so far as is known, from the Creation of the world to our own day. What great glory it would have been for the Holy Roman Church to see the Supreme Pontiff, her Chief, gather together, as into the most famous and most holy of monasteries, all those ministers of God who dwell in the city of Rome, to live there, as it were in a new earthly Paradise, a celestial, angelic, and most holy life, giving an example to all Christendom, and awakening the minds of the infidels to the true worship of God and of the Blessed Jesus Christ! But this great work remained unfinished – nay, scarcely begun – by reason of the death of that Pontiff; and the little that was carried out is known by his arms, or the device that he used as his arms, namely, two keys crossed on a field of red. The fifth of the five works that the same Pope intended to execute was the Church of S. Pietro, which he had proposed to make so vast, so rich, and so ornate, that it is better to be silent than to attempt to speak of it, because I could not describe even the least part of it, and the rather as the model was afterwards destroyed, and others have been made by other architects. If any man wishes to gain a full knowledge of the grand conception of Pope Nicholas V in this matter, let him read what Giannozzo Manetti, a noble and learned citizen of Florence, has written with the most minute detail in the Life of the said Pontiff, who availed himself in all the aforesaid designs, as has been said, as well as in his others, of the intelligence and great industry of Bernardo Rossellino.

Antonio, brother of Bernardo (to return at length to the point whence, with so fair an occasion, I digressed), wrought his sculptures about the year 1490; and since the more men's works display diligence and difficulties the more they are admired, and these two characteristics are particularly noticeable in Antonio's works, he deserves fame and honour as a most illustrious example from which

modern sculptors have been able to learn how those statues should be made that are to secure the greatest praise and fame by reason of their difficulties. For after Donatello he did most towards adding a certain finish and refinement to the art of sculpture, seeking to give such depth and roundness to his figures that they appear wholly round and finished, a quality which had not been seen to such perfection in sculpture up to that time; and since he first introduced it, in the ages after his and in our own it appears a marvel.

DESIDERIO DA SETTIGNANO, Sculptor

V ERY great is the obligation that is owed to Heaven and to Nature by those who bring their works to birth without effort and with a certain grace which others cannot give to their creations, either by study or by imitation. It is a truly celestial gift, which pours down on these works in such a manner, that they ever have about them a loveliness and a charm which attract not only those who are versed in that calling, but also many others who do not belong to the profession. And this springs from facility in the production of the good, which presents no crudeness or harshness to the eye, such as is often shown by works wrought with labour and difficulty; and this grace and simplicity, which give universal pleasure and are recognized by all, are seen in all the works made by Desiderio.

Of this man, some say that he came from Settignano, a place two miles distant from Florence, while certain others hold him to be a Florentine; but this matters nothing, the distance between the one place and the other being so small. He was an imitator of the manner of Donato, although he had a natural gift of imparting very great grace and loveliness to his heads; and in the expressions of his women and children there is seen a delicate, sweet, and charming manner, produced as much by nature, which had inclined him to this, as by the zeal with which he had practised his intelligence in the art. In his youth he wrought the base of Donato's David, which is in the Duke's Palace in Florence, making on it in marble certain very beautiful harpies, and some vine-tendrils in bronze, very graceful and well conceived. On the façade of the house of the Gianfigliazzi he made a large and very beautiful coat of arms, with a lion; besides other works in stone,

which are in the same city. For the Chapel of the Brancacci in the Carmine he made an angel of wood; and he finished with marble the Chapel of the Sacrament in S. Lorenzo, carrying it to complete perfection with much diligence. There was in it a child of marble in the round, which was removed and is now set up on the altar at the festivals of the Nativity of Christ, as an admirable work; and in place of this Baccio da Montelupo made another, also of marble, which stands permanently over the Tabernacle of the Sacrament. In S. Maria Novella he made a marble tomb for the Blessed Villana, with certain graceful little angels, and portrayed her there from nature in such a manner that she appears not dead but asleep; and for the Nuns of the Murate he wrought a little Madonna with a lovely and graceful manner, in a tabernacle standing on a column; insomuch that both these works are very highly esteemed and very greatly prized. In S. Pietro Maggiore, also, he made the Tabernacle of the Sacrament in marble with his usual diligence; and although there are no figures in this work, yet it shows a beautiful manner and infinite grace, like his other works. And he portrayed from the life, likewise in marble, the head of Marietta degli Strozzi, who was so beautiful that the work turned out very excellent.

In S. Croce he made a tomb for Messer Carlo Marsuppini of Arezzo, which not only amazed the craftsmen and the people of understanding who saw it at that time, but still fills with marvel all who see it at the present day; for on the sarcophagus he wrought some foliage, which, although somewhat stiff and dry, was held – since but few antiquities had been discovered up to that time – to be something very beautiful. Among other parts of the said work are seen certain wings, acting as ornaments for a shell at the foot of the sarcophagus, which seem to be made not of marble but of feathers – difficult things to imitate in marble, seeing that the chisel is not able to counterfeit hair and feathers. There is a large shell of marble, more real than if it were an actual shell. There are also some children and some angels, executed with a beautiful and lively manner; and consummate excellence and art are likewise seen in the figure of the dead, portrayed from nature on the sarcophagus, and in a Madonna in low-relief on a medallion, wrought after the manner of Donato with judgment and most admirable grace; as are many other works that he made in low-relief on marble, some of which are in the guardaroba of the Lord Duke Cosimo, and in particular a medallion with the head of Our Lord Jesus Christ and with that

of John the Baptist as a boy. At the foot of the tomb of the said
Messer Carlo he laid a large stone in memory of Messer Giorgio,
a famous Doctor, and Secretary to the Signoria of Florence, with
a very beautiful portrait in low-relief of Messer Giorgio, clad in
his Doctor's robes according to the use of those times.

If death had not snatched so prematurely from the world a spirit
which worked so nobly, he would have done so much later on by
means of experience and study, that he would have outstripped in
art all those whom he had surpassed in grace. Death cut the thread
of his life at the age of twenty-eight, which caused great grief to
those who were looking forward to seeing so great an intellect attain
to perfection in old age; and they were left in the deepest dismay at
such a loss. He was followed by his relatives and by many friends
to the Church of the Servi; and a vast number of epigrams and
sonnets continued for a long time to be placed on his tomb, of
which I have contented myself with including only the following:

COME VIDE NATURA
 DAR DESIDERIO AI FREDDI MARMI VITA,
 E POTER LA SCULTURA
 AGGUAGLIAR SUA BELLEZZA ALMA E INFINITA,
 SI FERMÒ SBIGOTTITA
 E DISSE; OMAI SARÀ MIA GLORIA OSCURA.
 E PIENA D'ALTO SDEGNO
 TRONCÒ LA VITA A COSÌ BELL' INGEGNO.
 MA IN VAN; CHE SE COSTUI
 DIÈ VITA ETERNA AI MARMI, E I MARMI A LUI.

The sculptures of Desiderio date about 1485. He left unfinished a
figure of S. Mary Magdalene in Penitence, which was afterwards
completed by Benedetto da Maiano, and is now in S. Trinita in
Florence, on the right hand as one enters the church; and the beauty
of this figure is beyond the power of words to express. In our book
are certain very beautiful pen-drawings by Desiderio; and his portrait
was obtained from some of his relatives in Settignano.

MINO DA FIESOLE, Sculptor
[MINO DI GIOVANNI]

WHEN our craftsmen seek to do no more in the works that they
execute than to imitate the manner of their masters, or that of

some other man of excellence whose method of working pleases them, either in the attitudes of the figures, or in the expressions of the heads, or in the folds of the draperies, and when they study these things only, they may with time and diligence come to make them exactly the same, but they cannot by these means alone attain to perfection in their art, seeing that it is clearly evident that one who ever walks behind rarely comes to the front, since the imitation of nature becomes fixed in the manner of a crafts-man who has developed that manner out of long practice. For imitation is a definite art of copying what you represent exactly after the model of the most beautiful things of nature, which you must take pure and free from the manner of your master or that of others, who also reduce to a manner the things that they take from nature. And although it may appear that the imitations made by excellent craftsmen are natural objects, or absolutely similar, it is not possible with all the diligence in the world to make them so similar that they shall be like nature herself, or even, by selecting the best, to compose a body so perfect as to make art excel nature. Now, if this is so, it follows that only objects taken from nature can make pictures and sculptures per-fect, and that if a man studies closely only the manner of other craftsmen, and not bodies and objects of nature, it is inevitable that he should make works inferior both to nature and to those of the man whose manner he adopts. Wherefore it has been seen in the case of many of our craftsmen, who have refused to study anything save the works of their masters, leaving nature on one side, that they have failed to gain any real knowledge of them or to surpass their masters, but have done very great injury to their own powers; whereas, if they had studied the manner of their masters and the objects of nature together, they would have pro-duced much greater fruits in their works than they did. This is seen in the works of the sculptor Mino da Fiesole, who, having an intelligence capable of achieving whatsoever he wished, was so captivated by the manner of his master Desiderio da Settignano, by reason of the beautiful grace that he gave to the heads of women, children, and every other kind of figure, which appeared to Mino's judgment to be superior to nature, that he practised and studied it alone, abandoning natural objects and thinking them use-less; wherefore he had more grace than solid grounding in his art.

It was on the hill of Fiesole, a very ancient city near Florence, that there was born the sculptor Mino di Giovanni, who, having

been apprenticed to the craft of stone-cutting under Desiderio da Settignano, a young man excellent in sculpture, showed so much inclination to his master's art, that, while he was labouring at the hewing of stones, he learnt to copy in clay the works that Desiderio had made in marble; and this he did so well that his master, seeing that he was likely to make progress in that art, brought him forward and set him to work on his own figures in marble, in which he sought with very great attention to reproduce the model before him. Nor did he continue long at this before he became passing skilful in that calling; at which Desiderio was greatly pleased, and still more pleased was Mino by the loving-kindness of his master, seeing that Desiderio was ever ready to teach him how to avoid the errors that can be committed in that art. Now, while he was on the way to becoming excellent in his profession, his ill luck would have it that Desiderio should pass to a better life, and this loss was a very great blow to Mino, who departed from Florence, almost in despair, and went to Rome. There, assisting masters who were then executing works in marble, such as tombs of Cardinals, which were placed in S. Pietro, although they have since been thrown to the ground in the building of the new church, he became known as a very experienced and capable master; and he was commissioned by Cardinal Guglielmo Destovilla, who was pleased with his manner, to make the marble altar where lies the body of S. Jerome, in the Church of S. Maria Maggiore, together with scenes in low-relief from his life, which he executed to perfection, with a portrait of that Cardinal.

Afterwards, when Pope Paul II, the Venetian, was erecting his Palace of S. Marco, Mino was employed thereon in making certain coats of arms. After the death of that Pope, Mino was commissioned to make his tomb, which he delivered finished and erected in S. Pietro in the space of two years. This tomb was then held to be the richest, both in ornaments and in figures, that had ever been made for any Pontiff; but it was thrown to the ground by Bramante in the demolition of S. Pietro, and remained there buried among the rubbish for some years, until 1547, when certain Venetians had it rebuilt in the old S. Pietro, against a wall near the Chapel of Pope Innocent. And although some believe that this tomb is by the hand of Mino del Reame, yet, notwithstanding that these two masters lived almost at the same time, it is without doubt by the

hand of Mino da Fiesole. It is true, indeed, that the said Mino del Reame made some little figures on the base, which can be recognized; if in truth his name was Mino, and not, as some maintain, Dino.

But to return to our craftsman; having acquired a good name in Rome by the said tomb, by the sarcophagus that he made for the Minerva, on which he placed a marble statue of Francesco Tornabuoni from nature, which is held very beautiful, and by other works, it was not long before he returned to Fiesole with a good sum of money saved, and took a wife. And no long time after this, working for the Nuns of the Murate, he made a marble tabernacle in half-relief to contain the Sacrament, which was brought to perfection by him with all the diligence in his power. This he had not yet fixed into its place, when the Nuns of S. Ambrogio – who desired to have an ornament made, similar in design but richer in adornment, to contain that most holy relic, the Miracle of the Sacrament – hearing of the ability of Mino, commissioned him to execute that work, which he finished with so great diligence that those nuns, being satisfied with him, gave him all that he asked as the price of the work. And a little after this he undertook, at the instance of Messer Dietisalvi Neroni, to make a little panel with figures of Our Lady with the Child in her arms, and S. Laurence on one side and S. Leonard on the other, in half-relief, which was intended for the priests or chapter of S. Lorenzo; but it has remained in the Sacristy of the Badia of Florence. For those monks he made a marble medallion containing a Madonna in relief with the Child in her arms, which they placed over the principal door of entrance into the church; and since it gave great satisfaction to all, he received a commission for a tomb for the Magnificent Chevalier, Messer Bernardo de' Giugni, who, having been an honourable man of high repute, rightly received this memorial from his brothers. On this tomb, besides the sarcophagus and the portrait from nature of the dead man, Mino executed a figure of Justice, which resembles the manner of Desiderio closely, save only that its draperies are a little too full of detail in the carving. This work induced the Abbot and Monks of the Badia of Florence, in which place the said tomb was erected, to entrust Mino with the making of one for Count Ugo, son of the Marquis Uberto of Magdeburg, who bequeathed great wealth and many privileges to that abbey. And so, desiring to honour him as much as they could, they caused

Mino to make a tomb of Carrara marble, which was the most
beautiful work that Mino ever made; for in it there are some
boys, upholding the arms of that Count, who are standing in very
spirited attitudes, with a childish grace; and besides the figure of
the dead Count, with his likeness, which he made on the sarco-
phagus, in the middle of the wall above the bier there is a figure
of Charity, with certain children, wrought with much diligence
and very well in harmony with the whole. The same is seen in a
Madonna with the Child in her arms, in a lunette, which Mino
made as much like the manner of Desiderio as he could; and if
he had assisted his methods of work by studying from the life,
there is no doubt that he would have made very great progress
in his art. This tomb, with all its expenses, cost 1,600 lire, and he
finished it in 1481, thereby acquiring much honour, and obtaining
a commission to make a tomb for Lionardo Salutati, Bishop of
Fiesole, in the Vescovado of that place, in a chapel near the
principal chapel, on the right hand as one goes up; on which
tomb he portrayed him in his episcopal robes, as lifelike as
possible. For the same Bishop he made a head of Christ in
marble, life-size and very well wrought, which was left among
other bequests to the Hospital of the Innocenti; and at the pres-
ent day the Very Reverend Don Vincenzio Borghini, Prior of that
hospital, holds it among his most precious examples of these arts,
in which he takes a delight beyond my power to express in words.

In the Pieve of Prato Mino made a pulpit entirely of marble,
in which there are stories of Our Lady, executed with much
diligence and put together so well, that the work appears all of
one piece. This pulpit stands over one corner of the choir, almost
in the middle of the church, above certain ornaments made under
the direction of the same Mino. He also made portraits of Piero
di Lorenzo de' Medici and his wife, marvellously lifelike and true
to nature. These two heads stood for many years over two doors
in Piero's apartment in the house of the Medici, each in a lunette;
afterwards they were removed, with the portraits of many other
illustrious men of that house, to the guardaroba of the Lord
Duke Cosimo. Mino also made a Madonna in marble, which is
now in the Audience Chamber of the Guild of the Masters in
Wood and Stone; and to Perugia, for Messer Baglione Ribi, he
sent a marble panel, which was placed in the Chapel of the Sac-
rament in S. Pietro, the work being in the form of a tabernacle,
with S. John on one side and S. Jerome on the other – good

figures in half-relief. The Tabernacle of the Sacrament in the Duomo of Volterra is likewise by his hand, with the two angels standing one on either side of it, so well and so diligently executed that this work is deservedly praised by all craftsmen.

Finally, attempting one day to move certain stones, and not having the needful assistance at hand, Mino fatigued himself so greatly that he was seized by pleurisy and died of it; and he was honourably buried by his friends and relatives in the Canon's house at Fiesole in the year 1486. The portrait of Mino is in our book of drawings, but I do not know by whose hand; it was given to me together with some drawings made with blacklead by Mino himself, which have no little beauty.

LORENZO COSTA, Painter of Ferrara

Although men have ever practised the arts of design more in Tuscany than in any other province of Italy, and perhaps of Europe, yet it is none the less true that in every age there has arisen in the other provinces some genius who has proved himself rare and excellent in the same professions, as has been shown up to the present in many of the Lives, and will be demonstrated even more in those that are to follow. It is true, indeed, that where there are no studies, and where men are not disposed by custom to learn, they are not able to advance so rapidly or to become so excellent as they do in those places where craftsmen are for ever practising and studying in competition. But as soon as one or two make a beginning, it seems always to come to pass that many others – such is the force of excellence – strive to follow them, with honour both for themselves and for their countries.

Lorenzo Costa of Ferrara, being inclined by nature to the art of painting, and hearing that Fra Filippo, Benozzo, and others were celebrated and highly esteemed in Tuscany, betook himself to Florence in order to see their works; and on his arrival, finding that their manner pleased him greatly, he stayed there many months, striving to imitate them to the best of his power, particularly in drawing from nature. In this he succeeded so happily, that, after returning to his own country, although his manner was a little dry and hard, he made many praiseworthy works there; as may be seen from the choir of the Church of S. Domenico in

Ferrara, wrought entirely by his hand, from which it is evident that he used great diligence in his art and put much labour into his works. In the guardaroba of the Lord Duke of Ferrara there are seen portraits from life in many pictures by his hand, which are very well wrought and very lifelike. In the houses of noblemen, likewise, there are works by his hand which are held in great veneration.

In the Church of S. Domenico at Ravenna, in the Chapel of S. Sebastiano, he painted the panel in oil and certain scenes in fresco, which were much extolled. Being next summoned to Bologna, he painted a panel in the Chapel of the Mariscotti in S. Petronio, representing S. Sebastian bound to the column and pierced with arrows, with many other figures, which was the best work in distemper that had been made up to that time in that city. By his hand, also, was the panel of S. Jerome in the Chapel of the Castelli, and likewise that of S. Vincent, wrought in like manner in distemper, which is in the Chapel of the Griffoni; the predella of this he caused to be painted by a pupil of his, who acquitted himself much better than the master did in the panel, as will be told in the proper place. In the same city, and in the same church, Lorenzo painted a panel for the Chapel of the Rossi, with Our Lady, S. James, S. George, S. Sebastian, and S. Jerome; which work is better and sweeter in manner than any other that he ever made.

Afterwards, having entered the service of Signor Francesco Gonzaga, Marquis of Mantua, Lorenzo painted many scenes for him, partly in gouache and partly in oil, in an apartment in the Palace of S. Sebastiano. In one is the Marchioness Isabella, portrayed from life, accompanied by many ladies who are singing various parts and making a sweet harmony. In another is the Goddess Latona, who is transforming certain peasants into frogs, according to the fable. In the third is the Marquis Francesco, led by Hercules along the path of virtue upon the summit of a mountain consecrated to Eternity. In another picture the same Marquis is seen triumphant on a pedestal, with a staff in his hand; and round him are many nobles and retainers with standards in their hands, all rejoicing and full of jubilation at his greatness, among whom there is an infinite number of portraits from the life. And in the great hall, where the triumphal processions by the hand of Mantegna now are, he painted two pictures, one at each end. In the first, which is in gouache, are many naked figures lighting

fires and making sacrifices to Hercules; and in this is a portrait from life of the Marquis, with his three sons, Federigo, Ercole, and Ferrante, who afterwards became very great and very illustrious lords; and there are likewise some portraits of great ladies. In the other, which was painted in oil many years after the first, and which was one of the last works that Lorenzo executed, is the Marquis Federigo, grown to man's estate, with a staff in his hand, as General of Holy Church under Leo X; and round him are many lords portrayed by Costa from the life.

In Bologna, in the Palace of Messer Giovanni Bentivogli, the same man painted certain rooms in competition with many other masters; but of these, since they were thrown to the ground in the destruction of that palace, no further mention will be made. But I will not forbear to say that, of the works that he executed for the Bentivogli, only one remained standing – namely, the chapel that he painted for Messer Giovanni in S. Jacopo, wherein he wrought two scenes of triumphal processions, which are held very beautiful, with many portraits. In the year 1497, also, for Jacopo Chedini, he painted a panel for a chapel in S. Giovanni in Monte, in which he wished to be buried after death; in this he made a Madonna, S. John the Evangelist, S. Augustine, and other saints. On a panel in S. Francesco he painted a Nativity, S. James, and S. Anthony of Padua. In S. Pietro he made a most beautiful beginning in a chapel for Domenico Garganelli, a gentleman of Bologna; but, whatever may have been the reason, after making some figures on the ceiling, he left it unfinished, nay, scarcely begun.

In Mantua, besides the works that he executed there for the Marquis, of which we have spoken above, he painted a Madonna on a panel for S. Silvestro; and on one side, S. Sylvester recommending the people of that city to her, and, on the other, S. Sebastian, S. Paul, S. Elizabeth, and S. Jerome. It is reported that the said panel was placed in that church after the death of Costa, who, having finished his life in Mantua, in which city his descendants have lived ever since, wished to have a burial-place in that church both for himself and for his successors.

The same man made many other pictures, of which nothing more will be said, for it is enough to have recorded the best. His portrait I received in Mantua from Fermo Ghisoni, an excellent painter, who assured me that it was by the hand of Costa, who was a passing good draughtsman, as may be seen from a pen-drawing on parchment in our book, wherein is the Judgment of

Solomon, with a S. Jerome in chiaroscuro, which are both very well wrought.

Disciples of Lorenzo were Ercole da Ferrara, his compatriot, whose Life will be written below, and Lodovico Malino, likewise of Ferrara, by whom there are many works in his native city and in other places; but the best that he made was a panel which is in the Church of S. Francesco in Bologna, in a chapel near the principal door, representing Jesus Christ at the age of twelve disputing with the Doctors in the Temple. The elder Dosso of Ferrara, of whose works mention will be made in the proper place, also learnt his first principles from Costa. And this is as much as I have been able to gather about the life and works of Lorenzo Costa of Ferrara.

ERCOLE FERRARESE, Painter
[ERCOLE DA FERRARA]

ALTHOUGH, long before Lorenzo Costa died, his disciple Ercole Ferrarese was in very good repute and was invited to work in many places, he would never abandon his master (a thing which is rarely wont to happen), and was content to work with him for meagre gains and praise, rather than labour by himself for greater profit and credit. For this gratitude, in view of its rarity among the men of to-day, all the more praise is due to Ercole, who, knowing himself to be indebted to Lorenzo, put aside all thought of his own interest in favour of his master's wishes, and was like a brother or a son to him up to the end of his life.

Ercole, then, who was a better draughtsman than Costa, painted, below the panel executed by Lorenzo in the Chapel of S. Vincenzio in S. Petronio, certain scenes in distemper with little figures, so well and with so beautiful and good a manner, that it is scarcely possible to see anything better, or to imagine the labour and diligence that Ercole put into the work: and thus the predella is a much better painting than the panel. Both were wrought at one and the same time during the life of Costa. After his master's death, Ercole was employed by Domenico Garganelli to finish that chapel in S. Petronio which Lorenzo, as has been said above, had begun, completing only a small part. Ercole, to whom the said Domenico was giving four ducats a month for

this, with his own expenses and those of a boy, and all the colours that were to be used for the painting, set himself to work and finished the whole in such a manner, that he surpassed his master by a long way both in drawing and colouring as well as in invention. In the first part, or rather, wall, is the Crucifixion of Christ, wrought with much judgment: for besides the Christ, who is seen there already dead, he represented very well the tumult of the Jews who have come to see the Messiah on the Cross, among whom there is a marvellous variety of heads, whereby it is seen that Ercole sought with very great pains to make them so different one from another that they should not resemble each other in any respect. There are also some figures bursting into tears of sorrow, which demonstrate clearly enough how much he sought to imitate reality. There is the swooning of the Madonna, which is most moving; but much more so are the Maries, who are facing her, for they are seen full of compassion and with an aspect so heavy with sorrow, that it is almost impossible to imagine it, at seeing that which mankind holds most dear dead before their eyes, and themselves in danger of losing the second. Among other notable things in this work is Longinus on horseback, riding a lean beast, which is foreshortened and in very strong relief; and in him we see the impiety that made him pierce the side of Christ, and the penitence and conversion that followed from his enlightenment. He gave strange attitudes, likewise, to the figures of certain soldiers who are playing for the raiment of Christ, with bizarre expressions of countenance and fanciful garments. Well wrought, too, with beautiful invention, are the Thieves on the Cross. And since Ercole took much delight in making fore-shortenings, which, if well conceived, are very beautiful, he made in that work a soldier on a horse, which, rearing its fore-legs on high, stands out in such a manner that it appears to be in relief; and as the wind is bending a banner that the soldier holds in his hand, he is making a most beautiful effort to hold it up. He also made a S. John, flying away wrapped in a sheet. In like manner, the soldiers that are in this work are very well wrought, with more natural and appropriate movements than had been seen in any other figures up to that time; and all these attitudes and gestures, which could scarcely be better done, show that Ercole had a very great intelligence and took great pains with his art.

On the wall opposite to this one the same man painted the Passing of Our Lady, who is surrounded by the Apostles in very

beautiful attitudes, among whom are six figures portrayed so well from life, that those who knew them declare that these are most vivid likenesses. In the same work he also made his own portrait, and that of Domenico Garganelli, the owner of the chapel, who, when it was finished, moved by the love that he bore to Ercole and by the praises that he heard given to the work, bestowed upon him a thousand lire in Bolognese currency. It is said that Ercole spent twelve years in labouring at this work; seven in executing it in fresco, and five in retouching it on the dry. It is true, indeed, that during this time he painted some other works; and in particular, so far as is known, the predella of the high-altar of S. Giovanni in Monte, in which he wrought three scenes of the Passion of Christ.

Ercole was eccentric in character, particularly in his custom of refusing to let any man, whether painter or not, see him at work; wherefore he was greatly hated in Bologna by the painters of that city, who have ever borne an envious hatred to the strangers who have been summoned to work there; nay, they sometimes show the same among themselves out of rivalry with each other, although this may be said to be the particular vice of the professors of these our arts in every place. Certain Bolognese painters, then, having come to an agreement one day with a carpenter, shut themselves up by his help in the church, close to the chapel where Ercole was working; and when night came, breaking into it by force, they did not content themselves with seeing the work, which should have sufficed them, but carried off all his cartoons, sketches, and designs, and every other thing of value that was there. At this Ercole fell into such disdain that when the work was finished he departed from Bologna, without stopping another day there, taking with him Duca Tagliapietra, a sculptor of much renown, who carved the very beautiful foliage in marble which is in the parapet in front of the chapel wherein Ercole painted the said work, and who afterwards made all the stone windows of the Ducal Palace at Ferrara, which are most beautiful. Ercole, therefore, weary at length of living away from home, remained ever after in company with this man in Ferrara, and made many works in that city.

Ercole had an extraordinary love of wine, and his frequent drunkenness did much to shorten his life, which he had enjoyed without any accident up to the age of forty, when he was smitten one day by apoplexy, which made an end of him in a short time.

He left a pupil, the painter Guido Bolognese, who, in 1491, as may be seen from the place where he put his name, under the portico of S. Pietro at Bologna, painted a Crucifixion in fresco, with the Maries, the Thieves, horses, and other passing good figures. And desiring very greatly to become esteemed in that city, as his master had been, he studied so zealously and subjected himself to so many hardships that he died at the age of thirty-five. If Guido had set himself to learn his art in his childhood, and not, as he did, at the age of eighteen, he would not only have equalled his master without difficulty, but would even have surpassed him by a great measure. In our book there are drawings by the hands of Ercole and Guido, very well wrought, and executed with grace and in a good manner.

JACOPO, GIOVANNI, AND GENTILE BELLINI, Painters of Venice

ENTERPRISES that are founded on excellence, although their beginnings often appear humble and mean, keep climbing higher step by step, nor do they ever halt or take rest until they have reached the supreme heights of glory: as could be clearly seen from the poor and humble beginning of the house of the Bellini, and from the rank to which it afterwards rose by means of painting.

Jacopo Bellini, a painter of Venice, having been a disciple of Gentile da Fabriano, worked in competition with that Domenico who taught the method of colouring in oil to Andrea dal Castagno; but, although he laboured greatly to become excellent in that art, he did not acquire fame therein until after the departure of Domenico from Venice. Then, finding himself in that city without any competitor to equal him, he kept growing in credit and fame, and became so excellent that he was the greatest and most renowned man in his profession. And to the end that the name which he had acquired in painting might not only be maintained in his house and for his descendants, but might grow greater, there were born to him two sons of good and beautiful intelligence, strongly inclined to the art: one was Giovanni, and the other Gentile, to whom he gave that name in tender memory of Gentile da Fabriano, who had been his master and like a loving

GIOVANNI BELLINI PITTOR
VINIZIANO.

father to him. Now, when the said two sons had grown to a certain age, Jacopo himself with all diligence taught them the rudiments of drawing; but no long time passed before both one and the other surpassed his father by a great measure, whereat he rejoiced greatly, ever encouraging them and showing them that he desired them to do as the Tuscans did, who gloried among themselves in making efforts to outstrip each other, according as one after another took up the art: even so should Giovanni vanquish himself, and Gentile should vanquish them both, and so on in succession.

The first works that brought fame to Jacopo were the portraits of Giorgio Cornaro and of Caterina, Queen of Cyprus; a panel which he sent to Verona, containing the Passion of Christ, with many figures, among which he portrayed himself from the life; and a picture of the Story of the Cross, which is said to be in the Scuola of S. Giovanni Evangelista. All these works and many others were painted by Jacopo with the aid of his sons; and the last-named picture was painted on canvas, as it has been almost always the custom to do in that city, where they rarely paint, as is done elsewhere, on panels of the wood of that tree that is called by many oppio* and by some gattice.† This wood, which grows mostly beside rivers or other waters, is very soft, and admirable for painting on, for it holds very firmly when joined together with carpenters' glue. But in Venice they make no panels, and, if they do make a few, they use no other wood than that of the fir, of which that city has a great abundance by reason of the River Adige, which brings a very great quantity of it from Germany, not to mention that no small amount comes from Sclavonia. It is much the custom in Venice, then, to paint on canvas, either because it does not split and does not grow worm-eaten, or because it enables pictures to be made of any size that is desired, or because, as was said elsewhere, they can be sent easily and conveniently wherever they are wanted, with very little expense and labour. Be the reason what it may, Jacopo and Gentile, as was said above, made their first works on canvas.

To the last-named Story of the Cross Gentile afterwards added by himself seven other pictures, or rather, eight, in which he painted the miracle of the Cross of Christ, which the said Scuola preserves as a relic; which miracle was as follows. The

* Poplar. † White poplar.

said Cross was thrown, I know not by what chance, from the Ponte della Paglia into the Canal, and, by reason of the reverence that many bore to the piece of the Cross of Christ that it contained, they threw themselves into the water to recover it; but it was the will of God that no one should be worthy to succeed in grasping it save the Prior of that Scuola. Gentile, therefore, representing this story, drew in perspective, along the Grand Canal, many houses, the Ponte della Paglia, the Piazza di S. Marco, and a long procession of men and women walking behind the clergy; also many who have leapt into the water, others in the act of leaping, many half immersed, and others in other very beautiful actions and attitudes; and finally he painted the said Prior recovering the Cross. Truly great were the labour and diligence of Gentile in this work, considering the infinite number of people, the many portraits from life, the diminution of the figures in the distance, and particularly the portraits of almost all the men who then belonged to that Scuola, or rather, Confraternity. Last comes the picture of the replacing of the said Cross, wrought with many beautiful conceptions. All these scenes, painted on the aforesaid canvases, acquired a very great name for Gentile.

Afterwards, Jacopo withdrew to work entirely by himself, as did his two sons, each of them devoting himself to his own studies in the art. Of Jacopo I will make no further mention, seeing that his works were nothing out of the ordinary in comparison with those of his sons, and because he died not long after his sons withdrew themselves from him; and I judge it much better to speak at some length only of Giovanni and Gentile. I will not, indeed, forbear to say that although these brothers retired to live each by himself, nevertheless they had so much respect for each other, and both had such reverence for their father, that each, extolling the other, ever held himself inferior in merit; and thus they sought modestly to surpass one another no less in goodness and courtesy than in the excellence of their art.

The first works of Giovanni were some portraits from the life, which gave much satisfaction, and particularly that of Doge Loredano – although some say that this was a portrait of Giovanni Mozzenigo, brother of that Piero who was Doge many years before Loredano. Giovanni then painted a panel for the altar of S. Caterina da Siena in the Church of S. Giovanni, in which picture – a rather large one – he painted Our Lady seated, with the Child in her arms, and S. Dominic, S. Jerome, S. Catherine,

S. Ursula, and two other Virgins; and at the feet of the Madonna he made three boys standing, who are singing from a book – a very beautiful group. Above this he made the inner part of a vault in a building, which is very beautiful. This work was one of the best that had been made in Venice up to that time. For the altar of S. Giobbe in the Church of that Saint, the same man painted a panel with good design and most beautiful colouring, in the middle of which he made the Madonna with the Child in her arms, seated on a throne slightly raised from the ground, with nude figures of S. Job and S. Sebastian, beside whom are S. Dominic, S. Francis, S. John, and S. Augustine; and below are three boys, sounding instruments with much grace. This picture was not only praised then, when it was seen as new, but it has likewise been extolled ever afterwards as a very beautiful work.

Certain noblemen, moved by the great praises won by these works, began to suggest that it would be a fine thing, in view of the presence of such rare masters, to have the Hall of the Great Council adorned with stories, in which there should be depicted the glories and the magnificence of their marvellous city – her great deeds, her exploits in war, her enterprises, and other things of that kind, worthy to be perpetuated by painting in the memory of those who should come after – to the end that there might be added, to the profit and pleasure drawn from the reading of history, entertainment both for the eye and for the intellect, from seeing the images of so many illustrious lords wrought by the most skilful hands, and the glorious works of so many noblemen right worthy of eternal memory and fame. And so Giovanni and Gentile, who kept on making progress from day to day, received the commission for this work by order of those who governed the city, who commanded them to make a beginning as soon as possible. But it must be remarked that Antonio Viniziano had made a beginning long before with the painting of the same Hall, as was said in his Life, and had already finished a large scene, when he was forced by the envy of certain malignant spirits to depart and to leave that most honourable enterprise without carrying it on further.

Now Gentile, either because he had more experience and greater skill in painting on canvas than in fresco, or for some other reason, whatever it may have been, contrived without difficulty to obtain leave to execute that work not in fresco but on canvas. And thus, setting to work, in the first scene he made

the Pope presenting a wax candle to the Doge, that he might bear
it in the solemn processions which were to take place; in which
picture Gentile painted the whole exterior of S. Marco, and made
the said Pope standing in his pontifical robes, with many prelates
behind him, and the Doge likewise standing, accompanied by
many Senators. In another part he represented the Emperor Bar-
barossa; first, when he is receiving the Venetian envoys in friendly
fashion, and then, when he is preparing for war, in great disdain;
in which scene are very beautiful perspectives, with innumerable
portraits from the life, executed with very good grace and amid
a vast number of figures. In the following scene he painted the
Pope exhorting the Doge and the Signori of Venice to equip
thirty galleys at their common expense, to go out to battle against
Frederick Barbarossa. This Pope is seated in his rochet on the
pontifical chair, with the Doge beside him and many Senators at
his feet. In this part, also, Gentile painted the Piazza and the
façade of S. Marco, and the sea, but in another manner, with so
great a multitude of men that it is truly a marvel. Then in another
part the same Pope, standing in his pontifical robes, is giving his
benediction to the Doge, who appears to be setting out for the
fray, armed, and with many soldiers at his back; behind the Doge
are seen innumerable noblemen in a long procession, and in the
same part are the Palace and S. Marco, drawn in perspective. This
is one of the best works that there are to be seen by the hand of
Gentile, although there appears to be more invention in that
other which represents a naval battle, because it contains an in-
finite number of galleys fighting together and an incredible
multitude of men, and because, in short, he showed clearly there-
in that he had no less knowledge of naval warfare than of his
own art of painting. And indeed, all that Gentile executed in this
work – the crowd of galleys engaged in battle; the soldiers
fighting; the boats duly diminishing in perspective; the finely or-
dered combat; the soldiers furiously striving, defending, and strik-
ing; the wounded dying in various manners; the cleaving of the
water by the galleys; the confusion of the waves; and all the kinds
of naval armament – all this vast diversity of subjects, I say,
cannot but serve to prove the great spirit, art, invention, and
judgment of Gentile, each detail being most excellently wrought
in itself, as well as the composition of the whole. In another
scene he made the Doge returning with the victory so much
desired, and the Pope receiving him with open arms, and giving

him a ring of gold wherewith to espouse the sea, as his successors have done and still do every year, as a sign of the true and perpetual dominion that they deservedly hold over it. In this part there is Otto, son of Frederick Barbarossa, portrayed from the life, and kneeling before the Pope; and as behind the Doge there are many armed soldiers, so behind the Pope there are many Cardinals and noblemen. In this scene only the poops of the galleys appear; and on the Admiral's galley is seated a Victory painted to look like gold, with a crown on her head and a sceptre in her hand.

The scenes that were to occupy the other parts of the Hall were entrusted to Giovanni, the brother of Gentile; but since the order of the stories that he painted there is connected with those executed in great part, but not finished, by Vivarino, it is necessary to say something of the latter. That part of the Hall which was not done by Gentile was given partly to Giovanni and partly to the said Vivarino, to the end that rivalry might induce each man to do his best. Vivarino, then, putting his hand to the part that belonged to him, painted, beside the last scene of Gentile, the aforesaid Otto offering to the Pope and to the Venetians to go to conclude peace between them and his father Frederick; and, having obtained this, he is dismissed on oath and goes his way. In this first part, besides other things, which are all worthy of consideration, Vivarino painted an open temple in beautiful perspective, with steps and many figures. Before the Pope, who is seated and surrounded by many Senators, is the said Otto on his knees, binding himself by an oath. Beside this scene, he painted the arrival of Otto before his father, who is receiving him gladly; with buildings wrought most beautifully in perspective, Barbarossa on his throne, and his son kneeling and taking his hand, accompanied by many Venetian noblemen, who are portrayed from the life so finely that it is clear that he imitated nature very well. Poor Vivarino would have completed the remainder of his part with great honour to himself, but, having died, as it pleased God, from exhaustion and through being of a weakly habit of body, he carried it no further – nay, even what he had done was not wholly finished, and it was necessary for Giovanni Bellini to retouch it in certain places.

Meanwhile, Giovanni had also made a beginning with four scenes, which follow in due order those mentioned above. In the first he painted the said Pope in S. Marco – which church he portrayed exactly as it stood – presenting his foot to Frederick Barbarossa to kiss; but this first picture of Giovanni's, whatever

may have been the reason, was rendered much more lifelike and incomparably better by the most excellent Tiziano. However, continuing his scenes, Giovanni made in the next the Pope saying Mass in S. Marco, and afterwards, between the said Emperor and the Doge, granting plenary and perpetual indulgence to all who should visit the said Church of S. Marco at certain times, particularly at that of the Ascension of Our Lord. There he depicted the interior of that church, with the said Pope in his pontifical robes at the head of the steps that issue from the choir, surrounded by many Cardinals and noblemen – a vast group, which makes this a crowded, rich, and beautiful scene. In the one below this the Pope is seen in his rochet, presenting a canopy to the Doge, after having given another to the Emperor and keeping two for himself. In the last that Giovanni painted are seen Pope Alexander, the Emperor, and the Doge arriving in Rome, without the gates of which the Pope is presented by the clergy and by the people of Rome with eight standards of various colours and eight silver trumpets, which he gives to the Doge, that he and his successors may have them for insignia. Here Giovanni painted Rome in somewhat distant perspective, a great number of horses, and an infinity of foot-soldiers, with many banners and other signs of rejoicing on the Castle of S. Angelo. And since these works of Giovanni, which are truly very beautiful, gave infinite satisfaction, arrangements were just being made to give him the commission to paint all the rest of that Hall, when, being now old, he died.

Up to the present we have spoken of nothing save the Hall, in order not to interrupt the sequence of the scenes; but now we must turn back a little and say that there are many other works to be seen by the hand of the same man. One is a panel which is now on the high-altar of S. Domenico in Pesaro. In the Church of S. Zaccheria in Venice, in the Chapel of S. Girolamo, there is a panel of Our Lady and many saints, executed with great diligence, with a building painted with much judgment; and in the same city, in the Sacristy of the Friars Minor, called the 'Cà Grande,' there is another by the same man's hand, wrought with beautiful design and a good manner. There is likewise one in S. Michele di Murano, a monastery of Monks of Camaldoli; and in the old Church of S. Francesco della Vigna, a seat of the Frati del Zoccolo, there was a picture of a Dead Christ, so beautiful that it was highly extolled before Louis XI, King of France, whereupon he demanded it from its owners with great insistence,

so that they were forced, although very unwillingly, to gratify his wish. In its place there was put another with the name of the same Giovanni, but not so beautiful or so well executed as the first; and some believe that this substitute was wrought for the most part by Girolamo Moretto, a pupil of Giovanni. The Confraternity of S. Girolamo also possesses a work with little figures by the same Bellini, which is much extolled. And in the house of Messer Giorgio Cornaro there is a picture, likewise very beautiful, containing Christ, Cleophas, and Luke.

In the aforesaid Hall he also painted, though not at the same time, a scene of the Venetians summoning forth from the Monastery of the Carità a Pope – I know not which – who, having fled to Venice, had secretly served for a long time as cook to the monks of that monastery; in which scene there are many portraits from the life, and other very beautiful figures.

No long time after, certain portraits were taken to Turkey by an ambassador as presents for the Grand Turk, which caused such astonishment and marvel to that Emperor, that, although pictures are forbidden among that people by the Mahometan law, nevertheless he accepted them with great good-will, praising the art and the craftsman without ceasing; and what is more, he demanded that the master of the work should be sent to him. Whereupon the Senate, considering that Giovanni had reached an age when he could ill endure hardships, not to mention that they did not wish to deprive their own city of so great a man, particularly because he was then engaged on the aforesaid Hall of the Great Council, determined to send his brother Gentile, believing that he would do as well as Giovanni. Therefore, having caused Gentile to make his preparations, they brought him safely in their own galleys to Constantinople, where, after being presented by the Commissioner of the Signoria to Mahomet, he was received very willingly and treated with much favour as something new, above all after he had given that Prince a most lovely picture, which he greatly admired, being wellnigh unable to believe that a mortal man had within himself so much divinity, so to speak, as to be able to represent the objects of nature so vividly. Gentile had been there no long time when he portrayed the Emperor Mahomet from the life so well, that it was held a miracle. That Emperor, after having seen many specimens of his art, asked Gentile whether he had the courage to paint his own portrait; and Gentile, having answered 'Yes,' did not allow many

days to pass before he had made his own portrait with a mirror, with such resemblance that it appeared alive. This he brought to the Sultan, who marvelled so greatly thereat, that he could not but think that he had some divine spirit within him; and if it had not been that the exercise of this art, as has been said, is forbidden by law among the Turks, that Emperor would never have allowed Gentile to go. But either in fear of murmurings, or for some other reason, one day he summoned him to his presence, and after first causing him to be thanked for the courtesy that he had shown, and then praising him in marvellous fashion as a man of the greatest excellence, he bade him demand whatever favour he wished, for it would be granted to him without fail. Gentile, like the modest and upright man that he was, asked for nothing save a letter of recommendation to the most Serene Senate and the most Illustrious Signoria of Venice, his native city. This was written in the warmest possible terms, and afterwards he was dismissed with honourable gifts and with the dignity of Chevalier. Among other things given to him at parting by that Sovereign, in addition to many privileges, there was placed round his neck a chain wrought in the Turkish manner, equal in weight to 250 gold crowns, which is still in the hands of his heirs in Venice.

Departing from Constantinople, Gentile returned after a most prosperous voyage to Venice, where he was received with gladness by his brother Giovanni and by almost the whole city, all men rejoicing at the honours paid to his talent by Mahomet. Afterwards, on going to make his reverence to the Doge and the Signoria, he was received very warmly, and commended for having given great satisfaction to that Emperor according to their desire. And to the end that he might see in what great account they held the letters in which that Prince had recommended him, they decreed him a provision of 200 crowns a year, which was paid to him for the rest of his life. Gentile made but few works after his return; finally, having almost reached the age of eighty, and having executed the aforesaid works and many others, he passed to the other life, and was given honourable burial by his brother Giovanni in S. Giovanni e Paolo, in the year 1501.

Giovanni, thus bereft of Gentile, whom he had ever loved most tenderly, went on doing a little work, although he was old, to pass the time. And having devoted himself to making portraits from the life, he introduced into Venice the fashion that everyone of a certain rank should have his portrait painted either by him

or by some other master; wherefore in all the houses of Venice there are many portraits, and in many gentlemen's houses one may see their fathers and grandfathers, up to the fourth generation, and in some of the more noble they go still farther back – a fashion which has ever been truly worthy of the greatest praise, and existed even among the ancients. Who does not feel infinite pleasure and contentment, to say nothing of the honour and adornment that they confer, at seeing the images of his ancestors, particularly if they have been famous and illustrious for their part in governing their republics, for noble deeds performed in peace or in war, or for learning or any other notable and distinguished talent? And to what other end, as has been said in another place, did the ancients set up images of their great men in public places, with honourable inscriptions, than to kindle in the minds of their successors a love of excellence and of glory?

For Messer Pietro Bembo, then, before he went to live with Pope Leo X, Giovanni made a portrait of the lady that he loved, so lifelike that, even as Simone Sanese had been celebrated in the past by the Florentine Petrarca, so was Giovanni deservedly celebrated in his verses by this Venetian, as in the following sonnet:

O imagine mia celeste e pura,

where, at the beginning of the second quatrain, he says,

Credo che'l mio Bellin con la figura,

with what follows. And what greater reward can our craftsmen desire for their labours than that of being celebrated by the pens of illustrious poets, as that most excellent Tiziano has been by the very learned Messer Giovanni della Casa, in that sonnet which begins –

Ben veggio, Tiziano, in forme nuove,

and in that other –

Son queste, Amor, le vaghe treccie bionde.

Was not the same Bellini numbered among the best painters of his age by the most famous Ariosto, at the beginning of the thirty-third canto of the *'Orlando Furioso'* ?

But to return to the works of Giovanni – that is, to his principal works, for it would take too long to try to make mention of all the pictures and portraits that are in the houses of

gentlemen in Venice and in other parts of that country. In Rimini, for Signor Sigismondo Malatesti, he made a large picture containing a Pietà, supported by two little boys, which is now in S. Francesco in that city. And among other portraits he made one of Bartolommeo da Liviano, Captain of the Venetians.

Giovanni had many disciples, for he was ever most willing to teach anyone. Among them, now sixty years ago, was Jacopo da Montagna, who imitated his manner closely, in so far as is shown by his works, which are to be seen in Padua and in Venice. But the man who imitated him most faithfully and did him the greatest honour was Rondinello da Ravenna, of whom Giovanni availed himself much in all his works. This master painted a panel in S. Domenico at Ravenna, and another in the Duomo, which is held a very beautiful example of that manner. But the work that surpassed all his others was that which he made in the Church of S. Giovanni Battista, a seat of the Carmelite Friars, in the same city; in which picture, besides Our Lady, he made a very beautiful head in a figure of S. Alberto, a friar of that Order, and the whole figure is much extolled. A pupil of Giovanni's, also, although he gained but little thereby, was Benedetto Coda of Ferrara, who dwelt in Rimini, where he made many pictures, leaving behind him a son named Bartolommeo, who did the same. It is said that Giorgione da Castelfranco also pursued his first studies of art under Giovanni, and likewise many others, both from the territory of Treviso and from Lombardy, of whom there is no need to make record.

Finally, having lived ninety years, Giovanni passed from this life, overcome by old age, leaving an eternal memorial of his name in the works that he had made both in his native city of Venice and abroad; and he was honourably buried in the same church and in the same tomb in which he had laid his brother Gentile to rest. Nor were there wanting in Venice men who sought to honour him when dead with sonnets and epigrams, even as he, when alive, had honoured both himself and his country. About the same time that these Bellini were alive, or a little before, many pictures were painted in Venice by Giacomo Marzone, who, among other things, painted one in the Chapel of the Assumption in S. Lena – namely, the Virgin with a palm, S. Benedict, S. Helen, and S. John; but in the old manner, with the figures on tip-toe, as was the custom of those painters who lived in the time of Bartolommeo da Bergamo.

COSIMO ROSSELLI, Painter of Florence

Many men take an unholy delight in covering others with ridicule and scorn – a delight which generally turns to their own confusion, as it came to pass in the case of Cosimo Rosselli, who threw back on their own heads the ridicule of those who sought to vilify his labours. This Cosimo, although he was not one of the rarest or most excellent painters of his time, nevertheless made works that were passing good. In his youth he painted a panel in the Church of S. Ambrogio in Florence, which is on the right hand as one enters the church; and three figures over an arch for the Nuns of S. Jacopo delle Murate. In the Church of the Servi, also in Florence, he painted the panel of the Chapel of S. Barbara; and in the first court, before one enters into the church, he wrought in fresco the story of the Blessed Filippo taking the Habit of Our Lady. For the Monks of Cestello he painted the panel of their high-altar, with another in a chapel in the same church; and likewise that one which is in a little church above the Bernardino, beside the entrance to Cestello. He painted a standard for the children of the Company of the said Bernardino, and likewise that of the Company of S. Giorgio, on which there is an Annunciation. For the aforesaid Nuns of S. Ambrogio he painted the Chapel of the Miracle of the Sacrament, which is a passing good work, and is held the best of his in Florence; in this he counterfeited a procession on the piazza of that church, with the Bishop bearing the Tabernacle of the said Miracle, accompanied by the clergy and by an infinity of citizens and women in costumes of those times. Here, among many others, is a portrait from life of Pico della Mirandola, so excellently wrought that it appears not a portrait but a living man. In the Church of S. Martino in Lucca, by the entrance into the church through the lesser door of the principal façade, on the right hand, he painted a scene of Nicodemus making the statue of the Holy Cross, and then that statue being brought by sea in a boat and by land to Lucca. In this work are many portraits, and in particular that of Paolo Guinigi, which he copied from one done in clay by Jacopo della Fonte when the latter made the tomb of Paolo's wife. In S. Marco at Florence, in the Chapel of the Cloth Weavers, he painted a panel with the Holy Cross in the middle, and, at the sides, S. Mark, S. John the

Evangelist, S. Antonino, Archbishop of Florence, and other figures.

Being afterwards summoned, with the other painters, to execute the work that Pope Sixtus IV had undertaken in the Chapel of the Palace, he laboured there in company with Sandro Botticelli, Domenico Ghirlandajo, the Abbot of S. Clemente, Luca da Cortona, and Pietro Perugino, and painted three scenes with his own hand, wherein he depicted the Submersion of Pharaoh in the Red Sea, the Preaching of Christ to the people on the shore of the Sea of Tiberias, and the Last Supper of the Apostles with the Saviour. In this last scene he made an octagonal table drawn in perspective, with the ceiling above it likewise octagonal, the eight angles of which he foreshortened so well as to show that he had as good a knowledge of this art as any of the others. It is said that the Pope had offered a prize, which was to be given to the man who, in the judgment of the Pontiff himself, should turn out to have done the best work in these pictures. The scenes finished, therefore, His Holiness went to see them; and each of the painters had done his utmost to merit the said prize and honour. Cosimo, feeling himself weak in invention and draughtsmanship, had sought to conceal his shortcomings by covering his work with the finest ultramarine blues and other lively colours, and had illuminated his scenes with a plentiful amount of gold, so that there was no tree, or plant, or drapery, or cloud, that was not thus illuminated; for he was convinced that the Pope, like a man who knew little of that art, must therefore give him the prize of victory. When the day arrived on which the works of all were to be unveiled, that of Cosimo was seen with the rest, and was scorned and ridiculed with much laughter and jeering by all the other craftsmen, who all mocked him instead of having compassion on him. But the scorners turned out to be the scorned, for, as Cosimo had foreseen, those colours at the first glance so dazzled the eyes of the Pope, who had little knowledge of such things, although he took no little delight in them, that he judged the work of Cosimo to be much better than that of the others. And so, causing the prize to be given to him, he bade all the others cover their pictures with the best blues that could be found, and to pick them out with gold, to the end that they might be similar to those of Cosimo in colouring and in richness. Whereupon the poor painters, in despair at having to satisfy the small intelligence of the Holy Father, set themselves to spoil all

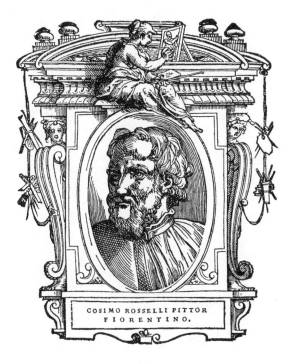

COSIMO ROSSELLI PITTOR
FIORENTINO.

the good work that they had done; and Cosimo laughed at the men who had just been laughing at his methods.

Afterwards, returning to Florence with some money, he set himself to work as usual, living much at his ease, and having as his companion that Piero, his disciple, who was ever called Piero di Cosimo, and who assisted him in his labours in the Sistine Chapel at Rome, and painted there, besides other things, a landscape in the picture of the Preaching of Christ, which landscape is held to be the best thing there. Andrea di Cosimo also worked with him, occupying himself much with grotesques. Finally, having reached the age of sixty-eight, Cosimo died in the year 1484, wasted away by a long infirmity; and he was buried in S. Croce by the Company of Bernardino.

Cosimo took so much delight in alchemy that he wasted therein all that he possessed, as all do who meddle with it, insomuch that it swallowed up all his means and finally reduced him from easy circumstances to the greatest poverty. He was a very good draughtsman, as may be seen in our book, not only from the drawing of the aforesaid story of the Preaching which he painted in the Sistine Chapel, but also from many others made with the style and in chiaroscuro. And in the said book we have his portrait by the hand of Agnolo di Donnino, a painter who was much his friend. This Agnolo showed great diligence in his works, as may be seen, not to mention his drawings, in the loggia of the Hospital of Bonifazio, where, upon the corbel of a vault, there is a Trinity in fresco by his hand; and beside the door of the said hospital, where the foundlings now live, there are certain beggars painted by the same man, with the Director receiving them, all very well wrought, and likewise certain women. This man spent his life labouring and wasting all his time over drawings, without putting them into execution; and at length he died as poor as he could well be. But to return to Cosimo; he left only one son, who was a builder and a passing good architect.

CECCA, Engineer of Florence

IF necessity had not forced men to exercise their ingenuity for their own advantage and convenience, architecture would not have become so excellent and so marvellous in the minds and in

the works of those who have practised it in order to acquire profit and fame, gaining that great honour which is paid to them every day by all who have knowledge of the good. It was necessity that first gave rise to buildings; necessity that created ornaments for them; necessity that led to the various Orders, the statues, the gardens, the baths, and all those other sumptuous adjuncts which all desire but few possess; and it was necessity that excited rivalry and competition in the minds of men with regard not only to buildings, but also to their accessories. For this reason craftsmen have been forced to display industry in inventing appliances for traction, and in making engines of war, waterworks, and all those devices and contrivances which, under the name of mechanical and architectural inventions, confer beauty and convenience on the world, discomfiting their enemies and assisting their friends. And whenever a man has been able to make such things better than his fellows, he has not only raised himself beyond all the anxieties of want, but has also been consummately extolled and prized by all other men.

This was the case in the time of our fathers with the Florentine Cecca, into whose hands there came many highly honourable works in his day; and in these he acquitted himself so well, toiling in the service of his country with economy and with great satisfaction to his fellow-citizens, that his ingenious and industrious labours have made him famous and illustrious among the number of distinguished and renowned craftsmen. It is said that in his youth Cecca was a very good carpenter, and that he had concentrated all his powers on seeking to solve the difficulties connected with engines, and how to make machines for assaulting walls in war – scaling-ladders for climbing into cities, battering-rams for breaching fortifications, defences for protecting soldiers in the attack, and everything that could injure his enemies and assist his friends – wherefore, being a person of the greatest utility to his country, he well deserved the permanent provision that the Signoria of Florence gave him. For this reason, when there was no war going on, he would go through the whole territory inspecting the fortresses and the walls of cities and townships, and, if any were weak, he would provide them with designs for ramparts and everything else that was wanting.

It is said that the Clouds which were borne in procession throughout Florence on the festival of S. John – things truly most ingenious and beautiful – were invented by Cecca, who was much

employed in such matters at that time, when the city was greatly given to holding festivals. In truth, although such festivals and representations have now fallen almost entirely out of use, they were very beautiful spectacles, and they were celebrated not only by the Companies, or rather, Confraternities, but also in the private houses of gentlemen, who were wont to form certain associations and societies, and to meet together at certain times to make merry; and among them there were ever many courtly craftsmen, who, besides being fanciful and amusing, served to make the preparations for such festivals. Among others, four most solemn public spectacles took place almost every year, one for each quarter of the city, with the exception of that of S. Giovanni, for the festival of which a most solemn procession was held, as will be told. The quarter of S. Maria Novella kept the feast of S. Ignazio; S. Croce, that of S. Bartholomew, called S. Baccio; S. Spirito, that of the Holy Spirit; and the Carmine, those of the Ascension of Our Lord and of the Assumption of Our Lady. This festival of the Ascension – for of the others of importance an account has been or will be given – was very beautiful, seeing that Christ was uplifted on a cloud covered with angels from a Mount very well made of wood, and was borne upwards to a Heaven, leaving the Apostles on the Mount; and the whole was so well contrived that it was a marvel, above all because the said Heaven was somewhat larger than that of S. Felice in Piazza, although the machinery was almost the same. And since the said Church of the Carmine, where this representation used to take place, is no little broader and higher than that of S. Felice, in addition to the part that supported Christ another Heaven was sometimes erected, according as it was thought advisable, over the chief tribune, wherein were certain great wheels made in the shape of reels, which, from the centres to the edges, moved in most beautiful order ten circles standing for the ten Heavens, which were all full of little lights representing the stars, contained in little copper lamps hanging on pivots, so that when the wheels revolved they remained upright, in the manner of certain lanterns that are now universally used by all. From this Heaven, which was truly a very beautiful thing, there issued two stout ropes fastened to the staging or tramezzo* which is in the said church, and over which the representation took place. To these ropes

* See note on p. 90.

were attached, by each end of a so-called brace-fastening, two little bronze pulleys which supported an iron upright fixed into a level platform, on which stood two angels fastened by their girdles. These angels were kept upright by a counterpoise of lead which they had under their feet, and by another that was under the platform on which they stood; and this also served to make them balanced one with another. The whole was covered with a quantity of cotton-wool, very well arranged in the form of a cloud, which was full of cherubim and seraphim, and similar kinds of angels, varied in colour and very well contrived. These angels, when a little rope was unwound from the Heaven above, came down the two larger ropes on to the said tramezzo, where the representation took place, and announced to Christ that He was to ascend into Heaven, and performed their other functions. And since the iron to which they were bound by the girdle was fixed to the platform on which they stood, in such a way that they could turn round and round, they could make obeisance and turn about both when they had come forth and when they were returning, according as was necessary; wherefore in reascending they turned towards the Heaven, and were then drawn up again as they had come down.

These machines and inventions are said to have been Cecca's, for, although Filippo Brunelleschi had made similar things long before, many additions were made to them with great judgment by Cecca; and it was from these that the thought came to the same man to make those Clouds which were borne in procession through the city every year on S. John's Eve, and the other beautiful things that were made. And this was his charge, because, as it has been said, he was a servant of the public.

Now with this occasion it will not be out of place to describe some of the features of the said festival and procession, to the end that some memory of them may descend to posterity, seeing that they have now for the most part fallen into disuse. First, then, the Piazza di S. Giovanni was all covered over with blue cloth, on which were sewn many large lilies of yellow cloth; and in the middle, on certain circles also of cloth, and ten braccia in diameter, were the arms of the People and Commune of Florence, with those of the Captain of the Guelph party and others; and all around, from the borders of the said canopy, which covered the whole piazza, vast as it is, there hung great banners also of cloth, painted with various devices, with the arms

of magisterial bodies and guilds, and with many lions, which form one of the emblems of the city. This canopy, or rather, awning, made thus, was about twenty braccia off the ground, and was supported by very strong ropes fastened to a number of irons, which are still to be seen round the Church of S. Giovanni, on the façade of S. Maria del Fiore, and on the houses that surround the said piazza on every side. Between one rope and another ran cords that likewise supported the awning, which was so well strengthened throughout, particularly at the edges, with ropes, cords, linings, double widths of cloth, and hems of sacking, that it is impossible to imagine anything better. What is more, everything was arranged so well and with such great diligence, that although the awning was often swelled out and shaken by the wind, which is always very powerful in that place, as everyone knows, yet it was never disturbed or damaged in any way whatever. This awning was made of five pieces, to the end that it might be easier to handle, but, when set into place, they were all joined and fastened and sewn together in such a manner that it appeared like one whole. Three pieces covered the piazza and the space that is between S. Giovanni and S. Maria del Fiore; and in the middle piece, in a straight line between the principal doors, were the aforesaid circles containing the arms of the Commune. And the remaining two pieces covered the sides – one towards the Misericordia, and the other towards the Canon's house and the Office of Works of S. Giovanni.

The Clouds, which were made of various kinds and with diverse inventions by the Companies, were generally fashioned in the following manner. A square framework was made of planks, about two braccia in height, with four stout legs at the corners, contrived after the manner of the trestles of a table, and fastened together with cross-pieces. On this framework two panels were laid crosswise, each one braccio wide, with a hole in the middle half a braccio in diameter, in which was fixed a high pole, whereon there was placed a mandorla all covered with cotton-wool, cherubim, lights, and other ornaments, and within this, on a horizontal bar of iron, there sat or stood, according as might be desired, a person representing that Saint whom the particular Company principally honoured as their peculiar patron and protector – to be exact, a Christ, or a Madonna, or a S. John, or some other – and the draperies of this figure covered the iron bar in such a manner that it could not be seen. Round the same

pole, lower down, below the mandorla, there radiated four or five
iron bars in the manner of the branches of a tree, and at the end
of each, attached likewise with irons, stood a little boy dressed
like an angel. These boys could move round and round at pleas-
ure on the iron brackets on which their feet rested, for the
brackets hung on hinges. And with similar branches there were
sometimes made two or three tiers of angels or of saints, accord-
ing to the nature of the subjects to be represented. The whole of
this structure, with the pole and the iron bars (which sometimes
represented a lily, sometimes a tree, and often a cloud or some
other similar thing), was covered with cotton-wool, and, as has
been said, with cherubim, seraphim, golden stars, and other such-
like ornaments. Within were porters or peasants, who carried it
on their shoulders, placing themselves round the wooden base
that we have called the framework, in which, below the places
where the weight rested on their shoulders, were fixed cushions
of leather stuffed with down, or cotton-wool, or some other soft
and yielding material. All the machinery, steps, and other things
were covered, as has been said above, with cotton-wool, which
made a beautiful effect; and all these contrivances were called
Clouds. Behind them came troops of men on horseback and
foot-soldiers of various sorts, according to the nature of the story
to be represented, even as in our own day they go behind the
cars or other things that are used in place of the said Clouds. Of
the form of the latter I have some designs in my book of
drawings, very well done by the hand of Cecca, which are truly
ingenious and full of beautiful conceptions.

It was from the plans of the same man that those saints were
made that went or were carried in processions, either dead or
tortured in various ways, for some appeared to be transfixed by
a lance or a sword, others had a dagger in the throat, and others
had other suchlike weapons in their bodies. With regard to this,
it is very well known to-day that it is done with a sword, lance,
or dagger broken in half, the pieces of which are held firmly
opposite to one another on either side by iron rings, after taking
away the proportionate amount that has to appear to be fixed in
the person of the sufferer; wherefore I will say no more about
them, save that they seem for the most part to have been in-
vented by Cecca.

The giants, likewise, that went about in the said festival, were
made in the following manner. Certain men who were very skilful

at walking on stilts, or, as they are called in other parts, on wooden legs, had some made five or six braccia high, and, having dressed and decked them with great masks and other ornaments in the way of draperies, and imitations of armour, so that they seemed to have the members and heads of giants, they mounted them and walked dexterously along, appearing truly to be giants. In front of them, however, they had a man who carried a pike, on which the giant leant with one hand, but in such a fashion that the pike appeared to be his own weapon, whether mace, lance, or a great bell-clapper, such as Morgante is said by the poets of romance to have been wont to carry. And even as there were giants, so there were also giantesses, which produced a truly beautiful and marvellous effect.

Different from these, again, were the little phantoms, for these walked on similar stilts five or six braccia high, without anything save their own proper form, in such a manner that they appeared to be true spirits. They likewise had a man in front of them with a pike to assist them; but it is stated that some actually walked very well at so great a height without leaning on anything whatsoever, and I am sure that he who knows what Florentine brains are will in no way marvel at this. For, not to mention that native of Montughi (near Florence) who has surpassed all the masters that ever lived at climbing and dancing on the rope, whoever knew a man called Ruvidino, who died less than ten years ago, remembers that climbing to any height on a rope or cord, leaping from the walls of Florence to the earth, and walking on stilts much higher than those described above, were as easy to him as it is for an ordinary man to walk on the level. Wherefore it is no marvel if the men of those times, who practised suchlike exercises for money or for other reasons, did what has been related above, and even greater things.

I will not speak of certain waxen candles which used to be painted with various fanciful devices, but so rudely that they have given their name to vulgar painters, insomuch that bad pictures are called 'candle puppets'; for it is not worth the trouble. I will only say that at the time of Cecca they fell for the most part into disuse, and that in their place were made the cars that are still used to-day, in the form of triumphal chariots. The first of these was the car* of the Mint, which was brought to that perfection

* The word in the Italian text is not '*carro*' but '*cero*,' which is obviously an error.

which is still seen every year when it is sent out for the said festival by the Masters and Lords of the Mint, with a S. John on the highest part and with many other angels and saints around and below him, all represented by living persons. Not long ago it was determined that one should be made for every borough that gave an offering of wax, and ten were made, in order to do magnificent honour to that festival; but the plan was carried no further, by reason of events that supervened no long time after. That first car of the Mint, then, was made under the direction of Cecca by Domenico, Marco, and Giuliano del Tasso, who were among the best master-carpenters, both in squared-work and in carving, who were then working in Florence; and in this car, among other things, no small praise is due to the wheels below it, which are pivoted, in order that the structure may be able to turn sharp corners, and may be managed in such a manner as to shake it as little as possible, particularly for the sake of those who stand fastened upon it.

The same man made a structure for the cleaning and restoration of the mosaics in the tribune of S. Giovanni, which could be turned, raised, lowered, and advanced at pleasure, and that with such ease that two men could handle it; which invention gave Cecca very great repute.

When the Florentine army was besieging Piancaldoli, Cecca ingeniously contrived to enable the soldiers to enter it by means of mines, without striking a blow. Afterwards, continuing to follow the same army to certain other strongholds, his evil fortune would have it that he should be killed while attempting to measure certain heights at a difficult point; for when he had put his head out beyond the wall in order to let a plumb-line down, a priest who was with the enemy (who feared the genius of Cecca more than the might of the whole camp) discharged a catapult at him and fixed a great dart in his head, insomuch that the poor fellow died on the spot. The fate and the loss of Cecca caused great grief to the whole army and to his fellow-citizens; but since there was no remedy, they sent him back in a coffin to Florence, where his sisters gave him honourable burial in S. Piero Scheraggio; and below his portrait in marble there was placed the following epitaph:

FABRUM MAGISTER CICCA, NATUS OPPIDIS VEL OBSIDENDIS VEL TUENDIS, HIC JACET. VIXIT ANN. XXXXI, MENS. IV, DIES

XIV. OBIIT PRO PATRIA TELO ICTUS. PIÆ SORORES MONUMENTUM
FECERUNT MCCCCXCIX.

DON BARTOLOMMEO DELLA GATTA, ABBOT
OF S. CLEMENTE, Illuminator and Painter

RARELY does it happen that a man of good character and exemplary life fails to be provided by Heaven with the best of friends and with honourable dwellings, or to be held in veneration when alive by reason of the goodness of his ways, and very greatly regretted when dead by all who knew him, as was Don Bartolommeo della Gatta, Abbot of S. Clemente in Arezzo, who was excellent in diverse pursuits and most praiseworthy in all his actions. This man, who was a monk of the Angeli in Florence, a seat of the Order of Camaldoli, was in his youth – perchance for the reasons mentioned above in the Life of Don Lorenzo – a very rare illuminator, and a very able master of design. Of this we have proof in the books that he illuminated for the Monks of SS. Fiore e Lucilla in the Abbey of Arezzo, particularly a missal that was presented to Pope Sixtus, in which, on the first page of the Secret Prayers, there was a very beautiful Passion of Christ. Those are likewise by his hand which are in S. Martino, the Duomo of Lucca.

A little while after these works the said Abbey of S. Clemente in Arezzo was presented to this father by Mariotto Maldoli of Arezzo, General of the Order of Camaldoli, who belonged to the same family from which sprang that Maldolo who gave the site and lands of Camaldoli, then called Campo di Maldolo, to S. Romualdo, the founder of that Order. Don Bartolommeo, in gratitude for that benefice, afterwards executed many works for that General and for his Order. After this there came the plague of 1468, by reason of which the Abbot, like many others, stayed indoors without going about much, and devoted himself to painting large figures; and seeing that he was succeeding as well as he could desire, he began to execute certain works. The first was a S. Rocco that he painted on a panel for the Rectors of the Confraternity of Arezzo, which is now in the Audience Chamber where they assemble. This figure is recommending the people of Arezzo to Our Lady, and in this picture he portrayed the Piazza

of the said city and the holy house of that Confraternity, with certain grave-diggers who are returning from burying the dead. He also painted another S. Rocco for the Church of S. Pietro, likewise on a panel, wherein he portrayed the city of Arezzo exactly as it stood at that time, when it was very different from what it is to-day. And he made another, which was much better than the two mentioned above, on a panel which is in the Chapel of the Lippi in the Church of the Pieve of Arezzo; and this S. Rocco is a rare and beautiful figure, almost the best that he ever made, and the head and hands are as beautiful and natural as they could be. In the same city of Arezzo, in S. Pietro, a seat of the Servite Friars, he painted an Angel Raphael on a panel; and in the same place he made a portrait of the Blessed Jacopo Filippo of Piacenza.

Afterwards, being summoned to Rome, he painted a scene in the Chapel of Pope Sixtus, in company with Luca da Cortona and Pietro Perugino. On returning to Arezzo, he painted a S. Jerome in Penitence in the Chapel of the Gozzari in the Vescovado; and this figure, lean and shaven, with the eyes fixed most intently on the Crucifix, and beating his breast, shows very clearly how greatly the passions of love can disturb the chastity even of a body so grievously wasted away. In this work he made an enormous crag, with certain cliffs of rock, among the fissures of which he painted some stories of that Saint, with very graceful little figures. After this, in a chapel in S. Agostino, for the Nuns of the Third Order, as they are called, he wrought in fresco a Coronation of Our Lady, which is very well done and much extolled; and below this, in another chapel, a large panel with an Assumption and certain angels beautifully robed in delicate draperies. This panel, for a work made in distemper, is much extolled, and in truth it was wrought with good design and executed with extraordinary diligence. In the lunette that is over the door of the Church of S. Donato, in the Fortress of Arezzo, the same man painted in fresco a Madonna with the Child in her arms, S. Donatus, and S. Giovanni Gualberto, all very beautiful figures. In the Abbey of S. Fiore in the said city, beside the principal door of entrance into the church, there is a chapel painted by his hand, wherein are S. Benedict and other saints, wrought with much grace, good handling, and sweetness.

For Gentile of Urbino, Bishop of Arezzo, who was much his friend, and with whom he almost always lived, he painted a Dead

Christ in a chapel in the Palace of the Vescovado; and in a loggia he portrayed the Bishop himself, his vicar, and Ser Matteo Francini, his court-notary, who is reading a Bull to him; and there he also made his own portrait and those of certain canons of that city. For the same Bishop he designed a loggia which issues from the Palace and leads to the Vescovado, on the same level with both. In the centre of this the Bishop had intended to make a place of burial for himself in the form of a chapel, in which he wished to be interred after his death; and he had carried it well on, when he was overtaken by death, and it remained unfinished, for, although he left orders that it should be completed by his successor, nothing more was done, as generally happens with works of this sort which are left by a man to be finished after his death. For the said Bishop the Abbot painted a large and beautiful chapel in the Duomo Vecchio, but, as it had only a short life, there is no need to say more about it.

Besides this, he made works in various places throughout the whole city, such as three figures in the Carmine, and the Chapel of the Nuns of S. Orsina. At Castiglione Aretino, for the Chapel of the High-Altar in the Pieve of S. Giuliano, he painted a panel in distemper, containing a very beautiful Madonna, S. Julian, and S. Michelagnolo – figures very well wrought and executed, particularly S. Julian, who, with his eyes fixed on the Christ lying in the arms of the Madonna, appears to be much afflicted at having killed his father and mother. In a chapel a little below this, likewise, is a little door painted by his hand (which formerly belonged to an old organ), wherein there is a S. Michael, which is held to be a marvellous thing, with a child in swaddling-clothes, which appears alive, in the arms of a woman. For the Nuns of the Murate at Arezzo he painted the Chapel of the High-Altar, a work which is truly much extolled. At Monte San Savino he painted a shrine opposite to the Palace of Cardinal di Monte, which was held very beautiful. And at Borgo San Sepolcro, where there is now the Vescovado, he decorated a chapel, which brought him very great praise and profit.

Don Clemente was a man of very versatile intelligence, and, besides being a great musician, he made organs of lead with his own hand. In S. Domenico he made one of cardboard, which has ever remained sweet and good; and in S. Clemente there was another, also by his hand, which was placed on high, with the keyboard below on the level of the choir – truly with very

beautiful judgment, since, the place being such that the monks were few, he wished that the organist should sing as well as play. And since this Abbot loved his Order, like a true minister and not a squanderer of the things of God, he enriched that place greatly with buildings and pictures, particularly by rebuilding the principal chapel of his church and painting the whole of it; and in two niches, one on either side of it, he painted a S. Rocco and a S. Bartholomew, which were ruined together with the church.

But to return to the Abbot, who was a good and worthy churchman. He left a disciple in painting named Maestro Lappoli, an Aretine, who was an able and practised painter, as is shown by the works from his hand which are in S. Agostino, in the Chapel of S. Sebastiano, where there is that Saint wrought in relief by the same man, with figures round him, in painting, of S. Biagio, S. Rocco, S. Anthony of Padua, and S. Bernardino; while on the arch of the chapel is an Annunciation, and on the vaulting are the four Evangelists, wrought in fresco with a high finish. By the hand of the same man, in another chapel on the left hand as one enters the said church by the side-door, is a Nativity in fresco, with the Madonna receiving the Annunciation from the Angel, in the figure of which Angel he portrayed Giuliano Bacci, then a young man of very beautiful aspect. Over the said door, on the outer side, he made an Annunciation, with S. Peter on one side and S. Paul on the other, portraying in the face of the Madonna the mother of Messer Pietro Aretino, a very famous poet. In S. Francesco, for the Chapel of S. Bernardino, he painted a panel with that Saint, who appears alive, and so beautiful that this is the best figure that he ever made. In the Chapel of the Pietramaleschi in the Vescovado he painted a very beautiful S. Ignazio on a panel in distemper; and in the Pieve, at the entrance of the upper door which opens on the piazza, a S. Andrew and a S. Sebastian. For the Company of the Trinità, by order of Buoninsegna Buoninsegni of Arezzo, he made a work with beautiful invention, which can be numbered among the best that he ever executed, and this was a Crucifix over an altar, with a S. Martin on one side and a S. Rocco on the other, and two figures kneeling at the foot, one in the form of a poor man, lean, emaciated, and wretchedly clothed, from whom there issued certain rays that shone straight on the wounds of the Saviour, while the Saint gazed on him most intently; and the other in the form of a rich man, clothed in purple and fine linen, and all ruddy and

cheerful in countenance, whose rays, as he was adoring Christ, although they were issuing from his heart, like those of the poor man, appeared not to shine directly on the wounds of the Crucified Christ, but to stray and spread over certain plains and fields full of grain, green crops, cattle, gardens, and other suchlike things, while some diverged over the sea towards certain boats laden with merchandise; and others, finally, shone on certain money-changers' tables. All these things were wrought by Matteo with judgment, great mastery, and much diligence; but they were thrown to the ground no long time after in the making of a chapel. Beneath the pulpit of the Pieve the same man made a Christ with the Cross for Messer Leonardo Albergotti.

A disciple of the Abbot of S. Clemente, likewise, was a Servite friar of Arezzo, who painted in colours the façade of the house of the Belichini in Arezzo, and two chapels in fresco, one beside the other, in S. Pietro. Another disciple of Don Bartolommeo was Domenico Pecori of Arezzo, who made three figures in distemper on a panel at Sargiano, and painted a very beautiful banner in oil, to be carried in processions, for the Company of S. Maria Maddalena. For Messer Presentino Bisdomini, in the Chapel of S. Andrea in the Pieve, he made a picture of S. Apollonia, similar to that mentioned above; and he finished many works left incomplete by his master, such as the panel of S. Sebastian and S. Fabiano with the Madonna, in S. Pietro, for the family of the Benucci. In the Church of S. Antonio he painted the panel of the high-altar, wherein is a very devout Madonna, with some saints; and since the said Madonna is adoring the Child, whom she has in her lap, he made it appear that a little angel, kneeling behind her, is supporting Our Lord on a cushion, the Madonna not being able to uphold Him because she has her hands clasped in the act of adoration. In the Church of S. Giustino, for Messer Antonio Roselli, he painted a chapel with the Magi in fresco; and for the Company of the Madonna, in the Pieve, he painted a very large panel containing a Madonna in the sky, with the people of Arezzo beneath, in which he made many portraits from the life. In this last work he was helped by a Spanish painter, who painted very well in oil and therein gave assistance to Domenico, who had not as much skill in painting in oil as he had in distemper. With the help of the same man he executed a panel for the Company of the Trinità, containing the Circumcision of Our Lord, which was held a very good work,

and a 'Noli Me Tangere' in fresco in the garden of S. Fiore. Finally, he painted a panel with many figures in the Vescovado, for Messer Donato Marinelli, Primicere. This work, which then brought him and still continues to bring him very great honour, shows good invention, good design, and strong relief; and in making it, being now very old, he called in the aid of a Sienese painter, Capanna, a passing good master, who painted so many walls in chiaroscuro and so many panels in Siena, and who, if he had lived longer, would have done himself much credit in his art, in so far as one may judge from the little that he executed. Domenico wrought for the Confraternity of Arezzo a baldacchino painted in oil, a rich and costly work, which was lent not many years ago for the holding of a representation in S. Francesco at the festival of S. John and S. Paul, to adorn a Paradise near the roof of the church. A fire breaking out in consequence of the great quantity of lights, this work was burnt, together with the man who was representing God the Father, who, being fastened, could not escape, as the angels did, and many church-hangings were destroyed, while great harm came to the spectators, who, terrified by the fire, struggled furiously to fly from the church, everyone seeking to be the first, so that about eighty were trampled down in the press, which was something very pitiful. This baldacchino was afterwards reconstructed with greater richness, and painted by Giorgio Vasari. Domenico then devoted himself to the making of glass windows, and there were three by his hand in the Vescovado, which were ruined by the artillery in the wars.

Another pupil of the same master was the painter Angelo di Lorentino, who was a man of passing good ability. He painted the arch over the door of S. Domenico, and if he had received assistance he would have become a very good master.

The Abbot died at the age of eighty-three, leaving unfinished the Temple of the Madonna delle Lacrime, for which he had made a model; it was afterwards completed by various masters. He deserves praise, then, as illuminator, architect, painter, and musician. He was given burial by his monks in his Abbey of S. Clemente, and his works have ever been so highly esteemed in the said city that the following verses may be read over his tomb:

PINGEBAT DOCTE ZEUSIS, CONDEBAT ET AEDES
NICON, PAN CAPRIPES, FISTULA PRIMA TUA EST.

NON TAMEN EX VOBIS MECUM CERTAVERIT ULLUS;
QUÆ TRES FECISTIS, UNICUS HÆC FACIO.

He died in 1461, having added to the art of illumination that beauty which is seen in all his works, as some drawings by his hand can bear witness which are in our book. His method of working was afterwards imitated by Girolamo Padovano in some books that he illuminated for S. Maria Nuova in Florence; by Gherardo, a Florentine illuminator; (and by Attavante,*) who was also called Vante, of whom we have spoken in another place, particularly with regard to those of his works which are in Venice; with respect to which I included word for word a note sent to me by certain gentlemen of Venice, contenting myself, in order to recompense them for the great pains that they had taken to discover all that is to be read there, with relating the whole as they wrote it, since I had no personal knowledge of these works on which to form a judgment of my own.

GHERARDO, Illuminator of Florence

I⊤ is certain that among all the enduring works that are made in colours there is none that resists the assault of wind and water better than mosaic. And well was this known in his day to the elder Lorenzo de' Medici of Florence, who, like a man of spirit given to investigating the memorials of the ancients, sought to bring back into use what had been hidden for many years, and, since he took great delight in pictures and sculptures, could not fail to take delight also in mosaic. Wherefore, seeing that Gherardo, an illuminator of that time and a man of inquiring brain, was investigating the difficulties of that calling, he showed him great favour, as one who ever assisted those in whom he saw some germ of spirit and intellect. Placing him, therefore, in the company of Domenico del Ghirlandajo, he obtained for him from the Wardens of Works of S. Maria del Fiore a commission for decorating the chapels of the transepts, beginning with that of the Sacrament, wherein lies the body of S. Zanobi. Whereupon

* The words in brackets have been added to correct an obvious omission in the text. The account of Attavante is to be found at the end of the Life of Fra Giovanni Angelico.

Gherardo, growing ever in keenness of intelligence, would have executed most marvellous works in company with Domenico, if death had not intervened, as may be judged from the beginning of that chapel, which remained unfinished.

Gherardo, in addition to his mosaics, was a most delicate illuminator, and he also made large figures on walls. Without the Porta alla Croce there is a shrine in fresco by his hand, and there is another in Florence, much extolled, at the head of the Via Larga. On the façade of the Church of S. Gilio at S. Maria Nuova, beneath the stories painted by Lorenzo di Bicci, wherein is the consecration of that church by Pope Martin V, Gherardo depicted the same Pope conferring the monk's habit and many privileges on the Director of the Hospital. In this scene there were far fewer figures than it appeared to require, because it was cut in half by a shrine containing a Madonna, which has been removed recently by Don Isidoro Montaguto, the present Director of that place, in the reconstructing of a principal door for the building; and Francesco Brini, a young painter of Florence, has been commissioned to paint the rest of the scene. But to return to Gherardo; it would scarcely have been possible for even a well-practised master to accomplish without great fatigue and diligence what he did in that work, which is wrought most excellently in fresco. For the church of the same hospital Gherardo illuminated an infinite number of books, with some for S. Maria del Fiore in Florence, and certain others for Matthias Corvinus, King of Hungary. These last, on the death of the said King, together with some by the hand of Vante and of other masters who worked for that King in Florence, were purchased and taken over by the Magnificent Lorenzo de' Medici, who placed them among those so greatly celebrated which were being collected for the formation of the library afterwards built by Pope Clement VII, which is now being thrown open to the public by order of Duke Cosimo.

Having thus developed, as has been related, from a master of illumination into a painter, in addition to the said works, he made some great figures in a large cartoon for the Evangelists that he had to make in mosaic in the Chapel of S. Zanobi. But before the Magnificent Lorenzo de' Medici had obtained for him the commission for the said chapel, wishing to show that he understood the art of mosaic, and that he could work without a companion, he made a life-size head of S. Zanobi, which remained in

S. Maria del Fiore, and on days of the highest solemnity it is set up on the altar of the said Saint, or in some other place, as a rare thing.

The while that Gherardo was labouring at these things, there were brought to Florence certain prints in the German manner wrought by Martin and by Albrecht Dürer; whereupon, being much pleased with that sort of engraving, he set himself to work with the graver and copied some of those plates very well, as may be seen from certain examples that are in our book, together with some drawings by the same man's hand. Gherardo painted many pictures which were sent abroad, one of which is in the Chapel of S. Caterina da Siena in the Church of S. Domenico at Bologna, containing a very good painting of S. Catherine. And in S. Marco at Florence, over the table of Pardons, he painted a lunette full of very graceful figures. But the more he satisfied others the less did he satisfy himself in any of his works, with the exception of mosaic, in which sort of painting he was rather the rival than the companion of Domenico Ghirlandajo; and if he had lived longer he would have become most excellent in that art, for he was very willing to take pains with it, and he had discovered the greater part of its best secrets.

Some declare that Attavante, otherwise Vante, an illuminator of Florence, of whom we have spoken above in more than one place, was a disciple of Gherardo, as was Stefano, likewise a Florentine illuminator; but I hold it as certain, considering that both lived at the same time, that Attavante was rather the friend, companion, and contemporary of Gherardo than his disciple. Gherardo died well advanced in years, leaving everything that he used in his art to his disciple Stefano, who, devoting himself no long time after to architecture, abandoned the art of illuminating, and handed over all his appliances in connection with that profession to the elder Boccardino, who illuminated the greater part of the books that are in the Badia of Florence. Gherardo died at the age of sixty-three, and his works date about the year of our salvation 1470.

DOMENICO GHIRLANDAJO, Painter of Florence

DOMENICO DI TOMMASO DEL GHIRLANDAJO, who, from his talent and from the greatness and the vast number of his works,

may be called one of the most important and most excellent masters of his age, was made by nature to be a painter; and for this reason, in spite of the opposition of those who had charge of him (which often nips the finest fruits of our intellects in the bud by occupying them with work for which they are not suited, and by diverting them from that to which nature inclines them), he followed his natural instinct, secured very great honour for himself and profit for his art and for his kindred, and became the great delight of his age. He was apprenticed by his father to his own art of goldsmith, in which Tommaso was a master more than passing good, for it was he who made the greater part of the silver votive offerings that were formerly preserved in the press of the Nunziata, and the silver lamps of the chapel, which were all destroyed in the siege of the city in the year 1529. Tommaso was the first who invented and put into execution those ornaments worn on the head by the girls of Florence, which are called ghirlande;* whence he gained the name of Ghirlandajo, not only because he was their first inventor, but also because he made an infinite number of them, of a beauty so rare that none appeared to please save such as came out of his shop.

Being thus apprenticed to the goldsmith's art, but taking no pleasure therein, he was ever occupied in drawing. Endowed by nature with a perfect spirit and with an admirable and judicious taste in painting, although he was a goldsmith in his boyhood, yet, by devoting himself ever to design, he became so quick, so ready, and so facile, that many say that while he was working as a goldsmith he would draw a portrait of all who passed the shop, producing a likeness in a second; and of this we still have proof in an infinite number of portraits in his works, which show a most lifelike resemblance.

His first pictures were in the Chapel of the Vespucci in Ognissanti, where there is a Dead Christ with some saints, and a Misericordia over an arch, in which is the portrait of Amerigo Vespucci, who made the voyages to the Indies; and in the refectory of that place he painted a Last Supper in fresco. In S. Croce, on the right hand of the entrance into the church, he painted the Story of S. Paulino; wherefore, having acquired very great fame and coming into much credit, he painted a chapel in S. Trinita for Francesco Sassetti, with stories of S. Francis. This work was

* Garlands.

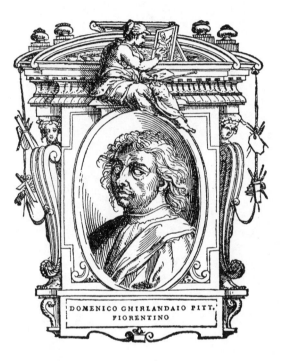

DOMENICO GHIRLANDAIO PITT.
FIORENTINO

admirably executed by him, and wrought with grace, lovingness, and a high finish; and he counterfeited and portrayed therein the Ponte a S. Trinita, with the Palace of the Spini. On the first wall he depicted the story of S. Francis appearing in the air and restoring the child to life; and here, in those women who see him being restored to life – after their sorrow for his death as they bear him to the grave – there are seen gladness and marvel at his resurrection. He also counterfeited the friars issuing from the church behind the Cross, together with some grave-diggers, to bury him, all wrought very naturally; and there are likewise other figures marvelling at that event which give no little pleasure to the eye, among which are portraits of Maso degli Albizzi, Messer Agnolo Acciaiuoli, and Messer Palla Strozzi, eminent citizens often cited in the history of the city. On another wall he painted S. Francis, in the presence of the vicar, renouncing his inheritance from his father, Pietro Bernardone, and assuming the habit of sackcloth, which he is girding round him with the cord. On the middle wall he is shown going to Rome and having his Rule confirmed by Pope Honorius, and presenting roses in January to that Pontiff. In this scene he depicted the Hall of the Consistory, with Cardinals seated around, and certain steps ascending to it, furnishing the flight of steps with a balustrade, and painting there some half-length figures portrayed from the life, among which is the portrait of the elder Lorenzo de' Medici, the Magnificent; and there he also painted S. Francis receiving the Stigmata. In the last he made the Saint dead, with his friars mourning for him, among whom is one friar kissing his hands – an effect that could not be rendered better in painting; not to mention that a Bishop in full robes, with spectacles on his nose, is chanting the prayers for the dead so vividly, that only the lack of sound shows him to be painted. In one of two pictures that are on either side of the panel he portrayed Francesco Sassetti on his knees, and in the other his wife, Monna Nera, with their children (but these last are in the aforesaid scene of the child being restored to life), and with certain beautiful maidens of the same family, whose names I have not been able to discover, all in the costumes and fashions of that age, which gives no little pleasure. Besides this, he made four Sibyls on the vaulting, and an ornament above the arch on the front wall without the chapel, containing the scene of the Tiburtine Sibyl making the Emperor Octavian adore Christ, which is executed in a masterly manner for a work in fresco, with much

vivacity and loveliness in the colours. To this work he added a panel wrought in distemper, also by his hand, containing a Nativity of Christ that should amaze any person of understanding, wherein he portrayed himself and made certain heads of shepherds, which are held to be something divine. Of this Sibyl and of other parts of this work there are some very beautiful drawings in our book, made in chiaroscuro, and in particular the view in perspective of the Ponte a S. Trinita.

For the Frati Ingesuati he painted a panel for their high-altar, with certain Saints kneeling – namely, S. Giusto, Bishop of Volterra, who was the titular Saint of that church; S. Zanobi, Bishop of Florence; an Angel Raphael; a S. Michael, clad in most beautiful armour; and other saints. For this work Domenico truly deserves praise, for he was the first who began to counterfeit with colours certain trimmings and ornaments of gold, which had not been done up to that time; and he swept away in great measure those borders of gilding that were made with mordant or with bole, which were more suitable for church-hangings than for the work of good masters. More beautiful than all the other figures is the Madonna, who has the Child in her arms and four little angels round her. This panel, which is wrought as well as any work in distemper could be, was then placed in the church of those friars without the Porta a Pinti; but since that building, as will be told elsewhere, was destroyed, it is now in the Church of S. Giovannino, within the Porta S. Piero Gattolini, where there is the Convent of the aforesaid Ingesuati.

In the Church of Cestello he painted a panel – afterwards finished by his brothers David and Benedetto – containing the Visitation of Our Lady, with certain most charming and beautiful heads of women. In the Church of the Innocenti he painted the Story of the Magi on a panel in distemper, which is much extolled. In this are heads most beautiful in expression and varied in features, both young and old; and in the head of Our Lady, in particular, are seen all the dignity, beauty, and grace that art can give to the Mother of the Son of God. On the tramezzo* of the Church of S. Marco there is another panel, with a Last Supper in the guest-room, both executed with diligence; and in the house of Giovanni Tornabuoni there is a round picture with the Story

* See note on p. 90.

of the Magi, wrought with diligence. In the Little Hospital, for the elder Lorenzo de' Medici, he painted the story of Vulcan, in which many nude figures are at work with hammers making thunderbolts for Jove. And in the Church of Ognissanti in Florence, in competition with Sandro di Botticello, he painted a S. Jerome in fresco (which is now beside the door that leads to the choir), surrounding him with an infinite number of instruments and books, such as are used by the learned. The friars having occasion to remove the choir from the place where it stood, this picture, together with that of Sandro di Botticello, has been bound round with irons and transported without injury into the middle of the church, at the very time when these Lives are being printed for the second time. He also painted the arch over the door of S. Maria Ughi, and a little shrine for the Guild of Linen-Manufacturers, and likewise a very beautiful S. George, slaying the Dragon, in the same Church of Ognissanti. And in truth he had a very good knowledge of the method of painting on walls, which he did with very great facility, although he was scrupulously careful in the composition of his works.

Being then summoned to Rome by Pope Sixtus IV to paint his chapel, in company with other masters, he painted there Christ calling Peter and Andrew from their nets, and the Resurrection of Jesus Christ, the greater part of which has since been spoilt in consequence of being over the door, on which it became necessary to replace an architrave that had fallen down. There was living in Rome at this same time Francesco Tornabuoni, a rich and honoured merchant, much the friend of Domenico. This man, whose wife had died in childbirth, as is told in the Life of Andrea Verrocchio, desiring to honour her as became their noble station, had caused a tomb to be made for her in the Minerva; and he also wished Domenico to paint the whole wall against which this tomb stood, and likewise to make for it a little panel in distemper. On that wall, therefore, he painted four stories – two of S. John the Baptist and two of the Madonna – which brought him truly great praise at that time. And Francesco took so much pleasure in his dealings with Domenico, that, when the latter returned to Florence rich in honour and in gains, Francesco recommended him by letters to his relative Giovanni, telling him how well the painter had served him in that work, and how well satisfied the Pope had been with his pictures. Hearing this, Giovanni began to contemplate employing him on some magnificent

work, such as would honour his own memory and bring fame
and profit to Domenico.

Now it chanced that the principal chapel of S. Maria Novella
(a convent of Preaching Friars), formerly painted by Andrea Or-
cagna, was injured in many parts by rain in consequence of the
roof of the vaulting being badly covered. For this reason many
citizens had wished to restore it, or rather, to have it painted
anew; but the owners, who belonged to the family of the Ricci,
had never consented to this, being unable to bear so great an
expense themselves, and unwilling to allow others to do so, lest
they should lose the rights of ownership and the distinction of
the arms handed down to them by their ancestors. Giovanni,
then, being desirous that Domenico should make him his me-
morial there, set to work in this matter, trying various ways; and
finally he promised the Ricci to bear the whole expense himself,
to give them some sort of recompense, and to have their arms
placed in the most conspicuous and honourable place in that
chapel. And so they came to an agreement, making a contract in
the form of a very precise instrument according to the terms
described above. Giovanni allotted this work to Domenico, with
the same subjects as were painted there before; and they agreed
that the price should be 1,200 gold ducats of full weight, with 200
more in the event of the work giving satisfaction to Giovanni.
Thereupon Domenico put his hand to the work and laboured
without ceasing for four years until he had finished it – which
was in 1485 – to the very great satisfaction and contentment of
Giovanni, who, while admitting that he had been well served, and
confessing ingenuously that Domenico had earned the additional
200 ducats, said that he would be pleased if he would be satisfied
with the original price. And Domenico, who esteemed glory and
honour much more than riches, immediately let him off all the
rest, declaring that he set much greater store on having given him
satisfaction than on the matter of complete payment.

Giovanni afterwards caused two large coats of arms to be
made of stone – one for the Tornaquinci and the other for the
Tornabuoni – and placed on the pilasters without the chapel, and
in the arch he placed other arms belonging to that family, which
is divided into various names and various arms – namely, in
addition to the two already mentioned, those of the Ghiachinotti,
Popoleschi, Marabottini, and Cardinali. And afterwards, when
Domenico painted the altar-panel, he caused to be placed in the

gilt ornament, under an arch, as a finishing touch to that panel, a very beautiful Tabernacle of the Sacrament, on the frontal of which he made a little shield a quarter of a braccio in length, containing the arms of the said owners – that is, the Ricci. And a fine jest it was at the opening of the chapel, for these Ricci looked for their arms with much ado, and finally, not being able to find them, went off to the Tribunal of Eight, contract in hand. Whereupon the Tornabuoni showed that these arms had been placed in the most conspicuous and most honourable part of the work; and although the others exclaimed that they were invisible, they were told that they were in the wrong, and that they must be content, since the Tornabuoni had caused them to be placed in so honourable a position as the neighbourhood of the most Holy Sacrament. And so it was decided by that tribunal that they should be left untouched, as they may be seen to-day. Now, if this should appear to anyone to be outside the scope of the Life that I have to write, let him not be vexed, for it all flowed naturally from the tip of my pen. And it should serve, if for nothing else, at least to show how easily poverty falls a prey to riches, and how riches, if accompanied by discretion, achieve without censure anything that a man desires.

But to return to the beautiful works of Domenico; in that chapel, first of all, are the four Evangelists on the vaulting, larger than life; and, on the window-wall, stories of S. Dominic, S. Peter Martyr, S. John going into the Desert, the Madonna receiving the Annunciation from the Angel, and many patron saints of Florence on their knees above the window; while at the foot, on the right hand, is a portrait from life of Giovanni Tornabuoni, with one of his wife on the left, which are both said to be very lifelike. On the right-hand wall are seven scenes – six below, in compartments as large as the wall allows, and the last above, twice as broad as any of the others and bounded by the arch of the vaulting; and on the left-hand wall are also seven scenes from the life of S. John the Baptist. The first on the right-hand wall is the Expulsion of Joachim from the Temple, wherein patience is depicted in his countenance, with that contempt and hatred in the faces of the others which the Jews felt for those who came to the Temple without having children. In this scene, in the part near the window, are four men portrayed from life, one of whom, old, shaven, and wearing a red cap, is Alesso Baldovinetti, Domenico's master in painting and in mosaic.

Another, bare-headed, who is holding one hand on his side and is wearing a red mantle, with a blue garment below, is Domenico himself, the master of the work, who portrayed himself in a mirror. The one who has long black locks and thick lips is Bastiano da San Gimignano, his disciple and brother-in-law; and the last, who has his back turned, with a little cap on his head, is the painter David Ghirlandajo, his brother. All these are said, by those who knew them, to be truly vivid and lifelike portraits. In the second scene is the Nativity of Our Lady, executed with great diligence, and, among other notable things that he painted therein, there is in the building (drawn in perspective) a window that gives light to the room, which deceives all who see it. Besides this, while S. Anna is in bed, and certain ladies are visiting her, he painted some women washing the Madonna with great care – one is getting ready the water, another is preparing the swaddling-clothes, a third is busy with some service, a fourth with another, and, while each is attending to her own duty, another woman is holding the little child in her arms and making her laugh by smiling at her, with a womanly grace truly worthy of such a work; besides many other expressions that are in each figure. In the third, which is above the first, is the Madonna ascending the steps of the Temple, with a building which recedes from the eye correctly enough, in addition to a nude figure that brought him praise at that time, when few were to be seen, although it had not that complete perfection which is shown by those painted in our own day, for those masters were not as excellent as ours. Next to this is the Marriage of Our Lady, wherein he represented the unbridled rage of those who are breaking their rods because they do not blossom like that of Joseph; and this scene has an abundance of figures in an appropriate building. In the fifth are seen the Magi arriving in Bethlehem with a great number of men, horses, and dromedaries, and a variety of other things – a scene truly well composed. Next to this is the sixth, showing the impious cruelty practised by Herod against the Innocents, wherein there is seen a most beautiful combat between women and soldiers, with horses that are striking and driving them about; and in truth this is the best of all the stories that are to be seen by his hand, for it is executed with judgment, intelligence, and great art. There may be seen therein the impious resolution of those who, at the command of Herod, without regard for the mothers, are slaying those poor infants, among which is one, still clinging

to the breast, that is dying from wounds received in its throat, so that it is sucking, not to say drinking, as much blood as milk from that breast – an effect truly natural, and, being wrought in such a manner as it is, able to kindle a spark of pity in the coldest heart. There is also a soldier who has seized a child by force, and while he runs off with it, pressing it against his breast to kill it, the mother is seen hanging from his hair in the utmost fury, and forcing him to bend his back in the form of an arch, so that three very beautiful effects are shown among them – one in the death of the child, which is seen expiring; the second in the impious rage of the soldier, who, feeling himself drawn backwards so strangely, is shown in the act of avenging himself on the child; and the third is that the mother, seeing the death of her babe, is seeking with fury, grief, and disdain to prevent the villain from going off scathless; and the whole is truly more the work of a philosopher admirable in judgment than of a painter. There are many other emotions depicted, which will demonstrate to him who studies them that this man was without doubt an excellent master in his time. Above this, in the seventh scene, which embraces the space of two, and is bounded by the arch of the vaulting, are the Death and the Assumption of Our Lady, with an infinite number of angels, and innumerable figures, landscapes, and other ornaments, of which he used to paint an abundance in his facile and practised manner.

On the other wall are stories of S. John, and in the first is Zacharias sacrificing in the Temple, when the Angel appears to him and makes him dumb for his unbelief. In this scene, showing how sacrifices in temples are ever attended by a throng of the most distinguished men, and wishing to make it as honourable as he was able, he portrayed a good number of the Florentine citizens who then governed that State, particularly all those of the house of Tornabuoni, both young and old. Besides this, in order to show that his age was rich in every sort of talent, above all in learning, he made a group of four half-length figures conversing together at the foot of the scene, representing the most learned men then to be found in Florence. The first of these, who is wearing the dress of a Canon, is Messer Marsilio Ficino; the second, in a red mantle, with a black band round his neck, is Cristofano Landino; the figure turning towards him is Demetrius the Greek; and he who is standing between them, with one hand slightly raised, is Messer Angelo Poliziano; and all are very lifelike

and vivacious. In the second scene, next to this, there follows the
Visitation of Our Lady to S. Elizabeth, with a company of many
women dressed in costumes of those times, among whom is a
portrait of Ginevra de' Benci, then a most beautiful maiden. In
the third, above the first, is the birth of S. John, wherein there is
a very beautiful scene, for while S. Elizabeth is lying in bed, and
certain neighbours come to see her, and the nurse is seated suck-
ling the infant, one woman is joyfully demanding it from her, that
she may show to the others what an unexampled feat the mistress
of the house has performed in her old age. Finally, there is a
woman, who is very beautiful, bringing fruits and flasks from the
country, according to the Florentine custom. In the fourth scene,
next to this, is Zacharias, still dumb, marvelling – but with
undaunted heart – that this child should have been born to him;
and while they keep asking him about the name, he is writing on
his knee, with his eyes fixed on his son, whom a woman who has
knelt down before him is holding reverently in her arms, and he
is tracing with his pen on the paper, 'John shall be his name,' to
the no little marvel of many other figures, who appear to be in
doubt whether the thing be true or not. There follows in the fifth
his preaching to the multitude, in which scene there is shown that
attention which the populace ever gives when hearing new things,
particularly in the heads of the Scribes, who, while listening to
John, appear from a certain expression of countenance to be
deriding his law, and even to hate it; and there are seen many
men and women, variously attired, both standing and seated. In
the sixth S. John is seen baptizing Christ, in whose reverent
expression Domenico showed very clearly the faith that should be
placed in such a Sacrament. And since this did not fail to achieve
a very great effect, he depicted many already naked and bare-
footed, waiting to be baptized, and revealing faith and willingness
carved in their faces; and one among them, who is taking off his
shoe, personifies readiness itself. In the last, which is in the arch
next to the vaulting, are the sumptuous Feast of Herod and the
Dance of Herodias, with an infinite number of servants perfor-
ming various services in that scene; not to mention the grandeur
of an edifice drawn in perspective, which proves the talent of
Domenico no less clearly than do the other pictures.

The panel, which stands by itself, he executed in distemper, as
he did the other figures in the six pictures. Besides the Madonna,
who is seated in the sky with the Child in her arms, and the other

saints who are round her, there are S. Laurence and S. Stephen, who are absolutely alive, with S. Vincent and S. Peter Martyr, who lack nothing save speech. It is true that a part of this panel remained unfinished in consequence of his death; but he had carried it so far on that there was nothing left to complete save certain figures on the back, where there is the Resurrection of Christ, with three figures in the other pictures, and the whole was afterwards finished by Benedetto and David Ghirlandajo, his brothers. This chapel was held to be a very beautiful work, grand, ornate, and lovely, through the vivacity of the colours, through the masterly finish in their application on the walls, and because very little retouching was done on the dry, not to mention the invention and the composition of the subjects. And in truth Domenico deserves the greatest praise on all accounts, particularly for the liveliness of the heads, which, being portrayed from nature, present to every eye most lifelike effigies of many distinguished persons.

For the same Giovanni Tornabuoni, at his Villa of Casso Maccherelli, which stands on the River Terzolle at no great distance from the city, he painted a chapel which has since been half destroyed through being too near to the river; but the paintings, although they have been uncovered for many years, continually washed by rain and scorched by the sun, have remained so fresh that one might think they had been covered – so great is the value of working in fresco, when the work is done with care and judgment and not retouched on the dry. He also made many figures of Florentine Saints, with most beautiful adornments, in that hall of the Palace of the Signoria which contains the marvellous clock of Lorenzo della Volpaia. And so great was his love of working and of giving satisfaction to all, that he commanded his lads to accept any work that might be brought to his shop, even hoops for women's baskets, saying that if they would not do them he would paint them himself, to the end that none might leave the shop unsatisfied. But when household cares fell upon him he was troubled, and he therefore laid the charge of all expenditure on his brother David, saying to him, 'Leave me to work, and do thou provide, for now that I have begun to understand the methods of this art, it grieves me that they will not commission me to paint the whole circuit of the walls of the city of Florence with stories'; thus revealing a spirit absolutely invincible and resolute in every action.

For S. Martino in Lucca he painted S. Peter and S. Paul on a panel. In the Abbey of Settimo, without Florence, he painted the wall of the principal chapel in fresco, with two panels in distemper in the tramezzo* of the church. In Florence, also, he executed many pictures, round, square, and of other kinds, which can only be seen in the houses of individual citizens. In Pisa he painted the recess behind the high-altar of the Duomo, and he worked in many parts of that city, painting, for example, on the front wall of the Office of Works, a scene of King Charles, portrayed from life, making supplication for Pisa; and two panels in distemper, that of the high-altar and another, for the Frati Gesuati in S. Girolamo. In that place there is also a picture of S. Rocco and S. Sebastian by the hand of the same man, which was given by one or other of the Medici to those fathers, who have therefore added to it the arms of Pope Leo X.

He is said to have been so accurate in draughtsmanship, that, when making drawings of the antiquities of Rome, such as arches, baths, columns, colossea, obelisks, amphitheatres, and aqueducts, he would work with the eye alone, without rule, compasses, or measurements; and after he had made them, on being measured, they were found absolutely correct, as if he had used measurements. He drew the Colosseum by the eye, placing at the foot of it a figure standing upright, from the proportions of which the whole edifice could be measured; this was tried by some masters after his death, and found quite correct.

Over a door of the cemetery of S. Maria Nuova he painted a S. Michael in fresco, clad in armour which reflects the light most beautifully – a thing seldom done before his day. At the Abbey of Passignano, a seat of the Monks of Vallombrosa, he wrought certain works in company with his brother David and Bastiano da San Gimignano. Here the two others, finding themselves poorly fed by the monks before the arrival of Domenico, complained to the Abbot, praying him to have them better served, since it was not right that they should be treated like bricklayers' labourers. This the Abbot promised to do, saying in excuse that it was due more to the ignorance of the monks who looked after strangers than to malice. Domenico arrived, but everything continued just the same; whereupon David, seeking out the Abbot once again, declared with due apologies that he was not doing

* See note on p. 90.

this for his own sake but on account of the merits and talents of his brother. But the Abbot, like the ignorant man that he was, made no other answer. That evening, then, when they had sat down to supper, up came the stranger's steward with a board covered with bowls and messes only fit for a hangman, exactly the same as before. Thereupon David, flying into a rage, upset the soup over the friar, and, seizing the loaf that was on the table, fell upon him with it and belaboured him in such a manner that he was carried away to his cell more dead than alive. The Abbot, who was already in bed, got up and ran to the noise, believing that the monastery was tumbling down; and finding the friar in a sorry plight, he began to upbraid David. Enraged by this, David bade him be gone out of his sight, saying that the talent of Domenico was worth more than all the pigs of Abbots like him that had ever lived in that monastery. Whereupon the Abbot, seeing himself in the wrong, did his utmost from that time onwards to treat them like the important men that they were.

This work finished, Domenico returned to Florence, where he painted a panel for Signor di Carpi, sending another to Rimini for Signor Carlo Malatesta, who had it placed in his chapel in S. Domenico. The latter panel was in distemper, with three very beautiful figures, and with little scenes below; and behind were figures painted to look like bronze, with very great design and art. Besides these, he painted two panels for the Abbey of S. Giusto, a seat of the Order of Camaldoli, without Volterra; these panels, which are wondrously beautiful, he executed at the order of the Magnificent Lorenzo de' Medici, for the reason that the abbey was then held 'in commendam' by his son Cardinal Giovanni de' Medici, who was afterwards Pope Leo. This abbey was restored not many years ago by the Very Reverend Messer Giovan Batista Bava of Volterra, who likewise held it 'in commendam,' to the said Congregation of Camaldoli.

Being then summoned to Siena through the agency of the Magnificent Lorenzo de' Medici, Domenico undertook to adorn the façade of the Duomo with mosaics, Lorenzo acting as surety for him in this work to the extent of 20,000 ducats. And he began the work with much confidence and a better manner, but, being overtaken by death, he left it unfinished; even as, by reason of the death of the aforesaid Magnificent Lorenzo, there remained unfinished at Florence the Chapel of S. Zanobi, on which Domenico had begun to work in mosaic in company with the

illuminator Gherardo. By the hand of Domenico is a very beautiful Annunciation in mosaic that is to be seen over that side-door of S. Maria del Fiore which leads to the Servi; and nothing better than this has yet been seen among the works of our modern masters of mosaic. Domenico used to say that painting was mere drawing, and that the true painting for eternity was mosaic.

A pupil of his, who lived with him in order to learn, was Bastiano Mainardi da San Gimignano, who became a very able master of his manner in fresco; wherefore he went with Domenico to San Gimignano, where they painted in company the Chapel of S. Fina, which is a beautiful work. Now the faithful and willing service of Bastiano, who acquitted himself very well, induced Domenico to judge him worthy to have a sister of his own for wife; and so their friendship was changed into relationship – a proof of liberality worthy of a loving master, who was pleased to reward the proficiency that his disciple had acquired by labouring at his art. Domenico caused the said Bastiano to paint a Madonna ascending into Heaven in the Chapel of the Baroncelli and Bandini in S. Croce (although he made the cartoon himself), with S. Thomas below receiving the Girdle – a beautiful work in fresco. In Siena, in an apartment of the Palace of the Spannocchi, Domenico and Bastiano together painted many scenes in distemper, with little figures; and in Pisa, in addition to the aforesaid recess in the Duomo, they filled the whole arch of that chapel with angels, besides painting the folding doors that close the organ, and beginning to overlay the ceiling with gold. Afterwards, just when Domenico was about to put his hand to some very great works both in Pisa and in Siena, he fell sick of a most grievous putrid fever, which cut short his life in five days. As he lay ill, the Tornabuoni sent him a hundred ducats of gold as a gift, proving their regard and particular friendship for Domenico in return for his unceasing labours in the service of Giovanni and of his house. Domenico lived forty-four years, and he was buried with beautiful obsequies in S. Maria Novella by his brothers David and Benedetto and his son Ridolfo, amid much weeping and sorrowful regrets. The loss of so great a man was a great grief to his friends; and many excellent foreign painters, hearing that he was dead, wrote to his relatives lamenting his most untimely death. The disciples that he left were David and Benedetto Ghirlandajo, Bastiano Mainardi da San Gimignano, the Florentine Michelagnolo Buonarroti, Francesco Granaccio, Niccolò Cieco,

Jacopo del Tedesco, Jacopo dell' Indaco, Baldino Baldinelli, and
other masters, all Florentines. He died in 1495.

Domenico enriched the art of painting by working in mosaic
with a manner more modern than was shown by any of the
innumerable Tuscans who essayed it, as is proved by the works
that he wrought, few though they may be. Wherefore he has
deserved to be held in honour and esteem for such rich and
undying benefits to art, and to be celebrated with extraordinary
praises after his death.

ANTONIO AND PIERO POLLAIUOLO,
Painters and Sculptors of Florence

MANY men begin in a humble spirit with unimportant works,
who, gaining courage from proficiency, grow also in power and
ability, in such a manner that they aspire to greater undertakings
and almost reach Heaven with their beautiful thoughts. Raised by
fortune, they very often chance upon some liberal Prince, who,
finding himself well served by them, is forced to remunerate their
labours so richly that their descendants derive great benefits and
advantages from them. Wherefore such men walk through this
life to the end with so much glory, that they leave marvellous
memorials of themselves to the world, as did Antonio and Piero
del Pollaiuolo, who were greatly esteemed in their day for the
rare acquirements that they had made with their industry and
labour.

These men were born in the city of Florence, one no long
time after the other, from a father of humble station and no great
wealth, who, recognizing by many signs the good and acute in-
telligence of his sons, but not having the means to educate them
in letters, apprenticed Antonio to the goldsmith's art under Bar-
toluccio Ghiberti, a very excellent master in that calling at that
time; and Piero he placed under Andrea dal Castagno, who
was then the best painter in Florence, to learn painting. Antonio,
then, being pushed on by Bartoluccio, not only learnt to set
jewels and to fire enamels on silver, but was also held the best
master of the tools of that art. Wherefore Lorenzo Ghiberti, who
was then working on the doors of S. Giovanni, having observed
the manner of Antonio, called him into that work in company

with many other young men, and set him to labour on one of the
festoons which he then had in hand.

On this Antonio made a quail which is still in existence, so
beautiful and so perfect that it lacks nothing but the power of
flight. Antonio, therefore, had not spent many weeks over this
work before he was known as the best, both in design and in
patient execution, of all those who were working there, and as
more gifted and more diligent than any other. Whereupon, grow-
ing ever both in ability and in fame, he left Bartoluccio and
Lorenzo, and opened a fine and magnificent goldsmith's shop for
himself in the Mercato Nuovo in that city. And for many years
he followed that art, never ceasing to make new designs, and
executing in relief wax candles and other things of fancy, which
in a short time caused him to be held – as he was – the first
master of his calling.

There lived at the same time another goldsmith called Maso
Finiguerra, who had an extraordinary fame, and deservedly, since
there had never been seen any master of engraving and of niello
who could make so great a number of figures as he could,
whether in a small or in a large space; as is still proved by certain
paxes in the Church of S. Giovanni in Florence, wrought by him
with most minutely elaborated stories from the Passion of Christ.
This man drew very well and in abundance, and in our book are
many of his drawings of figures, both draped and nude, and
scenes done in water-colour. In competition with him Antonio
executed certain scenes, in which he equalled him in diligence and
surpassed him in design; wherefore the Consuls of the Guild of
Merchants, seeing the excellence of Antonio, and remembering
that there were certain scenes in silver to be wrought for the altar
of S. Giovanni, such as it had ever been the custom for various
masters to make at different times, determined among themselves
that Antonio also should make some. This came to pass; and his
works turned out so excellent, that they are recognized as the best
among them all. These were the Feast of Herod and the Dance
of Herodias; but more beautiful than anything else was the
S. John that is in the middle of the altar, a work wrought wholly
with the chasing-tool, and much extolled. For this reason he was
commissioned by the said Consuls to make the candelabra of
silver, each three braccia in height, and the Cross in proportion;
which work he brought to such perfection, with such an abund-
ance of carving, that it has ever been esteemed a marvellous thing

ANTONIO POLLAIVOLO PITTO.
E SCVLTOR FIOR.

both by foreigners and by his countrymen. In this calling he took infinite pains, both with the works that he executed in gold and with those in enamel and silver. Among these are some very beautiful paxes in S. Giovanni, coloured by the action of fire, which are such that they could be scarcely improved with the brush; and some of his marvellous enamels may be seen in other churches in Florence, Rome, and other parts of Italy.

He taught this art to the Florentine Mazzingo and to Giuliano del Facchino, both passing good masters, and to Giovanni Turini of Siena, who surpassed these his companions considerably in that profession, in which, from Antonio di Salvi – who made many good works, such as a large silver Cross for the Badia of Florence, and other things – to our own day, there has been nothing done than can be held in particular account. But of his works and of those of the Pollaiuoli many have been destroyed and melted down to meet the necessities of the city in times of war.

For this reason, recognizing that this art gave no long life to the labours of its craftsmen, and desiring to gain a more lasting memory, Antonio resolved to pursue it no longer. And so, his brother Piero being a painter, he associated himself with him in order to learn the methods of handling and using colours; but it appeared to him an art so different from the goldsmith's, that, if he had not been so hasty in resolving to abandon his own art entirely, it might well have been that he would never have brought himself to turn to the other. However, spurred by fear of shame rather than by hope of profit, in a few months he acquired a practical knowledge of colouring and became an excellent master. He associated himself entirely with Piero, and they made many pictures in company; among others, since they took great delight in colour, a panel in oil in S. Miniato al Monte without Florence, for the Cardinal of Portugal. On this panel, which was placed on the altar of his chapel, they painted S. James the Apostle, S. Eustace, and S. Vincent, which have been much extolled. Piero, in particular, painted certain prophets on the wall in oil (a method that he had learnt from Andrea dal Castagno), in the corners of the angels below the architrave, where the lunettes of the arches run; and in one of the lunettes he painted the Virgin receiving the Annunciation, with three figures. For the Capitani di Parte he painted a Madonna with the Child in her arms in a lunette, with a frieze of seraphim all round, also wrought in oil. They also painted in oil, on canvas, on a pilaster

of S. Michele in Orto, an Angel Raphael with Tobias; and they made certain Virtues in the Mercatanzia of Florence, in the very place where that Tribunal holds its sittings. In the Proconsulate Antonio made portraits from life of Messer Poggio, Secretary to the Signoria of Florence, who continued the History of Florence after Messer Leonardo d' Arezzo, and of Messer Giannozzo Manetti, a man of no small learning and repute, in the same place where other masters some time before had made portraits of Zanobi da Strada, a poet of Florence, Donato Acciaiuoli, and others. In the Chapel of the Pucci, in S. Sebastiano de' Servi, he painted the panel of the altar, which is a rare and excellent work, containing marvellous horses, nudes, and very beautiful figures in foreshortening, and S. Sebastian himself portrayed from life – namely, from Gino di Lodovico Capponi. This work received greater praise than any other that Antonio ever made, since, seeking to imitate nature to the utmost of his power, he showed in one of the archers, who is resting his cross-bow against his chest and bending down to the ground in order to load it, all the force that a man of strong arm can exert in loading that weapon, for we see his veins and muscles swelling, and the man himself holding his breath in order to gain more strength. Nor is this the only figure wrought with careful consideration, for all the others in their various attitudes also demonstrate clearly enough the thought and the intelligence that he put into this work, which was certainly appreciated by Antonio Pucci, who gave him 300 crowns for it, declaring that he was barely paying him for the colours. It was finished in the year 1475.

Gaining courage from this, therefore, he painted at S. Miniato fra le Torri, without the Gate, a S. Cristopher ten braccia in height, a very beautiful work executed in a modern manner, the figure being better proportioned than any other of that size that had been made up to that time. He then made a Crucifix with S. Antonino, on canvas, which was placed in the chapel of that Saint in S. Marco. In the Palace of the Signoria of Florence, at the Porta della Catena, he made a S. John the Baptist; and in the house of the Medici he painted for the elder Lorenzo three figures of Hercules in three pictures, each five braccia in height. The first of these, which is slaying Antæus, is a very beautiful figure, in which the strength of Hercules as he crushes the other is seen most vividly, for the muscles and nerves of that figure are all strained in the struggle to destroy Antæus. The head of Her-

cules shows the gnashing of the teeth so well in harmony with the other parts, that even the toes of his feet are raised in the effort. Nor did he take less pains with Antæus, who, crushed in the arms of Hercules, is seen sinking and losing all his strength, and giving up his breath through his open mouth. The second Hercules, who is slaying the Lion, has the left knee pressed against its chest, and, setting his teeth and extending his arms, and grasping the Lion's jaws with both his hands, he is opening them and rending them asunder by main force, although the beast is tearing his arms grievously with its claws in self-defence. The third picture, wherein Hercules is slaying the Hydra, is something truly marvellous, particularly the serpent, which he made so lively and so natural in colouring that nothing could be made more life-like. In that beast are seen venom, fire, ferocity, rage, and such vivacity, that he deserves to be celebrated and to be closely imitated in this by all good craftsmen.

For the Company of S. Angelo in Arezzo he executed an oil-painting on cloth, with a Crucifix on one side, and on the other S. Michael in combat with the Dragon, as beautiful as any work that there is to be seen by his hand; for the figure of S. Michael, who is bravely confronting the Dragon, setting his teeth and knitting his brows, truly seems to have descended from Heaven in order to effect the vengeance of God against the pride of Lucifer, and it is indeed a marvellous work. He had a more modern grasp of the nude than the masters before his day, and he dissected many bodies in order to study their anatomy. He was the first to demonstrate the method of searching out the muscles, in order that they might have their due form and place in his figures, and he engraved on copper a battle of nude figures all girt round with a chain; and after this one he made other engravings, with much better workmanship than had been shown by the other masters who had lived before him.

For these reasons, then, he became famous among craftsmen, and after the death of Pope Sixtus IV he was summoned by his successor, Pope Innocent, to Rome, where he made a tomb of metal for the said Innocent, wherein he portrayed him from nature, seated in the attitude of giving the Benediction; and this was placed in S. Pietro. That of the said Pope Sixtus, which was finished at very great cost, was placed in the chapel that is called by the name of that Pontiff. It stands quite by itself, with very rich adornments, and on it there lies an excellent figure of the

Pope; and the tomb of Innocent stands in S. Pietro, beside the chapel that contains the Lance of Christ. It is said that the same man designed the Palace of the Belvedere for the said Pope Innocent, although, since he had little experience of building, it was erected by others. Finally, after becoming rich, these two brothers died almost at the same time in 1498, and were buried by their relatives in S. Pietro in Vincula; and in memory of them, beside the middle door, on the left as one enters into the church, there were placed two medallions of marble with their portraits and with the following epitaph:

ANTONIUS PULLARIUS PATRIA FLORENTINUS, PICTOR INSIG-
NIS, QUI DUORUM PONTIF. XISTI ET INNOCENTII ÆREA
MONIMENTA MIRO OPIFIC. EXPRESSIT, RE FAMIL. COMPOSITA
EX TEST. HIC SE CUM PETRO FRATRE CONDI VOLUIT. VIX.
AN. LXXII. OBIIT ANNO SAL. MIID.

The same man made a very beautiful battle of nude figures in low-relief and of metal, which went to Spain; of this every crafts-man in Florence has a plaster cast. And after his death there were found the design and model that he had made at the command of Lodovico Sforza for the equestrian statue of Francesco Sforza, Duke of Milan, of which design there are two forms in our book; in one the Duke has Verona beneath him, and in the other he is on a pedestal covered with battle pieces, in full armour, and forc-ing his horse to leap on a man in armour. But the reason why he did not put these designs into execution I have not yet been able to discover. The same man made some very beautiful medals; among others, one representing the conspiracy of the Pazzi, con-taining on one side the heads of Lorenzo and Giuliano de' Medici, and on the reverse the choir of S. Maria del Fiore, with the whole event exactly as it happened. He also made the medals of certain Pontiffs, and many other things that are known to craftsmen.

Antonio was seventy-two years of age when he died, and Piero sixty-five. The former left many disciples, among whom was An-drea Sansovino. Antonio had a most fortunate life in his day, finding rich Pontiffs, and his own city at the height of its great-ness and delighting in talent, wherefore he was much esteemed; whereas, if he had chanced to live in an unfavourable age, he would not have produced such fruits as he did, since troublous times are deadly enemies to the sciences in which men labour and take delight.

For S. Giovanni in Florence, after the design of this man, there were made two dalmatics, a chasuble, and a cope, of double brocade, all woven in one piece without a single seam; and for these, as borders and ornaments, there were embroidered the stories of the life of S. John, with most delicate workmanship and art, by Paolo da Verona, a divine master of that profession and rare in intelligence beyond all others, who executed the figures no less well with the needle than Antonio would have done them with his brush; wherefore we owe no small obligation to the one for his design and to the other for his patience in embroidering it. This work took twenty-six years to complete; but of these embroideries, which, being made with the close stitch, are not only more durable but also seem like a real painting done with the brush, the good method is now all but lost, since we now use a more open stitch, which is less durable and less lovely to the eye.

SANDRO BOTTICELLI
[*ALESSANDRO FILIPEPI OR SANDRO DI BOTTICELLO*],
Painter of Florence

AT the same time with the elder Lorenzo de' Medici, the Magnificent, which was truly a golden age for men of intellect, there also flourished one Alessandro, called Sandro after our custom, and surnamed Di Botticello for a reason that we shall see below. This man was the son of Mariano Filipepi, a citizen of Florence, who brought him up with care, and had him instructed in all those things that are usually taught to children before they are old enough to be apprenticed to some calling. But although he found it easy to learn whatever he wished, nevertheless he was ever restless, nor was he contented with any form of learning, whether reading, writing, or arithmetic, insomuch that his father, weary of the vagaries of his son's brain, in despair apprenticed him as a goldsmith with a boon-companion of his own, called Botticello, no mean master of that art in his day.

Now in that age there was a very close connection – nay, almost a constant intercourse – between the goldsmiths and the painters; wherefore Sandro, who was a ready fellow and had devoted himself wholly to design, became enamoured of painting,

and determined to devote himself to that. For this reason he spoke out his mind freely to his father, who, recognizing the inclination of his brain, took him to Fra Filippo of the Carmine, a most excellent painter of that time, with whom he placed him to learn the art, according to Sandro's own desire. Thereupon, devoting himself heart and soul to that art, Sandro followed and imitated his master so well that Fra Filippo, growing to love him, taught him very thoroughly, so that he soon rose to such a rank as none would have expected for him.

While still quite young, he painted a figure of Fortitude in the Mercatanzia of Florence, among the pictures of Virtues that were wrought by Antonio and Piero del Pollaiuolo. For the Chapel of the Bardi in S. Spirito at Florence he painted a panel, wrought with diligence and brought to a fine completion, which contains certain olive-trees and palms executed with consummate lovingness. He painted a panel for the Convertite Nuns, and another for those of S. Barnaba. In the tramezzo* of the Ognissanti, by the door that leads into the choir, he painted for the Vespucci a S. Augustine in fresco, with which he took very great pains, seeking to surpass all the painters of his time, and particularly Domenico Ghirlandajo, who had made a S. Jerome on the other side; and this work won very great praise, for in the head of that Saint he depicted the profound meditation and acute subtlety that are found in men of wisdom who are ever concentrated on the investigation of the highest and most difficult matters. This picture, as was said in the Life of Ghirlandajo, has this year (1564) been removed safe and sound from its original position.

Having thus come into credit and reputation, he was commissioned by the Guild of Porta Santa Maria to paint in S. Marco a panel with the Coronation of Our Lady and a choir of angels, which he designed and executed very well. He made many works in the house of the Medici for the elder Lorenzo, particularly a Pallas on a device of great branches, which spouted forth fire: this he painted of the size of life, as he did a S. Sebastian. In S. Maria Maggiore in Florence, beside the Chapel of the Panci-atichi, there is a very beautiful Pietà with little figures. For various houses throughout the city he painted round pictures, and many female nudes, of which there are still two at Castello, a villa of Duke Cosimo's; one representing the birth of Venus, with those

* See note on p. 90.

SANDRO BOTTICELLI PITT.
FIORENTINO

Winds and Zephyrs that bring her to the earth, with the Cupids; and likewise another Venus, whom the Graces are covering with flowers, as a symbol of spring; and all this he is seen to have expressed very gracefully. Round an apartment of the house of Giovanni Vespucci, now belonging to Piero Salviati, in the Via de' Servi, he made many pictures which were enclosed by frames of walnut-wood, by way of ornament and panelling, with many most lively and beautiful figures. In the house of the Pucci, likewise, he painted with little figures Boccaccio's tale of Nastagio degli Onesti in four square pictures of most charming and beautiful workmanship, and the Epiphany in a round picture. For a chapel in the Monastery of Cestello he painted an Annunciation on a panel. Near the side-door of S. Pietro Maggiore, for Matteo Palmieri, he painted a panel with an infinite number of figures – namely, the Assumption of Our Lady, with the zones of Heaven as they are represented, and the Patriarchs, the Prophets, the Apostles, the Evangelists, the Martyrs, the Confessors, the Doctors, the Virgins, and the Hierarchies; all from the design given to him by Matteo, who was a learned and able man. This work he painted with mastery and consummate diligence; and at the foot is a portrait of Matteo on his knees, with that of his wife. But for all that the work is most beautiful, and should have silenced envy, nevertheless there were certain malignant slanderers who, not being able to do it any other damage, said that both Matteo and Sandro had committed therein the grievous sin of heresy. As to whether this be true or false, I cannot be expected to judge; it is enough that the figures painted therein by Sandro are truly worthy of praise, by reason of the pains that he took in drawing the zones of Heaven and in the distribution of figures, angels, foreshortenings, and views, all varied in diverse ways, the whole being executed with good design.

At this time Sandro was commissioned to paint a little panel with figures three-quarters of a braccio in length, which was placed between two doors in the principal façade of S. Maria Novella, on the left as one enters the church by the door in the centre. It contains the Adoration of the Magi, and wonderful feeling is seen in the first old man, who, kissing the foot of Our Lord, and melting with tenderness, shows very clearly that he has achieved the end of his long journey. The figure of this King is an actual portrait of the elder Cosimo de' Medici, the most lifelike and most natural that is to be found of him in our own day. The

second, who is Giuliano de' Medici, father of Pope Clement VII, is seen devoutly doing reverence to the Child with a most intent expression, and presenting Him with his offering. The third, also on his knees, appears to be adoring Him and giving Him thanks, while confessing that He is the true Messiah; this is Giovanni, son of Cosimo.

It is not possible to describe the beauty that Sandro depicted in the heads that are therein seen, which are drawn in various attitudes, some in full face, some in profile, some in three-quarter face, others bending down, and others, again, in various manners; with different expressions for the young and the old, and with all the bizarre effects that reveal to us the perfection of his skill; and he distinguished the Courts of the three Kings one from another, insomuch that one can see which are the retainers of each. This is truly a most admirable work, and executed so beautifully, whether in colouring, drawing, or composition, that every crafts-man at the present day stands in a marvel thereat. And at that time it brought him such great fame, both in Florence and abroad, that Pope Sixtus IV, having accomplished the building of the chapel of his palace in Rome, and wishing to have it painted, ordained that he should be made head of that work; whereupon he painted therein with his own hand the following scenes – namely, the Temptation of Christ by the Devil, Moses slaying the Egyptian, Moses receiving drink from the daughters of Jethro the Midianite, and likewise fire descending from Heaven on the sacrifice of the sons of Aaron, with certain Sanctified Popes in the niches above the scenes. Having therefore acquired still greater fame and reputation among the great number of competitors who worked with him, both Florentines and men of other cities, he received from the Pope a good sum of money, the whole of which he consumed and squandered in a moment during his residence in Rome, where he lived in haphazard fashion, as was his wont.

Having at the same time finished and unveiled the part that had been assigned to him, he returned immediately to Florence, where, being a man of inquiring mind, he made a commentary on part of Dante, illustrated the Inferno, and printed it; on which he wasted much of his time, bringing infinite disorder into his life by neglecting his work. He also printed many of the drawings that he had made, but in a bad manner, for the engraving was poorly done. The best of these that is to be seen by his hand is

the Triumph of the Faith effected by Fra Girolamo Savonarola of Ferrara, of whose sect he was so ardent a partisan that he was thereby induced to desert his painting, and, having no income to live on, fell into very great distress. For this reason, persisting in his attachment to that party, and becoming a Piagnone* (as the members of the sect were then called), he abandoned his work; wherefore he ended in his old age by finding himself so poor, that, if Lorenzo de' Medici, for whom, besides many other things, he had done some work at the little hospital in the district of Volterra, had not succoured him the while that he lived, as did afterwards his friends and many excellent men who loved him for his talent, he would have almost died of hunger.

In S. Francesco, without the Porta a San Miniato, there is a Madonna in a round picture by the hand of Sandro, with some angels of the size of life, which was held a very beautiful work. Sandro was a man of very pleasant humour, often playing tricks on his disciples and his friends; wherefore it is related that once, when a pupil of his who was called Biagio had made a round picture exactly like the one mentioned above, in order to sell it, Sandro sold it for six florins of gold to a citizen; then, finding Biagio, he said to him, 'At last I have sold this thy picture; so this evening it must be hung on high, where it will be seen better, and in the morning thou must go to the house of the citizen who has bought it, and bring him here, that he may see it in a good light in its proper place; and then he will pay thee the money.' 'O, my master,' said Biagio, 'how well you have done.' Then, going into the shop, he hung the picture at a good height, and went off. Meanwhile Sandro and Jacopo, who was another of his disciples, made eight caps of paper, like those worn by citizens, and fixed them with white wax on the heads of the eight angels that surrounded the Madonna in the said picture. Now, in the morning, up comes Biagio with his citizen, who had bought the picture and was in the secret. They entered the shop, and Biagio, looking up, saw his Madonna seated, not among his angels, but among the Signoria of Florence, with all those caps. Thereupon he was just about to begin to make an outcry and to excuse himself to the man who had bought it, when, seeing that the other, instead of complaining, was actually praising the picture, he kept silent

* Mourner, or Weeper.

himself. Finally, going with the citizen to his house, Biagio received his payment of six florins, the price for which his master had sold the picture; and then, returning to the shop just as Sandro and Jacopo had removed the paper caps, he saw his angels as true angels, and not as citizens in their caps. All in a maze, and not knowing what to say, he turned at last to Sandro and said: 'Master, I know not whether I am dreaming, or whether this is true. When I came here before, these angels had red caps on their heads, and now they have not; what does it mean?' 'Thou art out of thy wits, Biagio,' said Sandro; 'this money has turned thy head. If it were so, thinkest thou that the citizen would have bought the picture?' 'It is true,' replied Biagio, 'that he said nothing to me about it, but for all that it seemed to me strange.' Finally, all the other lads gathered round him and wrought on him to believe that it had been a fit of giddiness.

Another time a cloth-weaver came to live in a house next to Sandro's, and erected no fewer than eight looms, which, when at work, not only deafened poor Sandro with the noise of the treadles and the movement of the frames, but shook his whole house, the walls of which were no stronger than they should be, so that what with the one thing and the other he could not work or even stay at home. Time after time he besought his neighbour to put an end to this annoyance, but the other said that he both would and could do what he pleased in his own house; whereupon Sandro, in disdain, balanced on the top of his own wall, which was higher than his neighbour's and not very strong, an enormous stone, more than enough to fill a wagon, which threatened to fall at the slightest shaking of the wall and to shatter the roof, ceilings, webs, and looms of his neighbour, who, terrified by this danger, ran to Sandro, but was answered in his very own words – namely, that he both could and would do whatever he pleased in his own house. Nor could he get any other answer out of him, so that he was forced to come to a reasonable agreement and to be a good neighbour to Sandro.

It is also related that Sandro, for a jest, accused a friend of his own of heresy before his vicar, and the friend, on appearing, asked who the accuser was and what the accusation; and having been told that it was Sandro, who had charged him with holding the opinion of the Epicureans, and believing that the soul dies with the body, he insisted on being confronted with the accuser before the judge. Sandro therefore appeared, and the other said:

'It is true that I hold this opinion with regard to this man's soul, for he is an animal. Nay, does it not seem to you that he is the heretic, since without a scrap of learning, and scarcely knowing how to read, he plays the commentator to Dante and takes his name in vain?'

It is also said that he had a surpassing love for all whom he saw to be zealous students of art; and that he earned much, but wasted everything through negligence and lack of management. Finally, having grown old and useless, and being forced to walk with crutches, without which he could not stand upright, he died, infirm and decrepit, at the age of seventy-eight, and was buried in Ognissanti at Florence in the year 1515.

In the guardaroba of the Lord Duke Cosimo there are two very beautiful heads of women in profile by his hand, one of which is said to be the mistress of Giuliano de' Medici, brother of Lorenzo, and the other Madonna Lucrezia de' Tornabuoni, wife of the said Lorenzo. In the same place, likewise by the hand of Sandro, is a Bacchus who is raising a cask with both his hands, and putting it to his mouth – a very graceful figure. And in the Duomo of Pisa he began an Assumption, with a choir of angels, in the Chapel of the Impagliata; but afterwards, being displeased with it, he left it unfinished. In S. Francesco at Montevarchi he painted the panel of the high-altar; and in the Pieve of Empoli, on the same side as the S. Sebastian of Rossellino, he made two angels. He was among the first to discover the method of decorating standards and other sorts of hangings with the so-called inlaid work, to the end that the colours might not fade and might show the tint of the cloth on either side. By his hand, and made thus, is the baldacchino of Orsanmichele, covered with beautiful and varied figures of Our Lady; which proves how much better such a method preserves the cloth than does the use of mordants, which eat it away and make its life but short, although, being less costly, mordants are now used more than anything else.

Sandro's drawings were extraordinarily good, and so many, that for some time after his death all the craftsmen strove to obtain some of them; and we have some in our book, made with great mastery and judgment. His scenes abounded with figures, as may be seen from the embroidered border of the Cross that the Friars of S. Maria Novella carry in processions, all made from his design. Great was the praise, then, that Sandro deserved for

all the pictures that he chose to make with diligence and love, as he did the aforesaid panel of the Magi in S. Maria Novella, which is marvellous. Very beautiful, too, is a little round picture by his hand that is seen in the apartment of the Prior of the Angeli in Florence, in which the figures are small but very graceful and wrought with beautiful consideration. Of the same size as the aforesaid panel of the Magi, and by the same man's hand, is a picture in the possession of Messer Fabio Segni, a gentleman of Florence, in which there is painted the Calumny of Apelles, as beautiful as any picture could be. Under this panel, which Sandro himself presented to Antonio Segni, who was much his friend, there may now be read the following verses, written by the said Messer Fabio:

INDICIO QUEMQUAM NE FALSO LÆDERE TENTENT
TERRARUM REGES, PARVA TABELLA MONET.
HUIC SIMILEM ÆGYPTI REGI DONAVIT APELLES;
REX FUIT ET DIGNUS MUNERE, MUNUS EO.

BENEDETTO DA MAIANO, Sculptor and Architect

BENEDETTO DA MAIANO, a sculptor of Florence, who was in his earliest years a wood-carver, was held the most able master of all who were then handling the tools of that profession; and he was particularly excellent as a craftsman in that form of work which, as has been said elsewhere, was introduced at the time of Filippo Brunelleschi and Paolo Uccello – namely, the inlaying of pieces of wood tinted with various colours, in order to make views in perspective, foliage, and many other diverse things of fancy. In this craft, then, Benedetto da Maiano was in his youth the best master that there was to be found, as is clearly demonstrated by many works of his that are to be seen in various parts of Florence, particularly by all the presses in the Sacristy of S. Maria del Fiore, the greater part of which he finished after the death of his uncle Giuliano; these are full of figures executed in inlaid work, foliage, and other devices, all wrought with great expense and craftsmanship. Having gained a very great name through the novelty of this art, he made many works, which were sent to diverse places and to various Princes; and among others

King Alfonso of Naples had the furniture for a study, made under the direction of Giuliano uncle of Benedetto, who was serving that King as architect. Benedetto himself went to join him there; but, being displeased with the position, he returned to Florence, where, no long time after, he made for Matthias Corvinus, King of Hungary, who had many Florentines in his Court and took delight in all rare works, a pair of coffers inlaid in wood with difficult and most beautiful craftsmanship. He then determined, being invited with great favour by that King, to consent to go thither at all costs; and so, having packed up his coffers and embarked with them on board ship, he set off for Hungary. There, after doing obeisance to that King, by whom he was received most graciously, he sent for the said coffers and had them unpacked in the presence of the monarch, who was very eager to see them; whereupon he saw that the damp from the water and the exhalations from the sea had so softened the glue, that, on the opening of the waxed cloths, almost all the pieces which had been attached to the coffers fell to the ground. Whether Benedetto, therefore, in the presence of so many nobles, stood in dumb amazement, everyone may judge for himself. However, putting the work together as well as he was able, he contrived to leave the King well enough satisfied; but in spite of this he took an aversion to that craft and could no longer endure it, through the shame that it had brought upon him.

And so, casting off all timidity, he devoted himself to sculpture, in which art he had already worked at Loreto while living with his uncle Giuliano, making a lavatory with certain angels of marble for the sacristy. Labouring at this art, before he left Hungary he gave that King to know that if he had been put to shame at the beginning, the fault had lain with that craft, which was a mean one, and not with his intellect, which was rare and exalted. Having therefore made in those parts certain works both in clay and in marble, which gave great pleasure to that King, he returned to Florence; and he had no sooner arrived there than he was commissioned by the Signori to make the marble ornament for the door of their Audience Chamber. For this he made some boys supporting with their arms certain festoons, all very beautiful; but the most beautiful part of the work was the figure in the middle, two braccia in height, of a young S. John, which is held to be a thing of rare excellence. And to the end that the whole work might be by his own hand, he made by himself

the woodwork that closes the said door, and executed a figure with inlaid woods on either part of it, that is, Dante on one and Petrarca on the other; which two figures are enough to show to any man who may have seen no other work of that kind by the hand of Benedetto, how rare and excellent a master he was of that craft. This Audience Chamber has been painted in our own day by Francesco Salviati at the command of the Lord Duke Cosimo, as will be told in the proper place.

In S. Maria Novella at Florence, where Filippino painted the chapel, Benedetto afterwards made a tomb of black marble, with a Madonna and certain angels in a medallion, with much diligence, for the elder Filippo Strozzi, whose portrait, which he made there in marble, is now in the Strozzi Palace. The same Benedetto was commissioned by the elder Lorenzo de' Medici to make in S. Maria del Fiore a portrait of the Florentine painter Giotto, which he placed over the epitaph, of which enough has been said above in the Life of Giotto himself. This piece of marble sculpture is held to be passing good. Having afterwards gone to Naples by reason of the death of his uncle Giuliano, whose heir he was, Benedetto, besides certain works that he executed for that King, made a marble panel for the Count of Terranuova in the Monastery of the Monks of Monte Oliveto, containing an Annunciation with certain saints, and surrounded by very beautiful boys, who are supporting some festoons; and in the predella of the said work he made many low-reliefs in a good manner. In Faenza he made a very beautiful tomb of marble for the body of S. Savino, and on this he wrought six scenes in low-relief from the life of that Saint, with much invention and design both in the buildings and in the figures; insomuch that both from this work and from others by his hand he was recognized as a man excellent in sculpture. Wherefore, before he left Romagna, he was commissioned to make a portrait of Galeotto Malatesta. He also made one, I know not whether before this or after, of Henry VII, King of England, after a drawing on paper that he had received from some Florentine merchants. The studies for these two portraits, together with many other things, were found in his house after his death.

Having finally returned to Florence, he made in S. Croce, for Pietro Mellini, a citizen of Florence and a very rich merchant at that time, the marble pulpit that is seen there, which is held to be a very rare thing and more beautiful than any other that has

ever been executed in that manner, since the marble figures that are to be seen therein, in the stories of S. Francis, are wrought with so great excellence and diligence that nothing more could be looked for in marble. For with great art Benedetto carved there trees, rocks, houses, views in perspective, and certain things in marvellously bold relief; not to mention a projection on the ground below the said pulpit, which serves as a tomb-stone, wrought with so much design that it is not possible to praise it enough. It is said that in making this work he had some difficulty with the Wardens of Works of S. Croce, because, while he wished to erect the said pulpit against a column that sustains some of the arches which support the roof, and to perforate that column in order to accommodate the steps and the entrance to the pulpit, they would not consent, fearing lest it might be so weakened by the hollow required for the steps as to collapse under the weight above, with great damage to a part of that church. But Mellini having guaranteed that the work would be finished without any injury to the church, they finally consented. Having, therefore, bound the outer side of the column with bands of bronze (the part, namely, from the pulpit downwards, which is covered with hard stone), Benedetto made within it the steps for ascending to the pulpit, and in proportion as he hollowed it out within, so did he strengthen the outer side with the said hard stone, in the manner that is still to be seen. And he brought this work to perfection to the amazement of all who see it, showing in each part and in the whole together the utmost excellence that could be desired in such a work.

Many declare that the elder Filippo Strozzi, when intending to build his palace, sought the advice of Benedetto, who made him a model, according to which it was begun, although it was afterwards carried on and finished by Cronaca on the death of Benedetto. The latter, having acquired enough to live upon, would do no more works in marble after those described above, save that he finished in S. Trinita the S. Mary Magdalene begun by Desiderio da Settignano, and made the Crucifix that is over the altar of S. Maria del Fiore, with certain others like it.

As for architecture, although he put his hand to but few works, yet in these he showed no less judgment than in sculpture; particularly in three ceilings which were made at very great expense, under his guidance and direction, in the Palace of the Signoria at Florence. The first of these was the ceiling of the hall

that is now called the Sala de' Dugento, over which it was proposed to make, not a similar hall, but two apartments, that is, a hall and an audience chamber, so that it was necessary to make a wall, and no light one either, containing a marble door of reasonable thickness; wherefore, for the execution of such a work, there was need of intelligence and judgment no less than those possessed by Benedetto.

Benedetto, then, in order not to diminish the said hall and yet divide the space above into two, went to work in the following manner. On a beam one braccio in thickness, and as long as the whole breadth of the hall, he laid another consisting of two pieces, in such a manner that it projected with its thickness to the height of two-thirds of a braccio. At the ends, these two beams, bound and secured together very firmly, gave a height of two braccia at the edge of the wall on each side; and the said two ends were grooved with a claw-shaped cut, in such a way that there could be laid upon them an arch of half a braccio in thickness, made of two layers of bricks, with its flanks resting on the principal walls. These two beams, then, were dove-tailed together with tenon and mortise, and so firmly bound and united with good bands of iron, that out of two there was made one single beam. Besides this, having made the said arch, and wishing that these timbers of the ceiling should have nothing more to sustain than the wall under the arch, and that the arch itself should sustain the rest, he also attached to this arch two great supports of iron, which, being firmly bolted to the said beams below, upheld and still uphold them; while, even if they were not to suffice by themselves, the arch would be able – by means of the said supports which encircle the beams, one on one side of the marble door and one on the other – to support a weight much greater than that of the partition wall, which is made of bricks and half a braccio in thickness. What is more, he had the bricks in the said wall laid on edge and in the manner of an arch, so that the pressure came against the solid part, at the corners, and the whole was thus more stable. In this manner, by means of the good judgment of Benedetto, the said Sala de' Dugento remained as large as before, and over the same space, with a partition wall between, were made the hall that is called the Sala dell' Orivolo* and the Audience

* *I.e.*, clock.

Chamber wherein is the Triumph of Camillus, painted by the hand of Salviati. The soffit of this ceiling was richly wrought and carved by Marco del Tasso and his brothers, Domenico and Giuliano, who likewise executed that of the Sala dell' Orivolo and that of the Audience Chamber. And since the said marble door had been made double by Benedetto, on the arch of the inner door – we have already spoken of the outer one – he wrought a seated figure of Justice in marble, with the globe of the world in one hand and a sword in the other; and round the arch run the following words:

DILIGITE JUSTITIAM QUI JUDICATIS TERRAM.

The whole of this work was executed with marvellous diligence and art.

For the Church of the Madonna delle Grazie, which is a little distance without the city of Arezzo, the same man made a portico with a flight of steps in front of the door. In making the portico he placed the arches on the columns, and right round alongside the roof he made an architrave, frieze, and great cornice; and in the latter, by way of drip, he placed a garland of rosettes carved in grey-stone, which jut out to the extent of one braccio and a third, insomuch that between the projection of the front of the cyma above to the dentils and ovoli below the drip there is a space of two braccia and a half, which, with the half braccio added by the tiles, makes a projecting roof all round of three braccia in width, beautiful, rich, useful, and ingenious. In this work there is a contrivance worthy to be well considered by craftsmen, for, wishing to give this roof all that projection without modillions or corbels to support it, he made the slabs, on which the rosettes are carved, so large that only the half of their length projected, and the other half was built into the solid wall; wherefore, being thus counterpoised, they were able to support the rest and all that was laid upon them, as they have done up to the present day, without any danger to that building. And since he did not wish this roof to appear to be made, as it was, of pieces, he surrounded it all, piece by piece, with a moulding made of sections well dove-tailed and let into one another, which served as a ground to the garland of rosettes; and this united the whole work together in such a manner that all who see it judge it to be of one piece. In the same place he had a flat ceiling made of gilded rosettes, which is much extolled.

Now Benedetto had bought a farm without Prato, on the road from the Porta Fiorentina in the direction of Florence, and no more than half a mile from that place. On the main road, beside the gate, he built a most beautiful little chapel, with a niche wherein he placed a Madonna with the Child in her arms, so well wrought in terra-cotta, that even as it is, with no other colour, it is as beautiful as if it were of marble. So are two angels that are above by way of ornament, each with a candelabrum in his hand. On the predella of the altar there is a Pietà with Our Lady and S. John, made of marble and very beautiful. At his death he left in his house many things begun both in clay and in marble. Benedetto was a very good draughtsman, as may be seen in certain drawings in our book. Finally he died in 1498, at the age of fifty-four, and was honourably buried in S. Lorenzo; and he left directions that all his property, after the death of certain of his relatives, should go to the Company of the Bigallo.

While Benedetto in his youth was working as a joiner and at the inlaying of wood, he had among his rivals Baccio Cellini, piper to the Signoria of Florence, who made many very beautiful inlaid works in ivory, and among others an octagon of figures in ivory, outlined in black and marvellously beautiful, which is in the guardaroba of the Duke. In like manner, Girolamo della Cecca, a pupil of Baccio and likewise piper to the Signoria, also executed many inlaid works at that same time. A contemporary of these was David Pistoiese, who made a S. John the Evangelist of inlaid work at the entrance to the choir of S. Giovanni Evangelista in Pistoia – a work more notable for great diligence in execution than for any great design. There was also Geri Aretino, who wrought the choir and the pulpit of S. Agostino at Arezzo with figures and views in perspective, likewise of inlaid wood. This Geri was a very fanciful man, and he made with wooden pipes an organ most perfect in sweetness and softness, which is still at the present day over the door of the Sacristy of the Vescovado at Arezzo, with its original goodness as sound as ever – a work worthy of marvel, and first put into execution by him. But not one of these men, nor any other, was as excellent by a great measure as was Benedetto; wherefore he deserves to be ever numbered with praise among the best craftsmen of his professions.

ANDREA VERROCCHIO,
Painter, Sculptor and Architect of Florence

ANDREA DEL VERROCCHIO, a Florentine, was in his day a goldsmith, a master of perspective, a sculptor, a wood-carver, a painter, and a musician; but in the arts of sculpture and painting, to tell the truth, he had a manner somewhat hard and crude, as one who acquired it rather by infinite study than by the facility of a natural gift. Even if he had been as poor in this facility as he was rich in the study and diligence that exalted him, he would have been most excellent in those arts, which, for their highest perfection, require a union of study and natural power. If either of these is wanting, a man rarely attains to the first rank; but study will do a great deal, and thus Andrea, who had it in greater abundance than any other craftsman whatsoever, is counted among the rare and excellent masters of our arts.

In his youth he applied himself to the sciences, particularly to geometry. Among many other things that he made while working at the goldsmith's art were certain buttons for copes, which are in S. Maria del Fiore at Florence; and he also made larger works, particularly a cup, full of animals, foliage, and other bizarre fancies, which is known to all goldsmiths, and casts are taken of it; and likewise another, on which there is a very beautiful dance of little children. Having given a proof of his powers in these two works, he was commissioned by the Guild of Merchants to make two scenes in silver for the ends of the altar of S. Giovanni, from which, when put into execution, he acquired very great praise and fame.

There were wanting at this time in Rome some of those large figures of the Apostles which generally stood on the altar of the Chapel of the Pope, as well as certain other works in silver that had been destroyed; wherefore Pope Sixtus sent for Andrea and with great favour commissioned him to do all that was necessary in this matter, and he brought the whole to perfection with much diligence and judgment. Meanwhile, perceiving that the many antique statues and other things that were being found in Rome were held in very great esteem, insomuch that the famous bronze horse was set up by the Pope at S. Giovanni Laterano, and that even the fragments – not to speak of complete works – which

were being discovered every day, were prized, Andrea determined to devote himself to sculpture. And so, completely abandoning the goldsmith's art, he set himself to cast some little figures in bronze, which were greatly extolled. Thereupon, growing in courage, he began to work in marble. Now in those days the wife of Francesco Tornabuoni had died in childbirth, and her husband, who had loved her much, and wished to honour her in death to the utmost of his power, entrusted the making of a tomb for her to Andrea, who carved on a slab over a sarcophagus of marble the lady herself, her delivery, and her passing to the other life; and beside this he made three figures of Virtues, which were held very beautiful, for the first work that he had executed in marble; and this tomb was set up in the Minerva.

Having then returned to Florence with money, fame, and honour, he was commissioned to make a David of bronze, two braccia and a half in height, which, when finished, was placed in the Palace, with great credit to himself, at the head of the staircase, where the Catena was. The while that he was executing the said statue, he also made that Madonna of marble which is over the tomb of Messer Lionardo Bruni of Arezzo in S. Croce; this he wrought, when still quite young, for Bernardo Rossellino, architect and sculptor, who executed the whole of that work in marble, as has been said. The same Andrea made a half-length Madonna in half-relief, with the Child in her arms, in a marble panel, which was formerly in the house of the Medici, and is now placed, as a very beautiful thing, over a door in the apartment of the Duchess of Florence. He also made two heads of metal, likewise in half-relief; one of Alexander the Great, in profile, and the other a fanciful portrait of Darius; each being a separate work by itself, with variety in the crests, armour, and everything else. Both these heads were sent to Hungary by the elder Lorenzo de' Medici, the Magnificent, to King Matthias Corvinus, together with many other things, as will be told in the proper place.

Having acquired the name of an excellent master by means of these works, above all through many works in metal, in which he took much delight, he made a tomb of bronze in S. Lorenzo, wholly in the round, for Giovanni and Pietro di Cosimo de' Medici, with a sarcophagus of porphyry supported by four corner-pieces of bronze, with twisted foliage very well wrought and finished with the greatest diligence. This tomb stands between the Chapel of the Sacrament and the Sacristy, and no

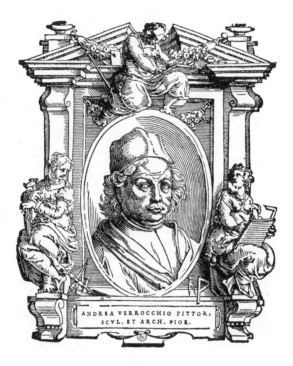

ANDREA VERROCCHIO PITTOR,
SCVL. ET ARCH. PIOR.

work could be better done, whether wrought in bronze or cast; above all since at the same time he showed therein his talent in architecture, for he placed the said tomb within the embrasure of a window which is about five braccia in breadth and ten in height, and set it on a base that divides the said Chapel of the Sacrament from the old Sacristy. And over the sarcophagus, to fill up the embrasure right up to the vaulting, he made a grating of bronze ropes in a pattern of mandorle, most natural, and adorned in certain places with festoons and other beautiful things of fancy, all remarkable and executed with much mastery, judgment, and invention.

Now Donatello had made for the Tribunal of Six of the Mercanzia that marble shrine which is now opposite to S. Michael, in the Oratory of Orsanmichele, and for this there was to have been made a S. Thomas in bronze, feeling for the wound in the side of Christ; but at that time nothing more was done, for some of the men who had the charge of this wished to have it made by Donatello, and others favoured Lorenzo Ghiberti. Matters stood thus as long as Donatello and Ghiberti were alive; but finally the said two statues were entrusted to Andrea, who, having made the models and moulds, cast them; and they came out so solid, complete, and well made, that it was a most beautiful casting. Thereupon, setting himself to polish and finish them, he brought them to that perfection which is seen at the present day, which could not be greater than it is, for in S. Thomas we see incredulity and a too great anxiety to assure himself of the truth, and at the same time the love that makes him lay his hand in a most beautiful manner on the side of Christ; and in Christ Himself, who is raising one arm and opening His raiment with a most spontaneous gesture, and dispelling the doubts of His incredulous disciple, there are all the grace and divinity, so to speak, that art can give to any figure. Andrea clothed both these figures in most beautiful and well-arranged draperies, which give us to know that he understood that art no less than did Donato, Lorenzo, and the others who had lived before him; wherefore this work well deserved to be set up in a shrine made by Donatello, and to be ever afterwards held in the greatest price and esteem.

Now the fame of Andrea could not go further or grow greater in that profession, and he, as a man who was not content with being excellent in one thing only, but desired to become the same

in others as well by means of study, turned his mind to painting, and so made the cartoons for a battle of nude figures, very well drawn with the pen, to be afterwards painted in colours on a wall. He also made the cartoons for some historical pictures, and afterwards began to put them into execution in colours; but for some reason, whatever it may have been, they remained unfinished. There are some drawings by his hand in our book, made with much patience and very great judgment, among which are certain heads of women, beautiful in expression and in the adornment of the hair, which Leonardo da Vinci was ever imitating for their beauty. In our book, also, are two horses with the due measures and protractors for reproducing them on a larger scale from a smaller, so that there may be no errors in their proportions; and there is in my possession a horse's head of terra-cotta in relief, copied from the antique, which is a rare work. The Very Reverend Don Vincenzio Borghini has some of his drawings in his book, of which we have spoken above; among others, a design for a tomb made by him in Venice for a Doge, a scene of the Adoration of Christ by the Magi, and the head of a woman painted on paper with the utmost delicacy. He also made for Lorenzo de' Medici, for the fountain of his Villa at Careggi, a boy of bronze squeezing a fish, which the Lord Duke Cosimo has caused to be placed, as may be seen at the present day, on the fountain that is in the courtyard of his Palace; which boy is truly marvellous.

Afterwards, the building of the Cupola of S. Maria del Fiore having been finished, it was resolved, after much discussion, that there should be made the copper ball which, according to the instructions left by Filippo Brunelleschi, was to be placed on the summit of that edifice. Whereupon the task was given to Andrea, who made the ball four braccia high, and, placing it on a knob, secured it in such a manner that afterwards the cross could be safely erected upon it; and the whole work, when finished, was put into position with very great rejoicing and delight among the people. Truly great were the ingenuity and diligence that had to be used in making it, to the end that it might be possible, as it is, to enter it from below, and also in securing it with good fastenings, lest the winds might do it damage.

Andrea was never at rest, but was ever labouring at some work either in painting or in sculpture; and sometimes he would change from one to another, in order to avoid growing weary of

working always at the same thing, as many do. Wherefore, although he did not put the aforesaid cartoons into execution, yet he did paint certain pictures; among others, a panel for the Nuns of S. Domenico in Florence, wherein it appeared to him that he had acquitted himself very well; whence, no long time after, he painted another in S. Salvi for the Monks of Vallombrosa, containing the Baptism of Christ by S. John. In this work he was assisted by Leonardo da Vinci, his disciple, then quite young, who painted therein an angel with his own hand, which was much better than the other parts of the work; and for that reason Andrea resolved never again to touch a brush, since Leonardo, young as he was, had acquitted himself in that art much better than he had done.

Now Cosimo de' Medici, having received many antiquities from Rome, had caused to be set up within the door of his garden, or rather, courtyard, which opens on the Via de' Ginori, a very beautiful Marsyas of white marble, bound to a tree-trunk and ready to be flayed; and his grandson Lorenzo, into whose hands there had come the torso and head of another Marsyas, made of red stone, very ancient, and much more beautiful than the first, wished to set it beside the other, but could not, because it was so imperfect. Thereupon he gave it to Andrea to be restored and completed, and he made the legs, thighs, and arms that were lacking in this figure out of pieces of red marble, so well that Lorenzo was highly satisfied and had it placed opposite to the other, on the other side of the door. This ancient torso, made to represent a flayed Marsyas, was wrought with such care and judgment that certain delicate white veins, which were in the red stone, were carved by the craftsman exactly in the right places, so as to appear to be little nerves, such as are seen in real bodies when they have been flayed; which must have given to that work, when it had its original finish, a most lifelike appearance.

The Venetians, meanwhile, wishing to honour the great valour of Bartolommeo da Bergamo, thanks to whom they had gained many victories, in order to encourage others, and having heard the fame of Andrea, summoned him to Venice, where he was commissioned to make an equestrian statue of that captain in bronze, to be placed on the Piazza di SS. Giovanni e Polo. Andrea, then, having made the model of the horse, had already begun to get it ready for casting in bronze, when, thanks to the

favour of certain gentlemen, it was determined that Vellano da Padova should make the figure and Andrea the horse. Having heard this, Andrea broke the legs and head of his model and returned in great disdain to Florence, without saying a word. The Signoria, receiving news of this, gave him to understand that he should never be bold enough to return to Venice, for they would cut his head off; to which he wrote in answer that he would take good care not to, because, once they had cut a man's head off, it was not in their power to put it on again, and certainly not one like his own, whereas he could have replaced the head that he had knocked off his horse with one even more beautiful. After this answer, which did not displease those Signori, his payment was doubled and he was persuaded to return to Venice, where he restored his first model and cast it in bronze; but even then he did not finish it entirely, for he caught a chill by overheating himself during the casting, and died in that city within a few days; leaving unfinished not only that work (although there was only a little polishing to be done), which was set up in the place for which it was destined, but also another which he was making in Pistoia, that is, the tomb of Cardinal Forteguerra, with the three Theological Virtues, and a God the Father above; which work was afterwards finished by Lorenzetto, a sculptor of Florence.

Andrea was fifty-six years of age when he died. His death caused infinite grief to his friends and to his disciples, who were not few; above all to the sculptor Nanni Grosso, a most eccentric person both in his art and in his life. This man, it is said, would not have worked outside his shop, particularly for monks or friars, if he had not had free access to the door of the vault, or rather, wine-cellar, so that he might go and drink whenever he pleased, without having to ask leave. It is also told of him that once, having returned from S. Maria Nuova completely cured of some sickness, I know not what, he was visited by his friends, who asked him how it went with him. 'Ill,' he answered. 'But thou art cured,' they replied. 'That is why it goes ill with me,' said he, 'for I would dearly love a little fever, so that I might lie there in the hospital, well attended and at my ease.' As he lay dying, again in the hospital, there was placed before him a wooden Crucifix, very rude and clumsily wrought; whereupon he prayed them to take it out of his sight and to bring him one by the hand of Donato, declaring that if they did not take it away he would die in misery, so greatly did he detest badly wrought works in his own art.

Disciples of the same Andrea were Pietro Perugino and Leonardo da Vinci, of whom we will speak in the proper place, and Francesco di Simone of Florence, who made a tomb of marble in the Church of S. Domenico in Bologna, with many little figures, which appear from the manner to be by the hand of Andrea, for Messer Alessandro Tartaglia, a doctor of Imola, and another in S. Pancrazio at Florence, facing the sacristy and one of the chapels of the church, for the Chevalier Messer Pietro Minerbetti. Another pupil of Andrea was Agnolo di Polo, who worked with great mastery in clay, filling the city with works by his hand; and if he had deigned to apply himself properly to his art, he would have made very beautiful things. But the one whom he loved more than all the others was Lorenzo di Credi, who brought his remains from Venice and laid them in the Church of S. Ambrogio, in the tomb of Ser Michele di Cione, on the stone of which there are carved the following words:

SER MICHÆLIS DE CIONIS, ET SUORUM.

And beside them:

HIC OSSA JACENT ANDREÆ VERROCHII, QUI OBIIT
VENETIIS, MCCCCLXXXVIII.

Andrea took much delight in casting in a kind of plaster which would set hard – that is, the kind that is made of a soft stone which is quarried in the districts of Volterra and of Siena and in many other parts of Italy. This stone, when burnt in the fire, and then pounded and mixed with tepid water, becomes so soft that men can make whatever they please with it; but afterwards it solidifies and becomes so hard, that it can be used for moulds for casting whole figures. Andrea, then, was wont to cast in moulds of this material such natural objects as hands, feet, knees, legs, arms, and torsi, in order to have them before him and imitate them with greater convenience. Afterwards, in his time, men began to cast the heads of those who died – a cheap method; wherefore there are seen in every house in Florence, over the chimney-pieces, doors, windows, and cornices, infinite numbers of such portraits, so well made and so natural that they appear alive. And from that time up to the present the said custom has been continued, and it still continues, with great convenience to ourselves, for it has given us portraits of many who have been included in the stories in the Palace of Duke Cosimo.

And for this we should certainly acknowledge a very great obligation to the talent of Andrea, who was one of the first to begin to bring the custom into use.

From this men came to make more perfect images, not only in Florence, but in all the places in which there is devoutness, and to which people flock to offer votive images, or, as they are called, 'miracoli,' in return for some favour received. For whereas they were previously made small and of silver, or only in the form of little panels, or rather of wax, and very clumsy, in the time of Andrea they began to be made in a much better manner, since Andrea, having a very strait friendship with Orsino, a Florentine worker in wax, who had no little judgment in that art, began to show him how he could become excellent therein. Now the due occasion arrived in the form of the death of Giuliano de' Medici and the danger incurred by his brother Lorenzo, who was wounded in S. Maria del Fiore, when it was ordained by the friends and relatives of Lorenzo that images of him should be set up in many places, to render thanks to God for his deliverance. Wherefore Orsino, among others that he made, executed three life-size figures of wax with the aid and direction of Andrea, making the skeleton within of wood, after the method described elsewhere, interwoven with split reeds, which were then covered with waxed cloths folded and arranged so beautifully that nothing better or more true to nature could be seen. Then he made the heads, hands, and feet with wax of greater thickness, but hollow within, portrayed from life, and painted in oils with all the ornaments of hair and everything else that was necessary, so lifelike and so well wrought that they seemed no mere images of wax, but actual living men, as may be seen in each of the said three, one of which is in the Church of the Nuns of Chiarito in the Via di S. Gallo, opposite to the Crucifix that works miracles. This figure is clothed exactly as Lorenzo was, when, with his wounded throat bandaged, he showed himself at the window of his house before the eyes of the people, who had flocked thither to see whether he were alive, as they hoped, or to avenge him if he were dead. The second figure of the same man is in the lucco, the gown peculiar to the citizens of Florence; and it stands in the Servite Church of the Nunziata, over the lesser door, which is beside the counter where candles are sold. The third was sent to S. Maria degli Angeli at Assisi, and set up before the Madonna of that place, where the same Lorenzo de' Medici, as has been

already related, caused the road to be paved with bricks all the way from S. Maria to that gate of Assisi which leads to S. Francesco, besides restoring the fountains that his grandfather Cosimo had caused to be made in that place. But to return to the images of wax: all those in the said Servite Church are by the hand of Orsino, which have a large O in the base as a mark, with an R within it and a cross above; and they are all so beautiful that there are few since his day who have equalled him. This art, although it has remained alive up to our own time, is nevertheless rather on the decline than otherwise, either because men's devoutness has diminished, or for some other reason, whatever it may be.

And to return to Verrocchio; besides the aforesaid works, he made Crucifixes of wood, with certain things of clay, in which he was excellent, as may be seen from the models for the scenes that he executed for the altar of S. Giovanni, from certain very beautiful boys, and from a head of S. Jerome, which is held to be marvellous. By the hand of the same man is the boy on the clock of the Mercato Nuovo, who has his arms working free, in such a manner that he can raise them to strike the hours with a hammer that he holds in his hands; which was held in those times to be something very beautiful and fanciful. And let this be the end of the Life of that most excellent sculptor, Andrea Verrocchio.

There lived in the time of Andrea one Benedetto Buglioni, who received the secret of glazed terra-cotta work from a woman related to the house of Andrea della Robbia; wherefore he made many works in that manner both in Florence and abroad, particularly a Christ rising from the dead, with certain angels, which, for a work in glazed terra-cotta, is beautiful enough, in the Church of the Servi, near the Chapel of S. Barbara. He made a Dead Christ in a chapel in S. Pancrazio, and the lunette that is seen over the principal door of the Church of S. Pietro Maggiore. From Benedetto the secret descended to Santi Buglioni, the only man who now knows how to work at this sort of sculpture.

ANDREA MANTEGNA, Painter of Mantua

How great is the effect of reward on talent is known to him who labours valiantly and receives a certain measure of recompense, for he feels neither discomfort, nor hardship, nor fatigue,

when he expects honour and reward for them; nay, what is more, they render his talent every day more renowned and illustrious. It is true, indeed, that there is not always found one to recognize, esteem, and remunerate it as that of Andrea Mantegna was recognized. This man was born from very humble stock in the district of Mantua; and, although as a boy he was occupied in grazing herds, he was so greatly exalted by destiny and by his merit that he attained to the honourable rank of Chevalier, as will be told in the proper place. When almost full grown he was taken to the city, where he applied himself to painting under Jacopo Squarcione, a painter of Padua, who – as it is written in a Latin letter from Messer Girolamo Campagnola to Messer Leonico Timeo, a Greek philosopher, wherein he gives him information about certain old painters who served the family of Carrara, Lords of Padua – took him into his house, and a little time afterwards, having recognized the beauty of his intelligence, adopted him as his son. Now this Squarcione knew that he himself was not the most able painter in the world; wherefore, to the end that Andrea might learn more than he himself knew, he made him practise much on casts taken from ancient statues and on pictures painted upon canvas which he caused to be brought from diverse places, particularly from Tuscany and from Rome. By these and other methods, therefore, Andrea learnt not a little in his youth; and the competition of Marco Zoppo of Bologna, Dario da Treviso, and Niccolò Pizzolo of Padua, disciples of his master and adoptive father, was of no small assistance to him, and a stimulus to his studies.

Now after Andrea, who was then no more than seventeen years of age, had painted the panel of the high-altar of S. Sofia in Padua, which appears wrought by a mature and well-practised master, and not by a youth, Squarcione was commissioned to paint the Chapel of S. Cristofano, which is in the Church of the Eremite Friars of S. Agostino in Padua; and he gave the work to the said Niccolò Pizzolo and to Andrea. Niccolò made therein a God the Father seated in Majesty between the Doctors of the Church, and these paintings were afterwards held to be in no way inferior to those that Andrea executed there. And in truth, if Niccolò, whose works were few, but all good, had taken as much delight in painting as he did in arms, he would have become excellent, and might perchance have lived much longer than he did; for he was ever under arms and had many enemies, and one

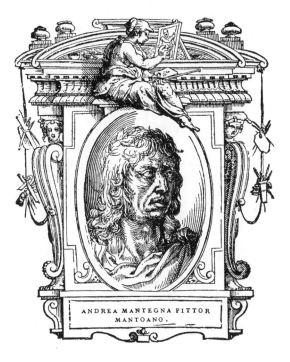

ANDREA MANTEGNA PITTOR
MANTOANO.

day, when returning from work, he was attacked and slain by treachery. Niccolò left no other works that I know of, save another God the Father in the Chapel of Urbano Perfetto.*

Andrea, thus left alone in the said chapel, painted the four Evangelists, which were held very beautiful. By reason of this and other works Andrea began to be watched with great expectation, and with hopes that he would attain to that success to which he actually did attain; wherefore Jacopo Bellini, the Venetian painter, father of Gentile and Giovanni, and rival of Squarcione, contrived to get him to marry his daughter, the sister of Gentile. Hearing this, Squarcione fell into such disdain against Andrea that they were enemies ever afterwards; and in proportion as Squarcione had formerly been ever praising the works of Andrea, so from that day onward did he ever decry them in public. Above all did he censure without reserve the pictures that Andrea had made in the said Chapel of S. Cristofano, saying that they were worthless, because in making them he had imitated the ancient works in marble, from which it is not possible to learn painting perfectly, for the reason that stone is ever from its very essence hard, and never has that tender softness that is found in flesh and in things of nature, which are pliant and move in various ways; adding that Andrea would have made those figures much better, and that they would have been more perfect, if he had given them the colour of marble and not such a quantity of colours, because his pictures resembled not living figures but ancient statues of marble or other suchlike things. This censure piqued the mind of Andrea; but, on the other hand, it was of great service to him, for, recognizing that Squarcione was in great measure speaking the truth, he set himself to portray living people, and made so much progress in this art, that, in a scene which still remained to be painted in the said chapel, he showed that he could wrest the good from living and natural objects no less than from those wrought by art. But for all this Andrea was ever of the opinion that the good ancient statues were more perfect and had greater beauty in their various parts than is shown by nature, since, as he judged and seemed to see from those statues, the excellent masters of old had wrested from living people all the perfection of nature, which rarely assembles and unites all possible beauty into one single body, so that it is necessary to take one part from one body and another part from

* This seems to be a printer's or copyist's error for Prefetto.

another. In addition to this, it appeared to him that the statues were more complete and more thorough in the muscles, veins, nerves, and other particulars, which nature, covering their sharpness somewhat with the tenderness and softness of flesh, sometimes makes less evident, save perchance in the body of an old man or in one greatly emaciated; but such bodies, for other reasons, are avoided by craftsmen. And that he was greatly enamoured of this opinion is recognized from his works, in which, in truth, the manner is seen to be somewhat hard and sometimes suggesting stone rather than living flesh. Be this as it may, in this last scene, which gave infinite satisfaction, Andrea portrayed Squarcione in an ugly and corpulent figure, lance and sword in hand. In the same work he portrayed the Florentine Noferi, son of Messer Palla Strozzi, Messer Girolamo della Valle, a most excellent physician, Messer Bonifazio Fuzimeliga, Doctor of Laws, Niccolò, goldsmith to Pope Innocent VIII, and Baldassarre da Leccio, all very much his friends, whom he represented clad in white armour, burnished and resplendent, as real armour is, and truly with a beautiful manner. He also portrayed there the Chevalier Messer Bonramino, and a certain Bishop of Hungary, a man wholly witless, who would wander about Rome all day, and then at night would lie down to sleep like a beast in a stable; and he made a portrait of Marsilio Pazzo in the person of the executioner who is cutting off the head of S. James, together with one of himself. This work, in short, by reason of its excellence, brought him a very great name.

The while that he was working on this chapel, he also painted a panel, which was placed on the altar of S. Luca in S. Justina, and afterwards he wrought in fresco the arch that is over the door of S. Antonino, on which he wrote his name. In Verona he painted a panel for the altar of S. Cristofano and S. Antonio, and he made some figures at the corner of the Piazza della Paglia. In S. Maria in Organo, for the Monks of Monte Oliveto, he painted the panel of the high-altar, which is most beautiful, and likewise that of S. Zeno. And among other things that he wrought while living in Verona and sent to various places, one, which came into the hands of an Abbot of the Abbey of Fiesole, his friend and relative, was a picture containing a half-length Madonna with the Child in her arms, and certain heads of angels singing, wrought with admirable grace; which picture, now to be seen in the library of that place, has been held from that time to our own to be a rare thing.

Now, the while that he lived in Mantua, he had laboured much in the service of the Marquis Lodovico Gonzaga, and that lord, who always showed no little esteem and favour towards the talent of Andrea, caused him to paint a little panel for the Chapel of the Castle of Mantua; in which panel there are scenes with figures not very large but most beautiful. In the same place are many figures foreshortened from below upwards, which are greatly extolled, for although his treatment of the draperies was somewhat hard and precise, and his manner rather dry, yet everything there is seen to have been wrought with much art and diligence. For the same Marquis, in a hall of the Palace of S. Sebastiano in Mantua, he painted the Triumph of Cæsar, which is the best thing that he ever executed. In this work we see, grouped with most beautiful design in the triumph, the ornate and lovely car, the man who is vituperating the triumphant Cæsar, and the relatives, the perfumes, the incense, the sacrifices, the priests, the bulls crowned for the sacrifice, the prisoners, the booty won by the soldiers, the ranks of the squadrons, the elephants, the spoils, the victories, the cities and fortresses counterfeited in various cars, with an infinity of trophies borne on spears, and a variety of helmets and body-armour, head-dresses, and ornaments and vases innumerable; and in the multitude of spectators is a woman holding the hand of a boy, who, having pierced his foot with a thorn, is showing it, weeping, to his mother, in a graceful and very lifelike manner. Andrea, as I may have pointed out elsewhere, had a good and beautiful idea in this scene, for, having set the plane on which the figures stood higher than the level of the eye, he placed the feet of the foremost on the outer edge and outline of that plane, making the others recede inwards little by little, so that their feet and legs were lost to sight in the proportion required by the point of view; and so, too, with the spoils, vases, and other instruments and ornaments, of which he showed only the lower part, concealing the upper, as was required by the rules of perspective; which same consideration was also observed with much diligence by Andrea degli Impiccati* in the Last Supper, which is in the Refectory of S. Maria Nuova. Wherefore it is seen that in that age these able masters set about investigating with much subtlety, and imitating with great labour, the true properties of natural

* Andrea dal Castagro.

objects. And this whole work, to put it briefly, is as beautiful and as well wrought as it could be; so that if the Marquis loved Andrea before, he loved and honoured him much more ever afterwards.

What is more, he became so famous thereby that Pope Innocent VIII, hearing of his excellence in painting and of the other good qualities wherewith he was so marvellously endowed, sent for him, even as he was sending for many others, to the end that he might adorn with his pictures the walls of the Belvedere, the building of which had just been finished. Having gone to Rome, then, greatly favoured and recommended by the Marquis, who made him a Chevalier in order to honour him the more, he was received lovingly by that Pontiff and straightway commissioned to paint a little chapel that is in the said place. This he executed with diligence and love, and with such minuteness that the vaulting and the walls appear rather illuminated than painted; and the largest figures that are therein, which he painted in fresco like the others, are over the altar, representing the Baptism of Christ by S. John, with many people around, who are showing by taking off their clothes that they wish to be baptized. Among these is one who, seeking to draw off a stocking that has stuck to his leg through sweat, has crossed that leg over the other and is drawing the stocking off inside out, with such great effort and difficulty, that both are seen clearly in his face; which bizarre fancy caused marvel to all who saw it in those times. It is said that this Pope, by reason of his many affairs, did not pay Mantegna as often as he would have liked, and that therefore, while painting certain Virtues in terretta in that work, he made a figure of Discretion among the rest, whereupon the Pope, having gone one day to see the work, asked Andrea what figure that was; to which Andrea answered that it was Discretion; and the Pope added: 'If thou wouldst have her suitably accompanied, put Patience beside her.' The painter understood what the meaning of the Holy Father was, and he never said another word. The work finished, the Pope sent him back to the Duke with much favour and honourable rewards.

The while that Andrea was working in Rome, he painted, besides the said chapel, a little picture of the Madonna with the Child sleeping in her arms; and within certain caverns in the landscape, which is a mountain, he made some stone-cutters quarrying stone for various purposes, all wrought with such delicacy and such great patience, that it does not seem possible

for such good work to be done with the thin point of a brush. This picture is now in the possession of the most Illustrious Lord, Don Francesco Medici, Prince of Florence, who holds it among his dearest treasures.

In our book is a drawing by the hand of Andrea on a half-sheet of royal folio, finished in chiaroscuro, wherein is a Judith who is putting the head of Holofernes into the wallet of her Moorish slave-girl; which chiaroscuro is executed in a manner no longer used, for he left the paper white to serve for the light in place of white lead, and that so delicately that the separate hairs and other minute details are seen therein, no less than if they had been wrought with much diligence by the brush; wherefore in a certain sense this may be called rather a work in colour than a drawing. The same man, like Pollaiuolo, delighted in engraving on copper; and, among other things, he made engravings of his own Triumphs, which were then held in great account, since nothing better had been seen.

One of the last works that he executed was a panel-picture for S. Maria della Vittoria, a church built after the direction and design of Andrea by the Marquis Francesco, in memory of the victory that he gained on the River Taro, when he was General of the Venetian forces against the French. In this panel, which was wrought in distemper and placed on the high-altar, there is painted the Madonna with the Child seated on a pedestal; and below are S. Michelagnolo, S. Anna, and Joachim, who are presenting the Marquis – who is portrayed from life so well that he appears alive – to the Madonna, who is offering him her hand. Which picture, even as it gave and still continues to give universal pleasure, also satisfied the Marquis so well that he rewarded most liberally the talent and labour of Andrea, who, having been re-munerated by Princes for all his works, was able to maintain his rank of Chevalier most honourably up to the end of his life.

Andrea had competitors in Lorenzo da Lendinara – who was held in Padua to be an excellent painter, and who also wrought some things in terra-cotta for the Church of S. Antonio – and in certain others of no great worth. He was ever the friend of Dario da Treviso and Marco Zoppo of Bologna, since he had been brought up with them under the discipline of Squarcione. For the Friars Minor of Padua this Marco painted a loggia which serves as their chapter-house; and at Pesaro he painted a panel that is now in the new Church of S. Giovanni Evangelista; besides

portraying in a picture Guidobaldo da Montefeltro, at the time when he was Captain of the Florentines. A friend of Mantegna's, likewise, was Stefano, a painter of Ferrara, whose works were few but passing good; and by his hand is the adornment of the sarcophagus of S. Anthony to be seen in Padua, with the Virgin Mary, that is called the Vergine del Pilastro.

But to return to Andrea himself; he built a very beautiful house in Mantua for his own use, which he adorned with paintings and enjoyed while he lived. Finally he died in 1517, at the age of sixty-six, and was buried with honourable obsequies in S. Andrea; and on his tomb, over which stands his portrait in bronze, there was placed the following epitaph:

ESSE PAREM HUNC NORIS, SI NON PRÆPONIS, APELLI,
ÆNEA MANTINEÆ QUI SIMULACRA VIDES.

Andrea was so kindly and praiseworthy in all his actions, that his memory will ever live, not only in his own country, but in the whole world; wherefore he well deserved, no less for the sweetness of his ways than for his excellence in painting, to be celebrated by Ariosto at the beginning of his thirty-third canto, where he numbers him among the most illustrious painters of his time, saying:

Leonardo, Andrea Mantegna, Gian Bellino.

This master showed painters a much better method of foreshortening figures from below upwards, which was truly a difficult and ingenious invention; and he also took delight, as has been said, in engraving figures on copper for printing, a method of truly rare value, by means of which the world has been able to see not only the Bacchanalia, the Battle of Marine Monsters, the Deposition from the Cross, the Burial of Christ, and His Resurrection, with Longinus and S. Andrew, works by Mantegna himself, but also the manners of all the craftsmen who have ever lived.

FILIPPO LIPPI, Painter of Florence
[FILIPPINO]

THERE was at this same time in Florence a painter of most beautiful intelligence and most lovely invention, namely, Filippo, son of Fra Filippo of the Carmine, who, following in the steps

of his dead father in the art of painting, was brought up and instructed, being still very young, by Sandro Botticelli, notwithstanding that his father had commended him on his death-bed to Fra Diamante, who was much his friend – nay, almost his brother. Such was the intelligence of Filippo, and so abundant his invention in painting, and so bizarre and new were his ornaments, that he was the first who showed to the moderns the new method of giving variety to vestments, and embellished and adorned his figures with the girt-up garments of antiquity. He was also the first to bring to light grotesques, in imitation of the antique, and he executed them on friezes in terretta or in colours, with more design and grace than the men before him had shown; wherefore it was a marvellous thing to see the strange fancies that he expressed in painting. What is more, he never executed a single work in which he did not avail himself with great diligence of Roman antiquities, such as vases, buskins, trophies, banners, helmet-crests, adornments of temples, ornamental head-dresses, strange kinds of draperies, armour, scimitars, swords, togas, mantles, and such a variety of other beautiful things, that we owe him a very great and perpetual obligation, seeing that he added beauty and adornment to art in this respect.

In his earliest youth he completed the Chapel of the Brancacci in the Carmine at Florence, begun by Masolino, and left not wholly finished by Masaccio on account of his death. Filippo, therefore, gave it its final perfection with his own hand, and executed what was lacking in one scene, wherein S. Peter and S. Paul are restoring to life the nephew of the Emperor. In the nude figure of this boy he portrayed the painter Francesco Granacci, then a youth; and he also made portraits of the Chevalier, Messer Tommaso Soderini, Piero Guicciardini, father of Messer Francesco the historian, Piero del Pugliese, and the poet Luigi Pulci; likewise Antonio Pollaiuolo, and himself as a youth, as he then was, which he never did again throughout the whole of his life, so that it has not been possible to find a portrait of him at a more mature age. In the scene following this he portrayed Sandro Botticelli, his master, and many other friends and people of importance; among others, the broker Raggio, a man of great intelligence and wit, who executed in relief on a conch the whole Inferno of Dante, with all the circles and divisions of the pits and the nethermost well in their exact proportions, and all the figures and details that were most ingeniously imagined and described by

that great poet; which conch was held in those times to be a marvellous thing.

Next, in the Chapel of Francesco del Pugliese at Campora, a seat of the Monks of the Badia, without Florence, he painted a panel in distemper of S. Bernard, to whom Our Lady is appearing with certain angels, while he is writing in a wood; which picture is held to be admirable in certain respects, such as rocks, books, herbage, and similar things, that he painted therein, besides the portrait from life of Francesco himself, so excellent that he seems to lack nothing save speech. This panel was removed from that place on account of the siege, and placed for safety in the Sacristy of the Badia of Florence. In S. Spirito in the same city, for Tanai de' Nerli, he painted a panel with Our Lady, S. Martin, S. Nicholas, and S. Catherine; with a panel in the Chapel of the Rucellai in S. Pancrazio, and a Crucifix and two figures on a ground of gold in S. Raffaello. In front of the Sacristy of S. Francesco, without the Porta a S. Miniato, he made a God the Father, with a number of children. At Palco, a seat of the Frati del Zoccolo, without Prato, he painted a panel; and in the Audience Chamber of the Priori in that territory he executed a little panel containing the Madonna, S. Stephen, and S. John the Baptist, which has been much extolled. On the Canto al Mercatale, also in Prato, in a shrine opposite to the Nuns of S. Margherita, and near some houses belonging to them, he painted in fresco a very beautiful Madonna, with a choir of seraphim, on a ground of dazzling light. In this work, among other things, he showed art and beautiful judgment in a dragon that is at the feet of S. Margaret, which is so strange and horrible, that it is revealed to us as a true fount of venom, fire, and death; and the whole of the rest of the work is so fresh and vivacious in colouring, that it deserves infinite praise.

He also wrought certain things in Lucca, particularly a panel in a chapel of the Church of S. Ponziano, which belongs to the Monks of Monte Oliveto; in the centre of which chapel there is a niche containing a very beautiful S. Anthony in relief by the hand of Andrea Sansovino, a most excellent sculptor. Being invited to go to Hungary by King Matthias, Filippo refused, but made up for this by painting two very beautiful panels for that King in Florence, and sending them to him; and in one of these he made a portrait of the King, taken from his likeness on medals. He also sent certain works to Genoa; and beside the

FILIPPO LIPPI PITTOR
FIORENTINO

Chapel of the High-Altar in S. Domenico at Bologna, on the left hand, he painted a S. Sebastian on a panel, which was a thing worthy of much praise. For Tanai de' Nerli he executed another panel in S. Salvadore, without Florence; and for his friend Piero del Pugliese he painted a scene with little figures, executed with so much art and diligence that when another citizen besought him to make a second like it, he refused, saying that it was not possible to do it.

After these things he executed a very great work in Rome for the Neapolitan Cardinal, Olivieri Caraffa, at the request of the elder Lorenzo de' Medici, who was a friend of that Cardinal. While going thither for that purpose, he passed through Spoleto at the wish of Lorenzo, in order to give directions for the making of a marble tomb for his father Fra Filippo at the expense of Lorenzo, who had not been able to obtain his body from the people of Spoleto for removal to Florence. Filippo, therefore, made a beautiful design for the said tomb, and Lorenzo had it erected after that design (as has been told in another place), sumptuous and beautiful. Afterwards, having arrived in Rome, Filippo painted a chapel in the Church of the Minerva for the said Cardinal Caraffa, depicting therein scenes from the life of S. Thomas Aquinas, and certain most beautiful poetical compositions ingeniously imagined by himself, for he had a nature ever inclined to this. In the scene, then, wherein Faith has taken Infidelity captive, there are all the heretics and infidels. Hope has likewise overcome Despair, and so, too, there are many other Virtues that have subjugated the Vice that is their opposite. In a disputation is S. Thomas defending the Church 'ex cathedra' against a school of heretics, and holding vanquished beneath him Sabellius, Arius, Averroes, and others, all clothed in graceful garments; of which scene we have in our book of drawings the original design by Filippo's own hand, with certain others by the same man, wrought with such mastery that they could not be bettered. There, too, is the scene when, as S. Thomas is praying, the Crucifix says to him, 'Bene scripsisti de me, Thoma'; while a companion of the Saint, hearing that Crucifix thus speaking, is standing amazed and almost beside himself. In the panel is the Virgin receiving the Annunciation from Gabriel; and on the main wall there is her Assumption into Heaven, with the twelve Apostles round the sepulchre. The whole of this work was held, as it still is, to be very excellent and wrought perfectly for a work

in fresco. It contains a portrait from life of the said Cardinal Olivieri Caraffa, Bishop of Ostia, who was buried in this chapel in the year 1511, and afterwards removed to the Piscopio in Naples.

Having returned to Florence, Filippo undertook to paint at his leisure the Chapel of the elder Filippo Strozzi in S. Maria Novella, and he actually began it; but, having finished the ceiling, he was compelled to return to Rome, where he wrought a tomb with stucco-work for the said Cardinal, and decorated with gesso a little chapel beside that tomb in a part of the same Church of the Minerva, together with certain figures, some of which were executed by his disciple, Raffaellino del Garbo. The chapel described above was valued by Maestro Lanzilago of Padua and by the Roman Antonio, known as Antoniasso, two of the best painters that were then in Rome, at 2,000 ducats of gold, without the cost of the blues and of the assistants. Having received this sum, Filippo returned to Florence, where he finished the afore-said Chapel of the Strozzi, which was executed so well, and with so much art and design, that it causes all who see it to marvel, by reason of the novelty and variety of the bizarre things that are seen therein – armed men, temples, vases, helmet-crests, armour, trophies, spears, banners, garments, buskins, head-dresses, sacer-dotal vestments, and other things – all executed in so beautiful a manner that they deserve the highest commendation. In this work there is the scene of Drusiana being restored to life by S. John the Evangelist, wherein we see most admirably expressed the marvel of the bystanders at beholding a man restore life to a dead woman by a mere sign of the cross; and the greatest amaze-ment of all is seen in a priest, or rather philosopher, whichever he may be, who is clothed in ancient fashion and has a vase in his hand. In the same scene, likewise, among a number of women draped in various manners, there is a little boy, who, terrified by a small spaniel spotted with red, which has seized him with its teeth by one of his swathing-bands, is running round his mother and hiding himself among her clothes, and appears to be as much afraid of being bitten by the dog as his mother is awestruck and filled with a certain horror at the resurrection of Drusiana. Next to this, in the scene where S. John himself is being boiled in oil, we see the wrath of the judge, who is giving orders for the fire to be increased, and the flames reflected on the face of the man who is blowing at them; and all the figures are painted in beau-tiful and varied attitudes. On the other side is S. Philip in the

Temple of Mars, compelling the serpent, which has slain the son of the King with its stench, to come forth from below the altar. In certain steps the painter depicted the hole through which the serpent issued from beneath the altar, and so well did he paint the cleft in one of the steps, that one evening one of Filippo's lads, wishing to hide something, I know not what, from the sight of someone who was knocking for admittance, ran up in haste in order to conceal it in the hole, being wholly deceived by it. Filippo also showed so much art in the serpent, that its venom, fetid breath, and fire, appear rather real than painted. Greatly extolled, too, is his invention in the scene of the Crucifixion of that Saint, for he imagined to himself, so it appears, that the Saint was stretched on the cross while it lay on the ground, and that afterwards the whole was drawn up and raised on high by means of ropes, cords, and poles; which ropes and cords are wound round certain fragments of antiquities, pieces of pillars, and bases, and pulled by certain ministers. On the other side the weight of the said cross and of the Saint who is stretched nude thereon is supported by two men, on the one hand by a man with a ladder, with which he is propping it up, and on the other hand by another with a pole, upholding it, while two others, setting a lever against the base and stem of the cross, are balancing its weight and seeking to place it in the hole made in the ground, wherein it had to stand upright. But why say more? It would not be possible for the work to be better either in invention or in drawing, or in any other respect whatsoever of industry or art. Besides this, it contains many grotesques and other things wrought in chiaroscuro to resemble marble, executed in strange fashion with invention and most beautiful drawing.

For the Frati Scopetini, also, at S. Donato, without Florence, which is called Scopeto and is now in ruins, he painted a panel with the Magi presenting their offerings to Christ, finished with great diligence, wherein he portrayed the elder Pier Francesco de' Medici, son of Lorenzo di Bicci, in the figure of an astrologer who is holding a quadrant in his hand, and likewise Giovanni, father of Signor Giovanni de' Medici, and another Pier Francesco, brother of that Signor Giovanni, and other people of distinction. In this work are Moors, Indians, costumes of strange shapes, and a most bizarre hut. In a loggia at Poggio a Cajano he began a Sacrifice in fresco for Lorenzo de' Medici, but it remained unfinished. And for the Nunnery of S. Geronimo,

above the Costa di S. Giorgio in Florence, he began the panel of the high-altar, which was brought nearly to completion after his death by the Spaniard Alonzo Berughetta, but afterwards wholly finished by other painters, Alonzo having gone to Spain. In the Palazzo della Signoria he painted the panel of the hall where the Council of Eight held their sittings, and he made the design for another large panel, with its ornament, for the Sala del Consiglio; which design his death prevented him from beginning to put into execution, although the ornament was carved; which ornament is now in the possession of Maestro Baccio Baldini, a most excellent physician of Florence, and a lover of every sort of talent. For the Church of the Badia of Florence he made a very beautiful S. Jerome; and he began a Deposition from the Cross for the high-altar of the Friars of the Nunziata, but only finished the figures in the upper half of the picture, for, being overcome by a most cruel fever and by that contraction of the throat that is commonly known as quinsy, he died in a few days at the age of forty-five.

Thereupon, having ever been courteous, affable, and kindly, he was lamented by all those who had known him, and particularly by the youth of his noble native city, who, in their public festivals, masques, and other spectacles, ever availed themselves, to their great satisfaction, of the ingenuity and invention of Filippo, who has never had an equal in things of that kind. Nay, he was so excellent in all his actions, that he blotted out the stain (if stain it was) left to him by his father – blotted it out, I say, not only by the excellence of his art, wherein he was inferior to no man of his time, but also by the modesty and regularity of his life, and, above all, by his courtesy and amiability; and how great are the force and power of such qualities to conciliate the minds of all men without exception, is only known to those who either have experienced or are experiencing it. Filippo was buried by his sons in S. Michele Bisdomini, on April 13, 1505; and while he was being borne to his tomb all the shops in the Via de' Servi were closed, as is done sometimes for the obsequies of great men.

Among the disciples of Filippo, who all failed by a great measure to equal him, was Raffaellino del Garbo, who made many works, as will be told in the proper place, although he did not justify the opinions and hopes that were conceived of him while Filippo was alive and Raffaellino himself still a young man. The fruits, indeed, are not always equal to the blossoms that are

seen in the spring. Nor did any great success come to Niccolò Zoccolo, otherwise known as Niccolò Cartoni, who was likewise a disciple of Filippo, and painted at Arezzo the wall that is over the altar of S. Giovanni Decollato; a little panel, passing well done, in S. Agnesa; a panel over a lavatory in the Abbey of S. Fiora, containing a Christ who is asking for water from the woman of Samaria; and many other works, which, since they were commonplace, are not mentioned.

BERNARDINO PINTURICCHIO,
Painter of Perugia

EVEN as many are assisted by fortune without being endowed with much talent, so, on the contrary, there is an infinite number of able men who are persecuted by an adverse and hostile fortune; whence it is clearly manifest that she acknowledges as her children those who depend upon her without the aid of any talent, since it pleases her to exalt by her favour certain men who would never be known through their own merit; which is seen in Pinturicchio of Perugia, who, although he made many works and was assisted by various helpers, nevertheless had a much greater name than his works deserved. However, he was a man who had much practice in large works, and ever kept many assistants to aid him in his labours. Now, having worked at many things in his early youth under his master Pietro da Perugia,* receiving a third of all that was earned, he was summoned to Siena by Cardinal Francesco Piccolomini to paint the library made by Pope Pius II in the Duomo of that city. It is true, indeed, that the sketches and cartoons for all the scenes that he painted there were by the hand of Raffaello da Urbino, then a youth, who had been his companion and fellow-disciple under the same Pietro, whose manner the said Raffaello had mastered very well. One of these cartoons is still to be seen at the present day in Siena, and some of the sketches, by the hand of Raffaello, are in our book.

Now the stories in this work, wherein Pinturicchio was aided by many pupils and assistants, all of the school of Pietro, were divided into ten pictures. In the first is painted the scene when

* Pietro Perugino.

the said Pope Pius II was born to Silvio Piccolomini and Vittoria, and was called Æneas, in the year 1405, in Valdorcia, at the township of Corsignano, which is now called Pienza after the name of that Pope, who afterwards enriched it with buildings and made it a city; and in this picture are portraits from nature of the said Silvio and Vittoria. In the same is the scene when, in company with Cardinal Domenico of Capranica, he is crossing the Alps, which are covered with ice and snow; on his way to the Council of Bâle. In the second the Council is sending Æneas on many embassies – namely, to Argentina (three times), to Trent, to Constance, to Frankfurt, and to Savoy. In the third is the sending of the same Æneas by the Antipope Felix as ambassador to the Emperor Frederick III, with whom the ready intelligence, the eloquence, and the grace of Æneas found so much favour that he was given the poet's crown of laurel by Frederick himself, who made him his Protonotary, received him into the number of his friends, and appointed him his First Secretary. In the fourth he is sent by Frederick to Eugenius IV, by whom he was made Bishop of Trieste, and then Archbishop of Siena, his native city. In the fifth scene the same Emperor, who is about to come to Italy to receive the crown of Empire, is sending Æneas to Tela-mone, a port of the people of Siena, to meet his wife, Leonora, who was coming from Portugal. In the sixth Æneas is going to Calistus IV,* at the bidding of the said Emperor, to induce him to make war against the Turks; and in this part, Siena being harassed by the Count of Pittigliano and by others at the instigation of King Alfonso of Naples, that Pontiff is sending him to treat for peace. This effected, war is planned against the Orientals; and he, having returned to Rome, is made a Cardinal by the said Pontiff. In the seventh, Calistus being dead, Æneas is seen being created Supreme Pontiff, and called Pius II. In the eighth the Pope goes to Mantua for the Council about the expedition against the Turks, where the Marquis Lodovico receives him with most splendid pomp and incredible magnificence. In the ninth the same Pope is placing in the catalogue of saints – or, as the saying is, canonizing – Catherine of Siena, a holy woman and nun of the Preaching Order. In the tenth and last, while preparing a vast expedition against the Turks with the help and favour of all

* This seems to be an error for Calistus III.

the Christian Princes, Pope Pius dies at Ancona; and a hermit of the Hermitage of Camaldoli, a holy man, sees the soul of the said Pontiff being borne by Angels into Heaven at the very moment of his death, as may also be read. Afterwards, in the same picture, the body of the same Pope is seen being borne from Ancona to Rome by a vast and honourable company of lords and prelates, who are lamenting the death of so great a man and so rare and holy a Pontiff. The whole of this work is full of portraits from the life, so numerous that it would be a long story to recount their names; and it is all painted with the finest and most lively colours, and wrought with various ornaments of gold, and with very well designed partitions in the ceiling. Below each scene is a Latin inscription, which describes what is contained therein. In the centre of this library the said Cardinal Francesco Piccolomini, nephew of the Pope, placed the three Graces of marble, ancient and most beautiful, which are still there, and which were the first antiquities to be held in price in those times. This library, wherein are all the books left by the said Pius II, was scarcely finished, when the same Cardinal Francesco, nephew of the aforesaid Pontiff, Pius II, was created Pope, choosing the name of Pius III in memory of his uncle. Over the door of that library, which opens into the Duomo, the same Pinturicchio painted in a very large scene, occupying the whole extent of the wall, the Coronation of the said Pope Pius III, with many portraits from life; and beneath it may be read these words:

PIUS III SENENSIS, PII SECUNDI NEPOS, MDIII, SEPTEMBRIS XXI, APERTIS ELECTUS SUFFRAGIIS, OCTAVO OCTOBRIS CORONATUS EST.

When Pinturicchio was working with Pietro Perugino and painting at Rome in the time of Pope Sixtus, he had also been in the service of Domenico della Rovere, Cardinal of San Clemente; wherefore the said Cardinal, having built a very beautiful palace in the Borgo Vecchio, charged Pinturicchio to paint the whole of it, and to make on the façade the coat of arms of Pope Sixtus, with two little boys as supporters. The same master executed certain works for Sciarra Colonna in the Palace of S. Apostolo; and no long time after – namely, in the year 1484 – Innocent VIII, the Genoese, caused him to paint certain halls and loggie in the Palace of the Belvedere, where, among other things, by order of that Pope, he painted a loggia full of landscapes,

depicting therein Rome, Milan, Genoa, Florence, Venice, and Naples, after the manner of the Flemings; and this, being a thing not customary at that time, gave no little satisfaction. In the same place, over the principal door of entrance, he painted a Madonna in fresco. In S. Pietro, in the chapel that contains the Lance which pierced the side of Christ, he painted a panel in distemper, with the Madonna larger than life, for the said Innocent VIII; and he painted two chapels in the Church of S. Maria del Popolo, one for the aforesaid Domenico della Rovere, Cardinal of San Clemente, who was afterwards buried therein, and the other for Cardinal Innocenzio Cibo, wherein he also was afterwards buried; and in each of these chapels he portrayed the Cardinal who had caused him to paint it. In the Palace of the Pope he painted certain rooms that look out upon the courtyard of S. Pietro, the ceilings and paintings of which were renovated a few years ago by Pope Pius IV. In the same palace Alexander VI caused Pinturicchio to paint all the rooms that he occupied, together with the whole of the Borgia Tower, wherein he wrought stories of the liberal arts in one room, besides decorating all the ceilings with stucco and gold; but, since they did not then know the method of stucco-work that is now in use, the aforesaid ornaments are for the most part ruined. Over the door of an apartment in the said palace he portrayed the Signora Giulia Farnese in the countenance of a Madonna, and, in the same picture, the head of Pope Alexander in a figure that is adoring her.

Bernardino was much given to making gilt ornaments in relief for his pictures, to satisfy people who had little understanding of his art with the more showy lustre that this gave them, which is a most barbarous thing in painting. Having then executed a story of S. Catherine in the said apartments, he depicted the arches of Rome in relief and the figures in painting, insomuch that, the figures being in the foreground and the buildings in the background, the things that should recede stand out more prominently than those that should strike the eye as the larger — a very grave heresy in our art.

In the Castello di S. Angelo he painted a vast number of rooms with grotesques; and in the Great Tower, in the garden below, he painted stories of Pope Alexander, with portraits of the Catholic Queen, Isabella; Niccolò Orsino, Count of Pittigliano; Gianjacomo Trivulzi, and many other relatives and friends of the said Pope, in particular Cæsar Borgia and his brother and sisters,

with many talented men of those times. At Monte Oliveto in Naples, in the Chapel of Paolo Tolosa, there is a panel with an Assumption by the hand of Pinturicchio. This master made an infinite number of other works throughout all Italy, which, since they are of no great excellence, and wrought in a superficial manner, I will pass over in silence. Pinturicchio used to say that a painter could only give the greatest relief to his figures when he had it in himself, without owing anything to principles or to others. He also made works in Perugia, but these were few. In the Araceli he painted the Chapel of S. Bernardino; and in S. Maria del Popolo, where, as we have said, he painted the two chapels, he made the four Doctors of the Church on the vaulting of the principal chapel.

Afterwards, having reached the age of fifty-nine, he was commissioned to paint the Nativity of Our Lady on a panel in S. Francesco at Siena. To this he set his hand, and the friars assigned to him a room to live in, which they gave to him, as he wished, empty and stripped of everything, save only a huge old chest, which appeared to them too awkward to remove. But Pinturicchio, like the strange and whimsical man that he was, made such an outcry at this, and repeated it so often, that finally in despair the friars set themselves to carry it away. Now their good fortune was such, that in removing it there was broken a plank which contained 500 Roman ducats of gold; at which Pinturicchio was so displeased, and felt so aggrieved at the good luck of those poor friars, that it can hardly be imagined – nay, he took it so much to heart, being unable to get it out of his thoughts, that it was the death of him. His pictures date about the year 1513.

A companion and friend of Pinturicchio, although he was a much older man, was Benedetto Buonfiglio, a painter of Perugia, who executed many works in company with other masters in the Papal Palace at Rome. In the Chapel of the Signoria in Perugia, his native city, he painted scenes from the life of S. Ercolano, Bishop and Protector of that city, and in the same place certain miracles wrought by S. Louis. In S. Domenico he painted the story of the Magi on a panel in distemper, and many saints on another. In the Church of S. Bernardino he painted a Christ in the sky, with S. Bernardino himself, and a multitude below. In short, this master was in no little repute in his native city before Pietro Perugino had come to be known.

Another friend of Pinturicchio, associated with him in not a few of his works, was Gerino Pistoiese, who was held to be a diligent colourist and a faithful imitator of the manner of Pietro Perugino, with whom he worked nearly up to his death. He did little work in his native city of Pistoia; but for the Company of the Buon Gesù in Borgo San Sepolcro he painted a Circumcision in oil on a panel, which is passing good. In the Pieve of the same place he painted a chapel in fresco; and on the bank of the Tiber, on the road that leads to Anghiari, he painted another chapel, also in fresco, for the Commune. And he painted still another chapel in the same place, in S. Lorenzo, an abbey of the Monks of Camaldoli. By reason of all these works he made so long a stay in the Borgo that he almost adopted it as his home. He was a sorry fellow in matters of art, labouring with the greatest difficulty, and toiling with such pains at the execution of a work, that it was a torture to him.

At this same time there was a painter in the city of Foligno, Niccolò Alunno, who was held to be excellent, for it was little the custom before Pietro Perugino's day to paint in oil, and many were held to be able men who did not afterwards justify this opinion. Niccolò therefore gave no little satisfaction with his works, since, although he only painted in distemper, he portrayed the heads of his figures from life, so that they appeared alive, and his manner won considerable praise. In S. Agostino at Foligno there is a panel by his hand with a Nativity of Christ, and a predella with little figures. At Assisi he painted a banner that is borne in processions, besides the panel of the high-altar in the Duomo, and another panel in S. Francesco. But the best painting that Niccolò ever did was in a chapel in the Duomo, where, among other things, there is a Pietà, with two angels who are holding two torches and weeping so naturally, that I do not believe that any other painter, however excellent, would have been able to do much better. In the same place he also painted the façade of S. Maria degli Angeli, besides many other works of which there is no need to make mention, it being enough to have touched on the best. And let this be the end of the Life of Pinturicchio, who, besides his other qualities, gave no little satisfaction to many princes and lords because he finished and delivered his works quickly, which is their pleasure, although such works are perchance less excellent than those that are made slowly and deliberately.

FRANCESCO FRANCIA, Goldsmith and Painter of Bologna

FRANCESCO FRANCIA, who was born in Bologna in the year 1450, of parents who were artisans, but honest and worthy enough, was apprenticed in his earliest boyhood to the gold-smith's art, in which calling he worked with intelligence and spirit; and as he grew up he became so well proportioned in person and appearance, and so sweet and pleasant in manner and speech, that he was able to keep the most melancholy of men cheerful and free from care with his talk; for which reason he was beloved not only by all those who knew him, but also by many Italian princes and other lords. While working as a goldsmith, then, he gave attention to design, in which he took so much pleasure, that his mind began to aspire to higher things, and he made very great progress therein, as may be seen from many works in silver that he executed in his native city of Bologna, and particularly from certain most excellent works in niello. In this manner of work he often put twenty most beautiful and well-proportioned little figures within a space no higher than the breadth of two fingers and not much more in length. He also enamelled many works in silver, which were destroyed at the time of the ruin and exile of the Bentivogli. In a word, he did every-thing that can be done in that art better than any other man.

But that in which he delighted above all, and in which he was truly excellent, was the making of dies for medals, wherein he was the rarest master of his day, as may be seen in some that he made with a most lifelike head of Pope Julius II, which bear comparison with those of Caradosso; not to mention that he made medals of Signor Giovanni Bentivogli, in which he appears alive, and of an infinite number of princes, who would stop in Bologna on their way through the city, whereupon he would make their portraits in wax for medals, and afterwards, having finished the matrices of the dies, he would send them; for which, besides immortal fame, he also received very rich presents. As long as he lived he was ever Master of the Mint in Bologna, for which he made the stamps of all the dies, both under the rule of the Bentivogli and also during the lifetime of Pope Julius, after their departure, as is proved by the coins struck by that Pope on his entrance into the city, which had on one side his head

portrayed from life, and on the other these words: BONONIA PER JULIUM A TYRANNO LIBERATA. So excellent was he held in this profession, that he continued to make the dies for the coinage down to the time of Pope Leo; and the impressions of his dies are so greatly prized, and those who have some hold them in such esteem, that money cannot buy them.

Now it came to pass that Francia, being desirous of greater glory, and having known Andrea Mantegna and many other painters who had gained wealth and honours by their art, determined to try whether he could succeed in that part of painting which had to do with colour; his drawing was already such that it could well bear comparison with theirs. Thereupon, having made arrangements to try his hand, he painted certain portraits and some little things, keeping in his house for many months men of that profession to teach him the means and methods of colouring, insomuch that, having very good judgment, he soon acquired the needful practice. The first work that he made was a panel of no great size for Messer Bartolommeo* Felicini, who placed it in the Misericordia, a church without Bologna; in which panel there is a Madonna seated on a throne, with many other figures, and the said Messer Bartolommeo portrayed from life. This work, which was wrought in oil with the greatest diligence, was painted by him in the year 1490; and it gave such satisfaction in Bologna, that Messer Giovanni Bentivogli, desiring to honour his own chapel, which was in S. Jacopo in that city, with works by this new painter, commissioned him to paint a panel with the Madonna in the sky, two figures on either side of her, and two angels below sounding instruments; which work was so well executed by Francia, that he won from Messer Giovanni, besides praise, a most honourable present. Wherefore Monsignore de' Bentivogli, impressed by this work, caused him to paint a panel containing the Nativity of Christ, which was much extolled, for the high-altar of the Misericordia; wherein, besides the design, which is not otherwise than beautiful, the invention and the colouring are worthy of nothing but praise. In this work he made a portrait of Monsignore de' Bentivogli from the life (a very good likeness, so it is said by those who knew him), clothed in that very pilgrim's dress in which he returned from Jerusalem. He also painted a panel in the Church of the Nunziata, without the Porta

* The text says 'Messer Bart....'

di S. Mammolo, representing the Madonna receiving the Annunciation from the Angel, with two figures on either side, which is held to be a very well executed work.

Now that Francia's works had spread his fame abroad, even as his painting in oil had brought him both profit and repute, so he determined to try whether he would succeed as well at working in fresco. Messer Giovanni Bentivogli had caused his palace to be painted by diverse masters of Ferrara and Bologna, and by certain others from Modena; but, having seen Francia's experiments in fresco, he determined that this master should paint a scene on one wall of an apartment that he occupied for his own use. There Francia painted the camp of Holofernes, guarded by various sentinels both on foot and on horseback, who were keeping watch over the pavilions; and the while that they were intent on something else, the sleeping Holofernes was seen surprised by a woman clothed in widow's garments, who, with her left hand, was holding his hair, which was wet with the heat of wine and sleep, and with her right hand she was striking the blow to slay her enemy, the while that an old wrinkled handmaid, with the true air of a most faithful slave, and with her eyes fixed on those of her Judith in order to encourage her, was bending down and holding a basket near the ground, to receive therein the head of the slumbering lover. This scene was one of the most beautiful and most masterly that Francia ever painted, but it was thrown to the ground in the destruction of that edifice at the time of the expulsion of the Bentivogli, together with another scene over that same apartment, coloured to look like bronze, and representing a disputation of philosophers, which was excellently wrought, with his conception very well expressed. These works brought it about that he was loved and honoured by Messer Giovanni and all the members of his house, and, after them, by all the city.

In the Chapel of S. Cecilia, which is attached to the Church of S. Jacopo, he painted two scenes wrought in fresco, in one of which he made the Marriage of Our Lady with Joseph, and in the other the Death of S. Cecilia – a work held in great esteem by the people of Bologna. And, indeed, Francia gained such mastery and such confidence from seeing his works advancing towards the perfection that he desired, that he executed many pictures, of which I will make no mention, it being enough for me to point out, to all who may wish to see his works, only the best and most notable. Nor did his painting hinder him from carrying on both

the Mint and his other work of making medals, as he had done from the beginning. Francia, so it is said, felt the greatest sorrow at the departure of Messer Giovanni Bentivogli, for he had received such great benefits from Messer Giovanni, that it caused him infinite grief; however, like the prudent and orderly man that he was, he kept at his work. After his parting from his patron, he painted three panels that went to Modena, in one of which there was the Baptism of Christ by S. John; in the second, a very beautiful Annunciation; and in the last, which was placed in the Church of the Frati dell' Osservanza, a Madonna in the sky with many figures.

The fame of so excellent a master being spread abroad by means of so many works, the cities contended with one another to obtain his pictures. Whereupon he painted a panel for the Black Friars of S. Giovanni in Parma, containing a Dead Christ in the lap of Our Lady, surrounded by many figures; which panel was universally held to be a most beautiful work; and the same friars, therefore, thinking that they had been well served, induced him to make another for a house of theirs at Reggio in Lombardy, wherein he painted a Madonna with many figures. At Cesena, likewise for the church of these friars, he executed another panel, painting therein the Circumcision of Christ, with lovely colouring. Nor would the people of Ferrara consent to be left behind by their neighbours; nay, having determined to adorn their Duomo with works by Francia, they commissioned him to paint a panel, on which he made a great number of figures; and they named it the panel of Ognissanti. He painted one in S. Lorenzo at Bologna, with a Madonna, a figure on either side, and two children below, which was much extolled; and scarcely had he finished this when he had to make another in S. Giobbe, representing a Crucifixion, with that Saint kneeling at the foot of the Cross, and two figures at the sides.

So widely had the fame and the works of this craftsman spread throughout Lombardy, that even from Tuscany men sent for something by his hand, as they did from Lucca, whither there went a panel containing a S. Anne and a Madonna, with many other figures, and a Dead Christ above in the lap of His Mother; which work is set up in the Church of S. Fridiano, and is held in great price by the people of Lucca. For the Church of the Nunziata in Bologna he painted two other panels, which were wrought with much diligence; and in the Misericordia, likewise,

without the Porta a Strà Castione, at the request of a lady of the Manzuoli family, he painted another, wherein he depicted the Madonna with the Child in her arms, S. George, S. John the Baptist, S. Stephen, and S. Augustine, with an angel below, who has his hands clasped with such grace, that he appears truly to belong to Paradise. He executed another for the Company of S. Francesco in the same city, and likewise one for the Company of S. Gieronimo. He lived in close intimacy with Messer Polo Zambeccaro, who, being much his friend, and wishing to have some memorial of him, caused him to paint a rather large picture of the Nativity of Christ, which is one of the most celebrated works that he ever made; and for this reason Messer Polo commissioned him to paint at his villa two figures in fresco, which are very beautiful. He also executed a most charming scene in fresco in the house of Messer Gieronimo Bolognino, with many varied and very beautiful figures.

All these works together had won him such veneration in that city, that he was held in the light of a god; and what made this infinitely greater was that the Duke of Urbino caused him to paint a set of horse's caparisons, in which he made a vast forest of trees that had caught fire, from which there were issuing great numbers of all sorts of animals, both of the air and of the earth, and certain figures – a terrible, awful, and truly beautiful thing, which was held in no little esteem by reason of the time spent in painting the plumage of the birds, and the various sorts of terrestrial animals, to say nothing of the diversity of foliage and the variety of branches that were seen in the different trees. For this work Francia was rewarded with gifts of great value as a recompense for his labours, not to mention that the Duke ever held himself indebted to him for the praises that he received for it. Duke Guido Baldo, also, has in his guardaroba a picture of the Roman Lucretia, which he esteems very highly, by the same man's hand, together with many other pictures, of which mention will be made when the time comes.

After these things he painted a panel for the altar of the Madonna in SS. Vitale e Agricola; in which panel are two very beautiful angels, who are playing on the lute. I will not enumerate the pictures that are scattered throughout Bologna in the houses of gentlemen of that city, and still less the infinite number of portraits that he made from life, for it would be too wearisome. Let it be enough to say that while he was living in such glory and

enjoying the fruits of his labours in peace, Raffaello da Urbino was in Rome, and all day long there flocked round him many strangers, among them many gentlemen of Bologna, eager to see his works. And since it generally comes to pass that every man extols most willingly the intellects of his native place, these Bolognese began to praise the works, the life, and the talents of Francia in the presence of Raffaello, and they established such a friendship between them with these words, that Francia and Raffaello sent letters of greeting to each other. And Francia, hearing such great praise spoken of the divine pictures of Raffaello, desired to see his works; but he was now old, and too fond of his comfortable life in Bologna. Now after this it came about that Raffaello painted in Rome for Cardinal Santi Quattro, of the Pucci family, a panel-picture of S. Cecilia, which had to be sent to Bologna to be placed in a chapel of S. Giovanni in Monte, where there is the tomb of the Blessed Elena dall' Olio. This he packed up and addressed to Francia, who, as his friend, was to have it placed on the altar of that chapel, with the ornament, just as he had prepared it himself. Right readily did Francia accept this charge, which gave him a chance of seeing a work by Raffaello, as he had so much desired. And having opened the letter that Raffaello had written to him, in which he besought Francia, if there were any scratch in the work, to put it right, and likewise, as a friend, to correct any error that he might notice, with the greatest joy he had the said panel taken from its case into a good light. But such was the amazement that it caused him, and so great his marvel, that, recognizing his own error and the foolish presumption of his own rash confidence, he took it greatly to heart, and in a very short time died of grief.

Raffaello's panel was divine, not so much painted as alive, and so well wrought and coloured by him, that among all the beautiful pictures that he painted while he lived, although they are all miraculous, it could well be called most rare. Wherefore Francia, half dead with terror at the beauty of the picture, which lay before his eyes challenging comparison with those by his own hand that he saw around him, felt all confounded, and had it placed with great diligence in that chapel of S. Giovanni in Monte for which it was destined; and taking to his bed in a few days almost beside himself, thinking that he was now almost of no account in his art in comparison with the opinion held both by himself and by others, he died of grief and melancholy, so some

believe, overtaken by the same fate, through contemplating too attentively that most lifelike picture of Raffaello's, as befell Fivizzano from feasting his eyes with his own beautiful Death, about which the following epigram was written:

Me veram pictor divinus mente recepit;
 Admota est operi deinde perita manus.
Dumque opere in facto defigit lumina pictor,
 Intentus nimium, palluit et moritur.
Viva igitur sum mors, non mortua mortis imago,
 Si fungor quo mors fungitur officio.

However, certain others say that his death was so sudden, that from many symptoms it appeared to be due rather to poison or apoplexy than to anything else. Francia was a prudent man, most regular in his way of life, and very robust. After his death, in the year 1518, he was honourably buried by his sons in Bologna.

PIETRO PERUGINO, Painter
[*PIETRO VANNUCCI, OR PIETRO DA CASTEL DELLA PIEVE*]

How great a benefit poverty may be to men of genius, and how potent a force it may be to make them become excellent – nay, perfect – in the exercise of any faculty whatsoever, can be seen clearly enough in the actions of Pietro Perugino, who, flying from the extremity of distress at Perugia, and betaking himself to Florence in the desire to attain to some distinction by means of his talent, remained for many months without any other bed than a miserable chest to sleep in, turning night into day, and devoting himself with the greatest ardour to the unceasing study of his profession. And, having made a habit of this, he knew no other pleasure than to labour continually at his art, and to be for ever painting; for with the fear of poverty constantly before his eyes, he would do for gain such work as he would probably not have looked at if he had possessed the wherewithal to live. Riches, indeed, might perchance have closed the path on which his talent should advance towards excellence, no less effectually than poverty opened it to him, while necessity spurred him on in his desire to rise from so low and miserable a condition, if not to supreme

eminence, at least to a rank in which he might have the means
of life. For this reason he never took heed of cold, of hunger, of
hardship, of discomfort, of fatigue, or of ridicule, if only he might
one day live in ease and repose; ever saying, as it were by way of
proverb, that after bad weather there must come the good, and
that during the good men build the houses that are to shelter
them when there is need.

But in order that the rise of this craftsman may be better
known, let me begin with his origin, and relate that, according to
common report, there was born in the city of Perugia, to a poor
man of Castello della Pieve, named Cristofano, a son who was
baptized with the name of Pietro. This son, brought up amid
misery and distress, was given by his father as a shop-boy to a
painter of Perugia, who was no great master of his profession,
but held in great veneration both the art and the men who were
excellent therein; nor did he ever cease to tell Pietro how much
gain and honour painting brought to those who practised it well,
and he would urge the boy to the study of that art by recounting
to him the rewards won by ancient and modern masters; where-
fore he fired his mind in such a manner, that Pietro took it into
his head to try, if only fortune would assist him, to become one
of these. For this reason he was often wont to ask any man
whom he knew to have seen the world, in what part the best
craftsmen in that calling were formed; particularly his master,
who always gave him one and the same answer – namely, that it
was in Florence more than in any other place that men became
perfect in all the arts, especially in painting, since in that city men
are spurred by three things. The first is censure, which is uttered
freely and by many, seeing that the air of that city makes men's
intellects so free by nature, that they do not content themselves,
like a flock of sheep, with mediocre works, but ever consider
them with regard to the honour of the good and the beautiful
rather than out of respect for the craftsman. The second is that,
if a man wishes to live there, he must be industrious, which is
naught else than to say that he must continually exercise his
intelligence and his judgment, must be ready and adroit in
his affairs, and, finally, must know how to make money, seeing that
the territory of Florence is not so wide or abundant as to enable
her to support at little cost all who live there, as can be done in
countries that are rich enough. The third, which is perchance no
less potent than the others, is an eager desire for glory and hon-

PIETRO PERVGINO,
PITTORE.

our, which is generated mightily by that air in the men of all professions; and this desire, in all persons of spirit, will not let them stay content with being equal, much less inferior, to those whom they see to be men like themselves, although they may recognize them as masters – nay, it forces them very often to desire their own advancement so eagerly, that, if they are not kindly or wise by nature, they turn out evil-speakers, ungrateful, and unthankful for benefits. It is true, indeed, that when a man has learnt there as much as suffices him, he must, if he wishes to do more than live from day to day like an animal, and desires to become rich, take his departure from that place and find a sale abroad for the excellence of his works and for the repute conferred on him by that city, as the doctors do with the fame derived from their studies. For Florence treats her craftsmen as time treats its own works, which, when perfected, it destroys and consumes little by little.

Moved by these counsels, therefore, and by the persuasions of many others, Pietro came to Florence, minded to become excellent; and well did he succeed, for the reason that in those times works in his manner were held in very great price. He studied under the discipline of Andrea Verrocchio, and his first figures were painted without the Porta a Prato, in the Nunnery of S. Martino, now in ruins by reason of the wars. In Camaldoli he made a S. Jerome on a wall, which was then much esteemed by the Florentines and celebrated with great praise, for the reason that he made that Saint old, lean, and emaciated, with his eyes fixed on the Crucifix, and so wasted away, that he seems like an anatomical model, as may be seen from a copy of that picture which is in the hands of the aforesaid Bartolommeo Gondi. In a few years, then, he came into such credit, that his works filled not only Florence and all Italy, but also France, Spain, and many other countries to which they were sent. Wherefore, his paintings being held in very great price and repute, merchants began to buy them up wholesale and to send them abroad to various countries, to their own great gain and profit.

For the Nuns of S. Chiara he painted a Dead Christ on a panel, with such lovely and novel colouring, that he made the craftsmen believe that he would become excellent and marvellous. In this work there are seen some most beautiful heads of old men, and likewise certain figures of the Maries, who, having ceased to weep, are contemplating the Dead Jesus with extra-

ordinary awe and love; not to mention that he made therein a landscape that was then held most beautiful, because the true method of making them, such as it appeared later, had not yet been seen. It is said that Francesco del Pugliese offered to give to the aforesaid nuns three times as much money as they had paid to Pietro, and to have a similar one made for them by the same man's hand, but that they would not consent, because Pietro said that he did not believe he could equal it.

There were also many things by the hand of Pietro in the Convent of the Frati Gesuati, without the Porta a Pinti; and since the said church and convent are now in ruins, I do not wish, with this occasion, and before I proceed further with this Life, to grudge the labour of giving some little account of them. This church, then, the architect of which was Antonio di Giorgio of Settignano, was forty braccia long and twenty wide. At the upper end one ascended by four treads, or rather steps, to a platform six braccia in extent, on which stood the high-altar, with many ornaments carved in stone; and on the said altar was a panel with a rich ornament, by the hand, as has been related, of Domenico Ghirlandajo. In the centre of the church was a partition-wall, with a door wrought in open-work from the middle upwards, on either side of which was an altar, while over either altar, as will be told, there stood a panel by the hand of Pietro Perugino. Over the said door was a most beautiful Crucifix by the hand of Benedetto da Maiano, with a Madonna on one side and a S. John on the other, both in relief. Before the said platform of the high-altar, and against the said partition-wall, was a choir of the Doric Order, very well wrought in walnut-wood; and over the principal door of the church there was another choir, which rested on well-strengthened wood-work, with the under part forming a ceiling, or rather soffit, beautifully partitioned, and with a row of balusters acting as parapet to the front of the choir, which faced towards the high-altar. This choir was very convenient to the friars of that convent for holding their night services, for saying their individual prayers, and likewise for week-days. Over the principal door of the church – which was made with most beautiful ornaments of stone, and had a portico in front raised on columns, which made a covered way as far as the door of the convent – was a lunette with a very beautiful figure of S. Giusto, the Bishop, and an angel on either side, by the hand of the illuminator Gherardo; and this because that church was dedicated

to the said S. Giusto, and within it those friars preserved a relic of that Saint – that is, an arm. At the entrance of the convent was a little cloister of exactly the same size as the church – namely, forty braccia long and twenty wide – with arches and vaulting going right round and supported by columns of stone, thus making a spacious and most commodious loggia on every side. In the centre of the court of this cloister, which was all neatly paved with squared stone, was a very beautiful well, with a loggia above, which likewise rested on columns of stone, and made a rich and beautiful ornament. In this cloister were the chapter-house of the friars, the side-door of entrance into the church, and the stairs that ascended to the dormitory and other rooms for the use of the friars. On the farther side of this cloister, in a straight line with the principal door of the convent, was a passage as long as the chapter-house and the steward's room put together, leading into another cloister larger and more beautiful than the first; and the whole of this straight line – that is, the forty braccia of the loggia of the first cloister, the passage, and the line of the second cloister – made a very long enfilade, more beautiful than words can tell, and the rather as from that farther cloister, in the same straight line, there issued a garden-walk two hundred braccia in length; and all this, as one came from the principal door of the convent, made a marvellous view. In the said second cloister was a refectory, sixty braccia long and eighteen wide, with all those well-appointed rooms, and, as the friars call them, offices, which were required in such a convent. Over this was a dormitory in the shape of a **T**, one part of which – namely, the principal part in the direct line, which was sixty braccia long – was double – that is to say, it had cells on either side, and at the upper end, in a space of fifteen braccia, was an oratory, over the altar of which there was a panel by the hand of Pietro Perugino; and over the door of this oratory was another work by the same man's hand, in fresco, as will be told. And on the same floor, above the chapter-house, was a large room where those fathers worked at making glass windows, with the little furnaces and other conveniences that were necessary for such an industry; and since while Pietro lived he made the cartoons for many of their works, those that they executed in his time were all excellent. Then the garden of this convent was so beautiful and so well kept, and the vines were trained round the cloister and in every place with such good order, that nothing

better could be seen in the neighbourhood of Florence. In like manner the room wherein they distilled scented waters and medicines, as was their custom, had all the best conveniences that could possibly be imagined. In short, that convent was one of the most beautiful and best appointed that there were in the State of Florence; and it is for this reason that I have wished to make this record of it, and the rather as the greater part of the pictures that were therein were by the hand of our Pietro Perugino.

Returning at length to this Pietro, I have to say that of the works that he made in the said convent none has been preserved save the panels, since those executed in fresco were thrown to the ground, together with the whole of that building, by reason of the siege of Florence, when the panels were carried to the Porta a S. Pier Gattolini, where a home was given to those friars in the Church and Convent of S. Giovannino. Now the two panels on the aforesaid partition-wall were by the hand of Pietro; and in one was Christ in the Garden, with the Apostles sleeping, in whom Pietro showed how well sleep can prevail over pains and discomforts, having represented them asleep in attitudes of perfect ease. In the other he made a Pietà – that is, Christ in the lap of Our Lady – surrounded by four figures no less excellent than any others in his manner; and, to mention only one thing, he made the Dead Christ all stiffened, as if He had been so long on the Cross that the length of time and the cold had reduced Him to this; wherefore he painted Him supported by John and the Magdalene, all sorrowful and weeping. In another panel he painted the Crucifixion, with the Magdalene, and, at the foot of the Cross, S. Jerome, S. John the Baptist, and the Blessed Giovanni Colombino, founder of that Order; all with infinite diligence. These three panels have suffered considerably, and they are all cracked in the dark parts and where there are shadows; and this comes to pass when the first coat of colour, which is laid on the ground (for three coats of colour are used, one over the other), is worked on before it is thoroughly dry; wherefore afterwards, with time, in the drying, they draw through their thickness and come to have the strength to make those cracks; which Pietro could not know, seeing that in his time they were only just beginning to paint well in oil.

Now, the works of Pietro being much commended by the Florentines, a Prior of the same Convent of the Ingesuati, who took delight in art, caused him to make a Nativity, with the Magi,

on a wall in the first cloister, after the manner of a miniature. This he brought to perfect completion with great loveliness and a high finish, and it contained an infinite number of different heads, many of them portrayed from life, among which was the head of Andrea del Verrocchio, his master. In the same court, over the arches of the columns, he made a frieze with heads of the size of life, very well executed, among which was one of the said Prior, so lifelike and wrought in so good a manner, that it was judged by the most experienced craftsmen to be the best thing that Pietro ever made. In the other cloister, over the door that led into the refectory, he was commissioned to paint a scene of Pope Boniface confirming the habit of his Order to the Blessed Giovanni Colombino, wherein he portrayed eight of the aforesaid friars, and made a most beautiful view receding in perspective, which was much extolled, and rightly, since Pietro made a particular profession of this. In another scene below the first he began a Nativity of Christ, with certain angels and shepherds, wrought with the freshest colouring. And in an arch over the door of the aforesaid oratory he made three half-length figures – Our Lady, S. Jerome, and the Blessed Giovanni – with so beautiful a manner, that this was held to be one of the best mural paintings that Pietro ever wrought.

The said Prior, so I once heard tell, was very excellent at making ultramarine blues, and, therefore, having an abundance of them, he desired that Pietro should use them freely in all the above-mentioned works; but he was nevertheless so mean and suspicious that he would never trust Pietro, and always insisted on being present when he was using blue in the work. Wherefore Pietro, who had an honest and upright nature, and had no desire for another man's goods save in return for his own labour, took the Prior's distrust very ill, and resolved to put him to shame; and so, having taken a basin of water, and having laid on the ground for draperies or for anything else that he wished to paint in blue and white, from time to time he caused the Prior, who turned grudgingly to his little bag, to put some ultramarine into the little vase that contained the tempera-water, and then, setting to work, at every second stroke of the brush Pietro would dip his brush in the basin, so that there remained more in the water than he had used on the picture. The Prior, who saw his little bag becoming empty without much to show for it in the work, kept saying time after time: 'Oh, what a quantity of ultramarine this plaster

consumes!' 'Does it not?' Pietro would answer. After the departure of the Prior, Pietro took the ultramarine from the bottom of the basin, and gave it back to him when he thought the time had come, saying: 'Father, this is yours; learn to trust honest men, who never cheat those who trust them, although, if they wished, they could cheat such distrustful persons as yourself.'

By reason of these works, then, and many others, Pietro came into such repute that he was almost forced to go to Siena, where he painted a large panel, which was held very beautiful, in S. Francesco; and he painted another in S. Agostino, containing a Crucifix with some saints. A little time after this, for the Church of S. Gallo in Florence, he painted a panel-picture of S. Jerome in Penitence, which is now in S. Jacopo tra Fossi, where the aforesaid friars live, near the Canto degli Alberti. He was commissioned to paint a Dead Christ, with the Madonna and S. John, above the steps of the side-door of S. Pietro Maggiore; and this he wrought in such a manner, that it has been preserved, although exposed to rain and wind, as fresh as if it had only just been finished by Pietro's hand. Truly intelligent was Pietro's understanding of colour, both in fresco and in oil; wherefore all experienced craftsmen are indebted to him, for it is through him that they have knowledge of the lights that are seen throughout his works.

In S. Croce, in the same city, he made a Pietà – that is, Our Lady with the Dead Christ in her arms – and two figures, which are marvellous to behold, not so much for their excellence, as for the fact that they have remained so fresh and vivid in colouring, painted as they are in fresco. He was commissioned by Bernardino de' Rossi, a citizen of Florence, to paint a S. Sebastian to be sent into France, the price agreed on being one hundred gold crowns; but this work was sold by Bernardino to the King of France for four hundred gold ducats. At Vallombrosa he painted a panel for the high-altar; and in the Certosa of Pavia, likewise, he executed a panel for the friars of that place. At the command of Cardinal Caraffa of Naples he painted an Assumption of Our Lady, with the Apostles marvelling round the tomb, for the high-altar of the Piscopio; and for Abbot Simone de' Graziani of Borgo a San Sepolcro he executed a large panel, which was painted in Florence, and then borne to S. Gilio in the Borgo on the shoulders of porters, at very great expense. To S. Giovanni

in Monte at Bologna he sent a panel with certain figures standing upright, and a Madonna in the sky.

Thereupon the fame of Pietro spread so widely throughout Italy and abroad, that to his great glory he was summoned to Rome by Pope Sixtus IV to work in his chapel in company with the other excellent craftsmen. There, in company with Don Bartolommeo della Gatta, Abbot of S. Clemente at Arezzo, he painted the scene of Christ giving the keys to S. Peter; and likewise the Nativity and Baptism of Christ, and the Birth of Moses, with the daughter of Pharaoh finding him in the little ark. And on the same wall where the altar is he painted a mural picture of the Assumption of Our Lady, with a portrait of Pope Sixtus on his knees. But these works were thrown to the ground in preparing the wall for the Judgment of the divine Michelagnolo, in the time of Pope Paul III. On a vault of the Borgia Tower in the Papal Palace he painted certain stories of Christ, with some foliage in chiaroscuro, which had an extraordinary name for excellence in his time. In S. Marco, likewise in Rome, he painted a story of two martyrs beside the Sacrament – one of the best works that he made in Rome. For Sciarra Colonna, also, in the Palace of S. Apostolo, he painted a loggia and certain rooms.

These works brought him a very great sum of money; wherefore, having resolved to remain no longer in Rome, and having departed in good favour with the whole Court, he returned to his native city of Perugia, in many parts of which he executed panels and works in fresco; and, in particular, a panel-picture painted in oils for the Chapel of the Palace of the Signori, containing Our Lady and other saints. In S. Francesco del Monte he painted two chapels in fresco, one with the story of the Magi going to make offering to Christ, and the other with the martyrdom of certain friars of S. Francis, who, going to the Soldan of Babylon, were put to death. In S. Francesco del Convento, likewise, he painted two panels in oil, one with the Resurrection of Christ, and the other with S. John the Baptist and other saints. For the Church of the Servi he also painted two panels, one of the Transfiguration of Our Lord, and in the other, which is beside the sacristy, the Story of the Magi; but, since these are not of the same excellence as the other works of Pietro, it is held to be certain that they are among the first that he made. In the Chapel of the Crocifisso in S. Lorenzo, the Duomo of the same city, there are

by the hand of Pietro the Madonna, the other Maries, S. John,
S. Laurence, S. James, and other saints. And for the Altar of the
Sacrament, where there is preserved the ring with which the Vir-
gin Mary was married, he painted the Marriage of the Virgin.

Afterwards he painted in fresco the whole of the Audience
Chamber of the Cambio,* adorning the compartments of the
vaulting with the seven planets, drawn in certain cars by diverse
animals, according to the old usage; on the wall opposite to the
door of entrance he painted the Nativity and Resurrection of
Christ, with a panel containing S. John the Baptist in the midst
of certain other saints. The side-walls he painted in his own
manner; one with figures of Fabius Maximus, Socrates, Numa
Pompilius, F. Camillus, Pythagoras, Trajan, L. Sicinius, the Spar-
tan Leonidas, Horatius Cocles, Fabius, Sempronius, the Athenian
Pericles, and Cincinnatus. On the other wall he made the
Prophets, Isaiah, Moses, Daniel, David, Jeremiah, and Solomon;
and the Sibyls, the Erythræan, the Libyan, the Tiburtine, the Del-
phic, and the others. Below each of the said figures he placed, in
the form of a written motto, something said by them, and appro-
priate to that place. And in one of the ornaments he made his
own portrait, which appears absolutely alive, and he wrote
his own name below it in the following manner:

PETRUS PERUSINUS EGREGIUS PICTOR.
PERDITA SI FUERAT, PINGENDO HIC RETULIT ARTEM;
SI NUNQUAM INVENTA ESSET HACTENUS, IPSE DEDIT.
ANNO D. 1500.

This work, which was very beautiful and more highly extolled
than any other that was executed by Pietro in Perugia, is now
held in great price by the men of that city in memory of so
famous a craftsman of their own country. Afterwards, in the
principal chapel of the church of S. Agostino, the same man
executed a large panel standing by itself and surrounded by a rich
ornament, with S. John baptizing Christ on the front part, and
on the back – that is, on the side that faces the choir – the
Nativity of Christ, with certain saints in the upper parts, and in
the predella many scenes wrought very diligently with little
figures. And in the chapel of S. Niccolò, in the said church, he
painted a panel for Messer Benedetto Calera.

* Exchange or Bank

After this, returning to Florence, he painted a S. Bernard on a panel for the Monks of Cestello, and in the chapter-house a crucifix, the Madonna, S. Benedict, S. Bernard, and S. John. And in S. Domenico da Fiesole, in the second chapel on the right hand, he painted a panel containing Our Lady and three figures, among which is a S. Sebastian worthy of the highest praise. Now Pietro had done so much work, and he always had so many works in hand, that he would very often use the same subjects; and he had reduced the theory of his art to a manner so fixed, that he made all his figures with the same expression. By that time Michelagnolo Buonarroti had already come to the front, and Pietro greatly desired to see his figures, by reason of the praise bestowed on him by craftsmen; and seeing the greatness of his own name, which he had acquired in every place through so grand a beginning, being obscured, he was ever seeking to wound his fellow-workers with biting words. For this reason, besides certain insults aimed at him by the craftsmen, he had only himself to blame when Michelagnolo told him in public that he was a clumsy fool at his art. But Pietro being unable to swallow such an affront, they both appeared before the Tribunal of Eight, where Pietro came off with little honour. Meanwhile the Servite Friars of Florence, wishing to have the altar-piece of their high-altar painted by some famous master, had handed it over, by reason of the departure of Leonardo da Vinci, who had gone off to France, to Filippino; but he, when he had finished half of one of two panels that were to adorn the altar, passed from this life to the next; wherefore the friars, by reason of the faith that they had in Pietro, entrusted him with the whole work. In that panel, wherein he was painting the Deposition of Christ from the Cross, Filippino had finished the figures of Nicodemus that are taking Him down; and Pietro continued the lower part with the Swooning of the Madonna, and certain other figures. Now this work was to be composed of two panels, one facing towards the choir of the friars, and the other towards the body of the church, and the Deposition from the Cross was to be placed behind, facing the choir, with the Assumption of Our Lady in front; but Pietro made the latter so commonplace, that the Deposition of Christ was placed in front, and the Assumption on the side of the choir. These panels have now been removed, both one and the other, and replaced by the Tabernacle of the Sacrament; they have been set up over certain other altars in that church, and out of the

whole work there only remain six pictures, wherein are some saints painted by Pietro in certain niches. It is said that when the work was unveiled, it received no little censure from all the new craftsmen, particularly because Pietro had availed himself of those figures that he had been wont to use in other pictures; with which his friends twitted him, saying that he had taken no pains, and that he had abandoned the good method of working, either through avarice or to save time. To this Pietro would answer: 'I have used the figures that you have at other times praised, and which have given you infinite pleasure; if now they do not please you, and you do not praise them, what can I do?' But they kept assailing him bitterly with sonnets and open insults; whereupon, although now old, he departed from Florence and returned to Perugia.

There he executed certain works in fresco in the Church of S. Severo, a place belonging to the Monks of the Order of Camaldoli, wherein Raffaello da Urbino, when quite young and still the disciple of Pietro, had painted certain figures, as will be told in his Life. Pietro likewise worked at Montone, at La Fratta, and in many other places in the district of Perugia; more particularly in S. Maria degli Angeli at Assisi, where he painted in fresco a Christ on the Cross, with many figures, on the wall at the back of the Chapel of the Madonna, which faces the choir of the monks. And for the high-altar of the Church of S. Pietro, an abbey of Black Friars in Perugia, he painted a large panel containing the Ascension, with the Apostles below gazing up to Heaven; in the predella of which panel are three stories, wrought with much diligence – namely, that of the Magi, the Baptism of Christ, and His Resurrection. The whole of this picture is seen to be full of beautiful and careful work, insomuch that it is the best of those wrought in oil by the hand of Pietro which are in Perugia. The same man began a work in fresco of no small importance at Castello della Pieve, but did not finish it.

It was ever Pietro's custom on his going and coming between the said Castello and Perugia, like a man who trusted nobody, to carry all the money that he possessed about his person. Wherefore certain men, lying in wait for him at a pass, robbed him, but at his earnest entreaty they spared his life for the love of God; and afterwards, by means of the services of his friends, who were numerous enough, he also recovered a great part of the money that had been taken from him; but none the less he came near dying of vexation. Pietro was a man of very little religion, and he

could never be made to believe in the immortality of the soul –
nay, with words in keeping with his head of granite, he rejected
most obstinately every good suggestion. He placed all his hopes
in the goods of fortune, and he would have sold his soul for
money. He earned great riches; and he both bought and built
houses in Florence, and acquired much settled property both at
Perugia and at Castello della Pieve. He took a most beautiful
young woman to wife, and had children by her; and he delighted
so greatly in seeing her wearing beautiful head-dresses, both
abroad and at home, that it is said that he would often tire her
head with his own hand. Finally, having reached the age of
seventy-eight, Pietro finished the course of his life at Castello
della Pieve, where he was honourably buried, in the year 1524.

Pietro made many masters in his own manner, and one among
them, who was truly most excellent, devoted himself heart and
soul to the honourable studies of painting, and surpassed his
master by a great measure; and this was the miraculous Raffaello
Sanzio of Urbino, who worked for many years under Pietro in
company with his father, Giovanni de' Santi. Another disciple of
this man was Pinturicchio, a painter of Perugia, who, as it has
been said in his life, ever held to Pietro's manner. His disciple,
likewise, was Rocco Zoppo, a painter of Florence, by whose hand
is a very beautiful Madonna in a round picture, which is in the
possession of Filippo Salviati; although it is true that it was
brought to completion by Pietro himself. The same Rocco painted
many pictures of Our Lady, and made many portraits, of which
there is no need to speak; I will only say that in the Sistine Chapel
in Rome he painted portraits of Girolamo Riario and of F. Pietro,
Cardinal of San Sisto. Another disciple of Pietro was Montevar-
chi, who painted many pictures in San Giovanni di Valdarno;
more particularly, in the Madonna, the stories of the Miracle of
the Milk. He also left many works in Montevarchi, his birth-place.
Likewise a pupil of Pietro's, working with him for no little time,
was Gerino da Pistoia, of whom there has been mention in the
Life of Pinturicchio; and so also was Baccio Ubertino of Florence,
who was most diligent both in colouring and in drawing, for
which reason Pietro made much use of him. By this man's hand
is a drawing in our book, done with the pen, of Christ being
scourged at the Column, which is a very lovely thing.

A brother of this Baccio, and likewise a disciple of Pietro, was
Francesco, called Il Bacchiacca by way of surname, who was a

most diligent master of little figures, as may be seen in many works wrought by him in Florence, above all in the house of Giovan Maria Benintendi and in that of Pier Francesco Borgherini. Bacchiacca delighted in painting grotesques, wherefore he covered a little cabinet belonging to the Lord Duke Cosimo with animals and rare plants, drawn from nature, which are held very beautiful. Besides this, he made the cartoons for many tapestries, which were afterwards woven in silk by the Flemish master, Giovanni Rosto, for the apartments of his Excellency's Palace. Still another disciple of Pietro was the Spaniard Giovanni, called Lo Spagna by way of surname, who was a better colourist than any of the others whom Pietro left behind him at his death; after which this Giovanni would have settled in Perugia, if the envy of the painters of that city, so hostile to strangers, had not persecuted him in such wise as to force him to retire to Spoleto, where, by reason of his excellence and virtue, he obtained a wife of good family and was made a citizen of that city. He made many works in that place, and likewise in all the other cities of Umbria; and at Assisi, in the lower Church of S. Francesco, he painted the panel of the Chapel of S. Caterina, for the Spanish Cardinal Egidio, and also one in S. Damiano. In S. Maria degli Angeli, in the little chapel where S. Francis died, he painted some half-length figures of the size of life – that is, certain companions of S. Francis and other saints – all very lifelike, on either side of a S. Francis in relief.

But the best master among all the aforesaid disciples of Pietro was Andrea Luigi of Assisi, called L'Ingegno, who in his early youth competed with Raffaello da Urbino under the discipline of Pietro, who always employed him in the most important pictures that he made; as may be seen in the Audience Chamber of the Cambio in Perugia, where there are some very beautiful figures by his hand; in those that he wrought at Assisi; and, finally, in the Chapel of Pope Sixtus at Rome. In all these works Andrea gave such proof of his worth, that he was expected to surpass his master by a great measure, and so, without a doubt, it would have come to pass; but fortune, which is almost always pleased to oppose herself to lofty beginnings, did not allow L'Ingegno to reach perfection, for a flux of catarrh fell upon his eyes, whence the poor fellow became wholly blind, to the infinite grief of all who knew him. Hearing of this most pitiful misfortune, Pope Sixtus, like a man who ever loved men of talent, ordained that a yearly provision should be paid to Andrea in Assisi during

his lifetime by those who managed the revenues there; and this was done until he died at the age of eighty-six.

Likewise disciples of Pietro, and also natives of Perugia, were Eusebio San Giorgio, who painted the panel of the Magi in S. Agostino; Domenico di Paris, who made many works in Perugia and in the neighbouring townships, being followed by his brother Orazio; and also Gian Niccola, who painted Christ in the Garden on a panel in S. Francesco, the panel of Ognissanti in the Chapel of the Baglioni in S. Domenico, and stories of S. John the Baptist in fresco in the Chapel of the Cambio. Benedetto Caporali, otherwise called Bitti, was also a disciple of Pietro, and there are many pictures by his hand in his native city of Perugia. And he occupied himself so greatly with architecture, that he not only executed many works, but also wrote a commentary on Vitruvius in the manner that all can see, for it is printed; in which studies he was followed by his son Giulio, a painter of Perugia.

But not one out of all these disciples ever equalled Pietro's diligence, or the grace of colouring that he showed in that manner of his own, which pleased his time so much, that many came from France, from Spain, from Germany, and from other lands, to learn it. And a trade was done in his works, as has been said, by many who sent them to diverse places, until there came the manner of Michelagnolo, which, having shown the true and good path to these arts, has brought them to that perfection which will be seen in the Third Part, about to follow, wherein we will treat of the excellence and perfection of art, and show to craftsmen that he who labours and studies continuously, and not in the way of fantasy or caprice, leaves true works behind him and acquires fame, wealth, and friends.

VITTORE SCARPACCIA (CARPACCIO), AND OTHER VENETIAN AND LOMBARD PAINTERS

It is very well known that when some of our craftsmen make a beginning in some province, they are afterwards followed by many, one after another; and very often there is an infinite number of them at one and the same time, for the reason that rivalry, emulation, and the fact that they have been dependent on others, one on one excellent master, and one on another, bring it about

that the craftsmen seek with all the greater effort to surpass one another, to the utmost of their ability. And even when many depend on one, no sooner do they separate, either at the death of their master or for some other reason, than they straightway also separate in aim; whereupon each seeks to prove his own worth, in order to appear better than the rest and a master by himself.

Of many, then, who flourished almost at one and the same time and in one and the same province, and about whom I have not been able to learn and am not able to write every particular, I will give some brief account, to the end that, now that I find myself at the end of the Second Part of this my work, I may not omit some who have laboured to leave the world adorned by their works. Of these men, I say, besides having been unable to discover their whole history, I have not even been able to find the portraits, excepting that of Scarpaccia, whom for this reason I have made head of the others. Let my readers therefore accept what I can offer in this connection, seeing that I cannot offer what I would wish. There lived, then, in the March of Treviso and in Lombardy, during a period of many years, Stefano Veronese, Aldigieri da Zevio, Jacopo Davanzo of Bologna, Sebeto da Verona, Jacobello de Flore, Guerriero da Padova, Giusto, Girolamo Campagnola and his son Giulio, and Vincenzio Bresciano; Vittore, Sebastiano,* and Lazzaro* Scarpaccia, Venetians; Vincenzio Catena, Luigi Vivarini, Giovan Battista da Conigliano, Marco Basarini,† Giovanetto Cordegliaghi, Il Bassiti, Bartolommeo Vivarini, Giovanni Mansueti, Vittore Bellini, Bartolommeo Montagna of Vicenza, Benedetto Diana, and Giovanni Buonconsigli, with many others, of whom there is no need to make mention here.

To begin with the first, I start by saying that Stefano Veronese, of whom I gave some account in the Life of Agnolo Gaddi, was a painter more than passing good in his day. And when Donatello was working in Padua, as has been already told in his Life, going on one of several occasions to Verona, he was struck with marvel at the works of Stefano, declaring that the pictures which he had made in fresco were the best that had been wrought in those parts up to that time. The first works of

* It is now generally accepted that these two men are one, under the name of Lazzaro Bastiani.

† This master has been identified with Il Bassiti, under the name of Basaiti.

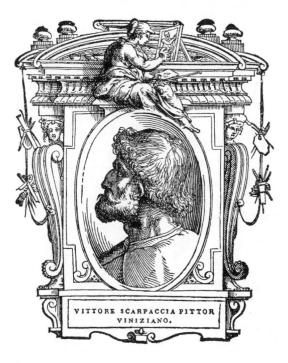

VITTORE SCARPACCIA PITTOR
VINIZIANO.

this man were in the tramezzo* of the Church of S. Antonio at Verona, at the top of a wall on the left, below the curve of a part of the vaulting; and the subjects were a Madonna with the Child in her arms, and S. James and S. Anthony, one on either side of her. This work is held very beautiful in that city even at the present day, by reason of a certain liveliness that is seen in the said figures, particularly in the heads, which are wrought with much grace. In S. Niccolò, a parish church of that city, likewise, he painted a S. Nicholas in fresco, which is very beautiful. On the front of a house in the Via di S. Polo, which leads to the Porta del Vescovo, he painted the Virgin, with certain very beautiful angels and a S. Christopher; and over the wall of the Church of S. Consolata in the Via del Duomo, in a recess made in the wall, he painted a Madonna and certain birds, in particular a peacock, his emblem. In S. Eufemia, a convent of the Eremite Friars of S. Augustine, he painted over the side-door a S. Augustine with two other saints, and under the mantle of this S. Augustine are many friars and nuns of his Order; but the most beautiful things in this work are two half-length prophets of the size of life, for the reason that they have the most beautiful and most lifelike heads that Stefano ever made; and the colouring of the whole work, having been executed with diligence, has remained beautiful even to our own day, notwithstanding that it has been much exposed to rain, wind, and frost. If this work had been under cover, it would still be as beautiful and fresh as it issued from his hands, for the reason that Stefano did not retouch it on the dry, but used diligence in executing it well in fresco; as it is, it has suffered a little. Within the church, in the Chapel of the Sacrament – namely, round the Tabernacle – he afterwards painted certain angels flying, some of whom are sounding instruments, some singing, and others burning incense before the Sacrament; together with a figure of Jesus Christ, which he painted at the top as a finish to the Tabernacle. Below there are other angels, who are supporting Him, clothed in white garments reaching to their feet, and ending, as it were, in clouds, which was an idea peculiar to Stefano in painting figures of angels, whom he always made most gracious in countenance and very beautiful in expression. In this same work are lifesize figures of S. Augustine and S. Jerome, one on either side; and these are supporting with their hands the Church of God, as if to show that both of them

* See note on p. 90.

defend Holy Church from heretics with their learning, and support her. On a pilaster of the principal chapel in the same church he painted a S. Eufemia in fresco, with a beautiful and gracious expression of countenance; and there he wrote his own name in letters of gold, perchance since it appeared to him to be, as in fact it is, one of the best pictures that he had made; and according to his custom he painted there a very beautiful peacock, and beside it two lion cubs, which are not very beautiful, because at that time he could not see live ones, as he saw the peacock. He also painted for the same place a panel containing, as was the custom in those times, many half-length figures, such as S. Niccola da Tolentino and others; and he filled the predella with scenes in little figures from the life of that Saint. In S. Fermo, a church in the same city belonging to the Friars of S. Francis, he painted, as an ornament for a Deposition from the Cross on the wall opposite to the side-door of entrance, twelve half-length prophets of the size of life, with Adam and Eve lying below them, and his usual peacock, which is almost the hall-mark of pictures executed by him.

In Mantua, at the Martello gate of the Church of S. Domeni-co, the same Stefano painted a most beautiful Madonna; the head of which Madonna, when they had need to build in that place, those fathers placed with care in the tramezzo* of the church – that is, in the Chapel of S. Orsola, which belongs to the Recuperati family, and contains some pictures in fresco by the hand of the same man. And in the Church of S. Francesco, on the right hand as one enters by the principal door, there is a row of chapels formerly built by the noble Della Ramma family, in one of which are seated figures of the four Evangelists, painted on the vaulting by the hand of Stefano; and behind their shoulders, for a background, he made certain espaliers of roses, with a cane trellis-work in a pattern of mandorle, above which are various trees and other greenery full of birds, particularly of peacocks; and there are also some very beautiful angels. In this same church, on a column on the right hand as one enters, he painted a lifesize figure of S. Mary Magdalene. And in the same city, on the frontal of a door in the street called Rompilanza, he painted in fresco a Madonna with the Child in her arms, and some angels kneeling before her; and the background he made of trees covered with fruit.

* See note on p. 90.

These, then, are the works that are found to have been executed by Stefano, although it may well be believed, since his life was not a short one, that he made many others. But even as I have not been able to discover any more of them, so I have failed to find his surname, his father's name, his portrait, or any other particulars. Some declare that before he came to Florence he was a disciple of Maestro Liberale, a painter of Verona; but this matters nothing. It is enough that he learnt all that there was of the good in him from Agnolo Gaddi in Florence.

Of the same city of Verona was Aldigieri da Zevio, who was very much the friend of the Signori della Scala, and who, besides many other works, painted the Great Hall of their Palace (which is now the habitation of the Podestà), depicting therein the War of Jerusalem, according as it is described by Josephus. In this work Aldigieri showed great spirit and judgment, distributing one scene over the walls of that hall on every side, with a single ornament encircling it right round; on the upper part of which ornament, as it were to set it off, he placed a row of medallions, in which it is believed that there are the portraits from life of many distinguished men of those times, particularly of many of those Signori della Scala; but, since the truth about this is not known, I will say no more of it. I must say, indeed, that Aldigieri showed in this work that he had intelligence, judgment, and invention, seeing that he took into consideration all the things that can be taken into consideration in a serious war. Besides this, the colouring has remained very fresh; and among many portraits of men of distinction and learning, there is seen that of Messer Francesco Petrarca.

Jacopo Avanzi, a painter of Bologna, shared the work of this hall with Aldigieri, and below the aforesaid pictures he painted two most beautiful Triumphs, likewise in fresco, with so much art and so good a manner, that Girolamo Campagnola declares that Mantegna used to praise them as pictures of the rarest merit. The same Jacopo, together with Aldigieri and Sebeto da Verona, painted the Chapel of S. Giorgio, which is beside the Church of S. Antonio, in Padua, according to the directions left in the testaments of the Marquesses of Carrara. Jacopo Avanzi painted the upper part; below this were certain stories of S. Lucia, with a Last Supper, by Aldigieri; and Sebeto painted stories of S. John. Afterwards these three masters, having all returned to Verona, joined together to paint a wedding-feast, with many portraits and

costumes of those times, in the house of the Counts Serenghi. Now the work of Jacopo Avanzi was held to be the best of all; but, since mention has been made of him in the Life of Niccolò d' Arezzo by reason of the works that he made in Bologna in competition with the painters Simone, Cristofano, and Galasso, I will say no more about him in this place.

A man who was held in esteem at Venice about the same time, although he adhered to the Greek manner, was Jacobello de Flore, who made a number of works in that city; in particular, a panel for the Nuns of the Corpus Domini, which stands on the altar of S. Domenico in their church. A competitor of this master was Giromin Morzone, who painted a number of pictures in Venice and in many cities of Lombardy; but, since he held to the old manner and made all his figures on tip-toe, we will say nothing about him, save that there is a panel by his hand, with many saints, on the Altar of the Assumption in the Church of S. Lena.

A much better master than Morzone was Guerriero, a painter of Padua, who, besides many other works, painted the principal chapel of the Eremite Friars of S. Augustine in Padua, and a chapel for the same friars in the first cloister. He also painted a little chapel in the house of the Urban Prefect, and the Hall of the Roman Emperors, where the students go to dance at the time of the Carnival. He also painted in fresco, in the Chapel of the Podestà of the same city, some scenes from the Old Testament.

Giusto, likewise a painter of Padua, painted in the Chapel of S. Giovanni Battista, without the Church of the Vescovado, not only certain scenes from the Old Testament and the New, but also the Revelations of the Apocalypse of S. John the Evangelist; and in the upper part he made a Paradise containing many choirs of angels and other adornments, wrought with beautiful conceptions. In the Church of S. Antonio he painted in fresco the Chapel of S. Luca; and in a chapel in the Church of the Eremite Friars of S. Augustine he painted the liberal arts, with the virtues and vices beside them, and likewise those who have been celebrated for their virtues, and those who have fallen by reason of their vices into the extreme of misery and into the lowest depth of Hell.

There was working in Padua, in this man's time, Stefano, a painter of Ferrara, who, as has been said elsewhere, adorned with various pictures the chapel and the tomb wherein is the body of

S. Anthony, and also painted the Virgin Mary that is called the Vergine del Pilastro.

Another man who was held in esteem in the same times was Vincenzio, a painter of Brescia, according to the account of Filarete, as was also Girolamo Campagnola, another Paduan painter, and a disciple of Squarcione. Then Giulio, son of Girolamo, made many beautiful works of painting, illumination, and copper-engraving, both in Padua and in other places. In the same city of Padua many things were wrought by Niccolò Moreto, who lived eighty years, and never ceased to exercise his art.

Besides these there were many others, who were connected with Gentile and Giovanni Bellini; but Vittore Scarpaccia was truly the first among them who made works of importance. His first works were in the Scuola of S. Orsola, where he painted on canvas the greater part of the stories that are there, representing the life and death of that Saint; the labours of which pictures he contrived to carry out so well and with such great diligence and art, that he acquired thereby the name of a very good and practised master. This, so it is said, was the reason that the people of Milan caused him to paint a panel in distemper with many figures for the Friars Minor, in their Chapel of S. Ambrogio. On the altar of the Risen Christ in the Church of S. Antonio he painted the scene of Christ appearing to the Magdalene and the other Maries, in which he made a very beautiful view in perspective of a landscape receding into the distance; and in another chapel he painted the story of the Martyrs – that is, their crucifixion – in which work he made more than three hundred figures, what with the large and the small, besides a number of horses and trees, an open Heaven, figures both nude and clothed in diverse attitudes, many foreshortenings, and so many other things, that it can be seen that he did not execute it without extraordinary labour. For the altar of the Madonna, in the Church of S. Giobbe in Canareio, he painted her presenting the Infant Christ to Simeon, and depicted the Madonna herself standing, and Simeon in his cope between two ministers clothed as Cardinals; behind the Virgin are two women, one of whom has two doves, and below are three boys, who are playing on a lute, a serpent, and a lyre, or rather a viol; and the colouring of the whole panel is very charming and beautiful. And, in truth, Vittore was a very diligent and practised master, and many pictures by his hand that are in

Venice, both portraits from life and other kinds, are much esteemed for works wrought in those times. He taught his art to two brothers of his own, who imitated him closely, one being Lazzaro, and the other Sebastiano; and by their hand is a panel on the altar of the Virgin in the Church of the Nuns of the Corpus Domini, showing her seated between S. Catherine and S. Martha, with other female saints, two angels who are sounding instruments, and a very beautiful view of buildings in perspective as a background to the whole work, of which we have the original drawings, by the hand of these men, in our book.

Another passing good painter in the time of these masters was Vincenzio Catena, who occupied himself much more with making portraits from the life than with any other sort of painting; and, in truth, some that are to be seen by his hand are marvellous – among others, that of a German of the Fugger family, a man of rank and importance, who was then living in the Fondaco de' Tedeschi at Venice, was painted with great vivacity.

Another man who made many works in Venice, about the same time, was a disciple of Giovanni Bellini, Giovan Battista da Conigliano, by whose hand is a panel on the altar of S. Pietro Martire in the aforesaid Church of the Nuns of the Corpus Domini, containing the said Saint, S. Nicholas, and S. Benedict, with landscapes in perspective, an angel tuning a cithern, and many little figures more than passing good. And if this man had not died young, it may be believed that he would have equalled his master.

The name of a master not otherwise than good, likewise, in the same art and at the same time, was enjoyed by Marco Basarini, who, painting in Venice, where he was born from a Greek father and mother, executed in S. Francesco della Vigna a panel with a Deposition of Christ from the Cross, and another panel in the Church of S. Giobbe, representing Christ in the Garden, and below Him the three Apostles, who are sleeping, and S. Francis, S. Dominic, and two other saints; but what was most praised in this work was a landscape with many little figures wrought with good grace. In that same church the same Marco painted S. Bernardino on a rock, with other saints.

Giovanetto Cordegliaghi made an infinity of devotional pictures in the same city; nay, he scarcely worked at anything else, and, in truth, he had in this sort of painting a very delicate and sweet manner, no little better than that of the aforesaid masters.

In S. Pantaleone, in a chapel beside the principal one, this man painted S. Peter making disputation with two other saints, who are wearing most beautiful draperies, and are wrought with a beautiful manner.

Marco Bassiti was in good repute almost at the same time, and by his hand is a large panel in the Church of the Carthusian Monks at Venice, in which he painted Christ between Peter and Andrew on the Sea of Tiberias, with the sons of Zebedee; making therein an arm of the sea, a mountain, and part of a city, with many persons in the form of little figures. Many other works by this man could be enumerated, but let it be enough to have spoken of this one, which is the best.

Bartolommeo Vivarini of Murano also acquitted himself very well in the works that he made, as may be seen, besides many other examples, in the panel that he executed for the altar of S. Luigi in the Church of SS. Giovanni e Polo; in which panel he portrayed the said S. Luigi seated, wearing the cope, with S. Gregory, S. Sebastian, and S. Dominic on one side of him, and on the other side S. Nicholas, S. Jerome, and S. Rocco, and above them half-length figures of other saints.

Another man who executed his pictures very well, taking much delight in counterfeiting things of nature, figures, and distant landscapes, was Giovanni Mansueti, who, imitating the works of Gentile Bellini not a little, made many pictures in Venice. At the upper end of the Audience Chamber of the Scuola of S. Marco he painted a S. Mark preaching on the Piazza; in which picture he painted the façade of the church, and, among the multitude of men and women who are listening to the Saint, Turks, Greeks, and the faces of men of diverse nations, with bizarre costumes. In the same place, in another scene wherein he painted S. Mark healing a sick man, he made a perspective view of two staircases and many loggie. In another picture, near to that one, he made a S. Mark converting an infinite multitude to the faith of Christ; in this he made an open temple, with a Crucifix on an altar, and throughout the whole work there are diverse persons with a beautiful variety of expression, dress, and features.

The work in the same place was continued after him by Vittore Bellini, who made a view of buildings in perspective, which is passing good, in a scene wherein S. Mark is taken prisoner and bound, with a number of figures, in which he imitated his predecessors. After these men came Bartolommeo Montagna of

Vicenza, a passing good painter, who lived ever in Venice and made many pictures there; and he painted a panel in the Church of S. Maria d' Artone at Padua. Benedetto Diana, likewise, was a painter no less esteemed than the masters mentioned above, as is proved, to say nothing of his other works, by those from his hand that are in S. Francesco della Vigna at Venice, where, for the altar of S. Giovanni, he painted that Saint standing between two other saints, each of whom has a book in his hand.

Another man who was accounted a good master was Giovanni Buonconsigli, who painted a picture in the Church of SS. Giovanni e Polo for the altar of S. Tommaso d' Aquino, showing that Saint surrounded by many figures, to whom he is reading the Holy Scriptures; and he made therein a perspective view of buildings, which is not otherwise than worthy of praise. There also lived in Venice throughout almost the whole course of his life the Florentine sculptor, Simon Bianco, as did Tullio Lombardo, an excellent master of intaglio.

In Lombardy, likewise, there were excellent sculptors in Bartolommeo Clemente of Reggio and Agostino Busto; and, in intaglio, Jacopo Davanzo of Milan, with Gasparo and Girolamo Misceroni. In Brescia there was a man who was able and masterly at working in fresco, called Vincenzio Verchio, who acquired a very great name in his native place by reason of his beautiful works. The same did Girolamo Romanino, a fine master of design, as is clearly demonstrated by the works made by him in Brescia and in the neighbourhood for many miles around. And not inferior to these – nay, even superior – was Alessandro Moretto, who was very delicate in his colouring, and much the friend of diligence, as the works made by him demonstrate.

But to return to Verona, in which city there have flourished excellent craftsmen, even as they flourish more than ever to-day; there, in times past, were excellent masters in Francesco Bonsignori and Francesco Caroto, and afterwards Maestro Zeno of Verona, who painted the panel of S. Marino in Rimini, with two others, all with much diligence. But the man who surpassed all others in making certain marvellous figures from life was Il Moro of Verona, or rather, as others called him, Francesco Turbido, by whose hand is a portrait now in the house of Monsignor de' Martini at Venice, of a gentleman of the house of Badovaro, painted in the character of a shepherd; which portrait appears absolutely alive, and can challenge comparison with any of the

great number that have been seen in these parts. Battista d' Angelo, son-in-law of this Francesco, is also so lovely in colouring and so masterly in drawing, that he is rather superior than inferior to his father-in-law. But since it is not my intention to speak at present of the living, it must suffice me to have spoken in this place of some with regard to whose lives, as I said at the beginning of this Life, I have not been able to discover every particular with equal minuteness, to the end that their talents and merits may receive from me at least all that little which I, who would fain make it much, am able to give them.

JACOPO, CALLED L'INDACO, Painter

JACOPO, called L' Indaco, who was a disciple of Domenico del Ghirlandajo, and who worked in Rome with Pinturicchio, was a passing good master in his day; and although he did not make many works, yet those that he did make are worthy of commendation. Nor is there any need to marvel that only very few works issued from his hands, for the reason that, being a gay and humorous fellow and a lover of good cheer, he harboured but few thoughts and would never work save when he could not help it; and so he used to say that doing nothing else but labour, without taking a little pleasure in the world, was no life for a Christian. He lived in close intimacy with Michelagnolo, for when that craftsman, supremely excellent beyond all who have ever lived, wished to have some recreation after his studies and his continuous labours of body and mind, no one was more pleasing to him for the purpose or more suited to his humour than this man.

Jacopo worked for many years in Rome, or, to be more precise, he lived many years in Rome, working very little. By his hand, in that city, is the first chapel on the right hand as one enters the Church of S. Agostino by the door of the façade; on the vaulting of which chapel are the Apostles receiving the Holy Spirit, and on the wall below are two stories of Christ – in one His taking Peter and Andrew from their nets, and in the other the Feast of Simon and the Magdalene, in which there is a ceiling of planks and beams, counterfeited very well. In the panel of the same chapel, which he painted in oil, is a Dead Christ, wrought and executed with much mastery and diligence. In the Trinità at

Rome, likewise, there is a little panel by his hand with the Coronation of Our Lady. But what need is there to say more about this man? What more, indeed, is there to say? It is enough that he loved gossiping as much as he always hated working and painting.

Now seeing that, as has been said, Michelagnolo used to take pleasure in this man's chattering and in the jokes that he was ever making, he kept him almost always at his table; but one day Jacopo wearied him – as such fellows more often than not do come to weary their friends and patrons with their incessant babbling, so often ill-timed and senseless; babbling, I call it, for reasonable talk it cannot be called, since for the most part there is neither reason nor judgment in such people – and Michelagnolo, who, perchance, had other thoughts in his mind at the time and wished to get rid of him, sent him to buy some figs; and no sooner had Jacopo left the house than Michelagnolo bolted the door behind him, determined not to open to him when he came back. L' Indaco, then, on returning from the market-square, perceived, after having knocked at the door for a time in vain, that Michelagnolo did not intend to open to him; whereupon, flying into a rage, he took the figs and the leaves and spread them all over the threshold of the door. This done, he went his way and for many months refused to speak to Michelagnolo; but at last, becoming reconciled with him, he was more his friend than ever. Finally, having reached the age of sixty-eight, he died in Rome.

Not unlike Jacopo was a younger brother of his, whose proper name was Francesco, although he too was afterwards called L' Indaco by way of surname; and he, likewise, was a painter, and more than passing good. He was not unlike Jacopo – I mean, in his unwillingness to work (to say the least), and in his love of talking – but in one respect he surpassed Jacopo, for he was ever speaking evil of everyone and decrying the works of every craftsman. This man, after having wrought certain things in Montepulciano both in painting and in clay, painted a little panel for the Audience Chamber of the Company of the Nunziata in Arezzo, containing an Annunciation, and a God the Father in Heaven surrounded by many angels in the form of children. And in the same city, on the first occasion when Duke Alessandro went there, he made a most beautiful triumphal arch, with many figures in relief, at the gate of the Palazzo de' Signori; and also, in competition with other painters who executed a number of other

works for the entry of the said Duke, the scenery for the representation of a play, which was held to be very beautiful. Afterwards, having gone to Rome at the time when the Emperor Charles V was expected there, he made some figures in clay, and a coat of arms in fresco for the Roman people on the Campidoglio, which was much extolled. But the best work that ever issued from the hands of this master, and the most highly praised, was a little study wrought in stucco for the Duchess Margherita of Austria in the Palace of the Medici at Rome – a thing so beautiful and so ornate that there is nothing better to be seen; nor do I believe that it is possible, in a certain sense, to do with silver what L' Indaco did in this work with stucco. From these things it may be judged that if this man had taken pleasure in work and had made use of his intelligence, he would have become excellent.

Francesco drew passing well, but Jacopo much better, as may be seen in our book.

LUCA SIGNORELLI OF CORTONA, Painter
[LUCA DA CORTONA]

LUCA SIGNORELLI, an excellent painter, of whom, according to the order of time, we have now to speak, was more famous throughout Italy in his day, and his works were held in greater price than has ever been the case with any other master at any time whatsoever, for the reason that in the works that he executed in painting he showed the true method of making nudes, and how they can be caused, although only with art and difficulty, to appear alive. He was a pupil and disciple of Piero dal Borgo a San Sepolcro, and greatly did he strive in his youth to imitate his master, and even to surpass him; and the while that he was working with Piero at Arezzo, living in the house of his uncle Lazzaro Vasari, as it has been told, he imitated the manner of the said Piero so well that the one could scarcely be distinguished from the other.

The first works of Luca were in S. Lorenzo at Arezzo, where he painted the Chapel of S. Barbara in fresco in the year 1472; and he painted for the Company of S. Caterina, on cloth and in oil, the banner that is borne in processions, and likewise that of the Trinità, although this does not appear to be by the hand of Luca, but by Piero dal Borgo himself. In S. Agostino in the same

city he painted the panel of S. Niccola da Tolentino, with most beautiful little scenes, executing the work with good drawing and invention; and in the same place, in the Chapel of the Sacrament, he made two angels wrought in fresco. In the Chapel of the Accolti in the Church of S. Francesco, for Messer Francesco, Doctor of Laws, he painted a panel in which he portrayed the said Messer Francesco with some of his relatives. In this work is a S. Michael weighing souls, who is admirable; and in him there is seen the knowledge of Luca, both in the splendour of his armour and in the reflected lights, and, in short, throughout the whole work. In his hands he placed a pair of scales, in which are nude figures, very beautifully foreshortened, one going up and the other down; and among other ingenious things that are in this picture is a nude figure most skilfully transformed into a devil, with a lizard licking the blood from a wound in its body. Besides this, there is a Madonna with the Child on her lap, with S. Stephen, S. Laurence, S. Catherine, and two angels, of whom one is playing on a lute and the other on a rebec; and all these figures are draped and adorned so beautifully that it is a marvel. But the most miraculous part of this panel is the predella, which is full of Friars of the said S. Catherine in the form of little figures.

In Perugia, also, he made many works; among others, a panel in the Duomo for Messer Jacopo Vannucci of Cortona, Bishop of that city; in which panel are Our Lady, S. Onofrio, S. Ercolano, S. John the Baptist, and S. Stephen, with a most beautiful angel, who is tuning a lute. At Volterra, over the altar of a Company in the Church of S. Francesco, he painted in fresco the Circumcision of Our Lord, which is considered beautiful to a marvel, although the Infant, having been injured by damp, was restored by Sodoma and made much less beautiful than before. And, in truth, it would be sometimes better to leave works half spoilt, when they have been made by men of excellence, rather than to have them retouched by inferior masters. In S. Agostino in the same city he painted a panel in distemper, and the predella of little figures, with stories of the Passion of Christ; and this is held to be extraordinarily beautiful. At S. Maria a Monte he painted a Dead Christ on a panel for the monks of that place; and at Città di Castello a Nativity of Christ in S. Francesco, with a S. Sebastian on another panel in S. Domenico. In S. Margherita, a seat of the Frati del Zoccolo in his native city of Cortona, he painted a Dead Christ, one of the rarest of his works; and for the

Company of the Gesù, in the same city, he executed three panels, of which the one that is on the high-altar is marvellous, showing Christ administering the Sacrament to the Apostles, and Judas placing the Host into his wallet. In the Pieve, now called the Vescovado, in the Chapel of the Sacrament, he painted some lifesize prophets in fresco; and round the tabernacle are some angels who are opening out a canopy, with S. Jerome and S. Thomas Aquinas at the sides. For the high-altar of the said church he painted a panel with a most beautiful Assumption, and he designed the pictures for the principal round window of the same church; which pictures were afterwards executed by Stagio Sassoli of Arezzo. In Castiglione Aretino he made a Dead Christ, with the Maries, over the Chapel of the Sacrament; and in S. Francesco, at Lucignano, he painted the folding-doors of a press, wherein there is a tree of coral surmounted by a cross. At Siena, in the Chapel of S. Cristofano in S. Agostino, he painted a panel with some saints, in the midst of whom is a S. Cristopher in relief.

Having gone from Siena to Florence in order to see both the works of those masters who were then living and those of many already dead, he painted for Lorenzo de' Medici certain nude gods on a canvas, for which he was much commended, and a picture of Our Lady with two little prophets in terretta, which is now at Castello, a villa of Duke Cosimo's. These works, both the one and the other, he presented to the said Lorenzo, who would never be beaten by any man in liberality and magnificence. He also painted a round picture of Our Lady, which is in the Audience Chamber of the Captains of the Guelph party – a very beautiful work. At Chiusuri in the district of Siena, the principal seat of the Monks of Monte Oliveto, he painted eleven scenes of the life and acts of S. Benedict on one side of the cloister. And from Cortona he sent some of his works to Montepulciano; to Foiano the panel which is on the high-altar of the Pieve; and other works to other places in Valdichiana. In the Madonna, the principal church of Orvieto, he finished with his own hand the chapel that Fra Giovanni da Fiesole had formerly begun there; in which chapel he painted all the scenes of the end of the world with bizarre and fantastic invention – angels, demons, ruins, earthquakes, fires, miracles of Antichrist, and many other similar things besides, such as nudes, foreshortenings, and many beautiful figures; imagining the terror that there shall be on that

last and awful day. By means of this he encouraged all those who have lived after him, insomuch that since then they have found easy the difficulties of that manner; wherefore I do not marvel that the works of Luca were ever very highly extolled by Michelagnolo, nor that in certain parts of his divine Judgment, which he made in the chapel, he should have deigned to avail himself in some measure of the inventions of Luca, as he did in the angels, the demons, the division of the Heavens, and other things, in which Michelagnolo himself imitated Luca's method, as all may see. In this work Luca portrayed himself and many of his friends; Niccolò, Paolo, and Vitelozzo Vitelli, Giovan Paolo and Orazio Baglioni, and others whose names are not known. In the Sacristy of S. Maria at Loreto he painted in fresco the four Evangelists, the four Doctors, and other saints, all very beautiful; and for this work he was liberally rewarded by Pope Sixtus.

It is said that a son of his, most beautiful in countenance and in person, whom he loved dearly, was killed at Cortona; and that Luca, heart-broken as he was, had him stripped naked, and with the greatest firmness of soul, without lamenting or shedding a tear, portrayed him, to the end that, whenever he might wish, he might be able by means of the work of his own hands to see that which nature had given him and adverse fortune had snatched away.

Being then summoned by the said Pope Sixtus to work in the chapel of his Palace in competition with many other painters, he painted therein two scenes, which are held the best among so many; one is Moses declaring his testament to the Jewish people on having seen the Promised Land, and the other is his death.

Finally, having executed works for almost every Prince in Italy, and being now old, he returned to Cortona, where, in those last years of his life, he worked more for pleasure than for any other reason, as one who, being used to labour, neither could nor would stay idle. In this his old age, then, he painted a panel for the Nuns of S. Margherita at Arezzo, and one for the Company of S. Girolamo, which was paid for in part by Messer Niccolò Gamurrini, Doctor of Laws and Auditor of the Ruota,* who is portrayed from life in that panel, kneeling before the Madonna, to whom he is being presented by a S. Nicholas who is in the same panel; there are also S. Donatus and S. Stephen, and lower

* A judicial court, the members of which sat in rotation.

down a nude S. Jerome, and a David who is singing to a psaltery; and also two prophets, who, as it appears from the scrolls that they have in their hands, are speaking about the Conception. This work was brought from Cortona to Arezzo on the shoulders of the men of that Company; and Luca, old as he was, insisted on coming to set it in place, and partly also in order to revisit his friends and relatives. And since he lodged in the house of the Vasari, in which I then was, a little boy of eight years old, I remember that the good old man, who was most gracious and courteous, having heard from the master who was teaching me my first letters, that I gave my attention to nothing in lesson-time save to drawing figures, I remember, I say, that he turned to my father Antonio and said to him: 'Antonio, if you wish little Giorgio not to become backward, by all means let him learn to draw, for, even were he to devote himself to letters, design cannot be otherwise than helpful, honourable, and advantageous to him, as it is to every gentleman.' Then, turning to me, who was standing in front of him, he said: 'Mind your lessons, little kinsman.' He said many other things about me, which I withhold, for the reason that I know that I have failed by a great measure to justify the opinion which the good old man had of me. And since he heard, as was true, that the blood used to flow from my nose at that age in such quantities that this left me sometimes half dead, with infinite lovingness he bound a jasper round my neck with his own hand; and this memory of Luca will stay for ever fixed in my mind. The said panel set in place, he returned to Cortona, accompanied for a great part of the way by many citizens, friends, and relatives, as was due to the excellence of Luca, who always lived rather as a noble and a man of rank than as a painter.

About the same time a palace had been built for Cardinal Silvio Passerini of Cortona, half a mile beyond the city, by Benedetto Caporali, a painter of Perugia, who, delighting in architecture, had written a commentary on Vitruvius a short time before; and the said Cardinal determined to have almost the whole of it painted. Wherefore Benedetto, putting his hand to this with the aid of Maso Papacello of Cortona (who was his disciple and had also learnt not a little from Giulio Romano, as will be told), of Tommaso, and of other disciples and lads, did not cease until he had painted it almost all over in fresco. But the Cardinal wishing to have some painting by the hand of Luca as well, he, old as he was, and hindered by palsy, painted in fresco,

on the altar-wall of the chapel of that palace, the scene of S. John the Baptist baptizing the Saviour; but he was not able to finish it completely, for while still working at it he died, having reached the age of eighty-two.

Luca was a man of most excellent character, true and loving with his friends, sweet and amiable in his dealings with every man, and, above all, courteous to all who had need of him, and kindly in teaching his disciples. He lived splendidly, and he took delight in clothing himself well. And for these good qualities he was ever held in the highest veneration both in his own country and abroad.

And so, with the end of this master's life, which was in 1521, we will bring to an end the Second Part of these Lives; concluding with Luca, as the man who, with his profound mastery of design, particularly in nudes, and with his grace in invention and in the composition of scenes, opened to the majority of crafts-men the way to the final perfection of art, to which those men who followed were afterwards enabled to add the crown, of whom we are henceforward to speak.

PART III

PREFACE TO THE THIRD PART

TRULY GREAT was the advancement conferred on the arts of architecture, painting, and sculpture by those excellent masters of whom we have written hitherto, in the Second Part of these Lives, for to the achievements of the early masters they added rule, order, proportion, draughtsmanship, and manner; not, indeed, in complete perfection, but with so near an approach to the truth that the masters of the third age, of whom we are henceforward to speak, were enabled, by means of their light, to aspire still higher and attain to that supreme perfection which we see in the most highly prized and most celebrated of our modern works. But to the end that the nature of the improvement brought about by the aforesaid craftsmen may be even more clearly understood, it will certainly not be out of place to explain in a few words the five additions that I have named, and to give a succinct account of the origin of that true excellence which, having surpassed the age of the ancients, makes the modern so glorious.

Rule, then, in architecture, was the process of taking measurements from antiquities and studying the ground-plans of ancient edifices for the construction of modern buildings. Order was the separating of one style from another, so that each body should receive its proper members, with no more interchanging between Doric, Ionic, Corinthian, and Tuscan. Proportion was the universal law applying both to architecture and to sculpture, that all bodies should be made correct and true, with the members in proper harmony; and so, also, in painting. Draughtsmanship was the imitation of the most beautiful parts of nature in all figures, whether in sculpture or in painting; and for this it is necessary to have a hand and a brain able to reproduce with absolute accuracy and precision, on a level surface – whether by drawing on paper, or on panel, or on some other level surface – everything that the eye sees; and the same is true of relief in sculpture. Manner then attained to the greatest beauty from the practice which arose of

constantly copying the most beautiful objects, and joining together these most beautiful things, hands, heads, bodies, and legs, so as to make a figure of the greatest possible beauty. This practice was carried out in every work for all figures, and for that reason it is called the beautiful manner.

These things had not been done by Giotto or by the other early craftsmen, although they had discovered the rudiments of all these difficulties, and had touched them on the surface; as in their drawing, which was sounder and more true to nature than it had been before, and likewise in harmony of colouring and in the grouping of figures in scenes, and in many other respects of which enough has been said. Now although the masters of the second age improved our arts greatly with regard to all the qualities mentioned above, yet these were not made by them so perfect as to succeed in attaining to complete perfection, for there was wanting in their rule a certain freedom which, without being of the rule, might be directed by the rule and might be able to exist without causing confusion or spoiling the order; which order had need of an invention abundant in every respect, and of a certain beauty maintained in every least detail, so as to reveal all that order with more adornment. In proportion there was wanting a certain correctness of judgment, by means of which their figures, without having been measured, might have, in due relation to their dimensions, a grace exceeding measurement. In their drawing there was not the perfection of finish, because, although they made an arm round and a leg straight, the muscles in these were not revealed with that sweet and facile grace which hovers midway between the seen and the unseen, as is the case with the flesh of living figures; nay, they were crude and excoriated, which made them displeasing to the eye and gave hardness to the manner. This last was wanting in the delicacy that comes from making all figures light and graceful, particularly those of women and children, with the limbs true to nature, as in the case of men, but veiled with a plumpness and fleshiness that should not be awkward, as they are in nature, but refined by draughtsmanship and judgment. They also lacked our abundance of beautiful costumes, our great number and variety of bizarre fancies, loveliness of colouring, wide knowledge of buildings, and distance and variety in landscapes. And although many of them, such as Andrea Verrocchio and Antonio del Pollaiuolo, and many others more modern, began to seek to make their figures with

more study, so as to reveal in them better draughtsmanship, with a degree of imitation more correct and truer to nature, nevertheless the whole was not yet there, even though they had one very certain assurance – namely, that they were advancing towards the good, and their figures were thus approved according to the standard of the works of the ancients, as was seen when Andrea Verrocchio restored in marble the legs and arms of the Marsyas in the house of the Medici in Florence. But they lacked a certain finish and finality of perfection in the feet, hands, hair, and beards, although the limbs as a whole are in accordance with the antique and have a certain correct harmony in the proportions. Now if they had had that minuteness of finish which is the perfection and bloom of art, they would also have had a resolute boldness in their works; and from this there would have followed delicacy, refinement, and supreme grace, which are the qualities produced by the perfection of art in beautiful figures, whether in relief or in painting; but these qualities they did not have, although they give proof of diligent striving. That finish, and that certain something that they lacked, they could not achieve so readily, seeing that study, when it is used in that way to obtain finish, gives dryness to the manner.

After them, indeed, their successors were enabled to attain to it through seeing excavated out of the earth certain antiquities cited by Pliny as amongst the most famous, such as the Laocoon, the Hercules, the Great Torso of the Belvedere, and likewise the Venus, the Cleopatra, the Apollo, and an endless number of others, which, both with their sweetness and their severity, with their fleshy roundness copied from the greatest beauties of nature, and with certain attitudes which involve no distortion of the whole figure but only a movement of certain parts, and are revealed with a most perfect grace, brought about the disappearance of a certain dryness, hardness, and sharpness of manner, which had been left to our art by the excessive study of Piero della Francesca, Lazzaro Vasari, Alesso Baldovinetti, Andrea dal Castagno, Pesello, Ercole Ferrarese, Giovanni Bellini, Cosimo Rosselli, the Abbot of S. Clemente, Domenico del Ghirlandajo, Sandro Botticelli, Andrea Mantegna, Filippo, and Luca Signorelli. These masters sought with great efforts to do the impossible in art by means of labour, particularly in foreshortenings and in things unpleasant to the eye, which were as painful to see as they were difficult for them to execute. And although their works were

for the most part well drawn and free from errors, yet there was
wanting a certain resolute spirit which was never seen in them,
and that sweet harmony of colouring which the Bolognese Fran-
cia and Pietro Perugino first began to show in their works; at the
sight of which people ran like madmen to this new and more
lifelike beauty, for it seemed to them quite certain that nothing
better could ever be done. But their error was afterwards clearly
proved by the works of Leonardo da Vinci, who, giving a
beginning to that third manner which we propose to call the
modern – besides the force and boldness of his drawing, and the
extreme subtlety wherewith he counterfeited all the minute-
nesses of nature exactly as they are – with good rule, better order,
right proportion, perfect drawing, and divine grace, abounding
in resources and having a most profound knowledge of art,
may be truly said to have endowed his figures with motion and
breath.

There followed after him, although at some distance,
Giorgione da Castelfranco, who obtained a beautiful gradation of
colour in his pictures, and gave a sublime movement to his works
by means of a certain darkness of shadow, very well conceived;
and not inferior to him in giving force, relief, sweetness, and
grace to his pictures, with his colouring, was Fra Bartolommeo
di San Marco. But more than all did the most gracious Raffaello
da Urbino, who, studying the labours of the old masters and
those of the modern, took the best from them, and, having
gathered it together, enriched the art of painting with that
complete perfection which was shown in ancient times by the
figures of Apelles and Zeuxis; nay, even more, if we may make
bold to say it, as might be proved if we could compare their
works with his. Wherefore nature was left vanquished by his
colours; and his invention was facile and peculiar to himself, as
may be perceived by all who see his painted stories, which are as
vivid as writings, for in them he showed us places and buildings
true to reality, and the features and costumes both of our own
people and of strangers, according to his pleasure; not to mention
his gift of imparting grace to the heads of young men, old men,
and women, reserving modesty for the modest, wantonness for
the wanton, and for children now mischief in their eyes, now
playfulness in their attitudes; and the folds of his draperies, also,
are neither too simple nor too intricate, but of such a kind that
they appear real.

In the same manner, but sweeter in colouring and not so bold, there followed Andrea del Sarto, who may be called a rare painter, for his works are free from errors. Nor is it possible to describe the charming vivacity seen in the works of Antonio da Correggio, who painted hair in detail, not in the precise manner used by the masters before him, which was constrained, sharp, and dry, but soft and feathery, with each single hair visible, such was his facility in making them; and they seemed like gold and more beautiful than real hair, which is surpassed by that which he painted.

The same did Francesco Mazzuoli of Parma, who excelled him in many respects in grace, adornment, and beauty of manner, as may be seen in many of his pictures, which smile on whoever beholds them; and even as there is a perfect illusion of sight in the eyes, so there is perceived the beating of the pulse, according as it best pleased his brush. But whosoever shall consider the mural paintings of Polidoro and Maturino, will see figures in attitudes that seem beyond the bounds of possibility, and he will wonder with amazement how it can be possible, not to describe with the tongue, which is easy, but to express with the brush the tremendous conceptions which they put into execution with such mastery and dexterity, in representing the deeds of the Romans exactly as they were.

And how many there are who, having given life to their figures with their colours, are now dead, such as Il Rosso, Fra Sebastiano, Giulio Romano, and Perino del Vaga! For of the living, who are known to all through their own efforts, there is no need to speak here. But what most concerns the whole world of art is that they have now brought it to such perfection, and made it so easy for him who possesses draughtsmanship, invention, and colouring, that, whereas those early masters took six years to paint one panel, our modern masters can paint six in one year, as I can testify with the greatest confidence both from seeing and from doing; and our pictures are clearly much more highly finished and perfect than those executed in former times by masters of account.

But he who bears the palm from both the living and the dead, transcending and eclipsing all others, is the divine Michelagnolo Buonarroti, who holds the sovereignty not merely of one of these arts, but of all three together. This master surpasses and excels not only all those moderns who have almost vanquished nature,

but even those most famous ancients who without a doubt did so gloriously surpass her; and in his own self he triumphs over moderns, ancients, and nature, who could scarcely conceive anything so strange and so difficult that he would not be able, by the force of his most divine intellect and by means of his industry, draughtsmanship, art, judgment, and grace, to excel it by a great measure; and that not only in painting and in the use of colour, under which title are comprised all forms, and all bodies upright or not upright, palpable or impalpable, visible or invisible, but also in the highest perfection of bodies in the round, with the point of his chisel. And from a plant so beautiful and so fruitful, through his labours, there have already spread branches so many and so noble, that, besides having filled the world in such unwonted profusion with the most luscious fruits, they have also given the final form to these three most noble arts. And so great and so marvellous is his perfection, that it may be safely and surely said that his statues are in all their parts much more beautiful than the ancient; for if we compare the heads, hands, arms, and feet shaped by the one with those of the others, we see in his a greater depth and solidity, a grace more completely graceful, and a much more absolute perfection, accomplished with a manner so facile in the overcoming of difficulties, that it is not possible ever to see anything better. And the same may be believed of his pictures, which, if we chanced to have some by the most famous Greeks and Romans, so that we might compare them face to face, would prove to be as much higher in value and more noble as his sculptures are clearly superior to all those of the ancients.

But if we admire so greatly those most famous masters who, spurred by such extraordinary rewards and by such good-fortune, gave life to their works, how much more should we not celebrate and exalt to the heavens those rare intellects who, not only without reward, but in miserable poverty, bring forth fruits so precious? We must believe and declare, then, that if, in this our age, there were a due meed of remuneration, there would be without a doubt works greater and much better than were ever wrought by the ancients. But the fact that they have to grapple more with famine than with fame, keeps our hapless intellects submerged, and, to the shame and disgrace of those who could raise them up but give no thought to it, prevents them from becoming known.

And let this be enough to have said on this subject; for it is now time to return to the Lives, and to treat in detail of all those who have executed famous works in this third manner, the creator of which was Leonardo da Vinci, with whom we will now begin.

LEONARDO DA VINCI,*
Painter and Sculptor of Florence

THE greatest gifts are often seen, in the course of nature, rained by celestial influences on human creatures; and sometimes, in supernatural fashion, beauty, grace, and talent are united beyond measure in one single person, in a manner that to whatever such an one turns his attention, his every action is so divine, that, surpassing all other men, it makes itself clearly known as a thing bestowed by God (as it is), and not acquired by human art. This was seen by all mankind in Leonardo da Vinci, in whom, besides a beauty of body never sufficiently extolled, there was an infinite grace in all his actions; and so great was his genius, and such its growth, that to whatever difficulties he turned his mind, he solved them with ease. In him was great bodily strength, joined to dexterity, with a spirit and courage ever royal and magnanimous; and the fame of his name so increased, that not only in his lifetime was he held in esteem, but his reputation became even greater among posterity after his death.

Truly marvellous and celestial was Leonardo, the son of Ser Piero da Vinci; and in learning and in the rudiments of letters he would have made great proficiency, if he had not been so variable and unstable, for he set himself to learn many things, and then, after having begun them, abandoned them. Thus, in arithmetic, during the few months that he studied it, he made so much progress, that, by continually suggesting doubts and difficulties to the master who was teaching him, he would very often bewilder

* Two accurate literal translations of the same original must often coincide; and in dealing with this beautiful Life, the translator has had to take the risk either of seeming to copy the almost perfect rendering of Mr. H. P. Horne, or of introducing unsatisfactory variants for mere variety's sake. Having rejected the latter course, he feels doubly bound to record once more his deep obligation to Mr. Horne's example.

him. He gave some little attention to music, and quickly resolved to learn to play the lyre, as one who had by nature a spirit most lofty and full of refinement: wherefore he sang divinely to that instrument, improvising upon it. Nevertheless, although he occupied himself with such a variety of things, he never ceased drawing and working in relief, pursuits which suited his fancy more than any other. Ser Piero, having observed this, and having considered the loftiness of his intellect, one day took some of his drawings and carried them to Andrea del Verrocchio, who was much his friend, and besought him straitly to tell him whether Leonardo, by devoting himself to drawing, would make any proficience. Andrea was astonished to see the extraordinary beginnings of Leonardo, and urged Ser Piero that he should make him study it; wherefore he arranged with Leonardo that he should enter the workshop of Andrea, which Leonardo did with the greatest willingness in the world. And he practised not one branch of art only, but all those in which drawing played a part; and having an intellect so divine and marvellous that he was also an excellent geometrician, he not only worked in sculpture, making in his youth, in clay, some heads of women that are smiling, of which plaster casts are still taken, and likewise some heads of boys which appeared to have issued from the hand of a master; but in architecture, also, he made many drawings both of ground-plans and of other designs of buildings; and he was the first, although but a youth, who suggested the plan of reducing the river Arno to a navigable canal from Pisa to Florence. He made designs of flour-mills, fulling-mills, and engines, which might be driven by the force of water: and since he wished that his profession should be painting, he studied much in drawing after nature, and sometimes in making models of figures in clay, over which he would lay soft pieces of cloth dipped in clay, and then set himself patiently to draw them on a certain kind of very fine Rheims cloth, or prepared linen: and he executed them in black and white with the point of his brush, so that it was a marvel, as some of them by his hand, which I have in our book of drawings, still bear witness; besides which, he drew on paper with such diligence and so well, that there is no one who has ever equalled him in perfection of finish; and I have one, a head drawn with the style in chiaroscuro, which is divine.

And there was infused in that brain such grace from God, and a power of expression in such sublime accord with the intellect

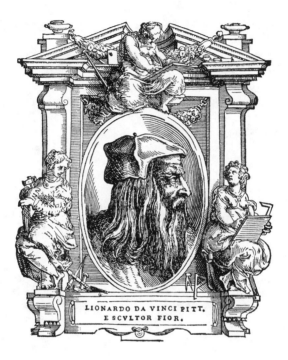

LIONARDO DA VINCI PITT.
E SCVLTOR FIOR.

and memory that served it, and he knew so well how to express his conceptions by draughtsmanship, that he vanquished with his discourse, and confuted with his reasoning, every valiant wit. And he was continually making models and designs to show men how to remove mountains with ease, and how to bore them in order to pass from one level to another; and by means of levers, windlasses, and screws, he showed the way to raise and draw great weights, together with methods for emptying harbours, and pumps for removing water from low places, things which his brain never ceased from devising; and of these ideas and labours many drawings may be seen, scattered abroad among our craftsmen; and I myself have seen not a few. He even went so far as to waste his time in drawing knots of cords, made according to an order, that from one end all the rest might follow till the other, so as to fill a round; and one of these is to be seen in stamp, most difficult and beautiful, and in the middle of it are these words, 'Leonardus Vinci Accademia.' And among these models and designs, there was one by which he often demonstrated to many ingenious citizens, who were then governing Florence, how he proposed to raise the Temple of S. Giovanni in Florence, and place steps under it, without damaging the building; and with such strong reasons did he urge this, that it appeared possible, although each man, after he had departed, would recognize for himself the impossibility of so vast an undertaking.

He was so pleasing in conversation, that he attracted to himself the hearts of men. And although he possessed, one might say, nothing, and worked little, he always kept servants and horses, in which latter he took much delight, and particularly in all other animals, which he managed with the greatest love and patience; and this he showed when often passing by the places where birds were sold, for, taking them with his own hand out of their cages, and having paid to those who sold them the price that was asked, he let them fly away into the air, restoring to them their lost liberty. For which reason nature was pleased so to favour him, that, wherever he turned his thought, brain, and mind, he displayed such divine power in his works, that, in giving them their perfection, no one was ever his peer in readiness, vivacity, excellence, beauty, and grace.

It is clear that Leonardo, through his comprehension of art, began many things and never finished one of them, since it seemed to him that the hand was not able to attain to the

perfection of art in carrying out the things which he imagined; for the reason that he conceived in idea difficulties so subtle and so marvellous, that they could never be expressed by the hands, be they ever so excellent. And so many were his caprices, that, philosophizing of natural things, he set himself to seek out the properties of herbs, going on even to observe the motions of the heavens, the path of the moon, and the courses of the sun.

He was placed, then, as has been said, in his boyhood, at the instance of Ser Piero, to learn art with Andrea del Verrocchio, who was making a panel-picture of S. John baptizing Christ, when Leonardo painted an angel who was holding some garments; and although he was but a lad, Leonardo executed it in such a manner that his angel was much better than the figures of Andrea; which was the reason that Andrea would never again touch colour, in disdain that a child should know more than he.

He was commissioned to make a cartoon for a door-hanging that was to be executed in Flanders, woven in gold and silk, to be sent to the King of Portugal, of Adam and Eve sinning in the Earthly Paradise; wherein Leonardo drew with the brush in chiaroscuro, with the lights in lead-white, a meadow of infinite kinds of herbage, with some animals, of which, in truth, it may be said that for diligence and truth to nature divine wit could not make it so perfect. In it is the fig-tree, together with the foreshortening of the leaves and the varying aspects of the branches, wrought with such lovingness that the brain reels at the mere thought how a man could have such patience. There is also a palm-tree which has the radiating crown of the palm, executed with such great and marvellous art that nothing save the patience and intellect of Leonardo could avail to do it. This work was carried no farther; wherefore the cartoon is now at Florence, in the blessed house of the Magnificent Ottaviano de' Medici, presented to him not long ago by the uncle of Leonardo.

It is said that Ser Piero da Vinci, being at his villa, was besought as a favour, by a peasant of his, who had made a buckler with his own hands out of a fig-tree that he had cut down on the farm, to have it painted for him in Florence, which he did very willingly, since the countryman was very skilful at catching birds and fishing, and Ser Piero made much use of him in these pursuits. Thereupon, having had it taken to Florence, without saying a word to Leonardo as to whose it was, he asked him to paint something upon it. Leonardo, having one day taken this buckler

in his hands, and seeing it twisted, badly made, and clumsy, straightened it by the fire, and, having given it to a turner, from the rude and clumsy thing that it was, caused it to be made smooth and even. And afterwards, having given it a coat of gesso, and having prepared it in his own way, he began to think what he could paint upon it, that might be able to terrify all who should come upon it, producing the same effect as once did the head of Medusa. For this purpose, then, Leonardo carried to a room of his own into which no one entered save himself alone, lizards great and small, crickets, serpents, butterflies, grasshoppers, bats, and other strange kinds of suchlike animals, out of the number of which, variously put together, he formed a great ugly creature, most horrible and terrifying, which emitted a poisonous breath and turned the air to flame; and he made it coming out of a dark and jagged rock, belching forth venom from its open throat, fire from its eyes, and smoke from its nostrils, in so strange a fashion that it appeared altogether a monstrous and horrible thing; and so long did he labour over making it, that the stench of the dead animals in that room was past bearing, but Leonardo did not notice it, so great was the love that he bore towards art. The work being finished, although it was no longer asked for either by the countryman or by his father, Leonardo told the latter that he might send for the buckler at his convenience, since, for his part, it was finished. Ser Piero having therefore gone one morning to the room for the buckler, and having knocked at the door, Leonardo opened to him, telling him to wait a little; and, having gone back into the room, he adjusted the buckler in a good light on the easel, and put to the window, in order to make a soft light, and then he bade him come in to see it. Ser Piero, at the first glance, taken by surprise, gave a sudden start, not thinking that that was the buckler, nor merely painted the form that he saw upon it, and, falling back a step, Leonardo checked him, saying, 'This work serves the end for which it was made; take it, then, and carry it away, since this is the effect that it was meant to produce.' This thing appeared to Ser Piero nothing short of a miracle, and he praised very greatly the ingenious idea of Leonardo; and then, having privately bought from a pedlar another buckler, painted with a heart transfixed by an arrow, he presented it to the countryman, who remained obliged to him for it as long as he lived. Afterwards, Ser Piero sold the buckler of Leonardo secretly to some merchants in Florence, for a

hundred ducats; and in a short time it came into the hands of the Duke of Milan, having been sold to him by the said merchants for three hundred ducats.

Leonardo then made a picture of Our Lady, a most excellent work, which was in the possession of Pope Clement VII; and, among other things painted therein, he counterfeited a glass vase full of water, containing some flowers, in which, besides its marvellous naturalness, he had imitated the dew-drops on the flowers, so that it seemed more real than the reality. For Antonio Segni, who was very much his friend, he made, on a sheet of paper, a Neptune executed with such careful draughtsmanship that it seemed absolutely alive. In it one saw the ocean troubled, and Neptune's car drawn by sea-horses, with fantastic creatures, marine monsters and winds, and some very beautiful heads of sea-gods. This drawing was presented by Fabio, the son of Antonio, to Messer Giovanni Gaddi, with this epigram:

> Pinxit Virgilius Neptunum, pinxit Homerus,
> Dum maris undisoni per vada flectit equos.
> Mente quidem vates illum conspexit uterque,
> Vincius ast oculis; jureque vincit eos.

The fancy came to him to paint a picture in oils of the head of a Medusa, with the head attired with a coil of snakes, the most strange and extravagant invention that could ever be imagined; but since it was a work that took time, it remained unfinished, as happened with almost all his things. It is among the rare works of art in the Palace of Duke Cosimo, together with the head of an angel, who is raising one arm in the air, which, coming forward, is foreshortened from the shoulder to the elbow, and with the other he raises the hand to the breast.

It is an extraordinary thing how that genius, in his desire to give the highest relief to the works that he made, went so far with dark shadows, in order to find the darkest possible grounds, that he sought for blacks which might make deeper shadows and be darker than other blacks, that by their means he might make his lights the brighter; and in the end this method turned out so dark, that, no light remaining there, his pictures had rather the character of things made to represent an effect of night, than the clear quality of daylight; which all came from seeking to give greater relief, and to achieve the final perfection of art.

He was so delighted when he saw certain bizarre heads of

men, with the beard or hair growing naturally, that he would follow one that pleased him a whole day, and so treasured him up in idea, that afterwards, on arriving home, he drew him as if he had had him in his presence. Of this sort there are many heads to be seen, both of women and of men, and I have several of them, drawn by his hand with the pen, in our book of drawings, which I have mentioned so many times; such was that of Amerigo Vespucci, which is a very beautiful head of an old man drawn with charcoal, and likewise that of Scaramuccia, Captain of the Gypsies, which afterwards came into the hands of M. Donato Valdambrini of Arezzo, Canon of S. Lorenzo, left to him by Giambullari.

He began a panel-picture of the Adoration of the Magi, containing many beautiful things, particularly the heads, which was in the house of Amerigo Benci, opposite the Loggia de' Peruzzi; and this, also, remained unfinished, like his other works.

It came to pass that Giovan Galeazzo, Duke of Milan, being dead, and Lodovico Sforza raised to the same rank, in the year 1494, Leonardo was summoned to Milan in great repute to the Duke, who took much delight in the sound of the lyre, to the end that he might play it: and Leonardo took with him that instrument which he had made with his own hands, in great part of silver, in the form of a horse's skull – a thing bizarre and new – in order that the harmony might be of greater volume and more sonorous in tone; with which he surpassed all the musicians who had come together there to play. Besides this, he was the best improviser in verse of his day. The Duke, hearing the marvellous discourse of Leonardo, became so enamoured of his genius, that it was something incredible: and he prevailed upon him by entreaties to paint an altar-panel containing a Nativity, which was sent by the Duke to the Emperor.

He also painted in Milan, for the Friars of S. Dominic, at S. Maria delle Grazie, a Last Supper, a most beautiful and marvellous thing; and to the heads of the Apostles he gave such majesty and beauty, that he left the head of Christ unfinished, not believing that he was able to give it that divine air which is essential to the image of Christ. This work, remaining thus all but finished, has ever been held by the Milanese in the greatest veneration, and also by strangers as well; for Leonardo imagined and succeeded in expressing that anxiety which had seized the Apostles in wishing to know who should betray their Master. For

which reason in all their faces are seen love, fear, and wrath, or rather, sorrow, at not being able to understand the meaning of Christ; which thing excites no less marvel than the sight, in contrast to it, of obstinacy, hatred, and treachery in Judas; not to mention that every least part of the work displays an incredible diligence, seeing that even in the table-cloth the texture of the stuff is counterfeited in such a manner that linen itself could not seem more real.

It is said that the Prior of that place kept pressing Leonardo, in a most importunate manner, to finish the work; for it seemed strange to him to see Leonardo sometimes stand half a day at a time, lost in contemplation, and he would have liked him to go on like the labourers hoeing in his garden, without ever stopping his brush. And not content with this, he complained of it to the Duke, and that so warmly, that he was constrained to send for Leonardo and delicately urged him to work, contriving nevertheless to show him that he was doing all this because of the importunity of the Prior. Leonardo, knowing that the intellect of that Prince was acute and discerning, was pleased to discourse at large with the Duke on the subject, a thing which he had never done with the Prior: and he reasoned much with him about art, and made him understand that men of lofty genius sometimes accomplish the most when they work the least, seeking out inventions with the mind, and forming those perfect ideas which the hands afterwards express and reproduce from the images already conceived in the brain. And he added that two heads were still wanting for him to paint; that of Christ, which he did not wish to seek on earth; and he could not think that it was possible to conceive in the imagination that beauty and heavenly grace which should be the mark of God incarnate. Next, there was wanting that of Judas, which was also troubling him, not thinking himself capable of imagining features that should represent the countenance of him who, after so many benefits received, had a mind so cruel as to resolve to betray his Lord, the Creator of the world. However, he would seek out a model for the latter; but if in the end he could not find a better, he should not want that of the importunate and tactless Prior. This thing moved the Duke wondrously to laughter, and he said that Leonardo had a thousand reasons on his side. And so the poor Prior, in confusion, confined himself to urging on the work in the garden, and left Leonardo in peace, who finished only the head of Judas, which

seems the very embodiment of treachery and inhumanity; but that of Christ, as has been said, remained unfinished. The nobility of this picture, both because of its design, and from its having been wrought with an incomparable diligence, awoke a desire in the King of France to transport it into his kingdom; wherefore he tried by all possible means to discover whether there were architects who, with cross-stays of wood and iron, might have been able to make it so secure that it might be transported safely; without considering any expense that might have been involved thereby, so much did he desire it. But the fact of its being painted on the wall robbed his Majesty of his desire; and the picture remained with the Milanese. In the same refectory, while he was working at the Last Supper, on the end wall where is a Passion in the old manner, Leonardo portrayed the said Lodovico, with Massimiliano, his eldest son; and, on the other side, the Duchess Beatrice, with Francesco, their other son, both of whom after-wards became Dukes of Milan; and all are portrayed divinely well.

While he was engaged on this work, he proposed to the Duke to make a horse in bronze, of a marvellous greatness, in order to place upon it, as a memorial, the image of the Duke. And on so vast a scale did he begin it and continue it, that it could never be completed. And there are those who have been of the opinion (so various and so often malign out of envy are the judgments of men) that he began it with no intention of finishing it, because, being of so great a size, an incredible difficulty was encountered in seeking to cast it in one piece; and it might also be believed that, from the result, many may have formed such a judgment, since many of his works have remained unfinished. But, in truth, one can believe that his vast and most excellent mind was ham-pered through being too full of desire, and that his wish ever to seek out excellence upon excellence, and perfection upon perfec-tion, was the reason of it. 'Tal che l' opera fosse ritardata dal desio,' as our Petrarca has said. And, indeed, those who saw the great model that Leonardo made in clay vow that they have never seen a more beautiful thing, or a more superb; and it was preserved until the French came to Milan with King Louis of France, and broke it all to pieces. Lost, also, is a little model of it in wax, which was held to be perfect, together with a book on the anatomy of the horse made by him by way of study.

He then applied himself, but with greater care, to the anatomy of man, assisted by and in turn assisting, in this research, Messer

Marc' Antonio della Torre, an excellent philosopher, who was then lecturing at Pavia, and who wrote of this matter; and he was one of the first (as I have heard tell) that began to illustrate the problems of medicine with the doctrine of Galen, and to throw true light on anatomy, which up to that time had been wrapped in the thick and gross darkness of ignorance. And in this he found marvellous aid in the brain, work, and hand of Leonardo, who made a book drawn in red chalk, and annotated with the pen, of the bodies that he dissected with his own hand, and drew with the greatest diligence; wherein he showed all the frame of the bones; and then added to them, in order, all the nerves, and covered them with muscles; the first attached to the bone, the second that hold the body firm, and the third that move it; and beside them, part by part, he wrote in letters of an ill-shaped character, which he made with the left hand, backwards; and whoever is not practised in reading them cannot understand them, since they are not to be read save with a mirror. Of these papers on the anatomy of man, a great part is in the hands of Messer Francesco da Melzo, a gentleman of Milan, who in the time of Leonardo was a very beautiful boy, and much beloved by him, and now is a no less beautiful and gentle old man; and he holds them dear, and keeps such papers together as if they were relics, in company with the portrait of Leonardo of happy memory; and to all who read these writings, it seems impossible that that divine spirit should have discoursed so well of art, and of the muscles, nerves, and veins, and with such diligence of everything. So, also, there are in the hands of ———,* a painter of Milan, certain writings of Leonardo, likewise in characters written with the left hand, backwards, which treat of painting, and of the methods of drawing and colouring. This man, not long ago, came to Florence to see me, wishing to print this work, and he took it to Rome, in order to put it into effect; but I do not know what may afterwards have become of it.

And to return to the works of Leonardo; there came to Milan, in his time, the King of France, wherefore Leonardo being asked to devise some bizarre thing, made a lion which walked several steps and then opened its breast, and showed it full of lilies.

In Milan he took for his assistant the Milanese Salai, who was most comely in grace and beauty, having fine locks, curling in

* This name is missing in the text.

ringlets, in which Leonardo greatly delighted; and he taught him many things of art; and certain works in Milan, which are said to be by Salai, were retouched by Leonardo.

He returned to Florence, where he found that the Servite Friars had entrusted to Filippino the painting of the panel for the high-altar of the Nunziata; whereupon Leonardo said that he would willingly have done such a work. Filippino, having heard this, like the amiable fellow that he was, retired from the undertaking; and the friars, to the end that Leonardo might paint it, took him into their house, meeting the expenses both of himself and of all his household; and thus he kept them in expectation for a long time, but never began anything. In the end, he made a cartoon containing a Madonna and a S. Anne, with a Christ, which not only caused all the craftsmen to marvel, but, when it was finished, men and women, young and old, continued for two days to flock for a sight of it to the room where it was, as if to a solemn festival, in order to gaze at the marvels of Leonardo, which caused all those people to be amazed; for in the face of that Madonna was seen whatever of the simple and the beautiful can by simplicity and beauty confer grace on a picture of the Mother of Christ, since he wished to show that modesty and that humility which are looked for in an image of the Virgin, supremely content with gladness at seeing the beauty of her Son, whom she was holding with tenderness in her lap, while with most chastened gaze she was looking down at S. John, as a little boy, who was playing with a lamb; not without a smile from S. Anne, who, overflowing with joy, was beholding her earthly progeny become divine – ideas truly worthy of the brain and genius of Leonardo. This cartoon, as will be told below, afterwards went to France. He made a portrait of Ginevra d' Amerigo Benci, a very beautiful work; and abandoned the work for the friars, who restored it to Filippino; but he, also, failed to finish it, having been overtaken by death.

Leonardo undertook to execute, for Francesco del Giocondo, the portrait of Monna Lisa, his wife; and after toiling over it for four years, he left it unfinished; and the work is now in the collection of King Francis of France, at Fontainebleau. In this head, whoever wished to see how closely art could imitate nature, was able to comprehend it with ease; for in it were counterfeited all the minutenesses that with subtlety are able to be painted, seeing that the eyes had that lustre and watery sheen which are

always seen in life, and around them were all those rosy and pearly tints, as well as the lashes, which cannot be represented without the greatest subtlety. The eyebrows, through his having shown the manner in which the hairs spring from the flesh, here more close and here more scanty, and curve according to the pores of the skin, could not be more natural. The nose, with its beautiful nostrils, rosy and tender, appeared to be alive. The mouth, with its opening, and with its ends united by the red of the lips to the flesh-tints of the face, seemed, in truth, to be not colours but flesh. In the pit of the throat, if one gazed upon it intently, could be seen the beating of the pulse. And, indeed, it may be said that it was painted in such a manner as to make every valiant craftsman, be he who he may, tremble and lose heart. He made use, also, of this device: Monna Lisa being very beautiful, he always employed, while he was painting her portrait, persons to play or sing, and jesters, who might make her remain merry, in order to take away that melancholy which painters are often wont to give to the portraits that they paint. And in this work of Leonardo's there was a smile so pleasing, that it was a thing more divine than human to behold; and it was held to be something marvellous, since the reality was not more alive.

By reason, then, of the excellence of the works of this most divine craftsman, his fame had so increased that all persons who took delight in art – nay, the whole city of Florence – desired that he should leave them some memorial, and it was being proposed everywhere that he should be commissioned to execute some great and notable work, whereby the commonwealth might be honoured and adorned by the great genius, grace and judgment that were seen in the works of Leonardo. And it was decided between the Gonfalonier and the chief citizens, the Great Council Chamber having been newly built – the architecture of which had been contrived with the judgment and counsel of Giuliano da San Gallo, Simone Pollaiuoli, called Il Cronaca, Michelagnolo Buonarroti, and Baccio D'Agnolo, as will be related with more detail in the proper places – and having been finished in great haste, it was ordained by public decree that Leonardo should be given some beautiful work to paint; and so the said hall was allotted to him by Piero Soderini, then Gonfalonier of Justice. Whereupon Leonardo, determining to execute this work, began a cartoon in the Sala del Papa, an apartment in S. Maria Novella, representing the story of Niccolò Piccinino, Captain of

Duke Filippo of Milan; wherein he designed a group of horsemen who were fighting for a standard, a work that was held to be very excellent and of great mastery, by reason of the marvellous ideas that he had in composing that battle; seeing that in it rage, fury, and revenge are perceived as much in the men as in the horses, among which two with the fore-legs interlocked are fighting no less fiercely with their teeth than those who are riding them do in fighting for that standard, which has been grasped by a soldier, who seeks by the strength of his shoulders, as he spurs his horse to flight, having turned his body backwards and seized the staff of the standard, to wrest it by force from the hands of four others, of whom two are defending it, each with one hand, and, raising their swords in the other, are trying to sever the staff; while an old soldier in a red cap, crying out, grips the staff with one hand, and, raising a scimitar with the other, furiously aims a blow in order to cut off both the hands of those who, gnashing their teeth in the struggle, are striving in attitudes of the utmost fierceness to defend their banner; besides which, on the ground, between the legs of the horses, there are two figures in fore-shortening that are fighting together, and the one on the ground has over him a soldier who has raised his arm as high as possible, that thus with greater force he may plunge a dagger into his throat, in order to end his life; while the other, struggling with his legs and arms, is doing what he can to escape death.

It is not possible to describe the invention that Leonardo showed in the garments of the soldiers, all varied by him in different ways, and likewise in the helmet-crests and other ornaments; not to mention the incredible mastery that he displayed in the forms and lineaments of the horses, which Leonardo, with their fiery spirit, muscles, and shapely beauty, drew better than any other master. It is said that, in order to draw that cartoon, he made a most ingenious stage, which was raised by contracting it and lowered by expanding. And conceiving the wish to colour on the wall in oils, he made a composition of so gross an admixture, to act as a binder on the wall, that, going on to paint in the said hall, it began to peel off in such a manner that in a short time he abandoned it, seeing it spoiling.

Leonardo had very great spirit, and in his every action was most generous. It is said that, going to the bank for the allowance that he used to draw every month from Piero Soderini, the cashier wanted to give him certain paper-packets of pence; but he

would not take them, saying in answer, 'I am no penny-painter.' Having been blamed for cheating Piero Soderini, there began to be murmurings against him; wherefore Leonardo so wrought upon his friends, that he got the money together and took it to Piero to repay him; but he would not accept it.

He went to Rome with Duke Giuliano de' Medici, at the election of Pope Leo, who spent much of his time on philosophical studies, and particularly on alchemy; where, forming a paste of a certain kind of wax, as he walked he shaped animals very thin and full of wind, and, by blowing into them, made them fly through the air, but when the wind ceased they fell to the ground. On the back of a most bizarre lizard, found by the vine-dresser of the Belvedere, he fixed, with a mixture of quicksilver, wings composed of scales stripped from other lizards, which, as it walked, quivered with the motion; and having given it eyes, horns, and beard, taming it, and keeping it in a box, he made all his friends, to whom he showed it, fly for fear. He used often to have the guts of a wether completely freed of their fat and cleaned, and thus made so fine that they could have been held in the palm of the hand; and having placed a pair of blacksmith's bellows in another room, he fixed to them one end of these, and, blowing into them, filled the room, which was very large, so that whoever was in it was obliged to retreat into a corner; showing how, transparent and full of wind, from taking up little space at the beginning they had come to occupy much, and likening them to virtue. He made an infinite number of such follies, and gave his attention to mirrors; and he tried the strangest methods in seeking out oils for painting, and varnish for preserving works when painted.

He made at this time, for Messer Baldassarre Turini da Pescia, who was Datary to Pope Leo, a little picture of the Madonna with the Child in her arms, with infinite diligence and art; but whether through the fault of whoever primed the panel with gesso, or because of his innumerable and capricious mixtures of grounds and colours, it is now much spoilt. And in another small picture he made a portrait of a little boy, which is beautiful and graceful to a marvel; and both of them are now at Pescia, in the hands of Messer Giuliano Turini. It is related that, a work having been allotted to him by the Pope, he straightway began to distil oils and herbs, in order to make the varnish; at which Pope Leo said: 'Alas! this man will never do anything, for he begins by thinking of the end of the work, before the beginning.'

There was very great disdain between Michelagnolo Buonar-
roti and him, on account of which Michelagnolo departed from
Florence, with the excuse of Duke Giuliano, having been
summoned by the Pope to the competition for the façade of
S. Lorenzo. Leonardo, understanding this, departed and went
into France, where the King, having had works by his hand, bore
him great affection; and he desired that he should colour the
cartoon of S. Anne, but Leonardo, according to his custom, put
him off for a long time with words.

Finally, having grown old, he remained ill many months, and,
feeling himself near to death, asked to have himself diligently
informed of the teaching of the Catholic faith, and of the good
way and holy Christian religion; and then, with many moans, he
confessed and was penitent; and although he could not raise
himself well on his feet, supporting himself on the arms of his
friends and servants, he was pleased to take devoutly the most
holy Sacrament, out of his bed. The King, who was wont often
and lovingly to visit him, then came into the room; wherefore he,
out of reverence, having raised himself to sit upon the bed, giving
him an account of his sickness and the circumstances of it,
showed withal how much he had offended God and mankind in
not having worked at his art as he should have done. Thereupon
he was seized by a paroxysm, the messenger of death; for which
reason the King having risen and having taken his head, in order
to assist him and show him favour, to the end that he might
alleviate his pain, his spirit, which was divine, knowing that it
could not have any greater honour, expired in the arms of the
King, in the seventy-fifth year of his age.

The loss of Leonardo grieved beyond measure all those who
had known him, since there was never any one who did so much
honour to painting. With the splendour of his aspect, which was
very beautiful, he made serene every broken spirit: and with his
words he turned to yea, or nay, every obdurate intention. By
his physical force he could restrain any outburst of rage: and
with his right hand he twisted the iron ring of a door-bell, or a
horse-shoe, as if it were lead. With his liberality he would assemble
together and support his every friend, poor or rich, if only he had
intellect and worth. He adorned and honoured, in every action,
no matter what mean and bare dwelling; wherefore, in truth,
Florence received a very great gift in the birth of Leonardo, and
an incalculable loss in his death. In the art of painting, he added

to the manner of colouring in oils a certain obscurity, whereby
the moderns have given great force and relief to their figures.
And in statuary, he proved his worth in the three figures of
bronze that are over the door of S. Giovanni, on the side towards
the north, executed by Giovan Francesco Rustici, but contrived
with the advice of Leonardo; which are the most beautiful pieces
of casting, the best designed, and the most perfect that have as
yet been seen in modern days. By Leonardo we have the anatomy
of the horse, and that of man even more complete. And so, on
account of all his qualities, so many and so divine, although he
worked much more by words than by deeds, his name and fame
can never be extinguished; wherefore it was thus said in his praise
by Messer Giovan Battista Strozzi:

> Vince costui pur solo
> Tutti altri; e vince Fidia e vince Apelle
> E tutto il lor vittorioso stuolo.

A disciple of Leonardo was Giovan Antonio Boltraffio of
Milan, a person of great skill and understanding, who, in the year
1500, painted with much diligence, for the Church of the Miseri-
cordia, without Bologna, a panel in oils containing Our Lady
with the Child in her arms, S. John the Baptist, S. Sebastian
naked, and the patron who caused it to be executed, portrayed
from the life, on his knees – a truly beautiful work, on which he
wrote his name, calling himself a disciple of Leonardo. He has
made other works, both at Milan and elsewhere; but it must be
enough here to have named this, which is the best. Another (of his
disciples) was Marco Oggioni, who painted, in S. Maria della Pace,
the Passing of Our Lady and the Marriage of Cana in Galilee.

GIORGIONE DA CASTELFRANCO,
Painter of Venice

At the same time when Florence was acquiring such fame by
reason of the works of Leonardo, no little adornment was con-
ferred on Venice by the talent and excellence of one of her
citizens, who surpassed by a great measure not only the Bellini,
whom the Venetians held in such esteem, but also every other
master who had painted up to that time in that city. This was

Giorgio, who was born at Castelfranco in the territory of Treviso, in the year 1478, when the Doge was Giovanni Mozzenigo, brother of Doge Piero. In time, from the nature of his person and from the greatness of his mind, Giorgio came to be called Giorgione; and although he was born from very humble stock, nevertheless he was not otherwise than gentle and of good breeding throughout his whole life. He was brought up in Venice, and took unceasing delight in the joys of love; and the sound of the lute gave him marvellous pleasure, so that in his day he played and sang so divinely that he was often employed for that purpose at various musical assemblies and gatherings of noble persons. He studied drawing, and found it greatly to his taste; and in this nature favoured him so highly, that he, having become enamoured of her beauties, would never represent anything in his works without copying it from life; and so much was he her slave, imitating her continuously, that he acquired the name not only of having surpassed Giovanni and Gentile Bellini, but also of being the rival of the masters who were working in Tuscany and who were the creators of the modern manner. Giorgione had seen some things by the hand of Leonardo with a beautiful gradation of colours, and with extraordinary relief, effected, as has been related, by means of dark shadows; and this manner pleased him so much that he was for ever studying it as long as he lived, and in oil-painting he imitated it greatly. Taking pleasure in the delights of good work, he was ever selecting, for putting into his pictures, the greatest beauty and the greatest variety that he could find. And nature gave him a spirit so benign, and with this, both in oil-painting and in fresco, he made certain living forms and other things so soft, so well harmonized, and so well blended in the shadows, that many of the excellent masters of his time were forced to confess that he had been born to infuse spirit into figures and to counterfeit the freshness of living flesh better than any other painter, not only in Venice, but throughout the whole world.

In his youth he executed in Venice many pictures of Our Lady and other portraits from nature, which are very lifelike and beautiful; of which we still have proof in three most beautiful heads in oils by his hand, which are in the study of the Very Reverend Grimani, Patriarch of Aquileia. One represents David – and it is reported to be his own portrait – with long locks reaching to the shoulders, as was the custom of those times; it is so vivacious and so fresh in colouring that it seems to be living flesh, and

there is armour on the breast, as there is on the arm with which he is holding the severed head of Goliath. The second is a much larger head, portrayed from nature; one hand is holding the red cap of a commander, and there is a cape of fur, below which is one of the old-fashioned doublets. This is believed to represent some military leader. The third is that of a boy, as beautiful as could be, with fleecy hair. These works demonstrate the excellence of Giorgione, and no less the affection which that great Patriarch has ever borne to his genius, holding them very dear, and that rightly. In Florence, in the house of the sons of Giovanni Borgherini, there is a portrait by his hand of the said Giovanni, taken when he was a young man in Venice, and in the same picture is the master who was teaching him; and there are no two heads to be seen with better touches in the flesh-colours or with more beautiful tints in the shadows. In the house of Anton de' Nobili there is another head of a captain in armour, very lively and spirited, which is said to be one of the captains whom Consalvo Ferrante took with him to Venice when he visited Doge Agostino Barberigo; at which time, it is related, Giorgione made a portrait of the great Consalvo in armour, which was a very rare work, insomuch that there was no more beautiful painting than this to be seen, and Consalvo took it away with him. Giorgione made many other portraits which are scattered throughout many parts of Italy; all very beautiful, as may be believed from that of Leonardo Loredano, painted by Giorgione when Leonardo was Doge, which I saw exhibited on one Ascension day, when I seemed to see that most illustrious Prince alive. There is also one at Faenza, in the house of Giovanni da Castel Bolognese, an excellent engraver of cameos and crystals; which work, executed for his father-in-law, is truly divine, since there is such a harmony in the gradation of the colours that it appears to be rather in relief than painted.

Giorgione took much delight in painting in fresco, and one among many works that he executed was the whole of a façade of the Ca Soranzo on the Piazza di S. Polo; wherein, besides many pictures and scenes and other things of fancy, there may be seen a picture painted in oils on the plaster, a work which has withstood rain, sun, and wind, and has remained fresh up to our own day. There is also a Spring, which appears to me to be one of the most beautiful works that he painted in fresco, and it is a great pity that time has consumed it so cruelly. For my part, I

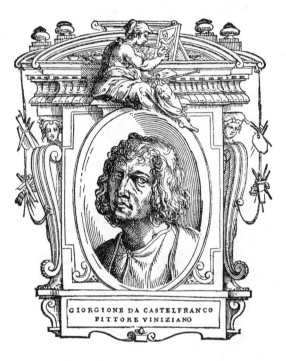

GIORGIONE DA CASTELFRANCO
PITTORE VINIZIANO

know nothing that injures works in fresco more than the sirocco, and particularly near the sea, where it always brings a salt moisture with it.

There broke out at Venice, in the year 1504, in the Fondaco de' Tedeschi by the Ponte del Rialto, a most terrible fire, which consumed the whole building and all the merchandise, to the very great loss of the merchants; wherefore the Signoria of Venice ordained that it should be rebuilt anew, and it was speedily finished with more accommodation in the way of living-rooms, and with greater magnificence, adornment, and beauty. Thereupon, the fame of Giorgione having grown great, it was ordained after deliberation by those who had charge of the matter, that Giorgione should paint it in fresco with colours according to his own fancy, provided only that he gave proof of his genius and executed an excellent work, since it would be in the most beautiful place and most conspicuous site in the city. And so Giorgione put his hand to the work, but thought of nothing save of making figures according to his own fancy, in order to display his art, so that, in truth, there are no scenes to be found there with any order, or representing the deeds of any distinguished person, either ancient or modern; and I, for my part, have never understood them, nor have I found, for all the inquiries that I have made, anyone who understands them, for in one place there is a woman, in another a man, in diverse attitudes, while one has the head of a lion near him, and another an angel in the guise of a Cupid, nor can one tell what it may all mean. There is, indeed, over the principal door, which opens into the Merceria, a woman seated who has at her feet the severed head of a giant, almost in the form of a Judith; she is raising the head with her sword, and speaking with a German, who is below her; but I have not been able to determine for what he intended her to stand, unless, indeed, he may have meant her to represent Germany. However, it may be seen that his figures are well grouped, and that he was ever making progress; and there are in it heads and parts of figures very well painted, and most vivacious in colouring. In all that he did there he aimed at being faithful to nature, without any imitation of another's manner; and the work is celebrated and famous in Venice, no less for what he painted therein than through its convenience for commerce and its utility to the commonwealth.

He executed a picture of Christ bearing the Cross, with a Jew dragging him along, which in time was placed in the Church of

S. Rocco, and which now, through the veneration that many feel for it, works miracles, as all may see. He worked in various places, such as Castelfranco, and throughout the territory of Treviso, and he made many portraits for Italian Princes; and many of his works were sent out of Italy, as things truly worthy to bear testimony that if Tuscany had a superabundance of craftsmen in every age, the region beyond, near the mountains, was not always abandoned and forgotten by Heaven.

It is related that Giorgione, at the time when Andrea Verrocchio was making his bronze horse, fell into an argument with certain sculptors, who maintained, since sculpture showed various attitudes and aspects in one single figure to one walking round it, that for this reason it surpassed painting, which only showed one side of a figure. Giorgione was of the opinion that there could be shown in a painted scene, without any necessity for walking round, at one single glance, all the various aspects that a man can present in many gestures – a thing which sculpture cannot do without a change of position and point of view, so that in her case the points of view are many, and not one. Moreover, he proposed to show in one single painted figure the front, the back, and the profile on either side, a challenge which brought them to their senses; and he did it in the following way. He painted a naked man with his back turned, at whose feet was a most limpid pool of water, wherein he painted the reflection of the man's front. At one side was a burnished cuirass that he had taken off, which showed his left profile, since everything could be seen on the polished surface of the piece of armour; and on the other side was a mirror, which reflected the other profile of the naked figure; which was a thing of most beautiful and bizarre fancy, whereby he sought to prove that painting does in fact, with more excellence, labour, and effect, achieve more at one single view of a living figure than does sculpture. And this work was greatly extolled and admired, as something ingenious and beautiful.

He also made a portrait from life of Caterina, Queen of Cyprus, which I once saw in the hands of the illustrious Messer Giovanni Cornaro. There is in our book a head coloured in oils, the portrait of a German of the Fugger family, who was at that time one of the chief merchants in the Fondaco de' Tedeschi, which is an admirable work; together with other sketches and drawings made by him with the pen.

While Giorgione was employed in doing honour both to himself and to his country, and frequenting many houses in order to entertain his various friends with his music, he became enamoured of a lady, and they took much joy, one with another, in their love. Now it happened that in the year 1511 she became infected with plague, without, however, knowing anything about it; and Giorgione, visiting her as usual, caught the plague in such a manner, that in a short time, at the age of thirty-four, he passed away to the other life, not without infinite grief on the part of his many friends, who loved him for his virtues, and great hurt to the world, which thus lost him. However, they could bear up against this hurt and loss, in that he left behind him two excellent disciples in Sebastiano, the Venetian, who afterwards became Friar of the Piombo* at Rome, and Tiziano da Cadore, who not only equalled him, but surpassed him greatly; of both of whom we will speak at the proper time, describing fully the honour and benefit that they have conferred on art.

ANTONIO DA CORREGGIO, Painter

I DO not wish to leave that country wherein our great mother Nature, in order not to be thought partial, gave to the world extraordinary men of that sort with which she had already for many and many a year adorned Tuscany; among whom was one endowed with an excellent and very beautiful genius, by name Antonio da Correggio, a most rare painter, who acquired the modern manner so perfectly, that in a few years, what with his natural gifts and his practice in art, he became a most excellent and marvellous craftsman. He was very timid by nature, and with great discomfort to himself he was continually labouring at the exercise of his art, for the sake of his family, which weighed upon him; and although it was a natural goodness that impelled him, nevertheless he afflicted himself more than was right in bearing the burden of those sufferings which are wont to crush mankind. He was very melancholy in his practice of art, a slave to her labours, and an unwearying investigator of all the difficulties of

* Signet-office, for the sealing of Papal Bulls and other papers of the Papal Court.

her realm; to which witness is borne by a vast multitude of figures in the Duomo of Parma, executed in fresco and well finished, which are to be found in the great tribune of the said church, and are seen foreshortened from below with an effect of marvellous grandeur.

Antonio was the first who began to work in the modern manner in Lombardy; wherefore it is thought that if he, with his genius, had gone forth from Lombardy and lived in Rome, he would have wrought miracles, and would have brought the sweat to the brow of many who were held to be great men in his time. For, his works being such as they are without his having seen any of the ancient or the best of the modern, it necessarily follows that, if he had seen them, he would have vastly improved his own, and, advancing from good to better, would have reached the highest rank. It may, at least, be held for certain that no one ever handled colours better than he, and that no craftsman ever painted with greater delicacy or with more relief, such was the softness of his flesh-painting, and such the grace with which he finished his works.

In the same place, also, he painted two large pictures executed in oils, in one of which, among other figures, there may be seen a Dead Christ, which was highly extolled. And in S. Giovanni, in the same city, he painted a tribune in fresco, wherein he represented Our Lady ascending into Heaven amidst a multitude of angels, with other saints around; as to which, it seems impossible that he should have been able, I do not say to express it with his hand, but even to conceive it in his imagination, so beautiful are the curves of the draperies and the expressions that he gave to those figures. Of these there are some drawings in our book, done in red chalk by his hand, with some very beautiful borders of little boys, and other borders drawn in that work by way of ornament, with various fanciful scenes of sacrifices in the ancient manner. And in truth, if Antonio had not brought his works to that perfection which is seen in them, his drawings (although they show excellence of manner, and the charm and practised touch of a master) would not have gained for him among craftsmen the name that he has won with his wonderful paintings. This art is so difficult, and has so many branches, that very often a craftsman is not able to practise them all to perfection; for there have been many who have drawn divinely well, but have shown some imperfection in colouring, and others have been marvellous in

colouring, but have not drawn half so well. All this depends on choice, and on the practice bestowed, in youth, in one case on drawing, in another on colour. But since all is learnt in order to carry works to the height of perfection, which is to put good colouring, together with draughtsmanship, into everything that is executed, for this reason Correggio deserves great praise, having attained to the height of perfection in the works that he coloured either in oils or in fresco; as he did in the Church of the Frati de' Zoccoli di S. Francesco, in the same city, where he painted an Annunciation in fresco so well, that, when it became necessary to pull it down in making some changes in that building, those friars caused the wall round it to be bound with timber strengthened with iron, and, cutting it away little by little, they saved it; and it was built by them into a more secure place in the same convent.

He painted, also, over one of the gates of that city, a Madonna who has the Child in her arms; and it is an astounding thing to see the lovely colouring of this work in fresco, through which he has won from passing strangers, who have seen nothing else of his, infinite praise and honour. For S. Antonio, likewise in that city, he painted a panel wherein is a Madonna, with S. Mary Magdalene; and near them is a boy in the guise of a little angel, holding a book in his hand, who is smiling, with a smile that seems so natural that he moves whoever beholds him to smile also, nor can any person, be his nature ever so melancholy, see him without being cheered. There is also a S. Jerome; and the whole work is coloured in a manner so wonderful and so astounding, that painters revere it for the marvel of its colouring, and it is scarcely possible to paint better.

In like manner, he executed square pictures and other paintings for many lords throughout Lombardy; and, among other works, two pictures in Mantua for Duke Federigo II, to be sent to the Emperor, a gift truly worthy of such a Prince. Giulio Romano, seeing these works, said that he had never seen any colouring that attained to such perfection. One was a naked Leda, and the other a Venus; both so soft in colouring, with the shadows of the flesh so well wrought, that they appeared to be not colours, but flesh. In one there was a marvellous landscape, nor was there ever a Lombard who painted such things better than he; and, besides this, hair so lovely in colour, and executed in detail with such exquisite finish, that it is not possible to see anything better. There were also certain Loves, executed with

beautiful art, who were making trial of their arrows, some of gold and some of lead, on a stone; and what lent most grace to the Venus was a clear and limpid stream, which ran among some stones and bathed her feet, but scarcely concealed any part of them, so that the sight of their delicate whiteness was a moving thing for the eye to behold. For which reason Antonio most certainly deserved all praise and honour during his lifetime, and the greatest glory from the lips and pens of men after his death.

In Modena, also, he painted a panel-picture of Our Lady, which is held in esteem by all painters, as the best picture in that city. In Bologna, likewise, in the house of the Ercolani, gentlemen of that city, there is a work by his hand, a Christ appearing to Mary Magdalene in the Garden, which is very beautiful. In Reggio there was a rare and most beautiful picture; and not long since, Messer Luciano Pallavigino, who takes much delight in noble paintings, passing through the city and seeing it, gave no thought to the cost, and, as if he had bought a jewel, sent it to his house in Genoa. At Reggio, likewise, is a panel containing a Nativity of Christ, wherein the splendour radiating from Him throws its light on the shepherds and all around on the figures that are contemplating Him; and among the many conceptions shown in that subject, there is a woman who, wishing to gaze intently at Christ, and not being able with her mortal sight to bear the light of His Divinity, which seems to be beating upon her with its rays, places a hand before her eyes; which is expressed so well that it is a marvel. Over the hut is a choir of angels singing, who are so well executed, that they appear rather to have rained down from Heaven than to have been made by the hand of a painter. And in the same city there is a little picture, a foot square, the rarest and most beautiful work that is to be seen by his hand, of Christ in the Garden, representing an effect of night, and painted with little figures; wherein the Angel, appearing to Christ, illumines Him with the splendour of his light, with such truth to nature, that nothing better can be imagined or expressed. Below, on a plain at the foot of the mountain, are seen the three Apostles sleeping, over whom the mountain on which Christ is praying casts a shadow, giving those figures a force which one is not able to describe. Far in the background, over a distant landscape, there is shown the appearing of the dawn; and on one side are seen coming some soldiers, with Judas. And although it is so small,

this scene is so well conceived, that there is no work of the same kind to equal it either in patience or in study.

Many things might be said of the works of this master; but since, among the eminent men of our art, everything that is to be seen by his hand is admired as something divine, I will say no more. I have used all possible diligence in order to obtain his portrait, but, since he himself did not make it, and he was never portrayed by others, for he always lived in retirement, I have not been able to find one. He was, in truth, a person who had no opinion of himself, nor did he believe himself to be an able master of his art, contrasting his deficiencies with that perfection which he would have liked to achieve. He was contented with little, and he lived like an excellent Christian.

Antonio, like a man who was weighed down by his family, was anxious to be always saving, and he had thereby become as miserly as he could well be. Wherefore it is related that, having received at Parma a payment of sixty crowns in copper coins, and wishing to take them to Correggio to meet some demand, he placed the money on his back and set out to walk on foot; but, being smitten by the heat of the sun, which was very great, and drinking water to refresh himself, he was seized by pleurisy, and had to take to his bed in a raging fever, nor did he ever raise his head from it, but finished the course of his life at the age of forty, or thereabout.

His pictures date about 1512; and he bestowed a very great gift on painting by his handling of colours, which was that of a true master; and it was by means of him that men's eyes were opened in Lombardy, where so many beautiful intellects have been seen in painting, following him in making works worthy of praise and memory. Thus, by showing them his treatment of hair, executed with such facility, for all the difficulty of painting it, he taught them how it should be painted; for which all painters owe him an everlasting debt. At their instance the following epigram was written to him by Messer Fabio Segni, a gentleman of Florence:

> Hujus cum regeret mortales spiritus artus
> Pictoris, Charites supplicuere Jovi.
> Non alia pingi dextra, Pater alme, rogamus;
> Hunc præter, nulli pingere nos liceat.
> Annuit his votis summi regnator Olympi,
> Et juvenem subito sidera ad alta tulit,

Ut posset melius Charitum simulacra referre
Præsens, et nudas cerneret inde Deas.

At this same time lived Andrea del Gobbo of Milan, a very
pleasing painter and colourist, many of whose works are scattered
about in the houses of his native city of Milan. There is a large
panel-picture of the Assumption of Our Lady, by his hand, in the
Certosa of Pavia, but it was left unfinished, on account of death
overtaking him; which panel shows how excellent he was, and
how great a lover of the labours of art.

PIERO DI COSIMO, Painter of Florence

WHILE Giorgione and Correggio, to their own great credit and
glory, were honouring the regions of Lombardy, Tuscany, on her
part, was not wanting in men of beautiful intellect; among whom,
not one of the least was Piero, the son of one Lorenzo, a gold-
smith, and a pupil of Cosimo Rosselli, after whom he was always
called Piero di Cosimo, and known by no other name. And in
truth, when a man teaches us excellence and gives us the secret
of living rightly, he deserves no less gratitude from us, and should
be held no less as a true father, than he who begets us and gives
us life and nothing more.

Piero was entrusted by his father, who saw in his son a lively
intelligence and an inclination to the art of design, to the care of
Cosimo, who took him with no ordinary willingness; and seeing
him grow no less in ability than in years, among the many dis-
ciples that he had, he bore him love as to a son, and always held
him as such. This young man had by nature a most lofty spirit,
and he was very strange, and different in fancy from the other
youths who were working with Cosimo in order to learn the same
art. He was at times so intent on what he was doing, that when
some subject was being discussed, as often happens, at the end
of the discussion it was necessary to go back to the beginning
and tell him the whole, so far had his brain wandered after some
other fancy of his own. And he was likewise so great a lover of
solitude, that he knew no pleasure save that of going off by
himself with his thoughts, letting his fancy roam and building his
castles in the air. Right good reason had Cosimo, his master, for

wishing him well, seeing that he made so much use of him in his works, that very often he caused him to execute things of great importance, knowing that Piero had a more beautiful manner, as well as better judgment, than himself. For this reason he took Piero with him to Rome, when he was summoned thither by Pope Sixtus in order to paint the scenes in his chapel; in one of which Piero executed a very beautiful landscape, as was related in the Life of Cosimo.

And since Piero drew most excellently from the life, he made in Rome many portraits of distinguished persons; in particular, those of Virginio Orsino and Ruberto Sanseverino, which he placed in the aforesaid scenes. Afterwards, also, he made a portrait of Duke Valentino, the son of Pope Alexander VI; which painting, to my knowledge, is not now to be found; but the cartoon by his hand still exists, being in the possession of the reverend and cultured M. Cosimo Bartoli, Provost of S. Giovanni. In Florence, he painted many pictures for a number of citizens, which are dispersed among their various houses, and of such I have seen some that are very good; and so, also, various things for many other persons. In the Noviciate of S. Marco is a picture by his hand of Our Lady, standing, with the Child in her arms, coloured in oils. And for the Chapel of Gino Capponi, in the Church of S. Spirito at Florence, he painted a panel wherein is the Visitation of Our Lady, with S. Nicholas, and a S. Anthony who is reading with a pair of spectacles on his nose, a very spirited figure. Here he counterfeited a book bound in parchment, somewhat old, which seems to be real, and also some balls that he gave to the S. Nicholas, shining and casting gleams of light and reflections from one to another; from which even by that time men could perceive the strangeness of his brain, and his constant seeking after difficulties.

Even better did he show this after the death of Cosimo, when he kept himself constantly shut up, and would not let himself be seen at work, leading the life of a man who was less man than beast. He would never have his rooms swept, he would only eat when hunger came to him, and he would not let his garden be worked or his fruit-trees pruned; nay, he allowed his vines to grow, and the shoots to trail over the ground, nor were his fig-trees ever trimmed, or any other trees, for it pleased him to see everything wild, like his own nature; and he declared that Nature's own things should be left to her to look after, without

lifting a hand to them. He set himself often to observe such animals, plants, or other things as Nature at times creates out of caprice, or by chance; in which he found a pleasure and satisfaction that drove him quite out of his mind with delight; and he spoke of them so often in his discourse, that at times, although he found pleasure in them, it became wearisome to others. He would sometimes stop to gaze at a wall against which sick people had been for a long time discharging their spittle, and from this he would picture to himself battles of horsemen, and the most fantastic cities and widest landscapes that were ever seen; and he did the same with the clouds in the sky.

He gave his attention to colouring in oils, having seen some works of Leonardo's, executed with that gradation of colour, and finished with that extraordinary diligence, which Leonardo used to employ when he wished to display his art. And so Piero, being pleased with his method, sought to imitate it, although he was afterwards very distant from Leonardo, and worlds away from any other manner. It may be said, in truth, that he changed his manner almost for every work that he executed.

If Piero had not been so solitary, and had taken more care of himself in his way of living than he did, he would have made known the greatness of his intellect in such a way that he would have been revered, whereas, by reason of his uncouth ways, he was rather held to be a madman, although in the end he did no harm save to himself alone, while his works were beneficial and useful to his art. For which reason every good intellect and every excellent craftsman should always be taught, from such an example, to keep his eyes on the end of life.

Nor will I refrain from saying that Piero, in his youth, being fanciful and extravagant in invention, was much employed for the masquerades that are held during the Carnival; and he became very dear to the young noblemen of Florence, having improved their festivals much in invention, adornment, grandeur, and pomp. As to that kind of pastime, it is said that he was one of the first to contrive to marshal them in the form of triumphal processions; at least, he improved them greatly, by accompanying the invention of the story represented, not only with music and with words suited to the subject, but also with a train of incredible pomp, formed of men on foot and on horseback, with habits and ornaments in keeping with the story; which produced a very rich and beautiful effect, and had in it something both

grand and ingenious. And it was certainly a very beautiful thing
to see, by night, twenty-five or thirty pairs of horses, most richly
caparisoned, with their riders in costume, according to the subject
of the invention, and six or eight grooms to each rider, with
torches in their hands, and all clothed in one and the same livery,
sometimes more than four hundred in number; and then the
chariot, or triumphal car, covered with ornaments, trophies, and
most bizarre things of fancy; altogether, a thing which makes
men's intellects more subtle, and gives great pleasure and satis-
faction to the people.

Among these spectacles, which were numerous and ingenious,
it is my pleasure to give a brief description of one, which was
contrived mostly by Piero, when he was already of a mature age,
and which was not, like many, pleasing through its beauty, but,
on the contrary, on account of a strange, horrible, and unex-
pected invention, gave no little satisfaction to the people: for
even as in the matter of food bitter things sometimes give mar-
vellous delight to the human palate, so do horrible things in such
pastimes, if only they be carried out with judgment and art; which
is evident in the representation of tragedies. This was the Car of
Death, wrought by him with the greatest secrecy in the Sala del
Papa, so that nothing could ever be found out about it, until it
was seen and known at one and the same moment. This trium-
phal chariot was an enormous car drawn by buffaloes, black all
over and painted with skeletons and white crosses; and upon the
highest point of the car stood a colossal figure of Death, scythe
in hand, and right round the car were a number of covered
tombs; and at all the places where the procession halted for the
chanting of dirges, these tombs opened, and from them issued
figures draped in black cloth, upon which were painted all the
bones of a skeleton, over their arms, breasts, flanks, and legs;
which, what with the white over the black, and the appearing in
the distance of some figures carrying torches, with masks that
represented a death's head both in front and behind, as well as
the neck, not only gave an appearance of the greatest reality, but
was also horrible and terrifying to behold. And these figures of
the dead, at the sound of certain muffled trumpets, low and
mournful in tone, came half out of their tombs, and, seating
themselves upon them, sang to music full of melancholy that
song so celebrated at the present day: 'Dolor, pianto, e peniten-
zia.' Before and after the car came a great number of the dead,

riding on certain horses picked out with the greatest diligence from among the leanest and most meagre that could be found, with black caparisons covered with white crosses; and each had four grooms draped in the garb of death, with black torches, and a large black standard with crosses, bones, and death's heads. After the car were trailed ten black standards; and as they walked, the whole company sang in unison, with trembling voices, that Psalm of David that is called the Miserere.

This dread spectacle, through its novelty and terror, as I have said, filled the whole city with fear and marvel together; and although at the first sight it did not seem suited to a Carnival, nevertheless, being new and very well arranged, it pleased the minds of all, and Piero, the creator and inventor of the whole, gained consummate praise and commendation for it; and it was the reason that afterwards, going from one thing to another, men continued to contrive lively and ingenious inventions, so that in truth, for such representations and for holding similar festivals, this city has never had an equal. And in those old men who saw it there still remains a vivid memory of it, nor are they ever weary of celebrating this fantastic invention. I have heard from the lips of Andrea di Cosimo, who helped him to carry out the work, and of Andrea del Sarto, who was Piero's disciple, and who also had a hand in it, that it was a common opinion at that time that this invention was intended to foreshadow the return of the Medici family to Florence in the year 1512, since at the time when the procession was held they were exiles, and, so to speak, dead, but destined in a short time to come to life; and in this sense were interpreted the following words in the song –

> Morti siam come vedete,
> Così morti vedrem voi;
> Fummo già come voi siete,
> Voi sarete come noi, etc.

whereby men wished to signify the return of that family (a resurrection, as it were, from death to life), and the expulsion and abasement of their enemies; or it may have been that many gave it that significance from the subsequent fact of the return of that illustrious house to Florence – so prone is the human intellect to applying every word and act that has come previously, to the events that happen afterwards. Certain it is that this was the opinion of many at that time; and it was much spoken of.

But to return to the art and actions of Piero; he was given the commission for a panel in the Church of the Servite Friars, in the Chapel of the Tedaldi, where they keep the garment and the pillow of S. Filippo, a brother of their Order; wherein he depicted Our Lady standing, raised from the ground on a pedestal, and uplifting her head towards Heaven, with a book in her hand, but without her Son; and above her is the Holy Spirit, bathing her with light. Nor did he wish that any other light than that of the Dove should illumine her and the figures that are round her, such as a S. Margaret and a S. Catherine, who are on their knees, adoring her, while S. Peter and S. John the Evangelist are standing, contemplating her, together with S. Filippo, the Servite Friar, and S. Antonino, Archbishop of Florence. Moreover, he made there a landscape that is very bizarre, what with the strange trees and certain grottoes. And in truth, there are some very beautiful things in this work, such as certain heads that reveal both draughtsmanship and grace; besides the colouring, which is very harmonious, for it is certain that Piero was a great master of colouring in oils. In the predella he painted some little scenes, very well executed; and, among others, there is one of S. Margaret issuing from the belly of the Dragon, wherein he made that animal so monstrous and hideous, that I do not think that there is anything better of that kind to be seen, for with its eyes it reveals venom, fire, and death, in an aspect truly terrifying. And certainly, as for such things, I do not believe that any one ever did them better than he, or came near him in imagining them; to which witness is borne by a marine monster that he made and presented to the Magnificent Giuliano de' Medici, which is so extravagant, bizarre, and fantastic in its deformity, that it seems impossible that Nature should produce anything so deformed and strange among her creations. This monster is now in the guardaroba of Duke Cosimo de' Medici, as is also a book, likewise by the hand of Piero, of animals of the same kind, most beautiful and bizarre, hatched very diligently with the pen, and finished with an incredible patience; which book was presented to him by M. Cosimo Bartoli, Provost of S. Giovanni, who is very much my friend, as he is of all our craftsmen, being a man who has always delighted, and still delights, in our profession.

He also executed, round a chamber in the house of Francesco del Pugliese, various scenes with little figures; nor is it possible to describe the different fantastic things that he delighted to paint in

all those scenes, what with the buildings, the animals, the costumes, the various instruments, and any other fanciful things that came into his head, since the stories were drawn from fables. These scenes, after the death of Francesco del Pugliese and his sons, were taken away, nor do I know what has become of them; and the same thing has happened to a picture of Mars and Venus, with her Loves and Vulcan, executed with great art and with an incredible patience.

Piero painted, for the elder Filippo Strozzi, a picture with little figures of Perseus delivering Andromeda from the Monster, in which are some very beautiful things. It is now in the house of Signor Sforza Almeni, First Chamberlain to Duke Cosimo, having been presented to him by Messer Giovanni Battista, the son of Lorenzo Strozzi, who knew how much that nobleman delighted in painting and sculpture; and he holds it in great account, for Piero never made a more lovely or more highly finished picture than this one, seeing that it is not possible to find a more bizarre or more fantastic sea-monster than that which Piero imagined and painted, or a fiercer attitude than that of Perseus, who is raising his sword in the air to smite the beast. In it, trembling between fear and hope, Andromeda is seen bound, most beautiful in countenance; and in the foreground are many people in various strange costumes, playing instruments and singing; among whom are some heads, smiling and rejoicing at seeing the deliverance of Andromeda, that are divine. The landscape is very beautiful, and the colouring sweet and full of grace. In short, with regard to the harmony and gradation of the colours, he executed this work with the greatest possible diligence.

He painted, also, a picture containing a nude Venus, with a Mars, likewise nude, who is sleeping in a meadow full of flowers, and all around are various Loves, who are carrying away, some here, some there, the helmet, armlets, and other pieces of armour of Mars; there is a grove of myrtle, with a Cupid that is afraid of a rabbit, and there are also the Doves of Venus and the other emblems of Love. This picture is at Florence, in the house of Giorgio Vasari, who keeps it in memory of that master, whose caprices have always pleased him.

The Director of the Hospital of the Innocenti was much the friend of Piero; and wishing to have a panel painted, which was to be placed in the Pugliese Chapel, near the entrance into the church, on the left hand, he gave the commission for it to Piero,

who brought it to completion at his leisure; but first he reduced his patron to despair, for on no account would he let him see it until it was finished. How strange this seemed to the patron, both because of their friendship, and because of his supplying Piero continually with money, without seeing what was being done, he himself showed, when, on the occasion of the final payment, he refused to give it to him without seeing the work. But, on Piero threatening that he would destroy all that he had painted, he was forced to give him the rest, and to wait patiently, in a greater rage than ever, for it to be set in place. This picture contains much that is truly beautiful.

He undertook to paint a panel for a chapel in the Church of S. Piero Gattolini, and in this he represented Our Lady seated, with four figures round her, and two angels in the sky, who are crowning her; which work, executed with such diligence that it brought him praise and honour, is now to be seen in S. Friano, the other church having been ruined. For the tramezzo* of the Church of S. Francesco, at Fiesole, he painted a little panel-picture of the Conception, which is a passing good little work, the figures being of no great size. For Giovanni Vespucci, who lived in a house now belonging to Piero Salviati, opposite to S. Michele, in the Via de' Servi, he executed some bacchanalian scenes, which are round an apartment; wherein he made such strange fauns, satyrs, sylvan gods, little boys, and bacchanals, that it is a marvel to see the diversity of the bay horses and garments, and the variety of the goatlike features, and all with great grace and most vivid truth to nature. In one scene is Silenus riding on an ass, with many children, some supporting him, and some giving him drink; and throughout the whole is a feeling of the joy of life, produced by the great genius of Piero. And in truth, in all that there is to be seen by his hand, one recognizes a spirit very different and far distant from that of other painters, and a certain subtlety in the investigation of some of the deepest and most subtle secrets of Nature, without grudging time or labour, but only for his own delight and for his pleasure in the art. And it could not well be otherwise; since, having grown enamoured of her, he cared nothing for his own comfort, and reduced himself to eating nothing but boiled eggs, which, in order to save firing,

* See note on p.90.

he cooked when he was boiling his glue, and not six or eight at a time, but in fifties; and, keeping them in a basket, he would eat them one by one. In this life he found such peculiar pleasure that any other, in comparison with his own, seemed to him slavery. He could not bear the crying of children, the coughing of men, the sound of bells, and the chanting of friars; and when the rain was pouring in torrents from the sky, it pleased him to see it streaming straight down from the roofs and splashing on the ground. He had the greatest terror of lightning; and, when he heard very loud thunder, he wrapped himself in his mantle, and, having closed the windows and the door of the room, he crouched in a corner until the storm should pass. He was very varied and original in his discourse, and sometimes said such beautiful things, that he made his hearers burst with laughter. But when he was old, and near the age of eighty, he had become so strange and eccentric that nothing could be done with him. He would not have assistants standing round him, so that his misanthropy had robbed him of all possible aid. He was sometimes seized by a desire to work, but was not able, by reason of the palsy, and fell into such a rage that he tried to force his hands to labour; but, as he muttered to himself, the mahl-stick fell from his grasp, and even his brushes, so that it was pitiable to behold. Flies enraged him, and even shadows annoyed him. And so, having become ill through old age, he was visited by one or two friends, who besought him to make his peace with God; but he would not believe that he was dying, and put them off from one day to another; not that he was hard of heart, or an unbeliever, for he was a most zealous Christian, although his life was that of a beast. He discoursed at times on the torments of those ills that destroy men's bodies, and of the suffering endured by those who come to die with their strength wasting away little by little, which he called a great affliction. He spoke evil of physicians, apothecaries, and those who nurse the sick, saying that they cause them to die of hunger; besides the tortures of syrups, medicines, clysters, and other martyrdoms, such as not being allowed to sleep when you are drowsy, making your will, seeing your relatives round you, and staying in a dark room. He praised death by the hand of justice, saying that it was a fine thing to go to your death in that way; to see the broad sky about you, and all that throng; to be comforted with sweetmeats and with kind words; to have the priest and the people praying for you; and to go into Paradise

with the Angels; so that whoever departed from this life at one blow, was very fortunate. And as he discoursed, he would twist everything to the strangest meanings that were ever heard. Wherefore, living in such strange fashion, he reduced himself to such a state with his extravagant fancies, that one morning he was found dead at the foot of a staircase, in the year 1521; and he was given burial in S. Piero Maggiore.

His disciples were many, and one among them was Andrea del Sarto, who was a host in himself. Piero's portrait I received from Francesco da San Gallo, who was much his friend and intimate companion, and who made it when Piero was old; which Francesco still has a work by the hand of Piero that I must not pass by, a very beautiful head of Cleopatra, with an asp wound round her neck, and two portraits, one of his father Giuliano, and the other of his grandfather Francesco Giamberti, which seem to be alive.

BRAMANTE DA URBINO, Architect

OF very great advantage to architecture, in truth, was the new method of Filippo Brunelleschi, who imitated and restored to the light, after many ages, the noble works of the most learned and marvellous ancients. But no less useful to our age was Bramante, in following the footsteps of Filippo, and making the path of his profession of architecture secure for all who came after him, by means of his courage, boldness, intellect, and science in that art, wherein he had the mastery not of theory only, but of supreme skill and practice. Nor could nature have created a more vigorous intellect, or one to exercise his art and carry it into execution with greater invention and proportion, or with a more thorough knowledge, than Bramante. But no less essential than all this was the election to the Pontificate, at that time, of Julius II, a Pope of great spirit, full of desire to leave memorials behind him. And it was fortunate both for us and for Bramante that he found such a Prince (a thing which rarely happens to men of great genius), at whose expense he might be able to display the worth of his intellect, and that mastery over difficulties which he showed in architecture. His ability was so universal in the buildings that he erected, that the outlines of the cornices, the shafts of the columns, the graceful capitals, the bases, the consoles and corners,

the vaults, the staircases, the projections, and every detail of every
Order of architecture, contrived from the counsel or model of
this craftsman, never failed to astonish all who saw them. Where-
fore it appears to me that the everlasting gratitude which is due
to the ancients from the intellects that study their works, is also
due from them to the labours of Bramante; for if the Greeks
were the inventors of architecture, and the Romans their imi-
tators, Bramante not only imitated what he saw, with new
invention, and taught it to us, but also added very great beauty
and elaboration to the art, which we see embellished by him at
the present day.

He was born at Castel Durante, in the State of Urbino, of
poor but honest parentage. In his boyhood, besides reading and
writing, he gave much attention to arithmetic; but his father, who
had need that he should earn money, perceiving that he delighted
much in drawing, applied him, when still a mere boy, to the art
of painting; whereupon Bramante gave much study to the works
of Fra Bartolommeo, otherwise called Fra Carnovale da Urbino,
who painted the panel-picture of S. Maria della Bella at
Urbino. But since he always delighted in architecture and pers-
pective, he departed from Castel Durante, and made his way to
Lombardy, where he went now to one city, and now to another,
working as best he could, but not on things of great cost or much
credit, having as yet neither name nor reputation. For this reason
he determined at least to see some noteworthy work, and betook
himself to Milan, in order to see the Duomo. In that city there
was then living one Cesare Cesariano, reputed to be a good
geometrician and an able architect, who wrote a commentary on
Vitruvius, and, out of despair at not having received for this the
remuneration that he had expected, became so strange that he
would work no more; and, having grown almost savage, he died
more like a beast than like a human being. There was also one
Bernardino da Trevio, a Milanese, engineer and architect for the
Duomo, and an excellent draughtsman, who was held by
Leonardo da Vinci to be a rare master, although his manner was
rather crude and somewhat hard in painting. By his hand is a
Resurrection of Christ to be seen at the upper end of the cloister
of the Grazie, with some very beautiful foreshortenings; and a
chapel in fresco in S. Francesco, containing the deaths of S. Peter
and S. Paul. He painted many other works in Milan, and he also
made a good number in the surrounding district, which are held

VITA DI BRAMANTE ARCHIT.

in esteem; and in our book there is a head of a very beautiful woman, in charcoal and lead-white, which still bears witness to the manner that he followed.

But to return to Bramante; having studied that building, and having come to know those engineers, he so took courage, that he resolved to devote himself wholly to architecture. Having therefore departed from Milan, he betook himself, just before the holy year of 1500, to Rome, where he was recognized by some friends, both from his own country and from Lombardy, and received a commission to paint, over the Porta Santa of S. Giovanni Laterano, which is opened for the Jubilee, the coat of arms of Pope Alexander VI, to be executed in fresco, with angels and other figures acting as supporters.

Bramante had brought some money from Lombardy, and he earned some more in Rome by executing certain works; and this he spent with the greatest economy, since he wished to be able to live independently, and at the same time, without having to work, to be free to take measurements, at his ease, of all the ancient buildings in Rome. And having put his hand to this, he set out, alone with his thoughts; and within no great space of time he had measured all the buildings in that city and in the Campagna without; and he went as far as Naples, and wherever he knew that there were antiquities. He measured all that was at Tivoli and in the Villa of Hadrian, and, as will be related afterwards in the proper place, made great use of it. The mind of Bramante becoming known in this way, the Cardinal of Naples, having noticed him, began to favour him. Whereupon, while Bramante was continuing his studies, the desire came to the said Cardinal to have the cloister of the Frati della Pace rebuilt in travertine, and he gave the charge of this cloister to Bramante, and he, desiring to earn money and to gain the good will of that Cardinal, set himself to work with all possible industry and diligence, and brought it quickly to perfect completion. And although it was not a work of perfect beauty, it gave him a very great name, since there were not many in Rome who followed the profession of architecture with such zeal, study, and resolution as Bramante.

At the beginning he served as under-architect to Pope Alexander VI for the fountain of Trastevere, and likewise for that which was made on the Piazza di S. Pietro. He also took part, together with other excellent architects, when his reputation had

increased, in the planning of a great part of the Palace of S. Giorgio, and of the Church of S. Lorenzo in Damaso, at the commission of Raffaello Riario, Cardinal of S. Giorgio, near the Campo di Fiore; which palace, whatever better work may have been executed afterwards, nevertheless was and still is held, on account of its greatness, to be a commodious and magnificent habitation; and the building of this edifice was carried out by one Antonio Montecavallo. Bramante was consulted with regard to the enlargement of S. Jacopo degli Spagnuoli, on the Piazza Navona, and likewise in the deliberations for the building of S. Maria de Anima, which was afterwards carried out by a German architect. From his design, also, was the Palace of Cardinal Adriano da Corneto in the Borgo Nuovo, which was built slowly, and then finally remained unfinished by reason of the flight of that Cardinal; and in like manner, the enlargement of the principal chapel of S. Maria del Popolo was executed from his design.

These works brought him so much credit in Rome, that he was considered the best architect, in that he was resolute, prompt, and most fertile in invention; and he was continually employed by all the great persons in that city for their most important undertakings. Wherefore, after Julius II had been elected Pope, in the year 1503, he entered into his service. The fancy had taken that Pontiff to so transform the space that lay between the Belvedere and the Papal Palace, as to give it the aspect of a square theatre, embracing a little valley that ran between the old Papal Palace and the new buildings that Innocent VIII had erected as a habitation for the Popes; and he intended, by means of two corridors, one on either side of this little valley, to make it possible to go from the Belvedere to the Palace under loggie, and also to go from the Palace to the Belvedere in the same way, and likewise, by means of various flights of steps, to ascend to the level of the Belvedere. Whereupon Bramante, who had very good judgment and an inventive genius in such matters, distributed two ranges of columns along the lowest part; first, a very beautiful Doric loggia, similar to the Colosseum of the Savelli (although, in place of half-columns, he used pilasters), and all built of travertine; and over this a second range of the Ionic Order, full of windows, of such a height as to come to the level of the first-floor rooms of the Papal Palace, and to the level of those of the Belvedere; intending to make, afterwards, a loggia more than four hundred paces long on the side towards Rome, and likewise

another on the side towards the wood, with which, one on either hand, he proposed to enclose the valley; into which, after it had been levelled, was to be brought all the water from the Belvedere; and for this a very beautiful fountain was to be made. Of this design, Bramante finished the first corridor, which issues from the Palace and leads to the Belvedere on the side towards Rome, except the upper loggia, which was to go above it. As for the opposite part, on the side towards the wood, the foundations, indeed, were laid, but it could not be finished, being interrupted by the death of Julius, and then by that of Bramante. His design was held to be so beautiful in invention, that it was believed that from the time of the ancients until that day, Rome had seen nothing better. But of the other corridor, as has been said, he left only the foundations, and the labour of finishing it has dragged on down to our own day, when Pius IV has brought it almost to completion.

Bramante also erected the head-wall of the Museum of ancient statues in the Belvedere, together with the range of niches; wherein were placed, in his life-time, the Laocoon, one of the rarest of ancient statues, the Apollo, and the Venus; and the rest of the statues were set up there afterwards by Leo X, such as the Tiber, the Nile, and the Cleopatra, with some others added by Clement VII; and in the time of Paul III and Julius III many important improvements were made, at great expense.

But to return to Bramante; he was very resolute, although he was hindered by the avarice of those who supplied him with the means to work, and he had a marvellous knowledge of the craft of building. This construction at the Belvedere was executed by him with extraordinary speed, and such was his eagerness as he worked, and that of the Pope, who would have liked to see the edifice spring up from the ground, without needing to be built, that the builders of the foundations brought the sand and the solid foundation-clay by night and let* it down by day in the presence of Bramante, who caused the foundations to be made without seeing anything more of the work. This inadvertence was the reason that all his buildings have cracked, and are in danger of falling down, as did this same corridor, of which a piece eighty braccia in length fell to the ground in the time of Clement VII,

* The word 'calavano' has been substituted here for the 'cavavano' of the text, which gives no sense.

and was afterwards rebuilt by Pope Paul III, who also had the foundations restored and the whole strengthened.

From his design, also, are many flights of steps in the Belvedere, varied according to their situations, whether high or low, in the Doric, Ionic, and Corinthian Orders – a very beautiful work, executed with extraordinary grace. And he had made a model for the whole, which is said to have been a marvellous thing, as may still be imagined from the beginning of the work, unfinished as it is. Moreover, he made a spiral staircase upon mounting columns, in such a way that one can ascend it on horseback; wherein the Doric passes into the Ionic, and the Ionic into the Corinthian, rising from one into the other; a work executed with supreme grace, and with truly excellent art, which does him no less honour than any other thing by his hand that is therein. This invention was copied by Bramante from S. Niccolò at Pisa, as was said in the Lives of Giovanni and Niccola of Pisa.

The fancy took Bramante to make, in a frieze on the outer façade of the Belvedere, some letters after the manner of ancient hieroglyphics, representing the name of the Pope and his own, in order to show his ingenuity: and he had begun thus, 'Julio II; Pont. Massimo,' having caused a head in profile of Julius Cæsar to be made, and a bridge, with two arches, which signified, 'Julio II, Pont.,' and an obelisk from the Circus Maximus, to represent 'Max.' At which the Pope laughed, and caused him to make the letters in the ancient manner, one braccio in height, which are there at the present day; saying that he had copied this folly from a door at Viterbo, over which one Maestro Francesco, an architect, had placed his name, carved in the architrave, and represented by a S. Francis (S. Francesco), an arch (arco), a roof (tetto), and a tower (torre), which, interpreted in his own way, denoted, 'Maestro Francesco Architettore.' The Pope, on account of his ability in architecture, was very well disposed towards him.

For these reasons he was rightly held worthy by the aforesaid Pope, who loved him very dearly for his great gifts, to be appointed to the Office of the Piombo, for which he made a machine for printing Bulls, with a very beautiful screw. In the service of that Pontiff Bramante went to Bologna, in the year 1504, when that city returned to the Church; and he occupied himself, throughout the whole war against Mirandola, on many ingenious things of the greatest importance. He made many

designs for ground-plans and complete buildings, which he drew very well; and of such there are some to be seen in our book, accurately drawn and executed with very great art. He taught many of the rules of architecture to Raffaello da Urbino; designing for him, for example, the buildings that Raffaello afterwards drew in perspective in that apartment of the Pope wherein there is Mount Parnassus; in which apartment he made a portrait of Bramante taking measurements with a pair of compasses.

The Pope resolved, having had the Strada Julia straightened out by Bramante, to place in it all the public offices and tribunals of Rome, on account of the convenience which this would bring to the merchants in their business, which up to that time had always been much hindered. Wherefore Bramante made a beginning with the palace that is to be seen by S. Biagio sul Tevere, wherein there is still an unfinished Corinthian temple, a thing of rare excellence. The rest of this beginning is in rustic work, and most beautiful; and it is a great pity that a work so honourable, useful, and magnificent, which is held by the masters of the profession to be the most beautiful example of design in that kind that has ever been seen, should not have been finished. He made, also, in the first cloister of S. Pietro a Montorio, a round temple of travertine, than which nothing more shapely or better conceived, whether in proportion, design, variety, or grace, could be imagined; and even more beautiful would it have been, if the whole extent of the cloister, which is not finished, had been brought to the form that is to be seen in a drawing by his hand. He directed the building, in the Borgo, of the palace which afterwards belonged to Raffaello da Urbino, executed with bricks and mould-castings, the columns and bosses being of the Doric Order and of rustic work – a very beautiful work – with a new invention in the making of these castings. He also made the design and preparations for the decoration of S. Maria at Loreto, which was afterwards continued by Andrea Sansovino; and an endless number of models for palaces and temples, which are in Rome and throughout the States of the Church.

So sublime was the intellect of this marvellous craftsman, that he made a vast design for restoring and rearranging the Papal Palace. And so greatly had his courage grown, on seeing the powers and desires of the Pope rise to the level of his own wishes and genius, that, hearing that he was minded to throw the Church of S. Pietro to the ground, in order to build it anew, he made

him an endless number of designs. And among those that he made was one that was very wonderful, wherein he showed the greatest possible judgment, with two bell-towers, one on either side of the façade, as we see it in the coins afterwards struck for Julius II and Leo X by Caradosso, a most excellent goldsmith, who had no peer in making dies, as may still be seen from the medal of Bramante, executed by him, which is very beautiful. And so, the Pope having resolved to make a beginning with the vast and sublime structure of S. Pietro, Bramante caused half of the old church to be pulled down, and put his hand to the work, with the intention that it should surpass, in beauty, art, invention, and design, as well as in grandeur, richness, and adornment, all the buildings that had been erected in that city by the power of the Commonwealth, and by the art and intellect of so many able masters; and with his usual promptness he laid the foundations, and carried the greater part of the building, before the death of the Pope and his own, to the height of the cornice, where are the arches to all the four piers; and these he turned with supreme expedition and art. He also executed the vaulting of the principal chapel, where the recess is, giving his attention at the same time to pressing on the building of the chapel that is called the Chapel of the King of France.

For this work he invented the method of casting vaults in wooden moulds, in such a manner that patterns of friezes and foliage, like carvings, come out in the plaster; and in the arches of this edifice he showed how they could be turned with flying scaffoldings, a method that we have since seen followed by Antonio da San Gallo. In the part that was finished by him, the cornice that runs right round the interior is seen to be so graceful, that no other man's hand could take away or alter anything from its design without spoiling it. It is evident from his capitals, which are of olive leaves within, and from all the Doric work on the outer side, which is extraordinarily beautiful, how sublime was the courage of Bramante, whereby, in truth, if he had possessed physical powers equal to the intellect that adorned his spirit, he would most certainly have achieved even more unexampled things than he did. This work, as will be related in the proper places, since his death and down to the present day, has been much mutilated by other architects, insomuch that it may be said that with the exception of four arches which support the tribune, nothing of his has remained there. For Raffaello da Urbino and

Giuliano da San Gallo, who carried on the work after the death of Julius II, together with Fra Giocondo of Verona, thought fit to begin to alter it; and after the death of those masters, Baldassarre Peruzzi, in building the Chapel of the King of France, in the transept on the side towards the Campo Santo, changed Bramante's design; and under Paul III Antonio da San Gallo changed it again entirely. Finally, Michelagnolo Buonarroti, sweeping away the countless opinions and superfluous expenses, has brought it to such beauty and perfection as not one of those others ever thought of, which all comes from his judgment and power of design; although he said to me several times that he was only the executor of the design and arrangements of Bramante, seeing that he who originally lays the foundations of a great edifice is its true creator. Vast, indeed, seemed the conception of Bramante in this work, and he gave it a very great beginning, which, even if he had begun on a smaller scale, neither San Gallo nor the others, nor even Buonarroti, would have had enough power of design to increase, although they were able to diminish it; so immense, stupendous, and magnificent was this edifice, and yet Bramante had conceived something even greater.

It is said that he was so eager to see this structure making progress, that he pulled down many beautiful things in S. Pietro, such as tombs of Popes, paintings, and mosaics, and that for this reason we have lost all trace of many portraits of distinguished persons, which were scattered throughout that church, which was the principal church of all Christendom. He preserved only the altar of S. Pietro, and the old tribune, round which he made a most beautiful ornament of the Doric Order, all of peperino-stone, to the end that when the Pope came to S. Pietro to say Mass, he might be able to stand within it with all his Court and with the Ambassadors of the Christian Princes; but death prevented him from finishing it entirely, and the Sienese Baldassarre afterwards brought it to completion.

Bramante was a very merry and pleasant person, ever delighting to help his neighbour. He was very much the friend of men of ability, and favoured them in whatever way he could; as may be seen from his kindness to the gracious Raffaello da Urbino, most celebrated of painters, whom he brought to Rome. He always lived in the greatest splendour, doing honour to himself; and in the rank to which his merits had raised him, what he possessed was nothing to what he would have been able to

spend. He delighted in poetry, and loved to improvise upon the lyre, or to hear others doing this: and he composed some sonnets, if not as polished as we now demand them, at least weighty and without faults. He was much esteemed by the prelates, and was received by an endless number of noblemen who made his acquaintance. In his lifetime he had very great renown, and even greater after his death, because of which the building of S. Pietro was interrupted for many years. He lived to the age of seventy, and he was borne to his tomb in Rome, with most honourable obsequies, by the Court of the Pope and by all the sculptors, architects, and painters. He was buried in S. Pietro, in the year 1514.

Very great was the loss that architecture suffered in the death of Bramante, who was the discoverer of many good methods wherewith he enriched that art, such as the invention of casting vaults, and the secret of stucco; both of which were known to the ancients, but had been lost until his time through the ruin of their buildings. And those who occupy themselves with measuring ancient works of architecture, find in the works of Bramante no less science and design than in any of the former; wherefore, among those who are versed in the profession, he can be accounted one of the rarest intellects that have adorned our age. He left behind him an intimate friend, Giuliano Leno, who had much to do with the buildings of his time, but was employed rather to make preparations and to carry out the wishes of whoever designed them, than to work on his own account, although he had judgment and great experience.

During his lifetime, Bramante employed in his works one Ventura, a carpenter of Pistoia, who was a man of very good ability, and drew passing well. This Ventura, while in Rome, delighted much in taking measurements of antiquities; and afterwards, wishing to live once more in his native place, he returned to Pistoia. Now it happened in that city, in the year 1509, that a Madonna, which is now called the Madonna della Umiltà, worked miracles; and since many offerings were brought to her, the Signoria that was then governing the city determined to build a temple in her honour. Whereupon Ventura, confronted with this opportunity, made with his own hand a model of an octagonal temple . . . * braccia in breadth and . . . braccia in height, with a

* These numbers are missing from the text.

vestibule or closed portico in front, very ornate within and truly beautiful. This having given satisfaction to the Signoria and to the chief men of the city, the building was begun according to the plans of Ventura, who, having laid the foundations of the vestibule and the temple, completely finished the vestibule, which he made very rich in pilasters and cornices of the Corinthian Order, with other carved stone-work; while all the vaults in that work were made in like manner, with squares surrounded by mouldings, also in stone, and filled with rosettes. Afterwards, the octagonal temple was also carried to the height of the last cornice, from which the vaulting of the tribune was to rise, during the lifetime of Ventura; and since he was not very experienced in works of that size, he did not consider how the weight of the tribune might be safely laid on the building, but made within the thickness of the wall, at the first range of windows, and at the second, where the others are, a passage that runs right round, whereby he contrived to weaken the walls so much, that, the edifice being without buttresses at the base, it was dangerous to raise a vault over it, and particularly on the angles at the corners, upon which all the weight of the vault of that tribune must rest. Wherefore, after the death of Ventura, there was no architect with courage enough to raise that vault: nay, they had caused long and stout beams of timber to be brought to the place, in order to make a tent-shaped roof; but this did not please the citizens, and they would not have it put into execution. And so the building remained for many years without a roof, until, in the year 1561, the Wardens of Works besought Duke Cosimo that his Excellency should so favour them as to cause that tribune to be vaulted. Whereupon, in order to meet their wishes, the Duke ordered Giorgio Vasari to go there and see whether he could find some method of vaulting it; and he, having done this, made a model raising the building to the height of eight braccia above the cornice that Ventura had left, in order to make buttresses for it; and he decreased the breadth of the passage that runs right round between the walls, and reinforced the building with buttresses, besides binding the corners and the parts below the passages that Ventura had made, between the windows, with stout keys of iron, double at the angles; which secured the whole in such a manner that the vault could be raised with safety. Whereupon his Excellency was pleased to visit the place, and, being satisfied with everything, gave orders for the work to be executed;

and so all the buttresses have been built, and a beginning has already been made with the raising of the cupola. Thus, then, the work of Ventura will become richer, greater in size and adornment, and better in proportions; but he truly deserves to have record made of him, since that building is the most noteworthy modern work in the city of Pistoia.

FRA BARTOLOMMEO DI SAN MARCO
[*BACCIO DELLA PORTA*],
Painter of Florence

NEAR the territory of Prato, which is ten miles distant from Florence, in a village called Savignano, was born Bartolommeo, known, according to the Tuscan custom, by the name of Baccio. He, having shown in his childhood not merely inclination, but also aptitude, for drawing, was placed, through the good services of Benedetto da Maiano, with Cosimo Rosselli, and lodged in the house of some relatives of his own, who lived at the Porta a S. Piero Gattolini; where he stayed for many years, so that he was never called or known by any other name than that of Baccio della Porta.

After taking his leave of Cosimo Rosselli, he began to study with great devotion the works of Leonardo da Vinci; and in a short time he made such proficience and such progress in colouring, that he acquired the name and reputation of being one of the best young men of his art, both in colouring and in drawing. He had a companion in Mariotto Albertinelli, who in a short time acquired his manner passing well; and together with him he executed many pictures of Our Lady, which are scattered throughout Florence. To speak of all these would take too long, and I will mention only some excellently painted by Baccio. There is one, containing a Madonna, in the house of Filippo di Averardo Salviati, which is most beautiful, and which he holds very dear and in great price. Another was bought not long since, at a sale of old furniture, by Pier Maria delle Pozze, a person greatly devoted to pictures, who, having recognized its beauty, will not let it go for any sum of money; in which work is a Madonna executed with extraordinary diligence. Piero del Pugliese had a little Madonna of marble, in very low relief, a very rare work by the hand of Donatello, for which, in order to do it

honour, he caused a wooden tabernacle to be made, with two little doors to enclose it. This he gave to Baccio della Porta, who painted, on the inner side of the doors, two little scenes, of which one was the Nativity of Christ, and the other His Circumcision; which Baccio executed with little figures after the manner of miniatures, in such a way that it would not be possible to do better work in oils; and then he painted Our Lady receiving the Annunciation from the Angel, in chiaroscuro, and likewise in oils, on the outer side of the same little doors, so as to be seen when they are closed. This work is now in the study of Duke Cosimo, wherein he keeps all his little antique figures of bronze, medals, and other rare pictures in miniature; and it is treasured by his most illustrious Excellency as a rare thing, as indeed it is.

Baccio was beloved in Florence for his virtues, for he was assiduous in his work, quiet and good by nature, and a truly God-fearing man; he had a great liking for a life of peace, and he shunned vicious company, delighted much in hearing sermons, and always sought the society of learned and serious persons. And in truth, it is seldom that nature creates a man of good parts and a gentle craftsman, without also providing him, after some time, with peace and favour, as she did for Baccio, who, as will be told below, obtained all that he desired. The report having spread abroad that he was no less good than able, his fame so increased that he was commissioned by Gerozzo di Monna Venna Dini to paint the chapel wherein the bones of the dead are kept, in the cemetery of the Hospital of S. Maria Nuova. There he began a Judgment in fresco, which he executed with such diligence and beauty of manner in the part which he finished, that he acquired extraordinary fame thereby, in addition to what he had already, and became greatly celebrated, on account of his having represented with excellent conceptions the Glory of Paradise, and Christ with the twelve Apostles judging the twelve Tribes, wherein the figures are soft in colouring and most beautifully draped. Moreover, in those figures that are being dragged to Hell, in the part that was designed but left unfinished, one sees the despair, grief, and shame of everlasting death, even as one perceives contentment and gladness in those that are being saved; although this work remained unfinished, since Baccio was inclined to give his attention more to religion than to painting. For there was living in S. Marco, at this time, Fra Girolamo Savonarola of Ferrara, of the Order of Preaching Friars, a very

famous theologian; and Baccio, going continually to hear his preaching, on account of the devotion that he felt for him, contracted a very strait intimacy with him, and passed almost all his time in the convent, having also become the friend of the other friars. Now it happened that Fra Girolamo, continuing his preaching, and crying out every day from the pulpit that lascivious pictures, music, and amorous books often lead the mind to evil, became convinced that it was not right to keep in houses where there were young girls painted figures of naked men and women. And at the next Carnival – when it was the custom in the city to make little huts of faggots and other kinds of wood on the public squares, and on the Tuesday evening, according to ancient use, to burn these, with amorous dances, in which men and women, joining hands, danced round these fires, singing certain airs – the people were so inflamed by Fra Girolamo, and he wrought upon them so strongly with his words, that on that day they brought to the place a vast quantity of nude figures, both in painting and in sculpture, many by the hand of excellent masters, and likewise books, lutes, and volumes of songs, which was a most grievous loss, particularly for painting. Thither Baccio carried all the drawings of nudes that he had made by way of studies, and he was followed by Lorenzo di Credi and by many others, who had the name of Piagnoni. And it was not long before Baccio, on account of the affection that he bore to Fra Girolamo, made a very beautiful portrait of him in a picture, which was then taken to Ferrara; but not long ago it came back to Florence, and it is now in the house of Filippo di Alamanno Salviati, who, since it is by the hand of Baccio, holds it very dear.

It happened, after this, that one day the opponents of Fra Girolamo rose against him, in order to take him and deliver him over to the hands of justice, on account of the disturbances that he had caused in the city; and his friends, seeing this, also banded themselves together, to the number of more than five hundred, and shut themselves up in S. Marco, and Baccio with them, on account of the great affection that he had for their party. It is true that, being a person of little courage, nay, even timorous and mean-spirited, and hearing an attack being made a little time after this on the convent, and men being wounded and killed, he began to have serious doubts about himself. For which reason he made a vow that if he were to escape from that turmoil, he would straightway assume the habit of that Order; which vow he carried

out afterwards most faithfully, for when the uproar had ceased, and Fra Girolamo had been taken and condemned to death, as the writers of history relate with more detail, Baccio betook himself to Prato and became a monk in S. Domenico, in that city, on July 26, in the year 1500, as is found written in the chronicles of that same convent in which he assumed the habit; to the great displeasure of all his friends, who were grieved beyond measure at having lost him, and particularly because they heard that he had taken it into his head to forsake his painting.

Whereupon Mariotto Albertinelli, his friend and companion, at the entreaties of Gerozzo Dini, took over the materials of Fra Bartolommeo – which was the name given by the Prior to Baccio, on investing him with the habit – and brought to completion the work of the Ossa in S. Maria Nuova; where he portrayed from life the Director of the Hospital at that time, and some friars skilled in surgery, with Gerozzo, the patron of the work, and his wife, full-length figures on their knees, upon the walls on either side; and in a nude figure that is seated, he portrayed Giuliano Bugiardini, his pupil, as a young man, with long locks according to the custom of that time, in which each separate hair might be counted, so carefully are they painted. He made there, likewise, his own portrait, in the head, with long locks, of a figure that is issuing from one of the tombs; and in that work, in the region of the blessed, there is also the portrait of Fra Giovanni da Fiesole, the painter, whose Life we have written. This painting was executed wholly in fresco, both by Fra Bartolommeo and by Mariotto, so that it has remained, and still remains, marvellously fresh, and is held in esteem by craftsmen, since it is scarcely possible to do better in that kind of work.

When Fra Bartolommeo had been many months in Prato, he was sent by his superiors to take up his abode in S. Marco at Florence, and on account of his virtues he was received very warmly by the friars of that convent. In those days Bernardo del Bianco had caused to be erected, in the Badia of Florence, a chapel of grey-stone, full of carving, and very rich and beautiful, from the design of Benedetto da Rovezzano: which chapel was and still is much esteemed on account of some ornamental work of great variety, wherein Benedetto Buglioni placed, in some niches, angels and other figures made of glazed terra-cotta, in the round, to adorn it the more, with friezes containing cherubs and the devices of Bianco. And Bernardo, wishing to set up in the

chapel a panel-picture that should be worthy of that adornment, and conceiving the idea that Fra Bartolommeo would be the right man for the work, sought in every possible way, through the intervention of his friends, to persuade him. Fra Bartolommeo was living in his convent, giving his attention to nothing save the divine offices and the duties of his Rule, although often besought by the Prior and by his dearest friends that he should work again at his painting; and for more than four years he had refused to touch a brush. But on this occasion, being pressed by Bernardo del Bianco, at length he began the panel-picture of S. Bernard, in which the Saint is writing, and gazing with such deep contemplation at the Madonna, with the Child in her arms, being borne by many angels and children, all coloured with great delicacy, that there is clearly perceived in him a certain celestial quality, I know not what, which seems, to him who studies it with attention, to shine out over that work, into which Baccio put much diligence and love; not to mention an arch executed in fresco, which is above it. He also made some pictures for Cardinal Giovanni de' Medici; and for Agnolo Doni he painted a picture of Our Lady, which stands on the altar of a chapel in his house – a work of extraordinary beauty.

At this time the painter Raffaelo da Urbino came to Florence to study his art, and taught the best principles of perspective to Fra Bartolommeo; and desiring to acquire the friar's manner of colouring, and being pleased with his handling of colours and his method of harmonizing them, Raffaello was always in his company. Fra Bartolommeo painted about the same time, in S. Marco at Florence, a panel with an infinite number of figures, which is now in the possession of the King of France, having been presented to him after being exposed to view for many months in S. Marco. Afterwards, he painted another in that convent, containing an endless number of figures, in place of the one that was sent into France; in which picture are some children who are flying in the air and holding open a canopy, executed with such good drawing and art, and with such strong relief, that they appear to stand out from the panel, while the colouring of the flesh reveals that beauty and excellence which every able craftsman seeks to give to his pictures; and this work is still considered at the present day to be most excellent. In it are many figures surrounding a Madonna, all most admirable, and executed with grace, feeling, boldness, spirit, and vivacity; and coloured,

moreover, in so striking a manner, that they seem to be in relief, since he wished to show that he was able not only to draw, but also to give his figures force and make them stand out by means of the darkness of the shadows, as may be seen in some children who are round a canopy, upholding it, who, as they fly through the air, almost project from the panel. Besides this, there is an Infant Christ who is marrying S. Catherine the Nun, than which it would not be possible to paint anything more lifelike with the dark colouring that he used. There is a circle of saints on one side diminishing in perspective, round the depth of a great recess, who are distributed with such fine design that they seem to be real; and the same may be seen on the other side. And in truth, in this manner of colouring, he imitated to a great extent the works of Leonardo; particularly in the darks, for which he used printer's smoke-black and the black of burnt ivory. This panel has now become much darker than it was when he painted it, on account of those blacks, which have kept growing heavier and darker. In the foreground, among the principal figures, he made a S. George in armour, who has a standard in his hand, a bold, spirited, and vivacious figure, in a beautiful attitude. There is also a S. Bartholomew, standing, a figure that deserves the highest praise; with two children who are playing, one on a lute, and the other on a lyre, one of whom he made with a leg drawn up and his instrument resting upon it, and with the hands touching the strings in the act of running over them, an ear intent on the harmony, the head upraised, and the mouth slightly open, in such a way that whoever beholds him cannot persuade himself that he should not also hear the voice. No less lifelike is the other, who, leaning on one side, and bending over with one ear to the lyre, appears to be listening to learn how far it is in accord with the sound of the lute and the voice, while, with his eyes fixed on the ground, and his ear turned intently towards his companion, who is playing and singing, he seeks to follow in harmony with the air. These conceptions and expressions are truly ingenious; the children, who are seated, and clothed in veiling, are marvellous and executed with great industry by the practised hand of Fra Bartolommeo; and the whole work is brought out into strong relief by a fine gradation of dark shadows.

A little time afterwards he painted another panel, to stand opposite to the former, and containing a Madonna surrounded by some saints, which is held to be a good work. He won

extraordinary praise for having introduced a method of blending the colouring of his figures in such a way as to add a marvellous degree of harmony to art, making them appear to be in relief and alive, and executing them with supreme perfection of manner.

Hearing much of the noble works made in Rome by Michelagnolo, and likewise those of the gracious Raffaello, and being roused by the fame, which was continually reaching him, of the marvels wrought by those two divine craftsmen, with leave from his Prior he betook himself to Rome. There he was entertained by Fra Mariano Fetti, Friar of the Piombo, for whom he painted two pictures of S. Peter and S. Paul at his Convent of S. Silvestro a Monte Cavallo. But since he did not succeed in working as well in the air of Rome as he had done in that of Florence, while the vast number of works that he saw, what with the ancient and the modern, bewildered him so that much of the ability and excellence that he believed himself to possess, fell away from him, he determined to depart, leaving to Raffaello the charge of finishing one of those pictures, that of S. Peter, which he had not completed; which picture was retouched all over by the hand of the marvellous Raffaello, and given to Fra Mariano.

Thus, then, Fra Bartolommeo returned to Florence. There he had been accused many times of not knowing how to paint nudes; for which reason he resolved to put himself to the test, and to show by means of his labour that he was as well fitted as any other master for the highest achievements of his art. Whereupon, to prove this, he painted a picture of S. Sebastian, naked, very lifelike in the colouring of the flesh, sweet in countenance, and likewise executed with corresponding beauty of person, whereby he won infinite praise from the craftsmen. It is said that, while this figure was exposed to view in the church, the friars found, through the confessional, women who had sinned at the sight of it, on account of the charm and melting beauty of the lifelike reality imparted to it by the genius of Fra Bartolommeo; for which reason they removed it from the church and placed it in the chapter-house, where it did not remain long before it was bought by Giovan Battista della Palla and sent to the King of France.

Fra Bartolommeo had fallen into a rage against the joiners who made the ornamental frames for his panels and pictures, for it was their custom, as it still is at the present day, always to cover an eighth part of the figures with the projecting inner edges of

the frames. He determined, therefore, to invent some means of doing without frames for panels; and for this S. Sebastian he caused the panel to be made in the form of a half-circle, wherein he drew a niche in perspective, which has the appearance of being carved in relief in the panel. Thus, painting a frame all round, he made an ornament for the figure in the middle; and he did the same for our S. Vincent, and for the S. Mark that will be described after the S. Vincent. For the arch of a door leading into the sacristy, he painted in oils, on wood, a figure of S. Vincent, a brother of that Order, representing him in the act of preaching on the Judgment, so that there may be perceived in his gestures, and particularly in his head, that vehemence and fury which are generally seen in the faces of preachers, when they are doing their utmost, with threats of the vengeance of God, to lead men hardened in sin into the perfect life; in such a manner that this figure appears, to one who studies it with attention, to be not painted but real and alive, with such strong relief is it executed; and it is a pity that it is all cracking and spoiling, on account of its having been painted with fresh coats of colour on fresh size, as I said of the works of Pietro Perugino in the Convent of the Ingesuati.

The fancy took him, in order to show that he was able to make large figures – for he had been told that his manner was that of a miniaturist – to paint on panel, for the wall in which is the door of the choir, a figure of S. Mark the Evangelist, five braccia in height, and executed with very good draughtsmanship and supreme excellence.

After this, Salvadore Billi, a Florentine merchant, on his return from Naples, having heard the fame of Fra Bartolommeo, and having seen his works, caused him to paint a panel-picture of Christ the Saviour, in allusion to his own name, with the four Evangelists round Him; wherein, at the foot, are also two little boys upholding the globe of the world, whose flesh, fresh and tender, is excellently painted, as is the whole work, in which there are likewise two prophets that are much extolled. This panel stands in the Nunziata at Florence below the great organ, according to the wish of Salvadore; it is a very beautiful work, finished by Fra Bartolommeo with much lovingness and great perfection; and it is surrounded by an ornament of marble, all carved by the hand of Pietro Rosselli.

Afterwards, having need of a change of air, the Prior at that time, who was his friend, sent him away to a monastery of his

Order, wherein, while he stayed there, he combined the labour of
his hands with the contemplation of death, with profit* both for
his soul and for the convent. For S. Martino in Lucca he painted
a panel wherein, at the feet of a Madonna, there is a little angel
playing on a lute, together with S. Stephen and S. John; in which
picture, executed with excellent draughtsmanship and colouring,
he proved his ability. For S. Romano, likewise, he painted a panel
on canvas of the Madonna della Misericordia, who is placed on
a pedestal of stone, with some angels holding her mantle; and
together with her he depicted a throng of people on some steps,
some standing, others seated, and others kneeling, but all gazing
at a figure of Christ on high who is sending down lightnings and
thunder-bolts upon the people. Clearly did Fra Bartolommeo
prove in this work how well he was able to manage the gradation
of shadows and darks in painting, giving extraordinary relief to
his figures, and showing a rare and excellent mastery over the
difficulties of his art in colouring, drawing, and invention; and
the work is as perfect as any that he ever made. For the same
church he painted another panel, also on canvas, containing a
Christ and S. Catherine the Martyr, together with a S. Catherine
of Siena, rapt in ecstasy from the earth, a figure as good as any
that could possibly be painted in that manner.

Returning to Florence, he gave some attention to the study of
music; and, delighting much therein, he would sometimes sing to
pass the time. At Prato, opposite to the prison, he painted a
panel-picture of the Assumption. He executed some pictures of
Our Lady for the house of the Medici, and also other paintings
for various people, such as a picture of Our Lady which Lodovi-
co di Lodovico Capponi has in his apartment, and likewise
another of the Virgin holding the Child in her arms, with two
heads of saints, that is in the possession of the very Excellent
Messer Lelio Torelli, Chief Secretary to the most Illustrious Duke
Cosimo, who holds it very dear both on account of the genius of
Fra Bartolommeo, and because he delights in, loves, and favours
not only the men of our art, but every fine intellect. In the house
of Piero del Pugliese, which now belongs to Matteo Botti, a
citizen and merchant of Florence, in an antechamber at the head
of a staircase, he painted a S. George in armour, on horseback,

* The word 'utilmente' is substituted here for the 'ultimamente' of the text,
which makes no sense.

who is slaying the Dragon with his lance – a very spirited figure. This he executed in chiaroscuro, in oils, a method that he much delighted to use for all his works, sketching them in the manner of a cartoon, with ink or with bitumen, before colouring them; as may still be seen from many beginnings of pictures and panels, which he left unfinished on account of his death, and as may also be perceived from many drawings by his hand, executed in chiaroscuro, of which the greater part are now in the Monastery of S. Caterina da Siena on the Piazza di S. Marco, in the possession of a nun who paints, and of whom record will be made in the proper place; while many made in the same way adorn our book of drawings, honouring his memory, and some are in the hands of Messer Francesco del Garbo, a most excellent physician.

Fra Bartolommeo always liked to have living objects before him when he was working; and in order to be able to draw draperies, armour, and other suchlike things, he caused a life-size figure of wood to be made, which moved at the joints; and this he clothed with real draperies, from which he painted most beautiful things, being able to keep them in position as long as he pleased, until he had brought his work to perfection. This figure, worm-eaten and ruined as it is, is in our possession, treasured in memory of him.

At Arezzo, for the Abbey of the Black Friars, he made a head of Christ in dark tints – a very beautiful work. He painted, also, the panel of the Company of the Contemplanti, which was preserved in the house of the Magnificent Messer Ottaviano de' Medici, and has now been placed in a chapel of that house, with many ornaments, by his son Messer Alessandro, who holds it very dear in memory of Fra Bartolommeo, and also because he takes vast pleasure in painting. In the chapel of the Noviciate of S. Marco there is a panel-picture of the Purification, very lovely, which he executed with good draughtsmanship and high finish. At S. Maria Maddalena, a seat of the Friars of his Order, without Florence, while staying there for his own pleasure, he made a Christ and a Magdalene; and he also painted certain things in fresco in that convent. In like manner, he wrought in fresco an arch over the strangers' apartment in S. Marco, in which he painted Christ with Cleophas and Luke, and made a portrait of Fra Niccolò della Magna, who was then a young man, and who afterwards became Archbishop of Capua, and finally a Cardinal. He began a panel for S. Gallo, afterwards finished by Giuliano

Bugiardini, which is now on the high-altar of S. Jacopo fra Fossi, on the Canto degli Alberti; and likewise a picture of the Rape of Dinah, now in the possession of Messer Cristofano Rinieri, and afterwards coloured by the same Giuliano, in which are buildings and conceptions that are much extolled.

From Piero Soderini he received the commission for the panel of the Council Chamber, which he began in such a manner, drawing it in chiaroscuro, that it seemed destined to do him very great credit; and, unfinished as it is, it now has a place of honour in the Chapel of the Magnificent Ottaviano de' Medici, in S. Lorenzo. In it are all the Patron Saints of the city of Florence, and those saints on whose days that city has gained her victories; and there is also the portrait of Fra Bartolommeo himself, made by him with a mirror. He had begun this picture, and had drawn the whole design, when it happened that, from working continually under a window, with the light from it beating on his back, he became completely paralyzed on that side of his body, and quite unable to move. Thereupon he was advised – such being the orders of his physicians – to go to the baths of San Filippo; where he stayed a long time, but became very little better thereby. Now Fra Bartolommeo was a great lover of fruit, which pleased his palate mightily, although it was ruinous to his health. Wherefore one morning, having eaten many figs, there came upon him, in addition to his other infirmity, a very violent fever, which cut short the course of his life in four days, at the age of forty-eight; when, still wholly conscious, he rendered up his soul to Heaven.

His death grieved his friends, and particularly the friars, who gave him honourable sepulture in their burial-place in S. Marco, on October 8, in the year 1517. He had a dispensation from attending any of the offices in the choir with the other friars, and the gains from his works went to the convent, enough money being left in his hands to pay for colours and other materials necessary for his painting.

He left disciples in Cecchino del Frate, Benedetto Cianfanini, Gabriele Rustici, and Fra Paolo Pistoiese, the latter inheriting all his possessions. This Fra Paolo painted many panels and pictures from his master's drawings, after his death; of which three are in S. Domenico at Pistoia, and one at S. Maria del Sasso in the Casentino.

Fra Bartolommeo gave such grace to his figures with his

colouring, and made them so novel and so modern in manner, that for these reasons he deserves to be numbered by us among the benefactors of art.

MARIOTTO ALBERTINELLI, Painter of Florence

MARIOTTO ALBERTINELLI, the closest and most intimate friend of Fra Bartolommeo – his other self, one might call him, not only on account of the constant connection and intercourse between them, but also through their similarity of manner during the period when Mariotto gave proper attention to art – was the son of Biagio di Bindo Albertinelli. At the age of twenty he abandoned his calling of gold-beater, in which he had been employed up to that time; and he learnt the first rudiments of painting in the workshop of Cosimo Rosselli, where he formed such an intimacy with Baccio della Porta, that they were one soul and one body. Such, indeed, was the brotherly friendship between them, that when Baccio took his leave of Cosimo, in order to practise his art as a master by himself, Mariotto went off with him; whereupon they lived for a long time, both one and the other, at the Porta a S. Piero Gattolini, executing many works in company. And since Mariotto was not so well grounded in drawing as was Baccio, he devoted himself to the study of such antiquities as were then in Florence, the greater part and the best of which were in the house of the Medici. He made a number of drawings of certain little panels in half-relief that were under the loggia in the garden, on the side towards S. Lorenzo, in one of which is Adonis with a very beautiful dog, and in another two nude figures, one seated, with a dog at its feet, and the other standing with the legs crossed, leaning on a staff. Both these panels are marvellous; and there are likewise two others of the same size, in one of which are two little boys carrying Jove's thunderbolt, while in the other is the nude figure of an old man, with wings on his shoulders and feet, representing Chance, and balancing a pair of scales in his hands. In addition to these works, that garden was full of torsi of men and women, which were a school not only for Mariotto, but for all the sculptors and painters of his time. A good part of these are now in the guardaroba of Duke Cosimo, and others, such as the two torsi of

Marsyas, the heads over the windows, and those of the Emperors over the doors, are still in the same place.

By studying these antiquities, Mariotto made great proficience in drawing; and he entered into the service of the mother of Duke Lorenzo, Madonna Alfonsina, who, desiring that he should devote himself to becoming an able master, offered him all possible assistance. Dividing his time, therefore, between drawing and colouring, he became a passing good craftsman, as is proved by some pictures that he executed for that lady, which were sent by her to Rome, for Carlo and Giordano Orsini, and which afterwards came into the hands of Cæsar Borgia. He made a very good portrait of Madonna Alfonsina from the life; and it seemed to him, on account of his friendship with her, that his fortune was made, when, in the year 1494, Piero de' Medici was banished, and her assistance and favour failed him. Whereupon he returned to the workshop of Baccio, where he set himself with even greater zeal to make models of clay and to increase his knowledge, labouring at the study of nature, and imitating the works of Baccio, so that in a few years he became a sound and practised master. And then, seeing his work succeeding so well, he so grew in courage, that, imitating the manner and method of his companion, the hand of Mariotto was taken by many for that of Fra Bartolommeo.

But when he heard that Baccio had gone off to become a monk, Mariotto was almost overwhelmed and out of his mind; and so strange did the news seem to him, that he was in despair, and nothing could cheer him. If it had not been, indeed, that Mariotto could not then endure having anything to do with monks, against whom he was ever railing, and belonged to the party that was opposed to the faction of Fra Girolamo of Ferrara, his love for Baccio would have wrought upon him so strongly, that it would have forced him to don the cowl in the same convent as his companion. However, he was besought by Gerozzo Dini, who had given the commission for the Judgment that Baccio had left unfinished in the Ossa, that he, having a manner similar to Baccio's, should undertake to finish it; whereupon, being also moved by the circumstance that the cartoon completed by the hand of Baccio and other drawings were there, and by the entreaties of Fra Bartolommeo himself, who had received money on account of the painting, and was troubled in conscience at not having kept his promise, he finished the work, and executed all

that was wanting with diligence and love, in such a way that many, not knowing this, think that it was painted by one single hand; and this brought him vast credit among craftsmen.

In the Chapter-house of the Certosa of Florence he executed a Crucifixion, with Our Lady and the Magdalene at the foot of the Cross, and some angels in the sky, who are receiving the blood of Christ; a work wrought in fresco, with diligence and lovingness, and passing well painted. Now some of the young men who were learning art under him, thinking that the friars were not giving them proper food, had counterfeited, without the knowledge of Mariotto, the keys of those windows opening into the friar's rooms, through which their pittance is passed; and sometimes, in secret, they stole some of it, now from one and now from another. There was a great uproar about this among the friars, since in the matter of eating they are as sensitive as any other person; but the lads did it with great dexterity, and, since they were held to be honest fellows, the blame fell on some of the friars, who were said to be doing it from hatred of one another. However, one day the truth was revealed, and the friars, to the end that the work might be finished, gave a double allowance to Mariotto and his lads, who finished the work with great glee and laughter.

For the Nuns of S. Giuliano in Florence he painted the panel of their high-altar, which he executed in a room that he had in the Gualfonda; together with another for the same church, with a Crucifix, some Angels, and God the Father, representing the Trinity, in oils and on a gold ground.

Mariotto was a most restless person, devoted to the pleasures of love, and a good liver in the matter of eating; wherefore, conceiving a hatred for the subtleties and brain-rackings of painting, and being often wounded by the tongues of other painters (according to the undying custom among them, handed down from one to another), he resolved to turn to a more humble, less fatiguing, and more cheerful art. And so, having opened a very fine inn, without the Porta S. Gallo, and a tavern and inn on the Ponte Vecchio, at the Dragon, he followed that calling for many months, saying that he had chosen an art without fore-shortenings, muscles, and perspectives, and, what was much more important, free from censure, and that the art which he had given up was quite the contrary of his new one, since the former imitated flesh and blood, and the latter made both blood and

flesh; and now, having good wine, he heard himself praised all day long, whereas before he used to hear nothing but censure.

However, having grown weary of this as well, and ashamed of the baseness of his calling, he returned to painting, and executed pictures and paintings for the houses of citizens in Florence. For Giovan Maria Benintendi he painted three little scenes with his own hand; and for the house of the Medici, at the election of Leo X, he painted a round picture of his arms, in oils, with Faith, Hope, and Charity, which hung for a long time over the door of their palace. He undertook to make, in the Company of S. Zanobi, near the Chapter-house of S. Maria del Fiore, a panel-picture of the Annunciation, which he executed with great labour. For this he caused special windows to be made, wishing to work on the spot, in order to be able to make the views recede, where they were high and distant, by lowering the tones, or to bring them forward, at his pleasure. Now he had conceived the idea that pictures which have no relief and force, combined with delicacy, are of no account; but since he knew that they cannot be made to stand out from the surface without shadows, which, if they are too dark, remain indistinct, while, if they are delicate, they have no force, he was eager to combine this delicacy with a certain method of treatment to which up to that time, so it seemed to him, art had not attained in any satisfactory manner. Wherefore, looking on this work as an opportunity for accomplishing this, he set himself, to this end, to make extraordinary efforts, which may be recognized in a figure of God the Father, which is in the sky, and in some little children, who stand out from the panel in strong relief against a dark background in perspective that he made there with a ceiling in the form of a barrel-shaped vault, which, with its arches curving and its lines diminishing to a point, recedes inwards in such a manner that it appears to be in relief; besides which, there are some angels scattering flowers as they fly, that are very graceful.

This work was painted out and painted in again many times by Mariotto before he could bring it to completion. He was for ever changing the colouring, making it now lighter, now darker, and sometimes more lively and glowing, sometimes less; but, never being completely satisfied, and never persuaded that he had done justice with his hand to the thoughts of his intellect, he wished to find a white that should be more brilliant than lead-white, and set himself, therefore, to clarify the latter, in order to

be able to heighten the highest light to his own satisfaction. However, having recognized that he was not able to express by means of art all that the intelligence of the human brain grasps and comprehends, he contented himself with what he had achieved, since he could not attain to what it was not possible to reach. This work brought Mariotto praise and honour among craftsmen, but by no means as much profit as he hoped to gain from his patrons in return for his labours, since a dispute arose between him and those who had commissioned him to paint it. But Pietro Perugino, then an old man, Ridolfo Ghirlandajo, and Francesco Granacci valued it, and settled the price of the work by common consent.

For S. Pancrazio, in Florence, Mariotto painted a semicircular picture of the Visitation of Our Lady. For S. Trinita, likewise, he executed with diligence a panel-picture of Our Lady, S. Jerome, and S. Zanobi, at the commission of Zanobi del Maestro; and for the Church of the Congregation of the Priests of S. Martino, he painted a picture on panel of the Visitation, which is much extolled. He was invited to the Convent of La Quercia, without Viterbo; but after having begun a panel there, he conceived a desire to see Rome. Having made his way to that city, therefore, he executed to perfection for the Chapel of Fra Mariano Fetti, in S. Silvestro di Monte Cavallo, a panel-picture in oils of S. Dominic, S. Catherine of Siena, with Christ marrying her, and Our Lady, in a delicate manner. He then returned to La Quercia, where he had a mistress, to whom, on account of the desire that he had felt while he was in Rome and could not enjoy her love, he sought to show that he was valiant in the lists; wherefore he exerted himself so much, that, being no longer young and so stalwart in such efforts, he was forced to take to his bed. And laying the blame for this on the air of the place, he had himself carried to Florence in a litter; but no expedients or remedies availed him in his sickness, from which he died in a few days, at the age of forty-five. He was buried in S. Piero Maggiore, in that city.

There are some drawings by the hand of this master in our book, executed with the pen and in chiaroscuro, which are very good; particularly a spiral staircase, drawn with great ingenuity in perspective, of which he had a good knowledge.

Mariotto had many disciples; among others, Giuliano Bugiardini and Franciabigio, both Florentines, and Innocenzio da

Imola, of whom we will speak in the proper place. Visino, a painter of Florence, was likewise his disciple, and excelled all these others in drawing, colouring, and industry, showing, also, a better manner in the works that he made, which he executed with great diligence. A few of them are still in Florence; and one can study his work at the present day in the house of Giovan Battista d' Agnol Doni, in a mirror*-picture painted in oils after the manner of a miniature, wherein are Adam and Eve naked, eating the apple, a work executed with great care; and from another picture, of Christ being taken down from the Cross, together with the Thieves, in which there is a beautifully contrived complication of ladders, with some men aiding each other to take down the body of Christ, and others bearing one of the Thieves on their shoulders to burial, and all the figures in varied and fantastic attitudes, suited to that subject, and proving that he was an able man. The same master was brought by some Florentine merchants to Hungary, where he executed many works and gained great renown. But the poor man was soon in danger of coming to an evil end, because, being of a frank and free-spoken nature, he was not able to endure the wearisome persistence of some Hungarians, who kept tormenting him all day long with praises of their own country, as if there were no pleasure or happiness in anything except eating and drinking in their stifling rooms, and no grandeur or nobility save in their King and his Court, all the rest of the world being rubbish. It seemed to him (and indeed it is true) that in Italy there was another kind of excellence, culture, and beauty; and one day, being weary of their nonsense, and chancing to be a little merry, he let slip the opinion that a flask of Trebbiano and a berlingozzo† were worth all the Kings and Queens that had ever reigned in those regions. And if the matter had not happened to fall into the hands of a Bishop, who was a gentleman and a man of the world, and also, above all, a tactful person, both able and willing to turn the thing into a joke, Visino would have learnt not to play with savages; for those brutes of

* The words of the text, 'un quadro d' una spera,' are a little obscure; but the translator has been strengthened in his belief that his rendering is correct by seeing a little picture, painted on a mirror, and numbered 7697, in the Victoria and Albert Museum. The subject of this picture, which the translator was enabled to see by the courtesy of Mr. B. S. Long, of the Department of Paintings, is the same as that of the work mentioned by Vasari, and it may be a copy.

† Florentine puff-pastry.

Hungarians, not understanding his words, and thinking that he had uttered something terrible, such as a threat that would rob their King of his life and throne, wished to give him short shrift and crucify him by mob-law. But the good Bishop drew him out of all embarrassment, and, appraising the merit of the excellent master at its true value, and putting a good complexion on the affair, restored him to the favour of the King, who, on hearing the story, was much amused by it. His good fortune, however, did not last long, for, not being able to endure the stifling rooms and the cold air, which ruined his constitution, in a short time this brought his life to an end; although his repute and fame survived in the memory of those who knew him when alive, and of those who saw his works in the years after his death. His pictures date about the year 1512.

RAFFAELLINO DEL GARBO, Painter of Florence

RAFFAELO DEL GARBO, while he was a little boy, was called by the pet name of Raffaellino, which he retained ever afterwards; and in his earliest days he gave such promise in his art, that he was already numbered among the most excellent masters, a thing which happens to few. But still fewer meet the fate which afterwards came upon him, in that from a splendid beginning and almost certain hopes, he arrived at a very feeble end. For it is a general rule, in the world both of nature and of art, for things to grow gradually from small beginnings, little by little, until they reach their highest perfection. It is true, however, that many laws both of art and of nature are unknown to us, nor do they hold to one unvarying order at all times and in every case, a thing which very often renders uncertain the judgments of men. How this may happen is seen in Raffaellino, since it appeared that in him nature and art did their utmost to set out from extraordinary beginnings, the middle stage of which was below mediocrity, and the end almost nothing.

In his youth he drew as much as any painter who has ever exercised himself in drawing in order to become perfect; wherefore there may still be seen, throughout the world of art, a great number of his drawings, which have been dispersed by a son of his for ridiculous prices, partly drawn with the style, partly with

the pen or in water-colours, but all on tinted paper, heightened with lead-white, and executed with marvellous boldness and mastery; and there are many of them in our book, drawn in a most beautiful manner. Besides this, he learnt to paint so well in distemper and in fresco, that his first works were executed with an incredible patience and diligence, as has been related.

In the Minerva, round the tomb of Cardinal Caraffa, he painted the vaulted ceiling, with such delicacy, that it seems like the work of an illuminator; wherefore it was held in great estimation by craftsmen at that time. His master, Filippo, regarded him in some respects as a much better painter than himself; and Raffaellino had acquired Filippo's manner so well, that there were few who could distinguish the one from the other. Later, after having left his master, he gave much more delicacy to that manner in the draperies, and greater softness to hair and to the expressions of the heads; and he was held in such expectation by craftsmen, that, while he followed this manner, he was considered the first of the young painters of his day. Now the family of the Capponi, having built a chapel that is called the Paradiso, on the hill below the Church of S. Bartolommeo a Monte Oliveto, without the Porta a S. Friano, wished to have the panel executed by Raffaellino, and gave him the commission; whereupon he painted in oils the Resurrection of Christ, with some soldiers who have fallen, as if dead, round the Sepulchre. These figures are very spirited and beautiful, and they have the most graceful heads that it is possible to see; among which, in the head of a young man, is a marvellous portrait of Niccola Capponi, while, in like manner, the head of one who is crying out because the stone covering of the tomb has fallen upon him, is most beautiful and bizarre. Wherefore the Capponi, having seen that Raffaellino's picture was a rare work, caused a frame to be made for it, all carved, with round columns richly adorned with burnished gold on a ground of bole. Before many years had passed, the campanile of that building was struck by lightning, which pierced the vault and fell near that panel, which, having been executed in oils, suffered no harm; but where the fluid passed near the gilt frame, it consumed the gold, leaving nothing there but the bare bole. It has seemed to me right to say that much with regard to oil-painting, to the end that all may see how important it is to know how to guard against such injury, which lightning has done not only to this work, but to many others.

He painted in fresco, at the corner of a house that now belongs to Matteo Botti, between the Canto del Ponte alla Carraja and the Canto della Cuculia, a little shrine containing Our Lady with the Child in her arms, with S. Catherine and S. Barbara kneeling, a very graceful and carefully executed work. For the Villa of Marignolle, belonging to the Girolami, he painted two most beautiful panels, with Our Lady, S. Zanobi, and other saints; and he filled the predella below both of these with little figures representing scenes from the lives of those saints, executed with great diligence. On the wall above the door of the Church of the Nuns of S. Giorgio, he painted a Pietà, with a group of the Maries; and in like manner, in another arch below this, a figure of Our Lady, a work worthy of great praise, executed in the year 1504. In the Church of S. Spirito at Florence, in a panel over that of the Nerli, which his master Filippo had executed, he painted a Pietà, which is held to be a very good and praiseworthy work; but in another, representing S. Bernard, he fell short of that standard. Below the door of the sacristy are two panel-pictures by his hand; one showing S. Gregory the Pope saying Mass, when Christ appears to him, naked, with the Cross on His shoulder, and shedding blood from His side, with the deacon and sub-deacon, in their vestments, serving the Mass, and two angels swinging censers over the body of Christ. For another chapel, lower down, he executed a panel-picture containing Our Lady, S. Jerome, and S. Bartholomew. On these two works he bestowed no little labour; but he went on deteriorating from day to day. I do not know to what I should attribute his misfortune, for poor Raffaellino was not wanting in industry, diligence, and application; yet they availed him little. It is believed, indeed, that, becoming overburdened and impoverished by the cares of a family, and being compelled to use for his daily needs whatever he earned, not to mention that he was a man of no great spirit and undertook to do work for small prices, in this way he went on growing worse little by little; although there is always something of the good to be seen in his works.

For the Monks of Cestello, on the wall of their refectory, he painted a large scene coloured in fresco, in which he depicted the miracle wrought by Jesus Christ with the five loaves and two fishes, with which he satisfied five thousand people. For the Abbot de' Panichi he executed the panel-picture of the high-altar in the Church of S. Salvi, without the Porta alla Croce, painting

therein Our Lady, S. Giovanni Gualberto, S. Salvi, S. Bernardo, a Cardinal of the Uberti family, and S. Benedetto the Abbot, and, at the sides, S. Batista and S. Fedele in armour, in two niches on either hand of the picture, which had a rich frame; and in the predella are several scenes, with little figures, from the Life of S. Giovanni Gualberto. In all this he acquitted himself very well, because he was assisted in his wretchedness by that Abbot, who took pity on him for the sake of his talents; and in the predella of the panel Raffaellino made a portrait of him from life, together with one of the General who was then ruling his Order. In S. Piero Maggiore, on the right as one enters the church, there is a panel by his hand, and in the Murate there is a picture of S. Sigismund, the King. For Girolamo Federighi, in that part of S. Pancrazio where he was afterwards buried, he painted a Trinity in fresco, with portraits of him and of his wife on their knees; and here he began to decline into pettiness of manner. He also made two figures in distemper for the Monks of Cestello, a S. Rocco and a S. Ignazio, which are in the Chapel of S. Sebastiano. And in a little chapel on the abutment of the Ponte Rubaconte, on the side towards the Mills, he painted a Madonna, a S. Laurence, and another saint.

In the end he was reduced to undertaking any work, however mean; and he was employed by certain nuns and other persons, who were embroidering a quantity of church vestments and hangings at that time, to make designs in chiaroscuro and ornamental borders containing saints and stories, for ridiculous prices. For although he had deteriorated, there sometimes issued from his hand most beautiful designs and fancies, as is proved by many drawings that were sold and dispersed after the death of those who used them for embroidery; of which there are many in the book of the illustrious hospital-director,* that show how able he was in draughtsmanship. This was the reason that many vestments, hangings, and ornaments, which are held to be very beautiful, were made for the churches of Florence and throughout the Florentine territory, and also for Cardinals and Bishops in Rome. At the present day this method of embroidery, which was used by Paolo da Verona, the Florentine Galieno, and others like them, is almost lost, and another method, with wide stitches, has been introduced, which has neither the same beauty

* Don Vincenzio Borghini.

nor the same careful workmanship, and is much less durable than the other. Wherefore, in return for this benefit, although poverty caused him misery and hardship during his lifetime, he deserves to have honour and glory for his talents after his death.

And in truth Raffaellino was unfortunate in his connections, for he always mixed with poor and humble people, like a man who had sunk and become ashamed of himself, seeing that in his youth he had given such great promise, and now knew how distant he was from the extraordinary excellence of the works that he had made at that time. And thus, growing old, he fell away so much from his early standard, that his works no longer appeared to be by his hand; and forgetting his art more and more every day, he was reduced to painting, in addition to his usual panels and pictures, the meanest kinds of works. And he sank so low that everything was a torment to him, but above all his burdensome family of children, which turned all his ability in art into mere clumsiness. Wherefore, being overtaken by infirmities and impoverished, he finished his life in misery at the age of fifty-eight, and was buried in S. Simone, at Florence, by the Company of the Misericordia, in the year 1524.

He left behind him many pupils who became able masters. One, who went in his boyhood to learn the rudiments of art from Raffaellino, was the Florentine painter Bronzino, who afterwards acquitted himself so well under the wing of Jacopo da Pontormo, another painter of Florence, that he has made as much proficience in the art as his master Jacopo. The portrait of Raffaellino was copied from a drawing that belonged to Bastiano da Monte Carlo, who was also his disciple, and who, for a man with no draughtsmanship, became a passing good master.

TORRIGIANO, Sculptor of Florence

GREAT is the power of anger in the soul of one who is seeking, with arrogance and pride, to gain a reputation for excellence in some profession, when he sees rising in the same art, at a time when he does not expect it, some unknown man of beautiful genius, who not only equals him, but in time surpasses him by a great measure. Of such persons, in truth, it may be said that there is no iron that they would not gnaw in their rage, nor any evil

which they would not do if they were able, for it seems to them too grievous an affront in the eyes of the world, that children whom they saw born should have reached maturity almost in one bound from their cradles. They do not reflect that every day one may see the will of young men, spurred on by zeal in their tender years, and exercised by them in continual studies, rise to infinite heights; while the old, led by fear, pride, and ambition, lose the cunning of their hands, so that the better they think to work, the worse they do it, and where they believe that they are advancing, they are going backwards. Wherefore, out of envy, they never give credit to the young for the perfection of their works, however clearly they may see it, on account of the obstinacy that possesses them. And it is known from experience that when, in order to show what they can do, they exert themselves to the utmost of their power, they often produce works that are ridiculous and a mere laughing-stock. In truth, when craftsmen have reached the age when the eye is no longer steady and the hand trembles, their place, if they have saved the wherewithal to live, is to give advice to men who can work, for the reason that the arts of painting and sculpture call for a mind in every way vigorous and awake (as it is at the age when the blood is boiling), full of burning desire, and a capital enemy of the pleasures of the world. And whoever is not temperate with regard to the delights of the world should shun the studies of any art or science whatsoever, seeing that such pleasures and study can never agree well together. Since, therefore, these arts involve so many burdens, few, indeed, are they who attain to the highest rank; and those who start with eagerness from the post are greater in number than those who run well in the race and win the prize.

Now there was more pride than art, although he was very able, to be seen in Torrigiano, a sculptor of Florence, who in his youth was maintained by the elder Lorenzo de' Medici in the garden which that magnificent citizen possessed on the Piazza di S. Marco in Florence. This garden was in such wise filled with the best ancient statuary, that the loggia, the walks, and all the apartments were adorned with noble ancient figures of marble, pictures, and other suchlike things, made by the hands of the best masters who ever lived in Italy or elsewhere. And all these works, in addition to the magnificence and adornment that they conferred on that garden, were as a school or academy for the young painters and sculptors, as well as for all others who were studying

the arts of design, and particularly for the young nobles; since the Magnificent Lorenzo had a strong conviction that those who are born of noble blood can attain to perfection in all things more readily and more speedily than is possible, for the most part, for men of humble birth, in whom there are rarely seen those conceptions and that marvellous genius which are perceived in men of illustrious stock. Moreover, the less highly born, having generally to defend themselves from hardship and poverty, and being forced in consequence to undertake any sort of work, however mean, are not able to exercise their intellect, or to attain to the highest degree of excellence. Wherefore it was well said by the learned Alciato – when speaking of men of beautiful genius, born in poverty, who are not able to raise themselves, because, in proportion as they are impelled upwards by the wings of their genius, so are they held down by their poverty –

Ut me pluma levat, sic grave mergit onus.

Lorenzo the Magnificent, then, always favoured men of genius, and particularly such of the nobles as showed an inclination for these our arts; wherefore it is no marvel that from that school there should have issued some who have amazed the world. And what is more, he not only gave the means to buy food and clothing to those who, being poor, would otherwise not have been able to pursue the studies of design, but also bestowed extraordinary gifts on any one among them who had acquitted himself in some work better than the others; so that the young students of our arts, competing thus with each other, thereby became very excellent, as I will relate.

The guardian and master of these young men, at that time, was the Florentine sculptor Bertoldo, an old and practised craftsman, who had once been a disciple of Donato. He taught them, and likewise had charge of the works in the garden, and of many drawings, cartoons, and models by the hand of Donato, Pippo,* Masaccio, Paolo Uccello, Fra Giovanni, Fra Filippo, and other masters, both native and foreign. It is a sure fact that these arts can only be acquired by a long course of study in drawing and diligently imitating works of excellence; and whoever has not such facilities, however much he may be assisted by nature, can never arrive at perfection, save late in life.

* Filippo Brunelleschi.

But to return to the antiquities of the garden; they were in great part dispersed in the year 1494, when Piero, the son of the aforesaid Lorenzo, was banished from Florence, all being sold by auction. The greater part of them, however, were restored to the Magnificent Giuliano in the year 1512, at the time when he and the other members of the House of Medici returned to their country; and at the present day they are for the most part preserved in the guardaroba of Duke Cosimo. Truly magnificent was the example thus given by Lorenzo, and whenever Princes and other persons of high degree choose to imitate it, they will always gain everlasting honour and glory thereby; since he who assists and favours, in their noble undertakings, men of rare and beautiful genius, from whom the world receives such beauty, honour, convenience and benefit, deserves to live for ever in the minds and memories of mankind.

Among those who studied the arts of design in that garden, the following all became very excellent masters; Michelagnolo, the son of Lodovico Buonarroti; Giovan Francesco Rustici; Torrigiano Torrigiani; Francesco Granacci; Niccolò, the son of Jacopo* Soggi; Lorenzo di Credi, and Giuliano Bugiardini; and, among the foreigners, Baccio da Montelupo, Andrea Contucci of Monte Sansovino, and others, of whom mention will be made in the proper places.

Torrigiano, then, whose Life we are now about to write, was a student in the garden with those named above; and he was not only powerful in person, and proud and fearless in spirit, but also by nature so overbearing and choleric, that he was for ever tyrannizing over all the others both with words and deeds. His chief profession was sculpture, yet he worked with great delicacy in terra-cotta, in a very good and beautiful manner. But not being able to endure that any one should surpass him, he would set himself to spoil with his hands such of the works of others as showed an excellence that he could not achieve with his brain; and if these others resented this, he often had recourse to something stronger than words. He had a particular hatred for Michelagnolo, for no other reason than that he saw him attending zealously to the study of art, and knew that he used to draw in secret at his own house by night and on feast-days, so that he came to succeed better in the garden than all the others, and was

* The name given in the text is Domenico.

therefore much favoured by Lorenzo the Magnificent. Wherefore, moved by bitter envy, Torrigiano was always seeking to affront him, both in word and deed; and one day, having come to blows, Torrigiano struck Michelagnolo so hard on the nose with his fist, that he broke it, insomuch that Michelagnolo had his nose flattened for the rest of his life. This matter becoming known to Lorenzo, he was so enraged that Torrigiano, if he had not fled from Florence, would have suffered some heavy punishment.

Having therefore made his way to Rome, where Alexander VI was then pressing on the work of the Borgia Tower, Torrigiano executed in it a great quantity of stucco-work, in company with other masters. Afterwards, money being offered in the service of Duke Valentino, who was making war against the people of Romagna, Torrigiano was led away by certain young Florentines; and, having changed himself in a moment from a sculptor to a soldier, he bore himself valiantly in those campaigns of Romagna. He did the same under Paolo Vitelli in the war with Pisa; and he was with Piero de' Medici at the action on the Garigliano, where he won the right to arms, and the name of a valiant standard-bearer.

But in the end, recognizing that he was never likely to reach the rank of captain that he desired, although he deserved it, and that he had saved nothing in the wars, and had, on the contrary, wasted his time, he returned to sculpture. For certain Florentine merchants, then, he made small works in marble and bronze, little figures, which are scattered throughout the houses of citizens in Florence, and he executed many drawings in a bold and excellent manner, as may be seen from some by his hand that are in our book, together with others which he made in competition with Michelagnolo. And having been brought by those merchants to England, he executed there, in the service of the King, an endless number of works in marble, bronze, and wood, competing with some masters of that country, to all of whom he proved superior. For this he was so well and so richly rewarded, that, if he had not been as reckless and unbridled as he was proud, he might have lived a life of ease and ended his days in comfort; but what happened to him was the very opposite.

After this, having been summoned from England into Spain, he made many works there, which are scattered about in various places, and are held in great estimation; and, among others, he

made a Crucifix of terra-cotta, which is the most marvellous thing
that there is in all Spain. For a monastery of Friars of S. Jerome,
without the city of Seville, he made another Crucifix; a S.
Jerome in Penitence, with his lion, the figure of that Saint being
a portrait of an old house-steward of the Botti family, Florentine
merchants settled in Spain; and a Madonna with the Child. This
last figure was so beautiful that it led to his making another like
it for the Duke of Arcus, who, in order to obtain it, made such
promises to Torrigiano, that he believed that it would make him
rich for the rest of his life. The work being finished, the Duke
gave him so many of those coins that are called 'maravedis,'
which are worth little or nothing, that Torrigiano, to whose
house there came two persons laden with them, became even
more confirmed in his belief that he was to be a very rich man.
But afterwards, having shown this money to a Florentine friend
of his, and having asked him to count it and reckon its value in
Italian coin, he saw that all that vast sum did not amount to thirty
ducats; at which, holding himself to have been fooled, he went
in a violent rage to where the figure was that he had made for
the Duke, and wholly destroyed it. Whereupon that Spaniard,
considering himself affronted, denounced Torrigiano as a heretic;
on which account he was thrown into prison, and after being
examined every day, and sent from one inquisitor to the other,
he was finally judged to deserve the severest penalty. But this was
never put into execution, because Torrigiano himself was plunged
thereby into such melancholy, that, remaining many days without
eating, and thus becoming very weak, little by little he put an end
to his own life; and in this way, by denying himself his food, he
avoided the shame into which he would perchance have fallen,
for it was believed that he had been condemned to death.

The works of this master date about the year of our sal-
vation, 1515, and he died in the year 1522.

GIULIANO AND ANTONIO DA SAN GALLO,
Architects of Florence

FRANCESCO DI PAOLO GIAMBERTI, who was a passing good
architect in the time of Cosimo de' Medici, and was much em-
ployed by him, had two sons, Giuliano and Antonio, whom he

apprenticed to the art of wood-carving. One of these two sons, Giuliano, he placed with Francione, a joiner, an ingenious person, who gave attention at the same time to wood-carving and to perspective, and with whom Francesco was very intimate, since they had executed many works in company, both in carving and in architecture, for Lorenzo de' Medici. This Giuliano learnt so well all that Francione taught him, that the carvings and beautiful perspectives that he afterwards executed by himself in the choir of the Duomo of Pisa are still regarded not without marvel at the present day, even among the many new perspectives.

While Giuliano was studying design, and his young blood ran hot in his veins, the army of the Duke of Calabria, by reason of the hatred which that lord bore to Lorenzo de' Medici, encamped before Castellina, in order to occupy the dominions of the Signoria of Florence, and also, if this should be successful, in order to accomplish some greater design. Wherefore Lorenzo the Magnificent was forced to send an engineer to Castellina, who might make mills and bastions, and should have the charge of handling the artillery, which few men at that time were able to do; and he sent thither Giuliano, considering him to have a mind more able, more ready, and more resolute than any other man, and knowing him already as the son of Francesco, who had been a devoted servant of the House of Medici.

Arriving at Castellina, therefore, Giuliano fortified that place with good walls and mills, both within and without, and furnished it with everything else necessary for the defence. Then, observing that the artillery-men stood at a great distance from their pieces, handling, loading, and discharging them with much timidity, he gave his attention to this, and so contrived that from that time onwards the artillery did harm to no one, whereas it had previously killed many of them, since they had not had judgment and knowledge enough to avoid suffering injury from the recoil. Having therefore taken charge of the artillery, Giuliano showed great skill in discharging it to the best possible advantage; and the Duke's forces so lost heart by reason of this and other adverse circumstances, that they were glad to make terms and depart from the town. In consequence of this Giuliano won no little praise from Lorenzo in Florence, and was looked upon with favour and affection ever afterwards.

Having meanwhile given his attention to architecture, he began the first cloister of the Monastery of Cestello, and executed

that part of it that is seen to be of the Ionic Order; placing capitals on the columns with volutes curving downwards to the collarino, where the shaft of the column ends, and making, below the ovoli and the fusarole, a frieze, one-third in height of the diameter of the column. This capital was copied from a very ancient one of marble, found at Fiesole by Messer Leonardo Salutati, Bishop of that place, who kept it for some time, together with other antiquities, in a house and garden that he occupied in the Via di S. Gallo, opposite to S. Agatà; and it is now in the possession of Messer Giovan Batista da Ricasoli, Bishop of Pistoia, and is prized for its beauty and variety, since among the ancient capitals there has not been seen another like it. But that cloister remained unfinished, because those monks were not then able to bear such an expense.

Meanwhile Giuliano had come into even greater credit with Lorenzo; and the latter, who was intending to build a palace at Poggio a Cajano, a place between Florence and Pistoia, and had caused several models to be made for it by Francione and by others, commissioned Giuliano, also, to make one of the sort of building that he proposed to erect. And Giuliano made it so completely different in form from the others, and so much to Lorenzo's fancy, that he began straightway to have it carried into execution, as the best of all the models; on which account he took Giuliano even more into his favour, and ever afterwards gave him an allowance.

After this, Giuliano wishing to make a vaulted ceiling for the great hall of that palace in the manner that we call barrel-shaped, Lorenzo could not believe, on account of the great space, that it could be raised. Whereupon Giuliano, who was building a house for himself in Florence, made a ceiling for his hall according to the design of the other, in order to convince the mind of that Magnificent Prince; and Lorenzo therefore gave orders for the ceiling at the Poggio to be carried out, which was successfully done.

By that time the fame of Giuliano had so increased, that, at the entreaty of the Duke of Calabria, he was commissioned by Lorenzo the Magnificent to make the model for a palace that was to be built at Naples; and he spent a long time over executing it. Now while he was working at this, the Castellan of Ostia, then Bishop della Rovere, who after a time became Pope Julius II, wishing to restore that stronghold and to put it into good order,

and having heard the fame of Giuliano, sent to Florence for him; and, having supplied him with a good provision, he kept him employed for two years in making therein all the useful improvements that he was able to execute by means of his art. And to the end that the model for the Duke of Calabria might not be neglected, but might be brought to conclusion, he left it to his brother Antonio, who finished it according to his directions, which, in executing it and carrying it to completion, he followed with great diligence, for he was no less competent in that art than Giuliano himself. Now Giuliano was advised by the elder Lorenzo to present it in person, to the end that he might show from the model itself the difficulties that he had triumphed over in making it. Whereupon he departed for Naples, and, having presented the work, was received with honour; for men were as much impressed by the gracious manner in which the Magnificent Lorenzo had sent him, as they were struck with marvel at the masterly work in the model, which gave such satisfaction that the building was straightway begun near the Castel Nuovo.

After Giuliano had been some time in Naples, he sought leave from the Duke to return to Florence; whereupon he was presented by the King with horses and garments, and, among other things, with a silver cup containing some hundreds of ducats. These things Giuliano would not accept, saying that he served a patron who had no need of silver or gold, but that if he did indeed wish to give him some present or some token of approbation, to show that he had been in that city, he might bestow upon him some of his antiquities, which he would choose himself. These the King granted to him most liberally, both for love of the Magnificent Lorenzo and on account of Giuliano's own worth; and they were a head of the Emperor Hadrian, which is now above the door of the garden at the house of the Medici, a nude woman, more than life-size, and a Cupid sleeping, all in marble and in the round. Giuliano sent them as presents to the Magnificent Lorenzo, who expressed vast delight at the gift, and never tired of praising the action of this most liberal of craftsmen, who had refused gold and silver for the sake of art, a thing which few would have done. That Cupid is now in the guardaroba of Duke Cosimo.

Having then returned to Florence, Giuliano was received most graciously by the Magnificent Lorenzo. Now the fancy had taken that Prince to build a convent capable of holding a hundred

friars, without the Porta S. Gallo, in order to give satisfaction to Fra Mariano da Ghinazzano, a most learned member of the Order of Eremite Friars of S. Augustine. For this convent models were made by many architects, and in the end that of Giuliano was put into execution, which was the reason that Lorenzo, from this work, gave him the name of Giuliano da San Gallo. Wherefore Giuliano, who heard himself called by everyone 'da San Gallo,' said one day in jest to the Magnificent Lorenzo, 'By giving me this new name of "da San Gallo," you are making me lose the ancient name of my house, so that, in place of going forward in the matter of lineage, as I thought to do, I am going backward.' Whereupon Lorenzo answered that he would rather have him become the founder of a new house through his own worth, than depend on others; at which Giuliano was well content.

Meanwhile the work of S. Gallo was carried on, together with Lorenzo's other buildings; but neither the convent nor the others were finished, by reason of the death of Lorenzo. And even the completed part of this structure of S. Gallo did not long remain standing, because in 1530, on account of the siege of Florence, it was destroyed and thrown to the ground, together with the whole suburb, the piazza of which was completely surrounded by very beautiful buildings; and at the present day there is no trace to be seen there of house, church, or convent.

At this time there took place the death of the King of Naples, whereupon Giuliano Gondi, a very rich Florentine merchant, returned from that city to Florence, and commissioned Giuliano da San Gallo, with whom he had become very intimate on account of his visit to Naples, to build him a palace in rustic work, opposite to S. Firenze, above the place where the lions used to be. This palace was to form the angle of the piazza and to face the old Mercatanzia; but the death of Giuliano Gondi put a stop to the work. In it, among other things, Giuliano made a chimney-piece, very rich in carvings, and so varied and beautiful in composition, that up to that time there had never been seen the like, nor one with such a wealth of figures. The same master made a palace for a Venetian in Camerata, without the Porta a Pinti, and many houses for private citizens, of which there is no need to make mention.

Lorenzo the Magnificent, in order to benefit the commonwealth and adorn the State, and at the same time to leave behind him some splendid monument, in addition to the endless number

that he had already erected, wished to execute the fortification of the Poggio Imperiale, above Poggibonsi, on the road to Rome, with a view to founding a city there; and he would not lay it out without the advice and design of Giuliano. Wherefore that master began that most famous structure, in which he made the well-designed and beautiful range of fortifications that we see at the present day.

These works brought him such fame, that he was then summoned to Milan, through the mediation of Lorenzo, by the Duke of Milan, to the end that he might make for him the model of a palace; and there Giuliano was no less honoured by the Duke than he had previously been honoured by the King of Naples, when that Sovereign had invited him to that city. For when he had presented the model to him, on the part of the Magnificent Lorenzo, the Duke was filled with astonishment and marvel at seeing the vast number of beautiful adornments in it, so well arranged and distributed, and all accommodated in their places with art and grace; for which reason all the materials necessary for the work were got together, and they began to put it into execution. In the same city, together with Giuliano, was Leonardo da Vinci, who was working for the Duke; and Leonardo, speaking with Giuliano about the casting of the horse that he was proposing to make, received from him some excellent suggestions. This work was broken to pieces on the arrival of the French, so that the horse was never finished; nor could the palace be brought to completion.

Having returned to Florence, Giuliano found that his brother Antonio, who worked for him on his models, had become so excellent, that there was no one in his day who was a better master in carving, particularly for large Crucifixes of wood; to which witness is borne by the one over the high-altar of the Nunziata in Florence, by another that is kept by the Friars of S. Gallo in S. Jacopo tra Fossi, and by a third in the Company of the Scalzo, which are all held to be very good. But Giuliano removed him from that profession and caused him to give his attention to architecture, in company with himself, since he had many works to execute, both public and private.

Now it happened, as it is always happening, that Fortune, the enemy of talent, robbed the followers of the arts of their hope and support by the death of Lorenzo de' Medici, which was a heavy loss not only to all able craftsmen and to his country, but

also to all Italy. Wherefore Giuliano, together with all the other
lofty spirits, was left wholly inconsolable; and in his grief he
betook himself to Prato, near Florence, in order to build the
Temple of the Madonna delle Carcere, since all building in
Florence, both public and private, was at a standstill. He lived in
Prato, therefore, three whole years, supporting the expense, dis-
comfort, and sorrow as best he could.

At the end of that time, it being proposed to roof the Church
of the Madonna at Loreto, and to raise the cupola, which had
been formerly begun but not finished by Giuliano da Maiano, and
those who had charge of the matter doubting that the piers were
too weak to bear such a weight, they wrote, therefore, to Giulia-
no, that if he desired such a work, he should go and see it for
himself. And having gone, like the bold and able man that he
was, he showed them that the cupola could be raised with ease,
and that he had courage enough for the task; and so many, and
of such a kind, were the reasons that he put before them, that
the work was allotted to him. After receiving this commission, he
caused the work in Prato to be despatched, and made his way,
with the same master-builders and stone-cutters, to Loreto. And
to the end that this structure, besides beauty of form, might be
firm, solid, stable, and well bound in the stonework, he sent to
Rome for pozzolana*; nor was any lime used that was not mixed
with it, nor any stone built in without it; and thus, within the
space of three years, it was brought to perfect completion, ready
for use.

Giuliano then went to Rome, where, for Pope Alexander VI,
he restored the roof of S. Maria Maggiore, which was falling into
ruin; and he made there the ceiling that is to be seen at the
present day. While he was thus employed about the Court,
Bishop della Rovere, who had been the friend of Giuliano from
the time when he was Castellan of Ostia, and who had been
created Cardinal of S. Pietro in Vincula, caused him to make a
model for the Palace of S. Pietro in Vincula. And a little time
after, desiring to build a palace in his own city of Savona, he
wished to have it erected likewise from the design and under the
eye of Giuliano. But such a journey was difficult for Giuliano, for
the reason that his ceiling was not yet finished, and Pope Alex-
ander would not let him go. He entrusted the finishing of it,

* A friable volcanic tufa.

therefore, to his brother Antonio, who, having a good and versatile intelligence, and coming thus into contact with the Court, entered into the service of the Pope, who conceived a very great affection for him; and this he proved when he resolved to restore, with new foundations and with defences after the manner of a castle, the Mausoleum of Hadrian, now called the Castello di S. Angelo, for Antonio was made overseer of this undertaking, and under his direction were made the great towers below, the ditches, and the rest of the fortifications that we see at the present day. This work brought him great credit with the Pope, and with his son, Duke Valentino; and it led to his building the fortress that is now to be seen at Città Castellana. Thus, then, while that Pontiff was alive, he was continually employed in building; and while working for him, he was rewarded by him no less than he was esteemed.

Giuliano had already carried well forward the work at Savona, when the Cardinal returned to Rome on some business of his own, leaving many workmen to bring the building to completion after the directions and design of Giuliano, whom he took with him to Rome. Giuliano made that journey willingly, wishing to see Antonio and his works; and he stayed there some months. During that time, however, the Cardinal fell into disgrace with the Pope, and departed from Rome, in order not to be taken prisoner, and Giuliano, as before, went in his company. On arriving at Savona, they set a much greater number of masterbuilders and other artificers to work on the building. But the threats of the Pope against the Cardinal becoming every day louder, it was not long before he made his way to Avignon. From there he sent as a present to the King of France a model for a palace that Giuliano had made for him, which was marvellous, very rich in ornament, and spacious enough for the accommodation of his whole Court. The royal Court was at Lyons when Giuliano presented his model; and the gift was so welcome and acceptable to the King, that he rewarded Giuliano liberally and gave him infinite praise, besides rendering many thanks for it to the Cardinal, who was at Avignon.

Meanwhile they received news that the palace at Savona was already nearly finished; whereupon the Cardinal determined that Giuliano should once more see the work, and Giuliano, having gone for this purpose to Savona, had not been there long when it was completely finished. Then, desiring to return to Florence,

where he had not been for a long time, Giuliano took the road for that city together with his master-builders. Now at that time the King of France had restored Pisa her liberty, and the war between the Florentines and the Pisans was still raging; and Giuliano, wishing to pass through Pisan territory, had a safe-conduct made out for his company at Lucca, for they had no small apprehension about the Pisan soldiers. Nevertheless, while passing near Altopascio, they were captured by the Pisans, who cared nothing for safe-conducts or for any other warrant that they might have. And for six months Giuliano was detained in Pisa, his ransom being fixed at three hundred ducats; nor was he able to return to Florence until he had paid it.

Antonio had heard this news in Rome, and, desiring to see his native city and his brother again, obtained leave to depart from Rome; and on his way he designed for Duke Valentino the fortress of Montefiascone. Finally, in the year 1503, he reached Florence, where the two brothers and their friends took joyful pleasure in each other's company.

There now ensued the death of Alexander VI, and the election of Pius III, who lived but a short time; whereupon the Cardinal of S. Pietro in Vincula was created Pontiff, under the name of Pope Julius II; which brought great joy to Giuliano, on account of his having been so long in his service, and he determined, therefore, to go to kiss the Pope's foot. Having then arrived in Rome, he was warmly received and welcomed lovingly, and was straightway commissioned to execute the first buildings undertaken by that Pope before the coming of Bramante.

Antonio, who had remained in Florence, continued, in the absence of Giuliano (Piero Soderini being Gonfalonier), the building of the Poggio Imperiale, to which all the Pisan prisoners were sent to labour, in order to finish the work the quicker. After this, by reason of the troubles at Arezzo, the old fortress was destroyed, and Antonio made the model for the new one, with the consent of Giuliano, who had come from Rome for this purpose, but soon returned thither; and this work was the reason that Antonio was appointed architect to the Commune of Florence for all the fortifications.

On the return of Giuliano to Rome, the question was being debated as to whether the divine Michelagnolo Buonarroti should make the tomb of Pope Julius; whereupon Giuliano exhorted the Pope to pursue that undertaking, adding that it seemed to him

that it was necessary to build a special chapel for such a monument, and that it should not be placed in the old S. Pietro, in which there was no space for it, whereas a new chapel would bring out all the perfection of the work. After many architects, then, had made designs, the matter little by little became one of such importance, that, in place of erecting a chapel, a beginning was made with the great fabric of the new S. Pietro. There had arrived in Rome, about that time, the architect Bramante of Castel Durante, who had been in Lombardy; and he went to work in such a manner, with various extraordinary means and methods of his own, and with his fantastic ideas, having on his side Baldassarre Peruzzi, Raffaello da Urbino, and other architects, that he put the whole undertaking into confusion; whereby much time was consumed in discussions. Finally – so well did he know how to set about the matter – the work was entrusted to him, as the man who had shown the finest judgment, the best intelligence, and the greatest invention.

Giuliano, resenting this, for it appeared to him that he had received an affront from the Pope, in view of the faithful service that he had rendered to him when his rank was not so high, and of the promise made to him by the Pope that he should have that building, sought leave to go; and so, notwithstanding that he was appointed companion to Bramante for other edifices that were being erected in Rome, he departed, and returned, with many gifts received from that Pontiff, to Florence.

This was a great joy to Piero Soderini, who straightway set him to work. Nor had six months gone by, when Messer Bartolommeo della Rovere, the nephew of the Pope, and a friend of Giuliano, wrote to him in the name of his Holiness that he should return for his own advantage to Rome; but neither terms nor promises availed to move Giuliano, who considered that he had been put to shame by the Pope. Finally, however, a letter was written to Piero Soderini, urging him in one way or another to send Giuliano to Rome, since his Holiness wished to finish the fortifications of the Great Round Tower, which had been begun by Nicholas V, and likewise those of the Borgo and the Belvedere, with other works; and Giuliano allowed himself to be persuaded by Soderini, and therefore went to Rome, where he received a gracious welcome and many gifts from the Pope.

Having afterwards gone to Bologna, from which the Bentivogli had just been driven out, the Pope resolved, by the advice of

Giuliano, to have a figure of himself in bronze made by Michelagnolo Buonarroti; and this was carried out, as will be related in the Life of Michelagnolo himself. Giuliano also followed the Pope to Mirandola, and after it was taken, having endured much fatigue and many discomforts, he returned with the Court to Rome. But the furious desire to drive the French out of Italy not having yet got out of the head of the Pope, he strove to wrest the government of Florence out of the hands of Piero Soderini, whose power was no small hindrance to him in the project that he had in mind. Whereupon, since the Pontiff, for these reasons, had turned aside from building and had embroiled himself in wars, Giuliano, by this time weary, and perceiving that attention was being given only to the construction of S. Pietro, and not much even to that, sought leave from him to depart. But the Pope answered him in anger, 'Do you believe that you are the only Giuliano da San Gallo to be found?' To which he replied that none could be found equal to him in faithful service, while he himself would easily find Princes truer to their promises than the Pope had been towards him. However, the Pontiff would by no means give him leave to go, saying that he would speak to him about it another time.

Meanwhile Bramante, having brought Raffaello da Urbino to Rome, set him to work at painting the Papal apartments; whereupon Giuliano, perceiving that the Pope took great delight in those pictures, and knowing that he wished to have the ceiling of the chapel of his uncle Sixtus painted, spoke to him of Michelagnolo, adding that he had already executed the bronze statue in Bologna. Which news pleased the Pope so much that he sent for Michelagnolo, who, on arriving in Rome, received the commission for the ceiling of that chapel.

A little time after this, Giuliano coming back once more to seek leave from the Pope to depart, his Holiness, seeing him determined on this, was content that he should return to Florence, without forfeiting his favour; and, after having blessed him, he gave him a purse of red satin containing five hundred crowns, telling him that he might return home to rest, but that he would always be his friend. Giuliano, then, having kissed the sacred foot, returned to Florence, at the very time when Pisa was surrounded and besieged by the army of Florence. No sooner had he arrived, therefore, than Piero Soderini, after the due greetings, sent him to the camp to help the military commissaries, who

had found themselves unable to prevent the Pisans from passing provisions into Pisa by way of the Arno. Giuliano made a design for a bridge of boats to be built at some better season, and then went back to Florence; and when spring had come, taking with him his brother Antonio, he made his way to Pisa, where they constructed a bridge, which was a very ingenious piece of work, since, besides the fact that, rising or falling with the water, and being well bound with chains, it stood safe and sound against floods, it carried out the desires of the commissaries in such a manner, cutting off Pisa from access to the sea by way of the Arno, that the Pisans, having no other expedient in their sore straits, were forced to come to terms with the Florentines; and so they surrendered. Nor was it long before the same Piero Soderini again sent Giuliano, with a vast number of master-builders, to Pisa, where with extraordinary swiftness he erected the fortress that still stands at the Porta a S. Marco, and also the gate itself, which he built in the Doric Order. And the while that Giuliano was engaged on this work, which was until the year 1512, Antonio went through the whole dominion, inspecting and restoring the fortresses and other public buildings.

After this, by the favour of the same Pope Julius, the house of Medici was reinstated in the government of Florence, from which they had been driven out on the invasion of Italy by Charles VIII, King of France, and Piero Soderini was expelled from the Palace; and the Medici showed their gratitude to Giuliano and Antonio for the services that they had rendered in the past to their illustrious family. Now Cardinal Giovanni de' Medici having been elected Pope a short time after the death of Julius II, Giuliano was forced once again to betake himself to Rome; where, Bramante dying not long after his arrival, it was proposed to give to Giuliano the charge of the building of S. Pietro. But he, being worn out by his labours, and crushed down by old age and by the stone, which made his life a burden, returned by leave of his Holiness to Florence; and that commission was given to the most gracious Raffaello da Urbino. And Giuliano, after two years, was pressed so sorely by his malady, that he died at the age of seventy-four in the year 1517, leaving his name to the world, his body to the earth, and his soul to God.

By his departure he left a heavy burden of sorrow to his brother Antonio, who loved him tenderly, and to a son of his own named Francesco, who was engaged in sculpture, although

he was still quite young. This Francesco, who has preserved up to our own day all the treasures of his elders, and holds them in veneration, executed many works at Florence and elsewhere, both in sculpture and in architecture, and by his hand is the Madonna of marble, with the Child in her arms, and lying in the lap of S. Anne, that is in Orsanmichele; which work, with the figures carved in the round out of one single block, was held, as it still is, to be very beautiful. He has also executed the tomb that Pope Clement caused to be made for Piero de' Medici at Monte Cassino, besides many other works, of which no mention is here made because the said Francesco is still alive.

After the death of Giuliano, Antonio, being a man who was not willing to stay idle, made two large Crucifixes of wood, one of which was sent into Spain, while the other, by order of the Vice-Chancellor, Cardinal Giulio de' Medici, was taken by Domenico Buoninsegni into France. It being then proposed to build the fortress of Livorno, Antonio was sent thither by Cardinal de' Medici to make the design for it; which he did, although it was afterwards not carried completely into execution, nor even after the method suggested by Antonio. After this, the men of Montepulciano determining, by reason of the miracles wrought by an image of Our Lady, to build a temple for it at very great cost, Antonio made the model for this, and became head of the undertaking; on which account he visited that building twice a year. At the present day it is to be seen carried to perfect completion, having been executed with supreme grace, and with truly marvellous beauty and variety of composition, by the genius of Antonio, and all the masonry is of a certain stone that has a tinge of white, after the manner of travertine. It stands without the Porta di S. Biagio, on the right hand, half-way up the slope of the hill. At this time, he made a beginning with a palace in the township of Monte San Sovino, for Antonio di Monte, Cardinal of Santa Prassedia; and he built another for the same man at Montepulciano, both being executed and finished with extraordinary grace.

He made the design for the side of the buildings of the Servite Friars (in Florence), on their Piazza, following the order of the Loggia of the Innocenti; and at Arezzo he made models for the aisles of the Madonna delle Lacrime, although that work was very badly conceived, because it is out of harmony with the original part of the building, and the arches at the ends are not in true

line with the centre. He also made a model for the Madonna of Cortona; but I do not think that this was put into execution. He was employed in the siege on the bastions and fortifications within the city, and in this undertaking he had as a companion his nephew Francesco. After this, the Giant of the Piazza, executed by the hand of Michelagnolo, having been set into place in the time of Giuliano, the brother of our Antonio, it was proposed to set up the other, which had been made by Baccio Bandinelli; and the task of bringing it safely into position was given to Antonio, who, taking Baccio d' Agnolo as his companion, carried this out by means of very powerful machines, and placed it in safety on the base that had been prepared for that purpose.

In the end, having become old, he took no pleasure in anything save agriculture, of which he had an excellent knowledge. And then, when on account of old age he was no longer able to bear the discomforts of this world, he rendered up his soul to God, in the year 1534, and was laid to rest by the side of his brother Giuliano in the tomb of the Giamberti, in the Church of S. Maria Novella.

The marvellous works of these two brothers will bear witness before the world to the extraordinary genius that they possessed; and for their lives, their honourable ways, and their every action, they were held in estimation by all men. Giuliano and Antonio bequeathed to the art of architecture methods that gave the Tuscan Order of building better form than any other architect had yet achieved, and the Doric Order they enriched with better measures and proportions than their predecessors, following the rules and canons of Vitruvius, had been wont to use. They collected in their houses at Florence an infinite number of most beautiful antiquities in marble, which adorned Florence, and still adorn her, no less than those masters honoured themselves and their art. Giuliano brought from Rome the method of casting vaults with such materials as made them ready carved; examples of which may be seen in a room in his own house, and in the vaulting of the Great Hall at Poggio a Cajano, which is still to be seen there. Wherefore we should acknowledge our obligation to their labours, whereby they fortified the dominion of Florence, adorned the city, and gave a name, throughout the many regions where they worked, to Florence and to the intellects of Tuscany, who, to honour their memory, have written to them these verses –

Cedite Romani structores, cedite Graii,
 Artis, Vitruvi, tu quoque cede parens.
Etruscos celebrare viros, testudinis arcus,
 Urna, tholus, statuæ, templa, domusque petunt.

RAFFAELLO DA URBINO
[*RAFFAELLO SANZIO*],
Painter and Architect

How bountiful and benign Heaven sometimes shows itself in showering upon one single person the infinite riches of its treasures, and all those graces and rarest gifts that it is wont to distribute among many individuals, over a long space of time, could be clearly seen in the no less excellent than gracious Raffaello Sanzio da Urbino, who was endowed by nature with all that modesty and goodness which are seen at times in those who, beyond all other men, have added to their natural sweetness and gentleness the beautiful adornment of courtesy and grace, by reason of which they always show themselves agreeable and pleasant to every sort of person and in all their actions. Him nature presented to the world, when, vanquished by art through the hands of Michelagnolo Buonarroti, she wished to be vanquished, in Raffaello, by art and character together. And in truth, since the greater part of the craftsmen who had lived up to that time had received from nature a certain element of savagery and madness, which, besides making them strange and eccentric, had brought it about that very often there was revealed in them rather the obscure darkness of vice than the brightness and splendour of those virtues that make men immortal, there was right good reason for her to cause to shine out brilliantly in Raffaello, as a contrast to the others, all the rarest qualities of the mind, accompanied by such grace, industry, beauty, modesty, and excellence of character, as would have sufficed to efface any vice, however hideous, and any blot, were it ever so great. Wherefore it may be surely said that those who are the possessors of such rare and numerous gifts as were seen in Raffaello da Urbino, are not merely men, but, if it be not a sin to say it, mortal gods; and that those who, by means of their works, leave an honourable name written in the archives of fame in this earthly world of ours, can also hope to have to enjoy in Heaven a worthy reward for their labours and merits.

VITA DI RAFFAELLO DA VRB.
PIT. ARCHITETTO.

Raffaello was born at Urbino, a very famous city in Italy, at three o'clock of the night on Good Friday, in the year 1483, to a father named Giovanni de' Santi, a painter of no great excellence, and yet a man of good intelligence, well able to direct his children on that good path which he himself had not been fortunate enough to have shown to him in his boyhood. And since Giovanni knew how important it is to rear infants, not with the milk of nurses, but with that of their own mothers, no sooner was Raffaello born, to whom with happy augury he gave that name at baptism, than he insisted that this his only child – and he had no more afterwards – should be suckled by his own mother, and that in his tender years he should have his character formed in the house of his parents, rather than learn less gentle or even boorish ways and habits in the houses of peasants or common people. When he was well grown, he began to exercise him in painting, seeing him much inclined to such an art, and possessed of a very beautiful genius: wherefore not many years passed before Raffaello, still a boy, became a great help to Giovanni in many works that he executed in the state of Urbino. In the end, this good and loving father, knowing that his son could learn little from him, made up his mind to place him with Pietro Perugino, who, as he heard tell, held the first place among painters at that time. He went, therefore, to Perugia: but not finding Pietro there, he set himself, in order to lessen the annoyance of waiting for him, to execute some works in S. Francesco. When Pietro had returned from Rome, Giovanni, who was a gentle and well-bred person, formed a friendship with him, and, when the time appeared to have come, in the most adroit method that he knew, told him his desire. And so Pietro, who was very courteous and a lover of beautiful genius, agreed to have Raffaello: whereupon Giovanni, going off rejoicing to Urbino, took the boy, not without many tears on the part of his mother, who loved him dearly, and brought him to Perugia, where Pietro, after seeing Raffaello's method of drawing, and his beautiful manners and character, formed a judgment of him which time, from the result, proved to be very true.

It is a very notable thing that Raffaello, studying the manner of Pietro, imitated it in every respect so closely, that his copies could not be distinguished from his master's originals, and it was not possible to see any clear difference between his works and Pietro's; as is still evident from some figures in a panel in

S. Francesco at Perugia, which he executed in oils for Madonna Maddalena degli Oddi. These are a Madonna who has risen into Heaven, with Jesus Christ crowning her, while below, round the sepulchre, are the twelve Apostles, contemplating the Celestial Glory, and at the foot of the panel is a predella divided into three scenes, painted with little figures, of the Madonna receiving the Annunciation from the Angel, of the Magi adoring Christ, and of Christ in the arms of Simeon in the Temple. This work is executed with truly supreme diligence; and one who had not a good knowledge of the two manners, would hold it as certain that it is by the hand of Pietro, whereas it is without a doubt by the hand of Raffaello.

After this work, Pietro returning to Florence on some business of his own, Raffaello departed from Perugia and went off with some friends to Città di Castello, where he painted a panel for S. Agostino in the same manner, and likewise one of a Crucifixion for S. Domenico, which, if his name were not written upon it, no one would believe to be a work by Raffaello, but rather by Pietro. For S. Francesco, also in the same city, he painted a little panel-picture of the Marriage of Our Lady, in which one may recognize the excellence of Raffaello increasing and growing in refinement, and surpassing the manner of Pietro. In this work is a temple drawn in perspective with such loving care, that it is a marvellous thing to see the difficulties that he was for ever seeking out in this branch of his profession.

Meanwhile, when he had acquired very great fame by following his master's manner, Pope Pius II* had given the commission for painting the library of the Duomo at Siena to Pinturicchio; and he, being a friend of Raffaello, and knowing him to be an excellent draughtsman, brought him to Siena, where Raffaello made for him some of the drawings and cartoons for that work. The reason that he did not continue at it was that some painters in Siena kept extolling with vast praise the cartoon that Leonardo da Vinci had made in the Sala del Papa† of a very beautiful group of horsemen, to be painted afterwards in the Hall of the Palace of the Signoria, and likewise some nudes executed by

* In the Life of Pinturicchio, Vasari says that this commission was given to Pinturicchio by Cardinal Francesco Piccolomini, who afterwards became Pope Pius III.

† The text reads Palazzo, which is obviously an error for Papa.

Michelagnolo Buonarroti in competition with Leonardo, and much better; and Raffaello, on account of the love that he always bore to the excellent in art, was seized by such a desire to see them, that, putting aside that work and all thought of his own advantage and comfort, he went off to Florence.

Having arrived there, and being pleased no less with the city than with those works, which appeared to him to be divine, he determined to take up his abode there for some time; and thus he formed a friendship with some young painters, among whom were Ridolfo Ghirlandajo, Aristotile da San Gallo, and others, and became much honoured in that city, particularly by Taddeo Taddei, who, being one who always loved any man inclined to excellence, would have him ever in his house and at his table. And Raffaello, who was gentleness itself, in order not to be beaten in courtesy, made him two pictures, which incline to his first manner, derived from Pietro, but also to the other much better manner that he afterwards acquired by study, as will be related; which pictures are still in the house of the heirs of the said Taddeo.

Raffaello also formed a very great friendship with Lorenzo Nasi; and for this Lorenzo, who had taken a wife about that time, he painted a picture in which he made a Madonna, and between her legs her Son, to whom a little S. John, full of joy, is offering a bird, with great delight and pleasure for both of them. In the attitude of each is a certain childlike simplicity which is wholly lovely, besides that they are so well coloured, and executed with such diligence, that they appear to be rather of living flesh than wrought by means of colour and draughtsmanship; the Madonna, likewise, has an air truly full of grace and divinity; and the foreground, the landscapes, and in short all the rest of the work, are most beautiful. This picture was held by Lorenzo Nasi, as long as he lived, in very great veneration, both in memory of Raffaello, who had been so much his friend, and on account of the dignity and excellence of the work; but afterwards, on August 9, in the year 1548, it met an evil fate, when, on account of the collapse of the hill of S. Giorgio, the house of Lorenzo fell down, together with the ornate and beautiful houses of the heirs of Marco del Nero, and other neighbouring dwellings. However, the pieces of the picture being found among the fragments of the ruins, the son of Lorenzo, Batista, who was a great lover of art, had them put together again as well as was possible.

After these works, Raffaello was forced to depart from Florence and go to Urbino, where, on account of the death of his mother and of his father Giovanni, all his affairs were in confusion. While he was living in Urbino, therefore, he painted for Guidobaldo da Montefeltro, then Captain of the Florentines, two pictures of Our Lady, small but very beautiful, and in his second manner, which are now in the possession of the most illustrious and excellent Guidobaldo, Duke of Urbino. For the same patron he painted a little picture of Christ praying in the Garden, with the three Apostles sleeping at some distance from Him. This painting is so highly finished, that a miniature could not be better, or in any way different; and after having been a long time in the possession of Francesco Maria, Duke of Urbino, it was then presented by the most illustrious Signora Leonora, his consort, to the Venetians Don Paolo Giustiniano and Don Pietro Quirini, hermits of the holy Hermitage of Camaldoli, who after-wards placed it, as a relic and a very rare thing, and, in a word, as a work by the hand of Raffaello da Urbino, and also to honour the memory of that most illustrious lady, in the apartment of the Superior of that hermitage, where it is held in the veneration that it deserves.

Having executed these works and settled his affairs, Raffaello returned to Perugia, where he painted a panel-picture of Our Lady, S. John the Baptist, and S. Nicholas, for the Chapel of the Ansidei in the Church of the Servite Friars. And in the Chapel of the Madonna in S. Severo, a little monastery of the Order of Camaldoli, in the same city, he painted in fresco a Christ in Glory, and a God the Father with angels round Him, and six saints seated, S. Benedict, S. Romualdo, S. Laurence, S. Jerome, S. Mauro, and S. Placido, three on either side; and on this picture, which was held at that time to be most beautiful for a work in fresco, he wrote his name in large and very legible letters. In the same city, also, he was commissioned by the Nuns of S. Anthony of Padua to paint a panel-picture of Our Lady, with Jesus Christ fully dressed, as it pleased those simple and venerable sisters, in her lap, and on either side of the Madonna S. Peter, S. Paul, S. Cecilia, and S. Catherine; to which two holy virgins he gave the sweetest and most lovely expressions of countenance and the most beautifully varied head-dresses that are anywhere to be seen, which was a rare thing in those times. Above this panel, in a lunette, he painted a very beautiful God the Father, and in the

predella of the altar three scenes with little figures, of Christ praying in the Garden, bearing the Cross (wherein are some soldiers dragging Him along with most beautiful movements), and lying dead in the lap of His Mother. This work is truly marvellous and devout; and it is held in great veneration by those nuns, and much extolled by all painters.

I will not refrain from saying that it was recognized, after he had been in Florence, that he changed and improved his manner so much, from having seen many works by the hands of excellent masters, that it had nothing to do with his earlier manner; indeed, the two might have belonged to different masters, one much more excellent than the other in painting.

Before he departed from Perugia, Madonna Atalanta Baglioni besought him that he should consent to paint a panel for her chapel in the Church of S. Francesco; but since he was not able to meet her wishes at that time, he promised her that, after returning from Florence, whither he was obliged to go on some affairs, he would not fail her. And so, having come to Florence, where he applied himself with incredible labour to the studies of his art, he made the cartoon for that chapel, with the intention of going, as he did, as soon as the occasion might present itself, to put it into execution.

While he was thus staying in Florence, Agnolo Doni – who was very careful of his money in other things, but willing to spend it, although still with the greatest possible economy, on works of painting and sculpture, in which he much delighted – caused him to make portraits of himself and of his wife; and these may be seen, painted in his new manner, in the possession of Giovan Battista, his son, in the beautiful and most commodious house that the same Agnolo built on the Corso de' Tintori, near the Canto degli Alberti, in Florence. For Domenico Canigiani, also, he painted a picture of Our Lady, with the Child Jesus welcoming a little S. John brought to Him by S. Elizabeth, who, as she holds him, is gazing with a most animated expression at a S. Joseph, who is standing with both his hands leaning on a staff, and inclines his head towards her, as though praising the greatness of God and marvelling that she, so advanced in years, should have so young a child. And all appear to be amazed to see with how much feeling and reverence the two cousins, for all their tender age, are caressing one another; not to mention that every touch of colour in the heads, hands, and feet seems to be

living flesh rather than a tint laid on by a master of that art. This most noble picture is now in the possession of the heirs of the said Domenico Canigiani, who hold it in the estimation that is due to a work by Raffaello da Urbino.

This most excellent of painters studied in the city of Florence the old works of Masaccio; and what he saw in those of Leonardo and Michelagnolo made him give even greater attention to his studies, in consequence of which he effected an extraordinary improvement in his art and manner. While he was living in Florence, Raffaello, besides other friendships, became very intimate with Fra Bartolommeo di San Marco, being much pleased with his colouring, and taking no little pains to imitate it: and in return he taught that good father the principles of perspective, to which up to that time the monk had not given any attention.

But at the very height of this friendly intercourse, Raffaello was recalled to Perugia, where he began by finishing the work for the aforesaid Madonna Atalanta Baglioni in S. Francesco, for which, as has been related, he had made the cartoon in Florence. In this most divine picture there is a Dead Christ being borne to the Sepulchre, executed with such freshness and such loving care, that it seems to the eye to have been only just painted. In the composition of this work, Raffaello imagined to himself the sorrow that the nearest and most affectionate relatives of the dead one feel in laying to rest the body of him who has been their best beloved, and on whom, in truth, the happiness, honour, and welfare of a whole family have depended. Our Lady is seen in a swoon; and the heads of all the figures are very gracious in their weeping, particularly that of S. John, who, with his hands clasped, bows his head in such a manner as to move the hardest heart to pity. And in truth, whoever considers the diligence, love, art, and grace shown by this picture, has great reason to marvel, for it amazes all who behold it, what with the air of the figures, the beauty of the draperies, and, in short, the supreme excellence that it reveals in every part.

This work finished, he returned to Florence, where he received from the Dei, citizens of that city, the commission for an altar-panel that was to be placed in their chapel in S. Spirito; and he began it, and brought the sketch very nearly to completion. At the same time he painted a picture that was afterwards sent to Siena, although, on the departure of Raffaello, it was left with Ridolfo Ghirlandajo, to the end that he might finish a piece of

blue drapery that was wanting. This happened because Bramante da Urbino, who was in the service of Julius II, wrote to Raffaello, on account of his being distantly related to him and also his compatriot, that he had so wrought upon the Pope, who had caused some new rooms to be made (in the Vatican), that Raffaello would have a chance of showing his worth in them. This proposal pleased Raffaello: wherefore, abandoning his works in Florence, and leaving the panel for the Dei unfinished, in the state in which Messer Baldassarre da Pescia had it placed in the Pieve of his native city after the death of Raffaello, he betook himself to Rome. Having arrived there, he found that most of the rooms in the Palace had been painted, or were still being painted, by a number of masters. To be precise, he saw that there was one room in which a scene had been finished by Piero della Francesca; Luca da Cortona had brought one wall nearly to completion; and Don Pietro* della Gatta, Abbot of S. Clemente at Arezzo, had begun some works there. Bramantino, the Milanese, had likewise painted many figures, which were mostly portraits from life, and were held to be very beautiful. After his arrival, therefore, having been received very warmly by Pope Julius, Raffaello began in the Camera della Segnatura a scene of the theologians reconciling Philosophy and Astrology with Theology: wherein are portraits of all the sages in the world, disputing in various ways. Standing apart are some astrologers, who have made various kinds of figures and characters of geomancy and astrology on some little tablets, which they send to the Evangelists by certain very beautiful angels; and these Evangelists are expounding them. Among them is Diogenes with his cup, lying on the steps, and lost in thought, a figure very well conceived, which, for its beauty and the characteristic negligence of its dress, is worthy to be extolled. There, also, are Aristotle and Plato, one with the Timæus in his hand, the other with the Ethics; and round them, in a circle, is a great school of philosophers. Nor is it possible to express the beauty of those astrologers and geometricians who are drawing a vast number of figures and characters with compasses on tablets: among whom, in the figure of a young man, shapely and handsome, who is throwing out his arms in admiration, and inclining his head, is the portrait of Federigo II, Duke of Mantua, who was then in Rome. There is also a figure

* This seems to be an error for Bartolommeo.

that is stooping to the ground, holding in its hand a pair of compasses, with which it is making a circle on a tablet: this is said to be the architect Bramante, and it is no less the man himself than if he were alive, so well is it drawn. Beside a figure with its back turned and holding a globe of the heavens in its hand, is the portrait of Zoroaster; and next to him is Raffaello, the master of the work, who made his own portrait by means of a mirror, in a youthful head with an air of great modesty, filled with a pleasing and excellent grace, and wearing a black cap.

Nor is one able to describe the beauty and goodness that are to be seen in the heads and figures of the Evangelists, to whose countenances he gave an air of attention and intentness very true to life, and particularly in those who are writing. Thus, behind S. Matthew, who is copying the characters from the tablet wherein are the figures (which is held before him by an angel), and writing them down in a book, he painted an old man who, having placed a piece of paper on his knee, is copying all that S. Matthew writes down; and while intent on his work in that uncomfortable position, he seems to twist his head and his jaws in time with the motion of the pen. And in addition to the details of the conceptions, which are numerous enough, there is the composition of the whole scene, which is truly arranged with so much order and proportion, that he may be said to have given therein such a proof of his powers as made men understand that he was resolved to hold the sovereignty, without question, among all who handled the brush.

He also adorned this work with a view in perspective and with many figures, executed in such a sweet and delicate manner, that Pope Julius was induced thereby to cause all the scenes of the other masters, both the old and the new, to be thrown to the ground, so that Raffaello alone might have the glory of all the labours that had been devoted to these works up to that time. The work of Giovanni Antonio Sodoma of Vercelli, which was above Raffaello's painting, was to be thrown down by order of the Pope; but Raffaello determined to make use of its compartments and grotesques. There were also some medallions, four in number, and in each of these he made a figure as a symbol of the scenes below, each figure being on the same side as the scene that it represented. Over the first scene, wherein he painted Philosophy, Astrology, Geometry, and Poetry making peace with Theology, is a woman representing Knowledge, who is seated on a

throne that is supported on either side by a figure of the Goddess Cybele, each with those many breasts which in ancient times were the attributes of Diana Polymastes; and her dress is of four colours, standing for the four elements; from the head downwards there is the colour of fire, below the girdle that of the sky, from the groin to the knees there is the colour of earth, and the rest, down to the feet, is the colour of water. With her, also, are some truly beautiful little boys. In another medallion, on the side towards the window that looks over the Belvedere, is a figure of Poetry, who is in the form of Polyhymnia, crowned with laurel, and holds an antique musical instrument in one hand, and a book in the other, and has her legs crossed. With a more than human beauty of expression in her countenance, she stands with her eyes uplifted towards Heaven, accompanied by two little boys, who are lively and spirited, and who make a group of beautiful variety both with her and with the others. On this side, over the aforesaid window, Raffaello afterwards painted Mount Parnassus. In the third medallion, which is above the scene where the Holy Doctors are ordaining the Mass, is a figure of Theology, no less beautiful than the others, with books and other things round her, and likewise accompanied by little boys. And in the fourth medallion, over the other window, which looks out on the court, he painted Justice with her scales, and her sword uplifted, and with the same little boys that are with the others; of which the effect is supremely beautiful, for in the scene on the wall below he depicted the giving of the Civil and the Canon Law, as we will relate in the proper place.

In like manner, on the same ceiling, in the angles of the pendentives, he executed four scenes which he drew and coloured with great diligence, but with figures of no great size. In one of these, that near the Theology, he painted the Sin of Adam, the eating of the apple, which he executed with a most delicate manner; and in the second, near the Astrology, is a figure of that science setting the fixed stars and planets in their places. In the next, that belonging to Mount Parnassus, is Marsyas, whom Apollo has caused to be bound to a tree and flayed; and on the side of the scene wherein the Decretals are given, there is the Judgment of Solomon, showing him proposing to have the child cut in half. These four scenes are all full of expression and feeling, and executed with excellent draughtsmanship, and with pleasing and gracious colouring.

But now, having finished with the vaulting – that is, the ceiling – of that apartment, it remains for us to describe what he painted below the things mentioned above, wall by wall. On the wall towards the Belvedere, where there are Mount Parnassus and the Fount of Helicon, he made round that mount a laurel wood of darkest shadows, in the verdure of which one almost sees the leaves quivering in the gentle zephyrs; and in the air are vast numbers of naked Loves, most beautiful in feature and expression, who are plucking branches of laurel and with them making garlands, which they throw and scatter about the mount. Over the whole, in truth, there seems to breathe a spirit of divinity, so beautiful are the figures, and such the nobility of the picture, which makes whoever studies it with attention marvel how a human brain, by the imperfect means of mere colours, and by excellence of draughtsmanship, could make painted things appear alive. Most lifelike, also, are those Poets who are seen here and there about the mount, some standing, some seated, some writing, and others discoursing, and others, again, singing or conversing together, in groups of four or six, according as it pleased him to distribute them. There are portraits from nature of all the most famous poets, ancient and modern, and some only just dead, or still living in his day; which were taken from statues or medals, and many from old pictures, and some, who were still alive, portrayed from the life by himself. And to begin with one end, there are Ovid, Virgil, Ennius, Tibullus, Catullus, Propertius, and Homer; the last-named, blind and chanting his verses with uplifted head, having at his feet one who is writing them down. Next, in a group, are all the nine Muses and Apollo, with such beauty in their aspect, and such divinity in the figures, that they breathe out a spirit of grace and life. There, also, are the learned Sappho, the most divine Dante, the gracious Petrarca, and the amorous Boccaccio, who are wholly alive, with Tibaldeo, and an endless number of other moderns; and this scene is composed with much grace, and executed with diligence.

On another wall he made a Heaven, with Christ, Our Lady, S. John the Baptist, the Apostles, the Evangelists, and the Martyrs, enthroned on clouds, with God the Father sending down the Holy Spirit over them all, and particularly over an endless number of saints, who are below, writing the Mass, and engaged in disputation about the Host, which is on the altar. Among these are the four Doctors of the Church, who have about them a vast

number of saints, such as Dominic, Francis, Thomas Aquinas, Buonaventura, Scotus, and Nicholas of Lira, with Dante, Fra Girolamo Savonarola of Ferrara, and all the Christian theologians, with an infinite number of portraits from nature; and in the air are four little children, who are holding open the Gospels. Anything more graceful or more perfect than these figures no painter could create, since those saints are represented as seated in the air, in a circle, and so well, that in truth, besides the appearance of life that the colouring gives them, they are foreshortened and made to recede in such a manner, that they would not be otherwise if they were in relief. Moreover, their vestments show a rich variety, with most beautiful folds in the draperies, and the expressions of the heads are more Divine than human; as may be seen in that of Christ, which reveals all the clemency and devoutness that Divinity can show to mortal men through the medium of painting. For Raffaello received from nature a particular gift of making the expressions of his heads very sweet and gracious; of which we have proof also in the Madonna, who, with her hands pressed to her bosom, gazing in contemplation upon her Son, seems incapable of refusing any favour; not to mention that he showed a truly beautiful sense of fitness, giving a look of age to the expressions of the Holy Patriarchs, simplicity to the Apostles, and faith to the Martyrs. Even more art and genius did he display in the holy Christian Doctors, in whose features, while they make disputation throughout the scene in groups of six or three or two, there may be seen a kind of eagerness and distress in seeking to find the truth of that which is in question, revealing this by gesticulating with their hands, making various movements of their persons, turning their ears to listen, knitting their brows, and expressing astonishment in many different ways, all truly well varied and appropriate; save only the four Doctors of the Church, who, illumined by the Holy Spirit, are unravelling and expounding, by means of the Holy Scriptures, all the problems of the Gospels, which are held up by those little boys who have them in their hands as they hover in the air.

On another wall, where the other window is, on one side, he painted Justinian giving the Laws to the Doctors to be revised; and above this, Temperance, Fortitude, and Prudence. On the other side he painted the Pope giving the Canonical Decretals; for which Pope he made a portrait from life of Pope Julius, and, beside him, Cardinal Giovanni de' Medici, who became Pope

Leo, Cardinal Antonio di Monte, and Cardinal Alessandro Farnese, who afterwards became Pope Paul III, with other portraits.

The Pope was very well satisfied with this work; and in order to make the panelling worthy of the paintings, he sent to Monte Oliveto di Chiusuri, a place in the territory of Siena, for Fra Giovanni da Verona, a great master at that time of perspective-views in inlaid woodwork, who made there not only the panelling right round, but also very beautiful doors and seats, wrought with perspective-views, which brought him great favour, rewards, and honour from the Pope. And it is certain that in that craft there was never any man more able than Giovanni, either in design or in workmanship: of which we still have proof in the Sacristy, wrought most beautifully with perspective-views in woodwork, of S. Maria in Organo in his native city of Verona, in the choir of Monte Oliveto di Chiusuri and that of S. Benedetto at Siena, in the Sacristy of Monte Oliveto at Naples, and also in the choir of the Chapel of Paolo da Tolosa in the same place, executed by that master. Wherefore he well deserved to be esteemed and held in very great honour by the convent of his Order, in which he died at the age of sixty-eight, in the year 1537. Of him, as of a person truly excellent and rare, I have thought it right to make mention, believing that this was due to his talents, which, as will be related in another place, led to many beautiful works being made by other masters after him.

But to return to Raffaello; his powers grew in such a manner, that he was commissioned by the Pope to go on to paint a second room, that near the Great Hall. And at this time, when he had gained a very great name, he also made a portrait of Pope Julius in a picture in oils, so true and so lifelike, that the portrait caused all who saw it to tremble, as if it had been the living man himself. This work is now in S. Maria del Popolo, together with a very beautiful picture of Our Lady, painted at the same time by the same master, and containing the Nativity of Jesus Christ, wherein is the Virgin laying a veil over her Son, whose beauty is such, both in the air of the head and in all the members, as to show that He is the true Son of God. And no less beautiful than the Child is the Madonna, in whom, besides her supreme loveliness, there may be seen piety and gladness. There is also a Joseph, who, leaning with both his hands on a staff, and lost in thoughtful contemplation of the King and Queen of Heaven, gazes with

the adoration of a most saintly old man. Both these pictures are exhibited on days of solemn festival.

By this time Raffaello had acquired much fame in Rome; but, although his manner was graceful and held by all to be very beautiful, and despite the fact that he had seen so many antiquities in that city, and was for ever studying, nevertheless he had not yet given thereby to his figures that grandeur and majesty which he gave to them from that time onward. For it happened in those days that Michelagnolo made the terrifying outburst against the Pope in the chapel, of which we will speak in his Life; whence he was forced to fly to Florence. Whereupon Bramante, having the keys of the chapel, allowed Raffaello, who was his friend, to see it, to the end that he might be able to learn the methods of Michelagnolo. And the sight of it was the reason that Raffaello straightway repainted, although he had already finished it, the Prophet Isaiah that is to be seen in S. Agostino at Rome, above the S. Anne by Andrea Sansovino; in which work, by means of what he had seen of Michelagnolo's painting, he made the manner immeasurably better and more grand, and gave it greater majesty. Wherefore Michelagnolo, on seeing afterwards the work of Raffaello, thought, as was the truth, that Bramante had done him that wrong on purpose in order to bring profit and fame to Raffaello.

Not long after this, Agostino Chigi, a very rich merchant of Siena, who was much the friend of every man of excellence, gave Raffaello the commission to paint a chapel; and this he did because a short time before Raffaello had painted for him in his softest manner, in a loggia of his palace, now called the Chigi, in the Trastevere, a Galatea in a car on the sea drawn by two dolphins, and surrounded by Tritons and many sea-gods. Raffaello, then, having made the cartoon for that chapel, which is at the entrance of the Church of S. Maria della Pace, on the right hand as one goes into the church by the principal door, executed it in fresco, in his new manner, which was no little grander and more magnificent than his earlier manner. In this painting Raffaello depicted some Prophets and Sibyls, before Michelagnolo's chapel had been thrown open to view, although he had seen it; and in truth it is held to be the best of his works, and the most beautiful among so many that are beautiful, for in the women and children that are in it, there may be seen a marvellous vivacity and perfect colouring. And this work caused him to be greatly esteemed both

in his lifetime and after his death, being the rarest and most excellent that Raffaello executed in all his life.

Next, spurred by the entreaties of a Chamberlain of Pope Julius, he painted the panel for the high-altar of the Araceli, wherein he made a Madonna in the sky, with a most beautiful landscape, a S. John, a S. Francis, and a S. Jerome represented as a Cardinal; in which Madonna may be seen a humility and a modesty truly worthy of the Mother of Christ; and besides the beautiful gesture of the Child as He plays with His Mother's hand, there is revealed in S. John that penitential air which fasting generally gives, while his head displays the sincerity of soul and frank assurance appropriate to those who live away from the world and despise it, and, in their dealings with mankind, make war on falsehood and speak out the truth. In like manner, the S. Jerome has his head uplifted with his eyes on the Madonna, deep in contemplation; and in them seem to be suggested all the learning and knowledge that he showed in his writings, while with both his hands he is presenting the Chamberlain, in the act of recommending him to her; which portrait of the Chamberlain is as lifelike as any ever painted. Nor did Raffaello fail to do as well in the figure of S. Francis, who, kneeling on the ground, with one arm outstretched, and with his head upraised, is gazing up at the Madonna, glowing with a love in tone with the feeling of the picture, which, both by the lineaments and by the colouring, shows him melting with affection, and taking comfort and life from the gracious sight of her beauty and of the vivacity and beauty of her Son. In the middle of the panel, below the Madonna, Raffaello made a little boy standing, who is raising his head towards her and holding an inscription: than whom none better or more graceful could be painted, what with the beauty of his features and the proportionate loveliness of his person. And in addition there is a landscape, which is singularly beautiful in its absolute perfection.

Afterwards, going on with the apartments of the Palace, he painted a scene of the Miracle of the Sacramental Corporal of Orvieto, or of Bolsena, whichever it may be called. In this scene there may be perceived in the face of the priest who is saying Mass, which is glowing with a blush, the shame that he felt on seeing the Host turned into blood on the Corporal on account of his unbelief. With terror in his eyes, dumbfoundered and beside himself in the presence of his hearers, he seems like one

who knows not what to do; and in the gesture of his hands may almost be seen the fear and trembling that a man would feel in such a case. Round him Raffaello made many figures, all varied and different, some serving the Mass, others kneeling on a flight of steps; and all, bewildered by the strangeness of the event, are making various most beautiful movements and gestures, while in many, both men and women, there is revealed a belief that they are to blame. Among the women is one who is seated on the ground at the foot of the scene, holding a child in her arms; and she, hearing the account that another appears to be giving her of the thing that has happened to the priest, turns in a marvellous manner as she listens to this, with a womanly grace that is very natural and lifelike. On the other side he painted Pope Julius hearing that Mass, a most marvellous work, wherein he made a portrait of Cardinal di San Giorgio, with innumerable others; and the window-opening he turned to advantage by making a flight of steps, in such a way that all the painting seems to be one whole: nay, it appears as if, were that window-space not there, the work would in nowise have been complete. Wherefore it may be truly credited to him that in the invention and composition of every kind of painted story, no one has ever been more dexterous, facile, and able than Raffaello.

This he also proved in another scene in the same place, opposite to the last-named, of S. Peter in the hands of Herod, and guarded in prison by men-at-arms; wherein he showed such a grasp of architecture, and such judgment in the buildings of the prison, that in truth the others after him seem to have more confusion than he has beauty. For he was ever seeking to represent stories just as they are written, and to paint in them things gracious and excellent; as is proved in this one by the horror of the prison, wherein that old man is seen bound in chains of iron between the two men-at-arms, by the deep slumber of the guards, and by the dazzling splendour of the Angel, which, in the thick darkness of the night, reveals with its light every detail of the prison, and makes the arms of the soldiers shine resplendent, in such a way that their burnished lustre seems more lifelike than if they were real, although they are only painted. No less art and genius are there in the action of S. Peter, when, freed from his chains, he goes forth from the prison, accompanied by the Angel, wherein one sees in the face of the Saint a belief that it is rather a dream than a reality; and so, also, terror and dismay are shown

in some other armed guards without the prison, who hear the noise of the iron door, while a sentinel with a torch in his hand rouses the others, and, as he gives them light with it, the blaze of the torch is reflected in all their armour; and all that its glow does not reach is illumined by the light of the moon. This composition Raffaello painted over the window, where the wall is darkest; and thus, when you look at the picture, the light strikes you in the face, and the real light conflicts so well with the different lights of the night in the painting, that the smoke of the torch, the splendour of the Angel, and the thick darkness of the night seem to you to be wholly real and natural, and you would never say that it was all painted, so vividly did he express this difficult conception. In it are seen shadows playing on the armour, other shadows projected, reflections, and a vaporous glare from the lights, all executed with darkest shade, and so well, that it may be truly said that he was the master of every other master; and as an effect of night, among all those that painting has ever produced, this is the most real and most divine, and is held by all the world to be the rarest.

On one of the unbroken walls, also, he painted the Divine Worship and the Ark of the Hebrews, with the Candlestick; and likewise Pope Julius driving Avarice out of the Temple, a scene as beautiful and as excellent as the Night described above. Here, in some bearers who are carrying Pope Julius, a most lifelike figure, in his chair, are portraits of men who were living at that time. And while the people, some women among them, are making way for the Pope, so that he may pass, one sees the furious onset of an armed man on horseback, who, accompanied by two on foot, and in an attitude of the greatest fierceness, is smiting and riding down the proud Heliodorus, who is seeking, at the command of Antiochus, to rob the Temple of all the wealth stored for the widows and orphans. Already the riches and treasures could be seen being removed and taken away, when, on account of the terror of the strange misfortune of Heliodorus, so rudely struck down and smitten by the three figures mentioned above (although, this being a vision, they are seen and heard by him alone), behold, they are all dropped and upset on the ground, those who were carrying them falling down through the sudden terror and panic that had come upon all the following of Heliodorus. Apart from these may be seen the holy Onias, the High Priest, dressed in his robes of office, with his eyes and hands

raised to Heaven, and praying most fervently, being seized with pity for the poor innocents who were thus nearly losing their possessions, and rejoicing at the help that he feels has come down from on high. Besides this, through a beautiful fancy of Raffaello's, one sees many who have climbed on to the socles of the column-bases, and, clasping the shafts, stand looking in most uncomfortable attitudes; with a throng of people showing their amazement in many various ways, and awaiting the result of this event.

This work is in every part so stupendous, that even the cartoons are held in the greatest veneration; wherefore Messer Francesco Masini, a gentleman of Cesena – who, without the help of any master, but giving his attention by himself from his earliest childhood, guided by an extraordinary instinct of nature, to drawing and painting, has painted pictures that have been much extolled by good judges of art – possesses, among his many drawings and some ancient reliefs in marble, certain pieces of the cartoon which Raffaello made for this story of Heliodorus, and he holds them in the estimation that they truly deserve. Nor will I refrain from saying that Messer Niccolò Masini, who has given me information about these matters, is as much a true lover of our arts as he is a man of real culture in all other things.

But to return to Raffaello; on the ceiling above these works, he then executed four scenes, God appearing to Abraham and promising him the multiplication of his seed, the Sacrifice of Isaac, Jacob's Ladder, and the Burning Bush of Moses: wherein may be recognized no less art, invention, draughtsmanship, and grace, than in the other works that he painted.

While the happy genius of this craftsman was producing such marvels, the envy of fortune cut short the life of Julius II, who had fostered such abilities, and had been a lover of every excellent work. Whereupon a new Pope was elected in Leo X, who desired that the work begun should be carried on; and Raffaello thereby soared with his genius into the heavens, and received endless favours from him, fortunate in having come upon a Prince so great, who had by the inheritance of blood a strong inclination for such an art. Raffaello, therefore, thus encouraged to pursue the work, painted on the other wall the Coming of Attila to Rome, and his encounter at the foot of Monte Mario with Leo III, who drove him away with his mere benediction. In

this scene Raffaello made S. Peter and S. Paul in the air, with swords in their hands, coming to defend the Church; and while the story of Leo III says nothing of this, nevertheless it was thus that he chose to represent it, perchance out of fancy, for it often happens that painters, like poets, go straying from their subject in order to make their work the more ornate, although their digressions are not such as to be out of harmony with their first intention. In those Apostles may be seen that celestial wrath and ardour which the Divine Justice is wont often to impart to the features of its ministers, charged with defending the most holy Faith; and of this we have proof in Attila, who is to be seen riding a black horse with white feet and a star on its forehead, as beautiful as it could be, for in an attitude of the utmost terror he throws up his head and turns his body in flight. There are other most beautiful horses, particularly a dappled jennet, which is ridden by a figure that has all the body covered with scales after the manner of a fish; which is copied from the Column of Trajan, wherein the figures have armour of that kind; and it is thought that such armour is made from the skins of crocodiles. There is Monte Mario, all aflame, showing that when soldiers march away, their quarters are always left a prey to fire. He made portraits from nature, also, in some mace-bearers accompanying the Pope, who are marvellously lifelike, as are the horses on which they are riding; and the same is true of the retinue of Cardinals, and of some grooms who are holding the palfrey on which rides the Pope in full pontificals (a portrait of Leo X, no less lifelike than those of the others), with many courtiers; the whole being a most pleasing spectacle and well in keeping with such a work, and also very useful to our art, particularly for those who have no such objects at their command.

At this same time he painted a panel containing Our Lady, S. Jerome robed as a Cardinal, and an Angel Raphael accompanying Tobias, which was placed in S. Domenico at Naples, in that chapel wherein is the Crucifix that spoke to S. Thomas Aquinas. For Signor Leonello da Carpi, Lord of Meldola, who is still alive, although more than ninety years old, he executed a picture that was most marvellous in colouring, and of a singular beauty, for it is painted with such force, and also with a delicacy so pleasing, that I do not think it is possible to do better. In the countenance of the Madonna may be seen such a divine air, and in her attitude such a dignity, that no one would be able to improve her; and he

made her with the hands clasped, adoring her Son, who is seated
on her knees, caressing a S. John, a little boy, who is adoring
Him, in company with S. Elizabeth and Joseph. This picture
was once in the possession of the very reverend Cardinal da
Carpi, the son of the said Signor Leonello, and a great lover of
our arts; and it should be at the present day in the hands of his
heirs.

Afterwards, Lorenzo Pucci, Cardinal of Santi Quattro, having
been created Grand Penitentiary, Raffaello was favoured by him
with a commission to paint a panel for S. Giovanni in Monte at
Bologna, which is now set up in the chapel wherein lies the body
of the Blessed Elena dall' Olio: in which work it is evident how
much grace, in company with art, could accomplish by means of
the delicate hands of Raffaello. In it is a S. Cecilia, who, entranced
by a choir of angels on high, stands listening to the sound, wholly
absorbed in the harmony; and in her countenance is seen that
abstraction which is found in the faces of those who are in ec-
stasy. Scattered about the ground, moreover, are musical instru-
ments, which have the appearance of being, not painted, but real
and true; and such, also, are some veils that she is wearing, with
vestments woven in silk and gold, and, below these, a marvellous
hair-shirt. And in a S. Paul, who has the right arm leaning on his
naked sword, and the head resting on the hand, one sees his
profound air of knowledge, no less well expressed than the trans-
formation of his pride of aspect into dignity. He is clothed in a
simple red garment by way of mantle, below which is a green
tunic, after the manner of the Apostles, and his feet are bare.
There is also S. Mary Magdalene, who is holding in her hands a
most delicate vase of stone, in an attitude of marvellous grace;
turning her head, she seems full of joy at her conversion; and
indeed, in that kind of painting, I do not think that anything
better could be done. Very beautiful, likewise, are the heads of
S. Augustine and S. John the Evangelist. Of a truth, other pic-
tures may be said to be pictures, but those of Raffaello life itself,
for in his figures the flesh quivers, the very breath may be per-
ceived, the pulse beats, and the true presentment of life is seen
in them; on which account this picture gave him, in addition to
the fame that he had already, an even greater name. Wherefore
many verses were written in his honour, both Latin and in the
vulgar tongue, of which, in order not to make my story longer
than I have set out to do, I will cite only the following:

Pingant sola alii referantque coloribus ora;
Cæciliæ os Raphael atque animum explicuit.

After this he also painted a little picture with small figures, which is likewise at Bologna, in the house of Count Vincenzio Ercolano, containing a Christ after the manner of Jove in Heaven, surrounded by the four Evangelists as Ezekiel describes them, one in the form of a man, another as a lion, the third an eagle, and the fourth an ox, with a little landscape below to represent the earth: which work, in its small proportions, is no less rare and beautiful than his others in their greatness.

To the Counts of Canossa in Verona he sent a large picture of equal excellence, in which is a very beautiful Nativity of Our Lord, with a daybreak that is much extolled, as is also the S. Anne, and, indeed, the whole work, which cannot be more highly praised than by saying that it is by the hand of Raffaello da Urbino. Wherefore those Counts rightly hold it in supreme veneration, nor have they ever consented, for all the vast prices that have been offered to them by many Princes, to sell it to anyone.

For Bindo Altoviti, he made a portrait of him when he was a young man, which is held to be extraordinary; and likewise a picture of Our Lady, which he sent to Florence, and which is now in the Palace of Duke Cosimo, in the chapel of the new apartments, which were built and painted by me, where it serves as altar-piece. In it is painted a very old S. Anne, seated, and holding out to Our Lady her Son, the features of whose countenance, as well as the whole of His nude form, are so beautiful that with His smile He rejoices whoever beholds Him; besides which, Raffaello depicted, in painting the Madonna, all the beauty that can be imparted to the aspect of a Virgin, with the complement of chaste humility in the eyes, honour in the brow, grace in the nose, and virtue in the mouth; not to mention that her raiment is such as to reveal infinite simplicity and dignity. And, indeed, I do not think that there is anything better to be seen than this whole work. There is a nude S. John, seated, with a female saint, who is likewise very beautiful; and for background there is a building, in which he painted a linen-covered window that gives light to the room wherein are the figures.

In Rome he made a picture of good size, in which he portrayed Pope Leo, Cardinal Giulio de' Medici, and Cardinal de'

Rossi. In this the figures appear to be not painted, but in full relief; there is the pile of the velvet, with the damask of the Pope's vestments shining and rustling, the fur of the linings soft and natural, and the gold and silk so counterfeited that they do not seem to be in colour, but real gold and silk. There is an illuminated book of parchment, which appears more real than the reality; and a little bell of wrought silver, which is more beautiful than words can tell. Among other things, also, is a ball of burnished gold on the Pope's chair, wherein are reflected, as if it were a mirror (such is its brightness), the light from the windows, the shoulders of the Pope, and the walls round the room. And all these things are executed with such diligence, that one may believe without any manner of doubt that no master is able, or is ever likely to be able, to do better. For this work the Pope was pleased to reward him very richly; and the picture is still to be seen in Florence, in the guardaroba of the Duke. In like manner he executed portraits of Duke Lorenzo and Duke Giuliano, with a perfect grace of colouring not achieved by any other than himself, which are in the possession of the heirs of Ottaviano de' Medici at Florence.

Thereupon there came to Raffaello a great increase of glory, and likewise of rewards; and for this reason, in order to leave some memorial of himself, he caused a palace to be built in the Borgo Nuovo at Rome, which Bramante executed with castings. Now, the fame of this most noble craftsman, by reason of the aforesaid works and many others, having passed into France and Flanders, Albrecht Dürer, a most marvellous German painter, and an engraver of very beautiful copperplates, rendered tribute to Raffaello out of his own works, and sent to him a portrait of himself, a head, executed by him in gouache on a cloth of fine linen, which showed the same on either side, the lights being transparent and obtained without lead-white, while the only grounding and colouring was done with water-colours, the white of the cloth serving for the ground of the bright parts. This work seemed to Raffaello to be marvellous, and he sent him, therefore, many drawings executed by his own hand, which were received very gladly by Albrecht. That head was among the possessions of Giulio Romano, the heir of Raffaello, in Mantua.

Raffaello, having thus seen the manner of the engravings of Albrecht Dürer, and desiring on his own behalf to show what could be done with his work by such an art, caused Marc'

Antonio Bolognese to make a very thorough study of the method; and that master became so excellent, that Raffaello commissioned him to make prints of his first works, such as the drawing of the Innocents, a Last Supper, the Neptune, and the S. Cecilia being boiled in oil. Marc' Antonio afterwards made for Raffaello a number of other engravings, which Raffaello finally gave to Baviera, his assistant, who had charge of a mistress whom Raffaello loved to the day of his death. Of her he made a very beautiful portrait, wherein she seemed wholly alive: and this is now in Florence, in the possession of that most gentle of men, Matteo Botti, a Florentine merchant, and an intimate friend of every able person, and particularly of painters, who treasures it as a relic, on account of the love that he bears to art, and above all to Raffaello. And no less esteem is shown to the works of our arts and to the craftsmen by his brother, Simon Botti, who, besides being held by us all to be one of the most loving spirits that show favour to the men of our professions, is held in estimation by me in particular as the best and greatest friend that ever man loved after a long experience; not to mention the good judgment that he has and shows in matters of art.

But to return to the engravings; the favour shown by Raffaello to Baviera was the reason that there afterwards sprang up Marco da Ravenna and a host of others, insomuch that the dearth of copper engravings was changed into that abundance that we see at the present day. Thereupon Ugo da Carpi, having a brain inclined to ingenious and fanciful things, and showing beautiful invention, discovered the method of wood-engraving, whereby, with three blocks, giving the middle values, the lights, and the shadows, it is possible to imitate drawings in chiaroscuro, which was certainly a thing of beautiful and fanciful invention; and from this, also, there afterwards came an abundance of prints, as will be related with greater detail in the Life of Marc' Antonio Bolognese.

Raffaello then painted for the Monastery of the Monks of Monte Oliveto, called S. Maria dello Spasmo, at Palermo, a panel-picture of Christ bearing the Cross, which is held to be a marvellous work. In this may be seen the impious ministers of the Crucifixion, leading Him with wrath and fury to His death on Mount Calvary; and Christ, broken with agony at the near approach of death, has fallen to the ground under the weight of the Tree of the Cross, and, bathed with sweat and blood, turns

towards the Maries, who are in a storm of weeping. Moreover, there is seen among them Veronica, who stretches out her arms and offers Him a cloth, with an expression of the tenderest love, not to mention that the work is full of men-at-arms both on horseback and on foot, who are pouring forth from the gate of Jerusalem with the standards of justice in their hands, in various most beautiful attitudes. This panel, when completely finished, but not yet brought to its resting-place, was very near coming to an evil end, for the story goes that after it had been put on shipboard, in order that it might be carried to Palermo, a terrible storm dashed against a rock the ship that was carrying it, in such a manner that the timbers broke asunder, and all the men were lost, together with the merchandise, save only the panel, which, safely packed in its case, was washed by the sea on to the shore of Genoa. There, having been fished up and drawn to land, it was found to be a thing divine, and was put into safe keeping; for it had remained undamaged and without any hurt or blemish, since even the fury of the winds and the waves of the sea had respect for the beauty of such a work. The news of this being then bruited abroad, the monks took measures to recover it, and no sooner had it been restored to them, by the favour of the Pope, than they gave satisfaction, and that liberally, to those who had rescued it. Thereupon it was once more put on board ship and brought at last to Sicily, where they set it up in Palermo; in which place it has more fame and reputation than the Mount of Vulcan itself.

While Raffaello was engaged on these works, which, having to gratify great and distinguished persons, he could not refuse to undertake – not to mention that his own private interests prevented him from saying them nay – yet for all this he never ceased to carry on the series of pictures that he had begun in the Papal apartments and halls; wherein he always kept men who pursued the work from his own designs, while he himself, continually supervising everything, lent to so vast an enterprise the aid of the best efforts of which he was capable. No long time passed, therefore, before he threw open that apartment of the Borgia Tower in which he had painted a scene on every wall, two above the windows, and two others on the unbroken walls. In one was the Burning of the Borgo Vecchio of Rome, when, all other methods having failed to put out the fire, S. Leo IV presents himself at the Loggia of his Palace and extinguishes it

completely with his benediction. In this scene are represented various perils. On one side are women who are bearing vessels filled with water in their hands and on their heads, whereby to extinguish the flames; and their hair and draperies are blown about by the terrible fury of a tempestuous wind. Others, who are seeking to throw water on the fire, are blinded by the smoke and wholly bewildered. On the other side, after the manner of Virgil's story of Anchises being carried by Æneas, is shown an old sick man, overcome by his infirmity and the flames of the fire; and in the figure of the young man are seen courage and strength, and great effort in all his limbs under the weight of the old man, who lies helpless on the young man's back. He is followed by an old woman with bare feet and disordered garments, who is flying from the fire; and a little naked boy runs before them. On the top of some ruins, likewise, may be seen a naked woman, with hair all dishevelled, who has her child in her hands and is throwing him to a man of her house, who, having escaped from the flames, is standing in the street on tiptoe, with arms outstretched to receive the child wrapped in swathing-bands; wherein the eager anxiety of the woman to save her son may be recognized no less clearly than her torment in the peril of the fierce flames, which are already licking around her. And no less suffering is evident in him who is receiving the child, both for its sake and on account of his own fear of death. Nor is it possible to describe the imagination that this most ingenious and most marvellous craftsman showed in a mother with her feet bare, her garments in disorder, her girdle unbound, and her hair dishevelled, who has gathered her children before her and is driving them on, holding part of her clothing in one hand, that they may escape from the ruins and from that blazing furnace; not to mention that there are also some women who, kneeling before the Pope, appear to be praying to his Holiness that he should make the fire cease.

The next scene is from the life of the same S. Leo IV, wherein Raffaello depicted the port of Ostia occupied by the fleet of the Turks, who had come to take the Pope prisoner. The Christians may be seen fighting against that fleet on the sea; and already there has come to the harbour an endless number of prisoners, who are disembarking from a boat and being dragged by the beard by some soldiers, who are very beautiful in features and most spirited in their attitudes. The prisoners, dressed in the

motley garb of galley-slaves, are being led before S. Leo, whose figure is a portrait of Pope Leo X. Here Raffaello painted his Holiness in pontificals, between Cardinal Santa Maria in Portico, who was Bernardo Divizio of Bibbiena, and Cardinal Giulio de' Medici, who afterwards became Pope Clement. Nor is it possible to describe in detail the beautiful conceptions that this most ingenious craftsman showed in the expressions of the prisoners, wherein one can recognize, without speech, their grief and the fear of death.

In the first of the other two scenes is Pope Leo X consecrating the most Christian King, Francis I of France, chanting the Mass in his pontificals, and blessing the oil for the anointing of the King, and likewise the royal crown. There, besides the great number of Cardinals and Bishops in their robes, who are assisting, he portrayed from life many Ambassadors and other persons, and also some figures dressed in the French fashion, according to the style of that time. In the other scene he painted the Crowning of the same King, wherein are portraits from life of the Pope and of Francis, one in armour and the other in his pontificals; besides which, all the Cardinals, Bishops, Chamberlains, Esquires, and Grooms of the Chamber are seated in due order in their places, as is the custom in the chapel, all in their robes and portrayed from life, among them being Giannozzo Pandolfini, Bishop of Troia, a close friend of Raffaello, with many others who were distinguished at that time. Near the King is a little boy kneeling, who is holding the royal crown – a portrait of Ippolito de' Medici, who afterwards became Cardinal and Vice-Chancellor, a man of great repute, and much the friend not only of this art, but of all others, to whose blessed memory I acknowledge a vast obligation, seeing that my first steps, such as they were, were taken under his auspices.

It is not possible to write of every detail in the works of this craftsman, wherein every least thing, although dumb, appears to have speech: save only of the bases executed below these pictures, with various figures of defenders and benefactors of the Church, and various terminal figures on either side of them, the whole being wrought in such a manner that everything reveals spirit, feeling, and thought, and with such a harmony and unity of colouring that nothing better can be conceived. And since the ceiling of that apartment had been painted by Pietro Perugino, his master, Raffaello would not destroy it, moved by respect for

his memory and by the love that he bore to the man who had been the origin of the rank that he held in his art.

Such was the greatness of this master, that he kept designers all over Italy, at Pozzuolo, and even in Greece; and he was for ever searching out everything of the good that might help his art.

Now, continuing his work, he also painted a hall, wherein were some figures of the Apostles and other saints in tabernacles, executed in terretta; and there he caused to be made by Giovanni da Udine, his disciple, who has no equal in the painting of animals, all the animals that Pope Leo possessed, such as the chameleon, the civet-cats, the apes, the parrots, the lions, the elephants, and other beasts even more strange. And besides embellishing the Palace greatly with grotesques and varied pavements, he also gave the designs for the Papal staircases, as well as for the loggie begun by the architect Bramante, but left unfinished on account of his death, and afterwards carried out with the new design and architecture of Raffaello, who made for this a model of wood with better proportion and adornment than had been accomplished by Bramante. The Pope wishing to demonstrate the greatness and magnificence of his generous ambition, Raffaello made the designs for the ornaments in stucco and for the scenes that were painted there, and likewise for the compartments; and as for the stucco and the grotesques, he placed at the head of that work Giovanni da Udine, and the figures he entrusted to Giulio Romano, although that master worked but little at them; and he also employed Giovanni Francesco, Il Bologna, Perino del Vaga, Pellegrino da Modena, Vincenzio da San Gimignano, and Polidoro da Caravaggio, with many other painters, who executed scenes and figures and other things that were required throughout that work, which Raffaello caused to be completed with such perfection, that he even sent to Florence for pavements by the hand of Luca della Robbia. Wherefore it is certain that with regard to the paintings, the stucco-ornaments, the arrangement, or any of the beautiful inventions, no one would be able to execute or even to imagine a more marvellous work; and its beauty was the reason that Raffaello received the charge of all the works of painting and architecture that were in progress in the Palace.

It is said that the courtesy of Raffaello was such that he prevailed upon the masons, in order that he might accommodate his friends, not to build the walls absolutely solid and unbroken, but to leave, above the old rooms below, various openings and spaces

for the storage of barrels, flasks, and wood; which holes and spaces so weakened the lower part of the masonry, that afterwards they had to be filled in, because the whole was beginning to show cracks. He commissioned Gian Barile to adorn all the doors and ceilings of woodwork with a good number of carvings, which he executed and finished with beautiful grace.

He gave architectural designs for the Vigna* of the Pope, and for many houses in the Borgo; in particular, for the Palace of Messer Giovanni Battista dall' Aquila, which was a very beautiful work. He also designed one for the Bishop of Troia, who had it built in the Via di S. Gallo at Florence. For the Black Friars of S. Sisto in Piacenza, he painted the picture for their high-altar, containing the Madonna with S. Sisto and S. Barbara, a truly rare and extraordinary work. He executed many pictures to be sent into France, and in particular, for the King, a S. Michael fighting with the Devil, which was held to be a marvellous thing. In this work he painted a fire-scarred rock, to represent the centre of the earth, from the fissures of which were issuing sulphurous flames; and in Lucifer, whose scorched and burned limbs are painted with various tints of flesh-colour, could be seen all the shades of anger that his venomous and swollen pride calls up against Him who overbears the greatness of him who is deprived of any kingdom where there might be peace, and doomed to suffer perpetual punishment. The opposite may be perceived in the S. Michael, clad in armour of iron and gold, who, although he is painted with a celestial air, yet has valour, force, and terror in his aspect, and has already thrown Lucifer down and hurled him backwards with his spear. In a word, this work was of such a kind that he won for it, and rightly, a most honourable reward from that King. He made portraits of Beatrice of Ferrara and other ladies, and in particular that of his own mistress, with an endless number of others.

Raffaello was a very amorous person, delighting much in women, and ever ready to serve them; which was the reason that, in the pursuit of his carnal pleasures, he found his friends more complacent and indulgent towards him than perchance was right. Wherefore, when his dear friend Agostino Chigi commissioned him to paint the first loggia in his palace, Raffaello was not able to give much attention to his work, on account of the love that

* Villa Madama.

he had for his mistress; at which Agostino fell into such despair, that he so contrived by means of others, by himself, and in other ways, as to bring it about, although only with difficulty, that this lady should come to live continually with Raffaello in that part of the house where he was working; and in this manner the work was brought to completion. For this work he made all the cartoons, and he coloured many of the figures in fresco with his own hand. And on the ceiling he made the Council of the Gods in Heaven, wherein, in the forms of the Gods, are seen many vestments and lineaments copied from the antique, and executed with very beautiful grace and draughtsmanship. In like manner he made the Marriage of Psyche, with ministers serving Jove, and the Graces scattering flowers over the table. In the spandrels of the vaulting he executed many scenes, in one of which is Mercury with his flute, who, as he flies, has all the appearance of descending from Heaven; and in another is Jove with an air of celestial dignity, kissing Ganymede; and in another, likewise, lower down, is the Car of Venus, and the Graces, with Mercury, drawing Psyche up to Heaven; with many other scenes from the poets in the other spandrels. And in the spherical triangles of the vaulting above the arches, between the spandrels, are many most beautiful little boys in foreshortening, hovering in the air and carrying all the instruments of the gods; Jove's lightnings and thunderbolts, the helmet, sword, and shield of Mars, Vulcan's hammers, the club and lion-skin of Hercules, the caduceus of Mercury, Pan's pipes, and the agricultural rakes of Vertumnus. All are accompanied by animals appropriate to their character; and the whole work, both as picture and as poem, is truly beautiful. Round these scenes he caused Giovanni da Udine to make a border of all kinds of flowers, foliage, and fruits, in festoons, which are as beautiful as they could be.

Raffaello made the designs for the architecture of the stables of the Chigi, and the design for the chapel of the aforesaid Agostino in S. Maria del Popolo, wherein, besides painting it, he made arrangements for the erection of a marvellous tomb, causing Lorenzetto, a sculptor of Florence, to execute two figures, which are still in his house in the Macello de' Corbi at Rome; but the death of Raffaello, followed by that of Agostino, brought it about that this work was given to Sebastiano Viniziano.

Meanwhile Raffaello had risen to such greatness, that Leo X ordained that he should set to work on the Great Hall on the

upper floor, wherein are the Victories of Constantine; and with this he made a beginning. A fancy likewise took the Pope to have some very rich tapestries made in gold and floss-silk; whereupon Raffaello drew and coloured with his own hand, of the exact form and size, all the cartoons, which were sent to Flanders to be woven; and the tapestries, when finished, were brought to Rome. This work was executed so marvellously, that it arouses astonishment in whoever beholds it, wondering how it could have been possible to weave the hair and beards in such detail, and to give softness to the flesh with mere threads; and it is truly rather a miracle than the work of human art, seeing that in these tapestries are animals, water, and buildings, all made in such a way that they seem to be not woven, but really wrought with the brush. The work cost 70,000 crowns, and it is still preserved in the Papal Chapel.

For Cardinal Colonna he painted a S. John on canvas, for which, on account of its beauty, that Cardinal had an extraordinary love; but happening to be attacked by illness, he was asked by Messer Jacopo da Carpi, the physician who cured him, to give it to him as a present; and because of this desire of Messer Jacopo, to whom he felt himself very deeply indebted, he gave it up. It is now in the possession of Francesco Benintendi, in Florence.

For Giulio de' Medici, Cardinal and Vice-Chancellor, he painted a panel-picture, to be sent into France, of the Transfiguration of Christ, at which he laboured without ceasing, and brought it to the highest perfection with his own hand. In this scene he represented Christ Transfigured on Mount Tabor, at the foot of which are the eleven Disciples awaiting Him. There may be seen a young man possessed by a spirit, who has been brought thither in order that Christ, after descending from the mountain, may deliver him; which young man stretches himself out in a distorted attitude, crying and rolling his eyes, and reveals his suffering in his flesh, his veins, and the beat of his pulse, all infected by that malignant spirit; and the colour of his flesh, as he makes those violent and fearsome gestures, is very pale. This figure is supported by an old man, who, having embraced him and taken heart, with his eyes wide open and the light shining in them, is raising his brows and wrinkling his forehead, showing at one and the same time both strength and fear; gazing intently, however, at the Apostles, he appears to be encouraging himself

by trusting in them. Among many women is one, the principal figure in that panel, who, having knelt down before the Apostles, and turning her head towards them, stretches her arms in the direction of the maniac and points out his misery; besides which the Apostles, some standing, some seated, and others kneeling, show that they are moved to very great compassion by such misfortune. And, indeed, he made therein figures and heads so fine in their novelty and variety, to say nothing of their extraordinary beauty, that it is the common opinion of all craftsmen that this work, among the vast number that he painted, is the most glorious, the most lovely, and the most divine. For whoever wishes to know how Christ Transfigured and made Divine should be represented in painting, must look at this work, wherein Raffaello made Him in perspective over that mount, in a sky of exceeding brightness, with Moses and Elias, who, illumined by a dazzling splendour, burst into life in His light. Prostrate on the ground, in attitudes of great beauty and variety, are Peter, James, and John; one has his head to the earth, and another, shading his eyes with his hands, is defending himself from the rays and intense light of the splendour of Christ. He, clothed in snow-white raiment, with His arms outstretched and His head raised, appears to reveal the Divine essence and nature of all the Three Persons united and concentrated in Himself by the perfect art of Raffaello, who seems to have summoned up all his powers in such a manner, in order to show the supreme force of his art in the countenance of Christ, that, after finishing this, the last work that he was to do, he never again touched a brush, being overtaken by death.

Now, having described the works of this most excellent craftsman, before I come to relate other particulars of his life and death, I do not wish to grudge the labour of saying something, for the benefit of the men of our arts, about the various manners of Raffaello. He, then, after having imitated in his boyhood the manner of his master, Pietro Perugino, which he made much better in draughtsmanship, colouring, and invention, believed that he had done enough; but he recognized, when he had reached a riper age, that he was still too far from the truth. For, after seeing the works of Leonardo da Vinci, who had no peer in the expressions of heads both of men and of women, and surpassed all other painters in giving grace and movement to his figures, he was left marvelling and amazed; and in a word, the

manner of Leonardo pleasing him more than any other that he had ever seen, he set himself to study it, and abandoning little by little, although with great difficulty, the manner of Pietro, he sought to the best of his power and knowledge to imitate that of Leonardo. But for all his diligence and study, in certain difficulties he was never able to surpass Leonardo; and although it appears to many that he did surpass him in sweetness and in a kind of natural facility, nevertheless he was by no means superior to him in that sublime groundwork of conceptions and that grandeur of art in which few have been the peers of Leonardo. Yet Raffaello came very near to him, more than any other painter, and above all in grace of colouring. But to return to Raffaello himself; in time he found himself very much hindered and impeded by the manner that he had adopted from Pietro when he was quite young, which he acquired with ease, since it was over-precise, dry, and feeble in draughtsmanship. His being unable to forget it was the reason that he had great difficulty in learning the beauties of the nude and the methods of difficult foreshortenings from the cartoon that Michelagnolo Buonarroti made for the Council Hall in Florence; and another might have lost heart, believing that he had been previously wasting his time, and would never have achieved, however lofty his genius, what Raffaello accomplished. But he, having purged himself of Pietro's manner, and having thoroughly freed himself of it, in order to learn the manner of Michelagnolo, so full of difficulties in every part, was changed, as it were, from a master once again into a disciple; and he forced himself with incredible study, when already a man, to do in a few months what might have called for the tender age at which all things are best acquired, and for a space of many years. For in truth he who does not learn in good time right principles and the manner that he wishes to follow, and does not proceed little by little to solve the difficulties of the arts by means of experience, seeking to understand every part, and to put it into practice, can scarcely ever become perfect; and even if he does, that can only be after a longer space of time and much greater labour.

When Raffaello resolved to set himself to change and improve his manner, he had never given his attention to nudes with that zealous study which is necessary, and had only drawn them from life in the manner that he had seen practised by his master Pietro, imparting to them the grace that he had from nature. He then devoted himself to studying the nude and to comparing the

muscles of anatomical subjects and of flayed human bodies with those of the living, which, being covered with skin, are not clearly defined, as they are when the skin has been removed; and going on to observe in what way they acquire the softness of flesh in the proper places, and how certain graceful flexures are produced by changing the point of view, and also the effect of inflating, lowering, or raising either a limb or the whole person, and likewise the concatenation of the bones, nerves, and veins, he became excellent in all the points that are looked for in a painter of eminence. Knowing, however, that in this respect he could never attain to the perfection of Michelagnolo, he reflected, like a man of supreme judgment, that painting does not consist only in representing the nude human form, but has a wider field; that one can enumerate among the perfect painters those who express historical inventions well and with facility, and who show fine judgment in their fancies; and that he who, in the composition of scenes, can make them neither confused with too much detail nor poor with too little, but distributed with beautiful invention and order, may also be called an able and judicious craftsman. To this, as Raffaello was well aware, may be added the enriching those scenes with a bizarre variety of perspectives, buildings, and landscapes, the method of clothing figures gracefully, the making them fade away sometimes in the shadows, and sometimes come forward into the light, the imparting of life and beauty to the heads of women, children, young men and old, and the giving them movement and boldness, according to necessity. He considered, also, how important is the furious flight of horses in battles, fierceness in soldiers, the knowledge how to depict all the sorts of animals, and above all the power to give such resemblance to portraits that they seem to be alive, and that it is known whom they represent; with an endless number of other things, such as the adornment of draperies, foot-wear, helmets, armour, women's head-dresses, hair, beards, vases, trees, grottoes, rocks, fires, skies turbid or serene, clouds, rain, lightning, clear weather, night, the light of the moon, the splendour of the sun, and innumerable other things, which are called for every moment by the requirements of the art of painting. Pondering over these things, I say, Raffaello resolved, since he could not approach Michelagnolo in that branch of art to which he had set his hand, to seek to equal, and perchance to surpass him, in these others; and he devoted himself, therefore, not to imitating the manner

of that master, but to the attainment of a catholic excellence in the other fields of art that have been described. And if the same had been done by many craftsmen of our own age, who, having determined to pursue the study of Michelagnolo's works alone, have failed to imitate him and have not been able to reach his extraordinary perfection, they would not have laboured in vain nor acquired a manner so hard, so full of difficulty, wanting in beauty and colouring, and poor in invention, but would have been able, by aiming at catholicity and at imitation in the other fields of art, to render service both to themselves and to the world.

Raffaello, then, having made this resolution, and having recognized that Fra Bartolommeo di San Marco had a passing good method of painting, well-grounded draughtsmanship, and a pleasing manner of colouring, although at times, in order to obtain stronger relief, he made too much use of darks, took from him what appeared to him to suit his need and his fancy – namely, a middle course, both in drawing and in colouring; and mingling with that method certain others selected from the best work of other masters, out of many manners he made one, which was looked upon ever afterwards as his own, and which was and always will be vastly esteemed by all craftsmen. This was then seen perfected in the Sibyls and Prophets of the work that he executed, as has been related, in S. Maria della Pace; in the carrying out of which work he was greatly assisted by having seen the paintings of Michelagnolo in the Chapel of the Pope. And if Raffaello had remained content with this same manner, and had not sought to give it more grandeur and variety in order to prove that he had as good a knowledge of the nude as Michelagnolo, he would not have lost a part of the good name that he had acquired; but the nudes that he made in that apartment of the Borgia Tower where there is the Burning of the Borgo, although they are fine, are not in every way excellent. In like manner, those that were painted likewise by him on the ceiling of the Palace of Agostino Chigi in the Trastevere did not give complete satisfaction, for they are wanting in that grace and sweetness which were peculiar to Raffaello; the reason of which, in great part, was the circumstance that he had them coloured by others after his design. However, repenting of this error, like a man of judgment, he resolved afterwards to execute by himself, without assistance from others, the panel-picture of the Transfiguration of Christ

that is in S. Pietro a Montorio, wherein are all those qualities which, as has already been described, are looked for and required in a good picture. And if he had not employed in this work, as it were from caprice, printer's smoke-black, the nature of which, as has been remarked many times, is to become ever darker with time, to the injury of the other colours with which it is mixed, I believe that the picture would still be as fresh as when he painted it; whereas it now appears to be rather a mass of shadows than aught else.

I have thought fit, almost at the close of this Life, to make this discourse, in order to show with what labour, study, and diligence this honoured craftsman always pursued his art; and even more for the sake of other painters, to the end that they may learn how to avoid those hindrances from which the wisdom and genius of Raffaello were able to deliver him. I must add this as well, that every man should be satisfied and contented with doing that work to which he feels himself drawn by a natural inclination, and should not seek, out of emulation, to put his hand to that for which nature has not adapted him; for otherwise he will labour in vain, and often to his own shame and loss. Moreover, where striving is enough, no man should aim at super-striving,* merely in order to surpass those who, by some great gift of nature, or by some special grace bestowed on them by God, have performed or are performing miracles in art; for the reason that he who is not suited to any particular work, can never reach, let him labour as he may, the goal to which another, with the assistance of nature, has attained with ease. Of this, among the old craftsmen, we may see an example in Paolo Uccello, who, striving against the limitations of his powers, in order to advance, did nothing but go backwards. The same has been done in our own day, no long time since, by Jacopo da Pontormo, and it has been proved by the experience of many others, as we have shown before and will point out yet again. And this, perchance, happens because Heaven always distributes its favours, to the end that every man may rest content with that which falls to him.

But now, having discoursed on these matters of art, perchance at greater length than was needful, let us return to the life and death of Raffaello. He had a strait friendship with Cardinal

* The use of this word, though perhaps too modern, seems to the translator to be the only way to preserve the play of words in the text.

Bernardo Divizio of Bibbiena, who had importuned him for many years to take a wife of his choosing; and Raffaello, while not directly refusing to obey the wishes of the Cardinal, had yet put the matter off, saying that he would rather wait till three or four years had passed. This term came upon Raffaello when he was not expecting it, and he was reminded by the Cardinal of his promise; whereupon, seeing himself bound, like the courteous man that he was, he would not break his word, and thus accepted as his wife a niece of that Cardinal. And because he was always very ill content with this entanglement, he continued to delay the matter in such a way that many months passed without the marriage being brought to pass. But it was with no dishonourable motive that he did this, for, having been so many years in the service of the Court, and being the creditor of Leo for a good sum, it had been hinted to him that when the hall on which he was engaged was finished, the Pope proposed to reward him for his labours and abilities by giving him a red hat, of which he had already determined to distribute a good number, and some of them to men of less merit than Raffaello.

Meanwhile, pursuing his amours in secret, Raffaello continued to divert himself beyond measure with the pleasures of love; whence it happened that, having on one occasion indulged in more than his usual excess, he returned to his house in a violent fever. The physicians, therefore, believing that he had overheated himself, and receiving from him no confession of the excess of which he had been guilty, imprudently bled him, insomuch that he was weakened and felt himself sinking; for he was in need rather of restoratives. Thereupon he made his will: and first, like a good Christian, he sent his mistress out of the house, leaving her the means to live honourably. Next, he divided his possessions among his disciples, Giulio Romano, whom he had always loved dearly, and the Florentine Giovanni Francesco, called Il Fattore, with a priest of Urbino, his kinsman, whose name I do not know. Then he gave orders that some of his wealth should be used for restoring with new masonry one of the ancient tabernacles in S. Maria Ritonda, and for making an altar, with a marble statue of Our Lady, in that church, which he chose as his place of repose and burial after death; and he left all the rest to Giulio and Giovanni Francesco, appointing as executor of his will Messer Baldassarre da Pescia, then Datary to the Pope. Finally, he confessed and was penitent, and ended the course of his life

at the age of thirty-seven, on the same day that he was born, which was Good Friday. And even as he embellished the world with his talents, so, it may be believed, does his soul adorn Heaven by its presence.

As he lay dead in the hall where he had been working, there was placed at his head the picture of the Transfiguration, which he had executed for Cardinal de' Medici; and the sight of that living picture, in contrast with the dead body, caused the hearts of all who beheld it to burst with sorrow. That work, in memory of the loss of Raffaello, was placed by the Cardinal on the high-altar of S. Pietro a Montorio; and on account of the nobility of his every action, it was held ever afterwards in great estimation. His body received that honourable burial which his noble spirit had deserved, for there was no craftsman who did not weep with sorrow and follow him to the grave. His death was also a great grief to the whole Court of the Pope, first because he had held in his lifetime the office of Groom of the Chamber, and likewise because he had been so dear to the Pope that his loss caused him to weep bitterly.

O happy and blessed spirit, in that every man is glad to speak of thee, to celebrate thy actions, and to admire every drawing that thou didst leave to us! When this noble craftsman died, the art of painting might well have died also, seeing that when he closed his eyes, she was left as it were blind. And now for us who have survived him, it remains to imitate the good, nay, the supremely excellent method bequeathed to us by him as a pattern, and, as is called for by his merit and our obligations, to hold a most grateful remembrance of this in our minds, and to pay the highest honour to his memory with our lips. For in truth we have from him art, colouring, and invention harmonized and brought to such a pitch of perfection as could scarcely be hoped for; nor may any intellect ever think to surpass him. And in addition to this benefit that he conferred on art, like a true friend to her, as long as he lived he never ceased to show how one should deal with great men, with those of middle station, and with the lowest. And, indeed, among his extraordinary gifts, I perceive one of such value that I for my part am amazed at it, in that Heaven gave him the power to produce in our art an effect wholly con-trary to the nature of us painters, which was that our craftsmen – I do not mean only the lesser, but also those whose humour it was to be great persons; and of this humour art creates a vast

number – while working in company with Raffaello, felt themselves naturally united and in such accord, that all evil humours vanished at the sight of him, and every vile and base thought fell away from their minds. Such unity was never greater at any other time than his; and this happened because they were overcome both by his courtesy and by his art, and even more by the good disposition of his nature, which was so full of gentleness and so overflowing with loving-kindness, that it was seen that the very animals, not to speak of men, honoured him. It is said that if any painter who knew him, and even any who did not know him, asked him for some drawing that he needed, Raffaello would leave his own work in order to assist him. And he always kept a vast number of them employed, aiding them and teaching them with such a love as might have been the due rather of his own children than of fellow-craftsmen; for which reason he was never seen to go to Court without having with him, as he left his house, some fifty painters, all able and excellent, who kept him company in order to do him honour. In short, he lived not like a painter, but like a prince. Wherefore, O art of painting, thou couldst then esteem thyself indeed most blessed, in possessing a craftsman who, both with his genius and his virtues, exalted thee higher than Heaven! Truly happy mightest thou call thyself, in that thy disciples, following in the footsteps of so great a man, have seen how life should be lived, and how important is the union of art and virtue, which, wedded in Raffaello, had strength to prevail on the magnificent Julius II and the magnanimous Leo X, exalted as they were in rank and dignity, to make him their most intimate friend and show him all possible generosity, insomuch that by their favour and by the wealth that they bestowed upon him, he was enabled to do vast honour both to himself and to art. Blessed, also, may be called all those who, employed in his service, worked under him, since whoever imitated him found that he had reached an honourable haven; and in like manner all those who imitate his labours in art will be honoured by the world, even as, by resembling him in uprightness of life, they will win rewards from Heaven.

Raffaello received from Bembo the following epitaph:

D. O. M.

RAPHAELLI SANCTIO JOAN. F. URBINAT.
PICTORI EMINENTISS. VETERUMQUE ÆMULO,
CUJUS SPIRANTEIS PROPE IMAGINEIS

<div align="center">

SI CONTEMPLERE,

NATURÆ ATQUE ARTIS FŒDUS

FACILE INSPEXERIS.

JULII II ET LEONIS X PONTT. MAXX.

PICTURÆ ET ARCHITECT. OPERIBUS

GLORIAM AUXIT.

VIXIT AN. XXXVII, INTEGER, INTEGROS.

QUO DIE NATUS EST, EO ESSE DESIIT,

VIII ID. APRIL. MDXX.

</div>

ILLE HIC EST RAPHAEL, TIMUIT QUO SOSPITE VINCI
RERUM MAGNA PARENS, ET MORIENTE MORI.

And Count Baldassarre Castiglione wrote of his death in the following manner:

> Quod lacerum corpus medica sanaverit arte,
> Hyppolitum Stygiis et revocarit aquis,
> Ad Stygias ipse est raptus Epidaurius undas;
> Sic precium vitæ mors fuit artifici.
> Tu quoque dum toto laniatam corpore Romam
> Componis miro, Raphael, ingenio,
> Atque urbis lacerum ferro, igni, annisque cadaver,
> Ad vitam antiquum jam revocasque decus,
> Movisti superum invidiam, indignataque mors est
> Te dudum extinctis reddere posse animam,
> Et quod longa dies paulatim aboleverat, hoc te
> Mortali spreta lege parare iterum.
> Sic, miser, heu, prima cadis intercepte juventa,
> Deberi et morti nostraque nosque mones.

GUGLIELMO DA MARCILLA
[GUILLAUME DE MARCILLAC, OR THE FRENCH PRIOR],
French Painter and Master of Glass Windows

AT this same time, wherein our arts were endowed by God with the greatest felicity that they could possibly enjoy, there flourished one Guglielmo da Marcilla, a Frenchman, who, from his constant residence in Arezzo, and from the affection that he bore to that city, may be said to have chosen it for his country, insomuch that all men considered and called him an Aretine. And, in truth, among the benefits that are derived from ability, one is that from whatever strange and distant region and from

however barbarous and unknown a race a man may come, be he who he may, if only he has a mind adorned with ability and practises some ingenious craft with his hands, no sooner does he make his first appearance in each city to which he turns his steps, demonstrating his worth, than the skill of his hand works so powerfully, that his name, passing from lip to lip, in a short time waxes great, and his qualities become very highly prized and honoured. And it happens often to a great number of men, who have left their country far behind them, that they chance upon nations that are lovers of ability and of foreigners, where, by reason of their upright walk of life, they find themselves recognized and cherished in such a manner, that they forget the country of their birth and choose a new one for their last resting-place.

Even so was Arezzo chosen as a final home by Guglielmo, who, as a youth in France, applied himself to the art of design, and together with that gave attention to glass windows, in which he made figures no less harmonious in colouring than if they had been painted with the greatest beauty and harmony in oils. While in his own country, persuaded by the entreaties of certain of his friends, he was present at the slaying of one who was their enemy: on which account he was forced to assume the habit of a monk in the Order of S. Dominic in France, in order to escape the courts and the hand of justice. But although he remained in that Order, yet he never abandoned the study of art; nay, continuing it, he arrived at the highest perfection.

Now, by order of Pope Julius II, a commission was given to Bramante da Urbino to have a number of glass windows made for the Palace; whereupon he, making inquiries about the most excellent craftsmen, received information of many who were working at that craft, and among them of some who were executing marvellous works in France; and of these he saw a specimen through the French Ambassador who was then at the Court of his Holiness, and who had in the frame of a window in his study a figure executed on a piece of white glass with a vast number of colours, fixed on the glass by the action of fire. Wherefore, by order of Bramante, a letter was written to France, inviting them to come to Rome, and offering them good payments. Thereupon Maestro Claudio, a Frenchman, the head of that art, having received the intelligence, and knowing the excellence of Guglielmo, so went to work with money and fair promises, that it was no difficult matter to draw him out of the convent, particularly

because Guglielmo, on account of the discourtesy shown to him and the jealousies that there always are among monks, was even more eager to leave it than was Maestro Claudio to get him out. They went, therefore, to Rome, where the habit of S. Dominic was changed for that of S. Peter.

Bramante at that time had caused two windows of travertine to be made in the Palace of the Pope, which were in the hall in front of the chapel, now embellished by a vaulted ceiling by Antonio da San Gallo, and by marvellous stucco-work from the hand of Perino del Vaga of Florence. These windows were executed by Maestro Claudio and Guglielmo, although afterwards, during the sack of Rome, they were broken to pieces, in order to extract the lead to make harquebus-balls; and they were truly marvellous. In addition to these, they made an endless number of them for the apartments of the Pope, which met with the same fate as the other two. And even now there is one to be seen in the room containing Raffaello's Burning of the Borgo, in the Borgia Tower; in which are angels who are holding the escutcheon of Leo X. They also made two windows for the chapel behind the Madonna in S. Maria del Popolo, with the stories of her life, which were highly praiseworthy examples of that craft.

These works brought them no less fame and renown than comfort in life. But Maestro Claudio, being very intemperate in eating and drinking, according to the custom of his race, which is a deadly thing in the air of Rome, fell sick of so violent a fever, that in six days he passed to the other life. Whereupon Guglielmo, left alone, and almost like one lost without his companion, painted by himself a window, likewise of glass, in S. Maria de Anima, the church of the Germans in Rome; which was the reason that Cardinal Silvio of Cortona made him an offer, and made a contract with him that he should execute some windows and other works in his native city of Cortona. Wherefore the Cardinal took him in his company to take up his abode in Cortona; and the first work that he executed was the façade of the Cardinal's house on the side towards the Piazza, which he painted in chiaroscuro, depicting therein Croton and the other original founders of that city. Thereupon the Cardinal, who saw that Guglielmo was no less upright as a man than excellent as a master of that art, caused him to execute, for the Pieve of Cortona, the window of the principal chapel, in which he made the Nativity of Christ and the Magi adoring Him.

Guglielmo was a man of fine spirit and intelligence, and of very great mastery in handling glass, and particularly in so distributing the colours that the brightest should come in the foremost figures, those in the other figures being darker in proportion as they receded; in which point he was a rare and truly excellent master. Moreover, he showed very good judgment in the painting of his figures; whereby he executed them with such unity, that they fell back into the distance little by little, in such a way that they did not cling either to the buildings or to the landscapes, and had the appearance of being painted on panel, or rather in relief. He showed invention and variety in the composition of scenes, making them rich and well grouped; and he rendered easy the process of making such pictures as are put together out of pieces of glass, which was held to be very difficult, as indeed it is for one who has not his skill and dexterity. He designed the pictures for his windows with such good method and order, that the mountings of lead and iron, which cross them in certain places, were so well fitted into the joinings of the figures and the folds of the draperies, that they cannot be seen – nay, they gave the whole such grace, that the brush could not have done more – and thus he was able to make a virtue of necessity.

Guglielmo used only two kinds of colour for the shading of such glass as he proposed to subject to the action of fire; one was scale of iron, and the other scale of copper. That of iron, which is dark, served to shade draperies, hair, and buildings; and the other, that of copper, which produces a tawny tint, served for flesh colours. He also made much use of a hard stone that comes from Flanders and France, called at the present day hematite, which is red in colour and is much employed for burnishing gold. This, having first been pounded in a bronze mortar, and then ground with an iron brazing instrument on a plate of copper or yellow brass, and tempered with gum, works divinely well on glass.

When Guglielmo first arrived in Rome, he was no great draughtsman, although he was well practised in every other respect. But having recognized the need of this, he applied himself to the study of drawing, in spite of his being well advanced in years; and thus little by little he achieved the improvement that is evident in the windows that he afterwards made for the Palace of the said Cardinal at Cortona, and for the other without the city, in a round window that is in the aforesaid Pieve, over the façade, on the right hand as one enters the church, wherein are

the arms of Pope Leo X, and likewise in two little windows that are in the Company of Gesù, in one of which is a Christ, and in the other a S. Onofrio. These are no little different from his early works, and much better.

Now while Guglielmo, as has been related, was living in Cortona, there died at Arezzo one Fabiano di Stagio Sassoli, an Aretine, who had been a very good master of the making of large windows. Thereupon the Wardens of Works for the Vescovado gave the commission for three windows in the principal chapel, each twenty braccia in height, to Stagio, the son of the said Fabiano, and to the painter Domenico Pecori; but when these were finished and fixed in their places, they gave no great satisfaction to the Aretines, although they were passing good and rather worthy of praise than otherwise. It happened at this time that Messer Lodovico Belichini, an excellent physician, and one of the first men in the government of the city of Arezzo, went to Cortona to cure the mother of the aforesaid Cardinal; and there he became well acquainted with our Guglielmo, with whom, when he had time, he was very willing to converse. And Guglielmo, who was then called the Prior, from his having received about that time the benefice of a priory, likewise conceived an affection for that physician, who asked him one day whether, with the good will of the Cardinal, he would go to Arezzo to execute some windows; at which Guglielmo promised that he would, and with the permission and good will of the Cardinal he made his way to that city. Now Stagio, of whom we have spoken above, having parted from the company of Domenico, received Guglielmo into his house; and the latter, for his first work, executed for a window of the Chapel of S. Lucia, belonging to the Albergotti, in the Vescovado of Arezzo, that Saint and a S. Sylvester, in so good a manner that the work may truly be said to be made with living figures, and not of coloured and transparent glass, or at least to be a picture worthy of praise and marvellous. For besides the mastery shown in the flesh-colours, the glasses are flashed; that is, in some places the first skin has been removed, and the glass then coloured with another tint; by which is meant, for example, the placing of yellow over red flashed glass, or the application of white and green over blue; which is a difficult and even miraculous thing in this craft. The first or true colour, then, such as red, blue, or green, covers the whole of one side; and the other part, which is as thick as the blade of a knife,

or a little more, is white. Many, being afraid that they might break the glasses, on account of their lack of skill in handling them, do not employ a pointed iron for removing that layer, but in place of this, for greater safety, set about grinding the glasses with a copper wheel fixed on the end of an iron instrument; and thus, little by little, by the use of emery, they contrive to leave only a layer of white glass, which turns out very clear. Then, if a yellow colour has to be applied to the piece of glass thus left white, at the moment when it is to be placed into the furnace for firing, it is painted by means of a brush with calcined silver, which is a colour similar to bole, but somewhat thick; and in the fire this melts over the glass, fuses, and takes a firm hold, penetrating into the glass and making a very beautiful yellow. These methods of working no one used better, or with more ingenuity and art, than Prior Guglielmo; and it is in these things that the difficulty consists, for painting the glass with oil-colours or in any other manner is little or nothing, and that it should be diaphanous or transparent is not a matter of much importance, whereas firing it in the furnace and making it such that it will withstand the action of water and remain fresh for ever, is a difficult work and well worthy of praise. Wherefore this excellent master deserves the highest praise, since there is not a man of his profession who has done as much, whether in design, or invention, or colouring, or general excellence.

He then made the great round-window of the same church, containing the Descent of the Holy Spirit, and likewise the Baptism of Christ by S. John, wherein he represented Christ in the Jordan, awaiting S. John, who has taken a cup of water in order to baptize Him, while a nude old man is taking off his shoes, and some angels are preparing Christ's raiment, and on high is the Father, sending down the Holy Spirit upon His Son. This window is over the baptismal font of that Duomo, for which he also executed the window containing the Resurrection of Lazarus on the fourth day after death; wherein it seems impossible that he could have included in so small a space such a number of figures, in which may be recognized the terror and amazement of the people, with the stench from the body of Lazarus, whose resurrection causes his two sisters to rejoice amid their tears. In this work are innumerable colours, flashed one over the other in the glass, and every least thing truly appears most natural in its own kind.

And whoever wishes to learn how much the hand of the Prior was able to effect in this art, should study the window of S. Matthew over the Chapel of that Apostle, and observe the marvellous invention of that scene, wherein he can see a living figure of Christ calling Matthew from his tables, while Matthew, following Him and stretching out his arms to receive Him, abandons the riches and treasures that he has acquired. And at the same time an Apostle may be seen in a very spirited attitude, awaking another who has fallen asleep on some steps; and in like manner there may also be perceived a S. Peter speaking with S. John, both being so beautiful that they seem truly divine. In this same window are temples in perspective, staircases, and figures so well grouped, and landscapes so natural, that one would never think it was glass, but rather a thing rained down from Heaven for the consolation of mankind. In the same place he made the window of S. Anthony and that of S. Nicholas, both most beautiful, with two others, one containing the scene of Christ driving the traders from the Temple, and the other that of the woman taken in adultery; all these works being held to be truly excellent and marvellous.

So fully were the labours and abilities of the Prior recognized by the Aretines, what with praises, favours, and rewards, and so satisfied and contented was he by this result, that he resolved to adopt that city as his home, and to change himself from a Frenchman into an Aretine. Afterwards, reflecting in his own mind that the art of glass-painting, on account of the destruction that takes place every moment in such works, was no lasting one, there came to him a desire to devote himself to painting, and he therefore undertook to execute for the Wardens of Works of the Vescovado in that city three very large vaults in fresco, thinking thus to leave a memorial of himself behind him. The Aretines, in return for this, presented to him a farm that belonged to the Confraternity of S. Maria della Misericordia, near their city, with some excellent houses, for his enjoyment during his lifetime. And they ordained that when the work was finished, its value should be estimated by some distinguished craftsman, and that the Wardens should make this good to him in full. Whereupon he made up his mind to show his worth in this undertaking, and he made his figures very large on account of the height, after the manner of the works in Michelagnolo's chapel. And so mightily did his wish to become excellent in such an art avail in him, that

although he was fifty years of age, he improved little by little in such a manner, that he showed that his knowledge and comprehension of the beautiful were not less than his delight in imitating the good in the execution of his work. He went on to represent the earlier events of the New Testament, even as in the three large works he had depicted the beginning of the Old. For this reason, therefore, I am inclined to believe that any man of genius who has the desire to attain to perfection, is able, if he will but take the pains, to make naught of the limits of any science. At the beginning of those works, indeed, he was alarmed by their size, and because he had never executed any before; which was the reason that he sent to Rome for Maestro Giovanni, a French miniaturist, who, coming to Arezzo, painted over S. Antonio an arch with a Christ in fresco, and for that Company the banner that is carried in processions, which he executed with great diligence, having received the commission for them from the Prior.

At the same time Guglielmo made the round window for the façade of the Church of S. Francesco, a great work, in which he represented the Pope in Consistory, with the Conclave of Cardinals, and S. Francis going to Rome for the confirmation of his Rule and bearing the roses of January. In this work he proved what a master of composition he was, so that it may be said with truth that he was born for that profession; nor may any craftsman ever think to equal him in beauty, in abundance of figures, or in grace. There are innumerable windows executed by him throughout that city, all most beautiful, such as the great round window in the Madonna delle Lacrime, containing the Assumption of Our Lady and the Apostles, and a very beautiful window with an Annunciation; a round window with the Marriage of the Virgin, and another containing a S. Jerome executed for the Spadari, and likewise three other windows below, in various parts of the church; with a most beautiful round window with the Nativity of Christ in the Church of S. Girolamo, and another in S. Rocco. He sent some, also, to various places, such as Castiglione del Lago, and one to Florence for Lodovico Capponi, to be set up in S. Felicita, where there is the panel by Jacopo da Pontormo, a most excellent painter, and the chapel adorned by him with mural paintings in oils and in fresco and with panel-pictures; which window came into the hands of the Frati Ingesuati in Florence, who worked at that craft, and they took it all to pieces in order to learn how it was made, removing many pieces as

specimens and replacing them with new ones, so that in the end they made quite a different window.

He also conceived the wish to paint in oils, and for the Chapel of the Conception in S. Francesco at Arezzo he executed a panel-picture wherein are some vestments very well painted, and many heads most lifelike, and so beautiful that he was honoured thereby ever afterwards, seeing that this was the first work that he had ever done in oils.

The Prior was a very honourable person, and delighted in agriculture and in making alterations in buildings; wherefore, having bought a most beautiful house, he made in it a vast number of improvements. As a man of religion, he was always most upright in his ways; and the remorse of conscience, on account of his departure from his convent, kept him sorely afflicted. For which reason he made a very beautiful window for the Chapel of the High-altar in S. Domenico, a convent of his Order at Arezzo; wherein he depicted a vine that issues from the body of S. Dominic and embraces a great number of sanctified friars, who constitute the tree of the Order; and at the highest point is Our Lady, with Christ, who is marrying S. Catherine of Siena – a work much extolled and of great mastery, for which he would accept no payment, believing himself to be much indebted to that Order. He sent a very beautiful window to S. Lorenzo in Perugia, and an endless number of others to many places round Arezzo.

And because he took much pleasure in matters of architecture, he made for the citizens of that country a number of designs of buildings and adornments for their city, such as the two doors of S. Rocco in stone, and the ornament of grey-stone that was added to the panel-picture of Maestro Luca in S. Girolamo; and he designed an ornament in the Abbey of Cipriano d' Anghiari, and another for the Company of the Trinità in the Chapel of the Crocifisso, and a very rich lavatory for the sacristy; which were all executed with great perfection by the stone-cutter Santi.

Finally, ever delighting in labour, and continually working both winter and summer at his mural painting, which breaks down the healthiest of men, he became so afflicted by the damp and so swollen with dropsy, that his physicians had to tap him, and in a few days he rendered up his soul to Him who had given it. First, like a good Christian, he partook of the Sacraments of the Church, and made his will. Then, having a particular devotion for the Hermits of Camaldoli, who have their seat on the summit

of the Apennines, twenty miles distant from Arezzo, he bequeathed to them his property and his body, and to Pastorino da Siena, his assistant, who had been with him many years, he left his glasses, his working-instruments, and his designs, of which there is one in our book, a scene of the Submersion of Pharaoh in the Red Sea.

This Pastorino afterwards applied himself to many other fields of art, and also to glass windows, although the works that he produced in that craft were but few. Guglielmo was much imitated, also, by one Maso Porro of Cortona, who was more able in firing and putting together the glass than in painting it. One of the pupils of Guglielmo was Battista Borro of Arezzo, who continues to imitate him greatly in the making of windows; and he also taught the first rudiments to Benedetto Spadari and to Giorgio Vasari of Arezzo.

The Prior lived sixty-two years, and died in the year 1537. He deserves infinite praise, in that by him there was brought into Tuscany the art of working in glass with the greatest mastery and delicacy that could be desired. Wherefore, since he conferred such great benefits upon us, we also will pay him honour, exalting him continually with loving and unceasing praise both for his life and for his works.

SIMONE, CALLED IL CRONACA
[*SIMONE DEL POLLAIUOLO*],
Architect of Florence

MANY intellects are lost that would make rare and worthy works, if, on coming into the world, they were to hit upon persons able and willing to set them to work on those labours for which they are fitted. But it often happens that he who has the means is neither capable nor willing; and if, indeed, there chances to be one willing to erect some worthy building, he often takes no manner of care to seek out an architect of real merit or of any loftiness of spirit. Nay, he puts his honour and glory into the keeping of certain thievish creatures, who generally disgrace the name and fame of such memorials; and in order to thrust forward into greatness those who depend entirely upon him (so great is the power of ambition), he often rejects the good designs that are offered to him, and puts into execution the very worst; wherefore

his own fame is left besmirched by the clumsiness of the work; since it is considered by all men of judgment that the craftsman and the patron who employs him, in that they are conjoined in their works, are of one and the same mind. And on the other hand, how many Princes of little understanding have there been, who, through having chanced upon persons of excellence and judgment, have obtained after death no less fame from the memory of their buildings than they enjoyed when alive from their sovereignty over their people.

Truly fortunate, however, in his day, was Cronaca, in that he not only had the knowledge, but also found those who kept him continually employed, and that always on great and magnificent works. Of him it is related that while Antonio Pollaiuolo was in Rome, working at the tombs of bronze that are in S. Pietro, there came to his house a young lad, his relative, whose proper name was Simone, and who had fled from Florence on account of some brawl. This Simone, having worked with a master in woodwork, and being much inclined to the art of architecture, began to observe the beautiful antiquities of that city, and, delighting in them, went about measuring them with the greatest diligence. And, going on with this, he had not been long in Rome before he showed that he had made much proficience, both in taking measurements and in carrying one or two things into execution.

Thereupon he conceived the idea of returning to Florence, and departed from Rome; and on arriving in his native city, having become a passing good master of words, he described the marvels of Rome and of other places with such accuracy, that from that time onwards he was called Il Cronaca, every man thinking that he was truly a chronicle of information in his discourse. Now he had become such that he was held to be the most excellent of the modern architects in the city of Florence, seeing that he had good judgment in choosing sites, and showed that he had an intellect more lofty than that of many others who were engaged in that profession; for it was evident from his works how good an imitator he was of antiquities, and how closely he had observed the rules of Vitruvius and the works of Filippo di Ser Brunellesco.

There was then in Florence that Filippo Strozzi who is now called 'the elder,' to distinguish him from his son; and he, being very rich, wished to leave to his native city and to his children, among other memorials of himself, one in the form of a beautiful

CRONACA ARCHITETTO
FIORENTINO.

palace. Wherefore Benedetto da Maiano, having been called upon by him for this purpose, made him a model entirely isolated, which was afterwards put into execution, although not in all its extent, as will be related below, for some of his neighbours would not give up their houses to accommodate him. Benedetto began the palace, therefore, in the best way that he could, and brought the outer shell almost to completion before the death of Filippo: which outer shell is in the Rustic Order, with varying degrees of rustication, as may be seen, since the boss-covered part from the first range of windows downwards, together with the doors, is very much Rustic, and the part from the first range of windows to the second is much less Rustic. Now it happened that at the very moment when Benedetto was leaving Florence, Cronaca returned from Rome; whereupon, Simone being presented to Filippo, the latter was so pleased with the model that he made for the courtyard and for the great cornice which goes round the outer side of the palace, that, having recognized the excellence of his intellect, he decided that thenceforward the whole work should pass through his hands, and availed himself of his services ever afterwards. Cronaca, then, in addition to the beautiful exterior in the Tuscan Order, made at the top a very magnificent Corinthian cornice, which serves to complete the roof; and half of it is seen finished at the present day, with such extraordinary grace that nothing could be added to it, nor could anything more beautiful be desired. This cornice was taken by Cronaca, who copied it in Rome with exact measurements, from an ancient one that is to be found at Spoglia Cristo, which is held to be the most beautiful among the many that are in that city; although it is true that it was enlarged by Cronaca to the proportions required by the palace, to the end that it might make a suitable finish, and might also complete the roof of that palace by means of its projection. Thus, then, the genius of Cronaca was able to make use of the works of others and to transform them almost into his own; which does not succeed with many, since the difficulty lies not in merely having drawings and copies of beautiful things, but in accommodating them to the purpose which they have to serve, with grace, true measurement, proportion, and fitness. But just as much as this cornice of Cronaca's was and always will be extolled, so was that one censured which was made for the Palace of the Bartolini in the same city by Baccio d'Agnolo, who, seeking to imitate Cronaca, placed over a small façade, delicate in detail, a

great ancient cornice copied with the exact measurements from the frontispiece of Monte Cavallo; which resulted in such ugliness, from his not having known how to adapt it with judgment, that it could not look worse, for it seems like an enormous cap on a small head. It is not enough for craftsmen, when they have executed their works, to excuse themselves, as many do, by saying that they were taken with exact measurements from the antique and copied from good masters, seeing that good judgment and the eye play a greater part in all such matters than measuring with compasses. Cronaca, then, executed half of the said cornice with great art right round that palace, together with dentils and ovoli, and finished it completely on two sides, counterpoising the stones in such a way, in order that they might turn out well bound and balanced, that there is no better masonry to be seen, nor any carried to perfection with more diligence. In like manner, all the other stones are so well put together, and with so high a finish, that the whole does not appear to be of masonry, but rather all of one piece. And to the end that everything might be in keeping, he caused beautiful pieces of iron-work to be made for all parts of the palace, as adornments for it, and the lanterns that are at the corners, which were all executed with supreme diligence by Niccolò Grosso, called Il Caparra, a smith of Florence. In those marvellous lanterns may be seen cornices, columns, capitals, and brackets of iron, fixed together with wonderful craftsmanship; nor has any modern ever executed in iron works so large and so difficult, and with such knowledge and mastery.

Niccolò Grosso was an eccentric and self-willed person, claiming justice for himself and giving it to others, and never covetous of what was not his own. He would never give anyone credit in the payment of his works, and always insisted on having his earnest-money. For this reason Lorenzo de' Medici called him Il Caparra,* and he was known to many others by that name. He had a sign fixed over his shop, wherein were books burning; wherefore, when one asked for time to make his payment, he would say, 'I cannot give it, for my books are burning, and I can enter no more debtors in them.' He was commissioned by the honourable Captains of the Guelph party to make a pair of and-irons, which, when he had finished them, were sent for several times. But he kept saying, 'On this anvil do I sweat and labour,

* Earnest-money.

and on it will I have my money paid down.' Whereupon they sent to him once more for the work, with a message that he should come for his money, for he would straightway be paid; but he, still obstinate, answered that they must first bring the money. The provveditore, therefore, knowing that the Captains wished to see the work, fell into a rage, and sent to him saying that he had received half the money, and that when he had dispatched the andirons, he would pay him the rest. On which account Caparra, recognizing that this was true, gave one of the andirons to the messenger, saying: 'Take them this one, for it is theirs; and if it pleases them, bring me the rest of the money, and I will hand over the other; but at present it is mine.' The officials, seeing the marvellous work that he had put into it, sent the money to his shop; and he sent them the other andiron. It is related, also, that Lorenzo de' Medici resolved to have some pieces of iron-work made, to be sent abroad as presents, in order that the excellence of Caparra might be made known. He went, therefore, to his shop, and happened to find him working at some things for certain poor people, from whom he had received part of the price as earnest-money. On Lorenzo making his request, Niccolò would in no way promise to serve him before having satisfied the others, saying that they had come to his shop before Lorenzo, and that he valued their money as much as his. To the same master some young men of the city brought a design, from which he was to make for them an iron instrument for breaking and forcing open other irons by means of a screw, but he absolutely refused to serve them; nay, he upbraided them, and said: 'Nothing will induce me to serve you in such a matter; for these things are nothing but thieves' tools, or instruments for abducting and dishonouring young girls. Such things are not for me, I tell you, nor for you, who seem to me to be honest men.' And they, perceiving that Caparra would not do their will, asked him who there was in Florence who might serve them; whereupon, flying into a rage, he drove them away with a torrent of abuse. He would never work for Jews, and was wont, indeed, to say that their money was putrid and stinking. He was a good man and a religious, but whimsical in brain and obstinate: and he would never leave Florence, for all the offers that were made to him, but lived and died in that city. Of him I have thought it right to make this record, because he was truly unique in his craft, and has never had and never will have an equal, as may be seen best

from the iron-work and the beautiful lanterns of the Palace of the Strozzi.

This palace was brought to completion by Cronaca, and adorned with a very rich courtyard in the Corinthian and Doric Orders, with ornaments in the form of columns, capitals, cornices, windows, and doors, all most beautiful. And if it should appear to anyone that the interior of this palace is not in keeping with the exterior, he must know that the fault is not Cronaca's, for the reason that he was forced to adapt his interior to an outer shell begun by others, and to follow in great measure what had been laid down by those before him; and it was no small feat for him to have given it such beauty as it displays. The same answer may be made to any who say that the ascent of the stairs is not easy, nor correct in proportion, but too steep and sudden; and likewise, also, to such as say that the rooms and apartments of the interior in general are out of keeping, as has been described, with the grandeur and magnificence of the exterior. Nevertheless this palace will never be held as other than truly magnificent, and equal to any private building whatsoever that has been erected in Italy in our own times; wherefore Cronaca rightly obtained, as he still does, infinite commendation for this work.

The same master built the Sacristy of S. Spirito in Florence, which is in the form of an octagonal temple, beautiful in proportions, and executed with a high finish; and among other things to be seen in this work are some capitals fashioned by the happy hand of Andrea dal Monte Sansovino, which are wrought with supreme perfection; and such, likewise, is the antechamber of that sacristy, which is held to be very beautiful in invention, although the coffered ceiling, as will be described, is not well distributed over the columns. The same Cronaca also erected the Church of S. Francesco dell' Osservanza on the hill of S. Miniato, without Florence; and likewise the whole of the Convent of the Servite Friars, which is a highly extolled work.

At this same time there was about to be built, by the advice of Fra Girolamo Savonarola, a most famous preacher of that day, the Great Council Chamber of the Palace of the Signoria in Florence; and for this opinions were taken from Leonardo da Vinci, Michelagnolo Buonarroti, although he was a mere lad, Giuliano da San Gallo, Baccio d' Agnolo, and Simone del Pollaiuolo, called Il Cronaca, who was the devoted friend and follower of Savonarola. These men, after many disputes, came to

an agreement, and decided that the Hall should be made in that form which it retained down to our own times, when, as has been mentioned and will be related yet again in another place, it was almost rebuilt. The charge of the whole work was given to Cronaca, as a man of talent and also as the friend of the aforesaid Fra Girolamo; and he executed it with great promptitude and diligence, showing the beauty of his genius particularly in the making of the roof, since the structure is of vast extent in every direction. He made the tie-beams of the roof-truss, which are thirty-eight braccia in length from wall to wall, of a number of timbers well scarfed and fastened together, since it was not possible to find beams of sufficient size for the purpose; and whereas the tie-beams of other roof-trusses have only one king-post, all those of this Hall have three each, a king-post in the middle, and a queen-post on either side. The rafters are long in proportion, and so are the struts of each king-post and queen-post; nor must I omit to say that the struts of the queen-posts, on the side nearest the wall, thrust against the rafters, and, towards the centre, against the struts of the king-post. I have thought it right to describe how this roof-truss is made, because it was constructed with beautiful design, and I have seen drawings made of it by many for sending to various places. When these tie-beams, thus contrived, had been drawn up and placed at intervals of six braccia, and the roof had been likewise laid down in a very short space of time, Cronaca attended to the fixing of the ceiling, which was then made of plain wood and divided into panels, each of which was four braccia square and surrounded by an ornamental cornice of few members; and a flat moulding was made of the same width as the planks, which enclosed the panels and the whole work, with large bosses at the intersections and the corners of the whole ceiling. And although the end walls of this Hall, one on either side, were eight braccia out of the square, they did not make up their minds, as they might have done, to thicken the walls so as to make it square, but carried them up to the roof just as they were, making three large windows on each of those end walls. But when the whole was finished, the Hall, on account of its extraordinary size, turned out to be too dark, and also stunted and wanting in height in relation to its great length and breadth; in short, almost wholly out of proportion. They sought, therefore, but with little success, to improve it by making two windows in the middle of the eastern side of the Hall, and four on

the western side. After this, in order to give it its final comple-
tion, they made on the level of the brick floor, with great rapidity,
being much pressed by the citizens, a wooden tribune right round
the walls of the Hall, three braccia both in breadth and height,
with seats after the manner of a theatre, and with a balustrade in
front; on which tribune all the magistrates of the city were to sit.
In the middle of the eastern side was a more elevated daïs, on
which the Signori sat with the Gonfalonier of Justice; and on
either side of this more prominent place was a door, one of them
leading to the Segreto* and the other to the Specchio.† Opposite
to this, on the west side, was an altar at which Mass was read,
with a panel by the hand of Fra Bartolommeo, as has been men-
tioned; and beside the altar was the pulpit for making speeches.
In the middle of the Hall, then, were benches in rows laid cross-
ways, for the citizens; while in the centre and at the corners of
the tribune were some gangways with six steps, providing a con-
venient ascent for the ushers in the collection of votes. In this
Hall, which was much extolled at that day for its many beautiful
features and the rapidity with which it was erected, time has since
served to reveal such errors as that it is low, dark, gloomy, and
out of the square. Nevertheless Cronaca and the others deserve
to be excused, both on account of the haste with which it was
executed at the desire of the citizens, who intended in time to
have it adorned with pictures and the ceiling overlaid with gold,
and because up to that day there had been no greater hall built
in Italy; although there are others very large, such as that of the
Palace of S. Marco in Rome, that of the Vatican, erected by Pius
II and Innocent VIII, that of the Castle of Naples, that of the
Palace of Milan, and those of Urbino, Venice, and Padua.

After this, to provide an ascent to this Hall, Cronaca, with the
advice of the same masters, made a great staircase six braccia
wide and curving in two flights, richly adorned with grey-stone,
and with Corinthian pilasters and capitals, double cornices, and
arches, of the same stone; and with barrel-shaped vaulting, and
windows with columns of variegated marble and carved marble
capitals. But although this work was much extolled, it would have
won even greater praise if the staircase had not turned out

* Room in which the beans used in voting for the election of magistrates were
counted.
† Office of those who had charge of the Specchio, the book in which were
inscribed the names of such citizens as were in arrears with their taxes.

inconvenient and too steep; for it is a sure fact that it could have been made more gentle, as has been done in the time of Duke Cosimo, within the same amount of space and no more, in the new staircase made, opposite to that of Cronaca, by Giorgio Vasari, which is so gentle in ascent and so convenient, that going up it is almost like walking on the level. This has been the work of the aforesaid Lord Duke Cosimo, who, being a man of most happy genius and most profound judgment both in the government of his people and in all other things, grudges neither expense nor anything else in his desire to make all the fortifications and other buildings, both public and private, correspond to the greatness of his own mind, and not less beautiful than useful or less useful than beautiful.

His Excellency, then, reflecting that the body of this Hall is the largest, the most magnificent, and the most beautiful in all Europe, has resolved to have it improved in such parts as are defective, and to have it made in every other part more ornate than any other structure in Italy, by the design and hand of Giorgio Vasari of Arezzo. And thus, the walls having been raised twelve braccia above their former height, in such a manner that the height from the pavement to the ceiling is thirty-two braccia, the roof-truss made by Cronaca to support the roof has been restored and replaced on high after a new arrangement; and the old ceiling, which was simple and commonplace, and by no means worthy of that Hall, has been remodelled with a system of compartments of great variety, rich in mouldings, full of carvings, and all overlaid with gold, together with thirty-nine painted panels, square, round, and octagonal, the greater number of which are each nine braccia in extent, and some even more, and all containing scenes painted in oils, with the largest figures seven or eight braccia high. In these stories, commencing with the very beginning, may be seen the rise, the honours, the victories, and the glorious deeds of the city and state of Florence, and in particular the wars of Pisa and Siena, together with an endless number of other things, which it would take too long to describe. And on each of the side walls there has been left a convenient space of sixty braccia, in each of which are to be painted three scenes in keeping with the ceiling and embracing the space of seven pictures on either side, which represent events from the wars of Pisa and Siena. These compartments on the walls are so large, that no greater spaces for the painting of historical pictures have

ever been seen either by the ancients or by the moderns. And the said compartments are adorned by some vast stone ornaments which meet at the ends of the Hall, at one side of which, namely, the northern side, the Lord Duke has caused to be finished a work begun and carried nearly to completion by Baccio Bandinelli, that is, a façade filled with columns and pilasters and with niches containing statues of marble; which space is to serve as a public audience chamber, as will be related in the proper place. On the other side, opposite to this, there is to be, in a similar façade that is being made by the sculptor and architect Ammanati, a fountain to throw up water in the Hall, with a rich and most beautiful adornment of columns and statues of marble and bronze. Nor will I forbear to say that this Hall, in consequence of the roof having been raised twelve braccia, has gained not only height, but also an ample supply of windows, since, in addition to the others that are higher up, in each of those end walls are to be made three large windows, which will be over the level of a corridor that is to form a loggia within the Hall and to extend on one side over the work of Bandinelli, whence there will be revealed a most beautiful view of the whole Piazza. But of this Hall, and of the other improvements that have been or are being made in the Palace, there will be a longer account in another place. This only let me say at present, that if Cronaca and those other ingenious craftsmen who gave the design for the Hall could return to life, in my belief they would not recognize either the Palace, or the Hall, or any other thing that is there. The Hall, namely, that part which is rectangular, without counting the works of Bandinelli and Ammanati, is ninety braccia in length and thirty-eight braccia in breadth.

But returning to Cronaca: in the last years of his life there entered into his head such a frenzy for the cause of Fra Girolamo Savonarola, that he would talk of nothing else but that. Living thus, in the end he died after a passing long illness, at the age of fifty-five, and was buried honourably in the Church of S. Ambrogio at Florence, in the year 1509; and after no long space of time the following epitaph was written for him by Messer Giovan Battista Strozzi:

CRONACA

VIVO, E MILLE E MILLE ANNI E MILLE ANCORA,
MERCÈ DE' VIVI MIEI PALAZZI E TEMPI,
BELLA ROMA, VIVRÀ L'ALMA MIA FLORA.

Cronaca had a brother called Matteo, who gave himself to sculpture and worked under the sculptor Antonio Rossellino; but although he was a man of good and beautiful intelligence, a fine draughtsman, and well practised in working marble, he left no finished work, because, being snatched from the world by death at the age of nineteen, he was not able to accomplish that which was expected from him by all who knew him.

DOMENICO PULIGO, Painter of Florence

IT is a marvellous and almost incredible thing, that many followers of the art of painting, through continual practice and handling of colours, either by an instinct of nature or by the trick of a good manner, acquired without any draughtsmanship or grounding, carry their works to such thorough completion, and very often contrive to make them so good, that, although the craftsmen themselves may be none of the rarest, their pictures force the world to extol them and to hold them in supreme veneration. And it has been perceived in the past from many examples, and in many of our painters, that the most vivacious and perfect works are produced by those who have a beautiful manner from nature, although they must exercise it with continual study and labour; while this gift of nature has such power, that even if they neglect or abandon the studies of art, and pay attention to nothing save the mere practice of painting and of handling colours with a grace infused in them by nature, at the first glance their works have the appearance of displaying all the excellent and marvellous qualities that are wont to appear after a close inspection in the works of those masters whom we hold to be the best. And that this is true, is demonstrated to us in our own day by experience, from the works of Domenico Puligo, a painter of Florence; wherein what has been said above may be clearly recognized by one who has knowledge of the matters of art.

While Ridolfo, the son of Domenico Ghirlandajo, was executing a number of works in painting at Florence, as will be related, he followed his father's habit of always keeping many young men painting in his workshop: which was the reason that not a few of them, through competing one with another, became very good

masters, some at making portraits from life, some at working in fresco, others in distemper, and others at painting readily on cloth. Making these lads execute pictures, panels, and canvases, in the course of a few years Ridolfo, with great profit for himself, sent an endless number of these to England, to Germany, and to Spain. Baccio Gotti and Toto del Nunziata, disciples of Ridolfo, were summoned, one to France by King Francis, and the other to England by the King of that country, each of whom invited them after having seen some of their work. Two other disciples of the same master remained with him, working under him for many years, because, although they had many invitations into Spain and Hungary from merchants and others, they were never induced either by promises or by money to tear themselves away from the delights of their country, in which they had more work to do than they were able to execute. One of these two was Antonio del Ceraiuolo, a Florentine, who, having been many years with Lorenzo di Credi, had learnt from him, above all, to draw so well from nature, that with supreme facility he gave his portraits an extraordinary likeness to the life, although otherwise he was no great draughtsman. And I have seen some heads portrayed from life by his hand, which, although they have, for example, the nose crooked, one lip small and the other large, and other suchlike deformities, nevertheless resemble the life, through his having well caught the expression of the subject; whereas, on the other hand, many excellent masters have made pictures and portraits of absolute perfection with regard to art, but with no resemblance whatever to those that they are supposed to represent. And to tell the truth, he who executes portraits must contrive, without thinking of what is looked for in a perfect figure, to make them like those for whom they are intended. When portraits are like and also beautiful, then may they be called rare works, and their authors truly excellent craftsmen. This Antonio, then, besides many portraits, executed a number of panel-pictures in Florence; but for the sake of brevity I will make mention only of two. One of these, wherein he painted a Crucifixion, with S. Mary Magdalene and S. Francis, is in S. Jacopo tra Fossi, on the Canto degli Alberti; and in the other, which is in the Nunziata, is a S. Michael who is weighing souls.

The other of the two aforesaid disciples was Domenico Puligo, who was more excellent in draughtsmanship and more pleasing and gracious in colouring than any of the others men-

tioned above. He, considering that his method of painting with softness, without overloading his works with colour or making them hard, but causing the distances to recede little by little as though veiled with a kind of mist, gave his pictures both relief and grace, and that although the outlines of the figures that he made were lost in such a way that his errors were concealed and hidden from view in the dark grounds into which the figures merged, nevertheless his colouring and the beautiful expressions of his heads made his works pleasing, always kept to the same method of working and to the same manner, which caused him to be held in esteem as long as he lived. But omitting to give an account of the pictures and portraits that he made while in the workshop of Ridolfo, some of which were sent abroad and some remained in the city, I shall speak only of those which he painted when he was rather the friend and rival of Ridolfo than his disciple, and of those that he executed when he was so much the friend of Andrea del Sarto, that nothing was more dear to him than to see that master in his workshop, in order to learn from him, showing him his works and asking his opinion of them, so as to avoid such errors and defects as those men often fall into who do not show their work to any other craftsman, but trust so much in their own judgment that they would rather incur the censure of all the world when those works are finished, than correct them by means of the suggestions of loving friends.

One of the first things that Domenico executed was a very beautiful picture of Our Lady for Messer Agnolo della Stufa, who has it in his Abbey of Capalona in the district of Arezzo, and holds it very dear for the great diligence of its execution and the beauty of its colouring. He painted another picture of Our Lady, no less beautiful than that one, for Messer Agnolo Niccolini, now Archbishop of Pisa and a Cardinal, who keeps it in his house on the Canto de' Pazzi in Florence; and likewise another, of equal size and excellence, which is now in the possession of Filippo dell' Antella, at Florence. In another, which is about three braccia in height, Domenico made a full-length Madonna with the Child between her knees, a little S. John, and another head; and this picture, which is held to be one of the best works that he executed, since there is no sweeter colouring to be seen, is at the present day in the possession of Messer Filippo Spini, Treasurer to the most Illustrious Prince of Florence, and a gentleman of magnificent spirit, who takes much delight in works of painting.

Among other portraits that Domenico made from the life, which are all beautiful and also good likenesses, the most beautiful is the one which he painted of Monsignore Messer Piero Carnesecchi, at that time a marvellously handsome youth, for whom he also made some other pictures, all very beautiful and executed with much diligence. In like manner, he portrayed in a picture the Florentine Barbara, a famous and most lovely courtesan of that day, much beloved by many no less for her fine culture than for her beauty, and particularly because she was an excellent musician and sang divinely. But the best work that Domenico ever executed was a large picture wherein he made a lifesize Madonna, with some angels and little boys, and a S. Bernard who is writing; which picture is now in the hands of Giovanni Gualberto del Giocondo, and of his brother Messer Niccolò, a Canon of S. Lorenzo in Florence.

The same master made many other pictures, which are dispersed among the houses of citizens, and in particular some wherein may be seen a half-length figure of Cleopatra, causing an asp to bite her on the breast, and others wherein is the Roman Lucretia killing herself with a dagger. There are also some very beautiful portraits from life and pictures by the same hand at the Porta a Pinti, in the house of Giulio Scali, a man whose judgment is as fine in the matters of our arts as it is in those of every other most noble and most honourable profession. Domenico executed for Francesco del Giocondo, in a panel for his chapel in the great tribune of the Church of the Servi at Florence, a S. Francis who is receiving the Stigmata; which work is very sweet and soft in colouring, and wrought with much diligence. In the Church of Cestello, round the Tabernacle of the Sacrament, he painted two angels in fresco, and on the panel of a chapel in the same church he made a Madonna with her Son in her arms, S. John the Baptist, S. Bernard, and other saints. And since it appeared to the monks of that place that he had acquitted himself very well in those works, they caused him to paint in a cloister of their Abbey of Settimo, without Florence, the Visions of Count Ugo, who built seven abbeys. And no long time after, Puligo painted, in a shrine at the corner of the Via Mozza da S. Catarina, a Madonna standing, with her Son in her arms marrying S. Catherine, and a figure of S. Peter Martyr. For a Company in the township of Anghiari he executed a Deposition from the Cross, which may be numbered among his best works.

But since it was his profession to attend rather to pictures of Our Lady, portraits, and other heads, than to great works, he gave up almost all his time to such things. Now if he had devoted himself not so much to the pleasures of the world, as he did, and more to the labours of art, there is no doubt that he would have made great proficience in painting, and especially as Andrea del Sarto, who was much his friend, assisted him on many occasions both with advice and with drawings; for which reason many of his works reveal a draughtsmanship as fine as the good and beautiful manner of the colouring. But the circumstance that Domenico was unwilling to endure much fatigue, and accustomed to labour rather in order to get through work and make money than for the sake of fame, prevented him from reaching a greater height. And thus, associating with gay spirits and lovers of good cheer, and with musicians and women, he died at the age of fifty-two, in the year 1527, in the pursuit of a love-affair, having caught the plague at the house of his mistress.

Colour was handled by him in so good and harmonious a manner, that it is for that reason, rather than for any other, that he deserves praise. Among his disciples was Domenico Beceri of Florence, who, giving a high finish to his colouring, executed his works in an excellent manner.

ANDREA DA FIESOLE, Sculptor
[ANDREA FERRUCCI]
AND OTHER CRAFTSMEN OF FIESOLE

SEEING that it is no less necessary for sculptors to have mastery over their carving-tools than it is for him who practises painting to be able to handle colours, it therefore happens that many who work very well in clay prove to be unable to carry their labours to any sort of perfection in marble; and some, on the contrary, work very well in marble, without having any more knowledge of design than a certain instinct for a good manner, I know not what, that they have in their minds, derived from the imitation of certain things which please their judgment, and which their imagination absorbs and proceeds to use for its own purposes. And it is almost a marvel to see the manner in which some sculptors, without in any way knowing how to draw on paper, nevertheless bring their works to a fine and praiseworthy

completion with their chisels. This was seen in Andrea, a sculptor of Fiesole, the son of Piero di Marco Ferrucci, who learnt the rudiments of sculpture in his earliest boyhood from Francesco di Simone Ferrucci, another sculptor of Fiesole. And although at the beginning he learnt only to carve foliage, yet little by little he became so well practised in his work that it was not long before he set himself to making figures; insomuch that, having a swift and resolute hand, he executed his works in marble rather with a certain judgment and skill derived from nature than with any knowledge of design. Nevertheless, he afterwards gave a little more attention to art, when, in the flower of his youth, he followed Michele Maini, likewise a sculptor of Fiesole; which Michele made the S. Sebastian of marble in the Minerva at Rome, which was so much praised in those days.

Andrea, then, having been summoned to work at Imola, built a chapel of grey-stone, which was much extolled, in the Innocenti in that city. After that work, he went to Naples at the invitation of Antonio di Giorgio of Settignano, a very eminent engineer, and architect to King Ferrante, with whom Antonio was in such credit, that he had charge not only of all the buildings in that kingdom, but also of all the most important affairs of State. On arriving in Naples, Andrea was set to work, and he executed many things for that King in the Castello di San Martino and in other parts of that city. Now Antonio died; and after the King had caused him to be buried with obsequies suited rather to a royal person than to an architect, and with twenty pairs of mourners following him to the grave, Andrea, recognizing that this was no country for him, departed from Naples and made his way back to Rome, where he stayed for some time, attending to the studies of his art, and also to some work.

Afterwards, having returned to Tuscany, he built the marble chapel containing the baptismal font in the Church of S. Jacopo at Pistoia, and with much diligence executed the basin of that font, with all its ornamentation. And on the main wall of the chapel he made two lifesize figures in half-relief – namely, S. John baptizing Christ, a work executed very well and with a beautiful manner. At the same time he made some other little works, of which there is no need to make mention. I must say, indeed, that although these things were wrought by Andrea rather with the skill of his hand than with art, yet there may be perceived in them a boldness and an excellence of taste worthy of

great praise. And, in truth, if such craftsmen had a thorough knowledge of design united to their practised skill and judgment, they would vanquish in excellence those who, drawing perfectly, only hack the marble when they set themselves to work it, and toil at it painfully with a sorry result, through not having practice and not knowing how to handle the tools with the skill that is necessary.

After these works, Andrea executed a marble panel that was placed exactly between the two flights of steps that ascend to the upper choir in the Church of the Vescovado at Fiesole; in which panel he made three figures in the round and some scenes in low-relief. And for S. Girolamo, at Fiesole, he made the little marble panel that is built into the middle of the church. Having come into repute by reason of the fame of these works, Andrea was commissioned by the Wardens of Works of S. Maria del Fiore, at the time when Cardinal Giulio de' Medici was governing Florence, to make a statue of an Apostle four braccia in height; at that time, I mean, when four other similar statues were allotted at one and the same moment to four other masters – one to Benedetto da Maiano, another to Jacopo Sansovino, a third to Baccio Bandinelli, and the fourth to Michelagnolo Buonarroti; which statues were eventually to be twelve in number, and were to be placed in that part of that magnificent temple where there are the Apostles painted by the hand of Lorenzo di Bicci. Andrea, then, executed his rather with fine skill and judgment than with design; and he acquired thereby, if not as much praise as the others, at least the name of a good and practised master. Wherefore he was almost continually employed ever afterwards by the Wardens of Works of that church; and he made the head of Marsilius Ficinus that is to be seen therein, within the door that leads to the chapter-house. He made, also, a marble fountain that was sent to the King of Hungary, which brought him great honour; and by his hand was a marble tomb that was sent, likewise, to Strigonia, a city of Hungary. In this tomb was a Madonna, very well executed, with other figures; and in it was afterwards laid to rest the body of the Cardinal of Strigonia. To Volterra Andrea sent two Angels of marble in the round; and for Marco del Nero, a Florentine, he made a lifesize Crucifix of wood, which is now in the Church of S. Felicita at Florence. He made a smaller one for the Company of the Assumption in Fiesole. Andrea also delighted in architecture, and he was the master of Mangone, the

stone-cutter and architect, who afterwards erected many palaces and other buildings in Rome in a passing good manner.

In the end, having grown old, Andrea gave his attention only to mason's work, like one who, being a modest and worthy person, loved a quiet life more than anything else. He received from Madonna Antonio Vespucci the commission for a tomb for her husband, Messer Antonio Strozzi; but since he could not work much himself, the two Angels were made for him by Maso Boscoli of Fiesole, his disciple, who afterwards executed many works in Rome and elsewhere, and the Madonna was made by Silvio Cosini of Fiesole, although it was not set into place immediately after it was finished, which was in the year 1522, because Andrea died, and was buried by the Company of the Scalzo in the Church of the Servi.

Silvio, when the said Madonna was set into place and the tomb of the Strozzi completely finished, pursued the art of sculpture with extraordinary zeal; wherefore he afterwards executed many works in a graceful and beautiful manner, and surpassed a host of other masters, above all in the bizarre fancy of his grotesques, as may be seen in the sacristy of Michelagnolo Buonarroti, from some carved marble capitals over the pilasters of the tombs, with some little masks so well hollowed out that there is nothing better to be seen. In the same place he made some friezes with very beautiful masks in the act of crying out; wherefore Buonarroti, seeing the genius and skill of Silvio, caused him to begin certain trophies to complete those tombs, but they remained unfinished, with other things, by reason of the siege of Florence. Silvio executed a tomb for the Minerbetti in their chapel in the tramezzo* of the Church of S. Maria Novella, as well as any man could, since, in addition to the beautiful shape of the sarcophagus, there are carved upon it various shields, helmet-crests, and other fanciful things, and all with as much design as could be desired in such a work. Being at Pisa in the year 1528, Silvio made there an Angel that was wanting over a column on the high-altar of the Duomo, to face the one by Tribolo; and he made it so like the other that it could not be more like even if it were by the same hand. In the Church of Monte Nero, near Livorno, he made a little panel of marble with two figures, for the Frati Ingesuati; and at Volterra he made a tomb for Messer

* See note on p. 90.

Raffaello da Volterra, a man of great learning, wherein he portrayed him from nature on a sarcophagus of marble, with some ornaments and figures. Afterwards, while the siege of Florence was going on, Niccolò Capponi, a most honourable citizen, died at Castel Nuovo della Garfagnana on his return from Genoa, where he had been as Ambassador from his Republic to the Emperor; and Silvio was sent in great haste to make a cast of his head, to the end that he might afterwards make one in marble, having already executed a very beautiful one in wax.

Now Silvio lived for some time with all his family in Pisa; and since he belonged to the Company of the Misericordia, which in that city accompanies those condemned to death to the place of execution, there once came into his head, being sacristan at that time, the strangest caprice in the world. One night he took out of the grave the body of one who had been hanged the day before; and, after having dissected it for the purposes of his art, being a whimsical fellow, and perhaps a wizard, and ready to believe in enchantments and suchlike follies, he flayed it completely, and with the skin, prepared after a method that he had been taught, he made a jerkin, which he wore for some time over his shirt, believing that it had some great virtue, without anyone ever knowing of it. But having once been upbraided by a good Father to whom he had confessed the matter, he pulled off the jerkin and laid it to rest in a grave, as the monk had urged him to do. Many other similar stories could be told of this man, but, since they have nothing to do with our history, I will pass them over in silence.

After the death of his first wife in Pisa, Silvio went off to Carrara. There he remained to execute some works, and took another wife, with whom, no long time after, he went to Genoa, where, entering the service of Prince Doria, he made a most beautiful escutcheon of marble over the door of his palace, and many ornaments in stucco all over that palace, after the directions given to him by the painter Perino del Vaga. He made, also, a very beautiful portrait in marble of the Emperor Charles V. But since it was Silvio's habit never to stay long in one place – for he was a wayward person – he grew weary of his prosperity in Genoa, and set out to make his way to France. He departed, therefore, but before arriving at Monsanese he turned back, and, stopping at Milan, he executed in the Duomo some scenes and figures and many ornaments, with much credit for himself.

And there, finally, he died at the age of forty-five. He was a man of fine genius, capricious, very dexterous in any kind of work, and a person who could execute with great diligence anything to which he turned his hand. He delighted in composing sonnets and improvising songs, and in his early youth he gave his attention to arms. If he had concentrated his mind on sculpture and design, he would have had no equal; and, even as he surpassed his master Andrea Ferrucci, so, had he lived, he would have surpassed many others who have enjoyed the name of excellent masters.

There flourished at the same time as Andrea and Silvio another sculptor of Fiesole, called Il Cicilia, who was a person of much skill; and a work by his hand may be seen in the Church of S. Jacopo, in the Campo Corbolini at Florence – namely, the tomb of the Chevalier Messer Luigi Tornabuoni, which is much extolled, particularly because he made therein the escutcheon of that Chevalier, in the form of a horse's head, as if to show, according to the ancient belief, that the shape of shields was originally taken from the head of a horse.

About the same time, also, Antonio da Carrara, a very rare sculptor, made three statues in Palermo for the Duke of Monteleone, a Neapolitan of the house of Pignatella, and Viceroy of Sicily – namely, three figures of Our Lady in different attitudes and manners, which were placed over three altars in the Duomo of Monteleone in Calabria. For the same patron he made some scenes in marble, which are in Palermo. He left behind him a son who is also a sculptor at the present day, and no less excellent than was his father.

VINCENZIO DA SAN GIMIGNANO AND TIMOTEO DA URBINO
[VINCENZIO TAMAGNI AND TIMOTEO DELLA VITE], Painters

HAVING now to write, after the Life of the sculptor Andrea da Fiesole, the Lives of two excellent painters, Vincenzio da San Gimignano of Tuscany, and Timoteo da Urbino, I propose to speak first of Vincenzio, as the man whose portrait is above,* and

* In the original edition of 1568.

immediately afterwards of Timoteo, since they lived almost at one and the same time, and were both disciples and friends of Raffaello.

Vincenzio, then, working in company with many others in the Papal Loggie for the gracious Raffaello da Urbino, acquitted himself in such a manner that he was much extolled by Raffaello and by all the others. Having therefore been set to work in the Borgo, opposite to the Palace of Messer Giovanni Battista dall' Aquila, with great credit to himself he painted on a façade a frieze in terretta, in which he depicted the Nine Muses, with Apollo in the centre, and above them some lions, the device of the Pope, which are held to be very beautiful. Vincenzio showed great diligence in his manner and softness in his colouring, and his figures were very pleasing in aspect; in short, he always strove to imitate the manner of Raffaello da Urbino, as may also be seen in the same Borgo, opposite to the Palace of the Cardinal of Ancona, from the façade of a house that was built by Messer Giovanni Antonio Battiferro of Urbino, who, in consequence of the strait friendship that he had with Raffaello, received from him the design for that façade, and also, through his good offices, many benefits and rich revenues at the Court. In this design, then, which was afterwards carried into execution by Vincenzio, Raffaello drew, in allusion to the name of the Battiferri, the Cyclopes forging thunderbolts for Jove, and in another part Vulcan making arrows for Cupid, with some most beautiful nudes and other very lovely scenes and statues. The same Vincenzio painted a great number of scenes on a façade in the Piazza di S. Luigi de' Francesi at Rome, such as the Death of Cæsar, a Triumph of Justice, and a battle of horsemen in a frieze, executed with spirit and much diligence; and in this work, close to the roof, between the windows, he painted some Virtues that are very well wrought. In like manner, on the façade of the Epifani, behind the Curia di Pompeo, and near the Campo di Fiore, he painted the Magi following the Star; with an endless number of other works throughout that city, the air and position of which seem to be in great measure the reason that men are inspired to produce marvellous works there. Experience teaches us, indeed, that very often the same man has not the same manner and does not produce work of equal excellence in every place, but makes it better or worse according to the nature of the place.

Vincenzio being in very good repute in Rome, there took

place in the year 1527 the ruin and sack of that unhappy city, which had been the mistress of the nations. Whereupon, grieved beyond measure, he returned to his native city of San Gimignano; and there, by reason of the sufferings that he had undergone, and the weakening of his love for art, now that he was away from the air which nourishes men of fine genius and makes them bring forth works of the rarest merit, he painted some things that I will pass over in silence, in order not to veil with them the renown and the great name that he had honourably acquired in Rome. It is enough to point out clearly that violence turns the most lofty intellects roughly aside from their chief goal, and makes them direct their steps into the opposite path; which may also be seen in a companion of Vincenzio, called Schizzone, who executed some works in the Borgo that were highly extolled, and also in the Campo Santo of Rome and in S. Stefano degl' Indiani, and who was likewise caused by the senseless soldiery to turn aside from art and in a short time to lose his life. Vincenzio died in his native city of San Gimignano, having had but little gladness in his life after his departure from Rome.

Timoteo, a painter of Urbino, was the son of Bartolommeo della Vite, a citizen of good position, and Calliope, the daughter of Maestro Antonio Alberto of Ferrara, a passing good painter in his day, as is shown by his works at Urbino and elsewhere. While Timoteo was still a child, his father dying, he was left to the care of his mother Calliope, with good and happy augury, from the circumstance that Calliope is one of the Nine Muses, and the conformity that exists between poetry and painting. Then, after he had been brought discreetly through his boyhood by his wise mother, and initiated by her into the studies of the simpler arts and likewise of drawing, the young man came into his first knowledge of the world at the very time when the divine Raffaello Sanzio was flourishing. Applying himself in his earliest years to the goldsmith's art, he was summoned by Messer Pier Antonio, his elder brother, who was then studying at Bologna, to that most noble city, to the end that he might follow that art, to which he seemed to be inclined by nature, under the discipline of some good master. While living, then, in Bologna, in which city he stayed no little time, and was much honoured and received by the noble and magnificent Messer Francesco Gombruti into his house with every sort of courtesy, Timoteo associated continually with men of culture and lofty intellect. Wherefore, having

become known in a few months as a young man of judgment, and inclined much more to the painter's than to the goldsmith's art, of which he had given proofs in some very well-executed portraits of his friends and of others, it seemed good to his brother, wishing to encourage the young man's natural genius, and also persuaded to this by his friends, to take him away from his files and chisels, and to make him devote himself entirely to the study of drawing. At which he was very content, and applied himself straightway to drawing and to the labours of art, copying and drawing all the best works in that city; and establishing a close intimacy with painters, he set out to such purpose on his new road, that it was a marvel to see the progress that he made from one day to another, and all the more because he learnt with facility the most difficult things without any particular teaching from any appointed master. And so, becoming enamoured of his profession, and learning many secrets of painting merely by sometimes seeing certain painters of no account making their mixtures and using their brushes, and guided by himself and by the hand of nature, he set himself boldly to colouring, and acquired a very pleasing manner, very similar to that of the new Apelles, his compatriot, although he had seen nothing by his hand save a few works at Bologna. Thereupon, after executing some works on panel and on walls with very good results, guided by his own good intellect and judgment, and believing that in comparison with other painters he had succeeded very well in everything, he pursued the studies of painting with great ardour, and to such purpose, that in course of time he found that he had gained a firm footing in his art, and was held in good repute and vast expectation by all the world.

Having then returned to his own country, now a man twenty-six years of age, he stayed there for some months, giving excellent proofs of his knowledge. Thus he executed, to begin with, the altar-piece of the Madonna for the altar of S. Croce in the Duomo, containing, besides the Virgin, S. Crescenzio and S. Vitale; and there is a little Angel seated on the ground, playing on a viola with a grace truly angelic and a childlike simplicity expressed with art and judgment. Afterwards he painted another altar-piece for the high-altar of the Church of the Trinità, together with a S. Apollonia on the left hand of that altar.

By means of these works and certain others, of which there is no need to make mention, the name and fame of Timoteo spread

abroad, and he was invited with great insistence by Raffaello to Rome; whither having gone with the greatest willingness, he was received with that loving kindness that was as peculiar to Raffaello as was his excellence in art. Working, then, with Raffaello, in little more than a year he made a great advance, not only in art, but also in prosperity, for in that time he sent home a good sum of money. While working with his master in the Church of S. Maria della Pace, he made with his own hand and invention the Sibyls that are in the lunettes on the right hand, so much esteemed by all painters. That they are his is maintained by some who still remember having seen them painted; and we have also testimony in the cartoons which are still to be found in the possession of his successors. On his own account, likewise, he afterwards painted the bier and the dead body contained therein, with the other things, so highly extolled, that are around it, in the Scuola of S. Caterina da Siena; and although certain men of Siena, carried away by love of their own country, attribute these works to others, it may easily be recognized that they are the handiwork of Timoteo, both from the grace and sweetness of the colouring, and from other memorials of himself that he left in that most noble school of excellent painters.

Now, although Timoteo was well and honourably placed in Rome, yet, not being able to endure, as many do, the separation from his own country, and also being invited and urged every moment to come home by the counsels of his friends and by the prayers of his mother, now an old woman, he returned to Urbino, much to the displeasure of Raffaello, who loved him dearly for his good qualities. And not long after, having taken a wife in Urbino at the suggestion of his family, and having become enamoured of his country, in which he saw that he was highly honoured, besides the circumstance, even more important, that he had begun to have children, Timoteo made up his mind firmly never again to consent to go abroad, notwithstanding, as may still be seen from some letters, that he was invited back to Rome by Raffaello. But he did not therefore cease to work, and he made many works in Urbino and in the neighbouring cities. At Forlì he painted a chapel in company with Girolamo Genga, his friend and compatriot; and afterwards he painted entirely with his own hand a panel that was sent to Città di Castello, and likewise another for the people of Cagli. At Castel Durante, also, he executed some works in fresco, which are truly worthy of praise, as

are all the other works by his hand, which bear witness that he was a graceful painter in figures, landscapes, and every other field of painting. In Urbino, at the instance of Bishop Arrivabene of Mantua, he painted the Chapel of S. Martino in the Duomo, in company with the same Genga; but the altar-panel and the middle of the chapel are entirely by the hand of Timoteo. For the same church, also, he painted a Magdalene standing, clothed in a short mantle, and covered below this by her own tresses, which reach to the ground and are so beautiful and natural, that the wind appears to move them; not to mention the divine beauty of the expression of her countenance, which reveals clearly the love that she bore to her Master.

In S. Agata there is another panel by the hand of the same man, with some very good figures. And for S. Bernardino, without that city, he made that work so greatly renowned that is at the right hand upon the altar of the Buonaventuri, gentlemen of Urbino; wherein the Virgin is represented with most beautiful grace as having received the Annunciation, standing with her hands clasped and her face and eyes uplifted to Heaven. Above, in the sky, in the centre of a great circle of light, stands a little Child, with His foot on the Holy Spirit in the form of a Dove, and holding in His left hand a globe symbolizing the dominion of the world, while, with the other hand raised, He gives the benediction; and on the right of the Child is an angel, who is pointing Him out with his finger to the Madonna. Below – that is, on the level of the Madonna, to her right – is the Baptist, clothed in a camel's skin, which is torn on purpose that the nude figure may be seen; and on her left is a S. Sebastian, wholly naked, and bound in a beautiful attitude to a tree, and wrought with such diligence that the figure could not have stronger relief nor be in any part more beautiful.

At the Court of the most illustrious Dukes of Urbino, in a little private study, may be seen an Apollo and two half-nude Muses by his hand, beautiful to a marvel. For the same patrons he executed many pictures, and made some decorations for apartments, which are very beautiful. And afterwards, in company with Genga, he painted some caparisons for horses, which were sent to the King of France, with such beautiful figures of various animals that they appeared to all who beheld them to have life and movement. He made, also, some triumphal arches similar to those of the ancients, on the occasion of the marriage of the

most illustrious Duchess Leonora to the Lord Duke Francesco Maria, to whom they gave vast satisfaction, as they did to the whole Court; on which account he was received for many years into the household of that Duke, with an honourable salary.

Timoteo was a bold draughtsman, and even more notable for the sweetness and charm of his colouring, insomuch that his works could not have been executed with more delicacy or greater diligence. He was a merry fellow, gay and festive by nature, and most acute and witty in his sayings and discourses. He delighted in playing every sort of instrument, and particularly the lyre, to which he sang, improvising upon it with extraordinary grace. He died in the year of our salvation 1524, the fifty-fourth of his life, leaving his native country as much enriched by his name and his fine qualities as it was grieved by his loss. He left in Urbino some unfinished works, which were finished afterwards by others and show by comparison how great were the worth and ability of Timoteo.

In our book are some drawings by his hand, very beautiful and truly worthy of praise, which I received from the most excellent and gentle Messer Giovanni Maria, his son – namely, a pensketch for the portrait of the Magnificent Giuliano de' Medici, which Timoteo made when Giuliano was frequenting the Court of Urbino and that most famous academy, a 'Noli me tangere,' and a S. John the Evangelist sleeping while Christ is praying in the Garden, all very beautiful.

ANDREA DAL MONTE SANSOVINO
[ANDREA CONTUCCI],
Sculptor and Architect

ALTHOUGH Andrea, the son of Domenico Contucci of Monte Sansovino, was born from a poor father, a tiller of the earth, and rose from the condition of shepherd, nevertheless his conceptions were so lofty, his genius so rare, and his mind so ready, both in his works and in his discourses on the difficulties of architecture and perspective, that there was not in his day a better, rarer, or more subtle intellect than his, nor one that was more able than he was to render the greatest doubts clear and lucid; wherefore he well deserved to be held in his own times, by all who were qualified to judge, to be supreme in those professions.

Andrea was born, so it is said, in the year 1460; and in his child-hood, while looking after his flocks, he would draw on the sand the livelong day, as is also told of Giotto, and copy in clay some of the animals that he was guarding. So one day it happened that a Florentine citizen, who is said to have been Simone Vespucci, at that time Podestà of the Monte, passing by the place where Andrea was looking after his little charges, saw the boy standing all intent on drawing or modelling in clay. Whereupon he called to him, and, having seen what was the boy's bent, and heard whose son he was, he asked for him from Domenico Contucci, who graciously granted his request; and Simone promised to place him in the way of learning design, in order to see what virtue there might be in that inclination of nature, if assisted by continual study.

Having returned to Florence, then, Simone placed him to learn art with Antonio del Pollaiuolo, under whom Andrea made such proficience, that in a few years he became a very good master. In the house of that Simone, on the Ponte Vecchio, there may still be seen a cartoon executed by him at that time, of Christ being scourged at the Column, drawn with much diligence; and, in addition, two marvellous heads in terra-cotta, copied from ancient medals, one of the Emperor Nero, and the other of the Emperor Galba, which heads served to adorn a chimney-piece; but the Galba is now at Arezzo, in the house of Giorgio Vasari. Afterwards, while still living in Florence, he made an altar-piece in terra-cotta for the Church of S. Agata at Monte Sansovino, with a S. Laurence and some other saints, and little scenes most beautifully executed. And no long time after this he made another like it, containing a very beautiful Assumption of Our Lady, S. Agata, S. Lucia, and S. Romualdo; which altar-piece was after-wards glazed by the Della Robbia family.

Then, pursuing the art of sculpture, he made in his youth for Simone del Pollaiuolo, otherwise called Il Cronaca, two capitals for pilasters in the Sacristy of S. Spirito, which brought him very great fame, and led to his receiving a commission to execute the antechamber that is between the said sacristy and the church; and since the space was very small, Andrea was forced to use great ingenuity. He made, therefore, a structure of grey-stone in the Corinthian Order, with twelve round columns, six on either side; and having laid architrave, frieze, and cornice over these columns, he then raised a barrel-shaped vault, all of the same stone, with

a coffer-work surface full of carvings, which was something novel, rich and varied, and much extolled. It is true, indeed, that if the mouldings of that coffer-work ceiling, which serve to divide the square and round panels by which it is adorned, had been contrived so as to fall in a straight line with the columns, with truer proportion and harmony, this work would be wholly perfect in every part; and it would have been an easy thing to do this. But, according to what I once heard from certain old friends of Andrea, he used to defend himself by saying that he had adhered in his vault to the method of the coffering in the Ritonda at Rome, wherein the ribs that radiate from the round window in the centre above, from which that temple gets its light, serve to enclose the square sunk panels containing the rosettes, which diminish little by little, as likewise do the ribs; and for that reason they do not fall in a straight line with the columns. Andrea used to add that if he who built the Temple of the Ritonda, which is the best designed and proportioned that there is, and made with more harmony than any other, paid no attention to this in a vault of such size and importance, much less should he do so in a coffered ceiling with far smaller panels. Nevertheless many crafts-men, and Michelagnolo in particular, have been of the opinion that the Ritonda was built by three architects, of whom the first carried it as far as the cornice that is above the columns, and the second from the cornice upwards, the part, namely, that contains those windows of more graceful workmanship, for in truth this second part is very different in manner from the part below, since the vaulting was carried out without any relation between the coffering and the straight lines of what is below. The third is believed to have made the portico, which was a very rare work. And for these reasons the masters who practise this art at the present day should not fall into such an error and then make excuses, as did Andrea.

After that work, having received from the family of the Cor-binelli the commission for the Chapel of the Sacrament in the same church, he carried it out with much diligence, imitating in the low-reliefs Donato and other excellent craftsmen, and sparing no labour in his desire to do himself credit, as, indeed, he did. In two niches, one on either side of a very beautiful tabernacle, he placed two saints somewhat more than one braccio in height, S. James and S. Matthew, executed with such spirit and excel-lence, that every sort of merit is revealed in them and not one

fault. Equally good, also, are two Angels in the round that are the crowning glory of this work, with the most beautiful draperies – for they are in the act of flying – that are anywhere to be seen; and in the centre is a little naked Christ full of grace. There are also some scenes with little figures in the predella and over the tabernacle, all so well executed that the point of a brush could scarcely do what Andrea did with his chisel. But whosoever wishes to be amazed by the diligence of this extraordinary man should look at the architecture of this work as a whole, for it is so well executed and joined together in its small proportions that it appears to have been chiselled out of one single stone. Much extolled, also, is a large Pietà of marble that he made in half-relief on the front of the altar, with the Madonna and S. John weeping. Nor could one imagine any more beautiful pieces of casting than are the bronze gratings that enclose that chapel, with their ornaments of marble, and with stags, the device, or rather the arms, of the Corbinelli, which serve as adornments for the bronze candelabra. In short, this work was executed without any sparing of labour, and with all the best considerations that could possibly be imagined.

By these and by other works the name of Andrea spread far and wide, and he was sought for from the elder Lorenzo de' Medici, the Magnificent, in whose garden, as has been related, he had pursued the studies of design, by the King of Portugal; and, being therefore sent to him by Lorenzo, he executed for that King many works of sculpture and of architecture, and in particular a very beautiful palace with four towers, and many other buildings. Part of the palace was painted after designs and cartoons by the hand of Andrea, who drew very well, as may be seen from some drawings by his own hand in our book, finished with a charcoal-point, and some other architectural drawings, showing excellent design. He also made for that King a carved altar of wood, containing some Prophets; and likewise a very beautiful battle-piece in clay, to be afterwards carved in marble, representing the wars that the King waged with the Moors, who were vanquished by him; and no work by the hand of Andrea was ever seen that was more spirited or more terrible than this, what with the movements and various attitudes of the horses, the heaps of dead, and the vehement fury of the soldiers in combat. And he made a figure of S. Mark in marble, which was a very rare work. While in the service of that King, Andrea also gave his attention to some difficult and fantastic architectural works, according to

the custom of that country, in order to please the King; of which things I once saw a book at Monte Sansovino in the possession of his heirs, which is now in the hands of Maestro Girolamo Lombardo, who was his disciple, and to whom it fell, as will be related, to finish some works begun by Andrea.

Having been nine years in Portugal, and growing weary of that service, and desirous of seeing his relatives and friends in Tuscany again, Andrea determined, now that he had put together a good sum of money, to obtain leave from the King and return home. And so, having been granted permission, although not willingly, he returned to Florence, leaving behind him one who should complete such of his works as remained unfinished. After arriving in Florence, he began in the year 1500 a marble group of S. John baptizing Christ, which was to be placed over that door of the Temple of S. Giovanni that faces the Misericordia; but he did not finish it, because he was almost forced to go to Genoa, where he made two figures of marble, Christ, or rather S. John, and a Madonna, which are truly worthy of the highest praise. And those at Florence remained unfinished, and are still to be found at the present day in the Office of Works of the said S. Giovanni.

He was then summoned to Rome by Pope Julius II, and received the commission for two tombs of marble, which were erected in S. Maria del Popolo – one for Cardinal Ascanio Sforza, and the other for the Cardinal of Recanati, a very near relative of the Pope – and these works were wrought so perfectly by Andrea that nothing more could be desired, since they were so well executed and finished, and with such purity, beauty, and grace, that they reveal the true consideration and proportion of art. There may be seen there, also, a Temperance with an hour-glass in her hand, which is held to be a thing divine; and, indeed, it does not appear to be a modern work, but ancient and wholly perfect. And although there are other figures there similar to it, yet on account of its attitude and grace it is much the best; not to mention that nothing could be more pleasing and beautiful than the veil that she has around her, which is executed with such delicacy that it is a miracle to behold.

In S. Agostino at Rome, on a pilaster in the middle of the church, he made in marble a S. Anne embracing a Madonna with the Child, a little less than lifesize. This work may be counted as one of the best of modern times, since, even as a lively and wholly natural gladness is seen in the old woman, and a divine

beauty in the Madonna, so the figure of the Infant Christ is so well wrought, that no other was ever executed with such delicacy and perfection. Wherefore it well deserved that for many years a succession of sonnets and various other learned compositions should be attached to it, of which the friars of that place have a book full, which I myself have seen, to my no little marvel. And in truth the world was right in doing this, for the reason that the work can never be praised enough.

The fame of Andrea having thereby grown greater, Leo X, who had resolved that the adornment with wrought marble of the Chamber of the Madonna in S. Maria at Loreto should be carried out, according to the beginning made by Bramante, ordained that Andrea should bring that work to completion. The ornamentation of that Chamber, which Bramante had begun, had at the corners four double projections, which, adorned by pillars with bases and carved capitals, rested on a socle rich with carvings, and two braccia and a half in height; over which socle, between the two aforesaid pillars, he had made a large niche to contain seated figures, and, above each of these niches, a smaller one, which, reaching to the collarino of the capitals of those pillars, left a frieze of the same height as the capitals. Above these were afterwards laid architrave, frieze, and richly carved cornice, which, going right round all the four walls, project over the four corners; and in the middle of each of the larger walls – for the Chamber is greater in length than in breadth – were left two spaces, since there was the same projection in the centre of those walls as there was at the corners; whence the larger niche below, with the smaller one above it, came to be enclosed by a space of five braccia on either side. In this space were two doors, one on either side, through which one entered into the chapel; and above the doors was a space of five braccia between one niche and another, wherein were to be carved scenes in marble. The front wall was the same, but without niches in the centre, and the height of the socle, with the projection, formed an altar, which was set off by the pillars and the niches at the corners. In the same front wall, in the centre, was a space of the same breadth as the spaces at the sides, to contain some scenes in the upper part, while below, the same in height as the spaces of the sides, but beginning immediately above the altar, was a bronze grating opposite to the inner altar, through which it was possible to hear the Mass and to see the inside of the Chamber and the aforesaid

altar of the Madonna. Altogether, then, the spaces and compartments for the scenes were seven: one in front, above the grating, two on each of the longer sides, and two on the upper part – that is to say, behind the altar of the Madonna; and, in addition, there were eight large and eight small niches, with other smaller spaces for the arms and devices of the Pope and of the Church.

Andrea, then, having found the work in this condition, distributed over these spaces, with a rich and beautiful arrangement, scenes from the life of the Madonna. In one of the two side-walls, he began in one part the Nativity of the Madonna, and executed half of it; and it was completely finished afterwards by Baccio Bandinelli. In the other part he began the Marriage of the Virgin, but this also remained unfinished, and after the death of Andrea it was completed as we see it by Raffaello da Montelupo. On the front wall he arranged that there should be made, in two small squares which are on either side of the bronze grating, in one the Visitation and in the other the scene of the Virgin and Joseph going to have themselves enrolled for taxes; which scenes were afterwards executed by Francesco da San Gallo, then a young man. Then, in that part where the greatest space is, Andrea made the Angel Gabriel bringing the Annunciation to the Virgin – which happened in that very chamber which these marbles enclose – with such grace and beauty that there is nothing better to be seen, for he made the Virgin wholly intent on that Salutation, and the Angel, kneeling, appears to be not of marble, but truly celestial, with 'Ave Maria' issuing from his mouth. In company with Gabriel are two other Angels, in full-relief and detached from the marble, one of whom is walking after him and the other appears to be flying. Behind a building stand two other Angels, carved out by the chisel in such a way that they seem to be alive. In the air, on a cloud much undercut – nay, almost entirely detached from the marble – are many little boys upholding a God the Father, who is sending down the Holy Spirit by means of a ray of marble, which, descending from Him completely detached, appears quite real; as, likewise, is the Dove upon it, which represents the Holy Spirit. Nor can one describe how great is the beauty and how delicate the carving of a vase filled with flowers, which was made in this work by the gracious hand of Andrea, who lavished so much excellence on the plumes of the Angels, the hair, the grace of their features and draperies, and, in short, on every other thing, that this divine work cannot be

extolled enough. And, in truth, that most holy place, which was the very house and habitation of the Mother of the Son of God, could not obtain from the resources of the world a greater, richer, or more beautiful adornment than that which it received from the architecture of Bramante and the sculpture of Andrea Sansovino; although, even if it were entirely of the most precious gems of the East, it would be little more than nothing in comparison with such merits.

Andrea spent an almost incredible amount of time over this work, and therefore had no time to finish the others that he had begun; for, in addition to those mentioned above, he began in a space on one of the side-walls the Nativity of Jesus Christ, with the Shepherds and four Angels singing; and all these he finished so well that they seem to be wholly alive. But the story of the Magi, which he began above that one, was afterwards finished by Girolamo Lombardo, his disciple, and by others. On the back wall he arranged that two large scenes should be made, one above the other; in one, the Death of Our Lady, with the Apostles bearing her to her burial, four Angels in the air, and many Jews seeking to steal that most holy corpse; and this was finished after Andrea's lifetime by the sculptor Bologna. Below this one, then, he arranged that there should be made a scene of the Miracle of Loreto, showing in what manner that chapel, which was the Chamber of Our Lady, wherein she was born, brought up, and saluted by the Angel, and in which she reared her Son up to the age of twelve and lived ever after His Death, was finally carried by the Angels, first into Sclavonia, afterwards to a forest in the territory of Recanati, and in the end to the place where it is now held in such veneration and continually visited in solemn throng by all the Christian people. This scene, I say, was executed in marble on that wall, according to the arrangement made by Andrea, by the Florentine sculptor Tribolo, as will be related in due place. Andrea likewise blocked out the Prophets for the niches, but did not finish them completely, save one alone, and the others were afterwards finished by the aforesaid Girolamo Lombardo and by other sculptors, as will be seen in the Lives that are to follow. But with regard to all the works wrought by Andrea in this undertaking, they are the most beautiful and best executed works of sculpture that had ever been made up to that time.

In like manner, the Palace of the Canons of the same church was also carried on by Andrea, after the arrangements made by

Bramante at the commission of Pope Leo. But this, also, re-
mained unfinished after the death of Andrea, and the building
was continued under Clement VII by Antonio da San Gallo, and
then by the architect Giovanni Boccalino, under the patronage of
the very reverend Cardinal da Carpi, up to the year 1563. While
Andrea was at work on the aforesaid Chapel of the Virgin,
there were built the fortifications of Loreto and other works,
which were highly extolled by the all-conquering Signor Giovanni
de' Medici, with whom Andrea had a very strait friendship,
having become first acquainted with him in Rome.

Having four months of holiday in the year for repose while
he was working at Loreto, he used to spend that time in agricul-
ture at his native place of Monte Sansovino, enjoying meanwhile
a most tranquil rest with his relatives and friends. Living thus at
the Monte during the summer, he built there a commodious
house for himself and bought much property; and for the Friars
of S. Agostino in that place he had a cloister made, which, al-
though small, is very well designed, but also out of the square,
since those Fathers insisted on having it built over the old walls.
Andrea, however, made the interior rectangular by increasing the
thickness of the pilasters at the corners, in order to change it
from an ill-proportioned structure into one with good and true
measurements. He designed, also, for a Company that had its seat
in that cloister, under the title of S. Antonio, a very beautiful door
of the Doric Order; and likewise the tramezzo* and pulpit of the
Church of S. Agostino. He also caused a little chapel to be
built for the friars half-way down the hill on the descent to the
fountain, without the door that leads to the old Pieve, although
they had no wish for it. He made the design for the house of
Messer Pietro, a most skilful astrologer, at Arezzo; and a large
figure of terra-cotta for Montepulciano, of King Porsena,
which was a rare work, although I have never seen it again
since the first time, so that I fear that it may have come to an
evil end. And for a German priest, who was his friend, he
made a lifesize S. Rocco of terra-cotta, very beautiful; which
priest had it placed in the Church of Battifolle, in the district
of Arezzo. This was the last piece of sculpture that Andrea
executed.

He gave the design, also, for the steps ascending to the

* See note on p. 90.

Vescovado of Arezzo; and for the Madonna delle Lagrime, in the same city, he made the design of a very beautiful ornament that was to be executed in marble, with four figures, each four braccia high; but this work was carried no farther, on account of the death of our Andrea. For he, having reached the age of sixty-eight, and being a man who would never stay idle, set to work to move some stakes from one place to another at his villa, whereby he caught a chill; and in a few days, worn out by a continuous fever, he died, in the year 1529.

The death of Andrea grieved his native place by reason of the honour that he had brought it, and his sons and the women of his household, who lost both their dearest one and their support. And not long ago Muzio Camillo, one of the three aforesaid sons, who was displaying a most beautiful intellect in the studies of learning and letters, followed him, to the great loss of his family and displeasure of his friends.

Andrea, in addition to his profession of art, was truly a person of much distinction, for he was wise in his discourse, and reasoned most beautifully on every subject. He was prudent and regular in his every action, much the friend of learned men, and a philosopher of great natural gifts. He gave much attention to the study of cosmography, and left to his family a number of drawings and writings on the subject of distances and measurements. He was somewhat small in stature, but robust and beautifully made. His hair was soft and long, his eyes light in colour, his nose aquiline, and his skin pink and white; but he had a slight impediment in his speech.

His disciples were the aforesaid Girolamo Lombardo, the Florentine Simone Cioli, Domenico dal Monte Sansovino (who died soon after him), and the Florentine Leonardo del Tasso, who made the S. Sebastian of wood over his own tomb in S. Ambrogio at Florence, and the marble panel of the Nuns of S. Chiara. A disciple of Andrea, likewise, was the Florentine Jacopo Sansovino – so called after his master – of whom there will be a long account in the proper place.

Architecture and sculpture, then, are much indebted to Andrea, in that he enriched the one with many rules of measurement and devices for drawing weights, and with a degree of diligence that had not been employed before, and in the other he brought his marble to perfection with marvellous judgment, care, and mastery.

BENEDETTO DA ROVEZZANO, Sculptor

GREAT, I think, must be the displeasure of those who, having executed some work of genius, yet, when they hope to enjoy the fruits of this in their old age, and to see the beautiful results achieved by other intellects in works similar to their own, and to be able to perceive what perfection there may be in that field of art that they themselves have practised, find themselves robbed by adverse fortune, by time, by a bad habit of body, or by some other cause, of the sight of their eyes; whence they are not able, as they were before, to perceive either the deficiencies or the perfection of men whom they hear of as living and practising their own professions. And even more are they grieved to hear the praises of the new masters, not through envy, but because they are not able to judge, like others, whether that fame be well-deserved or not.

This misfortune happened to Benedetto da Rovezzano, a sculptor of Florence, of whom we are now about to write the Life, to the end that the world may know how able and practised a sculptor he was, and with what diligence he carved marble in strong relief against its ground in the marvellous works that he made. Among the first of many labours that this master executed in Florence, may be numbered a chimney-piece of grey-stone that is in the house of Pier Francesco Borgherini, wherein are capitals, friezes, and many other ornaments, carved by his hand in open-work with great diligence. In the house of Messer Bindo Altoviti, likewise, is a chimney-piece by the same hand, with a lavatory of marble, and some other things executed with much delicacy; but everything in these that has to do with architecture was designed by Jacopo Sansovino, then a young man.

Next, in the year 1512, Benedetto received the commission for a tomb of marble, with rich ornaments, in the principal chapel of the Carmine in Florence, for Piero Soderini, who had been Gonfalonier in that city; and that work was executed by him with incredible diligence, seeing that, besides foliage, carved emblems of death, and figures, he made therein with basanite, in low-relief, a canopy in imitation of black cloth, with so much grace and such beautiful finish and lustre, that the stone appears to be exquisite black satin rather than basanite. And, to put it in a few words, for all that the hand of Benedetto did in this work there is no praise that would not seem too little.

BENEDETTO DA ROVEZZANO
SCVLTORE

And since he also gave his attention to architecture, there was restored from the design of Benedetto a house near S. Apostolo in Florence, belonging to Messer Oddo Altoviti, Patron and Prior of that church. There Benedetto made the principal door in marble, and, over the door of the house, the arms of the Altoviti in grey-stone, with the wolf, lean, excoriated, and carved in such strong relief, that it seems to be almost separate from the shield; and some pendant ornaments carved in openwork with such delicacy, that they appear to be not of stone, but of the finest paper. In the same church, above the two chapels of Messer Bindo Altoviti, for which Giorgio Vasari of Arezzo painted the panel-picture of the Conception in oils, Benedetto made a marble tomb for the said Messer Oddo, surrounded by an ornament full of most masterly foliage, with a sarcophagus, likewise very beautiful.

Benedetto also executed, in competition with Jacopo Sansovino and Baccio Bandinelli, as has been related, one of the Apostles, four and a half braccia in height, for S. Maria del Fiore – namely, a S. John the Evangelist, which is a passing good figure, wrought with fine design and skill. This figure is in the Office of Works, in company with the others.

Next, in the year 1515, the chiefs and heads of the Order of Vallombrosa, wishing to transfer the body of S. Giovanni Gualberto from the Abbey of Passignano to the Church of S. Trinita, an abbey of the same Order, in Florence, commissioned Benedetto to make a design, upon which he was to set to work, for a chapel and tomb combined, with a vast number of lifesize figures in the round, which were to be suitably distributed over that work in some niches separated by pilasters filled with ornaments and friezes and with delicately carved grotesques. And below this whole work there was to be a base one braccio and a half in height, wherein were to be scenes from the life of the said S. Giovanni Gualberto; while endless numbers of other ornaments were to be round the sarcophagus, and as a crown to the work. On this tomb, then, Benedetto, assisted by many carvers, laboured continually for ten years, with vast expense to that Congregation; and he brought the work to completion in their house of Guarlondo, a place near San Salvi, without the Porta alla Croce, where the General of the Order that was having the work executed almost always lived. Benedetto, then, carried out the making of that chapel and tomb in such a manner as amazed Florence; but, as Fate would have it – for even marbles and the

finest works of men of excellence are subject to the whims of fortune – after much discord among those monks, their government was changed, and the work remained unfinished in the same place until the year 1530. At which time, war raging round Florence, all those labours were ruined by soldiers, the heads wrought with such diligence were impiously struck off from the little figures, and the whole work was so completely destroyed and broken to pieces, that the monks afterwards sold what was left for a mere song. If any one wishes to see a part of it, let him go to the Office of Works of S. Maria del Fiore, where there are a few pieces, bought as broken marble not many years ago by the officials of that place. And, in truth, even as everything is brought to fine completion in those monasteries and other places where peace and concord reign, so, on the contrary, nothing ever reaches perfection or an end worthy of praise in places where there is naught save rivalry and discord, because what takes a good and wise man a hundred years to build up can be destroyed by an ignorant and crazy boor in one day. And it seems as if fortune wishes that those who know the least and delight in nothing that is excellent, should always be the men who govern and command, or rather, ruin, everything: as was also said of secular Princes, with no less learning than truth, by Ariosto, at the beginning of his seventeenth canto. But returning to Benedetto: it was a sad pity that all his labours and all the money spent by that Order should have come to such a miserable end.

By the same architect were designed the door and vestibule of the Badia of Florence, and likewise some chapels, among them that of S. Stefano, erected by the family of the Pandolfini. Finally, Benedetto was summoned to England into the service of the King, for whom he executed many works in marble and in bronze, and, in particular, his tomb; from which works, through the liberality of that King, he gained enough to be able to live in comfort for the rest of his life. Thereupon he returned to Florence; but, after he had finished some little things, a sort of giddiness, which even in England had begun to affect his eyes, and other troubles caused, so it was said, by standing too long over the fire in the founding of metals, or by some other reasons, in a short time robbed him completely of the sight of his eyes; wherefore he ceased to work about the year 1550, and to live a few years after that. Benedetto endured that blindness during the last years of his life with the patience of a good Christian,

thanking God that He had first enabled him, by means of his labours, to live an honourable life.

Benedetto was a courteous gentleman, and he always delighted in the society of men of culture. His portrait was copied from one made, when he was a young man, by Agnolo di Donnino. This original is in our book of drawings, wherein there are also some drawings very well executed by the hand of Benedetto, who deserves, on account of all those works, to be numbered among our most excellent craftsmen.

BACCIO DA MONTELUPO, Sculptor AND RAFFAELLO, HIS SON

So strong is the belief of mankind that those who are negligent in the arts which they profess to practise can never arrive at any perfection in them, that it was in the face of the judgment of many that Baccio da Montelupo learnt the art of sculpture; and this happened to him because in his youth, led astray by pleasures, he would scarcely ever study, and, although he was exhorted and upbraided by many, he thought little or nothing of art. But having come to years of discretion, which bring sense with them, he was forced straightway to learn how far he was from the good way. Whereupon, seeing with shame that others were going ahead of him in that art, he resolved with a stout heart to follow and practise with all possible zeal that which in his idleness he had hitherto shunned. This resolution was the reason that he produced in sculpture such fruits as the opinions of many no longer expected from him.

Having thus devoted himself with all his powers to his art, and practising it continually, he became a rare and excellent master. And of this he gave a proof in a work in hard-stone, wrought with the chisel, on the corner of the garden attached to the Palace of the Pucci in Florence; which was the escutcheon of Pope Leo X, with two children supporting it, executed in a beautiful and masterly manner. He made a Hercules for Pier Francesco de' Medici; and from the Guild of Porta Santa Maria he received the commission for a statue of S. John the Evangelist, to be executed in bronze, in securing which he had many difficulties, since a number of masters made models in competition with

him. This figure was afterwards placed on the corner of S. Michele in Orto, opposite to the Ufficio; and the work was finished by him with supreme diligence. It is said that when he had made the figure in clay, all who saw the arrangement of the armatures, and the moulds laid upon them, held it to be a beautiful piece of work, recognizing the rare ingenuity of Baccio in such an enterprise; and when they had seen it cast with the utmost facility, they gave Baccio credit for having shown supreme mastery, and having made a solid and beautiful casting. These labours endured in that profession, brought him the name of a good and even excellent master; and that figure is esteemed more than ever at the present day by all craftsmen, who hold it to be most beautiful.

Setting himself also to work in wood, he carved lifesize Crucifixes, of which he made an endless number for all parts of Italy, and among them one that is over the door of the choir of the Monks of S. Marco at Florence. These are all excellent and full of grace, but there are some that are much more perfect than the rest, such as the one of the Murate in Florence, and another, no less famous than the first, in S. Pietro Maggiore; and for the Monks of SS. Fiora e Lucilla he made a similar one, which they placed over the high-altar of their abbey at Arezzo, and which is held to be much the most beautiful of them all. For the visit of Pope Leo X to Florence, Baccio erected between the Palace of the Podestà and the Badia a very beautiful triumphal arch of wood and clay; with many little works, which have either disappeared or been dispersed among the houses of citizens.

Having grown weary, however, of living in Florence, he went off to Lucca, where he executed some works in sculpture, and even more in architecture, in the service of that city, and, in particular, the beautiful and well-designed Temple of S. Paulino, the Patron Saint of the people of Lucca, built with proofs of a fine and well-trained intelligence both within and without, and richly adorned. Living in that city, then, up to the eighty-eighth year of his life, he ended his days there, and received honourable burial in the aforesaid S. Paulino from those whom he had honoured when alive.

A contemporary of Baccio was Agostino, a very famous sculptor and carver of Milan, who began in S. Maria, at Milan, the tomb of Monsignore de Foix, which remains unfinished even now; and in it may still be seen many large figures, some finished,

some half completed, and others only blocked out, with a number of scenes in half-relief, in pieces and not built in, and a great quantity of foliage and trophies. For the Biraghi, also, he made another tomb, which is finished and erected in S. Francesco, with six large figures, the base wrought with scenes, and other very beautiful ornaments, which bear witness to the masterly skill of that valiant craftsman.

Baccio left at his death, among other sons, Raffaello, who applied himself to sculpture, and not merely equalled his father, but surpassed him by a great measure. This Raffaello, beginning in his youth to work in clay, in wax, and in bronze, acquired the name of an excellent sculptor, and was therefore taken by Antonio da San Gallo to Loreto, together with many others, in order to finish the ornamentation of that Chamber, according to the directions left by Andrea Sansovino; where Raffaello completely finished the Marriage of Our Lady, begun by the said Sansovino, executing many things in a beautiful and perfect manner, partly over the beginnings of Andrea, and partly from his own invention. Wherefore he was deservedly esteemed to be one of the best craftsmen who worked there in his time.

He had finished this work, when Michelagnolo, by order of Pope Clement VII, proceeded to finish the new sacristy and the library of S. Lorenzo in Florence; and that master, having recognized the talent of Raffaello, made use of him in that work, and caused him to execute, among other things, after the model that he himself had made, the S. Damiano of marble which is now in that sacristy – a very beautiful statue, very highly extolled by all men. After the death of Clement, Raffaello attached himself to Duke Alessandro de' Medici, who was then having the fortress of Prato built; and he made for him in grey-stone, on one of the extremities of the chief bastion of that fortress – namely, on the outer side – the escutcheon of the Emperor Charles V, upheld by two nude and lifesize Victories, which were much extolled, as they still are. And for the extremity of another bastion, in the direction of the city, on the southern side, he made the arms of Duke Alessandro in the same kind of stone, with two figures. Not long after, he executed a large Crucifix of wood for the Nuns of S. Apollonia; and for Alessandro Antinori, a very rich and noble merchant of Florence at that time, he prepared a most magnificent festival for the marriage of his daughter, with statues, scenes, and many other most beautiful ornaments.

Having then gone to Rome, he received from Buonarroti a commission to make two figures of marble, each five braccia high, for the tomb of Julius II, which was finished and erected at that time by Michelagnolo in S. Pietro in Vincula. But Raffaello, falling ill while he was executing this work, was not able to put into it his usual zeal and diligence, on which account he lost credit thereby, and gave little satisfaction to Michelagnolo. At the visit of the Emperor Charles V to Rome, for which Pope Paul III prepared a festival worthy of that all-conquering Prince, Raffaello made with clay and stucco, on the Ponte S. Angelo, fourteen statues so beautiful, that they were judged to be the best that had been made for that festival. And, what is more, he executed them with such rapidity that he was in time to come to Florence, where the Emperor was likewise expected, to make within the space of five days and no more, on the abutment of the Ponte a S. Trinita, two Rivers of clay, each five braccia high, the Rhine to stand for Germany and the Danube for Hungary.

After this, having been summoned to Orvieto, he made in marble, in a chapel wherein the excellent sculptor Mosca had previously executed many most beautiful ornaments, the story of the Magi in half-relief, which proved to be a very fine work, on account of the great variety of figures and the good manner with which he executed them.

Then, having returned to Rome, he was appointed by Tiberio Crispo, at that time Castellan of the Castello di S. Angelo, as architect of that great structure; whereupon he set in order many rooms there, adorning them with carvings in many kinds of stone and various sorts of variegated marbles on the chimney-pieces, windows, and doors. In addition to this, he made a marble statue, five braccia high, of the Angel of that Castle, which is on the summit of the great square tower in the centre, where the standard flies, after the likeness of that Angel that appeared to S. Gregory, who, having prayed that the people should be delivered from a most grievous pestilence, saw him sheathing his sword in the scabbard. Later, when the said Crispo had been made a Cardinal, he sent Raffaello several times to Bolsena, where he was building a palace. Nor was it long before the very reverend Cardinal Salviati and Messer Baldassarre Turini da Pescia commissioned Raffaello, who had already left the service of the Castle and of Cardinal Crispo, to make the statue of Pope Leo that is now over his tomb in the Minerva at Rome. That work finished,

Raffaello made a tomb for the same Messer Baldassarre in the Church of Pescia, where that gentleman had built a chapel of marble. And for a chapel in the Consolazione, at Rome, he made three figures of marble in half-relief. But afterwards, having given himself up to the sort of life fit rather for a philosopher than for a sculptor, and wishing to live in peace, he retired to Orvieto, where he undertook the charge of the building of S. Maria, in which he made many improvements; and with this he occupied himself for many years, growing old before his time.

I believe that Raffaello, if he had undertaken great works, as he might have done, would have executed more things in art, and better, than he did. But he was too kindly and considerate, avoiding all conflict, and contenting himself with that wherewith fortune had provided him; and thus he neglected many opportunities of making works of distinction. Raffaello was a very masterly draughtsman, and he had a much better knowledge of all matters of art than had been shown by his father Baccio. In our book are some drawings by the hand both of the one and of the other; but those of Raffaello are much the finer and more graceful, and executed with better art. In his architectural decorations Raffaello followed in great measure the manner of Michelagnolo, as is proved by the chimney-pieces, doors, and windows that he made in the aforesaid Castello di S. Angelo, and by some chapels built under his direction, in a rare and beautiful manner, at Orvieto.

But returning to Baccio: his death was a great grief to the people of Lucca, who had known him as a good and upright man, courteous to all, and very loving. Baccio's works date about the year of our Lord 1533. His dearest friend, who learnt many things from him, was Zaccaria da Volterra, who executed many works in terra-cotta at Bologna, some of which are in the Church of S. Giuseppe.

LORENZO DI CREDI, Painter of Florence

THE while that Maestro Credi, an excellent goldsmith in his day, was working in Florence with very good credit and repute, Andrea Sciarpelloni placed with him, to the end that he might learn that craft, his son Lorenzo, a young man of beautiful intellect and

excellent character. And since the ability and willingness of the master to teach were not greater than the zeal and readiness with which the disciple absorbed whatever was shown to him, no long time passed before Lorenzo became not only a good and diligent designer, but also so able and finished a goldsmith, that no young man of that time was his equal; and this brought such honour to Credi, that from that day onward Lorenzo was always called by everyone, not Lorenzo Sciarpelloni, but Lorenzo di Credi.

Growing in courage, then, Lorenzo attached himself to Andrea Verrocchio, who at that time had taken it into his head to devote himself to painting; and under him, having Pietro Perugino and Leonardo da Vinci as his companions and friends, although they were rivals, he set himself with all diligence to learn to paint. And since Lorenzo took an extraordinary pleasure in the manner of Leonardo, he contrived to imitate it so well that there was no one who came nearer to it than he did in the high finish and thorough perfection of his works, as may be seen from many drawings that are in our book, executed with the style, with the pen, or in water-colours, among which are some drawings made from models of clay covered with waxed linen cloths and with liquid clay, imitated with such diligence, and finished with such patience, as it is scarcely possible to conceive, much less to equal.

For these reasons, then, Lorenzo was so beloved by his master, that, when Andrea went to Venice to cast in bronze the horse and the statue of Bartolommeo da Bergamo, he left to Lorenzo the whole management and administration of his revenues and affairs, and likewise all his drawings, reliefs, statues, and art materials. And Lorenzo, on his part, loved his master Andrea so dearly, that, besides occupying himself with incredible zeal with his interests in Florence, he also went more than once to Venice to see him and to render him an account of his good administration, which was so much to the satisfaction of his master, that, if Lorenzo had consented, Andrea would have made him his heir. Nor did Lorenzo prove in any way ungrateful for this good-will, for, after the death of Andrea, he went to Venice and brought his body to Florence; and then he handed over to his heirs everything that was found to belong to Andrea, except his drawings, pictures, sculptures, and all other things connected with art.

The first paintings of Lorenzo were a round picture of Our Lady, which was sent to the King of Spain (the design of which picture he copied from one by his master Andrea), and a picture,

much better than the other, which was likewise copied by Lorenzo from one by Leonardo da Vinci, and also sent to Spain; and so similar was it to that by Leonardo, that no difference could be seen between the one and the other. By the hand of Lorenzo is a Madonna in a very well executed panel, which is beside the great Church of S. Jacopo at Pistoia; and another, also, which is in the Hospital of the Ceppo, and is one of the best pictures in that city. Lorenzo painted many portraits, and when he was a young man he made that one of himself which is now in the possession of his disciple, Gian Jacopo, a painter in Florence, together with many other things left to him by Lorenzo, among which are the portrait of Pietro Perugino and that of Lorenzo's master, Andrea Verrocchio. He also made a portrait of Girolamo Benivieni, a man of great learning, and much his friend.

For the Company of S. Sebastiano, behind the Church of the Servi in Florence, he executed a panel-picture of Our Lady, S. Sebastian, and other saints; and for the altar of S. Giuseppe, in S. Maria del Fiore, he painted the first-named saint. To Montepulciano he sent a panel that is now in the Church of S. Agostino, containing a Crucifix, Our Lady, and S. John, painted with much diligence. But the best work that Lorenzo ever executed, and that to which he devoted the greatest care and zeal, in order to surpass himself, was the one that is in a chapel at Cestello, a panel containing Our Lady, S. Julian, and S. Nicholas; and whoever wishes to know how necessary it is for a painter to work with a high finish in oils if he desires that his pictures should remain fresh, must look at this panel, which is painted with such a finish as could not be excelled.

While still a young man, Lorenzo painted a S. Bartholomew on a pilaster in Orsanmichele, and for the Nuns of S. Chiara, in Florence, a panel-picture of the Nativity of Christ, with some shepherds and angels; in which picture, besides other things, he took great pains with the imitation of some herbage, painting it so well that it appears to be real. For the same place he made a picture of S. Mary Magdalene in Penitence; and in a round picture that is in the house of Messer Ottaviano de' Medici he painted a Madonna. For S. Friano he painted a panel; and he executed some figures in S. Matteo at the Hospital of Lelmo. For S. Reparata he painted a picture with the Angel Michael, and for the Company of the Scalzo he made a panel-picture, executed with much diligence. And, in addition to these works, he made many

pictures of Our Lady and others, which are dispersed among the houses of citizens in Florence.

Having thus got together a certain sum of money by means of these labours, and being a man who loved quiet more than riches, Lorenzo retired to S. Maria Nuova in Florence, where he lived and had a comfortable lodging until his death. Lorenzo was much inclined to the sect of Fra Girolamo of Ferrara, and always lived like an upright and orderly man, showing a friendly courtesy whenever the occasion arose. Finally, having come to the seventy-eighth year of his life, he died of old age, and was buried in S. Pietro Maggiore, in the year 1530.

He showed such a perfection of finish in his works, that any other painting, in comparison with his, must always seem merely sketched and dirty. He left many disciples, and among them Giovanni Antonio Sogliani and Tommaso di Stefano. Of Sogliani there will be an account in another place; and as for Tommaso, he imitated his master closely in his high finish, and made many works in Florence and abroad, including a panel-picture for Marco del Nero at his villa of Arcetri, of the Nativity of Christ, executed with great perfection of finish. But ultimately it became Tommaso's principal profession to paint on cloth, insomuch that he painted church-hangings better than any other man. Now Stefano, the father of Tommaso, had been an illuminator, and had also done something in architecture; and Tommaso, after his father's death, in order to follow in his steps, rebuilt the bridge of Sieve, which had been destroyed by a flood about that time, at a distance of ten miles from Florence, and likewise that of S. Piero a Ponte on the River Bisenzio, which is a beautiful work; and afterwards he erected many buildings for monasteries and other places. Then, being architect to the Guild of Wool, he made the model for the new buildings which were constructed by that Guild behind the Nunziata; and, finally, having reached the age of seventy or more, he died in the year 1564, and was buried in S. Marco, to which he was followed by an honourable train of the Academy of Design.

But returning to Lorenzo: he left many works unfinished at his death, and, in particular, a very beautiful picture of the Passion of Christ, which came into the hands of Antonio da Ricasoli, and a panel painted for M. Francesco da Castiglioni, Canon of S. Maria del Fiore, who sent it to Castiglioni. Lorenzo had no wish to make many large works, because he took great pains in

executing his pictures, and devoted an incredible amount of la-
bour to them, for the reason, above all, that the colours which
he used were ground too fine; besides which, he was always
purifying and distilling his nut-oils, and he made mixtures of
colours on his palette in such numbers, that from the first of the
light tints to the last of the darks there was a gradual succession
involving an over-careful and truly excessive elaboration, so that
at times he had twenty-five or thirty of them on his palette. For
each tint he kept a separate brush; and where he was working he
would never allow any movement that might raise dust. Such
excessive care is perhaps no more worthy of praise than the other
extreme of negligence, for in all things one should observe a
certain mean and avoid extremes, which are generally harmful.

LORENZETTO, Sculptor and Architect of Florence AND BOCCACCINO, Painter of Cremona

It happens at times, after Fortune has kept the talent of some
fine intellect subjected for a period by poverty, that she thinks
better of it, and at an unexpected moment provides all sorts of
benefits for one who has hitherto been the object of her hatred,
so as to atone in one year for the affronts and discomforts of
many. This was seen in Lorenzo, the son of Lodovico the bell-
founder, a Florentine, who was engaged in the work both of
architecture and of sculpture, and was loved so dearly by Raffael-
lo da Urbino, that he not only was assisted by him and employed
in many enterprises, but also received from the same master a
wife in the person of a sister of Giulio Romano, a disciple of
Raffaello.

Lorenzetto* – for thus he was always called – finished in his
youth the tomb of Cardinal Forteguerra, formerly begun by An-
drea Verrocchio, which was erected in S. Jacopo at Pistoia; and
there, among other things, is a Charity by the hand of Lorenzetto,
which is not otherwise than passing good. And a little afterwards
he made a figure for Giovanni Bartolini, to adorn his garden;
which finished, he went to Rome, where in his first years he
executed many works, of which there is no need to make any

* Diminutive of Lorenzo.

further record. Then, receiving from Agostino Chigi, at the instance of Raffaello da Urbino, the commission to make a tomb for him in S. Maria del Popolo, where Agostino had built a chapel, Lorenzo set himself to work on this with all the zeal, diligence, and labour in his power, in order to come out of it with credit and to give satisfaction to Raffaello, from whom he had reason to expect much favour and assistance, and also in the hope of being richly rewarded by the liberality of Agostino, a man of great wealth. Nor were these labours expended without an excellent result, for, assisted by Raffaello, he executed the figures to perfection: a nude Jonah delivered from the belly of the whale, as a symbol of the resurrection from the dead, and an Elijah, living by grace, with his cruse of water and his bread baked in the ashes, under the juniper-tree. These statues, then, were brought to the most beautiful completion by Lorenzetto with all the art and diligence at his command, but he did not by any means obtain for them that reward which his great labours and the needs of his family called for, since, death having closed the eyes of Agostino, and almost at the same time those of Raffaello, the heirs of Agostino, with scant respect, allowed these figures to remain in Lorenzetto's workshop, where they stood for many years. In our own day, indeed, they have been set into place on that tomb in the aforesaid Church of S. Maria del Popolo; but Lorenzo, robbed for those reasons of all hope, found for the present that he had thrown away his time and labour.

Next, by way of executing the testament of Raffaello, Lorenzo was commissioned to make a marble statue of Our Lady, four braccia high, for the tomb of Raffaello in the Temple of S. Maria Ritonda, where the tabernacle was restored by order of that master. The same Lorenzo made a tomb with two children in half-relief, for a merchant of the Perini family, in the Trinità at Rome. And in architecture he made the designs for many houses; in particular, that of the Palace of Messer Bernardino Caffarelli, and in the Valle, for Cardinal Andrea della Valle, the inner façade, and also the design of the stables and of the upper garden. In the composition of that work he included ancient columns, bases, and capitals, and around the whole, to serve as base, he distributed ancient sarcophagi covered with carved scenes. Higher up, below some large niches, he made another frieze with fragments of ancient works, and above this, in those niches, he

placed some statues, likewise ancient and of marble, which, although they were not entire – some being without the head, some without arms, others without legs, and every one, in short, with something missing – nevertheless he arranged to the best advantage, having caused all that was lacking to be restored by good sculptors. This was the reason that other lords have since done the same thing and have restored many ancient works; as, for example, Cardinals Cesis, Ferrara, and Farnese, and, in a word, all Rome. And, in truth, antiquities restored in this way have more grace than those mutilated trunks, members without heads, or figures in any other way maimed and defective. But to return to the aforesaid garden: over the niches was placed the frieze that is still seen there, of supremely beautiful ancient scenes in half-relief; and this invention of Lorenzo's stood him in very good stead, since, after the troubles of Pope Clement had abated, he was employed by him with much honour and profit to himself. For the Pope had seen, when the fight for the Castello di S. Angelo was raging, that two little chapels of marble, which were at the head of the bridge, had been a source of mischief, in that some harquebusiers, standing in them, shot down all who exposed themselves at the walls, and, themselves in safety, inflicted great losses and baulked the defence; and his Holiness resolved to remove those chapels and to set up in place of them two marble statues on pedestals. And so, after the S. Paul of Paolo Romano, of which there has been an account in another Life, had been set in place, the commission for the other, a S. Peter, was given to Lorenzetto, who acquitted himself passing well, but did not surpass the work of Paolo Romano. These two statues were set up, and are to be seen at the present day at the head of the bridge.

After Pope Clement was dead, Baccio Bandinelli was given the commissions for the tombs of that Pope and of Leo X, and Lorenzo was entrusted with the marble masonry that was to be executed for them; whereupon the latter spent no little time over that work. Finally, at the election of Paul III as Pontiff, when Lorenzo was in sorry straits and almost worn out, having nothing but a house which he had built for himself in the Macello de' Corbi, and being weighed down by his five children and by other expenses, Fortune changed and began to raise him and to set him back on a better path; for Pope Paul wishing to have the building of S. Pietro continued, and neither Baldassarre of Siena nor any

of the others who had been employed in that work being now alive, Antonio da San Gallo appointed Lorenzo as architect for that structure, wherein the walls were being built at a fixed price of so much for every four braccia. Thereupon Lorenzo, without exerting himself, in a few years became more famous and prosperous than he had been after many years of endless labour, through having found God, mankind, and Fortune all propitious at that one moment. And if he had lived longer, he would have done even more towards wiping out those injuries that a cruel fate had unjustly brought upon him during his best period of work. But after reaching the age of forty-seven, he died of fever in the year 1541.

The death of this master caused great grief to his many friends, who had always known him as a loving and reasonable man. And since he had always lived like an upright and orderly citizen, the Deputati of S. Pietro gave him honourable burial in a tomb, on which they placed the following epitaph:

SCULPTORI LAURENTIO FLORENTINO

ROMA MIHI TRIBUIT TUMULUM, FLORENTIA VITAM:
NEMO ALIO VELLET NASCI ET OBIRE LOCO.
MDXLI
VIX. ANN. XLVII, MEN. II, D. XV.

Boccaccino of Cremona, who lived about the same time, had acquired the name of a rare and excellent painter in his native place and throughout all Lombardy, and his works were very highly extolled, when he went to Rome to see the works, so much renowned, of Michelagnolo; but no sooner had he seen them than he sought to the best of his power to disparage and revile them, believing that he could exalt himself almost exactly in proportion as he vilified a man who truly was in the matters of design, and indeed in all others without exception, supremely excellent. This master, then, was commissioned to paint the Chapel of S. Maria Traspontina; but when he had finished it and thrown it open to view, it was a revelation to all those who thought that he would soar above the heavens, for they saw that he could not reach even to the level of the lowest floor of a house. And so the painters of Rome, on seeing the Coronation of Our Lady that he had painted in that work, with some children flying around her, changed from marvel to laughter.

From this it may be seen that when people begin to exalt with their praise men who are more excellent in name than in deeds, it is a difficult thing to contrive to bring such men down to their true level with words, however reasonable, before their own works, wholly contrary to their reputation, reveal what the masters so celebrated really are. And it is a very certain fact that the worst harm that one man can do to another is the giving of praise too early to any intellect engaged in work, since such praise, swelling him with premature pride, prevents him from going any farther, and a man so greatly extolled, on finding that his works have not that excellence which was expected, takes the censure too much to heart, and despairs completely of ever being able to do good work. Wise men, therefore, should fear praise much more than censure, for the first flatters and deceives, and the second, revealing the truth, gives instruction.

Boccaccino, then, departing from Rome, where he felt himself wounded and torn to pieces, returned to Cremona, and there continued to practise painting to the best of his power and knowledge. In the Duomo, over the arches in the middle, he painted all the stories of the Madonna; and this work is much esteemed in that city. He also made other works throughout that city and in the neighbourhood, of which there is no need to make mention.

He taught his art to a son of his own, called Camillo, who, applying himself to the art with more study, strove to make amends for the shortcomings of the boastful Boccaccino. By the hand of this Camillo are some works in S. Gismondo, which is a mile distant from Cremona; and these are esteemed by the people of Cremona as the best paintings that they have. He also painted the façade of a house on their Piazza, all the compartments of the vaulting and some panels in S. Agata, and the façade of S. Antonio, together with other works, which made him known as a practised master. If death had not snatched him from the world before his time, he would have achieved a most honourable success, for he was advancing on the good way; and even for those works that he has left to us, he deserves to have record made of him.

But returning to Boccaccino; without having ever made any improvement in his art, he passed from this life at the age of fifty-eight. In his time there lived in Milan a passing good illuminator, called Girolamo, whose works may be seen in good

numbers both in that city and throughout all Lombardy. A Mi-
lanese, likewise, living about the same time, was Bernardino del
Lupino,* a very delicate and pleasing painter, as may be seen
from many works by his hand that are in that city, and from a
Marriage of Our Lady at Sarone, a place twelve miles distant from
Milan, and other scenes that are in the Church of S. Maria, ex-
ecuted most perfectly in fresco. He also worked with a very high
finish in oils, and he was a courteous person, and very liberal with
his possessions; wherefore he deserves all the praise that is due
to any craftsman who makes the works and ways of his daily life
shine by the adornment of courtesy no less than do his works of
art on account of their excellence.

BALDASSARRE PERUZZI,
Painter and Architect of Siena

Among all the gifts that Heaven distributes to mortals, none,
in truth, can or should be held in more account than talent, with
calmness and peace of soul, for the first makes us for ever im-
mortal, and the second blessed. He, then, who is endowed with
these gifts, in addition to the deep gratitude that he should feel
towards God, must make himself known among other men al-
most as a light amid darkness. And even so, in our own times,
did Baldassarre Peruzzi, a painter and architect of Siena, of whom
we can say with certainty that the modesty and goodness which
were revealed in him were no mean offshoots of that supreme
serenity for which the minds of all who are born in this world
are ever sighing, and that the works which he left to us are most
honourable fruits of that true excellence which was infused in
him by Heaven.

Now, although I have called him above, Baldassarre of Siena,
because he was always known as a Sienese, I will not withhold
that even as seven cities contended for Homer, each claiming that
he was her citizen, so three most noble cities of Tuscany –
Florence, Volterra, and Siena – have each held that Baldassarre
was her son. But, to tell the truth, each of them has a share in
him, seeing that Antonio Peruzzi, a noble citizen of Florence,

* Luini.

that city being harassed by civil war, went off, in the hope of a quieter life, to Volterra; and after living some time there, in the year 1482 he took a wife in that city, and in a few years had two children, one a boy, called Baldassarre, and the other a girl, who received the name of Virginia. Now it happened that war pursued this man who sought nothing but peace and quiet, and that no long time afterwards Volterra was sacked; whence Antonio was forced to fly to Siena, and to live there in great poverty, having lost almost all that he had.

Meanwhile Baldassarre, having grown up, was for ever associating with persons of ability, and particularly with goldsmiths and draughtsmen; and thus, beginning to take pleasure in the arts, he devoted himself heart and soul to drawing. And not long after, his father being now dead, he applied himself to painting with such zeal, that in a very short time he made marvellous progress therein, imitating living and natural things as well as the works of the best masters. In this way, executing what work he could find, he was able to maintain himself, his mother, and his sister with his art, and to pursue the studies of painting.

His first work – apart from some things at Siena, not worthy of mention – was in a little chapel near the Porta Fiorentina at Volterra, wherein he executed some figures with such grace, that they led to his forming a friendship with a painter of Volterra, called Piero, who lived most of his time in Rome, and going off with that master to that city, where he was doing some work in the Palace for Alexander VI. But after the death of Alexander, Maestro Piero working no more in that place, Baldassarre entered the workshop of the father of Maturino, a painter of no great excellence, who at that time had always plenty of work to do in the form of commonplace commissions. That painter, then, placing a panel primed with gesso before Baldassarre, but giving him no scrap of drawing or cartoon, told him to make a Madonna upon it. Baldassarre took a piece of charcoal, and in a moment, with great mastery, he had drawn what he wished to paint in the picture; and then, setting his hand to the colouring, in a few days he painted a picture so beautiful and so well finished, that it amazed not only the master of the workshop, but also many painters who saw it; and they, recognizing his ability, contrived to obtain for him the commission to paint the Chapel of the High-Altar in the Church of S. Onofrio, which he executed in fresco with much grace and in a very beautiful manner. After this,

he painted two other little chapels in fresco in the Church of S. Rocco a Ripa. Having thus begun to be in good repute, he was summoned to Ostia, where he painted most beautiful scenes in chiaroscuro in some apartments of the great tower of the fortress; in particular, a hand-to-hand battle after the manner in which the ancient Romans used to fight, and beside this a company of soldiers delivering an assault on a fortress, wherein the attackers, covered by their shields, are seen making a beautiful and spirited onslaught and planting their ladders against the walls, while the men within are hurling them back with the utmost fury. In this scene, also, he painted many antique instruments of war, and likewise various kinds of arms; with many other scenes in another hall, which are held to be among the best works that he ever made, although it is true that he was assisted in this work by Cesare da Milano.

After these labours, having returned to Rome, Baldassarre formed a very strait friendship with Agostino Chigi of Siena, both because Agostino had a natural love for every man of talent, and because Baldassarre called himself a Sienese. And thus, with the help of so great a man, he was able to maintain himself while studying the antiquities of Rome, and particularly those in architecture, wherein, out of rivalry with Bramante, in a short time he made marvellous proficience, which afterwards brought him, as will be related, very great honour and profit. He also gave attention to perspective, and became such a master of that science, that we have seen few in our own times who have worked in it as well as he. Pope Julius II having meanwhile built a corridor in his Palace, with an aviary near the roof, Baldassarre painted there, in chiaroscuro, all the months of the year and the pursuits that are practised in each of them. In this work may be seen an endless number of buildings, theatres, amphitheatres, palaces, and other edifices, all distributed with beautiful invention in that place. He then painted, in company with other painters, some apartments in the Palace of S. Giorgio for Cardinal Raffaello Riario, Bishop of Ostia; and he painted a façade opposite to the house of Messer Ulisse da Fano, and also that of the same Messer Ulisse, wherein he executed stories of Ulysses that brought him very great renown and fame.

Even greater was the fame that came to him from the model of the Palace of Agostino Chigi, executed with such beautiful grace that it seems not to have been built, but rather to have

sprung into life; and with his own hand he decorated the exterior with most beautiful scenes in terretta. The hall, likewise, is adorned with rows of columns executed in perspective, which, with the depth of the intercolumniation, cause it to appear much larger. But what is the greatest marvel of all is a loggia that may be seen over the garden, painted by Baldassarre with scenes of the Medusa turning men into stone, such that nothing more beautiful can be imagined; and then there is Perseus cutting off her head, with many other scenes in the spandrels of that vaulting, while the ornamentation, drawn in perspective with colours, in imitation of stucco, is so natural and lifelike, that even to excellent craftsmen it appears to be in relief. And I remember that when I took the Chevalier Tiziano, a most excellent and honoured painter, to see that work, he would by no means believe that it was painted, until he had changed his point of view, when he was struck with amazement. In that place are some works executed by Fra Sebastiano Viniziano, in his first manner; and by the hand of the divine Raffaello, as has been related, there is a Galatea being carried off by sea-gods.

Baldassarre also painted, beyond the Campo di Fiore, on the way to the Piazza Giudea, a most beautiful façade in terretta with marvellous perspectives, for which he received the commission from a Groom of the Chamber to the Pope; and it is now in the possession of Jacopo Strozzi, the Florentine. In like manner, he wrought for Messer Ferrando Ponzetti, who afterwards became a Cardinal, a chapel at the entrance of the Church of the Pace, on the left hand, with little scenes from the Old Testament, and also with some figures of considerable size; and for a work in fresco this is executed with much diligence. But even more did he prove his worth in painting and perspective near the high-altar of the same church, where he painted a scene for Messer Filippo da Siena, Clerk of the Chamber, of Our Lady going into the Temple, ascending the steps, with many figures worthy of praise, such as a gentleman in antique dress, who, having dismounted from his horse, with his servants waiting, is giving alms to a beggar, quite naked and very wretched, who may be seen asking him for it with pitiful humility. In this place, also, are various buildings and most beautiful ornaments; and right round the whole work, executed likewise in fresco, are counterfeited decorations of stucco, which have the appearance of being attached to the wall with large rings, as if it were a panel painted in oils.

And in the magnificent festival that the Roman people prepared on the Campidoglio when the baton of Holy Church was given to Duke Giuliano de' Medici, out of six painted scenes which were executed by six different painters of eminence, that by the hand of Baldassarre, twenty-eight braccia high and fourteen broad, showing the betrayal of the Romans by Julia Tarpeia, was judged to be without a doubt better than any of the others. But what amazed everyone most was the perspective-view or scenery for a play, which was so beautiful that it would be impossible to imagine anything finer, seeing that the variety and beautiful manner of the buildings, the various loggie, the extravagance of the doors and windows, and the other architectural details that were seen in it, were so well conceived and so extraordinary in invention, that one is not able to describe the thousandth part.

For the house of Messer Francesco di Norcia, on the Piazza de' Farnesi, he made a very graceful door of the Doric Order; and for Messer Francesco Buzio he executed, near the Piazza degl' Altieri, a very beautiful façade, in the frieze of which he painted portraits from life of all the Roman Cardinals who were then alive, while on the wall itself he depicted the scenes of Cæsar receiving tribute from all the world, and above he painted the twelve Emperors, who are standing upon certain corbels, being foreshortened with a view to being seen from below, and wrought with extraordinary art. For this whole work he rightly obtained vast commendation. In the Banchi he executed the escutcheon of Pope Leo, with three children, that seemed to be alive, so tender was their flesh. For Fra Mariano Fetti, Friar of the Piombo, he made a very beautiful S. Bernard in terretta in his garden at Montecavallo. And for the Company of S. Catherine of Siena, on the Strada Giulia, in addition to a bier for carrying the dead to burial, he executed many other things, all worthy of praise. In Siena, also, he gave the design for the organ of the Carmine; and he made some other works in that city, but none of much importance.

Later, having been summoned to Bologna by the Wardens of Works of S. Petronio, to the end that he might make the model for the façade of that church, he made for this two large ground-plans and two elevations, one in the modern manner and the other in the German; and the latter is still preserved in the Sacristy of the same S. Petronio, as a truly extraordinary work, since

he drew that building in such sharply-detailed perspective that it appears to be in relief. In the house of Count Giovan Battista Bentivogli, in the same city, he made several drawings for the aforesaid structure, which were so beautiful, that it is not possible to praise enough the wonderful expedients sought out by this man in order not to destroy the old masonry, but to join it in beautiful proportion with the new. For the Count Giovan Battista mentioned above he made the design of a Nativity with the Magi, in chiaroscuro, wherein it is a marvellous thing to see the horses, the equipage, and the courts of the three Kings, executed with supreme beauty and grace, as are also the walls of the temples and some buildings round the hut. This work was afterwards given to be coloured by the Count to Girolamo Trevigi, who brought it to fine completion. Baldassarre also made the design for the door of the Church of S. Michele in Bosco, a most beautiful monastery of the Monks of Monte Oliveto, without Bologna; and the design and model of the Duomo of Carpi, which was very beautiful, and was built under his direction according to the rules of Vitruvius. And in the same place he made a beginning with the Church of S. Niccola, but it was not finished at that time, because Baldassarre was almost forced to return to Siena in order to make designs for the fortifications of that city, which were afterwards carried into execution under his supervision.

He then returned to Rome, where, after building the house that is opposite to the Farnese Palace, with some others within that city, he was employed in many works by Pope Leo X. That Pontiff wished to finish the building of S. Pietro, begun by Julius II after the design of Bramante, but it appeared to him that the edifice was too large and lacking in cohesion; and Baldassarre made a new model, magnificent and truly ingenious, and revealing such good judgment, that some parts of it have since been used by other architects. So diligent, indeed, was this craftsman, so rare and so beautiful his judgment, and such the method with which his buildings were always designed, that he has never had an equal in works of architecture, seeing that, in addition to his other gifts, he combined that profession with a good and beautiful manner of painting. He made the design of the tomb of Adrian VI, and all that is painted round it is by his hand; and Michelagnolo, a sculptor of Siena, executed that tomb in marble, with the help of our Baldassarre.

When the Calandra, a play by Cardinal Bibbiena, was performed before the same Pope Leo, Baldassarre made the scenic setting, which was no less beautiful – much more so, indeed – than that which he had made on another occasion, as has been related above. In such works he deserved all the greater praise, because dramatic performances, and consequently the scenery for them, had been out of fashion for a long time, festivals and sacred representations taking their place. And either before or after (it matters little which) the performance of the aforesaid Calandra, which was one of the first plays in the vulgar tongue to be seen or performed, in the time of Leo X, Baldassarre made two such scenes, which were marvellous, and opened the way to those who have since made them in our own day. Nor is it possible to imagine how he found room, in a space so limited, for so many streets, so many palaces, and so many bizarre temples, loggie, and various kinds of cornices, all so well executed that it seemed that they were not counterfeited, but absolutely real, and that the piazza was not a little thing, and merely painted, but real and very large. He designed, also, the chandeliers and the lights within that illuminated the scene, and all the other things that were necessary, with much judgment, although, as has been related, the drama had fallen almost completely out of fashion. This kind of spectacle, in my belief, when it has all its accessories, surpasses any other kind, however sumptuous and magnificent.

Afterwards, at the election of Pope Clement VII in the year 1524, he prepared the festivities for his coronation. He finished with peperino-stone the front of the principal chapel, formerly begun by Bramante, in S. Pietro; and in the chapel wherein is the bronze tomb of Pope Sixtus, he painted in chiaroscuro the Apostles that are in the niches behind the altar, besides making the design of the Tabernacle of the Sacrament, which is very graceful.

Then in the year 1527, when the cruel sack of Rome took place, our poor Baldassarre was taken prisoner by the Spaniards, and not only lost all his possessions, but was also much maltreated and outraged, because he was grave, noble, and gracious of aspect, and they believed him to be some great prelate in disguise, or some other man able to pay a fat ransom. Finally, however, those impious barbarians having found that he was a painter, one of them, who had borne a great affection to

Bourbon, caused him to make a portrait of that most rascally captain, the enemy of God and man, either letting Baldassarre see him as he lay dead, or giving him his likeness in some other way, with drawings or with words. After this, having slipped from their hands, Baldassarre took ship to go to Porto Ercole, and thence to Siena; but on the way he was robbed of everything and stripped to such purpose, that he went to Siena in his shirt. However, he was received with honour and reclothed by his friends, and a little time afterwards he was given a provision and a salary by the Commonwealth, to the end that he might give his attention to the fortification of that city. Living there, he had two children; and, besides what he did for the public service, he made many designs of houses for his fellow-citizens, and the design for the ornament of the organ, which is very beautiful, in the Church of the Carmine.

Meanwhile, the armies of the Emperor and the Pope had advanced to the siege of Florence, and his Holiness sent Baldassarre to the camp to Baccio Valori, the Military Commissary, to the end that Baccio might avail himself of his services for the purposes of his operations and for the capture of the city. But Baldassarre, loving the liberty of his former country more than the favour of the Pope, and in no way fearing the indignation of so great a Pontiff, would never lend his aid in any matter of importance. The Pope, hearing of this, for a short time bore him no little ill-will; but when the war was finished, Baldassarre desiring to return to Rome, Cardinals Salviati, Trivulzi, and Cesarino, to all of whom he had given faithful service in many works, restored him to the favour of the Pope and to his former appointments. He was thus able to return without hindrance to Rome, where, not many days after, he made for the Signori Orsini the designs of two very beautiful palaces, which were built on the way to Viterbo, and of some other edifices for Apuglia. But meanwhile he did not neglect the studies of astrology, nor those of mathematics and the others in which he much delighted, and he began a book on the antiquities of Rome, with a commentary on Vitruvius, making little by little illustrative drawings beside the writings of that author, some of which are still to be seen in the possession of Francesco da Siena, who was his disciple, and among them some papers with drawings of ancient edifices and of the modern manner of building.

While living in Rome, also, he made the design for the house of the Massimi, drawn in an oval form, with a new and beautiful manner of building; and for the façade he made a vestibule of Doric columns showing great art and good proportion, with a beautiful distribution of detail in the court and in the disposition of the stairs; but he was not able to see this work finished, for he was overtaken by death.

And yet, although the talents and labours of this noble craftsman were so great, they brought much more benefit to others than to himself; for, while he was employed by Popes, Cardinals, and other great and rich persons, not one of them ever gave him any remarkable reward. That this should have happened is not surprising, not so much through want of liberality in such patrons, although for the most part they are least liberal where they should be the very opposite, as through the timidity and excessive modesty, or rather, to be more exact in this case, the lack of shrewdness of Baldassarre. To tell the truth, in proportion as one should be discreet with magnanimous and liberal Princes, so should one always be pressing and importunate with such as are miserly, unthankful, and discourteous, for the reason that, even as in the case of the generous importunate asking would always be a vice, so with the miserly it is a virtue, and with such men it is discretion that would be the vice.

In the last years of his life, then, Baldassarre found himself poor and weighed down by his family. Finally, having always lived a life without reproach, he fell grievously ill, and took to his bed; and Pope Paul III, hearing this, and recognizing too late the harm that he was like to suffer in the loss of so great a man, sent Jacopo Melighi, the accountant of S. Pietro, to give him a present of one hundred crowns, and to make him most friendly offers. However, his sickness increased, either because it was so ordained, or, as many believe, because his death was hastened with poison by some rival who desired his place, from which he drew two hundred and fifty crowns of salary; and, the physicians discovering this too late, he died, very unwilling to give up his life, more on account of his poor family than for his own sake, as he thought in what sore straits he was leaving them. He was much lamented by his children and his friends, and he received honourable burial, next to Raffaello da Urbino, in the Ritonda, whither he was followed by all the painters, sculptors, and architects of Rome, doing him honour and bewailing him; with the following epitaph:

BALTHASARI PERUTIO SENENSI, VIRO ET PICTURA ET
ARCHITECTURA ALIISQUE INGENIORUM ARTIBUS ADEO EX-
CELLENTI, UT SI PRISCORUM OCCUBUISSET TEMPORIBUS, NOS-
TRA ILLUM FELICIUS LEGERENT. VIX. ANN. LV, MENS. XI, DIES XX.
LUCRETIA ET JO. SALUSTIUS OPTIMO CONJUGI ET PARENTI,
NON SINE LACRIMIS SIMONIS, HONORII, CLAUDII, ÆMILIÆ,
AC SULPITIÆ, MINORUM FILIORUM, DOLENTES POSUERUNT,
DIE IIII JANUARII, MDXXXVI.

The name and fame of Baldassarre became greater after his
death than they had been during his lifetime; and then, above all,
was his talent missed, when Pope Paul III resolved to have
S. Pietro finished, because men recognized how great a help he
would have been to Antonio da San Gallo. For, although Anto-
nio had to his credit all that is to be seen executed by him, yet it
is believed that in company with Baldassarre he would have done
more towards solving some of the difficulties of that work. The
heir to many of the possessions of Baldassarre was Sebastiano
Serlio of Bologna, who wrote the third book on architecture and
the fourth on the antiquities of Rome with their measurements;
in which works the above-mentioned labours of Baldassarre were
partly inserted in the margins, and partly turned to great advant-
age by the author. Most of these writings of Baldassarre came
into the hands of Jacomo Melighino of Ferrara, who was after-
wards chosen by Pope Paul as architect for his buildings, and of
the aforesaid Francesco da Siena, his former assistant and dis-
ciple, by whose hand is the highly renowned escutcheon of Cardi-
nal Trani in Piazza Navona, with some other works. From this
Francesco we received the portrait of Baldassarre, and informa-
tion about some matters which I was not able to ascertain when
this book was published for the first time. Another disciple of
Baldassarre was Virgilio Romano, who executed a façade with
some prisoners in sgraffito-work in the centre of the Borgo
Nuovo in his native city, and many other beautiful works. From
the same master, also, Antonio del Rozzo, a citizen of Siena and
a very excellent engineer, learnt the first principles of architecture;
and Baldassarre was followed, in like manner, by Riccio, a painter
of Siena, who, however, afterwards imitated to no small extent
the manner of Giovanni Antonio Sodoma of Vercelli. And an-
other of his pupils was Giovan Battista Peloro, an architect of
Siena, who gave much attention to mathematics and cosmo-
graphy, and made with his own hand mariner's compasses,

quadrants, many irons and instruments for measuring, and like-
wise the ground-plans of many fortifications, most of which are
in the possession of Maestro Giuliano, a goldsmith of Siena, who
was very much his friend. This Giovan Battista made for Duke
Cosimo de' Medici a plan of Siena, all in relief and altogether
marvellous, with the valleys and the surroundings for a mile and
a half round – the walls, the streets, the forts, and, in a word, a
most beautiful model of the whole place. But, since he was un-
stable by nature, he left Duke Cosimo, although he had a good
allowance from that Prince; and, thinking to do better, he made
his way into France, where he followed the Court without any
success for a long time, and finally died at Avignon. And al-
though he was an able and well-practised architect, yet in no
place are there to be seen any buildings erected by him or after
his design, for he always stayed such a short time in any one
place, that he could never bring anything to completion; where-
fore he consumed all his time with designs, measurements, mod-
els, and caprices. Nevertheless, as a follower of our arts, he has
deserved to have record made of him.

Baldassarre drew very well in every manner, with great judg-
ment and diligence, but more with the pen, in water-colours, and
in chiaroscuro, than in any other way, as may be seen from many
drawings by his hand that belong to different craftsmen. Our
book, in particular, contains various drawings; and in one of these
is a scene full of invention and caprice, showing a piazza filled
with arches, colossal figures, theatres, obelisks, pyramids, temples
of various kinds, porticoes, and other things, all after the antique,
while on a pedestal stands a Mercury, round whom are all sorts
of alchemists with bellows large and small, retorts, and other
instruments for distilling, hurrying about and giving him a clyster
in order to purge his body – an invention as ludicrous as it is
beautiful and bizarre.

Friends and intimate companions of Baldassarre, who was
always courteous, modest, and gentle with every man, were Do-
menico Beccafumi of Siena, an excellent painter, and Il Capanna,
who, in addition to many other works that he painted in Siena,
executed the façade of the house of the Turchi and another that
is on the Piazza.

GIOVAN FRANCESCO PENNI OF FLORENCE
[*CALLED IL FATTORE*]
AND PELLEGRINO DA MODENA, Painters

GIOVAN FRANCESCO PENNI, called Il Fattore, a painter of Florence, was no less indebted to Fortune than he was to the goodness of his own nature, in that his ways of life, his inclination for painting, and his other qualities brought it about that Raffaello da Urbino took him into his house and educated him together with Giulio Romano, looking on both of them ever afterwards as his children, and proving at his death how much he thought both of the one and of the other by leaving them heirs to his art and to his property alike. Now Giovan Francesco, who began from his boyhood, when he first entered the house of Raffaello, to be called Il Fattore, and always retained that name, imitated in his drawings the manner of Raffaello, and never ceased to follow it, as may be perceived from some drawings by his hand that are in our book. And it is nothing wonderful that there should be many of these to be seen, all finished with great diligence, because he delighted much more in drawing than in colouring.

The first works of Giovan Francesco were executed by him in the Papal Loggie at Rome, in company with Giovanni da Udine, Perino del Vaga, and other excellent masters; and in these may be seen a marvellous grace, worthy of a master striving at perfection of workmanship. He was very versatile, and he delighted much in making landscapes and buildings. He was a good colourist in oils, in fresco, and in distemper, and made excellent portraits from life; and he was much assisted in every respect by nature, so that he gained great mastery over all the secrets of art without much study. He was a great help to Raffaello, therefore, in painting a large part of the cartoons for the tapestries of the Pope's Chapel and of the Consistory, and particularly the ornamental borders. He also executed many other things from the cartoons and directions of Raffaello, such as the ceiling for Agostino Chigi in the Trastevere, with many pictures, panels, and various other works, in which he acquitted himself so well, that every day he won greater affection from Raffaello. On the Monte Giordano, in Rome, he painted a façade in chiaroscuro, and in S. Maria de Anima, by the side-door that leads to the Pace, a

S. Christopher in fresco, eight braccia high, which is a very good figure; and in this work is a hermit with a lantern in his hand, in a grotto, executed with good draughtsmanship, harmony, and grace.

Giovan Francesco then came to Florence, and painted for Lodovico Capponi at Montughi, a place without the Porta a San Gallo, a shrine with a Madonna, which is much extolled.

Raffaello having meanwhile been overtaken by death, Giulio Romano and Giovan Francesco, who had been his disciples, remained together for a long time, and finished in company such of Raffaello's works as had been left unfinished, and in particular those that he had begun in the Vigna of the Pope, and likewise those of the Great Hall in the Palace, wherein are painted by the hands of these two masters the stories of Constantine, with excellent figures, executed in an able and beautiful manner, although the invention and the sketches of these stories came in part from Raffaello. While these works were in progress, Perino del Vaga, a very excellent painter, took to wife a sister of Giovan Francesco; on which account they executed many works in company. And afterwards Giulio and Giovan Francesco, continuing to work together, painted a panel in two parts, containing the Assumption of Our Lady, which went to Monteluci, near Perugia; and also other works and pictures for various places.

Then, receiving a commission from Pope Clement to paint a panel-picture like the one by Raffaello (which is in S. Pietro a Montorio), which was to be sent to France, whither Raffaello had meant to send the first, they began it; but soon afterwards, having fallen out with each other, they divided their inheritance of drawings and everything else left to them by Raffaello, and Giulio went off to Mantua, where he executed an endless number of works for the Marquis. Thither, not long afterwards, Giovan Francesco also made his way, drawn either by love of Giulio or by the hope of finding work; but he received so cold a welcome from Giulio that he soon departed, and, after travelling round Lombardy, he returned to Rome. And from Rome he went to Naples by ship in the train of the Marchese del Vasto, taking with him the now finished copy of the panel-picture of S. Pietro a Montorio, with other works, which he left in Ischia, an island belonging to the Marquis, while the panel was placed where it is at the present day, in the Church of S. Spirito degli Incurabili at

Naples. Having thus settled in Naples, where he occupied himself with drawing and painting, Giovan Francesco was entertained and treated with great kindness by Tommaso Cambi, a Florentine merchant, who managed the affairs of that nobleman. But he did not live there long, because, being of a sickly habit of body, he fell ill and died, to the great grief of the noble Marquis and of all who knew him.

He had a brother called Luca, likewise a painter, who worked in Genoa with his brother-in-law Perino, as well as at Lucca and many other places in Italy. In the end he went to England, where, after executing certain works for the King and for some merchants, he finally devoted himself to making designs for copperplates for sending abroad, which he had engraved by Flemings. Of such he sent abroad a great number, which are known by his name as well as by the manner; and by his hand, among others, is a print wherein are some women in a bath, the original of which, by the hand of Luca himself, is in our book.

A disciple of Giovan Francesco was Leonardo, called Il Pistoia because he came from that city, who executed some works at Lucca, and made many portraits from life in Rome. At Naples, for Diomede Caraffa, Bishop of Ariano, and now a Cardinal, he painted a panel-picture of the Stoning of S. Stephen for his chapel in S. Domenico. And for Monte Oliveto he painted another, which was placed on the high-altar, although it was afterwards removed to make room for a new one, similar in subject, by the hand of Giorgio Vasari of Arezzo. Leonardo earned large sums from these Neapolitan nobles, but he accumulated little, for he squandered it all as it came to his hand; and finally he died in Naples, leaving behind him the reputation of having been a good colourist, but not of having shown much excellence in draughtsmanship.

Giovan Francesco lived forty years, and his works date about 1528.

A friend of Giovan Francesco, and likewise a disciple of Raffaello, was Pellegrino da Modena, who, having acquired in his native city the name of a man of fine genius for painting, and having heard of the marvels of Raffaello da Urbino, determined, in order to justify by means of labour the hopes already conceived of him, to go to Rome. Arriving there, he placed himself under Raffaello, who never refused anything to men of ability. There were then in Rome very many young men who were

working at painting and seeking in mutual rivalry to surpass one another in draughtsmanship, in order to win the favour of Raffaello and to gain a name among men; and thus Pellegrino, giving unceasing attention to his studies, became not only a good draughtsman, but also a well-practised master of the whole of his art. And when Leo X commissioned Raffaello to paint the Loggie, Pellegrino also worked there, in company with the other young men; and so well did he succeed, that Raffaello afterwards made use of him in many other things.

He executed three figures in fresco in S. Eustachio at Rome, over an altar near the entrance into the church; and in the Church of the Portuguese, near the Scrofa, he painted in fresco the Chapel of the High-Altar, as well as the altar-piece. Afterwards, Cardinal Alborense having caused a chapel richly adorned with marbles to be erected in S. Jacopo, the Church of the Spanish people, with a S. James of marble by Jacopo Sansovino, four braccia and a half in height, and much extolled, Pellegrino painted there in fresco the stories of that Apostle, giving an air of great sweetness to his figures in imitation of his master Raffaello, and designing the whole composition so well, that the work made him known as an able man with a fine and beautiful genius for painting. This work finished, he made many others in Rome, both by himself and in company with others.

But finally, when death had come upon Raffaello, Pellegrino returned to Modena, where he executed many works; among others, he painted for a Confraternity of Flagellants a panel-picture in oils of S. John baptizing Christ, and another panel for the Church of the Servi, containing S. Cosimo and S. Damiano, with other figures. Afterwards, having taken a wife, he had a son, who was the cause of his death. For this son, having come to words with some companions, young men of Modena, killed one of them; the news of which being carried to Pellegrino, he, in order to help his son from falling into the hands of justice, set out to smuggle him away. But he had not gone far from his house, when he stumbled against the relatives of the dead youth, who were going about searching for the murderer; and they, confronting Pellegrino, who had no time to escape, and full of fury because they had not been able to catch his son, gave him so many wounds that they left him dead on the ground. This event was a great grief to the people of Modena, who knew that by the death of Pellegrino they had been robbed of a spirit truly excellent and rare.

A contemporary of this craftsman was the Milanese Gaudenzio, a resolute, well-practised, and excellent painter, who made many works in fresco at Milan; and in particular, for the Frati della Passione, a most beautiful Last Supper, which remained unfinished by reason of his death. He also painted very well in oils, and there are many highly-esteemed works by his hand at Vercelli and Veralla.

ANDREA DEL SARTO,
A most excellent Painter of Florence

At length, after the Lives of many craftsmen who have been excellent, some in colouring, some in drawing, and others in invention, we have come to the most excellent Andrea del Sarto, in whose single person nature and art demonstrated all that painting can achieve by means of draughtsmanship, colouring, and invention, insomuch that, if Andrea had possessed a little more fire and boldness of spirit, to correspond to his profound genius and judgment in his art, without a doubt he would have had no equal. But a certain timidity of spirit and a sort of humility and simplicity in his nature made it impossible that there should be seen in him that glowing ardour and that boldness which, added to his other qualities, would have made him truly divine in painting; for which reason he lacked those adornments and that grandeur and abundance of manners which have been seen in many other painters. His figures, however, for all their simplicity and purity, are well conceived, free from errors, and absolutely perfect in every respect. The expressions of his heads, both in children and in women, are gracious and natural, and those of men, both young and old, admirable in their vivacity and animation; his draperies are beautiful to a marvel, and his nudes very well conceived. And although his drawing is simple, all that he coloured is rare and truly divine.

Andrea was born in Florence, in the year 1478, to a father who was all his life a tailor; whence he was always called Andrea del Sarto by everyone. Having come to the age of seven, he was taken away from his reading and writing school and apprenticed to the goldsmith's craft. But in this he was always much more willing to practise his hand in drawing, to which he was drawn

by a natural inclination, than in using the tools for working in
silver or gold; whence it came to pass that Gian Barile, a painter
of Florence, but one of gross and vulgar taste, having seen the
boy's good manner of drawing, took him under his protection,
and, making him abandon his work as goldsmith, directed him to
the art of painting. Andrea, beginning with much delight to prac-
tise it, recognized that nature had created him for that profession;
and in a very short space of time, therefore, he was doing such
things with colours as filled Gian Barile and the other craftsmen
in the city with marvel. Now after three years, through continual
study, he had acquired an excellent mastery over his work, and
Gian Barile saw that by persisting in his studies the boy was likely
to achieve an extraordinary success. Having therefore spoken of
him to Piero di Cosimo, who was held at that time to be one of
the best painters in Florence, he placed Andrea with Piero. And
Andrea, as one full of desire to learn, laboured and studied with-
out ceasing; while nature, which had created him to be a painter,
so wrought in him, that he handled and managed his colours with
as much grace as if he had been working for fifty years. Where-
fore Piero conceived an extraordinary love for him, feeling mar-
vellous pleasure in hearing that when Andrea had any time to
himself, particularly on feast-days, he would spend the whole day
in company with other young men, drawing in the Sala del Papa,
wherein were the cartoons of Michelagnolo and Leonardo da
Vinci, and that, young as he was, he surpassed all the other
draughtsmen, both native and foreign, who were always compet-
ing there with one another.

Among these young men, there was one who pleased Andrea
more than any other with his nature and conversation, namely,
the painter Franciabigio; and Franciabigio, likewise, was attracted
by Andrea. Having become friends, therefore, Andrea said to
Franciabigio that he could no longer endure the caprices of Piero,
who was now old, and that for this reason he wished to take a
room for himself. Hearing this, Franciabigio, who was obliged to
do the same thing because his master Mariotto Albertinelli had
abandoned the art of painting, said to his companion Andrea that
he also was in need of a room, and that it would be to the
advantage of both of them if they were to join forces. Having
therefore taken a room on the Piazza del Grano, they executed
many works in company; among others, the curtains that cover
the panel-pictures on the high-altar of the Servi; for which they

ANDREA DEL SARTO PITTOR
FIORENTINO

received the commission from a sacristan very closely related to Franciabigio. On one of those curtains, that which faces the choir, they painted the Annunciation of the Virgin; and on the other, which is in front, a Deposition of Christ from the Cross, like that of the panel-picture which was there, painted by Filippo and Pietro Perugino.

The men of that company in Florence which is called the Company of the Scalzo used to assemble at the head of the Via Larga, above the houses of the Magnificent Ottaviano de' Medici, and opposite to the garden of S. Marco, in a building dedicated to S. John the Baptist, which had been built in those days by a number of Florentine craftsmen, who had made there, among other things, an entrance-court of masonry with a loggia which rested on some columns of no great size. And some of them, perceiving that Andrea was on the way to becoming known as an excellent painter, and being richer in spirit than in pocket, determined that he should paint round that cloister twelve pictures in chiaroscuro – that is to say, in fresco with terretta – containing twelve scenes from the life of S. John the Baptist. Whereupon, setting his hand to this, he painted in the first the scene of S. John baptizing Christ, with much diligence and great excellence of manner, whereby he gained credit, honour, and fame to such an extent, that many persons turned to him with commissions for works, as to one whom they thought to be destined in time to reach that honourable goal which was foreshadowed by his extraordinary beginnings in his profession.

Among other works that he made in that first manner, he painted a picture which is now in the house of Filippo Spini, held in great veneration in memory of so able a craftsman. And not long after this he was commissioned to paint for a chapel in S. Gallo, the Church of the Eremite Observantines of the Order of S. Augustine, without the Porta a S. Gallo, a panel-picture of Christ appearing in the garden to Mary Magdalene in the form of a gardener; which work, what with the colouring and a certain quality of softness and harmony, is sweetness itself, and so well executed, that it led to his painting two others not long afterwards for the same church, as will be related below. This panel is now in S. Jacopo tra Fossi, on the Canto degli Alberti, together with the two others.

After these works, Andrea and Franciabigio, leaving the Piazza del Grano, took new rooms in the Sapienza, near the Convent

of the Nunziata; whence it came about that Andrea and Jacopo
Sansovino, who was then a young man and was working at sculp-
ture in the same place under his master Andrea Contucci, formed
so warm and so strait a friendship together, that neither by day
nor by night were they ever separated one from another. Their
discussions were for the most part on the difficulties of art, so
that it is no marvel that both of them should have afterwards
become most excellent, as is now being shown of Andrea and as
will be related in the proper place of Jacopo.

There was at this same time in the Convent of the Servi,
selling the candles at the counter, a friar called Fra Mariano dal
Canto alla Macine, who was also sacristan; and he heard everyone
extolling Andrea mightily and saying that he was by way of mak-
ing marvellous proficience in painting. Whereupon he planned to
fulfil a desire of his own without much expense; and so, ap-
proaching Andrea, who was a mild and guileless fellow, on the
side of his honour, he began to persuade him under the cloak of
friendship that he wished to help him in a matter which would
bring him honour and profit and would make him known in such
a manner, that he would never be poor any more. Now many
years before, as has been related above, Alesso Baldovinetti had
painted a Nativity of Christ in the first cloister of the Servi, on
the wall that has the Annunciation behind it; and in the same
cloister, on the other side, Cosimo Rosselli had begun a scene of
S. Filippo, the founder of that Servite Order, assuming the habit.
But Cosimo had not carried that scene to completion, because
death came upon him at the very moment when he was working
at it. The friar, then, being very eager to see the rest finished,
thought of serving his own ends by making Andrea and Fran-
ciabigio, who, from being friends, had become rivals in art, com-
pete with one another, each doing part of the work. This, besides
effecting his purpose very well, would make the expense less and
their efforts greater. Thereupon, revealing his mind to Andrea, he
persuaded him to undertake that enterprise, by pointing out to
him that since it was a public and much frequented place, he
would become known on account of such a work no less by
foreigners than by the Florentines; that he should not look for
any payment in return, or even for an invitation to undertake it,
but should rather pray to be allowed to do it; and that if he were
not willing to set to work, there was Franciabigio, who, in order
to make himself known, had offered to accept it and to leave the

matter of payment to him. These incitements did much to make Andrea resolve to undertake the work, and the rather as he was a man of little spirit; and the last reference to Franciabigio induced him to make up his mind completely and to come to an agreement, in the form of a written contract, with regard to the whole work, on the terms that no one else should have a hand in it. The friar, then, having thus pledged him and given him money, demanded that he should begin by continuing the life of S. Filippo, without receiving more than ten ducats from him in payment of each scene; and he told Andrea that he was giving him even that out of his own pocket, and was doing it more for the benefit and advantage of the painter than through any want or need of the convent.

Andrea, therefore, pursuing that work with the utmost diligence, like one who thought more of honour than of profit, after no long time completely finished the first three scenes and unveiled them. One was the scene of S. Filippo, now a friar, clothing the naked. In another he is shown rebuking certain gamesters, who blasphemed God and laughed at S. Filippo, mocking at his admonition, when suddenly there comes a lightning-flash from Heaven, which, striking a tree under the shade of which they were sheltering, kills two of them and throws the rest into an incredible panic. Some, with their hands to their heads, cast themselves forward in dismay; others, crying aloud in their terror, turn to flight; a woman, beside herself with fear at the sound of the thunder, is running away so naturally that she appears to be truly alive; and a horse, breaking loose amid this uproar and confusion, reveals with his leaps and fearsome movements what fear and terror are caused by things so sudden and so unexpected. In all this one can see how carefully Andrea looked to variety of incident in the representation of such events, with a forethought truly beautiful and most necessary for one who practises painting. In the third he painted the scene of S. Filippo delivering a woman from evil spirits, with all the most characteristic considerations that could be imagined in such an action. All these scenes brought extraordinary fame and honour to Andrea; and thus encouraged, he went on to paint two other scenes in the same cloister. On one wall is S. Filippo lying dead, with his friars about him making lamentation; and in addition there is a dead child, who, touching the bier on which S. Filippo lies, comes to life again, so that he is first seen dead, and then

revived and restored to life, and all with a very beautiful, natural, and appropriate effect. In the last picture on that side he represented the friars placing the garments of S. Filippo on the heads of certain children; and there he made a portrait of Andrea della Robbia, the sculptor, in an old man clothed in red, who comes forward, stooping, with a staff in his hand. There, too, he portrayed Luca, his son; even as in the other scene mentioned above, in which S. Filippo lies dead, he made a portrait of another son of Andrea, named Girolamo, a sculptor and very much his friend, who died not long since in France.

Having thus finished that side of the cloister, and considering that if the honour was great, the payment was small, Andrea resolved to give up the rest of the work, however much the friar might complain. But the latter would not release him from his bond without Andrea first promising that he would paint two other scenes, at his own leisure and convenience, however, and with an increase of payment; and thus they came to terms.

Having come into greater repute by reason of these works, Andrea received commissions for many pictures and works of importance; among others, one from the General of the Monks of Vallombrosa, for painting an arch of the vaulting, with a Last Supper on the front wall, in the Refectory of the Monastery of S. Salvi, without the Porta alla Croce. In four medallions on that vault he painted four figures, S. Benedict, S. Giovanni Gualberto, S. Salvi the Bishop, and S. Bernardo degli Uberti of Florence, a friar of that Order and a Cardinal; and in the centre he made a medallion containing three faces, which are one and the same, to represent the Trinity. All this was very well executed for a work in fresco, and Andrea, therefore, came to be valued at his true worth in the art of painting. Whereupon he was commissioned at the instance of Baccio d' Agnolo to paint in fresco, in a close on the steep path of Orsanmichele, which leads to the Mercato Nuovo, the Annunciation still to be seen there, executed on a minute scale, which brought him but little praise; and this may have been because Andrea, who worked well without over-exerting himself or forcing his powers, is believed to have tried in this work to force himself and to paint with too much care.

As for the many pictures that he executed after this for Florence, it would take too long to try to speak of them all; and I will only say that among the most distinguished may be numbered the one that is now in the apartment of Baccio Barbadori,

containing a full-length Madonna with a Child in her arms, S. Anne, and S. Joseph, all painted in a beautiful manner and held very dear by Baccio. He made one, likewise well worthy of praise, which is now in the possession of Lorenzo di Domenico Borghini, and another of Our Lady for Leonardo del Giocondo, which at the present day is in the hands of Piero, the son of Leonardo. For Carlo Ginori he painted two of no great size, which were bought afterwards by the Magnificent Ottaviano de' Medici; and one of these is now in his most beautiful villa of Campi, while the other, together with many other modern pictures executed by the most excellent masters, is in the apartment of the worthy son of so great a father, Signor Bernardetto, who not only esteems and honours the works of famous craftsmen, but is also in his every action a truly generous and magnificent nobleman.

Meanwhile the Servite friar had allotted to Franciabigio one of the scenes in the above-mentioned cloister; but that master had not yet finished making the screen, when Andrea, becoming apprehensive, since it seemed to him that Franciabigio was an abler and more dexterous master than himself in the handling of colours in fresco, executed, as it were out of rivalry, the cartoons for his two scenes, which he intended to paint on the angle between the side-door of S. Bastiano and the smaller door that leads from the cloister into the Nunziata. Having made the cartoons, he set to work in fresco; and in the first scene he painted the Nativity of Our Lady, a composition of figures beautifully proportioned and grouped with great grace in a room, wherein some women who are friends and relatives of the newly delivered mother, having come to visit her, are standing about her, all clothed in such garments as were customary at that time, and other women of lower degree, gathered around the fire, are washing the newborn babe, while others are preparing the swathing-bands and doing other similar services. Among them is a little boy, full of life, who is warming himself at the fire, with an old man resting in a very natural attitude on a couch, and likewise some women carrying food to the mother who is in bed, with movements truly lifelike and appropriate. And all these figures, together with some little boys who are hovering in the air and scattering flowers, are most carefully considered in their expressions, their draperies, and every other respect, and so soft in colour, that the figures appear to be of flesh and everything else rather real than painted.

In the other scene Andrea painted the three Magi from the East, who, guided by the Star, went to adore the Infant Jesus Christ. He represented them dismounted, as though they were near their destination; and that because there was only the space embracing the two doors to separate them from the Nativity of Christ which may be seen there, by the hand of Alesso Baldovinetti. In this scene Andrea painted the Court of those three Kings coming behind them, with baggage, much equipment, and many people following in their train, among whom, in a corner, are three persons portrayed from life and wearing the Florentine dress, one being Jacopo Sansovino, a full-length figure looking straight at the spectator, while another, with an arm in foreshortening, who is leaning against him and making a sign, is Andrea, the master of the work, and a third head, seen in profile behind Jacopo, is that of Ajolle, the musician. There are, in addition, some little boys who are climbing on the walls, in order to be able to see the magnificent procession and the fantastic animals that those three Kings have brought with them. This scene is quite equal in excellence to that mentioned above; nay, in both the one and the other he surpassed himself, not to speak of Franciabigio, who also finished his.

At this same time Andrea painted for the Abbey of S. Godenzo, a benefice belonging to the same friars, a panel which was held to be very well executed. And for the Friars of S. Gallo he made a panel-picture of Our Lady receiving the Annunciation from the Angel, wherein may be seen a very pleasing harmony of colouring, while the heads of some Angels accompanying Gabriel show a sweet gradation of tints and a perfectly executed beauty of expression in their features; and the predella below this picture was painted by Jacopo da Pontormo, who was a disciple of Andrea at that time, and gave proofs at that early age that he was destined to produce afterwards those beautiful works which he actually did execute in Florence with his own hand, although in the end he became one might say another painter, as will be related in his Life.

Andrea then painted for Zanobi Girolami a picture with figures of no great size, wherein was a story of Joseph, the son of Jacob, which was finished by him with unremitting diligence, and therefore held to be a very beautiful painting. Not long after this, he undertook to execute for the men of the Company of S. Maria della Neve, situated behind the Nunnery of

S. Ambrogio, a little panel with three figures – Our Lady, S. John the Baptist, and S. Ambrogio; which work, when finished, was placed in due time on the altar of that Company.

Meanwhile, thanks to his talent, Andrea had become intimate with Giovanni Gaddi, afterwards appointed Clerk of the Chamber, who, always delighting in the arts of design, was then keeping Jacopo Sansovino continually at work. Being pleased, therefore, with the manner of Andrea, he caused him to paint a picture of Our Lady for himself, which was very beautiful, for Andrea painted various patterns and other ingenious devices round it, so that it was considered to be the most beautiful work that he had executed up to that time. After this he made for Giovanni di Paolo, the mercer, another picture of Our Lady, which, being truly lovely, gave infinite pleasure to all who saw it. And for Andrea Santini he executed another, containing Our Lady, Christ, S. John, and S. Joseph, all wrought with such diligence that the painting has always been esteemed in Florence as worthy of great praise.

All these works acquired such a name for Andrea in his city, that among the many, both young and old, who were painting at that time, he was considered one of the most excellent who were handling brushes and colours. Wherefore he found himself not only honoured, but even, although he exacted the most paltry prices for his labours, in a condition to do something to help and support his family, and also to shelter himself from the annoyances and anxieties which afflict those of us who live in poverty. But he became enamoured of a young woman, and a little time afterwards, when she had been left a widow, he took her for his wife; and then he had more than enough to do for the rest of his life, and much more trouble than he had suffered in the past, for the reason that, in addition to the labours and annoyances that such entanglements generally involve, he undertook others into the bargain, such as that of letting himself be harassed now by jealousy, now by one thing, and now by another.

But to return to the works of his hand, which were as rare as they were numerous: after those of which mention has been made above, he painted for a friar of S. Croce, of the Order of Minorites, who was then Governor of the Nunnery of S. Francesco in Via Pentolini, and delighted much in paintings, a panel-picture destined for the Church of those Nuns, of Our Lady standing on high upon an octagonal pedestal, at the corners of

which are seated some Harpies, as it were in adoration of the Virgin; and she, using one hand to uphold her Son, who is clasping her most tenderly round the neck with His arms, in a very beautiful attitude, is holding a closed book in the other hand and gazing on two little naked boys, who, while helping her to stand upright, serve as ornaments about her person. This Madonna has on her right a beautifully painted S. Francis, in whose face may be seen the goodness and simplicity that truly belonged to that saintly man; besides which, the feet are marvellous, and so are the draperies, because Andrea always rounded off his figures with a very rich flow of folds and with certain most delicate curves, in such a way as to reveal the nude below. On her left hand she has a S. John the Evangelist, represented as a young man and in the act of writing his Gospel, in a very beautiful manner. In this work, moreover, over the building and the figures, is a film of transparent clouds, which appear to be really moving. This pic- ture, among all Andrea's works, is held at the present day to be one of singular and truly rare beauty. For the joiner Nizza, also, he made a picture of Our Lady, which was considered to be no less beautiful than any of his other works.

After this, the Guild of Merchants determined to have some triumphal chariots made of wood after the manner of those of the ancient Romans, to the end that these might be drawn in procession on the morning of S. John's day, in place of certain altar-cloths and wax tapers which the cities and townships carry in token of tribute, passing before the Duke and the chief magis- trates; and out of ten that were made at that time, Andrea painted some with scenes in oils and in chiaroscuro, which were much extolled. But although it was proposed that some should be made every year, until such time as every city and district had one of its own, which would have produced a show of extraordinary magnificence, nevertheless this custom was abandoned in the year 1527.

Now, while Andrea was adorning his city with these and other works, and his name was growing greater every day, the men of the Company of the Scalzo resolved that he should finish the work in their cloister, which he had formerly begun by painting the scene of the Baptism of Christ. Having resumed that work, therefore, more willingly, he executed two scenes there, with two very beautiful figures of Charity and Justice to adorn the door that leads into the building of the Company. In one of these

scenes he represented S. John preaching to the multitude in a spirited attitude, lean in person, as befitted the life that he was leading, and with an expression of countenance filled with inspiration and thoughtfulness. Marvellous, likewise, are the variety and the vivacity of his hearers, some being shown in admiration, and all in astonishment, at hearing that new message and a doctrine so singular and never heard before. Even more did Andrea exert his genius in painting the same John baptizing with water a vast number of people, some of whom are stripping off their clothes, some receiving the baptism, and others, naked, waiting for him to finish baptizing those who are before them. In all of them Andrea showed a vivid emotion, with a burning desire in the gestures of those who are eager to be purified of their sins; not to mention that all the figures are so well executed in that chiaroscuro, that the whole has the appearance of a real and most lifelike scene in marble.

I will not refrain from saying that while Andrea was employed on these and other pictures, there appeared certain copper engravings by Albrecht Dürer, and Andrea made use of them, taking some of the figures and transforming them into his manner. And this has caused some people, while not saying that it is a bad thing for a man to make adroit use of the good work of others, to believe that Andrea had not much invention.

At that time there came to Baccio Bandinelli, then a draughtsman of great repute, a desire to learn to paint in oils. Whereupon, knowing that no man in Florence knew how to do that better than our Andrea, he commissioned him to paint his portrait, which was a good likeness of him at that age, as may be seen even yet; and thus, by watching him paint that work and others, he saw his method of colouring, although afterwards, either by reason of the difficulty or from lack of inclination, he did not pursue the use of colours, finding more satisfaction in sculpture.

Andrea executed for Alessandro Corsini a picture of a Madonna seated on the ground with a Child in her arms, surrounded by many little boys, which was finished with beautiful art and with very pleasing colour; and for a mercer, much his friend, who kept a shop in Rome, he made a most beautiful head. Giovan Battista Puccini of Florence, likewise, taking extraordinary pleasure in the manner of Andrea, commissioned him to paint a picture of Our Lady for sending into France; but it proved to be so fine that he kept it for himself, and would by no means send it. However,

having been asked, while transacting the affairs of his business in France, to undertake to send choice paintings to that country, he caused Andrea to paint a picture of a Dead Christ surrounded by some Angels, who were supporting Him and contemplating with gestures of sorrow and compassion their Maker sunk to such a pass through the sins of the world. This work, when finished, gave such universal satisfaction, that Andrea, urged by many entreaties, had it engraved in Rome by the Venetian Agostino; but it did not succeed very well, and he would never again give any of his works to be engraved. But to return to the picture: it gave no less satisfaction in France, whither it was sent, than it had done in Florence, insomuch that the King, kindled with even greater desire to have works by Andrea, gave orders that he should execute others; which was the reason that Andrea, encouraged by his friends, resolved to go in a short time to France.

But meanwhile the Florentines, hearing in the year 1515 that Pope Leo X wished to grace his native city with his presence, ordained for his reception extraordinary festivities and a sumptuous and magnificent spectacle, with so many arches, façades, temples, colossal figures, and other statues and ornaments, that there had never been seen up to that time anything richer, more gorgeous, or more beautiful; for there was then flourishing in that city a greater abundance of fine and exalted intellects than had ever been known at any other period. At the entrance of the Porta di S. Piero Gattolini, Jacopo di Sandro, in company with Baccio da Montelupo, made an arch covered with historical scenes. Giuliano del Tasso made another at S. Felice in Piazza, with some statues and the obelisk of Romulus at S. Trinita, and Trajan's Column in the Mercato Nuovo. In the Piazza de' Signori, Antonio, the brother of Giuliano da San Gallo, erected an octagonal temple, and Baccio Bandinelli made a Giant for the Loggia. Between the Badia and the Palace of the Podestà there was an arch erected by Granaccio and Aristotele da San Gallo, and Il Rosso made another on the Canto de' Bischeri with a very beautiful design and a variety of figures. But what was admired more than everything else was the façade of S. Maria del Fiore, made of wood, and so well decorated with various scenes in chiaroscuro by our Andrea, that nothing more could have been desired. The architecture of this work was by Jacopo Sansovino, as were some scenes in low-relief and many figures carved in the round; and it was declared by the Pope that this structure – which

was designed by Lorenzo de' Medici, father of that Pontiff, when he was alive – could not have been more beautiful, even if it had been of marble. The same Jacopo made a horse similar to the one in Rome, which was held to be a miracle of beauty, on the Piazza di S. Maria Novella. An endless number of ornaments, also, were executed for the Sala del Papa in the Via della Scala, and that street was half filled with most beautiful scenes wrought by the hands of many craftsmen, but designed for the most part by Baccio Bandinelli. Wherefore, when Leo entered Florence, on the third day of September in the same year, this spectacle was pronounced to be the grandest that had ever been devised, and the most beautiful.

But to return now to Andrea: being again requested to make another picture for the King of France, in a short time he finished one wherein he painted a very beautiful Madonna, which was sent off immediately, the merchants receiving for it four times as much as they had paid. Now at that very time Pier Francesco Borgherini had caused to be made by Baccio d' Agnolo some panelling, chests, chairs, and a bed, all carved in walnut-wood, for the furnishing of an apartment; wherefore, to the end that the paintings therein might be equal in excellence to the rest of the work, he commissioned Andrea to paint part of the scenes on these with figures of no great size, representing the acts of Joseph the son of Jacob, in competition with some of great beauty that had been executed by Granaccio and Jacopo da Pontormo. Andrea, then, devoting an extraordinary amount of time and diligence to the work, strove to bring it about that they should prove to be more perfect than those of the others mentioned above; in which he succeeded to a marvel, for in the variety of events happening in the stories he showed how great was his worth in the art of painting. So excellent were those scenes, that an attempt was made by Giovan Battista della Palla, on account of the siege of Florence, to remove them from the places where they were fixed, in order to send them to the King of France; but, since they were fixed in such a way that it would have meant spoiling the whole work, they were left where they were, together with a picture of Our Lady, which is held to be a very choice work.

After this Andrea executed a head of Christ, now kept by the Servite Friars on the altar of the Nunziata, of such beauty, that I for my part do not know whether any more beautiful image of

the head of Christ could be conceived by the intellect of man. For the chapels in the Church of S. Gallo, without the Porta S. Gallo, there had been painted, in addition to the two panel-pictures by Andrea, a number of others, which were not equal to his; wherefore, since there was a commission to be given for another, those friars contrived to persuade the owner of the chapel to give it to Andrea; and he, beginning it immediately, made therein four figures standing, engaged in a disputation about the Trinity. One of these is S. Augustine, who, robed as a Bishop and truly African in aspect, is moving impetuously towards S. Peter Martyr, who is holding up an open book in a proud and sublime attitude: and the head and figure of the latter are much extolled. Beside him is a S. Francis holding a book in one hand and pressing the other against his breast; and he appears to be expressing with his lips a glowing ardour that makes him almost melt away in the heat of the discussion. There is also a S. Laurence, who, being young, is listening, and seems to be yielding to the authority of the others. Below them are two figures kneeling, one a Magdalene with most beautiful draperies, whose countenance is a portrait of Andrea's wife; for in no place did he paint a woman's features without copying them from her, and if perchance it happened at times that he took them from other women, yet, from his being used to see her continually, and from the circumstances that he had drawn her so often, and, what is more, had her impressed on his mind, it came about that almost all the heads of women that he made resembled her. The other kneeling figure is a S. Sebastian, who, being naked, shows his back, which appears to all who see it to be not painted, but of living flesh. And indeed, among so many works in oils, this was held by craftsmen to be the best, for the reason that there may be seen in it signs of careful consideration in the proportions of the figures, and much order in the method, with a sense of fitness in the expressions of the faces, the heads of the young showing sweetness of expression, those of the old hardness, and those of middle age a kind of blend that inclines both to the first and to the second. In a word, this panel is most beautiful in all its parts; and it is now to be found in S. Jacopo tra Fossi on the Canto degli Alberti, together with others by the hand of the same master.

While Andrea was living poorly enough in Florence, engaged in these works, but without bettering himself a whit, the two pictures that he had sent to France had been duly considered in

that country by King Francis I; and among many others which had been sent from Rome, from Venice, and from Lombardy, they had been judged to be by far the best. The King therefore praising them mightily, it was remarked to him that it would be an easy matter to persuade Andrea to come to France to serve his Majesty; which news was so agreeable to the King, that he gave orders that all that was necessary should be done, and that money for the journey should be paid to Andrea in Florence. Andrea then set out for France with a glad heart, taking with him his assistant Andrea Sguazzella; and, having arrived at last at the Court, they were received by the King with great kindness and rejoicing. Before the very day of his arrival had passed by, Andrea proved for himself how great were the courtesy and the liberality of that magnanimous King, receiving presents of money and rich and honourable garments. Beginning to work soon afterwards, he became so dear to the King and to all the Court, that he was treated lovingly by everyone, and it appeared to him that his departure from his country had brought him from one extreme of wretchedness to the other extreme of bliss. Among his first works was a portrait from life of the Dauphin, the son of the King, born only a few months before, and still in swaddling-clothes; and when he took this to the King, he received a present of three hundred gold crowns. Then, continuing to work, he painted for the King a figure of Charity, which was considered a very rare work and was held by that Sovereign in the estimation that it deserved. After that, his Majesty granted him a liberal allowance and did all that he could to induce Andrea to stay willingly with him, promising him that he should never want for anything; and this because he liked Andrea's resoluteness in his work, and also the character of the man, who was contented with everything. Moreover, giving great satisfaction to the whole Court, he executed many pictures and various other works; and if he had kept in mind the condition from which he had escaped and the place to which fortune had brought him, there is no doubt that he would have risen – to say nothing of riches – to a most honourable rank. But one day, when he was at work on a S. Jerome in Penitence for the mother of the King, there came to him some letters from Florence, written by his wife; and he began, whatever may have been the reason, to think of departing. He sought leave, therefore, from the King, saying that he wished to go to Florence, but would return without fail to his Majesty

after settling some affairs; and he would bring his wife with him, in order to live more at his ease in France, and would come back laden with pictures and sculptures of value. The King, trusting in him, gave him money for that purpose; and Andrea swore on the Testament to return to him in a few months.

Thus, then, he arrived in Florence, and for several months blissfully took his joy of his fair lady, his friends, and the city. And finally, the time at which he was to return having passed by, he found in the end that what with building, taking his pleasure, and doing no work, he had squandered all his money and likewise that of the King. Even so he wished to return, but he was more influenced by the sighs and prayers of his wife than by his own necessities and the pledge given to the King, so that, in order to please his wife, he did not go back; at which the King fell into such disdain, that for a long time he would never again look with a favourable eye on any painter from Florence, and he swore that if Andrea ever came into his hands he would give him a very different kind of welcome, with no regard whatever for his abilities. And thus Andrea, remaining in Florence, and sinking from the highest rung of the ladder to the very lowest, lived and passed the time as best he could.

After Andrea's departure to France, the men of the Scalzo, thinking that he would never return, had entrusted all the rest of the work in their cloister to Franciabigio, who had already executed two scenes there, when, seeing Andrea back in Florence, they persuaded him to set his hand to the work once more; and he, continuing it, painted four scenes, one beside another. In the first is S. John taken before Herod. In the second are the Feast and the Dance of Herodias, with figures very well grouped and appropriate. In the third is the Beheading of S. John, wherein the minister of justice, a half-nude figure, is beautifully drawn, as are all the others. In the fourth Herodias is presenting the head; and here there are figures expressing their astonishment, which are wrought with most beautiful thought and care. These scenes have been for some time the study and school of many young men who are now excellent in our arts.

In a shrine without the Porta a Pinti, at a corner where the road turns towards the Ingesuati, he painted in fresco a Madonna seated with a Child in her arms, and a little S. John who is smiling, a figure wrought with extraordinary art and with such perfect execution, that it is much extolled for its beauty and

vivacity; and the head of the Madonna is a portrait of his wife from nature. This shrine, on account of the incredible beauty of the painting, which is truly marvellous, was left standing in 1530, when, because of the siege of Florence, the aforesaid Convent of the Ingesuati was pulled down, together with many other very beautiful buildings.

About the same time the elder Bartolommeo Panciatichi, who was carrying on a great mercantile business in France, desiring to leave a memorial of himself in Lyons, ordered Baccio d'Agnolo to have a panel painted for him by Andrea, and to send it to him there; saying that he wanted the subject to be the Assumption of Our Lady, with the Apostles about the tomb. This work, then, Andrea carried almost to completion; but since the wood of the panel split apart several times, he would sometimes work at it, and sometimes leave it alone, so that at his death it remained not quite finished. Afterwards it was placed by the younger Bartolommeo Panciatichi in his house, as a work truly worthy of praise on account of the beautiful figures of the Apostles; not to speak of the Madonna, who is surrounded by a choir of little boys standing, while certain others are supporting her and bearing her upwards with extraordinary grace. And in the foreground of the panel, among the Apostles, is a portrait of Andrea, so natural that it seems to be alive. It is now at the villa of the Baroncelli, a little distance from Florence, in a small church built by Piero Salviati near his villa to do honour to the picture.

At the head of the garden of the Servi, in two angles, Andrea painted two scenes of Christ's Vineyard, one showing the planting, staking, and binding of the vines, and then the husbandman summoning to the labour those who were standing idle, among whom is one who, being asked whether he wishes to join the work, sits rubbing his hands and pondering whether he will go among the other labourers, exactly as those idle fellows do who have but little mind to work. Even more beautiful is the other scene, wherein the same husbandman is causing them to be paid, while they murmur and complain, and one among them, who is counting over his money by himself, wholly intent on examining his share, seems absolutely alive, as also does the steward who is paying out the wages. These scenes are in chiaroscuro, and executed with extraordinary mastery in fresco. After them he painted a Pietà, coloured in fresco, which is very beautiful, in a niche at the head of a staircase in the noviciate of the same

convent. He also painted another Pietà in a little picture in oils, in addition to a Nativity, for the room in that convent wherein the General, Angelo Aretino, once lived.

The same master painted for Zanobi Bracci, who much desired to have some work by his hand, for one of his apartments, a picture of Our Lady, in which she is on her knees, leaning against a rock, and contemplating Christ, who lies on a heap of drapery and looks up at her, smiling; while a S. John, who stands there, is making a sign to the Madonna, as if to say that her Child is the true Son of God. Behind these figures is a S. Joseph with his head resting on his hands, which are lying on a rock; and he appears to be filled with joy at seeing the human race become divine through that Birth.

Cardinal Giulio de' Medici having been commissioned by Pope Leo to see to the adorning with stucco and paintings of the ceiling in the Great Hall of Poggio a Caiano, a palatial villa of the Medici family, situated between Pistoia and Florence, the charge of arranging for that work and of paying out the money was given to the Magnificent Ottaviano de' Medici, as to a person who, not falling short of the standard of his ancestors, was well informed in such matters and a loving friend to all the masters of our arts, and delighted more than any other man to have his dwellings adorned with the works of the most excellent. Ottaviano ordained, therefore, although the commission for the whole work had already been given to Franciabigio, that he should have only a third, Andrea another, and Jacopo da Pontormo the last. But it was found impossible, for all the efforts that the Magnificent Ottaviano made to urge them on, and for all the money that he offered and even paid to them, to get the work brought to completion; and Andrea alone finished with great diligence a scene on one wall, representing Cæsar being presented with tribute of all kinds of animals. The drawing for this work is in our book, with many others by his hand; it is in chiaroscuro, and is the most finished that he ever made. In this picture Andrea, in order to surpass Franciabigio and Jacopo, subjected himself to unexampled labour, drawing in it a magnificent perspective-view and a very masterly flight of steps, which formed the ascent to the throne of Cæsar. And these steps he adorned with very well-designed statues, not being content with having proved the beauty of his genius in the variety of figures that are carrying on their backs all those different animals, such as the figure of an

Indian who is wearing a yellow coat, and carrying on his shoulders a cage drawn in perspective with some parrots both within it and without, the whole being rarely beautiful; and such, also, as some who are leading Indian goats, lions, giraffes, panthers, lynxes, and apes, with Moors and other lovely things of fancy, all grouped in a beautiful manner and executed divinely well in fresco. On these steps, also, he made a dwarf seated and holding a box containing a chameleon, which is so well executed in all the deformity of its fantastic shape, that it is impossible to imagine more beautiful proportions than those that he gave it. But, as has been said, this work remained unfinished, on account of the death of Pope Leo; and although Duke Alessandro de' Medici had a great desire that Jacopo da Pontormo should finish it, he was not able to prevail on him to put his hand to it. And in truth it suffered a very grievous wrong in the failure to complete it, seeing that the hall, for one in a villa, is the most beautiful in the world.

After returning to Florence, Andrea painted a picture with a nude half-length figure of S. John the Baptist, a very beautiful thing, which he executed at the commission of Giovan Maria Benintendi, who presented it afterwards to the Lord Duke Cosimo.

While affairs were proceeding in this manner, Andrea, remembering sometimes his connection with France, sighed from his heart: and if he had hoped to find pardon for the fault he had committed, there is no doubt that he would have gone back. Indeed, to try his fortune, he sought to see whether his talents might be helpful to him in the matter. Thus he painted a picture of a half-naked S. John the Baptist, meaning to send it to the Grand Master of France, to the end that he might occupy himself with restoring the painter to the favour of the King. However, whatever may have been the reason, he never sent it after all, but sold it to the Magnificent Ottaviano de' Medici, who always valued it much as long as he lived, even as he did two pictures of Our Lady executed for him by Andrea in one and the same manner, which are in his house at the present day.

Not long afterwards he was commissioned by Zanobi Bracci to paint a picture for Monsignore di San Biause,* which he executed with all possible diligence, hoping that it might enable him

* Jacques de Beaune.

to regain the favour of King Francis, to whose service he desired
to return. He also executed for Lorenzo Jacopi a picture of much
greater size than was usual, containing a Madonna seated with the
Child in her arms, accompanied by two other figures that are
seated on some steps; and the whole, both in drawing and in
colouring, is similar to his other works. He painted for Giovanni
d'Agostino Dini, likewise, a picture of Our Lady, which is now
much esteemed for its beauty; and he made so good a portrait
from life of Cosimo Lapi, that it seems absolutely alive.

Afterwards, in the year 1523, the plague came to Florence and
also to some places in the surrounding country; and Andrea, in
order to avoid that pestilence and also to do some work, went at
the instance of Antonio Brancacci to the Mugello to paint a panel
for the Nuns of S. Piero a Luco, of the Order of Camaldoli,
taking with him his wife and a stepdaughter, together with his
wife's sister and an assistant. Living quietly there, then, he set his
hand to the work. And since those venerable ladies showed more
and more kindness and courtesy every day to his wife, to himself,
and to the whole party, he applied himself with the greatest
possible willingness to executing that panel, in which he painted
a Dead Christ mourned by Our Lady, S. John the Evangelist, and
the Magdalene, figures so lifelike, that they appear truly to have
spirit and breath. In S. John may be seen the loving tenderness
of that Apostle, with affection in the tears of the Magdalene, and
bitter sorrow in the face and whole attitude of the Madonna,
whose aspect, as she gazes on Christ, who seems to be truly a
real corpse and in relief, is so pitiful, that she fills with helpless
awe and bewilderment the minds of S. Peter and S. Paul, who are
contemplating the Dead Saviour of the World in the lap of His
mother. From these marvellous conceptions it is clear how much
Andrea delighted in finish and perfection of art; and to tell the
truth, this panel has given more fame to that convent than all the
buildings and all the other costly works, however magnificent and
extraordinary, that have been executed there.

This picture finished, Andrea, seeing that the danger of the
plague was not yet past, stayed some weeks more in the same
place, where he was so well received and treated with such kind-
ness. During that time, in order not to be idle, he painted not
only a Visitation of Our Lady to S. Elizabeth, which is in the
church, on the right hand above the Manger, serving as a crown
to a little ancient panel, but also, on a canvas of no great size, a

most beautiful head of Christ, somewhat similar to that on the altar of the Nunziata, but not so finished. This head, which may in truth be numbered among the better works that issued from the hands of Andrea, is now in the Monastery of the Monks of the Angeli at Florence, in the possession of that very reverend father, Don Antonio da Pisa, who loves not only the men of excellence in our arts, but every man of talent without exception. From this picture several copies have been taken, for Don Silvano Razzi entrusted it to the painter Zanobi Poggini, to the end that he might make a copy for Bartolommeo Gondi, who had asked him for one, and some others were made, which are held in vast veneration in Florence.

In this manner, then, Andrea passed without danger the time of the plague, and those nuns received from the genius of that great man such a work as can bear comparison with the most excellent pictures that have been painted in our day; wherefore it is no marvel that Ramazzotto, the captain of mercenaries of Scaricalasino, sought to obtain it on several occasions during the siege of Florence, in order to send it to his chapel in S. Michele in Bosco at Bologna.

On his return to Florence, Andrea executed for Beccuccio da Gambassi, the glass-blower, who was very much his friend, a panel-picture of Our Lady in the sky with the Child in her arms, and four figures below, S. John the Baptist, S. Mary Magdalene, S. Sebastian, and S. Rocco; and in the predella he made portraits from nature, which are most lifelike, of Beccuccio and his wife. This panel is now at Gambassi, a township in Valdelsa, between Volterra and Florence. For a chapel in the villa of Zanobi Bracci at Rovezzano, he painted a most beautiful picture of Our Lady suckling a Child, with a Joseph, all executed with such diligence that they stand out from the panel, so strong is the relief; and this picture is now in the house of M. Antonio Bracci, the son of that Zanobi. About the same time, also, and in the above-mentioned cloister of the Scalzo, Andrea painted two other scenes, in one of which he depicted Zacharias offering sacrifice and being made dumb by the Angel appearing to him, while in the other is the Visitation of Our Lady, beautiful to a marvel.

Now Federigo II, Duke of Mantua, in passing through Florence on his way to make obeisance to Clement VII, saw over a door in the house of the Medici that portrait of Pope Leo between Cardinal Giulio de' Medici and Cardinal de' Rossi, which

the most excellent Raffaello da Urbino had formerly painted; and being extraordinarily pleased with it, he resolved, being a man who delighted in pictures of such beauty, to make it his own. And so, when he was in Rome and the moment seemed to him to have come, he asked for it as a present from Pope Clement, who courteously granted his request. Thereupon orders were sent to Florence to Ottaviano de' Medici, under whose care and government were Ippolito and Alessandro, that he should have it packed up and taken to Mantua. This matter was very displeasing to the Magnificent Ottaviano, who would never have consented to deprive Florence of such a picture, and he marvelled that the Pope should have given it up so readily. However, he answered that he would not fail to satisfy the Duke; but that, since the frame was bad, he was having a new one made, and when it had been gilt he would send the picture with every possible precaution to Mantua. This done, Messer Ottaviano, in order to 'save both the goat and the cabbage,' as the saying goes, sent privately for Andrea and told him how the matter stood, and how there was no way out of it but to make an exact copy of the picture with the greatest care and send it to the Duke, secretly retaining the one by the hand of Raffaello. Andrea, then, having promised to do all in his power and knowledge, caused a panel to be made similar in size and in every respect, and painted it secretly in the house of Messer Ottaviano. And to such purpose did he labour, that when it was finished even Messer Ottaviano, for all his understanding in matters of art, could not tell the one from the other, nor distinguish the real and true picture from the copy; especially as Andrea had counterfeited even the spots of dirt, exactly as they were in the original. And so, after they had hidden the picture of Raffaello, they sent the one by the hand of Andrea, in a similar frame, to Mantua; at which the Duke was completely satisfied, and above all because the painter Giulio Romano, a disciple of Raffaello, had praised it, failing to detect the trick. This Giulio would always have been of the same opinion, and would have believed it to be by the hand of Raffaello, but for the arrival in Mantua of Giorgio Vasari, who, having been as it were the adoptive child of Messer Ottaviano, and having seen Andrea at work on that picture, revealed the truth. For Giulio making much of Vasari, and showing him, after many antiquities and paintings, that picture of Raffaello's, as the best work that was there, Giorgio said to him, 'A beautiful work it is, but in no way by the hand

of Raffaello.' 'What?' answered Giulio. 'Should I not know it, when I recognize the very strokes that I made with my own brush?' 'You have forgotten them,' said Giorgio, 'for this picture is by the hand of Andrea del Sarto; and to prove it, there is a sign (to which he pointed) that was made in Florence, because when the two were together they could not be distinguished.' Hearing this, Giulio had the picture turned round, and saw the mark; at which he shrugged his shoulders and said these words, 'I value it no less than if it were by the hand of Raffaello – nay, even more, for it is something out of the course of nature that a man of excellence should imitate the manner of another so well, and should make a copy so like. It is enough that it should be known that Andrea's genius was as valiant in double harness as in single.' Thus, then, by the wise judgment of Messer Ottaviano, satisfaction was given to the Duke without depriving Florence of so choice a work, which, having been presented to him afterwards by Duke Alessandro, he kept in his possession for many years; and finally he gave it to Duke Cosimo, who has it in his guarda-roba together with many other famous pictures.

While Andrea was making this copy, he also painted for the same Messer Ottaviano a picture with only the head of Cardinal Giulio de' Medici, who afterwards became Pope Clement; and this head, which was similar to that by Raffaello, and very beautiful, was presented eventually by Messer Ottaviano to old Bishop de' Marzi.

Not long after, Messer Baldo Magini of Prato desiring to have a most beautiful panel-picture painted for the Madonna delle Carcere in his native city, for which he had already caused a very handsome ornament of marble to be made, one of the many painters proposed to him was Andrea. Wherefore Messer Baldo, having more inclination for him than for any of the others, although he had no great understanding in such a matter, had almost given him to believe that he and no other should do the work, when a certain Niccolò Soggi of Sansovino, who had some interest at Prato, was suggested to Messer Baldo for the undertaking, and assisted to such purpose by the assertion that there was not a better master to be found, that the work was given to him. Meanwhile, Andrea's supporters sending for him, he, holding it as settled that the work was to be his, went off to Prato with Domenico Puligo and other painters who were his friends. Arriving there, he found that Niccolò not only had persuaded

Messer Baldo to change his mind, but also was bold and shameless enough to say to him in the presence of Messer Baldo that he would compete with Andrea for a bet of any sum of money in painting something, the winner to take the whole. Andrea, who knew what Niccolò was worth, answered, although he was generally a man of little spirit, 'Here is my assistant, who has not been long in our art. If you will bet with him, I will put down the money for him; but with me you shall have no bet for any money in the world, seeing that, if I were to beat you, it would do me no honour, and if I were to lose, it would be the greatest possible disgrace.' And, saying to Messer Baldo that he should give the work to Niccolò, because he would execute it in such a manner as would please the folk that went to market, he returned to Florence.

There he was commissioned to paint a panel for Pisa, divided into five pictures, which were afterwards placed round the Madonna of S. Agnese, beside the walls of that city, between the old Citadel and the Duomo. Making one figure, then, in each picture, he painted in two of them S. John the Baptist and S. Peter, one on either side of the Madonna that works miracles; and in the others are S. Catharine the Martyr, S. Agnese, and S. Margaret, each a figure by itself, and all so beautiful as to fill with marvel anyone who beholds them, and considered to be the most gracious and lovely women that he ever painted.

M. Jacopo, a Servite friar, in releasing and absolving a woman from a vow, had told her that she must have a figure of Our Lady painted over the outer side of that lateral door of the Nunziata which leads into the cloister; and therefore, finding Andrea, he said to him that he had this money to spend, and that although it was not much it seemed to him right, since the other works executed by Andrea in that place had brought him such fame, that he and no other should paint this one as well. Andrea, who was nothing if not an amiable man, moved by the persuasions of the friar and by his own desire for profit and glory, answered that he would do it willingly; and shortly afterwards, putting his hand to the work, he painted in fresco a most beautiful Madonna seated with her Son in her arms, and S. Joseph leaning on a sack, with his eyes fixed upon an open book. And of such a kind was this work, in draughtsmanship, grace, and beauty of colouring, as well as in vivacity and relief, that it proved that he outstripped and surpassed by a great measure all the painters who had

worked up to that time. Such, indeed, is this picture, that by its own merit and without praise from any other quarter it makes itself clearly known as amazing and most rare.

There was wanting only one scene in the cloister of the Scalzo for it to be completely finished; wherefore Andrea, who had added grandeur to his manner after having seen the figures that Michelagnolo had begun and partly finished for the Sacristy of S. Lorenzo, set his hand to executing this last scene. In this, giving the final proof of his improvement, he painted the Birth of S. John the Baptist, with figures that were very beautiful and much better and stronger in relief than the others made by him before in the same place. Most beautiful, among others in this work, are a woman who is carrying the new-born babe to the bed on which lies S. Elizabeth, who is likewise a most lovely figure, and Zacharias, who is writing on a paper that he has placed on his knee, holding it with one hand and with the other writing the name of his son, and all with such vivacity, that he lacks nothing save the breath of life. Most beautiful, also, is an old woman who is seated on a stool, smiling with gladness at the delivery of the other aged woman, and revealing in her attitude and expression all that would be seen in a living person after such an event.

Having finished that work, which is certainly well worthy of all praise, he painted for the General of Vallombrosa a panel-picture with four very lovely figures, S. John the Baptist, S. Giovanni Gualberto, founder of that Order, S. Michelagnolo, and S. Bernardo, a Cardinal and a monk of the Order, with some little boys in the centre that could not be more vivacious or more beautiful. This panel is at Vallombrosa, on the summit of a rocky height, where certain monks live in some rooms called 'the cells,' separated from the others, and leading as it were the lives of hermits.

After this he was commissioned by Giuliano Scala to paint a panel-picture, which was to be sent to Serrazzana, of a Madonna seated with the Child in her arms, and two half-length figures from the knees upwards, S. Celso and S. Julia, with S. Onofrio, S. Catharine, S. Benedict, S. Anthony of Padua, S. Peter, and S. Mark; which panel was held to be equal to the other works of Andrea. And in the hands of Giuliano Scala, in place of the balance due to him of a sum of money that he had paid for the owners of that work, there remained a lunette containing an

Annunciation, which was to go above the panel, to complete it; and it is now in his chapel in the great tribune round the choir of the Church of the Servi.

The Monks of S. Salvi had let many years pass by without thinking of having a beginning made with their Last Supper, which they had commissioned Andrea to execute at the time when he painted the arch with the four figures; but finally an Abbot, who was a man of judgment and breeding, determined that he should finish that work. Thereupon Andrea, who had already pledged himself to it on a previous occasion, far from making any demur, put his hand to the task, and, working at it one piece at a time when he felt so inclined, finished it in a few months, and that in such a manner, that the work was held to be, as it certainly is, the most spontaneous and the most vivacious in colouring and drawing that he ever made, or that ever could be made. For, among other things, he gave infinite grandeur, majesty, and grace to all the figures, insomuch that I know not what to say of this Last Supper that would not be too little, it being such that whoever sees it is struck with amazement. Wherefore it is no marvel that on account of its excellence it was left standing amid the havoc of the siege of Florence, in the year 1529, at which time the soldiers and destroyers, by command of those in authority, pulled down all the suburbs without the city, and all the monasteries, hospitals, and other buildings. These men, I say, having destroyed the Church and Campanile of S. Salvi, and beginning to throw down part of the convent, had come to the refectory where this Last Supper is, when their leader, seeing so marvellous a painting, of which he may have heard speak, abandoned the undertaking and would not let any more of that place be destroyed, reserving the task until such time as there should be no alternative.

Andrea then painted for the Company of S. Jacopo, called the Nicchio, on a banner for carrying in processions, a S. James fondling a little boy dressed as a Flagellant by stroking him under the chin, with another boy who has a book in his hand, executed with beautiful grace and naturalness. He made a portrait from life of a steward of the Monks of Vallombrosa, who lived almost always in the country on the affairs of his monastery; and this portrait was placed under a sort of bower, in which he had made pergole and contrivances of his own in various fanciful designs, so that it was buffeted by wind and rain, according to the pleasure

of that steward, who was the friend of Andrea. And because, when the work was finished, there were some colours and lime left over, Andrea, taking a tile, called to his wife Lucrezia and said to her: 'Come here, for these colours are left over, and I wish to make your portrait, so that all may see how well you have preserved your beauty even at your time of life, and yet may know how your appearance has changed, which will make this one different from your early portraits.' But the woman, who may have had something else in her mind, would not stand still; and Andrea, as it were from a feeling that he was near his end, took a mirror and made a portrait of himself on that tile, of such perfection, that it seems alive and as real as nature; and that portrait is in the possession of the same Madonna Lucrezia, who is still living.

He also portrayed a Canon of Pisa, very much his friend; and the portrait, which is lifelike and very beautiful, is still in Pisa. He then began for the Signoria the cartoons for the paintings to be executed on the balustrades of the Ringhiera in the Piazza, with many beautiful things of fancy to represent the quarters of the city, and with the banners of the Consuls of the chief Guilds supported by some little boys, and also ornaments in the form of images of all the virtues, and likewise the most famous mountains and rivers of the dominion of Florence. But this work, thus begun, remained unfinished on account of Andrea's death, as was also the case with a panel – although it was all but finished – which he painted for the Abbey of the Monks of Vallombrosa at Poppi in the Casentino. In that panel he painted an Assumption of Our Lady, who is surrounded by many little boys, with S. Giovanni Gualberto, S. Bernardo the Cardinal (a monk of their Order, as has been related), S. Catharine, and S. Fedele; and, unfinished as it is, the picture is now in that Abbey of Poppi. The same happened to a panel of no great size, which, when finished, was to have gone to Pisa. But he left completely finished a very beautiful picture which is now in the house of Filippo Salviati, and some others.

About the same time Giovan Battista della Palla, having bought all the sculptures and pictures of note that he could obtain, and causing copies to be made of those that he could not buy, had despoiled Florence of a vast number of choice works, without the least scruple, in order to furnish a suite of rooms for the King of France, which was to be richer in suchlike ornaments

than any other in the world. And this man, desiring that Andrea should return to the service and favour of the King, commissioned him to paint two pictures. In one of these Andrea painted Abraham in the act of trying to sacrifice his son; and that with such diligence, that it was judged that up to that time he had never done anything better. Beautifully expressed in the figure of the patriarch was seen that living and steadfast faith which made him ready without a moment of dismay or hesitation to slay his own son. The same Abraham, likewise, could be seen turning his head towards a very beautiful little angel, who appeared to be bidding him stay his hand. I will not describe the attitude, the dress, the foot-wear, and other details in the painting of that old man, because it is not possible to say enough of them; but this I must say, that the boy Isaac, tender and most beautiful, was to be seen all naked, trembling with the fear of death, and almost dead without having been struck. The same boy had only the neck browned by the heat of the sun, and white as snow those parts that his draperies had covered during the three days' journey. In like manner, the ram among the thorns seemed to be alive, and Isaac's draperies on the ground rather real and natural than painted. And in addition there were some naked servants guarding an ass that was browsing, and a landscape so well represented that the real scene of the event could not have been more beautiful or in any way different. This picture, having been bought by Filippo Strozzi after the death of Andrea and the capture of Battista, was presented by him to Signor Alfonso Davalos, Marchese del Vasto, who had it carried to the island of Ischia, near Naples, and placed in one of his apartments in company with other most noble paintings.

In the other picture Andrea painted a very beautiful Charity, with three little boys; and this was afterwards bought from the wife of Andrea, after his death, by the painter Domenico Conti, who sold it later to Niccolò Antinori, who treasures it as a rare work, as indeed it is.

During this time there came to the Magnificent Ottaviano de' Medici, seeing from that last picture how much Andrea had improved his manner, a desire to have a picture by his hand. Whereupon Andrea, who was eager to serve that lord, to whom he was much indebted, because he had always shown favour to men of lofty intellect, and particularly to painters, executed for him a picture of Our Lady seated on the ground with the Child riding

astride on her knees, while He turns His head towards a little S. John supported by an old S. Elizabeth, a figure so natural and so well painted that she appears to be alive, even as every other thing is wrought with incredible diligence, draughtsmanship, and art. Having finished this picture, Andrea carried it to Messer Ottaviano; but since that lord had something else to think about, Florence being then besieged, he told Andrea, while thanking him profoundly and making his excuses, to dispose of it as he thought best. To which Andrea made no reply but this: 'The labour was endured for you, and yours the work shall always be.' 'Sell it,' answered Messer Ottaviano, 'and use the money, for I know what I am talking about.' Andrea then departed and returned to his house, nor would he ever give the picture to anyone, for all the offers that were made to him; but when the siege was raised and the Medici back in Florence, he took it once more to Messer Ottaviano, who accepted it right willingly, thanking him and paying him double. The work is now in the apartment of his wife, Madonna Francesca, sister to the very reverend Salviati, who holds the beautiful pictures left to her by her magnificent consort in no less account than she does the duty of retaining and honouring his friends.

For Giovanni Borgherini Andrea painted another picture almost exactly like the one of Charity mentioned above, containing a Madonna, a little S. John offering to Christ a globe that represents the world, and a very beautiful head of S. Joseph.

There came to Paolo da Terrarossa, a friend to the whole body of painters, who had seen the sketch for the aforesaid Abraham, a wish to have some work by the hand of Andrea. Having therefore asked him for a copy of that Abraham, Andrea willingly obliged him and made a copy of such a kind, that in its minuteness it was by no means inferior to the large original. Wherefore Paolo, well satisfied with it and wishing to pay him, asked him the price, thinking that it would cost him what it was certainly worth; but Andrea asked a mere song, and Paolo, almost ashamed, shrugged his shoulders and gave him all that he claimed. The picture was afterwards sent by him to Naples . . .* and it is the most beautiful and the most highly honoured painting in that place.

* There is here a gap in the text.

During the siege of Florence some captains had fled the city with the pay-chests; on which account Andrea was asked to paint on the façade of the Palace of the Podestà and in the Piazza not only those captains, but also some citizens who had fled and had been proclaimed outlaws. He said that he would do it; but in order not to acquire, like Andrea dal Castagno, the name of Andrea degl' Impiccati, he gave it out that he was entrusting the work to one of his assistants, called Bernardo del Buda. However, having made a great enclosure, which he himself entered and left by night, he executed those figures in such a manner that they appeared to be the men themselves, real and alive. The soldiers, who were painted on the façade of the old Mercatanzia in the Piazza, near the Condotta, were covered with whitewash many years ago, that they might be seen no longer; and the citizens, whom he painted entirely with his own hand on the Palace of the Podestà, were destroyed in like manner.

After this, being very intimate in these last years of his life with certain men who governed the Company of S. Sebastiano, which is behind the Servite Convent, Andrea made for them with his own hand a S. Sebastian from the navel upwards, so beautiful that it might well have seemed that these were the last strokes of the brush which he was to make.

The siege being finished, Andrea was waiting for matters to mend, although with little hope that his French project would succeed, since Giovan Battista della Palla had been taken prisoner, when Florence became filled with soldiers and stores from the camp. Among those soldiers were some lansquenets sick of the plague, who brought no little terror into the city and shortly afterwards left it infected. Thereupon, either through this apprehension or through some imprudence in eating after having suffered much privation in the siege, one day Andrea fell grievously ill and took to his bed with death on his brow; and finding no remedy for his illness, and being without much attention – for his wife, from fear of the plague, kept as far away from him as she could – he died, so it is said, almost without a soul being aware of it; and he was buried by the men of the Scalzo with scant ceremony in the Church of the Servi, near his own house, in the place where the members of that Company are always buried.

The death of Andrea was a very great loss to the city and to art, because up to the age of forty-two, which he attained, he went on always improving from one work to another in such

wise that, if he had lived longer, he would have continued to
confer benefits on art; for the reason that it is better to go on
making progress little by little, advancing with a firm and steady
foot through the difficulties of art, than to seek to force one's
intellect and nature in a single effort. Nor is there any doubt that
if Andrea had stayed in Rome when he went there to see the
works of Raffaello and Michelagnolo, and also the statues and
ruins of that city, he would have enriched his manner greatly in
the composition of scenes, and would one day have given more
delicacy and greater force to his figures; which has never been
thoroughly achieved save by one who has been some time in
Rome, to study those works in detail and grow familiar with
them. Having then from nature a sweet and gracious manner
of drawing and great facility and vivacity of colouring, both in
fresco-work and in oils, it is believed without a doubt that if he
had stayed in Rome, he would have surpassed all the craftsmen
of his time. But some believe that he was deterred from this by
the abundance of works of sculpture and painting, both ancient
and modern, that he saw in that city, and by observing the many
young men, disciples of Raffaello and of others, resolute in
draughtsmanship and working confidently and without effort,
whom, like the timid fellow that he was, he did not feel it in him
to excel. And so, not trusting himself, he resolved, as the best
course for him, to return to Florence; where, reflecting little by
little on what he had seen, he made such proficience that his
works have been admired and held in price, and, what is more,
imitated more often after his death than during his lifetime. Who-
ever has some holds them dear, and whoever has consented to
sell them has received three times as much as was paid to him,
for the reason that he never received anything but small prices
for his works, both because he was timid by nature, as has been
related, and also because certain master-joiners, who were execut-
ing the best works at that time in the houses of citizens, would
never allow any commission to be given to Andrea (so as to
oblige their friends), save when they knew that he was in great
straits, for at such times he would accept any price. But this does
not prevent his works from being most rare, or from being held
in very great account, and that rightly, since he was one of the
best and greatest masters who have lived even to our own day.
In our book are many drawings by his hand, all good; but in
particular there is one that is altogether beautiful, of the scene

that he painted at Poggio, showing the tribute of all the animals from the East being presented to Cæsar. This drawing, which is executed in chiaroscuro, is a rare thing, and the most finished that Andrea ever made; for when he drew natural objects for reproduction in his works, he made mere sketches dashed off on the spot, contenting himself with marking the character of the reality; and afterwards, when reproducing them in his works, he brought them to perfection. His drawings, therefore, served him rather as memoranda of what he had seen than as models from which to make exact copies in his pictures.

The disciples of Andrea were innumerable, but they did not all pursue the same course of study under his discipline, for some stayed with him a long time, and some but little; which was the fault, not of Andrea, but of his wife, who, tyrannizing arrogantly over them all, and showing no respect to a single one of them, made all their lives a burden. Among his disciples, then, were Jacopo da Pontormo; Andrea Sguazzella, who adhered to the manner of Andrea and decorated a palace, a work which is much extolled, without the city of Paris in France; Solosmeo; Pier Francesco di Jacopo di Sandro, who has painted three panels that are in S. Spirito; Francesco Salviati; Giorgio Vasari of Arezzo, who was the companion of the aforesaid Salviati, although he did not stay long with Andrea; Jacopo del Conte of Florence; and Nannoccio, who is now in France with Cardinal de Tournon, in the highest credit. In like manner, Jacopo, called Jacone, was a disciple of Andrea and much his friend, and an imitator of his manner. This Jacone, while Andrea was alive, received no little help from him, as is evident in all his works, and particularly in the façade executed for the Chevalier Buondelmonti on the Piazza di S. Trinita.

The heir to Andrea's drawings and other art-possessions, after his death, was Domenico Conti, who made little proficience in painting; but one night he was robbed – by some men of the same profession, so it is thought – of all the drawings, cartoons, and other things that he had from Andrea, nor was it ever discovered who these men were. Now Domenico, as one not ungrateful for the benefits received from his master, and desiring to render to him after his death the honours that he deserved, prevailed upon Raffaello da Montelupo to make for him out of courtesy a very handsome tablet of marble, which was built into a pilaster in the Church of the Servi, with the following epitaph,

written for him by the most learned Messer Piero Vettori, then a young man:

ANDREÆ SARTIO
ADMIRABILIS INGENII PICTORI, AC VETERIBUS ILLIS OMNIUM
JUDICIO COMPARANDO,
DOMINICUS CONTES DISCIPULUS, PRO LABORIBUS IN SE
INSTITUENDO SUSCEPTIS,
GRATO ANIMO POSUIT.
VIXIT ANN. XLII. OB. ANN. MDXXX.

After no long time, certain citizens, Wardens of Works of that church, rather ignorant than hostile to honoured memories, so went to work out of anger that the tablet should have been set up in that place without their leave, that they had it removed; nor has it yet been re-erected in any other place. Thus, perchance, Fortune sought to show that the power of the Fates prevails not only during our lives, but also over our memorials after death. In spite of them, however, the works and the name of Andrea are likely to live a long time, as are these my writings, I hope, to preserve their memory for many ages.

We must conclude, then, that if Andrea showed poor spirit in the actions of his life, contenting himself with little, this does not mean that in art he was otherwise than exalted in genius, most resolute, and masterly in every sort of labour; and with his works, in addition to the adornment that they confer on the places where they are, he rendered a most valuable service to his fellow-craftsmen with regard to manner, drawing, and colouring, and that with fewer errors than any other painter of Florence, for the reason that, as has been said above, he understood very well the management of light and shade and how to make things recede in the darks, and painted his pictures with a sweetness full of vivacity; not to mention that he showed us the method of working in fresco with perfect unity and without doing much retouching on the dry, which makes his every work appear to have been painted in a single day. Wherefore he should serve in every place as an example to Tuscan craftsmen, and receive supreme praise and a palm of honour among the number of their most celebrated champions.

MADONNA PROPERZIA DE' ROSSI
Sculptor* of Bologna

I⊤ is an extraordinary thing that in all those arts and all those exercises wherein at any time women have thought fit to play a part in real earnest, they have always become most excellent and famous in no common way, as one might easily demonstrate by an endless number of examples. Everyone, indeed, knows what they are all, without exception, worth in household matters; besides which, in connection with war, likewise, it is known who were Camilla, Harpalice, Valasca, Tomyris, Penthesilea, Molpadia, Orizia, Antiope, Hippolyta, Semiramis, Zenobia, and, finally, Mark Antony's Fulvia, who so often took up arms, as the historian Dion tells us, to defend her husband and herself. But in poetry, also, they have been truly marvellous, as Pausanias relates. Corinna was very celebrated as a writer of verse, and Eustathius makes mention in his 'Catalogue of the Ships of Homer' – as does Eusebius in his book of 'Chronicles' – of Sappho, a young woman of great renown, who, in truth, although she was a woman, was yet such that she surpassed by a great measure all the eminent writers of that age. And Varro, on his part, gives extraordinary but well-deserved praise to Erinna, who, with her three hundred verses, challenged the fame of the brightest light of Greece, and counterbalanced with her one small volume, called the 'Elecate,' the ponderous 'Iliad' of the great Homer. Aristophanes celebrates Carissena, a votary of the same profession, as a woman of great excellence and learning; and the same may be said for Teano, Merone, Polla, Elpe, Cornificia, and Telesilla, to the last of whom, in honour of her marvellous talents, a most beautiful statue was set up in the Temple of Venus.

Passing by the numberless other writers of verse, do we not read that Arete was the teacher of the learned Aristippus in the difficulties of philosophy, and that Lastheneia and Assiotea were disciples of the divine Plato? In the art of oratory, Sempronia and Hortensia, women of Rome, were very famous. In grammar, so Athenæus relates, Agallis was without an equal. And as for the prediction of the future, whether we class this with astrology or

* The translator is unwilling to use the somewhat ugly word 'sculptress.'

M. PROPERZIA DE ROSSI SCVL.
BOLOGNESE.

with magic, it is enough to say that Themis, Cassandra, and Manto had an extraordinary renown in their times; as did Isis and Ceres in matters of agriculture, and the Thespiades in the whole field of the sciences.

But in no other age, for certain, has it been possible to see this better than in our own, wherein women have won the highest fame not only in the study of letters – as has been done by Signora Vittoria del Vasto, Signora Veronica Gambara, Signora Caterina Anguisciuola, Schioppa, Nugarola, Madonna Laura Battiferri, and a hundred others, all most learned as well in the vulgar tongue as in the Latin and the Greek – but also in every other faculty. Nor have they been too proud to set themselves with their little hands, so tender and so white, as if to wrest from us the palm of supremacy, to manual labours, braving the roughness of marble and the unkindly chisels, in order to attain to their desire and thereby win fame; as did, in our own day, Properzia de' Rossi of Bologna, a young woman excellent not only in household matters, like the rest of them, but also in sciences without number, so that all the men, to say nothing of the women, were envious of her.

This Properzia was very beautiful in person, and played and sang in her day better than any other woman of her city. And because she had an intellect both capricious and very ready, she set herself to carve peach-stones, which she executed so well and with such patience, that they were singular and marvellous to behold, not only for the subtlety of the work, but also for the grace of the little figures that she made in them and the delicacy with which they were distributed. And it was certainly a miracle to see on so small a thing as a peach-stone the whole Passion of Christ, wrought in most beautiful carving, with a vast number of figures in addition to the Apostles and the ministers of the Crucifixion. This encouraged her, since there were decorations to be made for the three doors of the first façade of S. Petronio all in figures of marble, to ask the Wardens of Works, by means of her husband, for a part of that work; at which they were quite content, on the condition that she should let them see some work in marble executed by her own hand. Whereupon she straightway made for Count Alessandro de' Peppoli a portrait from life in the finest marble, representing his father, Count Guido, which gave infinite pleasure not only to them, but also to the whole city; and the Wardens of Works, therefore, did not fail to allot a part of

the work to her. In this, to the vast delight of all Bologna, she made an exquisite scene, wherein – because at that time the poor woman was madly enamoured of a handsome young man, who seemed to care but little for her – she represented the wife of Pharaoh's Chamberlain, who, burning with love for Joseph, and almost in despair after so much persuasion, finally strips his garment from him with a womanly grace that defies description. This work was esteemed by all to be most beautiful, and it was a great satisfaction to herself, thinking that with this illustration from the Old Testament she had partly quenched the raging fire of her own passion. Nor would she ever do any more work in connection with that building, although there was no person who did not beseech her that she should go on with it, save only Maestro Amico, who out of envy always dissuaded her and went so far with his malignity, ever speaking ill of her to the Wardens, that she was paid a most beggarly price for her work.

She also made two angels in very strong relief and beautiful proportions, which may now be seen, although against her wish, in the same building. In the end she devoted herself to copper-plate engraving, which she did without reproach, gaining the highest praise. And so the poor love-stricken young woman came to succeed most perfectly in everything, save in her unhappy passion.

The fame of an intellect so noble and so exalted spread throughout all Italy, and finally came to the ears of Pope Clement VII, who, immediately after he had crowned the Emperor in Bologna, made inquiries after her; but he found that the poor woman had died that very week, and had been buried in the Della Morte Hospital, as she had directed in her last testament. At which the Pope, who was eager to see her, felt much sorrow at her death; but more bitter even was it for her fellow-citizens, who regarded her during her lifetime as one of the greatest miracles produced by nature in our days.

In our book are some very good drawings by the hand of this Properzia, done with the pen and copied from the works of Raffaello da Urbino; and her portrait was given to me by certain painters who were very much her friends.

But, although Properzia drew very well, there have not been wanting women not only to equal her in drawing, but also to do as good work in painting as she did in sculpture. Of these the first is Sister Plautilla, a nun and now Prioress in the Convent of

S. Caterina da Siena, on the Piazza di S. Marco in Florence. She, beginning little by little to draw and to imitate in colours pictures and paintings by excellent masters, has executed some works with such diligence, that she has caused the craftsmen to marvel. By her hand are two panels in the Church of that Convent of S. Caterina, of which the one with the Magi adoring Jesus is much extolled. In the choir of the Convent of S. Lucia, at Pistoia, there is a large panel, containing Our Lady with the Child in her arms, S. Thomas, S. Augustine, S. Mary Magdalene, S. Catherine of Siena, S. Agnese, S. Catherine the Martyr, and S. Lucia; and another large panel by the same hand was sent abroad by the Director of the Hospital of Lelmo. In the refectory of the aforesaid Convent of S. Caterina there is a great Last Supper, with a panel in the work-room, both by the hand of the same nun. And in the houses of gentlemen throughout Florence there are so many pictures, that it would be tedious to attempt to speak of them all. A large picture of the Annunciation belongs to the wife of the Spaniard, Signor Mondragone, and Madonna Marietta de' Fedini has another like it. There is a little picture of Our Lady in S. Giovannino, at Florence; and an altar-predella in S. Maria del Fiore, containing very beautiful scenes from the life of S. Zanobi. And because this venerable and talented sister, before executing panels and works of importance, gave attention to painting in miniature, there are in the possession of various people many wonderfully beautiful little pictures by her hand, of which there is no need to make mention. The best works from her hand are those that she has copied from others, wherein she shows that she would have done marvellous things if she had enjoyed, as men do, advantages for studying, devoting herself to drawing, and copying living and natural objects. And that this is true is seen clearly from a picture of the Nativity of Christ, copied from one which Bronzino once painted for Filippo Salviati. In like manner, the truth of such an opinion is proved by this, that in her works the faces and features of women, whom she has been able to see as much as she pleased, are no little better than the heads of the men, and much nearer to the reality. In the faces of women in some of her works she has portrayed Madonna Costanza de' Doni, who has been in our time an unexampled pattern of beauty and dignity; painting her so well, that it is impossible to expect more from a woman who, for the reasons mentioned above, has had no great practice in her art.

With much credit to herself, likewise, has Madonna Lucrezia, the daughter of Messer Alfonso Quistelli della Mirandola, and now the wife of Count Clemente Pietra, occupied herself with drawing and painting, as she still does, after having been taught by Alessandro Allori, the pupil of Bronzino; as may be seen from many pictures and portraits executed by her hand, which are worthy to be praised by all. But Sofonisba of Cremona, the daughter of Messer Amilcaro Anguisciuola, has laboured at the difficulties of design with greater study and better grace than any other woman of our time, and she has not only succeeded in drawing, colouring, and copying from nature, and in making excellent copies of works by other hands, but has also executed by herself alone some very choice and beautiful works of painting. Wherefore she well deserved that King Philip of Spain, having heard of her merits and abilities from the Lord Duke of Alba, should have sent for her and caused her to be escorted in great honour to Spain, where he keeps her with a rich allowance about the person of the Queen, to the admiration of all that Court, which reveres the excellence of Sofonisba as a miracle. And it is no long time since Messer Tommaso Cavalieri, a Roman gentleman, sent to the Lord Duke Cosimo (in addition to a drawing by the hand of the divine Michelagnolo, wherein is a Cleopatra) another drawing by the hand of Sofonisba, containing a little girl laughing at a boy who is weeping because one of the cray-fish out of a basket full of them, which she has placed in front of him, is biting his finger; and there is nothing more graceful to be seen than that drawing, or more true to nature. Wherefore, in memory of the talent of Sofonisba, who lives in Spain, so that Italy has no abundance of her works, I have placed it in my book of drawings.

We may truly say, then, with the divine Ariosto, that –

> Le donne son venute in eccellenza
> Di ciascun' arte ov' hanno posto cura.

And let this be the end of the Life of Properzia, sculptor of Bologna.

ALFONSO LOMBARDI OF FERRARA, MICHELAGNOLO DA SIENA, AND GIROLAMO SANTA CROCE OF NAPLES, Sculptors, AND DOSSO AND BATTISTA DOSSI, Painters of Ferrara

ALFONSO OF FERRARA, working in his early youth with stucco and wax, made an endless number of portraits from life on little medallions for many nobles and gentlemen of his own country. Some of these are still to be seen, white in colour and made of wax or stucco, and bear witness to the fine intellect and judgment that he possessed; such as those of Prince Doria, of Duke Alfonso of Ferrara, of Clement VII, of the Emperor Charles V, of Cardinal Ippolito de' Medici, of Bembo, of Ariosto, and of other suchlike personages. Finding himself in Bologna at the coronation of Charles V, he executed the decorations of the door of S. Petronio as a part of the preparations for that festival; and he had come into such repute through being the first to introduce the good method of making portraits from life in the form of medals, as has been related, that there was not a single man of distinction in those Courts for whom he did not execute some work, to his own great profit and honour. But, not being content with the gain and the glory that came to him from making works in clay, in wax, and in stucco, he set himself to work in marble; and such was the proficience that he showed in some things that he made, although these were of little importance, that he was commissioned to execute the tomb of Ramazzotto, which brought him very great fame and honour, in S. Michele in Bosco, without Bologna. After that work he made some little scenes of marble in half-relief on the predella of the altar at the tomb of S. Dominic, in the same city. And for the door of S. Petronio, also, on the left hand of the entrance into the church, he executed some little scenes in marble, containing a very beautiful Resurrection of Christ. But what pleased the people of Bologna most of all was the Death of Our Lady, wrought with a very hard mixture of clay and stucco, with figures in full-relief, in an upper room of the Della Vita Hospital; and marvellous, among other things in that work, is the Jew who leaves his hands fixed to the bier of the Madonna. With the same mixture, also, he made a large Hercules with the dead Hydra under his feet, for the upper room of

the Governor in the Palazzo Pubblico of that city; which statue was executed in competition with Zaccaria da Volterra, who was greatly surpassed by the ability and excellence of Alfonso. For the Madonna del Baracane the same master made two Angels in stucco, who are upholding a canopy in half-relief; and in some medallions in the middle aisle of S. Giuseppe, between one arch and another, he made the twelve Apostles from the waist upwards, of terra-cotta and in full-relief. In terra-cotta, likewise, for the corners of the vaulting of the Madonna del Popolo in the same city, he executed four figures larger than life; namely, S. Petronio, S. Procolo, S. Francis, and S. Dominic, figures which are all very beautiful and grand in manner. And by the hand of the same man are some works in stucco at Castel Bolognese, and some others in the Company of S. Giovanni at Cesena.

Let no one marvel that hitherto our account of this master has dealt with scarcely any work save in clay, wax, and stucco, and very little in marble, because – besides the fact that Alfonso was always inclined to that sort of work – after passing a certain age, being very handsome in person and youthful in appearance, he practised art more for pleasure and to satisfy his own vanity than with any desire to set himself to chisel stone. He used always to wear on his arms, on his neck, and in his clothing, ornaments of gold and suchlike fripperies, which showed him to be rather a courtier, vain and wanton, than a craftsman desirous of glory. Of a truth, just as such ornaments enhance the splendour of those to whom, on account of their wealth, high estate, and noble blood, they are becoming, so are they worthy of reproach in craftsmen and others, who should not measure themselves, some for one reason and some for another, with the rich, seeing that such persons, in place of being praised, are held in less esteem by men of judgment, and often laughed to scorn. Now Alfonso, charmed with himself and indulging in expressions and wanton excesses little worthy of a good craftsman, on one occasion robbed himself through this behaviour of all the glory that he had won by labouring at his profession. For one evening, chancing to be at a wedding in the house of a Count in Bologna, and having made love for some time to a lady of quality, he had the luck to be invited by her to dance the torch-dance; whereupon, whirling round with her, and overcome by the frenzy of his passion, he said with a trembling voice, sighing deeply, and gazing at his lady with eyes full of tenderness: 'S'amor non è, che dunque è quel ch''

io sento?'* Hearing this, the lady, who had a shrewd wit, answered, in order to show him his error: 'A louse, perhaps.' Which answer was heard by many, so that the saying ran through all Bologna, and he was held to scorn ever afterwards. Truly, if Alfonso had given his attention not to the vanities of the world, but to the labours of art, without a doubt he would have produced marvellous works; for if he achieved this in part without exerting himself much, what would he have done if he had faced the dust and heat?

The aforesaid Emperor Charles V being in Bologna, and the most excellent Tiziano da Cadore having come to make a portrait of his Majesty, Alfonso likewise was seized with a desire to execute a portrait of that Sovereign. And having no other means of contriving to do that, he besought Tiziano, without revealing to him what he had in mind, that he should do him the favour of introducing him, in the place of one of those who used to carry his colours, into the presence of his Majesty. Wherefore Tiziano, who loved him much, like the truly courteous man that he has always been, took Alfonso with him into the apartments of the Emperor. Alfonso, as soon as Tiziano had settled down to work, took up a position behind him, in such a way that he could not be seen by the other, who was wholly intent on his portrait; and, taking up a little box in the shape of a medallion, he made therein a portrait of the Emperor in stucco, and had it finished at the very moment when Tiziano had likewise brought his picture to completion. The Emperor then rising, Alfonso closed the box and had already hidden it in his sleeve, to the end that Tiziano might not see it, when his Majesty said to him: 'Show me what you have done.' He was thus forced to give his portrait humbly into the hand of the Emperor, who, having examined it and praised it highly, said to him: 'Would you have the courage to do it in marble?' 'Yes, your sacred Majesty,' answered Alfonso. 'Do it, then,' added the Emperor, 'and bring it to me in Genoa.' How unusual this proceeding must have seemed to Tiziano every man may imagine for himself. For my part, I believe that it must have appeared to him that he had compromised his credit. But what must have seemed to him most strange was this, that when his Majesty sent a present of a thousand crowns to Tiziano, he bade him give the half, or five hundred crowns, to Alfonso, keeping

* 'What is it that I feel, if it is not love?'

the other five hundred for himself, at which it is likely enough that Tiziano felt aggrieved. Alfonso, then, setting to work with the greatest zeal in his power, brought the marble head to completion with such diligence, that it was pronounced to be a very fine thing: which was the reason that, when he had taken it to the Emperor, his Majesty ordered that three hundred crowns more should be given to him.

Alfonso having come into great repute through the gifts and praises bestowed on him by the Emperor, Cardinal Ippolito de' Medici took him to Rome, where he kept many sculptors and painters about his person, in addition to a vast number of other men of ability; and he commissioned him to make a copy in marble of a very famous antique head of the Emperor Vitellius. In that work Alfonso justified the opinion held of him by the Cardinal and by all Rome, and he was charged by the same patron to make a portrait-bust in marble of Pope Clement VII, after the life, and shortly afterwards one of Giuliano de' Medici, father of the Cardinal; but the latter was left not quite finished. These heads were afterwards sold in Rome, and bought by me at the request of the Magnificent Ottaviano de' Medici, together with some pictures; and in our own day they have been placed by the Lord Duke Cosimo de' Medici in that hall of the new apartments of his palace wherein I have painted, on the ceiling and the walls, all the stories of Pope Leo X; they have been placed, I say, in that hall, over the doors made of that red veined marble which is found near Florence, in company with the heads of other illustrious men of the house of Medici.

But returning to Alfonso; he then went on to execute many works in sculpture for the same Cardinal, but these, being small things, have disappeared. After the death of Clement, when a tomb had to be made for him and also for Leo, the work was allotted by Cardinal de' Medici to Alfonso; whereupon he made a model with figures of wax, which was held to be very beautiful, after some sketches by Michelagnolo Buonarroti, and went off to Carrara with money to have the marble quarried. But not long afterwards the Cardinal, having departed from Rome on his way to Africa, died at Itri, and the work slipped out of the hands of Alfonso, because he was dismissed by its executors, Cardinals Salviati, Ridolfi, Pucci, Cibo, and Gaddi, and it was entrusted by the favour of Madonna Lucrezia Salviati, daughter of the great Lorenzo de' Medici, the elder, and sister of Leo, to Baccio

Bandinelli, a sculptor of Florence, who had made models for it during the lifetime of Clement.

For this reason Alfonso, thus knocked off his high horse and almost beside himself, determined to return to Bologna; and, having arrived in Florence, he presented to Duke Alessandro a most beautiful head in marble of the Emperor Charles V, which is now in Carrara, whither it was sent by Cardinal Cibo, who removed it after the death of Duke Alessandro from the guarda-roba of that Prince. The Duke, when Alfonso arrived in Florence, was in the humour to have his portrait taken; for it had already been done on medals by Domenico di Polo, a gem-engraver, and by Francesco di Girolamo dal Prato, for the coinage by Benve-nuto Cellini, and in painting by Giorgio Vasari of Arezzo and Jacopo da Pontormo, and he wished that Alfonso should likewise portray him. Wherefore he made a very beautiful portrait of him in relief, much better than the one executed by Danese da Car-rara, and then, since he was wholly set on going to Bologna, he was given the means to make one there in marble, after the model. And so, having received many gifts and favours from Duke Alessandro, Alfonso returned to Bologna, where, being still far from content on account of the death of the Cardinal, and sorely vexed by the loss of the tombs, there came upon him a pestilent and incurable disease of the skin, which wasted him away little by little, until, having reached the age of forty-nine, he passed to a better life, never ceasing to rail at Fortune, which had robbed him of a patron to whom he might have looked for all the blessings which could make him happy in this life, and saying that she should have closed his own eyes, since she had reduced him to such misery, rather than those of Cardinal Ippolito de' Medici. Alfonso died in the year 1536.

Michelagnolo, a sculptor of Siena, after he had spent the best years of his life in Sclavonia with other excellent sculptors, made his way to Rome on the following occasion. After the death of Pope Adrian, Cardinal Hincfort, who had been the friend and favourite of that Pontiff, determined, as one not ungrateful for the benefits received from him, to erect to him a tomb of marble; and he gave the charge of this to Baldassarre Peruzzi, the painter of Siena. And that master, having made the model, desired that the sculptor Michelagnolo, his friend and compatriot, should undertake the work on his own account. Michelagnolo, therefore, made on that tomb a life-size figure of Pope Adrian, lying upon

the sarcophagus and portrayed from nature, with a scene, also in marble, below him, showing his arrival in Rome and the Roman people going to meet him and to do him homage. Around the tomb, moreover, in four niches, are four Virtues in marble, Justice, Fortitude, Peace, and Prudence, all executed with much diligence by the hand of Michelagnolo after the counsel of Baldassarre. It is true, indeed, that some of the things that are in this work were wrought by the Florentine sculptor, Tribolo, then a very young man, and these were considered the best of all; but Michelagnolo executed the minor details of the work with supreme diligence and subtlety, and the little figures that are in it deserve to be extolled more than all the rest. Among other things, there are some variegated marbles wrought with a high finish, and put together so well that nothing more could be desired. For these labours Michelagnolo received a just and honourable reward from the aforesaid Cardinal, and was treated with much favour by him for the rest of his life; and, in truth, with right good reason, seeing that this tomb and the Cardinal's gratitude have done as much to bring fame to him as did the work to give a name to Michelagnolo in his lifetime and renown after his death. This work finished, no long time elapsed before Michelagnolo passed from this life to the next, at about the age of fifty.

Girolamo Santa Croce of Naples, although he was snatched from us by death in the very prime of life, at a time when greater things were looked for from him, yet showed in the works of sculpture that he made at Naples during his few years, what he would have done if he had lived longer; for the works that he executed in sculpture at Naples were wrought and finished with all the lovingness that could be desired in a young man who wishes to surpass by a great measure those who for many years before his day have held the sovereignty in some noble profession. In S. Giovanni Carbonaro at Naples he built the Chapel of the Marchese di Vico, which is a round temple, partitioned by columns and niches, with some tombs carved with much diligence. And because the altar-piece of this chapel, made of marble in half-relief and representing the Magi bringing their offerings to Christ, is by the hand of a Spaniard, Girolamo executed in emulation of this work a S. John in a niche, so beautifully wrought in full-relief, that it showed that he was not inferior to the Spaniard either in courage or in judgment; on which account he won such

a name, that, although Giovanni da Nola was held in Naples to be a marvellous sculptor and better than any other, nevertheless Girolamo worked in competition with him as long as he lived, notwithstanding that his rival was now old and had executed a vast number of works in that city, where it is much the custom to make chapels and altar-pieces of marble. Competing with Giovanni, then, Girolamo undertook to execute a chapel in Monte Oliveto at Naples, just within the door of the church, on the left hand, while Giovanni executed another opposite to his, on the other side, in the same style. In his chapel Girolamo made a life-size Madonna in the round, which is held to be a very beautiful figure; and since he took infinite pains in executing the draperies and the hands, and in giving bold relief to the marble by undercutting, he brought it to such perfection that it was the general opinion that he had surpassed all those who had handled tools for working marble at Naples in his time. This Madonna he placed between a S. John and a S. Peter, figures very well conceived and executed, and finished in a beautiful manner, as are also some children which are placed above them.

In addition to these, he made two large and most beautiful statues in full-relief for the Church of Capella, a seat of the Monks of Monte Oliveto. He then began a statue of the Emperor Charles V, at the time of his return from Tunis; but after he had blocked it and carved it with the pointed chisel, and even in some places with the broad-toothed chisel, it remained unfinished, because fortune and death, envying the world such excellence, snatched him from us at the age of thirty-five. It was confidently expected that Girolamo, if he had lived, even as he had outstripped all his compatriots in his profession, would also have surpassed all the craftsmen of his time. Wherefore his death was a grievous blow to the Neapolitans, and all the more because he had been endowed by nature not only with a most beautiful genius, but also with as much modesty, sweetness, and gentleness as could be looked for in mortal man; so that it is no marvel if all those who knew him are not able to restrain their tears when they speak of him. His last sculptures were executed in 1537, in which year he was buried at Naples with most honourable obsequies.

Old as he was, Giovanni da Nola, who was a well-practised sculptor, as may be seen from many works made by him at Naples with good skill of hand, but not with much design, still

remained alive. Him Don Pedro di Toledo, Marquis of Villafranca, and at that time Viceroy of Naples, commissioned to execute a tomb of marble for himself and his wife; and therein Giovanni made a great number of scenes of the victories obtained by that lord over the Turks, with many statues for the same work, which stands quite by itself, and was executed with much diligence. This tomb was to have been taken to Spain; but, since that nobleman did not do this while he was alive, it remained in Naples. Giovanni died at the age of seventy, and was buried in Naples, in the year 1558.

About the same time that Heaven presented to Ferrara, or rather, to the world, the divine Lodovico Ariosto, there was born in the same city the painter Dosso, who, although he was not as rare among painters as Ariosto among poets, nevertheless acquitted himself in his art in such a manner, that, besides the great esteem wherein his works were held in Ferrara, his merits caused the learned poet, his intimate friend, to honour his memory by mentioning him in his most celebrated writings; so that the pen of Messer Lodovico has given more renown to the name of Dosso than did all the brushes and colours that he used in the whole of his life. Wherefore I, for my part, declare that there could be no greater good-fortune than that of those who are celebrated by such great men, since the might of the pen forces most of mankind to accept their fame, even though they may not wholly deserve it.

Dosso was much beloved by Duke Alfonso of Ferrara: first for his good abilities in the art of painting, and then because he was a very pleasant and amiable person – a manner of man in whom the Duke greatly delighted. Dosso had the reputation in Lombardy of executing landscapes better than any other painter engaged in that branch of the profession, whether in mural painting, in oils, or in gouache; and all the more after the German manner became known. In Ferrara, for the Cathedral Church, he executed a panel-picture with figures in oils, which was held to be passing beautiful; and in the Duke's Palace he painted many rooms, in company with a brother of his, called Battista. These two were always enemies, one against the other, although they worked together by the wish of the Duke. In the court of the said palace they executed stories of Hercules in chiaroscuro, with an endless number of nudes on those walls; and in like manner they painted many works on panel and in fresco throughout all

Ferrara. By their hands is a panel in the Duomo of Modena; and they painted many things in the Cardinal's Palace at Trento, in company with other painters.

At this same time the painter and architect, Girolamo Genga, was executing various decorations in the Imperiale Palace, above Pesaro, as will be related in the proper place, for Duke Francesco Maria of Urbino; and among the number of painters who were summoned to that work by order of the same Signor Francesco Maria, invitations were sent to Dosso and Battista of Ferrara, principally for the painting of landscapes; many paintings having been executed long before in that palace by Francesco di Miroz-zo* of Forlì, Raffaello dal Colle of Borgo a San Sepolcro, and many others. Now, having arrived at the Imperiale, Dosso and Battista, according to the custom of men of their kidney, found fault with most of the paintings that they saw, and promised the Duke that they would do much better work; and Genga, who was a shrewd person, seeing how the matter was likely to end, gave them an apartment to paint by themselves. Thereupon, setting to work, they strove with all labour and diligence to display their worth; but, whatever may have been the reason, never in all the course of their lives did they do any work less worthy of praise, or rather, worse, than that one. It seems often to happen, indeed, that in their greatest emergencies, when most is expected of them, men become blinded and bewildered in judgment, and do worse work than at any other time; which may result, perchance, from their own malign and evil disposition to be always finding fault with the works of others, or from their seeking to force their genius overmuch, seeing that to proceed step by step according to the ruling of nature, yet without neglecting diligence and study, appears to be a better method than seeking to wrest from the brain, as it were by force, things that are not there; and it is a fact that in the other arts as well, but above all in that of writing, lack of spontaneity is only too easily recognized, and also, so to speak, over-elaboration in everything.

Now, when the work of the Dossi was unveiled, it proved to be so ridiculous that they left the service of the Duke in disgrace; and he was forced to throw to the ground all that they had executed, and to have it repainted by others after the designs of Genga.

* This seems to be an error for Melozzo.

Finally, they painted a very beautiful panel-picture in the Duomo of Faenza for the Chevalier, M. Giovan Battista de' Buosi, of Christ disputing in the Temple; in which work they surpassed themselves, by reason of the new manner that they used, and particularly in the portraits of that Chevalier and of others. That picture was set up in that place in the year 1536. Ultimately Dosso, having grown old, spent his last years without working, being pensioned until the close of his life by Duke Alfonso. And in the end Battista survived him, executing many works by himself, and maintaining himself in a good condition. Dosso was buried in his native city of Ferrara.

There lived in the same times the Milanese Bernazzano, a very excellent painter of landscapes, herbage, animals, and other things of earth, air, and water. And since, as one who knew himself to have little aptitude for figures, he did not give much attention to them, he associated himself with Cesare da Sesto, who painted them very well and in a beautiful manner. It is said that Bernazzano executed in a courtyard some very beautiful landscapes in fresco, in which he painted a strawberry-bed full of strawberries, ripe, green, and in blossom, and so well imitated, that some peacocks, deceived by their natural appearance, were so persistent in picking at them as to make holes in the plaster.

GIOVANNI ANTONIO LICINIO OF PORDENONE, AND OTHER PAINTERS OF FRIULI

It would seem, as has been remarked already in the same connection, that Nature, the kindly mother of the universe, sometimes presents the rarest things to certain places that never had any knowledge of such gifts, and that at times she creates in some country men so much inclined to design and to painting, that, without masters, but only by imitating living and natural objects, they become most excellent. And it also happens very often that when one man has begun, many set themselves to work in competition with him, and labour to such purpose, without seeing Rome, Florence, or any other place full of notable pictures, but merely through rivalry one with another, that marvellous works are seen to issue from their

hands. All this may be seen to have happened more particularly in Friuli, where, in our own day, in consequence of such a beginning, there has been a vast number of excellent painters – a thing which had not occurred in those parts for many centuries.

While Giovanni Bellini was working in Venice and teaching his art to many, as has been related, he had two disciples who were rivals one with another – Pellegrino da Udine, who, as will be told, was afterwards called Da San Daniele, and Giovanni Martini of Udine. Let us begin, then, by speaking of Giovanni. He always imitated the manner of Bellini, which was somewhat crude, hard, and dry; nor was he ever able to give it sweetness or softness, although he was a diligent and finished painter. This may have happened because he was always making trial of certain reflections, half-lights, and shadows, with which, cutting the relief in the middle, he contrived to define light and shade very abruptly, in such a way that the colouring of all his works was always crude and unpleasant, although he strove laboriously with his art to imitate Nature. By the hand of this master are numerous works in many places in Friuli, particularly in the city of Udine, in the Duomo of which there is a panel-picture executed in oils, of S. Mark seated with many figures round him, which is held to be the best of all that he ever painted. There is another on the altar of S. Ursula in the Church of the Friars of S. Pietro Martire, wherein the first-mentioned Saint is standing with some of her virgins round her, all painted with much grace and beautiful expressions of countenance. This Giovanni, besides being a passing good painter, was endowed by Nature with beauty and grace of features and an excellent character, and, what is most desirable, with such foresight and power of management, that, after his death, in default of heirs male, he left an inheritance of much property to his wife. And she, being, so I have heard, a lady as shrewd as she was beautiful, knew so well how to manage her life after the death of her husband, that she married two very beautiful daughters into the richest and most noble houses of Udine.

Pellegrino da San Daniele, who was a rival of Giovanni, as has been related, and a man of greater excellence in painting, received at baptism the name of Martino. But Giovanni Bellini, judging that he was destined to become, as he afterwards did, a truly rare master of art, changed his name from Martino to Pellegrino.*

* *I.e.,* singular or rare.

And even as his name was changed, so he may be said by chance to have changed his country, since, living by preference at San Daniele, a township ten miles distant from Udine, and spending most of his time in that place, where he had taken a wife, he was called ever afterwards not Martino da Udine, but Pellegrino da San Daniele. He painted many pictures in Udine, and some may still be seen on the doors of the old organ, on the outer side of which is painted a sunken arch in perspective, containing a S. Peter seated among a multitude of figures and handing a pastoral staff to S. Ermacora the Bishop. On the inner side of the same doors, likewise, in some niches, he painted the four Doctors of the Church in the act of studying. For the Chapel of S. Giuseppe he executed a panel-picture in oils, drawn and coloured with much diligence, in the middle of which is S. Joseph standing in a beautiful attitude, with an air of dignity, and beside him is Our Lord as a little Child, while S. John the Baptist is below in the garb of a little shepherd-boy, gazing intently on his Master. And since this picture is much extolled, we may believe what is said of it – namely, that he painted it in competition with the aforesaid Giovanni, and that he put forward every effort to make it, as it proved to be, more beautiful than that which Giovanni painted of S. Mark, as has been related above. Pellegrino also painted at Udine, for the house of Messer Pre Giovanni, intendant to the illustrious Signori della Torre, a picture of Judith from the waist upwards, with the head of Holofernes in one hand, which is a very beautiful work. By the hand of the same man is a large panel in oils, divided into several pictures, which may be seen on the high-altar of the Church of S. Maria in the town of Civitale, at a distance of eight miles from Udine; and in it are some heads of virgins and other figures with great beauty of expression. And in his township of San Daniele, in a chapel of S. Antonio, he painted in fresco scenes of the Passion of Jesus Christ, and that so finely that he well deserved to be paid more than a thousand crowns for the work. He was much beloved for his talents by the Dukes of Ferrara, and, in addition to other favours and many gifts, he obtained through their good offices two Canonicates in the Duomo of Udine for two of his relatives.

Among his pupils, of whom he had many, making much use of them and rewarding them liberally, was one of Greek nationality, a man of no little ability, who had a very beautiful manner and imitated Pellegrino closely. But Luca Monverde of Udine,

who was much beloved by Pellegrino, would have been superior to the Greek, if he had not been snatched from the world prematurely when still a mere lad; although one work by his hand was left on the high-altar of S. Maria delle Grazie in Udine, a panel-picture in oils, his first and last, in which, in a recess in perspective, there is a Madonna seated on high with the Child in her arms, painted by him with a soft gradation of shadow, while on the level surface below there are two figures on either side, so beautiful that they show that if he had lived longer he would have become truly excellent.

Another disciple of the same Pellegrino was Bastianello Florigorio, who painted a panel-picture that is over the high-altar of S. Giorgio in Udine, of a Madonna in the sky surrounded by an endless number of little angels in various attitudes, all adoring the Child that she holds in her arms; while below there is a very well executed landscape. There is also a very beautiful S. John, and a S. George in armour and on horseback, who, foreshortened in a spirited attitude, is slaying the Dragon with his lance; while the Maiden, who is there on one side, appears to be thanking God and the glorious Virgin for the succour sent to her. In the head of the S. George Bastianello is said to have made his own portrait. He also painted two pictures in fresco in the Refectory of the Friars of S. Pietro Martire: in one is Christ seated at table with the two disciples at Emmaus, and breaking the bread with a benediction, and in the other is the death of S. Peter Martyr. The same master painted in fresco in a niche on a corner of the Palace of M. Marguando, an excellent physician, a nude man in foreshortening, representing a S. John, which is held to be a good painting. Finally, he was forced through some dispute to depart from Udine, for the sake of peace, and to live like an exile in Civitale.

Bastianello had a crude and hard manner, because he much delighted in drawing works in relief and objects of Nature by candle-light. He had much beauty of invention, and he took great pleasure in executing portraits from life, making them truly beautiful and very like; and at Udine, among others, he made one of Messer Raffaello Belgrado, and one of the father of M. Giovan Battista Grassi, an excellent painter and architect, from whose loving courtesy we have received much particular information touching our present subject of Friuli. Bastianello lived about forty years.

Another disciple of Pellegrino was Francesco Floriani of Udine, who is still alive and is a very good painter and architect, like his younger brother, Antonio Floriani, who, thanks to his rare abilities in his profession, is now in the service of his glorious Majesty the Emperor Maximilian. Some of the pictures of that same Francesco were to be seen two years ago in the possession of the Emperor, who was then a King; one of these being a Judith who has cut off the head of Holofernes, painted with admirable judgment and diligence. And in the collection of that monarch there is a book of pen-drawings by the same master, full of lovely inventions, buildings, theatres, arches, porticoes, bridges, palaces, and many other works of architecture, all useful and very beautiful.

Gensio Liberale was also a disciple of Pellegrino, and in his pictures, among other things, he imitated every sort of fish excellently well. This master is now in the service of the Archduke Ferdinand of Austria, a splendid position, which he deserves, for he is a very good painter.

But among the most illustrious and renowned painters of the territory of Friuli, the rarest and most famous in our day – since he has surpassed those mentioned above by a great measure in the invention of scenes, in draughtsmanship, in boldness, in mastery over colour, in fresco work, in swiftness of execution, in strength of relief, and in every other department of our arts – is Giovanni Antonio Licinio, called by some Cuticello. This master was born at Pordenone, a township in Friuli, twenty-five miles from Udine; and since he was endowed by nature with a beautiful genius and an inclination for painting, he devoted himself without any teacher to the study of natural objects, imitating the style of Giorgione da Castelfranco, because that manner, seen by him many times in Venice, had pleased him much. Now, having learnt the rudiments of art, he was forced, in order to save his life from a pestilence that had fallen upon his native place, to take to flight; and thus, passing many months in the surrounding country, he executed various works in fresco for a number of peasants, gaining at their expense experience of using colour on plaster. Wherefore, since the surest and best method of learning is practice and a sufficiency of work, it came to pass that he became a well-practised and judicious master of that kind of painting, and learned to make colours produce the desired effect when used in a fluid state, which is done on account of the white, which dries

the plaster and produces a brightness that ruins all softness. And so, having mastered the nature of colours, and having learnt by long practice to work very well in fresco, he returned to Udine, where he painted for the altar of the Nunziata, in the Convent of S. Pietro Martire, a panel-picture in oils containing the Madonna at the moment of receiving the Salutation from the Angel Gabriel; and in the sky he made a God the Father surrounded by many little boys, who is sending down the Holy Spirit. This work, which is executed with good drawing, grace, vivacity, and relief, is held by all craftsmen of judgment to be the best that he ever painted.

In the Duomo of the same city, on the balustrade of the organ, below the doors already painted by Pellegrino, he painted a story of S. Ermacora and Fortunatus, also in oils, graceful and well designed. In the same city, in order to gain the friendship of the Signori Tinghi, he painted in fresco the façade of their palace; in which work, wishing to make himself known and to prove what a master he was of architectural invention and of working in fresco, he made a series of compartments and groups of varied ornaments full of figures in niches; and in three great spaces in the centre of the work he painted scenes with figures in colours, two spaces, high and narrow, being on either side, and one square in shape in the middle; and in the latter he painted a Corinthian column planted with its base in the sea, with a Siren on the right hand, holding the column upright, and a nude Neptune on the left supporting it on the other side; while above the capital of the column there is a Cardinal's hat, the device, so it is said, of Pompeo Colonna, who was much the friend of the owners of that palace. In one of the two other spaces are the Giants being slain with thunderbolts by Jove, with some dead bodies on the ground very well painted and most beautifully foreshortened. On the other side is a Heaven full of Gods, and on the earth two Giants who, club in hand, are in the act of striking at Diana, who, defending herself in a bold and spirited attitude, is brandishing a blazing torch as if to burn the arms of one of them.

At Spelimbergo, a large place fifteen miles above Udine, the balustrade and the doors of the organ in the great church are painted by the hand of the same master; on the outer side of one door is the Assumption of Our Lady, and on the inner side S. Peter and S. Paul before Nero, gazing at Simon Magus in the

air above; while on the other door there is the Conversion of S. Paul, and on the balustrade the Nativity of Christ.

Through this work, which is very beautiful, and many others, Pordenone came into repute and fame, and was summoned to Vicenza, whence, after having executed some works there, he made his way to Mantua, where he coloured a façade in fresco with marvellous grace for M. Paris, a gentleman of that city. Among other beautiful inventions which are in that work, much praise is due to a frieze of antique letters, one braccio and a half in height, at the top, below the cornice, among which, passing in and out of them, are many little children in various attitudes, all most beautiful.

That work finished, he returned in great credit to Piacenza, and there, besides many other works, he painted the whole of the tribune of S. Maria di Campagna, although by reason of his departure a part remained unfinished, which was afterwards finished with great diligence by Maestro Bernardo da Vercelli. In the same church he painted two chapels in fresco: one with stories of S. Catherine, and the other with the Nativity of Christ and the Adoration of the Magi, both being worthy of the highest praise. He then painted some poetical pictures in the beautiful garden of M. Barnaba dal Pozzo, a doctor; and, in the said Church of S. Maria di Campagna, the picture of S. Augustine, which is on the left hand as one enters the church. All these most beautiful works brought it about that the gentlemen of that city persuaded him to take a wife there, and always held him in vast veneration.

Going afterwards to Venice, where he had formerly executed some works, he painted a wall of S. Geremia, on the Grand Canal, and a panel-picture in oils for the Madonna del Orto, with many figures, making a particular effort to prove his worth in the S. John the Baptist. He also painted many scenes in fresco on the façade of the house of Martin d'Anna on the same Grand Canal; in particular, a Curtius on horseback in foreshortening, which has the appearance of being wholly in the round, like the Mercury flying freely through the air, not to speak of many other things that all prove his ability. That work pleased the whole city of Venice beyond measure, and Pordenone was therefore extolled more highly than any other man who had ever worked in the city up to that time.

Among other reasons that caused him to give an incredible

amount of effort to all his works, was his rivalry with the most excellent Tiziano; since, setting himself to compete with him, he hoped by means of continual study and by a bold and resolute method of working in fresco to wrest from the hands of Tiziano that sovereignty which he had gained with so many beautiful works; employing, also, unusual methods outside the field of art, such as that of being obliging and courteous and associating continually and of set purpose with great persons, making his interests universal, and taking a hand in everything. And, in truth, this rivalry was a great assistance to him, for it caused him to devote the greatest zeal and diligence in his power to all his works, so that they proved worthy of eternal praise.

For these reasons, then, he was commissioned by the Wardens of S. Rocco to paint in fresco the chapel of that church, with all the tribune. Setting his hand, therefore, to this work, he painted a God the Father in the tribune, with a vast number of children in various beautiful attitudes, radiating from Him. In the frieze of the same tribune he painted eight figures from the Old Testament, with the four Evangelists in the angles, and the Transfiguration of Christ over the high-altar; and in the two lunettes at the sides are the four Doctors of the Church. By the hand of the same master are two large pictures in the middle of the church: in one is Christ healing an endless number of the sick, all very well painted, and in the other is S. Christopher carrying Jesus Christ on his shoulders. On the wooden tabernacle of the same church, wherein the vessels of silver are kept, he painted a S. Martin on horseback, with many beggars who are bringing votive offerings, in a building in perspective.

This work, which was much extolled and brought him honour and profit, was the reason that M. Jacopo Soranzo, having become his intimate friend, caused him to be commissioned to paint the Sala de' Pregai in competition with Tiziano; and there he executed many pictures with figures seen foreshortened from below, which are very beautiful, together with a frieze of marine monsters painted in oils round that hall. These works made him so dear to the Senate, that as long as he lived he always received an honourable salary from them. And since, out of rivalry, he always sought to do work in places where Tiziano had also worked, he painted for S. Giovanni di Rialto a S. John, as Almoner, giving alms to beggars, and also placed on an altar a picture of S. Sebastian, S. Rocco, and other saints, which was very

beautiful, but yet not equal to the work of Tiziano, although many, more out of malignity than out of a love for the truth, exalted that of Giovanni Antonio. The same master painted in the cloister of S. Stefano many scenes in fresco from the Old Testament, and one from the New, divided one from another by various Virtues; and in these figures he displayed amazing fore-shortenings, in which method of painting he always delighted, seeking to introduce them into his every composition with no fear of difficulties, and making them more ornate than any other painter.

Prince Doria had built a palace on the seashore in Genoa, and had commissioned Perino del Vaga, a very celebrated painter, to paint halls, apartments, and ante-chambers both in oils and in fresco, which are quite marvellous for the richness and beauty of the paintings. But seeing that Perino was not then giving much attention to the work, and wishing to make him do by the spur of emulation what he was not doing by himself, he sent for Pordenone, who began with an open terrace, wherein, follow-ing his usual manner, he executed a frieze of children, who are hurrying about in very beautiful attitudes and unloading a barque full of merchandise. He also painted a large scene of Jason asking leave from his uncle to go in search of the Golden Fleece. But the Prince, seeing the difference that there was be-tween the work of Perino and that of Pordenone, dismissed the latter, and summoned in his place Domenico Beccafumi of Siena, an excellent painter and a rarer master than Pordenone. And he, glad to serve so great a Prince, did not scruple to leave his native city of Siena, where there are so many marvellous works by his hand; but he did not paint more than one single scene in that palace, because Perino brought everything to completion by him-self.

Giovanni Antonio then returned to Venice, where he was given to understand that Ercole, Duke of Ferrara, had brought a great number of masters from Germany, and had caused them to begin to make fabrics in silk, gold, floss-silk, and wool, for his own use and pleasure, but that he had no good designers of figures in Ferrara, since Girolamo da Ferrara had more ability for portraits and separate things than for difficult and complicated scenes, which called for great power of art and design; and that he should enter the service of that Prince. Whereupon, desiring to gain fame no less than riches, he departed from Venice, and

on reaching Ferrara was received with great warmth by the Duke. But a little time after his arrival, being attacked by a most grievous affliction of the chest, he took to his bed with the doom of death upon him, and, growing continually worse and finding no remedy, within three days or little more he finished the course of his life, at the age of fifty-six. This seemed a strange thing to the Duke, and also to Pordenone's friends; and there were not wanting men who for many months believed that he had died of poison. The body of Giovanni Antonio was buried with honour, and his death was a grief to many, particularly in Venice, for the reason that he was ready of speech and the friend and companion of many, and delighted in music; and his readiness and grace of speech came from his having given attention to the study of Latin. He always made his figures grand, and was very rich in invention, and so versatile that he could imitate everything very well; but he was, above all, resolute and most facile in works in fresco.

A disciple of Pordenone was Pomponio Amalteo of San Vito, who won by his good qualities the honour of becoming the son-in-law of his master. This Pomponio, always following that master in matters of art, has acquitted himself very well in all his works, as may be seen at Udine from the doors of the new organ, painted in oils, on the outer side of which is Christ driving the traders from the Temple, and on the inner side the story of the Pool of Bethesda and the Resurrection of Lazarus. In the Church of S. Francesco, in the same city, there is a panel-picture in oils by the hand of the same man, of S. Francis receiving the Stigmata, with some very beautiful landscapes, and with a sunrise from which, in the midst of some rays of the greatest splendour, there radiates the celestial light, which pierces the hands, feet, and side of S. Francis, who, kneeling devoutly and full of love, receives it, while his companion lies on the ground, in foreshortening, all overcome with amazement. Pomponio also painted in fresco for the Friars of La Vigna, at the end of their refectory, Jesus Christ between the two disciples at Emmaus. In the township of San Vito, his native place, twenty miles distant from Udine, he painted in fresco the Chapel of the Madonna in the Church of S. Maria, in so beautiful a manner, and so much to the satisfaction of all, that he has won from the most reverend Cardinal Maria Grimani, Patriarch of Aquileia and Lord of San Vito, the honour of being enrolled among the nobles of that place.

I have thought it right in this Life of Pordenone to make mention of these excellent craftsmen of Friuli, both because it appears to me that their talents deserve it, and to the end that it may be recognized in the account to be given later how much more excellent are those who, after such a beginning, have lived since that day, as will be related in the Life of Giovanni Ricamatori of Udine, to whom our age owes a very great obligation for his works in stucco and his grotesques.

But returning to Pordenone; after the works mentioned above as having been executed by him at Venice in the time of the most illustrious Gritti, he died, as has been related, in the year 1540. And because he was one of the most able men that our age has possessed, and for the reason, above all, that his figures seem to be in the round and detached from their walls, and almost in relief, he can be numbered among those who have rendered assistance to art and benefit to the world.

GIOVANNI ANTONIO SOGLIANI,
Painter of Florence

VERY often do we see in the sciences of learning and in the more liberal of the manual arts, that those men who are melancholy are the most assiduous in their studies and show the greatest patience in supporting the burden of their labours; so that there are few of that disposition who do not become excellent in such professions. Even so did Giovanni Antonio Sogliani, a painter of Florence, whose cast of countenance was so cold and woeful that he looked like the image of melancholy; and such was the power of this humour over him that he gave little thought to anything but matters of art, with the exception of his household cares, through which he endured most grievous anxieties, although he had enough to live in comfort. He worked at the art of painting under Lorenzo di Credi for four-and-twenty years, living with him, honouring him always, and rendering him every sort of service. Having become during that time a very good painter, he showed afterwards in all his works that he was a most faithful disciple of his master and a close imitator of his manner. This was seen from his first paintings, in

the Church of the Osservanza on the hill of San Miniato without Florence, for which he painted a panel-picture copied from the one that Lorenzo had executed for the Nuns of S. Chiara, containing the Nativity of Christ, and no less excellent than the one of Lorenzo.

Afterwards, having left his master, he painted for the Church of S. Michele in Orto, at the commission of the Guild of Vintners, a S. Martin in oils, robed as a Bishop, which gave him the name of a very good master. And since Giovanni Antonio had a vast veneration for the works and the manner of Fra Bartolommeo di San Marco, and made great efforts to approach that manner in his colouring, it may be seen from a panel which he began but did not finish, not being satisfied with it, how much he imitated that painter. This panel remained in his house during his lifetime as worthless: but after his death it was sold as a piece of old rubbish to Sinibaldo Gaddi, and he had it finished by Santi Titi dal Borgo, then a mere boy, and placed it in a chapel of his own in S. Domenico da Fiesole. In this work are the Magi adoring Jesus Christ, who is in the lap of His Mother, and in one corner is his own portrait from life, which is a passing good likeness.

He then painted for Madonna Alfonsina, the wife of Piero de' Medici, a panel-picture that was placed as a votive offering over the altar of the Chapel of the Martyrs in the Camaldolite Church at Florence: in which picture he painted the Crucifixion of S. Arcadio and other martyrs with their crosses in their arms, and two figures, half covered with draperies and half naked, kneeling with their crosses on the ground, while in the sky are some little angels with palms in their hands. This work, which was painted with much diligence, and executed with good judgment in the colouring and in the heads, which are very lifelike, was placed in the above-mentioned Camaldolite Church; but that monastery was taken on account of the siege of Florence from those Eremite Fathers, who used devoutly to celebrate the Divine offices in the church, and was afterwards given to the Nuns of S. Giovannino, of the Order of the Knights of Jerusalem, and finally destroyed; and the picture, being one which may be numbered among the best works that Sogliani painted, was placed by order of the Lord Duke Cosimo in one of the chapels of the Medici family in S. Lorenzo.

The same master executed for the Nuns of the Crocetta a Last

Supper coloured in oils, which was much extolled at that time. And in a shrine in the Via de' Ginori, he painted in fresco for Taddeo Taddei a Crucifix with Our Lady and S. John at the foot, and in the sky some angels lamenting Christ, very lifelike – a picture truly worthy of praise, and a well-executed example of work in fresco. By the hand of Sogliani, also, is a Crucifix in the Refectory of the Abbey of the Black Friars in Florence, with angels flying about and weeping with much grace; and at the foot the Madonna, S. John, S. Benedict, S. Scholastica, and other figures. For the Nuns of the Spirito Santo, on the hill of San Giorgio, he painted two pictures that are in their church, one of S. Francis, and the other of S. Elizabeth, Queen of Hungary and a sister of that Order. For the Company of the Ceppo he painted the banner for carrying in processions, which is very beautiful, representing on the front of it the Visitation of Our Lady, and on the other side S. Niccolò the Bishop, with two children dressed as Flagellants, one of whom holds his book and the other the three balls of gold. On a panel in S. Jacopo sopra Arno he painted the Trinity, with an endless number of little boys, S. Mary Magdalene kneeling, S. Catherine, S. James, and two figures in fresco standing at the sides, S. Jerome in Penitence and S. John; and in the predella he made his assistant, Sandrino del Calzolaio, execute three scenes, which won no little praise.

On the end wall of the Oratory of a Company in the township of Anghiari, he executed on panel a Last Supper in oils, with figures of the size of life; and on one of the two adjoining walls (namely, the sides) he painted Christ washing the feet of the Apostles, and on the other a servant bringing two vessels of water. The work is held in great veneration in that place, for it is indeed a rare thing, and one that brought him both honour and profit. A picture that he executed of a Judith who had cut off the head of Holofernes, being a very beautiful work, was sent to Hungary. And likewise another, in which was the Beheading of S. John the Baptist, with a building in perspective for which he had copied the exterior of the Chapter-house of the Pazzi, which is in the first cloister of S. Croce, was sent as a most beautiful work to Naples by Paolo da Terrarossa, who had given the commission for it. For one of the Bernardi, also, Sogliani executed two other pictures, which were placed in a chapel in the Church of the Osservanza at San Miniato, containing two lifesize figures in oils – S. John the Baptist and S. Anthony of Padua. But as for

the panel that was to stand between them, Giovanni Antonio, being dilatory by nature and leisurely over his work, lingered over it so long that he who had given the commission died: wherefore that panel, which was to contain a Christ lying dead in the lap of His Mother, remained unfinished.

After these things, when Perino del Vaga, having departed from Genoa on account of his resentment against Prince Doria, was working at Pisa, where the sculptor Stagio da Pietrasanta had begun the execution of the new chapels in marble at the end of the nave of the Duomo, together with that space behind the high-altar, which serves as a sacristy, it was ordained that the said Perino, as will be related in his Life, with other masters, should begin to fill up those adornments of marble with pictures. But Perino being recalled to Genoa, Giovanni Antonio was commissioned to set his hand to the pictures that were to adorn the aforesaid recess behind the high-altar, and to deal in his works with the sacrifices of the Old Testament, as symbols of the Sacrifice of the Most Holy Sacrament, which was there over the centre of the high-altar. Sogliani, then, painted in the first picture the sacrifice that Noah and his sons offered when they had gone forth from the Ark, and afterwards those of Cain and of Abel; which were all highly extolled, but above all that of Noah, because some of the heads and parts of the figures in it were very beautiful. The picture of Abel is charming for its landscapes, which are very well executed, and the head of Abel himself, which is the very presentment of goodness; but quite the opposite is that of Cain, which has the mien of a truly sorry villain. And if Sogliani had pursued the work with energy instead of being dilatory, he would have been charged by the Warden, who had given him his commission and was much pleased with his manner and character, to execute all the work in that Duomo, whereas at that time, in addition to the pictures already mentioned, he painted no more than one panel, which was destined for the chapel wherein Perino had begun to work; and this he finished in Florence, but in such wise that it pleased the Pisans well enough and was held to be very beautiful. In it are the Madonna, S. John the Baptist, S. George, S. Mary Magdalene, S. Margaret, and other saints. His picture, then, having given satisfaction, Sogliani received from the Warden a commission for three other panels, to which he set his hand, but did not finish them in the lifetime of that Warden, in whose place Bastiano

della Seta was elected; and he, perceiving that the business was moving but slowly, allotted four pictures for the aforesaid sacristy behind the high-altar to Domenico Beccafumi of Siena, an excellent painter, who dispatched them very quickly, as will be told in the proper place, and also painted a panel there, and other painters executed the rest. Giovanni Antonio, then, working at his leisure, finished two other panels with much diligence, painting in each a Madonna surrounded by many saints. And finally, having made his way to Pisa, he there painted the fourth and last, in which he acquitted himself worse than in any other, either through old age, or because he was competing with Beccafumi, or for some other reason.

But the Warden Bastiano, perceiving the slowness of the man, and wishing to bring the work to an end, allotted the three other panels to Giorgio Vasari of Arezzo, who finished two of them, those that are beside the door of the façade. In the one nearer the Campo Santo is Our Lady with the Child in her arms, with S. Martha caressing Him. There, also, on their knees, are S. Cecilia, S. Augustine, S. Joseph, and S. Guido the Hermit, and in the foreground a nude S. Jerome, with S. Luke the Evangelist, and some little boys uplifting a piece of drapery, and others holding flowers. In the other, by the wish of the Warden, he painted another Madonna with her Son in her arms, S. James the Martyr, S. Matthew, S. Sylvester the Pope, and S. Turpè the Chevalier. Having to paint the Madonna, and not wishing to repeat the same composition (although he had varied it much in other respects), he made her with Christ dead in her arms, and those saints as it were round a Deposition from the Cross; and on the crosses, planted on high and made of tree-trunks, are fixed two naked Thieves, surrounded by horses and ministers of the crucifixion, with Joseph, Nicodemus, and the Maries; all for the satisfaction of the Warden, who wished that in those new pictures there should be included all the saints that there had been in the past in the various dismantled chapels, in order to renew their memory in the new works. One picture was still wanting to complete the whole, and this was executed by Bronzino, who painted a nude Christ and eight saints. And in this manner were those chapels brought to completion, all of which Giovanni Antonio could have done with his own hand if he had not been so slow.

And since Sogliani had won much favour with the Pisans,

after the death of Andrea del Sarto he was commissioned to finish a panel for the Company of S. Francesco, which the said Andrea left only sketched; which panel is now in the building of that Company on the Piazza di S. Francesco at Pisa. The same master executed some rows of cloth-hangings for the Wardens of Works of the aforesaid Duomo, and many others in Florence, because he took pleasure in doing that sort of work, and above all in company with his friend Tommaso di Stefano, a painter of Florence.

Being summoned by the Friars of S. Marco in Florence to paint a work in fresco at the head of their refectory, at the expense of one of their number, a lay-brother of the Molletti family, who had possessed a rich patrimony when in the world, Giovanni Antonio wished to paint there the scene of Jesus Christ feeding five thousand persons with five loaves and two fishes, in order to make the most of his powers; and he had already made the design for it, with many women and children and a great multitude of other people, when the friars refused to have that story, saying that they wanted something definite, simple, and familiar. Whereupon, to please them, he painted the scene when S. Dominic, being in the refectory with his friars and having no bread, made a prayer to God, when the table was miraculously covered with bread, brought by two angels in human form. In this work he made portraits of many friars who were then in the convent, which have the appearance of life, and particularly that of the lay-brother of the Molletti family, who is serving at table. Then, in the lunette above the table, he painted S. Dominic at the foot of a Crucifix, with Our Lady and S. John the Evangelist, who are weeping, and at the sides S. Catherine of Siena and S. Antonino, Archbishop of Florence, a brother of their Order. All this, for a work in fresco, was executed with much diligence and a high finish; but Sogliani would have been much more successful if he had executed what he had designed, because painters express the conceptions of their own minds better than those of others. On the other hand, it is only right that he who pays the piper should call the tune. The design for the Miracle of the Loaves and Fishes is in the hands of Bartolommeo Gondi, who, in addition to a large picture that he has by the hand of Sogliani, also possesses many drawings and heads painted from life on tinted paper, which he received from the wife of the painter, who had been very much his friend, after his death. And

we, also, have in our book some drawings by the same hand, which are beautiful to a marvel.

Sogliani began for Giovanni Serristori a large panel-picture which was to be placed in S. Francesco dell' Osservanza, without the Porta a S. Miniato, with a vast number of figures, among which are some marvellous heads, the best that he ever made; but it was left unfinished at the death of the said Giovanni Serristori. Nevertheless, since Giovanni Antonio had received full payment, he finished it afterwards little by little, and gave it to Messer Alamanno di Jacopo Salviati, the son-in-law and heir of Giovanni Serristori; and he presented it, frame and all, to the Nuns of S. Luca, who have it over their high-altar in the Via di S. Gallo.

Giovanni Antonio executed many other works in Florence, some of which are in the houses of citizens, and some were sent to various countries; but of these there is no need to make mention, for we have spoken of the most important. Sogliani was an upright person, very religious, always occupied with his own business, and never interfering with his fellow-craftsmen.

One of his disciples was Sandrino del Calzolaio, who painted the shrine that is on the Canto delle Murate, and, in the Hospital of the Temple, a S. John the Baptist who is assigning shelter to the poor; and he would have done more work, and good work, if he had not died as young as he did. Another of his disciples was Michele, who afterwards went to work with Ridolfo Ghirlandajo, whose name he took; and likewise Benedetto, who went with Antonio Mini, a disciple of Michelagnolo Buonarroti, to France, where he has executed many beautiful works. And another, finally, was Zanobi di Poggino, who has painted many works throughout the city.

In the end, being weary and broken in health after having been long tormented by the stone, Giovanni Antonio rendered up his soul to God at the age of fifty-two. His death was much lamented, for he had been an excellent man, and his manner had been much in favour, since he gave an air of piety to his figures, in such a fashion as pleases those who, delighting little in the highest and most difficult flights of art, love things that are seemly, simple, gracious, and sweet. His body was opened after his death, and in it were found three stones, each as big as an egg; but as long as he lived he would never consent to have them extracted, or to hear a word about them.

GIROLAMO DA TREVISO, Painter

Rarely does it happen that those who persist in working in the country in which they were born, are exalted by Fortune to that height of prosperity which their talents deserve; whereas, if a man tries many, he must in the end find one wherein sooner or later he succeeds in being recognized. And it often comes to pass that one who attains to the reward of his labours late in life, is prevented by the venom of death from enjoying it for long, even as we shall see in the case of Girolamo da Treviso.

This painter was held to be a very good master; and although he was no great draughtsman, he was a pleasing colourist both in oils and in fresco, and a close imitator of the methods of Raffaello da Urbino. He worked much in his native city of Treviso; and he also executed many works in Venice, such as, in particular, the façade of the house of Andrea Udoni, which he painted in fresco, with some friezes of children in the courtyard, and one of the upper apartments: all of which he executed in colour, and not in chiaroscuro, because the Venetians like colour better than anything else. In a large scene in the middle of this façade is a Juno, seen from the thighs upwards, flying on some clouds with the moon on her head, over which are raised her arms, one holding a vase and the other a bowl. He also painted there a Bacchus, fat and ruddy, with a vessel that he is upsetting, and holding with one arm a Ceres who has many ears of corn in her hands. There, too, are the Graces, with five little boys who are flying below and welcoming them, in order, so they signify, to make the house of the Udoni abound with their gifts; and to show that the same house was a friendly haven for men of talent, he painted Apollo on one side and Pallas on the other. This work was executed with great freshness, so that Girolamo gained from it both honour and profit.

The same master painted a picture for the Chapel of the Madonna in S. Petronio, in competition with certain painters of Bologna, as will be related in the proper place. And continuing to live in Bologna, he executed many pictures there; and in S. Petronio, in the Chapel of S. Antonio da Padova, he depicted in oils, in imitation of marble, all the stories of the life of the latter Saint, in which, without a doubt, there may be perceived grace, judgment, excellence, and a great delicacy of finish. He

painted a panel-picture for S. Salvatore, of the Madonna ascending the steps of the Temple, with some saints; and another of the Madonna in the sky, with some children, and S. Jerome and S. Catherine beneath, which is certainly the weakest work by his hand that is to be seen in Bologna. Over a great portal, also, in Bologna, he painted in fresco a Crucifix with Our Lady and S. John, all worthy of the highest praise. For S. Domenico, at Bologna, he executed a panel-picture in oils of Our Lady with some saints, which is the best of his works; it is near the choir, as one ascends to the tomb of S. Dominic, and in it is the portrait of the patron who had it painted. In like manner, he painted a picture for Count Giovanni Battista Bentivogli, who had the cartoon by the hand of Baldassarre of Siena, representing the story of the Magi: a work which he carried to a very fine completion, although it contained more than a hundred figures. There are also many other works by the hand of Girolamo in Bologna, both in private houses and in the churches. In Galiera he painted in chiaroscuro the façade of the Palace of the Teofamini, with another façade behind the house of the Dolfi, which is considered in the judgment of many craftsmen to be the best work that he ever executed in that city.

He went to Trento, and, in company with other painters, painted the palace of the old Cardinal, from which he gained very great fame. Then, returning to Bologna, he gave his attention to the works that he had begun. Now it happened that there was much talk throughout Bologna about having a panel-picture painted for the Della Morte Hospital, for which various designs were made by way of competition, some in drawing and some in colour. And since many thought that they had the first claim, some through interest and others because they held themselves to be most worthy of such a commission, Girolamo was left in the lurch; and considering that he had been wronged, not long afterwards he departed from Bologna. And thus the envy of others raised him to such a height of prosperity as he had never thought of; since, if he had been chosen for the work, it would have impeded the blessings that his good fortune had prepared for him. For, having made his way to England, he was recommended by some friends, who favoured him, to King Henry; and presenting himself before him, he entered into his service, although not as painter, but as engineer. Then, making trial of his skill in various edifices, copied from some in Tuscany and other

parts of Italy, that King pronounced them marvellous, rewarded him with a succession of presents, and decreed him a provision of four hundred crowns a year; and he was given the means to build an honourable abode for himself at the expense of the King. Thereupon Girolamo, raised from one extreme of distress to the other extreme of grandeur, lived a most happy and contented life, thanking God and Fortune for having turned his steps to a country where men were so favourable to his talents. But this unwonted happiness was not destined to last long, for the war between the French and the English being continued, and Girolamo being charged with superintending all the work of the bastions and fortifications, the artillery, and the defences of the camp, it happened one day, when the city of Boulogne in Picardy was being bombarded, that a ball from a demi-cannon came with horrid violence and cut him in half on his horse's back. And thus, Girolamo being at the age of thirty-six, his life, his earthly honours, and all his greatness were extinguished at one and the same moment, in the year 1544.

POLIDORO DA CARAVAGGIO AND
MATURINO, Painters

In the last age of gold, as the happy age of Leo X might have been called for all noble craftsmen and men of talent, an honoured place was held among the most exalted spirits by Polidoro da Caravaggio, a Lombard, who had not become a painter after long study, but had been created and produced as such by Nature. This master, having come to Rome at the time when the Loggie of the Papal Palace were being built for Leo under the direction of Raffaello da Urbino, carried the pail, or we should rather say the hod, full of lime, for the masons who were doing the work, until he had reached the age of eighteen. But, when Giovanni da Udine had begun to paint there, the building and the painting proceeding together, Polidoro, whose will and inclination were much drawn to painting, could not rest content until he had become intimate with all the most able of the young men, in order to study their methods and manners of art, and to set himself to draw. And out of their number he chose as his companion the Florentine Maturino, who was then working in the

Papal Chapel, and was held to be an excellent draughtsman of antiquities. Associating with him, Polidoro became so enamoured of that art, that in a few months, having made trial of his powers, he executed works that astonished every person who had known him in his former condition. On which account, the work of the Loggie proceeding, he exercised his hand to such purpose in company with those young painters, who were well-practised and experienced in painting, and learned the art so divinely well, that he did not leave that work without carrying away the true glory of being considered the most noble and most beautiful intellect that was to be found among all their number. Thereupon the love of Maturino for Polidoro, and of Polidoro for Maturino, so increased, that they determined like brothers and true companions to live and die together; and, uniting their ambitions, their purses, and their labours, they set themselves to work together in the closest harmony and concord. But since there were in Rome many who had great fame and reputation, well justified by their works, for making their paintings more lively and vivacious in colour and more worthy of praise and favour, there began to enter into their minds the idea of imitating the methods of Baldassarre of Siena, who had executed several façades of houses in chiaroscuro, and of giving their attention thenceforward to that sort of work, which by that time had come into fashion.

They began one, therefore, on Montecavallo, opposite to S. Silvestro, in company with Pellegrino da Modena, which encouraged them to make further efforts to see whether this should be their profession; and they went on to execute another opposite to the side-door of S. Salvatore del Lauro, and likewise painted a scene by the side-door of the Minerva, with another, which is a frieze of marine monsters, above S. Rocco a Ripetta. And during this first period they painted a vast number of them throughout all Rome, but not so good as the others; and there is no need to mention them here, since they afterwards did better work of that sort. Gaining courage, therefore, from this, they began to study the antiquities of Rome, counterfeiting the ancient works of marble in their works in chiaroscuro, so that there remained no vase, statue, sarcophagus, scene, or any single thing, whether broken or entire, which they did not draw and make use of. And with such constancy and resolution did they give their minds to this pursuit, that they both acquired the ancient manner, the work of the one being so like that of the other, that, even as their

minds were guided by one and the same will, so their hands expressed one and the same knowledge. And although Maturino was not as well assisted by Nature as Polidoro, so potent was the faithful imitation of one style by the two in company, that, wherever either of them placed his hand, the work of both one and the other, whether in composition, expression, or manner, appeared to be the same.

In the Piazza di Capranica, on the way to the Piazza Colonna, they painted a façade with the Theological Virtues, and a frieze of very beautiful invention beneath the windows, including a draped figure of Rome representing the Faith, and holding the Chalice and the Host in her hands, who has taken captive all the nations of the earth; and all mankind is flocking up to bring her tribute, while the Turks, overcome at the last, are shooting arrows at the tomb of Mahomet; all ending in the words of Scripture, 'There shall be one fold and one Shepherd.' And, indeed, they had no equals in invention; of which we have witness in all their works, abounding in personal ornaments, vestments, foot-wear, and things bizarre and strange, and executed with an incredible beauty. And another proof is that their works are continually being drawn by all the foreign painters; wherefore they conferred greater benefits on the art of painting with the beautiful manner that they displayed and with their marvellous facility, than have all the others together who have lived from Cimabue downwards. It has been seen continually, therefore, in Rome, and is still seen, that all the draughtsmen are inclined more to the works of Polidoro and Maturino than to all the rest of our modern pictures.

In the Borgo Nuovo they executed a façade in sgraffito, and on the Canto della Pace another likewise in sgraffito; with a façade of the house of the Spinoli, not far from that last-mentioned, on the way to the Parione, containing athletic contests according to the custom of the ancients, and their sacrifices, and the death of Tarpeia. Near the Torre di Nona, on the side towards the Ponte S. Angelo, may be seen a little façade with the Triumph of Camillus and an ancient sacrifice. In the road that leads to the Imagine di Ponte, there is a most beautiful façade with the story of Perillus, showing him being placed in the bronze bull that he had made; wherein great effort may be seen in those who are thrusting him into that bull, and terror in those who are waiting to behold a death so unexampled, besides which there is the seated figure of Phalaris (so I believe), ordaining with

an imperious air of great beauty the punishment of the inhuman spirit that had invented a device so novel and so cruel in order to put men to death with greater suffering. In this work, also, may be perceived a very beautiful frieze of children, painted to look like bronze, and other figures. Higher up than this they painted the façade of the house where there is the image which is called the Imagine di Ponte, wherein are seen several stories illustrated by them, with the Senatorial Order dressed in the garb of ancient Rome. And in the Piazza della Dogana, beside S. Eustachio, there is a façade of battle-pieces; and within that church, on the right as one enters, may be perceived a little chapel with figures painted by Polidoro.

They also executed another above the Farnese Palace for the Cepperelli, and a façade behind the Minerva in the street that leads to the Maddaleni; and in the latter, which contains scenes from Roman history, may be seen, among other beautiful things, a frieze of children in triumph, painted to look like bronze, and executed with supreme grace and extraordinary beauty. On the façade of the Buoni Auguri, near the Minerva, are some very beautiful stories of Romulus, showing him when he is marking out the site of his city with the plough, and when the vultures are flying over him; wherein the vestments, features, and persons of the ancients are so well imitated, that it truly appears as if these were the very men themselves. Certain it is that in that field of art no man ever had such power of design, such practised mastery, a more beautiful manner, or greater facility. And every craftsman is so struck with wonder every time that he sees these works, that he cannot but be amazed at the manner in which Nature has been able in this age to present her marvels to us by means of these men.

Below the Corte Savella, also, on the house bought by Signora Costanza, they painted the Rape of the Sabines, a scene which reveals the raging desire of the captors no less clearly than the terror and panic of the wretched women thus carried off by various soldiers, some on horseback and others in other ways. And not only in this one scene are there such conceptions, but also (and even more) in the stories of Mucius and Horatius, and in the Flight of Porsena, King of Tuscany. In the garden of M. Stefano dal Bufalo, near the Fountain of Trevi, they executed some most beautiful scenes of the Fount of Parnassus, in which they made grotesques and little figures, painted very well in colour. On the

house of Baldassini, also, near S. Agostino, they executed scenes and sgraffiti, with some heads of Emperors over the windows in the court. On Montecavallo, near S. Agata, they painted a façade with a vast number of different stories, such as the Vestal Tuccia bringing water from the Tiber to the Temple in a sieve, and Claudia drawing the ship with her girdle; and also the rout effected by Camillus while Brennus is weighing the gold. On another wall, round the corner, are Romulus and his brother being suckled by the wolf, and the terrible combat of Horatius, who is defending the head of the bridge, alone against a thousand swords, while behind him are many very beautiful figures in various attitudes, working with might and main to hew away the bridge with pickaxes. There, also, is Mucius Scaevola, who, before the eyes of Porsena, is burning his own hand, which had erred in slaying the King's minister in place of the King; and in the King's face may be seen disdain and a desire for vengeance. And within that house they executed a number of landscapes.

They decorated the façade of S. Pietro in Vincula, painting therein stories of S. Peter, with some large figures of Prophets. And so widespread was the fame of these masters by reason of the abundance of their work, that the pictures painted by them with such beauty in public places enabled them to win extraordinary praise in their lifetime, with glory infinite and eternal through the number of their imitators after death. On a façade, also, in the square where stands the Palace of the Medici, behind the Piazza Navona, they painted the Triumphs of Paulus Emilius, with a vast number of other Roman stories. And at S. Silvestro di Montecavallo they executed some little things for Fra Mariano, both in the house and in the garden; and in the church they painted his chapel, with two scenes in colour from the life of S. Mary Magdalene, in which the disposition of the landscapes is executed with supreme grace and judgment. For Polidoro, in truth, executed landscapes and groups of trees and rocks better than any other painter, and it is to him that art owes that facility which our modern craftsmen show in their works.

They also painted many apartments and friezes in various houses at Rome, executing them with colours in fresco and in distemper; but these works were attempted by them as trials, because they were never able to achieve with colours that beauty which they always displayed in their works in chiaroscuro, in their

imitations of bronze, or in terretta. This may still be seen in the house of Torre Sanguigna, which once belonged to the Cardinal of Volterra, on the façade of which they painted a most beautiful decoration in chiaroscuro, and in the interior some figures in colour, the painting of which is so badly executed, that in it they diverted from its true excellence the good design which they always had. And this appeared all the more strange because of there being beside them an escutcheon of Pope Leo, with nude figures, by the hand of Giovan Francesco Vetraio, who would have done extraordinary things if death had not taken him from our midst. However, not cured by this of their insane confidence, they also painted some children in colour for the altar of the Martelli in S. Agostino at Rome, a work which Jacopo Sansovino completed by making a Madonna of marble; and these children appear to be by the hands, not of illustrious masters, but of simpletons just beginning to learn. Whereas, on the side where the altar-cloth covers the altar, Polidoro painted a little scene of a Dead Christ with the Maries, which is a most beautiful work, showing that in truth that sort of work was more their profession than the use of colours.

Returning, therefore, to their usual work, they painted two very beautiful façades in the Campo Marzio; one with the stories of Ancus Martius, and the other with the Festivals of the Saturnalia, formerly celebrated in that place, with all the two-horse and four-horse chariots circling round the obelisks, which are held to be most beautiful, because they are so well executed both in design and in nobility of manner, that they reproduce most vividly those very spectacles as representations of which they were painted. On the Canto della Chiavica, on the way to the Corte Savella, they painted a façade which is a divine thing, and is held to be the most beautiful of all the beautiful works that they executed; for, in addition to the story of the maidens passing over the Tiber, there is at the foot, near the door, a Sacrifice painted with marvellous industry and art, wherein may be seen duly represented all the instruments and all those ancient customs that used to have a place in sacrifices of that kind. Near the Piazza del Popolo, below S. Jacopo degli Incurabili, they painted a façade with stories of Alexander the Great, which is held to be very fine; and there they depicted the ancient statues of the Nile and the Tiber from the Belvedere. Near S. Simeone they painted the façade of the Gaddi Palace, which is truly a cause of marvel and

amazement, when one observes the lovely vestments in it, so many and so various, and the vast number of ancient helmets, girdles, buskins, and barques, adorned with all the delicacy and abundance of detail that an inventive imagination could conceive. There, with a multitude of beautiful things which overload the memory, are represented all the ways of the ancients, the statues of sages, and most lovely women: and there are all the sorts of ancient sacrifices with their ritual, and an army in the various stages between embarking and fighting with an extraordinary variety of arms and implements, all executed with such grace and finished with such masterly skill, that the eye is dazzled by the vast abundance of beautiful inventions. Opposite to this is a smaller façade, which could not be improved in beauty and variety; and there, in the frieze, is the story of Niobe causing herself to be worshipped, with the people bringing tribute, vases, and various kinds of gifts; which story was depicted by them with such novelty, grace, art, force of relief and genius in every part, that it would certainly take too long to describe the whole. Next, there follows the wrath of Latona, and her terrible vengeance on the children of the over-proud Niobe, whose seven sons are slain by Phœbus and the seven daughters by Diana; with an endless number of figures in imitation of bronze, which appear to be not painted but truly of metal. Above these are executed other scenes, with some vases in imitation of gold, innumerable things of fancy so strange that mortal eye could not picture anything more novel or more beautiful, and certain Etruscan helmets; but one is left confused by the variety and abundance of the conceptions, so beautiful and so fanciful, which issued from their minds. These works have been imitated by a vast number of those who labour at that branch of art. They also painted the courtyard of that house, and likewise the loggia, which they decorated with little grotesques in colour that are held to be divine. In short, all that they touched they brought to perfection with infinite grace and beauty; and if I were to name all their works, I should fill a whole book with the performances of these two masters alone, since there is no apartment, palace, garden, or villa in Rome that does not contain some work by Polidoro and Maturino.

Now, while Rome was rejoicing and clothing herself in beauty with their labours, and they were awaiting the reward of all their toil, the envy of Fortune, in the year 1527, sent Bourbon to Rome; and he gave that city over to sack. Whereupon was

divided the companionship not only of Polidoro and Maturino, but of all the thousands of friends and relatives who had broken bread together for so many years in Rome. Maturino took to flight, and no long time passed before he died, so it is believed in Rome, of plague, in consequence of the hardships that he had suffered in the sack, and was buried in S. Eustachio. Polidoro turned his steps to Naples; but on his arrival, the noblemen of that city taking but little interest in fine works of painting, he was like to die of hunger. Working, therefore, at the commission of certain painters, he executed a S. Peter in the principal chapel of S. Maria della Grazia; and in this way he assisted those painters in many things, more to save his life than for any other reason. However, the fame of his talents having spread abroad, he executed for Count ... a vault painted in distemper, together with some walls, all of which is held to be very beautiful work. In like manner, he executed a courtyard in chiaroscuro for Signor ..., with some loggie, which are very beautiful, rich in ornaments, and well painted. He also painted for S. Angelo, beside the Pescheria at Naples, a little panel in oils, containing a Madonna and some naked figures of souls in torment, which is held to be most beautiful, but more for the drawing than for the colouring; and likewise some pictures for the Chapel of the High-Altar, each with a single full-length figure, and all executed in the same manner.

It came to pass that Polidoro, living in Naples and seeing his talents held in little esteem, determined to take his leave of men who thought more of a horse that could jump than of a master whose hands could give to painted figures the appearance of life. Going on board ship, therefore, he made his way to Messina, where, finding more consideration and more honour, he set himself to work; and thus, working continually, he acquired good skill and mastery in the use of colour. Thereupon he executed many works, which are dispersed in various places; and turning his attention to architecture, he gave proof of his worth in many buildings that he erected. After a time, Charles V passing through Messina on his return from victory in Tunis, Polidoro made in his honour most beautiful triumphal arches, from which he gained vast credit and rewards. And then this master, who was always burning with desire to revisit Rome, which afflicts with an unceasing yearning those who have lived there many years, when making trial of other countries, painted as his last work in

Messina a panel-picture of Christ bearing the Cross, executed in oils with much excellence and very pleasing colour. In it he made a number of figures accompanying Christ to His Death – soldiers, pharisees, horses, women, children, and the Thieves in front; and he kept firmly before his mind the consideration of how such an execution must have been marshalled, insomuch that his nature seemed to have striven to show its highest powers in this work, which is indeed most excellent. After this he sought many times to shake himself free of that country, although he was looked upon with favour there; but he had a reason for delay in a woman, beloved by him for many years, who detained him with her sweet words and cajoleries. However, so mightily did his desire to revisit Rome and his friends work in him, that he took from his bank a good sum of money that he possessed, and, wholly determined, prepared to depart.

Polidoro had employed as his assistant for a long time a lad of the country, who bore greater love to his master's money than to his master; but, the money being kept, as has been said, in the bank, he was never able to lay his hands upon it and carry it off. Wherefore, an evil and cruel thought entering his head, he resolved to put his master to death with the help of some accomplices, on the following night, while he was sleeping, and then to divide the money with them. And so, assisted by his friends, he set upon Polidoro in his first sleep, while he was slumbering deeply, and strangled him with a cloth. Then, giving him several wounds, they made sure of his death; and in order to prove that it was not they who had done it, they carried him to the door of the woman whom he had loved, making it appear that her relatives or other persons of the house had killed him. The assistant gave a good part of the money to the villains who had committed so hideous an outrage, and bade them be off. In the morning he went in tears to the house of a certain Count, a friend of his dead master, and related the event to him; but for all the diligence that was used for many days in seeking for the perpetrator of the crime, nothing came to light. By the will of God, however, nature and virtue, in disdain at being wounded by the hand of fortune, so worked in one who had no interest in the matter, that he declared it to be impossible that any other but the assistant himself could have committed the murder. Whereupon the Count had him seized and put to the torture, and without the application of any further torment he confessed the crime and was

condemned by the law to the gallows; but first he was torn with red-hot pincers on the way to execution, and finally quartered.

For all this, however, life was not restored to Polidoro, nor was there given back to the art of painting a genius so resolute and so extraordinary, such as had not been seen in the world for many an age. If, indeed, at the time when he died, invention, grace, and boldness in the painting of figures could have laid down their lives, they would have died with him. Happy was the union of nature and art which embodied a spirit so noble in human form; and cruel was the envy and hatred of his fate and fortune, which robbed him of life with so strange a death, but shall never through all the ages rob him of his name. His obsequies were performed with full solemnity, and he was given burial in the Cathedral Church, lamented bitterly by all Messina, in the year 1543.

Great, indeed, is the obligation owed by craftsmen to Polidoro, in that he enriched art with a great abundance of vestments, all different and most strange, and of varied ornaments, and gave grace and adornment to all his works, and likewise made figures of every sort, animals, buildings, grotesques, and landscapes, all so beautiful, that since his day whosoever has aimed at catholicity has imitated him. It is a marvellous thing and a fearsome to see from the example of this master the instability of Fortune and what she can bring to pass, causing men to become excellent in some profession from whom something quite different might have been expected, to the no small vexation of those who have laboured in vain for many years at the same art. It is a marvellous thing, I repeat, to see those same men, after much travailing and striving, brought by that same Fortune to a miserable and most unhappy end at the very moment when they were hoping to enjoy the fruits of their labours; and that with calamities so monstrous and terrible, that pity herself takes to flight, art is outraged, and benefits are repaid with an extraordinary and incredible ingratitude. Wherefore, even as painting may rejoice in the fruitful life of Polidoro, so could he complain of Fortune, which at one time showed herself friendly to him, only to bring him afterwards, when it was least expected, to a dreadful death.

IL ROSSO, Painter of Florence

Men of account who apply themselves to the arts and pursue them with all their powers are sometimes exalted and honoured beyond measure, at a moment when it was least expected, before the eyes of all the world, as may be seen clearly from the labours that Il Rosso, a painter of Florence, devoted to the art of painting; for if these were not acknowledged in Rome and Florence by those who could reward them, yet in France he found one to recompense him for them, and that in such sort, that his glory might have sufficed to quench the thirst of the most over-weening ambition that could possess the heart of any craftsman, be he who he may. Nor could he have obtained in this life greater dignities, honour, or rank, seeing that he was regarded with favour and much esteemed beyond any other man of his profession by a King so great as is the King of France. And, indeed, his merits were such, that, if Fortune had secured less for him, she would have done him a very great wrong, for the reason that Rosso, in addition to his painting, was endowed with a most beautiful presence; his manner of speech was gracious and grave; he was an excellent musician, and had a fine knowledge of philosophy; and what was of greater import than all his other splendid qualities was this, that he always showed the invention of a poet in the grouping of his figures, besides being bold and well-grounded in draughtsmanship, graceful in manner, sublime in the highest flights of imagination, and a master of beautiful composition of scenes. In architecture he showed an extraordinary excellence; and he was always, however poor in circumstances, rich in the grandeur of his spirit. For this reason, whosoever shall follow in the labours of painting the walk pursued by Rosso, must be celebrated without ceasing, as are that master's works, which have no equals in boldness and are executed without effort and strain, since he kept them free of that dry and painful elaboration to which so many subject themselves in order to veil the worthlessness of their works with the cloak of importance.

In his youth, Rosso drew from the cartoon of Michelagnolo, and would study art with but few masters, having a certain opinion of his own that conflicted with their manners; as may be seen from a shrine executed in fresco for Piero Bartoli at Marignolle, without the Porta a S. Piero Gattolini in Florence,

containing a Dead Christ, wherein he began to show how great was his desire for a manner bold and grand, graceful and marvellous beyond that of all others. While still a beardless boy, at the time when Lorenzo Pucci was made a Cardinal by Pope Leo, he executed over the door of S. Sebastiano de' Servi the arms of the Pucci, with two figures, which made the craftsmen of that day marvel, for no one expected for him such a result as he achieved. Wherefore he so grew in courage, that, after having painted a picture with a half-length figure of Our Lady and a head of S. John the Evangelist for Maestro Jacopo, a Servite friar, who was something of a poet, at his persuasion he painted the Assumption of the Madonna in the cloister of the Servites, beside the scene of the Visitation, which was executed by Jacopo da Pontormo. In this he made a Heaven full of angels, all in the form of little naked children dancing in a circle round the Madonna, foreshortened with a most beautiful flow of outlines and with great grace of manner, as they wheel through the sky: insomuch that, if the colouring had been executed by him with that mature mastery of art which he afterwards came to achieve, he would have surpassed the other scenes by a great measure, even as he actually did equal them in grandeur and excellence of design. He made the Apostles much burdened with draperies, and, indeed, overloaded with their abundance; but the attitudes and some of the heads are more than beautiful.

The Director of the Hospital of S. Maria Nuova commissioned him to paint a panel: but when he saw it sketched, having little knowledge of that art, the Saints appeared to him like devils; for it was Rosso's custom in his oil-sketches to give a sort of savage and desperate air to the faces, after which, in finishing them, he would sweeten the expressions and bring them to a proper form. At this the patron fled from his house and would not have the picture, saying that the painter had cheated him.

In like manner, over another door that leads into the cloister of the Convent of the Servites, Rosso painted the escutcheon of Pope Leo, with two children; but it is now ruined. And in the houses of citizens may be seen several of his pictures and many portraits. For the visit of Pope Leo to Florence he executed a very beautiful arch on the Canto de' Bischeri. Afterwards he painted a most beautiful picture of the Dead Christ for Signor di Piombino, and also decorated a little chapel for him. At Volterra, likewise, he painted a most lovely Deposition from the Cross.

IL ROSSO PITTOR, E ARCH.
FIORENTINO

Having therefore grown in credit and fame, he executed for S. Spirito, in Florence, the panel-picture of the Dei family, which they had formerly entrusted to Raffaello da Urbino, who abandoned it because of the cares of the work that he had undertaken in Rome. This picture Rosso painted with marvellous grace, draughtsmanship, and vivacity of colouring. Let no one imagine that any work can display greater force or show more beautifully from a distance than this one, which, on account of the boldness of the figures and the extravagance of the attitudes, no longer employed by any of the other painters, was held to be an extraordinary work. And although it did not bring him much credit at that time, the world has since come little by little to recognize its excellence and has given it abundant praise; for with regard to the blending of colour it would be impossible to excel it, seeing that the lights which are in the brightest parts unite with the lower lights little by little as they merge into the darks, with such sweetness and harmony, and with such masterly skill in the projection of the shadows, that the figures stand out from one another and bring each other into relief by means of the lights and shades. Such vigour, indeed, has this work, that it may be said to have been conceived and executed with more judgment and mastery than any that has ever been painted by any other master, however superior his judgment.

For S. Lorenzo, at the commission of Carlo Ginori, he painted a panel-picture of the Marriage of Our Lady, which is held to be a most beautiful work. And, in truth, with regard to his facility of method, there has never been anyone who has been able to surpass him in masterly skill and dexterity, or even to approach within any distance of him; and he was so sweet in colouring, and varied his draperies with such grace, and took such delight in his art, that he was always held to be marvellous and worthy of the highest praise. Whosoever shall observe this work must recognize that all that I have written is most true, above all as he studies the nudes, which are very well conceived, with all the requirements of anatomy. His women are full of grace, and the draperies that adorn them fanciful and bizarre. He showed, also, the sense of fitness that is necessary in the heads of the old, with their harshness of features, and in those of women and children, with expressions sweet and pleasing. He was so rich in invention, that he never had any space left over in his pictures, and he executed all his work with such facility and grace, that it was a marvel.

For Giovanni Bandini, also, he painted a picture with some very beautiful nudes, representing the scene of Moses slaying the Egyptian, wherein were things worthy of the highest praise; and this was sent, I believe, into France. And for Giovanni Cavalcanti, likewise, he executed another, which went to England, of Jacob receiving water from the women at the well; this was held to be a divine work, seeing that it contained nudes and women wrought with supreme grace. For women, indeed, he always delighted to paint transparent pieces of drapery, head-dresses with intertwined tresses, and ornaments for their persons.

While Rosso was engaged on this work, he was living in the Borgo de' Tintori, the rooms of which look out on the gardens of the Friars of S. Croce; and he took much pleasure in a great ape, which had the intelligence rather of a man than of a beast. For this reason he held it very dear, and loved it like his own self; and since it had a marvellous understanding, he made use of it for many kinds of service. It happened that this beast took a fancy to one of his assistants, by name Battistino, who was a young man of great beauty; and from the signs that his Battistino made to him he understood all that he wished to say. Now against the wall of the rooms at the back, which looked out upon the garden of the friars, was a pergola belonging to the Guardian, loaded with great Sancolombane grapes; and the young men used to let the ape down with a rope to the pergola, which was some distance from their window, and pull the beast up again with his hands full of grapes. The Guardian, finding his pergola stripped, but not knowing the culprit, suspected that it must be mice, and lay in hiding; and seeing Rosso's ape descending, he flew into a rage, seized a long pole, and rushed at him with hands uplifted in order to beat him. The ape, seeing that whether he went up or stayed where he was, the Guardian could reach him, began to spring about and destroy the pergola, and then, making as though to throw himself on the friar's back, seized with both his hands the outermost crossbeams which enclosed the pergola. Meanwhile the friar made play with his pole, and the ape, in his terror, shook the pergola to such purpose, and with such force, that he tore the stakes and rods out of their places, so that both pergola and ape fell headlong on the back of the friar, who shrieked for mercy. The rope was pulled up by Battistino and the others, who brought the ape back into the room safe and sound. Thereupon the Guardian, drawing off and planting himself on a terrace that

he had there, said things not to be found in the Mass; and full of anger and resentment he went to the Council of Eight, a tribunal much feared in Florence. There he laid his complaint; and, Rosso having been summoned, the ape was condemned in jest to carry a weight fastened to his tail, to prevent him from jumping on pergole, as he did before. And so Rosso made a wooden cylinder swinging on a chain, and kept it on the ape, in such a way that he could go about the house but no longer jump about over other people's property. The ape, seeing himself condemned to such a punishment, seemed to guess that the friar was responsible. Every day, therefore, he exercised himself in hopping step by step with his legs, holding the weight with his hands; and thus, resting often, he succeeded in his design. For, being one day loose about the house, he hopped step by step from roof to roof, during the hour when the Guardian was away chanting Vespers, and came to the roof over his chamber. There, letting go the weight, he kept up for half an hour such a lovely dance, that not a single tile of any kind remained unbroken. Then he went back home; and within three days, when rain came, were heard the Guardian's lamentations.

Rosso, having finished his works, took the road to Rome with Battistino and the ape; in which city his works were sought for with extraordinary eagerness, great expectations having been awakened about them by the sight of some drawings executed by him, which were held to be marvellous, for Rosso drew divinely well and with the highest finish. There, in the Pace, over the pictures of Raffaello, he executed a work which is the worst that he ever painted in all his days. Nor can I imagine how this came to pass, save from a reason which has been seen not only in his case, but also in that of many others, and which appears to be an extraordinary thing, and one of the secrets of nature; and it is this, that he who changes his country or place of habitation seems to change his nature, talents, character, and personal habits, insomuch that sometimes he seems to be not the same man but another, and all dazed and stupefied. This may have happened to Rosso in the air of Rome, and on account of the stupendous works of architecture and sculpture that he saw there, and the paintings and statues of Michelagnolo, which may have thrown him off his balance; which works also drove Fra Bartolommeo di San Marco and Andrea del Sarto to flight, and prevented them from executing anything in Rome. Certain it is,

be the cause what it may, that Rosso never did worse; and, what is more, this work has to bear comparison with those of Raffaello da Urbino.

At this time he painted for Bishop Tornabuoni, who was his friend, a picture of a Dead Christ supported by two angels, which was a most beautiful piece of work, and is now in the possession of the heirs of Monsignor della Casa. For Baviera he made drawings of all the Gods, for copper-plates, which were afterwards engraved by Jacopo Caraglio; one of them being Saturn changing himself into a horse, and the most noteworthy that of Pluto carrying off Proserpine. He executed a sketch for the Beheading of S. John the Baptist, which is now in a little church on the Piazza de' Salviati in Rome.

Meanwhile the sack of the city took place, and poor Rosso was taken prisoner by the Germans and used very ill, for, besides stripping him of his clothes, they made him carry weights on his back barefooted and with nothing on his head, and remove almost the whole stock from a cheesemonger's shop. Thus ill-treated by them, he escaped with difficulty to Perugia, where he was warmly welcomed and reclothed by the painter Domenico di Paris, for whom he drew the cartoon for a panel-picture of the Magi, a very beautiful work, which is to be seen in the house of Domenico. But he did not stay long in that place, for, hearing that Bishop Tornabuoni, who was very much his friend, and had also fled from the sack, had gone to Borgo a San Sepolcro, he made his way thither.

There was living at that time in Borgo a San Sepolcro a pupil of Giulio Romano, the painter Raffaello dal Colle; and this master, having undertaken for a small price to paint a panel for S. Croce, the seat of a Company of Flagellants, in his native city, lovingly resigned the commission and gave it to Rosso, to the end that he might leave some example of his handiwork in that place. At this the Company showed resentment, but the Bishop gave him every facility; and when the picture, which brought him credit, was finished, it was set up in S. Croce. The Deposition from the Cross that it contains is something very rare and beautiful, because he rendered in the colours a certain effect of darkness to signify the eclipse that took place at Christ's death, and because it was executed with very great diligence.

Afterwards, at Città di Castello, he received the commission for a panel-picture, on which he was about to set to work, when,

as it was being primed with gesso, a roof fell upon it and broke it to pieces; while upon him there came a fever so violent, that he was like to die of it, on which account he had himself carried from Castello to Borgo a San Sepolcro. This malady being followed by a quartan fever, he then went on to the Pieve a San Stefano for a change of air, and finally to Arezzo, where he was entertained in the house of Benedetto Spadari, who so went to work with the help of Giovanni Antonio Lappoli of Arezzo and the many friends and relatives that they had, that Rosso was commissioned to paint in fresco a vault previously allotted to the painter Niccolò Soggi, in the Madonna delle Lagrime. And so eager were they that he should leave such a memorial of himself in that city, that he was given a payment of three hundred crowns of gold. Whereupon Rosso began his cartoons in a room that they had allotted to him in a place called Murello; and there he finished four of them. In one he depicted our First Parents, bound to the Tree of the Fall, with Our Lady drawing from their mouths the Sin in the form of the Apple, and beneath her feet the Serpent; and in the air – wishing to signify that she was clothed with the sun and moon – he made nude figures of Phœbus and Diana. In the second is Moses bearing the Ark of the Covenant, represented by Our Lady surrounded by five Virtues. In another is the Throne of Solomon, also represented by the Madonna, to whom votive offerings are being brought, to signify those who have recourse to her for benefits: together with other bizarre fancies, which were conceived by the fruitful brain of M. Giovanni Pollastra, the friend of Rosso and a Canon of Arezzo, in compliment to whom Rosso made a most beautiful model of the whole work, which is now in my house at Arezzo. He also drew for that work a study of nude figures, which is a very choice thing; and it is a pity that it was never finished, for, if he had put it into execution and painted it in oils, instead of having to do it in fresco, it would indeed have been a miracle. But he was ever averse to working in fresco, and therefore went on delaying the execution of the cartoons, meaning to have the work carried out by Raffaello dal Borgo and others, so that in the end it was never done.

At that same time, being a courteous person, he made many designs for pictures and buildings in Arezzo and its neighbourhood; among others, one for the Rectors of the Fraternity, of the chapel which is at the foot of the Piazza, wherein there is now

the Volto Santo. For the same patrons he drew the design for a panel-picture to be painted by his hand, containing a Madonna with a multitude under her cloak, which was to be set up in the same place; and this design, which was not put into execution, is in our book, together with many other most beautiful drawings by the hand of the same master.

But to return to the work that he was to execute in the Madonna delle Lagrime: there came forward as his security for this work Giovanni Antonio Lappoli of Arezzo, his most faithful friend, who gave him proofs of loving kindness with every sort of service. But in the year 1530, when Florence was being besieged, the Aretines, having been restored to liberty by the small judgment of Papo Altoviti, attacked the citadel and razed it to the ground. And because that people looked with little favour on Florentines, Rosso would not trust himself to them, and went off to Borgo a San Sepolcro, leaving the cartoons and designs for his work hidden away in the citadel.

Now those who had given him the commission for the panel at Castello, wished him to finish it; but he, on account of the illness that he had suffered at Castello, would not return to that city. He finished their panel, therefore, at Borgo a San Sepolcro; nor would he ever give them the pleasure of a glance at it. In it he depicted a multitude, with Christ in the sky being adored by four figures, and he painted Moors, Gypsies, and the strangest things in the world; but, with the exception of the figures, which are perfect in their excellence, the composition is concerned with anything rather than the wishes of those who ordered the picture of him. At the same time that he was engaged on that work, he disinterred dead bodies in the Vescovado, where he was living, and made a most beautiful anatomical model. Rosso was, in truth, an ardent student of all things relating to art, and few days passed without his drawing some nude from life.

He had always had the idea of finishing his life in France, and of thus delivering himself from that misery and poverty which are the lot of men who work in Tuscany, or in the country where they were born; and he resolved to depart. And with a view to appearing more competent in all matters, and to being ignorant of none, he had just learned the Latin tongue; when there came upon him a reason for further hastening his departure. For one Holy Thursday, on which day matins are chanted in the evening, one of his disciples, a young Aretine, being in church, made a

blaze of sparks and flames with a lighted candle-end and some resin, at the moment when the 'darkness,' as they call it, was in progress; and the boy was reproved by some priests, and even struck. Seeing this, Rosso, who had the boy seated at his side, sprang up full of anger against the priests. Thereupon an uproar began, without anyone knowing what it was all about, and swords were drawn against poor Rosso, who was busy with the priests. Taking to flight, therefore, he contrived to regain his own rooms without having been struck or overtaken by anyone. But he held himself to have been affronted; and having finished the panel for Castello, without troubling about his work at Arezzo or the wrong that he was doing to Giovanni Antonio, his security (for he had received more than a hundred and fifty crowns), he set off by night. Taking the road by Pesaro, he made his way to Venice, where, being entertained by Messer Pietro Aretino, he made for him a drawing, which was afterwards engraved, of Mars sleeping with Venus, with the Loves and Graces despoiling him and carrying off his cuirass. Departing from Venice, he found his way into France, where he was received by the Florentine colony with much affection. There he painted some pictures, which were afterwards placed in the Gallery at Fontainebleau; and these he then presented to King Francis, who took infinite pleasure in them, but much more in the presence, speech, and manner of Rosso, who was imposing in person, with red hair in accordance with his name, and serious, deliberate, and most judicious in his every action. The King, then, after straightway granting him an allowance of four hundred crowns, and giving him a house in Paris, which he occupied but seldom, because he lived most of the time at Fontainebleau, where he had rooms and lived like a nobleman, appointed him superintendent over all the buildings, pictures, and other ornaments of that place.

There, in the first place, Rosso made a beginning with a gallery over the lower court, which he completed not with a vault, but with a ceiling, or rather, soffit, of woodwork, partitioned most beautifully into compartments. The side-walls he decorated all over with stucco-work, fantastic and bizarre in its distribution, and with carved cornices of many kinds; and on the piers were lifesize figures. Everything below the cornices, between one pier and another, he adorned with festoons of stucco, vastly rich, and others painted, and all composed of most beautiful fruits and every sort of foliage. And then, in a large space, he caused to be

painted after his own designs, if what I have heard is true, about twenty-four scenes in fresco, representing, I believe, the deeds of Alexander the Great; for which, as I have said, he made all the designs, executing them in chiaroscuro with water-colours. At the two ends of this gallery are two panel-pictures in oils by his hand, designed and painted with such perfection, that there is little better to be seen in the art of painting. In one of these are a Bacchus and a Venus, executed with marvellous art and judgment. The Bacchus is a naked boy, so tender, soft, and delicate, that he seems to be truly of flesh, yielding to the touch, and rather alive than painted; and about him are some vases painted in imitation of gold, silver, crystal, and various precious stones, so fantastic, and surrounded by devices so many and so bizarre, that whoever beholds this work, with its vast variety of invention, stands in amazement before it. Among other details, also, is a Satyr raising part of a pavilion, whose head, in its strange, goatlike aspect, is a marvel of beauty, and all the more because he seems to be smiling and full of joy at the sight of so beautiful a boy. There is also a little boy riding on a wonderful bear, with many other ornaments full of grace and beauty. In the other picture are Cupid and Venus, with other lovely figures; but the figure to which Rosso gave the greatest attention was the Cupid, whom he represented as a boy of twelve, although well grown, riper in features than is expected at that age, and most beautiful in every part.

The King, seeing these works, and liking them vastly, conceived an extraordinary affection for Rosso; wherefore no long time passed before he gave him a Canonicate in the Sainte Chapelle of the Madonna at Paris, with so many other revenues and benefits, that Rosso lived like a nobleman, with a goodly number of servants and horses, giving banquets and showing all manner of courtesies to all his friends and acquaintances, especially to the Italian strangers who arrived in those parts.

After this, he executed another hall, which is called the Pavilion, because it is in the form of a Pavilion, being above the rooms on the first floor, and thus situated above any of the others. This apartment he decorated from the level of the floor to the roof with a great variety of beautiful ornaments in stucco, figures in the round distributed at equal intervals, and children, festoons, and various kinds of animals. In the compartments on the walls are seated figures in fresco, one in each; and such is

their number, that there may be seen among them images of all the Heathen Gods and Goddesses of the ancients. Last of all, above the windows, is a frieze all adorned with stucco, and very rich, but without pictures.

He then executed a vast number of works in many chambers, bathrooms, and other apartments, both in stucco and in painting, of some of which drawings may be seen, executed in engraving and published abroad, which are full of grace and beauty; as are also the numberless designs that Rosso made for salt-cellars, vases, bowls, and other things of fancy, all of which the King afterwards caused to be executed in silver; but these were so numerous that it would take too long to mention them all. Let it be enough to say that he made designs for all the vessels of a sideboard for the King, and for all the details of the trappings of horses, triumphal masquerades, and everything else that it is possible to imagine, showing in these such fantastic and bizarre conceptions, that no one could do better.

In the year 1540, when the Emperor Charles V went to France under the safeguard of King Francis, and visited Fontainebleau, having with him not more than twelve men, Rosso executed one half of the decorations that the King ordained in order to honour that great Emperor, and the other half was executed by Francesco Primaticcio of Bologna. The works that Rosso made, such as arches, colossal figures, and other things of that kind, were, so it was said at the time, the most astounding that had ever been made by any man up to that age. But a great part of the rooms finished by Rosso at the aforesaid Palace of Fontainebleau were destroyed after his death by the same Francesco Primaticcio, who has made a new and larger structure in the same place.

Among those who worked with Rosso on the aforesaid decorations in stucco and relief, and beloved by him beyond all the others, were the Florentine Lorenzo Naldino, Maestro Francesco of Orleans, Maestro Simone of Paris, Maestro Claudio, likewise a Parisian, Maestro Lorenzo of Picardy, and many others. But the best of them all was Domenico del Barbieri, who is an excellent painter and master of stucco, and a marvellous draughtsman, as is proved by his engraved works, which may be numbered among the best in common circulation. The painters, likewise, whom he employed in those works at Fontainebleau, were Luca Penni, brother of Giovan Francesco Penni, called Il Fattore, who was a disciple of Raffaello da Urbino; the Fleming Leonardo, a very

able painter, who executed the designs of Rosso to perfection in colours; Bartolommeo Miniati, a Florentine; with Francesco Caccianimici, and Giovan Battista da Bagnacavallo. These last entered his service when Francesco Primaticcio went by order of the King to Rome, to make moulds of the Laocoon, the Apollo, and many other choice antiquities, for the purpose of casting them afterwards in bronze. I say nothing of the carvers, the master-joiners, and innumerable others of whom Rosso availed himself in those works, because there is no need to speak of them all, although many of them executed works worthy of much praise.

In addition to the things mentioned above, Rosso executed with his own hand a S. Michael, which is a rare work. For the Constable he painted a panel-picture of the Dead Christ, a choice thing, which is at a seat of that noble, called Ecouen; and he also executed some exquisite miniatures for the King. He then drew a book of anatomical studies, intending to have it printed in France; of which there are some sheets by his own hand in our book of drawings. Among his possessions, also, after he was dead, were found two very beautiful cartoons, in one of which is a Leda of singular beauty, and in the other the Tiburtine Sibyl showing to the Emperor Octavian the Glorious Virgin with the Infant Christ in her arms. In the latter he drew the King, the Queen, their Guard, and the people, with such a number of figures, and all so well drawn, that it may be said with truth that this was one of the most beautiful things that Rosso ever did.

By reason of these works and many others, of which nothing is known, he became so dear to the King, that a little before his death he found himself in possession of more than a thousand crowns of income, without counting the allowances for his work, which were enormous; insomuch that, living no longer as a painter, but rather as a prince, he kept a number of servants and horses to ride, and had his house filled with tapestries, silver, and other valuable articles of furniture. But Fortune, who never, or very seldom, maintains for long in high estate one who puts his trust too much in her, brought him headlong down in the strangest manner ever known. For while Francesco di Pellegrino, a Florentine, who delighted in painting and was very much his friend, was associating with him in the closest intimacy, Rosso was robbed of some hundreds of ducats; whereupon the latter,

suspecting that no one but the same Francesco could have done this, had him arrested by the hands of justice, rigorously examined, and grievously tortured. But he, knowing himself innocent, and declaring nothing but the truth, was finally released; and, moved by just anger, he was forced to show his resentment against Rosso for the shameful charge that he had falsely laid upon him. Having therefore issued a writ for libel against him, he pressed him so closely, that Rosso, not being able to clear himself or make any defence, felt himself to be in a sorry plight, perceiving that he had not only accused his friend falsely, but had also stained his own honour; and to eat his words, or to adopt any other shameful method, would likewise proclaim him a false and worthless man. Resolving, therefore, to kill himself by his own hand rather than be punished by others, he took the following course. One day that the King happened to be at Fontainebleau, he sent a peasant to Paris for a certain most poisonous essence, pretending that he wished to use it for making colours or varnishes, but intending to poison himself, as he did. The peasant, then, returned with it; and such was the malignity of the poison, that, merely through holding his thumb over the mouth of the phial, carefully stopped as it was with wax, he came very near losing that member, which was consumed and almost eaten away by the deadly potency of the poison. And shortly afterwards it slew Rosso, although he was in perfect health, he having drunk it to the end that it might take his life, as it did in a few hours.

This news, being brought to the King, grieved him beyond measure, since it seemed to him that by the death of Rosso he had lost the most excellent craftsman of his day. However, to the end that the work might not suffer, he had it carried on by Francesco Primaticcio of Bologna, who, as has been related, had already done much work for him; giving him a good Abbey, even as he had presented a Canonicate to Rosso.

Rosso died in the year 1541, leaving great regrets behind him among his friends and brother-craftsmen, who have learned by his example what benefits may accrue from a prince to one who is eminent in every field of art, and well-mannered and gentle in all his actions, as was that master, who for many reasons deserved, and still deserves, to be admired as one truly most excellent.

BARTOLOMMEO DA BAGNACAVALLO, AND OTHER PAINTERS OF ROMAGNA

I⊤ is certain that the result of emulation in the arts, caused by a desire for glory, proves for the most part to be one worthy of praise; but when it happens that the aspirant, through presumption and arrogance, comes to hold an inflated opinion of himself, in course of time the name for excellence that he seeks may be seen to dissolve into mist and smoke, for the reason that there is no advance to perfection possible for him who knows not his own failings and has no fear of the work of others. More readily does hope mount towards proficience for those modest and studious spirits who, leading an upright life, honour the works of rare masters and imitate them with all diligence, than for those who have their heads full of smoky pride, as had Bartolommeo da Bagnacavallo, Amico of Bologna, Girolamo da Cotignola, and Innocenzio da Imola, painters all, who, living in Bologna at one and the same time, felt the greatest jealousy of one another that could possibly be imagined. And, what is more, their pride and vainglory, not being based on the foundation of ability, led them astray from the true path, which brings to immortality those who strive more from love of good work than from rivalry. This circumstance, then, was the reason that they did not crown the good beginnings that they had made with that final excellence which they expected; for their presuming to the name of masters turned them too far aside from the good way.

Bartolommeo da Bagnacavallo had come to Rome in the time of Raffaello, in order to attain with his works to that perfection which he believed himself to be already grasping with his intellect. And being a young man who had some fame at Bologna and had awakened expectations, he was set to execute a work in the Church of the Pace at Rome, in the first chapel on the right hand as one enters the church, above the chapel of Baldassarre Peruzzi of Siena. But, thinking that he had not achieved the success that he had promised himself, he returned to Bologna. There he and the others mentioned above, in competition one with another, executed each a scene from the Lives of Christ and His Mother in the Chapel of the Madonna in S. Petronio, near the door of the façade, on the right hand as one enters the church; among

which little difference in merit is to be seen between one and another. But Bartolommeo acquired from this work the reputation of having a manner both softer and stronger than the others; and although there is a vast number of strange things in the scene of Maestro Amico, in which he depicted the Resurrection of Christ with armed men in crouching and distorted attitudes, and many soldiers crushed flat by the stone of the Sepulchre, which has fallen upon them, nevertheless that of Bartolommeo, as having more unity of design and colouring, was more extolled by other craftsmen. On account of this Bartolommeo associated himself with Biagio Bolognese, a person with much more practice than excellence in art; and they executed in company at S. Salvatore, for the Frati Scopetini, a refectory which they painted partly in fresco and partly 'a secco,' containing the scene of Christ satisfying five thousand people with five loaves and two fishes. They painted, also, on a wall of the library, the Disputation of S. Augustine, wherein they made a passing good view in perspective. These masters, thanks to having seen the works of Raffaello and associated with him, had a certain quality which, upon the whole, gave promise of excellence, but in truth they did not attend as they should have done to the more subtle refinements of art. Yet, since there were no painters in Bologna at that time who knew more than they did, they were held by those who then governed the city, as well as by all the people, to be the best masters in Italy.

By the hand of Bartolommeo are some round pictures in fresco under the vaulting of the Palace of the Podestà, and a scene of the Visitation of S. Elizabeth in S. Vitale, opposite to the Palace of the Fantucci. In the Convent of the Servites at Bologna, round a panel-picture of the Annunciation painted in oils, are some saints executed in fresco by Innocenzio da Imola. In S. Michele in Bosco Bartolommeo painted in fresco the Chapel of Ramazzotto, a faction-leader in Romagna. In a chapel in S. Stefano the same master painted two saints in fresco, with some little angels of considerable beauty in the sky; and in S. Jacopo, for Messer Annibale del Corello, a chapel in which he represented the Circumcision of Our Lord, with a number of figures, above which, in a lunette, he painted Abraham sacrificing his son to God. This work, in truth, was executed in a good and able manner. For the Misericordia, without Bologna, he painted a little panel-picture in distemper of Our Lady and some saints;

with many pictures and other works, which are in the hands of various persons in that city.

This master, in truth, was above mediocrity both in the uprightness of his life and in his works, and he was superior to the others in drawing and invention, as may be seen from a drawing in our book, wherein is Jesus Christ, as a boy, disputing with the Doctors in the Temple, with a building executed with good mastery and judgment. In the end, he finished his life at the age of fifty-eight.

He had always been much envied by Amico of Bologna, an eccentric man of extravagant brain, whose figures, executed by him throughout all Italy, but particularly in Bologna, where he spent most of his time, are equally eccentric and even mad, if one may say so. If, indeed, the vast labour which Amico devoted to drawing had been pursued with a settled object, and not by caprice, he might perchance have surpassed many whom we regard as rare and able men. And even so, such is the value of persistent labour, that it is not possible that out of a mass of work there should not be found some that is good and worthy of praise; and such, among the vast number of works that this master executed, is a façade in chiaroscuro on the Piazza de' Marsigli, wherein are many historical pictures, with a frieze of animals fighting together, very spirited and well executed, which is almost the best work that he ever painted. He painted another façade at the Porta di S. Mammolo, and a frieze round the principal chapel of S. Salvatore, so extravagant and so full of absurdities that it would provoke laughter in one who was on the verge of tears. In a word, there is no church or street in Bologna which has not some daub by the hand of this master.

In Rome, also, he painted not a little; and in S. Friano, at Lucca, he filled a chapel with inventions fantastic and bizarre, among which are some things worthy of praise, such as the stories of the Cross and some of S. Augustine. In these are innumerable portraits of distinguished persons of that city; and, to tell the truth, this was one of the best works that Maestro Amico ever executed with colours in fresco.

In S. Jacopo, at Bologna, he painted at the altar of S. Niccola some stories of the latter Saint, and below these a frieze with views in perspective, which deserve to be extolled. When the Emperor Charles V visited Bologna, Amico made a triumphal arch, for which Alfonso Lombardi executed statues in relief, at

the gate of the Palace. And it is no marvel that the work of
Amico revealed skill of hand rather than any other quality, for it
is said that, like the eccentric and extraordinary person that he
was, he went through all Italy drawing and copying every work
of painting or relief, whether good or bad, on which account he
became something of an adept in invention; and when he found
anything likely to be useful to him, he laid his hands upon it
eagerly, and then destroyed it, so that no one else might make
use of it. The result of all this striving was that he acquired the
strange, mad manner that we know.

Finally, having reached the age of seventy, what with his art
and the eccentricity of his life, he became raving mad, at which
Messer Francesco Guicciardini, a noble Florentine, and a most
trustworthy writer of the history of his own times, who was then
Governor of Bologna, found no small amusement, as did the
whole city. Some people, however, believe that there was some
method mixed with this madness of his, because, having sold
some property for a small price while he was mad and in very
great straits, he asked for it back again when he regained his
sanity, and recovered it under certain conditions, since he had
sold it, so he said, when he was mad. I do not swear, indeed, that
this is true, for it may have been otherwise; but I do say that I
have often heard the story told.

Amico also gave his attention to sculpture, and executed to
the best of his ability, in marble, a Dead Christ with Nicodemus
supporting Him. This work, which he treated in the manner seen
in his pictures, is on the right within the entrance of the Church
of S. Petronio. He used to paint with both hands at the same
time, holding in one the brush with the bright colour, and in the
other that with the dark. But the best joke of all was that he had
his leather belt hung all round with little pots full of tempered
colours, so that he looked like the Devil of S. Macario with all
those flasks of his; and when he worked with his spectacles on
his nose, he would have made the very stones laugh, and particu-
larly when he began to chatter, for then he babbled enough for
twenty, saying the strangest things in the world, and his whole
demeanour was a comedy. Certain it is that he never used to
speak well of any person, however able or good, and however
well dowered he saw him to be by Nature or Fortune. And, as
has been said, he so loved to chatter and tell stories, that one
evening, at the hour of the Ave Maria, when a painter of Bologna,

after buying cabbages in the Piazza, came upon Amico, the latter kept him under the Loggia del Podestà with his talk and his amusing stories, without the poor man being able to break away from him, almost till daylight, when Amico said: 'Now go and boil your cabbages, for the time is getting on.'

He was the author of a vast number of other jokes and follies, of which I shall not make mention, because it is now time to say something of Girolamo da Cotignola. This master painted many pictures and portraits from life in Bologna, and among them are two in the house of the Vinacci, which are very beautiful. He made a portrait after death of Monsignore de Foix, who died in the rout of Ravenna, and not long after he executed a portrait of Massimiliano Sforza. For S. Giuseppe he painted a panel-picture which brought him much praise, and, for S. Michele in Bosco, the panel-picture in oils which is in the Chapel of S. Benedetto. The latter work led to his executing, in company with Biagio Bolognese, all the scenes which are round that church, laid on in fresco and executed 'a secco,' wherein are seen proofs of no little mastery, as has been said in speaking of the manner of Biagio. The same Girolamo painted a large altar-piece for S. Colomba at Rimini, in competition with Benedetto da Ferrara and Lattanzio, in which work he made a S. Lucia rather wanton than beautiful. And in the great tribune of that church he executed a Coronation of Our Lady, with the twelve Apostles and the four Evangelists, with heads so gross and hideous that they are an outrage to the eye.

He then returned to Bologna, but had not been there long when he went to Rome, where he made portraits from life of many men of rank, and in particular that of Pope Paul III. But, perceiving that it was no place for him, and that he was not likely to acquire honour, profit, or fame among so many noble craftsmen, he went off to Naples, where he found some friends who showed him favour, and above all M. Tommaso Cambi, a Florentine merchant, and a devoted lover of pictures and antiquities in marble, by whom he was supplied with everything of which he was in need. Thereupon, setting to work, he executed a panel-picture of the Magi, in oils, for the chapel of one M. Antonello, Bishop of I know not what place, in Monte Oliveto, and another panel-picture in oils for S. Aniello, containing the Madonna, S. Paul, and S. John the Baptist, with portraits from life for many noblemen.

Being now well advanced in years, he lived like a miser, and was always trying to save money; and after no long time, having little more to do in Naples, he returned to Rome. There some friends of his, having heard that he had saved a few crowns, persuaded him that he ought to get married and live a properly-regulated life. And so, thinking that he was doing well for himself, he let those friends deceive him so completely that they imposed upon him for a wife, to suit their own convenience, a prostitute whom they had been keeping. Then, after he had married her and come to a knowledge of her, the truth was revealed, at which the poor old man was so grieved that he died in a few weeks at the age of sixty-nine.

And now to say something of Innocenzio da Imola. This master was for many years in Florence with Mariotto Albertinelli; and then, having returned to Imola, he executed many works in that place. But finally, at the persuasion of Count Giovan Battista Bentivogli, he went to live in Bologna, where one of his first works was a copy of a picture formerly executed by Raffaello da Urbino for Signor Leonello da Carpi. And for the Monks of S. Michele in Bosco he painted in fresco, in their chapter-house, the Death of Our Lady and the Resurrection of Christ, works which were executed with truly supreme diligence and finish. For the church of the same monks, also, he painted the panel of the high-altar, the upper part of which is done in a good manner. For the Servites of Bologna he executed an Annunciation on panel, and for S. Salvatore a Crucifixion, with many pictures of various kinds throughout the whole city. At the Viola, for the Cardinal of Ivrea, he painted three loggie in fresco, each containing two scenes, executed in colour from designs by other painters, and yet finished with much diligence. He painted in fresco a chapel in S. Jacopo, and for Madonna Benozza a panel-picture in oils, which was not otherwise than passing good. He made a portrait, also, besides many others, of Cardinal Francesco Alidosio, which I have seen at Imola, together with the portrait of Cardinal Bernardino Carvajal, and both are works of no little beauty.

Innocenzio was a very good and modest person, and therefore always avoided any dealings or intercourse with the painters of Bologna, who were quite the opposite in nature, and he was always exerting himself beyond the limits of his strength; wherefore, when he fell sick of a putrid fever at the age of fifty-six, it found him so weak and exhausted that it killed him in a few days.

He left unfinished, or rather, scarcely begun, a work that he had undertaken without Bologna, and this was completed to perfection, according to the arrangement made by Innocenzio before his death, by Prospero Fontana, a painter of Bologna.

The works of all the above-named painters date from 1506 to 1542, and there are drawings by the hands of them all in our book.

FRANCIABIGIO, Painter of Florence
[FRANCIA]

THE fatigues that a man endures in this life in order to raise himself from the ground and protect himself from poverty, succouring not only himself but also his nearest and dearest, have such virtue, that the sweat and the hardships become full of sweetness, and bring comfort and nourishment to the minds of others, insomuch that Heaven, in its bounty, perceiving one drawn to a good life and to upright conduct, and also filled with zeal and inclination for the studies of the sciences, is forced to be benign and favourably disposed towards him beyond its wont; as it was, in truth, towards the Florentine painter Francia. This master, having applied himself to the art of painting for a just and excellent reason, laboured therein not so much out of a desire for fame as from a wish to bring assistance to his needy relatives; and having been born in a family of humble artisans, people of low degree, he sought to raise himself from that position. In this effort he was much spurred by his rivalry with Andrea del Sarto, then his companion, with whom for a long time he shared both work-room and the painter's life; on account of which life they made great proficience, one through the other, in the art of painting.

Francia learned the first principles of art in his youth by living for some months with Mariotto Albertinelli. And being much inclined to the study of perspective, at which he was always working out of pure delight, while still quite young he gained a reputation for great ability in Florence. The first works painted by him were a S. Bernard executed in fresco in S. Pancrazio, a church opposite to his own house, and a S. Catharine of Siena, executed likewise in fresco, on a pilaster in the Chapel of the Rucellai; whereby, exerting himself in that art, he gave proofs of his fine

qualities. Much more, even, was he established in repute by a picture which is in a little chapel in S. Pietro Maggiore, containing Our Lady with the Child in her arms, and a little S. John caressing Jesus Christ. He also gave proof of his excellence in a shrine executed in fresco, in which he painted the Visitation of Our Lady, on a corner of the Church of S. Giobbe, behind the Servite Convent in Florence. In the figure of that Madonna may be seen a goodness truly appropriate, with profound reverence in that of the older woman; and the S. Job he painted poor and leprous, and also rich and restored to health. This work so revealed his powers that he came into credit and fame; whereupon the men who were the rulers of that church and brotherhood gave him the commission for the panel-picture of their high-altar, in which Francia acquitted himself even better; and in that work he painted a Madonna, and S. Job in poverty, and made a portrait of himself in the face of S. John the Baptist.

There was built at that time, in S. Spirito at Florence, the Chapel of S. Niccola, in which was placed a figure of that Saint in the round, carved in wood from the model by Jacopo Sansovino; and Francia painted two little angels in two square pictures in oils, one on either side of that figure, which were much extolled, and also depicted the Annunciation in two round pictures; and the predella he adorned with little figures representing the miracles of S. Nicholas, executed with such diligence that he deserves much praise for them. In S. Pietro Maggiore, by the door, and on the right hand as one enters the church, is an Annunciation by his hand, wherein he made the Angel still flying through the sky, and the Madonna receiving the Salutation on her knees, in a most graceful attitude; and he drew there a building in perspective, which was a masterly thing, and was much extolled. And, in truth, although Francia had a somewhat dainty manner, because he was very laborious and constrained in his work, nevertheless he showed great care and diligence in giving the true proportions of art to his figures.

He was commissioned to execute a scene in the cloister in front of the Church of the Servites, in competition with Andrea del Sarto; and there he painted the Marriage of Our Lady, wherein may be clearly recognized the supreme faith of Joseph, who shows in his face as much awe as joy at his marriage with her. Besides this, Francia painted there one who is giving him some blows, as is the custom in our own day, in memory of the

wedding; and in a nude figure he expressed very happily the rage
and disappointment that drive him to break his rod, which had
not blossomed, the drawing of which, with many others, is in our
book. In the company of Our Lady, also, he painted some
women with most beautiful expressions and head-dresses, things
in which he always delighted. And in all this scene he did not
paint a single thing that was not very well considered; as is, for
example, a woman with a child in her arms, who, turning to go
home, has cuffed another child, who has sat down in tears and
refuses to go, pressing one hand against his face in a very graceful
manner. Certain it is that he executed every detail in this scene,
whether large or small, with much diligence and love, on account
of the burning desire that he had to show therein to craftsmen
and to all other good judges how great was his respect for the
difficulties of art, and how successfully he could solve them by
faithful imitation.

Not long after this, on the occasion of a festival, the friars
wished that the scenes of Andrea, and likewise that of Francia,
should be uncovered; and the night after Francia had finished his
with the exception of the base, they were so rash and presump-
tuous as to uncover them, not thinking, in their ignorance of art,
that Francia would want to retouch or otherwise change his
figures. In the morning, both the painting of Francia and those
of Andrea were open to view, and the news was brought to
Francia that Andrea's works and his own had been uncovered; at
which he felt such resentment, that he was like to die of it. Seized
with anger against the friars on account of their presumption and
the little respect that they had shown to him, he set off at his best
speed and came up to the work; and then, climbing on to the
staging, which had not yet been taken to pieces, although the
painting had been uncovered, and seizing a mason's hammer that
was there, he beat some of the women's heads to fragments, and
destroyed that of the Madonna, and also tore almost completely
away from the wall, plaster and all, a nude figure that is breaking
a rod. Hearing the noise, the friars ran up, and, with the help of
some laymen, seized his hands, to prevent him from destroying
it completely. But, although in time they offered to give him
double payment, he, on account of the hatred that he had con-
ceived for them, would never restore it. By reason of the rev-
erence felt by other painters both for him and for the work, they
have refused to finish it; and so it remains, even in our own day,

as a memorial of that event. This fresco is executed with such diligence and so much love, and it is so beautiful in its freshness, that Francia may be said to have worked better in fresco than any man of his time, and to have blended and harmonized his paintings in fresco better than any other, without needing to retouch the colours; wherefore he deserves to be much extolled both for this and for his other works.

At Rovezzano, without the Porta alla Croce, near Florence, he painted a shrine with a Christ on the Cross and some saints; and in S. Giovannino, at the Porta a S. Piero Gattolini, he executed a Last Supper of the Apostles in fresco.

No long time after, on the departure for France of the painter Andrea del Sarto, who had begun to paint the stories of S. John the Baptist in chiaroscuro in a cloister of the Company of the Scalzo at Florence, the men of that Company, desiring to have that work finished, engaged Francia, to the end that he, being an imitator of the manner of Andrea, might complete the paintings begun by the other. Thereupon Francia executed the decorations right round one part of that cloister, and finished two of the scenes, which he painted with great diligence. These are, first S. John the Baptist obtaining leave from his father Zacharias to go into the desert, and then the meeting of Christ and S. John on the way, with Joseph and Mary standing there and beholding them embrace one another. But more than this he did not do, on account of the return of Andrea, who then went on to finish the rest of the work.

With Ridolfo Ghirlandajo he prepared a most beautiful festival for the marriage of Duke Lorenzo, with two sets of scenery for the dramas that were performed, executing them with much method, masterly judgment, and grace; on account of which he acquired credit and favour with that Prince. This service was the reason that he received the commission for gilding the ceiling of the Hall of Poggio a Caiano, in company with Andrea di Cosimo. And afterwards, in competition with Andrea del Sarto and Jacopo da Pontormo, he began, on a wall in that hall, the scene of Cicero being carried in triumph by the citizens of Rome. This work had been undertaken by the liberality of Pope Leo, in memory of his father Lorenzo, who had caused the edifice to be built, and had ordained that it should be painted with scenes from ancient history and other ornaments according to his pleasure. And these had been entrusted by the learned historian, M. Paolo Giovio,

Bishop of Nocera, who was then chief in authority near the person of Cardinal Giulio de' Medici, to Andrea del Sarto, Jacopo da Pontormo, and Franciabigio, that they might demonstrate the power and perfection of their art in the work, each receiving thirty crowns every month from the magnificent Ottaviano de' Medici. Thereupon Francia executed on his part, to say nothing of the beauty of the scene, some buildings in perspective, very well proportioned. But the work remained unfinished on account of the death of Leo; and afterwards, in the year 1532, it was begun again by Jacopo da Pontormo at the commission of Duke Alessandro de' Medici, but he lingered over it so long, that the Duke died and it was once more left unfinished.

But to return to Francia; so ardent was his love for the matters of art, that there was no summer day on which he did not draw some study of a nude figure from the life in his workroom, and to that end he always kept men in his pay. For S. Maria Nuova, at the request of Maestro Andrea Pasquali, an excellent physician of Florence, he executed an anatomical figure, in consequence of which he made a great advance in the art of painting, and pursued it ever afterwards with more zeal. He then painted in the Convent of S. Maria Novella, in the lunette over the door of the library, a S. Thomas confuting the heretics with his learning, a work which is executed with diligence and a good manner. There, among other details, are two children who serve to uphold an escutcheon in the ornamental border; and these are very fine, full of the greatest beauty and grace, and painted in a most lovely manner.

He also executed a picture with little figures for Giovanni Maria Benintendi, in competition with Jacopo da Pontormo, who painted another of the same size for that patron, containing the story of the Magi; and two others were painted by Francesco d'Albertino.* In his work Francia represented the scene of David seeing Bathsheba in her bath; and there he painted some women in a manner too smooth and dainty, and drew a building in perspective, wherein is David giving letters to the messengers, who are to carry them to the camp to the end that Uriah the Hittite may meet his death; and under a loggia he painted a royal banquet of great beauty. This work contributed greatly to the

* Francesco Ubertini, called Il Bacchiacca.

fame and honour of Francia, who, if he had much ability for large figures, had much more for little figures.

Francia also made many most beautiful portraits from life; one, in particular, for Matteo Sofferroni, who was very much his friend, and another for a countryman, the steward of Pier Francesco de' Medici at the Palace of S. Girolamo da Fiesole, which seems absolutely alive, with many others. And since he undertook any kind of work without being ashamed, so long as he was pursuing his art, he set his hand to whatever commission was given to him; wherefore, in addition to many works of the meanest kind, he painted a most beautiful 'Noli me tangere' for the cloth-weaver Arcangelo, at the top of a tower that serves as a terrace, in Porta Rossa; with an endless number of other trivial works, executed by Francia because he was a person of sweet and kindly nature and very obliging, of which there is no need to say more.

This master loved to live in peace, and for that reason would never take a wife; and he was always repeating the trite proverb, 'The fruits of a wife are cares and strife.' He would never leave Florence, because, having seen some works by Raffaello da Urbino, and feeling that he was not equal to that great man and to many others of supreme renown, he did not wish to compete with craftsmen of such rare excellence. In truth, the greatest wisdom and prudence that a man can possess is to know himself, and to refrain from exalting himself beyond his true worth. And, finally, having acquired much by constant work, for one who was not endowed by nature with much boldness of invention or with any powers but those that he had gained by long study, he died in the year 1524 at the age of forty-two.

One of Francia's disciples was his brother Agnolo, who died after having painted a frieze that is in the cloister of S. Pancrazio, and a few other works. The same Agnolo painted for the perfumer Ciano, an eccentric man, but respected after his kind, a sign for his shop, containing a gipsy woman telling the fortune of a lady in a very graceful manner, which was the idea of Ciano, and not without mystic meaning. Another who learnt to paint from the same master was Antonio di Donnino Mazzieri, who was a bold draughtsman, and showed much invention in making horses and landscapes. He painted in chiaroscuro the cloister of S. Agostino at Monte Sansovino, executing therein scenes from the Old Testament, which were much extolled. In the Vescovado

of Arezzo he painted the Chapel of S. Matteo, with a scene, among other things, showing that Saint baptizing a King, in which he made a portrait of a German, so good that it seems to be alive. For Francesco del Giocondo he executed the story of the Martyrs in a chapel behind the choir of the Servite Church in Florence; but in this he acquitted himself so badly, that he lost all his credit and was reduced to undertaking any sort of work.

Francia taught his art also to a young man named Visino, who, to judge from what we see of him, would have become an excellent painter, if he had not died young, as he did; and to many others, of whom I shall make no further mention. He was buried by the Company of S. Giobbe in S. Pancrazio, opposite to his own house, in the year 1525; and his death was truly a great grief to all good craftsmen, seeing that he had been a talented and skilful master, and very modest in his every action.

MORTO DA FELTRO AND ANDREA DI COSIMO FELTRINI, Painters

THE painter Morto da Feltro, who was as original in his life as he was in his brain and in the new fashion of grotesques that he made, which caused him to be held in great estimation, found his way as a young man to Rome at the time when Pinturicchio was painting the Papal apartments for Alexander VI, with the loggie and lower rooms in the Great Tower of the Castello di S. Angelo, and some of the upper apartments. He was a melancholy person, and was constantly studying the antiquities; and seeing among them sections of vaults and ranges of walls adorned with grotesques, he liked these so much that he never ceased from examining them. And so well did he grasp the methods of drawing foliage in the ancient manner, that he was second to no man of his time in that profession. He was never tired, indeed, of examining all that he could find below the ground in Rome in the way of ancient grottoes, with vaults innumerable. He spent many months in Hadrian's Villa at Tivoli, drawing all the pavements and grottoes that are there, both above ground and below. And hearing that at Pozzuolo, in the Kingdom of Naples, ten miles from the city, there were many walls covered with ancient grotesques, both executed in relief with stucco and painted, and

said to be very beautiful, he devoted several months to studying them on the spot. Nor was he content until he had drawn every least thing in the Campana, an ancient road in that place, full of antique sepulchres; and he also drew many of the temples and grottoes, both above and below the ground, at Trullo, near the seashore. He went to Baia and Mercato di Sabbato, both places full of ruined buildings covered with scenes, searching out everything in such a manner that by means of his long and loving labour he grew vastly in power and knowledge of his art.

Having then returned to Rome, he worked there many months, giving his attention to figures, since he considered that in that part of his profession he was not the master that he was held to be in the execution of grotesques. And after he had conceived this desire, hearing the renown that Leonardo and Michelagnolo had in that art on account of the cartoons executed by them in Florence, he set out straightway to go to that city. But, after he had seen those works, he did not think himself able to make the same improvement that he had made in his first profession, and he went back, therefore, to work at his grotesques.

There was then living in Florence one Andrea di Cosimo Feltrini, a painter of that city, and a young man of much diligence, who received Morto into his house and entertained him with most affectionate attentions. Finding pleasure in the nature of Morto's art, Andrea also gave his mind to that vocation, and became an able master, being in time even more excellent than Morto, and much esteemed in Florence, as will be told later. And it was through Andrea that Morto came to paint for Piero Soderini, who was then Gonfalonier, decorations of grotesques in an apartment of the Palace, which were held to be very beautiful; but in our own day these have been destroyed in rearranging the apartments of Duke Cosimo, and repainted. For Maestro Valerio, a Servite friar, Morto decorated the empty space on a chair-back, which was a most beautiful work; and for Agnolo Doni, likewise, in a chamber, he executed many pictures with a variety of bizarre grotesques. And since he also delighted in figures, he painted Our Lady in some round pictures, in order to see whether he could become as famous for them as he was (for his grotesques).

Then, having grown weary of staying in Florence, he betook

himself to Venice; and attaching himself to Giorgione da Castelfranco, who was then painting the Fondaco de' Tedeschi, he set himself to assist him and executed the ornamentation of that work. And in this way he remained many months in that city, attracted by the sensuous pleasures and delights that he found there.

He then went to execute works in Friuli, but he had not been there long when, finding that the rulers of Venice were enlisting soldiers, he entered their service; and before he had had much experience of that calling he was made Captain of two hundred men. The army of the Venetians had advanced by that time to Zara in Sclavonia; and one day, when a brisk skirmish took place, Morto, desiring to win a greater name in that profession than he had gained in the art of painting, went bravely forward, and, after fighting in the mêlée, was left dead on the field, even as he had always been in name,* at the age of forty-five. But in fame he will never be dead, because those who exercise their hands in the arts and produce everlasting works, leaving memorials of themselves after death, are destined never to suffer the death of their labours, for writers, in their gratitude, bear witness to their talents. Eagerly, therefore, should our craftsmen spur themselves on with incessant study to such a goal as will ensure them an undying name both through their own works and through the writings of others, since, by so doing, they will gain eternal life both for themselves and for the works that they leave behind them after death.

Morto restored the painting of grotesques in a manner more like the ancient than was achieved by any other painter, and for this he deserves infinite praise, in that it is after his example that they have been brought in our own day, by the hands of Giovanni da Udine and other craftsmen, to the great beauty and excellence that we see. For, although the said Giovanni and others have carried them to absolute perfection, it is none the less true that the chief praise is due to Morto, who was the first to bring them to light and to devote his whole attention to paintings of that kind, which are called grotesques because they were found for the most part in the grottoes of the ruins of Rome; besides which, every man knows that it is easy to make additions to anything once it has been discovered.

* From the word 'Morto,' which means 'dead.'

The painting of grotesques was continued in Florence by Andrea Feltrini, called Di Cosimo, because he was a disciple of Cosimo Rosselli in the study of figures (which he executed passing well), as he was afterwards of Morto in that of grotesques, of which we have spoken. In this kind of painting Andrea had from nature such power of invention and such grace that he was the first to make ornaments of greater grandeur, abundance, and richness than the ancient, and quite different in manner; and he gave them better order and cohesion, and enriched them with figures, such as are not seen in Rome or in any other place but Florence, where he executed a great number. In this respect there has never been any man who has surpassed him in excellence, as may be seen from the ornament and the predella painted with little grotesques in colour round the Pietà that Pietro Perugino executed for the altar of the Serristori in S. Croce at Florence. These are heightened with various colours on a ground of red and black mixed together, and are wrought with much facility and with extraordinary boldness and grace.

Andrea introduced the practice of covering the façades of houses and palaces with an intonaco of lime mixed with the black of ground charcoal, or rather, burnt straw, on which intonaco, when still fresh, he spread a layer of white plaster. Then, having drawn the grotesques, with such divisions as he desired, on some cartoons, he dusted them over the intonaco, and proceeded to scratch it with an iron tool, in such a way that his designs were traced over the whole façade by that tool; after which, scraping away the white from the grounds of the grotesques, he went on to shade them or to hatch a good design upon them with the same iron tool. Finally, he went over the whole work, shading it with a liquid water-colour like water tinted with black. All this produces a very pleasing, rich, and beautiful effect; and there was an account of the method in the twenty-sixth chapter, dealing with sgraffiti, in the Treatise on Technique.

The first façades that Andrea executed in this manner were that of the Gondi, which is full of delicacy and grace, in Borg' Ognissanti, and that of Lanfredino Lanfredini, which is very ornate and rich in the variety of its compartments, on the Lungarno between the Ponte S. Trinita and the Ponte della Carraja, near S. Spirito. He also decorated in sgraffito the house of Andrea and Tommaso Sertini, near S. Michele in Piazza Padella, making it more varied and grander in manner than the two others. He

painted in chiaroscuro the façade of the Church of the Servite
Friars, for which work he caused the painter Tommaso di Stefano
to paint in two niches the Angel bringing the Annunciation to the
Virgin; and in the court, where there are the stories of S. Filippo
and of Our Lady painted by Andrea del Sarto, he executed be-
tween the two doors a very beautiful escutcheon of Pope Leo X.
And on the occasion of the visit of that Pontiff to Florence he
executed many beautiful ornaments in the form of grotesques on
the façade of S. Maria del Fiore, for Jacopo Sansovino, who gave
him his sister for wife. He executed the baldachin under which the
Pope walked, covering the upper part with most beautiful grot-
esques, and the hangings round it with the arms of that Pope and
other devices of the Church; and this baldachin was afterwards
presented to the Church of S. Lorenzo in Florence, where it is still
to be seen. He also decorated many standards and banners for the
visit of Leo, and in honour of many who were made Chevaliers
by that Pontiff and by other Princes, of which there are some hung
up in various churches in that city.

Andrea, working constantly in the service of the house of
Medici, assisted at the preparations for the wedding of Duke
Giuliano and that of Duke Lorenzo, executing an abundance of
various ornaments in the form of grotesques; and so, also, in the
obsequies of those Princes. In all this he was largely employed by
Franciabigio, Andrea del Sarto, Pontormo, and Ridolfo Ghirlan-
dajo, and by Granaccio for triumphal processions and other fes-
tivals, since nothing good could be done without him. He was
the best man that ever touched a brush, and, being timid by
nature, he would never undertake any work on his own account,
because he was afraid of exacting the money for his labours. He
delighted to work the whole day long, and disliked annoyances
of any kind; for which reason he associated himself with the
gilder Mariotto di Francesco, one of the most able and skilful
men at his work that ever existed in the world of art, very adroit
in obtaining commissions, and most dexterous in exacting pay-
ments and doing business. This Mariotto also brought the gilder
Raffaello di Biagio into the partnership, and the three worked
together, sharing equally all the earnings of the commissions that
they executed; and this association lasted until death parted them,
Mariotto being the last to die.

To return to the works of Andrea; he decorated for Giovanni
Maria Benintendi all the ceilings of his house, and executed the

ornamentation of the ante-chambers, wherein are the scenes painted by Franciabigio and Jacopo da Pontormo. He went with Franciabigio to Poggio, and executed in terretta the ornaments for all the scenes there in such a way that there is nothing better to be seen. For the Chevalier Guidotti he decorated in sgraffito the façade of his house in the Via Larga, and he also executed another of great beauty for Bartolommeo Panciatichi, on the house (now belonging to Ruberto de' Ricci) which he built on the Piazza degli Agli. Nor am I able to describe all the friezes, coffers, and strong-boxes, or the vast quantity of ceilings, which Andrea decorated with his own hand, for the whole city is full of these, and I must refrain from speaking of them. But I must mention the round escutcheons of various kinds that he made, for they were such that no wedding could take place without his having his workshop besieged by one citizen or another; nor could any kind of brocade, linen, or cloth of gold, with flowered patterns, ever be woven, without his making the designs for them, and that with so much variety, grace, and beauty, that he breathed spirit and life into all such things. If Andrea, indeed, had known his own value, he would have made a vast fortune; but it sufficed him to live in love with his art.

I must not omit to tell that in my youth, while in the service of Duke Alessandro de' Medici, I was commissioned, when Charles V came to Florence, to make the banners for the Castle, or rather, as it is called at the present day, the Citadel; and among these was a standard of crimson cloth, eighteen braccia wide at the staff and forty in length, and surrounded by borders of gold containing the devices of the Emperor Charles V and of the house of Medici, with the arms of his Majesty in the centre. For this work, in which were used forty-five thousand leaves of gold, I summoned to my assistance Andrea for the borders and Mariotto for the gilding; and many things did I learn from that good Andrea, so full of love and kindness for those who were studying art. And so great did the skill of Andrea then prove to be, that, besides availing myself of him for many details of the arches that were erected for the entry of his Majesty, I chose him as my companion, together with Tribolo, when Madama Margherita, daughter of Charles V, came to be married to Duke Alessandro, in making the festive preparations that I executed in the house of the Magnificent Ottaviano de' Medici on the Piazza di S. Marco, which was adorned with grotesques by his hand, with

statues by the hand of Tribolo, and with figures and scenes by my hand. At the last he was much employed for the obsequies of Duke Alessandro, and even more for the marriage of Duke Cosimo, when all the devices in the courtyard, described by M. Francesco Giambullari, who wrote an account of the festivities of that wedding, were painted by Andrea with ornaments of great variety. And then Andrea – who, by reason of a melancholy humour which often oppressed him, was on many occasions on the point of taking his own life, but was observed so closely and guarded so well by his companion Mariotto that he lived to be an old man – finished the course of his life at the age of sixty-four, leaving behind him the name of a good and even rarely excellent master of grotesque-painting in our own times, wherein every succeeding craftsman has always imitated his manner, not only in Florence, but also in other places.

MARCO CALAVRESE, Painter

WHEN the world possesses some great light in any science, every least part is illuminated by its rays, some with greater brightness and some with less; and the miracles that result are also greater or less according to differences of air and place. Constantly, in truth, do we see a particular country producing a particular kind of intellect fitted for a particular kind of work, for which others are not fitted, nor can they ever attain, whatever labours they may endure, to the goal of supreme excellence. And if we marvel when we see growing in some province a fruit that has not been wont to grow there, much more can we rejoice in a man of fine intellect when we find him in a country where men of the same bent are not usually born. Thus it was with the painter Marco Calavrese, who, leaving his own country, chose for his habitation the sweet and pleasant city of Naples. He had been minded, indeed, on setting out, to make his way to Rome, and there to achieve the end that rewards the student of painting; but the song of the Siren was so sweet to him, and all the more because he delighted to play on the lute, and the soft waters of Sebeto so melted his heart, that he remained a prisoner in body of that land until he rendered up his spirit to Heaven and his mortal flesh to earth.

Marco executed innumerable works in oils and in fresco, and he proved himself more able than any other man who was practising the same art in that country in his day. Of this we have proof in the work that he executed at Aversa, ten miles distant from Naples; and, above all, in a panel-picture in oils on the high-altar of the Church of S. Agostino, with a large ornamental frame, and various pictures painted with scenes and figures, in which he represented S. Augustine disputing with the heretics, with stories of Christ and Saints in various attitudes both above and at the sides. In this work, which shows a manner full of harmony and drawing towards the good manner of our modern works, may also be seen great beauty and facility of colouring; and it was one of the many labours that he executed in that city and for various places in the kingdom.

Marco always lived a gay life, enjoying every minute to the full, for the reason that, having no rivalry to contend with in painting from other craftsmen, he was always adored by the Neapolitan nobles, and contrived to have himself rewarded for his works by ample payments. And so, having come to the age of fifty-six, he ended his life after an ordinary illness.

He left a disciple in Giovan Filippo Crescione, a painter of Naples, who executed many pictures in company with his brother-in-law, Leonardo Castellani, as he still does; but of these men, since they are alive and in constant practice of their art, there is no need to make mention.

The pictures of Maestro Marco were executed by him between 1508 and 1542. He had a companion in another Calabrian (whose name I do not know), who worked for a long time in Rome with Giovanni da Udine and executed many works by himself in that city, particularly façades in chiaroscuro. The same Calabrian also painted in fresco the Chapel of the Conception in the Church of the Trinità, with much skill and diligence.

At this same time lived Niccola, commonly called by everyone Maestro Cola dalla Matrice, who executed many works in Calabria, at Ascoli, and at Norcia, which are very well known, and which gained for him the name of a rare master – the best, indeed, that there had ever been in these parts. And since he also gave his attention to architecture, all the buildings that were erected in his day at Ascoli and throughout all that province had him as architect. Cola, without caring to see Rome or to change his country, remained always at Ascoli, living happily for some

time with his wife, a woman of good and honourable family, and endowed with extraordinary nobility of spirit, as was proved when the strife of parties arose at Ascoli, in the time of Pope Paul III. For then, while she was flying with her husband, with many soldiers in pursuit, more on her account (for she was a very beautiful young woman) than for any other reason, she resolved, not seeing any other way in which she could save her own honour and the life of her husband, to throw herself from a high cliff to the depth below. At which all the soldiers believed that she was not only mortally injured, but dashed to pieces, as indeed she was; wherefore they left the husband without doing him any harm, and returned to Ascoli. After the death of this extraordinary woman, worthy of eternal praise, Maestro Cola passed the rest of his life with little happiness. A short time afterwards, Signor Alessandro Vitelli, who had become Lord of Matrice,* took Maestro Cola, now an old man, to Città di Castello, where he caused him to paint in his palace many works in fresco and many other pictures; which works finished, Maestro Cola returned to finish his life at Matrice.

This master would have acquitted himself not otherwise than passing well, if he had practised his art in places where rivalry and emulation might have made him attend with more study to painting, and exercise the beautiful intellect with which it is evident that he was endowed by nature.

FRANCESCO MAZZUOLI, Painter of Parma
[*PARMIGIANO*]

AMONG the many natives of Lombardy who have been endowed with the gracious gift of design, with a lively spirit of invention, and with a particular manner of making beautiful landscapes in their pictures, we should rate as second to none, and even place before all the rest, Francesco Mazzuoli of Parma, who was bountifully endowed by Heaven with all those parts that are necessary to make a supreme painter, insomuch that he gave to his figures, in addition to what has been said of many others, a certain nobility, sweetness, and grace in the attitudes which belonged to him alone. To his heads, likewise, it is evident that he

* Amatrice.

gave all the consideration that is needful; and his manner has therefore been studied and imitated by innumerable painters, because he shed on art a light of grace so pleasing, that his works will always be held in great price, and himself honoured by all students of design. Would to God that he had always pursued the studies of painting, and had not sought to pry into the secrets of congealing mercury in order to become richer than Nature and Heaven had made him; for then he would have been without an equal, and truly unique in the art of painting, whereas, by searching for that which he could never find, he wasted his time, wronged his art, and did harm to his own life and fame.

Francesco was born at Parma in the year 1504, and because he lost his father when he was still a child of tender age, he was left to the care of two uncles, brothers of his father, and both painters, who brought him up with the greatest lovingness, teaching him all those praiseworthy ways that befit a Christian man and a good citizen. Then, having made some little growth, he had no sooner taken pen in hand in order to learn to write, than he began, spurred by Nature, who had consecrated him at his birth to design, to draw most marvellous things; and the master who was teaching him to write, noticing this and perceiving to what heights the genius of the boy might in time attain, persuaded his uncles to let him give his attention to design and painting. Whereupon, being men of good judgment in matters of art, although they were old and painters of no great fame, and recognizing that God and Nature had been the boy's first masters, they did not fail to take the greatest pains to make him learn to draw under the discipline of the best masters, to the end that he might acquire a good manner. And coming by degrees to believe that he had been born, so to speak, with brushes in his fingers, on the one hand they urged him on, and on the other, fearing lest overmuch study might perchance spoil his health, they would sometimes hold him back. Finally, having come to the age of sixteen, and having already done miracles of drawing, he painted a S. John baptizing Christ, of his own invention, on a panel, which he executed in such a manner that even now whoever sees it stands marvelling that such a work should have been painted so well by a boy. This picture was placed in the Nunziata, the seat of the Frati de' Zoccoli at Parma. Not content with this, however, Francesco resolved to try his hand at working in fresco, and therefore painted a chapel in S. Giovanni Evangelista, a house of

Black Friars of S. Benedict; and since he succeeded in that kind of work, he painted as many as seven.

But about that time Pope Leo X sent Signor Prospero Colonna with an army to Parma, and the uncles of Francesco, fearing that he might perchance lose time or be distracted, sent him in company with his cousin, Girolamo Mazzuoli, another boy-painter, to Viadana, a place belonging to the Duke of Mantua, where they lived all the time that the war lasted; and there Francesco painted two panels in distemper. One of these, in which are S. Francis receiving the Stigmata, and S. Chiara, was placed in the Church of the Frati de' Zoccoli; and the other, which contains a Marriage of S. Catharine, with many figures, was placed in S. Piero. And let no one believe that these are works of a young beginner, for they seem to be rather by the hand of a full-grown master.

The war finished, Francesco, having returned with his cousin to Parma, first completed some pictures that he had left unfinished at his departure, which are in the hands of various people. After this he painted a panel-picture in oils of Our Lady with the Child in her arms, with S. Jerome on one side and the Blessed Bernardino da Feltro on the other, and in the head of one of these figures he made a portrait of the patron of the picture, which is so wonderful that it lacks nothing save the breath of life. All these works he executed before he had reached the age of nineteen.

Then, having conceived a desire to see Rome, like one who was on the path of progress and heard much praise given to the works of good masters, and particularly to those of Raffaello and Michelagnolo, he spoke out his mind and desire to his old uncles, who, thinking that such a wish was not otherwise than worthy of praise, said that they were content that he should go, but that it would be well for him to take with him some work by his own hand, which might serve to introduce him to the noblemen of that city and to the craftsmen of his profession. This advice was not displeasing to Francesco, and he painted three pictures, two small and one of some size, representing in the last the Child in the arms of the Madonna, taking some fruits from the lap of an Angel, and an old man with his arms covered with hair, executed with art and judgment, and pleasing in colour. Besides this, in order to investigate the subtleties of art, he set himself one day to make his own portrait, looking at himself in a convex barber's

mirror. And in doing this, perceiving the bizarre effects produced by the roundness of the mirror, which twists the beams of a ceiling into strange curves, and makes the doors and other parts of buildings recede in an extraordinary manner, the idea came to him to amuse himself by counterfeiting everything. Thereupon he had a ball of wood made by a turner, and, dividing it in half so as to make it the same in size and shape as the mirror, set to work to counterfeit on it with supreme art all that he saw in the glass, and particularly his own self, which he did with such lifelike reality as could not be imagined or believed. Now everything that is near the mirror is magnified, and all that is at a distance is diminished, and thus he made the hand engaged in drawing somewhat large, as the mirror showed it, and so marvellous that it seemed to be his very own. And since Francesco had an air of great beauty, with a face and aspect full of grace, in the likeness rather of an angel than of a man, his image on that ball had the appearance of a thing divine. So happily, indeed, did he succeed in the whole of the work, that the painting was no less real than the reality, and in it was seen the lustre of the glass, the reflection of every detail, and the lights and shadows, all so true and natural, that nothing more could have been looked for from the brain of man.

Having finished these works, which were held by his old uncles to be out of the ordinary, and even considered by many other good judges of art to be miracles of beauty, and having packed up both pictures and portrait, he made his way to Rome, accompanied by one of the uncles. There, after the Datary had seen the pictures and appraised them at their true worth, the young man and his uncle were straightway introduced to Pope Clement, who, seeing the works and the youthfulness of Francesco, was struck with astonishment, and with him all his Court. And afterwards his Holiness, having first shown him much favour, said that he wished to commission him to paint the Hall of the Popes, is which Giovanni da Udine had already decorated all the ceiling with stucco-work and painting. And so, after presenting his pictures to the Pope, and receiving various gifts and marks of favour in addition to his promises, Francesco, spurred by the praise and glory that he heard bestowed upon him, and by the hope of the profit that he might expect from so great a Pontiff, painted a most beautiful picture of the Circumcision, which was held to be extraordinary in invention on account of three most fanciful lights that shone in the work; for the first figures were

illuminated by the radiance of the countenance of Christ, the second received their light from others who were walking up some steps with burning torches in their hands, bringing offerings for the sacrifice, and the last were revealed and illuminated by the light of the dawn, which played upon a most lovely landscape with a vast number of buildings. This picture finished, he presented it to the Pope, who did not do with it what he had done with the others; for he had given the picture of Our Lady to Cardinal Ippolito de' Medici, his nephew, and the mirror-portrait to Messer Pietro Aretino, the poet, who was in his service, but the picture of the Circumcision he kept for himself; and it is believed that it came in time into the possession of the Emperor. The mirror-portrait I remember to have seen, when quite a young man, in the house of the same Messer Pietro Aretino at Arezzo, where it was sought out as a choice work by the strangers passing through that city. Afterwards it fell, I know not how, into the hands of Valerio Vicentino, the crystal-engraver, and it is now in the possession of Alessandro Vittoria, a sculptor in Venice, the disciple of Jacopo Sansovino.

But to return to Francesco; while studying in Rome, he set himself to examine all the ancient and modern works, both of sculpture and of painting, that were in that city, but held those of Michelagnolo Buonarroti and Raffaello da Urbino in supreme veneration beyond all the others; and it was said afterwards that the spirit of that Raffaello had passed into the body of Francesco, when men saw how excellent the young man was in art, and how gentle and gracious in his ways, as was Raffaello, and above all when it became known how much Francesco strove to imitate him in everything, and particularly in painting. Nor was this study in vain, for many little pictures that he painted in Rome, the greater part of which afterwards came into the hands of Cardinal Ippolito de' Medici, were truly marvellous; and even such is a round picture with a very beautiful Annunciation, executed by him for Messer Agnolo Cesis, which is now treasured as a rare work in the house of that family. He painted a picture, likewise, of the Madonna with Christ, some Angels, and a S. Joseph, which are beautiful to a marvel on account of the expressions of the heads, the colouring, and the grace and diligence with which they are seen to have been executed. This work was formerly in the possession of Luigi Gaddi, and it must now be in the hands of his heirs.

Hearing the fame of this master, Signor Lorenzo Cibo, Captain of the Papal Guard, and a very handsome man, had a portrait of himself painted by Francesco, who may be said to have made, not a portrait, but a living figure of flesh and blood. Having then been commissioned to paint for Madonna Maria Bufolini of Città di Castello a panel-picture which was to be placed in S. Salvatore del Lauro, in a chapel near the door, Francesco painted in it a Madonna in the sky, who is reading and has the Child between her knees, and on the earth he made a figure of S. John, kneeling on one knee in an attitude of extraordinary beauty, turning his body, and pointing to the Infant Christ; and lying asleep on the ground, in foreshortening, is a S. Jerome in Penitence.

But he was prevented from bringing this work to completion by the ruin and sack of Rome in 1527, which was the reason not only that the arts were banished for a time, but also that many craftsmen lost their lives. And Francesco, also, came within a hair's breadth of losing his, seeing that at the beginning of the sack he was so intent on his work, that, when the soldiers were entering the houses, and some Germans were already in his, he did not move from his painting for all the uproar that they were making; but when they came upon him and saw him working, they were so struck with astonishment at the work, that, like the gentlemen that they must have been, they let him go on. And thus, while the impious cruelty of those barbarous hordes was ruining the unhappy city and all its treasures, both sacred and profane, without showing respect to either God or man, Francesco was provided for and greatly honoured by those Germans, and protected from all injury. All the hardship that he suffered at that time was this, that he was forced, one of them being a great lover of painting, to make a vast number of drawings in water-colours and with the pen, which formed the payment of his ransom. But afterwards, when these soldiers changed their quarters, Francesco nearly came to an evil end, because, going to look for some friends, he was made prisoner by other soldiers and compelled to pay as ransom some few crowns that he possessed. Wherefore his uncle, grieved by that and by the fact that this disaster had robbed Francesco of his hopes of acquiring knowledge, honour, and profit, and seeing Rome almost wholly in ruins and the Pope the prisoner of the Spaniards, determined to take him back to Parma. And so he set Francesco on his way to his native city, but himself remained for some days in Rome,

where he deposited the panel-picture painted for Madonna Maria Bufolini with the Friars of the Pace, in whose refectory it remained for many years, until finally it was taken by Messer Giulio Bufolini to the church of his family in Città di Castello.

Having arrived in Bologna, and finding entertainment with many friends, and particularly in the house of his most intimate friend, a saddler of Parma, Francesco stayed some months in that city, where the life pleased him, during which time he had some works engraved and printed in chiaroscuro, among others the Beheading of S. Peter and S. Paul, and a large figure of Diogenes. He also prepared many others, in order to have them engraved on copper and printed, having with him for this purpose one Maestro Antonio da Trento; but he did not carry this intention into effect at the time, because he was forced to set his hand to executing many pictures and other works for gentlemen of Bologna. The first picture by his hand that was seen at Bologna was a S. Rocco of great size in the Chapel of the Monsignori in S. Petronio; to which Saint he gave a marvellous aspect, making him very beautiful in every part, and conceiving him as somewhat relieved from the pain that the plague-sore in the thigh gave him, which he shows by looking with uplifted head towards Heaven in the act of thanking God, as good men do in spite of the adversities that fall upon them. This work he executed for one Fabrizio da Milano, of whom he painted a portrait from the waist upwards in the picture, with the hands clasped, which seems to be alive; and equally real, also, seems a dog that is there, with some landscapes which are very beautiful, Francesco being particularly excellent in this respect.

He then painted for Albio, a physician of Parma, a Conversion of S. Paul, with many figures and a landscape, which was a very choice work. And for his friend the saddler he executed another picture of extraordinary beauty, containing a Madonna turned to one side in a lovely attitude, and several other figures. He also painted a picture for Count Giorgio Manzuoli, and two canvases in gouache, with some little figures, all graceful and well executed, for Maestro Luca dai Leuti.

One morning about this time, while Francesco was still in bed, the aforesaid Antonio da Trento, who was living with him as his engraver, opened a strong-box and robbed him of all the copper-plate engravings, woodcuts, and drawings that he possessed; and he must have gone off to the Devil, for all the news that was ever

heard of him. The engravings and woodcuts, indeed, Francesco recovered, for Antonio had left them with a friend in Bologna, perchance with the intention of reclaiming them at his convenience; but the drawings he was never able to get back. Driven almost out of his mind by this, he returned to his painting, and made a portrait, for the sake of money, of I know not what Count of Bologna. After that he painted a picture of Our Lady, with a Christ who is holding a globe of the world. The Madonna has a most beautiful expression, and the Child is also very natural; for he always gave to the faces of children a vivacious and truly childlike air, which yet reveals that subtle and mischievous spirit that children often have. And he attired the Madonna in a very unusual fashion, clothing her in a garment that had sleeves of yellowish gauze, striped, as it were, with gold, which gave a truly beautiful and graceful effect, revealing the flesh in a natural and delicate manner; besides which, the hair is painted so well that there is none better to be seen. This picture was painted for Messer Pietro Aretino, but Francesco gave it to Pope Clement, who came to Bologna at that time; then, in some way of which I know nothing, it fell into the hands of Messer Dionigi Gianni, and it now belongs to his son, Messer Bartolommeo, who has been so accommodating with it that it has been copied fifty times, so much is it prized.

The same master painted for the Nuns of S. Margherita, in Bologna, a panel-picture containing a Madonna, S. Margaret, S. Petronio, S. Jerome, and S. Michael, which is held in vast veneration, as it deserves, since in the expressions of the heads and in every other part it is as fine as all the other works of this painter. He made many drawings, likewise, and in particular some for Girolamo del Lino, and some for Girolamo Fagiuoli, a goldsmith and engraver, who desired them for engraving on copper; and these drawings are held to be full of grace. For Bonifazio Gozzadino he painted his portrait from life, with one of his wife, which remained unfinished. He also began a picture of Our Lady, which was afterwards sold in Bologna to Giorgio Vasari of Arezzo, who has it in the new house built by himself at Arezzo, together with many other noble pictures, works of sculpture, and ancient marbles.

When the Emperor Charles V was at Bologna to be crowned by Clement VII, Francesco, who went several times to see him at table, but without drawing his portrait, made a likeness of that

Emperor in a very large picture in oils, wherein he painted Fame crowning him with laurel, and a boy in the form of a little Hercules offering him a globe of the world, giving him, as it were, the dominion over it. This work, when finished, he showed to Pope Clement, who was so pleased with it that he sent it and Francesco together, accompanied by the Bishop of Vasona, then Datary, to the Emperor; at which his Majesty, to whom it gave much satisfaction, hinted that it should be left with him. But Francesco, being ill advised by an insincere or injudicious friend, refused to leave it, saying that it was not finished; and so his Majesty did not have it, and Francesco was not rewarded for it, as he certainly would have been. This picture, having afterwards fallen into the hands of Cardinal Ippolito de' Medici, was presented by him to the Cardinal of Mantua; and it is now in the guardaroba of the Duke of that city, with many other most noble and beautiful pictures.

After having been so many years out of his native place, as we have related, during which he had gained much experience in art, without accumulating any store of riches, but only of friends, Francesco, in order to satisfy his many friends and relatives, finally returned to Parma. Arriving there, he was straightway commissioned to paint in fresco a vault of some size in the Church of S. Maria della Steccata; but since in front of that vault there was a flat arch which followed the curve of the vaulting, making a sort of façade, he set to work first on the arch, as being the easier, and painted therein six very beautiful figures, two in colour and four in chiaroscuro. Between one figure and another he made some most beautiful ornaments, surrounding certain rosettes in relief, which he took it into his head to execute by himself in copper, taking extraordinary pains over them.

At this same time he painted for the Chevalier Baiardo, a gentleman of Parma and his intimate friend, a picture of a Cupid, who is fashioning a bow with his own hand, and at his feet are seated two little boys, one of whom catches the other by the arm and laughingly urges him to touch Cupid with his finger, but he will not touch him, and shows by his tears that he is afraid of burning himself at the fire of Love. This picture, which is charming in colour, ingenious in invention, and executed in that graceful manner of Francesco's that has been much studied and imitated, as it still is, by craftsmen and by all who delight in art, is now in the study of Signor Marc' Antonio Cavalca, heir to the

Chevalier Baiardo, together with many drawings of every kind by the hand of the same master, all most beautiful and highly finished, which he has collected. Even such are the many drawings, also by the hand of Francesco, that are in our book; and particularly that of the Beheading of S. Peter and S. Paul, of which, as has been related, he published copper-plate engravings and woodcuts, while living in Bologna. For the Church of S. Maria de' Servi he painted a panel-picture of Our Lady with the Child asleep in her arms, and on one side some Angels, one of whom has in his arms an urn of crystal, wherein there glitters a Cross, at which the Madonna gazes in contemplation. This work remained unfinished, because he was not well contented with it; and yet it is much extolled, and a good example of his manner, so full of grace and beauty.

Meanwhile Francesco began to abandon the work of the Steccata, or at least to carry it on so slowly that it was evident that he was not in earnest. And this happened because he had begun to study the problems of alchemy, and had quite deserted his profession of painting, thinking that he would become rich quicker by congealing mercury. Wherefore, wearing out his brain, but not in imagining beautiful inventions and executing them with brushes and colour-mixtures, he wasted his whole time in handling charcoal, wood, glass vessels, and other suchlike trumperies, which made him spend more in one day than he earned by a week's work at the Chapel of the Steccata. Having no other means of livelihood, and being yet compelled to live, he was wasting himself away little by little with those furnaces; and what was worse, the men of the Company of the Steccata, perceiving that he had completely abandoned the work, and having perchance paid him more than his due, as is often done, brought a suit against him. Thereupon, thinking it better to withdraw, he fled by night with some friends to Casal Maggiore. And there, having dispersed a little of the alchemy out of his head, he painted a panel-picture for the Church of S. Stefano, of Our Lady in the sky, with S. John the Baptist and S. Stephen below. Afterwards he executed a picture, the last that he ever painted, of the Roman Lucretia, which was a thing divine and one of the best that were ever seen by his hand; but it has disappeared, however that may have happened, so that no one knows where it is.

By his hand, also, is a picture of some nymphs, which is now in the house of Messer Niccolò Bufolini at Città di Castello, and

a child's cradle, which was painted for Signora Angiola de' Rossi of Parma, wife of Signor Alessandro Vitelli, and is likewise at Città di Castello.

In the end, having his mind still set on his alchemy, like every other man who has once grown crazed over it, and changing from a dainty and gentle person into an almost savage man with long and unkempt beard and locks, a creature quite different from his other self, Francesco went from bad to worse, became melancholy and eccentric, and was assailed by a grievous fever and a cruel flux, which in a few days caused him to pass to a better life. And in this way he found an end to the troubles of this world, which was never known to him save as a place full of annoyances and cares. He wished to be laid to rest in the Church of the Servite Friars, called La Fontana, one mile distant from Casal Maggiore; and he was buried naked, as he had directed, with a cross of cypress upright on his breast. He finished the course of his life on the 24th of August, in the year 1540, to the great loss of art on account of the singular grace that his hands gave to the pictures that he painted.

Francesco delighted to play on the lute, and had a hand and a genius so well suited to it that he was no less excellent in this than in painting. It is certain that if he had not worked by caprice, and had laid aside the follies of the alchemists, he would have been without a doubt one of the rarest and most excellent painters of our age. I do not deny that working at moments of fever-heat, and when one feels inclined, may be the best plan. But I do blame a man for working little or not at all, and for wasting all his time over cogitations, seeing that the wish to arrive by trickery at a goal to which one cannot attain, often brings it about that one loses what one knows in seeking after that which it is not given to us to know. If Francesco, who had from nature a spirit of great vivacity, with a beautiful and graceful manner, had persisted in working every day, little by little he would have made such proficience in art, that, even as he gave a beautiful, gracious, and most charming expression to his heads, so he would have surpassed his own self and the others in the solidity and perfect excellence of his drawing.

He left behind him his cousin Girolamo Mazzuoli, who, with great credit to himself, always imitated his manner, as is proved by the works by his hand that are in Parma. At Viadana, also, whither he fled with Francesco on account of the war, he painted,

young as he was, a very beautiful Annunciation on a little panel for S. Francesco, a seat of the Frati de' Zoccoli; and he painted another for S. Maria ne' Borghi. For the Conventual Friars of S. Francis at Parma he executed the panel-picture of their high-altar, containing Joachim being driven from the Temple, with many figures. And for S. Alessandro, a convent of nuns in that city, he painted a panel with the Madonna in Heaven, the Infant Christ presenting a palm to S. Giustina, and some Angels drawing back a piece of drapery, with S. Alexander the Pope and S. Benedict. For the Church of the Carmelite Friars he painted the panel-picture of their high-altar, which is very beautiful, and for S. Sepolcro another panel-picture of some size. In S. Giovanni Evangelista, a church of nuns in the same city, are two panel-pictures by the hand of Girolamo, of no little beauty, but not equal to the doors of the organ or to the picture of the high-altar, in which is a most beautiful Transfiguration, executed with much diligence. The same master has painted a perspective-view in fresco in the refectory of those nuns, with a picture in oils of the Last Supper of Christ with the Apostles, and fresco-paintings in the Chapel of the High-Altar in the Duomo. And for Madama Margherita of Austria, Duchess of Parma, he has made a portrait of the Prince Don Alessandro, her son, in full armour, with his sword over a globe of the world, and an armed figure of Parma kneeling before him.

In a chapel of the Steccata, at Parma, he has painted in fresco the Apostles receiving the Holy Spirit, and on an arch similar to that which his cousin Francesco painted he has executed six Sibyls, two in colour and four in chiaroscuro; while in a niche opposite to that arch he has painted the Nativity of Christ, with the Shepherds adoring Him, which is a very beautiful picture, although it was left not quite finished. For the high-altar of the Certosa, without Parma, he has painted a panel-picture with the three Magi; a panel for S. Piero, an abbey of Monks of S. Bernard, at Pavia; another for the Duomo of Mantua, at the commission of the Cardinal; and yet another panel for S. Giovanni in the same city, containing a Christ in a glory of light, surrounded by the Apostles, with S. John, of whom He appears to be saying, 'Sic eum volo manere,' etc.; while round this panel, in six large pictures, are the miracles of the same S. John the Evangelist.

In the Church of the Frati Zoccolanti, on the left hand, there is a large panel-picture of the Conversion of S. Paul, a very

beautiful work, by the hand of the same man. And for the high-altar of S. Benedetto in Pollirone, a place twelve miles distant from Mantua, he has executed a panel-picture of Christ in the Manger being adored by the Shepherds, with Angels singing. He has also painted – but I do not know exactly at what time – a most beautiful picture of five Loves, one of whom is sleeping, and the others are despoiling him, one taking away his bow, another his arrows, and the others his torch, which picture belongs to the Lord Duke Ottavio, who holds it in great account by reason of the excellence of Girolamo. This master has in no way fallen short of the standard of his cousin Francesco, being a fine painter, gentle and courteous beyond belief; and since he is still alive, there are seen issuing from his brush other works of rare beauty, which he has constantly in hand.

A close friend of the aforesaid Francesco Mazzuoli was Messer Vincenzio Caccianimici, a gentleman of Bologna, who painted and strove to the best of his power to imitate the manner of Francesco. This Vincenzio was a very good colourist, so that the works which he executed for his own pleasure, or to present to his friends and various noblemen, are truly well worthy of praise; and such, in particular, is a panel-picture in oils, containing the Beheading of S. John the Baptist, which is in the chapel of his family in S. Petronio. This talented gentleman, by whose hand are some very beautiful drawings in our book, died in the year 1542.

JACOPO PALMA AND LORENZO LOTTO,
Painters of Venice
[*PALMA VECCHIO*]

So potent are mastery and excellence, even when seen in only one or two works executed to perfection by a man in the art that he practises, that, no matter how small these may be, craftsmen and judges of art are forced to extol them, and writers are compelled to celebrate them and to give praise to the craftsman who has made them; even as we are now about to do for the Venetian Palma. This master, although not very eminent, nor remarkable for perfection of painting, was nevertheless so careful and diligent, and subjected himself so zealously to the labours of art, that a certain proportion of his works, if not all, have something good

in them, in that they are close imitations of life and of the natural appearance of men.

Palma was much more remarkable for his patience in harmonizing and blending colours than for boldness of design, and he handled colour with extraordinary grace and finish. This may be seen in Venice from many pictures and portraits that he executed for various gentlemen; but of these I shall say nothing more, since I propose to content myself with making mention of some altar-pieces and of a head that I hold to be marvellous, or rather, divine. One of the altar-pieces he painted for S. Antonio, near Castello, at Venice, and another for S. Elena, near the Lido, where the Monks of Monte Oliveto have their monastery. In the latter, which is on the high-altar of that church, he painted the Magi presenting their offerings to Christ, with a good number of figures, among which are some heads truly worthy of praise, as also are the draperies, executed with a beautiful flow of folds, which cover the figures. Palma also painted a life-size S. Barbara for the altar of the Bombardieri in the Church of S. Maria Formosa, with two smaller figures at the sides, S. Sebastian and S. Anthony; and the S. Barbara is one of the best figures that this painter ever executed. The same master also executed another altar-piece, in which is a Madonna in the sky, with S. John below, for the Church of S. Moisè, near the Piazza di S. Marco. In addition to this, Palma painted a most beautiful scene for the hall wherein the men of the Scuola of S. Marco assemble, on the Piazza di SS. Giovanni e Paolo, in emulation of those already executed by Giovanni Bellini, Giovanni Mansueti, and other painters. In this scene is depicted a ship which is bringing the body of S. Mark to Venice; and there may be seen counterfeited by Palma a terrible tempest on the sea, and some barques tossed and shaken by the fury of the winds, all executed with much judgment and thoughtful care. The same may be said of a group of figures in the air, and of the demons in various forms who are blowing, after the manner of winds, against the barques, which, driven by oars, and striving in various ways to break through the dangers of the towering waves, are like to sink. In short, to tell the truth, this work is of such a kind, and so beautiful in invention and in other respects, that it seems almost impossible that brushes and colours, employed by human hands, however excellent, should be able to depict anything more true to reality or more natural; for in it may be seen the fury of the winds, the

strength and dexterity of the men, the movements of the waves, the lightning-flashes of the heavens, the water broken by the oars, and the oars bent by the waves and by the efforts of the rowers. Why say more? I, for my part, do not remember to have ever seen a more terrible painting than this, which is executed in such a manner, and with such care in the invention, the drawing, and the colouring, that the picture seems to quiver, as if all that is painted therein were real. For this work Jacopo Palma deserves the greatest praise, and the honour of being numbered among those who are masters of art and who are able to express with facility in their pictures their most sublime conceptions. For many painters, in difficult subjects of that kind, achieve in the first sketch of their work, as though guided by a sort of fire of inspiration, something of the good and a certain measure of boldness; but afterwards, in finishing it, the boldness vanishes, and nothing is left of the good that the first fire produced. And this happens because very often, in finishing, they consider the parts and not the whole of what they are executing, and thus, growing cold in spirit, they come to lose their vein of boldness; whereas Jacopo stood ever firm in the same intention and brought to perfection his first conception, for which he received vast praise at that time, as he always will.

But without a doubt, although the works of this master were many, and all much esteemed, that one is better than all the others and truly extraordinary in which he made his own portrait from life by looking at himself in a mirror, with some camel-skins about him, and certain tufts of hair, and all so lifelike that nothing better could be imagined. For so much did the genius of Palma effect in this particular work, that he made it quite miraculous and beautiful beyond belief, as all men declare, the picture being seen almost every year at the Festival of the Ascension. And, in truth, it well deserves to be celebrated, in point of draughtsmanship, colouring, and mastery of art – in a word, on account of its absolute perfection – beyond any other work whatsoever that had been executed by any Venetian painter up to that time, since, besides other things, there may be seen in the eyes a roundness so perfect, that Leonardo da Vinci and Michelagnolo Buonarroti would not have done it in any other way. But it is better to say nothing of the grace, the dignity, and the other qualities that are to be seen in this portrait, because it is not possible to say as much of its perfection as would exhaust its

IACOMO PALMA PITTOR
VINIZIANO.

merits. If Fate had decreed that Palma should die after this work, he would have carried off with him the glory of having surpassed all those whom we celebrate as our rarest and most divine intellects; but the duration of his life, keeping him at work, brought it about that, not maintaining the high beginning that he had made, he came to deteriorate as much as most men had thought him destined to improve. Finally, content that one or two supreme works should have cleared him of some of the censure that the others had brought upon him, he died in Venice at the age of forty-eight.

A friend and companion of Palma was Lorenzo Lotto, a painter of Venice, who, after imitating for some time the manner of the Bellini, attached himself to that of Giorgione, as is shown by many pictures and portraits which are in the houses of gentlemen in Venice. In the house of Andrea Odoni there is a portrait of him, which is very beautiful, by the hand of Lorenzo. And in the house of Tommaso da Empoli, a Florentine, there is a picture of the Nativity of Christ, painted as an effect of night, which is one of great beauty, particularly because the splendour of Christ is seen to illuminate the picture in a marvellous manner; and there is the Madonna kneeling, with a portrait of Messer Marco Loredano in a full-length figure that is adoring Christ. For the Carmelite Friars the same master painted an altar-piece showing S. Nicholas in his episcopal robes, poised in the air, with three Angels; below him are S. Lucia and S. John, on high some clouds, and beneath these a most beautiful landscape, with many little figures and animals in various places. On one side is S. George on horseback, slaying the Dragon, and at a little distance the Maiden, with a city not far away, and an arm of the sea. For the Chapel of S. Antonino, Archbishop of Florence, in SS. Giovanni e Paolo, Lorenzo executed an altar-piece containing the first-named Saint seated with two priests in attendance, and many people below.

While this painter was still young, imitating partly the manner of the Bellini and partly that of Giorgione, he painted an altar-piece, divided into six pictures, for the high-altar of S. Domenico at Recanati. In the central picture is the Madonna with the Child in her arms, giving the habit, by the hands of an Angel, to S. Dominic, who is kneeling before the Virgin; and in this picture are also two little boys, one playing on a lute and the other on a rebeck. In the second picture are the Popes S. Gregory and

S. Urban; and in the third is S. Thomas Aquinas, with another saint, who was Bishop of Recanati. Above these are the three other pictures; and in the centre, above the Madonna, is a Dead Christ, supported by an Angel, with His Mother kissing His arm, and S. Magdalene. Over the picture of S. Gregory are S. Mary Magdalene and S. Vincent; and in the third – namely, above the S. Thomas Aquinas – are S. Gismondo and S. Catharine of Siena. In the predella, which is a rare work painted with little figures, there is in the centre the scene of S. Maria di Loreto being carried by the Angels from the regions of Sclavonia to the place where it now stands. Of the two scenes that are on either side of this, one shows S. Dominic preaching, the little figures being the most graceful in the world, and the other Pope Honorius confirming the Rule of S. Dominic. In the middle of this church is a figure of S. Vincent, the Friar, executed in fresco by the hand of the same master. And in the Church of S. Maria di Castelnuovo there is an altar-piece in oils of the Transfiguration of Christ, with three scenes painted with little figures in the predella – Christ leading the Apostles to Mount Tabor, His Prayer in the Garden, and His Ascension into Heaven.

After these works Lorenzo went to Ancona, at the very time when Mariano da Perugia had finished a panel-picture, with a large ornamental frame, for the high-altar of S. Agostino. This did not give much satisfaction; and Lorenzo was commissioned to paint a picture, which is placed in the middle of the same church, of Our Lady with the Child in her lap, and two figures of Angels in the air, in foreshortening, crowning the Virgin.

Finally, being now old, and having almost lost his voice, Lorenzo made his way, after executing some other works of no great importance at Ancona, to the Madonna of Loreto, where he had already painted an altar-piece in oils, which is in a chapel at the right hand of the entrance into the church. There, having resolved to finish his life in the service of the Madonna, and to make that holy house his habitation, he set his hand to executing scenes with figures one braccio or less in height round the choir, over the seats of the priests. In one scene he painted the Birth of Jesus Christ, and in another the Magi adoring Him. Next came the Presentation to Simeon, and after that the Baptism of Christ by John in the Jordan. There was also the Woman taken in Adultery being led before Christ, and all these were executed with

much grace. Two other scenes, likewise, did he paint there, with an abundance of figures; one of David causing a sacrifice to be offered, and in the other was the Archangel Michael in combat with Lucifer, after having driven him out of Heaven.

These works finished, no long time had passed when, even as he had lived like a good citizen and a true Christian, so he died, rendering up his soul to God his Master. These last years of his life he found full of happiness and serenity of mind, and, what is more, we cannot but believe that they gave him the earnest of the blessings of eternal life; which might not have happened to him if at the end of his life he had been wrapped up too closely in the things of this world, which, pressing too heavily on those who put their whole trust in them, prevent them from ever raising their minds to the true riches and the supreme blessedness and felicity of the other life.

There also flourished in Romagna at this time the excellent painter Rondinello, of whom we made some slight mention in the Life of Giovanni Bellini, whose disciple he was, assisting him much in his works. This Rondinello, after leaving Giovanni Bellini, laboured at his art to such purpose, that, being very diligent, he executed many works worthy of praise; of which we have witness in the panel-picture of the high-altar in the Duomo at Forlì, showing Christ giving the Communion to the Apostles, which he painted there with his own hand, executing it very well. In the lunette above this picture he painted a Dead Christ, and in the predella some scenes with little figures, finished with great diligence, representing the actions of S. Helena, the mother of the Emperor Constantine, in the finding of the Cross. He also painted a single figure of S. Sebastian, which is very beautiful, in a picture in the same church. For the altar of S. Maria Maddalena, in the Duomo of Ravenna, he painted a panel-picture in oils containing the single figure of that Saint; and below this, in a predella, he executed three scenes with very graceful little figures. In one is Christ appearing to Mary Magdalene in the form of a gardener, in another S. Peter leaving the ship and walking over the water towards Christ, and between them the Baptism of Jesus Christ; and all are very beautiful. For S. Giovanni Evangelista, in the same city, he painted two panel-pictures, one with that Saint consecrating the church, and in the other three martyrs, S. Cantius, S. Cantianus, and S. Cantianilla, figures of great beauty. In S. Apollinare, also in that city, are two pictures, highly extolled,

each with a single figure, S. John the Baptist and S. Sebastian. And in the Church of the Spirito Santo there is a panel, likewise by his hand, containing the Madonna placed between the Virgin Martyr S. Catharine and S. Jerome. For S. Francesco, likewise, he painted two panel-pictures, one of S. Catharine and S. Francis, and in the other Our Lady with S. James the Apostle, S. Francis, and many figures. For S. Domenico, in like manner, he executed two other panels, one of which, containing the Madonna and many figures, is on the left hand of the high-altar, and the other, a work of no little beauty, is on a wall of the church. And for the Church of S. Niccolò, a convent of Friars of S. Augustine, he painted another panel with S. Laurence and S. Francis. So much was he commended for all these works, that during his lifetime he was held in great account, not only in Ravenna but throughout all Romagna. Rondinello lived to the age of sixty, and was buried in S. Francesco at Ravenna.

This master left behind him Francesco da Cotignola, a painter likewise held in estimation in that city, who painted many works; in particular, for the high-altar of the Church of the Abbey of Classi in Ravenna, a panel-picture of some size representing the Raising of Lazarus, with many figures. There, opposite to that work, in the year 1548, Giorgio Vasari executed for Don Romualdo da Verona, Abbot of that place, another panel-picture containing the Deposition of Christ from the Cross, with a large number of figures. Francesco also painted a panel-picture of the Nativity of Christ, which is of great size, for S. Niccolò, and likewise two panels, with various figures, for S. Sebastiano. For the Hospital of S. Catarina he painted a panel-picture with Our Lady, S. Catharine, and many other figures; and for S. Agata he painted a panel with Christ Crucified, the Madonna at the foot of the Cross, and a good number of other figures, for which he won praise. And for S. Apollinare, in the same city, he executed three panel-pictures; one for the high-altar, containing the Madonna, S. John the Baptist, and S. Apollinare, with S. Jerome and other saints; another likewise of the Madonna, with S. Peter and S. Catharine; and in the third and last Jesus Christ bearing His Cross, but this he was not able to finish, being overtaken by death.

Francesco was a very pleasing colourist, but not so good a draughtsman as Rondinello; yet he was held in no small estimation by the people of Ravenna. He chose to be buried after his death in S. Apollinare, for which he had painted the said figures,

being content that his remains, when he was dead, should lie at rest in the place for which he had laboured when alive.

NOTES

These notes, which do not claim to be complete, are principally concerned with the current locations of works of art referred to by Vasari. The term *in situ* is employed to refer to works which have remained in the same building; it does not necessarily imply that a painting or statue may not have moved within a church or palace. Furthermore, some churches have been completely rebuilt since the Renaissance – St Peter's in Rome is an obvious example – but *in situ* still seems the most convenient way to refer to the works they contain.

p. 52 Reredos – Now in the Uffizi Gallery, Florence, and by the Master of St Cecilia.
St Francis – In the Bardi Chapel, and by the Master of the Bardi Chapel St Francis.
S. Trinita Madonna – Now in the Uffizi, Florence.

p. 53 Pisa Madonna – Now in the Louvre, Paris.

p. 54 Old and New Testament – Not by Cimabue, but by artists of the Roman School, including the so-called Isaac Master.

p. 55 Rucellai Madonna – By Duccio and in the Uffizi, Florence.

p. 57 Chapter-house – Now given to Andrea da Firenze, not Simone (Martini) da Siena.

p. 70 Sarcophagus – Still *in situ*. It represents Hippolytus and Phaedra.

p. 75 S. Giovanni (Baptistery) Pulpit – Still *in situ*.
Siena Pulpit – Still *in situ*.

p. 80 Pistoia Pulpit – Still *in situ*.

p. 81 Pisa Duomo Pulpit – Still *in situ*.

p. 98 Bardi and Peruzzi Chapels – Both contain three scenes on each wall.
Baroncelli Chapel – Giotto's Coronation is still *in situ*. The frescoes are by Taddeo Gaddi.

pp. 99–100 Modern scholarship tends to doubt that Giotto painted at Assisi.

p. 105 Navicella – Now in the Atrium of St Peter's, Rome, but much altered.

p. 111 Dormition – Now in the Berlin Gallery.

p. 112 The Arena or Scrovegni Chapel is Giotto's masterpiece.

Chapel frescoes, which were completed by Filippino Lippi.

p. 319 S. Ambrogio – Now in the Uffizi, Florence, and executed in collaboration with Masolino.

S. Niccolò Annunciation – By Masolino, and in the National Gallery of Art, Washington.

p. 320 The Pisa Altarpiece, of 1426, is divided between the National Gallery, London (Madonna), Capodimonte, Naples (Crucifixion), the Berlin Gallery (Adoration of Magi, etc.), and elsewhere.

pp. 320–21 S. Maria Maggiore – Divided between the National Gallery, London, the Philadelphia Museum of Art, and Capodimonte, Naples, this altarpiece is mostly by Masolino, with some assistance from Masaccio.

pp. 328–9 Both crucifixes are still *in situ*.

pp. 363–4 Annunciation – Only four putti survive, and are made of terracotta.

p. 365 Coscia Tomb – Still *in situ* in the Baptistery.

Magdalene – Now in the Museo dell' Opera del Duomo, Florence.

pp. 367–8 Judith – Now in the Palazzo Vecchio, Florence.

p. 368 David – Now in the Bargello, Florence.

p. 369 The Martelli David is in the National Gallery of Art, Washington. The St John (the Baptist) is in the Bargello, Florence. Neither is thought to be by Donatello.

p. 370 Archbishop's (Cardinal Brancacci) Tomb, Prato pulpit, Gattamelata – All still *in situ*.

p. 371 St Jerome – Now in the Museo Civico, Faenza, and not universally accepted as by Donatello.

The lavabo (waterstoup) is given to Verrocchio alone.

p. 372 St Louis of Toulouse – Now in the Museo dell' Opera at S. Croce.

p. 373 Mercury – Now called *Amor Attys*, and in the Bargello, Florence.

p. 389 Fra Giovanni (Angelico) Deposition – Now in the Museo di S. Marco, Florence.

p. 399 Dead Christ – Now in the Pinacoteca Ambrosiana, Milan.

S. Agostino – Four panels of Saints (National Gallery, London, Frick Collection, New York, Museo Poldi

Pezzoli, Milan, Museo de Arte Antiqua, Lisbon) from this altarpiece are known.

Misericordia – An altarpiece on panel now in the Pinacoteca, Borgo San Sepolcro.

Resurrection – Still *in situ*.

Loreto – These frescoes are by Melozzo da Forlì.

S. Francesco – Still *in situ*.

p.401 Magdalene – Still *in situ*.

Perugia Altarpiece – Now in the Galleria Nazionale dell' Umbria there.

p.403 catarrh = cataract.

p.405 S. Marco Altarpiece – The main panel is in the Museo di S. Marco. The predella is now divided between the Louvre, Paris, the National Gallery of Ireland, Dublin, and the Alte Pinakothek, Munich.

S. Domenico Altarpiece – Still *in situ*.

Annunciation – Now in the Museo Diocesano, Fiesole.

p.406 Fiesole Coronation – Now in the Louvre, Paris.

Nunziata – Now in the Museo di S. Marco, Florence.

pp.406–7 Deposition and Linen-manufacturers – Both now in the Museo di S. Marco, Florence.

p.407 Dead Christ, Last Judgment, and S. Piero Martire – All now in the Museo di S. Marco, Florence.

p.427 The surviving fragments of the S. Cassiano Altarpiece are in the Kunsthistorisches Museum, Vienna.

p.429 Andrea Riccio (of Padua) – The real author of the statues was Antonio Rizzo of Verona.

p.433 The bronze bas-reliefs were started by Bellano (Vellano), and completed by Riccio, who was also responsible for the candelabrum.

p.436 Confirmation of Rule – Still in S. Maria del Carmine.

p.437 Coronation (S. Ambrogio), S. Croce, Camaldolite Nativity – All three in the Uffizi, Florence.

Medici Nativity – Now in the Berlin Gallery.

p.438 Signoria pictures – Both now in the National Gallery, London.

S. Spirito – Now in the Louvre, Paris.

Marsuppini – Now in the Pinacoteca Vaticana, Rome.

Annalena – Now in the Uffizi, Florence.

pp.439–40 Death of St Bernard (*recte* St Jerome) – Now in the Prato Gallery.

p.441 Nativity of the Virgin – Now in the Pitti Palace, Florence.

St Augustine – The picture by Botticelli now in the Uffizi, Florence.

p.442 St Lawrence – Now in the Metropolitan Museum of Art, New York.

pp.448–9 Crucifixion – Now in the Museo del Castagno, Florence.

p.449 Famous Men – Now in the Uffizi, Florence.

Both the St Julian and the St Jerome are now visible.

Baptist and St Francis – By Domenico Veneziano, and in the Museo at S. Croce.

p.451 Carnesecchi – Now in the National Gallery, London.

p.453 S. Miniato – Now in the Berlin Gallery.

Famous Men – Now in the Uffizi, Florence.

p.455 Magi – Now in the Uffizi, Florence.

S. Niccolò – The Virgin and Child are in the Royal Collection; the four attendant saints are in the Uffizi, Florence. Four scenes from the predella are in the Pinacoteca Vaticana, Rome; the fifth is in the National Gallery of Art, Washington.

Perugia – Now in the Galleria Nazionale dell' Umbria.

p.459 Francesco Peselli – Pesellino.

Predella – Now in the Uffizi, and by Pesellino.

p.460 S. Jacopo – Now in the National Gallery, London. By Pesellino, and completed by Fra Filippo Lippi. A fifth predella panel is in the Hermitage, St Petersburg.

p.461 Company of St Mark – Now in the National Gallery, London.

p.463 Ascension – The remaining fragments are in the Pinacoteca Vaticana, Rome.

p.468 Organ doors – Now in the Museo dell' Opera del Duomo.

p.469 Empoli St Sebastian – Now in the Museo della Collegiata there.

p.480 Lorenzo Costa – Vasari confuses him with Francesco del Cossa.

p.481 St Vincent – The main panel, by Cossa, is in the National Gallery, London.

p.482 Ercole de' Roberti's predella is in the Pinacoteca Vaticana, Rome.

	Ghedini (Chedini) Altarpiece – By Costa and still *in situ*.
p.483	Mazzolino Dispute of Christ – Now in the Berlin Gallery.
pp.483–4	Garganelli frescoes – In S. Pietro, not S. Petronio. Destroyed, but in part known through copies.
p.485	Predella – Two elements are in the Gemäldegalerie, Dresden, one in the Walker Art Gallery, Liverpool.
p.492	Pesaro Coronation – Now in the Museo Civico there. S. Michele – Either the Resurrection in Berlin or the Madonna and Saints in Düsseldorf.
p.497	S. Ambrogio Altarpiece and Chapel – Still *in situ*. Altarpiece of the Chapel of St Barbara – Accademia, Florence. Cestello High Altar – Coronation of the Virgin, S. Maria Maddalena dei Pazzi, Florence. Picture for another chapel in the same church – Madonna and Child with St Thomas and St Augustine, now in S. Spirito, Florence.
p.518	Nativity – Still *in situ*. St Justus Altarpiece – Now in the Uffizi, Florence. Visitation – Now in the Louvre, Paris. Innocenti Magi – Now in the Museo there.
pp.518–19	Round picture of Magi – Now in the Uffizi, Florence.
pp.524–5	The front side of the Tornabuoni Altarpiece is in the Alte Pinakothek, Munich; the back is in the Berlin Gallery.
p.527	Rimini Altarpiece – Now in the Pinacoteca there.
p.530	Feast of Herod, and candelabrum – Both in the Museo dell' Opera del Duomo.
pp.531–2	S. Miniato Saints – Now in the Uffizi, Florence. Tobias and Raphael – By Piero, and now in the Galleria Sabauda, Turin. Virtues – Now in the Uffizi, Florence. St Sebastian – Now in the National Gallery, London.
pp.532–3	Hercules panels – These large paintings have disappeared. Small versions of Hercules and Antaeus, and Hercules and the Hydra, are in the Uffizi, Florence.
p.533	St Michael – Possibly the painting by Piero in the Museo Bardini, Florence.
p.534	The drawings are in the Metropolitan Museum of Art,

New York, and the Graphische Sammlung in Munich.
Pazzi Medal – Actually by Bertoldo di Giovanni.

p. 535 Embroidery – The remaining elements are in the Museo dell' Opera del Duomo, Florence.

p. 537 Nastagio – Three of the scenes are in the Prado, Madrid; the fourth in a Private Collection, Florence.
Annunciation – Now in the Uffizi, Florence.
Assumption – By Francesco Botticini, and in the National Gallery, London.
Magi – Now in the Uffizi, Florence.

p. 538 Dante drawings – Now in the Kupferstichkabinett, Berlin.

p. 542 Calumny – Now in the Uffizi, Florence.

p. 549 Horse – Now at the Capitol, Rome.

p. 550 David – Now in the Bargello, Florence.

p. 552 Boy – Now in the Pitti Palace, Florence.

p. 553 Marsyas – Now in the Uffizi, Florence.

p. 554 Forteguerri – The Tomb is in part by Verrocchio. A terracotta model for it is in the Victoria and Albert Museum, London.

p. 558 Eremitani – Only the Assumption and Martyrdom of St Christopher survived bombing in World War II.

p. 560 St Luke – Now in the Brera, Milan.
S. Maria in Organo – Now in the Castello Sforzesco, Milan.
S. Zeno – Still *in situ*.
Madonna for Abbot – Probably the panel in the Brera, Milan.

p. 561 Castle Chapel – The so-called Uffizi triptych was probably part of this decoration.
Triumph of Caesar – Now in the Royal Collection, Hampton Court.

pp. 562–3 Madonna and Child – The Madonna of the Quarries. Now in the Uffizi, Florence.

p. 563 Judith drawing – Now in the Uffizi, Florence.
Madonna della Vittoria – Now in the Louvre, Paris.
Pesaro Zoppo – Now in the Berlin Gallery.

p. 566 St Bernard – Now in the Badia, Florence.
St Pancrazio – Now in the National Gallery, London.
Crucifixion – Formerly in the Berlin Gallery; presumed destroyed in World War II.

Prato Virgin and Saints – Actually by Fra Filippo Lippi and in the Galleria Comunale, Prato.

pp. 569–70 Magi, Signoria Madonna and Saints – Both in the Uffizi, Florence.

pp. 571–3 Library – Still *in situ*. Related drawings by Raphael are in the Uffizi, and the Pierpont Morgan Library, New York.

p. 575 Assumption – Now in Capodimonte, Naples.

p. 578 Felicini – Now in the Pinacoteca Nazionale, Bologna.

pp. 578–9 Nativity and Annunciation – Both in the Pinacoteca Nazionale, Bologna.

p. 580 Baptism – Now in the Gemäldegalerie, Dresden.

Annunciation – Now in the Galleria Estense, Modena, but by Francesco Bianchi Ferrari.

Madonna and Saints – Formerly in the Berlin Gallery; presumed destroyed in World War II.

Dead Christ – Now in the Pinacoteca Nazionale, Parma.

Circumcision – In the Church of the Madonna del Monte, Cesena.

Crucifixion – Now in the Louvre, Paris.

S. Frediano (Fridiano) Altarpiece – Now in the National Gallery, London.

Manzuoli Madonna – Now in the Pinacoteca Nazionale, Bologna.

p. 581 Lucretia – Now in the Gemäldegalerie, Dresden.

pp. 585–6 Dead Christ – Now in the Pitti Palace, Florence.

p. 588 Agony in the Garden and Pietà – Both now in the Uffizi, Florence.

p. 590 St Sebastian – Now in the Louvre, Paris.

Vallombrosa – Now in the Uffizi, Florence.

Certosa – Three panels now in the National Gallery, London.

p. 592 Marriage of Virgin – Now at the Musée des Beaux-Arts, Caen.

p. 593 St Bernard – Now in the Alte Pinakothek, Munich.

Deposition – Now in the Accademia, Florence.

p. 594 The Ascension is now in the Musée des Beaux-Arts, Rouen.

pp. 595–6 Bacchiaccha – The Borgherini panels are in the National Gallery, London.

p.601 The frescoes in the Chapel of S. Giorgio are still *in situ*, and attributed to Altichiero (Aldigieri) and Avanzi.

p.603 Vincenzio – Foppa.

St Ursula cycle – Now in the Accademia, Venice.

Frari Altarpiece – Still *in situ*, but by Alvise Vivarini and Marco Basaiti.

Martyrs and Presentation – Both now in the Accademia, Venice.

p.604 Lazzaro and Sebastian – Lazzaro Bastiani.

Corpus Domini – Now in the Brera, Milan.

Marco Basarini – Basaiti.

Agony in the Garden – Now in the Accademia, Venice.

p.605 Basaiti's Calling of the Sons of Zebedee – Now in the Accademia, Venice.

p.606 Torbido (Turbido) Portrait – Possibly the picture fitting this description now in the Museo Civico, Padua.

p.610 Perugia, Virgin and Child with Saints Onofrius, Ercolano, John the Baptist, Stephen – Now in the Museo del Duomo, Perugia.

S. Francesco, Volterra – Circumcision, now in the National Gallery, London.

S. Agostino, Volterra – Virgin and Child with Saints, now in the Galleria Communale, Volterra; the predella praised by Vasari is either lost or unidentified.

S. Francesco, Città di Castello – Adoration of the Shepherds, now in the National Gallery, London.

S. Domenico, Città di Castello – Martyrdom of St Sebastian, now in the Pinacoteca Communale, Città di Castello.

S. Margherita, Cortona – Lamentation, now in the Museo Diocesano, Cortona.

p.611 Compagnia del Gesù, Cortona – Communion of the Apostles, now in the Museo Diocesano, Cortona.

Cortona, high altar of Cathedral – Assumption of the Virgin, now in the Museo Diocesano, Cortona.

Castiglione Aretino (now called Castiglione Fiorentino) – Lamentation, now in the Collegiata, Castiglione Fiorentino.

S. Francesco, Lucignano – the doors have been

dismantled and Signorelli's work probably lost, but the tree is in the Museo Communale, Lucignano.

S. Agostino, Siena – Bichi chapel, wings for sculpted altarpiece depicting St Christopher (dismantled).

> Wings: Saints Catherine of Siena, Mary Magdalene and Jerome; Saints Augustine, Catherine of Alexandria and Anthony of Padua. These are now in the Gemäldegalerie, Berlin-Dahlem.
>
> Nudes in a Landscape – Now in the Toledo Museum of Art, Toledo, Ohio.
>
> Predella panels: Martyrdom of St Catherine of Alexandria – Now in the Sterling and Francine Clark Art Institute, Williamstown, Massachusetts.
>
> Feast in the House of Simon – Now in the National Gallery of Ireland, Dublin.
>
> Lamentation – Now in the Stirling-Maxwell Collection, Pollockshaws, Scotland.
>
> Fragment of a fresco with Sybil Eritrea – *in situ.*

Medici Villa, Castello – Virgin and Child, now in the Uffizi, Florence.

Audience Hall, Guelph Party Palace, Florence – tondo of Virgin and Child, now in the Uffizi, Florence.

Monte Oliveto, Cloister, wall with stories from the life of St Benedict – *in situ.*

Montepulciano – Work unspecified by Vasari, but there is a small altarpiece of the Virgin and Child by Signorelli's workshop in the church of S. Lucia.

Foiano – Collegiata de S. Martino, Coronation of the Virgin. *In situ*, attributed to Signorelli's workshop.

Orvieto – Capella Nuova o di S. Brizio. *In situ*, vault started by Fra Angelico and finished by Signorelli; walls by Signorelli.

p.612 Loreto – Basilica della S. Casa, Sacristy. Fresco in vault depicting Evangelists, etc. is still *in situ.*

Vatican, Sistine Chapel – The Testament of Moses, *in situ.*

S. Margherita, Arezzo – Virgin and Child with Saints Francis, Claire, Margaret and Mary Magdalene, now in the Pinacoteca, Arezzo. The predella is in the Museo Diocesano, Cathedral Sacristy, Arezzo.

pp.612–13 Compagnia di S. Girolamo, Arezzo – Virgin and

Child with Saints, now in the Pinacoteca, Arezzo. The predella panels – Esther before Ahasuerus, and Three Visions of the Triumph of St Jerome – Now in the National Gallery, London.

pp.613–14 Passerini Palace (called il Palazzone) – Baptism of Christ, *in situ* but later repainted; originally by Signorelli's workshop to his designs.

p.619 Laocoon etc. – All these statues are in the Vatican, with the exception of the Farnese Hercules, which is in the Museo Archaeologico, Naples.

p.628 Baptism – Now in the Uffizi, Florence.

p.630 Madonna – Possibly the picture in the Alte Pinakothek, Munich.

Neptune – A preparatory drawing is in the Royal Library, Windsor.

Medusa – A related picture, not by Leonardo, is in the Uffizi, Florence.

pp.631–3 Last Supper – Much damaged, but still *in situ*.

p.633 Portrait of Duke – Not by Leonardo; the fresco of the Passion is by Montorfano.

p.635 Cartoon – This is not to be confused with the cartoon in the National Gallery, London.

Ginevra de' Benci – Now in the National Gallery of Art, Washington.

pp.635–6 Mona Lisa – Now in the Louvre, Paris.

pp.636–7 Sala del Papa cartoon – The composition is known through copies, and depicts the Battle of Anghiari.

p.640 Rustici group – Still *in situ*.

Misericordia Altarpiece – Now in the Louvre, Paris.

pp.641–2 David – Now in the Herzog Anton Ulrich-Museum, Braunschweig.

p.643 Fondaco – Surviving fragments are in the Cà d'Oro, Venice.

pp.643–4 Christ carrying the Cross – Now in the Scuola di San Rocco, and variously attributed to Giorgione and Titian.

p.646 Vasari confuses the Duomo cupola with the one in S. Giovanni Evangelista.

Dead Christ – This and the Martyrdom of Saints Placidus and Flavia, originally in S. Giovanni Evangelista, are now in the Galleria Nazionale, Parma.

The Assumption is in the Duomo, Parma.

p. 647 Annunciation, Virgin and Child, Virgin and Child with St Jerome and Mary Magdalene – All three works now in the Galleria Nazionale, Parma.

pp. 647–8 Leda and Venus – Vasari's description contains elements of the Leda (Berlin), the Danaë (Borghese Gallery, Rome) and the Io (Kunsthistorisches Museum, Vienna).

p. 648 Modena picture – Possibly the Mystic Marriage of St Catherine with St Sebastian in the Louvre, Paris.

Noli me tangere – Now in the Prado, Madrid.

pp. 648–9 Agony in the Garden – Now in the Wellington Museum, London.

p. 651 Visitation – Now in the National Gallery of Art, Washington.

p. 655 Servi Altarpiece – Now in the Uffizi, Florence.

p. 657 Madonna and Saints – Now in the Museum of the Spedale degli Innocenti.

Immaculate Conception – Still *in situ*.

Silenus – Now in the Art Museum, Worcester (Mass.).

p. 660 S. Maria della Bella – These panels are now in the Museum of Fine Arts, Boston, and the Metropolitan Museum, New York.

p. 671 Nativity and Circumcision – Now in the Uffizi, Florence.

Last Judgment – Now in the Museo di San Marco, Florence.

p. 674 St Bernard – Now in the Uffizi, Florence.

King of France's picture – Now in the Louvre, Paris.

S. Marco Altarpiece – Now in the Pitti Palace, Florence.

p. 676 St Peter and St Paul – Now in the Pinacoteca Vaticana, Rome.

p. 677 Nunziata picture – Now in the Pitti Palace, Florence.

p. 678 Virgin and Child with St Stephen and St John the Baptist; Madonna della Misericordia; Christ (*recte* God the Father) – All three pictures are now in the Pinacoteca, Lucca.

Assumption – Now in Capodimonte, Naples.

p. 679 'A nun who paints' (Sor Plautilla Nelli) – A considerable number of these drawings are in the Boymans–Van Beuningen Museum, Rotterdam.

Contemplanti – Formerly in the Berlin Museum; supposedly destroyed in World War II.

Purification – Now in the Kunsthistorisches Museum, Vienna.

Christ and Pilgrims (Cleophas and Luke) – Now in the Ospizio della Maddalena, Le Caldine.

S. Jacopo – The Pietà now in the Pitti Palace, Florence.

p.680 Rape of Dinah (completed by Bugiardini) – Now in the Kunsthistorisches Museum, Vienna.

Council Chamber picture – Now in the Museo di S. Marco, Florence.

p.683 Certosa fresco – Still *in situ*.

S. Giuliano and Trinity – Both now in the Accademia, Florence.

p.684 Annunciation – Now in the Accademia, Florence.

Virgin with St Jerome and St Zanobius – Now in the Louvre, Paris.

p.685 S. Martino Visitation – Now in the Uffizi, Florence.

p.688 Resurrection – Now in the Uffizi, Florence.

p.689 St Bernard – Still *in situ*.

pp.689–90 S. Salvi picture – Now in the Louvre, Paris.

p.695 England – Notably the Tomb of Henry VII in Westminster Abbey.

p.696 St Jerome – Now in the Seville Museum.

p.708 Madonna and Child with St Anne – Still *in situ*.

p.712 Assumption – Now in the Pinacoteca Vaticana, Rome.

Crucifixion – Now in the National Gallery, London.

Marriage of Virgin – Now in the Brera, Milan.

p.713 Nasi – The Madonna del Cardellino, now in the Uffizi, Florence.

p.714 Ansidei Madonna – Now in the National Gallery, London.

S. Severo – Still *in situ*.

S. Antonio – Now in the Metropolitan Museum, New York.

p.715 The Agony is in the Metropolitan Museum, New York; Christ carrying the Cross in the National Gallery, London; the Lamentation in the Isabella Stewart Gardner Museum, Boston.

Baglioni Entombment – Now in the Borghese Gallery, Rome.

Doni Portraits – Now in the Pitti Palace, Florence.

pp. 715–16 Canigiani – Now in the Alte Pinakothek, Munich.

p. 716 Dei – The Madonna del Baldacchino, now in the Pitti Palace, Florence.

pp. 716–17 Siena – La Belle Jardinière, now in the Louvre, Paris.

p. 719 Parnassus – Vasari describes the print after Raphael's first idea by Marcantonio Raimondi.

p. 722 Pope Julius – Now in the National Gallery, London.
Madonna – Now in the Musée Condé, Chantilly.

p. 733 Isaiah, Galatea, Pace – Still *in situ*.

p. 724 Madonna with St John, St Francis and St Jerome – Madonna of Foligno, now in the Pinacoteca Vaticana, Rome. The donor was Sigismondo de' Conti.

p. 728 Virgin with St Jerome and Angel Raphael – Madonna of the Fish, now in the Prado, Madrid.
Carpi Madonna – Now in Capodimonte, Naples.
St Cecilia – Now in the Pinacoteca Nazionale, Bologna.

p. 730 Vision of Ezekiel – Now in the Pitti Palace, Florence.
Nativity – Now in the Prado, Madrid.
Bindo Altoviti – Now in the National Gallery of Art, Washington.
Altoviti Madonna – Madonna dell' Impannata, now in the Pitti Palace, Florence.

pp. 730–31 Leo X and Cardinals – Now in the Uffizi, Florence.

pp. 731–2 Drawings for Dürer – One inscribed by Dürer now in the Albertina, Vienna.

p. 732 Christ bearing Cross – The Spasimo di Sicilia, now in the Prado, Madrid.

p. 737 Madonna with St Sisto and St Barbara – The Sistine Madonna, now in the Gemäldegalerie, Dresden.
St Michael – Now in the Louvre, Paris.

p. 739 Tapestry cartoons – Now in the Victoria and Albert Museum, London. Tapestries now in the Pinacoteca Vaticana, Rome.
St John – Now in the Uffizi, Florence.

pp. 739–40 Transfiguration – Now in the Pinacoteca Vaticana, Rome.

p. 770 Vision of St Bernard – Now in the Walters Art Gallery, Baltimore.
Cleopatra and Lucretia – Pictures of these subjects are in the Museum of Fine Arts, Budapest, and formerly

in a Private Collection, Cincinnati.

Cestello Madonna – Now in S. Maria Maddalena de' Pazzi, Florence.

p. 779 Madonna and Saints – Now in the Brera, Milan.

p. 782 St John the Evangelist – There is an Agony in the Garden by Viti in the City Art Gallery, Bristol.

p. 783 Della Robbia Assumption – Now in S. Chiara, Monte San Savino.

pp. 784–5 Corbellini – Still *in situ*.

p. 786 St John baptizing – Still *in situ*.

Popolo Tombs – Still *in situ*.

pp. 786–7 St Anne – Still *in situ*.

pp. 787ff. Loreto – Still *in situ*.

p. 801 Pistoia Madonna – Still *in situ*.

Virgin with St Julian and St Nicholas – Now in the Louvre, Paris.

Nativity – Now in the Uffizi, Florence.

p. 804 Jonah and Elijah, and Virgin – Still *in situ*.

p. 813 Magi cartoon and G. da Treviso (Girolamo Trevigi) picture – Both now in the National Gallery, London.

Adrian VI Tomb – In S. Maria dell' Anima, Rome.

p. 820 Assumption – Now in the Pinacoteca Vaticana, Rome.

Transfiguration (the 'panel-picture like the one by Raffaello') – Now in the Prado, Madrid.

p. 823 Passione Last Supper – Still *in situ*.

p. 825 Scalzo frescoes – Still *in situ*.

Noli me tangere – Now in the Museo di S. Salvi, Florence.

pp. 826ff. Nunziata frescoes – Still *in situ*.

p. 828 S. Salvi – Still *in situ*.

pp. 831–2 Madonna of the Harpies – Now in the Uffizi, Florence.

p. 835 Borgherini Joseph – Now in the Pitti Palace, Florence.

pp. 835–6 Head of Christ – Still *in situ*.

p. 836 Trinity – Now in the Pitti Palace, Florence.

p. 837 Charity – Now in the Louvre, Paris.

p. 839 Panciatichi Assumption – Now in the Pitti Palace, Florence.

p. 840 Poggio a Caiano – Still *in situ*.

p. 841 Baptist – Now in the Pitti Palace, Florence.

p. 842 Luco Pietà – Now in the Pitti Palace, Florence.

p. 843 Becuccio Altarpiece – Now in the Pitti Palace, Florence.

p.846 Pisa Saints – Still *in situ*.
 Madonna with St Joseph – Madonna del sacco, still *in situ*.
p.847 Vallombrosa Saints – Now in the Pitti Palace, Florence.
p.847 Serrazzana Altarpiece – Formerly in the Berlin Gallery; presumed destroyed in 1945.
pp.847–8 Annunciation – Now in the Pitti Palace, Florence.
pp.848–9 Lucrezia Portrait – Now in the Uffizi, Florence.
p.849 Assumption – Now in the Pitti Palace, Florence.
p.850 Palla Isaac – Now in the Gemäldegalerie, Dresden.
pp.850–51 Virgin – Now in the Pitti Palace, Florence.
p.851 Borgherini Virgin – Now in the Metropolitan Museum of Art, New York.
 Povolo Abraham – Now in the Cleveland Museum.
p.857 Passion of Christ – Now in the Museo Civico, Bologna.
p.858 Joseph and Potiphar's wife – Still *in situ*.
p.860 Cavalieri Cleopatra by Michelangelo – Now in the Uffizi, Florence.
 Cavalieri Boy pinched by Crab – Now in Capodimonte, Naples.
p.865 Danese da Carrara – Danese Cattaneo.
p.870 Christ disputing – Known through a copy *in situ*.
p.873 Florigorio – Still *in situ*.
pp.875–6 Spilimbergo – Still *in situ*.
p.876 S. Maria di Campagna – Actually in Piacenza, and still *in situ*.
 Madonna dell' Orto panel – Now in the Accademia, Venice.
pp.877–8 St Sebastian, St Roch, and St Catherine – Still *in situ*.
p.881 Sogliani Nativity – Now in the Collegiata, Castiglione Florentino.
p.885 S. Marco fresco – Still *in situ*.
p.893 S. Silvestro Chapel – Still *in situ*.
p.897 Christ carrying the Cross – Now in Capodimonte, Naples.
p.900 Assumption – Still *in situ*.
 S. Maria Nuova Madonna and Saints – Now in the Uffizi, Florence.
 Deposition – Now in the Pinacoteca, Volterra.
p.901 Dei Altarpiece – Now in the Pitti Palace, Florence.
 Marriage of the Virgin – Still *in situ*.

p.902 Moses defending the daughters of Jethro – Now in the Uffizi, Florence.

p.904 Deposition – Now in the Pinacoteca, Borgo San Sepolcro.

pp.905–6 Città di Castello Altarpiece – In the Duomo there.

p.907 Mars and Venus drawing – Now in the Louvre, Paris.

p.908 Bacchus – A version of this composition, possibly autograph, is in the Musée des Beaux-Arts, Luxembourg.

p.910 Dead Christ – Now in the Louvre, Paris.

p.931 Marco Cardisco St Augustine – Now in Capodimonte, Naples.

p.933 Parmigianino Baptism – Now in the Berlin Gallery.

p.934 Marriage of St Catherine – Now in S. Francesco, Bardi.

Madonna and two Saints – A copy is in the Pinacoteca Nazionale, Parma.

Holy Family – Now in the Prado, Madrid.

pp.934–5 Self-Portrait – Now in the Kunsthistorisches Museum, Vienna.

pp.935–6 Circumcision – Now in the Detroit Institute of Art.

p.937 Lorenzo Cibo – Now in the Statens Museum, Copenhagen.

Bufalini Altarpiece – Now in the National Gallery, London.

p.938 St Roch – Still *in situ*.

St Paul – Now in the Kunsthistorisches Museum, Vienna.

p.939 Madonna holding globe – Madonna della Rosa; now in the Gemäldegalerie, Dresden.

S. Margherita – Now in the Pinacoteca Nazionale, Bologna.

Vasari Madonna – Now in the Courtauld Institute, London.

pp.939–40 Charles V – Lost, but known through copies.

p.940 Steccata – Still *in situ*.

Cupid – Now in the Kunsthistorisches Museum, Vienna.

p.941 Madonna with sleeping Child – The Madonna of the Long Neck, now in the Uffizi, Florence.

Casalmaggiore Madonna – Now in the Gemäldegalerie, Dresden.

pp. 942–3 Mazuoli – Girolamo Bedoli; Joachim and Carmine –
Now in the Pinacoteca Nazionale, Parma.

p. 943 S. Alessandro and S. Sepolcro – Still *in situ*.
Organ doors – Now in Pinacoteca Nazionale, Parma.
Alessandro Portrait – Now in Pinacoteca Nazionale,
Parma.
Nativity – Still *in situ*.
St John – In the Duomo, Mantua. Five scenes from
the life of the Saint are in the Palazzo Ducale there.

p. 944 Nativity – Now in the Louvre, Paris.
Five Cupids – Now in the Musée Condé, Chantilly.

p. 945 S. Antonio – A fragment of this Marriage of the Virgin
was formerly in the Giovanelli Collection, Venice.
Present whereabouts unknown.
Magi – Now in the Brera, Milan.
St Barbara Altarpiece – Still *in situ*.
St Mark – Still *in situ*; the attribution is much disputed.

p. 947 Odoni Portrait – Now in the Royal Collection.
Carmine St Nicholas, and Giovanni e Paolo Antonius
– Still *in situ*.

pp. 947–8 Recanati Altarpiece – Now in the Pinacoteca Comun-
ale. An element of the predella is in the Kunsthistor-
isches Museum, Vienna.
Recanati Transfiguration – Now in the Pinacoteca
Comunale. The elements of the predella are in the
Hermitage, St Petersburg, and the Brera, Milan
(actually an Assumption).
Ancona Virgin and Child – Now in the Pinacoteca
Comunale there.

pp. 948–9 Loreto pictures – The David sacrificing is actually of
Abraham and Melchisidec. All six are in the Palazzo
Apostolico, Loreto.

INDEX

OF THE CRAFTSMEN MENTIONED IN VOLUME 1

NOTE.—*To bring this Index within as reasonable a compass as possible cross-references, such as* Agnolo Bronzino. See Bronzino, Agnolo, *are printed* Agnolo *Bronzino, the italics indicating the name under which the page-numbers will be found.*

JAMES JOYCE
Dubliners
A Portrait of the Artist as
a Young Man
Ulysses

FRANZ KAFKA
Collected Stories
The Castle
The Trial

JOHN KEATS
The Poems

SØREN KIERKEGAARD
Fear and Trembling and
The Book on Adler

MAXINE HONG KINGSTON
The Woman Warrior and
China Men
(US only)

RUDYARD KIPLING
Collected Stories
Kim

THE KORAN
(tr. Marmaduke Pickthall)

CHODERLOS DE LACLOS
Les Liaisons dangereuses

GIUSEPPE TOMASI DI
LAMPEDUSA
The Leopard

MIKHAIL LERMONTOV
A Hero of Our Time

PRIMO LEVI
If This is a Man and The Truce
(UK only)
The Periodic Table

NICCOLÒ MACHIAVELLI
The Prince

THOMAS MANN
Buddenbrooks
Collected Stories (UK only)
Death in Venice and Other Stories
(US only)
Doctor Faustus
Joseph and His Brothers
The Magic Mountain

MARCUS AURELIUS
Meditations

GABRIEL GARCÍA MÁRQUEZ
The General in His Labyrinth
Love in the Time of Cholera
One Hundred Years of Solitude

ANDREW MARVELL
The Complete Poems

W. SOMERSET MAUGHAM
Collected Stories

HERMAN MELVILLE
The Complete Shorter Fiction
Moby-Dick

JOHN STUART MILL
On Liberty and Utilitarianism

JOHN MILTON
The Complete English Poems

MARY WORTLEY MONTAGU
Letters

MICHEL DE MONTAIGNE
The Complete Works

THOMAS MORE
Utopia

VLADIMIR NABOKOV
Lolita
Pale Fire
Pnin
Speak, Memory

THE NEW TESTAMENT
(King James Version)

THE OLD TESTAMENT
(King James Version)

GEORGE ORWELL
Animal Farm
Nineteen Eighty-Four
Essays

THOMAS PAINE
Rights of Man
and Common Sense

BORIS PASTERNAK
Doctor Zhivago

SYLVIA PLATH
The Bell Jar (US only)

PLATO
The Republic
Symposium and Phaedrus

This book is set in GARAMOND, the first typeface in
the ambitious programme of matrix production
undertaken by the Monotype Corporation
under the guidance of Stanley Morrison
in 1922. Although named after the
great French royal typographer,
Claude Garamond (1499–
1561), it owes much to
Jean Jannon of Sedan
(1580–1658).

CHINUA ACHEBE
Things Fall Apart

AESCHYLUS
The Oresteia

ISABEL ALLENDE
The House of the Spirits

THE ARABIAN NIGHTS
(2 vols, tr. Husain Haddawy)

AUGUSTINE
The Confessions

JANE AUSTEN
Emma
Mansfield Park
Northanger Abbey
Persuasion
Pride and Prejudice
Sanditon and Other Stories
Sense and Sensibility

GIORGIO BASSANI
The Garden of the Finzi-Continis

SIMONE DE BEAUVOIR
The Second Sex

SAMUEL BECKETT
Molloy, Malone Dies,
The Unnamable
(US only)

SAUL BELLOW
The Adventures of Augie March

WILLIAM BLAKE
Poems and Prophecies

JORGE LUIS BORGES
Ficciones

JAMES BOSWELL
The Life of Samuel Johnson
The Journal of a Tour to
the Hebrides

CHARLOTTE BRONTË
Jane Eyre
Villette

EMILY BRONTË
Wuthering Heights

MIKHAIL BULGAKOV
The Master and Margarita

ITALO CALVINO
If on a winter's night a traveler

ALBERT CAMUS
The Plague, The Fall, Exile and
the Kingdom, and Selected Essays
The Outsider (UK)
The Stranger (US)

MIGUEL DE CERVANTES
Don Quixote

RAYMOND CHANDLER
The novels (2 vols)
Collected Stories

GEOFFREY CHAUCER
Canterbury Tales

ANTON CHEKHOV
The Complete Short Novels
My Life and Other Stories
The Steppe and Other Stories

CONFUCIUS
The Analects

JOSEPH CONRAD
Heart of Darkness
Lord Jim
Nostromo
The Secret Agent
Typhoon and Other Stories
Under Western Eyes
Victory

DANTE ALIGHIERI
The Divine Comedy

CHARLES DARWIN
The Origin of Species
The Voyage of the Beagle
(in 1 vol.)

DANIEL DEFOE
Moll Flanders
Robinson Crusoe

CHARLES DICKENS
Bleak House
David Copperfield
Dombey and Son
Great Expectations
Hard Times
Little Dorrit
Martin Chuzzlewit